AI for Games

AI for Games

Ian Millington

CRC Press Taylor & Francis Group 6000 Broken Sound Parkway NW, Suite 300 Boca Raton, FL 33487-2742

© 2019 by Taylor & Francis Group, LLC CRC Press is an imprint of Taylor & Francis Group, an Informa business

No claim to original U.S. Government works

Version Date: 20190221

International Standard Book Number-13: 978-1-138-48397-2 (Hardback)

This book contains information obtained from authentic and highly regarded sources. Reasonable efforts have been made to publish reliable data and information, but the author and publisher cannot assume responsibility for the validity of all materials or the consequences of their use. The authors and publishers have attempted to trace the copyright holders of all material reproduced in this publication and apologize to copyright holders if permission to publish in this form has not been obtained. If any copyright material has not been acknowledged please write and let us know so we may rectify in any future reprint.

Except as permitted under U.S. Copyright Law, no part of this book may be reprinted, reproduced, transmitted, or utilized in any form by any electronic, mechanical, or other means, now known or hereafter invented, including photocopying, microfilming, and recording, or in any information storage or retrieval system, without written permission from the publishers.

For permission to photocopy or use material electronically from this work, please access www.copyright.com (http://www.copyright.com/) or contact the Copyright Clearance Center, Inc. (CCC), 222 Rosewood Drive, Danvers, MA 01923, 978-750-8400. CCC is a not-for-profit organization that provides licenses and registration for a variety of users. For organizations that have been granted a photocopy license by the CCC, a separate system of payment has been arranged.

Trademark Notice: Product or corporate names may be trademarks or registered trademarks, and are used only for identification and explanation without intent to infringe.

Library of Congress Cataloging-in-Publication Data

Names: Millington, Ian, author.

Title: AI for games / Ian Millington.

Other titles: AI for games

Description: Third edition. | Boca Raton: Taylor & Francis, a CRC title, part of the Taylor & Francis imprint, a member of the Taylor & Francis Group, the academic division of T&F Informa, plc, [2019] | Includes

bibliographical references.

Identifiers: LCCN 2018041305 | ISBN 9781138483972 (hardback: acid-free paper)

Subjects: LCSH: Computer games--Programming. | Computer animation. |

Artificial intelligence.

Classification: LCC QA76.76.C672 M549 2019 | DDC 794.8/1525--dc23

LC record available at https://lccn.loc.gov/2018041305

Visit the Taylor & Francis Web site at http://www.taylorandfrancis.com

and the CRC Press Web site at http://www.crcpress.com

for Daniel
my favorite game designer

CONTENTS

	PART I AI and Games	1
CHAPTER	INTRODUCTION	3
1	1.1 What Is AI?	4
	1.1.1 Academic AI	5
	1.1.2 Game AI	8
	1.2 Model of Game AI	10
	1.2.1 Movement	11
	1.2.2 Decision Making	11
	1.2.3 Strategy	12
	1.2.4 Infrastructure	12
	1.2.5 Agent-Based AI	13 13
	1.3 Algorithms and Data Structures	
	1.3.1 Algorithms	14
	1.3.2 Representations	14 17
	1.3.3 Implementation	18
	1.4 Layout of the Book	18
CHAPTER	GAME AI	21
2	2.1 The Complexity Fallacy	21
	2.1.1 When Simple Things Look Good	21
	2.1.2 When Complex Things Look Bad	22
	2.1.3 The Perception Window	23
	2.1.4 Changes of Behavior	24
	2.2 The Kind of AI in Games	24
	2.2.1 Hacks	25
	2.2.2 Heuristics	26

viii CONTENTS

	2.3 Spee	d and Memory Constraints	28
	2.3.1	Processor Issues	28
	2.3.2	Memory Concerns	30
	2.3.3	Platforms	32
	2.4 The	AI Engine	35
	2.4.1	Structure of an AI Engine	35
	2.4.2	Tool Concerns	37
	2.4.3	Putting It All Together	37
	PART I		39
CHAPTER	MOVE	4ENT	41
3	3.1 The	Basics of Movement Algorithms	42
	3.1.1	Two-Dimensional Movement	43
	3.1.2	Statics	44
	3.1.3	Kinematics	47
		ematic Movement Algorithms	51
	3.2.1	Seek	51
	3.2.2	Wandering	54
	3.3 Stee	ring Behaviors	56
	3.3.1	Steering Basics	
	3.3.2	Variable Matching	
	3.3.3	Seek and Flee	58
	3.3.4	Arrive	60
	3.3.5	Align	63
	3.3.6	Velocity Matching	67
	3.3.7	Delegated Behaviors	
	3.3.8	Pursue and Evade	68
	3.3.9	Face	. 72
	3.3.10	Looking Where You're Going	. 72
	3.3.11	Wander	73
	3.3.12	Path Following	
	3.3.13	Separation	
	3.3.14	Collision Avoidance	
	3.3.15	Obstacle and Wall Avoidance	. 90
	3.3.16	Summary	. 95

3.4	Com	bining Steering Behaviors
	3.4.1	Blending and Arbitration
	3.4.2	Weighted Blending
	3.4.3	Priorities
	3.4.4	Cooperative Arbitration
	3.4.5	Steering Pipeline
3.5	Pred	icting Physics
	3.5.1	Aiming and Shooting
	3.5.2	Projectile Trajectory
	3.5.3	The Firing Solution
	3.5.4	Projectiles with Drag
	3.5.5	Iterative Targeting
3.6	Jumi	ping
	3.6.1	Jump Points
	3.6.2	Landing Pads
	3.6.3	Hole Fillers
3.7		rdinated Movement
5.7	3.7.1	Fixed Formations
	3.7.2	Scalable Formations
	3.7.3	Emergent Formations
	3.7.4	Two-Level Formation Steering
	3.7.5	Implementation
	3.7.6	Extending to More Than Two Levels
	3.7.7	Slot Roles and Better Assignment
	3.7.8	Slot Assignment
	3.7.9	Dynamic Slots and Plays
	3.7.10	Tactical Movement
3.8		
3.0		or Control
	3.8.1	Output Filtering
		Capability-Sensitive Steering
• •	3.8.3	Common Actuation Properties
3.9		ement in the Third Dimension
	3.9.1	Rotation in Three Dimensions
	3.9.2	Converting Steering Behaviors to Three Dimensions 179
	3.9.3	Align
	3.9.4	Align to Vector
	3.9.5	Face
	3.9.6	Look Where You're Going
	3.9.7	Wander
	3.9.8	Faking Rotation Axes

CHAPTER	PATHF	INDING	195
4	4.1 The	Pathfinding Graph	196
	4.1.1 4.1.2 4.1.3	Graphs	. 198
	4.1.4 4.1.5	Terminology	. 202
	4.2 Dijk	stra	. 203
	4.2.1 4.2.2 4.2.3 4.2.4 4.2.5	The Problem The Algorithm Pseudo-Code Data Structures and Interfaces Performance of Dijkstra	. 204 . 209 . 211 . 213
	4.2.6	Weaknesses	
	4.3.1 4.3.2 4.3.3 4.3.4 4.3.5 4.3.6 4.3.7 4.3.8	The Problem The Algorithm Pseudo-Code Data Structures and Interfaces Implementation Notes Algorithm Performance Node Array A* Choosing a Heuristic Id Representations Tile Graphs Dirichlet Domains Points of Visibility Navigation Meshes Non-Translational Problems Cost Functions	. 215 . 215 . 219 . 222 . 227 . 228 . 230 . 237 . 239 . 242 . 244 . 244 . 252
	4.4.7	Path Smoothing	
	•	roving on A*	
	4.6.1 4.6.2 4.6.3 4.6.4	The Hierarchical Pathfinding Graph Pathfinding on the Hierarchical Graph Hierarchical Pathfinding on Exclusions Strange Effects of Hierarchies on Pathfinding	. 258 . 261 . 264
	4.6.5 4.7 Oth	Instanced Geometry	
	4.7 Our		

	4.7.2	Dynamic Pathfinding
	4.7.3	Other Kinds of Information Reuse
	4.7.4	Low Memory Algorithms
	4.7.5	Interruptible Pathfinding
	4.7.6	Pooling Planners
	4.8 Cor	ntinuous Time Pathfinding
	4.8.1	The Problem
	4.8.2	The Algorithm
	4.8.3	Implementation Notes
	4.8.4	Performance
	4.8.5	Weaknesses
	4.9 Mov	vement Planning
	4.9.1	Animations
	4.9.2	Movement Planning
	4.9.3	Example
	4.9.4	Footfalls
CHAPTER	DECIS	ION MAKING 297
5	5.1 Ove	rview of Decision Making
	5.2 Dec	ision Trees
	5.2.1	The Problem
	5.2.2	The Algorithm
	5.2.3	Pseudo-Code
	5.2.4	Knowledge Representation
	5.2.5	Implementation Notes
	5.2.6	Performance of Decision Trees
	5.2.7	Balancing the Tree
	5.2.8	Beyond the Tree
	5.2.9	Random Decision Trees
	5.3 State	e Machines
	5.3.1	The Problem
	5.3.2	The Algorithm
	5.3.3	Pseudo-Code
	5.3.4	Data Structures and Interfaces
	5.3.5	Performance
	5.3.6	Implementation Notes
	5.3.7	Hard-Coded FSM
	5.3.8	Hierarchical State Machines
	5.3.9	Combining Decision Trees and State Machines
		•

5.4 Beh	avior Trees					 	338
5.4.1	Implementing Behavior Trees					 	345
5.4.2	Pseudo-Code					 	345
5.4.3	Decorators					 	349
5.4.4	Concurrency and Timing					 	355
5.4.5	Adding Data to Behavior Trees					 	364
5.4.6	Reusing Trees					 	369
5.4.7	Limitations of Behavior Trees					 	373
5.5 Fuzz	zy Logic					 	374
5.5.1	A Warning						
5.5.2	Introduction to Fuzzy Logic					 	375
5.5.3	Fuzzy Logic Decision Making						
5.5.4	Fuzzy State Machines						
5.6 Mar	rkov Systems						
5.6.1	Markov Processes						
5.6.2	Markov State Machine						
	al-Oriented Behavior						
5.7.1	Goal-Oriented Behavior						
5.7.1	Simple Selection						
5.7.3	Overall Utility						
5.7.4	Timing						
5.7.5	Overall Utility GOAP						
5.7.6	GOAP with IDA*						
5.7.7	Smelly GOB						
	•						
	e-Based Systems						
5.8.1	The Problem						
5.8.2	The Algorithm						
5.8.3 5.8.4	Pseudo-Code						
5.8.4	Data Structures and Interfaces						
	Rule Arbitration						
5.8.6	Unification						
5.8.7	Rete						
5.8.8 5.8.9	Extensions						
	ckboard Architectures						
5.9.1	The Problem						
5.9.2	The Algorithm						
5.9.3	Pseudo-Code						
5.9.4	Data Structures and Interfaces						
5.9.5 5.9.6	Performance						
5.9.6	Other Things Are Blackboard Systems						40/

			CONTENTS	xii
	5.10 Act	on Execution		469
	5.10.1	Types of Action		
	5.10.2	The Algorithm		
	5.10.3	Pseudo-Code		
	5.10.4	Data Structures and Interfaces		
	5.10.5	Implementation Notes		
	5.10.6	Performance		479
	5.10.7	Putting It All Together		479
CHAPTER	TACTIO	CAL AND STRATEGIC AI		485
6	6.1 Way	point Tactics		486
	6.1.1	Tactical Locations		486
	6.1.2	Using Tactical Locations		496
	6.1.3	Generating the Tactical Properties of a Waypoint		
	6.1.4	Automatically Generating the Waypoints		
	6.1.5	The Condensation Algorithm		507
	6.2 Tact	ical Analyses		511
	6.2.1	Representing the Game Level		
	6.2.2	Simple Influence Maps		
	6.2.3	Terrain Analysis		519
	6.2.4	Learning with Tactical Analyses		521
	6.2.5	A Structure for Tactical Analyses		
	6.2.6	Map Flooding		
	6.2.7	Convolution Filters		
	6.2.8	Cellular Automata		
	6.3 Tact	ical Pathfinding		548
	6.3.1	The Cost Function		
	6.3.2	Tactic Weights and Concern Blending		549
	6.3.3	Modifying the Pathfinding Heuristic		551
	6.3.4	Tactical Graphs for Pathfinding		
	6.3.5	Using Tactical Waypoints		553
	6.4 Coo	rdinated Action		554
	6.4.1	Multi-Tier AI		
	6.4.2	Emergent Cooperation		561
	6.4.3	Scripting Group Actions		564
	6.4.4	Military Tactics		568

LEARNING	575
7.1 Learning Basics	576
7.1.1 Online or Offline Learning	576

xiv CONTENTS

7.1.2	Intra-Behavior Learning
7.1.3	Inter-Behavior Learning
7.1.4	A Warning
7.1.5	Over-Learning
7.1.6	The Zoo of Learning Algorithms
7.1.7	The Balance of Effort
7.2 Para	meter Modification
7.2.1	The Parameter Landscape
7.2.2	Hill Climbing
7.2.3	Extensions to Basic Hill Climbing
7.2.4	Annealing
7.3 Acti	on Prediction
7.3.1	Left or Right
7.3.2	Raw Probability
7.3.3	String Matching
7.3.4	N-Grams
7.3.5	Window Size
7.3.6	Hierarchical N-Grams
7.3.7	Application in Combat
7.4 Dec	ision Learning
7.4.1	The Structure of Decision Learning 602
7.4.2	What Should You Learn?
7.4.3	Four Techniques
7.5 Nair	ve Bayes Classifiers
7.5.1	Pseudo-Code
7.5.2	Implementation Notes
7.6 Dec	ision Tree Learning
7.6.1	ID3
7.6.2	ID3 with Continuous Attributes 618
7.6.3	Incremental Decision Tree Learning 622
7.7 Rei	nforcement Learning
7.7.1	The Problem
7.7.2	The Algorithm
7.7.3	Pseudo-Code
7.7.4	Data Structures and Interfaces
7.7.5	Implementation Notes
7.7.6	Performance
7.7.7	Tailoring Parameters
7.7.8	Weaknesses and Realistic Applications 637
779	Other Ideas in Reinforcement Learning 640

	7.8 Art	ificial Neural Networks
	7.8.1	Overview
	7.8.2	The Problem
	7.8.3	The Algorithm
	7.8.4	Pseudo-Code
	7.8.5	Data Structures and Interfaces
	7.8.6	Implementation Caveats
	7.8.7	Performance
	7.8.8	Other Approaches
	7.9 Dee	ep Learning
	7.9.1	What is Deep Learning?
	7.9.2	Data
CHAPTER	DDOCI	COURAL CONTENT CENTRALION
	PROCE	EDURAL CONTENT GENERATION 669
8	8.1 Pseu	udorandom Numbers
	8.1.1	Numeric Mixing and Game Seeds 671
	8.1.2	Halton Sequence
	8.1.3	Phyllotaxic Angles
	8.1.4	Poisson Disk
	8.2 Line	denmayer Systems
	8.2.1	Simple L-systems
	8.2.2	Adding Randomness to L-systems
	8.2.3	Stage-Specific Rules
	8.3 Lan	dscape Generation
	8.3.1	Modifiers and Height-Maps
	8.3.2	Noise
	8.3.3	Perlin Noise
	8.3.4	Faults
	8.3.5	Thermal Erosion
	8.3.6	Hydraulic Erosion
	8.3.7	Altitude Filtering
		ageons and Maze Generation
	8.4.1	Mazes by Depth First Backtracking
	8.4.2	Minimum Spanning Tree Algorithms
	8.4.3 8.4.4	Recursive Subdivision
		Generate and Test
		pe Grammars
	8.5.1	Running the Grammar
	8.5.2	Planning

CHAPTER	BOARD GAMES	741
9	9.1 Game Theory	742
	9.1.1 Types of Games	
	9.1.2 The Game Tree	
	9.2 Minimaxing	747
	9.2.1 The Static Evaluation Function	
	9.2.2 Minimaxing	
	9.2.3 The Minimaxing Algorithm	
	9.2.4 Negamaxing	
	9.2.5 AB Pruning	755
	9.2.6 The AB Search Window	
	9.2.7 Negascout	761
	9.3 Transposition Tables and Memory	
	9.3.1 Hashing Game States	
	9.3.2 What to Store in the Table	
	9.3.3 Hash Table Implementation	
	9.3.4 Replacement Strategies	769
	9.3.5 A Complete Transposition Table	
	9.3.6 Transposition Table Issues	
	9.3.7 Using Opponent's Thinking Time	
	9.4 Memory-Enhanced Test Algorithms	
	9.4.1 Implementing Test	
	9.4.2 The MTD Algorithm	
	9.4.3 Pseudo-Code	
	9.5 Monte Carlo Tree Search (MCTS)	
	9.5.1 Pure Monte Carlo Tree Search	
	9.5.2 Adding Knowledge	
	9.6 Opening Books and Other Set Plays	
	9.6.1 Implementing an Opening Book	
	9.6.2 Learning for Opening Books	
	9.6.3 Set Play Books	
	9.7 Further Optimizations	
	9.7.1 Iterative Deepening	786
	9.7.2 Variable Depth Approaches	
	9.8 Game Knowledge	
	9.8.1 Creating a Static Evaluation Function	
	9.8.2 Learning the Static Evaluation Function	
	9.9 Turn-Based Strategy Games	
	9.9.1 Impossible Tree Size	
	9.9.2 Real-Time AI in a Turn-Based Game	177

PART III Supporting Technolog

	Supporting Technologies	801
CHAPTER	EXECUTION MANAGEMENT	803
10	10.1 Scheduling	804
	10.1.1 The Scheduler	
	10.1.2 Interruptible Processes	
	10.1.3 Load-Balancing Scheduler	
	10.1.4 Hierarchical Scheduling	
	10.1.5 Priority Scheduling	818
	10.2 Anytime Algorithms	820
	10.3 Level of Detail	821
	10.3.1 Graphics Level of Detail	
	10.3.2 AI LOD	
	10.3.3 Scheduling LOD	
	10.3.4 Behavioral LOD	
	10.3.5 Group LOD	
	10.3.6 In Summary	833
CHAPTER	WORLD INTERFACING	835
11	11.1 Communication	836
	11.1.1 Polling	
	11.1.2 Events	
	11.1.3 Determining Which Approach to Use	
	11.2 Event Managers	
	11.2.1 Implementation	
	11.2.2 Event Casting	
	11.2.3 Inter-Agent Communication	
	11.3 Polling Stations	. 846
	11.3.1 Pseudo-Code	
	11.3.2 Performance	
	11.3.3 Implementation Notes	
	11.3.4 Abstract Polling	. 848
	11.4 Sense Management	. 849
	11.4.1 Faking It	
	11.4.2 What Do We Know?	
	11.4.3 Sensory Modalities	. 852
	11.4.4 Region Sense Manager	
	11.4.5 Finite Element Model Sense Manager	. 865

xviii CONTENTS

CHAPTER	TOOLS AND CONTENT CREATION	875
12	12.0.1 Toolchains Limit AI	
	12.0.2 Where AI Knowledge Comes From	876
	12.1 Knowledge for Pathfinding and Waypoints	877
	12.1.1 Manually Creating Region Data	
	12.1.2 Automatic Graph Creation	
	12.1.3 Geometric Analysis	
	12.1.4 Data Mining	
	12.2 Knowledge for Movement	
	12.2.1 Obstacles	
	12.2.2 High-Level Staging	
	12.3 Knowledge for Decision Making	
	12.3.1 Object Types	
	12.3.2 Concrete Actions	
	12.4 The Toolchain	
	12.4.1 Integrated Game Engines	890
	12.4.2 Custom Data-Driven Editors	
	12.4.3 AI Design Tools	
	12.4.4 Remote Debugging	
	12.4.5 Plug-Ins	890
CHAPTER	PROGRAMMING GAME AI	901
13	13.1 Implementation Language	902
	13.1.1 C++	
	13.1.2 C#	
	13.1.3 Swift	
	13.1.4 Java	
	13.1.5 JavaScript	
	13.2 Scripted AI	909
	13.2.1 What Is Scripted AI?	910
	13.2.2 What Makes a Good Scripting Language?	
	13.2.3 Embedding	
	13.2.4 Choosing an Open Source Language	
	13.2.5 A Language Selection	
	13.3 Creating a Language	
	13.3.1 Rolling Your Own	921

PART IV

	Designing Game AI	927
CHAPTER	DESIGNING GAME AI	929
14	14.1 The Design	929
	14.1.1 Example	
	14.1.2 Evaluating the Behaviors	
	14.1.3 Selecting Techniques	
	14.1.4 The Scope of One Game	
	14.2 Shooters	937
	14.2.1 Movement and Firing	
	14.2.2 Decision Making	
	14.2.3 Perception	
	14.2.4 Pathfinding and Tactical AI	
	14.2.5 Shooter-Like Games	942
	14.2.6 Melee Combat	943
	14.3 Driving	946
	14.3.1 Movement	
	14.3.2 Pathfinding and Tactical AI	
	14.3.3 Driving-Like Games	
	14.4 Real-Time Strategy	
	14.4.1 Pathfinding	
	14.4.2 Group Movement	
	14.4.3 Tactical and Strategic AI	
	14.4.4 Decision Making	
	14.4.5 MOBAs	
	14.5 Sports	955
	14.5.1 Physics Prediction	
	14.5.2 Playbooks and Content Creation	
	14.6 Turn-Based Strategy Games	
	14.6.1 Timing	
	14.6.2 Helping the Player	
		200
CHAPTER	AI-BASED GAME GENRES	959
15	15.1 Teaching Characters	960
	15.1.1 Representing Actions	
	15.1.2 Representing the World	
	15.1.3 Learning Mechanism	
	15.1.4 Predictable Mental Models	963

xx CONTENTS

15.2 Floc	king and Herding Games										965
15.2.1	Making the Creatures										965
15.2.2	Tuning Steering for Interactivity .										965
15.2.3	Steering Behavior Stability										967
15.2.4	Ecosystem Design										967
REFER	ENCES										971
Books, Pe	riodicals, Papers and Websites										971
Games .											976
INDEX											983

PART I AI and Games

INTRODUCTION

G AME DEVELOPMENT lives in its own technical world. It has its own idioms, skills, and challenges. That's one of the reasons games are so much fun to work on. Each game has its own rules, its own aesthetic, its own trade-offs, and the hardware it will run on keeps changing. There's a reasonably good chance you will be the first person to meet and beat a new programming challenge.

Despite numerous efforts to standardize game development, in line with the rest of the software industry (efforts that go back at least 25 years), the style of programming in a game is still rather unique. There is a focus on speed, but it differs from real-time programming for embedded or control applications. There is a focus on clever algorithms, but it doesn't share the same rigor as database server engineering. It draws techniques from a huge range of different sources, but almost without exception modifies them beyond resemblance. And, to add an extra layer of intrigue, developers make their modifications in different ways, often under extreme time pressure, and tailored entirely to the game at hand, leaving algorithms unrecognizable from studio to studio or project to project.

As exciting and challenging as this may be, it makes it difficult for new developers to get the information they need. Twenty years ago, it was almost impossible to get hold of information about techniques and algorithms that real developers used in their games. There was an atmosphere of secrecy, even alchemy, about the coding techniques in top studios. Then came the Internet and an ever-growing range of websites, along with books, conferences, and periodicals. It is now easier than ever to teach yourself new techniques in game development.

This book is designed to help you master one element of game development: artificial intelligence (AI). There have been many articles published about different aspects of game AI: websites on particular techniques, compilations in book form, some introductory texts, and

plenty of lectures at development conferences. But this book was designed to cover it all, as a coherent whole.

In my career I have developed many AI modules for lots of different genres of games. I developed AI middleware tools that have a lot of new research and clever content. I have worked on research and development for next-generation AI, and I get to do a lot with some very clever technologies. However, throughout this book I tried to resist the temptation to pass off how I think it should be done as how it is done. My aim has been to tell it like it is (or for those technologies I mention that are still emerging, to tell you how most people agree it will be).

The meat of this book covers a wide range of techniques for game AI. Some of them are barely techniques, more like a general approach or development style. Some are full-blown algorithms, ready to implement in a reusable way. And others are shallow introductions to huge fields that would fill multiple books on their own. In these cases, I've tried to give enough of an overview for you to understand how and why an approach may be useful (or not).

This book is intended for a wide range of readers: from hobbyists or students looking to get a solid understanding of game AI through to professionals who need a comprehensive reference to techniques they may not have used before. I will assume you can program (though I will not assume any particular language—see Chapter 13 for a discussion of implementation languages), and I will assume you have high-school level mathematical knowledge.

Before we get into the techniques themselves, this chapter introduces AI, its history, and the way it is used. We'll look at a model of AI to help fit the techniques together, and I'll give some background on how the rest of the book is structured.

1.1 WHAT IS AI?

Artificial intelligence is about making computers able to perform the thinking tasks that humans and animals are capable of.

We can program computers to have superhuman abilities in solving many problems: arithmetic, sorting, searching, and so on. Some of these problems were originally considered AI problems, but as they have been solved in more and more comprehensive ways, they have slipped out of the domain of AI developers.

But there are many things that computers aren't good at which we find trivial: recognizing familiar faces, speaking our own language, deciding what to do next, and being creative. These are the domain of AI: trying to work out what kinds of algorithms are needed to display these properties.

Often the dividing line between AI and not-AI is merely difficulty: things we can't do require AI, things we can are tricks and math. It is tempting to get into a discussion of what is 'real' AI, to try defining 'intelligence', 'consciousness' or 'thought'. In my experience, it is an impossible task, largely irrelevant to the business of making games.

In academia, some AI researchers are motivated by those philosophical questions: understanding the nature of thought and the nature of intelligence and building software to model

how thinking might work. Others are motivated by psychology: understanding the mechanics of the human brain and mental processes. And yet others are motivated by engineering: building algorithms to perform human-like tasks. This threefold distinction is at the heart of academic AI, and the different concerns are responsible for different subfields of the subject.

As games developers, we are practical folks; interested in only the engineering side. We build algorithms that make game characters appear human or animal-like. Developers have always drawn from academic research, where that research helps them get the job done, and ignored the rest.

It is worth taking a quick overview of the AI work done in academia to get a sense of what exists in the subject and what might be worth plagiarizing.

1.1.1 ACADEMIC AI

To tell the story, I will divide academic AI into three periods: the early days, the symbolic era, and the natural computing and statistical era. This is a gross oversimplification, of course, and they all overlap to some extent, but I find it a useful distinction. For a collection of papers which give a much more nuanced and fleshed out account, see [38].

The Early Days

The early days include the time before computers, where philosophy of mind occasionally made forays into AI with such questions as: "What produces thought?" "Could you give life to an inanimate object?" "What is the difference between a cadaver and the human it previously was?" Tangential to this was the popular taste in automata, mechanical robots, from the 18th century onward. Intricate clockwork models were created that displayed the kind of animated, animal- or human-like behaviors that we now employ game artists to create in a modeling package (for an academic history and discussion, see [23], and for an in-depth look at two piano playing examples, see [74]).

In the war effort of the 1940s, the need to break enemy codes [8] and to perform the calculations required for atomic warfare motivated the development of the first programmable computers [46]. Given that these machines were being used to perform calculations that would otherwise be done by a person, it was natural for programmers to be interested in AI. Several computing pioneers (such as Turing, von Neumann, and Shannon) were also pioneers in early AI. Turing, in particular, has become an adopted father to the field, as a result of a philosophical paper he published in 1950 [70].

The Symbolic Era

From the late 1950s through to the early 1980s the main thrust of AI research was "symbolic" systems. A symbolic system is one in which the algorithm is divided into two components: a set of knowledge (represented as symbols such as words, numbers, sentences, or pictures) and a reasoning algorithm that manipulates those symbols to create new combinations that hopefully represent problem solutions or new knowledge.

An expert system, one of the purest expressions of this approach, is among the most famous AI techniques. If today all the AI headlines talk about "deep learning," in the 1980s, they name dropped "expert systems." An expert system has a large database of knowledge and it applies a collection of rules to draw conclusions or to discover new things (see Section 5.8). Other symbolic approaches applicable to games include blackboard architectures (5.9), pathfinding (Chapter 4), decision trees (Section 5.2) and state machines (Section 5.3). These and many more are described in this book.

A common feature of symbolic systems is a trade-off: when solving a problem the more knowledge you have, the less work you need to do in reasoning. Often, reasoning algorithms consist of searching: trying different possibilities to get the best result. This leads us to the golden rule of AI, that we will see in various forms throughout this book:

Search and knowledge are intrinsically linked. The more knowledge you have, the less searching for an answer you need; the more search you can do (i.e., the faster you can search), the less knowledge you need.

It was suggested by researchers Newell and Simon in 1976 that knowledge infused search (known as 'heuristic search') is the way all intelligent behavior arises [45]. Unfortunately, despite its having several solid and important features, this theory has been largely discredited as an account of all intelligence. Nevertheless, many people with a recent education in AI are not aware that, as an engineering trade-off, knowledge versus search is unavoidable. Recent work on the mathematics of problem solving has proved this theoretically [76]. At a practical level, AI engineers have always known it.

The Natural Computing / Statistical Era

Through the 1980s and into the early 1990s, there was an increasing frustration with symbolic approaches. The frustration came from various directions.

From an engineering point of view, the early successes on simple problems didn't seem to scale to more difficult problems. For example: it seemed easy to develop AI that understood (or appeared to understand) simple sentences, but developing an understanding of a full human language seemed no nearer. This was compounded by hype: when AI touted as 'the next big thing' failed to live up to its billing, confidence in the whole sector crashed.

There was also an influential philosophical argument that symbolic approaches weren't biologically plausible. You can't understand how a human being plans a route by using a symbolic route-planning algorithm any more than you can understand how human muscles work by studying a forklift truck.

The effect was a move toward natural computing: techniques inspired by biology or other natural systems. These techniques include neural networks, genetic algorithms, and simulated

annealing.1 Many natural computing techniques have been around for a long time. Neural networks, for example, predate the symbolic era; they were first suggested in 1943 [39].

But in the 1980s through to the early 2000s they received the bulk of the research effort. When I began my PhD in artificial intelligence in the 90s, it was difficult to find research places in Expert Systems, for example. I studied genetic algorithms; most of my peers were working on neural networks.

Despite its origin as a correlate to biology, AI research heavily applied mathematics, particularly probability and statistics, to understanding and optimizing natural computing techniques. The ability to handle all the uncertainty and messiness of real-world data, in contrast to the clean and rigid boundaries of the symbolic approaches, led to the development of a wide range of other probabilistic techniques, such as Bayes nets, support-vector machines (SVMs), and Gaussian processes.

The biggest change in AI in the last decade has not come from a breakthrough in academia. We are living in a time when AI is again back in the newspapers: self driving cars, deep fakes, world champion Go programs, and home virtual assistants. This is the era of deep learning. Though many academic innovations are used, these systems are still fundamentally powered by neural networks, now made practical by the increase in computing power.

Engineering

Though newspaper headlines and high-profile applications have flourished in the last five years, AI has been a key technology relevant to solving real-world problems for decades. Navigation systems in cars, job scheduling in factories, voice recognition and dictation, and largescale search are all more than 20 years old. Google's search technology, for example, has long been underpinned by AI. It is no coincidence that Peter Norvig is both a Director of Research at Google and the co-author (along with his former graduate adviser, professor Stuart Russell) of the canonical undergraduate textbook for modern academic AI [54].

When something is hot, it is tempting to assume it is the only thing that matters. When natural computing techniques took center stage, there was a tendency to assume that symbolic approaches were dead. Similarly, with talk of deep learning everywhere, you might be forgiven for thinking that is what should be used.

But we always come back to the same trade-off: search vs knowledge. Deep learning is the ultimate in the compute intensive search, AlphaGo Zero (the third iteration of the AlphaGo software, [60]) was given very minimal knowledge of the rules of the game, but extraordinary amounts of processing time to try different strategies and learn the best. On the other hand, a character that needs to use a health pack when injured can be told that explicitly:

IF injured THEN use health pack

Though old, a good introduction to Genetic Algorithms can be found in [41], and Simulated Annealing in [34]. In their current vogue as Deep Learning, there are many more contemporary resources on neural networks. For a gentle and shallow introduction, see [21], for a more comprehensive guide, [18].

No search required.

The only way any algorithm can outperform another is either to consume more processing power (more search), or to be optimized toward a specific set of problems (more knowledge of the problem).

In practice, engineers work from both sides. A voice recognition program, for example, converts the input signals using known formulae into a format where the neural network can decode it. The results are then fed through a series of symbolic algorithms that look at words from a dictionary and the way words are combined in the language. A statistical algorithm optimizing the order of a production line will have the rules about production encoded into its structure, so it can't possibly suggest an illegal timetable: the knowledge is used to reduce the amount of search required.

Unfortunately, games are usually designed to run on consumer hardware. And while AI is important, graphics have always taken the majority of the processing power. This seems in no danger of changing. For AI designed to run on the device during the game, low computation / high knowledge approaches are often the clear winners. And these are very often symbolic: approaches pioneered in academia in the 70s and 80s.

We'll look at several statistical computing techniques in this book, useful for specific problems. But I have enough experience to know that for games they are often unnecessary: the same effect can often be achieved better, faster, and with more control using a simpler approach. This hasn't changed significantly since the first edition of this book in 2004. Overwhelmingly the AI used in games is still symbolic technology.

1.1.2 GAME AI

Pac-Man [140] was the first game many people remember playing with fledgling AI. Up to that point there had been *Pong* clones with opponent-controlled bats (following the ball up and down) and countless shooters in the *Space Invaders* mold. But Pac-Man had definite enemy characters that seemed to conspire against you, moved around the level just as you did, and made life tough.

Pac-Man relied on a very simple AI technique: a state machine (which I'll cover later in Chapter 5). Each of the four monsters (later called *ghosts* after a disastrously flickering port to the Atari 2600) occupied one of three states: chasing, scattering (heading for the corners at specific time intervals), and frightened (when Pac-Man eats a power up). For each state they choose a tile as their target, and turn toward it at each junction. In chase mode, each ghost chooses the target according to a slightly different hard-coded rule, giving them their personalities. A complete breakdown of the Pac-Man game mechanics, including the AI algorithms, can be found at [49].

Game AI didn't change much until the mid-1990s. Most computer-controlled characters prior to then were about as sophisticated as a Pac-Man ghost.

Take a classic like *Golden Axe* [176] eight years later. Enemy characters stood still (or walked back and forward a short distance) until the player got close to them, whereupon they

homed in on the player. Golden Axe had a neat innovation with enemies that would enter a running state to rush past the player and then switch back to homing mode, attacking from behind. Surrounding the player looks impressive, but the underlying AI is no more complex than Pac-Man.

In the mid-1990s AI began to be a selling point for games. Games like Beneath a Steel Sky [174] even mentioned AI on the back of the box. Unfortunately, its much-hyped "Virtual Theater" AI system simply allowed characters to walk backward and forward through the game—hardly a real advancement.

Goldeneye 007 [165] probably did the most to show gamers what AI could do to improve gameplay. Still relying on characters with a small number of well-defined states, Goldeneye added a sense simulation system: characters could see their colleagues and would notice if they were killed (see Section 11.4 for details). Sense simulation was the topic of the moment, with Thief: The Dark Project [132] and Metal Gear Solid [129] basing their whole game design on the technique.

In the mid-1990s real-time strategy (RTS) games also were beginning to take off. Warcraft [85] was one of the first times pathfinding (Chapter 4) was widely noticed in action (though it had been used several times before). AI researchers were working with emotional models of soldiers in a military battlefield simulation in 1998 when they saw Warhammer: Dark Omen [141] doing the same thing. It was also one of the first times people saw robust formation motion (Section 3.7) in action.

Halo [91] introduced decision trees (Section 5.2), now a standard method for characters to decide what to do. F.E.A.R. [144] used goal oriented action planning (GOAP, see Section 5.7.6) for the same purpose. With the success of AlphaGo, deep learning (Section 7.9) has become a hot topic, though it is still only practicable off-line.

Some games are designed around the AI. Creatures [101] did this in 1997, but games like The Sims [136] and its sequels, or Black & White [131] have carried on the torch. Creatures still has one of the most complex AI systems seen in a game, with a simulated hormone system and a neural network-based brain for each creature (Steve Grand, the game's designer, describes the technology he created in [19]).

Games like Half Life [193] and The Last of Us [149] use AI controlled characters to collaborate with the player, meaning they are on screen for much longer, and any faults are much more noticeable.

First person shooters and RTS games have been subjected to significant academic research (there is an annual competition for Starcraft AI, for example). RTS games incorporate AI techniques used in military simulation (to the extent that Full Spectrum Warrior [157] started life as a military training simulator).

Sports games and driving games in particular have their own AI challenges, some of which remain largely unsolved (dynamically calculating the fastest way around a race track, for example, would also be helpful to motorsport teams), while role-playing games (RPGs) with complex character interactions still implemented as conversation trees feel overdue for something better (interesting and sophisticated conversation AI has been implemented in games

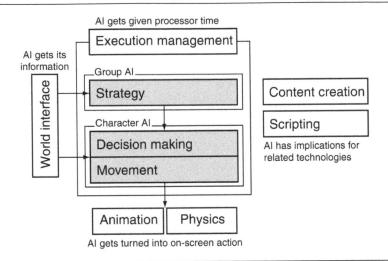

Figure 1.1: The AI model

such as *Façade* [161] and *Blood and Laurels* [130], the one released game using the short lived Versu game engine).

We have come a long way, certainly. But, though we have a massive diversity of AI in games, many genres are still using the simple AI of 1979 because that's all they need.

The AI in most games addresses three basic needs: the ability to move characters, the ability to make decisions about where to move, and the ability to think tactically or strategically. Even though we have a broad range of approaches, they all fulfill the same three basic requirements.

1.2 MODEL OF GAME AI

In this book there is a vast zoo of algorithms and techniques. It would be easy to get lost, so it's important to understand how the bits fit together.

To help, I've used a consistent structure to contextualize the AI used in a game. This isn't the only possible model, and it isn't the only model that would benefit from the techniques in this book. But to make discussions clearer, I will show how each technique fits into a general structure for making intelligent game characters.

Figure 1.1 illustrates this model. It splits the AI task into three sections: movement, decision making, and strategy. The first two sections contain algorithms that work on a character-by-character basis, and the last section operates on a team or side. Around these three AI elements is a whole set of additional infrastructure.

Not all game applications require all levels of AI. Board games like Chess or Risk require

only the strategy level; the characters in the game (if they can even be called that) don't make their own decisions and don't need to worry about how to move.

On the other hand, there is no strategy at all in many games. Non-player characters in a platform game, such as Hollow Knight [183], or Super Mario Bros. [152] are purely reactive, making their own simple decisions and acting on them. There is no coordination that makes sure the enemy characters do the best job of thwarting the player.

1.2.1 MOVEMENT

Movement refers to algorithms that turn decisions into some kind of motion. When an enemy character without a projectile attack needs to attack the player in Super Mario Sunshine [154], it first heads directly for the player. When it is close enough, it can actually do the attacking. The decision to attack is carried out by a set of movement algorithms that home in on the player's location. Only then can the attack animation be played and the player's health be depleted.

Movement algorithms can be more complex than simply homing in. A character may need to avoid obstacles on the way or even work their way through a series of rooms. A guard in some levels of Splinter Cell [189] will respond to the appearance of the player by raising an alarm. This may require navigating to the nearest wall-mounted alarm point, which can be a long distance away and may involve complex navigation around obstacles or through corridors.

Lots of actions are carried out using animation directly. If a Sim, in The Sims, is sitting by the table with food in front of her and wants to carry out an eating action, then the eating animation is simply played. Once the AI has decided that the character should eat, no more AI is needed (the animation technology used is not covered in this book). If the same character is by the back door when she wants to eat, however, movement AI needs to guide her to the chair (or to some other nearby source of food).

1.2.2 DECISION MAKING

Decision making involves a character working out what to do next. Typically, each character has a range of different behaviors that they could choose to perform: attacking, standing still, hiding, exploring, patrolling, and so on. The decision making system needs to work out which of these behaviors is the most appropriate at each moment of the game. The chosen behavior can then be executed using movement AI and animation technology.

At its simplest, a character may have very simple rules for selecting a behavior. The farm animals in various levels of the Zelda games will stand still unless the player gets too close, whereupon they will move away a small distance.

At the other extreme, enemies in Half-Life 2 [194] display complex decision making, where they will try a number of different strategies to reach the player: chaining together intermediate actions such as throwing grenades and laying down suppression fire in order to achieve their goals.

Some decisions may require movement AI to carry them out. A melee (hand-to-hand) attack will require the character to get close to its victim. In combat heavy games such as *Dark Souls* [115] decision-making moves the character toward their target, and also determines which attack, and thus which animation, is performed. In other games, once the decision is made, a predetermined animation is played without any additional movement (a Sim eating, for example) or the state of the game is directly modified without any kind of visual feedback (when a country AI in *Sid Meier's Civilization VI* [113] elects to research a new technology, for example, it simply happens with no visual feedback to the player).

1.2.3 STRATEGY

You can go a long way with movement AI and decision making AI, and most action-based three-dimensional (3D) games use only these two elements. But to coordinate a whole team, some strategic AI is required.

In the context of this book, strategy refers to an overall approach used by a group of characters. In this category are AI algorithms that don't control just one character, but influence the behavior of a whole set of characters. Each character in the group may (and usually will) have their own decision making and movement algorithms, but overall their decision making will be influenced by a group strategy.

In the original *Half-Life* [193], enemies worked as a team to surround and eliminate the player. One would often rush past the player to take up a flanking position. This has been followed in more recent games, such as the evolving AI engine in the *Medal of Honor* [78] franchise. Over time we have seen increasing sophistication in the kinds of strategic actions that a team of enemies can carry out.

1.2.4 INFRASTRUCTURE

AI algorithms on their own are only half of the story, however. In order to actually build AI for a game, we'll need a whole set of additional infrastructure. The movement requests need to be turned into action in the game by using either animation or, increasingly, physics simulation.

Similarly, the AI needs information from the game to make sensible decisions. This is sometimes called "perception" (especially in academic AI): working out what information the character knows. In practice, it is much broader than just simulating what each character can see or hear, but includes all interfaces between the game world and the AI. This world interfacing is often a significant proportion of the work done by an AI programmer, and in my experience it is a large proportion of the AI debugging effort.

Finally, the whole AI system needs to be managed so it uses the right amount of processor time and memory. While some kind of execution management typically exists for each area

of the game (level of detail algorithms for rendering, for example), managing the AI raises a whole set of techniques and algorithms of its own.

Each of these components may be thought of as being out of the remit of the AI developer. Sometimes they are (in particular, the animation system is often part of the graphics engine, or increasingly has its own dedicated programmers), but they are so crucial to getting the AI working that they can't be avoided altogether. In this book I have covered each infrastructure component except animation in some depth.

1.2.5 AGENT-BASED AI

I don't use the term "agents" very much in this book, even though the model I've described is an agent-based model.

In this context, agent-based AI is about producing autonomous characters that take in information from the game data, determine what actions to take based on the information, and carry out those actions.

It can be seen as bottom-up design: you start by working out how each character will behave and by implementing the AI needed to support that. The overall behavior of the game is then a function of how the individual character behaviors work together. The first two elements of the AI model we'll use, movement and decision making, make up the AI for an agent in the game.

In contrast, a non-agent-based AI seeks to work out how everything ought to act from the top down and builds a single system to simulate everything. An example is the traffic and pedestrian simulation in the cities of Grand Theft Auto 3 [104]. The overall traffic and pedestrian flows are calculated based on the time of day and city region and are only turned into individual cars and people when the player can see them.

The distinction is hazy, however. We'll look at level of detail techniques that are very much top down, while most of the character AI is bottom up. A good AI developer will mix and match any reliable techniques that get the job done, regardless of the approach. That pragmatic approach is the one I always follow. So in this book, I avoid using agent-based terminology. and prefer to talk about game characters in general, however they are structured.

1.2.6 IN THE BOOK

In the text of the book each chapter will refer back to this model of AI, pointing out where that topic fits. The model is useful for understanding how things connect and which techniques are alternatives for others.

But the dividing lines aren't always sharp; this is intended to be a general model, not a straitjacket. In the final game code there are no joins. The whole set of AI techniques from each category, as well as a lot of the infrastructure, will all operate seamlessly together.

Many techniques fulfill roles in more than one category. Pathfinding, for example, can be both a movement and a decision making technique. Similarly, some tactical algorithms that analyze the threats and opportunities in a game environment can be used as decision makers for a single character or to determine the strategy of a whole team.

1.3 ALGORITHMS AND DATA STRUCTURES

There are three key elements to implementing the techniques described in this book: the algorithm itself, the data structures that the algorithm depends on, and the way the game world is represented to the algorithm (often encoded as an appropriate data structure). Each element is dealt with separately in the text.

1.3.1 ALGORITHMS

Algorithms are step-by-step processes that generate a solution to an AI problem. We will look at algorithms that generate routes through a game level to reach a goal, algorithms that work out which direction to move to intercept a fleeing enemy, algorithms that learn what the player should do next, and many others.

Data structures are the other side of the coin to algorithms. They hold data in such a way that an algorithm can rapidly manipulate it to reach a solution. Often, data structures need to be tuned for one particular algorithm, and their execution speeds are intrinsically linked.

You will need to know a set of elements to implement and tune an algorithm, and these are treated step by step in the text:

- The problem that the algorithm tries to solve
- A general description of how the solution works, including diagrams where they are needed
- A pseudo-code presentation of the algorithm
- An indication of the data structures required to support the algorithm, including pseudo-code, where required
- · Implementation advice, where needed
- Analysis of the algorithm performance: its execution speed, memory footprint, and scalability
- Weaknesses in the approach

Often, I will present a set of algorithms that gets increasingly more complex and powerful. The simpler algorithms are presented to help you get a feeling for why the complex algorithms have their structure. The stepping-stones are described a little more sketchily than the full system.

Some of the key algorithms in game AI have literally hundreds of variations. This book can't hope to catalog and describe them all. When a key algorithm is described, I will often give a quick survey of the major variations in briefer terms.

Performance Characteristics

To the greatest extent possible, I have tried to include execution properties of the algorithm in each case. Execution speed and memory consumption often depend on the size of the problem being considered. I have used the standard O() notation to indicate the order of the most significant element in this scaling.

An algorithm might be described as being $O(n \log n)$ in execution and O(n) in memory, where n is usually some kind of component of the problem, such as the number of other characters in the area, or the number of power-ups in the level.

A good text on general algorithms for computer science (e.g. [9] or [57]) will give a full mathematical treatment of how O() values are arrived at and the implications they have for the real-world performance of an algorithm. In this book I omit derivations or proofs. Where a complete indication of the complexity is too involved, I indicate the approximate running time or memory in the text, rather than attempt to derive an accurate O() value.

Some algorithms have misleading performance characteristics. It is possible to set up highly improbable situations to deliberately make them perform poorly. In regular use (and certainly in any use you're likely to have in a game), they will have much better performance. When this is the case, I have tried to indicate both the expected and the worst case results. Unless otherwise noted, you can probably ignore the worst case value safely.

Pseudo-Code

Algorithms in this book are presented in pseudo-code for brevity and simplicity. Pseudo-code is an imaginary programming language that cuts out any implementation details particular to any real programming language. It should describe the algorithm in sufficient detail so you can implement it in the language of your choice. The pseudo-code in this book has more of a procedural programming language feel compared to the pseudo-code you would find in more theoretical books on algorithms. In addition, I use pseudo-code to describe data structures and interfaces, as well as algorithms, because the algorithms in this book are often intimately tied to surrounding bits of software in a way that is more naturally captured with code.

Many AI algorithms need to work with relatively sophisticated data structures: lists, tables, priority queues, associative arrays, and so on. Some languages provide these built-in, others make them available as libraries, or accessed through functions. To make what is going on clearer, the pseudo-code treats these data structures as if they were part of the language, simplifying the code significantly.

When creating the pseudo-code in this book, I've stuck to these conventions, where possible:

Indentation indicates block structure and is normally preceded by a colon. There are
no including braces or "end" statements. This makes for much simpler code, with less
redundant lines to bloat the listings. Good programming style always uses indentation
as well as other block markers, so we may as well just use indentation.

- Functions are introduced by the keyword function, and classes are introduced by the keyword class. An inherited class specifies its parent class after the keyword extends. The pseudo-code will not include setters and getters, unless they are significant, all member variables will be accessible.
- Function parameters are included in parentheses, both when the function is defined and when it is called. Class methods are accessed by name using a period between the instance variable and the method—for example, instance.variable().
- · Types may be given after a variable name or parameter name, separated by a colon. The return type from a function follows ->.
- · All variables are local to the scope where they are declared, usually the function or method. Variables declared within a class definition, but not in a method, are class instance variables.
- The single equal sign = is an assignment operator, whereas the double equal sign == is an equality test. Assignment modifiers such as += exist for all mathematical operations.
- Looping constructs are while a and for a in b. The for loop can iterate over any array. It can also iterate over a series of numbers, using the syntax for a in 0..5.
- A range is indicated by 0..5. Ranges always include their lowest value, but not their highest, so 1..4 includes the numbers (1, 2, 3) only. Ranges can be open, such as 1... which is all numbers greater than or equal to 1; or ..4, which is identical to 0..4. Ranges can be decreasing, but notice that the highest value is still not in the range: so 4..0 is the set (3, 2, 1, 0).
- Boolean operators are and, or, and not. Boolean values can be either true or false.
- The symbol # introduces a comment for the remainder of the line.
- · Array elements are given in square brackets and are zero indexed (i.e., the first element of array a is a[0]). A sub-array is signified with a range in brackets, so a[2..5] is the sub-array consisting of the 3rd to 5th elements of the array a. Open range forms are valid: a[1..] is a sub-array containing all but the first element of a.
- In general, I assume that arrays are equivalent to lists. We can write them as lists and freely add and remove elements.

As an example, the following sample is pseudo-code for a simple algorithm to select the highest value from an unsorted array:

2. The justification for this interpretation is connected with the way that loops are normally used to iterate over an array. Indices for an array are commonly expressed as the range 0..length(array), in which case we don't want the last item in the range. If we are iterating backward, then the range length(array)..0 is similarly the one we need. I was undecided about this interpretation for a long time, but felt that the pseudo-code was more readable if it didn't contain lots of "-1" values. Usually this only happens when iterating over all the indices of an array, in which case the code looks correct. When I feel it may be ambiguous, I will clarify my intention with a note.

```
function maximum(array:float[]) -> float:
1
2
       max: float = array[0]
3
       for element in array[1..]:
4
           if element > max:
5
               max = element
       return max
```

Occasionally, an algorithm-specific bit of syntax will be explained as it arises in the text. Programming polymaths will probably notice that the pseudo-code has more than a passing resemblance to the Python programming language, with Ruby-like structures popping up occasionally and a seasoning of Lua. This is deliberate, insofar as Python is an easy-to-read language. Nonetheless, the similarity is only skin deep, listings are still pseudo-code and not Python implementations. The similarity is not supposed to suggest a language or an implementation bias.3

1.3.2 REPRESENTATIONS

Information in the game often needs to be turned into a suitable format for use by the AI. Often, this means converting it to a different representation or data structure. The game might store the level as meshes of 3D geometry and the character positions as (x, y, z) locations in the world.

Converting between these representations is a critical process because it often loses information (that's the point: to simplify out the irrelevant details), and you always run the risk of losing the wrong bits of data.

Choosing the correct representation is a key element of implementing AI, and certain representations are particularly important in game AI. Several of the algorithms in the book require the game to be presented to them in a particular format.

Although very similar to a data structure, we will often not worry directly about how the representation is implemented, but instead will focus on the interface it presents to the AI code. This makes it easier for you to integrate the AI techniques into your game, simply by creating the right glue code to turn your game data into the representation needed by the algorithms.

For example, imagine we want to work out if a character feels healthy or not as part of some algorithm for determining its actions. We might simply require a representation of the character with a method we can call:

3. In fact, while Python is a good language for rapid prototyping, and is widely used in the toolchains of game development, it is usually too slow for building the core AI engine in a production game. Languages such as Python, JavaScript, and particularly Lua are sometimes used as scripting languages in a game, and I'll cover their use in that context in Chapter 13.

```
class Character:
# Return true if the character feels healthy, and false otherwise.
function feelsHealthy() -> bool
```

You may then implement this by checking against the character's health score, by keeping a Boolean "healthy" value for each character, or even by running a whole algorithm to determine the character's psychological state and its perception of its own health. As far as the decision making routine is concerned, it doesn't matter how the value is being generated.

The pseudo-code defines an interface (in the object-oriented sense) that can be implemented in any way you choose.

When a representation is particularly important or tricky (and there are several that are), I will describe possible implementations in some depth.

1.3.3 IMPLEMENTATION

Even a decade ago, most developers used C++ for their AI code. A decade before that a significant number relied on C. Games development is much more varied now. Swift and Java (for mobile platforms), C# for the unity game engine, JavaScript on the web. There are many other languages used here and there in game development: Lisp, Lua, or Python, particularly as scripting languages; ActionScript for the few remaining Flash developers. I've personally worked with all these languages at one point or another, so I've tried to be as language independent as possible, while still giving some advice on implementation.

Of these, C and C++ are still used for code that absolutely, positively has to run as fast as possible. In places some of the discussion of data structures and optimizations will focus on C++, because the optimizations are C++ specific.

$1.4\,$ Layout of the book

This book is split into five sections.

Part I introduces AI and games in this chapter and Chapter 2, giving an overview of the book and the challenges that face the AI developer in producing interesting game characters.

Part II is the meat of the technology in the book, presenting a range of different algorithms and representations for each area of our AI model. It contains chapters on decision making (Chapter 5) and movement (Chapter 3) and a specific chapter on pathfinding (Chapter 4, a key element of game AI that has elements of both decision making and movement). It also contains information on tactical and strategic AI (Chapter 6), including AI for groups of characters. There is a chapter on learning (Chapter 7), a key frontier in game AI, and finally chapters on procedural content generation (Chapter 8) and board game AI (Chapter 9). None of these chapters attempts to connect the pieces into a complete game AI. It is a pick and mix array of techniques that can be used to get the job done.

Part III looks at the technologies that enable the AI to do its job. It covers everything

from execution management (Chapter 10) to world interfacing (Chapter 11), getting the game content into an AI-friendly format (Chapter 12), and the programming languages used to code your AI (Chapter 13).

Part IV looks at designing AI for games. It contains a genre-by-genre breakdown of the way techniques are often combined to make a full game (Chapter 14). If you are stuck trying to choose among the range of different technique options, you can look up your game style here and see what is normally done (then do it differently, perhaps). It also looks at a handful of AI-specific game genres that seek to use the AI in the book as the central gameplay mechanic (Chapter 15).

Finally, appendices provide references to other sources of information.

2

GAME AI

B^{EFORE} going into detail with particular techniques and algorithms, it is worth spending a little time thinking about what we need from our game's AI. This chapter looks at the high-level issues around game AI: what kinds of approaches work, what they need to take account of, and how they can all be put together.

2.1 The complexity fallacy

It is a common mistake to think that the more complex the AI in a game, the better the characters will look to the player. Creating good AI is all about matching the requirements of the game to the right behaviors and the right algorithms to produce them. There is a bewildering array of techniques in this book, and the right one isn't always the most obvious choice.

Countless examples of difficult to implement, complex AI have resulted in poor, or even stupid looking behavior. Equally, a very simple technique can be perfect, when used well.

2.1.1 When simple things look good

In the last chapter I mentioned *Pac-Man* [140], one of the first games with any form of character AI. The AI has three states: one normal state when the player is collecting pips; a second state when the player has eaten the power-up and is out for revenge; and a final state that triggers at timed intervals, to have the ghosts back off a little.

In all three states, each of the four ghosts has a target. It moves in a straight line until it reaches a junction, then chooses whichever route is closest to the direction of its target. It

doesn't attempt to plan the entire route, or even check its target can be reached, it just moves toward it. In their chasing state, when hunting the player, each ghost has its own simple snippet of code to choose a target. Blinky (the red ghost) always targets the player position. Pinky (the pink one, obviously) targets a square four spaces in front of the player, even if that is inside or on the other side of a wall. Inky (light blue) uses a modified offset of its own and the player's position. Clyde (orange) targets the player if they are far away, or the corner of the board if close. All these targeting routines can be implemented in a line or two of code.

This is about as simple as you can imagine an AI for a moving character. Any simpler and the ghosts would be either very predictable (if they always homed in) or purely random. On their own, the ghosts strategy can be easily predicted; their AI does not pose a challenge. But together, the different behaviors of each ghost are enough to make a significant opposing force—so much so that the AI to this day gets flattering comments. For example, this comment recently appeared on a website: "To give the game some tension, some clever AI was programmed into the game. The ghosts would group up, attack the player, then disperse. Each ghost had its own AI."

Other players have reported strategies among the ghosts: "The four of them are programmed to set a trap, with Blinky leading the player into an ambush where the other three lie in wait."

A simple AI, done well, can appear to a player to be much more intelligent than it is.

The same thing has been reported by many other developers on own their games. As an extreme example: a few years ago Chris Kingsley of Rebellion mentioned an unpublished Nintendo Game Boy title in which particular enemy characters simply home in on the player, but for variation, sidestep at random intervals as they move forward. Players reported that these characters 'anticipated' their firing patterns and dodged out of the way.

The AI wasn't anticipating anything, and only managed to dodge by coincidence some of the time. But a timely sidestep at a crucial moment stayed in the player's mind and shaped their perception of the AI.

2.1.2 WHEN COMPLEX THINGS LOOK BAD

Of course, the opposite thing can easily happen. A game that I looked forward to immensely was *Herdy Gerdy* [97], one of the launch games Sony used to tout the new gameplay possibilities of the 'emotion engine' chip in their PlayStation 2 hardware. The game is a herding game. An ecosystem of characters is present in the game level. The player has to herd individuals of different species into their corresponding pens. Herding had been used before and has since as a component of a bigger game, but in Herdy Gerdy it constituted all of the gameplay. There is a section on AI for this kind of game in Chapter 15.

Unfortunately, the characters' movement AI was not quite up to the challenge of its rich level design. It was easy to get them caught on the scenery, and their collision detection could leave them stuck in irretrievable places. This would be frustrating (though not uncommon)

in any game. But it interacted with the herding AI in a way that made some characters appear unexpectedly unintelligent. Reviews were mixed, and sales lackluster.

Unlike Herdy Gerdy, Black & White [131] achieved significant sales success. But at places it also suffered from great AI looking bad. The game involves teaching a character what to do by a combination of example and feedback. When people first play through the game, they often end up inadvertently teaching the creature bad habits, and in the worst cases it may become unable to carry out even the most basic actions. By paying more attention to how the creature's AI works, players are able to manipulate it better, but the illusion of teaching a real creature can be gone.

Most of the complex things I've seen that looked bad never made it to the final game. It is a perennial temptation for developers to use the latest techniques and the most hyped algorithms to implement their character AI. Late in development, when a learning AI still can't learn how to steer a car around a track without driving off at every corner, simpler algorithms come to the rescue and make it into the game's release.

Knowing when to be complex and when to stay simple is the most difficult element of the game AI programmer's art. The best AI programmers are those who can use a very simple technique to give the illusion of complexity.

This is easier when there is a tight feedback loop between implementation and game design. A slight modification to the requirements can mean a better AI technique can be used, which leads to a better game. Sometimes this means making the required behavior simpler, to make it much more robust. Unfortunately, with the large team sizes on mass-market PC and console games, it is difficult for a programmer to have much influence. Indie and mobile games, whose teams are much smaller, though not as small as they were a few years ago, still have more opportunity.

2.1.3 THE PERCEPTION WINDOW

Unless your AI is controlling an ever-present sidekick or a one-on-one enemy, chances are your player will only come across a character for a short time.

This can be a significantly short time for disposable guards whose life purpose is to be shot. More difficult enemies can be on-screen for a few minutes as their downfall is plotted and executed.

When we seek to understand someone in real life, we naturally put ourselves into their shoes. We look at their surroundings, the information they are gleaning from their environment, and the actions they are carrying out. The same happens with game characters. A guard standing in a dark room hears a noise: "I'd flick the light switch," we think. If the guard doesn't do that, we might assume they are stupid.

If we only catch a glimpse of someone for a short while, we don't have enough time to understand their situation. If we see a guard who has heard a noise suddenly turn away and move slowly in the opposite direction, we assume the AI is faulty. The guard should have moved across the room toward the noise. If we observed them for longer to see the guard

head over to a light switch by the exit, their action would be understandable. Then again, the guard might not flick on the light switch after all, and we might take that as a sign of poor implementation. But the guard may know that the light is inoperable, or they may have been waiting for a colleague to slip some cigarettes under the door and thought the noise was a predefined signal. If we knew all that, we'd know the action was intelligent after all.

This no-win situation is the perception window. You need to make sure that a character's AI matches its purpose in the game and the attention it will get from the player. Adding more AI to incidental characters might endear you to the rare gamer who spends hours analyzing each level, checking for curious behavior or bugs, but everyone else (including the publisher and the press) may think your programming was sloppy.

2.1.4 CHANGES OF BEHAVIOR

The perception window isn't only about time. Think about the ghosts in Pac-Man again. They might not give the impression of sentience, but they don't do anything out of place. This is because they rarely change behavior (the most noticeable is their transformation when the player eats a power-up).

Whenever a character in a game changes behavior, the change is far more conspicuous than the behavior itself. In the same way, when a character's behavior should obviously change and doesn't, it draws attention. If two guards are standing talking to each other and you shoot one down, the other guard shouldn't carry on the conversation!

A change in behavior almost always occurs when the player is nearby or has been spotted. This is the same in platform games as it is in real-time strategy. A good solution is to keep only two behaviors for incidental characters—a normal action and a player-spotted action.

2.2 THE KIND OF ALIN GAMES

Games have always come under criticism for being poorly programmed, in a software engineering sense: they use tricks, arcane optimizations, and unproven technologies to get extra speed or neat effects. Though game engines may be reused, gameplay code usually isn't (or at least isn't written with that in mind) and strong time pressures mean programmers often do whatever they need to get the game done. Game AI is no different.

There is a big gulf between what qualifies as AI in games (i.e. what is the responsibility of an AI programmer) and what the rest of the programming industry or academia considers to be AI.

In my experience, AI for a game is equal parts hacking (ad hoc solutions and neat effects), heuristics (rules of thumb that only work in most, but not all, cases), and algorithms (the "proper" stuff). Most of this book is aimed at the last group, because those are the techniques we can generalize, examine analytically, use in multiple games, and build into an AI engine.

But ad hoc solutions and heuristics are just as important and can breathe as much life into characters as the most complicated algorithm.

2.2.1 HACKS

There's a saying that goes "If it looks like a fish and swims like a fish, it's probably a fish." We understand a behavior by replicating it to a sufficient accuracy.

As a psychological approach it has some pedigree (it is related to the behaviorist school of psychology) but has been largely superseded. This fall from fashion has influenced psychological approaches to AI, as well. At one point it was quite acceptable to learn about human intelligence by making a machine to replicate it, but now that is considered poor science. And with good reason; after all, building a machine to play skillful Chess involves algorithms that evaluate millions of board positions. Human beings are simply not capable of this.

On the other hand, as AI engineers, we are not paid to be interested in the nature of reality or mind; we want characters that look right. In most cases, this means starting from human behaviors and trying to work out the easiest way to implement them in software.

Good AI in games usually works in this direction. Developers rarely build a great new algorithm and then ask themselves, "so what can I do with this?" Instead, you start with a design for a character and apply the most relevant tool to get the result.

This means that what qualifies as game AI may be unrecognizable as an AI technique. A simple random number generator applied judiciously can produce a lot of of believability. Generating a random number isn't an AI technique as such. In most languages there are builtin functions to get a random number, so there is certainly no point giving an algorithm for it! But it can work in a surprising number of situations.

Another good example of creative AI development is *The Sims* [136]. While there are reasonably complicated things going on under the surface, a lot of the character behavior is communicated with animation. Remove the character animation, and the AI would look far less impressive. In Star Wars: Episode 1 - Racer [133], characters who are annoyed gave a little sideswipe to other characters. Quake II [123] introduced the "gesture" command, now used in a vast range of first person games, where characters (and players) can flip their enemy off. All these require no significant AI infrastructure. They don't need complicated cognitive models, learning, or neural networks. They just need a few lines of code that schedule an animation at the appropriate time.

Always be on the lookout for simple things that can give the illusion of intelligence. If you want engaging emotional characters, is it possible to add a couple of emotion animations (a frustrated rub of the temple, perhaps, or a stamp of the foot) to your game? Triggering these in the right place is much easier than trying to represent the character's emotional state through their actions. Do you have a portfolio of behaviors that the character will choose from? Will the choice involve complex weighing of many factors? If so, it might be worth trying a version of the AI that picks a behavior purely at random (maybe with different probabilities for each behavior). You might be able to tell the difference, but your customers may not; so try it out before you code the complex version.

2.2.2 HEURISTICS

A heuristic is a rule of thumb, an approximate solution that might work in many situations but is unlikely to work in all.

Human beings use heuristics all the time. We don't try to work out all the consequences of our actions. Instead, we rely on general principles that we've found to work in the past (or that we have been taught or even brainwashed with, equally). It might range from something as simple as "if you lose something then retrace your steps to look for it" to heuristics that govern our life choices, such as "never trust a used-car salesman."

Heuristics have been codified and incorporated into some of the algorithms in this book, and saying "heuristic" to an AI programmer often conjures up images of pathfinding or goal-oriented behaviors. Beyond these, many of the techniques in this book rely on heuristics that may not always be explicit. There is a trade-off between speed and accuracy in areas such as decision making, movement, and tactical thinking (including board game AI). When accuracy is sacrificed, it is usually by replacing search for a correct answer with a heuristic.

A wide range of heuristics can be applied to general AI problems that don't require a particular algorithm.

In our perennial Pac-Man example, the ghosts move by taking the route at a junction that leads toward their current target. They don't attempt to calculate the best route: either the shortest or fastest. That might be quite complex and involve turning back on oneself, and it might be ultimately redundant as the position of the player continues to change. But the rule of thumb (move in the current direction of the target) works most of the time and provides sufficient competence for the player to understand that the ghosts aren't purely random in their motion.

In *Warcraft* [85] (and many other RTS games that followed) there is a heuristic that moves a character forward slightly so they can engage an enemy standing a fraction beyond the character's reach. While this worked in most cases, it wasn't always the best option. Many players got frustrated as comprehensive defensive structures went walkabout when enemies came close. Later, RTS games allowed the player to choose whether this behavior was switched on or not.

In many strategic games, including board games, different units or pieces are given a single numeric value to represent how "good" they are. In Chess, pawns are often given one point, bishops and knights three, rooks five, and the queen eight. This is a heuristic; it replaces complex calculations about the capabilities of a unit with a single number. And the number can be defined by the programmer in advance. The AI can work out which side is ahead simply by adding the numbers. In an RTS it can find the best value offensive unit to build by comparing the number with the cost. A lot of useful effects can be achieved just by manipulating the number.

There isn't an algorithm or a technique for this. And you won't find it in published AI research. But it is the bread and butter of an AI programmer's job.

Common Heuristics

A handful of heuristics appear over and over. They are good starting points when initially tackling a problem.

Most Constrained

Given the current state of the world, one item in a set needs to be chosen. The item chosen should be the one that would be an option for the fewest number of states.

For example, a squad of characters engages a group of enemies. One of the enemies is wearing a type of armor that only one rifle can penetrate. One squad member has this rifle. When they select who to attack, the most constrained heuristic comes into play; only one squad member can attack this enemy, so that is the action that they should take. Even if their weapon would be more powerful against different enemy, their squad mates should handle the others.

Do the Most Difficult Thing First

The hardest thing to do often has implications for lots of other actions. It is better to do this first, rather than find that the easy stuff goes well but is ultimately wasted.

For example, an army has two squads with empty slots. The computer schedules the creation of five Orc warriors and a huge Stone Troll. It wants to end up with balanced squads. How should it assign the units to squads? The Stone Troll requires the most slots, so is the hardest to assign. It should be placed first.

If the Orcs were assigned first, they would be balanced between the two squads, leaving room for half a Troll in each squad, but nowhere for the Troll to go.

Try the Most Promising Thing First

If there are a number of options open to the AI, it is often possible to give each one a really rough-and-ready score. Even if this score is dramatically inaccurate, trying the options in decreasing score order will provide better performance than trying things purely at random.

2.2.3 ALGORITHMS

And so we come to the final third of the AI programmer's job: building algorithms to support interesting character behavior. Hacks and heuristics will get you a long way, but relying on them solely means you'll have to constantly reinvent the wheel. General bits of AI, such as movement, decision making, and tactical thinking all benefit from tried and tested methods that can be endlessly reused.

This book is about these kinds of technique, and the next few chapters introduces a large number of them. Just remember that for every situation where a complex algorithm is the best way to go, there are likely to be several more where a simpler hack or heuristic will get the job done.

2.3 SPEED AND MEMORY CONSTRAINTS

The biggest constraint on the AI developer's job is the physical limitations of the machine. Game AI doesn't have the luxury of days of processing time and terabytes of memory. We don't even have the luxury of using all the processor and memory of the computer the game is running on. Other tasks need space and time, such as graphics, sound, networking, and input. In teams where different groups of developers have to work on their specialties in parallel, a speed and memory budget will be set.

One of the reasons AI techniques from academia or commercial research don't achieve widespread use is their processing time or memory requirements. An algorithm that might be compelling in a simple demo can slow a production game to a standstill.

This section looks at low-level hardware issues related to the design and construction of AI code. Most of what is contained here is general advice for all game code. If you're up to date with current game programming issues and just want to get to the AI, you can safely skip this section.

2.3.1 PROCESSOR ISSUES

The most obvious limitation on the efficiency of a game is the speed of the processor on which it is running. Originally all the games machines had a single main processor, which was also responsible for graphics. Most game hardware now has several CPUs (several processing cores on the same piece of silicon, usually), and dedicated GPUs for processing graphics.

As a general rule, CPUs are faster and more flexible, where a GPU is more parallel. When the task can be split up into many simple subtasks, all running at the same time, the tens up to thousands of processing cores on a GPU can be orders of magnitude faster than the same task running sequentially on the CPU.

Graphics card drivers used to have 'fixed function' pipelines, where the graphics code was built into the driver, and could only be tweaked within narrow parameters. It was impossible to do very much other than graphics on the graphics card. Now drivers support technologies such as Vulkan, DirectX 11, CUDA, and OpenCL, which allow general-purpose code to be executed on the GPU. As a result, more functionality has been moved to the GPU, freeing up more processing power on the CPU.

The share of the processing time dedicated to AI has grown in fits and starts over the last two decades. In some cases now making up most of the CPU load, with some AI running on the GPU. Along with the increase in processor speeds, this is obviously good news for AI developers wanting to apply more complicated algorithms, particularly to decision making and strategizing. But, while incremental improvements in processor time help unlock new techniques, they don't solve the underlying problem. Many AI algorithms take a long time to run. A comprehensive pathfinding system can take tens of milliseconds to run per character. Clearly, in an RTS with 1000 characters, there is no chance of running each frame.

Complex AI that does work in games needs to be split into bite-size components that

can be distributed over multiple frames. The chapter on resource management shows how to accomplish this. Applying these techniques to many long running AI algorithms can bring them into the realm of practicality.

Low-Level Concerns

One large change in the industry in the last 10 years has been the move away from C++ having a hegemony over game programming. Now, character behavior, game logic, and AI is often written in higher-level languages such as C#, Swift, Java, or even scripting languages. This is significant because these languages provide the programmer less ability to micromanage the performance characteristics of their code. There are AI programmers still working in C++, who still need a good knowledge of the 'bare metal' performance characteristics of the processors, but in my recent experience such programmers tend to be low-level specialists working on AI engines: portfolios of functionality designed to be reused in multiple games.

In the first and second edition of this book, I described three low-level issues in detail: SIMD, superscalar architectures, and virtual functions. In this edition I will describe them only briefly. For reasons I will describe below, in my own professional practice, I haven't been directly concerned with any of these for several years.

SIMD (single instruction, multiple data) are a set of registers on modern hardware large enough to fit several floating point numbers. Mathematical operators can be applied to these registers, which has the effect of running the same code against multiple pieces of data in parallel. This can dramatically speed up some code, particularly geometric reasoning. Although CPUs have dedicated registers for SIMD, they provide the best speed up on code that tends to suit the GPU. Optimizing for SIMD on the CPU is often redundant, when the code can be moved onto the GPU.

Superscalar CPUs have several execution paths active at the same time. Code is split among the parts to execute in parallel and the results are then recombined into the final result. When the result of one pipeline depends on another, this can involve either waiting, or guessing what the result might be and redoing the work if it proves to be wrong (known as branch prediction). In the last decade, multi-core CPUs, where several independent CPUs allow different threads to run in parallel, have become almost ubiquitous. Although each core may still be superscalar, this is now largely treated as a behind-the-scenes detail, irrelevant to AI programmers. Better speed ups can be attained by concentrating on making AI code parallelizable, rather than worrying about the details of branch prediction.

AI code can take advantage of this parallelism by either running AI for different characters in different threads, or by running all AI in a different thread to other game systems. These threads will then be executed in parallel on different cores, when available. Multiple threads doing the same thing (such as one character running its AI in each thread) is often more performant, as it is easier to make sure all processors are being used to the same capacity, and more flexible, as it scales without rebalancing to hardware with a different number of cores.

When AI routinely had to be careful of every single CPU cycle used, it was common to

avoid virtual classes in C++, with their virtual function call overhead. This meant avoiding object-oriented polymorphism, whenever possible. A virtual function call stores the memory location in which the function is implemented in a variable (in a structure called a function table, or vtable). Calling a function therefore involves looking up the variable at runtime, and then looking up the location that variable specifies. Though this extra look-up uses a trivial amount of time, it could interact significantly with the branch predictor and processor cache. For this reason virtual functions, and hence polymorphism, had a bad reputation. A reputation that has largely faded in the past 10 years. The code in this book has always been written in a polymorphic style. Now, game engines such as Unity, Unreal, Lumberyard, and Godot assume that game logic will be polymorphic.

2.3.2 MEMORY CONCERNS

Most AI algorithms do not require a large amount of RAM, often just a few, up to tens of megabytes. This small storage requirement, easily achievable on modest mobile devices, is ample for heavyweight algorithms such as terrain analysis and pathfinding. Massively multiplayer online games (MMOGs) typically require much more storage for their larger worlds, but are run on server farms where sufficient memory can be installed (even then, we are only talking gigabytes of RAM, rarely more). Huge worlds are usually sharded into separate sections, or else characters are limited to certain areas, further reducing the AI memory requirements.

So it is not the amount of memory which is usually the limiting factor, but the way it is used. Allocation, and cache coherence are both memory concerns that affect performance. They can both influence the implementation of an AI algorithm.

Allocation and Garbage Collection

Allocation is the process of asking for memory in which to place data. When that memory is no longer needed it is said to be freed or deallocated. Allocation and deallocation are relatively fast, as long as memory is available.

Low-level languages such as C require the programmer to free memory manually. Languages such as C++ and Swift, when memory is allocated for a particular object, provide 'reference counting.' This stores the number of places that know about the existence of the object. When the object is no longer referenced, the counter drops to 0, and the memory is freed. Unfortunately, both these approaches can mean that memory that should be freed is never freed. Either the programmer forgets to free manually, or there is a circular set of references, such that their counters never drop to 0. Many higher-level languages implement sophisticated algorithms to collect this 'garbage', i.e., free memory that is no longer useful. Unfortunately garbage collection can be expensive. In languages such as C#, particularly in the mono runtime that runs the Unity game engine, garbage collection can be slow enough to delay a rendering frame, causing a visual stutter. This is unacceptable to most developers.

As a result, implementing AI algorithms for higher-level languages often involves trying not to allocate and deallocate objects while a level is running. The data required for the entire level is reserved when the level begins, and only released when the level ends. Several of the algorithms in this book assume that new objects can be created at any time, and will be left to disappear when no longer needed. On a platform with time-consuming garbage collection, it may be important to modify these implementations. For example: several of the pathfinding algorithms (in Chapter 4) create and store data for each location in the map, when that location is first considered. When the path is complete, none of the intermediate location data are needed. A garbage-collection-friendly implementation might create a single pathfinding object, containing data for every location in the map. That same object is called whenever pathfinding is required, and it uses the preallocated location data it needs and ignores the rest. On its own, this implementation will be a little more complicated, and could be considerably more complex if multiple characters who need pathfinding must queue to use the one pathfinding object. To avoid complicating the underlying algorithm this book presents them in their simplest form: without regard for allocation.

Cache

Memory size alone isn't the only limitation on memory use. The time it takes to access memory from the RAM and prepare it for use by the processor is significantly longer than the time it takes for the processor to perform its operations. If processors had to rely on the main RAM, they'd be constantly stalled waiting for data.

All modern processors use at least one level of cache: a copy of the RAM held in the processor that can be very quickly manipulated. Cache is typically fetched in pages; a whole section of main memory is streamed to the processor. It can then be manipulated at will. When the processor has done its work, the cached memory is sent back to the main memory. The processor typically cannot work on the main memory: all the memory it needs must be on cache. An operating system may add additional complexity to this, as a memory request may have to pass through an operating system routine that translates the request into a request for real or virtual memory. This can introduce further constraints, as two bits of physical memory with a similar mapped address might not be available at the same time (called an aliasing failure).

Multiple levels of cache work the same way as a single cache. A large amount of memory is fetched to the lowest level cache, a subset of that is fetched to each higher level cache, and the processor only ever works on the highest level.

If an algorithm uses data spread around memory, then it is unlikely that the right memory will be in the cache from moment to moment. These cache misses are costly in time. The processor has to fetch a whole new chunk of memory into the cache for one or two instructions, then it has to stream it all back out and request another block. A good profiling system will show when cache misses are happening. In my experience, even in languages that don't give

you control over memory layout, dramatic speed ups can be achieved by making sure that all the data needed for one algorithm are kept in the same place, in the same few objects.

In this book, for ease of understanding, I've used an object-oriented style to lay out the data. All the data for a particular game object are kept together. This may not be the most cache-efficient solution. In a game with 1000 characters, it may be better to keep all their positions together in an array, so algorithms that make calculations based on location don't need to constantly jump around memory. As with all optimizations, profiling is everything, but a general level of efficiency can be gained by programming with data coherence in mind.

2.3.3 PLATFORMS

With the centralization of the industry around a few game engines, platform differences have less of an impact on AI design than they used to. Graphics programmers may still have to worry about console versus mobile, for example. But AI programming tends to be more general. In this section I will consider each of the major platforms for games, highlighting any issues specific to AI code.

PC

PCs can be the most powerful games machines, with hard-core gamers buying high-end expensive hardware. But they can be frustrating for developers because of their lack of consistency. Where a console has fixed hardware (or at least relatively few variations), there is a bewildering array of different configurations for PCs. There is a vast difference between a machine with a pair of top of the range video cards, SSD drives and fast memory, and a budget PC with integrated graphics.

Things are easier than they were: low-level developers rely on application programming interfaces (APIs) such as Vulkan and DirectX to insulate them from most hardware specifics, but the game still needs to detect feature support and speed and adjust accordingly. Developers working in an engine such as Unity and Unreal have it even easier, but may still need to use the built-in feature detection to ensure their game runs well on all systems.

Working with PCs involves building software that can scale from a casual gamer's limited system to the hard-core fan's up-to-date hardware. For graphics, this scaling can be reasonably modular; for example, for low-specification machines we switch off advanced rendering features. A simpler shadow algorithm might be used, or physically based shaders might be replaced by simple texture mapping. A change in graphics sophistication usually doesn't change gameplay.

AI is different. If the AI gets less time to work, how should it respond? It can try to perform less work. This is effectively the same as having more stupid AI, and can affect the difficulty level of the game. It is probably not acceptable to have your game be easier on lower specification machines. Similarly, if we try to perform the same amount of work, it might take longer. This can mean a lower frame rate, or it can mean more frames between characters

making decisions. Slow-to-react characters are also often easier to play against and can cause the same problems with QA.

The solution used by most developers is to target AI at the lowest common denominator: the minimum specification machine listed in the technical design document. The AI time doesn't scale at all with the capabilities of the machine. Faster machines simply use proportionally less of their processing budget on AI.

There are many games, however, where scalable AI is feasible. Many games use AI to control ambient characters: pedestrians walking along the sidewalk, members of the crowd cheering a race, or flocks of birds swarming in the sky. This kind of AI is freely scalable: more characters can be used when the processor time is available. Chapter 10 covers some techniques for level of detail AI that can cope with this scalability.

Console

Consoles can be simpler to work with than a PC. You know exactly the machine you are targeting, and you can usually see code in operation on your target machine. There is no future proofing for new hardware or ever-changing versions of APIs to worry about.

Developers working with next-generation technology often don't have the exact specs of the final machine or a reliable hardware platform (initial development kits are often little more than a dedicated emulator), but most console development has a fairly fixed target.

The technical requirements checklist (TRC) process, by which a console manufacturer places minimum standards on the operation of a game, serves to fix things like frame rates (although different territories may vary-PAL and NTSC, for example). This means that AI budgets can be locked down in terms of a fixed number of milliseconds. In turn, this makes it much easier to work out what algorithms can be used and to have a fixed target for optimization (provided that the budget isn't slashed at the last milestone to make way for the latest graphics technique used in a competitor's game).

The same game engines used for PC development target consoles, making cross-platform development much easier than it has been in the past. Fortunately few AI developers creating games are now working with the low-level details of a particular console. Almost all the lowlevel code is handled by engines or middleware.

Mobile

Apple launched the iPhone in 2007, ushering in a revolution in gaming as big as anything since the home consoles of the 80s. When the first edition of this book was released, in 2006, mobile gaming consisted of dedicated handheld consoles like the PlayStation Portable (PSP) and Nintendo's GameBoy advance. Now almost 100% of the market is for phones and tablets.

There are two platforms in the space: Apple, with its iOS devices (iPhone, iPad, iPod Touch), and Android. Until recently these were very different, and required games to be coded for each individually. Although both can use low-level languages such as C and C++, for higher-level languages Apple encourages the use of Swift (it formerly used Objective-C), and Android Java (or languages that compile into Java bytecode, such as Kotlin).

Both the major game engines by market share (Unreal and Unity), as well as many smaller competitors (e.g. Godot) support mobile platforms with the same game code, making platform-specific implementation unnecessary. There has been a big shift toward mobile developers working in a cross-platform way, using these tools. Factoring in the Steam platform as a viable marketplace for mobile games running on PC, I think there is no doubt this trend will soon become almost ubiquitous.

Smartphones capable of running games are powerful machines, comparable to last generation consoles, and PCs 5-10 old. There is no longer any practical difference between the kinds of AI that can be run on a PC or console and those that can be run on mobile. Phones may require simpler graphics or smaller crowd sizes, but in terms of algorithms, the same things now apply.

Virtual and Augmented Reality

At the time of writing, in early 2019, virtual and augmented reality are both extremely hyped, and a tiny proportion of the games market. The technology and the market is in rapid flux, and beyond generalities, very little that could be said now would be true in two years.

Virtual reality (VR) attempts to immerse the player in the game world by providing a stereoscopic 3D point of view. Depending on the hardware, a player's motion may also be detected and incorporated as movement in the game. VR requires separate views of the scene to be rendered for each eye, and to avoid motion sickness, higher frame rates are typically targeted (90fps, for example).

Up to this point most virtual reality devices have been displays tethered to an existing games machine, such as a PC (Oculus Rift and Vive), a console (PlayStation VR), or a phone (Gear VR). At the time of writing, companies are beginning to release standalone VR Products, based on mobile processors, with approximately similar performance to high-end phones.

Augmented reality (AR) uses semitransparent displays to add computer-generated elements to the real world. Although Microsoft released a development kit in early 2016, a consumer version has not yet followed. Magic Leap released their product in 2018, but saw limited demand. Augmented reality may also refer to games that use a mobile phone camera, and add computer-generated elements to the captured images. In that sense, *Pokémon Go* [150], for example, is considered an augmented reality game, but does not require specialist hardware.

While the visual presentation of VR games may be unconventional, the game logic rarely is. Most commercial game engines support VR, AR on mobile via camera, and are positioned to offer hardware AR support, when products are announced. VR and AR games are similar enough in design not to need unusual AI algorithms. It remains to be seen whether these platforms open new design possibilities. It also remains to be seen whether these platforms become a significant part of the industry.

2.4 THE ALENGINE

When I started in the industry, a game was mostly built from scratch. Some bits of code were dragged from previous projects, and some bits were reworked and reused, but most were new. A handful of companies used the same basic code to write multiple games, as long as the games were a similar style and genre. LucasArts' SCUMM engine, for example, was a gradually evolving game engine used to power many point-and-click adventure games.

Since then, game engines have become ubiquitous, a consistent technical platform on which multiple games are built. Low-level routines (like talking to the operating system, loading textures, model file formats, and so on) are shared among all titles, a set of tools are available for a broad range of games (e.g. 2D graphics, 3D graphics, networking), and finally interfaces are provided to add game-specific code on top. Originally these engines belonged to individual companies, but over time only the very largest companies could afford to keep their engines up-to-date. It is now common for large developers to license commercial engines.

The way AI is developed has changed, also. Initially, the AI was written for each game and sometimes for each character. Now there is an increasing tendency to have general AI routines, either built into the game engine, available to license as commercial add-ons, or created and reused in-house by a developer. This allows individual characters to be designed by level editors, game designers, or technical artists. The engine structure is fixed, and the AI for each character combines the components in an appropriate way. The algorithms described in this book are exposed to non-specialists through graphical front-ends. Dragging boxes and lines allows anyone to create a finite state machine (Section 5.3) or behavior tree (Section 5.4), for example.

So, building a game engine involves building AI tools that can be easily reused, combined, and applied in interesting ways. To support this, we need an AI structure that makes sense over multiple genres.

2.4.1 STRUCTURE OF AN AI ENGINE

In my experience, there are a few basic facilities that need to be in place for a general AI system. They conform to the model of AI given in Figure 2.1.

First, we must have some kind of infrastructure in two categories: a general mechanism for managing AI behaviors (deciding which behavior gets to run when, and so on) and a world interfacing system for getting information into the AI. Every AI algorithm needs to honor these mechanisms.

Second, we must have a means to turn whatever the AI wants to do into action on-screen. This consists of standard interfaces to a movement and an animation controller, which can turn requests such as "pull lever 1" or "walk stealthily to position x, y" into action.

Third, a standard behavior structure must serve as a liaison between the two. It is almost guaranteed that you will need to write one or two AI algorithms for each new game. Having

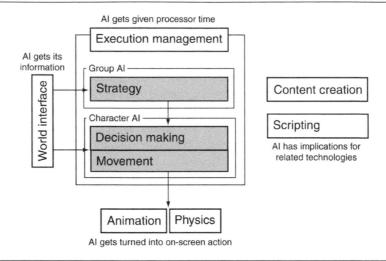

Figure 2.1: The AI model

all AI conform to the same structure helps this immensely. New code can be in development while the game is running, and the new AI can simply replace placeholder behaviors when it is ready.

All this needs to be thought out in advance. The structure needs to be in place before you get well into your AI coding. Part III of this book discusses support technologies, which are the first thing to implement in an AI engine. The individual techniques can then slot in.

Game engines do some of this for you, but not all. Each engine has its own mechanism to make sure your code is run, often in the form of base classes that you should derive from. But you may need to provide more fine-grained control: not every character needs its AI run in every frame. They also provide standard mechanisms for scheduling animations, but less often character movement. And they may provide basic tools for working out which character knows what (such as a built-in line of sight or sight cone check), but will need custom implementations for anything more complex. Unless you intend to use very simple techniques, you will need to create some infrastructure, and possibly some tools in the editor to support it.

I'm not going to emphasize this structure throughout the book. There are techniques that I will cover that can work on their own, and all the algorithms are fairly independent. For a demo, or a simple game, it might be sufficient to just use the technique. But a good AI structure helps promote reuse, and reduces debugging and development time.

2.4.2 TOOL CONCERNS

The complete AI engine will have a central pool of AI algorithms that can be applied to many characters. The definition for a particular character's AI will therefore consist of data (which may include scripts in some scripting language), rather than compiled code. The data specifies how a character is put together: what techniques will be used and how those techniques are parameterized and combined.

This data needs to come from somewhere. Data can be manually created, but this is no better than writing the AI by hand each time. Flexible tools ensure that the artists and designers can create the content in an easy way, while allowing the content to be inserted into the game without manual help. These are usually created as custom modes in the game engine editor: a tool for setting up character decision making rules, or an overlay onto the level used to mark tactical locations or places to avoid.

The need to expose search tools has its own effect on the choice of AI techniques. It is easy to set up behaviors that always act the same way. Steering behaviors (covered in Chapter 3) are a good example: they tend to be very simple, they are easily parameterized (with the physical capabilities of a character), and they do not change from character to character.

It is more difficult to use behaviors that have lots of conditions, where the character needs to evaluate special cases. Many of those covered in Chapter 5 operate this way. Those based on a tree (decision trees, behavior trees) are easier to represent visually. A rule-based system, on the other hand, needs to have complicated matching rules defined. When these are supported in a tool they typically look like program code, because a programming language is the most natural way to express them.

2.4.3 PUTTING IT ALL TOGETHER

The final structure of the AI engine might look something like Figure 2.2. Data are created in a tool (the modeling or level editor), which is then packaged for use in the game. When a level is loaded, the game AI behaviors are created from level data and registered with the AI engine. During gameplay, the main game code calls the AI engine which updates the behaviors, getting information from the world interface and finally applying their output to the game data.

The particular techniques used depend heavily on the genre of the game being developed. We'll see a wide range of techniques for many different genres in this book. As you develop your game AI, you'll need to take a mix and match approach to get the behaviors you are looking for. The final part of the book gives some hints on this; it looks at how the AI for games in the major genres are put together piece by piece.

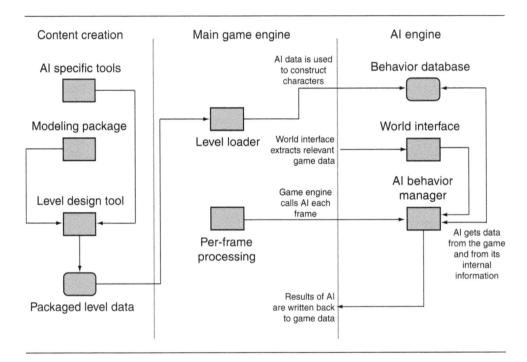

Figure 2.2: AI schematic

PART II

Techniques

3

MOVEMENT

O^{NE} of the most fundamental requirements of game AI is to sensibly move characters around. Even the earliest AI-controlled characters (the ghosts in *Pac-Man*, for example, or the opposing bat in some *Pong* variants) had movement algorithms that weren't far removed from modern games.

Movement forms the lowest level of AI techniques in our model, shown in Figure 3.1.

Many games, including some with quite decent-looking AI, rely solely on movement algorithms and don't have any more advanced decision making. At the other extreme, some games don't need moving characters at all. Resource management games and turn-based games often don't need movement algorithms; once a decision is made where to move, the character can simply be placed there.

There is also some degree of overlap between AI and animation; animation is also about movement. This chapter looks at large-scale movement: the movement of characters around the game level, rather than the movement of their limbs or faces. The dividing line isn't always clear, however. In many games, animation can take control over a character, including some large-scale movement. This may be as simple as the character moving a few steps to pull a lever. Or as complex as mini cut-scenes, completely animated, that seamlessly transition into and out of gameplay. These are not AI driven and therefore aren't covered here.

This chapter will look at a range of different AI-controlled movement algorithms, from the simple Pac-Man level up to the complex steering behaviors used for driving a racing car or piloting a spaceship in three dimensions.

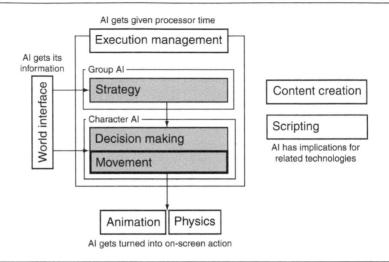

Figure 3.1: The AI model

$3.1\,$ the basics of movement algorithms

Unless you're writing an economic simulator, chances are the characters in your game need to move around. Each character has a current position and possibly additional physical properties that control its movement. A movement algorithm is designed to use these properties to work out where the character should be next.

All movement algorithms have this same basic form. They take geometric data about their own state and the state of the world, and they come up with a geometric output representing the movement they would like to make. Figure 3.2 shows this schematically. In the figure, the velocity of a character is shown as optional because it is only needed for certain classes of movement algorithms.

Some movement algorithms require very little input: just the position of the character and the position of an enemy to chase, for example. Others require a lot of interaction with the game state and the level geometry. A movement algorithm that avoids bumping into walls, for example, needs to have access to the geometry of the wall to check for potential collisions.

The output can vary too. In most games it is normal to have movement algorithms output a desired velocity. A character might see its enemy to the west, for example, and respond that its movement should be westward at full speed. Often, characters in older games only had two speeds: stationary and running (with maybe a walk speed in there, too, for patrolling). So the output was simply a direction to move in. This is kinematic movement; it does not account for how characters accelerate and slow down.

It is common now for more physical properties to be taken into account. Producing movement algorithms I will call "steering behaviors." Steering behaviors is the name given by Craig

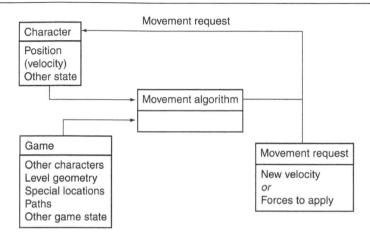

Figure 3.2: The movement algorithm structure

Reynolds to his movement algorithms [51]; they are not kinematic, but dynamic. Dynamic movement takes account of the current motion of the character. A dynamic algorithm typically needs to know the current velocities of the character as well as its position. A dynamic algorithm outputs forces or accelerations with the aim of changing the velocity of the character.

Dynamics adds an extra layer of complexity. Let's say your character needs to move from one place to another. A kinematic algorithm simply gives the direction to the target; your character moves in that direction until it arrives, whereupon the algorithm returns no direction. A dynamic movement algorithm needs to work harder. It first needs to accelerate in the right direction, and then as it gets near its target it needs to accelerate in the opposite direction, so its speed decreases at precisely the correct rate to slow it to a stop at exactly the right place. Because Craig's work is so well known, in the rest of this chapter I'll usually follow the most common terminology and refer to all dynamic movement algorithms as steering behaviors.

Craig Reynolds also invented the flocking algorithm used in countless films and games to animate flocks of birds or herds of other animals. We'll look at this algorithm later in the chapter. Because flocking is the most famous steering behavior, all steering algorithms (in fact, all movement algorithms) are sometimes wrongly called "flocking."

TWO-DIMENSIONAL MOVEMENT

Many games have AI that works in two dimensions (2D). Even games that are rendered in three dimensions (3D), usually have characters that are under the influence of gravity, sticking them to the floor and constraining their movement to two dimensions.

A lot of movement AI can be achieved in 2D, and most of the classic algorithms are only

defined for this case. Before looking at the algorithms themselves, we need to quickly cover the data needed to handle 2D math and movement.

Characters as Points

Although a character usually consists of a 3D model that occupies some space in the game world, many movement algorithms assume that the character can be treated as a single point. Collision detection, obstacle avoidance, and some other algorithms use the size of the character to influence their results, but movement itself assumes the character is at a single point.

This is a process similar to that used by physics programmers who treat objects in the game as a "rigid body" located at its center of mass. Collision detection and other forces can be applied anywhere on the object, but the algorithm that determines the movement of the object converts them so it can deal only with the center of mass.

3.1.2 STATICS

Characters in two dimensions have two linear coordinates representing the position of the object. These coordinates are relative to two world axes that lie perpendicular to the direction of gravity and perpendicular to each other. This set of reference axes is termed the orthonormal basis of the 2D space.

In most games the geometry is typically stored and rendered in three dimensions. The geometry of the model has a 3D orthonormal basis containing three axes: normally called x, y, and z. It is most common for the y-axis to be in the opposite direction to gravity (i.e., "up") and for the x and z axes to lie in the plane of the ground. Movement of characters in the game takes place along the x and z axes used for rendering, as shown in Figure 3.3. For this reason this chapter will use the x and z axes when representing movement in two dimensions, even though books dedicated to 2D geometry tend to use x and y for the axis names.

In addition to the two linear coordinates, an object facing in any direction has one orientation value. The orientation value represents an angle from a reference axis. In our case we use a counterclockwise angle, in radians, from the positive z-axis. This is fairly standard in game engines; by default (i.e., with zero orientation a character is looking down the z-axis).

With these three values the static state of a character can be given in the level, as shown in Figure 3.4.

Algorithms or equations that manipulate this data are called static because the data do not contain any information about the movement of a character.

We can use a data structure of the form:

```
class Static:
       position: Vector
2
       orientation: float
```

Figure 3.3: The 2D movement axes and the 3D basis

Figure 3.4: The positions of characters in the level

I will use the term *orientation* throughout this chapter to mean the direction in which a character is facing. When it comes to rendering characters, we will make them appear to face one direction by rotating them (using a rotation matrix). Because of this, some developers refer to orientation as *rotation*. I will use rotation in this chapter only to mean the process of changing orientation; it is an active process.

2½ Dimensions

Some of the math involved in 3D geometry is complicated. The linear movement in three dimensions is quite simple and a natural extension of 2D movement, but representing an orientation has tricky consequences that are better to avoid (at least until the end of the chapter).

As a compromise, developers often use a hybrid of 2D and 3D calculations which is known as 2½D, or sometimes four degrees of freedom.

In 2½ dimensions we deal with a full 3D position but represent orientation as a single value, as if we are in two dimensions. This is quite logical when you consider that most games involve characters under the influence of gravity. Most of the time a character's third dimension is constrained because it is pulled to the ground. In contact with the ground, it is effectively operating in two dimensions, although jumping, dropping off ledges, and using elevators all involve movement through the third dimension.

Even when moving up and down, characters usually remain upright. There may be a slight tilt forward while walking or running or a lean sideways out from a wall, but this tilting doesn't affect the movement of the character; it is primarily an animation effect. If a character remains upright, then the only component of its orientation we need to worry about is the rotation about the up direction.

This is precisely the situation we take advantage of when we work in 2½D, and the simplification in the math is worth the decreased flexibility in most cases.

Of course, if you are writing a flight simulator or a space shooter, then all the orientations are very important to the AI, so you'll have to support the mathematics for three-dimensional orientation. At the other end of the scale, if your game world is completely flat and characters can't jump or move vertically in any other way, then a strict 2D model is needed. In the vast majority of cases, $2\frac{1}{2}$ D is an optimal solution. I'll cover full 3D motion at the end of the chapter, but aside from that, all the algorithms described in this chapter are designed to work in $2\frac{1}{2}$ D.

Math

In the remainder of this chapter I will assume that you are comfortable using basic vector and matrix mathematics (i.e., addition and subtraction of vectors, multiplication by a scalar). Explanations of vector and matrix mathematics, and their use in computer graphics, are beyond the scope of this book. If you can find it, the older book Schneider and Eberly [56], covers mathematical topics in computer games to a much deeper level. An excellent, and more recent alternative is [36].

Positions are represented as a vector with x and z components of position. In $2\frac{1}{2}D$, a y component is also given.

In two dimensions we need only an angle to represent orientation. The angle is measured from the positive z-axis, in a right-handed direction about the positive y-axis (counterclockwise as you look down on the x-z plane from above). Figure 3.4 gives an example of how the scalar orientation is measured.

It is more convenient in many circumstances to use a vector representation of orientation. In this case the vector is a unit vector (it has a length of one) in the direction that the character is facing. This can be directly calculated from the scalar orientation using simple trigonometry:

$$ec{\omega_v} = egin{bmatrix} \sin \omega_s \ \cos \omega_s \end{bmatrix}$$

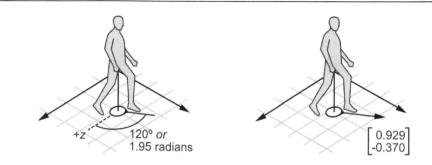

Figure 3.5: The vector form of orientation

where ω_s is the orientation as a scalar (i.e. a single number representing the angle), and $\vec{\omega_v}$ is the orientation expressed as a vector. I am assuming a right-handed coordinate system here, in common with most of the game engines I've worked on, if you use a left-handed system, then simply flip the sign of the x coordinate:

$$ec{\omega_v} = egin{bmatrix} -\sin\omega_s \ \cos\omega_s \end{bmatrix}$$

If you draw the vector form of the orientation, it will be a unit length vector in the direction that the character is facing, as shown in Figure 3.5.

3.1.3 KINEMATICS

So far, each character has two associated pieces of information: its position and its orientation. We can create movement algorithms to calculate a target velocity based on position and orientation alone, allowing the output velocity to change instantly.

While this is fine for many games, it can look unrealistic. A consequence of Newton's laws of motion is that velocities cannot change instantly in the real world. If a character is moving in one direction and then instantly changes direction or speed, it may look odd. To make smooth motion or to cope with characters that can't accelerate very quickly, we need either to use some kind of smoothing algorithm or to take account of the current velocity and use accelerations to change it.

To support this, the character keeps track of its current velocity as well as position. Algorithms can then operate to change the velocity slightly at each frame, giving a smooth motion.

Characters need to keep track of both their linear and their angular velocities. Linear velocity has both x and z components, the speed of the character in each of the axes in the

Left-handed coordinates work just as well with all the algorithms in this chapter. See [13] for more details of the
difference, and how to convert between them.

orthonormal basis. If we are working in 2½D, then there will be three linear velocity components, in x, y, and z.

The angular velocity represents how fast the character's orientation is changing. This is given by a single value: the number of radians per second that the orientation is changing.

I will call angular velocity rotation, since rotation suggests motion. Linear velocity will normally be referred to as simply velocity. We can therefore represent all the kinematic data for a character (i.e., its movement and position) in one structure:

```
class Kinematic:
   position: Vector
   orientation: float
    velocity: Vector
    rotation: float
```

Steering behaviors operate with these kinematic data. They return accelerations that will change the velocities of a character in order to move them around the level. Their output is a set of accelerations:

```
class SteeringOutput:
       linear: Vector
2
       angular: float
```

Independent Facing

Notice that there is nothing to connect the direction that a character is moving and the direction it is facing. A character can be oriented along the x-axis but be traveling directly along the z-axis. Most game characters should not behave in this way; they should orient themselves so they move in the direction they are facing.

Many steering behaviors ignore facing altogether. They operate directly on the linear components of the character's data. In these cases the orientation should be updated so that it matches the direction of motion.

This can be achieved by directly setting the orientation to the direction of motion, but doing so may mean the orientation changes abruptly.

A better solution is to move it a proportion of the way toward the desired direction: to smooth the motion over many frames. In Figure 3.6, the character changes its orientation to be halfway toward its current direction of motion in each frame. The triangle indicates the orientation, and the gray shadows show where the character was in previous frames, to illustrate its motion.

Updating Position and Orientation

If your game uses a physics engine, it may be used to update the position and orientation of characters. Even with a physics engine, some developers prefer to use only its collision

Figure 3.6: Smoothing facing direction of motion over multiple frames

detection on characters, and code custom movement controllers. So if you need to update position and orientation manually, you can use a simple algorithm of the form:

```
class Kinematic:
       # ... Member data as before ...
2
3
       function update(steering: SteeringOutput, time: float):
4
           # Update the position and orientation.
5
           half_t_sq: float = 0.5 * time * time
           position += velocity * time + steering.linear * half_t_sq
           orientation += rotation * time + steering.angular * half_t_sq
           # and the velocity and rotation.
10
           velocity += steering.linear * time
11
           rotation += steering.angular * time
12
```

The updates use high-school physics equations for motion. If the frame rate is high, then the update time passed to this function is likely to be very small. The square of this time is likely to be even smaller, and so the contribution of acceleration to position and orientation will be tiny. It is more common to see these terms removed from the update algorithm, to give what's known as the Newton-Euler-1 integration update:

```
class Kinematic:
       # ... Member data as before ...
2
3
       function update(steering: SteeringOutput, time: float):
           # Update the position and orientation.
           position += velocity * time
           orientation += rotation * time
           # and the velocity and rotation.
           velocity += steering.linear * time
10
           rotation += steering.angular * time
```

This is the most common update used for games. Note that, in both blocks of code I've assumed that we can do normal mathematical operations with vectors, such as addition and multiplication by a scalar. Depending on the language you are using, you may have to replace these primitive operations with function calls.

The *Game Physics* [12] book in the Morgan Kaufmann Interactive 3D Technology series, and my *Game Physics Engine Development* [40], also in that series, have a complete analysis of different update methods and cover a more complete range of physics tools for games (as well as detailed implementations of vector and matrix operations).

Variable Frame Rates

So far I have assumed that velocities are given in units per second rather than per frame. Older games often used per-frame velocities, but that practice largely died out, before being resurrected occasionally when gameplay began to be processed in a separate execution thread with a fixed frame rate, separate to graphics updates (Unity's FixedUpdate function compared to its variable Update, for example). Even with these functions available, it is more flexible to support variable frame rates, in case the fixed update rate needs changing. For this reason I will continue to use an explicit update time.

If the character is known to be moving at 1 meter per second and the last frame was of 20 milliseconds' duration, then they will need to move 20 millimeters.

Forces and Actuation

In the real world we can't simply apply an acceleration to an object and have it move. We apply forces, and the forces cause a change in the kinetic energy of the object. They will accelerate, of course, but the acceleration will depend on the inertia of the object. The inertia acts to resist the acceleration; with higher inertia, there is less acceleration for the same force.

To model this in a game, we could use the object's mass for the linear inertia and the moment of inertia (or inertia tensor in three dimensions) for angular acceleration.

We could continue to extend the character data to keep track of these values and use a more complex update procedure to calculate the new velocities and positions. This is the method used by physics engines: the AI controls the motion of a character by applying forces to it. These forces represent the ways in which the character can affect its motion. Although not common for human characters, this approach is almost universal for controlling cars in driving games: the drive force of the engine and the forces associated with the steering wheels are the only ways in which the AI can control the movement of the car.

Because most well-established steering algorithms are defined with acceleration outputs, it is not common to use algorithms that work directly with forces. Usually, the movement controller considers the dynamics of the character in a post-processing step called *actuation*.

Actuation takes as input a desired change in velocity, the kind that would be directly applied in a kinematic system. The actuator then calculates the combination of forces that it can apply to get as near as possible to the desired velocity change.

At the simplest level this is just a matter of multiplying the acceleration by the inertia to

give a force. This assumes that the character is capable of applying any force, however, which isn't always the case (a stationary car can't accelerate sideways, for example). Actuation is a major topic in AI and physics integration, and I'll return to actuation at some length in Section 3.8 of this chapter.

3.2 KINEMATIC MOVEMENT ALGORITHMS

Kinematic movement algorithms use static data (position and orientation, no velocities) and output a desired velocity. The output is often simply an on or off and a target direction, moving at full speed or being stationary. Kinematic algorithms do not use acceleration, although the abrupt changes in velocity might be smoothed over several frames.

Many games simplify things even further and force the orientation of a character to be in the direction it is traveling. If the character is stationary, it faces either a pre-set direction or the last direction it was moving in. If its movement algorithm returns a target velocity, then that is used to set its orientation.

This can be done simply with the function:

```
function newOrientation(current: float, velocity: Vector) -> float:
      # Make sure we have a velocity.
      if velocity.length() > 0:
          # Calculate orientation from the velocity.
5
          return atan2(-static.x, static.z)
      # Otherwise use the current orientation.
      else:
          return current
```

We'll look at two kinematic movement algorithms: seeking (with several of its variants) and wandering. Building kinematic movement algorithms is extremely simple, so we'll only look at these two as representative samples before moving on to dynamic movement algorithms, the bulk of this chapter.

I can't stress enough, however, that this brevity is not because they are uncommon or unimportant. Kinematic movement algorithms still form the bread and butter of movement systems in a lot of games. The dynamic algorithms in the rest of the book are widespread, where character movement is controlled by a physics engine, but they are still not ubiquitous.

3.2.1 **SEEK**

A kinematic seek behavior takes as input the character's static data and its target's static data. It calculates the direction from the character to the target and requests a velocity along this line. The orientation values are typically ignored, although we can use the newOrientation function above to face in the direction we are moving.

The algorithm can be implemented in a few lines:

```
class KinematicSeek:
       character: Static
2
       target: Static
       maxSpeed: float
       function getSteering() -> KinematicSteeringOutput:
           result = new KinematicSteeringOutput()
           # Get the direction to the target.
10
           result.velocity = target.position - character.position
11
12
           # The velocity is along this direction, at full speed.
13
           result.velocity.normalize()
14
           result.velocity *= maxSpeed
15
           # Face in the direction we want to move.
           character.orientation = newOrientation(
               character.orientation,
               result.velocity)
20
21
           result.rotation = 0
22
           return result
23
```

where the normalize method applies to a vector and makes sure it has a length of one. If the vector is a zero vector, then it is left unchanged.

Data Structures and Interfaces

We use the Static data structure as defined at the start of the chapter and a Kinematic-SteeringOutput structure for output. The KinematicSteeringOutput structure has the following form:

```
class KinematicSteeringOutput:
      velocity: Vector
2
       rotation: float
```

In this algorithm rotation is never used; the character's orientation is simply set based on their movement. You could remove the call to newOrientation if you want to control orientation independently somehow (to have the character aim at a target while moving, as in Tomb Raider [95], or twin-stick shooters such as The Binding of Isaac [151], for example).

Performance

The algorithm is O(1) in both time and memory.

Flee

If we want the character to run away from the target, we can simply reverse the second line of the getSteering method to give:

```
# Get the direction away from the target.
steering.velocity = character.position - target.position
```

The character will then move at maximum velocity in the opposite direction.

Arriving

The algorithm above is intended for use by a chasing character; it will never reach its goal, but it continues to seek. If the character is moving to a particular point in the game world, then this algorithm may cause problems. Because it always moves at full speed, it is likely to overshoot an exact spot and wiggle backward and forward on successive frames trying to get there. This characteristic wiggle looks unacceptable. We need to end by standing stationary at the target spot.

To achieve this we have two choices. We can just give the algorithm a large radius of satisfaction and have it be satisfied if it gets closer to its target than that. Alternatively, if we support a range of movement speeds, then we could slow the character down as it reaches its target, making it less likely to overshoot.

The second approach can still cause the characteristic wiggle, so we benefit from blending both approaches. Having the character slow down allows us to use a much smaller radius of satisfaction without getting wiggle and without the character appearing to stop instantly.

We can modify the seek algorithm to check if the character is within the radius. If so, it doesn't worry about outputting anything. If it is not, then it tries to reach its target in a fixed length of time. (I've used a quarter of a second, which is a reasonable figure; you can tweak the value if you need to.) If this would mean moving faster than its maximum speed, then it moves at its maximum speed. The fixed time to target is a simple trick that makes the character slow down as it reaches its target. At 1 unit of distance away it wants to travel at 4 units per second. At a quarter of a unit of distance away it wants to travel at 1 unit per second, and so on. The fixed length of time can be adjusted to get the right effect. Higher values give a more gentle deceleration, and lower values make the braking more abrupt.

The algorithm now looks like the following:

```
class KinematicArrive:
      character: Static
2
      target: Static
```

```
4
       maxSpeed: float
5
6
       # The satisfaction radius.
7
       radius: float
8
10
       # The time to target constant.
11
       timeToTarget: float = 0.25
12
       function getSteering() -> KinematicSteeringOutput:
13
            result = new KinematicSteeringOutput()
14
15
            # Get the direction to the target.
16
            result.velocity = target.position - character.position
17
18
            # Check if we're within radius.
19
            if result.velocity.length() < radius:</pre>
20
                # Request no steering.
21
                return null
22
23
            # We need to move to our target, we'd like to
24
            # get there in timeToTarget seconds.
25
            result.velocity /= timeToTarget
26
27
            # If this is too fast, clip it to the max speed.
28
            if result.velocity.length() > maxSpeed:
29
                result.velocity.normalize()
30
                result.velocity *= maxSpeed
31
32
            # Face in the direction we want to move.
33
            character.orientation = newOrientation(
                character.orientation,
35
                result.velocity)
36
37
            result.rotation = 0
38
            return result
```

I've assumed a length function that gets the length of a vector.

3.2.2 WANDERING

A kinematic wander behavior always moves in the direction of the character's current orientation with maximum speed. The steering behavior modifies the character's orientation, which allows the character to meander as it moves forward. Figure 3.7 illustrates this. The character is shown at successive frames. Note that it moves only forward at each frame (i.e., in the direction it was facing at the previous frame).

Figure 3.7: A character using kinematic wander

Pseudo-Code

It can be implemented as follows:

```
class KinematicWander:
2
       character: Static
       maxSpeed: float
3
5
       # The maximum rotation speed we'd like, probably should be smaller
       # than the maximum possible, for a leisurely change in direction.
       maxRotation: float
       function getSteering() -> KinematicSteeringOutput:
           result = new KinematicSteeringOutput()
10
11
           # Get velocity from the vector form of the orientation.
12
           result.velocity = maxSpeed * character.orientation.asVector()
13
14
           # Change our orientation randomly.
15
16
           result.rotation = randomBinomial() * maxRotation
17
           return result
18
```

Data Structures

Orientation values have been given an asVector function that converts the orientation into a direction vector using the formulae given at the start of the chapter.

Implementation Notes

I've used randomBinomial to generate the output rotation. This is a handy random number function that isn't common in the standard libraries of programming languages. It returns a random number between -1 and 1, where values around zero are more likely. It can be simply created as:

```
function randomBinomial() -> float:
    return random() - random()
```

where random() returns a random number from 0 to 1.

For our wander behavior, this means that the character is most likely to keep moving in its current direction. Rapid changes of direction are less likely, but still possible.

3.3 STEERING BEHAVIORS

Steering behaviors extend the movement algorithms in the previous section by adding velocity and rotation. In some genres (such as driving games) they are dominant; in other genres they are more context dependent: some characters need them, some characters don't.

There is a whole range of different steering behaviors, often with confusing and conflicting names. As the field has developed, no clear naming schemes have emerged to tell the difference between one atomic steering behavior and a compound behavior combining several of them together.

In this book I'll separate the two: fundamental behaviors and behaviors that can be built up from combinations of these.

There are a large number of named steering behaviors in various papers and code samples. Many of these are variations of one or two themes. Rather than catalog a zoo of suggested behaviors, we'll look at the basic structures common to many of them before looking at some exceptions with unusual features.

3.3.1 STEERING BASICS

By and large, most steering behaviors have a similar structure. They take as input the kinematic of the character that is moving and a limited amount of target information. The target information depends on the application. For chasing or evading behaviors, the target is often another moving character. Obstacle avoidance behaviors take a representation of the collision geometry of the world. It is also possible to specify a path as the target for a path following behavior.

The set of inputs to a steering behavior isn't always available in an AI-friendly format. Collision avoidance behaviors, in particular, need to have access to collision information in the level. This can be an expensive process: checking the anticipated motion of the character using ray casts or trial movement through the level.

Many steering behaviors operate on a group of targets. The famous flocking behavior, for example, relies on being able to move toward the average position of the flock. In these behaviors some processing is needed to summarize the set of targets into something that the behavior can react to. This may involve averaging properties of the whole set (to find and aim for their center of mass, for example), or it may involve ordering or searching among them (such as moving away from the nearest predator or avoiding bumping into other characters that are on a collision course).

Notice that the steering behavior isn't trying to do everything. There is no behavior to avoid obstacles while chasing a character and making detours via nearby power-ups. Each algorithm does a single thing and only takes the input needed to do that. To get more complicated behaviors, we will use algorithms to combine the steering behaviors and make them work together.

3.3.2 VARIABLE MATCHING

The simplest family of steering behaviors operates by variable matching: they try to match one or more of the elements of the character's kinematic to a single target kinematic.

We might try to match the position of the target, for example, not caring about the other elements. This would involve accelerating toward the target position and decelerating once we are near. Alternatively, we could try to match the orientation of the target, rotating so that we align with it. We could even try to match the velocity of the target, following it on a parallel path and copying its movements but staying a fixed distance away.

Variable matching behaviors take two kinematics as input: the character kinematic and the target kinematic. Different named steering behaviors try to match a different combination of elements, as well as adding additional properties that control how the matching is performed.

It is possible, but not particularly helpful, to create a general steering behavior capable of matching any subset of variables and simply tell it which combination of elements to match. I've made the mistake of trying this implementation myself. The problem arises when more than one element of the kinematic is being matched at the same time. They can easily conflict. We can match a target's position and orientation independently. But what about position and velocity? If we are matching velocities, between a character and its target, then we can't simultaneously be trying to get any closer.

A better technique is to have individual matching algorithms for each element and then combine them in the right combination later. This allows us to use any of the steering behavior combination techniques in this chapter, rather than having one hard-coded. The algorithms for combing steering behaviors are designed to resolve conflicts and so are perfect for this task.

For each matching steering behavior, there is an opposite behavior that tries to get as far away from matching as possible. A behavior that tries to catch its target has an opposite that tries to avoid its target; a behavior that tries to avoid colliding with walls has an opposite that hugs them (perhaps for use in the character of a timid mouse) and so on. As we saw in the kinematic seek behavior, the opposite form is usually a simple tweak to the basic behavior. We will look at several steering behaviors in a pair with their opposite, rather than separating them into separate sections.

3.3.3 SEEK AND FLEE

Seek tries to match the position of the character with the position of the target. Exactly as for the kinematic seek algorithm, it finds the direction to the target and heads toward it as fast as possible. Because the steering output is now an acceleration, it will accelerate as much as possible.

Obviously, if it keeps on accelerating, its speed will grow larger and larger. Most characters have a maximum speed they can travel; they can't accelerate indefinitely. The maximum can be explicit, held in a variable or constant, or it might be a function of speed-dependent drag, slowing the character down more strongly the faster it goes.

With an explicit maximum, the current speed of the character (the length of the velocity vector) is checked regularly, and is trimmed back if it exceeds the maximum speed. This is normally done as a post-processing step of the update function. It is not normally performed in a steering behavior. For example,

```
class Kinematic:
       # ... Member data as before ...
2
3
       function update(steering: SteeringOutput,
                        maxSpeed: float,
5
                        time: float):
6
           # Update the position and orientation.
7
           position += velocity * time
           orientation += rotation * time
10
           # and the velocity and rotation.
11
           velocity += steering.linear * time
12
            rotation += steering.angular * time
13
14
            # Check for speeding and clip.
15
            if velocity.length() > maxSpeed:
16
                velocity.normalize()
17
                velocity *= maxSpeed
18
```

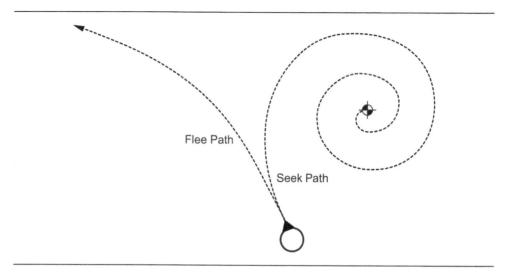

Figure 3.8: Seek and flee

Games that rely on physics engines typically include drag instead of a maximum speed (though they may use a maximum speed as well for safety). Without a maximum speed, the update does not need to check and clip the current velocity; the drag (applied in the physics update function) automatically limits the top speed.

Drag also helps another problem with this algorithm. Because the acceleration is always directed toward the target, if the target is moving, the seek behavior will end up orbiting rather than moving directly toward it. If there is drag in the system, then the orbit will become an inward spiral. If drag is sufficiently large, the player will not notice the spiral and will see the character simply move directly to its target.

Figure 3.8 illustrates the path that results from the seek behavior and its opposite, the flee path, described below.

Pseudo-Code

The dynamic seek implementation looks very similar to our kinematic version:

```
class Seek:
character: Kinematic
target: Kinematic

maxAcceleration: float

function getSteering() -> SteeringOutput:
result = new SteeringOutput()
```

```
# Get the direction to the target.
result.linear = target.position - character.position

# Give full acceleration along this direction.
result.linear.normalize()
result.linear *= maxAcceleration

result.angular = 0
return result
```

Note that I've removed the change in orientation that was included in the kinematic version. We can simply set the orientation, as we did before, but a more flexible approach is to use variable matching to make the character face in the correct direction. The align behavior, described below, gives us the tools to change orientation using angular acceleration. The "look where you're going" behavior uses this to face the direction of movement.

Data Structures and Interfaces

This class uses the SteeringOutput structure we defined earlier in the chapter. It holds linear and angular acceleration outputs.

Performance

The algorithm is again O(1) in both time and memory.

Flee

Flee is the opposite of seek. It tries to get as far from the target as possible. Just as for kinematic flee, we simply need to flip the order of terms in the second line of the function:

```
# Get the direction to the target.
steering.linear = character.position - target.position
```

The character will now move in the opposite direction of the target, accelerating as fast as possible.

3.3.4 ARRIVE

Seek will always move toward its goal with the greatest possible acceleration. This is fine if the target is constantly moving and the character needs to give chase at full speed. If the character

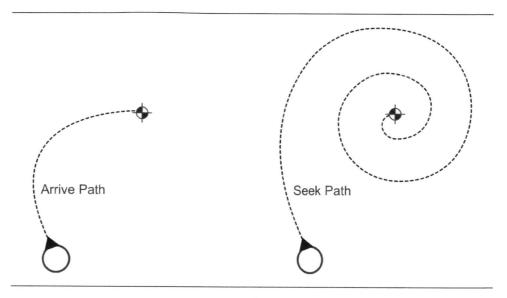

Figure 3.9: Seeking and arriving

arrives at the target, it will overshoot, reverse, and oscillate through the target, or it will more likely orbit around the target without getting closer.

If the character is supposed to arrive at the target, it needs to slow down so that it arrives exactly at the right location, just as we saw in the kinematic arrive algorithm. Figure 3.9 shows the behavior of each for a fixed target. The trails show the paths taken by seek and arrive. Arrive goes straight to its target, while seek orbits a bit and ends up oscillating. The oscillation is not as bad for dynamic seek as it was in kinematic seek: the character cannot change direction immediately, so it appears to wobble rather than shake around the target.

The dynamic arrive behavior is a little more complex than the kinematic version. It uses two radii. The arrival radius, as before, lets the character get near enough to the target without letting small errors keep it in motion. A second radius is also given, but is much larger. The incoming character will begin to slow down when it passes this radius. The algorithm calculates an ideal speed for the character. At the slowing-down radius, this is equal to its maximum speed. At the target point, it is zero (we want to have zero speed when we arrive). In between, the desired speed is an interpolated intermediate value, controlled by the distance from the target.

The direction toward the target is calculated as before. This is then combined with the desired speed to give a target velocity. The algorithm looks at the current velocity of the character and works out the acceleration needed to turn it into the target velocity. We can't immediately change velocity, however, so the acceleration is calculated based on reaching the target velocity in a fixed time scale.

This is exactly the same process as for kinematic arrive, where we tried to get the character

to arrive at its target in a quarter of a second. Because there is an extra layer of indirection (acceleration effects velocity which affects position) the fixed time period for dynamic arrive can usually be a little smaller; we'll use 0.1 as a good starting point.

When a character is moving too fast to arrive at the right time, its target velocity will be smaller than its actual velocity, so the acceleration is in the opposite direction—it is acting to slow the character down.

Pseudo-Code

The full algorithm looks like the following:

```
class Arrive:
1
2
       character: Kinematic
       target: Kinematic
3
       maxAcceleration: float
5
       maxSpeed: float
6
       # The radius for arriving at the target.
       targetRadius: float
10
       # The radius for beginning to slow down.
       slowRadius: float
12
13
       # The time over which to achieve target speed.
14
       timeToTarget: float = 0.1
15
16
       function getSteering() -> SteeringOutput:
17
            result = new SteeringOutput()
18
19
           # Get the direction to the target.
20
           direction = target.position - character.position
           distance = direction.length()
23
           # Check if we are there, return no steering.
24
            if distance < targetRadius:</pre>
25
                return null
26
27
            # If we are outside the slowRadius, then move at max speed.
28
            if distance > slowRadius:
29
                targetSpeed = maxSpeed
30
           # Otherwise calculate a scaled speed.
31
            else:
32
33
                targetSpeed = maxSpeed * distance / slowRadius
34
           # The target velocity combines speed and direction.
35
```

```
36
            targetVelocity = direction
            targetVelocity.normalize()
37
            targetVelocity *= targetSpeed
38
39
            # Acceleration tries to get to the target velocity.
40
            result.linear = targetVelocity - character.velocity
41
            result.linear /= timeToTarget
42
43
            # Check if the acceleration is too fast.
44
            if result.linear.length() > maxAcceleration:
45
                result.linear.normalize()
46
                result.linear *= maxAcceleration
49
            result.angular = 0
            return result
```

Performance

The algorithm is O(1) in both time and memory, as before.

Implementation Notes

Many implementations do not use a target radius. Because the character will slow down to reach its target, there isn't the same likelihood of oscillation that we saw in kinematic arrive. Removing the target radius usually makes no noticeable difference. It can be significant, however, with low frame rates or where characters have high maximum speeds and low accelerations. In general, it is good practice to give a margin of error around any target, to avoid annoying instabilities.

Leave

Conceptually, the opposite behavior of arrive is leave. There is no point in implementing it, however. If we need to leave a target, we are unlikely to want to accelerate with minuscule (possibly zero) acceleration first and then build up. We are more likely to accelerate as fast as possible. So for practical purposes the opposite of arrive is flee.

3.3.5 ALIGN

Align tries to match the orientation of the character with that of the target. It pays no attention to the position or velocity of the character or target. Recall that orientation is not directly

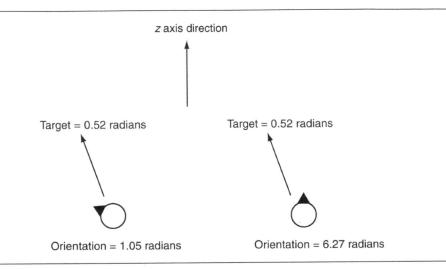

Figure 3.10: Aligning over a 2π radians boundary

related to direction of movement for a general kinematic. This steering behavior does not produce any linear acceleration; it only responds by turning.

Align behaves in a similar way to arrive. It tries to reach the target orientation and tries to have zero rotation when it gets there. Most of the code from arrive we can copy, but orientations have an added complexity that we need to consider.

Because orientations wrap around every 2π radians, we can't simply subtract the target orientation from the character orientation and determine what rotation we need from the result. Figure 3.10 shows two very similar align situations, where the character is the same angle away from its target. If we simply subtracted the two angles, the first one would correctly rotate a small amount clockwise, but the second one would travel all around to get to the same place.

To find the actual direction of rotation, we subtract the character orientation from the target and convert the result into the range $(-\pi,\pi)$ radians. We perform the conversion by adding or subtracting some multiple of 2π to bring the result into the given range. We can calculate the multiple to use by using the mod function and a little jiggling about. Most game engines or graphics libraries have one available (in Unreal Engine it is FMath::FindDeltaAngle, in Unity it is Mathf.DeltaAngle, though be aware that Unity uses degrees for its angles not radians).

We can then use the converted value to control rotation, and the algorithm looks very similar to arrive. Like arrive, we use two radii: one for slowing down and one to make orientations near the target acceptable. Because we are dealing with a single scalar value, rather than a 2D or 3D vector, the radius acts as an interval.

When we come to subtracting the rotation values, we have no problem we values repeat-

ing. Rotations, unlike orientations, don't wrap: a rotation of π is not the same as a rotational of 3π . In fact we can have huge rotation values, well out of the $(-\pi, \pi)$ range. Large values simply represent very fast rotation. Objects at very high speeds (such as the wheels in racing cars) may be rotating so fast that the updates we use here cause numeric instability. This is less of a problem on machines with 64-bit precision, but early physics on 32-bit machines often showed cars at high-speed having wheels that appeared to wobble. This has been resolved in robust physics engines, but it is worth knowing about, as the code we're discussing here is basically implementing a simple physics update. The simple approach is effective for moderate rotational speeds.

Pseudo-Code

Most of the algorithm is similar to arrive, we simply add the conversion:

```
class Align:
       character: Kinematic
       target: Kinematic
       maxAngularAcceleration: float
       maxRotation: float
       # The radius for arriving at the target.
       targetRadius: float
10
       # The radius for beginning to slow down.
11
       slowRadius: float
12
13
       # The time over which to achieve target speed.
       timeToTarget: float = 0.1
16
17
       function getSteering() -> SteeringOutput:
            result = new SteeringOutput()
18
19
            # Get the naive direction to the target.
20
            rotation = target.orientation - character.orientation
21
22
23
            # Map the result to the (-pi, pi) interval.
            rotation = mapToRange(rotation)
24
            rotationSize = abs(rotation)
25
26
            # Check if we are there, return no steering.
27
            if rotationSize < targetRadius:</pre>
28
                return null
29
30
            # If we are outside the slowRadius, then use maximum rotation.
31
            if rotationSize > slowRadius:
32
```

```
targetRotation = maxRotation
33
           # Otherwise calculate a scaled rotation.
34
           else:
35
               targetRotation =
36
                    maxRotation * rotationSize / slowRadius
37
38
           # The final target rotation combines speed (already in the
39
           # variable) and direction.
           targetRotation *= rotation / rotationSize
41
42
43
           # Acceleration tries to get to the target rotation.
           result.angular = targetRotation - character.rotation
44
           result.angular /= timeToTarget
45
46
           # Check if the acceleration is too great.
47
           angularAcceleration = abs(result.angular)
48
49
           if angularAcceleration > maxAngularAcceleration:
50
                result.angular /= angularAcceleration
                result.angular *= maxAngularAcceleration
51
52
53
           result.linear = 0
54
           return result
```

where the function abs returns the absolute (i.e., positive) value of a number; for example, -1 is mapped to 1.

Implementation Notes

Whereas in the arrive implementation there are two vector normalizations, in this code we need to normalize a scalar (i.e., turn it into either +1 or -1). To do this we use the result that:

```
normalizedValue = value / abs(value)
```

In a production implementation in a language where you can access the bit pattern of a floating point number (C and C++, for example), you can do the same thing by manipulating the non-sign bits of the variable. Some C libraries provide an optimized sign function faster than the approach above.

Performance

The algorithm, unsurprisingly, is O(1) in both memory and time.

The Opposite

There is no such thing as the opposite of align. Because orientations wrap around every 2π , fleeing from an orientation in one direction will simply lead you back to where you started. To face the opposite direction of a target, simply add π to its orientation and align to that value.

3.3.6 VELOCITY MATCHING

So far we have looked at behaviors that try to match position (linear position or orientation) with a target. We will do the same with velocity.

On its own this behavior is seldom used. It could be used to make a character mimic the motion of a target, but this isn't very useful. Where it does become critical is when combined with other behaviors. It is one of the constituents of the flocking steering behavior, for example.

We have already implemented an algorithm that tries to match a velocity. Arrive calculates a target velocity based on the distance to its target. It then tries to achieve the target velocity. We can strip the arrive behavior down to provide a velocity matching implementation.

Pseudo-Code

The stripped down code looks like the following:

```
class VelocityMatch:
1
       character: Kinematic
2
       target: Kinematic
3
       maxAcceleration: float
5
6
       # The time over which to achieve target speed.
       timeToTarget = 0.1
8
       function getSteering() -> SteeringOutput:
10
            result = new SteeringOutput()
12
            # Acceleration tries to get to the target velocity.
13
            result.linear = target.velocity - character.velocity
14
            result.linear /= timeToTarget
15
16
            # Check if the acceleration is too fast.
            if result.linear.length() > maxAcceleration:
18
                result.linear.normalize()
19
                result.linear *= maxAcceleration
20
21
            result.angular = 0
22
            return result
23
```

Performance

The algorithm is O(1) in both time and memory.

3.3.7 DELEGATED BEHAVIORS

We have covered the basic building block behaviors that help to create many others. Seek and flee, arrive, and align perform the steering calculations for many other behaviors.

All the behaviors that follow have the same basic structure: they calculate a target, either a position or orientation (they could use velocity, but none of those we're going to cover does), and then they delegate to one of the other behaviors to calculate the steering. The target calculation can be based on many inputs. Pursue, for example, calculates a target for seek based on the motion of another target. Collision avoidance creates a target for flee based on the proximity of an obstacle. And wander creates its own target that meanders around as it moves.

In fact, it turns out that seek, align, and velocity matching are the only fundamental behaviors (there is a rotation matching behavior, by analogy, but I've never seen an application for it). As we saw in the previous algorithm, arrive can be divided into the creation of a (velocity) target and the application of the velocity matching algorithm. This is common. Many of the delegated behaviors below can, in turn, be used as the basis of another delegated behavior. Arrive can be used as the basis of pursue, pursue can be used as the basis of other algorithms, and so on.

In the code that follows I will use a polymorphic style of programming to capture these dependencies. You could alternatively use delegation, having the primitive algorithms called by the new techniques. Both approaches have their problems. In our case, when one behavior extends another, it normally does so by calculating an alternative target. Using inheritance means we need to be able to change the target that the super-class works on.

If we use the delegation approach, we'd need to make sure that each delegated behavior has the correct character data, maxAcceleration, and other parameters. This requires duplication and data copying that using sub-classes removes.

3.3.8 PURSUE AND EVADE

So far we have moved based solely on position. If we are chasing a moving target, then constantly moving toward its current position will not be sufficient. By the time we reach where it is now, it will have moved. This isn't too much of a problem when the target is close and we are reconsidering its location every frame. We'll get there eventually. But if the character is a long distance from its target, it will set off in a visibly wrong direction, as shown in Figure 3.11.

Instead of aiming at its current position, we need to predict where it will be at some time in the future and aim toward that point. We did this naturally playing tag as children, which

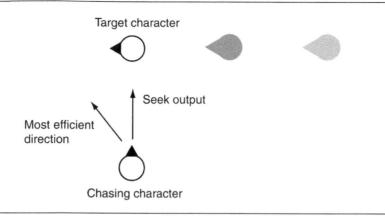

Figure 3.11: Seek moving in the wrong direction

is why the most difficult tag players to catch were those who kept switching direction, foiling our predictions.

We could use all kinds of algorithms to perform the prediction, but most would be overkill. Various research has been done into optimal prediction and optimal strategies for the character being chased (it is an active topic in military research for evading incoming missiles, for example). Craig Reynolds's original approach is much simpler: we assume the target will continue moving with the same velocity it currently has. This is a reasonable assumption over short distances, and even over longer distances it doesn't appear too stupid.

The algorithm works out the distance between character and target and works out how long it would take to get there, at maximum speed. It uses this time interval as its prediction lookahead. It calculates the position of the target if it continues to move with its current velocity. This new position is then used as the target of a standard seek behavior.

If the character is moving slowly, or the target is a long way away, the prediction time could be very large. The target is less likely to follow the same path forever, so we'd like to set a limit on how far ahead we aim. The algorithm has a maximum time parameter for this reason. If the prediction time is beyond this, then the maximum time is used.

Figure 3.12 shows a seek behavior and a pursue behavior chasing the same target. The pursue behavior is more effective in its pursuit.

Pseudo-Code

The pursue behavior derives from seek, calculates a surrogate target, and then delegates to seek to perform the steering calculation:

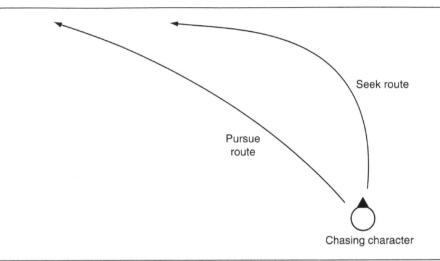

Figure 3.12: Seek and pursue

```
class Pursue extends Seek:
       # The maximum prediction time.
2
       maxPrediction: float
3
       # OVERRIDES the target data in seek (in other words this class has
5
       # two bits of data called target: Seek.target is the superclass
       # target which will be automatically calculated and shouldn't be
       # set, and Pursue.target is the target we're pursuing).
       target: Kinematic
10
       # ... Other data is derived from the superclass ...
11
12
       function getSteering() -> SteeringOutput:
13
           # 1. Calculate the target to delegate to seek
14
           # Work out the distance to target.
15
           direction = target.position - character.position
16
           distance = direction.length()
17
18
           # Work out our current speed.
19
           speed = character.velocity.length()
20
21
           # Check if speed gives a reasonable prediction time.
22
           if speed <= distance / maxPrediction:</pre>
23
                prediction = maxPrediction
24
25
```

```
# Otherwise calculate the prediction time.
26
            else:
27
                prediction = distance / speed
28
29
            # Put the target together.
30
            Seek.target = explicitTarget
31
            Seek.target.position += target.velocity * prediction
32
33
            # 2. Delegate to seek.
34
            return Seek.getSteering()
35
```

Implementation Notes

In this code I've used the slightly unsavory technique of naming a member variable in a derived class with the same name as the super-class. In most languages this will have the desired effect of creating two members with the same name. In our case this is what we want: setting the pursue behavior's target will not change the target for the seek behavior it extends.

Be careful, though! In some languages (Python, for example) you can't do this. You'll have to name the target variable in each class with a different name.

As mentioned previously, it may be beneficial to cut out these polymorphic calls altogether to improve the performance of the algorithm. We can do this by having all the data we need in the pursue class, removing its inheritance of seek, and making sure that all the code the class needs is contained in the getSteering method. This is faster, but at the cost of duplicating the delegated code in each behavior that needs it and obscuring the natural reuse of the algorithm.

Performance

Once again, the algorithm is O(1) in both memory and time.

Evade

The opposite behavior of pursue is evade. Once again we calculate the predicted position of the target, but rather than delegating to seek, we delegate to flee.

In the code above, the class definition is modified so that it is a sub-class of Flee rather than Seek and thus Seek.getSteering is changed to Flee.getSteering.

Overshooting

If the chasing character is able to move faster than the target, it will overshoot and oscillate around its target, exactly as the normal seek behavior does.

To avoid this, we can replace the delegated call to seek with a call to arrive. This illustrates the power of building up behaviors from their logical components; when we need a slightly different effect, we can easily modify the code to get it.

3.3.9 FACE

The face behavior makes a character look at its target. It delegates to the align behavior to perform the rotation but calculates the target orientation first.

The target orientation is generated from the relative position of the target to the character. It is the same process we used in the getOrientation function for kinematic movement.

Pseudo-Code

The implementation is very simple:

```
class Face extends Align:
       # Overrides the Align.target member.
2
       target: Kinematic
3
       # ... Other data is derived from the superclass ...
5
       # Implemented as it was in Pursue.
       function getSteering() -> SteeringOutput:
           # 1. Calculate the target to delegate to align
           # Work out the direction to target.
           direction = target.position - character.position
11
12
           # Check for a zero direction, and make no change if so.
13
           if direction.length() == 0:
14
               return target
15
16
           # 2. Delegate to align.
17
           Align.target = explicitTarget
           Align.target.orientation = atan2(-direction.x, direction.z)
19
           return Align.getSteering()
20
```

3.3.10 LOOKING WHERE YOU'RE GOING

So far, I have assumed that the direction a character is facing does not have to be its direction of motion. In many cases, however, we would like the character to face in the direction it is moving. In the kinematic movement algorithms we set it directly. Using the align behavior, we can give the character angular acceleration to make it face the correct direction. In this way the character changes facing gradually, which can look more natural, especially for aerial vehicles such as helicopters or hovercraft or for human characters that can move sideways (providing sidestep animations are available).

This is a process similar to the face behavior, above. The target orientation is calculated using the current velocity of the character. If there is no velocity, then the target orientation is set to the current orientation. We have no preference in this situation for any orientation.

Pseudo-Code

The implementation is even simpler than face:

```
class LookWhereYoureGoing extends Align:
       # No need for an overridden target member, we have
2
       # no explicit target to set.
       # ... Other data is derived from the superclass ...
       function getSteering() -> SteeringOutput:
           # 1. Calculate the target to delegate to align
           # Check for a zero direction, and make no change if so.
           velocity: Vector = character.velocity
10
           if velocity.length() == 0:
11
               return null
12
13
           # Otherwise set the target based on the velocity.
14
           target.orientation = atan2(-velocity.x, velocity.z)
15
16
           # 2. Delegate to align.
17
           return Align.getSteering()
18
```

Implementation Notes

In this case we don't need another target member variable. There is no overall target; we are creating the current target from scratch. So, we can simply use Align.target for the calculated target (in the same way we did with pursue and the other derived algorithms).

Performance

The algorithm is O(1) in both memory and time.

3.3.11 WANDER

The wander behavior controls a character moving aimlessly about.

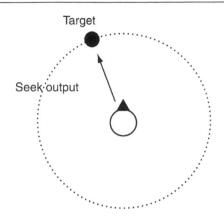

Figure 3.13: The kinematic wander as a seek

When we looked at the kinematic wander behavior, we perturbed the wander direction by a random amount each time it was run. This makes the character move forward smoothly, but the rotation of the character is erratic, appearing to twitch from side to side as it moves.

The simplest wander approach would be to move in a random direction. This is unacceptable, and therefore almost never used, because it produces linear jerkiness. The kinematic version added a layer of indirection but produced rotational jerkiness. We can smooth this twitching by adding an extra layer, making the orientation of the character indirectly reliant on the random number generator.

We can think of kinematic wander as behaving as a delegated seek behavior. There is a circle around the character on which the target is constrained. Each time the behavior is run, we move the target around the circle a little, by a random amount. The character then seeks the target. Figure 3.13 illustrates this configuration.

We can improve this by moving the circle around which the target is constrained. If we move it out in front of the character (where front is determined by its current facing direction) and shrink it down, we get the situation in Figure 3.14.

The character tries to face the target in each frame, using the face behavior to align to the target. It then adds an extra step: applying full acceleration in the direction of its current orientation.

We could also implement the behavior by having it seek the target and perform a 'look where you're going' behavior to correct its orientation.

In either case, the orientation of the character is retained between calls (so smoothing the changes in orientation). The angles that the edges of the circle subtend to the character determine how fast it will turn. If the target is on one of these extreme points, it will turn quickly. The target will twitch and jitter around the edge of the circle, but the character's orientation will change smoothly.

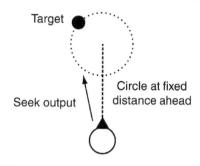

Figure 3.14: The full wander behavior

This wander behavior biases the character to turn (in either direction). The target will spend more time toward the edges of the circle, from the point of view of the character.

Pseudo-Code

```
class Wander extends Face:
       # The radius and forward offset of the wander circle.
       wanderOffset: float
       wanderRadius: float
       # The maximum rate at which the wander orientation can change.
       wanderRate: float
       # The current orientation of the wander target.
       wanderOrientation: float
10
11
       # The maximum acceleration of the character.
12
       maxAcceleration: float
13
14
       # Again we don't need a new target.
       # ... Other data is derived from the superclass ...
16
       function getSteering() -> SteeringOutput:
           # 1. Calculate the target to delegate to face
           # Update the wander orientation.
           wanderOrientation += randomBinomial() * wanderRate
21
           # Calculate the combined target orientation.
           targetOrientation = wanderOrientation + character.orientation
25
```

```
# Calculate the center of the wander circle.
26
            target = character.position +
27
                     wanderOffset * character.orientation.asVector()
28
29
            # Calculate the target location.
30
            target += wanderRadius * targetOrientation.asVector()
31
32
            # 2. Delegate to face.
33
            result = Face.getSteering()
34
35
            # 3. Now set the linear acceleration to be at full
36
            # acceleration in the direction of the orientation.
37
            result.linear =
38
                maxAcceleration * character.orientation.asVector()
39
40
            # Return it.
41
            return result
42
```

Data Structures and Interfaces

I've used the same as Vector function as earlier to get a vector form of the orientation.

Performance

The algorithm is O(1) in both memory and time.

3.3.12 PATH FOLLOWING

So far we've seen behaviors that take a single target or no target at all. Path following is a steering behavior that takes a whole path as a target. A character with path following behavior should move along the path in one direction.

Path following, as it is usually implemented, is a delegated behavior. It calculates the position of a target based on the current character location and the shape of the path. It then hands its target off to seek. There is no need to use arrive, because the target should always be moving along the path. We shouldn't need to worry about the character catching up with it.

The target position is calculated in two stages. First, the current character position is mapped to the nearest point along the path. This may be a complex process, especially if the path is curved or made up of many line segments. Second, a target is selected which is further along the path than the mapped point by some distance. To change the direction of motion along the path, we can change the sign of this distance. Figure 3.15 shows this in action. The current path location is shown, along with the target point a little way farther along. This

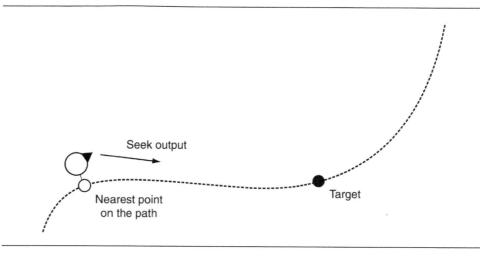

Figure 3.15: Path following behavior

approach is sometimes called "chase the rabbit," after the way greyhounds chase the cloth rabbit at the dog track.

Some implementations generate the target slightly differently. They first predict where the character will be in a short time and then map this to the nearest point on the path. This is a candidate target. If the new candidate target has not been placed farther along the path than it was at the last frame, then it is changed so that it is. I will call this predictive path following. It is shown in Figure 3.16. This latter implementation can appear smoother for complex paths with sudden changes of direction, but has the downside of cutting corners when two paths come close together.

Figure 3.17 shows this cutting-corner behavior. The character misses a whole section of the path. The character is shown at the instant its predictive future position crosses to a later part of the path.

This might not be what you want if, for example, the path represents a patrol route or a race track.

Pseudo-Code

```
class FollowPath extends Seek:
2
       path: Path
3
       # The distance along the path to generate the target. Can be
4
       # negative if the character is moving in the reverse direction.
5
       pathOffset: float
6
```

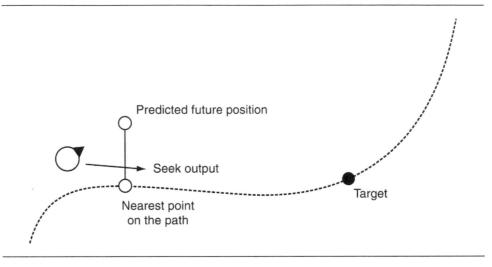

Figure 3.16: Predictive path following behavior

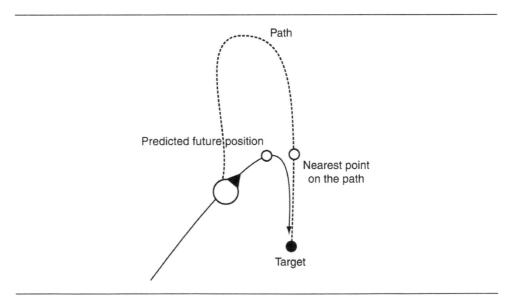

Figure 3.17: Vanilla and predictive path following

```
8
       # The current position on the path.
       currentParam: float
9
10
       # ... Other data is derived from the superclass ...
11
       function getSteering() -> SteeringOutput:
13
            # 1. Calculate the target to delegate to face.
14
            # Find the current position on the path.
15
            currentParam = path.getParam(character.position, currentPos)
16
            # Offset it.
            targetParam = currentParam + pathOffset
19
20
            # Get the target position.
21
            target.position = path.getPosition(targetParam)
22
23
            # 2. Delegate to seek.
24
            return Seek.getSteering()
25
```

We can convert this algorithm to a predictive version by first calculating a surrogate position for the call to path.getParam. The algorithm looks almost identical:

```
class FollowPath extends Seek:
 2
       path: Path
 3
       # The distance along the path to generate the target. Can be
       # negative if the character is moving in the reverse direction.
       pathOffset: float
       # The current position on the path.
       currentParam: float
       # The time in the future to predict the character's position.
       predictTime: float = 0.1
12
13
       # ... Other data is derived from the superclass ...
14
15
       function getSteering() -> SteeringOutput:
16
           # 1. Calculate the target to delegate to face.
17
           # Find the predicted future location.
18
           futurePos = character.position +
19
                        character.velocity * predictTime
20
21
           # Find the current position on the path.
22
           currentParam = path.getParam(futurePos, currentPos)
23
24
           # Offset it.
25
           targetParam = currentParam + pathOffset
26
```

```
# Get the target position.
target.position = path.getPosition(targetParam)

# 2. Delegate to seek.
return Seek.getSteering()
```

Data Structures and Interfaces

The path that the behavior follows has the following interface:

```
class Path:
function getParam(position: Vector, lastParam: float) -> float
function getPosition(param: float) -> Vector
```

Both these functions use the concept of a path parameter. This is a unique value that increases monotonically along the path. It can be thought of as a distance along the path. Typically, paths are made up of line or curve splines; both of these are easily assigned parameters. The parameter allows us to translate between the position on the path and positions in 2D or 3D space.

Path Types

Performing this translation (i.e., implementing a path class) can be tricky, depending on the format of the path used.

It is most common to use a path of straight line segments as shown in Figure 3.18. In this case the conversion is not too difficult. We can implement getParam by looking at each line segment in turn, determining which one the character is nearest to, and then finding the nearest point on that segment. For smooth curved splines common in some driving games, however, the math can be more complex. A good source for closest-point algorithms for a range of different geometries is Schneider and Eberly [56].

Keeping Track of the Parameter

The pseudo-code interface above provides for sending the last parameter value to the path in order to calculate the current parameter value. This is essential to avoid nasty problems when lines are close together.

We limit the getParam algorithm to only considering areas of the path close to the previous parameter value. The character is unlikely to have moved far, after all. This technique, assuming the new value is close to the old one, is called *coherence*, and it is a feature of many geometric algorithms. Figure 3.19 shows a problem that would fox a non-coherent path follower but is easily handled by assuming the new parameter is close to the old one.

Of course, you may really want corners to be cut or a character to move between very different parts of the path. If another behavior interrupts and takes the character across the

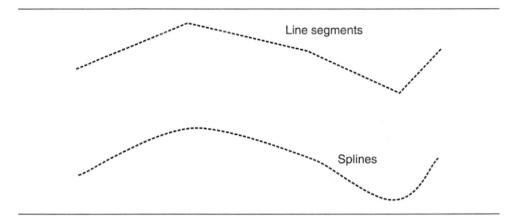

Figure 3.18: Path types

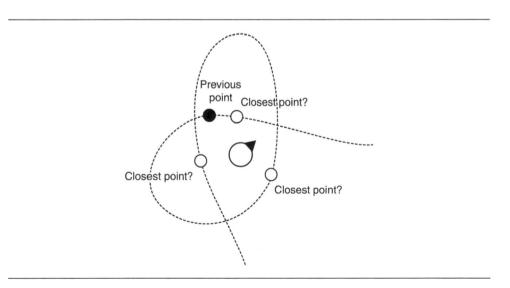

Figure 3.19: Coherence problems with path following

level, for example, you don't necessarily want it to come all the way back to pick up a circular patrol route. In this case, you'll need to remove coherence or at least widen the range of parameters that it searches for a solution.

Performance

The algorithm is O(1) in both memory and time. The getParam function of the path will usually be O(1), although it may be O(n), where n is the number of segments in the path. If this is the case, then the getParam function will dominate the performance scaling of the algorithm.

3.3.13 SEPARATION

The separation behavior is common in crowd simulations, where a number of characters are all heading in roughly the same direction. It acts to keep the characters from getting too close and being crowded.

It doesn't work as well when characters are moving across each other's paths. The collision avoidance behavior, below, should be used in this case.

Most of the time, the separation behavior has a zero output; it doesn't recommend any movement at all. If the behavior detects another character closer than some threshold, it acts in a way similar to an evade behavior to move away from the character. Unlike the basic evade behavior, however, the strength of the movement is related to the distance from the target. The separation strength can decrease according to any formula, but a linear or an inverse square law decay is common.

Linear separation looks like the following:

```
strength = maxAcceleration * (threshold - distance) / threshold
```

The inverse square law looks like the following:

```
strength = min(k / (distance * distance), maxAcceleration)
```

In each case, distance is the distance between the character and its nearby neighbor, threshold is the minimum distance at which any separation output occurs, and maxAccelerat ion is the maximum acceleration of the character. The k constant can be set to any positive value. It controls how fast the separation strength decays with distance.

Separation is sometimes called the "repulsion" steering behavior, because it acts in the same way as a physical repulsive force (an inverse square law force such as magnetic repulsion).

Where there are multiple characters within the avoidance threshold, either the closest can be selected, or the steering can be calculated for each in turn and summed. In the latter case, the final value may be greater than the maxAcceleration, in which case it should be clipped to that value.

Pseudo-Code

```
class Separation:
        character: Kinematic
 2
        maxAcceleration: float
        # A list of potential targets.
 5
        targets: Kinematic[]
 6
        # The threshold to take action.
        threshold: float
10
        # The constant coefficient of decay for the inverse square law.
11
        decayCoefficient: float
12
        function getSteering() -> SteeringOutput:
            result = new SteeringOutput()
16
            # Loop through each target.
17
            for target in targets:
18
                # Check if the target is close.
19
                direction = target.position - character.position
20
                distance = direction.length()
21
22
                if distance < threshold:
23
                    # Calculate the strength of repulsion
24
                    # (here using the inverse square law).
25
                     strength = min(
26
                         decayCoefficient / (distance * distance),
27
                         maxAcceleration)
28
29
                    # Add the acceleration.
30
                     direction.normalize()
31
                     result.linear += strength * direction
32
33
            return result
34
```

Implementation Notes

In the algorithm above, we simply look at each possible character in turn and work out whether we need to separate from them. For a small number of characters, this will be the fastest approach. For a few hundred characters in a level, we need a faster method.

Typically, graphics and physics engines rely on techniques to determine what objects are close to one another. Objects are stored in spatial data structures, so it is relatively easy to

make this kind of query. Multi-resolution maps, quad- or octrees, and binary space partition (BSP) trees are all popular data structures for rapidly calculating potential collisions. Each of these can be used by the AI to get potential targets more efficiently.

Implementing a spatial data structure for collision detection is beyond the scope of this book. Other books in this series cover the topic in much more detail, particularly Ericson [14] and van den Bergen [73].

Performance

The algorithm is O(1) in memory and O(n) in time, where n is the number of potential targets to check. If there is some efficient way of pruning potential targets before they reach the algorithm above, the overall performance in time will improve. A BSP system, for example, can give $O(\log n)$ time, where n is the total number of potential targets in the game. The algorithm above will always remain linear in the number of potential targets it checks, however.

Attraction

Using the inverse square law, we can set a negative value for the constant of decay and get an attractive force. The character will be attracted to others within its radius. This works, but is rarely useful.

Some developers have experimented with having lots of attractors and repulsors in their level and having character movement mostly controlled by these. Characters are attracted to their goals and repelled from obstacles, for example. Despite being ostensibly simple, this approach is full of traps for the unwary.

The next section, on combining steering behaviors, shows why simply having lots of attractors or repulsors leads to characters that regularly get stuck and why starting with a more complex algorithm ends up being less work in the long run.

Independence

The separation behavior isn't much use on its own. Characters will jiggle out of separation, but then never move again. Separation, along with the remaining behaviors in this chapter, is designed to work in combination with other steering behaviors. We return to how this combination works in the next section.

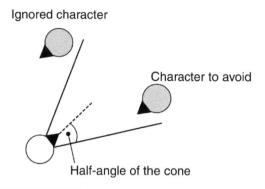

Figure 3.20: Separation cones for collision avoidance

3.3.14 COLLISION AVOIDANCE

In urban areas, it is common to have large numbers of characters moving around the same space. These characters have trajectories that cross each other, and they need to avoid constant collisions with other moving characters.

A simple approach is to use a variation of the evade or separation behavior, which only engages if the target is within a cone in front of the character. Figure 3.20 shows a cone that has another character inside it.

The cone check can be carried out using a dot product:

```
if dotProduct(orientation.asVector(), direction) > coneThreshold:
    # Do the evasion.
else:
    # Return no steering.
```

where direction is the direction between the behavior's character and the potential collision. The coneThreshold value is the cosine of the cone half-angle, as shown in Figure 3.20.

If there are several characters in the cone, then the behavior needs to avoid them all. We can approach this in a similar way to the separation behavior. It is often sufficient to find the average position and speed of all characters in the cone and evade that target. Alternatively, the closest character in the cone can be found and the rest ignored.

Unfortunately, this approach, while simple to implement, doesn't work well with more than a handful of characters. The character does not take into account whether it will actually collide but instead has a "panic" reaction to even coming close. Figure 3.21 shows a simple situation where the character will never collide, but our naive collision avoidance approach will still take action.

Figure 3.22 shows another problem situation. Here the characters will collide, but neither

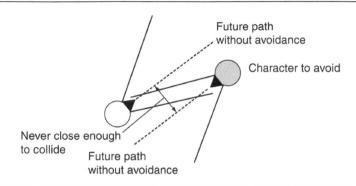

Figure 3.21: Two in-cone characters who will not collide

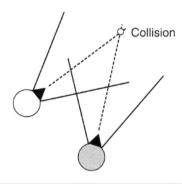

Figure 3.22: Two out-of-cone characters who will collide

will take evasive action because they will not have the other in their cone until the moment of collision.

A better solution works out whether or not the characters will collide if they keep to their current velocity. This involves working out the closest approach of the two characters and determining if the distance at this point is less than some threshold radius. This is illustrated in Figure 3.23.

Note that the closest approach will not normally be the same as the point where the future trajectories cross. The characters may be moving at very different velocities, and so are likely to reach the same point at different times. We simply can't see if their paths will cross to check if the characters will collide. Instead, we have to find the moment that they are at their closest, use this to derive their separation, and check if they collide.

The time of closest approach is given by

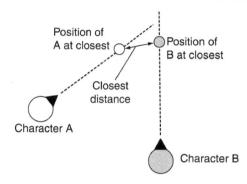

Figure 3.23: Collision avoidance using collision prediction

$$t_{\mathrm{closest}} = rac{d_p.d_v}{|d_v|^2}$$

where d_p is the current relative position of target to character (what we called the distance vector from previous behaviors):

$$d_p = p_t - p_c$$

and d_v is the relative velocity:

$$d_v = v_t - v_c$$

If the time of closest approach is negative, then the character is already moving away from the target, and no action needs to be taken.

From this time, the position of character and target at the time of closest approach can be calculated:

$$p_c' = p_c + v_c t_{\rm closest}$$

$$p_t' = p_t + v_t t_{\text{closest}}$$

We then use these positions as the basis of an evade behavior; we are performing an evasion based on our predicted future positions, rather than our current positions. In other words, the behavior makes the steering correction now, as if it were already at the most compromised position it will get to.

For a real implementation it is worth checking if the character and target are already in collision. In this case, action can be taken immediately, without going through the calculations to work out if they will collide at some time in the future. In addition, this approach

will not return a sensible result if the centers of the character and target will collide at some point. A sensible implementation will have some special case code for this unlikely situation to make sure that the characters will sidestep in different directions. This can be as simple as falling back to the evade behavior on the current positions of the character.

For avoiding groups of characters, averaging positions and velocities do not work well with this approach. Instead, the algorithm needs to search for the character whose closest approach will occur first and to react to this character only. Once this imminent collision is avoided, the steering behavior can then react to more distant characters.

Pseudo-Code

```
class CollisionAvoidance:
       character: Kinematic
2
       maxAcceleration: float
3
       # A list of potential targets.
5
       targets: Kinematic[]
       # The collision radius of a character (assuming all characters
       # have the same radius here).
       radius: float
10
       function getSteering() -> SteeringOutput:
12
           # 1. Find the target that's closest to collision
13
           # Store the first collision time.
14
           shortestTime: float = infinity
15
16
           # Store the target that collides then, and other data that we
17
           # will need and can avoid recalculating.
18
           firstTarget: Kinematic = null
19
           firstMinSeparation: float
20
           firstDistance: float
21
           firstRelativePos: Vector
22
           firstRelativeVel: Vector
23
24
           # Loop through each target.
25
            for target in targets:
26
                # Calculate the time to collision.
27
                relativePos = target.position - character.position
28
                relativeVel = target.velocity - character.velocity
29
                relativeSpeed = relativeVel.length()
30
                timeToCollision = dotProduct(relativePos, relativeVel) /
31
                                   (relativeSpeed * relativeSpeed)
32
33
                # Check if it is going to be a collision at all.
34
```

```
distance = relativePos.length()
35
                minSeparation = distance - relativeSpeed * timeToCollision
36
                if minSeparation > 2 * radius:
37
                    continue
38
39
                # Check if it is the shortest.
40
                if timeToCollision > 0 and timeToCollision < shortestTime:
41
                    # Store the time, target and other data.
42
                    shortestTime = timeToCollision
43
                    firstTarget = target
44
                    firstMinSeparation = minSeparation
45
                    firstDistance = distance
46
                    firstRelativePos = relativePos
47
                    firstRelativeVel = relativeVel
48
            # 2. Calculate the steering
            # If we have no target, then exit.
51
            if not firstTarget:
52
                return null
53
54
           # If we're going to hit exactly, or if we're already
55
            # colliding, then do the steering based on current position.
56
            if firstMinSeparation <= 0 or firstDistance < 2 * radius:
57
                relativePos = firstTarget.position - character.position
58
59
           # Otherwise calculate the future relative position.
60
           else:
61
                relativePos = firstRelativePos +
62
                               firstRelativeVel * shortestTime
63
64
           # Avoid the target.
            relativePos.normalize()
            result = new SteeringOutput()
68
            result.linear = relativePos * maxAcceleration
69
70
            result.anguar = 0
            return result
71
```

Performance

The algorithm is O(1) in memory and O(n) in time, where n is the number of potential targets to check.

As in the previous algorithm, if there is some efficient way of pruning potential targets before they reach the algorithm above, the overall performance in time will improve. This algorithm will always remain linear in the number of potential targets it checks, however.

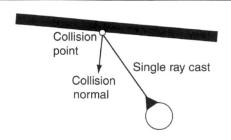

Figure 3.24: Collision ray avoiding a wall

3.3.15 OBSTACLE AND WALL AVOIDANCE

The collision avoidance behavior assumes that targets are spherical. It is interested in avoiding a trajectory too close to the center point of the target.

This can also be applied to any obstacle in the game that is easily represented by a bounding sphere. Crates, barrels, and small objects can be avoided simply this way.

More complex obstacles cannot be easily represented as circles. The bounding sphere of a large object, such as a staircase, can fill a room. We certainly don't want characters sticking to the outside of the room just to avoid a staircase in the corner. By far the most common obstacles in the game are walls, and they cannot be simply represented by bounding spheres at all.

The obstacle and wall avoidance behavior uses a different approach to avoiding collisions. The moving character casts one or more rays out in the direction of its motion. If these rays collide with an obstacle, then a target is created that will avoid the collision, and the character does a basic seek on this target. Typically, the rays are not infinite. They extend a short distance ahead of the character (usually a distance corresponding to a few seconds of movement).

Figure 3.24 shows a character casting a single ray that collides with a wall. The point and normal of the collision with the wall are used to create a target location at a fixed distance from the surface.

Pseudo-Code

```
class ObstacleAvoidance extends Seek:
detector: CollisionDetector

# The minimum distance to a wall (i.e., how far to avoid
# collision) should be greater than the radius of the character.
avoidDistance: float

# The distance to look ahead for a collision
```

```
9
       # (i.e., the length of the collision ray).
       lookahead: float
10
11
       # ... Other data is derived from the superclass ...
12
13
       function getSteering():
14
            # 1. Calculate the target to delegate to seek
15
            # Calculate the collision ray vector.
16
            ray = character.velocity
17
            ray.normalize()
            ray *= lookahead
20
            # Find the collision.
21
            collision = detector.getCollision(character.position, ray)
22
23
            # If have no collision, do nothing.
24
            if not collision:
25
                return null
26
27
            # 2. Otherwise create a target and delegate to seek.
28
            target = collision.position + collision.normal * avoidDistance
29
            return Seek.getSteering()
30
```

Data Structures and Interfaces

The collision detector has the following interface:

```
class CollisionDetector:
      function getCollision(position: Vector,
2
                             moveAmount: Vector) -> Collision
```

where getCollision returns the first collision for the character if it begins at the given position and moves by the given movement amount. Collisions in the same direction, but farther than moveAmount, are ignored.

Typically, this call is implemented by casting a ray from position to position + moveAmount and checking for intersections with walls or other obstacles.

The getCollision method returns a collision data structure of the form:

```
class Collision:
       position: Vector
2
       normal: Vector
```

where position is the collision point and normal is the normal of the wall at the point of collision. These are standard data to expect from a collision detection routine, and most engines provide such data as a matter of course (see Physics.Raycast in Unity, in Unreal Engine it requires more setup, see the documentation for Traces).

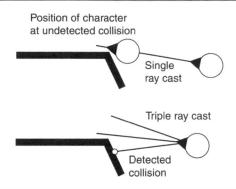

Figure 3.25: Grazing a wall with a single ray and avoiding it with three

Performance

The algorithm is O(1) in both time and memory, excluding the performance of the collision detector (or rather, assuming that the collision detector is O(1)). In reality, collision detection using ray casts is quite expensive and is almost certainly not O(1) (it normally depends on the complexity of the environment). You should expect that most of the time spent in this algorithm will be spent in the collision detection routine.

Collision Detection Problems

So far we have assumed that we are detecting collisions with a single ray cast. In practice, this isn't a good solution.

Figure 3.25 shows a one-ray character colliding with a wall that it never detects. Typically, a character will need to have two or more rays. The figure shows a three-ray character, with the rays splayed out to act like whiskers. This character will not graze the wall.

I have seen several basic ray configurations used over and over for wall avoidance. Figure 3.26 illustrates these.

There are no hard and fast rules as to which configuration is better. Each has its own particular idiosyncrasies. A single ray with short whiskers is often the best initial configuration to try but can make it impossible for the character to move down tight passages. The single ray configuration is useful in concave environments but grazes convex obstacles. The parallel configuration works well in areas where corners are highly obtuse but is very susceptible to the corner trap, as we'll see.

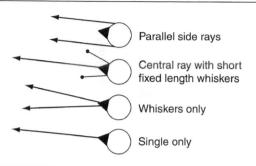

Figure 3.26: Ray configurations for obstacle avoidance

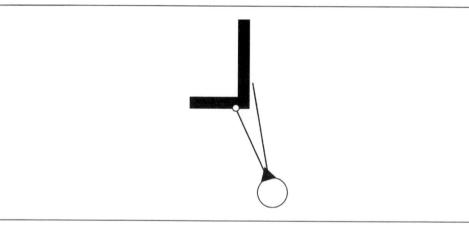

Figure 3.27: The corner trap for multiple rays

The Corner Trap

The basic algorithm for multi-ray wall avoidance can suffer from a crippling problem with acute angled corners (any convex corner, in fact, but it is more prevalent with acute angles). Figure 3.27 illustrates a trapped character. Currently, its left ray is colliding with the wall. The steering behavior will therefore turn it to the left to avoid the collision. Immediately, the right ray will then be colliding, and the steering behavior will turn the character to the right.

When the character is run in the game, it will appear to home into the corner directly, until it slams into the wall. It will be unable to free itself from the trap.

The fan structure, with a wide enough fan angle, alleviates this problem. Often, there is a trade-off, however, between avoiding the corner trap with a large fan angle and keeping the angle small to allow the character to access small passageways. At worst, with a fan angle near

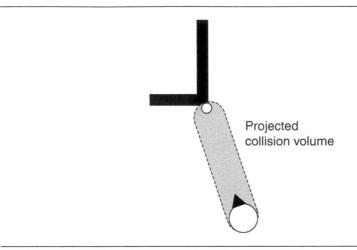

Figure 3.28: Collision detection with projected volumes

 π radians, the character will not be able to respond quickly enough to collisions detected on its side rays and will still graze against walls.

Several developers have experimented with adaptive fan angles. If the character is moving successfully without a collision, then the fan angle is narrowed. If a collision is detected, then the fan angle is widened. If the character detects many collisions on successive frames, then the fan angle will continue to widen, reducing the chance that the character is trapped in a corner.

Other developers implement specific corner-trap avoidance code. If a corner trap is detected, then one of the rays is considered to have won, and the collisions detected by other rays are ignored for a while.

Both approaches work well and represent practical solutions to the problem. The only complete solution, however, is to perform the collision detection using a projected volume rather than a ray, as shown in Figure 3.28.

Many game engines are capable of doing this, for the sake of modeling realistic physics. Unlike for AI, the projection distances required by physics are typically very small, however, and the calculations can be very slow when used in a steering behavior.

In addition, there are complexities involved in interpreting the collision data returned from a volume query. Unlike for physics, it is not the first collision point that needs to be considered (this could be the edge of a polygon on one extreme of the character model), but how the overall character should react to the wall. So far there is no widely trusted mechanism for doing volume prediction in wall avoidance.

For now, it seems that the most practical solution is to use adaptive fan angles, with one long ray cast and two shorter whiskers.

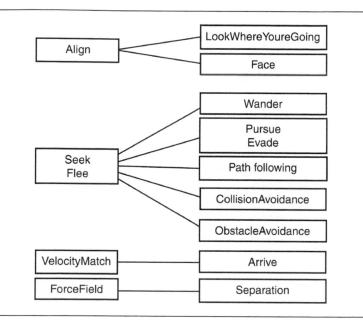

Figure 3.29: Steering family tree

3.3.16 SUMMARY

Figure 3.29 shows a family tree of the steering behaviors we have looked at in this section. We've marked a steering behavior as a child of another if it can be seen as extending the behavior of its parent.

3.4 COMBINING STEERING BEHAVIORS

Individually, steering behaviors can achieve a good degree of movement sophistication. In many games steering simply consists of moving toward a given location: the seek behavior.

Higher level decision making tools are responsible for determining where the character intends to move. This is often a pathfinding algorithm, generating intermediate targets on the path to a final goal.

This only gets us so far, however. A moving character usually needs more than one steering behavior. It needs to reach its goal, avoid collisions with other characters, tend toward safety as it moves, and avoid bumping into walls. Wall and obstacle avoidance can be particularly difficult to get when working with other behaviors. In addition, some complex steering, such as flocking and formation motion, can only be accomplished when more than one steering behavior is active at once.

This section looks at increasingly sophisticated ways of accomplishing this combination:

from simple blending of steering outputs to complicated pipeline architectures designed explicitly to support collision avoidance.

3.4.1 BLENDING AND ARBITRATION

By combining steering behaviors together, more complex movement can be achieved. There are two methods of combining steering behaviors: blending and arbitration.

Each method takes a portfolio of steering behaviors, each with its own output, and generates a single overall steering output. Blending does this by executing all the steering behaviors and combining their results using some set of weights or priorities. This is sufficient to achieve some very complex behaviors, but problems arise when there are a lot of constraints on how a character can move. Arbitration selects one or more steering behaviors to have complete control over the character. There are many arbitration schemes that control which behavior gets to have its way.

Blending and arbitration are not exclusive approaches, however. They are the ends of a

Blending may have weights or priorities that change over time. Some process needs to change these weights, and this might be in response to the game situation or the internal state of the character. The weights used for some steering behaviors may be zero; they are effectively switched off.

At the same time, there is nothing that requires an arbitration architecture to return a single steering behavior to execute. It may return a set of blending weights for combining a set of different behaviors.

A general steering system needs to combine elements of both blending and arbitration. Although we'll look at different algorithms for each, an ideal implementation will mix elements of both.

3.4.2 WEIGHTED BLENDING

The simplest way to combine steering behaviors is to blend their results together using weights.

Suppose we have a crowd of rioting characters in our game. The characters need to move as a mass, while making sure that they aren't consistently bumping into each other. Each character needs to stay by the others, while keeping a safe distance. Their overall behavior is a blend of two behaviors: arriving at the center of mass of the group and separation from nearby characters. At no point is the character doing just one thing. It is always taking both concerns into consideration.

Figure 3.30: Blending steering outputs

The Algorithm

A group of steering behaviors can be blended together to act as a single behavior. Each steering behavior in the portfolio is asked for its acceleration request, as if it were the only behavior operating.

These accelerations are combined together using a weighted linear sum, with coefficients specific to each behavior. There are no constraints on the blending weights; they don't have to sum to one, for example, and rarely do (i.e., it isn't a weighted mean).

The final acceleration from the sum may be too great for the capabilities of the character, so it is trimmed according to the maximum possible acceleration (a more complex actuation step can always be used; see Section 3.8 on motor control later in the chapter).

In our crowd example, we may use weights of 1 for both separation and cohesion. In this case the requested accelerations are summed and cropped to the maximum possible acceleration. This is the output of the algorithm. Figure 3.30 illustrates this process.

As in all parameterized systems, the choice of weights needs to be the subject of inspired guesswork or good trial and error. Research projects have tried to evolve the steering weights using genetic algorithms or neural networks. Results have not been encouraging, however, and manual experimentation still seems to be the most sensible approach.

Pseudo-Code

The algorithm for blended steering is as follows:

```
class BlendedSteering:
class BehaviorAndWeight:
behavior: SteeringBehavior
weight: float

behaviors: BehaviorAndWeight[]

# The overall maximum acceleration and rotation.
maxAcceleration: float
```

```
maxRotation: float
10
       function getSteering() -> SteeringOutput:
           result = new SteeringOutput()
           # Accumulate all accelerations.
           for b in behaviors:
16
                result += b.weight * b.behavior.getSteering()
18
           # Crop the result and return.
19
           result.linear = max(result.linear, maxAcceleration)
20
           result.angular = max(result.angular, maxRotation)
21
           return result
22
```

Data Structures

I have assumed that instances of the SteeringOutput structure can be added together and multiplied by a scalar. In each case these operations should be performed component-wise (i.e., linear and angular components should individually be added and multiplied).

Performance

The algorithm requires only temporary storage for the acceleration. It is O(1) in memory. It is O(n) for time, where n is the number of steering behaviors in the list. The practical execution speed of this algorithm depends on the efficiency of the component steering behaviors.

Flocking and Swarming

The original research into steering behaviors by Craig Reynolds modeled the movement patterns of flocks of simulated birds (known as "boids"). Though not the most commonly implemented in a game, flocking is the most commonly cited steering behavior. It relies on a simple weighted blend of simpler behaviors.

It is so ubiquitous that all steering behaviors are sometimes referred to, incorrectly, as "flocking." I've even seen AI programmers fall into this habit at times.

The flocking algorithm relies on blending three simple steering behaviors: move away from boids that are too close (separation), move in the same direction and at the same velocity as the flock (alignment and velocity matching), and move toward the center of mass of the flock (cohesion). The cohesion steering behavior calculates its target by working out the center of mass of the flock. It then hands off this target to a regular arrive behavior.

For simple flocking, using equal weights may be sufficient. To get a more biologically

Figure 3.31: The three components of flocking behaviors

Figure 3.32: The neighborhood of a boid

believable behavior, however, separation is more important than cohesion, which is more important than alignment. The latter two are sometimes seen reversed.

These behaviors are shown schematically in Figure 3.31.

In most implementations the flocking behavior is modified to ignore distant boids. In each behavior there is a neighborhood in which other boids are considered. Separation only avoids nearby boids; cohesion and alignment calculate and seek the position, facing, and velocity of only neighboring boids. The neighborhood is most commonly a simple radius, although Reynolds suggests it should have an angular cut-off, as shown in Figure 3.32.

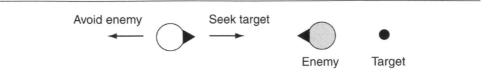

Figure 3.33: An unstable equilibrium

Problems

There are several important problems with blended steering behaviors in real games. It is no coincidence that demonstrations of blended steering often use very sparse outdoor environments, rather than indoor or urban levels.

In more realistic settings, characters can often get stuck in the environment in ways that are difficult to debug. As with all AI techniques, it is essential to be able to get good debugging information when you need it and at the very least to be able to visualize the inputs and outputs to each steering behavior in the blend.

Some of these problems, but by no means all of them, will be solved by introducing arbitration into the steering system.

Stable Equilibria

Blending steering behaviors causes problems when two steering behaviors want to do conflicting things. This can lead to the character doing nothing, being trapped at an equilibrium. In Figure 3.33, the character is trying to reach its destination while avoiding the enemy. The seek steering behavior is precisely balanced against the evade behavior.

This balance will soon sort itself out. As long as the enemy is stationary, numerical instability will give the character a minute lateral velocity. It will skirt around increasingly quickly before making a dash for the destination. This is an unstable equilibrium.

Figure 3.34 shows a more serious situation. Here, if the character does make it out of equilibrium slightly (as a result of limited floating point accuracy, for example), it will immediately head back into equilibrium. There is no escape for the character. It will stay fixed to the spot, looking stupid and indecisive. The equilibrium is stable.

Stable equilibria have a basin of attraction: the region of the level where a character will fall into the equilibrium point. If this basin is large, then the chances of a character becoming trapped are very large. Figure 3.34 shows a basin of attraction that extends in a corridor for an unlimited distance. Unstable equilibria effectively have a basin of zero size.

Basins of attraction aren't only defined by a set of locations. They might only attract characters that are traveling in a particular direction or that have a particular orientation. For this reason they can be very difficult to visualize and debug.

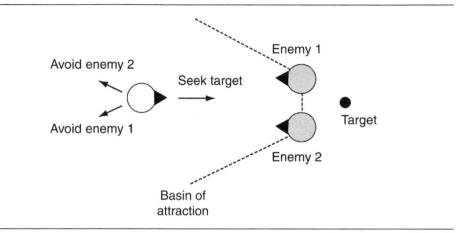

Figure 3.34: A stable equilibrium

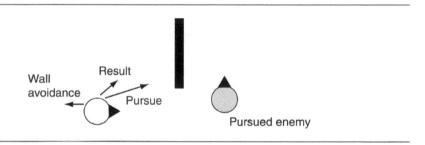

Figure 3.35: Can't avoid an obstacle and chase

Constrained Environments

Steering behaviors, either singly or blended, work well in environments with few constraints. Movement in an open 3D space has the fewest constraints. Most games, however, take place in constrained 2D worlds. Indoor environments, racetracks, and groups of characters moving in formation all greatly increase the number of constraints on a character's movement.

Figure 3.35 shows a chasing steering behavior returning a pathological suggestion for the motion of a character. The pursue behavior alone would collide with the wall, but adding the wall avoidance makes the direction even farther from the correct route for capturing the enemy.

This problem is often seen in characters trying to move at acute angles through narrow doorways, as shown in Figure 3.36. The obstacle avoidance behavior kicks in and can send the character past the door, missing the route it wanted to take.

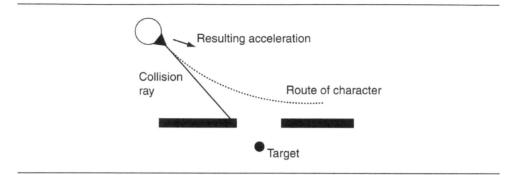

Figure 3.36: Missing a narrow doorway

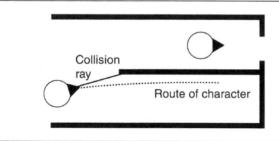

Figure 3.37: Long distance failure in a steering behavior

The problem of navigating into narrow passages is so perennial that many developers deliberately get their level designers to make wide passages where AI characters need to navigate.

Nearsightedness

Steering behaviors act locally. They make decisions based on their immediate surroundings only. As human beings, we anticipate the result of our actions and evaluate if it will be worth it. Basic steering behaviors can't do this, so they often take the wrong course of action to reach their goal.

Figure 3.37 shows a character avoiding a wall using a standard wall avoidance technique. The movement of the character catches the corner on just the wrong side. It will never catch the enemy now, but it won't realize that for a while.

There is no way to augment steering behaviors to get around this problem. Any behavior that does not lookahead can be foiled by problems that are beyond its horizon. The only way to solve this is to incorporate pathfinding into the steering system. This integration is discussed below, and the pathfinding algorithms themselves are found in the next chapter.

3.4.3 PRIORITIES

We have met a number of steering behaviors that will only request an acceleration in particular situations. Unlike seek or evade, which always produce an acceleration, collision avoidance, separation, and arrive will suggest no acceleration in many cases.

When these behaviors do suggest an acceleration, it is unwise to ignore it. A collision avoidance behavior, for example, should be honored immediately to avoid banging into another character.

When behaviors are blended together, their acceleration requests are diluted by the requests of the others. A seek behavior, for example, will always be returning maximum acceleration in some direction. If this is blended equally with a collision avoidance behavior, then the collision avoidance behavior will never have more than 50% influence over the motion of the character. This may not be enough to get the character out of trouble.

The Algorithm

A variation of behavior blending replaces weights with priorities. In a priority-based system, behaviors are arranged in groups with regular blending weights. These groups are then placed in priority order.

The steering system considers each group in turn. It blends the steering behaviors in the group together, exactly as before. If the total result is very small (less than some small, but adjustable, parameter), then it is ignored and the next group is considered. It is best not to check against zero directly, because numerical instability in calculations can mean that a zero value is never reached for some steering behaviors. Using a small constant value (conventionally called the epsilon parameter) avoids this problem.

When a group is found with a result that isn't small, its result is used to steer the character.

A pursuing character working in a team, for example, may have three groups: a collision avoidance group, a separation group, and a pursuit group. The collision avoidance group contains behaviors for obstacle avoidance, wall avoidance, and avoiding other characters. The separation group simply contains the separation behavior, which is used to avoid getting too close to other members of the chasing pack. The pursuit group contains the pursue steering behavior used to home in on the target.

If the character is far from any interference, the collision avoidance group will return with no desired acceleration. The separation group will then be considered but will also return with no action. Finally, the pursuit group will be considered, and the acceleration needed to continue the chase will be used. If the current motion of the character is perfect for the pursuit, this group may also return with no acceleration. In this case, there are no more groups to consider, so the character will have no acceleration, just as if they'd been exclusively controlled by the pursuit behavior.

In a different scenario, if the character is about to crash into a wall, the first group will return an acceleration that will help avoid the crash. The character will carry out this acceleration immediately, and the steering behaviors in the other groups will never be considered.

Pseudo-Code

The algorithm for priority-based steering is as follows:

```
# Should be a small value, effectively zero.
   epsilon: float
2
   class PrioritySteering:
4
       # Holds a list of BlendedSteering instances, which in turn
5
       # contain sets of behaviors with their blending weights.
6
       groups: BlendedSteering[]
7
8
       function getSteering() -> SteeringOutput:
9
           for group in groups:
10
                # Create the steering structure for accumulation.
11
                steering = group.getSteering()
12
13
                # Check if we're above the threshold, if so return.
                if steering.linear.length() > epsilon or
                   abs(steering.angular) > epsilon:
16
                    return steering
17
18
           # If we get here, it means that no group had a large enough
19
           # acceleration, so return the small acceleration from the
20
           # final group.
21
           return steering
22
```

Data Structures and Interfaces

The priority steering algorithm uses a list of BlendedSteering instances. Each instance in this list makes up one group, and within that group the algorithm uses the code we created before to blend behaviors together.

Implementation Notes

The algorithm relies on being able to find the absolute value of a scalar (the angular acceleration) using the abs function. This function is found in the standard libraries of most programming languages.

The method also uses the length method to find the magnitude of a linear acceleration vector. Because we're only comparing the result with a fixed epsilon value, we could use the squared magnitude instead (making sure our epsilon value is suitable for comparing against a squared distance). This would save a square root calculation.

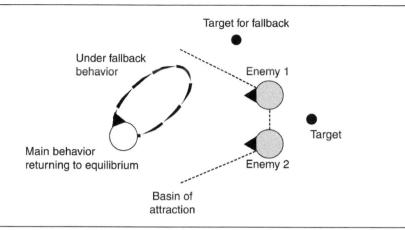

Figure 3.38: Priority steering avoiding unstable equilibrium

Performance

The algorithm requires only temporary storage for the acceleration. It is O(1) in memory. It is O(n) for time, where n is the total number of steering behaviors in all the groups. Once again, the practical execution speed of this algorithm depends on the efficiency of the getSteering methods for the steering behaviors it contains.

Equilibria Fallback

One notable feature of this priority-based approach is its ability to cope with stable equilibria. If a group of behaviors is in equilibrium, its total acceleration will be near zero. In this case the algorithm will drop down to the next group to get an acceleration.

By adding a single behavior at the lowest priority (wander is a good candidate), equilibria can be broken by reverting to a fallback behavior. This situation is illustrated in Figure 3.38.

Weaknesses

While this works well for unstable equilibria (it avoids the problem with slow creeping around the edge of an exclusion zone, for example), it cannot avoid large stable equilibria.

In a stable equilibrium the fallback behavior will engage at the equilibrium point and move the character out, whereupon the higher priority behaviors will start to generate acceleration requests. If the fallback behavior has not moved the character out of the basin of attraction, the higher priority behaviors will steer the character straight back to the equilibrium point. The character will oscillate in and out of equilibrium, but never escape.

Variable Priorities

The algorithm above uses a fixed order to represent priorities. Groups of behavior that appear earlier in the list will take priority over those appearing later in the list. In most cases priorities are fairly easy to fix; a collision avoidance, when activated, will always take priority over a wander behavior, for example.

In some cases, however, we'd like more control. A collision avoidance behavior may be low priority as long as the collision isn't imminent, becoming absolutely critical near the last possible opportunity for avoidance.

We can modify the basic priority algorithm by allowing each group to return a dynamic priority value. In the PrioritySteering.getSteering method, we initially request the priority values and then sort the groups into priority order. The remainder of the algorithm operates in exactly the same way as before.

Despite providing a solution for the occasional stuck character, there is only a minor practical advantage to using this approach. On the other hand, the process of requesting priority values and sorting the groups into order adds time. Although it is an obvious extension, my feeling is that if you are going in this direction, you may as well bite the bullet and upgrade to a full cooperative arbitration system.

3.4.4 COOPERATIVE ARBITRATION

So far we've looked at combining steering behaviors in an independent manner. Each steering behavior knows only about itself and always returns the same answer. To calculate the resulting steering acceleration, we select one or blend together several of these results. This approach has the advantage that individual steering behaviors are very simple and easily replaced. They can be tested on their own.

But as we've seen, there are a number of significant weaknesses in the approach that make it difficult to let characters loose without glitches appearing.

There is a trend toward increasingly sophisticated algorithms for combining steering behaviors. A core feature of this trend is the cooperation among different behaviors.

Suppose, for example, a character is chasing a target using a pursue behavior. At the same time it is avoiding collisions with walls. Figure 3.39 shows a possible situation. The collision is imminent and so needs to be avoided.

The collision avoidance behavior generates an avoidance acceleration away from the wall. Because the collision is imminent, it takes precedence, and the character is accelerated away.

The overall motion of the character is shown in Figure 3.39. It slows dramatically when it is about to hit the wall because the wall avoidance behavior is providing only a tangential acceleration.

The situation could be mitigated by blending the pursue and wall avoidance behaviors (although, as we've seen, simple blending would introduce other movement problems in situations with unstable equilibria). Even in this case it would still be noticeable because the forward acceleration generated by pursue is diluted by wall avoidance.

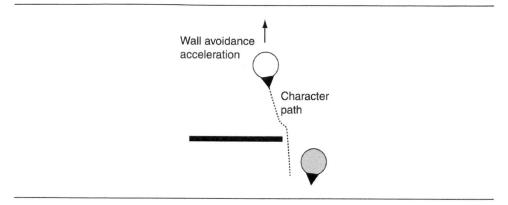

Figure 3.39: An imminent collision during pursuit

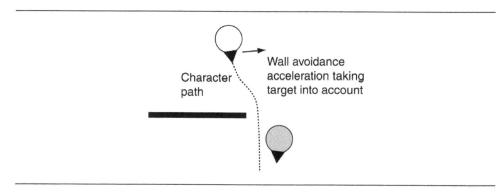

Figure 3.40: A context-sensitive wall avoidance

To get a believable behavior, we'd like the wall avoidance behavior to take into account what pursue is trying to achieve. Figure 3.40 shows a version of the same situation. Here the wall avoidance behavior is context sensitive; it understands where the pursue behavior is going, and it returns an acceleration which takes both concerns into account.

Obviously, taking context into account in this way increases the complexity of the steering algorithm. We can no longer use simple building blocks that selfishly do their own thing.

Many collaborative arbitration implementations are based on techniques we will cover in Chapter 5 on decision making. It makes sense; we're effectively making decisions about where and how to move. Decision trees, state machines, and blackboard architectures have all been used to control steering behaviors. Decision trees are the most common, as it is natural to implement each steering behavior as a decision tree node. Although less common, blackboard architectures are also particularly suited to cooperating steering behaviors; each

behavior is an expert that can read (from the blackboard) what other behaviors would like to do before having its own say.

Although decision trees are the most common, they can be finicky to get right. It isn't clear whether a breakthrough or another alternative approach will become the de facto standard for games. Cooperative steering behaviors is an area that many developers have independently stumbled across, and it is likely to be some time before any consensus is reached on an ideal implementation.

In the next section I will introduce the steering pipeline algorithm, an example of a dedicated approach that doesn't use the decision making technology in Chapter 5.

3.4.5 STEERING PIPELINE

The steering pipeline approach was pioneered by Marcin Chady, when we worked together at the AI middleware company Mindlathe. It was intended as an intermediate step between simply blending or prioritizing steering behaviors and implementing a complete movement planning solution (discussed in Chapter 4). It is a cooperative arbitration approach that allows constructive interaction between steering behaviors. It provides excellent performance in a range of situations that are normally problematic, including tight passages and integrating steering with pathfinding.

Bear in mind when reading this section that this is just one example of a cooperative arbitration approach that doesn't rely on other decision-making techniques. I am not suggesting this is the only way it can be done.

Algorithm

Figure 3.41 shows the general structure of the steering pipeline.

There are four stages in the pipeline: the targeters work out where the movement goal is, decomposers provide sub-goals that lead to the main goal, constraints limit the way a character can achieve a goal, and the actuator limits the physical movement capabilities of a character.

In all but the final stage, there can be one or more components. Each component in the pipeline has a different job to do. All are steering behaviors, but the way they cooperate depends on the stage.

Targeters

Targeters generate the top-level goal for a character. There can be several targets: a positional target, an orientation target, a velocity target, and a rotation target. We call each of these elements a channel of the goal (e.g., position channel, velocity channel). All goals in the algorithm can have any or all of these channels specified. An unspecified channel is simply a "don't care."

Individual channels can be provided by different behaviors (a chase-the-enemy targeter

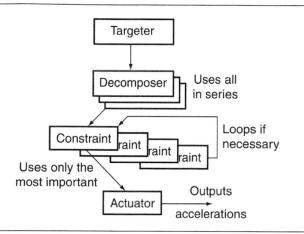

Figure 3.41: The steering pipeline

may generate the positional target, while a look-toward targeter may provide an orientation target), or multiple channels can be requested by a single targeter. When multiple targeters are used, only one may generate a goal in each channel. The algorithm we develop here trusts that the targeters cooperate in this way. No effort is made to avoid targeters overwriting previously set channels.

To the greatest extent possible, the steering system will try to fulfill all channels, although some sets of targets may be impossible to achieve all at once. We'll come back to this possibility in the actuation stage.

At first glance it can appear odd that we're choosing a single target for steering. Behaviors such as run away or avoid obstacle have goals to move away from, not to seek. The pipeline forces you to think in terms of the character's goal. If the goal is to run away, then the targeter needs to choose somewhere to run to. That goal may change from frame to frame as the pursuing enemy weaves and chases, but there will still be a single goal.

Other "away from" behaviors, like obstacle avoidance, don't become goals in the steering pipeline. They are constraints on the way a character moves and are found in the constraints stage.

Decomposers

Decomposers are used to split the overall goal into manageable sub-goals that can be more easily achieved.

The targeter may generate a goal somewhere across the game level, for example. A decomposer can check this goal, see that is not directly achievable, and plan a complete route (using a pathfinding algorithm, for example). It returns the first step in that plan as the sub-goal.

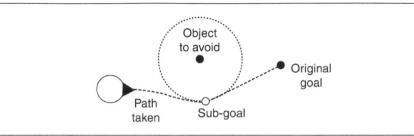

Figure 3.42: Collision avoidance constraint

This is the most common use for decomposers: to incorporate seamless path planning into the steering pipeline.

There can be any number of decomposers in the pipeline, and their order is significant. We start with the first decomposer, giving it the goal from the targeter stage. The decomposer can either do nothing (if it can't decompose the goal) or can return a new sub-goal. This sub-goal is then passed to the next decomposer, and so on, until all decomposers have been queried.

Because the order is strictly enforced, we can perform hierarchical decomposition very efficiently. Early decomposers should act broadly, providing large-scale decomposition. For example, they might be implemented as a coarse pathfinder. The sub-goal returned may still be a long way from the character. Later decomposers can then refine the sub-goal by decomposing it. Because they are decomposing only the sub-goal, they don't need to consider the big picture, allowing them to decompose in more detail. This approach will seem familiar when we look at hierarchical pathfinding in the next chapter. With a steering pipeline in place, we don't need a hierarchical pathfinding engine; we can simply use a set of decomposers pathfinding on increasingly detailed graphs.

Constraints

Constraints limit the ability of a character to achieve its goal or sub-goal. They detect if moving toward the current sub-goal is likely to violate the constraint, and if so, they suggest a way to avoid it. Constraints tend to represent obstacles: moving obstacles like characters or static obstacles like walls.

Constraints are used in association with the actuator, described below. The actuator works out the path that the character will take toward its current sub-goal. Each constraint is allowed to review that path and determine if it is sensible. If the path will violate a constraint, then it returns a new sub-goal that will avoid the problem. The actuator can then work out the new path and check if that one works and so on, until a valid path has been found.

It is worth bearing in mind that the constraint may only provide certain channels in its sub-goal. Figure 3.42 shows an upcoming collision. The collision avoidance constraint could generate a positional sub-goal, as shown, to force the character to swing around the obstacle. Equally, it could leave the position channel alone and suggest a velocity pointing away from the obstacle, so that the character drifts out from its collision line. The best approach depends to a large extent on the movement capabilities of the character and, in practice, takes some experimentation.

Of course, solving one constraint may violate another constraint, so the algorithm may need to loop around to find a compromise where every constraint is happy. This isn't always possible, and the steering system may need to give up trying to avoid getting into an endless loop. The steering pipeline incorporates a special steering behavior, deadlock, that is given exclusive control in this situation. This could be implemented as a simple wander behavior in the hope that the character will wander out of trouble. For a complete solution, it could call a comprehensive movement planning algorithm.

The steering pipeline is intended to provide believable yet lightweight steering behavior, so that it can be used to simulate a large number of characters. We could replace the current constraint satisfaction algorithm with a full planning system, and the pipeline would be able to solve arbitrary movement problems. I've found it best to stay simple, however. In the majority of situations, the extra complexity isn't needed, and the basic algorithm works fine.

As it stands, the algorithm is not always guaranteed to direct an agent through a complex environment. The deadlock mechanism allows us to call upon a pathfinder or another higher level mechanism to get out of trickier situations. The steering system has been specially designed to allow you to do that only when necessary, so that the game runs at the maximum speed. Always use the simplest algorithms that work.

The Actuator

Unlike each of the other stages of the pipeline, there is only one actuator per character. The actuator's job is to determine how the character will go about achieving its current sub-goal. Given a sub-goal and its internal knowledge about the physical capabilities of the character, it returns a path indicating how the character will move to the goal.

The actuator also determines which channels of the sub-goal take priority and whether any should be ignored.

For simple characters, like a walking sentry or a floating ghost, the path can be extremely simple: head straight for the target. The actuator can often ignore velocity and rotation channels and simply make sure the character is facing the target.

If the actuator does honor velocities, and the goal is to arrive at the target with a particular velocity, we may choose to swing around the goal and take a run up, as shown in Figure 3.43.

More constrained characters, like an AI-controlled car, will have more complex actuation: the car can't turn while stationary, it can't move in any direction other than the one in which it is facing, and the grip of the tires limits the maximum turning speed. The resulting path may be more complicated, and it may be necessary to ignore certain channels. For example, if the sub-goal wants us to achieve a particular velocity while facing in a different direction, then we know the goal is impossible. Therefore, we will probably throw away the orientation channel.

In the context of the steering pipeline, the complexity of actuators is often raised as a prob-

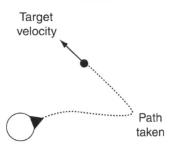

Figure 3.43: Taking a run up to achieve a target velocity

lem with the algorithm. It is worth bearing in mind that this is an implementation decision; the pipeline supports comprehensive actuators when they are needed (and you obviously have to pay the price in execution time), but they also support trivial actuators that take virtually no time at all to run.

Actuation as a general topic is covered later in this chapter, so we'll avoid getting into the grimy details at this stage. For the purpose of this algorithm, we will assume that actuators take a goal and return a description of the path the character will take to reach it.

Eventually, we'll want to actually carry out the steering. The actuator's final job is to return the forces and torques (or other motor controls—see Section 3.8 for details) needed to achieve the predicted path.

Pseudo-Code

The steering pipeline is implemented with the following algorithm:

```
class SteeringPipeline:
       character: Kinematic
2
       # Lists of components at each stage of the pipe.
4
       targeters: Targeter[]
5
       decomposers: Decomposer[]
6
       constraints: Constraint[]
7
       actuator: Actuator
8
       # The number of attempts the algorithm will make to find an
10
       # unconstrained route.
11
       constraintSteps: int
12
13
       # The deadlock steering behavior.
14
       deadlock: SteeringBehavior
15
16
```

```
function getSteering() -> SteeringOutput:
17
            # Firstly we get the top level goal.
18
            goal: Goal = new Goal()
            for targeter in targeters:
20
                targeterGoal = targeter.getGoal(character)
21
                goal.updateChannels(targeterGoal)
22
23
            # Now we decompose it.
24
            for decomposer in decomposers:
25
                goal = decomposer.decompose(character, goal)
26
27
            # Now we loop through the actuation and constraint process.
28
            for i in 0..constraintSteps:
29
                # Get the path from the actuator.
                path = actuator.getPath(character, goal)
31
                # Check for constraint violation.
33
                for constraint in constraints:
34
                    # If we find a violation, get a suggestion.
35
36
                    if constraint.isViolated(path):
37
                         goal = constraint.suggest(character, path, goal)
38
                        # Go to the next iteration of the 'for i in ...'
39
                        # loop to try for the new goal.
40
41
                        break continue
42
                # If we're here it is because we found a valid path.
43
                return actuator.output(character, path, goal)
44
45
           # We arrive here if we ran out of constraint steps.
46
            # We delegate to the deadlock behavior.
47
48
            return deadlock.getSteering()
```

Data Structures and Interfaces

We are using interface classes to represent each component in the pipeline. At each stage, a different interface is needed.

Targeter

Targeters have the form:

```
class Targeter:
    function getGoal(character: Kinematic) -> Goal
```

The getGoal function returns the targeter's goal.

Decomposer

Decomposers have the interface:

```
class Decomposer:
    function decompose(character: Kinematic, goal: Goal) -> Goal
```

The decompose method takes a goal, decomposes it if possible, and returns a sub-goal. If the decomposer cannot decompose the goal, it simply returns the goal it was given.

Constraint

Constraints have two methods:

```
class Constraint:
      function willViolate(path: Path) -> bool
2
      function suggest(character: Kinematic,
3
                         path: Path,
4
                         goal: Goal) -> Goal
```

The will Violate method returns true if the given path will violate the constraint at some point. The suggest method should return a new goal that enables the character to avoid violating the constraint. We can make use of the fact that suggest always follows a positive result from willViolate. Often, willViolate needs to perform calculations to determine if the path poses a problem. If it does, the results of these calculations can be stored in the class and reused in the suggest method that follows. The calculation of the new goal can be entirely performed in the willViolate method, leaving the suggest method to simply return the result. Any channels not needed in the suggestion should take their values from the current goal passed into the method.

Actuator

The actuator creates paths and returns steering output:

```
class Actuator:
2
      function getPath(character: Kinematic, goal: Goal) -> Path
      function output(character: Kinematic,
3
                       path: Path,
4
                       goal: Goal) -> SteeringOutput
5
```

The getPath function returns the route that the character will take to the given goal. The output function returns the steering output for achieving the given path.

Deadlock

The deadlock behavior is a general steering behavior. Its getSteering function returns a steering output that is simply returned from the steering pipeline.

Goal

Goals need to store each channel, along with an indication as to whether the channel should be used. The updateChannel method sets appropriate channels from another goal object. The structure can be implemented as:

```
class Goal:
       # Flags to indicate if each channel is to be used.
2
       hasPosition: bool = false
       hasOrientation: bool = false
4
       hasVelocity: bool = false
5
       hasRotation: bool = false
7
       # Data for each channel.
       position: Vector
9
       orientation: float
10
       velocity: Vector
11
       rotation: float
13
       # Updates this goal.
14
       function updateChannels(other: Goal):
15
            if other.hasPosition:
16
                position = other.position
17
                hasPosition = true
18
            if other.hasOrientation:
19
                orientation = other.orientation
20
                hasOrientation = true
21
            if other.hasVelocity:
22
                velocity = other.velocity
23
                hasVelocity = true
24
            if other.hasRotation:
25
                rotation = other.rotation
26
                hasRotation = true
```

Paths

In addition to the components in the pipeline, I have used an opaque data structure for the path. The format of the path doesn't affect this algorithm. It is simply passed between steering components unaltered.

In real projects I've used two different path implementations to drive the algorithm. Pathfinding-style paths, made up of a series of line segments, give point-to-point movement information. They are suitable for characters who can turn very quickly—for example, human beings walking. Point-to-point paths are very quick to generate, they can be extremely quick to check for constraint violation, and they can be easily turned into forces by the actuator.

The original version of this algorithm used a more general path representation. Paths are made up of a list of maneuvers, such as "accelerate" or "turn with constant radius." They are

suitable for the most complex steering requirements, including race car driving, which is a difficult test for any steering algorithm. This type of path can be more difficult to check for constraint violation, however, because it involves curved path sections.

It is worth experimenting to see if your game can make do with straight line paths before implementing more complex structures.

Performance

The algorithm is O(1) in memory. It uses only temporary storage for the current goal.

It is O(cn) in time, where c is the number of constraint steps and n is the number of constraints. Although c is a constant (and we could therefore say the algorithm is O(n) in time), it helps to increase its value as more constraints are added to the pipeline. In the past I've used a number of constraint steps similar to the number of constraints, giving an algorithm $O(n^2)$ in time.

The constraint violation test is at the lowest point in the loop, and its performance is critical. Profiling a steering pipeline with no decomposers will show that most of the time spent executing the algorithm is normally spent in this function.

Since decomposers normally provide pathfinding, they can be very long running, even though they will be inactive for much of the time. For a game where the pathfinders are extensively used (i.e., the goal is always a long way away from the character), the speed hit will slow the AI unacceptably. The steering algorithm needs to be split over multiple frames.

Example Components

Actuation will be covered in Section 3.8 later in the chapter, but it is worth taking a look at a sample steering component for use in the targeter, decomposer, and constraint stages of the pipeline.

Targeter

The chase targeter keeps track of a moving character. It generates its goal slightly ahead of its victim's current location, in the direction the victim is moving. The distance ahead is based on the victim's speed and a lookahead parameter in the targeter.

```
class ChaseTargeter extends Targeter:
      chasedCharacter: Kinematic
2
      # Controls how much to anticipate the movement.
      lookahead: float
5
```

```
function getGoal(kinematic):
7
           goal = new Goal()
8
            goal.position = chasedCharacter.position +
                            chasedCharacter.velocity * lookahead
10
            goal.hasPosition = true
11
            return goal
12
```

Decomposer

The pathfinding decomposer performs pathfinding on a graph and replaces the given goal with the first node in the returned plan. See Chapter 4 on pathfinding for more information.

```
class PlanningDecomposer extends Decomposer:
       graph: Graph
2
       heuristic: function(GraphNode, GraphNode) -> float
3
       function decompose(character: Kinematic, goal: Goal) -> Goal:
            # First we quantize our current location and our goal into
           # nodes of the graph.
            start: GraphNode = graph.getNode(kinematic.position)
            end: GraphNode = graph.getNode(goal.position)
10
           # If they are equal, we don't need to plan.
11
            if startNode == endNode:
12
                return goal
13
14
           # Otherwise plan the route.
15
           path = pathfindAStar(graph, start, end, heuristic)
16
17
           # Get the first node in the path and localize it.
           firstNode: GraphNode = path[0].asNode
19
           position: Vector = graph.getPosition(firstNode)
20
21
           # Update the goal and return.
22
           goal.position = position
23
           goal.hasPosition = true
24
           return goal
25
```

Constraint

The avoid obstacle constraint treats an obstacle as a sphere, represented as a single 3D point and a constant radius. For simplicity, I assume that the path provided by the actuator is a series of line segments, each with a start point and an end point.

```
class AvoidObstacleConstraint extends Constraint:
2
      # The obstacle bounding sphere.
3
      center: Vector
```

```
radius: float
4
5
       # Holds a margin of error by which we'd ideally like
6
       # to clear the obstacle. Given as a proportion of the
7
       # radius (i.e. should be > 1.0).
8
       margin: float
10
       # If a violation occurs, stores the part of the path
11
       # that caused the problem.
12
       problemIndex: int
13
       function willViolate(path: Path) -> bool:
15
           # Check each segment of the path in turn.
16
           for i in 0..len(path):
17
                segment = path[i]
18
19
                # If we have a clash, store the current segment.
20
                if distancePointToSegment(center, segment) < radius:</pre>
21
                    problemIndex = i
22
                    return true
23
24
           # No segments caused a problem.
25
           return false
26
27
       function suggest(_, path: Path, goal: Goal) -> Goal:
28
           # Find the closest point on the segment to the sphere center.
29
            segment = path[problemIndex]
30
           closest = closestPointOnSegment(segment, center)
31
32
           # Check if we pass through the center point.
33
            if closest.length() == 0:
34
                # Any vector at right angles to the segment will do.
35
                direction = segment.end - segment.start
                newDirection = direction.anyVectorAtRightAngles()
37
                newPosition = center + newDirection * radius * margin
38
39
           # Otherwise project the point out beyond the radius.
40
            else:
41
                offset = closest - center
42
                newPosition = center +
43
                               offset * radius * margin / closest.length()
44
45
            # Set up the goal and return.
46
            goal.position = newPosition
47
            goal.hasPosition = true
48
            return goal
49
```

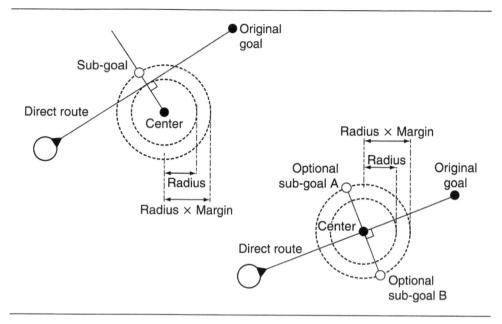

Figure 3.44: Obstacle avoidance projected and at right angles

The suggest method appears more complex that it actually is. We find a new goal by finding the point of closest approach and projecting it out so that we miss the obstacle by far enough. We need to check that the path doesn't pass right through the center of the obstacle, however, because in that case we can't project the center out. If it does, we use any point around the edge of the sphere, at a tangent to the segment, as our target. Figure 3.44 shows both situations in two dimensions and also illustrates how the margin of error works.

I added the anyVectorAtRightAngles method just to simplify the listing. It returns a new vector at right angles to its instance. This is normally achieved by using a cross product with some reference direction and then returning a cross product of the result with the original direction. This will not work if the reference direction is the same as the vector we start with. In this case a backup reference direction is needed.

Conclusion

The steering pipeline is one of many possible cooperative arbitration mechanisms. Unlike other approaches, such as decision trees or blackboard architectures, it is specifically designed for the needs of steering.

On the other hand, it is not the most efficient technique. While it will run very quickly for simple scenarios, it can slow down when the situation gets more complex. If you are determined to have your characters move intelligently, then you will have to pay the price in execution speed sooner or later (in fact, to guarantee it, you'll need full motion planning, which is even slower than pipeline steering). In many games, however, the prospect of some foolish steering is not a major issue, and it may be easier to use a simpler approach to combining steering behaviors, such as blending or priorities.

3.5 PREDICTING PHYSICS

A common requirement of AI in 3D games is to interact well with some kind of physics simulation. This may be as simple as the AI in variations of Pong, which tracked the current position of the ball and moved the bat so that it would rebound, or it might involve the character correctly calculating the best way to throw a ball so that it reaches a teammate who is running. We've seen a simple example of this already. The pursue steering behavior predicted the future position of its target by assuming it would carry on with its current velocity. A more complex prediction may involve deciding where to stand to minimize the chance of being hit by an incoming grenade.

In each case, we are doing AI not based on the character's own movement (although that may be a factor), but on the basis of other characters' or objects' movement.

By far, the most common requirement for predicting movement is for aiming and shooting firearms. This involves the solution of ballistic equations: the so-called "Firing Solution." In this section we will first look at firing solutions and the mathematics behind them. We will then look at the broader requirements of predicting trajectories and a method of iteratively predicting objects with complex movement patterns.

3.5.1 AIMING AND SHOOTING

Firearms, and their fantasy counterparts, are a key feature of game design. In the vast majority of action games, the characters can wield some variety of projectile weapon. In a fantasy game it might be a crossbow or fireball spell, and in a science fiction (sci-fi) game it could be a disrupter or phaser.

This puts two common requirements on the AI. Characters should be able to shoot accurately, and they should be able to respond to incoming fire. The second requirement is often omitted, since the projectiles from many firearms and sci-fi weapons move too fast for anyone to be able to react to. When faced with weapons such as rocket-propelled grenades (RPGs) or mortars, however, the lack of reaction can appear unintelligent.

Regardless of whether a character is giving or receiving fire, it needs to understand the likely trajectory of a weapon. For fast-moving projectiles over small distances, this can be approximated by a straight line, so older games tended to use simple straight line tests for shooting. With the introduction of increasingly complex physics simulation, however, shooting along a straight line to your targets is likely to result in your bullets landing in the dirt at their feet. Predicting correct trajectories is now a core part of the AI in shooters.

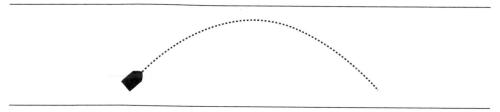

Figure 3.45: Parabolic arc

3.5.2 PROJECTILE TRAJECTORY

A moving projectile under gravity will follow a curved trajectory. In the absence of any air resistance or other interference, the curve will be part of a parabola, as shown in Figure 3.45. The projectile moves according to the formula:

$$\vec{p_t} = \vec{p_0} + \vec{u}s_m t + \frac{\vec{g}t^2}{2} \tag{3.1}$$

where $\vec{p_t}$ is its position (in three dimensions) at time t; $\vec{p_0}$ is the firing position (again in three dimensions); s_m is the muzzle velocity (the speed the projectile left the weapon—it is not strictly a velocity because it is not a vector), \vec{u} is the direction the weapon was fired in (a normalized three dimensional vector), t is the length of time since the shot was fired; and \vec{g} is the acceleration due to gravity. The notation \vec{x} denotes that x is a vector, others values are scalar.

It is worth noting that although the acceleration due to gravity on Earth is:

$$\vec{g} = \begin{bmatrix} 0 \\ -9.81 \\ 0 \end{bmatrix} \text{ms}^{-2}$$

(i.e. $9.81 \mathrm{ms}^{-2}$ in the down direction) this can look too slow in a game environment. Physics programmers often choose a value around double that for games, although some tweaking is needed to get the exact look. Even $9.81 \mathrm{ms}^{-2}$ may appear far too fast for certain objects, however, particularly the jumping of characters. To get the correct overall effect it isn't uncommon to have different objects with different gravity.

The simplest thing we can do with the trajectory equations is to determine if a character will be hit by an incoming projectile. This is a fairly fundamental requirement of any character in a shooter with slow-moving projectiles (such as grenades).

We will split this into two elements: determining where a projectile will land and determining if its trajectory will touch a target character.

Predicting a Landing Spot

The AI should determine where an incoming grenade will land and then move quickly away from that point (using a flee steering behavior, for example, or a more complex compound steering system that takes into account escape routes). If there's enough time, an AI character might move toward the grenade point as fast as possible (using arrive, perhaps) and then intercept and throw back the ticking grenade, forcing the player to pull the grenade pin and hold it for just the right length of time.

We can determine where a grenade will land, by solving the projectile equation for a fixed value of p_y (i.e., the height). If we know the current velocity of the grenade and its current position, we can solve for just the y component of the position, and get the time at which the grenade will reach a known height (i.e. the height of the floor on which the character is standing):

$$t_i = \frac{-u_y s_m \pm \sqrt{u_y^2 s_m^2 - 2g_y (p_{y0} - p_{yt})}}{g_y}$$
 (3.2)

where p_{yi} is the position of impact, and t_i is the time at which this occurs. There may be zero, one, or two solutions to this equation. If there are zero solutions, then the projectile never reaches the target height; it is always below it. If there is one solution, then the projectile reaches the target height at the peak of its trajectory. Otherwise, the projectile reaches the height once on the way up and once on the way down. We are interested in the solution when the projectile is descending, which will be the greater time value (since whatever goes up will later come down). If this time value is less than zero, then the projectile has already passed the target height and won't reach it again.

The time t_i from Equation 3.2 can be substituted into Equation 3.1 to get the complete position of impact:

$$\vec{p_i} = \begin{bmatrix} p_{x0} + u_x s_m t_i + \frac{1}{2} g_x t_i^2 \\ p_{yi} \\ p_{z0} + u_z s_m t_i + \frac{1}{2} g_z t_i^2 \end{bmatrix}$$
(3.3)

which further simplifies if (as it normally does) gravity only acts in the down direction, to:

$$\vec{p_i} = \begin{bmatrix} p_{x0} + u_x s_m t_i \\ p_{yi} \\ p_{z0} + u_z s_m t_i \end{bmatrix}$$
(3.4)

For grenades, we could compare the time to impact with the known length of the grenade fuse to determine whether it is safer to run from or catch and return the grenade.

Note that this analysis does not deal with the situation where the ground level is rapidly changing. If the character is on a ledge or walkway, for example, the grenade may miss impacting at its height entirely and sail down the gap behind it. We can use the result of Equation 3.3 to check if the impact point is valid.

For outdoor levels with rapidly fluctuating terrain, we can also use the equation iteratively,

generating (x, z) coordinates with Equation 3.3, then feeding the p_y coordinate of the impact point back into the equation, until the resulting (x, z) values stabilize. There is no guarantee that they will ever stabilize, but in most cases they do. In practice, however, high explosive projectiles typically damage a large area, so inaccuracies in the predicted impact point are difficult to spot when the character is running away.

The final point to note about incoming hit prediction is that the floor height of the character is not normally the height at which the character catches. If the character is intending to catch the incoming object (as it will in most sports games, for example), it should use a target height value at around chest height. Otherwise, it will appear to maneuver in such a way that the incoming object drops at its feet.

3.5.3 THE FIRING SOLUTION

To hit a target at a given point \vec{E} , we need to solve Equation 3.1. In most cases we know the firing point \vec{S} (i.e. $\vec{S}\equiv\vec{p_0}$), the muzzle velocity s_m , and the acceleration due to gravity \vec{g} ; we'd like to find just \vec{u} , the direction in which to fire (although finding the time to collision can also be useful for deciding if a slow moving shot is worth it).

Archers and grenade throwers can change the velocity of the projectile as they fire (i.e., they select an s_m value), but most weapons have a fixed value for s_m . We will assume, however, that characters who can select a velocity will always try to get the projectile to its target in the shortest time possible. In this case they will always choose their highest possible velocity.

In an indoor environment, with many obstacles (such as barricades, joists and columns) it might be advantageous for a character to throw their grenade more slowly so it arches over obstacles. Dealing with obstacles in this way gets to be very complex, and is best solved by a trial and error process, trying different s_m values (often trials are limited to a few fixed values: 'throw fast', 'throw slow' and 'drop', for example). For the purpose of this book we can assume that s_m is constant and known in advance.

The quadratic equation (Equation 3.1) has vector coefficients; add to this the requirement that the firing vector should be normalized,

$$|\vec{u}| = 1$$

and we have four equations in four unknowns:

$$E_x = S_x + u_x s_m t_i + \frac{1}{2} g_x t_i^2$$

$$E_y = S_y + u_y s_m t_i + \frac{1}{2} g_y t_i^2$$

$$E_z = S_z + u_z s_m t_i + \frac{1}{2} g_z t_i^2$$

$$1 = u_x^2 + u_y^2 + u_z^2$$

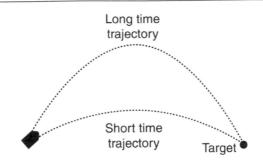

Figure 3.46: Two possible firing solutions

These can be solved to find the firing direction and the projectile's time to target. Firstly we get an expression for t_i :

$$|\vec{g}|^2 t_i^4 - 4(\vec{g}.\vec{\Delta} + s_m^2)t_i^2 + 4|\vec{\Delta}|^2 = 0$$

where $\vec{\Delta}$ is the vector from the start point to the end point, given by $\vec{\Delta}=\vec{E}-\vec{S}$. This is a quartic in t_i , with no odd powers. We can therefore use the quadratic equation formula to solve for t_i^2 and take the square root of the result. Doing this, we get:

$$t_i = +2\sqrt{\frac{\vec{g}.\vec{\Delta} + s_m^2 \pm \sqrt{(\vec{g}.\vec{\Delta} + s_m^2)^2 - |\vec{g}|^2 |\vec{\Delta}|^2}}{2|\vec{g}|^2}}$$

which gives us two real-valued solutions for time, of which we are only interested in the positive solutions. Note that we should strictly take into account negative solutions also (replacing the positive sign with a negative sign before the first square root). We omit these because solutions with a negative time are entirely equivalent to aiming in exactly the opposite direction to get a solution in positive time.

There are no solutions if:

$$(\vec{q}.\vec{\Delta} + s_m^2)^2 < |\vec{q}|^2 |\vec{\Delta}|^2$$

In this case the target point cannot be hit with the given muzzle velocity from the start point. If there is one solution, then we know the end point is at the absolute limit of the given firing capabilities. Usually, however, there will be two solutions, with different arcs to the target. This is illustrated in Figure 3.46. We will almost always choose the lower arc, which has the smaller time value, since it gives the target less time to react to the incoming projectile and produces a shorter arc that is less likely to hit obstacles (especially the ceiling).

We might want to choose the longer arc if we are firing over a wall, such as in a castlestrategy game.

With the appropriate t_i value selected, we can determine the firing vector using the equation:

$$\vec{u} = \frac{2\vec{\Delta} - \vec{g}t_i^2}{2s_m t_i}$$

The intermediate derivations of these equations are left as an exercise. This is admittedly a mess to look at, but can be easily implemented as follows:

```
function calculateFiringSolution(start: Vector,
                                      end: Vector,
                                      muzzleV: float,
                                      gravity: Vector) -> Vector:
       # Calculate the vector from the target back to the start.
       delta: Vector = start - end
       # Calculate the real-valued a,b,c coefficients of a
       # conventional quadratic equation.
       a = gravity.squareMagnitude()
10
       b = -4 * (dotProduct(gravity, delta) + muzzleV * muzzleV)
11
       c = 4 * delta.squareMagnitude()
12
13
       # Check for no real solutions.
14
       b2minus4ac = b * b - 4 * a * c
15
       if b2minus4ac < 0:
           return null
       # Find the candidate times.
       time0 = sqrt((-b + sqrt(b2minus4ac)) / (2 * a))
       time1 = sgrt((-b - sgrt(b2minus4ac)) / (2 * a))
21
22
       # Find the time to target.
23
       if time0 < 0:
24
           if time1 < 0:
25
               # We have no valid times.
26
               return null
27
           else:
28
               ttt = time1
       else:
           if time1 < 0:
               ttt = time0
32
           else:
33
               ttt = min(time0, time1)
34
35
       # Return the firing vector.
36
       return (delta * 2 - gravity * (ttt * ttt)) / (2 * muzzleV * ttt)
```

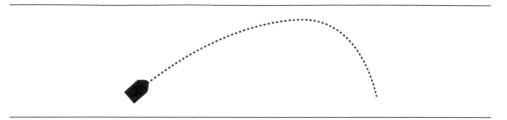

Figure 3.47: Projectile moving with drag

This code assumes that we can take the scalar product of two vectors using the a * b notation. The algorithm is O(1) in both memory and time.

3.5.4 PROJECTILES WITH DRAG

The situation becomes more complex if we introduce air resistance. Because it adds complexity, it is very common to see developers ignoring drag altogether for calculating firing solutions. Often, a drag-free implementation of ballistics is a perfectly acceptable approximation. Once again, the gradual move toward including drag in trajectory calculations is motivated by the use of physics engines. If the physics engine includes drag (and most of them do to avoid numerical instability problems), then a drag-free ballistic assumption can lead to inaccurate firing over long distances. It is worth trying an implementation without drag, however, even if you are using a physics engine. Often, the results will be perfectly usable and much simpler to implement.

The trajectory of a projectile moving under the influence of drag is no longer a parabolic arc. As the projectile moves, it slows down, and its overall path looks like Figure 3.47.

Adding drag to the firing calculations considerably complicates the mathematics, and for this reason most games either ignore drag in their firing calculations or use a kind of trial and error process that we'll look at in more detail later.

Although drag in the real world is a complex process caused by many interacting factors, drag in computer simulation is often dramatically simplified. Most physics engines relate the drag force to the speed of a body's motion with components related to either velocity or velocity squared or both. The drag force on a body, D, is given (in one dimension) by:

$$D = -kv - cv^2$$

where v is the velocity of the projectile, and k and c are both constants. The k coefficient is sometimes called the viscous drag and c the aerodynamic drag (or ballistic coefficient). These terms are somewhat confusing, however, because they do not correspond directly to real-world viscous or aerodynamic drag.

Adding these terms changes the equation of motion from a simple expression into a second-order differential equation:

$$\ddot{\vec{p_t}} = q - k\dot{\vec{p_t}} - c\dot{\vec{p_t}}|\dot{\vec{p_t}}|$$

Unfortunately, the second term in the equation, $c\vec{p_t}|\vec{p_t}|$, is where the complications set in. It relates the drag in one direction to the drag in another direction. Up to this point, we've assumed that for each of the three dimensions the projectile motion is independent of what is happening in the other directions. Here the drag is relative to the total speed of the projectile: even if it is moving slowly in the x-direction; for example, it will experience a great deal of drag if it is moving quickly in the z-direction. This is the characteristic of a non-linear differential equation, and with this term included there can be no simple equation for the firing solution.

Our only option is to use an iterative method that performs a simulation of the projectile's flight. We will return to this approach below.

More progress can be made if we remove the second term to give:

$$\ddot{\vec{p_t}} = q - k\dot{\vec{p_t}} \tag{3.5}$$

While this makes the mathematics tractable, it isn't the most common setup for a physics engine. If you need very accurate firing solutions and you have control over the kind of physics you are running, this may be an option. Otherwise, you will need to use an iterative method.

We can solve this equation to get an equation for the motion of the particle. If you're not interested in the math, you can skip to the next section.

Omitting the derivations, we solve Equation 3.5 and find that the trajectory of the particle is given by:

$$\vec{p_t} = \frac{\vec{g}t - \vec{A}e^{-kt}}{k} + \vec{B} \tag{3.6}$$

where \vec{A} and \vec{B} are constants found from the position and velocity of the particle at time t=0:

$$\vec{A} = s_m \vec{u} - \frac{\vec{g}}{k}$$

and

$$\vec{B} = \vec{p_0} - \frac{\vec{A}}{k}$$

We can use this equation for the path of the projectile on its own, if it corresponds to the drag in our physics (or if accuracy is less important). Or we can use it as the basis of an iterative algorithm in more complex physics systems.

Rotating and Lift

Another complication in the movement calculations occurs if the projectile is rotating while it is in flight.

We have treated all projectiles as if they are not rotating during their flight. Spinning projectiles (golf balls, for example) have additional lift forces applying to them as a result of their spin and are more complex still to predict. If you are developing an accurate golf game that simulates this effect (along with wind that varies over the course of the ball's flight), then it is likely to be impossible to solve the equations of motion directly. The best way to predict where the ball will land is to run it through your simulation code (possibly with a coarse simulation resolution, for speed).

3.5.5 ITERATIVE TARGETING

When we cannot create an equation for the firing solution, or when such an equation would be very complex or prone to error, we can use an iterative targeting technique. This is similar to the way that long-range weapons and artillery (euphemistically called "effects" in military speak) are really targeted.

The Problem

We would like to be able to determine a firing solution that hits a given target, even if the equations of motion for the projectile cannot be solved or if we have no simple equations of motion at all.

The generated firing solution may be approximate (i.e., it doesn't matter if we are slightly off center as long as we hit), but we need to be able to control its accuracy to make sure we can hit small or large objects correctly.

The Algorithm

The process has two stages. We initially make a guess as to the correct firing solution. The trajectory equations are then processed to check if the firing solution is accurate enough (i.e., does it hit the target?). If it is not accurate, then a new guess is made, based on the previous guess.

The process of testing involves checking how close the trajectory gets to the target location. In some cases we can find this mathematically from the equations of motion (although it is very likely that if we can find this, then we could also solve the equation of motion and find a firing solution without an iterative method). In most cases the only way to find the closest approach point is to follow a projectile through its trajectory and record the point at which it made its closest approach.

To make this process faster, we only test at intervals along the trajectory. For a relatively

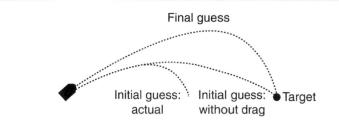

Figure 3.48: Refining the guess

slow-moving projectile with a simple trajectory, we might check every half second. For a fast-moving object with complex wind, lift, and aerodynamic forces, we may need to test every tenth of a second, or at worst the simulation frequency of the game. The position of the projectile is calculated at each time interval. These positions are linked by straight line segments, and we find the nearest point to our target on this line segment. We are approximating the trajectory by a piecewise linear curve.

We can add additional tests to avoid checking too far in the future. This is not normally a full collision detection process, because of the time that would take, but we do a simple test such as stopping when the projectile's height is a good deal lower than its target.

The initial guess for the firing solution can be generated from the firing solution function described earlier; that is, we assume there is no drag or other complex movement in our first guess.

After the initial guess, the refinement depends to some extent on the forces that exist in the game. If no wind is being simulated, then the direction of the first-guess solution in the x-z plane will be correct (called the "bearing"). We only need to tweak the angle between the x-z plane and the firing direction (called the "elevation"). This is shown in Figure 3.48.

If we have a drag coefficient, then the elevation will need to be higher than that generated by the initial guess. If the projectile experiences no lift, then the maximum elevation should be 45° . Any higher than that and the total flight distance will start decreasing again. If the projectile does experience lift, then it might be better to send it off higher, allowing it to fly longer and to generate more lift, which will increase its distance.

If we have a crosswind, then just adjusting the elevation will not be enough. We will also need to adjust the bearing. It is a good idea to iterate between the two adjustments in series: getting the elevation right first for the correct distance, then adjusting the bearing to get the projectile to land in the direction of the target, then adjusting the elevation to get the right distance, and so on.

You would be quite right if you get the impression that refining the guesses is akin to complete improvisation. In fact, real targeting systems for military weapons use complex simulations for the flights of their projectiles and a range of algorithms, heuristics, and search techniques to find the best solution. In games, the best approach is to get the AI running in a

real game environment and adjust the guess refinement rules until good results are generated quickly.

Whatever the sequence of adjustment or the degree to which the refinement algorithm takes into account physical laws, a good starting point is a binary search, the stalwart of many algorithms in computer science, described in depth in any good text on algorithmics or computer science.

Pseudo-Code

Because the refinement algorithm depends to a large extent on the kind of forces we are modeling in the game, the pseudo-code presented below will assume that we are trying to find a firing solution for a projectile moving with drag alone. This allows us to simplify the search from a search for a complete firing direction to just a search for an angle of elevation.

This is the most complex technique I've seen in a commercial action game for this situation, although, as I described, in military simulation more complex situations occur.

The code uses the equation of motion for a projectile experiencing only viscous drag, as we derived earlier.

```
function refineTargeting(start: Vector,
                             end: Vector,
                             muzzleV: float,
3
                             gravity: Vector,
                             margin: float) -> Vector:
5
6
       # Calculate a firing solution based on a firing angle.
       function checkAngle(angle):
8
           deltaPosition: Vector = target - source
           direction = convertToDirection(deltaPosition, angle)
10
           distance = distanceToTarget(direction, source, target, muzzleV)
11
           return direction, distance
12
13
       # Take an initial guess using the dragless firing solution.
14
       direction: Vector = calculateFiringSolution(
15
           source, target, muzzleVelocity, gravity)
16
17
       # Check if this is good enough.
18
       distance = distanceToTarget(direction, source, target, muzzleV)
19
       if -margin < distance < margin:</pre>
20
           return direction
21
       # Otherwise we will binary search, but we must ensure our minBound
23
       # undersoots and our maxBound overshoots.
24
       angle: float = asin(direction.y / direction.length())
25
       if distance > 0:
26
           # We've found a maximum bound. Use the shortest possible shot
27
```

```
# (shooting straight down) as the minimum bound.
28
            maxBound = angle
29
            minBound = - pi / 2
30
            direction, distance = checkAngle(minBound)
31
            if -margin < distance < margin:</pre>
32
                return direction
33
34
       # Otherwise we need to check we can find a maximum bound: maximum
35
       # distance is achieved when we fire at 45 degrees = pi / 4.
36
       else:
37
           minBound = angle
38
            maxBound = pi / 4
39
            direction, distance = checkAngle(maxBound)
40
            if -margin < distance < margin:</pre>
41
                return direction
            # Check if our longest shot can't make it.
44
            if distance < 0:
45
                return null
46
47
       # Now we have a minimum and maximum bound, so binary search.
48
       distance = infinity
49
       while abs(distance) >= margin:
50
            angle = (maxBound - minBound) / 2
51
            direction, distance = checkAngle(angle)
52
53
            # Change the appropriate bound.
54
            if distance < 0:
55
                minBound = angle
56
            else:
                maxBound = angle
59
60
       return direction
```

Data Structures and Interfaces

In the code we rely on three functions. The calculateFiringSolution function is the function we defined earlier. It is used to create a good initial guess.

The distanceToTarget function runs the physics simulator and returns how close the projectile got to the target. The sign of this value is critical. It should be positive if the projectile overshot its target and negative if it undershot. Simply performing a 3D distance test will always give a positive distance value, so the simulation algorithm needs to determine whether the miss was too far or too near and set the sign accordingly.

The convertToDirection function creates a firing direction from an angle. It can be implemented in the following way:

```
function convertToDirection(deltaPosition: Vector, angle: float):
2
       # Find the planar direction.
       direction = deltaPosition
3
       direction.y = 0
       direction.normalize()
       # Add in the vertical component.
       direction *= cos(angle)
       direction.y = sin(angle)
10
       return direction
11
```

Performance

The algorithm is O(1) in memory and $O(r \log n^{-1})$ in time, where r is the resolution of the sampling we use in the physics simulator for determining the closest approach to target, and n is the accuracy threshold that determines if a hit has been found.

Iterative Targeting without Motion Equations

Although the algorithm given above treats the physical simulation as a black-box, in the discussion we assumed that we could implement it by sampling the equations of motion at some resolution.

The actual trajectory of an object in the game may be affected by more than just mass and velocity. Drag, lift, wind, gravity wells, and all manner of other exotica can change the movement of a projectile. This can make it impossible to calculate a motion equation to describe where the projectile will be at any point in time.

If this is the case, then we need a different method of following the trajectory to determine how close to its target it gets. The real projectile motion, once it has actually been released, is likely to be calculated by a physics system. We can use the same physics system to perform miniature simulations of the motion for targeting purposes.

At each iteration of the algorithm, the projectile is set up and fired, and the physics is updated (normally at relatively coarse intervals compared to the normal operation of the engine; extreme accuracy is probably not needed). The physics update is repeatedly called, and the position of the projectile after each update is recorded, forming the piecewise linear curve we saw previously. This is then used to determine the closest point of the projectile to the target.

This approach has the advantage that the physical simulation can be as complex as necessary to capture the dynamics of the projectile's motion. We can even include other factors, such as a moving target.

On the other hand, this method requires a physics engine that can easily set up isolated simulations. If your physics engine is only optimized for having one simulation at a time (i.e., the current game world), then this will be a problem. Even if the physics system allows it, the technique can be time consuming. It is only worth contemplating when simpler methods (such as assuming a simpler set of forces for the projectile) give visibly poor results.

Other Uses of Prediction

Prediction of projectile motion is the most complex common type of motion prediction in games.

In games involving collisions as an integral part of gameplay, such as ice hockey games and pool or snooker simulators, the AI may need to be able to predict the results of impacts. This is commonly done using an extension of the iterative targeting algorithm: we have a go in a simulation and see how near we get to our goal.

Throughout this chapter I've used another prediction technique that is so ubiquitous that developers often fail to realize that its purpose is to predict motion.

In the pursue steering behavior, for example, the AI aims its motion at a spot some way in front of its target, in the direction the target is moving. It assumes that the target will continue to move in the same direction at the current speed, and it chooses a target position to effectively cut it off. If you remember playing tag at school, the good players did the same thing: predict the motion of the player they wanted to catch or evade.

We can add considerably more complex prediction to a pursuit behavior, making a genuine prediction as to a target's motion (if the target is coming up on a wall, for example, we know it won't carry on in the same direction and speed; it will swerve to avoid impact). Complex motion prediction for chase behaviors is the subject of active academic research (and is beyond the scope of this book). Despite the body of research done, games still use the simple version, assuming the prey will keep doing what they are doing.

Motion prediction is also used outside character-based AI. Networking technologies for multi-player games need to cope when the details of a character's motion have been delayed or disrupted by the network. In this case, the server can use a motion prediction algorithm (which is almost always the simple "keep doing what they were doing" approach) to guess where the character might be. If it later finds out it was wrong, it can gradually move the character to its correct position (common in massively multi-player games) or snap it immediately there (more common in shooters), depending on the needs of the game design.

3.6 JUMPING

Jumping is a significant problem for character movement in shooters. The regular steering algorithms are not designed to incorporate jumps, which are a core part of the shooter genre.

Jumps are inherently risky. Unlike other steering actions, they can fail, and such a failure may make it difficult or impossible to recover (at the very limit, it may kill the character).

For example, consider a character chasing an enemy around a flat level. The steering algorithm estimates that the enemy will continue to move at its current speed and so sets the character's trajectory accordingly. The next time the algorithm runs (usually the next frame, but it may be a little later if the AI is running every few frames) the character finds that its estimate was wrong and that its target has decelerated fractionally. The steering algorithm again assumes that the target will continue at its current speed and estimates again. Even though the character is decelerating, the algorithm can assume that it is not. Each decision it makes can be fractionally wrong, and the algorithm can recover the next time it runs. The cost of the error is almost zero.

By contrast, if a character decides to make a jump between two platforms, the cost of an error may be greater. The steering controller needs to make sure that the character is moving at the correct speed and in the correct direction and that the jump action is executed at the right moment (or at least not too late). Slight perturbations in the character's movement (caused by clipping an obstacle, for example, from gun recoil, or the blast wave from an explosion) can lead to the character missing the landing spot and plummeting to its doom, a dramatic failure.

Steering behaviors effectively distribute their thinking over time. Each decision they make is very simple, but because they are constantly reconsidering the decision, the overall effect is competent. Jumping is a one-time, failure-sensitive decision.

3.6.1 JUMP POINTS

The simplest support for jumps puts the onus on the level designer. Locations in the game level are labeled as being jump points. These regions need to be manually placed. If characters can move at many different speeds, then jump points also have an associated minimum velocity set. This is the velocity at which a character needs to be traveling in order to make the jump.

Depending on the implementation, characters either may seek to get as near their target velocity as possible or may simply check that the component of their velocity in the correct direction is sufficiently large.

Figure 3.49 shows two walkways with a jump point placed at their nearest point. A character that wishes to jump between the walkways needs to have enough velocity heading toward the other platform to make the jump. The jump point has been given a minimum velocity in the direction of the other platform.

In this case it doesn't make sense for a character to try to make a run up in that exact direction. The character should be allowed to have any velocity with a sufficiently large component in the correct direction, as shown in Figure 3.50.

If the structure of the landing area is a little different, however, the same strategy would result in disaster. In Figure 3.51 the same run up has disastrous results.

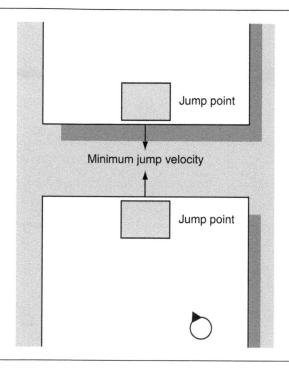

Figure 3.49: Jump points between walkways

Achieving the Jump

To achieve the jump, the character can use a velocity matching steering behavior to take a run up. For the period before its jump, the movement target is the jump point, and the velocity the character is matching is that given by the jump point. As the character crosses onto the jump point, a jump action is executed, and the character becomes airborne.

This approach requires very little processing at runtime:

- 1. The character needs to decide to make a jump. It may use some pathfinding system to determine that it needs to be on the other side of the gap, or else it may be using a simple steering behavior and be drawn toward the ledge.
- 2. The character needs to recognize which jump it will make. This will normally happen automatically when we are using a pathfinding system (see the section on jump links, below). If we are using a local steering behavior, then it can be difficult to determine that a jump is ahead in enough time to make it. A reasonable lookahead is required.
- 3. Once the character has found the jump point it is using, a new steering behavior takes over. That behavior performs velocity matching to bring the character into the jump point with the correct velocity and direction.

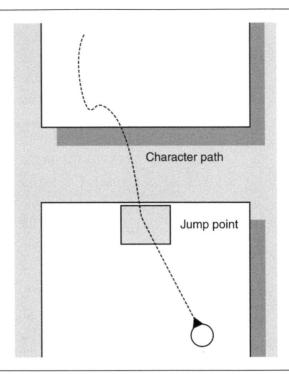

Figure 3.50: Flexibility in the jump velocity

4. When the character touches the jump point, a jump action is requested. The character doesn't need to work out when or how to jump, it simply gets thrown into the air as it hits the jump point.

Weaknesses

The examples at the start of this section hint at the problems suffered by this approach. In general, the jump point does not contain enough information about the difficulty of the jump for every possible jumping case.

Figure 3.52 illustrates a number of different jumps that are difficult to mark up using jump points. Jumping onto a thin walkway requires velocity in exactly the right direction, jumping onto a narrow ledge requires exactly the right speed, and jumping onto a pedestal involves correct speed and direction. Notice that the difficulty of the jump also depends on the direction it is taken from. Each of the jumps in Figure 3.52 would be easy in the opposite direction.

In addition, not all failed jumps are equal. A character might not mind occasionally miss-

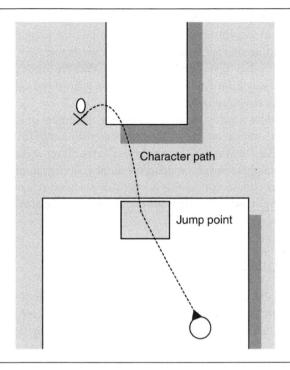

Figure 3.51: A jump to a narrower platform

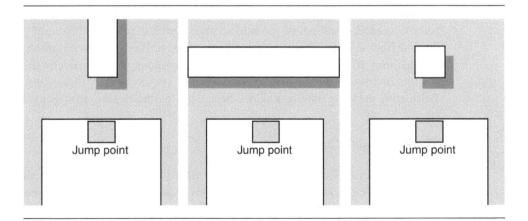

Figure 3.52: Three cases of difficult jump points

ing a jump if it only lands in two feet of water with an easy option to climb out. If the jump crosses a 50-foot drop into boiling lava, then accuracy is more important.

We can incorporate more information into the jump point—data that include the kinds of restrictions on approach velocities and how dangerous it would be to get it wrong. Because they are created by the level designer, such data are prone to error and difficult to tune. Bugs in the velocity information may not surface throughout QA if the AI characters don't happen to attempt the jump in the wrong way.

A common workaround is to limit the placement of jump points to give the AI the best chance of looking intelligent. If there are no risky jumps that the AI knows about, then it is less likely to fail. To avoid this being obvious to the player, some restrictions on the level structure are commonly imposed, reducing the number of risky jumps that the player can make, but AI characters choose not to. This is typical of many aspects of AI development: the capabilities of the AI put natural restrictions on the layout of the game's levels. Or, put another way, the level designers have to avoid exposing weaknesses in the AI.

3.6.2 LANDING PADS

A better alternative is to combine jump points with landing pads. A landing pad is another region of the level, very much like the jump point. Each jump point is paired with a landing pad. We can then simplify the data needed in the jump point. Rather than require the level designer to set up the required velocity, we can leave that up to the character.

When the character determines that it will make a jump, it adds an extra processing step. Using trajectory prediction code similar to that provided in the previous section, the character calculates the velocity required to land exactly on the landing pad when taking off from the jump point. The character can then use this calculation as the basis of its velocity matching algorithm.

This approach is significantly less prone to error. Because the character is calculating the velocity needed, it will not be prone to accuracy errors in setting up the jump point. It also benefits from allowing characters to take into account their own physics when determining how to jump. If characters are heavily laden with weapons, they may not be able to jump up so high. In this case they will need to have a higher velocity to carry themselves over the gap. Calculating the jump trajectory allows them to get the exact approach velocity they need.

The Trajectory Calculation

The trajectory calculation is slightly different to the firing solution we met previously. In the current case we know the start point S, end point E, gravity g, and the g component of velocity v_g . We don't know the time t, or the x and z components of velocity. We therefore have three equations in three unknowns:

$$E_x = S_x + v_x t$$

$$E_y = S_y + v_y t + \frac{1}{2} g_y t^2$$

$$E_z = S_z + v_z t$$

I have assumed here that gravity is acting in the vertical direction only and that the known jump velocity is also only in the vertical direction. To support other gravity directions, we would need to allow the maximum jump velocity not only to be just in the y-direction but also to have an arbitrary vector. The equations above would then have to be rewritten in terms of both the jump vector to find and the known jump velocity vector. This causes significant problems in the mathematics that are best avoided, especially since the vast majority of cases require y-direction jumps only, exactly as shown here.

I have also assumed that there is no drag during the trajectory. This is the most common situation. Drag is usually non-existent or negligible for these calculations. If you need to include drag for your game, then replace these equations with those given in Section 3.5.4; solving them will be correspondingly more difficult.

We can solve the system of equations to give:

$$t = \frac{-v_y \pm \sqrt{2g(E_y - S_y) + v_y^2}}{q}$$
 (3.7)

and then:

$$v_x = \frac{E_x - S_x}{t}$$

and:

$$v_z = \frac{E_z - S_z}{t}$$

Equation 3.7 has two solutions. We'd ideally like to achieve the jump in the fastest time possible, so we want to use the smaller of the two values. Unfortunately, this value might give us an impossible launch velocity, so we need to check and use the higher value if necessary.

We can now implement a jumping steering behavior to use a jump point and landing pad. This behavior is given a jump point when it is created and tries to achieve the jump. If the jump is not feasible, it will have no effect, and no acceleration will be requested.

Pseudo-Code

The jumping behavior can be implemented in the following way:

```
class Jump extends VelocityMatch:
       # The jump point to use.
2
       jumpPoint: JumpPoint
       # Keeps track of whether the jump is possible.
       canAchieve: bool = false
       # The movement capability of the character.
       maxSpeed: float
       maxTakeoffYSpeed: float
10
11
       # Retrieve the steering to make this jump.
12
       function getSteering() -> SteeringOutput:
13
           # Ensure we have a velocity we want to achieve.
14
           if not target: calculateTarget()
15
           if not canAchieve: return null
16
17
           # Check if we've hit the jump point. (NB: 'character'
18
           # is inherited from the VelocityMatch base class)
19
           if character.position.near(target.position) and
20
              character.velocity.near(target.velocity):
21
               # Perform the jump, and return no steering
22
               # (we'll be airborne, no need to steer).
23
               scheduleJumpAction()
24
               return null
25
           # Delegate the steering to get top the takeoff location.
           return VelocityMatch.getSteering()
28
29
       # Work out the trajectory calculation.
30
       function calculateTarget():
31
           target = new Kinematic()
32
           target.position = jumpPoint.takeoffLocation
33
34
35
           jumpVector = jumpPoint.landingLocation -
                         jumpPoint.takeoffLocation
           # Calculate the first jump time, and check if we can use it.
39
           sqrtTerm = sqrt(2 * gravity.y * jumpVector.y +
                            maxTakeoffYSpeed * maxTakeoffYSpeed)
           time: float = (maxTakeoffYSpeed - sgrtTerm) / gravity.y
           checkCanAchieveJumpTime(jumpVector, time)
           if not canAchieve:
               # Otherwise try the other square root.
44
45
               time = (maxTakeoffYSpeed + sgrtTerm) / gravity.y
               checkCanAchieveJumpTime(jumpVector, time)
46
```

```
47
       # Check whether a jump taking the given time is achievable.
48
49
       function checkJumpTime(jumpVector: Vector, time: float):
            # Calculate the planar speed.
50
            vx = jumpVector.x / time
52
            vz = jumpVector.z / time
            speedSq = vx * vx + vz * vz
53
54
            # Check it.
55
            if speedSq < maxSpeed * maxSpeed:</pre>
56
                # We have a valid solution, so store it.
57
                target.velocity.x = vx
58
                target.velocity.z = vz
59
                canAchieve = true
60
```

Data Structures and Interfaces

This code relies on a simple jump point data structure that has the following form:

```
class JumpPoint:
      takeoffLocation: Vector
2
      landingLocation: Vector
```

In addition, I have used the near method of a vector to determine if the vectors are roughly similar. This is used to make sure that we start the jump without requiring absolute accuracy from the character. The character is unlikely to ever hit a jump point completely accurately, so this function provides some margin of error. The particular margin for error depends on the game and the velocities involved: faster moving or larger characters require larger margins for error.

Finally, I have used a scheduleJumpAction function to force the character into the air. This can schedule an action to a regular action queue (a structure we will look at in depth in Chapter 5), or it can simply add the required vertical velocity directly to the character, sending it upward. The latter approach is fine for testing but makes it difficult to schedule a jump animation at the correct time. As we'll see later in the book, sending the jump through a central action resolution system allows us to simplify animation selection.

Implementation Notes

When implementing this behavior as part of an entire steering system, it is important to make sure it can take complete control of the character. If the steering behavior is combined with others using a blending algorithm, then it will almost certainly fail eventually. A character that is avoiding an enemy at a tangent to the jump will have its trajectory skewed. It either will not arrive at the jump point (and therefore not take off) or will jump in the wrong direction and plummet.

Performance

The algorithm is O(1) in both time and memory.

Jump Links

Rather than have jump points as a new type of game entity, many developers incorporate jumping into their pathfinding framework. Pathfinding will be discussed at length in Chapter 4, so I don't want to anticipate too much here.

As part of the pathfinding system, we will have to create a network of locations in the game. The connections that link locations have information stored with them (the distance between the locations in particular). We can simply add jumping information to this connection.

A connection between two nodes on either side of a gap is labeled as requiring a jump. At runtime, the link can be treated just like a jump point and landing pad pair, and the algorithm above can be applied to carry out the jump.

3.6.3 HOLE FILLERS

Another approach used by several developers allows characters to choose their own jump points. The level designer fills holes with an invisible object, labeled as a jumpable gap.

The character steers as normal but has a special variation of the obstacle avoidance steering behavior (we'll call it a jump detector). This behavior treats collisions with the jumpable gap object differently from collisions with walls. Rather than trying to avoid the wall, it moves toward it at full speed. At the point of collision (i.e., the last possible moment that the character is on the ledge), it executes a jump action and leaps into the air.

This approach has great flexibility; characters are not limited to a particular set of locations from which they can jump. In a room that has a large chasm running through it, for example, the character can jump across at any point. If it steers toward the chasm, the jump detector will execute the jump across automatically. There is no need for separate jump points on each side of the chasm. The same jumpable gap object works for both sides.

We can easily support one-directional jumps. If one side of the chasm is lower than the other, we could set up the situation shown in Figure 3.53. In this case the character can jump from the high side to the low side, but not the other way around. In fact, we can use very small versions of this collision geometry in a similar way to jump points (label them with a target velocity and they are the 3D version of jump points).

While hole fillers are flexible and convenient, this approach suffers even more from the problem of sensitivity to landing areas. With no target velocity, or notion of where the char-

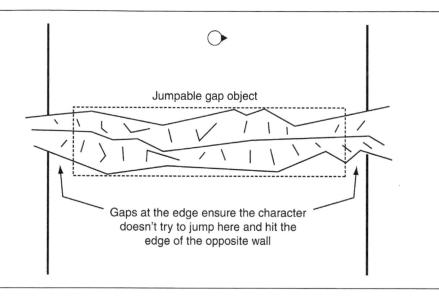

Figure 3.53: A one-direction chasm jump

acter wants to land, it will not be able to sensibly work out how to take off to avoid missing a landing spot. In the chasm example above, the technique is ideal because the landing area is so large, and there is very little possibility of failing the jump.

If you use this approach, then make sure you design levels that don't show the weaknesses in the approach. Aim only to have jumpable gaps that are surrounded by ample take off and landing space.

3.7 COORDINATED MOVEMENT

Games increasingly require groups of characters to move in a coordinated manner. Coordinated motion can occur at two levels. The individuals can make decisions that compliment each other, making their movements appear coordinated. Or they can make a decision as a whole and move in a prescribed, coordinated group.

Tactical decision making will be covered in Chapter 6. This section looks at ways to move groups of characters in a cohesive way, having already made the decision that they should move together. This is usually called formation motion.

Formation motion is the movement of a group of characters so that they retain some group organization. At its simplest it can consist of moving in a fixed geometric pattern such as a V or line abreast, but it is not limited to that. Formations can also make use of the environment. Squads of characters can move between cover points using formation steering with only minor modifications, for example. Formation motion is used in team sports games, squad-based

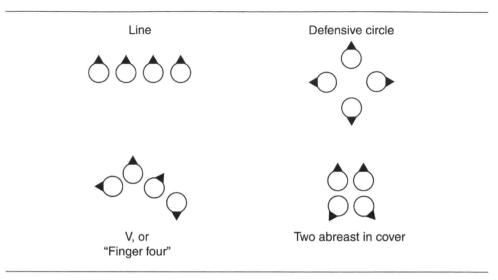

Figure 3.54: A selection of formations

games, real-time strategy games, and an increasing number of first-person shooters, driving games, and action adventures. It is a simple and flexible technique that is much quicker to write and execute and can produce much more stable behavior than collaborative tactical decision making.

3.7.1 FIXED FORMATIONS

The simplest kind of formation movement uses fixed geometric formations. A formation is defined by a set of slots: locations where a character can be positioned. Figure 3.54 shows some common formations used in military-inspired games.

One slot is marked as the leader's slot. All the other slots in the formation are defined relative to this slot. Effectively, it defines the "zero" for position and orientation in the formation.

The character at the leader's location moves through the world like any non-formation character would. It can be controlled by any steering behavior, it may follow a fixed path, or it may have a pipeline steering system blending multiple movement concerns. Whatever the mechanism, it does not take into account the fact that it is positioned in the formation.

The formation pattern is positioned and oriented in the game so that the leader is located in its slot, facing the appropriate direction. As the leader moves, the pattern also moves and turns in the game. In turn, each of the slots in the pattern move and turn in unison.

Each additional slot in the formation can then be filled by an additional character. The position of each character can be determined directly from the formation geometry, without requiring a kinematic or steering system of its own. Often, the character in the slot has its position and orientation set directly.

If a slot is located at r_s relative to the leader's slot, then the position of the character at that slot will be

$$p_s = p_l + \Omega_l r_s$$

where p_s is the final position of slot s in the game; p_l is the position of the leader character and Ω_l is the orientation of the leader character, in matrix form. In the same way the orientation of the character in the slot will be:

$$\omega_s = \omega_l + \omega_s$$

where ω_s is the orientation of the slot s, relative to the leader's orientation and ω_l is the orientation of the leader.

The movement of the leader character should take into account the fact that it is carrying the other characters with it. The algorithms it uses to move will be no different to a non-formation character, but it should have limits on the speed it can turn (to avoid outlying characters sweeping round at implausible speeds), and any collision or obstacle avoidance behaviors should take into account the size of the whole formation.

In practice, these constraints on the leader's movement make it difficult to use this kind of formation for anything but very simple formation requirements (small squads of troops in a strategy game where you control 10,000 units, for example).

3.7.2 SCALABLE FORMATIONS

In many situations the exact structure of a formation will depend on the number of characters that are participating in it. A defensive circle, for example, will be wider with 20 defenders than with 5. With 100 defenders, it may be possible to structure the formation in several concentric rings. Figure 3.55 illustrates this.

It is common to implement scalable formations without an explicit list of slot positions and orientations. A function can dynamically return the slot locations, given the total number of characters in the formation, for example.

This kind of implicit, scalable formation can be seen very clearly in Homeworld [172]. When additional ships are added to a formation, the formation accommodates them, changing its distribution of slots accordingly. Unlike our example so far, Homeworld uses a more complex algorithm for moving the formation around.

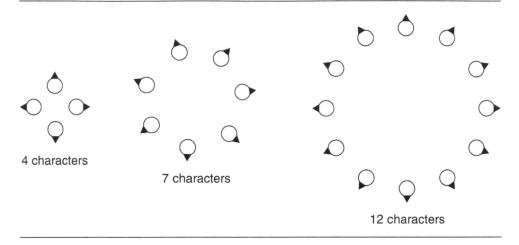

Figure 3.55: A defensive circle formation with different numbers of characters

3.7.3 EMERGENT FORMATIONS

Emergent formations provide a different solution to scalability. Each character has its own steering system using the arrive behavior. The characters select their target based on the position of other characters in the group.

Imagine that we are looking to create a large V formation. We can force each character to choose another target character in front of it and select a steering target behind and to the side, for example. If there is another character already selecting that target, then it selects another. Similarly, if there is another character already targeting a location very near, it will continue looking. Once a target is selected, it will be used for all subsequent frames, updated based on the position and orientation of the target character. If the target becomes impossible to achieve (it passes into a wall, for example), then a new target will be selected.

Overall, this emergent formation will organize itself into a V formation. If there are many members of the formation, the gap between the bars of the V will fill up with smaller V shapes. As Figure 3.56 shows, the overall arrowhead effect is pronounced regardless of the number of characters in the formation. In the figure, the lines connect a character with the character it is following.

There is no overall formation geometry in this approach, and the group does not necessarily have a leader (although it helps if one member of the group isn't trying to position itself relative to any other member). The formation emerges from the individual rules of each character, in exactly the same way as we saw flocking behaviors emerge from the steering behavior of each flock member.

This approach also has the advantage of allowing each character to react individually to obstacles and potential collisions. There is no need to factor in the size of the formation when

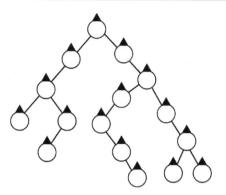

Figure 3.56: Emergent arrowhead formation

considering turning or wall avoidance, because each individual in the formation will act appropriately (as long as it has those avoidance behaviors as part of its steering system).

While this method is simple and effective, it can be difficult to set up rules to get just the right shape. In the V example above, a number of characters often end up jostling for position in the center of the V. With more unfortunate choices in each character's target selection, the same rule can give a formation consisting of a single long diagonal line with no sign of the characteristic V shape.

Debugging emergent formations, like any kind of emergent behavior, can be a challenge. The overall effect is often one of controlled disorder, rather than formation motion. For military groups, this characteristic disorder makes emergent formations of little practical use.

3.7.4 TWO-LEVEL FORMATION STEERING

We can combine strict geometric formations with the flexibility of an emergent approach using a two-level steering system. We use a geometric formation, defined as a fixed pattern of slots, just as before. Initially, we will assume we have a leader character, although we will remove this requirement later.

Rather than directly placing each character it its slot, it follows the emergent approach by using the slot at a target location for an arrive behavior. Characters can have their own collision avoidance behaviors and any other compound steering required.

This is two-level steering because there are two steering systems in sequence: first the leader steers the formation pattern, and then each character in the formation steers to stay in the pattern. As long as the leader does not move at maximum velocity, each character will have some flexibility to stay in its slot while taking account of its environment.

Figure 3.57 shows a number of agents moving in V formation through the woods. The

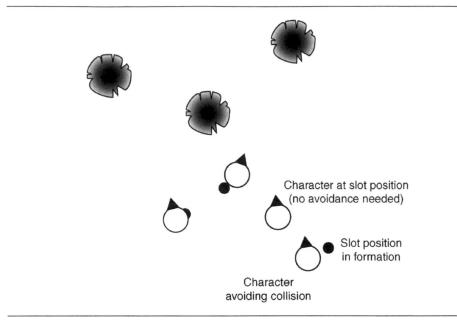

Figure 3.57: Two-level formation motion in a V

characteristic V shape is visible, but each character has moved slightly from its slot position to avoid bumping into trees.

The slot that a character is trying to reach may be briefly impossible to achieve, but its steering algorithm ensures that it still behaves sensibly.

Removing the Leader

In the example above, if the leader needs to move sideways to avoid a tree, then all the slots in the formation will also lurch sideways and every other character will lurch sideways to stay with the slot. This can look odd because the leader's actions are mimicked by the other characters, although they are largely free to cope with obstacles in their own way.

We can remove the responsibility for guiding the formation from the leader and have all the characters react in the same way to their slots. The formation is moved around by an invisible leader: a separate steering system that is controlling the whole formation, but none of the individuals. This is the second level of the two-level formation.

Because this new leader is invisible, it does not need to worry about small obstacles, bumping into other characters, or small terrain features. The invisible leader will still have a fixed location in the game, and that location will be used to lay out the formation pattern and determine the slot locations for all the proper characters. The location of the leader's slot in the

pattern will not correspond to any character, however. Because it is not acting like a slot, we call this the pattern's anchor point.

Having a separate steering system for the formation typically simplifies implementation. We no longer have different characters with different roles, and there is no need to worry about making one character take over as leader if another one dies.

The steering for the anchor point is often simplified. Outdoors, we might only need to use a single high-level arrive behavior, for example, or maybe a path follower. In indoor environments the steering will still need to take account of large-scale obstacles, such as walls. A formation that passes straight through into a wall will strand all its characters, making them unable to follow their slots.

Moderating the Formation Movement

So far information has flowed in only one direction: from the formation to the characters within it.

When we have a two-level steering system, this causes problems. The formation could be steering ahead, oblivious to the fact that its characters are having problems keeping up. When the formation was being led by a character, this was less of a problem, because difficulties faced by the other characters in the formation were likely to also be faced by the leader.

When we steer the anchor point directly, it is usually allowed to disregard small-scale obstacles and other characters. The characters in the formations may take considerably longer to move than expected because they are having to navigate these obstacles. This can lead to the formation and its characters getting a long way out of sync.

One solution is to slow the formation down. A good rule of thumb is to make the maximum speed of the formation around half that of the characters. In fairly complex environments, however, the slow down required is unpredictable, and it is better not to burden the whole game with slow formation motion for the sake of a few occasions when a faster speed would be problematic.

A better solution is to moderate the movement of the formation based on the current positions of the characters in its slots: in effect to keep the anchor point on a leash. If the characters in the slots are having trouble reaching their targets, then the formation as a whole should be held back to give them a chance to catch up.

This can be simply achieved by resetting the kinematic of the anchor point at each frame. Its position, orientation, velocity, and rotation are all set to the average of those properties for the characters in its slots. If the anchor point's steering system gets to run first, it will move forward a little, moving the slots forward and forcing the characters to move also. After the slot characters are moved, the anchor point is reined back so that it doesn't move too far ahead.

Because the position is reset at every frame, the target slot position will only be a little way ahead of the character when it comes to steer toward it. Using the arrive behavior will mean that each character is fairly nonchalant about moving such a small distance, and the speed for the slot characters will decrease. This, in turn, will mean that the speed of the formation decreases (because it is being calculated as the average of the movement speeds for the slot characters). On the following frame the formation's velocity will be even less. Over a handful of frames it will slow to a halt.

An offset is generally used to move the anchor point a small distance ahead of the center of mass. The simplest solution is to move it a fixed distance forward, as given by the velocity of the formation:

$$p_{\text{anchor}} = p_c + k_{\text{offset}} v_c \tag{3.8}$$

where p_c is the position, and v_c is the velocity of the center of mass. It is also necessary to set a very high maximum acceleration and maximum velocity for the formation's steering. The formation will not actually achieve this acceleration or velocity because it is being held back by the actual movement of its characters.

Drift

Moderating the formation motion requires that the anchor point of the formation always be at the center of mass of its slots (i.e., its average position). Otherwise, if the formation is supposed to be stationary, the anchor point will be reset to the average point, which will not be where it was in the last frame. The slots will all be updated based on the new anchor point and will again move the anchor point, causing the whole formation to drift across the level.

It is relatively easy, however, to recalculate the offsets of each slot based on a calculation of the center of mass of a formation. The center of mass of the slots is given by:

$$p_c = \frac{1}{n} \sum_{i=1..n} \begin{cases} p_{s_i} & \text{if slot } i \text{ is occupied} \\ 0 & \text{otherwise} \end{cases}$$

where p_{s_i} is the position of slot i. Changing from the old anchor point to the new involves changing each slot coordinate according to:

$$p_{s_i}' = p_{s_i} - p_c (3.9)$$

For efficiency, this should be done once and the new slot coordinates stored, rather than being repeated every frame. It may not be possible, however, to perform the calculation offline. Different combinations of slots may be occupied at different times. When a character in a slot gets killed, for example, the slot coordinates will need to be recalculated because the center of mass will have changed.

Drift also occurs when the anchor point is not at the average orientation of the occupied slots in the pattern. In this case, rather than drifting across the level, the formation will appear to spin on the spot. We can again use an offset for all the orientations based on the average orientation of the occupied slots:

$$\vec{\omega_c} = rac{ec{v_c}}{|ec{v_c}|}$$

where

$$\vec{v_c} = \frac{1}{n} \sum_{i=1..n} \begin{cases} \vec{\omega_{s_i}} & \text{if slot } i \text{ is occupied} \\ 0 & \text{otherwise} \end{cases}$$

and $\vec{\omega_{s_i}}$ is the orientation of slot i. The average orientation is given in vector form, and can be converted back into an angle ω_c , in the range $(-\pi,\pi)$. As before, changing from the old anchor point to the new one involves changing each slot orientation according to:

$$\omega_{s_i}' = \omega_{s_i} - \omega_c$$

This should also be done as infrequently as possible, being cached internally until the set of occupied slots changes.

3.7.5 IMPLEMENTATION

We can now implement the two-level formation system. The system consists of a formation manager that processes a formation pattern and generates targets for the characters occupying its slots.

```
class FormationManager:
       # The assignment characters to slots.
2
       class SlotAssignment:
3
            character: Character
            slotNumber: int
       slotAssignments: SlotAssignment[]
       # A Static (i.e., position and orientation) representing the
       # drift offset for the currently filled slots.
       driftOffset: Static
10
       # The formation pattern.
12
13
       pattern: FormationPattern
14
       # Update the assignment of characters to slots.
15
16
       function updateSlotAssignments():
           # A trivial assignment algorithm: we simply go through
17
           # each character and assign sequential slot numbers.
18
           for i in 0..slotAssignments.length():
19
                slotAssignments[i].slotNumber = i
20
21
           # Update the drift offset.
22
           driftOffset = pattern.getDriftOffset(slotAssignments)
23
24
       # Add a new character. Return false if no slots are available.
25
       function addCharacter(character: Character) -> bool:
26
```

```
# Check if the pattern supports more slots.
27
           occupiedSlots = slotAssignments.length()
28
           if pattern.supportsSlots(occupiedSlots + 1):
29
               # Add a new slot assignment.
30
               slotAssignment = new SlotAssignment()
31
               slotAssignment.character = character
32
               slotAssignments.append(slotAssignment)
33
               updateSlotAssignments()
34
               return true
35
           else:
36
               # Otherwise we've failed to add the character.
37
                return false
39
       # Remove a character from its slot.
       function removeCharacter(character: Character):
41
           slot = charactersInSlots.findIndexOfCharacter(character)
42
           slotAssignments.removeAt(slot)
43
           updateSlotAssignments()
44
45
       # Send new target locations to each character.
46
       function updateSlots():
47
           # Find the anchor point.
48
           anchor: Static = getAnchorPoint()
49
           orientationMatrix: Matrix = anchor.orientation.asMatrix()
50
51
           # Go through each character in turn.
52
           for i in 0..slotAssignments.length():
                slotNumber: int = slotAssignments[i].slotNumber
54
                slot: Static = pattern.getSlotLocation(slotNumber)
55
56
                # Transform by the anchor point position and orientation.
57
                location = new Static()
58
                location.position = anchor.position +
59
                                     orientationMatrix * slot.position
60
                location.orientation = anchor.orientation +
                                        slot.orientation
62
                # And add the drift component.
                location.position -= driftOffset.position
                location.orientation -= driftOffset.orientation
                # Send the static to the character.
                slotAssignments[i].character.setTarget(location)
70
       # The characteristic point of this formation (see below).
71
72
       function getAnchorPoint() -> Static
```

For simplicity, in the code I've assumed that we can look up a slot in the slotAssignments list by its character using a findIndexFromCharacter method. Similarly, I've used a removeAt method of the same list to remove an element at a given index.

Data Structures and Interfaces

The formation manager relies on access to the current anchor point of the formation through the getAnchorPoint function. This can be the location and orientation of a leader character, a modified center of mass of the characters in the formation, or an invisible but steered anchor point for a two-level steering system.

One implementation of getAnchorPoint could be to return the current center of mass of the characters in the formation.

The formation pattern class generates the slot offsets for a pattern, relative to its anchor point. It does this after being asked for its drift offset, given a set of assignments. In calculating the drift offset, the pattern works out which slots are needed. If the formation is scalable and returns different slot locations depending on the number of slots occupied, it can use the slot assignments passed into the getDriftOffset function to work out how many slots are used and therefore what positions each slot should occupy.

Each particular pattern (such as a V, wedge, circle) needs its own instance of a class that matches the formation pattern interface:

```
class FormationPattern:
      # The drift offset when characters are in the given set of slots.
2
      function getDriftOffset(slotAssignments) -> Static
      # Calculate and return the location of the given slot index.
      function getSlotLocation(slotNumber: int) -> Static
      # True if the pattern can support the given number of slots.
      function supportsSlots(slotCount) -> bool
```

In the manager class, I've also assumed that the characters provided to the formation manager can have their slot target set. The interface is simple:

```
class Character:
      # Set the steering target of the character.
2
      function setTarget(static: Static)
```

Implementation Caveats

In reality, the implementation of this interface will depend on the rest of the character data we need to keep track of for a particular game. Depending on how the data are arranged in your game engine, you may need to adjust the formation manager code so that it accesses your character data directly.

Performance

The target update algorithm is O(n) in time, where n is the number of occupied slots in the formation. It is O(1) in memory, excluding the resulting data structure into which the assignments are written, which is O(n) in memory, but is part of the overall class and exists before and after the class's algorithms run.

Adding or removing a character consists of two parts in the pseudo-code above: (1) the actual addition or removal of the character from the slot assignments list, and (2) the updating of the slot assignments on the resulting list of characters.

Adding a character is an O(1) process in both time and memory. Removing a character involves finding if the character is present in the slot assignments list. Using a suitable hashing representation, this can be $O(\log n)$ in time and O(1) in memory.

As given above, the assignment algorithm is O(n) in time and O(1) in memory (again excluding the assignment data structure). Typically, assignment algorithms will be more sophisticated and have worse performance than O(n), as we will see later in this chapter.

In the (somewhat unlikely) event that this kind of assignment algorithm is suitable, we can optimize it by having the assignment only reassign slots to characters that need to change (adding a new character, for example, may not require the other characters to change their slot numbers). I have deliberately not tried to optimize this algorithm, because we will see that it has serious behavioral problems that must be resolved with more complex assignment techniques.

Sample Formation Pattern

To make things more concrete, let's consider a usable formation pattern. The defensive circle posts characters around the circumference of a circle, so their backs are to the center. The circle can consist of any number of characters (although a huge number might look silly, we will not put any fixed limit).

The defensive circle formation class might look something like the following:

```
class DefensiveCirclePattern:
       # The radius of one character, this is needed to determine how
2
       # close we can pack a given number of characters around a circle.
3
       characterRadius: float
5
       # Calculate the number of slots in the pattern from the assignment
6
7
       # data. This is not part of the formation pattern interface.
8
       function calculateNumberOfSlots(assignments) -> int:
9
           # Find the number of filled slots: it will be the
10
           # highest slot number in the assignments.
```

```
filledSlots: int = 0
11
12
           for assignment in assignments:
                if assignment.slotNumber >= maxSlotNumber:
13
                    filledSlots = assignment.slotNumber
14
15
           # Add one to go from the index of the highest slot to
16
           # the number of slots needed.
17
           return filledSlots + 1
18
19
       # Calculate the drift offset (average position) of the pattern.
20
       function getDriftOffset(assignments) -> Static:
21
           # Add each assignment's contribution to the result.
22
           result = new Static()
23
           for assignment in assignments:
                location = getSlotLocation(assignment.slotNumber)
25
                result.position += location.position
26
                result.orientation += location.orientation
27
28
           # Divide through to get the drift offset.
29
           numberOfAssignments = assignments.length()
30
            result.position /= numberOfAssignments
31
            result.orientation /= numberOfAssignments
32
            return result
33
34
       # Calculate the position of a slot.
35
       function getSlotLocation(slotNumber: int) -> Static:
36
           # Place the slots around a circle based on their slot number.
37
           angleAroundCircle = slotNumber / numberOfSlots * pi * 2
38
39
           # The radius depends on the radius of the character, and the
40
           # number of characters in the circle: we want there to be no
41
           # gap between characters' shoulders.
42
            radius = characterRadius / sin(pi / numberOfSlots)
43
44
            result = new Static()
45
            result.position.x = radius * cos(angleAroundCircle)
46
            result.position.z = radius * sin(angleAroundCircle)
47
48
           # Characters face out.
49
            result.orientation = angleAroundCircle
50
           return result
52
53
       # We support any number of slots.
       function supportsSlots(slotCount) -> bool:
55
           return true
56
```

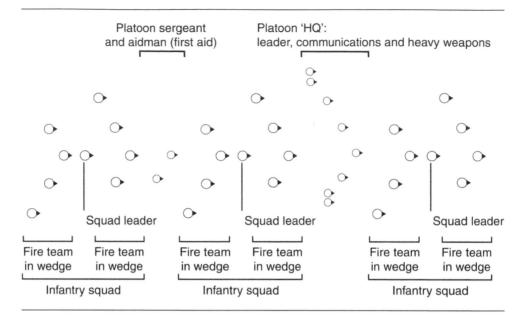

Figure 3.58: Nesting formations to greater depth

If we know we are using the assignment algorithm given in the previous pseudo-code, then we know that the number of slots will be the same as the number of assignments (since characters are assigned to sequential slots). In this case the calculateNumberOfSlots method can be simplified:

```
function calculateNumberOfSlots(assignments) -> int:
    return assignments.length()
```

In general, with more useful assignment algorithms, this may not be the case, so the long form above is usable in all cases, at the penalty of some decrease in performance.

3.7.6 EXTENDING TO MORE THAN TWO LEVELS

The two-level steering system can be extended to more levels, giving the ability to create formations of formations. This is becomingly increasingly important in military strategy games with lots of units; real armies are organized in this way.

The framework above can be simply extended to support any depth of formation. Each formation has its own steering anchor point, either corresponding to a leader character or representing the formation in an abstract way. The steering for this anchor point can be managed in turn by another formation. The anchor point is trying to stay in a slot position of a higher level formation.

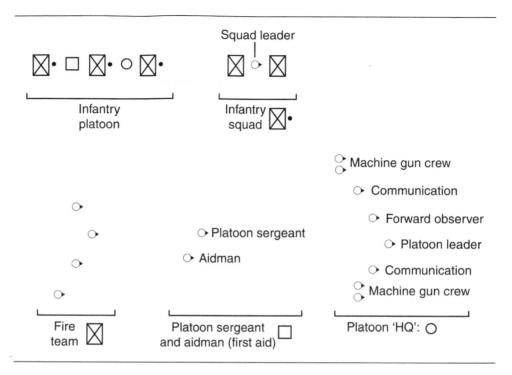

Figure 3.59: Nesting formations shown individually

Figure 3.58 shows an example adapted from the U.S. infantry soldiers training manual [71]. The infantry rifle fire team has its characteristic finger-tip formation (called the "wedge" in army-speak). These finger-tip formations are then combined into the formation of an entire infantry squad. In turn, this squad formation is used in the highest level formation: the column movement formation for a rifle platoon.

Figure 3.59 shows each formation on its own to illustrate how the overall structure of Figure 3.58 is constructed.2 Notice that in the squad formation there are three slots, one of which is occupied by an individual character. The same thing happens at an entire platoon level: additional individuals occupy slots in the formation. As long as both characters and formations expose the same interface, the formation system can cope with putting either an individual or a whole sub-formation into a single slot.

The squad and platoon formations in the example show a weakness in our current implementation. The squad formation has three slots. There is nothing to stop the squad leader's slot from being occupied by a rifle team, and there is nothing to stop a formation from having

The format of the diagram uses military mapping symbols common to all NATO countries. A full guide on military symbology can be found in Kourkolis [31], but it is not necessary to understand any details for our purposes in this book.

two leaders and only one rifle team. To avoid these situations we need to add the concept of slot roles.

3.7.7 SLOT ROLES AND BETTER ASSIGNMENT

So far I have assumed that any character can occupy each slot. While this is often the case, some formations are explicitly designed to give each character a different role. A rifle fire team in a military simulation game, for example, will have a rifleman, grenadier, machine gunner, and squad leader in very specific locations. In a real-time strategy game, it is often advisable to keep the heavy artillery in the center of a defensive formation, while using agile infantry troops in the vanguard.

Slots in a formation can have roles so that only certain characters can fill certain slots. When a formation is assigned to a group of characters (often, this is done by the player), the characters need to be assigned to their most appropriate slots. Whether using slot roles or not, this should not be a haphazard process, with lots of characters scrabbling over each other to reach the formation.

Assigning characters to slots in a formation is not difficult or error prone if we don't use slot roles. With roles it can become a complex problem. In game applications, a simplification can be used that gives good enough performance.

Hard and Soft Roles

Imagine a formation of characters in a fantasy RPG game. As they explore a dungeon, the party needs to be ready for action. Magicians and missile weapon users should be in the middle of the formation, surrounded by characters who fight hand to hand.

We can support this by creating a formation with roles. We have three roles: magicians (we'll assume that they do not need a direct line of sight to their enemy), missile weapon users (including magicians with fireballs and spells that do follow a trajectory), and melee (hand to hand) weapon users. Let's call these roles "melee," "missile," and "magic" for short.

Similarly, each character has one or more roles that it can fulfill. An elf might be able to fight with a bow or sword, while a dwarf may rely solely on its axe. Characters are only allowed to fill a slot if they can fulfill the role associated with that slot. This is known as a hard role.

Figure 3.60 shows what happens when a party is assigned to the formation. We have four kinds of character: fighters (F) fill melee slots, elves (E) fill either melee or missile slots, archers (A) fill missile slots, and mages (M) fill magic slots. The first party maps nicely onto the formation, but the second party, consisting of all melee combatants, does not.

We could solve this problem by having many different formations for different compositions of the party. In fact, this would be the optimal solution, since a party of sword-wielding thugs will move differently to one consisting predominantly of highly trained archers. Unfortunately, it requires lots of different formations to be designed. If the player can switch formation, this could multiply up to several hundred different designs.

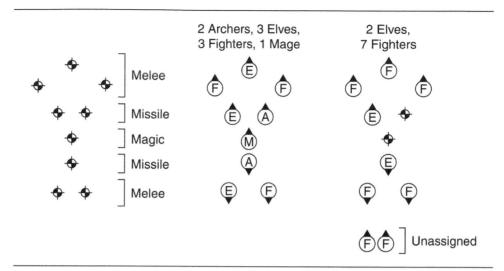

Figure 3.60: An RPG formation, and two examples of the formation filled

On the other hand, we could use the same logic that gave us scalable formations: we feed in the number of characters in each role, and we write code to generate the optimum formation for those characters. This would give us impressive results, again, but at the cost of more complex code. Most developers would ideally want to move as much content out of code as possible, ideally using separate tools to structure formation patterns and define roles.

A simpler compromise approach uses soft roles: roles that can be broken. Rather than a character having a list of roles it can fulfill, it has a set of values representing how difficult it would find it to fulfill every role. In our example, the elf would have low values for both melee and missile roles, but would have a high value for occupying the magic role. Similarly, the fighter would have high values in both missile and magic roles, but would have a very low value for the melee role.

The value is known as the slot cost. To make a slot impossible for a character to fill, its slot cost should be infinite. Normally, this is just a very large value. The algorithm below works better if the values aren't near to the upper limit of the data type (such as FLT_MAX in C) because several costs will be added. To make a slot ideal for a character, its slot cost should be zero. We can have different levels of unsuitable assignment for one character. Our mage might have a very high slot cost for occupying a melee role but a slightly lower cost for missile slots.

We would like to assign characters to slots in such a way that the total cost is minimized. If there are no ideal slots left for a character, then it can still be placed in a non-suitable slot. The total cost will be higher, but at least characters won't be left stranded with nowhere to go. In our example, the slot costs are given for each role below:

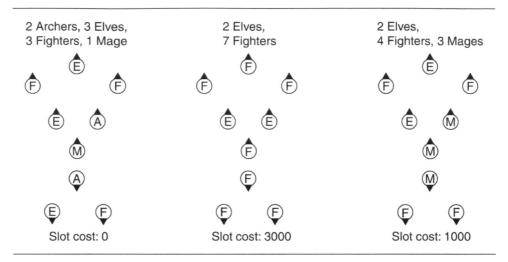

Figure 3.61: Different total slot costs for a party

	Magic	Missile	Melee
Archer	1000	0	1500
Elf	1000	0	0
Fighter	2000	1000	0
Mage	0	500	2000

Figure 3.61 shows that a range of different parties can now be assigned to our formation. These flexible slot costs are called soft roles. They act just like hard roles when the formation can be sensibly filled but don't fail when the wrong characters are available.

3.7.8 SLOT ASSIGNMENT

We have grazed along the topic of slot assignment several times in this section, but have not looked at the algorithm.

Slot assignment needs to happen relatively rarely in a game. Most of the time a group of characters will simply be following their slots around. Assignment usually occurs when a group of previously disorganized characters are assigned to a formation. We will see that it also occurs when characters spontaneously change slots in tactical motion.

For large numbers of characters and slots, the assignment can be done in many different ways. We could simply check each possible assignment and use the one with the lowest slot cost. Unfortunately, the number of assignments we need to check very quickly gets huge. The number of possible assignments of k characters to n slots is given by the permutations formula:

$$_{n}P_{k}\equiv rac{n!}{(n-k)!}$$

For a formation of 20 slots and 20 characters, this gives nearly 2500 trillion different possible assignments. Clearly, no matter how infrequently we need to do it, we can't check every possible assignment. And a highly efficient algorithm won't help us here. The assignment problem is an example of a non-polynomial time complete (NP-complete) problem; it cannot be properly solved in a reasonable amount of time by any algorithm.

Instead, we simplify the problem by using a heuristic. We won't be guaranteed to get the best assignment, but we will usually get a decent assignment very quickly. The heuristic assumes that a character will end up in a slot best suited to it. We can therefore look at each character in turn and assign it to a slot with the lowest slot cost.

We run the risk of leaving a character until last and having nowhere sensible to put it. We can improve the performance by considering highly constrained characters first and flexible characters last. The characters are given an ease of assignment value which reflects how difficult it is to find slots for them.

The ease of assignment value is given by:

$$\sum_{i=1..n} \begin{cases} \frac{1}{1+c_i} & \text{if } c_i < k \\ 0 & \text{otherwise} \end{cases}$$

where c_i is the cost of occupying slot i, n is the number of possible slots, and k is a slot-cost limit, beyond which a slot is too expensive to consider occupying.

Characters that can only occupy a few slots will have lots of high slot costs and therefore a low ease rating. Notice that we are not adding up the costs for each role, but for each actual slot. Our dwarf may only be able to occupy melee slots, but if there are twice the number of melee slots than other types, it will still be relatively flexible. Similarly, a magician that can fulfill both magic and missile roles will be inflexible if there is only one of each to choose from in a formation of ten slots.

The list of characters is sorted according to their ease of assignment values, and the most awkward characters are assigned first. This approach works in the vast majority of cases and is the standard approach for formation assignment.

Generalized Slot Costs

Slot costs do not necessarily have to depend only on the character and the slot roles. They can be generalized to include any difficulty a character might have in taking up a slot.

If a formation is spread out, for example, a character may choose a slot that is close instead of a more distant slot. Similarly, a light infantry unit may be willing to move farther to get into position than a heavy tank. This is not a major issue when the formations will be used for motion, but it can be significant in defensive formations. This is the reason we used a slot cost, rather than a slot score (i.e., high is bad and low is good, rather than the other way around). Distance can be directly used as a slot cost.

There may be other trade-offs in taking up a formation position. There may be a number of defensive slots positioned at cover points around the room. Characters should take up positions in order of the cover they provide. Partial cover should only be occupied if no better slot is available.

Whatever the source of variation in slot costs, the assignment algorithm will still operate normally. In a real implementation, I would generalize the slot cost mechanism to be a method call; the assignment code then asks a character how costly it will be to occupy a particular slot.

Implementation

We can now implement the assignment algorithm using generalized slot costs. The calculateAssignment method is part of the formation manager class, as before.

```
class FormationManager
2
       # ... other content as before ...
3
       function updateSlotAssignments():
5
           # A slot and its corresponding cost.
6
           class CostAndSlot:
                cost: float
                slot: int
10
            # A character's ease of assignment and its list of slots.
11
            class CharacterAndSlots:
12
                character: Character
13
                assignmentEase: float
14
                costAndSlots: CostAndSlot[]
15
16
            characterData: CharacterAndSlots[]
17
18
            # Compile the character data.
            for assignment in slotAssignments:
                datum = new CharacterAndSlots()
21
                datum.character = assignment.character
22
23
                # Add each valid slot to it.
24
                for slot in 0..pattern.numberOfSlots:
25
                    cost: float = pattern.getSlotCost(assignment.character)
26
                    if cost >= LIMIT: continue
28
                    slotDatum = new CostAndSlot()
29
                    slotDatum.slot = slot
30
                    slotDatum.cost = cost
31
                    datum.costAndSlots += slotDatum
32
33
```

```
# Add this slot to the character's ease of assignment.
34
                    datum.assignmentEase += 1 / (1 + cost)
35
36
                datum.costAndSlots.sortByCost()
37
                characterData += datum
38
            # Arrange characters in order of ease of assignment,
40
            # with the least easy first.
41
            characterData.sortByAssignmentEase()
42
43
            # Keep track of which slots we have filled. Initially all
44
            # values in this array should be false.
45
            filledSlots = new bool[pattern.numberOfSlots]
46
47
            # Make assignments.
48
            slotAssignments = []
49
            for characterDatum in characterData:
50
                # Choose the first slot in the list that is still open.
51
                for slot in characterDatum.costAndSlots:
                    if not filledSlots[slot]:
                        assignment = new SlotAssignment()
                        assignment.character = characterDatum.character
55
                        assignment.slotNumber = slot
56
                        slotAssignments.append(assignment)
57
58
                        # Reserve the slot.
59
                        filledSlots[slot] = true
60
61
                        # Go to the next character.
62
                        break continue
63
64
                # If we reach here, it is because a character has no
65
                # valid assignment. Some sensible action should be
                # taken, such as reporting to the player.
                throw new Error()
```

The break continue statement indicates that the innermost loop should be left and the surrounding loop should be restarted with the next element. In some languages this is not an easy control flow to achieve. In C/C++ it can be done by labeling the outermost loop and using a named continue statement (which will continue the named loop, automatically breaking out of any enclosing loops), but unfortunately this construct was not included in C#. See the reference information for your language, or search Stack Overflow, to see how to achieve the same effect.

Data Structures and Interfaces

In this code we have hidden a lot of complexity in data structures. There are two lists, characterData and costAndSlots, within the CharacterAndSlots structure that are both sorted.

In the first case, the character data are sorted by the ease of assignment rating, using the sortByAssignmentEase method. This can be implemented as any sort, or alternatively the method can be rewritten to sort as it goes, which may be faster if the character data list is implemented as a linked list, where data can be very quickly inserted. If the list is implemented as an array (which is normally faster), then it is better to leave the sort till last and use a fast in-place sorting algorithm such as quicksort.

In the second case, the character data is sorted by slot cost using the sortByCost method. Again, this can be implemented to sort as the list is compiled if the underlying data structure supports fast element inserts.

Performance

The performance of the algorithm is O(kn) in memory, where k is the number of characters and n is the number of slots. It is $O(ka \log a)$ in time, where a is the average number of slots that can be occupied by any given character. This is normally a lower value than the total number of slots but grows as the number of slots grows. If this is not the case, if the number of valid slots for a character is not proportional to the number of slots, then the performance of the algorithm is also O(kn) in time.

In either case, this is significantly faster than an $O(nP_k)$ process.

Often, the problem with this algorithm is one of memory rather than speed. There are ways to get the same algorithmic effect with less storage, if necessary, but at a corresponding increase in execution time.

Regardless of the implementation, this algorithm is often not fast enough to be used regularly for large groups (such as the armies in a RTS game). Because assignment happens rarely (when the user selects a new pattern, for example, or adds a unit to a formation), it can be split over several frames. The player is unlikely to notice a delay of a few frames before the characters begin to assemble into a formation.

3.7.9 DYNAMIC SLOTS AND PLAYS

So far we have assumed that the slots in a formation pattern are fixed relative to the anchor point. A formation is a fixed 2D pattern that can move around the game level. The framework we've developed so far can be extended to support dynamic formations that change shape over time.

Slots in a pattern can be dynamic, moving relative to the anchor point of the formation.

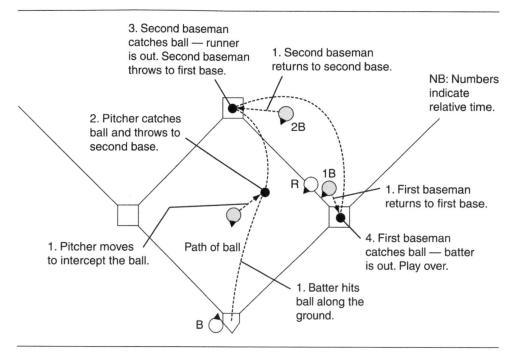

Figure 3.62: A 1-4-3 baseball double play

This is useful for introducing a degree of movement when the formation itself isn't moving, for implementing set plays in some sports games, and for using as the basis of tactical movement.

In an example from baseball, Figure 3.62 shows how fielders move to carry out one of several routine double plays.

This can be implemented as a formation. Each fielder has a fixed slot depending on the position they play. Initially, they are in a fixed pattern formation and are in their normal fielding positions (actually, there may be many of these fixed formations depending on the strategy of the defense). When the AI detects that the double play is on (in this case, there is a runner on first base and the ball can be intercepted by the pitcher but not before it hits the ground), it sets the formation pattern to a dynamic double play pattern. The slots move along the paths shown, bringing the fielders in place to throw out both batters.

In some cases, the slots don't need to move along a path; they can simply jump to their new locations and have the characters use their arrive behaviors to move there. In more complex plays, however, the route taken is not direct, and characters weave their way to their destination.

To support dynamic formations, an element of time needs to be introduced. We can simply extend our pattern interface to take a time value. This will be the time elapsed since the formation began. The pattern interface now looks like the following:

```
class FormationPattern:
2
      # ... other elements as before ...
3
      # Get the location of the given slot index at a given time.
5
      function getSlotLocation(slotNumber: int, time: float) -> Static
```

Unfortunately, this can cause problems with drift, since the formation will have its slots changing position over time. We could extend the system to recalculate the drift offset in each frame to make sure it is accurate. Many games that use dynamic slots and set plays do not use two-level steering, however. For example, the movement of slots in a baseball game is fixed with respect to the field, and in a football game, the plays are often fixed with respect to the line of scrimmage, possibly only scaled depending on how far from the goal-line that is. In this case, there is no need for two-level steering (the anchor point of the formation is fixed), and drift is not an issue, since it can be removed from the implementation.

Many sports titles use techniques similar to formation motion to manage the coordinated movement of players on the field. Some care does need to be taken to ensure that the players don't merrily follow their formation oblivious to what's actually happening on the field.

There is nothing to say that the moving slot positions have to be completely pre-defined. The slot movement can be determined dynamically by a coordinating AI routine. At the extreme, this gives complete flexibility to move players anywhere in response to the tactical situation in the game. But that simply shifts the responsibility for sensible movement onto a different bit of code and begs the question of how should that be implemented.

In practical use some intermediate solution is sensible. Figure 3.63 shows a set soccer play for a corner kick, where only three of the players have fixed play motions.

The movement of the remaining offensive players will be calculated in response to the movement of the defending team, while the key set-play players will be relatively fixed, so the player taking the corner knows where to place the ball. The player taking the corner may wait until just before they kick to determine which of the three potential scorers they will cross to. This again will be in response to the actions of the defense.

The decision can be made by any of the techniques in the decision making chapter (Chapter 5). We could, for example, look at the opposing players in each of A, B, and C's shot cone and pass to the character with the largest free angle to aim for.

3.7.10 TACTICAL MOVEMENT

An important application of formations is tactical squad-based movement.

When they are not confident of the security of the surrounding area, a military squad will move in turn, while other members of the squad provide a lookout and rapid return-offire if an enemy should be spotted. Known as bounding overwatch, this movement involves stationary squad members who remain in cover, while their colleagues run for the next cover point. Figure 3.64 illustrates this.

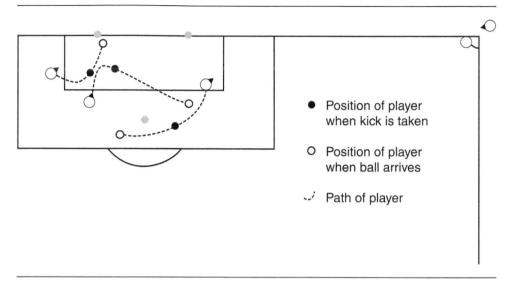

Figure 3.63: A corner kick in soccer

Dynamic formation patterns are not limited to creating set plays for sports games, they can also be used to create a very simple but effective approximation of bounding overwatch. Rather than moving between set locations on a sports field, the formation slots will move in a predictable sequence between whatever cover is near to the characters.

First we need access to the set of cover points in the game. A cover point is some location in the game where a character will be safe if it takes cover. These locations can be created manually by the level designers, or they can be calculated from the layout of the level. Chapter 6 will look at how cover points are created and used in much more detail. For our purposes here, we'll assume that there is some set of cover points available.

We need a rapid method of getting a list of cover points in the region surrounding the anchor point of the formation. The overwatch formation pattern accesses this list and chooses the closest set of cover points to the formation's anchor point. If there are four slots, it finds four cover points, and so on.

When asked to return the location of each slot, the formation pattern uses one of this set of cover points for each slot. This is shown in Figure 3.65. For each of the illustrated formation anchor points, the slot positions correspond to the nearest cover points.

Thus the pattern of the formation is linked to the environment, rather than geometrically fixed beforehand. As the formation moves, cover points that used to correspond to a slot will suddenly not be part of the set of nearest points. As one cover point leaves the list, another (by definition) will enter. The trick is to give the new arriving cover point to the slot whose cover point has just been removed and not assign all the cover points to slots afresh.

Because each character is assigned to a particular slot, using some kind of slot ID, the

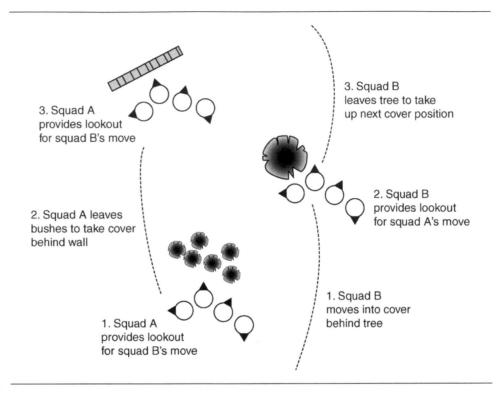

Figure 3.64: Bounding overwatch

newly valid slot should have the same ID as the recently disappeared slot. The cover points that are still valid should all still have the same IDs. This typically requires checking the new set of cover points against the old ones and reusing ID values.

Figure 3.66 shows the character at the back of the group assigned to a cover point called slot 4. A moment later, the cover point is no longer one of the four closest to the formation's anchor point. The new cover point, at the front of the group, reuses the slot 4 ID, so the character at the back (who is assigned to slot 4) now finds its target has moved and steers toward it.

Tactical Motion and Anchor Point Moderation

We can now run the formation system on our tactical formation. We need to turn off moderation of the anchor point's movement; otherwise, the characters are likely to get stuck at one set of cover points. Their center of mass will not change, since the formation is stationary at their cover points. Therefore, the anchor point will not move forward, and the formation will not get a chance to find new cover points.

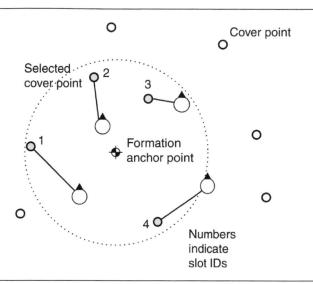

Figure 3.65: Formation patterns match cover points

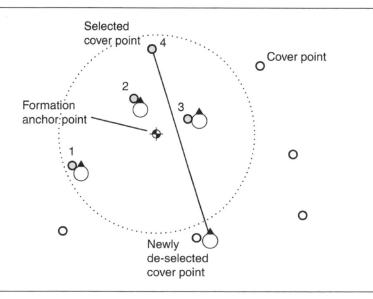

Figure 3.66: An example of slot change in bounding overwatch

Because moderation is now switched off, it is essential to make the anchor point move slowly in comparison with the individual characters. This is what you'd expect to see in any case, as bounding overwatch is not a fast maneuver.

An alternative is to go back to the idea of having a leader character that acts as the anchor point. This leader character can be under the player's control, or it can be controlled with some regular steering behavior. As the leader character moves, the rest of the squad moves in bounding overwatch around it. If the leader character moves at full speed, then its squad doesn't have time to take their defensive positions, and it appears as if they are simply following behind the leader. If the leader slows down, then they take cover around it.

To support this, make sure that any cover point near the leader is excluded from the list of cover points that can be turned into slots. Otherwise, other characters may try to join the leader in its cover.

3.8 MOTOR CONTROL

So far the chapter has looked at moving characters by being able to directly affect their physical state. This is an acceptable approximation in many cases. But, increasingly, motion is being controlled by physics simulation. This is almost universal in driving games, where it is the cars that are doing the steering. It was typically not used for human characters, but with the advent of integrated game engines such as Unity and Unreal Engine, it is often easier to use the physics system for all large-scale movement, including humans.

The outputs from steering behaviors can be seen as movement requests. An arrive behavior, for example, might request an acceleration in one direction. We can add a motor control layer to our movement solution that takes this request and works out how to best execute it; this is the process of actuation. In simple cases this is sufficient, but there are occasions where the capabilities of the actuator need to have an effect on the output of steering behaviors.

Think about a car in a driving game. It has physical constraints on its movement: it cannot turn while stationary; the faster it moves, the slower it can turn (without going into a skid); it can brake much more quickly than it can accelerate; and it only moves in the direction it is facing (we'll ignore power slides for now). On the other hand, a tank has different characteristics; it can turn while stationary, but it also needs to slow for sharp corners. And human characters will have different characteristics again. They will have sharp acceleration in all directions and different top speeds for moving forward, sideways, or backward.

When we simulate vehicles in a game, we need to take into account their physical capabilities. A steering behavior may request a combination of accelerations that is impossible for the vehicle to carry out. We need some way to end up with a maneuver that the character can perform.

A very common situation that arises in first- and third-person games is the need to match animations. Typically, characters have a palette of animations. A walk animation, for example, might be scaled so that it can support a character moving between 0.8 and 1.2 meters per second. A jog animation might support a range of 2.0 to 4.0 meters per second. The character

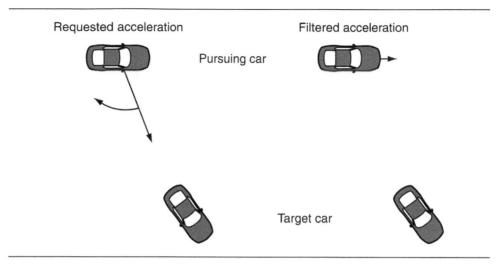

Figure 3.67: Requested and filtered accelerations

needs to move in one of these two ranges of speed; no other speed will do. The actuator, therefore, needs to make sure that the steering request can be honored using the ranges of movement that can be animated.

There are two ways of approaching actuation: output filtering and capability-sensitive steering.

3.8.1 **OUTPUT FILTERING**

The simplest approach to actuation is to filter the output of steering based on the capabilities of the character. In Figure 3.67, we see a stationary car that wants to begin chasing another. The indicated linear and angular accelerations show the result of a pursue steering behavior. Clearly, the car cannot perform these accelerations: it cannot accelerate sideways, and it cannot begin to turn without moving forward.

A filtering algorithm simply removes all the components of the steering output that cannot be achieved. In the example case the result has no angular acceleration and a smaller linear acceleration in its forward direction.

If the filtering algorithm is run every frame (even if the steering behavior isn't), then the car will take the indicated path. At each frame the car accelerates forward, allowing it to accelerate angularly. The rotation and linear motion serve to move the car into the correct orientation so that it can go directly after its quarry.

This approach is very fast, easy to implement, and surprisingly effective. It even naturally provides some interesting behaviors. If we rotate the car in the example below so that the target is almost behind it, then the path of the car will be a J-turn, as shown in Figure 3.68.

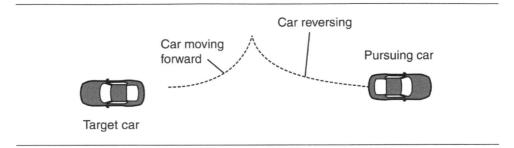

Figure 3.68: A J-turn emerges

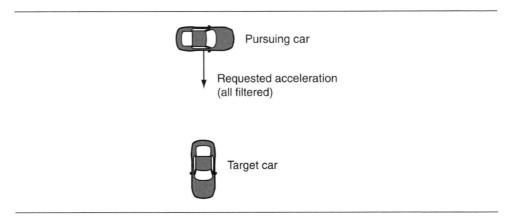

Figure 3.69: Everything is filtered: nothing to do

There are problems with this approach, however. When we remove the unavailable components of motion, we will be left with a much smaller acceleration than originally requested. In the first example above, the initial acceleration is small in comparison with the requested acceleration. In this case it doesn't look too bad. We can justify it by saying that the car is simply moving off slowly to perform its initial turn. In many cases it will be obvious and problematic.

The most obvious solution is to scale the final request so that it is the same magnitude as the initial request. This makes sure that a character doesn't move more slowly because its request is being filtered.

This works in some cases, but in Figure 3.69 the problem of filtering has become pathological. There is now no component of the request that can be performed by the car. Filtering alone will leave the car immobile until the target moves or until numerical errors in the calculation resolve the deadlock.

To resolve this last case, we can detect if the final result is zero and engage a different ac-

tuation method. This might be a complete solution such as the capability-sensitive technique below, or it could be a simple heuristic such as drive forward and turn hard.

In my experience a majority of cases can simply be solved with filtering-based actuation. Where it tends not to work is where there is a small margin of error in the steering requests. For driving at high speed, maneuvering through tight spaces, matching the motion in an animation, or jumping, the steering request needs to be honored as closely as possible. Filtering can cause problems, but, to be fair, so can the other approaches in this section (although to a lesser extent).

3.8.2 CAPABILITY-SENSITIVE STEERING

A different approach to actuation is to move the actuation into the steering behaviors themselves. Rather than generating movement requests based solely on where the character wants to go, the AI also takes into account the physical capabilities of the character.

If the character is pursuing an enemy, it will consider each of the maneuvers that it can apply and choose the one that best achieves the goal of catching the target. If the set of maneuvers that can be performed is relatively small (we can move forward or turn left or right, for example), then we can simply look at each in turn and determine the situation after the maneuver is complete. The winning action is the one that leads to the best situation (the situation with the character nearest its target, for example).

In most cases, however, there is an almost unlimited range of possible actions that a character can take. It may be able to move with a range of different speeds, for example, or to turn through a range of different angles. A set of heuristics is needed to work out what action to take depending on the current state of the character and its target. Section 3.8.3 gives examples of heuristic sets for a range of common movement AIs.

The key advantage of this approach is that we can use information discovered in the steering behavior to determine what movement to take. Figure 3.70 shows a skidding car that needs to avoid an obstacle. If we were using a regular obstacle avoiding steering behavior, then path A would be chosen. Using output filtering, this would be converted into putting the car into reverse and steering to the left.

We could create a new obstacle avoidance algorithm that considers both possible routes around the obstacle, in the light of a set of heuristics (such as those in Section 3.8.3).

Because a car will prefer to move forward to reach its target, it would correctly use route B, which involves accelerating to avoid the impact. This is the choice a rational human being would make.

There isn't a particular algorithm for capability-sensitive steering. It involves implementing heuristics that model the decisions a human being would make in the same situation: when it is sensible to use each of the vehicle's possible actions to get the desired effect.

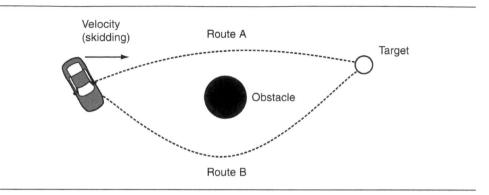

Figure 3.70: Heuristics make the right choice

Coping with Combined Steering Behaviors

Although it seems an obvious solution to bring the actuation into the steering behaviors, it causes problems when combining behaviors together. In a real game situation, where there will be several steering concerns active at one time, we need to do actuation in a more global way.

One of the powerful features of steering algorithms, as we've seen earlier in the chapter, is the ability to combine concerns to produce complex behaviors. If each behavior is trying to take into account the physical capabilities of the character, they are unlikely to give a sensible result when combined.

If you are planning to blend steering behaviors, or combine them using a decision tree, blackboard system, or steering pipeline, it is advisable to delay actuation to the last step, rather than actuating as you go.

This final actuation step will normally involve a set of heuristics. At this stage we don't have access to the inner workings of any particular steering behavior; we can't look at alternative obstacle avoidance solutions, for example. The heuristics in the actuator, therefore, need to be able to generate a roughly sensible movement guess for any kind of input; they will be limited to acting on one input request with no additional information.

COMMON ACTUATION PROPERTIES

This section looks at common actuation restrictions for a range of movement AI in games, along with a set of possible heuristics for performing context-sensitive actuation.

Human Characters

Human characters can move in any direction relative to their facing, although they are considerably faster in their forward direction than any other. As a result, they will rarely try to achieve their target by moving sideways or backward, unless the target is very close.

They can turn very fast at low speed, but their turning abilities decrease at higher speeds. This is usually represented by a "turn on the spot" animation that is only available to stationary or very slow-moving characters. At a walk or a run, the character may either slow and turn on the spot or turn in its motion (represented by the regular walk or run animation, but along a curve rather than a straight line).

Actuation for human characters depends, to a large extent, on the animations that are available. At the end of Chapter 4, we will look at a technique that can always find the best combination of animations to reach its goal. Most developers simply use a set of heuristics, however.

- If the character is stationary or moving very slowly, and if it is a very small distance from its target, it will step there directly, even if this involves moving backward or sidestepping.
- · If the target is farther away, the character will first turn on the spot to face its target and then move forward to reach it.
- · If the character is moving with some speed, and if the target is within a speed-dependent arc in front of it, then it will continue to move forward but add a rotational component (usually while still using the straight line animation, which puts a natural limit on how much rotation can be added to its movement without the animation looking odd).
- If the target is outside its arc, then it will stop moving and change direction on the spot before setting off once more.

The radius for sidestepping, how fast is "moving very slowly," and the size of the arc are all parameters that need to be determined and, to a large extent, that depend on the scale of the animations that the character will use.

Cars and Motorbikes

Typical motor vehicles are highly constrained. They cannot turn while stationary, and they cannot control or initiate sideways movement (skidding). At speed, they typically have limits to their turning capability, which is determined by the grip of their tires on the ground.

In a straight line, a motor vehicle will be able to brake more quickly than accelerate and will be able to move forward at a higher speed (though not necessarily with greater acceleration) than backward. Motorbikes almost always have the constraint of not being able to travel backward at all.

There are two decision arcs used for motor vehicles, as shown in Figure 3.71. The forward arc contains targets for which the car will simply turn without braking. The rear arc contains

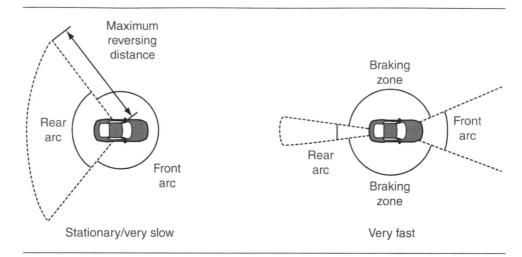

Figure 3.71: Decision arcs for motor vehicles

targets for which the car will attempt to reverse. This rear arc is zero for motorbikes and will usually have a maximum range to avoid cars reversing for miles to reach a target behind them.

At high speeds, the arcs shrink, although the rate at which they do so depends on the grip characteristics of the tires and must be found by tweaking. If the car is at low speed (but not at rest), then the two arcs should touch, as shown in the figure. The two arcs must still be touching when the car is moving slowly. Otherwise, the car will attempt to brake to stationary in order to turn toward a target in the gap. Because it cannot turn while stationary, this will mean it will be unable to reach its goal. If the arcs are still touching at too high a speed, then the car may be traveling too fast when it attempts to make a sharp turn and might skid.

- If the car is stationary, then it should accelerate.
- If the car is moving and the target lies between the two arcs, then the car should brake while turning at the maximum rate that will not cause a skid. Eventually, the target will cross back into the forward arc region, and the car can turn and accelerate toward it.
- If the target is inside the forward arc, then continue moving forward and steer toward it. Cars that should move as fast as possible should accelerate in this case. Other cars should accelerate to their optimum speed, whatever that might be (the speed limit for a car on a public road, for example).
- If the target is inside the rearward arc, then accelerate backward and steer toward it.

This heuristic can be a pain to parameterize, especially when using a physics engine to drive the dynamics of the car. Finding the forward arc angle so that it is near the grip limit of the tires but doesn't exceed it (to avoid skidding all the time) can be a pain. In most cases it is best to err on the side of caution, giving a healthy margin of error.

A common tactic is to artificially boost the grip of AI-controlled cars. The forward arc

can then be set so it would be right on the limit, if the grip was the same as for the player's car. In this case it is the AI that is limiting the capabilities of the car, not the physics, but its vehicle does not behave in an unbelievable or unfair way. The only downside with this approach is that the car will never skid out, which may be a desired feature of the game.

These heuristics are designed to make sure the car does not skid. In some games lots of wheel spinning and handbrake turns are the norm, and the parameters need to be tweaked to allow this.

Tracked Vehicles (Tanks)

Tanks behave in a very similar manner to cars and bikes. They are capable of moving forward and backward (typically with much smaller acceleration than a car or bike) and turning at any speed. At high speeds, their turning capabilities are limited by grip once more. At low speed or when stationary, they can turn very rapidly.

Tanks use decision arcs in exactly the same way as cars. There are two differences in the heuristic.

- The two arcs may be allowed to touch only at zero speed. Because the tank can turn without moving forward, it can brake right down to nothing to perform a sharp turn. In practice this is rarely needed, however. The tank can turn sharply while still moving forward. It doesn't need to stop.
- The tank does not need to accelerate when stationary.

3.9 MOVEMENT IN THE THIRD DIMENSION

So far we have looked at 2D steering behavior. We allowed the steering behavior to move vertically in the third dimension, but forced its orientation to remain about the up vector. This is 2½D, suitable for most development needs.

Full 3D movement is required if your characters aren't limited by gravity. Characters scurrying along the roof or wall, airborne vehicles that can bank and twist, and turrets that rotate in any direction are all candidates for steering in full three dimensions.

Because 21/2D algorithms are so easy to implement, it is worth thinking hard before you take the plunge into full three dimensions. There is often a way to shoehorn the situation into 2½D and take advantage of the faster execution that it provides. At the end of this chapter is an algorithm, for example, that can model the banking and twisting of aerial vehicles using 2½D math. There comes a point, however, where the shoehorning takes longer to code and is more finicky than the 3D math.

This section looks at introducing the third dimension into orientation and rotation. It then considers the changes that need to be made to the primitive steering algorithms we saw earlier. Finally, we'll look at a common problem in 3D steering: controlling the rotation for air and space vehicles.

3.9.1 ROTATION IN THREE DIMENSIONS

To move to full three dimensions we need to expand our orientation and rotation to be about any angle. Both orientation and rotation in three dimensions have three degrees of freedom. We can represent rotations using a 3D vector, consisting of the rotation around the x-, y- and z-axes. But for reasons beyond the scope of this book, doing so makes it difficult or impossible to combine or adjust orientations: we can end up with situations where seemingly very different vectors represent the same orientation, or when a desired change in orientation is impossible.

The most practical data structure for 3D orientation—the representation used most often in games—is the quaternion: a value with 4 real components, the size of which (i.e., the Euclidean size of the 4 components) is always 1. The requirement that the size is always 1 reduces the degrees of freedom from 4 (for 4 values) to 3.

Mathematically, quaternions are hypercomplex numbers. Their mathematics is not the same as that of a 4-element vector, so dedicated routines are needed for multiplying quaternions and multiplying position vectors by them. A good 3D math library will have the relevant code, and the graphics engine you are working with will almost certainly use quaternions. The Unity game engine, for example, uses quaternions internally, but provides functions to convert to and from axis angles.

It is possible to also represent orientation using matrices, and this was the dominant technique up until the mid-1990s. These 9-element structures have additional constraints to reduce the degrees of freedom to 3. Because they require a good deal of checking to make sure the constraints are not broken, they are no longer widely used.

In the two dimensional case, orientation was more complex than rotation. 2D orientation wraps every 2π radians, where rotation can have any value. An analogous thing happens in 3D. Orientation is best represented as a quaternion, but rotation can be a regular vector.

The rotation vector has three components. It is related to the axis of rotation and the speed of rotation according to:

$$\vec{r} = \begin{bmatrix} a_x \omega \\ a_y \omega \\ a_z \omega \end{bmatrix} \tag{3.10}$$

where $\begin{bmatrix} a_x & a_y & a_z \end{bmatrix}^T$ is the axis of rotation, and ω is the angular velocity, in radians per second (units are critical; the math is more complex if degrees per second are used).

The orientation quaternion has four components: $\begin{bmatrix} r & i & j & k \end{bmatrix}$, (sometimes called $\begin{bmatrix} w & x & y & z \end{bmatrix}$ —although personally I think that confuses them with a position vector, which in homogenous form has an additional w coordinate).

It is also related to an axis and angle. This time the axis and angle correspond to the minimal rotation required to transform from a reference orientation to the desired orientation. Every possible orientation can be represented as some rotation from a reference orientation about a single fixed axis.

The axis and angle are converted into a quaternion using the following equation:

$$\hat{q} = \begin{bmatrix} \cos\frac{\theta}{2} \\ a_x \sin\frac{\theta}{2} \\ a_y \sin\frac{\theta}{2} \\ a_z \sin\frac{\theta}{2} \end{bmatrix}$$
(3.11)

where $\begin{bmatrix} a_x & a_y & a_z \end{bmatrix}^T$ is the axis, as before, θ is the angle, and \hat{p} indicates that p is a quaternion.

Note that different implementations use different orders for the elements in a quaternion. Often, the r component appears at the end.

We have four numbers in the quaternion, but we only need 3 degrees of freedom. The quaternion needs to be further constrained, so that it has a size of 1 (i.e., it is a unit quaternion). This occurs when:

$$r^2 + i^2 + j^2 + k^2 = 1$$

Verifying that this always follows from the axis and angle representation is left as an exercise. Even though the math of quaternions used for geometrical applications normally ensure that quaternions remain of unit length, numerical errors can make them wander. Most quaternion math libraries have extra bits of code that periodically normalize the quaternion back to unit length. We will rely on the fact that quaternions are unit length.

The mathematics of quaternions is a wide field, and I will only cover those topics that we need in the following sections. Other books in this series, particularly Eberly [12], contain in-depth mathematics for quaternion manipulation.

3.9.2 CONVERTING STEERING BEHAVIORS TO THREE DIMENSIONS

In moving to three dimensions, only the angular mathematics has changed. To convert our steering behaviors into three dimensions, we divide them into those that do not have an angular component, such as pursue or arrive, and those that do, such as align. The former translates directly to three dimensions, and the latter requires different math for calculating the angular acceleration required.

Linear Steering Behaviors in Three Dimensions

In the first two sections of the chapter we looked at 14 steering behaviors. Of these, 10 did not explicitly have an angular component: seek, flee, arrive, pursue, evade, velocity matching, path following, separation, collision avoidance, and obstacle avoidance.

Each of these behaviors works linearly. They try to match a given linear position or velocity, or they try to avoid matching a position. None of them requires any modification to move from 2½D to 3 dimensions. The equations work unaltered with 3D positions.

Angular Steering Behaviors in Three Dimensions

The remaining four steering behaviors are align, face, look where you're going, and wander. Each of these has an explicit angular component. Align, look where you're going, and face are all purely angular. Align matches another orientation, face orients toward a given position, and look where you're going orients toward the current velocity vector.

Between the three purely angular behaviors we have orientation based on three of the four elements of a kinematic (it is difficult to see what orientation based on rotation might mean). We can update each of these three behaviors in the same way.

The wander behavior is different. Its orientation changes semi-randomly, and the orientation then motivates the linear component of the steering behavior. We will deal with wander separately.

3.9.3 ALIGN

Align takes as input a target orientation and tries to apply a rotation to change the character's current orientation to match the target.

In order to do this, we'll need to find the required rotation between the target and current quaternions. The quaternion that would transform the start orientation to the target orientation is

$$\hat{q} = \hat{s}^{-1}\hat{t}$$

where \hat{s} is the current orientation and \hat{t} is the target quaternion. Because we are dealing with unit quaternions (the square of their elements sum to 1), the quaternion inverse is equal to the conjugate \hat{q}^* , and is given by:

$$\hat{q}^{-1} = \begin{bmatrix} r \\ i \\ j \\ k \end{bmatrix}^{-1} = \begin{bmatrix} r \\ -i \\ -j \\ -k \end{bmatrix}$$

In other words, the axis components are flipped. This is because the inverse of the quaternion is equivalent to rotating about the same axis, but by the opposite angle (i.e. $\theta^{-1} = -\theta$). For each of the x, y and z components, related to $\sin \theta$, we have $\sin -\theta = -\sin \theta$, where as the w component is related to $\cos \theta$, and $\cos -\theta = -\cos \theta$, leaving the w component unchanged.

We now need to convert this quaternion into a rotation vector. Firstly we split the quaternion back into an axis and angle:

$$\theta = 2\cos^{-1}q_w$$

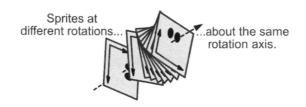

Figure 3.72: Infinite number of possible orientations per axis vector

$$\vec{a} = \frac{1}{\sin\frac{\theta}{2}} \begin{bmatrix} q_i \\ q_j \\ q_k \end{bmatrix}$$

In the same way as for the original align behavior, we would like to choose a rotation so that the character arrives at the target orientation with zero rotation speed. We know the axis through which this rotation needs to occur, and we have a total angle that needs to be achieved. We only need to find the rotation speed to choose.

Finding the correct rotation speed is equivalent to starting at zero orientation in two dimensions and having a target orientation of θ . We can apply the same algorithm used in two dimensions to generate a rotation speed, ω , and then combine this with the axis \vec{a} above to produce an output rotation, using Equation 3.10.

3.9.4 ALIGN TO VECTOR

Both the face steering behavior and look where you're going started with a vector along which the character should align. In the former case it is a vector from the current character position to a target, and in the latter case it is the velocity vector. We are assuming that the character is trying to position its z-axis (the axis it is looking down) in the given direction.

In two dimensions it is simple to calculate a target orientation from a vector using the atan2 function available in most languages. In three dimensions there is no such shortcut to generate a quaternion from a target facing vector.

In fact, there are an infinite number of orientations that look down a given vector, as illustrated in Figure 3.72. This means that there is no single way to convert a vector to an orientation. We have to make some assumptions to simplify things.

The most common assumption is to bias the target toward a "base" orientation. We'd like to choose an orientation that is as near to the base orientation as possible. In other words, we start with the base orientation and rotate it through the minimum angle possible (about an appropriate axis) so that its local z-axis points along our target vector.

This minimum rotation can be found by converting the z-direction of the base orientation

into a vector and then taking the vector product of this and the target vector. The vector product gives:

$$\vec{z_b} \times \vec{t} = \vec{r}$$

where $\vec{z_b}$ is the vector of the local z-direction in the base orientation, \vec{t} is the target vector and \vec{r} , being a cross product is defined to be:

$$\vec{r} = \vec{z_b} \times \vec{t} = (|\vec{z_b}||\vec{t}|\sin\theta)\vec{a_r} = \sin\theta\vec{a_r}$$

where θ is the angle, and $\vec{a_r}$ is the axis of minimum rotation. Because the axis will be a unit vector (i.e., $|\vec{a_r}| = 1$), we can recover angle $\theta = \sin^{-1} |\vec{r}|$ and divide \vec{r} by this to get the axis. This will not work if $\sin \theta = 0$ (i.e. $\theta = n\pi$ for all $n \in \mathbb{Z}$). This corresponds to an intuition about the physical properties of rotation: if the rotation angle is zero, then it doesn't make sense to talk about a rotation axis. If the rotation is of π radians (90°), then any axis will do: there is no particular axis that requires a smaller rotation than any other.

As long as $\sin \theta \neq 0$, we can generate a target orientation by first turning the axis and angle into a quaternion, \hat{r} (using Equation 3.11) and applying the formula:

$$\hat{t} = \hat{b}^{-1}\hat{r}$$

where \hat{b} is the quaternion representation of the base orientation, and \hat{t} is the target orientation to align to.

If $\sin \theta = 0$, then we have two possible situations: either the target z-axis is the same as the base z-axis, or it is π radians away from it. In other words: $\vec{z_b} = \pm \vec{z_t}$. In each case we use the base orientation's quaternion, with the appropriate sign change.

$$\hat{t} = egin{cases} +\hat{b} & ext{if } ec{z_b} = ec{z_t} \ -\hat{b} & ext{otherwise} \end{cases}$$

The most common base orientation is the zero orientation: $\begin{bmatrix} 1 & 0 & 0 \end{bmatrix}$. This has the effect that the character will stay upright when its target is in the x-z plane. Tweaking the base vector can provide visually pleasing effects. We could tilt the base orientation when the character's rotation is high to force them to lean into their turns, for example.

We will implement this process in the context of the face steering behavior below.

3.9.5 FACE

Using the align to vector process above, both face and look where you're going can be easily implemented using the same algorithm as we used at the start of the chapter, by replacing the atan2 calculation with the procedure above to calculate the new target orientation.

By way of an illustration, I will give an implementation for the face steering behavior in three dimensions. Since this is a modification of the algorithm given earlier in the chapter, I won't discuss the algorithm in any depth (see the previous version for more information).

```
class Face3D extends Align3D:
       # The base orientation used to calculate facing.
2
       baseOrientation: Quaternion
       # Overridden target.
5
       target: Kinematic3D
6
       # ... Other data is derived from the superclass ...
       # Calculate an orientation to face along a given vector.
10
       function calculateOrientation(vector):
11
           # Get the base vector by transforming the z-axis by base
12
           # orientation (this only needs to be done once for each
           # base orientation, so could be cached between calls).
14
15
            zVector = new Vector(0, 0, 1)
            baseZVector = zVector * baseOrientation
16
17
           # If we're done (or the opposite) use the base quaternion.
18
           if baseZVector == vector:
19
                return baseOrientation
20
           elif baseZVector == -vector:
21
                return -baseOrientation
22
23
           # Otherwise find the minimum rotation to the target.
24
           axis = crossProduct(baseZVector, vector)
25
           angle = asin(axis.length())
26
           axis.normalize()
27
           # Pack these into a quaternion and return it.
29
           sinAngle = sin(angle / 2)
30
           return new Quaternion(
31
                cos(angle / 2),
32
                sinAngle * axis.x,
33
                sinAngle * axis.y,
34
                sinAngle * axis.z)
35
36
       # Implemented as it was in Pursue.
37
       function getSteering() -> SteeringOutput3D:
38
           # 1. Calculate the target to delegate to align
39
           # Work out the direction to target.
40
           direction = target.position - character.position
41
42
           # Check for a zero direction, and make no change if so.
43
           if direction.length() == 0:
44
                return null
45
46
```

```
# 2. Delegate to align.
47
           Align3D.target = explicitTarget
48
           Align3D.target.orientation = calculateOrientation(direction)
49
           return Align3D.getSteering()
50
```

This implementation assumes that we can take the vector product of two vectors using a crossProduct function.

We also need to look at the mechanics of transforming a vector by a quaternion. In the code above this is performed with the * operator, so vector * quaternion should return a vector that is equivalent to rotating the given vector by the quaternion. Mathematically, this is given by:

$$\hat{v}' = \hat{q}\hat{v}\hat{q}^*$$

where \hat{v} is a quaternion derived from the vector, according to

$$\hat{v} = \begin{bmatrix} 0 \\ v_x \\ v_y \\ v_z \end{bmatrix}$$

and \hat{q}^* is the conjugate of the quaternion, which is the same as the inverse for unit quaternions. This can be implemented as:

```
# Transform the vector by the given quaternion.
  function transform(vector, orientation):
       # Convert the vector into a quaternion.
       vectorAsQ = new Quaternion(0, vector.x, vector.y, vector.z)
       # Transform it.
       vectorAsQ = orientation * vectorAsQ * (-orientation)
       # Unpick it into the resulting vector.
       return new Vector(vectorAsQ.i, vectorAsQ.j, vectorAsQ.k)
10
```

Quaternion multiplication, in turn, is defined by:

$$\hat{p}\hat{q} = egin{aligned} p_r q_r - p_i q_i - p_j q_j - p_k q_k \ p_r q_i + p_i q_r + p_j q_k - p_k q_j \ p_r q_j + p_j q_r - p_i q_k + p_k q_i \ p_r q_k + p_k q_r + p_i q_j - p_j q_i \end{aligned}$$

It is important to note that the order does matter. Unlike normal arithmetic, quaternion multiplication isn't commutative. In general, $\hat{p}\hat{q} \neq \hat{q}\hat{p}$.

3.9.6 LOOK WHERE YOU'RE GOING

Look where you're going would have a very similar implementation to face. We simply replace the calculation for the direction vector in the getSteering method with a calculation based on the character's current velocity:

```
# Work out the direction to target.
direction: Vector = character.velocity
direction.normalize()
```

3.9.7 **WANDER**

In the 2D version of wander, a target point was constrained to move around a circle offset in front of the character at some distance. The target moved around this circle randomly. The position of the target was held at an angle, representing how far around the circle the target lay, and the random change in that was generated by adding a random amount to the angle.

In three dimensions, the equivalent behavior uses a 3D sphere on which the target is constrained, again offset at a distance in front of the character. We cannot use a single angle to represent the location of the target on the sphere, however. We could use a quaternion, but it becomes difficult to change it by a small random amount without a good deal of math.

Instead, we represent the position of the target on the sphere as a 3D vector, constraining the vector to be of unit length. To update its position, we simply add a random amount to each component of the vector and normalize it again. To avoid the random change making the vector zero (and hence making it impossible to normalize), we make sure that the maximum change in any component is smaller than $\frac{1}{\sqrt{3}}$.

After updating the target position on the sphere, we transform it by the orientation of the character, scale it by the wander radius, and then move it out in front of the character by the wander offset, exactly as in the 2D case. This keeps the target in front of the character and makes sure that the turning angles are kept low.

Rather than using a single value for the wander offset, we now use a vector. This would allow us to locate the wander circle anywhere relative to the character. This is not a particularly useful feature. We will want it to be in front of the character (i.e., having only a positive z coordinate, with 0 for x and y values). Having it in vector form does simplify the math, however. The same thing is true of the maximum acceleration property: replacing the scalar with a 3D vector simplifies the math and provides more flexibility.

With a target location in world space, we can use the 3D face behavior to rotate toward it and accelerate forward to the greatest extent possible.

In many 3D games we want to keep the impression that there is an up and down direction. This illusion is damaged if the wanderer can change direction up and down as fast as it can in the x-z plane. To support this, we can use two radii for scaling the target position: one for scaling the x and z components and the other for scaling the y component. If the y scale is smaller, then the wanderer will turn more quickly in the x-z plane. Combined with using the

face implementation described above, with a base orientation where up is in the direction of the y-axis, this gives a natural look for flying characters, such as bees, birds, or aircraft.

The new wander behavior can be implemented as follows:

```
class Wander3D extends Face3D:
       # The radius and offset of the wander circle.
2
       wanderOffset: Vector
3
       wanderRadiusXZ: float
       wanderRadiusY: float
       # The maximum rate at which the wander orientation can change.
7
       # Should be strictly less than 1/sqrt(3) = 0.577 to avoid the
8
       # chance of ending up with a zero length wanderTarget.
9
       wanderRate: float
10
11
       # The current offset of the wander target.
12
       wanderTarget: Vector
13
14
       # The maximum acceleration of the character, though this is a 3D
15
       # vector, it typically has only a non-zero z component.
16
       maxAcceleration: Vector
17
       # ... Other data is derived from the superclass ...
20
       function getSteering() -> SteeringOutput3D:
21
           # 1. Calculate the target to delegate to face
22
           # Update the wander direction.
23
           wanderTarget.x += randomBinomial() * wanderRate
24
           wanderTarget.y += randomBinomial() * wanderRate
25
           wanderTarget.z += randomBinomial() * wanderRate
26
           wanderTarget.normalize()
27
28
           # Calculate the transformed target direction
29
           # and scale it.
30
           target = wanderTarget * character.orientation
31
           target.x *= wanderRadiusXZ
32
           target.y *= wanderRadiusY
33
           target.z *= wanderRadiusXZ
34
35
           # Offset by the center of the wander circle.
36
           target += character.position +
37
                      wanderOffset * character.orientation
38
39
           # 2. Delegate it to face.
40
           result = Face3D.getSteering(target)
41
42
           # 3. Now set the linear acceleration to be at full
43
```

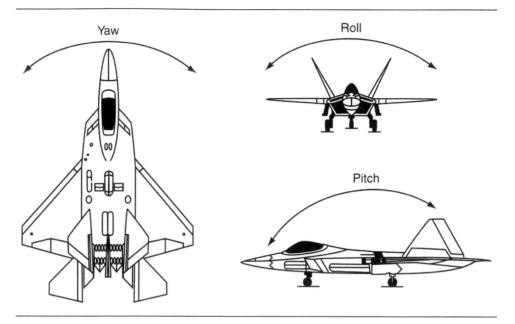

Figure 3.73: Local rotation axes of an aircraft

```
# acceleration in the direction of the orientation.
            result.linear = maxAcceleration * character.orientation
45
46
            # Return it.
47
            return result
48
```

Again, this is heavily based on the 2D version and shares its performance characteristics. See the original definition for more information.

3.9.8 **FAKING ROTATION AXES**

A common issue with vehicles moving in three dimensions is their axis of rotation. Whether spacecraft or aircraft, they have different turning speeds for each of their three axes (see Figure 3.73): roll, pitch, and yaw. Based on the behavior of aircraft, we assume that roll is faster than pitch, which is faster than yaw.

If a craft is moving in a straight line and needs to yaw, it will first roll so that its up direction points toward the direction of the turn, then it can pitch up to turn in the correct direction. This is how aircraft are piloted, and it is a physical necessity imposed by the design of the wing and control surfaces. In space there is no such restriction, but we want to give the player some kind of sense that craft obey physical laws. Having them yaw rapidly looks unbelievable, so we tend to impose the same rule: roll and pitch produce a yaw.

Most aircraft don't roll far enough so that all the turn can be achieved by pitching. In a conventional aircraft flying level, using only pitch to perform a right turn would involve rolling by π radians. This would cause the nose of the aircraft to dive sharply toward the ground, requiring significant compensation to avoid losing the turn (in a light aircraft it would be a hopeless attempt). Rather than tip the aircraft's local up vector so that it is pointing directly into the turn, we angle it slightly. A combination of pitch and yaw then provides the turn. The amount to tip is determined by speed: the faster the aircraft, the greater the roll. A Boeing 747 turning to come into land might only roll by $\frac{\pi}{6}$ radians (15°); an F-22 Raptor might tilt by $\frac{\pi}{2}$ radians (45°) or the same turn in an X-Wing by $\frac{5\pi}{6}$ (75°).

Most craft moving in three dimensions have an "up-down" axis. This can be seen in 3D space shooters as much as in aircraft simulators. Homeworld, for example, had an explicit up and down direction, to which craft would orient themselves when not moving. The up direction is significant because craft moving in a straight line, other than in the up direction, tend to align themselves with up.

The up direction of the craft points as near to up as the direction of travel will allow. This again is a consequence of aircraft physics: the wings of an aircraft are designed to produce lift in the up direction, so if you don't keep your local up direction pointing up, you are eventually going to fall out of the sky.

It is true that in a dog fight, for example, craft will roll while traveling in a straight line to get a better view, but this is a minor effect. In most cases the reason for rolling is to perform a turn.

It is possible to bring all this processing into an actuator to calculate the best way to trade off pitch, roll, and yaw based on the physical characteristics of the aircraft. If you are writing an AI to control a physically modeled aircraft, you may have to do this. For the vast majority of cases, however, this is overkill. We are interested in having enemies that just look right.

It is also possible to add a steering behavior that forces a bit of roll whenever there is a rotation. This works well but tends to lag. Pilots will roll before they pitch, rather than afterward. If the steering behavior is monitoring the rotational speed of the craft and rolling accordingly, there is a delay. If the steering behavior is being run every frame, this isn't too much of a problem. If the behavior is running only a couple of times a second, it can look very strange.

Both of the above approaches rely on techniques already covered in this chapter, so I won't revisit them here. There is another approach, used in some aircraft games and many space shooters, that fakes rotations based on the linear motion of the craft. It has the advantages that it reacts instantly and it doesn't put any burden on the steering system because it is a post-processing step. It can be applied to $2\frac{1}{2}$ D steering, giving the illusion of full 3D rotations.

The Algorithm

Movement is handled using steering behaviors as normal. We keep two orientation values. One is part of the kinematic data and is used by the steering system, and one is calculated for display. This algorithm calculates the latter value based on the kinematic data.

First, we find the speed of the vehicle: the magnitude of the velocity vector. If the speed is zero, then the kinematic orientation is used without modification. If the speed is below a fixed threshold, then the result of the rest of the algorithm will be blended with the kinematic orientation. Above the threshold the algorithm has complete control. As it drops below the threshold, there is a blend of the algorithmic orientation and the kinematic orientation, until at a speed of zero, the kinematic orientation is used.

At zero speed the motion of the vehicle can't produce any sensible orientation; it isn't moving. So we'll have to use the orientation generated by the steering system. The threshold and blending are there to make sure that the vehicle's orientation doesn't jump as it slows to a halt. If your application never has stationary vehicles (aircraft without the ability to hover, for example), then this blending can be removed.

The algorithm generates an output orientation in three stages. This output can then be blended with the kinematic orientation, as described above.

First, the vehicle's orientation about the up vector (its 2D orientation in a $2\frac{1}{2}$ D system) is found from the kinematic orientation. Call this value θ .

Second, the tilt of the vehicle is found by looking at the component of the vehicle's velocity in the up direction. The output orientation has an angle above the horizon given by:

$$\phi = \sin^{-1} \frac{\vec{v}.\vec{u}}{|\vec{v}|}$$

where v is its velocity (taken from the kinematic data) and u is a unit vector in the up direction. Third, the roll of the vehicle is found by looking at the vehicle's rotation speed about the up direction (i.e., the 2D rotation in a $2\frac{1}{2}$ D system). The roll is given by:

$$\psi = \tan^{-1} \frac{r}{k}$$

where r is the rotation, and k is a constant that controls how much lean there should be. When the rotation is equal to k, then the vehicle will have a roll of $\frac{\pi}{2}$ radians. Using this equation, the vehicle will never achieve a roll of π radians, but very fast rotation will give very steep rolls.

The output orientation is calculated by combining the three rotations in the order θ , ϕ , ψ .

Pseudo-Code

The algorithm has the following structure when implemented:

```
function getFakeOrientation(kinematic: Kinematic3D,
                                maxSpeed: float,
2
                                rollScale: float):
3
       current: Quaternion = kinematic.orientation
       # Find the blend factors.
       speed = kinematic.velocity.length()
       if speed == 0:
           # No change if we're stationary.
           return current
10
       else if speed < maxSpeed:
11
           # Partly use the unchanged orientation.
           fakeBlend = speed / maxSpeed
13
       else:
14
           # We're completely faked.
15
           fakeBlend = 1.0
16
       kinematicBlend = 1.0 - fakeBlend
18
       # Find the faked axis orientations.
19
       yaw = current.as2D0rientation()
20
       pitch = asin(kinematic.velocity.y / speed)
21
       roll = atan2(kinematic.rotation, rollScale)
22
23
       # Combine them as quaternions.
24
       faked = orientationInDirection(roll, Vector(0, 0, 1))
25
       faked *= orientationInDirection(pitch, Vector(1, 0, 0))
       faked *= orientationInDirection(yaw, Vector(0, 1, 0))
28
       # Blend result.
29
       return current * (1.0 - fakeBlend) + faked * fakeBlend
```

Data Structures and Interfaces

The code relies on appropriate vector and quaternion mathematics routines being available, and we have assumed that we can create a vector using a three argument constructor.

Most operations are fairly standard and will be present in any vector math library. The orientationInDirection function of a quaternion is less common. It returns an orientation quaternion representing a rotation by a given angle about a fixed axis. It can be implemented in the following way:

```
function orientationInDirection(angle, axis):
       sinAngle = sin(angle / 2)
2
3
      return new Quaternion(
4
          cos(angle / 2),
5
           sinAngle * axis.x,
```

```
sinAngle * axis.y,
6
           sinAngle * axis.z)
```

which is simply Equation 3.11 in code form.

Implementation Notes

The same algorithm also comes in handy in other situations. By reversing the direction of roll (ψ) , the vehicle will roll outward with a turn. This can be applied to the chassis of cars driving (excluding the ϕ component, since there will be no controllable vertical velocity) to fake the effect of soggy suspension. In this case a high k value is needed.

Performance

The algorithm is O(1) in both memory and time. It involves an arcsine and an arctangent call and three calls to the orientationInDirection function. Arcsine and arctan calls are typically slow, even compared to other trigonometry functions. Various faster implementations are available. In particular, an implementation using a low-resolution lookup table (256 entries or so) would be perfectly adequate for our needs. It would provide 256 different levels of pitch or roll, which would normally be enough for the player not to notice that the tilting isn't completely smooth. The remainder of the algorithm is so efficient, however, that slow trigonometry functions are unlikely to be noticeable unless your game has thousands of moving characters.

EXERCISES

- 3.1 An character is at p=(5,6) and it is moving with velocity v=(3,3): If its target is at location q = (8, 2), what is the desired direction to seek the target? (Hint: No trigonometry is required for this and other questions like it, just simple vector arithmetic.)
- 3.2 Using the same scenario as in Exercise 3.1, what is the desired direction to flee the target?
- 3.3 Using the same scenario as Exercise 3.1 and assuming the maximum speed of the AI character is 5, what are the final steering velocities for seek and flee?
- 3.4 Explain why the randomBinomial function described in Section 3.2.2 is more likely to return values around zero.
- 3.5 Using the same scenario as in Exercise 3.1, what are the final steering velocities for seek and flee if we use the dynamic version of seek and assume a maximum acceleration of 4.

Figure 3.74: Components of the flocking steering behavior

- 3.6 Using the dynamic movement model and the answer from Exercise 3.5, what is the final position and orientation of the character after the update call? Assume that the time is $\frac{1}{60}$ sec and that the maximum speed is still 5.
- 3.7 If the target in Exercise 3.1 is moving at a velocity u=(3,4) and the maximum prediction time is $\frac{1}{2}$ sec, what is the predicted position of the target?
- 3.8 Using the predicted target position from Exercise 3.7 what are the resulting steering vectors for pursuit and evasion?
- 3.9 The three diagrams in Figure 3.74 represent Craig Reynolds's concepts of separation, cohesion, and alignment that are commonly used for flocking behavior.

Assume the following table gives the positions (in relative coordinates) and velocities of the 3 characters (including the first) in the first character's neighborhood:

Character	Position	Velocity	Distance	Distance squared
1	(0,0)	(2,2)	0	0
2	(3, 4)	(2, 4)		
3	(5, 12)	(8, 2)		

- a) Fill in the the remainder of the table.
- b) Use the values you filled in for the table to calculate the unnormalized separation direction using the inverse square law (assume k=1 and that there is no maximum acceleration).
- c) Now calculate the center of mass of all the characters to determine the unnormalized cohesion direction.
- d) Finally, calculate the unnormalized alignment direction as the average velocity of the other characters.
- 3.10 Use the answers to Exercise 3.9 and weighting factors $\frac{1}{5}$, $\frac{2}{5}$, $\frac{2}{5}$ for (respectively) separation, cohesion, and alignment to show that the desired (normalized) flocking direction is approximately: (0.72222, 0.69166).

- 3.11 Suppose a character A is located at (4, 2) with a velocity of (3, 4) and another character B is located at (20, 12) with velocity (-5, -1). By calculating the time of closest approach (see 3.1), determine if they will collide. If they will collide, determine a suitable evasive steering vector for character A.
- 3.12 Suppose an AI-controlled spaceship is pursuing a target through an asteroid field and the current velocity is (3, 4). If the high-priority collision avoidance group suggests a steering vector of (0.01, 0.03), why might it be reasonable to consider a lower priority behavior instead?
- 3.13 Use Equation 3.2 to calculate the time before a ball in a soccer game lands on the pitch again if it is kicked from the ground at location (11, 4) with speed 10 in a direction $(\frac{3}{5}, \frac{4}{5})$
- 3.14 Use your answer to Exercise 3.13 and Equation 3.4 to calculate the position of impact of the ball. Why might the ball not actually end up at this location even if no other players interfere with it?
- 3.15 With reference to Figure 3.49, suppose a character is heading toward the jump point and will arrive in 0.1 time units and is currently traveling at velocity (0, 5), what is the required velocity matching steering vector if the minimum jump velocity is (0, 7)?
- 3.16 Show that in the case when the jump point and landing pad are the same height, Equation 3.7 reduces to approximately

$$t = 0.204v_y$$

- 3.17 Suppose there is a jump point at (10, 3, 12) and a landing pad at (12, 3, 20), what is the required jump velocity if we assume a maximum jump velocity in the y-direction of 2?
- 3.18 Suppose we have three characters in a V formation with coordinates and velocities given by the following table:

Character	Assigned Slot Position	Actual Position	Actual Velocity
1	(20, 18)	(20, 16)	(0, 1)
2	(8, 12)	(6, 11)	(3, 1)
3	(32, 12)	(28, 9)	(9, 7)

- a) Calculate the center of mass of the formation p_c and the average velocity v_c .
- b) Use these values and Equation 3.8 with $k_{\text{offset}} = 1$ to calculate p_{anchor} .
- Use your calculations to update the slot positions using the new calculated anchor point as in Equation 3.9.
- d) What would be the effect on the anchor and slot positions if character 3 was killed?
- 3.19 In Figure 3.60 if the 2 empty slots in the formation on the right (with 2 elves and 7 fighters) are filled with the unassigned fighters, what is the total slot cost? Use the same table that was used to calculate the slot costs in Figure 3.61.

- 3.20 Calculate the ease of assignment value for each of the four character types (archer, elf, fighter, mage) used in Figure 3.61 (assume k = 1600).
- 3.21 Verify that the axis and angle representation always results in unit quaternions.
- 3.22 Suppose a character's current orientation in a 3D world is pointing along the x-axis, what is the required rotation (as a quaternion) to align the character with a rotation of $\frac{2\pi}{3}$ around the axis $(\frac{8}{170}, \frac{15}{17}, 0)$?
- 3.23 Suppose a plane in a flight simulator game has velocity (5, 4, 1), orientation $\frac{p}{4}$, rotation $\frac{p}{16}$, and roll scale $\frac{p}{4}$. What is the associated fake rotation?

4

PATHFINDING

G AME CHARACTERS usually need to move around their level. Sometimes this movement is set in stone by the developers, such as a patrol route that a guard can follow blindly or a small fenced region in which a dog can randomly wander around. Fixed routes are simple to implement, but can easily be fooled if an object is pushed in the way. Free wandering characters can appear aimless and can easily get stuck.

More complex characters don't know in advance where they'll need to move. A unit in a real-time strategy game may be ordered to any point on the map by the player at any time, a patrolling guard in a stealth game may need to move to its nearest alarm point to call for reinforcements, and a platform game may require opponents to chase the player across a chasm using available platforms.

For each of these characters the AI must be able to calculate a suitable route through the game level to get from where it is now to its goal. We'd like the route to be sensible and as short or rapid as possible (it doesn't look smart if your character walks from the kitchen to the lounge via the attic).

This is pathfinding, sometimes called path planning, and it is everywhere in game AI.

In our model of game AI (Figure 4.1), pathfinding sits on the border between decision making and movement. Often, it is used simply to work out where to move to reach a goal; the goal is decided by another bit of AI, and the pathfinder simply works out how to get there. To accomplish this, it can be embedded in a movement control system so that it is only called when it is needed to plan a route. This is discussed in Chapter 3 on movement algorithms.

But pathfinding can also be placed in the driving seat, making decisions about where to move as well as how to get there. I'll look at a variation of pathfinding, open goal pathfinding, that can be used to work out both the path and the destination.

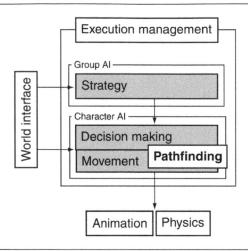

Figure 4.1: The AI model

The vast majority of games use pathfinding solutions based on an algorithm called A*. Although it's efficient and easy to implement, A* can't work directly with the game level data. It requires that the game level be represented in a particular data structure: a directed nonnegative weighted graph.

This chapter introduces the graph data structure and then looks at the older brother of the A* algorithm, the Dijkstra algorithm. Although Dijkstra is more often used in tactical decision making than in pathfinding, it is a simpler version of A*, so we'll cover it here on the way to the full A* algorithm.

Because the graph data structure isn't the way that most games would naturally represent their level data, we'll look in some detail at the knowledge representation issues involved in turning the level geometry into pathfinding data. Finally, we'll look at a handful of the many tens of useful variations of the basic A* algorithm.

4.1 THE PATHFINDING GRAPH

Neither A* nor Dijkstra (nor their many variations) can work directly on the geometry that makes up a game level. They rely on a simplified version of the level represented in the form of a graph. If the simplification is done well (and we'll look at how later in the chapter), then the plan returned by the pathfinder will be useful when translated back into game terms. On the other hand, in the simplification we throw away information, and that might be significant information. Poor simplification can mean that the final path isn't so good.

Pathfinding algorithms use a type of graph called a directed non-negative weighted graph. I'll work up to a description of the full pathfinding graph via simpler graph structures.

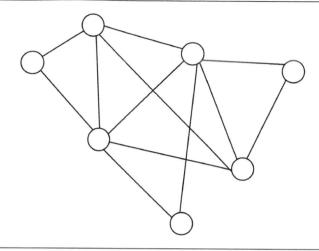

Figure 4.2: A general graph

4.1.1 **GRAPHS**

A graph is a mathematical structure often represented diagrammatically. It has nothing to do with the more common use of the word "graph" to mean any diagram, such as a pie chart or histogram.

A graph consists of two different types of element: nodes are often drawn as points or circles in a graph diagram, while connections link nodes together with lines (as we'll see below, both of these elements are called various different names by different people). Figure 4.2 shows a graph structure.

Formally, the graph consists of a set of nodes and a set of connections, where a connection is simply an unordered pair of nodes (the nodes on either end of the connection).

For pathfinding, each node usually represents a region of the game level, such as a room, a section of corridor, a platform, or a small region of outdoor space. Connections show which locations are connected. If a room adjoins a corridor, then the node representing the room will have a connection to the node representing the corridor. In this way the whole game level is split into regions, which are connected together. Later in the chapter, we'll see a way of representing the game level as a graph that doesn't follow this model, but in most cases this is the approach taken.

To get from one location in the level to another, we use connections. If we can go directly from our starting node to our target node, then our task is simple: we use the connection. Otherwise, we may have to use multiple connections and travel through intermediate nodes on the way.

A path through the graph consists of zero or more connections. If the start and end node

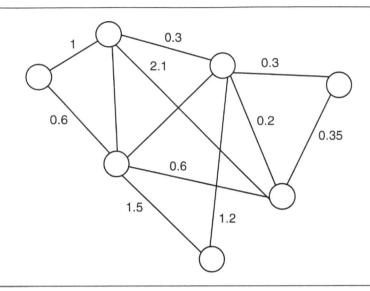

Figure 4.3: A weighted graph

are the same, then there are no connections in the path. If the nodes are connected, then only one connection is needed, and so on.

4.1.2 WEIGHTED GRAPHS

A weighted graph is made up of nodes and connections, just like the general graph. In addition to a pair of nodes for each connection, we add a numerical value. In mathematical graph theory this is called the weight, and in game applications it is more commonly called the cost (although the graph is still called a "weighted graph" rather than a "costed graph").

In the example graph shown in Figure 4.3, we see that each connection is labeled with an associated cost value.

The costs in a pathfinding graph often represent time or distance. If a node representing one end of a corridor is a long distance from the node representing the other, then the cost of the connection will be large. Similarly, moving between two areas with difficult terrain will take a long time, so the cost will be large.

The costs in a graph can represent more than just time or distance. They might represent strategic risk or loot availability, for example. We will see a number of applications of pathfinding to situations where the cost is a combination of time, distance, and other factors.

For a whole route through a graph, from a start node to a target node, we can work out the total path cost. It is simply the sum of the costs of each connection in the route. In Figure 4.4,

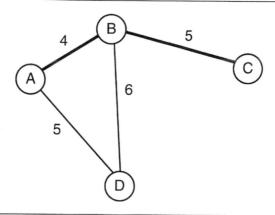

Figure 4.4: Total path cost from A to C is 4 + 5 = 9

if we are heading from node A to node C, via node B, and if the costs are 4 from A to B and 5 from B to C, then the total cost of the route is 9.

Representative Points in a Region

You might notice immediately that if two regions are connected (such as a room and a corridor), then the distance between them (and therefore the time to move between them) will be zero. If you are standing in a doorway, then moving from the room side of the doorway to the corridor side is instant. So shouldn't all connections have a zero cost?

We tend to measure connection distances or times from a representative point in each region. So we pick the center of the room and the center of the corridor. If the room is large and the corridor is long, then there is likely to be a large distance between their center points, so the cost will be large.

You will often see this in diagrams of pathfinding graphs, such as Figure 4.5: a representative point is marked in each region.

A complete analysis of this approach will be left to a later section. It is one of the subtleties of representing the game level for the pathfinder, and we'll return to the issues it causes at some length.

The Non-Negative Constraint

It doesn't seem to make sense to have negative costs. You can't have a negative distance between two points, and it can't take a negative amount of time to move there.

Mathematical graph theory does allow negative weights, however, and they have direct

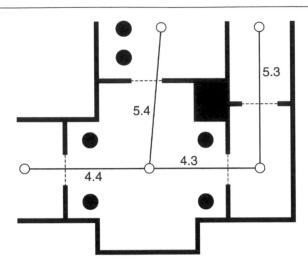

Figure 4.5: Weighted graph overlaid onto level geometry

applications in some practical problems. These problems are entirely outside of normal game development, and all of them are beyond the scope of this book. Writing algorithms that can work with negative weights is typically more complex than for those with strictly non-negative weights.

In particular, the Dijkstra and A* algorithms should only be used with non-negative weights. It is possible to construct a graph with negative weights such that a pathfinding algorithm will return a sensible result. In the majority of cases, however, Dijkstra and A* would go into an infinite loop. This is not an error in the algorithms. Mathematically, there is no such thing as a shortest path across many graphs with negative weights; a solution simply doesn't exist.

When I use the term "cost" in this book, it means a non-negative weight. Costs are always positive. We will never need to use negative weights or the algorithms that can cope with them. I've never needed to use them in any game development project I've worked on, and I can't foresee a situation when I might.

4.1.3 DIRECTED WEIGHTED GRAPHS

For many situations a weighted graph is sufficient to represent a game level, and I have seen implementations that use this format. We can go one stage further, however. The major pathfinding algorithms support the use of a more complex form of graph, the directed graph (see Figure 4.6), which is often useful to developers.

So far we've assumed that if it is possible to move between node A and node B (the room

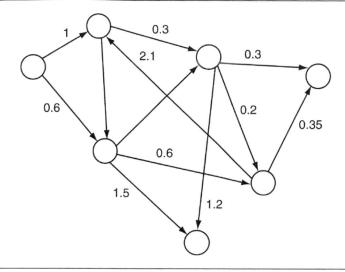

Figure 4.6: A directed weighted graph

and corridor, for example), then it is possible to move from node B to node A. Connections go both ways, and the cost is the same in both directions. Directed graphs instead assume that connections are in one direction only. If you can get from node A to node B, and vice versa, then there will be two connections in the graph: one for A to B and one for B to A.

This is useful in many situations. First, it is not always the case that the ability to move from A to B implies that B is reachable from A. If node A represents an elevated walkway and node B represents the floor of the warehouse underneath it, then a character can easily drop from A to B but will not be able to jump back up again.

Second, having two connections in different directions means that there can be two different costs. Let's take the walkway example again but add a ladder. Thinking about costs in terms of time, it takes almost no time at all to fall off the walkway, but it may take several seconds to climb back up the ladder. Because costs are associated with each connection, this can be simply represented: the connection from A (the walkway) to B (the floor) has a small cost, and the connection from B to A has a larger cost.

Mathematically, a directed graph is identical to a non-directed graph, except that the pair of nodes that makes up a connection is now ordered. Whereas a connection <node A, node B, cost> in a non-directed graph is identical to <node B, node A, cost> (so long as the costs are equal), in a directed graph they are different connections.

4.1.4 TERMINOLOGY

Terminology for graphs varies. In mathematical texts you often see vertices rather than nodes and edges rather than connections (and, as we've already seen, weights rather than costs). Many AI developers who actively research pathfinding use this terminology from exposure to the mathematical literature. It can be confusing in a game development context because vertices more commonly refer to a component of 3D geometry, something altogether different.

There is no agreed terminology for pathfinding graphs in games articles and seminars. I have seen locations and even "dots" for nodes, and I have seen arcs, paths, links, and "lines" for connections.

I will use the nodes and connections terminology throughout this chapter because it is common, relatively meaningful (unlike dots and lines), and unambiguous (arcs and vertices both have meaning in game graphics).

In addition, while I have talked about directed non-negative weighted graphs, almost all pathfinding literature just calls them graphs and assumes that you know what kind of graph is meant. I will do the same.

4.1.5 REPRESENTATION

We need to represent our graph in such a way that pathfinding algorithms such as A* and Dijkstra can work with it.

As we will see, the algorithms need to query the outgoing connections from any given node. And for each such connection, they need to have access to its cost and destination.

We can represent the graph to our algorithms using the following interface:

```
class Graph:
       # An array of connections outgoing from the given node.
2
       function getConnections(fromNode: Node) -> Connection[]
3
  class Connection:
5
       # The node that this connection came from.
       fromNode: Node
       # The node that this connection leads to.
       toNode: Node
10
11
       # The non-negative cost of this connection.
12
       function getCost() -> float
```

The graph class simply returns an array of connection objects for any node that is queried. From these objects the end node and cost can be retrieved.

A simple implementation of this class would store the connections for each node and simply return the list. Each connection would have the cost and end node stored in memory.

A more complex implementation might calculate the cost only when it is required, using information from the current structure of the game level.

Notice that there is no interface for a Node in this listing, because we don't need to specify one. In many cases it is sufficient just to give nodes a unique number and to use integers as the data type. In fact, we will see that this is a particularly powerful implementation because it opens up some specific, very fast optimizations of the A* algorithm.

4.2 DIJKSTRA

The Dijkstra algorithm is named for Edsger Dijkstra, the mathematician who devised it (and the same man who coined the famous programming phrase "GOTO considered harmful").

Dijkstra's algorithm [10] wasn't originally designed for pathfinding as games understand it. It was designed to solve a problem in mathematical graph theory, confusingly called "shortest path."

Where pathfinding in games has one start point and one goal point, the shortest path algorithm is designed to find the shortest routes to everywhere from an initial point. The solution to this problem will include a solution to the pathfinding problem (we've found the shortest route to everywhere, after all), but it is wasteful if we are going to throw away all the other routes. It can be modified to generate only the path we are interested in, but is still quite inefficient at doing that.

Because of these issues, Dijkstra is rarely used in production pathfinding. And to my knowledge never as the main pathfinding algorithm. Nonetheless, it is an important algorithm for tactical analysis (covered in Chapter 6, Tactical and Strategic AI) and has uses in a handful of other areas of game AI.

I will introduce it here rather than in that chapter, because it is a simpler version of the main pathfinding algorithm A*, and understanding Dijkstra enough to implement it is a good step to understanding and implementing A*.

4.2.1 THE PROBLEM

Given a graph (a directed non-negative weighted graph) and two nodes (called start and goal) in that graph, we would like to generate a path from start to goal such that the total path cost of that path is minimal, i.e. there should be no lower cost paths from start to goal.

There may be any number of paths with the same minimal cost. Figure 4.7 has 10 possible paths, all with the same minimal cost. When there is more than one optimal path, we only expect one to be returned, and we don't care which one it is.

Recall that the path we expect to be returned consists of a set of connections, not nodes. Two nodes may be linked by more than one connection, and each connection may have a different cost (it may be possible to either fall off a walkway or climb down a ladder, for example). We therefore need to know which connections to use; a list of nodes will not suffice.

Many games don't make this distinction. There is, at most, one connection between any

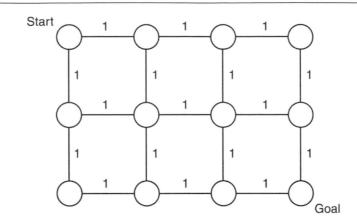

Figure 4.7: All optimal paths

pair of nodes. After all, if there are two connections between a pair of nodes, the pathfinder should always take the one with the lower cost. In some applications, however, the costs change over the course of the game or between different characters, and keeping track of multiple connections is useful.

There is no more work in the algorithm to cope with multiple connections. And for those applications where it is significant, it is often essential. For those reasons, I will always assume a path consists of connections.

4.2.2 THE ALGORITHM

Informally, Dijkstra works by considering paths that spread out from the start node along its connections. As it spreads out to more distant nodes, it keeps a record of the direction it came from (imagine it drawing chalk arrows on the floor to indicate the way back to the start). Eventually, one of these paths will reach the goal node and the algorithm can follow the chalk arrows back to its start point to generate the complete route. Because of the way Dijkstra regulates the spreading process, it guarantees that the first valid path it finds will also be the cheapest (or one of the cheapest if there are more with the same lowest cost). This valid path is found as soon as the algorithm considers the goal node. The chalk arrows always point back along the shortest route to the start.

Let's break this down in more detail.

Dijkstra works in iterations. At each iteration it considers one node of the graph and follows its outgoing connections, storing the node at the other end of those connections in a pending list. When the algorithm begins only the start node is placed in this list, so at the first iteration it considers the start node. At successive iterations it chooses a node from the

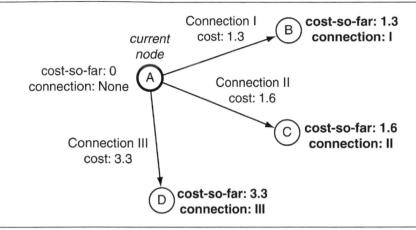

Figure 4.8: Dijkstra at the first node

list using an algorithm I'll describe shortly. I'll call each iteration's node the "current node." When the current node is the goal, the algorithm is done. If the list is ever emptied, we know that goal cannot be reached.

Processing the Current Node

During an iteration, Dijkstra considers each outgoing connection from the current node. For each connection it finds the end node and stores the total cost of the path so far (we'll call this the "cost-so-far"), along with the connection it arrived there from.

In the first iteration, where the start node is the current node, the total cost-so-far for each connection's end node is simply the cost of the connection. Figure 4.8 shows the situation after the first iteration. Each node connected to the start node has a cost-so-far equal to the cost of the connection that led there, as well as a record of which connection that was.

For iterations after the first, the cost-so-far for the end node of each connection is the sum of the connection cost and the cost-so-far of the current node (i.e., the node from which the connection originated). Figure 4.9 shows another iteration of the same graph. Here the cost-so-far stored in node E is the sum of cost-so-far from node B and the connection cost of Connection IV from B to E.

In implementations of the algorithm, there is no distinction between the first and successive iterations. By setting the cost-so-far value of the start node as 0 (since the start node is at zero distance from itself), we can use one piece of code for all iterations.

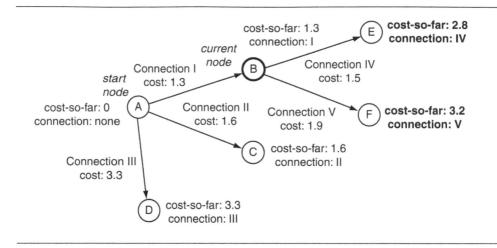

Figure 4.9: Dijkstra with a couple of nodes

The Node Lists

The algorithm keeps track of all the nodes it has seen so far in two lists: open and closed. In the open list it records all the nodes it has seen, but that haven't had their own iteration yet. It also keeps track of those nodes that have been processed in the closed list. To start with, the open list contains only the start node (with zero cost-so-far), and the closed list is empty.

Each node can be thought of as being in one of three categories: it can be in the closed list, having been processed in its own iteration; it can be in the open list, having been visited from another node, but not yet processed in its own right; or it can be in neither list. The node is sometimes said to be closed, open, or unvisited.

At each iteration, the algorithm chooses the node from the open list that has the smallest cost-so-far. This is then processed in the normal way. The processed node is then removed from the open list and placed on the closed list.

There is one complication. When we follow a connection from the current node, we've assumed that we'll end up at an unvisited node. We may instead end up at a node that is either open or closed, and we'll have to deal slightly differently with them.

Calculating Cost-So-Far for Open and Closed Nodes

If we arrive at an open or closed node during an iteration, then the node will already have a cost-so-far value and a record of the connection that led there. Simply setting these values will overwrite the previous work the algorithm has done.

Instead, we check if the route we've now found is better than the route that we've already

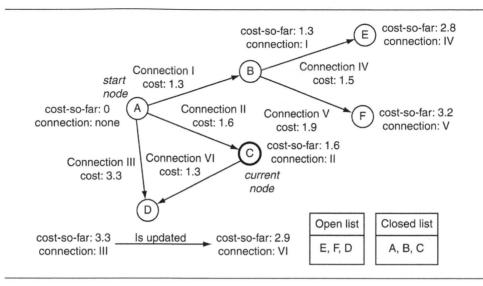

Figure 4.10: Open node update

found. Calculate the cost-so-far value as normal, and if it is higher than the recorded value (and it will be higher in almost all cases), then don't update the node at all and don't change what list it is on.

If the new cost-so-far value is smaller than the node's current cost-so-far, then update it with the better value, and set its connection record. The node should then be placed on the open list. If it was previously on the closed list, it should be removed from there.

Strictly speaking, Dijkstra will never find a better route to a closed node, so we could check if the node is closed first and not bother doing the cost-so-far check. A dedicated Dijkstra implementation would do this. We will see that the same is not true of the A* algorithm, however, and we will have to check for faster routes in both cases.

Figure 4.10 shows the updating of an open node in a graph. The new route, via node C, is faster, and so the record for node D is updated accordingly.

Terminating the Algorithm

The basic Dijkstra algorithm terminates when the open list is empty: it has considered every node in the graph that be reached from the start node, and they are all on the closed list.

For pathfinding, we are only interested in reaching the goal node, however, so we can stop earlier. The algorithm should terminate when the goal node is the smallest node on the open list.

Notice that this means we will have already reached the goal on a previous iteration, when

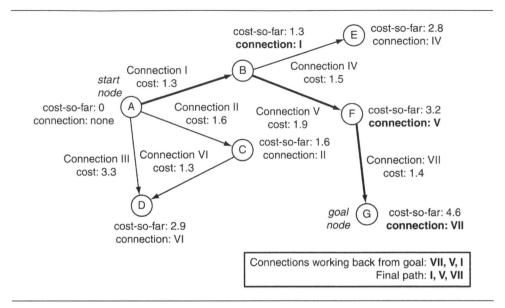

Figure 4.11: Following the connections to get a plan

it was placed into the open list. Why not simply terminate the algorithm as soon as we've found the goal?

Consider Figure 4.10 again. If D is the goal node, then we'll first find it when we're processing node B. So if we stop here, we'll get the route A–B–D, which is not the shortest route. To make sure there can be no shorter routes, we have to wait until the goal has the smallest cost-so-far. At this point, and only then, we know that a route via any other unprocessed node (either open or unvisited) must be longer.

This rule is often broken, and many developers implement their pathfinding algorithms to terminate as soon as the goal node is seen, rather than waiting for it to be selected from the open list. Whether this is done intentionally or because of a mistake in the implementation, in practice it is barely noticeable. The first route found to the goal is very often the shortest, and even when there is a shorter route, it is usually only a tiny amount longer.

Retrieving the Path

The final stage is to retrieve the path.

We do this by starting at the goal node and looking at the connection that was used to arrive there. We then go back and look at the start node of that connection and do the same. We continue this process, keeping track of the connections, until the original start node is reached. The list of connections is correct, but in the wrong order, so we reverse it and return the list as our solution.

Figure 4.11 shows a simple graph after the algorithm has run. The list of connections found by following the records back from the goal is reversed to give the complete path.

4.2.3 PSEUDO-CODE

The Dijkstra pathfinder takes as input a graph (conforming to the interface given in the previous section), a start node, and an end node. It returns an array of connection objects that represent a path from the start node to the end node.

```
function pathfindDijkstra(graph: Graph,
                              start: Node,
                              end: Node) -> Connection[]:
       # This structure is used to keep track of the information we need
       # for each node.
       class NodeRecord:
           node: Node
           connection: Connection
           costSoFar: float
10
       # Initialize the record for the start node.
11
       startRecord = new NodeRecord()
12
       startRecord.node = start
13
       startRecord.connection = null
14
       startRecord.costSoFar = 0
15
       # Initialize the open and closed lists.
17
       open = new PathfindingList()
       open += startRecord
       closed = new PathfindingList()
20
21
       # Iterate through processing each node.
22
       while length(open) > 0:
23
           # Find the smallest element in the open list.
24
           current: NodeRecord = open.smallestElement()
25
26
           # If it is the goal node, then terminate.
27
           if current.node == goal:
28
               break
           # Otherwise get its outgoing connections.
           connections = graph.getConnections(current)
           # Loop through each connection in turn.
           for connection in connections:
35
               # Get the cost estimate for the end node.
               endNode = connection.getToNode()
37
```

```
38
                endNodeCost = current.costSoFar + connection.getCost()
39
                # Skip if the node is closed.
40
                if closed.contains(endNode):
41
                    continue
42
43
                # .. or if it is open and we've found a worse route.
                else if open.contains(endNode):
45
                    # Here we find the record in the open list
46
                    # corresponding to the endNode.
47
                    endNodeRecord = open.find(endNode)
48
                    if endNodeRecord.cost <= endNodeCost:</pre>
49
                         continue
50
51
                # Otherwise we know we've got an unvisited node, so make a
52
                # record for it.
53
                else:
54
                    endNodeRecord = new NodeRecord()
55
                    endNodeRecord.node = endNode
                # We're here if we need to update the node. Update the
                # cost and connection.
59
                endNodeRecord.cost = endNodeCost
60
                endNodeRecord.connection = connection
61
62
                # And add it to the open list.
63
                if not open.contains(endNode):
64
                    open += endNodeRecord
65
            # We've finished looking at the connections for the current
67
            # node, so add it to the closed list and remove it from the
            # open list.
            open -= current
70
            closed += current
71
72
       # We're here if we've either found the goal, or if we've no more
73
       # nodes to search, find which.
74
       if current.node != goal:
75
            # We've run out of nodes without finding the goal, so there's
76
            # no solution.
77
            return null
78
79
       else:
80
           # Compile the list of connections in the path.
81
            path = []
82
83
           # Work back along the path, accumulating connections.
84
```

```
while current.node != start:
85
               path += current.connection
               current = current.connection.getFromNode()
89
           # Reverse the path, and return it.
           return reverse(path)
```

Other Functions

The pathfinding list is a specialized data structure that acts very much like a regular list. It holds a set of NodeRecord structures and supports the following additional methods:

- The smallestElement method returns the NodeRecord structure in the list with the lowest costSoFar value.
- The contains (node) method returns true only if the list contains a NodeRecord structure whose node member is equal to the given parameter.
- The find(node) method returns the NodeRecord structure from the list whose node member is equal to the given parameter.

In addition, I have used a function, reverse(array), that returns a reversed copy of a normal array.

4.2.4 DATA STRUCTURES AND INTERFACES

There are three data structures used in the algorithm: the simple list used to accumulate the final path, the pathfinding list used to hold the open and closed lists, and the graph used to find connections from a node (and their costs).

Simple List

The simple list is not very performance critical, since it is only used at the end of the pathfinding process. It can be implemented as a basic linked list (a std::list in C++, for example) or even a resizable array (such as std::vector in C++).

Pathfinding List

The open and closed lists in the Dijkstra algorithm (and in A*) are critical data structures that directly affect the performance of the algorithm. A lot of the optimization effort in pathfinding goes into their implementation. In particular, there are four operations on the list that are critical:

1. Adding an entry to the list (the += operator);

- 2. Removing an entry from the list (the -= operator);
- 3. Finding the smallest element (the smallestElement method);
- 4. Finding an entry in the list corresponding to a particular node (the contains and find methods both do this).

Finding a suitable balance between these four operations is key to building a fast implementation. Unfortunately, the balance is not always identical from game to game.

Because the pathfinding list is most commonly used with A* for pathfinding, a number of its optimizations are specific to that algorithm. I will wait to describe it in more detail until we have looked at A*.

Graph

We have seen the interface presented by the graph in the first section of this chapter.

The getConnections method is called low down in the loop and is typically a critical performance element to get right. The most common implementation has a lookup table indexed by a node (where nodes are numbered as consecutive integers). The entry in the lookup table is an array of connection objects. Thus, the getConnections method needs to do minimal processing and is efficient.

Some methods of translating a game level into a pathfinding graph do not allow for this simple lookup approach and can therefore lead to much slower pathfinding. Such situations are described in more detail later in the chapter, in Section 4.4 on world representation.

The getToNode and getCost methods of the Connection class are even more performance critical. In an overwhelming majority of implementations, however, no processing is performed in these methods, and they simply return a stored value in each case. The Connection class might therefore look like the following:

```
class Connection:
       cost: float
2
       fromNode: Node
       toNode: Node
       function getCost() -> float:
           return cost
       function getFromNode() -> Node:
g
           return fromNode
10
11
       function getToNode() -> Node:
12
           return toNode
```

For this reason the Connection class is rarely a performance bottleneck.

Of course, these values need to be calculated somewhere. This is usually done when the game level is converted into a graph and is an offline process independent of the pathfinder.

4.2.5 PERFORMANCE OF DIJKSTRA

The practical performance of Dijkstra in both memory and speed depends mostly on the performance of the operations in the pathfinding list data structure.

Ignoring the performance of the data structure for a moment, we can see the theoretical performance of the overall algorithm. The algorithm considers each node in the graph that is closer than the end node. Call this number n. For each of these nodes, it processes the inner loop once for each outgoing connection. Call the average number of outgoing connections per node m. So the algorithm itself is O(nm) in execution speed. The total memory use depends on both the size of the open list and the size of the closed list. When the algorithm terminates there will be n elements in the closed list and no more than nm elements in the open list (in fact, there will typically be fewer than n elements in the open list). So the worst case memory use is O(nm).

To include the data structure times, we note that both the list addition and the find operation (see the section on the pathfinding list data structure, above) are called nm times, while the extraction and smallestElement operations are called n times. If the order of the execution time for the addition or find operations is greater than O(m), or if the extraction and smallestElement operations are greater than O(1), then the actual execution performance will be worse than O(nm).

In order to speed up the key operations, data structure implementations are often chosen that have worse than O(nm) memory requirements.

When we look in more depth at the list implementations in the next section, we will consider their impact on performance characteristics.

If you look up Dijkstra in a computer science textbook, it may tell you that it is $O(n^2)$. In fact, this is exactly the result above. The worst conceivable performance occurs when the graph is so densely connected that $m \approx n$. This is almost never the case for the graphs that represent game levels: the number of connections per node stays roughly constant no matter how many nodes the level contains, so citing the performance as $O(n^2)$ would be misleading. Alternatively, the performance may be given as $O(m + n \log n)$ in time, which is the performance of the algorithm when using a 'Fibonacci heap' data structure for the node lists [57].

4.2.6 WEAKNESSES

The principle problem with Dijkstra is that it searches the entire graph indiscriminately for the shortest possible route. This is useful if we're trying to find the shortest path to every possible node (the problem that Dijkstra was designed for), but wasteful for point-to-point pathfinding.

We can visualize the way the algorithm works by showing the nodes currently on its open and closed lists at various stages through a typical run. This is shown in Figure 4.12.

In each case the boundary of the search is made up of nodes on the open list. This is

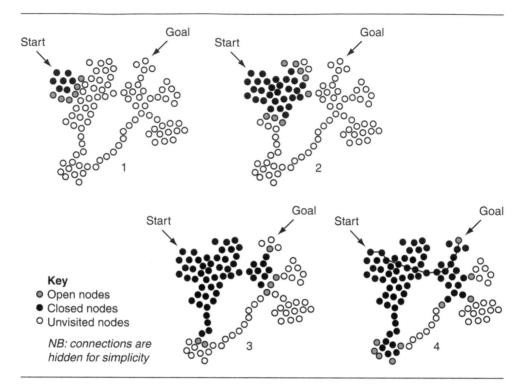

Figure 4.12: Dijkstra in steps

because the nodes closer to the start (i.e., with lower distance values) have already been processed and placed on the closed list.

The final part of Figure 4.12 shows the state of the lists when the algorithm terminates. The line shows the best path that has been calculated. Notice that most of the level has still been explored, even well away from the path that is generated.

The number of nodes that were considered, but never made part of the final route, is called the *fill* of the algorithm. In general, you want to consider as few nodes as possible, because each takes time to process.

Sometimes Dijkstra will generate a search pattern with a relatively small amount of fill. This is the exception rather than the rule, however. In the vast majority of cases, Dijkstra suffers from a terrible amount of fill.

Algorithms with big fills, like Dijkstra, are inefficient for point-to-point pathfinding and are rarely used. This brings us to the star of pathfinding algorithms: A^* . It can be thought of as a low-fill version of Dijkstra.

4.3 A*

Pathfinding in games is synonymous with the A* algorithm. Though first described in 1968 [20], it was popularized in the industry in the 1990s [65] and almost immediately became ubiquitous. A* is simple to implement, is very efficient, and has lots of scope for optimization. Every pathfinding system I've come across in the last 20 years has used some variation of A* as its key algorithm, and the technique has applications in game AI well beyond pathfinding too. In Chapter 5, we will see how A* can be used as a decision-making tool to plan complex series of actions for characters.

Unlike the Dijkstra algorithm, A* is designed for point-to-point pathfinding and is not used to solve the shortest path problem in graph theory. It can neatly be extended to more complex cases, as we'll see later, but it always returns a single path from source to goal.

4.3.1 THE PROBLEM

The problem is identical to that solved by our Dijkstra pathfinding algorithm.

Given a graph (a directed non-negative weighted graph) and two nodes in that graph (start and goal), we would like to generate a path such that the total path cost of that path is minimal among all possible paths from start to goal. Any path with minimal cost will do, and the path should consist of a list of connections from the start node to the goal node.

4.3.2 THE ALGORITHM

Informally, the algorithm works in much the same way as Dijkstra does. Rather than always considering the open node with the lowest cost-so-far value, we choose the node that is most likely to lead to the shortest overall path. The notion of "most likely" is controlled by a heuristic. If the heuristic is accurate, then the algorithm will be efficient. If the heuristic is terrible, then it can perform even worse than Dijkstra.

In more detail, A^* works in iterations. At each iteration it considers one node of the graph and follows its outgoing connections. The node (again called the "current node") is chosen using a selection algorithm similar to Dijkstra's, but with the significant difference of the heuristic, which we'll return to later.

Processing the Current Node

During an iteration, A* considers each outgoing connection from the current node. For each connection it finds the end node and stores the total cost of the path so far (the "cost-so-far") and the connection it arrived there from, just as before.

In addition, it also stores one more value: the estimate of the total cost for a path from the start node through this node and onto the goal (we'll call this value the estimated-total-cost).

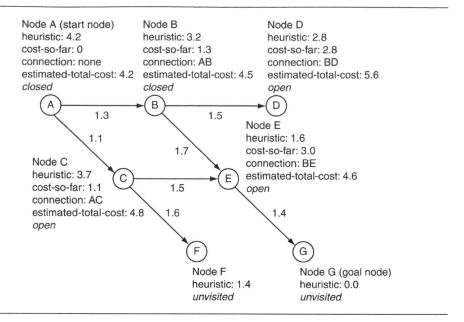

Figure 4.13: A* estimated-total-costs

This estimate is the sum of two values: the cost-so-far to reach the node and our estimate of how far it is from the node to the goal. This estimate is generated by a separate piece of code and isn't part of the algorithm.

These estimates are called the "heuristic value" of the node, and it cannot be negative (since the costs in the graph are non-negative, it doesn't make sense to have a negative estimate). The generation of this heuristic value is a key concern in implementing the A* algorithm, and we'll return to it later in some depth.

Figure 4.13 shows the calculated values for some nodes in a graph. The nodes are labeled with their heuristic values, and the two calculated values (cost-so-far and estimated-totalcost) are shown for the nodes that the algorithm has considered.

The Node Lists

As before, the algorithm keeps a list of open nodes that have been visited but not processed and closed nodes that have been processed. Nodes are moved onto the open list as they are found at the end of connections. Nodes are moved onto the closed list as they are processed in their own iteration.

Unlike previously, the node from the open list with the smallest estimated-total-cost is selected at each iteration. This is almost always different from the node with the smallest cost-so-far.

This alteration allows the algorithm to examine nodes that are more promising first. If a node has a small estimated-total-cost, then it must have a relatively short cost-so-far and a relatively small estimated distance to go to reach the goal. If the estimates are accurate, then the nodes that are closer to the goal are considered first, narrowing the search into the most profitable area.

Calculating Cost-So-Far for Open and Closed Nodes

As before, we may arrive at an open or closed node during an iteration, and we will have to revise its recorded values.

We calculate the cost-so-far value as normal, and if the new value is lower than the existing value for the node, then we will need to update it. Notice that we do this comparison strictly on the cost-so-far value (the only reliable value, since it doesn't contain any element of estimate), and not the estimated-total-cost.

Unlike Dijkstra, the A* algorithm can find better routes to nodes that are already on the closed list. If a previous estimate was very optimistic, then a node may have been processed thinking it was the best choice when, in fact, it was not.

This causes a knock-on problem. If a dubious node has been processed and put on the closed list, then it means all its connections have been considered. It may be possible that a whole set of nodes have had their cost-so-far values based on the cost-so-far of the dubious node. Updating the value for the dubious node is not enough. All its connections will also have to be checked again to propagate the new value.

In the case of revising a node on the open list, this isn't necessary, since we know that connections from a node on the open list haven't been processed yet.

Fortunately, there is a simple way to force the algorithm to recalculate and propagate the new value. We can remove the node from the closed list and place it back on the open list. It will then wait until it is the current node and have its connections reconsidered. Any nodes that rely on its value will also eventually be processed once more.

Figure 4.14 shows the same graph as the previous diagram, but two iterations later. It illustrates the updating of a closed node in a graph. The new route to E, via node C, is faster, and so the record for node E is updated accordingly, and it is placed on the open list. On the next iteration the value for node G is correspondingly revised.

So closed nodes that have their values revised are removed from the closed list and placed on the open list. Open nodes that have their values revised stay on the open list, as before.

Terminating the Algorithm

In many implementations, A^* terminates as (a correctly implemented version of) Dijkstra did: when the goal node is the smallest node on the open list.

But as we have already seen, a node that has the smallest estimated-total-cost value (and will therefore be processed next iteration and put on the closed list) may later need its values

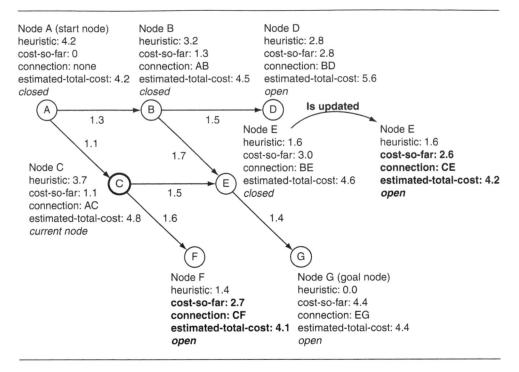

Figure 4.14: Closed node update

revised. We can no longer guarantee, just because the node is the smallest on the open list, that we have the shortest route there. So terminating A^* when the goal node is the smallest on the open list will not guarantee that the shortest route has been found.

It is natural, therefore, to ask whether we could run A* a little longer to generate a guaranteed optimal result. We can do this by requiring that the algorithm only terminates when the node in the open list with the smallest cost-so-far (not estimated-total-cost) has a cost-so-far value greater than the cost of the path we found to the goal. Then and only then can we guarantee that no future path will be found that forms a shortcut.

Unfortunately, this removes any benefit to using the A* algorithm. It can be shown that imposing this condition will generate the same amount of fill as running the Dijkstra pathfinding algorithm. The nodes may be searched in a different order, and there may be slight differences in the set of nodes on the open list, but the approximate fill level will be the same. In other words, it robs A* of any performance advantage and makes it effectively worthless.

A* implementations therefore completely rely on the fact that they can theoretically produce non-optimal results. Fortunately, this can be controlled using the heuristic function. Depending on the choice of heuristic function, we can guarantee optimal results, or we can deliberately allow sub-optimal results to give us faster execution. We'll return to the influence of the heuristic later in this section.

Because A^* so often flirts with sub-optimal results, a large number of A^* implementations instead terminate when the goal node is first visited without waiting for it to be the smallest on the open list. When I described the same thing for Dijkstra, I speculated that it was often an implementation mistake. For A^* it is more likely to be deliberate. Though the performance advantage is not as great as doing the same thing in Dijkstra, many developers feel that every little bit counts, especially as the algorithm won't necessarily be optimal in any case.

Retrieving the Path

We get the final path in exactly the same way as before: by starting at the goal and accumulating the connections as we move back to the start node. The connections are again reversed to form the correct path.

4.3.3 PSEUDO-CODE

Exactly as before, the pathfinder takes as input a graph (conforming to the interface given in the previous section), a start node, and an end node. It also requires an object that can generate estimates of the cost to reach the goal from any given node. In the code this object is heuristic. It is described in more detail later in the data structures section.

The function returns an array of connection objects that represents a path from the start node to the end node.

```
function pathfindAStar(graph: Graph,
 2
                            start: Node,
 3
                            end: Node,
 4
                            heuristic: Heuristic
 5
                            ) -> Connection[]:
       # This structure is used to keep track of the
 6
        # information we need for each node.
       class NodeRecord:
            node: Node
            connection: Connection
           costSoFar: float
11
            estimatedTotalCost: float
12
13
       # Initialize the record for the start node.
14
       startRecord = new NodeRecord()
15
       startRecord.node = start
16
       startRecord.connection = null
17
       startRecord.costSoFar = 0
18
       startRecord.estimatedTotalCost = heuristic.estimate(start)
19
20
       # Initialize the open and closed lists.
21
       open = new PathfindingList()
22
```

```
open += startRecord
       closed = new PathfindingList()
       # Iterate through processing each node.
26
       while length(open) > 0:
27
           # Find the smallest element in the open list (using the
28
           # estimatedTotalCost).
29
           current = open.smallestElement()
30
31
           # If it is the goal node, then terminate.
32
           if current.node == goal:
33
                break
           # Otherwise get its outgoing connections.
           connections = graph.getConnections(current)
37
38
           # Loop through each connection in turn.
39
            for connection in connections:
40
                # Get the cost estimate for the end node.
41
                endNode = connection.getToNode()
42
                endNodeCost = current.costSoFar + connection.getCost()
43
44
                # If the node is closed we may have to skip, or remove it
45
                # from the closed list.
46
                if closed.contains(endNode):
47
                    # Here we find the record in the closed list
48
                    # corresponding to the endNode.
49
                    endNodeRecord = closed.find(endNode)
51
                    # If we didn't find a shorter route, skip.
52
                    if endNodeRecord.costSoFar <= endNodeCost:</pre>
53
                        continue
54
55
                    # Otherwise remove it from the closed list.
56
                    closed -= endNodeRecord
57
58
                    # We can use the node's old cost values to calculate
59
                    # its heuristic without calling the possibly expensive
                    # heuristic function.
                    endNodeHeuristic = endNodeRecord.estimatedTotalCost -
                                        endNodeRecord.costSoFar
                # Skip if the node is open and we've not found a better
                # route.
66
                else if open.contains(endNode):
67
                    # Here we find the record in the open list
68
                    # corresponding to the endNode.
69
```

```
endNodeRecord = open.find(endNode)
 70
 71
 72
                      # If our route is no better, then skip.
                      if endNodeRecord.costSoFar <= endNodeCost:</pre>
 73
                          continue
 74
 75
                      # Again, we can calculate its heuristic.
 76
                      endNodeHeuristic = endNodeRecord.cost -
 77
                                          endNodeRecord.costSoFar
 78
 79
                  # Otherwise we know we've got an unvisited node, so make a
                 # record for it.
 81
                 else:
 83
                      endNodeRecord = new NodeRecord()
                      endNodeRecord.node = endNode
 84
 85
                      # We'll need to calculate the heuristic value using
 86
                      # the function, since we don't have an existing record
 87
                      # to use.
 88
                      endNodeHeuristic = heuristic.estimate(endNode)
 89
 90
                 # We're here if we need to update the node. Update the
 91
                 # cost, estimate and connection.
 92
                 endNodeRecord.cost = endNodeCost
 93
                 endNodeRecord.connection = connection
 94
                 endNodeRecord.estimatedTotalCost = endNodeCost +
 95
                      endNodeHeuristic
                 # And add it to the open list.
                 if not open.contains(endNode):
 98
                      open += endNodeRecord
 99
100
             # We've finished looking at the connections for the current
101
             # node, so add it to the closed list and remove it from the
102
             # open list.
103
             open -= current
104
             closed += current
105
106
        # We're here if we've either found the goal, or if we've no more
107
        # nodes to search, find which.
108
        if current.node != goal:
109
            # We've run out of nodes without finding the goal, so there's
110
            # no solution.
111
            return null
112
113
        else:
114
            # Compile the list of connections in the path.
115
```

```
path = []
            # Work back along the path, accumulating connections.
            while current.node != start:
119
                path += current.connection
120
                current = current.connection.getFromNode()
121
122
            # Reverse the path, and return it.
123
            return reverse(path)
124
```

Changes from Dijkstra

The algorithm is almost identical to the Dijkstra algorithm. It adds an extra check to see if a closed node needs updating and removing from the closed list. It also adds two lines to calculate the estimated-total-cost of a node using the heuristic function and adds an extra field in the NodeRecord structure to hold this information.

A set of calculations can be used to derive the heuristic value from the cost values of an existing node. This is done simply to avoid calling the heuristic function any more than is necessary. If a node has already had its heuristic calculated, then that value will be reused when the node needs updating.

Other than these minor changes, the code is identical.

As for the supporting code, the smallestElement method of the pathfinding list data structure should now return the NodeRecord with the smallest estimated-total-cost value, not the smallest cost-so-far value as before. Otherwise, the same implementations can be used.

4.3.4 DATA STRUCTURES AND INTERFACES

The graph data structure and the simple path data structure used to accumulate the path are both identical to those used in the Dijkstra algorithm. The pathfinding list data structure has a smallestElement method that now considers estimated-total-cost rather than cost-so-far but is otherwise the same.

Finally, we have added a heuristic function that generates estimates of the distance from a given node to the goal.

Pathfinding List

Recall from the discussion on Dijkstra that the four component operations required on the pathfinding list are the following:

- Adding an entry to the list (the += operator);
- 2. Removing an entry from the list (the -= operator);

- Finding the smallest element (the smallestElement method);
- 4. Finding an entry in the list corresponding to a particular node (the contains and find methods both do this).

Of these operations, numbers 3 and 4 are typically the most fruitful for optimization (although optimizing these often requires changes to numbers 1 and 2 in turn). We'll look at a particular optimization for number 4, which uses a non-list structure, later in this section.

A naive implementation of number 3, finding the smallest element in the list, involves looking at every node in the open list, every time through the algorithm, to find the lowest total path estimate.

There are lots of ways to speed this up, and all of them involve changing the way the list is structured so that the best node can be found quickly. This kind of specialized list data structure is usually called a *priority queue*. It minimizes the time it takes to find the best node.

In this book I won't cover different possible priority queue implementations. Priority queues are a common data structure detailed in any good algorithms text.

Priority Queues

The simplest approach is to require that the open list be sorted. This means that we can get the best node immediately because it is the first one in the list.

But making sure the list is sorted takes time. We could sort it each time we need it, but this would take a very long time. A more efficient way is to make sure that when we add things to the open list, they are in the right place. Previously, new nodes were appended to the list with no regard for order, a very fast process. Inserting the new node in its correct sorted position in the list takes longer.

This is a common trade-off when designing data structures: if you make it fast to add an item, it may be costly to get it back, and if you optimize retrieval, then adding may take time.

If the open list is already sorted, then adding a new item involves finding the correct insertion point in the list for the new item. In our implementation so far, we have used a linked list. To find the insertion point in a linked list we need to go through each item in the list until we find one with a higher total path estimate than ours. This is faster than searching for the best node, but still isn't too efficient.

If we use an array rather than a linked list, we can use a binary search to find the insertion point. This is faster, and for a very large lists (and the open list is often huge) it can provide a massive speed up.

Adding to a sorted list is faster than removing from an unsorted list. If we added nodes about as often as we removed them, then it would be better to have a sorted list. Unfortunately, A^* adds many more nodes than it retrieves to the open list. And it rarely removes nodes from the closed list at all.

Priority Heaps

Priority heaps are an array-based data structure which represents a tree of elements. Each item in the tree can have up to two children, both of which must have higher values.

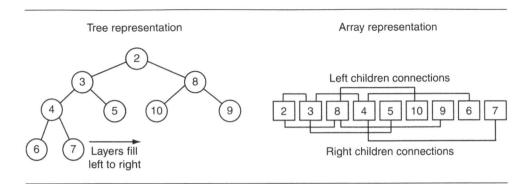

Figure 4.15: Priority heap

The tree is balanced, so that no branch is more than one level deeper than any other. In addition, it fills up each level from the left to the right. This is shown in Figure 4.15.

This structure is useful because it allows the tree to be mapped to a simple array in memory: the left and right children of a node are found in the array at position 2i and 2i + 1, respectively, where i is the position of the parent node in the array. See Figure 4.15 for an example, where the tree connections are overlaid onto the array representation.

With this ultra-compact representation of the heap, the well-known sorting algorithm heapsort can be applied, which takes advantage of the tree structure to keep nodes in order. Finding the smallest element takes constant time (it is always the first element: the head of the tree). Removing the smallest element, or adding any new element, takes $O(\log n)$, where n is the number of elements in the list.

The priority heap is a well-known data structure commonly used for scheduling problems and is the heart of an operating system's process manager.

Bucketed Priority Queues

Bucketed priority queues are more complex data structures that have partially sorted data. The partial sorting is designed to give a blend of performance across different operations, so adding items doesn't take too long and removing them is still fast.

The eponymous buckets are small lists that contain unsorted items within a specified range of values. The buckets themselves are sorted, but the contents of the buckets aren't.

To add to this kind of priority queue, you search through the buckets to find the one your node fits in. You then add it to the start of the bucket's list. This is illustrated in Figure 4.16.

The buckets can be arranged in a simple list, as a priority queue themselves, or as a fixed array. In the latter case, the range of possible values must be fairly small (total path costs often lie in a reasonably small range). Then the buckets can be arranged with fixed intervals: the first bucket might contain values from 0 to 10, the second from 10 to 20, and so on. In this case the data structure doesn't need to search for the correct bucket. It can go directly there, speeding up node adding even more.

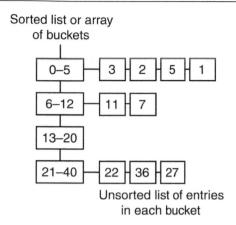

Figure 4.16: Bucketed priority queues

To find the node with the lowest score, you go to the first non-empty bucket and search its contents for the best node.

By changing the number of buckets, you can get just the right blend of adding and removal time. Tweaking the parameters is time consuming, however, and is rarely needed. For very large graphs, such as those representing levels in massively multi-player online games, the speed up can be worth the programming effort. In most cases it is not.

There are still more complex implementations, such as "multi-level buckets," which have sorted lists of buckets containing lists of buckets containing unsorted items (and so on). I have built a pathfinding system that used a multi-level bucket list, but it was more an act of hubris than a programming necessity, and I wouldn't do it again!

Implementations

In my experience there is little performance difference between priority heaps and bucketed queues in game pathfinding. I have built production implementations using both approaches. For very large pathfinding problems (with millions of nodes in the graph), bucketed priority queues can be written that are kinder to the processor's memory cache and are therefore much faster. For indoor levels with a few thousand or tens of thousands of nodes, the simplicity of a priority heap (and the fact that an implementation is often provided by the language or runtime) is often more appealing.

Heuristic Function

The heuristic is often talked about as a function, and it can be implemented as a function. Throughout this book, I've preferred to show it in pseudo-code as an object. The heuristic object used in the algorithm has a simple interface:

```
class Heuristic:
      # An estimated cost to reach the goal from the given node.
2
      function estimate(node: Node) -> float
```

A Heuristic for Any Goal

Because it is inconvenient to produce a different heuristic function for each possible goal in the world, the heuristic is often parameterized by the goal node. In that way a general heuristic implementation can be written that estimates the distance between any two nodes in the graph. The interface might look something like:

```
class Heuristic:
      # Stores the goal node that this heuristic is estimating for.
2
3
      goalNode: Node
4
      # Estimated cost to reach the stored goal from the given node.
5
      function estimate(fromNode: Node) -> float:
6
           return estimate(fromNode, goalNode)
7
8
      # Estimated cost to move between any two nodes.
9
       function estimate(fromNode: Node, toNode: Node) -> float
```

which can then be used to call the pathfinder in code such as:

```
pathfindAStar(graph, start, end, new Heuristic(end))
```

Heuristic Speed

The heuristic is called at the lowest point in the loop. Because it is making an estimate, it might involve some algorithmic process. If the process is complex, the time spent evaluating heuristics might quickly dominate the pathfinding algorithm.

While some situations may allow you to build a lookup table of heuristic values, in most cases the number of combinations is huge so this isn't practical.

Unless your implementation is trivial, I recommend that you run a profiler on the pathfinding system and look for ways to optimize the heuristic. I have seen situations where developers tried to squeeze extra speed from the pathfinding algorithm when over 80% of the execution time was spent evaluating heuristics.

4.3.5 IMPLEMENTATION NOTES

The design of the A* algorithm we've looked at so far is the most general. It can work with any kind of cost value, with any kind of data type for nodes, and with graphs that have a huge range of sizes.

This generality comes at a price. There are better implementations of A^* for most game pathfinding tasks. In particular, if we can assume that there is only a relatively small number of nodes in the graph (up to 100,000, say, to fit in around 2Mb of memory), and that these nodes can be numbered using sequential integers, then we can speed up our implementation significantly.

I call this node array A* (although you should be aware that I've made this name up; strictly, the algorithm is still just A*), and it is described in detail below.

Depending on the structure of the cost values returned and the assumptions that can be made about the graph, even more efficient implementations can be created. Most of these are outside the scope of this book (there are easily a book's worth of minor variations on A* pathfinding variations), but the most important are given in a brief introduction at the end of this chapter.

The general A* implementation is still useful, however. In some cases you may need a variable number of nodes (if your game's level is being paged into memory in sections, for example), or there just isn't enough memory available for more complex implementations. The general A* implementation is still the most common, and can be the absolute fastest on occasions where more efficient implementations are not suitable.

4.3.6 ALGORITHM PERFORMANCE

Once again, the biggest factor in determining the performance of A^* is the performance of its key data structures: the pathfinding list, the graph, and the heuristic.

Once again, ignoring these, we can look simply at the algorithm (this is equivalent to assuming that all data structure operations take constant time).

The number of iterations that A^* performs is given by the number of nodes whose total estimated-path-cost is less than that of the goal. We'll call this number l, different from n in the performance analysis of Dijkstra. In general, l should be less than n. The inner loop of A^* has the same complexity as Dijkstra, so the total speed of the algorithm is O(lm), where m is the average number of outgoing connections from each node, as before. Similarly for memory usage, A^* ends with O(lm) entries in its open list, which is the peak memory usage for the algorithm.

In addition to Dijkstra's performance concerns of the pathfinding list and the graph, we add the heuristic function. In the pseudo-code above, the heuristic value is calculated once per node and then reused. Still, this occurs very low in the loop, in the order of $\mathrm{O}(l)$ times. If the heuristic value were not reused, it would be called $\mathrm{O}(lm)$ times.

Often, the heuristic function requires some processing and can dominate the execution load of the algorithm. It is rare, however, for its implementation to directly depend on the

size of the pathfinding problem. Although it may be time-consuming, the heuristic will most commonly have O(1) execution time and require O(1) memory and so will not have an effect on the order of the performance of the algorithm. This is an example of when the algorithm's order doesn't necessarily tell you very much about the real performance of the code.

4.3.7 NODE ARRAY A*

Node array A* is my name for a common implementation of the A* algorithm that is faster in many cases than the general A* implementation above. In the code we looked at so far, data are held for each node in the open or closed lists, and these data are held as a NodeRecord instance. Records are created when a node is first considered and then moved between the open and closed lists, as required.

There is a key step in the algorithm where the lists are searched for a node record corresponding to a particular node.

Keeping a Node Array

We can make a trade-off by increasing memory use to improve execution speed. To do this, we create an array of all the node records for every node in the whole graph before the algorithm begins. This node array will include records for nodes that will never be considered (hence the waste of memory), as well as for those that would have been created anyway.

If nodes are numbered using sequential integers, we don't need to search for a node in the two lists at all. We can simply use the node number to look up its record in the array (this is the logic of using node integers that I mentioned at the start of the chapter).

Checking if a Node Is in Open or Closed

We need to find the node data in order to check if we've found a better route to a node or if we need to add the node to one of the two lists.

Our original algorithm checked through each list, open and closed, to see if the node was already there. This is a very slow process, especially if there are many nodes in each list. It would be useful if we could look at a node and immediately discover what list, if any, it was contained in.

To find out which list a node is in, we add a new value to the node record. This value tells us which of the three categories the node is in: unvisited, open, or closed. This makes the search step very fast indeed (in fact, there is no search, and we can go straight to the information we need).

The new NodeRecord structure looks like the following:

```
# The structure used to track the information we need for each node.

class NodeRecord:
    node: Node
    connection: Connection
    costSoFar: float
    estimatedTotalCost: float
    category: {CLOSED, OPEN, UNVISITED}
```

where the category member is OPEN, CLOSED, or UNVISITED.

The Closed List Is Irrelevant

Because we've created all the nodes in advance, and they are located in an array, we no longer need to keep a closed list at all. The only time the closed list is used is to check if a node is contained within it and, if so, to retrieve the node record. Because we have the node records immediately available, we can find the record. With the record, we can look at the category value and see if it has been closed.

The Open List Implementation

We can't get rid of the open list in the same way because we still need to be able to retrieve the element with the lowest score. We can use the array for times when we need to retrieve a node record, from either open or closed lists, but we'll need a separate data structure to hold the priority queue of nodes.

Because we no longer need to hold a complete node record in the priority queue, it can be simplified. Often, the priority queue simply needs to contain the node numbers, whose records can be immediately looked up from the node array.

Alternatively, the priority queue can be intertwined with the node array records by making the node records part of a linked list:

```
# The structure used to track the information we need for each node.

class NodeRecord:

node: Node

connection: Connection

costSoFar: float

estimatedTotalCost: float

category: {CLOSED, OPEN, UNVISITED}

nextRecordInList: NodeRecord
```

Although the array will not change order, each element of the array has a link to the next record in a linked list. The sequence of nodes in this linked list jumps around the array and can be used as a priority queue to retrieve the best node on the open list.

Although I've seen implementations that add other elements to the record to support more complex priority queues, my experience is that this general approach leads to wasted memory

(most nodes aren't in the list, after all), unnecessary code complexity (the code to maintain the priority queue can look very ugly), and cache problems (jumping around memory should be avoided when possible). It is preferable to use a separate priority queue of node indices and estimated-total-cost values.

A Variation for Large Graphs

Creating all the nodes in advance is a waste of space if you aren't going to consider most of them. For small graphs on a PC, the memory waste is often worth it for the speed up. For large graphs, or for consoles with limited memory, it can be problematic.

In C, or other languages with pointers, we can blend the two approaches to create an array of pointers to node records, rather than an array of records themselves, setting all the pointers to NULL initially.

In the A* algorithm, we create the nodes when they are needed, as before, and set the appropriate pointer in the array. When we come to find what list a node is in, we can see if it has been created by checking if its pointer is NULL (if it is, then it hasn't been created and, by deduction, must be unvisited), if it is there, and if it is in either the closed or open list.

This approach requires less memory than allocating all the nodes in advance, but may still take up too much memory for very large graphs.

On the other hand, for languages with costly garbage collection (such as C#, used in the Unity engine), it can be preferable to allocate objects upfront when the level is loaded, rather than creating them and garbage collecting them at each pathfinding call. This approach is unsuitable in that situation.

4.3.8 CHOOSING A HEURISTIC

The more accurate the heuristic, the less fill A* will experience, and the faster it will run. If you can get a perfect heuristic (one that always returns the exact minimum path distance between two nodes), A* will only consider nodes along with the minimum-cost path: the algorithm becomes O(p), where p is the number of steps in the path.

Unfortunately, to work out the exact distance between two nodes, you typically have to find the shortest route between them. This would mean solving the pathfinding problem which is what we're trying to do in the first place! In only a few cases will a practical heuristic be accurate.

For non-perfect heuristics, A* behaves slightly differently depending on whether the heuristic is too low or too high.

Underestimating Heuristics

If the heuristic is too low, so that it underestimates the actual path length, A* takes longer to run. The estimated-total-cost will be biased toward the cost-so-far (because the heuristic value is smaller than reality). So A* will prefer to examine nodes closer to the start node, rather than those closer to the goal. This will increase the time it takes to find the route through to the goal.

If the heuristic underestimates in all possible cases, then the result that A* produces will be the best path possible. It will be the exact same path that the Dijkstra algorithm would generate. This avoids the problem I described earlier with sub-optimal paths.

If the heuristic ever overestimates, however, this guarantee is lost.

In applications where accuracy is more important than performance, it is important to ensure that the heuristic is underestimating. When you read articles about path planning in commercial and academic problems, accuracy is often very important, and so underestimating heuristics abound. This bias in the literature to underestimating heuristics often influences game developers. In practice, try to resist dismissing overestimating heuristics outright. A game isn't about optimum accuracy; it's about believability.

Overestimating Heuristics

If the heuristic is too high, so that it overestimates the actual path length, A^* may not return the best path. A^* will tend to generate a path with fewer nodes in it, even if the connections between nodes are more costly.

The estimated-total-cost value will be biased toward the heuristic. The A* algorithm will pay proportionally less attention to the cost-so-far and will tend to favor nodes that have less distance to go. This will move the focus of the search toward the goal faster, but with the prospect of missing the best routes to get there.

This means that the total length of the path may be greater than that of the best path. Fortunately, it doesn't mean you'll suddenly get very poor paths. It can be shown that if the heuristic overestimates by at most x (i.e., x is the greatest overestimate for any node in the graph), then the final path will be no more than x too long.

An overestimating heuristic is sometimes called an "inadmissible heuristic." This doesn't mean you can't use it; it refers to the fact that the A* algorithm no longer returns the shortest path.

Overestimates can make A^* faster if they are almost perfect, because they home in on the goal more quickly. If they are only slightly overestimating, they will tend to produce paths that are often identical to the best path, so the quality of results is not a major issue.

But the margin for error is small. As a heuristic overestimates more, it rapidly makes A* perform worse. Unless your heuristic is consistently close to perfect, it can be more efficient to underestimate, and you get the added advantage of getting the correct answer.

Let's look at some common heuristics used in games.

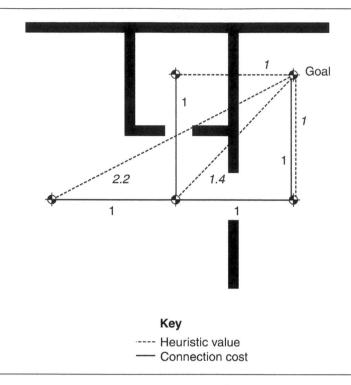

Figure 4.17: Euclidean distance heuristic

Euclidean Distance

Imagine that the cost values in our pathfinding problem refer to distances in the game level. The connection cost is generated by the distance between the representative points of two regions. This is a common case, especially in first-person shooter (FPS) games where each route through the level is equally possible for each character.

In this case (and in others that are variations on the pure distance approach), a common heuristic is Euclidean distance. It is guaranteed to be underestimating.

Euclidean distance is "as the crow flies" distance. It is measured directly between two points in space, through walls and obstructions.

Figure 4.17 shows Euclidean distances measured in an indoor level. The cost of a connection between two nodes is given by the distance between the representative points of each region. The estimate is given by the distance to the representative point of the goal node, even if there is no direct connection.

Euclidean distance is always either accurate or an underestimate. Traveling around walls or obstructions can only add extra distance. If there are no such obstructions, then the heuristic is accurate. Otherwise, it is an underestimate.

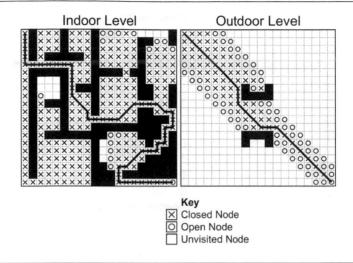

Figure 4.18: Euclidean distance fill characteristics

In outdoor settings, with few constraints on movement, Euclidean distance can be very accurate and provide fast pathfinding. In indoor environments, such as that shown in Figure 4.17, it can be a dramatic underestimate, causing less than optimal pathfinding.

Figure 4.18 shows the fill visualized for a pathfinding task through both tile-based indoor and outdoor levels. With the Euclidean distance heuristic, the fill for the indoor level is dramatic, and performance is poor. The outdoor level has minimal fill, and performance is good.

Cluster Heuristic

The cluster heuristic works by grouping nodes together in clusters. The nodes in a cluster represent some region of the level that is highly interconnected. Clustering can be done automatically using graph clustering algorithms that are beyond the scope of this book. Often, clustering is manual, however, or a by-product of the level design (portal-based game engines lend themselves well to having clusters for each room).

A lookup table is then prepared that gives the smallest path length between each pair of clusters. This is an offline processing step that requires running a lot of pathfinding trials between all pairs of clusters and accumulating their results. A sufficiently small set of clusters is selected so that this can be done in a reasonable time frame and stored in a reasonable amount of memory.

When the heuristic is called in the game, if the start and goal nodes are in the same cluster, then Euclidean distance (or some other fallback) is used to provide a result. Otherwise,

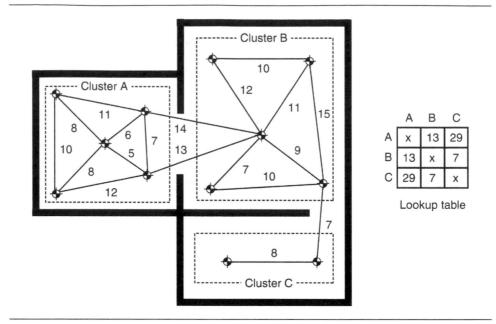

Figure 4.19: The cluster heuristic

the estimate is looked up in the table. This is shown in Figure 4.19 for a graph where each connection has the same cost in both directions.

The cluster heuristic often dramatically improves pathfinding performance in indoor areas over Euclidean distance, because it takes into account the convoluted routes that link seemingly nearby locations (the distance through a wall may be tiny, but the route to get between the rooms may involve lots of corridors and intermediate areas).

It has one caveat, however. Because all nodes in a cluster are given the same heuristic value, the A* algorithm cannot easily find the best route through a cluster. Visualized in terms of fill, a cluster will tend to be almost completely filled before the algorithm moves on to the next cluster.

If cluster sizes are small, then this is not a problem, and the accuracy of the heuristic can be excellent. On the other hand, the lookup table will be large (and the pre-processing time will be huge).

If cluster sizes are too large, then there will be marginal performance gain, and a simpler heuristic would be a better choice.

I've seen and experimented with various modifications to the cluster heuristic to provide better estimates within a cluster, including some that include several Euclidean distance calculations for each estimate. There are opportunities for performance gain here, but as yet there are no accepted techniques for reliable improvement. It seems to be a case of experimenting in the context of your game's particular level design.

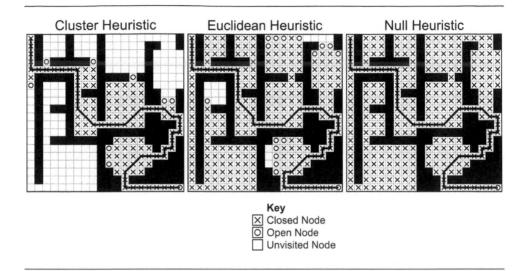

Figure 4.20: Fill patterns indoors

Clustering is intimately related to hierarchical pathfinding, explained in Section 4.6, which also clusters sets of locations together. Some of the calculations we'll meet there for distance between clusters can be adapted to calculate the heuristics between clusters.

Even without such optimizations, the cluster heuristic is worth trying for labyrinthine indoor levels.

Fill Patterns in A*

Figure 4.20 shows the fill patterns of a tile-based indoor level using A* with different heuristics.

The first example uses a cluster heuristic tailored specifically to this level. The second example used a Euclidean distance, and the final example has a zero heuristic which always returns 0 (the most dramatic underestimate possible). The fill increases in each example; the cluster heuristic has very little fill, whereas the zero heuristic fills most of the level.

This is a good example of the knowledge vs. search trade-off we looked at in Chapter 2.

If the heuristic is more complex and more tailored to the specifics of the game level, then the A^* algorithm needs to search less. It provides a good deal of knowledge about the problem. The ultimate extension of this is a heuristic with ultimate knowledge: completely accurate estimates. As we have seen, this would produce optimum A^* performance with no search.

On the other hand, the Euclidean distance provides a little knowledge. It knows that the cost of moving between two points depends on their distance apart. This little bit of knowledge helps, but still requires more searching than a better heuristic.

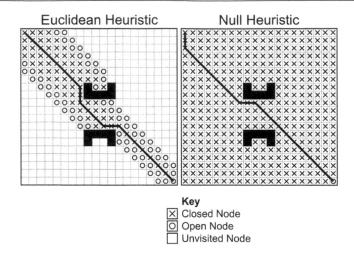

Figure 4.21: Fill patterns outdoors

The zero heuristic has no knowledge, and it requires lots of search.

In our indoor example, where there are large obstructions, the Euclidean distance is not the best indicator of the actual distance. In outdoor maps, it is far more accurate. Figure 4.21 shows the zero and Euclidean heuristics applied to an outdoor map, where there are fewer obstructions. Now the Euclidean heuristic is more accurate, and the fill is correspondingly lower.

In this case Euclidean distance is a very good heuristic, and we have no need to try to produce a better one. In fact, cluster heuristics don't tend to improve performance (and can dramatically reduce it) in open outdoor levels.

Quality of Heuristics

Producing a heuristic is far more of an art than a science. Its significance is underestimated by AI developers. With the speed of current generation games hardware, many developers use a simple Euclidean distance heuristic in all cases. Unless pathfinding is a significant part of your game's processor budget, it may not be worth giving it any more thought.

If you do attempt to optimize the heuristic, the only surefire way is to visualize the fill of your algorithm. This can be in-game or using output statistics that you can later examine. Acting blind is dangerous. I've found to my cost that tweaks to the heuristic I thought would be beneficial have produced inferior results.

Dijkstra Is A*

It is worth noticing that the Dijkstra algorithm is a subset of the A* algorithm. In A* we calculate the estimated-total-cost of a node by adding the heuristic value to the cost-so-far. A* then chooses a node to process based on this value.

If the heuristic always returns 0, then the estimated-total-cost will always be equal to the cost-so-far. When A* chooses the node with the smallest estimated-total-cost, it is choosing the node with the smallest cost-so-far. This is identical to Dijkstra. A* with a zero heuristic is the point to point version of Dijkstra.

4.4 WORLD REPRESENTATIONS

So far I've assumed that pathfinding takes place on a graph made up of nodes and connections with costs. This is the world that the pathfinding algorithm knows about, but game environments aren't made up of nodes and connections.

To squeeze your game level into the pathfinder you need to do some translation—from the geometry of the map and the movement capabilities of your characters to the nodes and connections of the graph and the cost function that values them.

For each pathfinding world representation, we must divide the game level into linked regions that correspond to nodes and connections. The different ways this can be achieved are called division schemes. Each division scheme has three important properties we'll consider in turn: quantization/localization, generation, and validity.

You might also be interested in Chapter 12, Tools and Content Creation, which looks at how the pathfinding data are created by the level designer or by an automatic process. In a complete game, the choice of world representation will have as much to do with your toolchain as technical implementation issues.

Quantization and Localization

Because the pathfinding graph will be simpler than the actual game level, some mechanism is needed to convert locations in the game into nodes in the graph. When a character decides it wants to reach a switch, for example, it needs to be able to convert its own position and the position of the switch into graph nodes. This process is called *quantization*.

Similarly, if a character is moving along a path generated by the pathfinder, it needs to convert nodes in the plan back into game world locations so that it can move correctly. This is called localization.

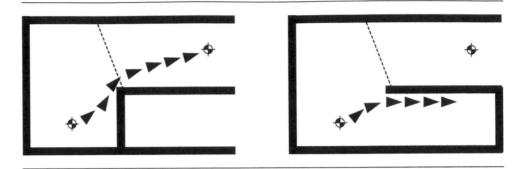

Figure 4.22: Two poor quantizations show that a path may not be viable

Generation

There are many ways of dividing up a continuous space into regions and connections for pathfinding. There are a handful of standard methods used regularly. Each works either manually (the division being done by hand) or algorithmically.

Ideally, of course, we'd like to use techniques that can be run automatically. On the other hand, manual techniques often give the best results, as they can be tuned for each particular game level.

The most common division scheme used for manual techniques is the Dirichlet domain. The most common algorithmic methods are tile graphs, points of visibility, and navigation meshes. Of these, navigation meshes and points of visibility are often augmented so that they automatically generate graphs with some user supervision.

Validity

If a plan tells a character to move along a connection from node A to node B, then the character should be able to carry out that movement. This means that wherever the character is in node A, it should be able to get to any point in node B. If the quantization regions around A and B don't allow this, then the pathfinder may have created a useless plan.

A division scheme is valid if all points in two connected regions can be reached from each other. In practice, most division schemes don't enforce validity. There can be different levels of validity, as Figure 4.22 demonstrates.

In the first part of the figure, the issue isn't too bad. An "avoid walls" algorithm (see Chapter 3) would easily cope with the problem. In the second figure with the same algorithm, it is terminal. Using a division scheme that gave the second graph would not be sensible. Using the first scheme will cause fewer problems. Unfortunately, the dividing line is difficult to predict, and an easily handled invalidity is only a small change away from being pathological.

It is important to understand the validity properties of graphs created by each division

scheme; at the very least it has a major impact on the types of character movement algorithm that can be used.

So, let's look at the major division schemes used in games.

4.4.1 TILE GRAPHS

Tile-based levels, in the form of two-dimensional (2D) isometric graphics, were ubiquitous at one point, and now are mostly seen in indie games. The tile is far from dead, however. Although strictly not made up of tiles, a large number of games use grids in which they place their three-dimensional (3D) models. Underlying the graphics is still a regular grid. A game such as Fortnite: Battle Royale [111], for example, places its buildings and structures on a strict grid to allow players' buildings to connect with them seamlessly.

Such a grid can be simply turned into a tile-based graph. Most real-time strategy (RTS) games still use tile-based graphs extensively, and many outdoor games use graphs based on height and terrain data.

Tile-based levels split the whole world into regular, usually square, regions (although hexagonal regions are occasionally seen in turn-based war simulation games).

Division Scheme

Nodes in the pathfinder's graph represent tiles in the game world. Each tile in the game world normally has an obvious set of neighbors (the eight surrounding tiles in a rectangular grid, for example, or the six in a hexagonal grid). The connections between nodes correspond to a link between a tile and its immediate neighbors.

Quantization and Localization

We can determine which tile any point in the world is within, and this is often a fast process. In the case of a square grid, we can simply use a character's x and z coordinates to determine the square it is contained in. For example:

```
tileX: int = floor(x / tileSize)
tileZ: int = floor(z / tileSize)
```

where floor is a function that returns the highest valued integer less than or equal to its argument, and tileX and tileZ identify the tile within the regular grid of tiles.

Similarly, for localization we can use a representative point in the tile (often the center of the tile) to convert a node back into a game location.

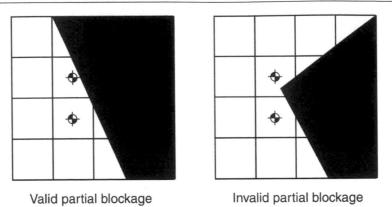

Figure 4.23: Tile-based graph with partially blocked validity

Generation

Tile-based graphs are generated automatically. In fact, because they are so regular (always having the same possible connections and being simple to quantize), they can be generated at runtime. An implementation of a tile-based graph doesn't need to store the connections for each node in advance. It can generate them as they are requested by the pathfinder.

Most games allow tiles to be blocked. In this case the graph will not return connections to blocked tiles, and the pathfinder will not try to move through them.

For tile-based grids representing outdoor height fields (a rectangular grid of height values), the costs often depend on gradient. The height field data are used to calculate a connection cost based both on distance and on gradient. Each sample in the height field represents the center point of a tile in the graph, and costs can be calculated based on distance and the change in elevation between the two points. In this way it will cost less to go downhill than uphill.

Validity

In many games that use tile-based layouts, a tile will be either completely blocked or completely empty. In this case, if the only tiles that are connected are empty, then the graph will be guaranteed to be valid.

When a graph node is only partially blocked, then the graph may not be valid, depending on the shape of the blockage. Figure 4.23 shows two cases: one in which a partial blockage does not make the graph invalid, and another in which it does.

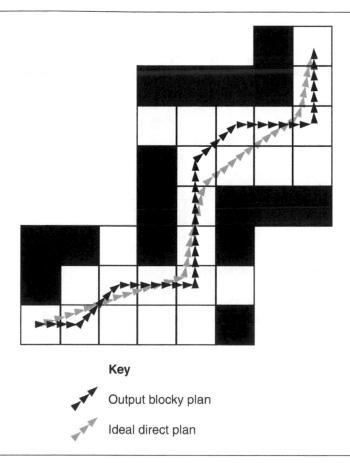

Figure 4.24: Tile-based plan is blocky

Usefulness

While tile-based levels are one of the easiest to convert to a graph representation, there are often a vast number of tiles in the game. A small RTS level can have many hundreds of thousands of tiles. This means that the pathfinder has to work hard to plan sensible paths.

When the plans returned by the pathfinder are drawn on the graph (using localization for each node in the plan), they can appear blocky and irregular. Characters following the plan will look strange. This is illustrated in Figure 4.24.

While this is a problem with all division schemes, it is most noticeable for tile-based graphs (see Section 4.4.7 on path smoothing for an approach to solving this problem).

Figure 4.25: Dirichlet domains as cones

DIRICHLET DOMAINS

A Dirichlet domain, also referred to as a Voronoi polygon in two dimensions, is a region around one of a finite set of source points whose interior consists of everywhere that is closer to that source point than any other.

Division Scheme

Pathfinding nodes have an associated point in space called the *characteristic point*, and the quantization takes place by mapping all locations in the point's Dirichlet domain to the node. To determine the node for a location in the game, we find the characteristic point that is closest.

The set of characteristic points is usually specified by a level designer as part of the level data.

You can think of Dirichlet domains as being cones originating from the source point. If you view them from the top, as in Figure 4.25, the area of each cone that you see is the area that "belongs" to that source point. This is often a useful visualization for troubleshooting.

The basic idea has been extended to use different falloff functions for each node, so some nodes have a larger "pull" than others in the quantization step. This is sometimes called a weighted Dirichlet domain: each point has an associated weight value that controls the size of its region. Changing the weight is equivalent to changing the slope on the cone; squatter cones end up with larger regions. But care needs to be taken. Once you change the slope, you can get strange effects.

Figure 4.26 shows the Dirichlet domains in a passageway. You can see that the end of the passageway belongs to the wrong source point: the fat cone has peaked back out. This can make it difficult to debug pathfinding problems.

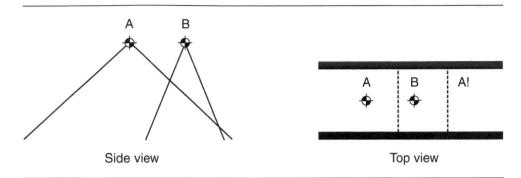

Figure 4.26: Problem domains with variable falloff

If you are manually assigning weighted Dirichlet domains, it's a good idea to have them displayed to check for overlapping problems.

Connections are placed between bordering domains. The pattern of connections can be found using a mathematical structure that has deep connections to Voronoi diagrams, called a *Delaunay triangulation*. The edges of the Delaunay triangulation are the connections in the graph, and the vertices are the characteristic points of the domains. Creating a Delaunay triangulation of a set of points is beyond the scope of this book. There are many websites dedicated to the algorithms for constructing a Delaunay triangulation. For an academic survey of the approaches, see [66].

Many developers don't bother with a mathematically correct algorithm, however. They either make the artist specify connections as part of their level design, or they ray cast between points to check for connections (see the points of visibility method below). Even if you use the Delaunay triangulation method, you will need to check that domains that touch can actually be moved between, as there might be a wall in the way, for example.

Quantization and Localization

Positions are quantized by finding the characteristic point that is closest.

Searching through all points to find the closest is a time-consuming process (an O(n) process, where n is the number of domains). Typically, we will use some kind of spatial partitioning algorithm (quad-tree, octree, binary space partition, or multi-resolution map) to allow us to consider only those points that are nearby.

The localization of a node is given by the position of the characteristic point that forms the domain (i.e., the tip of the cone in the example above).

Validity

Dirichlet domains can form intricate shapes. There is no way to guarantee that traveling from a point in one domain to a point in a connected domain will not pass through a third domain. This third domain might be impassable and might have been discounted by the pathfinder. In this case, following the path will lead to a problem. Strictly, therefore, Dirichlet domains produce invalid graphs.

In practice, however, the placement of nodes is often based on the structure of obstacles. Obstacles are not normally given their own domains, and so the invalidity of the graph is rarely exposed.

To make sure, you can provide some kind of backup mechanism (like an avoid walls steering behavior) to solve the issue and avoid your characters happily running headfirst into walls.

Usefulness

Dirichlet domains are very widely used. They have the advantage of being very easy to program (automatic generation of connections aside) and easy to change. It is possible to rapidly change the structure of the pathfinding graph in a level-editing tool without having to change any level geometry.

4.4.3 POINTS OF VISIBILITY

It can be shown that the optimal path through any 2D environment will always have inflection points (i.e., points on the path where the direction changes) at convex vertices in the environment. If the character that is moving has some radius, these inflection points are replaced by arcs of a circle at a distance away from the vertex. This is illustrated in Figure 4.27.

In three dimensions, the same thing applies, but inflection points are located at either convex polygon edges or vertices.

In either case, we can approximate these inflection points by choosing a characteristic point that is shifted out from the vertices a short distance. This will not give us the curves, but it will give us believable paths. These new characteristic points can be calculated from the geometry by extending out the geometry a little way and calculating where the edges of the new geometry are.

Division Scheme

Since these inflection points naturally occur in the shortest path, we can use them as nodes in the pathfinding graph.

Working on the actual level geometry will provide us with far too many inflection points. A simplified version is needed so that we can find inflection points where the large-scale ge-

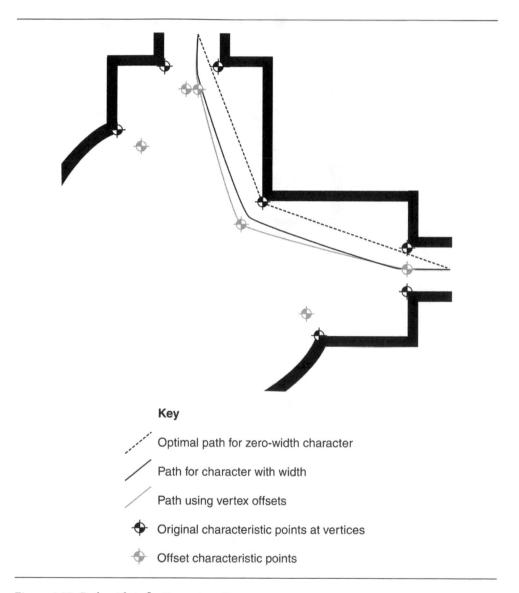

Figure 4.27: Path with inflections at vertices

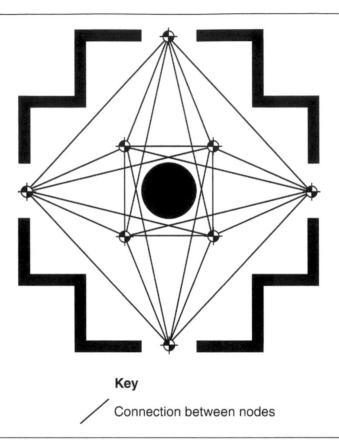

Figure 4.28: Points of visibility graph bloat

ometry changes. It may be possible to take these points from collision geometry, or they may need to be generated specially.

These inflection points can then be used as the node locations to build a graph.

To work out how these points are connected, rays are cast between them, and a connection is made if the ray doesn't collide with any other geometry. This is almost equivalent to saying that one point can be seen from the other. For this reason it is called a "points of visibility" approach. In many cases the resultant graph is huge. A complex cavern, for example, may have many hundreds of inflection points, each of which may be able to see most of the others. This is shown in Figure 4.28.

Quantization, Localization, and Validity

Points of visibility are usually taken to represent the centers of Dirichlet domains for the purpose of quantization.

In addition, if Dirichlet domains are used for quantization, points quantized to two connected nodes may not be able to reach each other. As we saw in Dirichlet domains above, this means that the graph is strictly invalid.

Usefulness

Despite its major shortcomings, a points of visibility approach is a relatively popular method for automatic graph generation.

However, in my opinion the results are not worth the effort. Initial results are positive but a lot of fiddling and clearing up by hand is needed to produce a final graph, which defeats the object. I'd recommend looking at navigation meshes instead: they share a lot of the same benefits, but dramatically reduce the number of connections, and require much less adjustment.

4.4.4 NAVIGATION MESHES

Tile-based graphs, Dirichlet domains, and points of visibility are all useful division schemes to have in your toolbox, but the majority of modern games with 3D environments use navigation meshes (often abbreviated to "navmesh") for pathfinding.

The navigation mesh approach to pathfinding takes advantage of the fact that the level designer already needs to specify the way the level is connected, the regions it has, and whether there is any AI in the game or not. The level itself is made up of polygons connected to other polygons. We can use this graphical structure as the basis of a pathfinding representation.

Division Scheme

Many games use floor polygons, as defined by artists, as regions. Each polygon acts as a node in the graph, as shown in Figure 4.29.

The graph is based on the mesh geometry of the level and therefore is often called a navigation mesh, or just "navmesh."

As the number of polygons in a scene has increased dramatically, over the last 15 years, it has become rarer for floors to be represented by a small number of large triangles. In the same way that the points-of-visibility approach requires simplified stand-in geometry to make its graphs tractable, navigation meshes are rarely able to work on the same geometry as the renderer. It is fairly common, however, for a scene to require a separate simplified collision geometry. This geometry is usually simple enough to build a navigation mesh.

Regardless of the source of the geometry, nodes in the graph represent polygons. Two

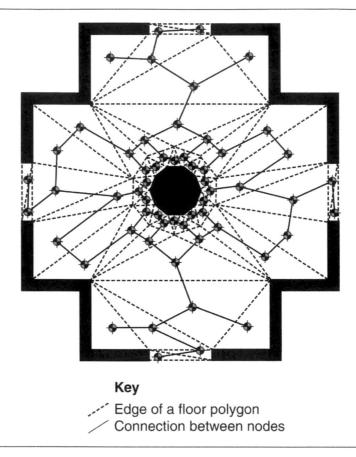

Figure 4.29: Polygonal mesh graph

nodes are connected if their corresponding polygons share an edge. Floor polygons are typically triangles, but may be quads. Nodes therefore have either three or four connections.

Creating a navigation mesh usually involves the artist labeling particular polygons as floor in their modeling package. They may need to do this anyway to specify sound effects or grip characteristics. Navigation meshes require less artist intervention than other approaches, with the exception of tile-based graphs.

Quantization and Localization

A position is localized into the floor polygon that contains it. We could search a large number of polygons to find the right one, or use a complex spatial data structure to speed up the query. But often we are better off using a coherence assumption.

Figure 4.30: Quantization into a gap

Coherence refers to the fact that, if we know which location a character was in at the previous frame, it is likely to be in the same node or an immediate neighbor on the next frame. We can check these nodes first. This approach is useful in lots of division schemes, but is particularly crucial when dealing with navigation maps.

However we determine the node, care must be taken when a character is not touching the floor. If we simply find the polygon vertically below it and quantize it there, it is possible for the character to be placed in a completely inappropriate node as it falls or jumps. In Figure 4.30, for example, the character is quantized to the bottom of the room, even though it is actually using the walkways above. This may then cause the character to replan its route as if it were in the bottom of the room; not the desired effect. Coherence can help here too, avoiding assigning a character to a node far from where it was last seen. But coherence alone does not solve all problems. Some special case code is generally needed that knows when a character is jumping, and either postpones pathfinding, or uses trajectory prediction to determine where it will land.

Localization can choose any point in the polygon, but normally uses the geometric center (the average position of its vertices). This works fine for triangles. For quads or polygons with more sides, the polygon must be convex for this to work. Geometric primitives used in graphics or physics engines have this requirement anyway. So if we are using the same primitives used for rendering or collision detection, we are safe.

Figure 4.31: Non-interpolation of the navigation mesh

Validity

The regions generated by navigation meshes can be problematic. We have assumed that any point in one region can move directly to any point in a connected region, but this may not be the case. See Figure 4.31 for an example that contains a pair of triangles with areas where traveling directly between them causes a collision.

Because floor polygons are created by the level designer, this situation can be mitigated. The geometry naturally created by most sensible level designers does not suffer from major problems.

Usefulness

Using this approach also requires additional processing to take into account the agent's geometry. Since not all locations in a floor polygon may be occupied by a character (some are too close to walls or other obstacles), some trimming is required; this may affect the connections generated by finding shared edges. This problem is especially evident at convex areas such as doorways.

For the occasional game that needs it, this approach offers the additional benefit of allowing characters to plan routes up walls, across ceilings, or for any other kind of geometry. This might be useful if characters stick to walls, for example. It is much more difficult to achieve the same result with other world representations.

Figure 4.32: Portal representation of a navigation mesh

Edges as Nodes

Floor polygons can also be converted into a pathfinding graph by assigning nodes to the edges between polygons and using connections across the face of each polygon. Figure 4.32 illustrates this.

This approach is also commonly used in association with portal-based rendering, where nodes are assigned to portals and where connections link all portals within the line of sight of one another. Portal rendering is a graphics technique where the geometry of the whole level is split into chunks, linked by portals, a 2D polygonal interface between the regions. By separating the level into chunks, it is easier to test which chunks need to be drawn, reducing the rendering time. Full details are beyond the scope of this book, but should be covered in any good modern text on game engine design.

In the navigation mesh, the edges of every floor polygon act like a portal and therefore have their own node. We don't need to do the line-of-sight tests. By definition, each edge of a convex floor polygon can be seen from every other edge.

Some articles suggest that the nodes on the edges of floor polygons are placed dynamically in the best position as the pathfinder does its work. Depending on the direction that the character is moving, the nodes should be at a different location. This is shown in Figure 4.33.

This is a kind of continuous pathfinding, and we'll look at the algorithm for continuous pathfinding later in the chapter. In my opinion, however, this approach is overkill. It is better to work with the faster fixed graph. If the resulting path looks too crinkled, then a path smoothing step (which I'll cover in Section 4.4.7) is perfectly sufficient.

Both the polygon-as-node and the edge-as-node representations are known as navigation

Figure 4.33: Different node positions for different directions

meshes. Often, one or the other approach is assumed, so it is worth making sure that whatever source you are using makes it clear which version they are talking about.

4.4.5 NON-TRANSLATIONAL PROBLEMS

There is nothing in the above discussion about regions and connections that requires us to be dealing with positions only.

In some tile-based games, where agents cannot turn quickly, tiles are created for each location and orientation, so an agent with a large turning circle can only move to a tile with a slightly different orientation in one step.

In Figure 4.34 an agent cannot turn without moving and can only turn by 90° at a time. Nodes A1, A2, A3, and A4 all correspond to the same location. They represent different orientations, however, and they have different sets of connections. The quantization of an agent's state into a graph node needs to take account of both its position and its orientation.

The result from planning on this graph will represent a sequence of translations and rotations. A plan on the graph in Figure 4.34 is shown in Figure 4.35.

4.4.6 COST FUNCTIONS

In the simplest cases, where we are interested in finding the shortest path, the cost of a connection can represent distance. The higher the cost, the larger the distance between nodes.

If we are interested in finding the quickest path to move along, we could use costs that depend on time. This isn't the same thing as distance; it is quicker to run 10 feet than to climb a 10-foot ladder.

Navigation software that plans a route on the road network uses exactly the algorithms in this chapter. Navigation apps often give users a choice between the fastest route and the shortest route, by modifying the cost function in this way.

Figure 4.34: A non-translational tile-based world

In games, we can add all sorts of other concerns to the costs on a graph. In an RTS, for example, we could make certain connections more costly if they were exposed to enemy fire or if they wandered too near to dangerous terrain. The final path would then be the one with the lowest danger.

Often, the cost function is a blend of many different concerns, and there can be different cost functions for different characters in a game. A reconnaissance squad, for example, may be interested in visibility and speed. A heavy artillery weapon would be more interested in terrain difficulty. Pathfinding that incorporates these concerns is called tactical pathfinding, and we'll look at it in depth in Chapter 6.

4.4.7 PATH SMOOTHING

A path that travels from node to node through a graph can appear erratic. Sensible node placing can give rise to very odd looking paths. Figure 4.36 shows a section of a level with nodes placed in a reasonable manner. The path constantly switches direction; a character following the path will not look intelligent.

Some world representations are more prone to rough paths than others. Portal representa-

Figure 4.35: Plan on a non-translational tile graph

tions with points of visibility connections can give rise to very smooth paths, while tile-based graphs tend to be highly erratic. The final appearance also depends on how characters act on the path. If they are using some kind of path following steering behavior (see Chapter 3), then the path will be gently smoothed by the steering. It is worth testing your game before assuming the path will need additional modification.

For some games, path smoothing is essential to get the AI looking smart. The path smoothing algorithm is relatively simple to implement but involves queries to the level geometry. Therefore, it can be somewhat time-consuming.

The Algorithm

We start with an input path, as generated from A*, or another pathfinding algorithm. We will assume in this algorithm that there is a clear route between any two adjacent nodes in the input path. In other words, we are assuming that the division scheme is valid.

To smooth the input path, we first create a new empty path. This is the output path. We add the start node to it. The output path will start and end at the same nodes as the input path.

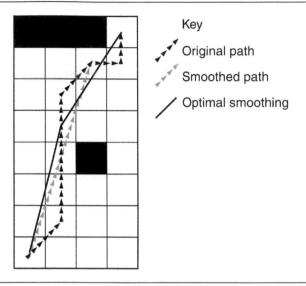

Figure 4.36: Smoothed path with optimal smoothing indicated

Starting at the third node in the input path, a ray is cast to each node in turn from the last node in the output path. We start at the third node because we are assuming that there is a clear line (a passed ray cast) between the first and second nodes.

When a ray fails to get through, the previous node in the input path is added to the output path. Ray casting starts again from the next node in the input path. When the end node is reached, it is added to the output path. The output path is used as the path to follow.

Figure 4.36 illustrates a path that has been smoothed with this algorithm.

Although this algorithm produces a smooth path, it doesn't search all possible smoothed paths to find the best one. The figure shows the smoothest possible path in our example; it cannot be generated by this algorithm. To generate the smoothest path, we'd need another search among all possible smoothed paths. This is rarely, if ever, necessary.

Pseudo-Code

The path smoothing algorithm takes an input path made up of nodes and returns a smoothed output path:

```
function smoothPath(inputPath: Vector[]) -> Vector[]:
    # If the path is only two nodes long, then we can't smooth it, so
    # return.
    if len(inputPath) == 2:
        return inputPath
```

```
6
       # Compile an output path.
       outputPath = [inputPath[0]]
       # Keep track of where we are in the input path. We start at 2,
10
11
       # because we assume two adjacent nodes will pass the ray cast.
12
       inputIndex: int = 2
13
       # Loop until we find the last item in the input.
14
       while inputIndex < len(inputPath) - 1:
15
           # Do the ray cast.
16
           fromPt = outputPath[len(outputPath) - 1]
17
           toPt = inputPath[inputIndex]
18
           if not rayClear(fromPt, toPt):
19
                # The ray cast failed, add the last node that passed to
                # the output list.
21
                outputPath += inputPath[inputIndex - 1]
22
23
           # Consider the next node.
24
           inputIndex ++
25
26
       # We've reached the end of the input path, add the end node to the
27
       # output and return it.
28
       outputPath += inputPath[len(inputPath) - 1]
29
30
       return outputPath
31
```

Data Structures and Interfaces

The pseudo-code works with paths that are a list of nodes. The pathfinding algorithms so far have returned a path as a list of connections. Although we could take this kind of path as input, the output path cannot be made up of connections. The smoothing algorithm links nodes that are in line of sight, but are unlikely to have any connections between them (if they were connected in the graph, the pathfinder would have found the smoothed route directly, unless their connections had dramatically large costs).

Performance

The path smoothing algorithm is O(1) in memory, requiring only temporary storage. It is O(n) in time, where n is the number of nodes in the path.

The majority of the time spent in this algorithm is spent carrying out ray casting checks.

4.5 IMPROVING ON A*

With a good heuristic, A* is a very efficient algorithm. Even simple implementations can plan across many tens of thousands of nodes in a frame. Even better performance can be achieved using additional optimizations, such as those we considered in the previous sections.

Many game environments are huge and contain hundreds of thousands or even millions of locations. Massively multi-player online games (MMOGs) may be hundreds of times larger still. While it is possible to run an A* algorithm on an environment of this size, it will be extremely slow and take a huge amount of memory. The results are also less than practical. If a character is trying to move between cities in an MMOG, then a route that tells it how to avoid a small boulder in the road five miles away is overkill. This problem can be better solved using hierarchical pathfinding.

Often, many different plans need to be made in quick succession: a whole army may need to plan its routes through a battlefield, for example. Other techniques, such as dynamic pathfinding, can increase the speed of replanning, and a number of A* variations dramatically reduce the amount of memory required to find a path, at the cost of some performance.

The remainder of this chapter will look at some of these issues in detail and will try to give a flavor for the range of different A* variations that are possible.

4.6 HIERARCHICAL PATHFINDING

Hierarchical pathfinding plans a route in much the same way as a person would. We plan a course overview route first and then refine it as needed. The high-level overview route might be "To get to the rear parking lot, we'll go down the stairs, out of the front lobby, and around the side of the building," or "We'll go through the office, out the fire door, and down the fire escape." For a longer route, the high-level plan would be even more abstract: "To get to the London office, we'll go to the airport, catch a flight, and get a cab when we land."

Each stage of the path will consist of another route plan. To get to the airport, for example, we need to know the route. The first stage of this route might be to get to the car. This, in turn, might require a plan to get to the rear parking lot, which in turn will require a plan to maneuver around the desks and get out of the office.

This is a very efficient way of pathfinding. To start with, we plan the abstract route, take the first step of that plan, find a route to complete it, and so on down to the level where we can actually move. After the initial multi-level planning, we only need to plan the next part of the route when we complete a previous section. When we arrive at the bottom of the stairs, on our way to the parking lot (and from there to the London office), we plan our route through the lobby. When we arrive at our car, we then have completed the "get to the car" stage of our more abstract plan, and we can plan the "drive to the airport" stage.

The plan at each level is typically simple, and we split the pathfinding problem over a long period of time, only doing the next bit when the current bit is complete.

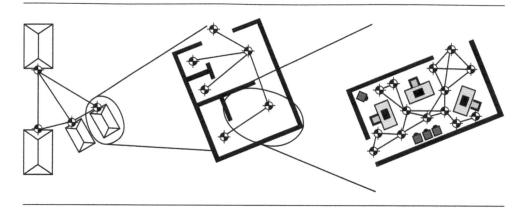

Figure 4.37: Hierarchical nodes

4.6.1 THE HIERARCHICAL PATHFINDING GRAPH

To be able to pathfind at higher levels we can still use the A* algorithm and all its optimizations. In order to support hierarchical pathfinding, we need to alter the graph data structure.

Nodes

This is done by grouping locations together to form clusters. The individual locations for a whole room, for example, can be grouped together. There may be 50 navigation points in the room, but for higher level plans they can be treated as one. This group can be treated as a single node in the pathfinder, as shown in Figure 4.37.

This process can be repeated as many times as needed. The nodes for all the rooms in one building can be combined into a single group, which can then be combined with all the buildings in a complex, and so on. The final product is a hierarchical graph. At each level of the hierarchy, the graph acts just like any other graph you might pathfind on.

To allow pathfinding on this graph, you need to be able to convert a node at the lowest level of the graph (which is derived from the character's position in the game level) to one at a higher level. This is the equivalent of the quantization step in regular graphs. A typical implementation will store a mapping from nodes at one level to groups at a higher level.

Connections

Pathfinding graphs require connections as well as nodes. The connections between higher level nodes need to reflect the ability to move between grouped areas. If any low-level node

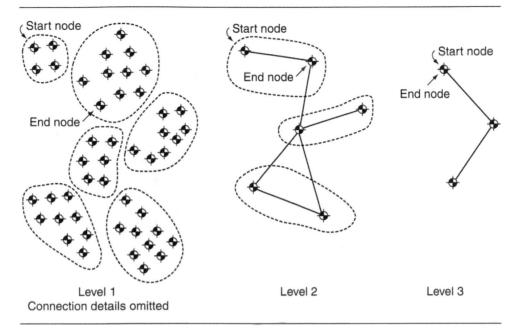

Figure 4.38: A hierarchical graph

in one group is connected to any low-level node in another group, then a character can move between the groups, and the two groups should have a connection.

Figure 4.38 shows the connections between two nodes based on the connectivity of their constituent nodes at the next level down in the hierarchy.

Connection Costs

The cost of a connection between two groups should reflect the difficulty of traveling between them. This can be specified manually, or it can be calculated from the cost of the low-level connections between those groups.

This is a complex calculation, however. Figure 4.39 shows that the cost of moving from group C to group D depends on whether you entered group C from group A (a cost of 5) or from group B (a cost of 2).

In general, the grouping should be chosen to minimize this problem, but it cannot be resolved easily.

There are three heuristics that are commonly used, straight or blended, to calculate the connection cost between groups.

Figure 4.39: A tile-based representation of a level with groups marked

Minimum Distance

The first is minimum distance. This heuristic says that the cost of moving between two groups is the cost of the cheapest link between any nodes in those groups. This makes sense because the pathfinder will try to find the shortest route between two locations. In the example above, the cost of moving from C to D would be 1. Note that if you entered C from either A or B, it would take more than one move to get to D. The value of 1 is almost certainly too low, but this may be an important property depending on how accurate you want your final path to be.

Maximin Distance

The second is the "maximin" distance. For each incoming link, the minimum distance to any suitable outgoing link is calculated. This calculation is usually done with a pathfinder. The largest of these values is then added to the cost of the outgoing link and used as the cost between groups.

In the example, to calculate the cost of moving from C to D, two costs are calculated: the minimum cost from C1 to C5 (4) and the minimum cost from C6 to C7 (1). The largest of these (C1 to C5) is then added to the cost of moving from C5 to D1 (1). This leaves a final cost from C to D of 5. To get from C to D from anywhere other than C1, this value will be too high. Just like the previous heuristic, this may be what you need.

Average Minimum Distance

A value in the middle of these extremes is sometimes better. The "average minimum" distance is a good general choice. This can be calculated in the same way as the maximin distance, but the values are averaged, rather than simply selecting the largest. In our example, to get from

C to D coming from B (i.e., via C6 and C7), the cost is 2, and when coming from A (via C2 to C5) it is 5. So the average cost of moving from C to D is $\frac{31}{2}$.

Summary of the Heuristics

The minimum distance heuristic is very optimistic. It assumes that there will never be any cost to moving around the nodes within a group. The maximin distance heuristic is pessimistic. It finds one of the largest possible costs and always uses that. The average minimum distance heuristic is pragmatic. It gives the average cost you'll pay over lots of different pathfinding requests.

The approach you choose isn't only dictated by accuracy; each heuristic has an effect on the kinds of paths returned by a hierarchical pathfinder. We'll return to why this is so after we look in detail at the hierarchical pathfinding algorithm.

4.6.2 PATHFINDING ON THE HIERARCHICAL GRAPH

Pathfinding on a hierarchical graph uses the normal A* algorithm. It applies the A* algorithm several times, starting at a high level of the hierarchy and working down. The results at high levels are used to limit the work it needs to do at lower levels.

Algorithm

Because a hierarchical graph may have many different levels, the first task is to find which level to begin on. We want as high a level as possible, so we do the minimum amount of work. However, we also don't want to be solving trivial problems either.

The initial level should be the first in which the start and goal locations are not at the same node. Any lower and we would be doing unnecessary work; any higher and the solution would be trivial, since the goal and start nodes are identical.

In Figure 4.38 the pathfinding should take place initially at level 2, because level 3 has the start and end locations at the same node.

Once a plan is found at the start level, then the initial stages of the plan need to be refined. We refine the initial stages because those are the most important for moving the character. We won't initially need to know the fine detail of the end of the plan; we can work that out nearer the time.

The first stage in the high-level plan is considered (occasionally, it can be useful to consider the first few; this is a heuristic that needs to be tried for different game worlds). This small section will be refined by planning at a slightly lower level in the hierarchy.

The start point is the same, but if we kept the end point the same we'd be planning through the whole graph at this level, so our previous planning would be wasted. So, the end point is set at the end of the first move in the high-level plan.

For example, if we are planning through a set of rooms, the first level we consider might give us a plan that takes us from where our character is in the lobby to the guardroom and from there to its goal in the armory. At the next level we are interested in maneuvering around obstacles in the room, so we keep the start location the same (where the character currently is), but set the end location to be the doorway between the lobby and the guardroom. At this level we will ignore anything we may have to do in the guardroom and beyond.

This process of lowering the level and resetting the end location is repeated until we reach the lowest level of the graph. Now we have a plan in detail for what the character needs to do immediately. We can be confident that, even though we have only looked in detail at the first few steps, making those moves will still help us complete our goal in a sensible way.

Pseudo-Code

The algorithm for hierarchical pathfinding has the following form:

```
function hierarchicalPathfind(graph: Graph,
2
                                   start: Node,
                                   end: Node,
3
                                   heuristic: Heuristic
4
                                    ) -> Connection[]:
5
       # Check if we have no path to find.
6
       if start == end:
7
           return null
8
9
       # Set up our initial pair of nodes.
10
       startNode: Node = start
11
       endNode: Node = end
12
       levelOfNodes: int = 0
13
14
       # Descend through levels of the graph.
15
       currentLevel: int = graph.getLevels() - 1
16
       while currentLevel >= 0:
17
            # Find the start and end nodes at this level.
18
            startNode = graph.getNodeAtLevel(0, start, currentLevel)
            endNode = graph.getNodeAtLevel(levelOfNodes,
20
21
                                             endNode.
                                             currentLevel)
22
            levelOfNodes = currentLevel
23
24
            # Are the start and end node the same?
25
            if startNode == endNode:
26
                # Skip this level.
27
                continue
28
29
           # Otherwise we can perform the plan.
30
31
            graph.setLevel(currentLevel)
            path = pathfindAStar(graph, startNode, endNode, heuristic)
32
33
```

```
# Take the first move of this plan and use it for the next.
34
           endNode = path[0].getToNode()
35
36
       # The last path we considered would have been the one at level
37
       # zero: we return it.
38
       return path
39
```

Data Structures and Interfaces

In the code above I have made some additions to our graph data structure. Its interface now looks like the following:

```
class HierarchicalGraph extends Graph:
       # ... Inherits getConnections from graph ...
3
       # Return the number of levels in the graph.
       function getLevels() -> int
6
       # Set the graph so all future calls to getConnections are treated
8
       # as requests at the given level.
       function setLevel(level: int)
10
11
       # Convert a node at the input level to a node at the output level.
12
       function getNodeAtLevel(inputLevel: int,
13
                                node: Node.
                                outputLevel: int) -> Node
```

The setLevel method switches the graph into a particular level. All calls to getConnections then act as if the graph was just a simple, non-hierarchical graph at that level. The A* function has no way of telling that it is working with a hierarchical graph; it doesn't need to.

The getNodeAtLevel method converts nodes between different levels of the hierarchy. When increasing the level of a node, we can simply find which higher level node it is mapped to. When decreasing the level of a node, however, one node might map to any number of nodes at the next level down.

This is just the same process as localizing a node into a position for the game. There are any number of positions in the node, but we select one in localization. The same thing needs to happen in the getNodeAtLevel method. We need to select a single node that can be representative of the higher level node. This is usually a node near the center, or it could be the node that covers the greatest area or the most connected node (an indicator that it is a significant one for route planning).

In an implementation I wrote for a previous company I used a fixed node at a lower level, generated by finding the node closest to the center of all those mapped to the same higher level

node. This is a fast, geometric, pre-processing step that doesn't require human intervention. This node was then stored with the higher level node, where it could be returned when needed without additional processing. This worked well and produced no problematic plans, but you may prefer to try different methods or manual specification by the level designer.

Performance

The A* algorithm has the same performance characteristics as before, since we are using it unchanged.

The hierarchical pathfinder function is O(1) in memory and O(p) in time, where p is the number of levels in the graph. Overall, the function is O(plm) in time. Obviously, this appears to be slower than the basic pathfinding algorithm.

And it may be. It is possible to have a hierarchical graph that is so poorly structured that the overall performance is lower. In general, however, there are p stages of the O(lm) A* algorithm, but in each case the number of iterations (l) should be much smaller than a raw A* call, and the practical performance will be significantly higher.

For large graphs (with millions of nodes, for example) it is not uncommon to see two orders of magnitude improvement in running speed, using several levels in the hierarchy. I used this technique in a performance demo in 2003 to allow characters to pathfind on a graph with a hundred million nodes in real time.

4.6.3 HIERARCHICAL PATHFINDING ON EXCLUSIONS

A character can only follow the plan generated by the hierarchical pathfinding algorithm for a short time. When it reaches the end of the lowest level plan, it will need to plan its next section in more detail.

When its plan runs out, the algorithm is called again, and the next section is returned. If you use a pathfinding algorithm that stores plans (see Section 4.7, Other Ideas in Pathfinding), the higher level plans won't need to be rebuilt from scratch (although that is rarely a costly process).

In some applications, however, you might prefer to get the whole detailed plan up front. In this case hierarchical pathfinding can still be used to make the planning more efficient.

The same algorithm is followed, but the start and end locations are never moved. Without further modification, this would lead to a massive waste of effort, as we are performing a complete plan at each level.

To avoid this, at each lower level, the only nodes that the pathfinder can consider are those that are within a group node that is part of the higher level plan.

For example, in Figure 4.40 the first high-level plan is shown. When the low-level plan is made (from the same start and end locations), all the shaded nodes are ignored. They are not even considered by the pathfinder. This dramatically reduces the size of the search, but it can also miss the best route, as shown.

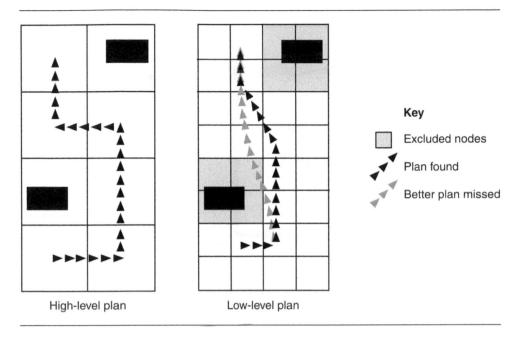

Figure 4.40: Switching off nodes as the hierarchy is descended

It is not as efficient as the standard hierarchical pathfinding algorithm, but it can still be a very powerful technique.

4.6.4 STRANGE EFFECTS OF HIERARCHIES ON PATHFINDING

It is important to realize that hierarchical pathfinding gives an approximate solution. Just like any other heuristic, it can perform well in certain circumstances and poorly in others. It may be that high-level pathfinding finds a route that could be shortcut at a lower level. This shortcut will never be found, because the high-level route is "locked in" and can't be reconsidered.

The source of this approximation is the link costs we calculated when we turned the lowest level graph into a hierarchical graph. Because no single value can accurately represent all the possible routes through a group of nodes, they will always be wrong some of the time.

Figures 4.41 and 4.42 show cases in which each method of calculating the link cost produces the wrong path.

In Figure 4.41 we see that because the minimum cost is 1 for all connections between rooms, the path planner chooses the route with the smallest number of rooms, rather than the much more direct route. The minimum cost method works well for situations where each room costs roughly the same to traverse.

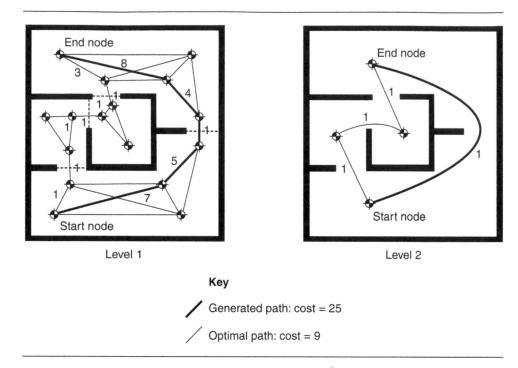

Figure 4.41: Pathological example of the minimum method

We see in Figure 4.42 that the obvious, direct route is not used because the connection has a very large maximin value. The maximin algorithm works better when every route has to pass through many rooms.

In the same example, using the average minimum method does not help, since there is only one route between rooms. The direct route is still not used. The average minimum method often performs better than the maximin method, except in cases where most of the rooms are long and thin with entrances at each end (networks of corridors, for example) or when there are few connections between rooms.

The failure of each of these methods doesn't indicate that there is another, better method that we haven't discussed yet; all possible methods will be wrong in some cases. Whatever method you use, it is important to understand what effects the wrongness has. One of the scenarios above, or a blend of them, is likely to provide the optimum trade-off for your game, but finding it is a matter of tweaking and testing.

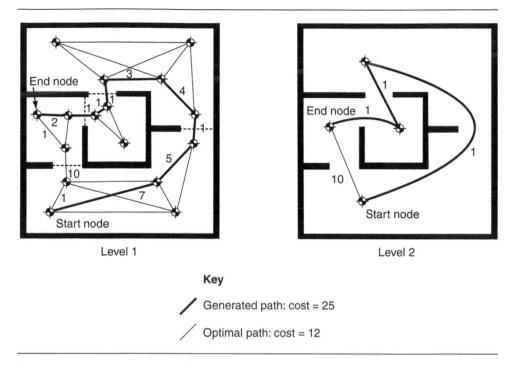

Figure 4.42: Pathological example of the maximin method

4.6.5 **INSTANCED GEOMETRY**

In a single-player game or a level-based multi-player game, all the detail for a level is typically unique. If multiple copies of the same geometry are used, then they are usually tweaked to be slightly different. The pathfinding graph is unique for the whole level, and it doesn't make sense to use the same subsection of the graph for more than one area in the level.

For massively multi-player games, or large open world RPGs, the whole world can consist of a single level. There is no way to have the same detailed, unique modeling on this scale. Most games at this scale use one large definition for the topology of the landscape (typically, a height field grid that can be represented to the pathfinding system as a tile-based graph). Onto this landscape buildings are placed, either as a whole or as entrances to a separate minilevel representing the inside of the building. Tombs, castles, caves, or spaceships can all be implemented in this way. I've used the technique to model bridges connecting islands in a squad-based game, for example. For simplicity, I'll refer to all these mini-levels as buildings in this section.

These placed buildings are sometimes unique (for special areas with significance to the game content). In most cases, however, they are somewhat generic. There may be 20 farmhouse designs, for example, but there may be hundreds of farmhouses across the world. In the same way that the game wouldn't store many copies of the geometry for the farmhouse, it shouldn't store many copies of the pathfinding graph.

We would like to be able to instantiate the pathfinding graph so that it can be reused for every copy of the building.

Algorithm

For each type of building in the game, we have a separate pathfinding graph. The pathfinding graph contains some special connections labeled as "exits" from the building. These connections leave from nodes that we'll call "exit nodes." They are not connected to any other node in the building's graph.

For each instance of a building in the game, we keep a record of its type and which nodes in the main pathfinding graph (i.e., the graph for the whole world) each exit is attached to. Similarly, we store a list of nodes in the main graph that should have connections into each exit node in the building graph. This provides a record of how the building's pathfinding graph is wired into the rest of the world.

Instance Graph

The building instance presents a graph to be used by the pathfinder. Let's call this the instance graph. Whenever it is asked for a set of connections from a node, it refers to the corresponding building type graph and returns the results.

To avoid the pathfinder getting confused about which building instance it is in, the instance makes sure that the nodes are changed so that they are unique to each instance.

The instance graph is simply acting as a translator. When asked for connections from a node, it translates the requested node into a node value understood by the building graph. It then delegates the connection request to the building graph, as shown in Figure 4.43. Finally, it translates the results so that the node values are all instance-specific again and returns the result to the pathfinder.

For exit nodes, the process adds an additional stage. The building graph is called in the normal way, and its results are translated. If the node is an exit node, then the instance graph adds the exit connections, with destinations set to the appropriate nodes in the main pathfinding graph.

Because it is difficult to tell the distance between nodes in different buildings, the connection costs of exit connections are often assumed to be zero. This is equivalent to saying that the source and destination nodes of the connection are at the same point in space.

World Graph

To support entrance into the building instance, a similar process needs to occur in the main pathfinding graph. Each node requested has its normal set of connections (the eight adjacent neighbors in a tile-based graph, for example). It may also have connections into a building instance. If so, the world graph adds the appropriate connection to the list. The destination

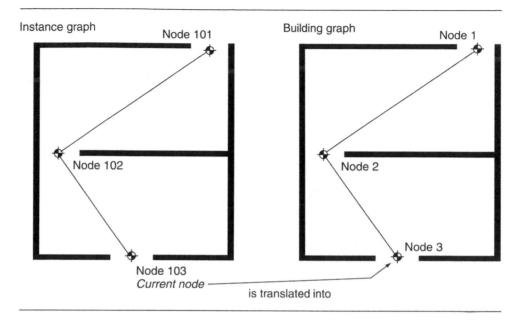

Figure 4.43: The delegation in progress

node of this connection is looked up in the instance definition, and its value is in instance graph format. This is illustrated in Figure 4.44.

The pathfinder, as we've implemented it in this chapter, can only handle one graph at a time. The world graph manages all the instance graphs to make it appear as if it is generating the whole graph. When asked for the connections from a node, it first works out which building instance the node value is from or if it is from the main pathfinding graph. If the node is taken from a building, it delegates to that building to process the getConnections request and returns the result unchanged. If the node is not taken from a building instance, it delegates to the main pathfinding graph, but this time adds connections for any entrance nodes into a building.

If you are building a pathfinder from scratch to use in a game where you need instancing, it is possible to include the instancing directly in the pathfinding algorithm, so it makes calls to both the top-level graph and the instanced graphs. This approach makes it much more difficult to later incorporate other optimizations such as hierarchical pathfinding, or node array A*, however, so we'll stick with the basic pathfinding implementation here.

Pseudo-Code

To implement instanced geometry we need two new implicit graphs: one for building instances and one for the main pathfinding graph.

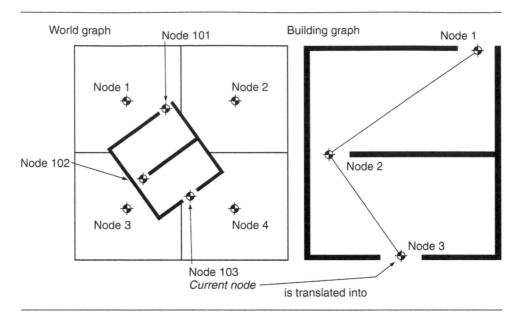

Figure 4.44: An instance in the world graph

In the code below I have added the data used to store the building instance with the instance graph class, since the same data are needed for each. The instance graph implementation therefore has the following form:

```
class InstanceGraph extends Graph:
       # The building graph to delegate to.
2
       building: Graph
3
4
       # Holds data for exit nodes.
5
       class ExitNodeAssignment:
6
           fromNode: Node
7
           toWorldNode: Node
8
       # A hash of assignments for connections to the outside world.
10
       exitNodes: HashMap[Node -> ExitNodeAssignment[]]
11
12
       # The offset for the nodes values used in this instance.
13
       nodeOffset: Node
15
       function getConnections(fromNode: Node) -> Connection[]:
16
           # Translate the node into building graph values.
17
           buildingFromNode: Node = fromNode - nodeOffset
18
19
```

```
# Delegate to the building graph.
20
            connections = building.getConnections(buildingFromNode)
21
            # Translate the returned connections into our node values.
23
            for connection in connections:
24
                connection.toNode += nodeOffset
25
26
                # Add connections for each exit from this node.
27
                for exitAssignment in exitNodes[fromNode]:
28
                    connection = new Connection()
29
                    connection.fromNode = fromNode
30
                    connection.toNode = exitAssignment.toWorldNode
31
                    connection.cost = 0
32
                    connections += connection
33
34
            return connections
35
```

The main pathfinding graph has the following structure:

```
class MainGraph extends Graph:
        # The graph for the rest of the world.
 2
       worldGraph: Graph
 3
       # Holds data for a building instance.
       class EntranceNodeAssignment:
 6
            fromNode: Node
            toInstanceNode: Node
            buildingGraph: Graph
10
       class Buildings extends HashMap[Node -> EntranceNodeAssignment[]]:
            # Return the graph containing the given node, or null.
            function getBuilding(node) -> Graph
14
       # Entrance node assignments.
15
       buildingInstances: Buildings
16
17
       function getConnections(fromNode: Node) -> Connection[]:
18
            # Check if fromNode is in the range of any building.
19
            building = buildingInstances.getBuilding(fromNode)
20
21
           # If we have a building, then delegate to it.
            if building:
23
                return building.getConnections(fromNode)
25
           # Otherwise, delegate to the world graph.
           connections = worldGraph.getConnections(fromNode)
27
           # Add connections for each entrance from this node.
29
```

```
for building in buildingInstances[fromNode]:

connection = new Connection

connection.fromNode = fromNode

connection.toNode = building.toInstanceNode

connection.cost = 0

connections += connection

return connections
```

Data Structures and Interfaces

In the instance graph class, we access the exit nodes as a hash, indexed by node number and returning a list of exit node assignments. This process is called every time the graph is asked for connections, so it needs to be implemented in as efficient a manner as possible. The building instances structure in the world graph class is used in exactly the same way, with the same efficiency requirements.

The building instances structure also has a getBuilding method in the pseudo-code above. This method takes a node and returns a building instance from the list if the node is part of the instance graph. If the node is part of the main pathfinding graph, then the method returns a null value. This method is also highly speed critical. Because a range of node values is used by each building, however, it can't be easily implemented as a hash table. A good solution is to perform a binary search on the nodeOffsets of the buildings. A further speed up can be made using coherence, taking advantage of the fact that if the pathfinder requests a node in a building instance, it is likely to follow it with requests to other nodes in the same building.

Implementation Notes

The translation process between instance node values and building node values assumes that nodes are numeric values. This is the most common implementation of nodes. However, they can be implemented as opaque data instead. In this case the translation operations (adding and subtracting nodeOffset in the pseudo-code) would be replaced by some other operation on the node data type.

The main pathfinding graph for a tile-based world is usually implicit. Rather than delegating from a new implicit graph implementation to another implicit implementation, it is probably better to combine the two. The getConnections method compiles the connections to each neighboring tile, as well as checks for building entrances.

Performance

Both the instance graph and the world graph need to perform a hash lookup for entrance or exit connections. This check takes place at the lowest part of the pathfinding loop and therefore is speed critical. For a well-balanced hash, the speed of hash lookup approaches O(1).

The world graph also needs to look up a building instance from a node value. In the case where nodes are numeric, this cannot be performed using a reasonably sized hash table. A binary search implementation is $O(\log_2 n)$ in time, where n is the number of buildings in the world. Judicial use of caching can reduce this to almost O(1) in practice, although pathological graph structures can theoretically foil any caching scheme and give the $O(log_2 n)$ worst case.

Both algorithms are O(1) in memory, requiring only temporary storage.

Weaknesses

This approach introduces a fair amount of complexity low down in the pathfinding loop. The performance of the pathfinder is extremely sensitive to inefficiencies in the graph data structure. I have seen a halving of execution speed by using this method. It is not worth the extra time if the game level is small enough to create a single master graph.

For massive worlds with instanced buildings, however, a single graph may not be an option, and instanced graphs are the only way to go. I would personally be reluctant to consider using instanced graphs in a production environment unless the pathfinding system was hierarchical (if the graph is big enough to need instanced buildings, it is big enough to need hierarchical pathfinding). This has the added advantage that each building instance can be treated as a single node higher up the hierarchy. When using a hierarchical pathfinding algorithm, moving to instanced geometry usually produces a much smaller drop in pathfinding speed, because instanced graphs are only considered when they are part of the plan.

Setting Node Offsets

In order for this code to work, we need to make sure that every building instance has a unique set of node values. The node values should not only be unique within instances of the same building type, but also between different building types. If node values are numeric, this can be simply accomplished by assigning the first building instance a nodeOffset equal to the number of nodes in the main pathfinding graph. Thereafter, subsequent building instances have offsets which differ from the previous building by the number of nodes in the previous building's graph.

For example, let's say we have a pathfinding graph of 10,000 nodes and three building instances. The first and third buildings are instances of a type with 100 nodes in the graph. The second building has 200 nodes in its graph. Then the node offset values for the building instances would be 10,000, 10,200, and 10,300.

4.7 OTHER IDEAS IN PATHFINDING

There are many variations on the A* algorithm that have been developed for specific applications. It would take a book this size to describe them all. This section takes a whirlwind tour of some of the most interesting. There are pointers to more information, including algorithm specifications, in the references at the end of the book.

4.7.1 OPEN GOAL PATHFINDING

In many applications there may be more than one possible node in the graph that is a goal. If a character is pathfinding to an alarm point, for example, then any alarm will do, and there will be multiple possible goals.

Rather than checking if a node is *the* goal, we need to check if the node is *a* goal. This has implications for the design of the heuristic: the heuristic needs to accurately report the distance to the nearest goal. To do that it needs to understand which goal will eventually be chosen.

Imagine a situation where a character is trying to reach one of two alarm points to raise the alarm. Alarm point A is near, but has been blocked by the player; alarm point B is much further away. The heuristic gives a low score for the area of the level close to point A, including the area that is in completely the wrong direction to get to point B. This low score is given because the heuristic believes that point A will be the chosen goal for these areas.

The pathfinder will search all around A, including all the areas in completely the wrong direction to get to B, before it starts to look at routes to B. In the worst case scenario, it could search the whole level before realizing that A is blocked.

Because of these kinds of issues, it is rare for game AI to use multiple goals at a great distance from one another. Usually, some kind of decision making process decides which alarm point to go to, and the pathfinding simply finds a route.

4.7.2 DYNAMIC PATHFINDING

So far we have always assumed that the pathfinder can know everything about the game level it is working in. We also assumed that what it knows cannot change: a connection will always be usable, and its cost will always be the same.

The methods I have described so far do not work well if the environment is changing in unpredictable ways or if its information is otherwise incomplete. When something changes, they have to start all over again.

But imagine human soldiers navigating through enemy terrain. They will have a map and possibly satellite intelligence showing the position of enemy encampments and defenses. Despite this information, they may come across a new site not shown on their map. Human beings will be able to accommodate this information, changing their route ahead to avoid detection by the newly discovered enemy squad.

We can achieve the same thing using the standard pathfinding algorithms. Each time we find some information that doesn't match what we expected, we can replan. This new pathfinding attempt would include the new information we've found.

This approach works, and in many cases it is perfectly adequate. But if the game level is constantly changing, there will be lots of replanning. This can eventually swamp the pathfinder; it has to start again before it finishes the previous plan, so no progress is ever made.

Dynamic pathfinding is an interesting modification to the pathfinding algorithm that allows the pathfinder to only recalculate the parts of the plan that may have changed. The dynamic version of A* is called D*. While it dramatically reduces the time required to pathfind in an uncertain environment, it requires a lot of storage space to keep intermediate data that might be required later. The original paper describing D* is [62], with a further refinement termed "focused D*" described in [63].

4.7.3 OTHER KINDS OF INFORMATION REUSE

The intermediate information gained while pathfinding (such as the path estimates and the parents of nodes in the open list) can be useful if the task changes midway through. This is the approach used by D^* and similar dynamic pathfinders.

Even if the task doesn't change, the same information can be useful to speed up successive pathfinding attempts. For example, if we calculate that the shortest path from A to D is [A B CD], then we know that the shortest path from B to D will be [BCD].

Keeping partial plans in storage can dramatically speed up future searches. If a pathfinder comes across a pre-built section of plan, it can often use it directly and save a lot of processing time.

Complete plans are easy to store and check. If exactly the same task is performed a second time, the plan is ready to use. However, the chance of having exactly the same task many times is small. More sophisticated algorithms, such as LPA* (lifelong planning A*, see [29]), keep information about small sections of a plan, which are much more likely to be useful in a range of different pathfinding tasks.

Like dynamic pathfinding, the storage requirements of this kind of algorithm are large. While they may be suited to small pathfinding graphs in first-person shooters, they are unlikely to be useful for large open air levels. Ironically, this is exactly the application where their increased speed would be useful.

4.7.4 LOW MEMORY ALGORITHMS

Memory is a major issue in designing a pathfinding algorithm. There are two well-known variations on the A* algorithm that have lower memory requirements. Accordingly, they are less open to optimizations such as dynamic pathfinding.

IDA*—Iterative Deepening A*

Iterative deepening A* [30] has no open or closed list and doesn't look very much like the standard A* algorithm.

IDA* starts with a "cut-off" value, a total path length beyond which it will stop searching. Effectively, it searches all possible paths until it finds one to the goal that is less than this cut-off

The initial cut-off value is small (it is the heuristic value of the starting node, which usually underestimates the path length), so there is unlikely to be a suitable path that gets to the goal.

Each possible path is considered, recursively. The total path estimate is calculated exactly as it is in the regular A* algorithm. If the total path estimate is less than the cut-off, then the algorithm extends the path and continues looking. Once all possible paths less than the cut-off are exhausted, the cut-off is increased slightly and the process starts again.

The new cut-off value should be the smallest path length, greater than the previous cut-off value, that was found in the previous iteration.

Because the cut-off value keeps increasing, eventually the cut-off value will be larger than the distance from the start to the goal, and the correct path will be found.

This algorithm requires no storage other than the list of nodes in the current plan being tested. It is very simple to implement, taking no more than 50 lines of code.

Unfortunately, by restarting the planning over and over, it is much less efficient than regular A* and is less efficient than Dijkstra in some cases. It should probably be reserved for instances when memory is the key limiting factor (such as on handheld devices, for example).

In some non-pathfinding situations, IDA* can be an excellent variation to use, however. It will get its moment of glory when we look at goal-oriented action planning, a decision making technique, in Chapter 5 (see Chapter 5 for a full implementation of IDA*).

SMA*—Simplified Memory-Bounded A*

Simplified memory-bounded A* [53] solves the storage problem by putting a fixed limit on the size of the open list. When a new node is processed, if it has a total path length (including heuristic) that is larger than any node in the list, it is discarded. Otherwise, it is added, and the node already in the list with the largest path length is removed.

This approach can be far more efficient than the IDA* approach, although it can still revisit the same node multiple times during a search. It is highly sensitive to the heuristic used. A heuristic that is a dramatic underestimate can see useless nodes eject important nodes from the open list.

SMA* is an example of a "lossy" search mechanism. In order to reduce search efficiency, it throws away information, assuming that the information it discards is not important. There is no guarantee that it is unimportant, however. In all cases with SMA*, the final path returned has no guarantee of being the optimal path. An early, unpromising node can be rejected from consideration, and the algorithm will never know that by following this seemingly unpromising line, it would have found the shortest path.

Setting a large limit on the size of the open list helps ease this problem, but defeats the object of limiting memory usage. At the other extreme, a limit of 1 node in the open list will see the algorithm wander toward its target, never considering any but the most promising path.

For high-performance memory limited applications, I feel that SMA* is underrated as an alternative to A*. One of the key problems in optimizing pathfinding at a low level is memory cache performance. By limiting the size of the open list to exactly the right size, SMA* can avoid problems that A* has with cache misses and aliasing.

4.7.5 INTERRUPTIBLE PATHFINDING

Planning is a time-consuming process. For large graphs, even the best pathfinding algorithm may take tens of milliseconds to plan a route. If the pathfinding code has to run in the constraints imposed by rendering every 60th or 30th of a second, it is likely to not have enough time to complete.

Pathfinding is an easily interruptible process. The A* algorithm, in the form described in this chapter, can be stopped after any iteration and resumed later. The data required to resume that algorithm are all contained in the open and closed lists, or their equivalents.

Pathfinding algorithms are often written so that they can perform over the course of several frames. The data are retained between frames to allow the algorithm to continue processing later. Because the character may move in this time, a pathfinding algorithm such as D* or LPA* can be useful to avoid having to start over.

Chapter 10 on execution management covers interruptible algorithms in more detail, along with the infrastructure code required to use them.

4.7.6 POOLING PLANNERS

Pathfinding was first used extensively in real-time strategy games. A large number of characters need to be able to navigate autonomously around the game environment. Consequently, there may be many pathfinding requests in progress at the same time.

We could simply complete a pathfinding task for one character before moving onto the next. With many characters and with pathfinding split over several frames, the queue for pathfinding time can mount.

Alternatively, we could use a separate pathfinding instance for each character in the game. Unfortunately, the data associated with a pathfinding algorithm can be sizable, especially if the algorithm is experiencing a high degree of fill or if we use an algorithm such as node array A*. Even if the data for all characters fit into memory, they will almost certainly not fit in the cache, and performance will slow accordingly.

RTS games use a pool of pathfinders and a pathfinding queue. When a character needs to plan a route, it places its request on a central pathfinding queue. A fixed set of pathfinders then services these requests in order (usually first-in, first-out order).

The same approach has been used to provide pathfinding for NPC characters in massively multi-player games. A server-based pathfinding pool processes requests from characters throughout the game, on an as needed basis.

When I worked on such a system for an MMORPG with lots of AI characters, I found that a variation on the LPA* algorithm was the best algorithm to use. Because each pathfinder was regularly asked to plan different routes, information from previous runs could be useful in cutting down execution time. For any pathfinding request, the chances are good that another character has had to pathfind a similar route in the past. This is especially true when hierarchical pathfinding is being performed, since the high-level components of the plan are common to thousands or even millions of requests.

After a while, an algorithm that reuses data will be more efficient, despite having to do extra work to store the data. Any form of data reuse is advantageous, including storing partial plans or keeping information about short through-routes in the data for each node (as with LPA*).

Despite the large amount of additional data in each pathfinder, in my tests the memory consumption was often reduced using this method. Faster pathfinding means fewer pathfinders can service the same volume of requests, which in turn means less memory used overall.

This approach is particularly significant in MMORPGs, where the same game level is active for days or weeks at a time (only changing when new buildings or new content alter the pathfinding graph). In an RTS it is less significant, but worth trying if the pathfinding code is causing performance bottlenecks.

4.8 CONTINUOUS TIME PATHFINDING

So far I have described discrete pathfinding. The only choices available to the pathfinding system occur at specific locations and times. The pathfinding algorithm doesn't get to choose where to change direction. It can only move directly between nodes in the graph. The locations of nodes are the responsibility of whatever or whoever creates the graph.

As we've seen, this is powerful enough to cope with the pathfinding tasks required in most games. Some of the inflexibility of fixed graphs can also be mitigated by path smoothing or by using steering behaviors to follow the path (there is a discussion of movement along a path with more details in Chapter 3).

There still remains a handful of scenarios in which regular pathfinding cannot be applied directly: situations where the pathfinding task is changing rapidly, but predictably. We can view it as a graph that is changing from moment to moment. Algorithms such as D* can cope with graphs that change dynamically, but they are only efficient when the graph changes infrequently.

Figure 4.45: Police car moving along a four-lane road

4.8.1 THE PROBLEM

There are many places where continuous pathfinding problems are useful, but I will give one extended example, drawn from a previous implementation I worked on.

Imagine we have an AI-controlled police vehicle moving along a busy city road, as shown in Figure 4.45. The car needs to travel as quickly as possible when pursuing a criminal or trying to reach a designated roadblock. For the sake of our example, we will assume there is not enough room to drive between two lanes of traffic; we have to stay in one lane.

Each lane of traffic has vehicles traveling along. We will not be concerned with how these vehicles are controlled at the moment, as long as they are moving fairly predictably (i.e., rarely changing lanes).

The pathfinding task for the police car is to decide when to change lanes. A path will consist of a period of time in a series of adjacent lanes. We could split this task down by placing a node every few yards along the road. At each node, the connections join to the next node in the same lane or to nodes in the adjacent lane.

If the other cars on the road are moving relatively quickly (such as the oncoming traffic), then a reasonable node spacing will inevitably mean that the police car misses opportunities to travel faster. Because the nodes are positioned in an arbitrary way, the player will see the police car sometimes make death-defying swerves through traffic (when the nodes line up just right), while at other times miss obvious opportunities to make progress (when the nodes don't correspond to the gaps in traffic).

Shrinking the spacing of the nodes down will help. But, for a fast-moving vehicle, a very fine graph would be required, most of which would be impossible to navigate because of vehicles in the way.

Even with a static graph, we couldn't use an algorithm such as A* to perform the pathfinding. A* assumes that the cost of traveling between two nodes is irrespective of the path to get to the first node. This isn't true of our situation. If the vehicle takes 10 seconds to reach a node, then there may be a gap in traffic, and the cost of the corresponding connection will be small. If the vehicle reaches the same node in 12 seconds, however, the gap may be closed, and the connection is no longer available (i.e., it has infinite cost). The A* family of algorithms cannot work directly with this kind of graph.

We need a pathfinding algorithm that can cope with a continuous problem.

4.8.2 THE ALGORITHM

The police car may change lanes at any point along the road; it isn't limited to specific locations. We can view the problem as being in two parts. First, we need to decide where and when it might be sensible to change lanes. Second, we can work out a route between these points.

The algorithm is also in two parts. We create a dynamic graph that contains information about position and timing for lane changes, and then we use a regular pathfinding algorithm (i.e., A^*) to arrive at a final route.

Previously, I mentioned that the A* family of algorithms is not capable of solving this problem. To redeem their use, we first need to reinterpret the pathfinding graph so that it no longer represents positions.

Nodes as States

So far we have assumed that each node in the pathfinding graph represents a position in the game level or, at most, a position and an orientation. Connections similarly represent which locations can be reached from a node.

As I stressed before, the pathfinding system doesn't understand what its graph represents. It is simply trying to find the best route in terms of the graph. We can make use of this.

Rather than having nodes as locations, we can interpret nodes in the graph to be states of the road. A node has two elements: a position (made up of a lane and a distance along the road section) and a time. A connection exists between two nodes if the end node can be reached from the start node and if the time it takes to reach the node is correct.

Figure 4.46 illustrates this. In the second lane there are two nodes at the same location, C and D. Each node has a different time. If the car traveling from A stayed in the same lane, then it would reach the end of the section in 5 seconds and so would be at node C. If it traveled via lane 1, at node B, then it would reach the end in 7 seconds and would be at node D. Nodes C and D are shown in the figure slightly apart, so you can see the connections. Because we are only concerned with the lane number and the distance, in reality they represent the exact same location.

Using a graph of this kind means that we've removed the path-dependent cost length. C and D are different nodes. If the traffic is different at that location after 5 seconds rather than 7 seconds, then the connections out from C and D will have different costs. This is fine, because they are different nodes. The pathfinding algorithm no longer has to worry about which route it came from. It can trust that the cost of a connection from a node will always be the same.

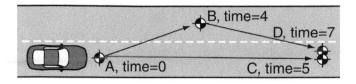

Figure 4.46: Different nodes with different times and the same position

Figure 4.47: Navigating a gap through oncoming traffic

Incorporating time into the pathfinding graph allows us to rescue A* as our pathfinding algorithm for this problem.

The Size of the Graph

Unfortunately, we've only moved the problem along, not really solved it. Now we have not only an infinite number of places where we can change lanes but also (because of acceleration and braking) an infinite number of nodes representing every possible time for every possible place along the road. We now truly have a huge pathfinding graph, far too large to use efficiently.

We get around this problem by dynamically generating only the subsection of the graph that is actually relevant to the task. Figure 4.47 shows a simple case of the car dodging sideways through a gap in the oncoming traffic.

There are any number of ways to accomplish this. We can drive at full speed into the center lane as soon as possible and immediately out to the far side. We could brake, wait until the gap comes closer, and then pull into the gap. We could brake and wait for all the cars to go by. The options are endless.

We constrain the problem by using a heuristic. We make two assumptions: (1) if the car is to change lanes, it will do so as soon as possible; and (2) it will move in its current lane to its next lane change as quickly as possible.

The first assumption is sound. There are no situations in which changing lanes earlier rather than later will give the car less flexibility. The opposite is not true. Changing lanes at the last possible moment will often mean that opportunities are missed.

Figure 4.48: When top speed isn't a good idea

The second assumption helps make sure the car is moving at top speed as much as possible. Unlike the first assumption, this may not be the best strategy. Figure 4.48 shows an extreme example.

Lane 4 is empty, but lanes 2 and 3 are both very busy. If the car streaks ahead to the front gap in lane 2, then it will not be able to cross into lane 3 and from there into lane 4. If it breaks, however, and waits until the second gap in lane 2 is aligned with the gap in lane 3, then it can streak through both gaps and onto the empty highway. In this case it pays to go slower initially.

In practice, such obvious pathological examples are rare. Drivers in a rush to get somewhere are quite likely to go as fast as they possibly can. Although it is not optimal, using this assumption produces AI drivers that behave plausibly: they don't look like they are obviously missing simple opportunities.

How the Graph Is Created

The graph is created as is required by the pathfinding algorithm. Initially, the graph has only a single node in it: the current location of the AI police car, with the current time.

When the pathfinder asks for outgoing connections from the current node, the graph examines the cars on the road and returns four sets of connections.

First, it returns a connection to one node for each adjacent lane that is vacant at this point. I will call these nodes the lane change nodes. Their connection cost is the time required to change lanes at the current speed, and the destination nodes will have a position and a time value reflecting the lane change.

Second, the graph adds a connection to a node immediately behind the next car in the current lane, assuming that it travels as fast as possible and breaks at the very last minute to match the car's speed (i.e., it doesn't keep traveling at top speed and slam into the back of the car). The arrive and velocity match behaviors from Chapter 3 can calculate this kind of maneuver.

I will call this node the boundary node. If the AI cannot possibly avoid the collision (i.e.,

Figure 4.49: The placement of nodes within the same lane

it can't brake fast enough), then the boundary node is omitted; we don't let the pathfinder even consider the possibility of crashing.

Next, the graph returns connections to nodes along the current lane immediately after the AI passes each car in each adjacent lane, up until it reaches the next car in the current lane. For calculating these nodes assume that the car travels in the same way as we calculated for the boundary node; i.e., as fast as possible, making sure it doesn't crash into the car in front. I will call these nodes safe opportunity nodes, because they represent the opportunity for the AI to change lanes, while making sure to avoid a collision with the car in front. Figure 4.49 shows this situation.

Because it is difficult to show time passing on a 2D graphic, I have indicated the position of each car in 1-second intervals as a black spot. Notice that the nodes in the current lane aren't placed immediately after the current position of each car, but immediately after the position of each car when the AI would reach it.

Finally, the graph returns a set of unsafe opportunity nodes. These are exactly the same as the safe opportunity nodes, but are calculated assuming that the car always travels at top speed and doesn't avoid slamming into the back of a car in front. These are useful because the pathfinder may choose to change lanes. There is no point in slowing down to avoid hitting a car in front if you intend to swerve around it into a different lane.

Notice that all four groups of connections are returned in the same set. They are all the connections outgoing from the current position of the police car; there is no distinction in the pathfinding algorithm. The connections and the nodes that they point to are created specially on this request.

The connections include a cost value. This is usually just a measure of time because we're trying to move as quickly as possible. It would also be possible to include additional factors in the cost. A police driver might factor in how close each maneuver comes to colliding with an innocent motorist. Particularly close swerves would then only be used if they saved a lot of time.

The nodes referenced by each connection include both position information and time information.

As we've seen, we couldn't hope to pre-create all nodes and connections, so they are built from scratch when the outgoing connections are requested from the graph.

On successive iterations of the pathfinding algorithm, the graph will be called again with

a new start node. Since this node includes both a position and a time, we can predict where the cars on the road will be and repeat the process of generating connections.

Which Pathfinder

Two routes through the graph may end up at an identical node (i.e., one with the same position and timing information). In this case the connections leaving the node should be identical in every respect. In practice, this happens very rarely; the pathfinding graph tends to resemble a tree rather than a connected network.

Because it is rare to revisit a node that has already been visited, there is little point in storing a large number of nodes for future reference. Combined with the large size of the resulting graphs, a memory-saving variant of A* is the best choice. IDA* is unsuitable because retrieving the outgoing connections from a node is a very time-consuming process. IDA* replans through the same set of nodes at each iteration, incurring a significant performance hit. This could be mitigated by caching the connections from each node, but that goes against the memory-saving ethos of IDA*.

In my own experiments, SMA* seemed to be an excellent choice for pathfinding in this kind of continuous, dynamic task.

The remainder of this section is concerned with the dynamic graph algorithm only. The particular choice of pathfinder responsible for the planning is independent of the way the graph is implemented.

4.8.3 IMPLEMENTATION NOTES

It is convenient to store driving actions in the connection data structure. When the final path is returned from the pathfinder, the driving AI will need to execute each maneuver. Each connection may have come from one of the four different categories, each of which involves a particular sequence of steering, acceleration, or breaking. There is no point in having to calculate this sequence again when it was calculated in the pathfinding graph. By storing it we can feed the action directly into the code that moves the car.

4.8.4 PERFORMANCE

The algorithm is O(1) in memory, requiring only temporary storage. It is O(n) in time, where n is the number of vehicles in adjacent lanes, closer than the nearest vehicle in the current lane. The performance of the algorithm may be hampered by acquiring the data on adjacent cars. Depending on the data structure that stores the traffic pattern, this can be itself an $O(\log_2 n)$ algorithm, where m is the number of cars in the lane (if it does a binary search for nearby cars, for example). By caching the results of the search each time, the practical performance can be brought back to O(n).

This algorithm is called at the lowest part of the pathfinding loop and therefore is highly speed critical.

4.8.5 WEAKNESSES

Continuous pathfinding is a fairly complex algorithm to implement, and highly dependent on the situation. The example above is tied directly to the requirements of the car moving along the multi-lane road. Other kinds of movement may require different heuristics.

In practice, it can be extremely difficult to debug the placement of dynamic nodes. Especially so since nodes involving time are difficult to visualize.

Even when working properly, the algorithm is not fast, even in comparison with other pathfinders. It should probably be used for only small sections of planning. In the police driving game on which I've based this section, we used continuous planning to plan a route for only the next 100 yards or so. The remainder of the route was planned only on an intersectionby-intersection basis. The pathfinding system that drove the car was hierarchical, with the continuous planner being the lowest level of the hierarchy.

4.9 MOVEMENT PLANNING

In the section on world representations, we looked briefly at situations where the orientation as well as the position of a character was used in planning. This helps to generate sensible paths for characters that cannot easily turn on the spot. In many cases pathfinding is used at a high level and doesn't need to take account of these kinds of constraints; they will be handled by the steering behaviors. Increasingly, however, characters are highly constrained, and the steering behaviors discussed in the previous chapter cannot produce sensible results.

The first genre of game to show this inadequacy was urban driving. Vehicles such as cars or lorries need maneuver room and can often have lots of constraints specific to their physical capabilities (a car, for example, may need to decelerate before it can turn to avoid skidding).

Even non-driving game genres, in particular first- and third-person action games, are often set in highly constrained environments where steering alone cannot succeed. As animation fidelity has improved, characters need to move more fluidly through their environment. It is unacceptable for feet to intersect a staircase as if it were a ramp, or to slide when a character turns at low speed. Movement planning is a technique for using the algorithms in this chapter to produce sensible character movement: animation, steering, local and large-scale level navigation.

4.9.1 ANIMATIONS

Most characters in a game have a range of animations that are used when the character is moving. A character may have a walk animation, a run animation, and a sprint animation,

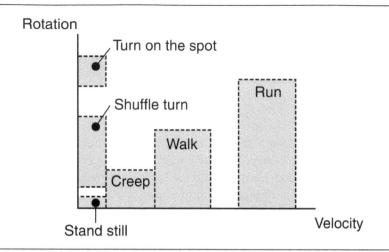

Figure 4.50: Velocity diagram for allowed animations

for example. Likewise, there are animations for turning—for example, turning while walking, turning on the spot, and turning while crouched.

Each of these animations can be used over a range of different movement scenarios. A walk animation, for example, needs to have the feet sticking to the ground and not sliding. So the character must move at a particular rate in order for the animation to look right. The speed of animation can be increased to accommodate slightly faster motion, but there are limits. Eventually, the character will look unbelievable.

It is possible to visualize animations as being applicable to a range of different movement speeds, both linear movement and angular movement. Figure 4.50 shows which animations can be used for different linear and angular velocities of a character.

Notice that not all the space of possible velocities has an associated animation. These are velocities that the character should not use for more than a moment.

In addition, it may not make sense to stop an animation before it has been completed. Most animation sets define transitions between walking and running and standing and crouching, for example. But a walk cycle may look odd being blended into a run cycle unless it has reached the right point for the transition to occur. This means that each movement has a natural length in the game world. Again, we can show this visually on a diagram. In this case, however, it is position and orientation shown, rather than velocity and rotation.

Notice in Figure 4.51 that the range over which the animations are believable is much smaller than for velocities.

It is possible to sidestep this problem entirely. Procedural animation, and human locomotion middleware is being applied to generating sensible animations for any movement required. It is not ubiquitous, however, and in many cases developers prefer motion captured

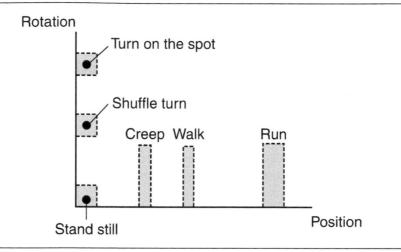

Figure 4.51: Position diagram for allowed animations

or handmade animations. Most games still use a modest portfolio of possible animations, along with blending and parameterization.

4.9.2 MOVEMENT PLANNING

In a highly constrained environment, the particular animations chosen may have a large impact on whether the character can maneuver correctly. A character that needs to move exactly 2 meters forward before doing a 30° right turn may not be able to use an animation that sends it 1.5 meters forward and rotates it by 45°.

To achieve a particular large-scale maneuver, the particular sequence of animations may be significant. In this case movement planning is required: planning a sequence of allowed maneuvers that lead to an overall state.

The Planning Graph

Just like pathfinding, movement planning uses a graph representation. In this case each node of the graph represents both the position and the state of the character at that point. A node may include the character's position vector, its velocity vector, and the set of allowable animations that can follow. A running character, for example, may have high velocity and be capable of only carrying out the "run," "transition run to walk," or "collide with object" animations.

Connections in the graph represent valid animations; they lead to nodes representing the state of the character after the animation is complete. A run animation, for example, may lead to the character being 2 meters farther forward and traveling at the same velocity.

With the graph defined in this way, a heuristic can be used that determines how close a character's state is to the goal. If the goal is to maneuver through a room full of exposed electrical wires, then the goal may be the door on the other side, and the heuristic may be based on distance alone. If the goal is to reach the edge of a platform traveling fast enough to jump a large gap, then the goal may include both position and velocity components.

Planning

With the graph defined in this way, the regular A* algorithm, or one of its siblings, can be used to plan a route. The route returned consists of a set of animations that, when executed in order, will move a character to its goal.

Care needs to be taken to define the goal in a broad way. If an exact position and orientation are given as a goal, then there may be no sequence of animations that exactly reach it, and the planning algorithm will fail (after considering every possible combination of animations, at a great cost of time). Rather, the goal needs to make sure the character is "near enough"; a range of states is allowable.

Infinite Graphs

Recall that an animation may be parameterized so that it can be used to travel a range of distances and through a range of velocities. Each possible distance and velocity would be a different state. So from one state the character may transition to any one of many similar states, depending on the speed it plays the following animation. If the velocities and positions are continuous (represented by real numbers), then there may be an infinite number of possible connections.

A* can be adapted to apply to infinite graphs. At each iteration of A*, all the successor nodes are examined using the heuristic function and added to the open list. To avoid this taking infinitely long, only the best successor nodes are returned for addition to the open list. This is often done by returning a few trial successors and then rating each heuristically. The algorithm can then try to generate a few more trials based on the best of the previous bunch, and so on until it is confident that the best successors have been provided. Although this technique is used in several non-game domains, it is slow and highly sensitive to the quality of the heuristic function.

To avoid the headaches involved in adapting A^* to operate on infinite graphs, it is common to divide up the possible range into a small set of discrete values. If an animation can be played at between 15 and 30 frames per second (fps), then there may be four different possible values exposed to the planner: 15, 20, 25, and 30 fps.

Another alternative is to use domain-specific simplifying heuristics, as we saw in the previous section on continuous pathfinding. This allows us to dynamically generate a small subset of the pathfinding graph based on heuristics about what sections of the graph might be useful.

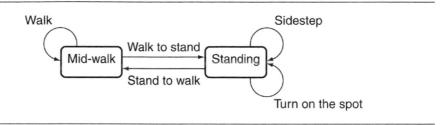

Figure 4.52: Example of an animation state machine

Implementation Issues

Even limiting the number of connections in this way, there are still a huge number of possible connections in the graph, and the graph tends to be very large indeed. The optimized versions of A^* require us to know in advance the number of nodes in the graph. In movement planning the graph is usually generated on the fly: the successor nodes are generated by applying allowable animations to the current state. A basic, two list A^* is therefore the most applicable for movement planning.

Typically, movement planning is only used for small sequences of movement. In the same way that the steering behavior of a character is guided by the large-scale pathfinding plan, movement planning can be used to fill in detail for just the next part of the overall route. If the plan states to move through a room with lots of live electrical wires, the movement planner may generate a sequence of animations to get to the other side only. It is unlikely to be used to generate a complete path through a level, because of the size of the graph involved and the planning time it would require.

4.9.3 EXAMPLE

As an example consider a walking bipedal character. The character has the following animations: walk, stand to walk, walk to stand, sidestep, and turn on the spot. Each animation starts or ends from one of two positions: mid-walk or standing still. The animation can be represented as the state machine in Figure 4.52, with the positions as states and the transitions as animations.

The animations can apply to the range of movement distances as shown on the graph in Figure 4.53.

The character is moving through the lava-filled room shown in Figure 4.54. There are many dangerous areas where the character should not walk. The character needs to work out a valid sequence of movements from its initial position to the opposite doorway. The goal is shown as a range of positions with no orientation. We don't care what speed the character is traveling, which way it is facing, or what its animation state is when it reaches the goal.

Running an A*-style algorithm, we get the route generated in Figure 4.55. It can be seen

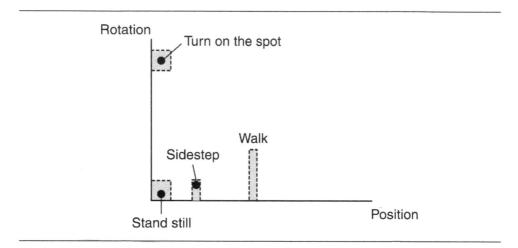

Figure 4.53: Example of position ranges for animations

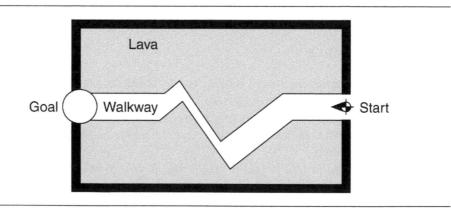

Figure 4.54: The dangerous room

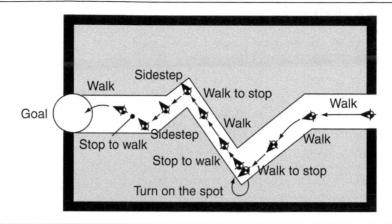

Figure 4.55: The example path through the dangerous room

that this avoids the dangers correctly using a combination of walking, turning, and sidestepping.

4.9.4 FOOTFALLS

When movement planning is used to determine where character's feet will be placed, it is called "footfall planning." This is an active area of research in robotics, requiring the pathfinding system to have very fine data about the path of limbs in each animation. This is probably at too fine a level of detail for games.

Most recent third-person games lock footfalls correctly: particularly when climbing stairs, but also when navigating narrow ledges or avoiding ground clutter. As far as I know, the current state of the art uses purely local constraints to achieve this: the character's footfall is examined and moved to the nearest suitable location, causing adjustments in the rest of the animation if required. This uses inverse kinematics algorithms for the animation, such algorithms are not normally associated with AI.

Footfall planning, on the other hand, would look ahead, using a series of animations to place footfalls in the correct locations to achieve a distant goal. As yet, I am not aware of anyone doing this.

EXERCISES

4.1 We can represent the graph in Figure 4.4 as a set of nodes and edges:

```
nodes
              \{A, B, C, D\}
edges
              \{(A, B): 4, (B, A): 4, (A, D): 5, (D, A): 5,
              (B, D) : 6, (D, B) : 6, (B, C) : 5, (C, B) : 5.
```

The following description is of a weighted directed graph taken from an MIT lecture by Tomas Lozano-Perez and Leslie Kaelbling:

```
nodes
              {S, A, B, C, D, G}
         =
edges
              \{(S, A) : 6, (S, B) : 15, (A, C) : 6, (A, D) : 12,
              (B, D): 3, (B, G): 15, (D, C): 9, (D, G): 6}.
```

Draw a diagram of the graph.

4.2 In the graph you drew in Exercise 4.1 assume that S is the start node and G is the goal node. If we use Dijkstra's algorithm to find the minimum cost path from S to G, then the following table shows the contents of the open list for the first 2 steps of the algorithm. Fill in the remaining 5 lines.

	Open List					
1	0: <i>S</i>					
2	6: $A \leftarrow S$, 15: $B \leftarrow S$					
3						
4						
5						
6						
7						

- 4.3 In the answer to Exercise 4.2, explain why we don't just stop when we visit the goal node for the first time.
- 4.4 For a node A, we can specify that the value of the heuristic function at the node is 5 by writing A:5. Update the diagram you drew for Exercise 4.1 with the following heuristic values:

```
nodes = \{S: 0, A: 6, B: 9, C: 3, D: 3, G: 0\}
```

4.5 If the A* algorithm is applied to the same graph as in Exercise 4.2, the following table shows the contents of the open list for the first 2 steps. Fill in the remaining 3 lines.

	Open List
1	0: S
2	12: $A \leftarrow S$, 24: $B \leftarrow S$
3	
4	
5	

4.6 Using the same graph as for Exercise 4.5, what is the maximum value of the heuristic at D before the heuristic no longer underestimates the actual cost?

4.7 A heuristic is called *consistent* if it has the property that for every node A and every successor B of A, the estimated cost of reaching the goal from A is no greater than the cost of getting from A to B plus the estimated cost of reaching the goal from B. In equation form:

$$h(A) \le cost(A, B) + h(B)$$

Is the heuristic defined in Exercise 4.4 consistent?

- 4.8 Explain why, if the heuristic used for A* is consistent and admissible, then you don't need a closed list.
- 4.9 How could you make any admissible heuristic into a consistent one?
- 4.10 The grid below shows costs associated with cells on a map. For example, suppose the cells of cost 1 correspond to flat grassland while the cells of cost 3 correspond to more mountainous areas.

1	1	1	1	1	1	1	1	1	1	1	1	1
1	1	1	1	1	3	1	1	1	1	1	1	1
1	1	1	3	3	3	3	3	3	1	3	3	1
1	1	1	1	3	3	3	1	1	1	1	1	1
1	1	1	1	1	3	3	1	1	1	1	1	1
1	1	1	1	1	1	1	1	1	1	1	1	1
1	1	1	1	1	1	1	1	1	1	1	1	1
1	1	1	1	3	1	1	1	1	1	3	1	3
3	3	1	3	3	1	3	3	1	3	3	3	3
1	1	1	3	3	1	1	1	1	3	3	3	3
1	1	1	1	3	1	1	1	1	1	3	1	3
1	1	1	1	1	1	1	1	1	1	1	1	1

If we wanted to speed up A* would we artificially *increase* or *decrease* the costs of the mountainous areas? Why? What is the downside of making the change?

- 4.11 A common trick used in games to avoid the expense of taking square roots is to perform all distance comparisons with the distance squared. Explain why using the distance squared, in place of the standard Euclidean distance, as a heuristic for A* would be a bad idea.
- 4.12 For a world represented as a tile graph, where m is the cost to move between any two adjacent tiles, the Manhattan distance heuristic can be defined as:

$$h(n) = m(|\mathsf{start}_x - \mathsf{goal}_x| + |\mathsf{start}_z - \mathsf{goal}_z|)$$

Explain why this might be a better heuristic to use on a tile graph than the Euclidean distance.

4.13 Draw the navigation mesh you would get by considering edges as nodes in Figure 4.29.

	B10	B11	C1
	В8	В9	
B5	В6	В7	
В3		В4	
B1		B2	
A4	A5	A6	
A1	A2	А3	

Figure 4.56: A representation of a game level as a grid

Figure 4.57: Important points marked on part of a simple level

- 4.14 Games need to take into account many factors beside distance when calculating path costs. We'll consider many examples in Chapter6, but try to think of some on your own in advance.
- 4.15 Compute the minimum, maximin, and average minimum distance costs of going from group B to group C in the tile-based representation of a level shown in Figure 4.56.
- 4.16 Figure 4.57 shows part of a level with 4 nodes, where S is the start, G is the goal, A is a node in a doorway, and B is a normal node. Nodes S, A, and G are all 3 units apart while B is 4 units from A.
 - Suppose for the door to open a character has to first stand in front of it for t seconds.

Assuming that a character moves at 1 unit per second, then for values of t=1 and t=7 draw a separate "nodes as states" graph like the one in Figure 4.46. For what value of t does it become faster to simply go around rather than wait for the door to open?

5

DECISION MAKING

A SK A GAMER about game AI, and they think about decision making: the ability of a character to decide what to do. Carrying out that decision (movement, animation, and the like) is taken for granted.

In reality, decision making is typically a small part of the effort needed to build great game AI. Most games use simple decision making systems: state machines and behavior trees. Rule-based systems are rarer, but important.

In recent years a lot of interest has been shown in more sophisticated decision making tools, such as fuzzy logic and neural networks. Despite notable uses in some high-profile games (often accompanied by much marketing fanfare), developers haven't been in a rush to embrace these technologies. It can be hard to get them working right.

Decision making is the middle component of our AI model (Figure 5.1), but despite this chapter's name, we will also cover a lot of techniques used in tactical and strategic AI. All the techniques here are applicable to both single-character and multiple-character decision making.

This chapter will look at a wide range of decision making tools, from very simple mechanisms that can be implemented in minutes to comprehensive decision making tools that require more sophistication but can support richer behaviors. At the end of the chapter we'll look at the output of decision making and how to act on it.

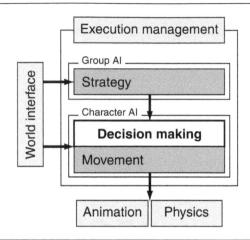

Figure 5.1: The AI model

$5.1\,$ overview of decision making

Although there are many different decision making techniques, we can look at them all as acting in the same way.

The character processes a set of information that it uses to generate an action that it wants to carry out. The input to the decision making system is the knowledge that a character possesses, and the output is an action request. The knowledge can be further broken down into external and internal knowledge. External knowledge is the information that a character knows about the game environment around it: the position of other characters, the layout of the level, whether a switch has been thrown, the direction that a noise is coming from, and so on. Internal knowledge is information about the character's internal state or thought processes: its health, its ultimate goals, what it was doing a couple of seconds ago, and so on.

Typically, the same knowledge can drive any of the algorithms in this chapter. Some internal data is particular to the algorithms themselves (a state machine needs to hold what state the character is currently in, for example, where a goal oriented behavior needs to know what its current goal is). The algorithms themselves control what kinds of internal knowledge can be used (whether it stores goals, states, plans, or probabilities), although they don't constrain what that knowledge represents, in game terms.

The behavior of an algorithm, correspondingly, can affect the game in two ways: they can request an action that will change the external state of the character (such as throwing a switch, firing a weapon, moving into a room) and they can change the internal state of the algorithm (such as adopting a new goal, or adjusting a probability). See Figure 5.2 for a schematic representation of this.

Changes to the internal state are, by definition, less visible to the player. In the same way

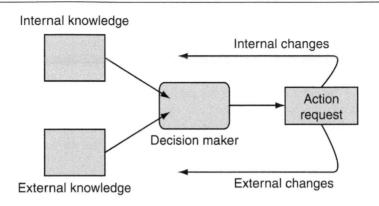

Figure 5.2: Decision making schematic

that changes in a person's mental state are not visible unless they act on them. But in most decision-making algorithms the internal state is where most of the work is done. Changes might correspond to altering the character's opinion of the player, changing its emotional state, or adopting a new goal. Again, algorithms will typically carry out those internal changes in a way that is particular to the algorithm, while external actions can be generated in a form that is identical for each algorithm.

The format and quantity of the knowledge available to the AI depends on the requirements of the game. Knowledge representation is intrinsically linked with most decision making algorithms. It is difficult to be completely general with knowledge representation, although we will consider some widely applicable mechanisms in Chapter 11.

Actions, on the other hand, can be treated more consistently. We'll return to the problem of representing and executing actions at the end of this chapter.

5.2 DECISION TREES

Decision trees are fast, easily implemented, and simple to understand. They are the simplest decision making technique that we'll look at, although extensions to the basic algorithm can make them quite sophisticated. They are used extensively to control characters and for other in-game decision making, such as animation control.

They have the advantage of being very modular and easy to create. I've seen them used for everything from animation to complex strategic and tactical AI.

Although it is rare in current games, decision trees can also be learned, and the learned tree is relatively easy to understand (compared to, for example, the weights of a neural network). We'll come back to this topic later, in Chapter 7.

5.2.1 THE PROBLEM

Given a set of knowledge about the current state of the game, and a set of possible actions that can be performed, we need to request an appropriate action.

The mapping between input and output may be quite complex. The same action can be used for many different sets of input, but any small change in one input value might make the difference between an action being sensible and an action appearing stupid.

We need a method that can easily group lots of inputs together under one action, while allowing the input values that are significant to control the output.

5.2.2 THE ALGORITHM

A decision tree is made up of connected decision points, also called choices or nodes. The tree has a starting decision, its root. For each decision, starting from the root, one of a set of options is chosen. These choices lead either to further decisions, or to a final action.

Each choice is made based on the character's knowledge. Because decision trees are often used as simple and fast decision mechanisms, characters usually refer directly to the global game state rather than having a representation of what they personally know.

The algorithm continues along the tree, making choices at each decision node until the decision process has no more decisions to consider. At each leaf of the tree an action is attached. When the decision algorithm arrives at an action, that action is carried out immediately.

Most decision tree nodes make very simple decisions, typically with only two possible responses. In Figure 5.3 the decisions relate to the position of an enemy.

Notice that one action can be placed at the end of multiple branches. In Figure 5.3 the character will choose to attack unless it can't see the enemy or is flanked. The attack action is present at two leaves.

Figure 5.4 shows the same decision tree with a decision having been made. The path taken by the algorithm is highlighted, showing the arrival at a single action, which may then be executed by the character.

Decisions

Decisions in a tree are simple. They typically check a single value and don't contain any Boolean logic (i.e., they don't join tests together with AND or OR).

Depending on the implementation and the data types of the values stored in the character's knowledge, different kinds of tests may be possible. A representative set is given in the following table:

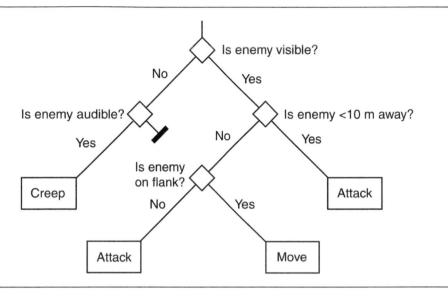

Figure 5.3: A decision tree

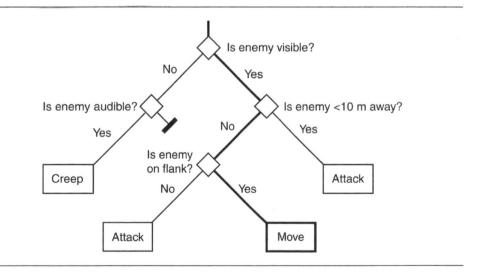

Figure 5.4: The decision tree with a decision made

Data Type	Decisions
Boolean	Value is true
Enumeration (i.e., a set of values only one of which might be allowable)	Matches one of a given set of values
Numeric value (either integer or floating point)	Value is within a given range
3D Vector	Vector has a length within a given range (this can be used to check the distance between the character and an enemy for example)

In addition to primitive types, it is common to allow custom decision tree nodes that can query the game and perform arbitrary logic. This allows the decision tree both to support game specific logic and to delegate more complex processing (such as line of sight tests, or physics prediction) to optimized and compiled code.

Combinations of Decisions

The decision tree is efficient because decisions are typically very simple, and those that are less performant are only called when necessary. Each decision makes only one test. Each decision can also be tested independently. When Boolean combinations of tests are required, the tree structure represents this.

To AND two decisions together, they are placed in series in the tree. The first part of Figure 5.5 illustrates a tree with two decisions, both of which need to be true in order for action 1 to be carried out. This tree has the logic "if A AND B, then carry out action 1, otherwise carry out action 2."

To OR two decisions together, we also use the decisions in series, but with the two actions swapped over from the AND example above. The second part of Figure 5.5 illustrates this. If either test returns true, then action 1 is carried out. Only if neither test passes is action 2 run. This tree has the logic "if A OR B, then carry out action 1, otherwise carry out action 2."

This ability for simple decision trees to build up any logical combination of tests is used in other decision making systems. We'll see it again in the Rete algorithm in Section 5.8 on rule-based systems.

Decision Complexity

Because decisions are built into a tree, the number of decisions that need to be considered is usually much smaller than the number of decisions in the tree. Figure 5.6 shows a decision tree with 15 different decisions and 16 possible actions. After the algorithm is run, we see that only four decisions are ever considered.

Decision trees are relatively simple to build and can be built in stages. A simple tree can

If A AND B then action 1, otherwise action 2

If A OR B then action 1, otherwise action 2

Figure 5.5: Trees representing AND and OR

be implemented initially, and then as the AI is tested in the game, additional decisions can be added to trap special cases or add new behaviors.

Branching

In the examples so far, and in most of the rest of the chapter, decisions will choose between two options. This is called a binary decision tree. There is no reason why you can't build your decision tree so that decisions can have any number of options. You can also have different decisions with different numbers of branches.

Imagine having a guard character in a military facility. The guard needs to make a decision based on the current alert status of the base. This alert status might be one of a set of states: "green," "yellow," "red," or "black," for example. Using the simple binary decision making tree described above, we'd have to build the tree in Figure 5.7 to make a decision.

The same value (the alert state) may be checked three times. This won't be as much of a problem if we order the checks so the most likely states come first. Even so, the decision tree may have to do the same work several times to make a decision.

We could allow our decision tree to have several branches at each decision point. With four branches, the same decision tree now looks like Figure 5.8.

This structure is flatter, only ever requires one decision, and is obviously more efficient.

Figure 5.6: Wide decision tree with decision

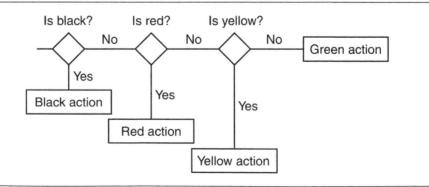

Figure 5.7: Deep binary decision tree

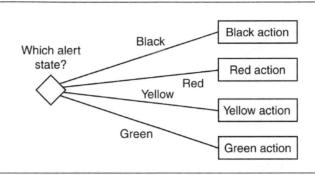

Figure 5.8: Flat decision tree with four branches

Despite the obvious advantages, it is more common to see decision trees using only binary decisions. for several reasons:

- 1. the underlying code for multiple branches usually simplifies down to a series of binary tests (if statements in C-like languages, for example), and so, although the decision tree is simpler with multiple branches, the same underlying code is being run, and its speed is usually not significantly different;
- 2. most of the common learning algorithms that work with decision trees require them to be binary;
- 3. and most importantly, binary decisions can simplify the implementation and tooling support.

You can do anything with a binary tree that you can do with a more complex tree, so it has become conventional to stick with two branches per decision. Most, although not all, of the decision tree systems I've worked with have used binary decisions. But ultimately it is a matter of implementation preference.

5.2.3 PSEUDO-CODE

A decision tree takes as input a tree definition, consisting of linked decision tree nodes. Decision tree nodes might be decisions or actions. In an object-oriented language, these may be sub-classes of a base tree node class, or implementations of a common interface. In each case a method is specified that is used to perform the decision tree algorithm. It is not defined in the base class (i.e., it is a pure virtual function):

```
class DecisionTreeNode:
      # Recursively walk through the tree.
2
       function makeDecision() -> DecisionTreeNode
3
```

Actions simply contain details of the action to run if the tree arrives there. Their structure depends on the action information needed by the game (see Section 5.10 later in the chapter for details on the structure of actions). Their makeDecision function simply returns the action (we'll see how this is used in a moment):

```
class Action extends DecisionTreeNode:
      function makeDecision() -> DecisionTreeNode:
2
           return this
```

Decisions have the following format:

```
class Decision extends DecisionTreeNode:
       trueNode: DecisionTreeNode
       falseNode: DecisionTreeNode
       # Defined in subclasses, with the appropriate type.
       function testValue() -> any
       # Perform the test.
       function getBranch() -> DecisionTreeNode
10
       # Recursively walk through the tree.
11
       function makeDecision() -> DecisionTreeNode
12
```

where the trueNode and falseNode members are pointers to other nodes in the tree, and the testValue method returns the piece of data in the character's knowledge which will form the basis of the test. The getBranch function carries out the test and returns the branch that should be followed. Often, there are different forms of the decision node structure for different types of tests (i.e., for different data types). For example, a decision for floating point values might look like the following:

```
class FloatDecision extends Decision:
       minValue: float
2
       maxValue: float
       function testValue() -> float
       function getBranch() -> DecisionTreeNode:
           if maxValue >= testValue() >= minValue:
                return trueNode
10
           else:
                return falseNode
11
```

A decision tree can be referred to by its root node: the first decision it makes. A decision tree with no decisions might have an action as its root. This can be useful for prototyping a character's AI, by forcing a particular action to always be returned from its decision tree.

The decision tree algorithm is recursively performed by the makeDecision method. It can be trivially expressed as:

```
class Decision extends DecisionTreeNode:
1
      function makeDecision() -> DecisionTreeNode:
2
           # Make the decision and recurse based on the result.
3
           branch: DecisionTreeNode = getBranch()
4
           return branch.makeDecision()
5
```

The makeDecision function is called initially on the root node of the decision tree.

Multiple Branches

We can implement a decision that supports multiple branches almost as simply. Its general form is:

```
class MultiDecision extends DecisionTreeNode:
       daughterNodes: DecisionTreeNode[]
2
       function testValue() -> int
       # Carries out the test and returns the node to follow.
       function getBranch() -> DecisionTreeNode:
           return daughterNodes[testValue()]
8
10
       # Recursively runs the algorithm, exactly as before.
       function makeDecision() -> DecisionTreeNode:
11
12
           branch: DecisionTreeNode = getBranch()
           return branch.makeDecision()
13
```

where daughterNodes is a mapping between possible values of the testValue and branches of the tree. This can be implemented as a hash table, or for a numeric test value it might be an array of daughter nodes that can be searched using a binary search algorithm.

5.2.4 KNOWLEDGE REPRESENTATION

Decision trees work directly with primitive data types. Decisions can be based on integers, floating point numbers, Booleans, or any other kind of game-specific data. One of the benefits of decision trees is that they require no translation of knowledge from the format used by the rest of the game.

Correspondingly, decision trees are most commonly implemented so they access the state of the game directly. If a decision tree needs to know how far the player is from an enemy, then it will most likely access the player and enemy's position directly.

This lack of translation can cause difficult-to-find bugs. If a decision in the tree is very rarely used, then it may not be obvious if it is broken. During development, the structure of the game state regularly changes, and this can break decisions that rely on a particular structure or implementation. A decision might detect, for example, which direction a security camera is pointing. If the underlying implementation changes from a simple angle to a full quaternion to represent the camera rotation, then the decision will break.

To avoid this situation, some developers choose to insulate all access to the state of the game. The techniques described in Chapter 11 on world interfacing provide this level of protection.

5.2.5 IMPLEMENTATION NOTES

The function above relies on being able to tell whether a node is an action or a decision and being able to call the test function on the decision and have it carry out the correct test logic (i.e., in object-oriented programming terms, the test function must be polymorphic).

Both are simple to implement using object-oriented languages with runtime-type information (i.e., we can detect which class an instance belongs to at runtime).

Many games written in C++ switch off RTTI (runtime-type information) for speed reasons, or else provide their own type information through non-standard mechanisms. In this case the "is instance of" test must be made using identification codes embedded into each class or another manual method.

Similarly, though it is much less performance critical now than 10 years ago, some developers prefer to avoid using virtual functions (the C++ implementation of polymorphism). In this case, some manual mechanism is needed to detect which kind of decision is needed and to call the appropriate test code.

5.2.6 PERFORMANCE OF DECISION TREES

You can see from the pseudo-code that the algorithm is very simple. It takes no memory, and its performance is linear with the number of nodes visited.

If we assume that each decision takes a constant amount of time and that the tree is balanced (see the next section for more details), then the performance of the algorithm is $O(\log_2 n)$, where n is the number of decision nodes in the tree. At worst it is O(n).

It is very common for the decisions to take constant time. The example decisions I gave in the table at the start of the section are all constant time processes. There are some decisions that take more time, however. A decision that checks if any enemy is visible, for example, may involve complex ray casting sight checks through the level geometry. If this decision is placed in a decision tree, then the execution time of the decision tree will be swamped by the execution time of this one decision.

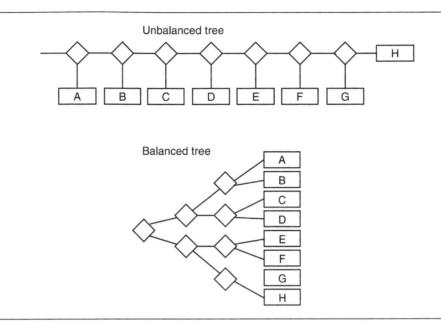

Figure 5.9: Balanced and unbalanced trees

BALANCING THE TREE

Decision trees are intended to run fast and are fastest when the tree is balanced. A balanced tree has about the same number of leaves on each branch. Compare the decision trees in Figure 5.9. The second is balanced (same number of behaviors in each branch), while the first is extremely unbalanced. Both have 8 behaviors and 7 decisions.

To get to behavior H, the first tree needs 8 decisions, whereas the second tree only needs 3. In fact, if all behaviors were equally likely, then the first tree would need an average of nearly $4\frac{1}{2}$ decisions, whereas the second tree would always only need 3.

At its worst, with a severely unbalanced tree, the decision tree algorithm goes from being $O(\log_2 n)$ to O(n). Clearly, we'd like to make sure we stay as balanced as possible, with the same number of leaves resulting from each decision.

Although a balanced tree is theoretically optimal, in practice the fastest tree structure is slightly more complex.

In reality, the different results of a decision are not equally likely. Consider the example trees in Figure 5.9 again. If we were likely to end up in behavior A the majority of the time, then the first tree would be more efficient; it gets to A in one step. The second tree takes 3 decisions to arrive at A.

In addition, not all decisions are equal. A decision that is very time consuming to run (such as one that searches for the distance to the nearest enemy) should only be taken if

Figure 5.10: Merging branches

absolutely necessary. Having this further down the tree, even at the expense of having an unbalanced tree, is a good idea.

Structuring the tree for maximum performance is a black art. Since decision trees are very fast anyway, it is rarely important to squeeze out every ounce of speed. Use these general guidelines: balance the tree, but make commonly used branches shorter than rarely used ones and put the most expensive decisions late.

5.2.8 BEYOND THE TREE

So far we have kept a strict branching pattern for our tree. We can extend the tree to allow branches to merge into a new decision. Figure 5.10 shows an example of this.

The algorithm I described earlier will support this kind of tree without modification. It is simply a matter of assigning the same decision to more than one trueNode or falseNode in the tree. It can then be reached in more than one way. This is just the same as assigning a single action to more than one leaf.

As well as merging, the code so far supports loops. Unfortunately the algorithm does not know how to process them. In Figure 5.11, the third decision in the tree has a falseNode earlier in the tree. The decision process can repeat forever, never finding a leaf.

Strictly, the valid decision structure is called a *directed acyclic graph* (DAG). In the context of this algorithm, it still is always called a decision tree.

Figure 5.11: Pathological tree

5.2.9 RANDOM DECISION TREES

Often, we don't want the choice of behavior to be completely predictable. Some element of random choice adds unpredictability, interest, and variation.

It is simple to add a decision into the decision tree that has a random element. We could generate a random number, for example, and choose a branch based on its value.

Because decision trees are intended to run frequently, reacting to the immediate state of the world, random decisions cause problems. Imagine running the tree in Figure 5.12 at every frame.

As long as the agent isn't under attack, the stand still and patrol behaviors will be chosen at random. This choice is made at every frame, so the character will appear to vacillate between standing and moving. This is likely to appear odd and unacceptable to the player.

To introduce random choices in the decision tree, the decision making process needs to become stable—if there is no relevant change in world state, there should be no change in decision. Note that this isn't the same as saying the agent should make the same decision every time for a particular world state. Faced with the same state later in the game, it can make different decisions, but at consecutive frames it should stay with one decision.

In the previous tree, every time the agent is not under attack it can stand still or patrol. We don't care which it does, but once it has chosen, it should continue doing that.

This is achieved by allowing the random decision to keep track of what it did last time. When the decision is first considered, a choice is made at random, and that choice is stored. The next time the decision is considered, there is no randomness, and the previous choice is automatically taken.

If the decision tree is run again, and the same decision is not considered, it means that

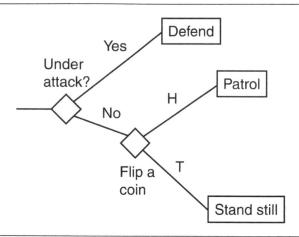

Figure 5.12: Random tree

some other decision went a different way-something in the world must have changed. In this case we need to get rid of the choice we made.

Pseudo-Code

This is the pseudo-code for a random binary decision:

```
class RandomDecision extends Decision:
       lastFrame: int = -1
2
       currentDecision: bool = false
3
       function testValue() -> bool:
           frame = getCurrentFrame()
           # Check if our stored decision is too old.
           if frame > lastFrame + 1:
               # Make a new decision and store it.
10
               currentDecision = randomBoolean()
11
           # Either way we need to store when we were last called.
13
           lastFrame = frame
15
           return currentDecision
```

To avoid having to go through each unused decision and remove its previous value, we store the frame number at which a stored decision is made. If the test method is called, and

the previous stored value was stored on the previous frame, we use it. If it was stored prior to that, then we create a new value.

This code relies on two functions:

- · frame returns the number of the current frame. This should increment by one each frame. If the decision tree isn't called every frame, then frame should be replaced by a function that increments each time the decision tree is called.
- randomBoolean returns a random Boolean value, either true or false.

This algorithm for a random decision can then be used with the decision tree algorithm provided above.

Timing Out

If the agent continues to do the same thing forever, it may look strange. The decision tree in our example above, for example, could leave the agent standing still forever, as long as we never attack.

Random decisions that are stored can be set with time-out information, so the agent changes behavior occasionally.

The pseudo-code for the decision now looks like the following:

```
class RandomDecisionWithTimeOut extends Decision:
       lastFrame: int = -1
       currentDecision: bool = false
3
       # Make a new decision after this number of frames.
5
       timeOut: int = 1000
       timeOutFrame: int = -1
       function testValue() -> bool:
           frame = getCurrentFrame()
10
11
           # Check if our stored decision is too old.
12
           if frame > lastFrame + 1 or frame >= timeOutFrame:
13
                # Make a new decision and store it.
14
                currentDecision = randomBoolean()
15
16
                # Schedule the next new decision.
17
                timeOutFrame = frame + timeOut
18
19
           # Either way we need to store when we were last called.
20
           lastFrame = frame
21
22
           return currentDecision
23
```

Again, this decision structure can be used directly with the previous decision tree algorithm.

There can be any number of more sophisticated timing schemes. For example, make the stop time random so there is extra variation, or alternate behaviors when they time out so the agent doesn't happen to stand still multiple times in a row. Use your imagination.

Using Random Decision Trees

I've included this section on random decision trees as a simple extension to the decision tree algorithm. It isn't a common technique: it is one I've used only once myself. But it is intended to illustrate the ease with which you can expand on the basic decision tree approach.

It is the kind of technique, however, that can breathe a lot more life into a simple algorithm for very little implementation cost. One perennial problem with decision trees is their predictability; they have a reputation for giving AI that is overly simplistic and prone to exploitation. Introducing just a simple random element in this way goes a long way toward rescuing the technique.

5.3 STATE MACHINES

Often, characters in a game will act in one of a limited set of ways. They will carry on doing the same thing until some event or influence makes them change. A Covenant warrior in Halo: Combat Evolved [91], for example, will stand at its post until it notices the player, then it will switch into attack mode, taking cover and firing.

We can support this kind of behavior using decision trees, and I went some way toward doing that using random decisions. In most cases, however, it is easier to use a technique designed for this purpose: state machines.

State machines are the technique most often used for this kind of decision making and, along with scripting (see Chapter 12, Section 13.3), still make up a majority of decision making systems used in games.

State machines take account of both the world around them (like decision trees) and their internal makeup (their state).

A Basic State Machine

In a state machine each character occupies one state. Normally, actions or behaviors are associated with each state. So, as long as the character remains in that state, it will continue carrying out the same action.

States are connected together by transitions. Each transition leads from one state to another, the target state, and each has a set of associated conditions. If the game determines that the conditions of a transition are met, then the character changes state to the transition's target state. When a transition's conditions are met, it is said to trigger, and when the transition is followed to a new state, it has *fired*.

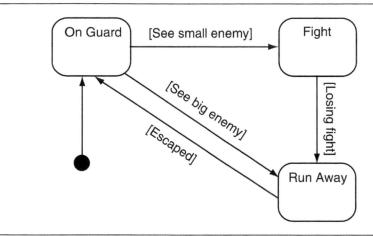

Figure 5.13: A simple state machine

Figure 5.13 shows a simple state machine with three states: On Guard, Fight, and Run Away. Notice that each state has its own set of transitions.

The state machine diagrams in this chapter are based on the Unified Modeling Language (UML) state chart diagram format, a standard notation used throughout software engineering. States are shown as curved corner boxes. Transitions are arrowed lines, labeled by the condition that triggers them. Conditions are contained in square brackets.

The solid circle in Figure 5.13 has only one transition without a trigger condition. The transition points to the initial state that will be entered when the state machine is first run.

You won't need an in-depth understanding of UML to understand this chapter. If you want to find out more about UML, I'd recommend searching online for a tutorial or consulting a reference book such as [48].

In a decision tree, the same set of decisions is always used, and any action can be reached at any time through the tree. In a state machine, only transitions from the current state are considered, so not every action can be reached at any particular time: only the current state and its neighbors.

Finite State Machines

In game AI any state machine with this kind of structure is usually called a finite state machine (FSM). This and the following sections will cover a range of increasingly powerful state machine implementations, all of which are often referred to as FSMs.

This causes confusion with non-games programmers, for whom the term FSM is more commonly used for a particular type of simple state machine. An FSM in computer science normally refers to an algorithm used for parsing text. Compilers use an FSM to tokenize the input code into symbols that can be interpreted by the compiler.

The Game FSM

The basic state machine structure is very general and admits any number of implementations. I have seen tens of different ways to implement a game FSM, and it is rare to find any two developers using exactly the same technique. That makes it difficult to put forward a single algorithm as being the "state machine" algorithm.

Later in this section, I'll describe a range of different implementation styles for the FSM, but I will work through just one main algorithm, chosen for its flexibility and the cleanness of its implementation.

5.3.1 THE PROBLEM

We would like a general system that supports arbitrary state machines with any kind of transition condition. The state machine will conform to the structure given above and will occupy only one state at a time.

5.3.2 THE ALGORITHM

To achieve this we use a generic state interface that can be implemented to include any specific code. The state machine keeps track of the set of possible states and records the current state it is in. Alongside each state, a series of transitions is maintained. Each transition is again a generic interface that can be implemented with the appropriate conditions. It simply reports to the state machine whether it is triggered or not.

At each iteration (normally each frame), the state machine's update function is called. This checks to see if any transition from the current state is triggered. The first transition that is triggered is scheduled to fire. The method then compiles a list of actions to perform from the currently active state. If a transition has been triggered, then the transition is fired.

This separation of the triggering and firing of transitions allows the transitions to also have their own actions. Often, transitioning from one state to another also involves carrying out some action. In this case, a fired transition can add the action it needs to those returned by the state.

5.3.3 PSEUDO-CODE

The state machine holds a list of states, with an indication of which one is the current state. It has an update function for triggering and firing transitions and a function that returns a set of actions to carry out:

```
class StateMachine:
       # We're in one state at a time.
2
        initialState: State
       currentState: State = initialState
       # Checks and applies transitions, returning a list of actions.
       function update() -> Action[]:
            # Assume no transition is triggered.
            triggered: Transition = null
10
            # Check through each transition and store the first
11
           # one that triggers.
12
            for transition in currentState.getTransitions():
13
                if transition.isTriggered():
14
                    triggered = transition
15
                    break
17
           # Check if we have a transition to fire.
18
            if triggered:
19
                # Find the target state.
20
                targetState = triggered.getTargetState()
21
22
                # Add the exit action of the old state, the
23
                # transition action and the entry for the new state.
24
                actions = currentState.getExitActions()
25
                actions += triggered.getActions()
26
                actions += targetState.getEntryActions()
27
28
                # Complete the transition and return the action list.
29
                currentState = targetState
30
                return actions
31
32
33
           # Otherwise just return the current state's actions.
34
                return currentState.getActions()
35
```

5.3.4 DATA STRUCTURES AND INTERFACES

The state machine relies on having states and transitions with a particular interface. The state interface has the following form:

```
class State:
      function getActions() -> Action[]
2
      function getEntryActions() -> Action[]
      function getExitActions() -> Action[]
4
      function getTransitions() -> Transition[]
```

Each of the getXActions methods should return a list of actions to carry out. As we will see below, the getEntryActions is only called when the state is entered from a transition, and the getExitActions is only called when the state is exited. The rest of the time that the state is active, getActions is called. The getTransitions method should return a list of transitions that are outgoing from this state.

The transition interface has the following form:

```
class Transition:
    function isTriggered() -> bool
    function getTargetState() -> State
    function getActions() -> Action[]
```

The isTriggered method returns true if the transition can fire, the getTargetState method reports which state to transition to, and the getAction method returns a list of actions to carry out when the transition fires.

Transition Implementation

Only one implementation of the state class should be required: it can simply hold the three lists of actions and the list of transitions as data members, returning them in the corresponding get methods.

In the same way, we can store the target state and a list of actions in the transition class and have its methods return the stored values. The isTriggered method is more difficult to generalize. Each transition will have its own set of conditions, and much of the power in this approach is allowing the transition to implement any kind of tests it likes.

Because state machines are often defined in a data file and read into the game at runtime, it is a common requirement to have a set of generic transitions. The state machine can then be constructed from the data file by using the appropriate transitions for each state.

In the previous section on decision trees, we saw generic testing decisions that operated on basic data types. The same principle can be used with state machine transitions: we have generic transitions that trigger when data they are looking at are in a given range.

Unlike decision trees, state machines don't provide a simple way of combining these tests to make more complex queries. If we need to transition on the condition that the enemy is far away AND health is low, then we need some way of combining triggers together.

In keeping with the polymorphic design for the state machine, we can accomplish this with the addition of another interface: the Condition interface. We can use a general transition class of the following form:

```
class Transition:
       actions: Action[]
2
       function getActions() -> Action[]:
3
           return actions
4
5
6
       targetState: State
```

```
function getTargetState() -> State:
           return targetState
8
       condition: Condition
10
       function isTriggered() -> bool:
11
           return condition.test()
```

The isTriggered function now delegates the testing to its condition member. Conditions have the following simple format:

```
class Condition:
      function test() -> bool
2
```

We can then make a set of sub-classes of the Condition class for particular tests, just like we did for decision trees:

```
class FloatCondition extends Condition:
      minValue: float
2
      maxValue: float
3
      function testValue() -> float # Test the data we're interested in.
      function test() -> bool:
7
           return minValue <= testValue <= maxValue
```

We can combine conditions together using Boolean sub-classes, such as AND, NOT, and OR:

```
class AndCondition extends Condition:
2
       conditionA: Condition
       conditionB: Condition
3
       function test() -> bool:
           return conditionA.test() and conditionB.test()
   class NotCondition extends Condition:
7
       condition: Condition
8
9
       function test() -> bool:
           return not condition.test()
10
11
  class OrCondition extends Condition:
12
       conditionA: Condition
13
       conditionB: Condition
14
       function test() -> bool:
15
16
           return conditionA.test() or conditionB.test()
```

and so on, for any level of sophistication we need.

Weaknesses

This approach to transitions gives a lot of flexibility, but at the price of lots of method calls. These method calls have to be polymorphic, which can slow down the call and confuse the processor. All this adds time, which may make it unsuitable for use in every frame on lots of characters. The slowdown is minor however. On modern hardware the complexity of a state machine is unlikely to be a performance bottleneck.

One advantage of this approach, that further doubles down on the polymorphic nature of the implementation, is that transitions can be implemented in a scripting language for special gameplay purposes. These are obviously even slower to execute, but the flexibility is often worth it, allowing gameplay logic to be created simply and merged seamlessly into the rest of the AI system.

5.3.5 PERFORMANCE

The state machine algorithm only requires memory to hold a triggered transition and the current state. It is O(1) in memory, and O(m) in time, where m is the number of transitions per state.

The algorithm calls other functions in both the state and the transition classes, and in most cases the execution time of these functions accounts for most of the time spent in the algorithm.

5.3.6 IMPLEMENTATION NOTES

As I mentioned earlier, there are any number of ways to implement a state machine.

The state machine described in this section is as flexible as possible. I have tried to aim for an implementation that allows you to experiment with any kind of state machine and add interesting features. In many cases, it may be too flexible. If you're only planning to use a small subset of its flexibility, then it is very likely to be unnecessarily inefficient.

5.3.7 HARD-CODED FSM

A few years back, almost all state machines were hard coded. The rules for transitions and the execution of actions were part of the game code. It has become less common as game engines have become more usable and generic, and as level designers have been given more control over building the state machine logic (especially via visual tools), but it is still an important approach.

Pseudo-Code

In a hard-coded FSM, the state machine consists of an enumerated value, indicating which state is currently occupied, and a function that checks if a transition should be followed. Here, I've combined the two into a class definition (although hard-coded FSMs tend to be associated with developers still working in a low-level language such as C).

```
class MvFSM:
2
        # Define the names for each state.
        enum State:
3
            PATROL
4
            DEFEND
5
            SLEEP
7
        # The current state.
9
        myState: State
10
11
        function update():
            # Find the correct state.
12
            if myState == PATROL:
13
                # Example transitions.
14
                 if canSeePlayer():
15
                     myState = DEFEND
16
                else if tired():
17
                     myState = SLEEP
18
19
            else if myState == DEFEND:
20
                # Example transitions.
21
                if not canSeePlayer():
22
                     myState = PATROL
23
            else if myState == SLEEP:
                # Example transitions.
26
                 if not tired():
27
                     myState = PATROL
28
29
        function notifyNoiseHeard(volume: float):
30
            if myState == SLEEP and volume > 10:
31
                myState = DEFEND
32
```

Notice that this is pseudo-code for a particular state machine rather than a type of state machine. In the update function there is a block of code for each state. In that block of code the conditions for each transition are checked in turn, and the state is updated if required. The transitions in this example all call functions (tired and canSeePlayer), which I am assuming have access to the current game state.

In addition, I've added a state transition in a separate function, notifyNoiseHeard. I am assuming that the game code will call this function whenever the character hears a loud noise. This illustrates the difference between a polling (asking for information explicitly) and an event-based (waiting to be told information) approach to state transitions. Chapter 11 on world interfacing contains more details on this distinction.

The update function is called in each frame, as before, and the current state is used to generate an output action. To do this, the FSM might have a method containing conditional blocks of the following form:

```
function getAction() -> Action:
2
      if myState == PATROL:
3
          return new PatrolAction()
      else if myState == DEFEND:
4
          return new DefendAction()
5
      else if myState == SLEEP:
6
           return new SleepAction()
```

Often, the state machine simply carries out the actions directly, rather than returning details of the action for another piece of code to execute.

Performance

This approach requires no memory and is O(n+m), where n is the number of states, and m is the number of transitions per state. Although this appears to perform worse than the flexible implementation, it is usually faster in practice for all but huge state machines (i.e., thousands of states).

Some implementations beat this performance, because they have inbuilt support for resuming execution in the middle of a function. Lua continuations, for example, allow us to yield execution within a function representing one state, then resume on the following frame. Such implementations are O(m). Being implemented in a higher level language, however, they are rarely faster than the low-level approach.

Weaknesses

Although hard-coded state machines are easy to write, they are notoriously difficult to maintain. State machines in games can often get fairly large, and this can appear as ugly and unclear code.

Most developers, however, find that the main drawback is the need for programmers to write the AI behaviors for each character. This implies a need to recompile the game each time the behavior changes. While it may not be a problem for a hobby game writer, it can become critical in a large game project that takes many minutes or hours to rebuild.

More complex structures, such as hierarchical state machines (see below), are also difficult to coordinate using hard-coded FSMs. With a more flexible implementation, debugging output can easily be added to all state machines, making it easier to track down problems in the AI.

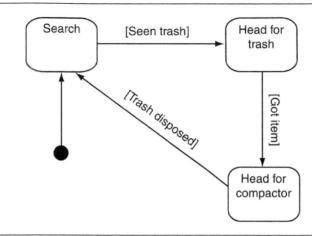

Figure 5.14: The basic cleaning robot state machine

5.3.8 HIERARCHICAL STATE MACHINES

On its own, one state machine is a powerful tool, but it can be difficult to express some behaviors. One common source of difficulty is "alarm behaviors."

Imagine a service robot that moves around a facility cleaning the floors. It has a state machine allowing it to do this. It might search around for objects that have been dropped, pick one up when it finds it, and carry it off to the trash compactor. This can be simply implemented using a normal state machine (see Figure 5.14).

Unfortunately, the robot can run low on power, whereupon it has to scurry off to the nearest electrical point and get recharged. Regardless of what it is doing at the time, it needs to stop, and when it is fully charged again it needs to pick up where it left off. The recharging periods could allow the player to sneak by unnoticed, for example, or allow the player to disable all electricity to the area and thereby disable the robot.

Leaving the current action to become recharged is an example of an alarm mechanism: something that interrupts normal behavior to respond to something important. Representing this in a state machine leads to a doubling in the number of states.

With one level of alarm this isn't a problem, but what would happen if we wanted the robot to hide when fighting breaks out in the corridor. If its hiding instinct is more important than its refueling instinct, then it will have to interrupt refueling to go hide. After the battle it will need to pick up refueling where it left off, after which it will pick up whatever it was doing before that. For just 2 levels of alarm, we would have 16 states.

Rather than combining all the logic into a single state machine, we can separate it into several. Each alarm mechanism has its own state machine, along with the original behavior. They are arranged in a hierarchy, so the next state machine down is only considered when the higher level state machine is not responding to its alarm.

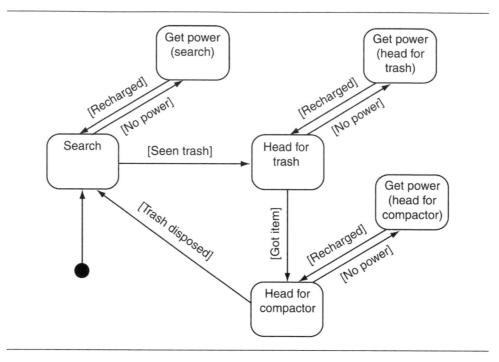

Figure 5.15: An alarm mechanism in a standard state machine

Figure 5.15 shows one alarm mechanism and corresponds exactly to the diagram above. In the diagrams, I show one state machine inside another to indicate a hierarchical state machine (Figure 5.16). The solid circle again represents the start state of the machine. When a composite state is first entered, the circle with H* inside it indicates which sub-state should be entered.

If the composite state has already been entered, then the previous sub-state is returned to. The H^* node is called the "history state" for this reason.

The details of why there's an asterisk after the H, and some of the other vagaries of the UML state chart diagram, are beyond the scope of this chapter. Refer to Pilone and Pitman [48] for more details.

Rather than having separate states to keep track of the non-alarm state, we add nested states. We still keep track of the state of the cleaning state machine, even if we are in the process of refueling. When the refueling is over, the cleaning state machine will pick up where it left off.

In effect, we are in more than one state at once. We might be in the "Refuel" state in the alarm mechanism, while at the same time we are also in the "Pick Up Object" state in the cleaning machine. Because there is a strict hierarchy, there is never any confusion about which state wins out: the highest state in the hierarchy is always in control.

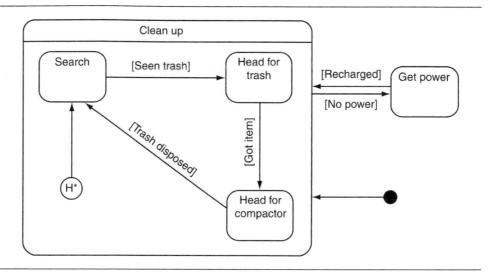

Figure 5.16: A hierarchical state machine for the robot

To implement this, we could simply arrange the state machines in our program so that one state machine calls another if it needs to. So if the refueling state machine is in its "Clean Up" state, it calls the cleaning state machine and asks it for the action to take. When it is in the "Refuel" state, it returns the refueling action directly.

While this would lead to slightly ugly code, it would implement our scenario. Most hierarchical state machines, however, support transitions between levels of the hierarchy, and for that we'll need more complex algorithms.

For example, let's expand our robot so that it can do something useful if there are no objects to collect. It makes sense that it will use the opportunity to go and recharge, rather than standing around waiting for its battery to go flat. The new state machine is shown in Figure 5.17.

Notice that I've added one more transition: from the "Search" state right out into the "Refuel" state. This transition is triggered when there are no objects to collect. Because we transitioned directly out of this state, the inner state machine no longer has any state. When the robot has refueled and the alarm system transitions back to cleaning, the robot will not have a record of where to pick up from, so it must start the state machine again from its initial node ("Search").

The Problem

We'd like an implementation of a state machine system that supports hierarchical state machines. We'd also like transitions that pass between different layers of the machine.

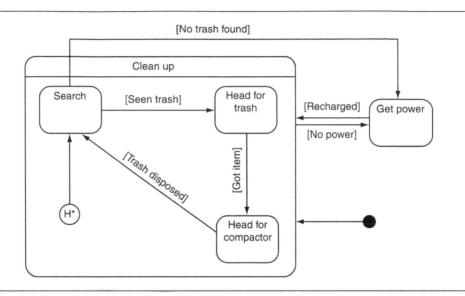

Figure 5.17: A hierarchical state machine with a cross-hierarchy transition

The Algorithm

In a hierarchical state machine, each state can be a complete state machine in its own right. We therefore rely on recursive algorithms to process the whole hierarchy. As with most recursive algorithms, this can be pretty tricky to follow. The simplest implementation covered here is doubly tricky because it recurses up and down the hierarchy at different points. I'd encourage you to use the informal discussion and examples in this section alongside the pseudo-code in the next section to get a feel for how it is all working.

The first part of the system returns the current state. The result is a list of states, from highest to lowest in the hierarchy. The state machine asks its current state to return its hierarchy. If the state is a terminal state, it returns itself; otherwise, it returns itself and adds to it the hierarchy from its own current state.

In Figure 5.18 the current state is [State L, State A].

The second part of the hierarchical state machine is its update. In the original state machine, each state machine started off in its initial state. Because the state machine always transitioned from one state to another, there was never any need to check if there was no state. State machines in a hierarchy can be in no state; they may have a cross-hierarchy transition. The first stage of the update, then, is to check if the state machine has a state. If not, it should enter its initial state.

Next, we check if the current state has a transition it wants to execute. Transitions at higher levels in the hierarchy always take priority, and the transitions of sub-states will not be considered if the super-state has one that triggers.

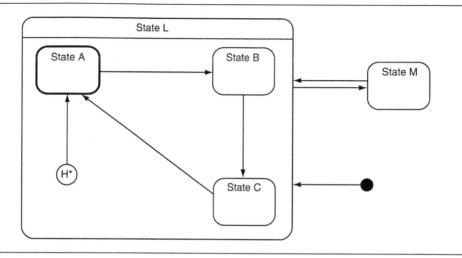

Figure 5.18: Current state in a hierarchy

A triggered transition may be one of three types: it might be a transition to another state at the current level of the hierarchy, it might be a transition to a state higher up in the hierarchy, or it might be a transition to a state lower in the hierarchy. Clearly, the transition needs to provide more data than just a target state. We allow it to return a relative level; how many steps up or down the hierarchy the target state is.

We could simply search the hierarchy for the target state and not require an explicit level. While this would be more flexible (we wouldn't have to worry about the level values being wrong), it would be considerably more time consuming. A hybrid, but fully automatic, extension could search the hierarchy once offline and store all appropriate level values.

So the triggered transition has a level of zero (state is at the same level), a level greater than zero (state is higher in the hierarchy), or a level less than zero (state is lower in the hierarchy). It acts differently depending on which category the level falls into.

If the level is zero, then the transition is a normal state machine transition and can be performed at the current level, using the same algorithm used in the finite state machine.

If the level is greater than zero, then the current state needs to be exited and nothing else needs to be done at this level. The exit action is returned, along with an indication to whomever called the update function that the transition hasn't been completed. We will return the exit action, the transition outstanding, and the number of levels higher to pass the transition. This level value is decreased by one as it is returned. As we will see, the update function will be returning to the next highest state machine in the hierarchy.

If the level is less than zero, then the current state needs to transition to the ancestor of the target state on the current level in the hierarchy. In addition, each of the children of that state also needs to do the same, down to the level of the final destination state. To achieve this we use a separate function, updateDown, that recursively performs this transition from

the level of the target state back up to the current level and returns any exit and entry actions along the way. The transition is then complete and doesn't need to be passed on up. All the accumulated actions can be returned.

So we've covered all possibilities if the current state has a transition that triggers. If it does not have a transition that triggers, then its action depends on whether the current state is a state machine itself. If not, and if the current state is a plain state, then we can return the actions associated with being in that state, just as before.

If the current state is a state machine, then we need to give it the opportunity to trigger any transitions. We can do this by calling its update function. The update function will handle any triggers and transitions automatically. As we saw above, a lower level transition that fires may have its target state at a higher level. The update function will return a list of actions, but it may also return a transition that it is passing up the hierarchy and that hasn't yet been fired.

If such a transition is received, its level is checked. If the level is zero, then the transition should be acted on at this level. The transition is honored, just as if it were a regular transition for the current state. If the level is still greater than zero (it should never be less than zero, because we are passing up the hierarchy at this point), then the state machine should keep passing it up. It does this, as before, by exiting the current state and returning the following pieces of information: the exit action, any actions provided by the current state's update function, the transition that is still pending, and the transition's level, less one.

If no transition is returned from the current state's update function, then we can simply return its list of actions. If we are at the top level of the hierarchy, the list alone is fine. If we are lower down, then we are also within a state, so we need to add the action for the state we're in to the list we return.

Fortunately, this algorithm is at least as difficult to explain as it is to implement. To see how and why it works, let's work through an example.

Examples

Figure 5.19 shows a hierarchical state machine that we will use as an example.

To clarify the actions returned for each example, we will say S-entry is the set of entry actions for state S and similarly S-active and S-exit for active and exit actions. In transitions, we use the same format: 1-actions for the actions associated with transition 1.

These examples can appear confusing if you skim through them. If you're having trouble with the algorithm, I urge you to follow through step by step with both the diagram above and the pseudo-code from the next section.

Suppose we start just in State L, and no transition triggers. We will transition into State [L, A], because L's initial state is A. The update function will return L-active and A-entry, because we are staying in L and just entering A.

Now suppose transition 1 is the only one that triggers. The top-level state machine will detect no valid transitions, so it will call state machine L to see if it has any. L finds that its current state (A) has a triggered transition. Transition 1 is a transition at the current level, so it is handled within L and not passed anywhere. A transitions to B, and L's update function returns A-exit, 1-actions, B-entry. The top-level state machine accepts these actions and adds

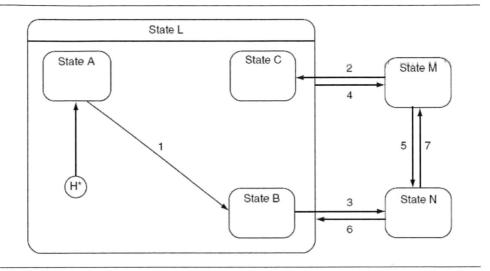

Figure 5.19: Hierarchical state machine example

its own active action. Because we have stayed in State L throughout, the final set of actions is A-exit, 1-actions, B-entry, L-active. The current state is [L, B].

From this state, transition 4 triggers. The top-level state machine sees that transition 4 triggers, and because it is a top-level transition it can be honored immediately. The transition leads to State M, and the corresponding actions are L-exit, 4-actions, M-entry. The current state is [M]. Note that L is still keeping a record of being in State B, but because the top-level state machine is in State M, this record isn't used at the moment.

We'll go from State M to State N in the normal way through transition 5. The procedure is exactly the same as for the previous example and the non-hierarchical state machine. Now transition 6 triggers. Because it is a level zero transition, the top-level state machine can honor it immediately. It transitions into State L and returns the actions N-exit, 6-actions, L-entry. But now L's record of being in State B is important; we end up in State [L, B] again. In our implementation we don't return the B-entry action, because we didn't return the B-exit action when we left State L previously. This is a personal preference on our part and isn't fixed in stone. If you want to exit and reenter State B, then you can modify your algorithm to return these extra actions at the appropriate time.

Now suppose from State [L, B] transition 3 triggers. The top-level state machine finds no triggers, so it will call state machine L to see if it has any. L finds that State B has a triggered transition. This transition has a level of one; its target is one level higher in the hierarchy. This means that State B is being exited, and it means that we can't honor the transition at this level. We return B-exit, along with the uncompleted transition, and the level minus one (i.e., zero, indicating that the next level up needs to handle the transition). So, control returns to the toplevel update function. It sees that L returned an outstanding transition, with zero level, so it honors it, transitioning in the normal way to State N. It combines the actions that L returned (namely, B-exit) with the normal transition actions to give a final set of actions: B-exit, L-exit, 3-actions, N-entry. Note that, unlike in our third example, L is no longer keeping track of the fact that it is in State B, because we transitioned out of that state. If we fire transition 6 to return to State L, then State L's initial state (A) would be entered, just like in the first example.

Our final example covers transitions with level less than zero. Suppose we moved from State N to State M via transition 7. Now we make transition 2 trigger. The top-level state machine looks at its current state (M) and finds transition 2 triggered. It has a level of minus one, because it is descending one level in the hierarchy. Because it has a level of minus one, the state machine calls the updateDown function to perform the recursive transition. The updateDown function starts at the state machine (L) that contains the final target state (C), asking it to perform the transition at its level. State machine L, in turn, asks the top-level state machine to perform the transition at its level. The top-level state machine changes from State M to State L, returning M-exit, L-entry as the appropriate actions. Control returns to state machine L's updateDown function. State machine L checks if it is currently in any state (it isn't, since we left State B in the last example). It adds its action (C-entry) to those returned by the top-level machine. Control then returns to the top-level state machine's update function: the descending transition has been honored; it adds the transition's actions to the result and returns M-exit, 2-actions, L-entry, C-entry.

If state machine L had still been in State B, then when L's updateDown function was called it would transition out of B and into C. It would add B-exit and C-entry to the actions that it received from the top-level state machine.

Pseudo-Code

The hierarchical state machine implementation is one of the longest algorithms in this book. The State and Transition classes are similar to those in the regular finite state machine. The Hierarchical State Machine class runs state transitions, and SubMachine State combines the functionality of the state machine and a state, for states that aren't at the top level of the hierarchy. All classes but Transition inherit from HSMBase, which simplifies the algorithm by allowing functions to treat anything in the hierarchy in the same way.

The HSMBase has the following form:

```
class HSMBase:
       # The structure returned by update.
2
       class UpdateResult:
           actions
           transition
           level
7
8
       function getActions() -> Action[]:
9
           return []
10
```

```
function update() -> UpdateResult:
11
            UpdateResult result = new UpdateResult()
12
            result.actions = getActions()
13
            result.transition = null
            result.level = 0
15
            return result
16
17
       function getStates() -> State[] # Unimplemented in base class.
18
```

The Hierarchical State Machine class has the following implementation:

```
class HierarchicalStateMachine extends HSMBase:
       # List of states at this level of the hierarchy.
2
       states: State
3
       # The initial state for when the machine has no current state.
5
       initialState: State
       # The current state of the machine.
       currentState: State = initialState
10
       # Gets the current state stack.
11
       function getStates() -> State[]:
12
            if currentState:
13
                return currentState.getStates()
14
            else:
15
                return []
16
17
       # Recursively updates the machine.
18
       function update() -> Action[]:
19
            # If we're in no state, use the initial state.
20
            if not currentState:
                currentState = initialState
22
                return currentState.getEntryActions()
23
24
            # Try to find a transition in the current state.
25
            triggeredTransition = null
26
            for transition in currentState.getTransitions():
27
                if transition.isTriggered():
28
                    triggeredTransition = transition
29
                    break
30
31
            # If we've found one, make a result structure for it.
32
            if triggeredTransition:
33
                result = new UpdateResult()
34
                result.actions = []
35
                result.transition = triggeredTransition
36
                result.level = triggeredTransition.getLevel()
37
```

```
38
           # Otherwise recurse down for a result.
39
           else:
40
                result = currentState.update()
41
42
           # Check if the result contains a transition.
43
            if result.transition:
44
                # Act based on its level.
45
                if result.level == 0:
46
                    # Its on our level: honor it.
47
                    targetState = result.transition.getTargetState()
48
                    result.actions += currentState.getExitActions()
49
                    result.actions += result.transition.getActions()
50
51
                    result.actions += targetState.getEntryActions()
52
                    # Set our current state.
53
                    currentState = targetState
54
55
                    # Add our normal action (we may be a state).
56
                    result.actions += getActions()
57
58
                    # Clear the transition, so nobody else does it.
59
                    result.transition = null
60
                else if result.level > 0:
                    # It's destined for a higher level
63
                    # Exit our current state.
64
                    result.actions += currentState.getExitActions()
65
                    currentState = null
66
67
                    # Decrease the number of levels to go.
68
                    result.level -= 1
69
70
                else:
71
72
                    # It needs to be passed down.
                    targetState = result.transition.getTargetState()
73
74
                    targetMachine = targetState.parent
75
                    result.actions += result.transition.getActions()
76
                    result.actions += targetMachine.updateDown(
77
                        targetState, -result.level)
78
                    # Clear the transition, so nobody else does it.
79
                    result.transition = null
80
81
           # If we didn't get a transition.
82
           else:
83
               # We can simply do our normal action.
84
```

```
result.action += getActions()
85
 86
             return result
 87
        # Recurses up the parent hierarchy, transitioning into each state
        # in turn for the given number of levels.
        function updateDown(state: State, level: int) -> Action[]:
91
            # If we're not at top level, continue recursing.
92
            if level > 0:
93
                 # Pass ourself as the transition state to our parent.
94
                 actions = parent.updateDown(this, level-1)
95
96
            # Otherwise we have no actions to add to.
97
            else:
98
                 actions = []
99
100
            # If we have a current state, exit it.
101
            if currentState:
102
                 actions += currentState.getExitActions()
103
104
105
            # Move to the new state, and return all the actions.
            currentState = state
106
            actions += state.getEntryActions()
107
108
            return actions
109
```

The State class is substantially the same as before, but adds an implementation for get-States:

```
class State extends HSMBase:
      function getStates() -> State:
2
           # If we're just a state, then the stack is just us.
3
           return [this]
4
5
      # As before...
6
      function getActions() -> Action[]
      function getEntryActions() -> Action[]
      function getExitActions() -> Action[]
9
      function getTransitions() -> Action[]
```

Similarly, the Transition class is the same but adds a method to retrieve the level of the transition:

```
class Transition:
      # Return the difference in levels of the hierarchy from
2
      # the source to the target of the transition.
3
      function getLevel() -> int
4
5
```

```
# As before...
6
      function isTriggered() -> bool
7
      function getTargetState() -> State
8
      function getActions() -> Action[]
```

Finally, the SubMachineState class merges the functionality of a state and a state machine:

```
class SubMachineState extends State, HierarchicalStateMachine:
       # Route to the state.
2
       function getActions() -> Action[]:
           return State.getActions()
       # Route update to the state machine.
       function update() -> Action[]:
           return HierarchicalStateMachine.update()
       # We get states by adding ourself to our active children.
10
       function getStates() -> State[]:
11
           if currentState:
12
               return [this] + currentState.getStates()
13
           else:
14
               return [this]
```

Implementation Notes

In the pseudo-code I have used multiple inheritance to implement SubMachineState. For languages (or programmers) that don't support multiple inheritance, there are two options. The SubMachineState could encapsulate HierarchicalStateMachine, or the Hierarchical-StateMachine can be converted so that it is a sub-class of State. The downside with the latter approach is that the top-level state machine will always return its active action from the update function, and getStates will always have it as the head of the list.

I have also elected to use a polymorphic structure for the state machine again. It is possible to implement the same algorithm without any polymorphic method calls. Given that it is complex enough already, however, I leave that as an exercise. My experience some years ago deploying a hierarchical state machine involved an implementation using polymorphic method calls. In-game profiling on both PC and PS2 showed that the method call overhead was not a bottleneck in the algorithm. In a system with hundreds or thousands of states, it may well be, as cache efficiency issues come into play.

An implementation of hierarchical state machines could be made significantly simpler than this by requiring that transitions can only occur between states at the same level. With this limitation in force, all the recursion code can be eliminated. If you don't need crosshierarchy transitions, then the simpler version will be easier to implement. It is unlikely to be any faster, however. Because the recursion isn't used when the transition is at the same level, the code above will run about as fast if all the transitions have a zero level.

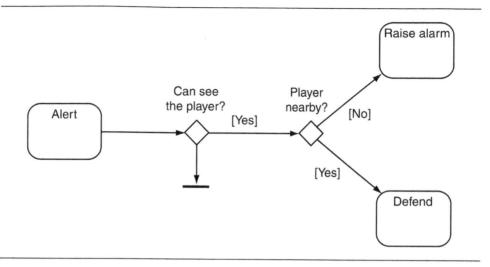

Figure 5.20: State machine with decision tree transitions

Performance

The algorithm is O(n) in memory, where n is the number of layers in the hierarchy. It requires temporary storage for actions when it recurses down and up the hierarchy.

Similarly, it is O(nt) in time, where t is the number of transitions per state. To find the correct transition to fire, it potentially needs to search each transition at each level of the hierarchy and O(nt) process. The recursion, both for a transition level less than zero and for a level greater than zero is O(n), so it does not affect the O(nt) for the whole algorithm.

5.3.9 COMBINING DECISION TREES AND STATE MACHINES

The implementation of transitions bears more than a passing resemblance to the implementation of decision trees. This is no coincidence, but it can be taken even further.

Decision trees are an efficient way of matching a series of conditions, and this has application in state machines for matching transitions.

We can combine the two approaches by replacing transitions from a state with a decision tree. The leaves of the tree, rather than being actions as before, are transitions to new states.

A simple state machine might look like Figure 5.20.

The diamond symbol is also part of the UML state chart diagram format, representing a decision. In UML there is no differentiation between decisions and transitions, and the decisions themselves are usually not labeled.

In this book I have labeled the decisions with the test that they perform, which is clearer for our needs.

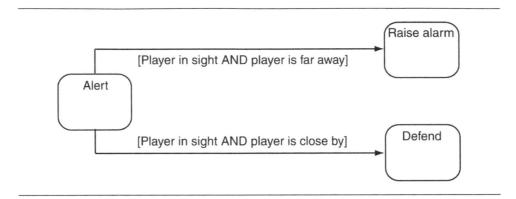

Figure 5.21: State machine without decision tree transitions

The figure shows that, when in the "Alert" state, a sentry has only one possible transition: via the decision tree. It quickly ascertains whether the sentry can see the player. If the sentry is not able to see the player, then the transition ends and no new state is reached. If the sentry is able to see the player, then the decision tree makes a choice based on the distance of the player. Depending on the result of this choice, two different states may be reached: "Raise Alarm" or "Defend." The latter can only be reached if a further test (distance to the player) passes.

To implement the same state machine without the decision nodes, the state machine in Figure 5.21 would be required. Note that now we have two very complex conditions and both have to evaluate the same information (distance to the player and distance to the alarm point). If the condition involved a time-consuming algorithm (such as the line of sight test in our example), then the decision tree implementation would be significantly faster.

Pseudo-Code

We can simply incorporate a decision tree into the state machine framework.

The decision tree, as before, consists of DecisionTreeNodes. These may be decisions (using the same Decision class as before) or TargetStates (which replace the Action class in the basic decision tree). TargetStates hold the state to transition to and can contain actions. As before, if a branch of the decision tree should lead to no result, then we can have some null value at the leaf of the tree.

```
class TargetState extends DecisionTreeNode:
       getActions() -> Action[]
2
       getTargetState() -> State
```

The decision making algorithm needs to change. Rather than testing for Actions to return, it now tests for TargetState instances:

```
function makeDecision(node) -> DecisionTreeNode:
1
       # Check if we need to make a decision.
2
       if not node or node is_instance_of TargetState:
3
           # We've got the target (or a null target), return it.
           return node
5
       else:
           # Make the decision and recurse based on the result.
           if node.test():
               return makeDecision(node.trueNode)
           else:
10
               return makeDecision(node.falseNode)
```

We can then build an implementation of the Transition interface that supports these decision trees. It has the following algorithm:

```
class DecisionTreeTransition extends Transition:
       # The target state at the end of the decision tree, when a
       # decision has been made.
3
       targetState: State = null
       # The root decision in the tree.
       decisionTreeRoot: DecisionTreeNode
       function getActions() -> Action[]:
           if targetState:
10
               return targetState.getActions()
11
           else:
12
               return []
13
14
       function getTargetState() -> State:
15
           if targetState:
16
                return targetState.getTargetState()
17
           else:
18
                return null
19
20
       function isTriggered() -> bool:
21
           # Get the result of the decision tree and store it.
22
           targetState = makeDecision(decisionTreeRoot)
23
24
           # Return true if the target state points to a destination,
25
           # otherwise assume that we don't trigger.
26
           return targetState != null
27
```

5.4 BEHAVIOR TREES

Behavior trees have become a popular tool for creating AI characters. Halo 2 [92] was one of the first high-profile games for which the use of behavior trees was described in detail and since then many more games have followed suit.

They are a synthesis of a number of techniques that have been around in AI for a while: Hierarchical State Machines, Scheduling, Planning, and Action Execution. Their strength comes from their ability to interleave these concerns in a way that is easy to understand and easy for non-programmers to create. Despite their growing ubiquity, however, there are things that are difficult to do well in behavior trees, and they aren't always a good solution for decision making.

Behavior trees have a lot in common with Hierarchical State Machines but, instead of a state, the main building block of a behavior tree is a task. A task can be something as simple as looking up the value of a variable in the game state, or executing an animation.

Tasks are composed into sub-trees to represent more complex actions. In turn, these complex actions can again be composed into higher level behaviors. It is this composability that gives behavior trees their power. Because all tasks have a common interface and are largely self-contained, they can be easily built up into hierarchies (i.e., behavior trees) without having to worry about the details of how each sub-task in the hierarchy is implemented.

Types of Task

Tasks in a behavior tree all have the same basic structure. They are given some CPU time to do their thing, and when they are ready they return with a status code indicating either success or failure (a Boolean value would suffice at this stage). Some developers use a larger set of return values, including an error status, when something unexpected went wrong, or a need more time status for integration with a scheduling system.

While tasks of all kinds can contain arbitrarily complex code, the most flexibility is provided if each task can be broken into the smallest parts that can usefully be composed. This is especially so because, while powerful just as a programming idiom, behavior trees really shine when coupled with a graphical user interface (GUI) to edit the trees. That way, designers, technical artists and level designers can potentially author complex AI behavior.

At this stage, our simple behavior trees will consist of three kinds of tasks: Conditions, Actions, and Composites.

Conditions test some property of the game. There can be tests for proximity (is the character within X units of an enemy?), tests for line of sight, tests on the state of the character (am I healthy?, do I have ammo?), and so on. Each of these kinds of tests needs to be implemented as a separate task, usually with some parameterization so they can be easily reused. Each Condition returns the success status code if the Condition is met and returns failure otherwise.

Actions alter the state of the game. There can be Actions for animation, for character

movement, to change the internal state of the character (resting raises health, for example), to play audio samples, to engage the player in dialog, and to engage specialized AI code (such as pathfinding). Just like Conditions, each Action will need to have its own implementation, and there may be a large number of them in your engine. Most of the time Actions will succeed (if there's a chance they might not, it is better to use Conditions to check for that before the character starts trying to act). It is possible to write Actions that fail if they can't complete, however.

If Conditions and Actions seem familiar from our previous discussion on decision trees and state machines, they should. They occupy a similar role in each technique (and we'll see more techniques with the same features later in this chapter). The key difference in behavior trees, however, is the use of a single common interface for all tasks. This means that arbitrary Conditions, Actions, and groups can be combined together without any of them needing to know what else is in the behavior tree.

Both Conditions and Actions sit at the leaf nodes of the tree. Most of the branches are made up of Composite nodes. As the name suggests, these keep track of a collection of child tasks (Conditions, Actions, or other Composites), and their behavior is based on the behavior of their children. Unlike Actions and Conditions, there are normally only a handful of Composite tasks because with only a handful of different grouping behaviors we can build very sophisticated behaviors.

For our simple behavior tree we'll consider two types of Composite tasks: Selector and Sequence. Both of these run each of their child behaviors in turn. When a child behavior is complete and returns its status code the Composite decides whether to continue through its children or whether to stop there and then and return a value.

A Selector will return immediately with a success status code when one of its children runs successfully. As long as its children are failing, it will keep on trying. If it runs out of children completely, it will return a failure status code.

A Sequence will return immediately with a failure status code when one of its children fails. As long as its children are succeeding, it will keep going. If it runs out of children, it will return in success.

Selectors are used to choose the first of a set of possible actions that is successful. A Selector might represent a character wanting to reach safety. There may be multiple ways to do that (take cover, leave a dangerous area, call for backup). The Selector will first try to take cover; if that fails, it will leave the area. If that succeeds, it will stop—there's no point also calling for backup, as we've solved the character's goal of reaching safety. If we exhaust all options without success, then the Selector itself has failed.

A Selector task is depicted graphically in Figure 5.22. First the Selector tries a task representing attacking the player; if it succeeds, it is done. If the attack task fails, the Selector node will go on to try a taunting animation instead. As a final fall back, if all else fails, the character can just stare menacingly.

Sequences represent a series of tasks that need to be undertaken. Each of our reachingsafety actions in the previous example may consist of a Sequence. To find cover we'll need to choose a cover point, move to it, and, when we're in range, play a roll animation to arrive

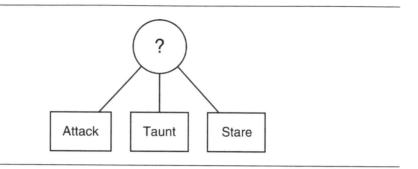

Figure 5.22: Example of a selector node in a behavior tree

Figure 5.23: Example of a sequence node in a behavior tree

behind it. If any of the steps in the sequence fails, then the whole sequence has failed: if we can't reach our desired cover point, then we haven't reached safety. Only if all the tasks in the Sequence are successful can we consider the Sequence as a whole to be successful.

Figure 5.23 shows a simple example of using a Sequence node. In this behavior tree the first child task is a condition that checks if there is a visible enemy. If the first child task fails, then the Sequence task will also immediately fail. If the first child task succeeds then we know there is a visible enemy, and the Sequence task goes on to execute the next child task, which is to turn away, followed by the running task. The Sequence task will then terminate successfully.

A Simple Example

We can use the tasks in the previous example to build a simple but powerful behavior tree. The behavior tree in this example represents an enemy character trying to enter the room in which the player is standing.

I will build up the tree in stages, to emphasize how the tree can be created and extended incrementally. This process of refining the behavior tree is part of its attraction, as simple

Move (into room)

Figure 5.24: The simplest behavior tree

Figure 5.25: A behavior tree with composite nodes

behaviors can be roughed in and then refined in response to play testing and additional development resources.

Our first stage, Figure 5.24, shows a behavior tree made up of a single task. It is a move action, to be carried out using whatever steering system our engine provides.

To run this task we give it CPU time, and it moves into the room. This was state-of-theart AI for entering rooms before Half-Life, of course, but wouldn't go down well in a shooter now! The simple example does make a point, however. When you're developing your AI using behavior trees, just a single naive behavior is all you need to get something working.

In our case, the enemy is too stupid: the player can simply close the door and confound the incoming enemy.

So, we'll need to make the tree a little more complex. In Figure 5.25, the behavior tree is made up of a Selector, which has two different things it can try, each of which is a Sequence. In the first case, it checks to see if the door is open, using a Condition task; then it moves into the room. In the second case, it moves to the door, plays an animation, opens the door, and then moves into the room.

Let's think about how this behavior tree is run. Imagine the door is open. When it is given CPU time, the Selector tries its first child. That child is made up of the Sequence task for moving through the open door. The Condition checks if the door is open. It is, so it returns success. So, the Sequence task moves on to its next child—moving through the door. This, like most actions, always succeeds, so the whole of the Sequence has been successful. Back at the top level, the Selector has received a success status code from the first child it tried, so it doesn't both trying its other child: it immediately returns in success.

What happens when the door is closed? As before the Selector tries its first child. That Sequence tries the Condition. This time, however, the Condition task fails. The Sequence doesn't bother continuing; one failure is enough, so it returns in failure. At the top level, the Selector isn't fazed by a failure; it just moves onto its next child. So, the character moves to the door, opens it, then enters.

This example shows an important feature of behavior trees: a Condition task in a Sequence acts like an IF-statement in a programming language. If the Condition is not met, then the Sequence will not proceed beyond that point. If the Sequence is in turn placed within a Selector, then we get the effect of IF-ELSE-statements: the second child is only tried if the Condition wasn't met for the first child. In pseudo-code the behavior of this tree is:

```
if isLocked(door):
1
      moveTo(door)
2
       open(door)
3
       moveTo(room)
  else:
5
       moveTo(room)
```

The pseudo-code and diagram show that we're using the final move action in both cases. There's nothing wrong with this. Later on in the section we'll look at how to reuse existing subtrees efficiently. For now it is worth saying that we could refactor our behavior tree to be more like the simpler pseudo-code:

```
if isLocked(door):
      moveTo(door)
      open(door)
3
      moveTo(room)
```

The result is shown in Figure 5.26. Notice that it is deeper than before; we've had to add another layer to the tree. While some people do like to think about behavior trees in terms of source code, it doesn't necessarily give you any insight in how to create simple or efficient trees.

In our final example in this section we'll deal with the possibility that the player has locked the door. In this case, it won't be enough for the character to just assume that the door can be opened. Instead, it will need to try the door first. Figure 5.27 shows a behavior tree for dealing with this situation. Notice that the Condition used to check if the door is locked doesn't appear at the same point where we check if the door is closed. Most people can't tell if a door is locked just by looking at it, so we want the enemy to go up to the door, try it, and then change behavior if it is locked. In the example, we have the character shoulder charging the door.

Figure 5.26: A more complicated refactored tree

I won't walk through the execution of this behavior tree in detail. Feel free to step through it yourself and make sure you understand how it would work if the door is open, if it is closed, and if it is locked.

At this stage we can start to see another common feature of behavior trees. Often they are made up of alternating layers of Sequences and Selectors. As long as the only Composite tasks we have are Sequence and Selector, it will always be possible to write the tree in this way.1 Even with the other kinds of Composite tasks we'll see later in the section, Sequence and Selector are still the most common, so this alternating structure is quite common.

We are probably just about at the point where our enemy's room-entering behavior would be acceptable in a current generation game. There's plenty more we can do here. We could add additional checks to see if there are windows to smash through. We could add behaviors to allow the character to use grenades to blow the door, we could have it pick up objects to barge the door, and we could have it pretend to leave and lie in wait for the player to emerge.

1. The reason for this may not immediately be obvious. If you think about a tree in which a Selector has another Selector as a child—its behavior will be exactly the same as if the child's children were inserted in the parent Selector. If one of the grandchildren returns in success, then its parent immediately returns in success, and so does the grandparent. The same is true for Sequence tasks inside other Sequence tasks. This means there is no functional reason for having two levels with the same kind of Composite task. There may, however, be non-functional reasons for using another grouping such as grouping related tasks together to more clearly understand what the overall tree is trying to achieve.

Figure 5.27: A behavior tree for a minimally acceptable enemy

Whatever we end up doing, the process of extending the behavior tree is exactly as I've shown it here, leaving the character AI playable at each intermediate stage.

Behavior Trees and Reactive Planning

Behavior trees implement a very simple form of planning, sometimes called reactive planning. Selectors allow the character to try things, and fall back to other behaviors if they fail. This isn't a very sophisticated form of planning: the only way characters can think ahead is if you manually add the correct conditions to their behavior tree. Nevertheless, even this rudimentary planning can give a good boost to the believability of your characters.

The behavior tree represents all possible Actions that your character can take. The route from the top level to each leaf represents one course of action,² and the behavior tree algorithm

2. Strictly this only applies to each leaf in a Selector and the last leaves in each Sequence.

searches among those courses of action in a left-to-right manner. In other words, it performs a depth-first search.

There is nothing about behavior trees or depth-first reactive planning that is unique, of course; we could do the same thing using other techniques, but typically they are much harder. The behavior of trying doors and barging through them if they are locked, for example, can be implemented using a finite state machine. But most people would find it quite unintuitive to create. You'd have to encode the fall-back behavior explicitly in the rules for state transitions. It would be fairly easy to write a script for this particular effect, but we'll soon see behavior trees that are difficult to turn into scripts without writing lots of infrastructure code to support the way behavior trees naturally work.

5.4.1 IMPLEMENTING BEHAVIOR TREES

Behavior trees are made up of independent tasks, each with its own algorithm and implementation. All of them conform to a basic interface which allows them to call one another without knowing how they are implemented. In this section, we'll look at a simple implementation based on the tasks introduced above.

5.4.2 PSEUDO-CODE

Behavior trees are easy to understand at the code level. We'll begin by looking at a possible base class for a task that all nodes in the tree can inherit from. The base class specifies a method used to run the task. The method should return a status code showing whether it succeeded or failed. In this implementation we will use the simplest approach and use the Boolean values True and False. The implementation of that method is normally not defined in the base class (i.e., it is a pure virtual function):

```
class Task:
2
      # Return on success (true) or failure (false).
      function run() -> bool
```

Here is an example of a simple task that asserts there is an enemy nearby:

```
class EnemyNear extends Task:
      function run() -> bool:
2
           # Task fails if there is no enemy nearby.
3
           return distanceToEnemy < 10
```

Another example of a simple task could be to play an animation:

```
class PlayAnimation extends Task:
2
       animationId: int
       speed: float = 1.0
3
4
```

```
5
       function run() -> bool:
           if animationEngine.ready():
               animationEngine.play(animationId, speed)
               return true
           else:
               # Task failure, the animation could not be played.
10
               return false
11
```

This task is parameterized to play one particular animation, and it checks to see if the animation engine is available before it does so.

One reason the animation engine might not be ready is if it was already busy playing a different animation. In a real game we'd want more control than this over the animation (we could still play a head-movement animation while the character was running, for example). We'll look at a more comprehensive way to implement resource-checking later in this section.

The Selector task can be implemented simply:

```
class Selector extends Task:
      children: Task[]
      function run() -> bool:
          for c in children:
5
               if c.run():
                   return true
          return false
```

The Sequence node is implemented similarly:

```
class Sequence extends Task:
      children: Task[]
2
      function run() -> bool:
          for c in children:
5
               if not c.run():
                   return false
           return true
```

Performance

The performance of a behavior tree depends on the tasks within it. A tree made up of just Selector and Sequence nodes and leaf tasks (Conditions and Actions) that are O(1) in performance and memory will be O(n) in memory and $O(\log n)$ in speed, where n is the number of nodes in the tree.

Implementation Notes

In the pseudo-code I have used Boolean values to represent the success and failure return values for tasks. In practice, it is a good idea to use a more flexible return type than Boolean values (an enum in C-based languages is ideal), because you may find yourself needing more than two return values, and it can be a serious drag to work through tens of task class implementations changing the return values.

Non-Deterministic Composite Tasks

Before we leave Selectors and Sequences for a while, it is worth looking at some simple variations that can make your AI more interesting and varied. The implementations above run each of their children in a strict order. The order is defined in advance by the person defining the tree. This is necessary in many cases: in our simple example above we absolutely have to check if the door is open before trying to move through it. Swapping that order would look very odd. Similarly for Selectors, there's no point trying to barge through the door if it is already open, we need to try the easy and obvious solutions first.

In some cases, however, this can lead to predictable AIs who always try the same things in the same order. In many Sequences there are some Actions that don't need to be in a particular order. If our room-entering enemy decided to smoke the player out, they might need to get matches and gasoline, but it wouldn't matter in which order as long as both matches and gasoline were in place before they tried to start the fire. If the player saw this behavior several times, it would be nice if the different characters acting this way didn't always get the components in the same order.

For Selectors, the situation can be even more obvious. Let's say that our enemy guard has five ways to gain entry. They can walk through the open door, open a closed door, barge through a locked door, smoke the player out, or smash through the window. We would want the first two of these to always be attempted in order, but if we put the remaining three in a regular Selector then the player would know what type of forced entry is coming first. If the forced entry actions normally worked (e.g., the door couldn't be reinforced, the fire couldn't be extinguished, the window couldn't be barricaded), then the player would never see anything but the first strategy in the list—wasting the AI effort of the tree builder.

These kinds of constraints are called "partial-order" constraints in the AI literature. Some parts may be strictly ordered, and others can be processed in any order. To support this in our behavior tree we use variations of Selectors and Sequences that can run their children in a random order.

The simplest would be a Selector that repeatedly tries a single child at random:

```
class RandomSelector extends Task:
    children: Task[]
    function run() -> bool:
        while true:
```

```
child = randomChoice(children)
7
               if child.run():
                   return true
```

This gives us randomness but has two problems: it may try the same child more than once, even several times in a row, and it will never give up, even if all its children repeatedly fail. For these reasons, this simple implementation isn't widely useful, but it can still be used, especially in combination with the parallel task we'll meet later in this section.

A better approach would be to walk through all the children in some random order. We can do this for either Selectors or Sequences. Using a suitable random shuffling procedure, we can implement this as:

```
class NonDeterministicSelector extends Task:
      children: Task[]
2
      function run() -> bool:
3
           shuffled = randomShuffle(children)
          for child in shuffled:
               if child.run():
                   return true
           return false
```

and

```
class NonDeterministicSequence extends Task:
      children: Task[]
2
      function run() -> bool:
3
           shuffled = randomShuffle(children)
           for child in shuffled:
               if not child.run():
                   return false
           return true
```

In each case, a shuffling step is added before running the children. This keeps the randomness but guarantees that all the children will be run and that the node will terminate when all the children have been exhausted.

Many standard libraries do have a random shuffle routine for their vector or list data types. If yours doesn't it is fairly easy to implement Durstenfeld's shuffle algorithm (also known as Fisher-Yates shuffling, or Knuth's Algorithm P. See [11] for a full description):

```
function randomShuffle(original: any[]) -> any[]:
      list = original.copy()
2
      n = list.length
      while n > 1:
           k = random.integerLessThan(n)
           list[n], list[k] = list[k], list[n]
       return list
```

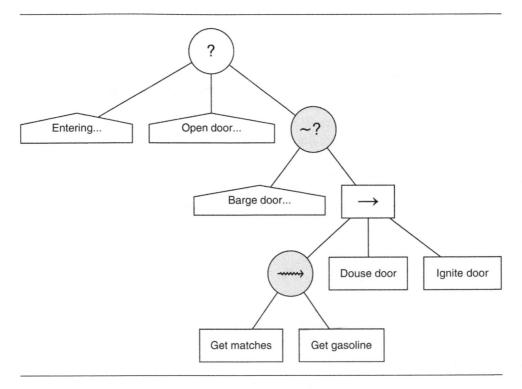

Figure 5.28: Example behavior tree with partial ordering

So we have fully ordered Composites, and we have non-deterministic Composites. To make a partially ordered AI strategy we put them together into a behavior tree. Figure 5.28 shows the tree for the previous example: an enemy AI trying to enter a room. Nondeterministic nodes are shown with a wave in their symbol and are shaded gray.

Although the figure only shows the low-level details for the strategy to smoke the player out, each strategy will have a similar form, being made up of fixed-order Composite tasks. This is very common; non-deterministic tasks usually sit within a framework of fixed-order tasks, both above and below.

5.4.3 DECORATORS

So far we've met three families of tasks in a behavior tree: Conditions, Actions, and Composites. There is a fourth that is significant: Decorators.

The name "decorator" is taken from object-oriented software engineering. The decorator pattern refers to a class that wraps another class, modifying its behavior. If the decorator has

the same interface as the class it wraps, then the rest of the software doesn't need to know if it is dealing with the original class or the decorator.

In the context of a behavior tree, a Decorator is a type of task that has one single child task and modifies its behavior in some way. You could think of it like a Composite task with a single child. Unlike the handful of Composite tasks we'll meet, however, there are many different types of useful Decorators.

One simple and very common category of Decorators makes a decision whether to allow their child behavior to run or not (they are sometimes called "filters"). If they allow the child behavior to run, then whatever status code it returns is used as the result of the filter. If they don't allow the child behavior to run, then they normally return in failure, so a Selector can choose an alternative action.

There are several standard filters that are useful. For example, we can limit the number of times a task can be run:

```
class Limit extends Decorator:
      runLimit: int
2
      runSoFar: int = 0
      function run() -> bool:
          if runSoFar >= runLimit:
              return false
          runSoFar++
          return child.run()
```

which could be used to make sure that a character doesn't keep trying to barge through a door that the player has reinforced.

We can use a Decorator to keep running a task until it fails:

```
class UntilFail extends Decorator:
      function run() -> bool:
2
          while true:
               result: bool = child.run()
               if not result:
                   break
6
          return true
```

We can combine this Decorator with other tasks to build up a behavior tree like the one in Figure 5.29. The code to create this behavior tree will be a sequence of calls to the task constructors that will look something like:

```
ex = Selector(
       Sequence(
2
           Visible,
3
           UntilFail(
4
                Sequence(
5
                    Conscious,
6
7
                    Hit,
```

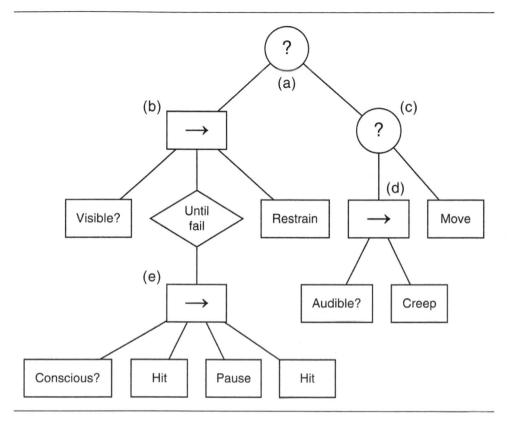

Figure 5.29: Example behavior tree

```
Pause,
8
                       Hit)),
9
             Restrain),
10
        Sequence(
11
             Audible,
12
             Creep),
13
        Move)
14
```

The basic behavior of this tree is similar to before. The Selector node at the root, labeled (a) in the figure, will initially try its first child task. This first child is a Sequence node, labeled (b). If there is no visible enemy, then the Sequence node (b) will immediately fail and the Selector node (a) at the root will try its second child.

The second child of the root node is another Selector node, labeled (c). Its first child (d) will succeed if there is an audible enemy, in which case the character will creep. Sequence node (d) will then terminate successfully, causing Selector node (c) to also terminate successfully. This, in turn, will cause the root node (a) to terminate successfully.

So far, we haven't reached the Decorator, so the behavior is exactly what we've seen before. In the case where there is a visible enemy, Sequence node (b) will continue to run its children, arriving at the decorator. The Decorator will execute Sequence node (e) until it fails. Node (e) can only fail when the character is no longer conscious, so the character will continually hit the enemy until it loses consciousness, after which the Selector node will terminate successfully. Sequence node (b) will then finally execute the task to tie up the unconscious enemy. Node (b) will now terminate successfully, followed by the immediate successful termination of the root node (a).

Notice that the Sequence node (e) includes a fixed repetition of hit, pause, hit. So, if the enemy happens to lose consciousness after the first hit in the sequence, then the character will still hit the subdued enemy one last time. This may give the impression of a character with a brutal personality. It is precisely this level of fine-grained control over potentially important details that is another key reason for the appeal of behavior trees.

In addition to filters that modify when and how often to call tasks, other Decorators can usefully modify the status code returned by a task:

```
class Inverter extends Decorator:
      function run() -> bool
2
          return not child.run()
```

I have given just a couple of simple Decorators here. There are many more we could implement and we'll see some more below. Each of the Decorators above have inherited from a base class Decorator. The base class is simply designed to manage its child task. In terms of our simple implementation this would be:

```
class Decorator extends Task:
    # Stores the child this task is decorating.
    child: Task
```

Despite the simplicity it is a good implementation decision to keep this code in a common base class. When you come to build a practical behavior tree implementation you'll need to decide when child tasks can be set and by whom. Having the task management code in one place is useful. The same advice goes for Composite tasks—it is wise to have a common base class below both Selector and Sequence.

Guarding Resources with Decorators

Before we leave Decorators there is one important Decorator type that isn't as trivial to implement as the example above. We've already seen why we need it when we implemented the PlayAnimation task above.

Often, parts of a behavior tree need to have access to some limited resource. In the example this was the skeleton of the character. The animation engine can only play one animation on each part of the skeleton at any time. If the character's hands are moving through the reload animation, they can't be asked to wave. There are other code resources that can be scarce. We

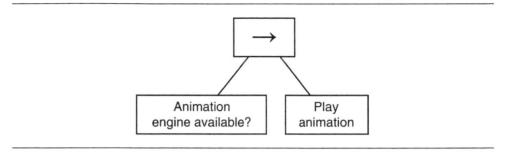

Figure 5.30: Guarding a resource using a Condition and Selector

might have a limited number of pathfinding instances available. Once they are all spoken for, other characters can't use them and should choose behaviors that avoid cluing the player into the limitation.

There are other cases where resources are limited in purely game terms. There's nothing to stop us playing two audio samples at the same time, but it would be odd if they were both supposed to be exclamations from the same character. Similarly, if one character is using a wall-mounted health station, no other character should be able to use it. The same goes for cover points in a shooter, although we might be able to fit a maximum of two or three characters in some cover points and only one in others.

In each of these cases, we need to make sure that a resource is available before we run some action. We could do this in three ways:

- 1. By hard-coding the test in the behavior, as we did with PlayAnimation
- 2. By creating a Condition task to perform the test and using a Sequence
- 3. By using a Decorator to guard the resource

The first approach I have demonstrated already. The second would be to build a behavior tree that looks something like Figure 5.30. Here, the Sequence first tries the Condition. If that fails, then the whole Sequence fails. If it succeeds, then the animation action is called.

This is a completely acceptable approach, but it relies on the designer of the behavior tree creating the correct structure each time. When there are lots of resources to check, this can be laborious or error prone.

The third option, building a Decorator, is somewhat more practical and more elegant.

The version of the Decorator we're going to create will use a mechanism called a semaphore. Semaphores are associated with parallel or multithreaded programming (and it is no coincidence that we're interested in them, as we'll see in the next section). They were originally invented by Edsger Dijkstra, of the Dijkstra algorithm fame.

Semaphores are a mechanism for ensuring that a limited resource is not over-subscribed. Unlike our PlayAnimation example, semaphores can cope with resources that aren't limited to one single user at a time. We might have a pool of ten pathfinders, for example, meaning at most ten characters can be pathfinding at a time. Semaphores work by keeping a tally of the number of resources there are available and the number of current users. Before using the resource, a piece of code must ask the semaphore if it can "acquire" it. When the code is done it should notify the semaphore that it can be "released."

To be properly thread safe, semaphores need some infrastructure, usually depending on low level operating system primitives for locking. Most programming languages have good libraries for semaphores, so you're unlikely to need to implement one yourself. We'll assume that semaphores are provided for us and have the following interface:

```
class Semaphore:
      maximumUsers: int
2
      # Return true if the acquisition is successful.
      function acquire() -> bool
      # Has no return value.
      function release()
```

With a semaphore implementation we can create our Decorator as follows:

```
class SemaphoreGuard extends Decorator:
       # The semaphore that we're using to guard a resource.
       semaphore: Semaphore
3
       function run() -> bool:
           if semaphore.acquire()
               result = child.run()
                semaphore.release()
                return result
           else:
10
                return false
11
```

The Decorator returns its failure status code when it cannot acquire the semaphore. This allows a select task higher up the tree to find a different action that doesn't involve the contested resource.

Notice that the guard doesn't need to have any knowledge of the actual resource it is guarding. It just needs the semaphore. This means with this one single class, and the ability to create semaphores, we can guard any kind of resource, whether it is an animation engine, a health station, or a pathfinding pool.

In this implementation we expect the semaphore to be used in more than one guard Decorator at more than one point in the tree (or in the trees for several characters if it represents some shared resource like a cover point).

To make it easy to create and access semaphores in several Decorators, it is common to see a factory that can create them by name:

```
semaphoreHashtable: HashTable[string -> Semaphore] = {}
2
  function getSemaphore(name: string, maximumUsers: int) -> Semaphore:
      if not semaphoreHashtable.has(name):
           semaphoreHashtable[name] = new Semaphore(maximumUsers)
5
      return semaphoreHashtable.get(name)
```

It is easy then for designers and level creators to create new semaphore guards by simply specifying a unique name for them. Another approach would be to pass in a name to the SemaphoreGuard constructor, and have it look up or create the semaphore from that name.

This Decorator gives us a powerful way of making sure that a resource isn't oversubscribed. But, so far this situation isn't very likely to arise. We've assumed that our tasks run until they return a result, so only one task gets to be running at a time. This is a major limitation, and one that would cripple our implementation. To lift it, we'll need to talk about concurrency, parallel programming, and timing.

5.4.4 CONCURRENCY AND TIMING

So far in this chapter we've managed to avoid the issue of running multiple behaviors at the same time. Decision trees are intended to run quickly—giving a result that can be acted upon. State machines are long-running processes, but their state is explicit, so it is easy to run them for a short time each frame (processing any transitions that are needed).

Behavior trees are different. We may have Actions in our behavior tree that take time to complete. Moving to a door, playing a door opening animation, and barging through the locked door all take time. When our game comes back to the AI on subsequent frames, how will it know what to do? We certainly don't want to start from the top of the tree again, as we might have left off midway through an elaborate sequence.

The short answer is that behavior trees as we have seen them so far are just about useless. They are only compatible with actions that can complete instantly, unlike most actions we would like to schedule in game. To improve the situation we need to assume some sort of concurrency: the ability of multiple bits of code to be running at the same time.

One approach to implementing this concurrency is to imagine each behavior tree running in its own thread. That way an Action can take seconds to carry out: the thread just sleeps while it is happening and wakes again to return True back to whatever task was above it in the tree. This would work, but typically developers want to use a well-defined number of threads. Adding additional threads for each character AI is unacceptable.

A more difficult approach is to merge behavior trees with the kind of cooperative multitasking and scheduling algorithms we will look at in Chapter 10. In practice, it can be highly wasteful to run lots of threads at the same time, and even on multi-core machines we might need to use a cooperative multitasking approach, with one thread running on each core and any number of lightweight or software threads running on each.

Although this is the most common practical implementation, I won't go into detail here.

Anytime algorithms are discussed later in the book, and the details are not particular to this algorithm. For now, to avoid this complexity I will assume we have a multithreaded implementation with as many threads as we need.

Waiting

In a previous example we met a Pause task that allowed a character to wait a moment between Actions to strike the player. This is a very common and useful task. We can implement it by simply putting the current thread to sleep for a while:

```
class Wait extends Task:
      duration: int
2
       function run() -> bool:
           sleep(duration)
           return result
```

There are more complex things we can do with waiting, of course. We can use it to time out a long-running task and return a value prematurely. We could create a version of our Limit task that prevents an Action being run again within a certain time frame or one that waits a random amount of time before returning to give variation in our character's behavior.

This is just the start of the tasks we could create using timing information. None of these ideas is particularly challenging to implement, so I will not provide pseudo-code here.

The Parallel Task

In our new concurrent world, we can make use of a third Composite task. It is called "Parallel," and along with Selector and Sequence it forms the backbone of almost all behavior trees.

The Parallel task acts in a similar way to the Sequence task. It has a set of child tasks, and it runs them until one of them fails. At that point, the Parallel task as a whole fails. If all of the child tasks complete successfully, the Parallel task returns with success. In this way, it is identical to the Sequence task and its non-deterministic variations.

The difference is the way it runs those tasks. Rather than running them one at a time, it runs them all simultaneously. We can think of it as creating a bunch of new threads, one per child, and setting the child tasks off together.

When one of the child tasks ends in failure, Parallel will terminate all of the other child threads that are still running. Just unilaterally terminating the threads could cause problems, leaving the game inconsistent or failing to free resources (such as acquired semaphores). The termination procedure is usually implemented as a request rather than a direct termination of the thread. In order for this to work, all the tasks in the behavior tree also need to be able to receive a termination request and clean up after themselves accordingly.

In one behavior tree system I developed, tasks have an additional method for this:

```
class Task:
      function run() -> bool
2
      function terminate() # No return type.
```

In a fully concurrent system, this terminate method will normally set a flag, and the run method is responsible for periodically checking if this flag is set and shutting down if it is. The code below simplifies this process, placing the actual termination code in the terminate method.3

With a suitable thread-handling API, our Parallel task might look like:

```
class Parallel extends Task:
        children: Task[]
2
        # Holds all the children currently running.
        runningChildren: Task[] = []
        # The final result for our run method.
        result: bool
        function run() -> bool:
10
            result = null
12
            # Internal functions, defined locally to this run method.
14
            function runChild(child):
15
                runningChildren += child
16
                returned = child.run()
                runningChildren -= child
18
19
                if returned == false:
20
                     # Write to the outer result variable.
21
                     result = false
22
23
                     # Stop all the running children.
24
                     terminate()
25
26
                else if runningChildren.length == 0:
27
                     result = true
28
29
            function terminate():
30
                for child in runningChildren:
31
                    child.terminate()
32
```

This isn't the best approach in practice because the termination code will rely on the current state of the run method and should therefore be run in the same thread. The terminate method, on the other hand, will be called from our Parallel thread, so should do as little as possible to change the state of its child tasks. Setting a Boolean flag is the bare minimum, so that is the best approach.

```
33
            # Start all our children running.
34
            for child in children:
35
                thread = new Thread()
36
                thread.start(runChild, child)
37
            # Wait until we have a result to return.
39
            while result == null:
41
                sleep()
42
43
            return result
```

In the run method, we create one new thread for each child. I'm assuming the thread's start method takes a first argument that is a function to run and additional arguments that are fed to that function. The threading libraries in a number of languages work that way. In languages where functions can't be passed to other functions, you'll need to pass an object, which means we will need to create another class that implements the correct interface.

After creating the threads, the run method then keeps sleeping, waking only to see if the result variable has been set. Many threading systems provide more efficient ways to wait on a variable change using condition variables or by allowing one thread to manually wake another (our child threads could manually wake the parent thread when they change the value of the result). Check your system documentation for more details.

The runChild method is called from our newly created thread and is responsible for calling the child task's run method to get it to do its thing. Before starting the child, it registers itself with the list of running children. If the Parallel task gets terminated, it can terminate the correct set of still-running threads. Finally runChild checks to see if the whole Parallel task should return False, or if not whether this child is the last to finish and the Parallel should return True. If neither of these conditions holds, then the result variable will be left unchanged, and the while loop in the Parallel's run method will keep sleeping.

Policies for Parallel

We'll see Parallel in use in a moment. First, it is worth saying that here I've assumed one particular *policy* for Parallel. A policy, in this case, is how the Parallel task decides when and what to return. In our policy we return failure as soon as one child fails, and we return success when all children succeed. As mentioned above, this is the same policy as the Sequence task. Although this is the most common policy, it isn't the only one.

We could also configure Parallel to have the policy of the Selector task so it returns success when its first child succeeds and failure only when all have failed. We could also use hybrid policies, where it returns success or failure after some specific number or proportion of its children have succeeded or failed.

It is much easier to brainstorm possible task variations than it is to find a set of useful tasks that designers and level designers intuitively understand and that can give rise to entertaining behaviors. Having too many tasks or too heavily parameterized tasks is not good for

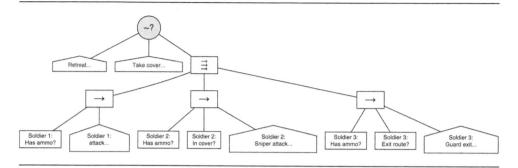

Figure 5.31: Using Parallel to implement group behavior

productivity. I've tried in this book to stick to the most common and most useful variations, but you will come across others in studios, game postmortems, or conferences.

Using Parallel

The Parallel task is most obviously used for sets of Actions that can occur at the same time. We might, for example, use Parallel to have our character roll into cover at the same time as shouting an insult and changing primary weapon. These three Actions don't conflict (they wouldn't use the same semaphore, for example), and so we could carry them out simultaneously. This is a quite low-level use of parallel—it sits low down in the tree controlling a small sub-tree.

At a higher level, we can use Parallel to control the behavior of a group of characters, such as a fire team in a military shooter. While each member of the group gets its own behavior tree for its individual Actions (shooting, taking cover, reloading, animating, and playing audio, for example), these group Actions are contained in Parallel blocks within a higher level Selector that chooses the group's behavior. If one of the team members can't possibly carry out their role in the strategy, then the Parallel will return in failure and the Selector will have to choose another option. This is shown abstractly in Figure 5.31. The sub-trees for each character would be complex in their own right, so I haven't shown them in detail here.

Both these uses of Parallel combine Action tasks. It is also possible to use Parallel to combine Condition tasks. This is particularly useful if you have certain Condition tests that take time and resources to complete. By starting a group of Condition tests together, failures in any of them will immediately terminate the others, reducing the resources needed to complete the full package of tests.

We can do something similar with Sequences, of course, putting the quick Condition tests first to act as early outs before committing resources to more complex tests (this is a good approach for complex geometry tests such as sight testing). Often, though, we might have a series of complex tests with no clear way to determine ahead of time which is most likely to

Figure 5.32: Using Sequence to enforce a Condition

fail. In that case, placing the Conditions in a Parallel task allows any of them to fail first and interrupt the others.

The Parallel Task for Condition Checking

One final common use of the Parallel task is to continually check whether certain Conditions are met while carrying out an Action. For example, we might want an ally AI character to manipulate a computer bank to open a door for the player to progress. The character is happy to continue its manipulation as long as the player guards the entrance from enemies. We could use a Parallel task to attempt an implementation as shown in Figures 5.32 and 5.33.

In both figures the Condition checks if the player is in the correct location. In Figure 5.32, we use Sequence, as before, to make sure the AI only carries out their Actions if the player is in position. The problem with this implementation is that the player can move immediately when the character begins work. In Figure 5.33, the Condition is constantly being checked. If it ever fails (because the player moves), then the character will stop what it is doing. We could embed this tree in a Selector that has the character encouraging the player to return to their post.

To make sure the Condition is repeatedly checked we have used the UntilFail Decorator to continually perform the checking, returning only if the Decorator fails. Based on our implementation of Parallel above, there is still a problem in Figure 5.33 which we don't have the tools to solve yet. We'll return to it shortly. As an exercise, can you follow the execution sequence of the tree and see what the problem is?

Using Parallel blocks to make sure that Conditions hold is an important use-case in behavior trees. With it we can get much of the power of a state machine, and in particular the state machine's ability to switch tasks when important events occur and new opportunities arise. Rather than events triggering transitions between states, we can use sub-trees as states and have them running in parallel with a set of conditions. In the case of a state machine, when the condition is met, the transition is triggered. With a behavior tree the behavior runs

Figure 5.33: Using Parallel to keep track of Conditions

as long as the Condition is met. A state-machine-like behavior is shown using a state machine in Figure 5.34.

This is a simplified tree for the janitor robot we met earlier in the chapter. Here it has two sets of behaviors: it can be in tidy-up mode, as long there is trash to tidy, or it can be in recharging mode. Notice that each "state" is represented by a sub-tree headed by a Parallel node. The Condition for each tree is the opposite of what you'd expect for a state machine: they list the Conditions needed to stay in the state, which is the logical complement of all the conditions for all the state machine transitions.

The top Repeat and Select nodes keep the robot continually doing something. We're assuming the repeat Decorator will never return, either in success or failure. So the robot keeps trying either of its behaviors, switching between them as the criteria are met.

At this level the Conditions aren't too complex, but for more states the Conditions needed to hold the character in a state would rapidly get unwieldy. This is particularly the case if your agents need a couple of levels of alarm behaviors—behaviors that interrupt others to take immediate, reactive action to some important event in the game. It becomes counterintuitive to code these in terms of Parallel tasks and Conditions, because we tend to think of the event causing a change of action, rather than the lack of the event allowing the lack of a change of action.

So, while it is technically possible to build behavior trees that show state-machine-like behavior, we can sometimes only do so by creating unintuitive trees. We'll return to this issue when we look at the limitations of behavior trees at the end of this section.

Figure 5.34: A behavior tree version of a state machine

Intra-Task Behavior

The example in Figure 5.33 showed a difficulty that often arises with using Parallel alongside behavior trees. As it stands, the tree shown would never return as long as the player didn't move out of position. The character would perform its actions, then stand around waiting for the Until-fail Decorator to finish, which, of course, it won't do as long as the player stays put. We could add an Action to the end of the Sequence where the character tells the player to head for the door, or we could add a task that returns False. Both of these would certainly terminate the Parallel task, but it would terminate in failure, and any nodes above it in the tree wouldn't know if it had failed after completion or not.

To solve this issue we need behaviors to be able to affect one another directly. We need to have the Sequence end with an Action that disables the Until-fail behavior and has it return True. Then, the whole Action can complete.

We can do this using two new tasks. The first is a Decorator. It simply lets its child node run normally. If the child returns a result, it passes that result on up the tree. But, if the child is still working, it can be asked to terminate itself, whereupon it returns a predetermined result. We will need to use concurrency again to implement this. We could define this as:

```
class Interrupter extends Decorator:
       # Is our child running?
2
       isRunning: bool
3
       # The final result for our run method.
5
       result: bool
6
7
       function run() -> bool:
8
            result = undefined
9
10
            # Start our child.
11
            thread = new Thread()
12
13
            thread.start(runChild, child)
            # Wait until we have a result to return.
15
           while result == undefined:
16
17
                sleep()
18
19
            return result
20
       function runChild(child):
21
22
            isRunning = true
            result = child.run()
23
            isRunning = false
24
25
       function terminate():
26
            if isRunning:
27
                child.terminate()
28
29
       function setResult(desiredResult: bool):
30
            result = desiredResult
```

If this task looks familiar, that's because it shares the same logic as Parallel. It is the equivalent of Parallel for a single child, with the addition of a single method that can be called to set the result from an external source, which is our second task. When it is called, it simply sets a result in an external Interrupter, then returns with success.

```
class PerformInterruption extends Task:
      # The interrupter we'll be interrupting.
2
      interrupter: Interrupter
3
      # The result we want to insert.
      desiredResult: bool
      function run() -> bool:
           interrupter.setResult(desiredResult)
           return true
```

Figure 5.35: Using Parallel and Interrupter to keep track of conditions

Together, these two tasks give us the ability to communicate between any two points in the tree. Effectively they break the strict hierarchy and allow tasks to interact horizontally.

With these two tasks, we can rebuild the tree for our computer-using AI character to look like Figure 5.35.

In practice there are a number of other ways in which pairs of behaviors can collaborate, but they will often have this same pattern: a Decorator and an Action. We could have a Decorator that can stop its child from being run, to be enabled and disabled by another Action task. We could have a Decorator that limits the number of times a task can be repeated but that can be reset by another task. We could have a Decorator that holds onto the return value of its child and only returns to its parent when another task tells it to. There are almost unlimited options, and behavior tree systems can easily bloat until they have very large numbers of available tasks, only a handful of which designers actually use.

Eventually this simple kind of inter-behavior communication will not be enough. Certain behavior trees are only possible when tasks have the ability to have richer conversations with one another.

5.4.5 ADDING DATA TO BEHAVIOR TREES

To move beyond the very simplest inter-behavior communication we need to allow tasks in our behavior tree to share data with one another. If you try to implement an AI using the behavior tree implementations we've seen so far you'll quickly encounter the problem of a lack of data. In our example of an enemy trying to enter a room, there was no indication of which room the character was trying to enter. We could just build big behavior trees with separate branches for each area of our level, but this would obviously be wasteful.

In a real behavior tree implementation, tasks need to know what to work on. You can think of a task as a sub-routine or function in a programming language. We might have a sub-tree that represents smoking the player out of a room, for example. If this were a sub-routine it would take an argument to control which room to smoke:

```
function smokeOut(room):
      matches = fetchMatches()
2
      gas = fetchGasoline()
3
      douseDoor(room.door, gas)
       ignite(room.door, matches)
```

In our behavior tree we need some similar mechanism to allow one sub-tree to be used in many related scenarios. Of course, the power of sub-routines is not just that they take parameters, but also that we can reuse them again and again in multiple contexts (we could use the "ignite" action to set fire to anything and use it from within lots of strategies). We'll return to the issue of reusing behavior trees as sub-routines later. For now, I will concentrate on how they get their data.

Although we want data to pass between behavior trees, we don't want to break their elegant and consistent API. We certainly don't want to pass data into tasks as parameters to their run method. This would mean that each task needs to know what arguments its child tasks take and how to find these data.

We could parameterize the tasks at the point where they are created, since at least some part of the program will always need to know what nodes are being created, but in most implementations this won't work, either. Behavior nodes get assembled into a tree typically when the level loads (again, we'll finesse this structure soon). We aren't normally building the tree dynamically as it runs. Even implementations that do allow some dynamic tree building still rely on most of the tree being specified before the behavior begins.

The most sensible approach is to decouple the data that behaviors need from the tasks themselves. I will show this by using an external data store for all the data that the behavior tree needs. Let's call this data store a blackboard. Later in this chapter, in Section 5.9 on blackboard architectures, I will show a representation of such a data structure and discuss some broader implications for its use. For now it is simply important to know that the blackboard can store any kind of data and that interested tasks can query it for the data they need.

Using this external blackboard, we can write tasks that are still independent of one another but can communicate when needed.

In a squad-based game, for example, we might have a collaborative AI that can autonomously engage the enemy. We could write one task to select an enemy (based on proximity or a tactical analysis, for example) and another task or sub-tree to engage that enemy. The task that selects the enemy writes down the selection it has made onto the blackboard. The

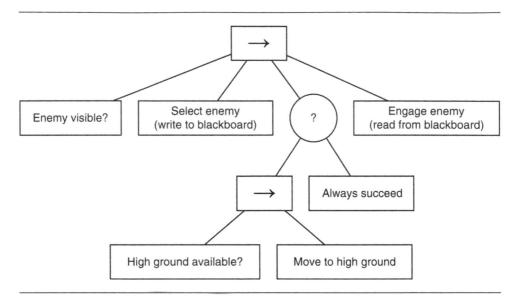

Figure 5.36: A behavior tree communicating via blackboard

task or tasks that engage the enemy query the blackboard for a current enemy. The behavior tree might look like Figure 5.36. The enemy detector could write:

```
target: enemy-10f9
```

to the blackboard. The Move and Shoot-at tasks would ask the blackboard for its current "target" values and use these to parameterize their behavior. The tasks should be written so that, if the blackboard had no target, then the task fails, and the behavior tree can look for something else to do.

In pseudo-code this might look like:

```
class MoveTo extends Task:
       # The blackboard we're using.
2
       blackboard: Blackboard
3
       function run() -> bool:
           target = blackboard.get('target')
           if target:
               character = blackboard.get('character')
               steering.arrive(character, target)
               return true
10
11
           else:
               return false
```

where the enemy detector might look like:

```
class SelectTarget extends Task:
       blackboard: Blackboard
2
       function run() -> bool:
           character = blackboard.get('character')
           candidates = enemiesVisibleTo(character)
            if candidates.length > 0:
                target = biggestThreat(candidates, character)
                blackboard.set('target', target)
                return true
10
           else:
11
                return false
12
```

In both these cases I've assumed that the task can find which character it is controlling by looking that information up in the blackboard. In most games we want some behavior trees to be used by many characters, so each will require its own blackboard.

Some implementations associate blackboards with specific sub-trees rather than having just one for the whole tree. This allows sub-trees to have their own private data-storage area. It is shared between nodes in that sub-tree, but not between sub-trees. This can be implemented using a particular Decorator whose job is to create a fresh blackboard before it runs its child:

```
class BlackboardManager extends Decorator:
      blackboard: Blackboard = null
2
      function run() -> bool:
           blackboard = new Blackboard()
           result = child.run()
           delete blackboard
           return result
```

Using this approach gives us a hierarchy of blackboards. When a task comes to look up some data, we want to start looking in the nearest blackboard, then in the blackboard above that, and so on until we find a result or reach the last blackboard in the chain:

```
class Blackboard:
2
       # The blackboard to fall back to.
       parent: Blackboard
3
       # Data as an associative array.
5
       data: HashTable[string -> any]
6
       function get(name: string) -> any:
8
           if name in data: return data[name]
           else if parent: return parent.get(name)
10
           else: return null
11
```

Having blackboards fall back in this way allows blackboards to work in the same way that variables in a programming language do. In programming languages this kind of structure would be called a "scope chain."4

The final element missing from our implementation is a mechanism for behavior trees to find their nearest blackboard. The easiest way to achieve this is to pass the blackboard down the tree as an argument to the run method. But didn't I say that we didn't want to change the interface? Well, yes, but what we wanted to avoid was having different interfaces for different tasks, so tasks would have to know what parameters to pass. By making all tasks accept a blackboard as their only parameter, we retain the anonymity of our tasks.

The task API now looks like this:

```
class Task:
      function run(blackboard: Blackboard) -> bool
2
      function terminate()
```

and our BlackboardManager task can then simply introduce a new blackboard to its child, making the blackboard fall back to the one it was given:

```
class BlackboardManager extends Decorator:
   blackboard: Blackboard = null
   function run(blackboard: Blackboard) -> bool:
       newBlackboard = new Blackboard()
       newBlackboard.parent = blackboard
        result = child.run()
       delete newBlackboard
        return result
```

Another approach to implementing hierarchies of blackboards is to allow tasks to query the task above them in the tree. This query moves up the tree recursively until it reaches a BlackboardManager task that can provide the blackboard. This approach keeps the original no-argument API for our task's run method, but adds extra code complexity to each task that needs to look up data.

Some developers use completely different approaches. Some game engines already have mechanisms in their scheduling system for passing around data along with bits of code to run. These systems can be repurposed to provide the blackboard data for a behavior tree, giving them automatic access to the data-debugging tools built into the engine. It would be a duplication of effort to implement either scheme above in this case.

It is worth noting that the scope chain we're building here is called a *dynamic scope chain*. In programming languages, dynamic scopes were the original way that scope chains were implemented, but it rapidly became obvious that they caused serious problems and were very difficult to write maintainable code for. Modern languages have all now moved over to static scope chains. For behavior trees, however, dynamic scope isn't a big issue and is probably more intuitive. I am not aware of any developers who have thought in such formal terms about data sharing, however, so I'm not aware of anyone who has practical experience of both approaches.

Whichever scheme you implement, blackboard data allow you to have communication between parts of your tree, and that communication may be of any complexity.

In the section on concurrency, above, we had pairs of tasks where one task calls methods on another. This simple approach to communication is fine in the absence of a richer dataexchange mechanism but should probably not be used if you are going to give your behavior tree tasks access to a full blackboard.

In that case, it is better to have them communicate by writing and reading from the blackboard rather than calling methods. Having all your tasks communicate in this way allows you to easily write new tasks to use existing data in novel ways, making it quicker to grow the functionality of your implementation.

5.4.6 REUSING TREES

In the final part of this section we'll look in more detail at how behavior trees get to be constructed in the first place, how we can reuse them for multiple characters, and how we can use sub-trees multiple times in different contexts. These are three separate but important elements to consider. They have related solutions, but we'll consider each in turn.

Instantiating Trees

Chances are, if you've taken a course on object-oriented programming, you were taught the dichotomy between instances of things and classes of things. We might have a class of soda machines, but the particular soda machine in the office lobby is an instance of that class. Classes are abstract concepts; instances are the concrete reality. This works for many situations, but not all. In particular, in game development, we regularly see situations where there are three, not two, levels of abstraction. So far in this chapter we've been ignoring this distinction, but if we want to reliably instantiate and reuse behavior trees we have to face it now.

At the first level we have the classes we've been defining in pseudo-code. They represent abstract ideas about how to achieve some task. We might have a task for playing an animation, for example, or a condition that checks whether a character is within range of an attack.

At the second level we have instances of these classes arranged in a behavior tree. The examples we've seen so far consist of instances of each task class at a particular part of the tree. So, in the behavior tree example of Figure 5.29, we have two Hit tasks. These are two instances of the Hit class. Each instance has some parameterization: the PlayAnimation task gets told what animation to play, the EnemyNear condition gets given a radius, and so on.

But now we're meeting the third level. A behavior tree is a way of defining a set of behaviors, but those behaviors can belong to any number of characters in the game at the same or different times. The behavior tree needs to be instantiated for a particular character at a particular time.

This three layers of abstraction don't map easily onto most regular class-based languages, and you'll need to do some work to make this seamless. There are a few approaches:

- 1. Use a language that supports more than two layers of abstraction.
- 2. Use a cloning operation to instantiate trees for characters.
- 3. Create a new intermediate format for the middle layer of abstraction.
- 4. Use behavior tree tasks that don't keep local state and use separate state objects.

The first approach is probably not practical. There is another way of doing object orientation (OO) that doesn't use classes. It is called prototype-based object orientation, and it allows you to have any number of different layers of abstraction. Despite being strictly more powerful than class-based OO, it was discovered much later, and unfortunately has had a hard time breaking into developers' mindsets. The only widespread language to support it is JavaScript.⁵

The second approach is the easiest to understand and implement. The idea is that, at the second layer of abstraction, we build a behavior tree from the individual task classes we've defined. We then use that behavior tree as an "archetype" or "prefab"; we keep it in a safe place and never use it to run any behaviors on. Any time we need an instance of that behavior tree we take a copy of the archetype and use the copy. That way we are getting all of the configuration of the tree, but we're getting our own copy. Some game engines provide this instantiation as part of their core services. Unity calls them prefabs, and Instantiate produces a working copy, which can be added to your scene. To implement this yourself, one method is to have each task have a clone method that makes a copy of itself. We can then ask the top task in the tree for a clone of itself and have it recursively build us a copy. This is assumed in the pseudo-code examples below. I've chosen this for simplicity, to avoid making the code examples engine-specific. In some languages, this isn't needed: "deep-copy" operations are provided by the built-in libraries that can do this for us.

Approach three is useful when the specification for the behavior tree is held in some data format. This is common—the AI author uses some editing tool that outputs some data structure saying what nodes should be in the behavior tree and what properties they should have. If we have this specification for a tree we don't need to keep a whole tree around as an archetype; we can just store the specification, and build an instance of it each time it is needed. Here, the only classes in our system are the original task classes, and the only instances are the final behavior trees. We've effectively added a new kind of intermediate layer of abstraction in the form of our custom data structure, which can be instantiated when needed. This is the mechanism that is used behind the scenes by Unity to instantiate prefabs. Prefabs are actually stored in XML.

Approach four is somewhat more complicated to implement but has been reported by some developers. The idea is that we write all our tasks so they never hold any state related to a specific use of that task for a specific character. They can hold any data at the middle

5. The story of prototype-based OO in JavaScript isn't a pretty one. Programmers taught to think in class-based OO can find it hard to adjust, and the web is littered with people making pronouncements about how JavaScript's objectoriented model is "broken." This has been so damaging to JavaScript's reputation that the most recent versions of the JavaScript specification have retrofitted the class-based model. Though such classes are syntactic sugar for prototypes, they give the impression of being something else, encouraging programmers to ignore their full power and wasting one of the most powerful and flexible aspects of the language.

level of abstraction: things that are the same for all characters at all times, but specific to that behavior tree. So, a Composite node can hold the list of children it is managing, for example (as long as we don't allow children to be dynamically added or removed at runtime). But, our Parallel node can't keep track of the children that are currently running. The current list of active children will vary from time to time and from character to character. These data do need to be stored somewhere, however, otherwise the behavior tree couldn't function. So this approach uses a separate data structure, similar to our blackboard, and requires all characterspecific data to be stored there. This approach treats our second layer of abstraction as the instances and adds a new kind of data structure to represent the third layer of abstraction. It is the most efficient, but it also requires a lot of bookkeeping work.

This three-layer problem isn't unique to behavior trees, of course. It arises any time we have some base classes of objects that are then configured, and the configurations are then instantiated. Allowing the configuration of game entities by non-programmers is so ubiquitous in large-scale game development (usually it is called "data-driven" development) that this problem keeps coming up, so much so that it is possible that whatever game engine you're working with already has some tools built in to cope with this situation, and the choice of approach outlined above becomes moot—you go with whatever the engine provides. If you are the first person on your project to hit the problem, it is worth really taking time to consider the options and build a system that will work for everyone else, too.

Reusing Whole Trees

With a suitable mechanism to instantiate behavior trees, we can build a system where many characters can use the same behavior.

During development, the AI authors create the behavior trees they want for the game and assign each one a unique name. A factory function can then be asked for a behavior tree matching a name at any time.

We might have a definition for our generic enemy character:

```
Enemy Character (goon):
      model = 'enemv34.model'
2
      texture = 'enemy34-urban.tex'
      weapon = pistol_4
4
      behavior = goon_behavior
```

When we create a new goon, the game requests a fresh goon behavior tree. Using the cloning approach to instantiating behavior trees, we might have code that looks like:

```
function createBehaviorTree(type: string) -> Task:
      archetype = behaviorTreeLibrary[type]
2
       return archetype.clone()
```

Clearly not onerous code! This example assumes the behavior tree library will be filled with the archetypes for all the behavior trees that we might need. This would normally be

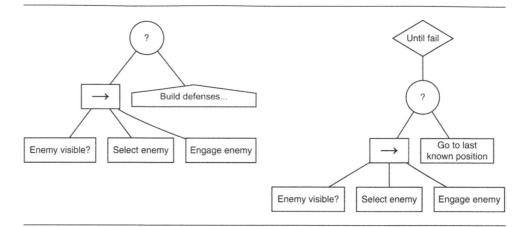

Figure 5.37: Common sub-trees across characters

done during the loading of the level, making sure that only the trees that might be needed in that level are loaded and instantiated into archetypes.

Reusing Sub-trees

With our behavior library in place, we can use it for more than simply creating whole trees for characters. We can also use it to store named sub-trees that we intend to use in multiple contexts. Take the example shown in Figure 5.37.

This shows two separate behavior trees. Notice that each of them has a sub-tree that is designed to engage an enemy. If we had tens of behavior trees for tens of different kinds of character, it would be incredibly wasteful to have to specify and duplicate these sub-trees. It would be great to reuse them. By reusing them we'd also be able to come along later and fix bugs or add more sophisticated functionality and know that every character in the game instantly benefits from the update.

We can certainly store partial sub-trees in our behavior tree library. Because every tree has a single root task, and because every task looks just the same, our library doesn't care whether it is storing sub-trees or whole trees. The added complication for sub-trees is how to get them out of the library and embedded in the full tree.

The simplest solution is to do this lookup when you create a new instance of your behavior tree. To do this you add a new "reference" task in your behavior tree that tells the game to go and find a named sub-tree in the library. This task is never run—it exists just to tell the instantiation mechanism to insert another sub-tree at this point.

For example, this class is trivial to implement using recursive cloning:

```
class SubtreeReference extends Task:
       # What named subtree are we referring to.
2
       referenceName: string
3
       function run() -> bool:
5
           throw Error("This_task_isn't_meant_to_be_run!")
6
7
       function clone() -> Task:
8
           return createBehaviorTree(referenceName)
```

In this approach our archetype behavior tree contains these reference nodes, but as soon as we instantiate our full tree it replaces itself with a copy of the sub-tree, built by the library.

Notice that the sub-tree is instantiated when the behavior tree is created, ready for a character's use. In memory-constrained platforms, or for games with thousands of AI characters, it may be worth holding off on creating the sub-tree until it is needed, saving memory in cases where parts of a large behavior tree are rarely used. This may be particularly useful where the behavior tree has a lot of branches for special cases: how to use a particular rare weapon, for example, or what to do if the player mounts some particularly clever ambush attempt. These highly specific sub-trees don't need to be created for every character, wasting memory; instead, they can be created on demand if the rare situation arises.

We can implement this using a Decorator. The Decorator starts without a child but creates that child when it is first needed:

```
class SubtreeLookupDecorator extends Decorator:
       subtreeName: string
2
       function run() -> bool:
4
           if child == null:
5
               child = createBehaviorTree(subtreeName)
               return child.run()
```

Obviously we could extend this further to delete the child and free the memory after it has been used, if we really want to keep the behavior tree as small as possible.

With the techniques we've now met, we have the tools to build a comprehensive behavior tree system with whole trees and specific components that can be reused by lots of characters in the game. There is a lot more we can do with behavior trees, in addition to tens of interesting tasks we could write and lots of interesting behaviors we could build. Behavior trees are certainly an exciting technology, but they don't solve all of our problems.

5.4.7 LIMITATIONS OF BEHAVIOR TREES

Over the last decade, behavior trees have come from nowhere to become a core technique in game AI, aided by good tool support in popular game engines. Inevitably with any hype, it can be easy to see them as a solution to almost every problem you can imagine in game AI. It is worth being a little cautious. Understanding what behavior trees are bad at is as important as understanding where they excel.

We've already seen a key limitation of behavior trees. They are reasonably clunky when representing the kind of state-based behavior that we met in the previous section. Not all state-based behavior causes problems. If your character transitions between types of behavior purely because of the success or failure of actions (so they get mad when they can't do something, for example), then behavior trees work fine. But they become much more cumbersome if you have a character who needs to respond to external events—interrupting a patrol route to suddenly go into hiding or to raise an alarm, for example—or a character than needs to switch strategies when its ammo is looking low. I'm not claiming those behaviors can't be implemented in behavior trees, just that it would be less idiomatic to do so.

Because behavior trees make it more difficult to think and design in terms of states, AI based solely on behavior trees tends to avoid these kinds of behavior. If you look at a behavior tree created by an artist or level designer, they tend to avoid noticeable changes of character disposition or alarm behavior. This is a shame, since those cues are simple and powerful and help raise the level of the AI.

We can build a hybrid system, of course, where characters have multiple behavior trees and use a state machine to determine which behavior tree they are currently running. Using the approach of having behavior tree libraries that we saw above, this provides the best of both worlds. Unfortunately, it also adds considerable extra burden to the AI authors and toolchain developers, since they now need to support two kinds of authoring: state machines and behavior trees.

An alternative approach would be to create tasks in the behavior tree that behave like state machines—detecting important events and terminating the current sub-tree to begin another. This merely moves the authoring difficulty, however, as we still need to build a system for AI authors to parameterize these relatively complex tasks.

Behavior trees on their own have been a big win for game AI, and developers will still be exploring their potential for many years. As long as they are pushing forward the state of the art, I suspect that there will not be a strong consensus on how best to avoid these limitations, with developers and tool vendors experimenting with their own approaches.

5.5 FUZZY LOGIC

So far the decisions we've made have been very cut and dried. Conditions and decisions have been true or false, and we haven't questioned the dividing line. Fuzzy logic is a set of mathematical techniques designed to cope with gray areas.

Imagine we're writing AI for a character moving through a dangerous environment. In a finite state machine approach, we could choose two states: "Cautious" and "Confident." When the character is cautious, it sneaks slowly along, keeping an eye out for trouble. When the character is confident, it walks normally. As the character moves through the level, it will switch between the two states. This may appear odd. We might think of the character getting gradually braver, but this isn't shown until suddenly it stops creeping and walks along as if nothing had ever happened.

Fuzzy logic allows us to blur the line between cautious and confident, giving us a whole spectrum of confidence levels. With fuzzy logic we can still make decisions like "walk slowly when cautious," but both "slowly" and "cautious" can include a range of degrees.

5.5.1 A WARNING

Fuzzy logic has been used in several games, and is applicable to many decision-making problems. It deserves its place in this book and in your toolbox of techniques. However, you should be aware that fuzzy logic has, for valid reasons, been largely discredited within the mainstream academic AI community for problems that probability can successfully model.

You can read more details in Russell and Norvig [54] but the executive summary is that it is always better to use probability to represent any kind of uncertainty. Put in more concrete terms, it has been proven that if you play any kind of zero-sum betting game, then a player who is not basing their decisions on probability theory can expect to eventually lose money. The reason is that flaws in any other theory of uncertainty, besides probability theory, can potentially be exploited by an opponent.

Fuzzy logic became more popular than probability theory in games partly because it is easier to translate simple rules (e.g. "walk slowly when cautious"). And partly because the perception has been that using probabilistic methods can be slow. With the advent of Bayes nets and other graphical modeling techniques, neither are such an issue. While I won't explicitly cover Bayes networks in this book, we will look at various other related approaches such as Markov systems.

5.5.2 INTRODUCTION TO FUZZY LOGIC

This section will give a quick overview of the fuzzy logic needed to understand the techniques in this chapter. Fuzzy logic itself is a huge subject, with many subtle features, and I don't have the space to cover all the interesting and useful bits of the theory. If you want a broad grounding, I'd recommend Buckley and Eslami [7], a widely used text on the subject that can be difficult to find or expensive now. For a more recent text, see [52].

Fuzzy Sets

In traditional logic we use the notion of a "predicate," a quality or description of something. A character might be hungry, for example. In this case, "hungry" is a predicate, and every character either does or doesn't have it. Similarly, a character might be hurt. There is no sense of how hurt; each character either does or doesn't have the predicate. There might be some

underlying number (hit points, for example), but there will be some dividing line to determine whether a character has the predicate.

We can view these predicates as sets. Everything to which the predicate applies is in the set, and everything else is outside.

These sets are called *classical sets*, and traditional logic can be formulated in terms of them. Fuzzy logic extends the notion of a predicate by giving it a value. So a character can be hurt with a value of 0.5, for example, or hungry with a value of 0.9. A character with a hurt value of 0.7 will be more hurt than one with a value of 0.3. So, rather than belonging to a set or being excluded from it, everything can partially belong to the set, and some things can belong to more than others.

In the terminology of fuzzy logic, these sets are called *fuzzy sets*, and the numeric value is called the *degree of membership*. So, a character with a hungry value of 0.9 is said to belong to the hungry set with a 0.9 degree of membership.

For each set, a degree of membership of 1 is given to something completely in the fuzzy set. It is equivalent to membership of the classical set. Similarly, the value of 0 indicates something completely outside the fuzzy set. When we look at the rules of logic, below, you'll find that all the rules of traditional logic still work when set memberships are either 0 or 1.

In theory, we could use any range of numeric values to represent the degree of membership. But I will use consistent values from 0 to 1 for degree of membership in this book, in common with almost all fuzzy logic texts. It is quite common, however, to implement fuzzy logic using integers (on a 0 to 255 scale, for example) because integer arithmetic is faster and more accurate than using floating point values.

Whatever value we use doesn't mean anything outside fuzzy logic. A common mistake is to interpret the value as a probability or a percentage. Occasionally, it helps to view it that way, but the results of applying fuzzy logic techniques will rarely be the same as if you applied probability techniques, and that can be confusing.

Membership of Multiple Sets

Anything can be a member of multiple sets at the same time. A character may be both hungry and hurt, for example. This is the same for both classical and fuzzy sets.

Often, in traditional logic we have a group of predicates that are mutually exclusive. A character cannot be both hurt and healthy, for example. In fuzzy logic this is no longer the case. A character can be hurt and healthy, it can be tall and short, and it can be confident and curious. The character will simply have different degrees of membership for each set (e.g., it may be 0.5 hurt and 0.5 healthy).

The fuzzy equivalent of mutual exclusion is the requirement that membership degrees sum to 1. So, if the sets of hurt and healthy characters are mutually exclusive, it would be invalid to have a character who is hurt 0.4 and healthy 0.7. Similarly, if we had three mutually exclusive sets—confident, curious, and terrified—a character who is confident 0.2 and curious 0.4 will be terrified 0.4.

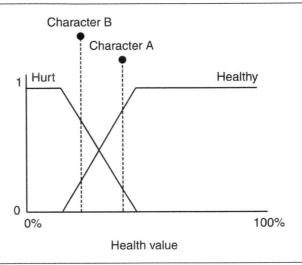

Figure 5.38: Membership functions

It is rare for implementations of fuzzy decision making to enforce this. Most implementations allow any sets of membership values, relying on the fuzzification method (see the next section) to give a set of membership values that approximately sum to 1. In practice, values that are slightly off make very little difference to the results.

Fuzzification

Fuzzy logic only works with degrees of membership of fuzzy sets. Since this isn't the format in which most games keep their data, some conversion is needed. Turning regular data into degrees of membership is called fuzzification; turning it back is, not surprisingly, defuzzification.

Numeric Fuzzification

The most common fuzzification technique is turning a numeric value into the membership of one or more fuzzy sets. Characters in the game might have a number of hit points, for example, which we'd like to turn into the membership of the "healthy" and "hurt" fuzzy sets.

This is accomplished by a membership function. For each fuzzy set, a function maps the input value (hit points, in our case) to a degree of membership. Figure 5.38 shows two membership functions, one for the "healthy" set and one for the "hurt" set.

From this set of functions, we can read off the membership values. Two characters are marked: character A is healthy 0.8 and hurt 0.2, while character B is healthy 0.3 and hurt 0.7.

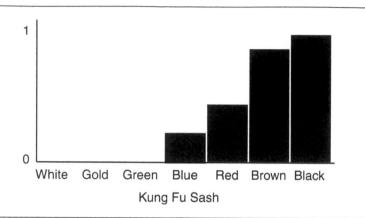

Figure 5.39: Membership function for enumerated value

Note that in this case the membership functions have been chosen so that the values they produce always sum to 1.

There is no limit to the number of different membership functions that can rely on the same input value, and their values don't need to add up to 1.

Fuzzification of Other Data Types

In a game context, we often also need to fuzzify Boolean values and enumerations. The most common approach is to store pre-determined membership values for each relevant set.

A character might have a Boolean value to indicate if it is carrying a powerful artifact. The membership function has a stored value for both true and false, and the appropriate value is chosen. If the fuzzy set corresponds directly to the Boolean value (if the fuzzy set is "possession of powerful artifact," for example), then the membership values will be 0 and 1.

The same structure holds for enumerated values, where there are more than two options: each possible value has a pre-determined stored membership value. In a martial arts fighting game, for example, characters might possess one of a set of sashes indicating their prowess. To determine the degree of membership in the "fearsome fighter" fuzzy set, the membership function in Figure 5.39 could be used.

Defuzzification

After applying whatever fuzzy logic we need, we are left with a set of membership values for fuzzy sets. To turn it back into useful data, we need to use a defuzzification technique.

The fuzzification technique we looked at in the last section is fairly obvious and almost ubiquitous. Unfortunately, there isn't a correspondingly obvious defuzzification method. There are several possible defuzzification techniques, and there is no clear consensus on which

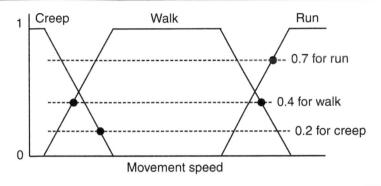

Figure 5.40: Impossible defuzzification

is the best to use. All have a similar basic structure, but differ in efficiency and stability of results.

Defuzzification involves turning a set of membership values into a single output value. The output value is almost always a number. It relies on having a set of membership functions for the output value. We are trying to reverse the fuzzification method: to find an output value that would lead to the membership values we know we have.

It is rare for this to be directly possible. In Figure 5.40, we have membership values of 0.2, 0.4, and 0.7 for the fuzzy sets "creep," "walk," and "run."

The membership functions show that there is no possible value for movement speed which would give us those membership values, if we fed it into the fuzzification system. We would like to get as near as possible, however, and each method approaches the problem in a different way.

It is worth noting that there is confusion in the terms used to describe defuzzification methods. You'll often find different algorithms described under the same name. The lack of any real meaning in the degree of membership values means that different but similar methods often produce equally useful results, encouraging confusion and a diversity of approaches.

Using the Highest Membership

We can simply choose the fuzzy set that has the greatest degree of membership and choose an output value based on that. In our example above, the "run" membership value is 0.7, so we could choose a speed that is representative of running.

There are four common points chosen: the minimum value at which the function returns 1 (i.e., the smallest value that would give a value of 1 for membership of the set), the maximum value (calculated the same way), the average of the two, and the bisector of the function. The bisector of the function is calculated by integrating the area under the curve of the membership function and choosing the point which bisects this area. Figure 5.41 shows this, along with other methods, for a single membership function.

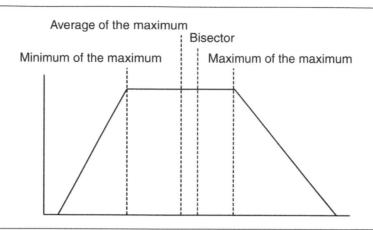

Figure 5.41: Minimum, average bisector, and maximum of the maximum

Although the integration process may be time consuming, it can be carried out once, possibly offline. The resulting value is then always used as the representative point for that set.

Figure 5.41 shows all four values for the example.

This is a very fast technique and simple to implement. Unfortunately, it provides only a coarse defuzzification. A character with membership values of 0 creep, 0 walk, 1 run will have exactly the same output speed as a character with 0.33 creep, 0.33 walk, 0.34 run.

Blending Based on Membership

A simple way around this limitation is to blend each characteristic point based on its corresponding degree of membership. So, a character with 0 creep, 0 walk, 1 run will use the characteristic speed for the run set (calculated in any of the ways we saw above: minimum, maximum, bisector, or average). A character with 0.33 creep, 0.33 walk, 0.34 run will have a speed given by

$$0.33v_{\mathsf{creep}} + 0.33v_{\mathsf{walk}} + 0.4v_{\mathsf{run}}$$

where v_{creep} is the characteristic speed for creeping, with the other variables similarly for walking and running.

The only proviso is to make sure that the multiplication factors are normalized. It is possible to have a character with 0.6 creep, 0.6 walk, 0.7 run. Simply multiplying the membership values by the characteristic points will likely give an output speed faster than running.

When the minimum values are blended, the resulting defuzzification is often called a Smallest of Maximum method, or Left of Maximum (LM). Similarly, a blend of the maxi-

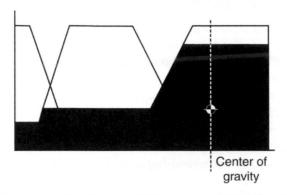

Figure 5.42: Membership function cropped, and all membership functions cropped

mums may be called Largest of Maximum (also occasionally LM!), or Right of Maximum. The blend of the average values can be known as Mean of Maximum (MoM).

Unfortunately, some references assume we only have one membership function involved in defuzzification. In these references you may find the same method names used to represent the unblended forms. Nomenclature among defuzzification methods is often a matter of guesswork.

In practice, it doesn't matter what they are called, as long as you can find one that works for you.

Center of Gravity

This technique is also known as centroid of area. This method takes into account all the membership values, rather than just the largest.

First, each membership function is cropped at the membership value for its corresponding set. So, if a character has a run membership of 0.4, the membership function is cropped above 0.4. This is shown in Figure 5.42 for one and for the whole set of functions.

The center of mass of the cropped regions is then found by integrating each in turn. This point is used as the output value. The center of mass point is labeled in the figure.

Using this method takes time. Unlike the bisector of area method, we can't do the integration offline because we don't know in advance what level each function will be cropped at. The resulting integration (often numeric, unless the membership function has a known integral) can take time.

It is worth noting that this center of gravity method, while often used, differs from the identically named method in the Institute of Electrical and Electronics Engineers (IEEE) specification for fuzzy control. The IEEE version doesn't crop each function before calculating its center of gravity. The resulting point is therefore constant for each membership function and so would come under a blended points approach in our categorization.

Choosing a Defuzzification Approach

Although the center of gravity approach is favored in many fuzzy logic applications, it is fairly complex to implement and can make it harder to add new membership functions. The results provided by the blended points approach is often just as good and is much quicker to calculate.

It also supports an implementation speed up that removes the need to use membership functions. Rather than calculating the representative points of each function, you can simply specify values directly. These values can then be blended in the normal way. In our example we can specify that a creep speed is 0.2 meters per second, while a walk is 1 meter per second, and a run is 3 meters per second. The defuzzification is then simply a weighted sum of these values, based on normalized degrees of membership.

Defuzzification to a Boolean Value

To arrive at a Boolean output, we use a single fuzzy set and a cut-off value. If the degree of membership for the set is less than the cut-off value, the output is considered to be false; otherwise, it is considered to be true.

If several fuzzy sets need to contribute to the decision, then they are usually combined using a fuzzy rule (see below) into a single set, which can then be defuzzified to the output Boolean.

Defuzzification to an Enumerated Value

The method for defuzzifying an enumerated value depends on whether the different enumerations form a series or if they are independent categories. Our previous example of martial arts belts forms a series: the belts are in order, and they fall in increasing order of prowess. By contrast, a set of enumerated values might represent different actions to carry out: a character may be deciding whether to eat, sleep, or watch a movie. These cannot easily be placed in any order.

Enumerations that can be ordered are often defuzzified as a numerical value. Each of the enumerated values corresponds to a non-overlapping range of numbers. The defuzzification is carried out exactly as for any other numerical output, and then an additional step places the output into its appropriate range, turning it into one of the enumerated options. Figure 5.43 shows this in action for the martial arts example: the defuzzification results in a "prowess" value, which is then converted into the appropriate belt color.

Enumerations that cannot be ordered are usually defuzzified by making sure a fuzzy set corresponds to each possible option (using a fuzzy rule to combine other sets, for example). There may be a fuzzy set for "eat," another for "sleep," and another for "watch movie." The set that has the highest membership value is chosen, and its corresponding enumerated value is output.

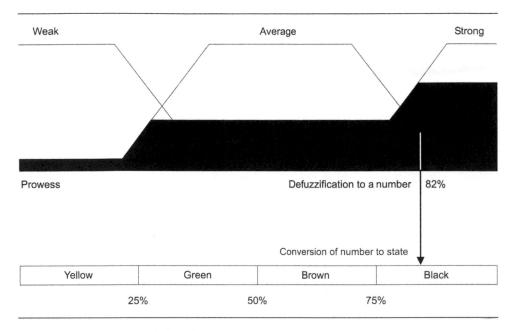

Figure 5.43: Enumerated defuzzification in a range

Combining Facts

Now that we've covered fuzzy sets and their membership, and how to get data in and out of fuzzy logic, we can look at the logic itself. Fuzzy logic is similar to traditional logic; logical operators (such as AND, OR, and NOT) are used to combine the truth of simple facts to understand the truth of complex facts. If we know the two separate facts "it is raining" and "it is cold," then we know the statement "it is raining and cold" is also true.

Unlike traditional logic, now each simple fact is not true or false, but is a numerical value—the degree of membership of its corresponding fuzzy set. It might be partially raining (membership of 0.5) and slightly cold (membership of 0.2). We need to be able to work out the truth value for compound statements such as "it is raining and cold."

In traditional logic we use a truth table, which tells us what the truth of a compound statement is based on the different possible truth values of its constituents. So AND is represented as:

A	В	A AND B
false	false	false
false	true	false
true	false	false
true	true	true

In fuzzy logic each operator has a numerical rule that lets us calculate the degree of truth based on the degrees of truth of each of its inputs. The fuzzy rule for AND is

$$m_{(A \text{ AND } B)} = \min(m_A, m_B)$$

where m_A is the degree of membership of set A (i.e., the truth value of A). As promised, the truth table for traditional logic corresponds to this rule, when 0 is used for false and 1 is used for true:

A	B	A AND B
0	0	0
0	1	0
1	0	0
1	1	1

The corresponding rule for OR is

$$m_{(AOR\ B)} = \max(m_A, m_B)$$

and for NOT it is

$$m_{(NOT\ A)} = 1 - m_A$$

Notice that, just like traditional logic, the NOT operator only relates to a single fact, whereas AND and OR relate to two facts.

The same correspondences present in traditional logic are used in fuzzy logic. So,

$$A \text{ OR } B = \text{NOT}(\text{NOT } A \text{ AND NOT } B)$$

Using these correspondences, we get the following table of fuzzy logic operators:

Expression	Equivalent	Fuzzy Equation
NOT A		$1-m_A$
A AND B		$\min(m_A, m_B)$
$A ext{ OR } B$		$\max(m_A, m_B)$
$A \times B$	NOT(B) AND A OR	$\max(\min(m_A, 1 - m_B), \min(1 - m_A, m_B))$
	NOT(A) AND B	
A NOR B	NOT(A OR B)	$1-\max(m_A,m_B)$
A NAND B	NOT(A AND B)	$1-\min(m_A,m_B)$

These definitions are, by far, the most common. Some researchers have proposed the use of alternative definitions for AND and OR and therefore also for the other operators. It is reasonably safe to assume these definitions; alternative formulations are almost always made explicit when they are used. And when implementing fuzzy logic in your own game, there isn't a clear advantage to using any alternative.

Fuzzy Rules

The final element of fuzzy logic we'll need is the concept of a fuzzy rule. Fuzzy rules relate the known membership of certain fuzzy sets to generate new membership values for other fuzzy sets. We might say, for example, "If we are close to the corner and we are traveling fast, then we should brake."

This rule relates two input sets: "close to the corner" and "traveling fast." It determines the degree of membership of the third set, "should brake." Using the definition for AND given above, we can see that:

```
m_{\text{Should Brake}} = \min(m_{\text{Close to Corner}}, m_{\text{Traveling Ouickly}})
```

If we knew that we were "close to the corner" with a membership of 0.6 and "traveling fast" with a membership of 0.9, then we would know that our membership of "should brake" is 0.6.

5.5.3 FUZZY LOGIC DECISION MAKING

There are several things we can do with fuzzy logic in order to make decisions. We can use it in any system where we'd normally have traditional logic AND, NOT, and OR. It can be used to determine if transitions in a state machine should fire. It can be used also in the rules of the rule-based system discussed later in the chapter.

In this section, we'll look at a different decision making structure that uses only rules involving the fuzzy logic AND operator.

The algorithm doesn't have a name. Developers often simply refer to it as "fuzzy logic." It is taken from a sub-field of fuzzy logic called fuzzy control and is typically used to build industrial controllers that take action based on a set of inputs.

I have heard it called a fuzzy state machine, though that is a name given more often to a different algorithm that I will describe in the next section. Inevitably, one could say that the nomenclature for these algorithms is somewhat fuzzy.

The Problem

In many problems a set of different actions can be carried out, but it isn't always clear which one is best. Often, the extremes are very easy to call, but there are gray areas in the middle. It is particularly difficult to design a solution when the actions are not just on/off but can be applied with some degree.

Take the example mentioned above of driving a car. The actions available to the car include steering and speed control (acceleration and braking), both of which can be done to a range of degrees. It is possible to brake sharply to a halt or simply tap the brake to shed some speed.

If the car is traveling headlong at high speed into a tight corner, then it is pretty clear we'd like to brake. If the car is out of a corner at the start of a long straightaway, then we'd like to floor the accelerator. These extremes are clear, but exactly when to brake and how hard to hit the pedal are gray areas that differentiate the great drivers from the mediocre.

The decision making techniques we've used so far will not help us very much in these circumstances. We could build a decision tree or finite state machine, for example, to help us brake at the right time, but it would be an either/or process.

A fuzzy logic decision maker should help to represent these gray areas. We can use fuzzy rules written to cope with the extreme situations. These rules should generate sensible (although not necessarily optimal) conclusions about which action is best in any intermediate situation.

The Algorithm

The decision maker has any number of crisp inputs. These may be numerical, enumerated, or Boolean values.

Each input is mapped into fuzzy states using membership functions as described earlier.

Some implementations require that an input be separated into two or more fuzzy states so that the sum of their degrees of membership is 1. In other words, the set of states represents all possible states for that input. We will see how this property allows us optimizations later in the section. Figure 5.44 shows an example of this with three input values: the first and second have two corresponding states, and the third has three states.

So the set of crisp inputs is mapped into lots of states, which can be arranged in mutually inclusive groups.

In addition to these input states, we have a set of output states. These output states are normal fuzzy states, representing the different possible actions that the character can take.

Linking the input and output states is a set of fuzzy rules. Typically, rules have the structure:

```
IF input-state-1 AND ... AND input-state-n THEN output-state
```

For example, using the three inputs in the figure above, we might have rules such as:

```
IF chasing AND corner-entry AND going-fast THEN brake
IF leading AND mid-corner AND going-slow THEN accelerate
```

Rules are structured so that each clause in a rule is a state from a different crisp input. Clauses are always combined with a fuzzy AND. In the example, there are always three clauses because we had three crisp inputs, and each clause represents one of the states from each input.

It is a common requirement to have a complete set of rules: one for each combination of states from each input. For our example, this would produce 18 rules $(2 \times 3 \times 3)$.

To generate the output, we go through each rule and calculate the degree of membership for the output state. This is simply a matter of taking the minimum degree of membership for the input states in that rule (since they are combined using AND). The final degree of membership for each output state will be the maximum output from any of the applicable rules.

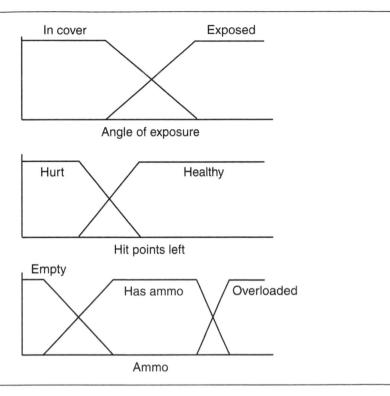

Figure 5.44: Exclusive mapping to states for fuzzy decision making

For example, in an oversimplified version of the previous example, we have two inputs (corner position and speed), each with two possible states. The rule block looks like the following:

```
IF corner-entry AND going-fast THEN brake
IF corner-exit AND going-fast THEN accelerate
IF corner-entry AND going-slow THEN accelerate
IF corner-exit AND going-slow THEN accelerate
```

We might have the following degrees of membership:

```
Corner-entry = 0.1
 Corner-exit = 0.9
  Going-fast = 0.4
 Going-slow = 0.6
```

Then the results from each rule are

Brake =
$$min(0.1, 0.4) = 0.1$$

Accelerate = $min(0.9, 0.4) = 0.4$
Accelerate = $min(0.1, 0.6) = 0.1$
Accelerate = $min(0.9, 0.6) = 0.6$

So, the final value for brake is 0.1, and the final value for accelerate is the maximum of the degrees given by each rule, namely 0.6.

The pseudo-code below includes a shortcut that means we don't need to calculate all the values for all the rules. When considering the second acceleration rule, for example, we know that the accelerate output will be at least 0.4 (the result from the first accelerate rule). As soon as we see the 0.1 value, we know that this rule will have an output of no more than 0.1 (since it takes the minimum). With a value of 0.4 already, the current rule cannot possibly be the maximum value for acceleration, so we may as well stop processing this rule.

After generating the correct degrees of membership for the output states, we can perform defuzzification to determine what to do (in our example, we might output a numeric value to indicate how hard to accelerate or break—in this case, a moderate acceleration).

Rule Structure

It is worth being clear about the rule structure used above. This is a structure that makes it efficient to calculate the degree of membership of the output state. Rules can be stored simply as a list of states, and they are always treated the same way because they are the same size (one clause per input variable), and their clauses are always combined using AND.

I've come across several misleading resources, most often web pages and tutorials, that present this structure as if it were somehow fundamental to fuzzy logic itself. There is nothing wrong with using any rule structure involving any kind of fuzzy operation (AND, OR, NOT, etc.) and any number of clauses. For very complex decision making with lots of inputs, parsing general fuzzy logic rules can be faster.

With the restriction that the set of fuzzy states for one input represents all possible states, and with the added restriction that all possible rule combinations are present (I'll call these "block format" rules), the system has a neat mathematical property. Any general rules using any number of clauses combined with any fuzzy operators can be expressed as a set of block format rules.

If you are having trouble seeing this, observe that with a complete set of ANDed rules we can specify any truth table we like (try it). Any set of consistent rules will have its own truth table, and we can directly model this using the block format rules.

In theory, any set of (non-contradictory) rules can be transformed into our format. Although there are transformations for this purpose, they are only of practical use for converting an existing set of rules. For developing a game, it is better to start by encoding rules in the format they are needed.

Pseudo-Code

The fuzzy decision maker can be implemented in the following way:

```
function fuzzyDecisionMaker(inputs: any[],
                                 membershipFns: MembershipFunction[][],
 2
                                 rules: FuzzyRule[]) -> float[]:
        # Will hold the degrees of membership for each input state and
        # output state, respectively.
 5
        inputDom: float[] = []
        outputDom: float[] = [0, 0, \ldots, 0]
        # Convert the inputs into state values.
        for i in 0..len(inputs):
10
            # Get the input value.
11
            input = inputs[i]
12
13
            # Get the membership functions for this input.
14
            membershipFnList = membershipFns[i]
15
16
            # Go through each membership function.
17
            for membershipFn in membershipFnList:
18
                # Convert the input into a degree of membership.
19
                inputDom[membershipFn.stateId] = membershipFn.dom(input)
20
21
        # Go through each rule.
22
        for rule in rules:
23
            # Get the current output d.o.m. for the conclusion state.
24
            best = outputDom[rule.conclusionStateId]
25
26
            # Hold the minimum of the inputDoms seen so far.
27
           min = 1
28
29
            # Go through each state in the input of the rule.
30
            for state in rule.inputStateIds:
31
                # Get the d.o.m. for this input state.
32
                dom = inputDom[state]
33
34
                # If we're smaller than the best conclusion so far, we may
35
                # as well exit now, because even if we are the smallest in
36
                # this rule, the conclusion will not be the best overall.
37
                if dom < best:
38
                    break continue # i.e., go to next rule.
39
40
                # Check if we're the lowest input d.o.m. so far.
41
                if dom < min:
42
                    min = dom
43
44
```

```
# min now holds the smallest d.o.m. of the inputs, and because
45
           # we didn't break above, we know it is larger than the current
46
           # best, so write the current best.
47
           outputDom[rule.conclusionStateId] = min
48
49
       # Return the output state degrees of membership.
50
       return outputDom
```

The function takes as input the set of input variables, a list of lists of membership functions, and a list of rules.

The membership functions are organized in lists where each function in the list operates on the same input variable. These lists are then combined in an overall list with one element per input variable. The inputs and membershipFns lists therefore have the same number of elements.

Data Structures and Interfaces

I have treated the membership functions as structures with the following form:

```
class MembershipFunction:
      stateId: int
2
      function dom(input: any) -> float
```

where stateId is the unique integer identifier of the fuzzy state for which the function calculates degree of membership. If membership functions define a zero-based continuous set of identifiers, then the corresponding degrees of membership can be simply stored in an array.

Rules also act as structures in the code above and have the following form:

```
class FuzzyRule:
       inputStateIds: int[]
2
       conclusionStateId: int
```

where the inputStateIds is a list of the identifiers for the states on the left-hand side of the rule, and the conclusionStateId is an integer identifier for the output state on the right-hand side of the rule.

The conclusion state id is also used to allow the newly generated degree of membership to be written to an array. The id numbers for input and output states should both begin from 0 and be continuous (i.e., there is an input 0 and an output 0, an input 1 and an output 1, and so on). They are treated as indices into two separate arrays.

Implementation Notes

The code illustrated above can implemented so that calculations are performed in parallel, using wide registers available in SIMD hardware (the PC's SSE extensions on the CPU, for example, or general-purpose GPU code). In this case the short circuit code illustrated will be omitted; such heavy branching isn't suitable for parallelizing the algorithm.

In a real implementation, it is common to retain the degrees of membership for input values that stay the same from frame to frame, rather than sending them through the membership functions each time.

The rule block is large, but predictable. Because every possible combination is present, it is possible to order the rules so they do not need to store the list of input state ids. A single array containing conclusions can be used, which is indexed by the offsets for each possible input state combination.

Performance

The algorithm is O(n+m) in memory, where n is the number of input states, and m is the number of output states. It simply holds the degree of membership for each.

Outside the algorithm itself, the rules need to be stored. This requires:

$$O\left(\prod_{k=0}^{i} n_k\right)$$

memory, where n_i is the number of states per input variable, and i is the number of input variables. So.

$$n = \sum_{k=0}^{1} n_k$$

The algorithm is

$$O\left(i\prod_{k=0}^{i}n_{k}\right)$$

in time, because there are

$$\prod_{k=0}^{i} n_k$$

rules, and each one has i clauses. Each clause needs to be evaluated in the algorithm.

Weaknesses

The overwhelming weakness of this approach is its lack of scalability. It works well for a small number of input variables and a small number of states per variable. To process a system with 10 input variables, each with 5 states, would require almost 10 million rules. This is well beyond the ability of anyone to create.

For larger systems of this kind, we can either use a small number of general fuzzy rules,

or we can use the Combs method for creating rules, where the number of rules scales linearly with the number of input states.

Combs Method

The Combs method relies on a simple result from classical logic: a rule of the form:

```
(a AND b) ENTAILS c
```

can be expressed as:

```
(a ENTAILS c) OR (b ENTAILS c)
```

where ENTAILS is a Boolean operator with its own truth table:

a	b	a ENTAILS b
true	true	true
true	false	false
false	true	true
false	false	false

As an exercise you can create the truth tables for the previous two logical statements and check that they are equal.

The ENTAILS operator is equivalent to "IF a THEN b." It says that should a be true, then b must be true. If a is not true, then it doesn't matter if b is true or not.

At first glance it may seem odd that (false ENTAILS true) is true, but this is quite logical. Suppose we say that:

```
IF I-am-in-the-bath THEN I-am-wet
```

So, if I'm in the bath then I am going to be wet (ignoring the possibility that I'm in an empty bath, of course). But you can be wet for many other reasons: getting caught in the rain, being in the shower, and so on. So I'm-wet can be true and I'm-in-the-bath can be false, and the rule would still be valid.

What this means is that we can write:

```
IF a AND b THEN c
```

as:

```
(IF a THEN c) OR (IF b THEN c)
```

Previously, we said that the conclusions of rules are ORed together, so we can split the new format rule into two separate rules:

```
IF a THEN c
IF b THEN c
```

For the purpose of this discussion, I will call this the Combs format (although that's not a widely used term).

The same thing works for larger rules:

```
IF a-1 AND ... AND a-n THEN c
```

can be rewritten as:

```
IF a-1 THEN c
IF a-n THEN c
```

So, we've gone from having rules involving all possible combinations of states to a simple set of rules with only one state in the IF-clause and one in the THEN-clause.

Because we no longer have any combinations, there will be the same number of rules as there are input states. Our example of 10 inputs with 5 states each gives us 50 rules only, rather than 10 million.

If rules can always be decomposed into this form, then why bother with the block format rules at all? Well, so far we've only looked at decomposing one rule, and we've hidden a problem. Consider the pair of rules:

```
IF corner-entry AND going-fast THEN brake
IF corner-exit AND going-fast THEN accelerate
```

These get decomposed into four rules:

```
IF corner-entry THEN brake
IF going-fast THEN brake
IF corner-exit THEN accelerate
IF going-fast THEN accelerate
```

This is an inconsistent set of rules; we can't both brake and accelerate at the same time. So when we're going fast, which is it to be? The answer, of course, is that it depends on where we are in the corner.

So, while one rule can be decomposed, more than one rule cannot. Unlike for block format rules, we cannot represent any truth table using Combs format rules. Because of this, there is no possible transformation that converts a general set of rules into this format. It may just so happen that a particular set of rules can be converted into the Combs format, but that is simply a happy coincidence.

The Combs method instead starts from scratch: the fuzzy logic designers build up rules, limiting themselves to the Combs format only. The overall sophistication of the fuzzy logic system will inevitably be limited, but the tractability of creating the rules means they can be tweaked more easily.

Our running example, which in block format was

```
IF corner-entry AND going-fast THEN brake
IF corner-exit AND going-fast THEN accelerate
```

```
IF corner-entry AND going-slow THEN accelerate
IF corner-exit AND going-slow THEN accelerate
```

could be expressed as:

```
IF corner-entry THEN brake
IF corner-exit THEN accelerate
IF going-fast THEN brake
IF going-slow THEN accelerate
```

With inputs of:

```
Corner-entry = 0.1
 Corner-exit = 0.9
  Going-fast = 0.4
 Going-slow = 0.6
```

the block format rules gave us results of

$$Brake = 0.1$$

Accelerate = 0.6

While Combs method gives us:

$$Brake = 0.4$$

 $Accelerate = 0.9$

When both sets of results are defuzzified, they are both likely to lead to a modest acceleration.

The Combs method is surprisingly practical in fuzzy logic systems. If the Combs method were used in classical logic (building conditions for state transitions, for example), it would end up hopelessly restrictive. But, in fuzzy logic, multiple fuzzy states can be active at the same time, and this means they can interact with one another (we can both brake and accelerate, for example, but the overall speed change depends on the degree of membership of both states). This interaction means that the Combs method produces rules that are still capable of producing interaction effects between states, even though those interactions are no longer explicit in the rules.

5.5.4 FUZZY STATE MACHINES

Although developers often talk about fuzzy state machines, they don't always mean the same thing by it. A fuzzy state machine can be any state machine with some element of fuzziness. It can have transitions that use fuzzy logic to trigger, or it might use fuzzy states rather than conventional states. It could even do both.

Although I've seen several approaches, with none of them particularly widespread, as an example I will illustrate the approach with a simple state machine that uses fuzzy states but crisp triggers for transitions.

The Problem

Regular state machines are suitable when the character is clearly in one state or another. As we have seen, there are many situations in which gray areas exist. We'd like to be able to have a state machine that can sensibly handle state transitions while allowing a character to be in multiple states at the same time.

The Algorithm

In the conventional state machine we kept track of the current state as a single value. Now we can be in any or even all states with some degree of membership (DOM). Each state therefore has its own DOM value. To determine which states are currently active (i.e., have a DOM greater than zero), we can simply look through all states. In most practical applications, only a subset of the states will be active at one time, so it can be more efficient to keep a separate list of all active states.

At each iteration of the state machine, the transitions belonging to all active states are given the chance to trigger. The first transition in each active state is fired. This means that multiple transitions can happen in one iteration. This is essential for keeping the fuzziness of the machine.

Unfortunately, because we will implement the state machine on a serial computer, the transitions can't be simultaneous. It is possible to cache all firing transitions and figure out the overall effect of combining them. In our algorithm we will use a simpler process: we will fire transitions belonging to each state in decreasing order of DOM.

If a transition fires, it can transition to any number of new states. The transition itself also has an associated degree of transition. The DOM of the target state is given by the DOM of the current state ANDed with the degree of transition.

For example, state A has a DOM of 0.4, and one of its transitions, T, leads to another state, B, with a degree of transition 0.6. Assume for now that the DOM of B is currently zero. The new DOM of B will be:

$$M_B = M_{(A \text{ AND } T)} = \min(0.4, 0.6) = 0.4$$

where M_x is the degree of membership of the set x, as before.

If the current DOM of state B is not zero, then the new value will be OR-ed with the existing value. Suppose it is 0.3 currently, we have

$$M'_B = M_{(B \text{ OR } (A \text{ AND } T))} = \max(0.3, 0.4) = 0.4$$

At the same time, the start state of the transition is ANDed with NOT T; that is, the degree to which we don't leave the start state is given by one minus the degree of transition. In our example, the degree of transition is 0.6. This is equivalent to saying 0.6 of the transition happens, so 0.4 of the transition doesn't happen. The DOM for state A is given by:

$$M'_A = M_{(A \text{ AND NOT } T)} = \min(0.4, 1 - 0.6) = 0.4$$

If you convert this into crisp logic, it is equivalent to the normal state machine behavior: the start state being active AND the transition firing causes the end state to be active. Because any such transition will cause the end state to be active, there may be several possible sources (i.e., they are ORed together). Similarly, when the transition has fired the start state is switched off, because the transition has effectively taken its activation and passed it on.

Transitions are triggered in the same way as for finite state machines. I will hide this functionality behind a method call, so any kind of tests can be performed, including tests involving fuzzy logic, if required.

The only other modification we need is to change the way actions are performed. Because actions in a fuzzy logic system are typically associated with defuzzified values, and because defuzzification typically uses more than one state, it doesn't make sense to have states directly request actions. Instead, I have separated all action requests out of the state machine and assumed that there is an additional, external defuzzification process used to determine the action required.

Pseudo-Code

The algorithm is simpler than the state machines we saw earlier. It can be implemented in the following way:

```
class FuzzyStateMachine:
       # Holds a state along with its current degree of membership.
2
       class StateAndDOM:
           state: int
           dom: float
       # The initial states, along with DOM values.
       initialStates: StateAndDOM[]
       # The current states, with DOM values.
10
       currentStates = initialStates
11
       # Checks and applies transitions.
13
       function update():
14
```

```
# Sorts the current states into DOM order.
15
            statesInOrder = currentStates.sortByDecreasingDOM()
16
17
            # Go through each state in turn.
18
            for state in statesInOrder:
19
20
                # Go through each transition in the state.
21
                for transition in currentState.getTransitions():
22
23
                    # Check for triggering.
24
                    if transition.isTriggered():
25
                         # Get the transition's degree of transition.
26
                         dot = transition.getDot()
27
28
                         # Move into all target states.
29
                         for endState in transition.getTargetStates():
30
                             # Update the degree of membership.
31
                             end = currentStates.get(endState)
32
                             end.dom = max(end.dom, min(state.dom, dot))
33
34
                             # Check if the state is new.
35
                             tf end.dom > 0 and not end in currentStates:
36
                                 currentStates.append(end)
37
38
                         # Remove some membership from the start.
39
                         state.dom = min(state.dom, 1 - dot)
40
41
                         # Check if we need to remove the start state.
42
                         if state.dom <= 0.0:
43
                             currentStates.remove(state)
44
45
                         # We don't look at any more transitions for this
46
                         # active state.
47
                         break
48
```

Data Structures and Interfaces

The currentStates member is a list of StateAndDom instances. In addition to its normal liststyle operations (i.e., iteration, removal of an element, testing for membership, addition of an element), it supports two operations specific for this algorithm.

The sortByDecreasingDOM method returns a copy of the list sorted in order of decreasing DOM values. It does not make copies of any of the StateAndDom instances in the list. We need a copy, since we'll be making changes to the original while we iterate through its contents. This can cause problems or infinite loops (although no infinite loops will be caused in this algorithm), so it is to be avoided as good programming practice.

The get method looks up a StateAndDom instance in the list from its state member. It therefore has the following form:

```
class StateAndDomList extends StateAndDom[]:
      function get(state: int) -> StateAndDom
2
      function sortByDecreasingDOM() -> StateAndDomList
```

where the base class is whatever data structure normally handles growable arrays. Transitions have the following form:

```
class Transition:
      function isTriggered() -> bool
      function getTargetStates() -> int[]
3
      function getDOT() -> float
```

The isTriggered method returns true if the transition can fire, the getTargetStates returns a list of states to transition to, and getDOT returns the degree of transition.

Implementation Notes

The isTriggered method of the Transition class can be implemented in the same way as for a standard state machine. It can use the infrastructure we developed earlier in the chapter, including decision trees.

It can also contain fuzzy logic to determine transitions. The degree of transition provides a mechanism to expose this fuzzy logic to the state machine.

Suppose, for example, that the isTriggered method uses some fuzzy logic to determine that its transition conditions are met with a DOM of 0.5. It can then expose 0.5 as the degree of transition, and the transition will have approximately half of its normal action on the state of the machine.

Performance

The algorithm requires temporary storage for each active state and therefore is O(n) in memory, where n is the number of active states (i.e., those with DOM > 0).

The algorithm looks at each transition for each active state and therefore is O(nm) in time, where m is the number of transitions per state.

As in all previous decision-making tools, the performance and memory requirements can easily be much higher if the algorithms in any of its data structures are not O(1) in both time and memory.

Multiple Degrees of Transition

It is possible to have a different degree of transition per target state. The degree of membership for target states is calculated in the same way as before.

The degree of membership of the start state is more complex. We take the current value and AND it with the NOT of the degree of transition, as before. In this case, however, there are multiple degrees of transition. To get a single value, we take the maximum of the degrees of transition (i.e., we OR them together first).

For example, say we have the following states:

State A =
$$0.5$$

State B = 0.6
State C = 0.4

then applying the transition:

$$A \longrightarrow B_{DOT=0.2} AND C_{DOT=0.7}$$

will give:

$$\begin{array}{lll} \text{State B} = \max(0.6, \min(0.2, 0.5)) &= 0.6 \\ \text{State C} = \max(0.4, \min(0.7, 0.5)) &= 0.5 \\ \text{State A} = \min(0.5, 1 - \max(0.2, 0.7)) &= 0.3 \end{array}$$

Again, if you unpack this in terms of classical logic, it matches with the behavior of the finite state machine.

With different degrees of transition to different states, we effectively have completely fuzzy transitions: the degrees of transition represent gray areas between transitioning fully to one state or another.

5.6 MARKOV SYSTEMS

The fuzzy state machine can simultaneously be in multiple states, each with an associated degree of membership. Being proportionally in a whole set of states is useful outside fuzzy logic. Whereas fuzzy logic does not assign any outside meaning to its degrees of membership (they need to be defuzzified into any useful quantity), it is sometimes useful to work directly with numerical values for states.

We might have a set of priority values, for example, controlling which of a group of characters gets to spearhead an assault, or a single character might use numerical values to represent the safety of each sniping position in a level. Both of these applications benefit from dynamic values. Different characters might lead in different tactical situations or as their relative health fluctuates during battle. The safety of sniping positions may vary depending on the position of enemies and whether protective obstacles have been destroyed.

This situation comes up regularly, and it is relatively simple to create an algorithm similar to a state machine to manipulate the values. There is no consensus as to what this kind of algorithm is called, however. Most often it is called a fuzzy state machine, with no distinction between implementations that use fuzzy logic and those that do not. In this book, I will reserve "fuzzy state machine" for algorithms involving fuzzy logic. The mathematics behind our implementation is a Markov process, so I will refer to the algorithm as a Markov state machine. Bear in mind that this nomenclature isn't widespread.

Before we look at the state machine, I will give a brief introduction to Markov processes.

5.6.1 MARKOV PROCESSES

We can represent the set of numerical states as a vector of numbers. Each position in the vector corresponds to a single state (e.g., a single priority value or the safety of a particular location). The vector is called the *state vector*.

There is no constraint on what values appear in the vector. There can be any number of zeros, and the entire vector can sum to any value. The application may put its own constraints on allowed values. If the values represent a distribution (what proportion of the enemy force is in each territory of a continent, for example), then they will sum to 1. Markov processes in mathematics are almost always concerned with the distribution of random variables. So much of the literature assumes that the state vector sums to 1.

The values in the state vector change according to the action of a transition matrix. Firstorder Markov processes (the only ones we will consider) have a single transition matrix that generates a new state vector from the previous values. Higher order Markov processes also take into account the state vector at earlier iterations.

Transition matrices are always square. The element at (i, j) in the matrix represents the proportion of element i in the old state vector that is added to element j in the new vector. One iteration of the Markov process consists of multiplying the state vector by the transition matrix, using normal matrix multiplication rules. The result is a state vector of the same size as the original. Each element in the new state vector has components contributed by every element in the old vector.

Conservative Markov Processes

A conservative Markov process ensures that the sum of the values in the state vector does not change over time. This is essential for applications where the sum of the state vector should always be fixed (where it represents a distribution, for example, or if the values represent the number of some object in the game). The process will be conservative if all the rows in the transition matrix sum to 1.

Iterated Processes

It is normally assumed that the same transition matrix applies over and over again to the state vector. There are techniques to calculate what the final, stable values in the state vector will be (it is an eigenvector of the matrix, as long as such a vector exists).

This iterative process forms a Markov chain.

In game applications, however, it is common for there to be any number of different transition matrices. Different transition matrices represent different events in the game, and they update the state vector accordingly.

Returning to our sniper example, let's say that we have a state vector representing the safety of four sniping positions:

$$V = \begin{bmatrix} 1.0 \\ 0.5 \\ 1.0 \\ 1.5 \end{bmatrix}$$

which sums to 4.0.

Taking a shot from the first position will alert the enemy to its existence. The safety of that position will diminish. But, while the enemy is focusing on the direction of the attack, the other positions will be correspondingly safer. We could use the transition matrix:

$$M = \begin{bmatrix} 0.1 & 0.3 & 0.3 & 0.3 \\ 0.0 & 0.8 & 0.0 & 0.0 \\ 0.0 & 0.0 & 0.8 & 0.0 \\ 0.0 & 0.0 & 0.0 & 0.8 \end{bmatrix}$$

to represent this case. Applying this to the state vector, we get the new safety values:

$$V = \begin{bmatrix} 0.1\\ 0.7\\ 1.1\\ 1.5 \end{bmatrix}$$

which sums to 3.4.

So the total safety has gone down (from 4.0 to 3.4). The safety of sniping point 1 has been decimated (from 1.0 to 0.1), but the safety of the other three points has marginally increased. There would be similar matrices for shooting from each of the other sniping points.

Notice that if each matrix had the same kind of form, the overall safety would keep decreasing. After a while, nowhere would be safe. This might be realistic (after being sniped at for a while, the enemy is likely to make sure that nowhere is safe), but in a game we might want the safety values to increase if no shots are fired. A matrix such as:

$$M = \begin{bmatrix} 1.0 & 0.1 & 0.1 & 0.1 \\ 0.1 & 1.0 & 0.1 & 0.1 \\ 0.1 & 0.1 & 1.0 & 0.1 \\ 0.1 & 0.1 & 0.1 & 1.0 \end{bmatrix}$$

would achieve this, if it is applied once for every minute that passes without gunfire.

Unless you are dealing with known probability distributions, the values in the transition matrix will be created by hand. Tuning values to give the desired effect can be difficult. It will depend on what the values in the state vector are used for. In applications I have worked on (related to steering behaviors and priorities in a rule-based system, both of which are described elsewhere in the book), the behavior of the final character has been quite tolerant of a range of values and tuning was not too difficult.

Markov Processes in Math and Science

In mathematics, a first-order Markov process is any probabilistic process where the future depends only on the present and not on the past. It is used to model changes in probability distribution over time.

The values in the state vector are probabilities for a set of events, and the transition matrix determines what probability each event will have at the next trial given their probabilities at the last trial. The states might be the probability of sun or probability of rain, indicating the weather on one day. The initial state vector indicates the known weather on one day (e.g., 0 if it was sunny), and by applying the transition we can determine the probability of the following day being sunny. By repeatedly applying the transition we have a Markov chain, and we can determine the probability of each type of weather for any time in the future.

In AI, Markov chains are more commonly found in prediction: predicting the future from the present. They are the basis of a number of techniques for speech recognition, for example, where it makes sense to predict what the user will say next to aid disambiguation of similarsounding words.

There are also algorithms to do learning with Markov chains (by calculating or approximating the values of the transition matrix). In the speech recognition example, the Markov chains undergo learning to better predict what a particular user is about to say.

5.6.2 MARKOV STATE MACHINE

Using Markov processes, we can create a decision making tool that uses numeric values for

The state machine will need to respond to conditions or events in the game by executing a transition on the state vector. If no conditions or events occur for a while, then a default transition can occur.

The Algorithm

We store a state vector as a simple list of numbers. The rest of the game code can use these values in whatever way is required.

We store a set of transitions. Transitions consist of a set of triggering conditions and a transition matrix. The trigger conditions are of exactly the same form as for regular state machines.

The transitions belong to the whole state machine, not to individual states.

At each iteration, we examine the conditions of each transition and determine which of them trigger. The first transition that triggers is then asked to fire, and it applies its transition matrix to the state vector to give a new value.

Default Transitions

We would like a default transition to occur after a while if no other transitions trigger. We could do this by implementing a type of transition condition that relies on time. The default transition would then be just another transition in the list, triggering when the timer counts down. The transition would have to keep an eye on the state machine, however, and make sure it resets the clock every time another transition triggers. To do this, it may have to directly ask the transitions for their trigger state, which is a duplication of effort, or the state machine would have to expose that information through a method.

Since the state machine already knows if no transitions trigger, it is more common to bring the default transition into the state machine as a special case. The state machine has an internal timer and a default transition matrix. If any transition triggers, the timer is reset. If no transitions trigger, then the timer is decremented. If the timer reaches zero, then the default transition matrix is applied to the state vector, and the timer is reset again.

Note that this can also be done in a regular state machine if a transition should occur after a period of inactivity. I've used it more often in numeric state machines, however.

Actions

Unlike a finite state machine, we are in no particular state. Therefore, states cannot directly control which action the character takes. In the finite state machine algorithm, the state class could return actions to perform for as long as the state was active. Transitions also returned actions that could be carried out when the transition was active.

In the Markov state machine, transitions still return actions, but states do not. There will be some additional code that uses the values in the state vector in some way. In our sniper example we can simply pick the largest safety value and schedule a shot from that position. However the numbers are interpreted, a separate piece of code is needed to turn the value into action.

Pseudo-Code

The Markov state machine has the following form:

```
class MarkovStateMachine:
    # The state vector.
    state: float[N]
```

```
# The frames to wait before using the default transition.
5
       resetTime: int
6
       # The default transition matrix.
       defaultTransitionMatrix: float[N,N]
10
       # The current countdown.
11
       currentTime: int = resetTime
12
13
       # A list of transitions.
14
       transitions: MarkovTransition[]
15
16
       function update() -> Action[]:
17
18
            # Check each transition for a trigger.
            triggeredTransition = null
19
20
            for transition in transitions:
21
                if transition.isTriggered():
                    triggeredTransition = transition
22
                    break
23
            # Check if we have a transition to fire.
            if triggeredTransition:
26
                # Reset the timer.
27
                currentTime = resetTime
28
29
                # Multiply the matrix and the state vector.
30
31
                matrix = triggeredTransition.getMatrix()
32
                state = matrix * state
33
                # Return the triggered transition's action list.
34
35
                return triggeredTransition.getActions()
37
           else:
38
                # Otherwise check the timer.
39
                currentTime -= 1
40
                if currentTime <= 0:</pre>
41
42
                    # Do the default transition.
                    state = defaultTransitionMatrix * state
43
                    currentTime = resetTime
44
45
                # Return no actions, since no transition triggered.
46
47
                return []
```

Data Structures and Interfaces

The transitions list in the state machine holds instances with the following interface:

```
class MarkovTransition:
      function isTriggered()
2
3
      function getMatrix()
       function getActions()
```

5.7 GOAL-ORIENTED BEHAVIOR

So far I have focused on approaches that react: a set of inputs is provided to the character, and a behavior selects an appropriate action. There is no implementation of desires or goals. The character merely reacts to input.

It is possible, of course, to make the character seem like it has goals or desires, even with the simplest decision making techniques. A character whose desire is to kill an enemy will hunt one down, will react to the appearance of an enemy by attacking, and will search for an enemy when there is a lack of one. The same character may also have the apparent desire to stay alive, in which case it will take account of its own protection, reacting to low health or the presence of danger. The underlying structure may be reacting to input, but the character doesn't need to appear that way.

In my experience, this is a misunderstanding that people who know academic AI have about game AI. Simple techniques can be made to appear more intelligent because the game world is inherently limited and the designer can constrain the way the player interacts with it. Smoke and mirrors is not an insult, it is the way we work. Because, for players, it doesn't matter what is controlling the character, as long as it looks right.

Simple techniques take us a long way. But there are more advanced approaches we can use to make the character more flexible in its goal seeking. In some game genres this is a useful approach. It is particularly visible in people simulation games, such as The Sims [136].

Here, only a few characters are on-screen at one time. Each has a range of emotional and physical parameters that change over time in relation to its environment and its actions. The player can often control the character's actions directly, although the character is always capable of independent action.

In a game such as The Sims, there is no overall goal to the game. In other titles such as Ghost Master [177], there is a definite aim (you try to scare the inhabitants out of a house using various ghosts and supernatural powers).

In this kind of game a wide range of different actions is available to characters. Actions might include boiling the kettle, sitting on a sofa, or talking to another character. The action itself is represented by a canned animation.

Characters need to demonstrate their emotional and physical state by choosing appropriate actions. They should eat when hungry, sleep when tired, chat to friends when lonely, and hug when in need of love. We could simply run a decision tree that selects available actions based on the current emotional and physical parameters of the character. In a game such as The Sims, this would lead to a very big decision tree. There are hundreds of parameterized actions to choose from for every character.

A better approach would be to present the character with a suite of possible actions and have it choose the one that best meets its immediate needs.

This is goal-oriented behavior (GOB), explicitly seeking to fulfill the character's internal goals. Like many algorithms in this book, the name can only be loosely applied. GOB may mean different things to different people, and it is often used either vaguely to refer to any goal seeking decision maker or to specific algorithms similar to those here. I will use it as a general term.

In this chapter we will begin with a very simple GOB framework and use it to implement a utility-based GOB decision maker. I will later describe goal-oriented action planning (GOAP), an extension to the basic GOB system that can plan sequences of actions to achieve its goal.

5.7.1 GOAL-ORIENTED BEHAVIOR

Goal-oriented behavior is a blanket term that covers any technique taking into account goals or desires. There isn't a single technique for GOB, and some of the other techniques in this chapter, notably rule-based systems, can be used to create goal-seeking characters.

In this section we will look at a utility-based decision making system that can choose from a range of actions based on its current goals. It is a system based on one I implemented myself for a client, and similar to one I am aware has been used elsewhere.

Goals

A character may have one or more goals, also called motives. There may be hundreds of possible goals, and the character can have any number of them currently active. They might have goals such as eat, regenerate health, or kill enemy. Each goal has a level of importance (often called insistence) represented by a number. A goal with a high insistence will tend to influence the character's behavior more strongly.

The character will try to fulfill its goal or to reduce its insistence. Some games allow goals to be completely satisfied (such as killing an enemy). Other games have a fixed set of goals that are always there, and they simply reduce the insistence when the goal is fulfilled (a character might always have a goal of "get healthy," for example, but at a low insistence when they are already healthy). A zero value for insistence is equivalent to a completely satisfied goal.

I am deliberately conflating goals and motives here. For the purpose of making great game characters, goals and motives can usually be treated as the same thing or at least blurred together somewhat. Strictly, they are quite distinct: motives might give rise to goals based on a character's beliefs, for example (i.e., we may have a goal of killing our enemy motivated by revenge for our colleagues, out of the belief that our enemy killed them). The exact definitions depend on the researcher. For our purposes, this is an extra layer we don't need for this algorithm, so I will treat motives and goals as largely the same thing and normally refer to them as goals.

We could easily implement goals without insistence values, but it makes it more difficult to choose which goals to focus on. I've chosen to use real numbers rather than Booleans, because the resulting algorithms are no more complex. If your game has thousands of characters with hundreds of goals, it might be worth just using on/off goals and saving storage space.

In a game like The Sims, the character's physical and emotional parameters can be interpreted as goal values. A character might have a hunger motive: the higher the hunger value, the more eating becomes a pressing goal.

Actions

In addition to a set of goals, we need a suite of possible actions to choose from. These actions can be generated centrally, but it is also common for them to be generated by objects in the world. In The Sims world, a kettle adds a "boil kettle" action and an empty oven adds an "insert raw food" action to the list of possibilities. In an action game an enemy might introduce an "attack me" action, while a door might expose a "lock" action.

The actions available depend on the current state of the game. The empty oven might check if the character is carrying raw food before positing its "insert" action. An oven containing raw food does not allow more food to be added; it exposes a "cook food" action. Similarly, the door exposes an "unlock" action if it is already locked or maybe an "insert key" action first before unlocking is allowed.

As the actions are added to the list of options, they are rated against each motive the character has. This rating shows how much impact the action would have on a particular motive. So the "playing with the games console" action might increase happiness a lot but also decrease energy.

In a shooter the actions are more atomic. Each action gives a list of goals that can be achieved. A "shoot" action, for example, can fulfill a kill enemy goal, as can a "spring-trap" action, and so on.

The goal that an action promises to fulfill might be several steps away. A piece of raw food might offer to fulfill hunger, for example. If the character picks it up, it will not become less hungry, but now the empty oven will offer the "insert" action, again promising to feed the character. The same thing continues through a "cook food" action, a "remove food from oven" action, and finally an "eat" action. In some games, the single action is made up of a sequence of actions. The "shoot" action might be made up of "draw weapon," "aim," and "fire" actions, for example. The action execution section at the end of this chapter has more details about this kind of combined action.

5.7.2 SIMPLE SELECTION

So, we have a set of possible actions and a set of goals. The actions promise to fulfill different goals. Continuing with the people simulation example, we might have:

```
Goal: Eat = 4 Goal: Sleep = 3
Action: Get-Raw-Food (Eat - 3)
Action: Get-Snack (Eat - 2)
Action: Sleep-In-Bed (Sleep - 4)
Action: Sleep-On-Sofa (Sleep - 2)
```

We can use a range of decision making tools to select an action and give intelligent-looking behavior. A simple approach would be to choose the most pressing goal (the one with the largest insistence) and find an action that either fulfills it completely or provides it with the largest decrease in insistence. In the example above, this would be the "get raw-food" action (which in turn might lead to cooking and eating the food). The change in goal insistence that is promised by an action is a heuristic estimate of its utility—the use that it might be to a character. The character naturally wants to choose the action with the highest utility, and the change in goal is used to do so.

If more than one action can fulfill a goal, we could choose between them at random or simply select the first one we find.

Pseudo-Code

We could implement this as:

```
function chooseAction(actions: Action[], goals: Goal[]) -> Action:
       # Find the most valuable goal to try and fulfil.
2
       topGoal: Goal = goals[0]
3
       for goal in goals[1..]:
           if goal.value > topGoal.value:
               topGoal = goal
       # Find the best action to take.
       bestAction: Action = actions[0]
       bestUtility: float = -actions[0].getGoalChange(topGoal)
10
11
       for action in actions[1..]:
12
           # We invert the change because a low change value is good (we
13
           # want to reduce the value for the goal) but utilities are
14
           # typically scaled so high values are good.
15
           utility = -action.getGoalChange(topGoal)
16
17
           # We look for the lowest change (highest utility).
18
           if thisUtility > bestUtility:
19
               bestUtility = thisUtility
20
```

```
bestAction = action

# Return the best action, to be carried out.
return bestAction
```

which is simply two max()-style blocks of code, one for the goal and one for the action.

Data Structures and Interfaces

In the code above, I have assumed that goals have an interface of the form:

```
class Goal:
name: string
value: float
```

and actions have the form:

```
class Action:
function getGoalChange(goal: Goal) -> float
```

Given a goal, the getGoalChange function returns the change in insistence that carrying out the action would provide.

Performance

The algorithm is O(n+m) in time, where n is the number of goals, and m is the number of possible actions. It is O(1) in memory, requiring only temporary storage. If goals are identified by an associated zero-based integer (it is simple do, since the full range of goals is normally known before the game runs), then the getGoalChange method of the action structure can be simply implemented by looking up the change in an array, a constant time operation.

Weaknesses

This approach is simple, fast, and can give surprisingly sensible results, especially in games with a limited number of actions available (such as shooters, third-person action or adventure games, or RPGs).

It has two major weaknesses, however: it fails to take account of side effects that an action may have, and it doesn't incorporate any timing information. We'll resolve these issues in turn.

5.7.3 OVERALL UTILITY

The previous algorithm worked in two steps. It first considered which goal to reduce, and then it decided the best way to reduce it. Unfortunately, dealing with the most pressing goal might have side effects on others.

Here is another people simulation example, where insistence is measured on a five-point scale:

```
Goal: Eat = 4 Goal: Bathroom = 3
Action: Drink-Soda (Eat - 2; Bathroom + 3)
Action: Visit-Bathroom (Bathroom - 4)
```

A character that is hungry and in need of the bathroom, as shown in the example, probably doesn't want to drink a soda. The soda may stave off the snack craving, but it will lead to the situation where the need for the toilet is at the top of the five-point scale. Clearly, human beings know that snacking can wait a few minutes for a bathroom break.

This unintentional interaction might end up being embarrassing, but it could equally be fatal. A character in a shooter might have a pressing need for a health pack, but running right into an ambush to get it isn't a sensible strategy. Clearly, we often need to consider side effects of actions.

We can do this by introducing a new value: the discontentment of the character. It is calculated based on all the goal insistence values, where high insistence leaves the character more discontent. The aim of the character is to reduce its overall discontentment level. It isn't focusing on a single goal any more, but on the whole set.

We could simply add together all the insistence values to give the discontentment of the character. A better solution is to scale insistence so that higher values contribute disproportionately high discontentment values. This accentuates highly valued goals and avoids a bunch of medium values swamping one high goal. From my experimentation, squaring the goal value is sufficient.

For example,

```
Goal: Eat = 4 Goal: Bathroom = 3
Action: Drink-Soda (Eat - 2; Bathroom + 2)
    after: Eat = 2, Bathroom = 5: Discontentment = 29
Action: Visit-Bathroom (Bathroom - 4)
    after: Eat = 4, Bathroom = 0: Discontentment = 16
```

To make a decision, each possible action is considered in turn. A prediction is made of the total discontentment after the action is completed. The action that leads to the lowest discontentment is chosen. The list above shows this choice in the same example as we saw before. Now the "visit bathroom" action is correctly identified as the best one.

Discontentment is simply a score we are trying to minimize; we could call it anything. In search literature (where GOB and GOAP are found in academic AI), it is known as an energy metric. This is because search theory is related to the behavior of physical processes (particularly, the formation of crystals and the solidification of metals), and the score driving them is equivalent to the energy. We'll stick with discontentment in this section, and return to energy metrics in the context of learning algorithms in Chapter 7.

Pseudo-Code

The algorithm now looks like the following:

```
function chooseAction(actions: Action[], goals: Goal[]) -> Action:
       # Find the action leading to the lowest discontentment.
2
       bestAction: Action = null
3
       bestValue: float = infinity
5
       for action in actions:
6
           thisValue = discontentment(action, goals)
7
            if this Value < best Value:
8
                bestValue = thisValue
9
                bestAction = action
10
11
       return bestAction
12
13
   function discontentment(action: Action, goals: Goal[]) -> float:
14
       # Keep a running total.
15
       discontentment: float = 0
16
17
       # Loop through each goal.
18
       for goal in goals:
19
            # Calculate the new value after the action.
20
            newValue = goal.value + action.getGoalChange(goal)
21
22
            # Get the discontentment of this value.
23
            discontentment += goal.getDiscontentment(value)
24
25
       return discontentment
26
```

Here I've split the process into two functions. The second function calculates the total discontentment resulting from taking one particular action. It, in turn, calls the getDiscontentment method of the Goal structure.

Having the goal calculate its discontentment contribution gives us extra flexibility, rather than always using the square of its insistence. Some goals may be really important and have very high discontentment values for large values (such as the stay-alive goal, for example); they can return their insistence cubed, for example, or to a higher power. Others may be relatively unimportant and make a tiny contribution only. In practice, this will need some tweaking in your game to get it right.

Data Structures and Interfaces

The action structure stays the same as before, but the Goal structure adds its getDiscontentment method, implemented as the following:

```
class Goal:
      value: float
2
3
      function getDiscontentment(newValue: float) -> float:
4
           return newValue * newValue
```

Performance

This algorithm remains O(1) in memory, but is now O(nm) in time, where n is the number of goals, and m is the number of actions, as before. It has to consider the discontentment factor of each goal for each possible action. For large numbers of actions and goals, it can be significantly slower than the original version.

For small numbers of actions and goals, with the right optimizations, it can actually be much quicker. This optimization speed up is because the algorithm is suitable for SIMD optimizations, where the discontentment values for each goal are calculated in parallel. The original algorithm doesn't have the same potential.

5.7.4 TIMING

In order to make an informed decision as to which action to take, the character needs to know how long the action will take to carry out. It may be better for an energy-deficient character to get a smaller boost quickly (by eating a chocolate bar, for example), rather than spending eight hours sleeping. Actions expose the time they take to complete, enabling us to work that into the decision making.

Actions that are the first of several steps to a goal will estimate the total time to reach the goal. The "pick up raw food" action, for example, may report a 30-minute duration. The picking up action is almost instantaneous, but it will take several more steps (including the long cooking time) before the food is ready.

Timing is often split into two components. Actions typically take time to complete, but in some games it may also take significant time to get to the right location and start the action. Because game time is often extremely compressed in some games, the length of time it takes to begin an action becomes significant. It may take 20 minutes of game time to walk from one side of the level to the other. This is a long journey to make to carry out a 10-minute-long action.

If it is needed, the length of journey required to begin an action cannot be directly provided by the action itself. It must be either provided as a guess (a heuristic such as "the time is proportional to the straight-line distance from the character to the object") or calculated accurately (by pathfinding the shortest route; see Chapter 4 for how).

There is significant overhead for pathfinding on every possible action available. For a game level with hundreds of objects and many hundreds or thousands of possible actions, pathfinding to calculate the timing of each one is impractical. A heuristic must be used. An alternative approach to this problem is given by the "Smelly" GOB extension, described at the end of this section.

Utility Involving Time

To use time in our decision making we have two choices: we could incorporate the time into our discontentment or utility calculation, or we could prefer actions that are short over those that are long, with all other things being equal. This is relatively easy to add to the previous structure by modifying the discontentment function to return a lower value for shorter actions. I will not go into details here.

A more interesting approach is to take into account the consequences of the extra time. In some games, goal values change over time: a character might get increasingly hungry unless it gets food, a character might tend to run out of ammo unless it finds an ammo pack, or a character might gain more power for a combo attack the longer it holds its defensive position.

When goal insistences change on their own, not only does an action directly affect some goals, but also the time it takes to complete an action may cause others to change naturally. This can be factored into the discontentment calculation we looked at previously. If we know how goal values will change over time (and that is a big "if" that we'll need to come back to), then we can factor those changes into the discontentment calculation.

Returning to our bathroom example, here is a character who is in desperate need of food:

```
Goal: Eat = 4 changing at + 4 per hour
Goal: Bathroom = 3 changing at + 2 per hour
Action: Eat-Snack (Eat - 2) 15 minutes
    after: Eat = 2, Bathroom = 3.5: Discontentment = 16.25
Action: Eat-Main-Meal (Eat - 4) 1 hour
    after: Eat = 0, Bathroom = 5: Discontentment = 25
Action: Visit-Bathroom (Bathroom - 4) 15 minutes
    after: Eat = 5, Bathroom = 0: Discontentment = 25
```

The character will clearly be looking for some food before worrying about the bathroom. It can choose between cooking a long meal and taking a quick snack. The quick snack is now the action of choice. The long meal will take so long that by the time it is completed, the need to go to the bathroom will be extreme. The overall discontentment with this action is high. On the other hand, the snack action is over quickly and allows ample time. Going directly to the bathroom isn't the best option, because the hunger motive is so pressing.

In a game with many possible actions to consider, or where goals do not change over time

(i.e., any insistence values are only there to bias the selection; they don't represent a constantly changing internal state for the character), this approach will not work so well.

Pseudo-Code

Only the discontentment function needs to be changed from our previous version of the algorithm. It now looks like the following:

```
function discontentment(action: Action, goals: Goal[]) -> float:
       # Keep a running total.
2
       discontentment: float = 0
       # Loop through each goal.
       for goal in action:
           # Calculate the new value after the action.
           newValue = goal.value + action.getGoalChange(goal)
           # Calculate the change due to time alone.
10
           newValue += action.getDuration() * goal.getChange()
11
12
           # Get the discontentment of this value.
13
           discontentment += goal.getDiscontentment(newValue)
14
```

It works by modifying the expected new value of the goal by both the action (as before) and the normal rate of change of the goal, multiplied by the action's duration.

Data Structures and Interfaces

To support this I have added a method to both the Goal and the Action class. The goal class now has the following format:

```
class Goal:
      value: float
      function getDiscontentment(newValue: float) -> float
3
      function getChange() -> float
```

The getChange method returns the amount of change that the goal normally experiences, per unit of time. We'll come back to how this might be done below. The action has the following interface:

```
class Action:
      function getGoalChange(goal: float) -> float
2
      function getDuration() -> float
```

where the new getDuration method returns the time it will take to complete the action. This

may include follow-on actions, if the action is part of a sequence, and may include the time it would take to reach a suitable location to start the action.

Performance

This algorithm has exactly the same performance characteristics as before: O(1) in memory and O(nm) in time (with n being the number of goals and m the number of actions, as before). If the Goal.getChange and Action.getDuration methods simply return a stored value, then the algorithm only adds an extra couple of operations over the basic form. These methods can be much more complicated, however. Action.getDuration, in particular, may well have to call the pathfinder. The performance of that will dominate this algorithm.

Calculating the Goal Change over Time

In some games the change in goals over time is fixed and set by the designers. The Sims, for example, has a basic rate at which each motive changes. Even if the rate isn't constant, but varies with circumstance, the game still knows the rate, because it is constantly updating each motive based on it. In both situations we can simply use the correct value directly in the getChange method.

In some situations we may not have any access to the value, however. In a shooter, where the "hurt" motive is controlled by the number of hits being taken, we don't know in advance how the value will change (it depends on what happens in the game). In this case, we need to approximate the rate of change.

The simplest and most effective way to do this is to regularly take a record of the change in each goal. Each time the GOB routine is run, we can quickly check each goal and find out how much it has changed (this is an O(n) process, so it won't dramatically affect the execution time of the algorithm). The change can be stored in a recency-weighted average such as:

```
rateSinceLastTime = changeSinceLastTime / timeSinceLast
basicRate = 0.95 * basicRate + 0.05 * rateSinceLastTime
```

where the 0.95 and 0.05 can be any values that sum to 1. The timeSinceLast value is the number of units of time that has passed since the GOB routine was last run.

This gives a natural pattern to a character's behavior. It lends a feel of context-sensitive decision making for virtually no implementation effort, and the recency-weighted average provides a very simple degree of learning. If the character is taking a beating, it will automatically act more defensively (because it will be expecting any action to cost it more health), whereas if it is doing well it will start to get bolder.

The Need for Planning

No matter what selection mechanism we use (within reason, of course), we have assumed that actions are only available for selection when the character can execute them. We would therefore expect characters to behave fairly sensibly and not to select actions that are currently impossible. We have looked at a method that considers the effects that one action has on many goals and have chosen an action to give the best overall result. The final result is often suitable for use in a game without any more sophistication.

Unfortunately, there is another type of interaction that our approach so far doesn't solve. Because actions are situation dependent, it is normal for one action to enable or disable several others. Problems like this have been deliberately designed out of most games using GOB (including The Sims, a great example of the limitations of the AI technique guiding level design), but it is easy to think of a simple scenario where they are significant.

Let's imagine a fantasy role-playing game, where a magic-using character has five fresh energy crystals in their wand. Powerful spells take multiple crystals of energy. The character is in desperate need of healing and would also like to fend off the large ogre descending on her. The motives and possible actions are shown below.

```
Goal: Heal = 4
2 Goal: Kill-Ogre = 3
Action: Fireball (Kill-Ogre - 2) 3 energy-slots
  Action: Lesser-Healing (Heal - 2) 2 energy-slots
  Action: Greater-Healing (Heal - 4) 3 energy-slots
```

The best combination is to cast the "lesser healing" spell, followed by the "fireball" spell, using the five magic slots exactly. Following the algorithm so far, however, the mage will choose the spell that gives the best result. Clearly, casting "lesser healing" leaves her in a worse health position than "greater healing," so she chooses the latter. Now, unfortunately, she hasn't enough juice left in the wand and ends up as ogre fodder. In this example, we could include the magic in the wand as part of the motives (we are trying to minimize the number of slots used), but in a game where there may be many hundreds of permanent effects (doors opening, traps sprung, routes guarded, enemies alerted), we might need an inconvenient number of additional motives.

To allow the character to properly anticipate the effects and take advantage of sequences of actions, a level of planning must be introduced. Goal-oriented action planning extends the basic decision making process. It allows characters to plan detailed sequences of actions that provide the overall optimum fulfillment of their goals.

5.7.5 OVERALL UTILITY GOAP

The utility-based GOB scheme considers the effects of a single action. The action gives an indication of how it will change each of the goal values, and the decision maker uses that information to predict what the complete set of values, and therefore the total discontentment, will be afterward.

We can extend this to more than one action in a series. Suppose we want to determine the best sequence of four actions. We can consider all combinations of four actions and predict the discontentment value after all are completed. The lowest discontentment value indicates the sequence of actions that should be preferred, and we can immediately execute the first of them.

This is basically the structure for GOAP: we consider multiple actions in sequence and try to find the sequence that best meets the character's goals in the long term. In this case, we are using the discontentment value to indicate whether the goals are being met. This is a flexible approach and leads to a simple but fairly inefficient algorithm. In the next section I will also describe a GOAP algorithm that tries to plan actions to meet a single goal.

There are two complications that make GOAP difficult. First, there is the sheer number of available combinations of actions. The original GOB algorithm was O(nm) in time, but for k steps, a naive GOAP implementation would be $O(nm^k)$ in time. For reasonable numbers of actions (remember The Sims may have hundreds of possibilities), and a reasonable number of steps to look ahead, this will be unacceptably long. We need to use either small numbers of goals and actions or some method to cut down some of this complexity.

Second, by combining available actions into sequences, we have not solved the problem of actions being enabled or disabled. Not only do we need to know what the goals will be like after an action is complete, but we also need to know what actions will then be available. We can't look for a sequence of four actions from the current set, because by the time we come to carry out the fourth action it might not be available to us.

To support GOAP, we need to be able to work out the future state of the world and use that to generate the action possibilities that will be present. When we predict the outcome of an action, it needs to predict all the effects, not just the change in a character's goals.

To accomplish this, we use a model of the world: a representation of the state of the world that can be easily changed and manipulated without changing the actual game state. This can be an accurate model of the game world. It is also possible to model the beliefs and knowledge of a character by deliberately limiting what is allowed in its model. A character that doesn't know about a troll under the bridge shouldn't have it in its model. Without modeling the belief, the character's GOAP algorithm would find the existence of the troll and take account of it in its planning. That may look odd, but normally isn't noticeable.

To store a complete copy of the game state for each character is likely to be overkill. Unless your game state is very simple, there will typically be many hundreds to tens of thousands of items of data to keep track of. Instead, world models can be implemented as a list of differences: the model only stores information when it is different from the actual game data. This way if an algorithm needs to find out some piece of data in the model, it first looks in the difference list. If the data aren't contained there, then it knows that it is unchanged from the game state and retrieves it from there.

The Algorithm

I have so far described a relatively simple problem for GOAP. There are a number of different academic approaches to GOAP, and they allow much more complicated problem domains. Features such as constraints (things about the world that must not be changed during a sequence of actions), partial ordering (sequences of actions, or action groups, that can be performed in any order), and uncertainty (not knowing what the exact outcome of an action will be) all add complexity that we don't need in most games. The algorithm I am about to describe is about as simple as GOAP can be, but in my experience it is fine for most game applications.

We start with a world model (it can match the current state of the world or represent the character's beliefs). From this model we should be able to get a list of available actions for the character, and we should be able to simply take a copy of the model. The planning is controlled by a maximum depth parameter that indicates how many moves to lookahead.

The algorithm creates an array of world models, with one more element than the value of the depth parameter. These will be used to store the intermediate states of the world as the algorithm progresses. The first world model is set to the current world model. It keeps a record of the current depth of its planning, initially zero. It also keeps a track of the best sequence of actions so far and the discomfort value it leads to.

The algorithm works iteratively, processing a single world model in an iteration. If the current depth is equal to the maximum depth, the algorithm calculates the discomfort value and checks it against the best so far. If the new sequence is the best, it is stored.

If the current depth is less than the maximum depth, then the algorithm finds the next unconsidered action available on the current world model. It sets the next world model in the array to be the result of applying the action to the current world model and increases its current depth. If there are no more actions available, then the current world model has been completed, and the algorithm decreases the current depth by one. When the current depth eventually returns to zero, the search is over.

This is a typical depth-first search technique, implemented without recursion. The algorithm will examine all possible sequences of actions down to our greatest depth. As mentioned above, this is wasteful and may take too long to complete for even modest problems. Unfortunately, it is the only way to guarantee that we get the best of all possible action sequences. If we are prepared to sacrifice that guarantee for reasonably good results in most situations, we can reduce the execution time dramatically.

To speed up the algorithm we can use a heuristic: we demand that we never consider actions that lead to higher discomfort values. This is a reasonable assumption in most cases, although there are many cases where it breaks down. Human beings often settle for momentary discomfort because it will bring them greater happiness in the long run. Nobody enjoys job interviews, for example, but it is worth it for the job afterward (or so you'd hope).

On the other hand, this approach does help avoid some nasty situations occurring in the middle of the plan. Recall the bathroom-or-soda dilemma earlier. If we don't look at the intermediate discomfort values, we might have a plan that takes the soda, has an embarrassing moment, changes clothes, and ends up with a reasonable discomfort level. Human beings wouldn't do this; they'd go for a plan that avoided the accident.

To implement this heuristic we need to calculate the discomfort value at every iteration and store it. If the discomfort value is higher than that at the previous depth, then the current model can be ignored, and we can immediately decrease the current depth and try another action.

In the prototypes I built when writing this book, this leads to around a 100-fold increase in speed in a Sims-like environment with a maximum depth of 4 and a choice of around 50 actions per stage. Even a maximum depth of 2 makes a big difference in the way characters choose actions (and increasing depth brings decreasing returns in believability each time).

Pseudo-Code

We can implement depth-first GOAP in the following way:

```
function planAction(worldModel: WorldModel, maxDepth: int) -> Action:
       # Create storage for world models at each depth, and actions that
2
       # correspond to them.
3
       models = new WorldModel[maxDepth+1]
       actions = new Action[maxDepth]
5
6
       # Set up the initial data.
7
       models[0] = worldModel
8
       currentDepth = 0
10
       # Keep track of the best action.
11
       bestAction = null
12
       bestValue = infinity
13
14
       # Iterate all actions at depth zero.
15
       while currentDepth >= 0:
16
            # Check if we're at maximum depth.
17
            if currentDepth >= maxDepth:
                # Calculate discontentment at the deepest level.
                currentValue =
20
                    models[currentDepth].calculateDiscontentment()
21
22
23
                # If the current value is the best, store the first step
                # of how we got here.
24
                if currentValue < bestValue:
25
                    bestValue = currentValue
26
                    bestAction = actions[0]
27
28
                # We're done at this depth, so drop back.
29
                currentDepth -= 1
30
```

```
31
           # Otherwise, we need to try the next action.
32
33
                nextAction = models[currentDepth].nextAction()
34
35
                if nextAction:
36
                    # We have an action to apply, copy the current
37
38
                    models[currentDepth+1] = models[currentDepth]
39
                    # and apply the action to the copy.
                    actions[currentDepth] = nextAction
42
                    models[currentDepth+1].applyAction(nextAction)
43
44
                    # and process it on the next iteration.
45
                    currentDepth += 1
46
47
                # Otherwise we have no action to try, so we're done at
48
                # this level.
49
                else:
50
                    # Drop back to the next highest level.
51
                    currentDepth -= 1
52
53
       # We've finished iterating, so return the result.
54
       return bestAction
```

The assignment between WorldModel instances in the models array:

```
models[currentDepth + 1] = models[currentDepth]
```

assumes that this kind of assignment is performed by copy. If you are using references, then the models will point to the same data, the applyAction method will apply the action to both, and the algorithm will not work.

Data Structures and Interfaces

The algorithm uses two data structures: Action and WorldModel. Actions can be implemented as before. The WorldModel structure has the following format:

```
class WorldModel:
      function calculateDiscontentment() -> float
2
      function nextAction() -> Action
3
      function applyAction(action: Action)
```

The discontentment method should return the total discontentment associated with the state of the world, as given in the model. This can be implemented using the same goal value totaling method we used before.

The applyAction method takes an action and applies it to the world model. It predicts what effect the action would have on the world model and updates its contents appropriately.

The nextAction method iterates through each of the valid actions that can be applied, in turn. When an action is applied to the model (i.e., the model is changed), the iterator resets and begins to return the actions available from the new state of the world. If there are no more actions to return, it should return a null value.

Implementation Notes

This implementation can be converted into a class, and the algorithm can be split into a setup routine and a method to perform a single iteration. The contents of the while loop in the function can then be called any number of times by a scheduling system (see Chapter 10 on execution management for a suitable algorithm). Particularly for large problems, this is essential to allow decent planning without compromising frame rates.

Notice in the algorithm that we're only keeping track of and returning the next action to take. To return the whole plan, we need to expand bestAction to hold a whole sequence, then it can be assigned all the actions in the actions array, rather than just the first element.

Performance

Depth-first GOAP is O(k) in memory and $O(nm^k)$ in time, where k is the maximum depth, n is the number of goals (used to calculate the discontentment value), and m is the mean number of actions available.

The addition of the heuristic can dramatically reduce the actual execution time (it has no effect on the memory use), but the order of scaling is still the same.

If most actions do not change the value of most goals, we can get to O(nm) in time by only recalculating the discontentment contribution of goals that actually change. In practice this isn't a major improvement, since the additional code needed to check for changes will slow down the implementation anyway. In my experiments it provided a small speed up on some complex problems and worse performance on simple ones.

Weaknesses

Although the technique is simple to implement, algorithmically this still feels like approaching the problem with brute force. Throughout the book I have stressed that as game developers we're allowed to do what works. But, when I came to build a GOAP system myself, I felt that the depth-first search was a little naive (not to mention poor for my reputation as an AI specialist), so I succumbed to a more complicated approach. In hindsight, the algorithm was overkill for the application, and I should have stuck to a simple version similar to the one described above. In fact, for this form of GOAP, there is no better solution than the depth-first

search. Heuristics, as we've seen, can bring some speed ups by pruning unhelpful options, but overall there is no better approach.

All this presumes that we want to use the overall discontentment value to guide our planning. At the start of the section we looked at an algorithm that chose a single goal to fulfill (based on its insistence) and then chose appropriate actions to fulfill it. If we abandon discontentment and return to this problem, then the A* algorithm we met in Chapter 4 on pathfinding can be applied, and its efficiency becomes dominant.

5.7.6 GOAP WITH IDA*

Our problem domain consists of a set of goals and actions. Goals have varying insistence levels that allow us to select a single goal to pursue. Actions tell us which goals they fulfill.

In the previous section we did not have a single goal; we were trying to find the best of all possible action sequences. Now we have a single goal, and we are interested in the best action sequence that leads to our goal. We need to constrain our problem to look for actions that completely fulfill a goal. In contrast to previous approaches that try to reduce as much insistence as possible (with complete fulfillment being the special case of removing it all), we now need to have a single distinct goal to aim at, otherwise A* can't work its magic.

We also need to define "best" in this case. Ideally, we'd like a sequence that is as short as possible. This could be short in terms of the number of actions or in terms of the total duration of actions. If some resource other than time is used in each action (such as magic power, money, or ammo), then we could factor this in also. In the same way as for pathfinding, the length of a plan may be a combination of many factors, as long as it can be represented as a single value. We will call the final measure the cost of the plan. We would ideally like to find the plan with the lowest cost.

With a single goal to achieve and a cost measurement to try to minimize, we can use A^* to drive our planner. A^* is used in its basic form in many GOAP applications, and modifications of it are found in most of the rest. I have already covered A^* in minute detail in Chapter 4, so I'll avoid going into too much detail on how it works here. You can go to Chapter 4 for a more intricate, step-by-step analysis of why this algorithm works.

IDA*

If the number of possible actions is large, the number of possible sequences will be huge. Unlike pathfinding when there are relatively few neighboring points for any location, in some games there may be hundreds of possible actions to take at any state.

In addition there may be no limit to the number of actions we can take. Unless we know when to stop looking, we could continue acting for years or decades without reaching our goal. Because goals may often be unachievable, we need to add a limit to the number of actions allowed in a sequence. This is equivalent to the maximum depth in the depth-first search approach. When using A* for pathfinding, we assume that there will be at least one valid

route to the goal, so we allow A* to search as deeply as it likes to find a solution. Eventually, the pathfinder will run out of locations to consider and will terminate.

In GOAP the same thing probably won't happen. There are always actions to be taken, and the computer can't tell if a goal is unreachable other than by trying every possible combination of actions. If the goal is unreachable, the algorithm will never terminate but will happily use ever-increasing amounts of memory. We add a maximum depth to curb this. Adding this depth limit makes our algorithm an ideal candidate for using the iterative deepening version of A*.

Many of the A* variations we discussed in Chapter 4 work for GOAP. You can use the full A* implementation, node array A*, or even simplified memory-bounded A* (SMA*). In my experience, however, iterative deepening A* (IDA*) is an excellent choice. It handles huge numbers of actions without swamping memory and allows us to easily limit the depth of the search. In the context of this chapter, it also has the advantage of being similar to the previous depth-first algorithm.

The Heuristic

All A* algorithms require a heuristic function. The heuristic estimates how far away a goal is. It allows the algorithm to preferentially consider actions close to the goal.

We will need a heuristic function that estimates how far a given world model is from having the goal fulfilled. This can be a difficult thing to estimate, especially when long sequences of coordinated actions are required. It may appear that no progress is being made, even though it is. If a heuristic is completely impossible to create, then we can use a null heuristic (i.e., one that always returns an estimate of zero). As in pathfinding, this makes A* behave in the same way as Dijkstra's algorithm: checking all possible sequences.

The Algorithm

IDA* starts by calling the heuristic function on the starting world model. The value is stored as the current search cut-off.

IDA* then runs a series of depth-first searches. Each depth-first search continues until either it finds a sequence that fulfills its goal or it exhausts all possible sequences. The search is limited by both the maximum search depth and the cut-off value. If the total cost of a sequence of actions is greater than the cut-off value, then the action is ignored.

If a depth-first search reaches a goal, then the algorithm returns the resulting plan. If the search fails to get there, then the cut-off value is increased slightly and another depth-first search is begun.

The cut-off value is increased to be the smallest total plan cost greater than the cut-off that was found in the previous search.

With no OPEN and CLOSED lists in IDA*, we aren't keeping track of whether we find a duplicate world state at different points in the search. GOAP applications tend to have a huge

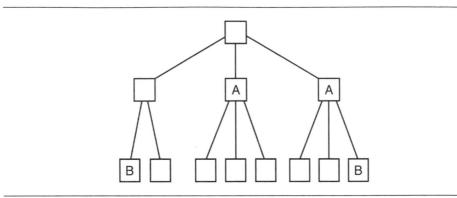

Figure 5.45: Why to replace transposition entries lower down

number of such duplications; sequences of actions in different orders, for example, often have the same result.

We want to avoid searching the same set of actions over and over in each depth-first search. We can use a transposition table to help do this. Transposition tables are commonly used in AI for board games, and we'll return to them in some length in Chapter 9 on board game AI.

For IDA*, the transposition table is a simple hash. Each world model must be capable of generating a good hash value for its contents. At each stage of the depth-first search, the algorithm hashes the world model and checks if it is already in the transposition table. If it is, then it is left there and the search doesn't process it. If not, then it is added, along with the number of actions in the sequence used to get there.

This is a little different from a normal hash table, with multiple entries per hash key. A regular hash table can take unlimited items of data, but gradually gets slower as you load it up. In our case, we can store just one item per hash key. If another world model comes along with the same hash key, then we can either process it fully without storing it or boot out the world model that's in its spot. This way we keep the speed of the algorithm high, without bloating the memory use. To decide whether to boot the existing entry, we use a simple rule of thumb: we replace an entry if the current entry has a smaller number of moves associated with it.

Figure 5.45 shows why this works. World models A and B are different, but both have exactly the same hash value. Unlabeled world models have their own unique hash values. The world model A appears twice. If we can avoid considering the second version, we can save a lot of duplication. The world model B is found first, however, and also appears twice. Its second appearance occurs later on, with fewer subsequent moves to process. If it was a choice between not processing the second A or the second B, we'd like to avoid processing A, because that would do more to reduce our overall effort.

By using this heuristic, where clashing hash values are resolved in favor of the higher level world state, we get exactly the right behavior in our example.

Pseudo-Code

The main algorithm for IDA* looks like the following:

```
function planAction(worldModel: WorldModel,
2
                        qoal: Goal,
                        heuristic: Heuristic,
3
                        maxDepth: int) -> Action:
       # Initial cutoff is the heuristic from the start model.
       cutoff: float = heuristic.estimate(worldModel)
       # Create a transposition table.
       transpositionTable = new TranspositionTable()
10
       # Iterate the depth first search until we have a valid plan, or
       # until we know there is none possible.
12
       while 0 < cutoff < infinity:
13
           # Get the new cutoff, or best action from the search.
14
           cutoff, action = doDepthFirst(
15
               worldModel, goal,
16
                transpositionTable, heuristic,
17
                maxDepth, cutoff)
18
19
       # If we have an action, return it.
20
       return action
21
```

Most of the work is done in the doDepthFirst function, which is very similar to the depthfirst GOAP algorithm we looked at previously:

```
function doDepthFirst(worldModel: WorldModel,
2
                          qoal: Goal,
                          heuristic: Heuristic,
3
                          transpositionTable: TranspositionTable,
                          maxDepth: int,
5
                          cutoff: float) -> (float, Action):
7
       # Create storage for world models at each depth, and
8
       # actions that correspond to them, with their cost.
9
       models = new WorldModel[maxDepth+1]
10
       actions = new Action[maxDepth]
11
       costs = new float[maxDepth]
12
13
       # Set up the initial data.
       models[0] = worldModel
15
       currentDepth: int = 0
16
17
       # Keep track of the smallest pruned cutoff.
18
       smallestCutoff: float = infinity
19
```

```
20
       # Iterate over all actions at depth zero.
21
       while currentDepth >= 0:
22
           # Check if we have a goal.
23
           if goal.isFulfilled(models[currentDepth]):
                # We can return from the depth first search
25
                # immediately with the result.
26
                return 0, actions[0]
27
28
           # Check if we're at maximum depth.
29
           if currentDepth >= maxDepth:
30
                # We're done at this depth, so drop back.
31
               currentDepth -= 1
32
33
                # Jump to the next iteration.
34
                continue
35
36
           # Calculate the total cost of the plan, we'll need it
37
           # in all other cases.
38
           cost = heuristic.estimate(models[currentDepth]) +
39
                   costs[currentDepth]
40
41
           # Check if we need to prune based on the cost.
42
           if cost > cutoff:
43
                # Check if this is the lowest prune.
                if cost < smallestCutoff:</pre>
45
                    smallestCutoff = cost
                # We're done at this depth, so drop back.
                currentDepth -= 1
49
50
                # Jump to the next iteration.
51
                continue
52
53
           # Otherwise, we need to try the next action.
54
           nextAction = models[currentDepth].nextAction()
55
           if nextAction:
                # We have an action to apply, copy the current model.
                models[currentDepth+1] = models[currentDepth]
                # and apply the action to the copy.
                actions[currentDepth] = nextAction
                models[currentDepth+1].applyAction(nextAction)
                costs[currentDepth+1] = costs[currentDepth] +
                                         nextAction.getCost()
66
```

```
# Check if we've already seen this state.
67
                if not transitionTable.has(models[currentDepth + 1]):
68
                    # Process the new state on the next iteration.
69
                    currentDepth += 1
70
71
                # Otherwise, we don't bother recursing, so on
72
                # the next iteration of the while loop, we'll
73
                # move on to the next action.
74
75
                # Set the model in the transition table every time
76
                # (in case the depth has changed).
77
                transitionTable.add(models[currentDepth + 1],
78
                                     currentDepth)
79
80
           # Otherwise we have no action to try.
81
           else:
82
                # Drop back to the next highest level.
83
                currentDepth -= 1
84
85
       # We've finished iterating, and didn't find an action.
86
        return smallestCutoff, null
```

Data Structures and Interfaces

The world model is exactly the same as before. The Action class now requires a getCost, which can be the same as the getDuration method used previously, if costs are controlled solely by time.

I have also added an isFulfilled method to the Goal class. When given a world model, it returns true if the goal is fulfilled in the world model.

The heuristic object has one method, estimate, which returns an estimate of the cost of reaching the goal from the given world model.

I have added a TranspositionTable data structure with the following interface:

```
class TranspositionTable:
2
      function has(worldModel: WorldModel) -> bool
      function add(worldModel: WorldModel, depth: int)
```

Assuming we have a hash function that can generate a hash integer from a world model, we can implement the transition table in the following way:

```
class TranspositionTable:
      # Holds a single table entry.
2
3
      class Entry:
           # The world model for the entry, all entries are initially
4
          # empty.
```

```
worldModel = null
6
7
           # The depth that the world model was found at. This is
8
           # initially infinity, because the replacement strategy we use
           # in the add method can then treat entries the same way
10
           # whether they are empty or not.
11
           depth = infinity
12
13
       # A fixed size array of entries.
14
       size: int
15
       entries: Entry[size]
16
       function has(worldModel: WorldModel) -> bool:
           # Get the hash value.
           hashValue: int = hash(worldModel)
20
21
           # Find the entry.
22
           entry: Entry = entries[hashValue % size]
23
24
           # Check if is the right one.
25
           return entry.worldModel == worldModel
26
27
       function add(worldModel: WorldModel, depth: int)
28
           # Get the hash value.
29
           hashValue: int = hash(worldModel)
30
           # Find the entry.
32
           entry: Entry = entries[hashValue % size]
33
34
           # Check if it is the right world model.
35
           if entry.worldModel == worldModel:
36
                # If we have a lower depth, use the new one.
37
                if depth < entry.depth:
38
                    entry.depth = depth
39
           # Otherwise we have a clash (or an empty slot).
           else:
                # Replace the slot if our new depth is lower.
43
                if depth < entry.depth:
44
45
                    entry.worldModel = worldModel
46
                    entry.depth = depth
```

The transition table typically doesn't need to be very large. In a problem with 10 actions at a time and a depth of 10, for example, we might only use a 1000-element transition table. As always, experimentation and profiling are the key to getting your perfect trade-off between speed and memory use.

Implementation Notes

The doDepthFirst function returns two items of data: the smallest cost that was cut off and the action to try. In a language such as C++, where multiple returns are inconvenient, the cut-off value is normally passed by reference, so it can be altered in place.

Performance

IDA* is O(t) in memory, where t is the number of entries in the transition table. It is $O(n^d)$ in time, where n is the number of possible actions at each world model and d is the maximum depth. This appears to have the same time as an exhaustive search of all possible alternatives. In fact, the extensive pruning of branches in the search means we will gain a great deal of speed from using IDA*. But, in the worst case (when there is no valid plan, for example, or when the only correct plan is the most expensive of all), we will need to do almost as much work as an exhaustive search.

5.7.7 SMELLY GOB

An alternative approach for making believable GOB is related to the sensory perception simulation discussed in Section 11.4.

In this model, each motive that a character can have (such as "eat" or "find information") is represented as a kind of smell; it gradually diffuses through the game level. Objects that have actions associated with them give out a cocktail of such "smells," one for each of the motives that its action affects. An oven, for example, may give out the "I can provide food" smell, while a bed might give out the "I can give you rest" smell.

Goal-oriented behavior can be implemented by having a character follow the smell for the motive it is most concerned with fulfilling. A character that is extremely hungry, for example, would follow the "I can provide food" smell and find its way to the cooker.

This approach reduces the need for complex pathfinding in the game. If the character has three possible sources of food, then conventional GOB would use a pathfinder to see how difficult each source of food was to get to. The character would then select the source that was the most convenient.

The smell approach diffuses out from the location of the food. It takes time to move around corners, it cannot move through walls, and it naturally finds a route through complicated levels. It may also include the intensity of the signal: the smell is greatest at the food source and gets fainter the farther away you get.

To avoid pathfinding, the character can move in the direction of the greatest concentration of smell at each frame. This will naturally be the opposite direction to the path the smell has taken to reach the character: it follows its nose right to its goal. Similarly, because the intensity of the smell dies out, the character will naturally move toward the source that is the easiest to get to.

This can be extended by allowing different sources to emit different intensities. Junk food, for example, can emit a small amount of signal, and a hearty meal can emit more. This way the character will favor less nutritious meals that are really convenient, while still making an effort to cook a balanced meal. Without this extension the character would always seek out junk food in the kitchen.

This "smell" approach was used in The Sims to guide characters to suitable actions. It is relatively simple to implement (you can use the sense management algorithms provided in Chapter 11, World Interfacing) and provides a good deal of realistic behavior. It has some limitations, however, and requires modification before it can be relied upon in a game.

Compound Actions

Many actions require multiple steps. Cooking a meal, for example, requires finding some raw food, cooking it, and then eating it. Food can also be found that does not require cooking. There is no point in having a cooker that emits the "I can provide food" signal if the character walks over to it and cannot cook anything because it isn't carrying any raw food.

Significant titles in this genre have typically combined elements of two different solutions to this problem: allowing a richer vocabulary of signals and making the emission of these signals depend on the state of characters in the game.

Action-Based Signals

The number of "smells" in the game can be increased to allow different action nuances to be captured. A different smell could be had for an object that provides raw food rather than cooked food. This reduces the elegance of the solution: characters can no longer easily follow the trail for the particular motive they are seeking. Instead of the diffusing signals representing motives, they are now, effectively, representing individual actions. There is an "I can cook raw food" signal, rather than an "I can feed you" signal.

This means that characters need to perform the normal GOB decision making step of working out which action to carry out in order to best fulfill their current goals. Their choice of action should depend not only on the actions they know are available but also on the pattern of action signals they can detect at their current location.

On the other hand, the technique supports a huge range of possible actions and can be easily extended as new sets of objects are created.

Character-Specific Signals

Another solution is to make sure that objects only emit signals if they are capable of being used by the character at that specific time. A character carrying a piece of raw food, for example, may be attracted by an oven (the oven is now giving out "I can give you food" signals). If the same character was not carrying any raw food, then it would be the fridge sending out "I can give you food" signals, and the oven would not emit anything.

This approach is very flexible and can dramatically reduce the amount of planning needed to achieve complex sequences of actions.

It has a significant drawback in that the signals diffusing around the game are now dependent on one particular character. Two characters are unlikely to be carrying exactly the same object or capable of exactly the same set of actions. This means that there needs to be a separate sensory simulation for each character. When a game has a handful of slow-moving characters, this is not a problem (characters make decisions only every few hundred frames, and sensory simulation can easily be split over many frames). For larger or faster simulations, this would not be practical.

5.8 RULE-BASED SYSTEMS

Rule-based systems were at the vanguard of AI research through the 1970s and early 1980s. Many of the most famous AI programs were built with them, and in their "expert system" incarnation, they were the best known AI technique before being supplanted by the recent media coverage of "deep learning." They have been used off and on in games for at least 20 years, despite having a reputation for being inefficient and difficult to implement. They remain a fairly uncommon approach, partly because similar behaviors can almost always be achieved in a simpler way using decision trees or state machines.

They do have their strengths, however, especially when characters need to reason about the world in ways that can't easily be anticipated by a designer and encoded into a decision tree. The biggest advantage of a rule-based system, however, is it its ability to justify its reasoning. This aids in content creation and debugging.

Rule-based systems have a common structure consisting of two parts: a database containing knowledge available to the AI and a set of if—then rules.

Rules can examine the database to determine if their "if" condition is met. Rules that have their conditions met are said to trigger. A triggered rule may be selected to fire, whereupon its "then" component is executed (Figure 5.46).

This is the same nomenclature I used in state machine transitions. In this case, however, the rules trigger based on the contents of the database, and their effects can be more general than causing a state transition.

Many rule-based systems also add a third component: an arbiter that gets to decide which triggered rule gets to fire. We'll look at a simple rule-based system first, along with a common optimization, and return to arbiters later in the section.

5.8.1 THE PROBLEM

In this section I will demonstrate a rule-based decision making system with many of the features typical of rule-based systems in traditional AI. The specification is quite complex and likely to be more flexible than is required for many games. Any simpler, however, and it is likely that state machines or decision trees would be a better way to achieve the same effect.

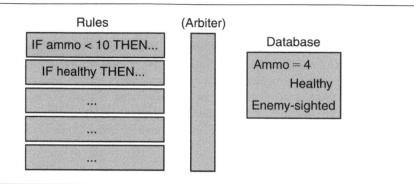

Figure 5.46: Schematic of a rule-based system

In this section I will survey some of the properties shared by many rule-based system implementations. Each property will be supported in the following algorithm. I shall introduce the contents of the database and rules using a very loose syntax. It is intended to illustrate the principles only. The following sections suggest a structure for each component that can be implemented.

Database Matching

The "if" condition of the rule is matched against the database; a successful match triggers the rule. The condition, normally called a pattern, typically consists of facts identical to those in the database, combined with Boolean operators such as AND, OR, and NOT.

Suppose we have a database containing information about the health of the soldiers in a fire team, for example. At one point in time the database contains the following information:

```
Captain: health = 51
Johnson: health = 38
Sale: health = 42
Whisker: health = 15
```

Whisker, the communications specialist, needs to be relieved of her radio when her health drops to zero. We might use a rule that triggers when it sees a pattern such as:

```
Whisker: health = 0
```

Of course, the rule should only trigger if Whisker still has the radio. So, first we need to add the appropriate information to the database. The database now contains the following information:

```
Captain: health = 51
Johnson: health = 38
```

```
Sale: health = 42
Whisker: health = 15
Whisker: has-radio
```

Now our rule can use a Boolean operator. The pattern becomes:

```
Whisker: health = 0 AND Whisker: has-radio
```

In practice we'd want more flexibility with the patterns that we can match. In our example, we want to relieve Whisker if she is very hurt, not just if she's dead. So the pattern should match a range:

```
Whisker: health < 0 AND Whisker: has-radio
```

So far we're on familiar ground. It is similar to the kind of tests we made for triggering a state transition or for making a decision in a decision tree.

To improve the flexibility of the system, it would be useful to add wild cards to the matching. We would like to be able to say, for example,

```
Anyone: health < 15
```

and have this match if there was anyone in the database with health less than 15. Similarly, we could say,

```
Anyone-1: health < 15 AND Anyone-2: health > 45
```

to make sure there was also someone who is healthy (maybe we want the healthy person to carry the weak one, for example).

Many rule-based systems use a more advanced type of wild-card pattern matching, called unification, which can include wild cards. We'll return to unification later in this section, after introducing the main algorithm.

Condition-Action Rules

A condition-action rule causes a character to carry out some action as a result of finding a match in the database. The action will normally be run outside of the rule-based system, although rules can be written that directly modify the state of the game.

Continuing our fire team example, we could have a rule that states:

```
IF Whisker: health = 0 AND Whisker: has-radio
THEN Sale: pick up the radio
```

If the pattern matches, and the rule fires, then the rule-based system tells the game that Sale should pick up the radio.

This doesn't directly change the information in the database. We can't assume that Sale can actually pick up the radio. Whisker may have fallen from a cliff with no safe way to get down. Sale's action can fail in many different ways, and the database should only contain knowledge about the state of the game. (In practice, it is sometimes beneficial to let the database contain the beliefs of the AI, in which case resulting actions are more likely to fail.)

Picking up the radio is a game action: the rule-based system acting as a decision maker chooses to carry out the action. The game gets to decide whether the action succeeds, and updates the database if it does.

Database Rewriting Rules

There are other situations in which the results of a rule can be incorporated directly into the database.

In the AI for a fighter pilot, we might have a database with the following contents:

```
Fuel: 1500 kg
Distance-from-base: 100 km
Enemies-sighted: Enemy-42, Enemy-21
Currently: patrolling
```

The first three elements, fuel, distance to base, and sighted enemies, are all controlled by the game code. They refer to properties of the state of the game and can only be changed by the AI scheduling actions. The last two items, however, are specific to the AI and don't have any meaning to the rest of the game.

Suppose we want a rule that changes the goal of the pilot from "patrol zone" to "attack" if an enemy is sighted. In this case we don't need to ask the game code to schedule a "change goal" action; we could use a rule that says something like:

```
IF number of sighted enemies > 0 and currently patrolling THEN
   remove(currently patrolling)
   add(attack first sighted enemy)
```

The remove function removes a piece of data from the database, and the add function adds a new one. If we didn't remove the first piece of data, we would be left with a database containing both patrol zone and attack goals. In some cases this might be the right thing to do (so the pilot can go back to patrolling when the intruder is destroyed, for example).

We would like to be able to combine both kinds of effects: those that request actions to be carried out by the game and those that manipulate the database. We would also like to execute arbitrary code as the result of a rule firing, for extra flexibility.

Forward and Backward Chaining

The rule-based system I've described so far is representative of the kind I've seen in games. It is known as "forward chaining." It starts with a known database of information and repeatedly applies rules that change the database contents (either directly or by changing the state of the game through character action).

Discussions of rule-based systems in other areas of AI will mention backward chaining. Backward chaining starts with a given piece of knowledge, the kind that might be found in the database. This piece of data is the goal. The system then tries to work out a series of rule firings that would lead from the current database contents to the goal. It typically does this by working backward, looking at the THEN components of rules to see if any could generate the goal. If it finds rules that can generate the goal, it then tries to work out how the conditions of those rules might be met, which might involve looking at the THEN component of other rules, and so on, until all the conditions are found in the database.

While backward chaining is a very important technique in many areas (such as theorem proving and planning), I have not come across any production AI code using it for games. I could visualize some contrived situations where it might be useful in a game, but for the purpose of this book, I will ignore it from here on.

Format of Data in the Database

The database contains the knowledge of a character. It must be able to contain any kind of game-relevant data, and each item of data should be identified. If we want to store the character's health in the database, we need both the health value and some identifier that indicates what the value means. The value on its own is not sufficient.

If we are interested in storing a Boolean value, then the identifier on its own is enough. If the Boolean value is true, then the identifier is placed in the database; if it is false, then the identifier is not included:

```
Fuel = 1500 \text{ kg}
patrol zone
```

In this example, the patrol-zone goal is such an identifier. It is an identifier with no value, and we can assume it is a Boolean with a value of true. The other example database entry had both an identifier (e.g., "fuel") and a value (1500). Let's define a Datum as a single item in the database. It consists of an identifier and a value. The value might not be needed (if it is a Boolean with the value of true), but I'll assume it is explicit, for convenience's sake.

A database containing only this kind of Datum object is inconvenient. In a game where a character's knowledge encompasses an entire fire team, we could have:

```
Captain: weapon = rifle
Johnson: weapon = machine-gun
Captain: rifle-ammo = 36
Johnson: machine-gun-ammo = 229
```

This nesting could go very deep. If we are trying to find the Captain's ammo, we might have to check several possible identifiers to see if any are present: Captain's-rifle-ammo, Captain's-RPG-ammo, Captain's-machine-gun-ammo, and so on.

Instead, we would like to use a hierarchical format for our data. We expand our Datum

so that it either holds a value or holds a set of Datum objects. Each of these Datum objects can likewise contain either a value or further lists. The data are nested to any depth.

Note that a Datum object can contain multiple Datum objects, but only one value. The value may be any type that the game understands, however, including structures containing many different variables or even function pointers, if required. The database treats all values as opaque types it doesn't understand, including built-in types.

Symbolically, we will represent one Datum in the database as:

```
(identifier content)
```

where content is either a value or a list of Datum objects. We can represent the previous database as:

```
(Captain's-weapon (Rifle (Ammo 36)))
(Johnson's-weapon (Machine-Gun (Ammo 229)))
```

This database has two Datum objects. Both contain one Datum object (the weapon type). Each weapon, in turn, contains one more Datum (ammo); in this case, the nesting stops, and the ammo has a value only.

We could expand this hierarchy to hold all the data for one person in one identifier:

```
Captain (Weapon (Rifle (Ammo 36) (Clips 2)))
(Health 65)
(Position [21, 46, 92])
```

Having this database structure will give us flexibility to implement more sophisticated rule matching algorithms, which in turn will allow us to implement more powerful AI.

Notation of Wild Cards

The notation I have used is reminiscent of the Lisp programming language. Because Lisp was overwhelmingly the language of choice for AI up until the 1990s, it will be familiar if you read any papers or books on rule-based systems. It is a simplified version for our needs. In this syntax wild cards are normally written as:

```
(?anyone (Health 0-15))
```

and are often called variables.

5.8.2 THE ALGORITHM

We start with a database containing data. Some external set of functions needs to transfer data from the current state of the game into the database. Additional data may be kept in the database (such as the current internal state of the character using the rule-based system). These functions are not part of this algorithm.

A set of rules is also provided. The IF-clause of the rule contains items of data to match in the database joined by any Boolean operator (AND, OR, NOT, XOR, etc.). We will assume matching is by absolute value for any value or by less-than, greater-than, or within-range operators for numeric types.

I will assume that rules are condition-action rules: they always call some function. It is easy to implement database rewriting rules in this framework by changing the values in the database within the action. This reflects the bias that rule-based systems used in games tend to contain more condition-action rules than database rewrites, unlike many industrial AI systems.

The rule-based system applies rules in iterations, and any number of iterations can be run consecutively. The database can be changed between each iteration, either by the fired rule or because other code updates its contents.

The rule-based system simply checks each of its rules to see if they trigger on the current database. The first rule that triggers is fired, and the action associated with the rule is run.

This is the naive algorithm for matching: it simply tries every possibility to see if any works. For all but the simplest systems, it is probably better to use a more efficient matching algorithm. The naive algorithm is one of the stepping stones I mentioned in the introduction to the book, probably not useful on its own but essential for understanding how the basics work before going on to a more complete system. Later in the section I will introduce Rete, an industry standard for faster matching.

5.8.3 PSEUDO-CODE

The rule-based system has an extremely simple algorithm of the following form:

```
function ruleBasedIteration(database: DataNode, rules: Rule[]):
       # Check each rule in turn.
2
       for rule in rules:
3
           # Create the empty set of bindings.
           bindings = []
           # Check for triggering.
           if rule.ifClause.matches(database, bindings):
8
               # Fire the rule.
                rule.getActions(bindings)
10
11
                # And exit: we're done for this iteration.
12
                break
13
14
       # If we get here, we've had no match, we could use a fallback
15
       # action, or simply do nothing.
```

The matches function of the rule's IF-clause checks through the database to make sure the clause matches.

DATA STRUCTURES AND INTERFACES

With an algorithm so simple, it is hardly surprising that most of the work is being done in the data structures. In particular, the matches function is taking the main burden. Before giving the pseudo-code for rule matching, we need to look at how the database is implemented and how IF-clauses of rules can operate on it.

The Database

The database can simply be a list or array of data items, represented by the DataNode class. DataGroups in the database hold additional data nodes, so overall the database becomes a tree of information.

Each node in the tree has the following base structure:

```
class DataNode:
    identifier: string
```

Non-leaf nodes correspond to data groups in the data and have the following form:

```
class DataGroup extends DataNode:
    children: DataNode[]
```

Leaves in the tree contain actual values and have the following form:

```
class Datum extends DataNode:
    value: any
```

The children of a data group can be any data node: either another data group or a Datum. I will assume some form of polymorphism for clarity, although in reality it is often better to implement this as a single structure combining the data members of all three structures.

Rules

Rules have the following structure:

```
class Rule:
       ifClause: Match
2
       function getActions(bindings: Bindings)
```

The ifClause is used to match against the database and is described below. The action function can perform any action required, including changing the database contents. It takes a list of bindings which is filled with the items in the database that match any wild cards in the IF-clause.

IF-Clauses

IF-clauses consist of a set of data items, in a format similar to those in the database, joined by Boolean operators. They need to be able to match the database, so we use a general data structure as the base class of elements in an IF-clause:

```
class Match:
       function matches(database: DataNode,
2
                        bindings: out Bindings) -> bool
3
```

The bindings parameter is both input and output, so it can be passed by reference in languages that support it. It initially should be an empty list (this is initialized in the rule-BasedIteration driver function above). When part of the IF-clause matches a "don't care" value (a wild card), it is added to the bindings.

The data items in the IF-clause are similar to those in the database. We need two additional refinements, however. First, we need to be able to specify a "don't care" value for an identifier to implement wild cards. This can simply be a pre-arranged identifier reserved for this purpose.

Second, we need to be able to specify a match of a range of values. Matching a single value, using a less-than operator or using a greater-than operator, can be performed by matching a range; for a single value, the range is zero width, and for less-than or greater-than it has one of its bounds at infinity. We can use a range as the most general match.

The Datum structure at the leaf of the tree is therefore replaced by a DatumMatch structure with the following form:

```
class DatumMatch extends Match:
       identifier: string
2
      minValue: float
3
      maxValue: float
```

Boolean operators are represented in the same way as with state machines; we use a polymorphic set of classes:

```
class And extends Match:
       match1: Match
       match2: Match
3
4
       function matches(database: DataNode,
5
                         bindings: out Bindings) -> bool:
6
           # True if we match both sub-matches.
           return match1.matches(database, bindings) and
8
                   match2.matches(database, bindings)
9
10
   class Not extends Match:
11
       match: Match
12
13
       function matches(database: DataNode,
14
                         bindings: out Bindings) -> bool:
15
```

```
# True if we don't match our submatch. Note we pass in
16
17
           # new bindings list, because we're not interested in
           # anything found: we're making sure there are no
18
           # matches.
19
           return not match.matches(database, [])
20
```

and so on for other operators. Note that the same implementation caveats apply as for the polymorphic Boolean operators covered in Section 5.3 on state machines. The same solutions can also be applied to optimizing the code.

Finally, we need to be able to match a data group. We need to support "don't care" values for the identifier, but we don't need any additional data in the basic data group structure. We have a data group match that looks like the following:

```
class DataGroupMatch extends Match:
      identifier: string
2
      children: Match[]
3
```

Item Matching

This structure allows us to easily combine matches on data items together. We are now ready to look at how matching is performed on the data items themselves.

The basic technique is to match the data item from the rule (called the *test item*) with any item in the database (called the database item). Because data items are nested, we will use a recursive procedure that acts differently for a data group and a Datum.

In either case, if the test data group or test Datum is the root of the data item (i.e., it isn't contained in another data group), then it can match any item in the database; we will check through each database item in turn. If it is not the root, then it will be limited to matching only a specific database item.

The matches function can be implemented in the base class, Match, only. It simply tries to match each individual item in the database one at a time. It has the following algorithm:

```
class Match:
       # ... Member data as before.
2
       function matches(database: DataNode,
3
                         bindings: out Bindings) -> bool:
4
           # Go through each item in the database.
5
           for item in database:
7
               # We've matched if we match any item.
               if matchesItem(item, bindings):
8
9
                    return true
10
           # We've failed to match all of them.
11
           return false
12
```

This simply tries each individual item in the database against a matchesItem method. The matchesItem method should check a specific data node for matching. The whole match succeeds if any item in the database matches.

Datum Matching

A test Datum will match if the database item has the same identifier and has a value within its bounds. It has the simple form:

```
class DatumMatch extends DataNodeMatch:
       # ... Member data as before.
2
       function matches(database: DataNode,
                         bindings: out Bindings) -> bool:
            # Is the item of the same type?
            if not item isinstance Datum:
                return false
            # Does the identifier match?
            if identifier.isWildcard() and identifier != item.identifier:
10
                return false
11
12
            # Does the value fit?
13
            if minValue <= item.value <= maxValue:
14
                # Do we need to add to the bindings list?
15
                if identifier.isWildcard():
16
                    # Add the binding.
17
                    bindings.appendBinding(identifier, item)
18
                # Return true, since we matched.
19
                return true
20
21
            else:
22
                return false
23
```

The isWildcard method should return true if the identifier is a wild card. If you used strings as identifiers and wanted to use Lisp-style wild-card names, you could check that the first character is a question mark, for example.

The bindings list has been given an appendBinding method that adds an identifier (which is always a wild card) and the database item it was matched to. If we are using an STL list in C++, for example, we could have it be a list of pair templates and append a new identifier, item pair. Alternatively, we could use a hash table indexed by identifier.

Data Group Matching

A test data group will match a database data group if its identifier matches and if all its children match at least one child of the database data group. Not all the children of the database data group need to be matched to something.

For example, if we are searching for a match to:

```
(?anyone (Health 0-54))
```

we would like it to match:

```
(Captain (Health 43) (Ammo 140))
```

even though ammo isn't mentioned in the test data group.

The matchesItem function for data groups has the following form:

```
class DataGroupMatch extends DataNodeMatch:
       # ... Member data as before.
2
       function matches(database: DataNode,
3
                         bindings: out Bindings) -> bool:
           # Is the item of the same type?
5
           if not item isinstance DataGroup:
6
                return false
8
           # Does the identifier match?
9
           if identifier != WILDCARD and identifier != item.identifier:
10
                return false
11
12
           # Is every child present.
13
           for child in this.children:
                # Use the children of the item as if it were a
15
                # database and call matches recursively.
17
                if not child.matches(item.children):
                    return false
18
19
           # We must have matched all children.
20
21
           # Do we need to add to the bindings list?
22
           if identifier.isWildcard():
23
24
               # Add the binding.
25
               bindings.appendBinding(identifier, item)
26
           return true
```

Summary

Figure 5.47 shows all our classes and interfaces in one diagram.

The figure is in standard UML class diagram form. I hope it is relatively obvious even if you're not a UML expert. Refer to an online UML tutorial or Pilone and Pitman's book [48] for more information on UML.

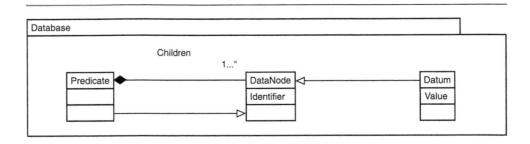

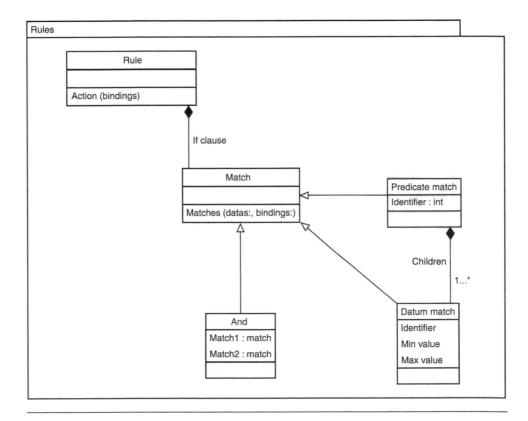

Figure 5.47: UML of the matching system

5.8.5 RULE ARBITRATION

Several rules may trigger on the database at the same time. Each rule is applicable, but only one can fire. In the algorithm described above I assumed that the first triggered rule is allowed to fire and no other rules are considered. This is a simple rule arbitration algorithm: "first applicable." It works fine as long as our rules are arranged in order of priority.

In general, an arbiter in a rule-based system is a chunk of code that decides which rules fire when more than one rule triggers. There are a number of common approaches to arbitration, each with its own characteristics.

First Applicable

This is the algorithm used so far. The rules are provided in a fixed order, and the first rule in the list that triggers gets to fire. The ordering enforces strict priority: rules earlier in the list have priority over later rules.

A serious problem often occurs with this arbitration strategy, however. If the rule does not change the content of the database, and if no external changes are imposed, then the same rule will continue to fire every time the system is run. This might be what is required (if the rule indicates what action to take based on the content of the database, for example), but it can often cause problems with endless repetition.

There is a simple extension used to reduce the severity of this issue. Rules that shouldn't endlessly repeat are suspended as soon as they fire. Their suspension is only lifted when the contents of the database change. This involves keeping track of the suspended state of each rule and clearing it when the database is modified.

Unfortunately, clearing the suspension whenever the database is modified can still allow the same situation to occur. If some content in the database is constantly changing (and it usually will, if information from the game world is being written into it each frame), but the items of data causing the problem rule to trigger are stable, then the rule will continue to fire. Some implementations keep track of the individual items of data that the rule is triggering on and suspend a fired rule until those particular items change.

Least Recently Used

A linked list holds all the rules in the system. The list is considered in order, just as before, and the first triggered rule in the list gets to fire. When a rule fires, it is removed from its position in the list and added to the end. After a while, the list contains rules in reverse order of use, and so picking the first triggered rule is akin to picking the least recently used rule.

This approach specifically combats the looping issue. It makes sure that opportunities for firing are distributed as much as possible over all rules.

Random Rule

If multiple rules trigger, then one rule is selected at random and allowed to fire.

Unlike the previous algorithms, this kind of arbiter needs to check every rule and get a list of all triggered rules. With such a list it can pick one member and fire it. Previous algorithms have only worked through the list until they found the first triggered rule. This arbitration scheme is correspondingly less efficient.

Most Specific Conditions

If the conditions for a rule are very easy to meet, and the database regularly triggers it, then it is likely to be a general rule useful in lots of situations, but not specialized. On the other hand, if a rule has difficult conditions to fulfill, and the system finds that it triggers, then it is likely to be very specific to the current situation. More specific rules should therefore be preferred over more general rules.

In a rule-based system where conditions are expressed as Boolean combined clauses, the number of clauses is a good indicator of the specificity of the rule.

Specificity can be judged based on the structure of the rules only. The priority order can be calculated before the system is used, and the rules can be arranged in order. The arbiter implementation is exactly the same, therefore, as the first applicable method. We only need to add an offline step to automatically adjust the rule order based on the number of clauses in the condition.

Dynamic Priority Arbitration

Any system of numerical priorities is identical to the first applicable method, if those priorities do not change when the system is running. We can simply arrange the rules in order of decreasing priority and run the first one that triggers. You will find some articles and books that present priority-based arbitration for static priorities, when a simple first-applicable approach would be identical in practice. Priorities can be useful, however, if they are dynamic.

Dynamic priorities can be returned by each rule based on how important its action might be in the current situation. Suppose we have a rule that matches "no more health packs" and schedules an action to find health packs, for example. When the character's health is high, the rule may return a very low priority. If there are any other rules that trigger, the health pack rule will be ignored, so the character will get on with what it is doing and only go hunting for health packs if it cannot think of an alternative. When the character is close to death, however, the rule returns a very high priority: the character will stop what it is doing and go to find health packs in order to stay alive.

We could implement dynamic priorities using several rules (one for "no more health packs AND low health" and one for "no more health packs AND high health," for example). Using dynamic priorities, however, allows the rule to gradually get more important, rather than suddenly becoming the top priority.

The arbiter checks all the rules and compiles a list of those that trigger. It requests the priority from each rule in the list and selects the highest value to fire.

Just as for random rule selection, this approach involves searching all possible rules before deciding which to trigger. It also adds a method call, which may involve the rule searching the database for information to guide its priority calculating. This is the most flexible, but by far the most time-consuming, arbitration algorithm of the five described here.

5.8.6 UNIFICATION

Suppose in our earlier example Whisker, the communications specialist, ended up dying. Her colleague Sale takes over carrying the radio. Now suppose that Sale is severely hurt; somebody else needs to take the radio. We could simply have a rule for each person that matches when they are hurt and carrying the radio.

We could instead introduce a rule whose pattern contains wild cards:

```
(?person (health 0-15))
AND
(Radio (held-by ?person))
```

The ?person name matches any person. These wild cards act slightly differently than conventional wild cards (the kind introduced in the section on matching above). If they were normal wild cards, then the rule would match the database:

```
(Johnson (health 38))
(Sale (health 15))
(Whisker (health 25))
(Radio (held-by Whisker))
```

The first ?person would match Sale, while the second would match Whisker. This is not what we want; we want the same person for both.

In unification, a set of wild cards are matched so that they all refer to the same thing. In our case, the rule would not match the above database, but it would match the following:

```
(Johnson (health 38))
(Sale (health 42))
(Whisker (health 15))
(Radio (held-by Whisker))
```

where both wild cards match the same thing: Whisker.

If we wanted to match different people with each wild card, we could request that by giving different names to each wild card. For example, we could use a pattern of the following form:

```
(?person-1 (health 0-15))
AND
(Radio (held-by ?person-2))
```

Unification is significant because it makes rule matching a great deal more powerful. To get the same effect without unification would require four rules in our example. There are other situations, such as the following pattern:

```
(Johnson (health ?value-1))
AND
(Sale (health ?value-2))
AND
?value-1 < ?value-2
```

where an almost infinite number of regular rules would be required if unification wasn't available (assuming that the health values are floating point numbers, it would require a little less than 232 rules, certainly too many to be practical).

To take advantage of this extra power, we'd like our rule-based system to support pattern matching with unification.

Performance

Unfortunately, unification has a downside: the most obvious implementation is computationally complex to process. To match a pattern such as:

```
(Whisker (health 0))
AND
(Radio (held-by Whisker))
```

we can split the pattern into two parts, known as clauses. Each clause can individually be checked against the database. If both clauses find a match, then the whole pattern matches.

Each part of the expression requires at most an O(n) search, where n is the number of items in the database. So, a pattern with m clauses is, at worst, an O(nm) process. We say at worst because, as we saw with decision trees, we might be able to avoid having to test the same thing multiple times and arrive at an $O(m \log_2 n)$ process.

In a pattern with connected wild cards, such as:

```
(?person (health < 15))
AND
(Radio (held-by ?person))
```

we can't split the two clauses up. The results from the first clause directly affect the pattern in the second clause. So, if matching the first clause comes back:

```
?person = Whisker
```

then the second clause is a search for:

```
(Radio (held-by Whisker))
```

The first clause might potentially match several items in the database, each of which needs to be tried with the second clause.

Using this approach, a two-clause search could take $O(n^2)$ time, and a pattern with mclauses could take $O(n^m)$ time. This is a dramatic increase from O(nm) for the original pattern. Although there are O(nm) linear algorithms for unification (at least the kind of unification we are doing here), they are considerably more complex than the simple divideand-conquer approach used in patterns without wild cards.

I will not take the time to go through a stand-alone unification algorithm here. They are not often used for this kind of rule-based system. Instead, we can take advantage of a different approach to matching altogether, which allows us to perform unification at the same time as speeding up the firing of all rules. This method is Rete.

5.8.7 **RETE**

The Rete algorithm is an AI industry standard for matching rules against a database. It is not the fastest algorithm around; there are several papers detailing faster approaches. But, because expert systems are commercially valuable, they don't tend to give full implementation details.6

Most commercial expert systems are based on Rete, and some of the more complex rulebased systems I've seen in games use approaches based on the Rete matching algorithm. It is a relatively simple algorithm that provides the basic starting point for more complex optimizations.

The Algorithm

The algorithm works by representing the patterns for all rules in a single data structure: the Rete. The Rete is a directed acyclic graph⁷ (see Chapter 4, Section 4.1 on the pathfinding graph for a complete description of this structure). Each node in the graph represents a single pattern in one or more rules. Each path through the graph represents the complete set of patterns for one rule. At each node we also store a complete list of all the facts in the database that match that pattern.

Figure 5.48 shows a simple example of a Rete for the following rules:

- 6. You should also be careful of proprietary algorithms because many are patented. Just because an algorithm is published doesn't mean it isn't patented. You could end up having to pay a license fee for your implementation, even if you wrote the source code from scratch. I am not a lawyer, so I would advise you to see an intellectual property attorney if you have any doubts.
- 7. Rete is simply a fancy anatomical name for a network.

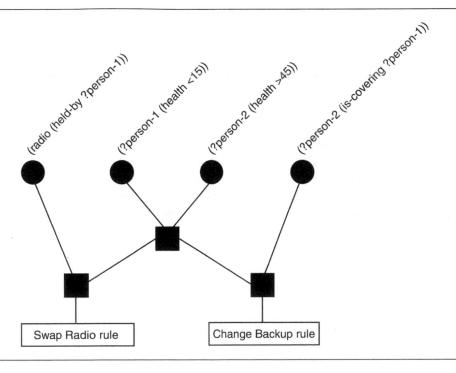

Figure 5.48: A Rete

```
Swap Radio Rule:
       IF
2
           (?person-1 (health < 15))
3
4
           (radio (held-by ?person-1))
           (?person-2 (health > 45))
       THEN
8
           remove(radio (held-by ?person-1))
           add(radio (held-by ?person-2))
10
11
   Change Backup Rule:
12
       IF
13
           (?person-1 (health < 15))
14
           AND
15
           (?person-2 (health > 45))
16
17
           (?person-2 (is-covering ?person-1))
18
       THEN
```

```
remove(?person-2 (is-covering ?person-1))
20
21
           add(?person-1 (is-covering ?person-2))
```

The first rule is as before: if someone carrying the radio is close to death, then give the radio to someone who is relatively healthy. The second rule is similar: if a soldier leading a buddy pair is close to death, then swap them around and make the soldier's buddy take the lead (if you're feeling callous you could argue the opposite, we suppose: the weak guy should be sent out in front).

There are three kinds of nodes in our Rete diagram. At the top of the network are nodes that represent individual clauses in a rule (known as pattern nodes). These are combined nodes representing the AND operation (called *join nodes*). Finally, the bottom nodes represent rules that can be fired: many texts on Rete do not include these rule nodes in the network, although they must exist in your implementation. Notice that the clauses:

```
(?person-1 (health < 15))
```

and

```
(?person-2 (health > 45))
```

are shared between both rules. This is one of the key speed features of the Rete algorithm; it doesn't duplicate matching effort.

Matching the Database

Conceptually, the database is fed into the top of the network. The pattern nodes try to find a match in the database. They find all the facts that match and pass them down to the join nodes. If the facts contain wild cards, the node will also pass down the variable bindings. So, if:

```
(?person (health < 15))
```

matches:

```
(Whisker (health 12))
```

then the pattern node will pass on the variable binding:

```
?person = Whisker
```

The pattern nodes also keep a record of the matching facts they are given to allow incremental updating, discussed later in the section.

Notice that rather than finding any match, we now find all matches. If there are wild cards in the pattern, we don't just pass down one binding, but all sets of bindings.

For example, if we have a fact:

```
(?person (health < 15))
```

and a database containing the facts:

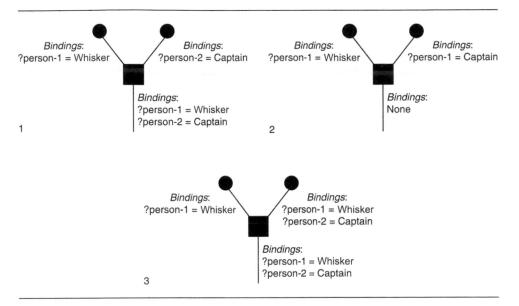

Figure 5.49: A join node with variable clash and two others without

```
(Whisker (health 12))
(Captain (health 9))
```

then there are two possible sets of bindings:

```
?person = Whisker
```

and

```
?person = Captain
```

Both can't be true at the same time, of course, but we don't yet know which will be useful, so we pass down both. If the pattern contains no wild cards, then we are only interested in whether or not it matches anything. In this case we can move on as soon as we find the first match because we won't be passing on a list of bindings.

The join node makes sure that both of its inputs have matched and any variables agree.

Figure 5.49 shows three situations. In the first situation, there are different variables in each input pattern node. Both pattern nodes match and pass in their matches. The join node passes out its output.

In the second situation, the join node receives matches from both its inputs, as before, but the variable bindings clash, so it does not generate an output. In the third situation, the same variable is found in both patterns, but there is one set of matches that doesn't clash, and the join node can output this.

The join node generates its own match list that contains the matching input facts it receives and a list of variable bindings. It passes this down the Rete to other join nodes or to a rule node.

If the join node receives multiple possible bindings from its input, then it needs to work out all possible combinations of bindings that may be correct. Take the previous example, and let's imagine we are processing the AND join in:

```
(?person (health < 15))
AND
(?radio (held-by ?person))
```

against the database:

```
(Whisker (health 12))
(Captain (health 9))
(radio-1 (held-by Whisker))
(radio-2 (held-by Sale))
```

The

```
(?person (health < 15))
```

pattern has two possible matches:

```
?person = Whisker
```

and

```
?person = Captain
```

The

```
(radio (held-by ?person-1))
```

pattern also has two possible matches:

```
?person = Whisker, ?radio = radio-1
```

and

```
?person = Sale, ?radio = radio-2
```

The join node therefore has two sets of two possible bindings, and there are four possible combinations, but only one is valid:

```
?person = Whisker, ?radio = radio-1
```

So this is the only one it passes down. If multiple combinations were valid, then it would pass down multiple bindings.

If your system doesn't need to support unification, then the join node can be much simpler: variable bindings never need to be passed in, and an AND join node will always output if it receives two inputs.

We don't have to limit ourselves to AND join nodes. We can use additional types of join nodes for different Boolean operators. Some of them (such as AND and XOR) require additional matching to support unification, but others (such as OR) do not and have a simple implementation whether unification is used or not. Alternatively, these operators can be implemented in the structure of the Rete, and AND join nodes are sufficient to represent them. This is exactly the same as we saw for decision trees.

Eventually, the descending data will stop (when no more join nodes or pattern nodes have output to send), or they will reach one or more rules. All the rules that receive input are triggered. We keep a list of rules that are currently triggered, along with the variable bindings and facts that triggered it. We call this a trigger record. A rule may have multiple trigger records, with different variable bindings, if it received multiple valid variable bindings from a join node or pattern.

Some kind of rule arbitration system needs to determine which triggered rule will go on to fire. (This isn't part of the Rete algorithm; it can be handled as before.)

An Example

Let's apply our initial Rete example to the following database:

```
(Captain (health 57) (is-covering Johnson))
(Johnson (health 38))
(Sale (health 42))
(Whisker (health 15) (is-covering Sale))
(Radio (held-by Whisker))
```

Figure 5.50 shows the network with the data stored at each node.

Notice that each pattern node is passing down all of the data that it matches. Each join node is acting as a filter. With this database, only the Swap Radio rule is active; the Change Backup rule doesn't get triggered because the join node immediately above it doesn't have a clash-free set of inputs. The Swap Radio rule gets a complete set of variable bindings and is told to fire.

We can use Rete by plugging in the complete database each time and seeing which rules fire. This is a simple approach, but in many applications data don't change much from iteration to iteration.

Rete is designed to keep hold of data and only update those nodes that need it. Each node keeps a list of the database facts that it matches or that it can join successfully. At successive iterations, only the data that have changed are processed, and knock-on effects are handled by walking down the Rete.

The update process consists of an algorithm to remove a database fact and another algorithm to add one (if a value has changed, then the database fact will be removed and then added back with the correct value).

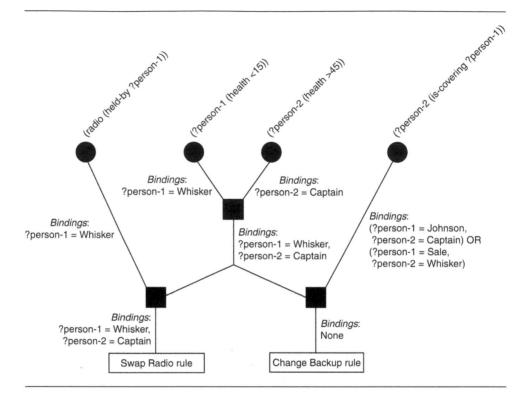

Figure 5.50: The Rete with data

Removing a Fact

To remove a fact, a removal request is sent to each pattern node. The request identifies the fact that has been removed. If the pattern node has a stored match on the fact, then the match is removed, and the removal request is sent down its outputs to any join nodes.

When a join node receives a removal request, it looks at its list of matches. If there are any entries that use the removed fact, it deletes them from its list and passes the removal request on down.

If a rule node receives a removal request, it removes any of its trigger records from the triggered list that contains the removed fact.

If any node doesn't have the given fact in its storage, then it needs to do nothing; it doesn't pass the request on down.

Adding a Fact

Adding a fact is very similar to removing one. Each pattern node is sent an addition request containing the new fact. Patterns that match the fact add it to their list and pass a notification of the new match down the Rete.

When a join node receives a new match, it checks if there are any new sets of non-clashing inputs that it can make, using the new fact. If there are, it adds them to its match list and sends the notification of the new match down. Notice that, unlike removal requests, the notification it sends down is different from the one it received. It is sending down notification of one or more whole new matches: a full set of inputs and variable bindings involving the new fact.

If a rule node receives a notification, it adds one or more trigger records to the trigger list containing the new input it received.

Once again, if the fact doesn't update the node, then there is no need to pass the addition request on.

Managing the Update

Each iteration, the update routine sends the appropriate series of add and remove requests to the pattern nodes. It doesn't check if rules are triggered during this process but allows them all to process. In general, it is more efficient to perform all the removals first and then all the new additions.

After all the updates have been performed, the triggered list contains all the rules that could be fired (along with the variable bindings that cause them to trigger). The rule arbiter can decide which rule should fire.

An Update Example

I will use the previous example to illustrate the update procedure. Let's say that, since the last update, Whisker has used a med-pack and Sale has been hit by enemy fire. We have four changes to make: two additions and two removals:

```
remove (Whisker (health 12))
add (Whisker (health 62))
remove (Sale (health 42))
add (Sale (health 5))
```

First, the removal requests are given to all the patterns. The check for low health used to have only Whisker in its match list. This is deleted, and the removal request is passed on. Join node A receives the request, removes the match involving Whisker from its match list, and passes on the request. Join node B does the same. The rule node now receives the removal request and removes the corresponding entry from the triggered list. The same process occurs for removing Sale's health, leaving the Rete as shown in Figure 5.51.

Now we can add the new data. First, Whisker's new health is added. This matches the

```
(?person (health > 45))
```

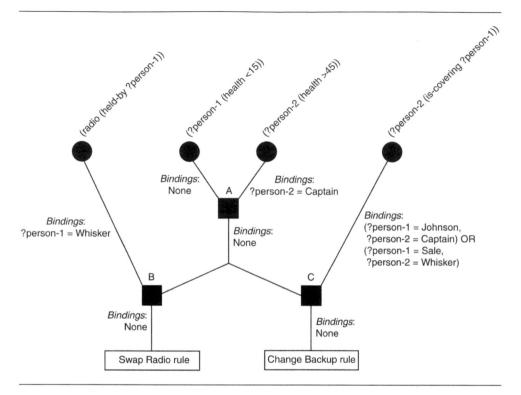

Figure 5.51: Rete in mid-update

pattern, which duly outputs notification of its new match. Join node A receives the notification, but can find no new matches, so the update stops there. Second, we add Sale's new health. The

```
(?person (health < 15))
```

pattern matches and sends notification down to join node A. Now join node A does have a valid match, and it sends notification on down the Rete. Join node B can't make a match, but join node C, previously inactive, now can make a match. It sends notification on to the Change Backup rule, which adds its newly triggered state to the triggered list. The final situation is shown in Figure 5.52.

The update management algorithm can now select one triggered rule from the list to fire. In our case, there is only one to choose, so it is fired.

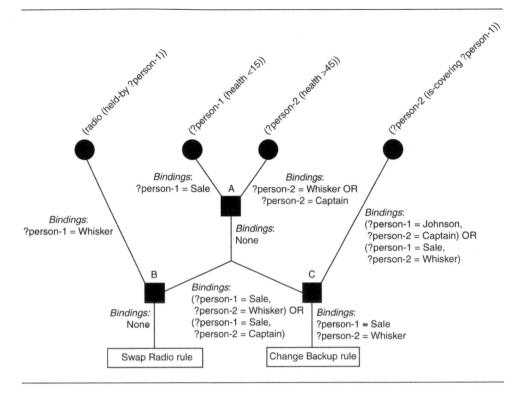

Figure 5.52: Rete after-update

Performance

Rete approaches O(nmp) in time, where n is the number of rules, m is the number of clauses per rule, and p is the number of facts in the database. If a large number of wild card matches is possible, then the process of unifying the bindings in the join node can take over the performance. In most practical systems, however, this isn't a major issue.

Rete is O(nmq) in memory, where q is the number of different wild-card matches per pattern. This is significantly higher than the basic rule matching system we developed first. In addition, in order to take advantage of the fast update, we need to keep the data between iterations. It is this high memory usage that gives the speed advantage.

5.8.8 EXTENSIONS

The ubiquity of rule-based systems in early AI research led to a whole host of different extensions, modifications, and optimizations. Each area in which a rule-based system was applied (such as language understanding, controlling industrial processes, diagnosing faults in machinery, and many others) has its own set of common tricks.

Very few of these are directly usable in games development. Given that rule-based systems are only needed in a minority of AI scenarios, we can safely ignore most of them here. I'd recommend Expert Systems: Principles and Programming [15], for more background on industrial uses. It comes with a copy of CLIPS, a reasonably general expert system shell.

There are two extensions that are widespread enough to be worth mentioning. The first manages huge rule-based systems and is of direct use to games developers. The second is justification, widely used in expert systems and useful to game developers when debugging their AI code.

An entire book on algorithms could be written covering different rule-based systems and their variants. Given their niche status in game development, I will limit this section to a brief overview of each extension.

Managing Large Rule Sets

One developer I consulted for used a simple rule-based system to control the team AI in a series of two-dimensional turn-based war games. Their rule set was huge, and as each game in the series was released they added a large number of new rules. Some new rules allowed the AI to cope with new weapons and power-ups, and other new rules were created as a result of player feedback from previous releases. Over the course of developing each title, bug reports from the QA department would lead to even more rules being added. After several iterations of the product, the set of rules was huge and difficult to manage. It also had serious implications for performance: with such a large rule set, even the Rete matching algorithm is too slow.

The solution was to group rules together. Each rule set could be switched on and off as it was needed. Only rules in active sets would be considered for triggering. Rules in disabled sets were never given the chance to trigger. This took the system down from several thousand rules to no more than a hundred active rules at any time.

This is a technique used in many large rule-based systems.

The rule-based system contains a single rule set which is always switched on. Inside this rule set are any number of rules and any number of other rule sets. Rule sets at this level or below can be switched on or off. This switching can be performed directly by the game code or in the THEN action of another rule.

Typically, each high-level rule set contains several rules and a few rule sets. The rules are only used to switch on and off the contained sets. This is arranged in a hierarchy, with the sets at the lowest level containing the useful rules that do the work.

At each iteration of the rule-based system, the top-level set is asked to provide one triggered rule that should be fired. This set looks through all its constituent rules, searching for triggers in the normal way. It also delegates the same query to any sets it contains: provide one

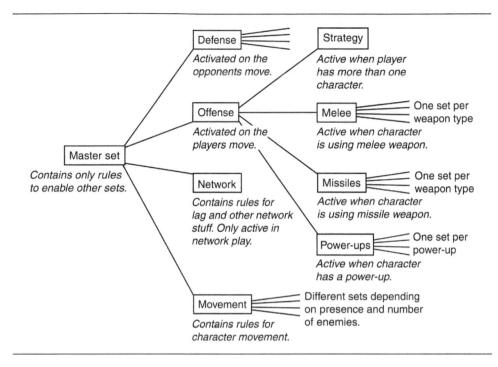

Figure 5.53: Schematic of the rule sets in the game

triggered rule that should be fired. Each set uses one of the arbitration algorithms to decide which rule to return for firing.

In the implementation of this process, shown in Figure 5.53, a different arbitration routine could be set for each set in the hierarchy. In the strategy game described above, this flexibility wasn't used, and all sets ran on a most specific strategy.

The hierarchy of sets allows a great deal of flexibility. At one point in the hierarchy, there was a rule set for all the rules corresponding to the peculiarities of each weapon in the game. Only one of these sets was enabled at any time: the set corresponding to the weapon held by the character. The enabling of the appropriate set was handled by the game code.

At another point in the hierarchy, there were sets containing rules for moving in the presence of enemies or moving freely. Because information about nearby enemies was being added to the database anyway, the AI switched between these two sets using five rules placed in the set that contained them.

An overview schematic of the rule sets is shown in Figure 5.53.

Justification in Expert Systems

Most generally, an expert system is any AI that encodes the knowledge from a human expert and performs that expert's job. Most expert systems are implemented using rule-based systems. Strictly, the expert system is the end product: the combination of the algorithm and rules that encodes the expert's knowledge. The algorithm itself is the rule-based system, also known as an expert system shell or sometimes a production system (the term production refers to the forward-chaining nature of the algorithm: it produces new knowledge from existing data).

A common extension to the basic rule-based system has been incorporated in many expert system shells: an audit trail of how knowledge came to be added.

When the rule-based system fires a database rewrite rule, any data added have additional information stored with them. The rule that created the data, the items of data in the database that the rule matched, the current values of these items, and a time stamp are all commonly retained. Let's call this the firing information. Similarly, when an item of data is removed, it is retained in a "deleted" list, accompanied by the same firing information. Finally, if an item of data is modified, its old value is retained along with the firing information.

In a game context, the data in the database can also be added or modified directly by the game. Similar auditing information is also retained, with an indication that the data were altered by an external process, rather than by the firing of a rule. Obviously, if a piece of data is changing every frame, it may not be sensible to keep a complete record of every value it has ever taken.

Any piece of data in the database can then be queried, and the expert system shell will return the audit trail of how the data got there and how the current value came to be set. This information can be recursive. If the data we are interested in came from a rule, we can ask where the matches came from that triggered that rule. This process can continue until we are left with just the items of data that were added by the game (or were there from the start).

In an expert system this is used to justify the decisions that the system makes. If the expert system is controlling a factory and chooses to shut down a production line, then the justification system can give the reasons for its decision.

In a game context, we don't need to justify decisions to the player, but during testing, it is often very useful to have a mechanism for justifying the behavior of a character. Rule-based systems can be so much more complicated than the previous decision making techniques in this chapter. Finding out the detailed and long-term causes of a strange-looking behavior can save days of debugging.

Some time ago I built an expert system shell specifically for inclusion in a game. I added a justification system late in the development cycle after a bout of hair-pulling problems. The difference in debugging power was dramatic. A sample portion of the output is shown below (the full output was around 200 lines long).

```
Carnage XS. V104 2002-9-12.
2 JUSTIFICATION FOR <Action: Grenade(2.2,0.5,2.1)>
  <Action: grenade ?target>
```

```
FROM RULE: flush-nest
4
     BINDINGS: target = (2.2, 0.5, 2.1)
5
     CONDITIONS:
6
      <Visible: heavy-weapon <ptr008F8850> at (2.2,0.5,2.1)>
7
       FROM RULE: covered-by-heavy-weapon
8
       BINDINGS: ?weapon = <ptr008F8850>
9
       CONDITIONS:
10
11
        <Ontology: machine-gun <ptr008F8850>>
12
         FROM FACT: <Ontology: machine-gun <ptr008F8850>>
        <Location: <ptr008F8850> at (2.2,0.5,2.1)>
13
         FROM FACT: <Location: <ptr008F8850> at (2.2,0.5,2.1)>
14
      <Visible: enemy-units in group>
15
16
```

To make sure the final game wasn't using lots of memory to store the firing data, the justification code was conditionally compiled so it didn't end up in the final product.

5.8.9 WHERE NEXT

The rule-based systems in this section represent the most complex non-learning decision makers I will cover in this book. A full Rete implementation with justification and rule set support is a formidable programming task that can support incredible sophistication of behavior. It can support more advanced AI than any seen in current-generation games. Its major weakness is the difficulty of writing good rule sets, known as "knowledge acquisition." When techniques such as state machines and behavior trees are easy to expose in a graphical editor, rule-based systems tend to be less frequently used, despite their power.

The remainder of this chapter looks at the problem of making decisions from some different angles, examining ways to combine different decision makers together, to script behaviors directly from code, and to execute actions that are requested from any decision making algorithm.

5.9 BLACKBOARD ARCHITECTURES

A blackboard system isn't a decision making tool in its own right. It is a mechanism for coordinating the actions of several decision makers.

The individual decision making systems can be implemented in any way: from a decision tree to an expert system or even to learning tools such as the neural networks we'll meet in Chapter 7. It is this flexibility that makes blackboard architectures appealing.

In the AI literature, blackboard systems are often large and unwieldy, requiring lots of management code and complicated data structures. For this reason they have something of a bad reputation among game AI programmers. At the same time, many developers implement

AI systems that use the same techniques without associating them with the term "blackboard architecture"

5.9.1 THE PROBLEM

We would like to be able to coordinate the decision making of several different techniques. Each technique may be able to make suggestions as to what to do next, but the final decision can only be made if they cooperate.

We may have a decision making technique specializing in targeting enemy tanks, for example. It can't do its stuff until a tank has been selected to fire at. A different kind of AI is used to select a firing target, but that bit of AI can't do the firing itself. Similarly, even when the target tank is selected, we may not be in a position where firing is possible. The targeting AI needs to wait until a route-planning AI can move to a suitable firing point.

We could simply put each bit of AI in a chain. The target selector AI chooses a target, the movement AI moves into a firing position, and the ballistics AI calculates the firing solution. This approach is very common but doesn't allow for information to pass in the opposite direction. If the ballistics AI calculates that it cannot make an accurate shot, then the targeting AI may need to calculate a new solution. On the other hand, if the ballistics AI can work out a shot, then there is no need to even consider the movement AI. Obviously, whatever objects are in the way do not affect the shell's trajectory.

We would like a mechanism whereby each AI can communicate freely without requiring all the communication channels to be set up explicitly.

5.9.2 THE ALGORITHM

The basic structure of a blackboard system has three parts: a set of different decision making tools (called experts in blackboard-speak), a blackboard, and an arbiter. This is illustrated in Figure 5.54.

The blackboard is an area of memory that any expert may use to read from and write to. Each expert needs to read and write in roughly the same language, although there will usually be messages on the blackboard that not everyone can understand.

Each expert looks at the blackboard and decides if there's anything on it that they can use. If there is, they ask to be allowed to have the chalk and board eraser for a while. When they get control they can do some thinking, remove information from the blackboard, and write new information, as they see fit. After a short time, the expert will relinquish control and allow other experts to have a go.

The arbiter picks which expert gets control at each go. Experts need to have some mechanism of indicating that they have something interesting to say. The arbiter chooses one at a time and gives it control. Often, none or only one expert wants to take control, and the arbiter is not required.

The algorithm works in iterations:

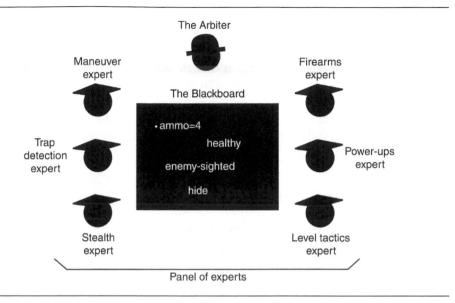

Figure 5.54: Blackboard architecture

- 1. Experts look at the board and indicate their interest.
- 2. The arbiter selects an expert to have control.
- 3. The expert does some work, possibly modifying the blackboard.
- 4. The expert voluntarily relinquishes control.

The algorithm used by the arbiter can vary from implementation to implementation. The simple and common approach I will describe here asks the experts to indicate how useful they think they can be in the form of a numeric insistence value. The arbiter can then simply pick the expert with the highest insistence value. In the case of a tie, a random expert is selected.

Extracting an Action

Suggested actions can be written to the blackboard by experts in the same way that they write any other information. At the end of an iteration (or multiple iterations if the system is running for longer), actions placed on the blackboard can be removed and carried out using the action execution techniques at the end of this chapter.

Often, an action can be suggested on the blackboard before it has been properly thought through. In our tank example, the targeting expert may post a "fire at tank 15" action on the board. If the algorithm stopped at that point, the action would be carried out without the ballistic and movement experts having had a chance to agree.

A simple solution is to store the potential action along with a set of agreement flags. An

action on the blackboard is only carried out if all relevant experts have agreed to it. This does not have to be every expert in the system, just those who would be capable of finding a reason not to carry the action out.

In our example the "fire at tank 15" action would have one agreement slot: that of the ballistics expert. Only if the ballistics expert has given the go ahead would the action be carried out. The ballistics expert may refuse to give the go ahead and instead either delete the action or add a new action "move into firing position for tank 15." With the "fire at tank 15" action still on the blackboard, the ballistics expert can wait to agree to it until the firing position is reached.

5.9.3 PSEUDO-CODE

The blackboardIteration function below takes as input a blackboard and a set of experts. It returns a list of actions on the blackboard that have been passed for execution. The function acts as the arbiter, following the highest insistence algorithm given above.

```
function blackboardIteration(blackboard: Blackboard.
                                 experts: Expert[]) -> Action[]:
2
       # Go through each expert for their insistence.
3
       bestExpert: Expert = null
       highestInsistence: float = 0
       for expert in experts:
           # Ask for the expert's insistence.
           insistence: float = expert.getInsistence(blackboard)
10
           # Check against the highest value so far.
11
           if insistence > highestInsistence:
12
               highestInsistence = insistence
13
               bestExpert = expert
15
       # Make sure somebody insisted.
16
17
       if bestExpert:
           # Give control to the most insistent expert.
18
           bestExpert.run(blackboard)
19
20
       # Return all passed actions from the blackboard.
21
       return blackboard.passedActions
22
```

5.9.4 DATA STRUCTURES AND INTERFACES

The blackboardIteration function relies on three data structures: a blackboard consisting of entries and a list of experts.

The Blackboard has the following structure:

```
class Blackboard:
       entries: BlackboardDatum[]
2
       passedActions: Action[]
```

It has two components: a list of blackboard entries and a list of ready-to-execute actions. The list of blackboard entries isn't used in the arbitration code above and is discussed in more detail later in the section on blackboard language. The actions list contains actions that are ready to execute (i.e., they have been agreed upon by every expert whose permission is required). It can be seen as a special section of the blackboard: a to-do list where only agreedupon actions are placed.

More complex blackboard systems also add meta-data to the blackboard that controls its execution, keeps track of performance, or provides debugging information. Just as for rule based systems, we can also add data to hold an audit trail for entries: which expert added them and when.

Other blackboard systems hold actions as just another entry on the blackboard itself, without a special section. For simplicity, I have elected to use a separate list; it is the responsibility of each expert to write to the "actions" section when an action is ready to be executed and to keep unconfirmed actions off the list. This makes it much faster to execute actions. We can simply work through this list rather than searching the main blackboard for items that represent confirmed actions.

Experts can be implemented in any way required. For the purpose of being managed by the arbiter in our code, they need to conform to the following interface:

```
class Expert:
    function getInsistence(blackboard: Blackboard) -> float
    function run(blackboard: Blackboard)
```

The qetInsistence function returns an insistence value (greater than zero) if the expert thinks it can do something with the blackboard. In order to decide on this, it will usually need to have a look at the contents of the blackboard. Because this function is called for each expert, the blackboard should not be changed at all from this function. It would be possible, for example, for an expert to return some insistence, only to have the interesting stuff removed from the blackboard by another expert. When the original expert is given control, it has nothing to do.

The getInsistence function should also run as quickly as possible. If the expert takes a long time to decide if it can be useful, then it should always claim to be useful. It can spend the time working out the details when it gets control. In our tanks example, the firing solution expert may take a while to decide if there is a way to fire. In this case, the expert simply looks on the blackboard for a target, and if it sees one, it claims to be useful. It may turn out later that there is no way to actually hit this target, but that processing is best done in the run function when the expert has control.

The run function is called when the arbiter gives the expert control. It should carry out

the processing it needs, read and write to the blackboard as it sees fit, and return. In general, it is better for an expert to take as little time as possible to run. If an expert requires lots of time, then it can benefit from stopping in the middle of its calculations and returning a very high insistence on the next iteration. This way the expert gets its time split into slices, allowing the rest of the game to be processed. Chapter 10 has more details on this kind of scheduling and time slicing.

The Blackboard Language

So far we haven't paid any attention to the structure of data on the blackboard. More so than any of the other techniques in this chapter, the format of the blackboard will depend on the application. Blackboard architectures can be used for steering characters, for example, in which case the blackboard will contain three-dimensional (3D) locations, combinations of maneuvers, or animations. Used as a decision making architecture, it might contain information about the game state, the position of enemies or resources, and the internal state of a character.

There are general features to bear in mind, however, that go some way toward a generic blackboard language. Because the aim is to allow different bits of code to talk to each other seamlessly, information on the blackboard needs at least three components: value, type identification, and semantic identification.

The value of a piece of data is self-explanatory. The blackboard will typically have to cope with a wide range of different data types, however, including structures. It might contain health values expressed as an integer and positions expressed as a 3D vector, for example.

Because the data can be in a range of types, its content needs to be identified. This can be a simple type code. It is designed to allow an expert to use the appropriate type for the data (in typed languages, such as C++ or C#, this is normally done by typecasting the value to the appropriate type). Blackboard entries could achieve this by being polymorphic: using a generic Datum base class with sub-classes for FloatDatum, Vector3Datum, and so on, or with runtime-type information (RTTI) in a language such as C++, or the sub-classes containing a type identifier. It is more common, however, to explicitly create a set of type codes to identify the data, whether or not RTTI is used.

The type identifier tells an expert what format the data are in, but it doesn't help the expert understand what to do with it. Some kind of semantic identification is also needed. The semantic identifier tells each expert what the value means. In production blackboard systems this is commonly implemented as a string (representing the name of the data). In a game, using lots of string comparisons can slow down execution, so some kind of magic number is often used.

A blackboard item may therefore look like the following:

```
class BlackboardDatum:
    id: string
    type: type
    value: any
```

The whole blackboard consists of a list of such instances.

In this approach complex data structures are represented in the same way as built-in types. All the data for a character (its health, ammo, weapon, equipment, and so on) could be represented in one entry on the blackboard or as a whole set of independent values.

We could make the system more general by adopting an approach similar to the one used in the rule-based system. Adopting a hierarchical data representation allows us to effectively expand complex data types and allows experts to understand parts of them without having to be hard-coded to manipulate the type. In languages such as Java, where code can examine the structure of a type (known as "reflection"), this would be less important. In C++, it can provide a lot of flexibility. An expert could look for just the information on a weapon, for example, without caring if the weapon is on the ground, in a character's hand, or currently being constructed.

While many blackboard architectures in non-game AI follow this approach, using nested data to represent their content, I have not seen it used in games. Hierarchical data tend to be associated with rule-based systems and flat lists of labeled data with blackboard systems (although the two approaches overlap, as we'll see below).

5.9.5 PERFORMANCE

The blackboard arbiter uses no memory and runs in O(n) time, where n is the number of experts. Often, each expert needs to scan through the blackboard to find an entry that it might be interested in. If the list of entries is stored as a simple list, this takes O(m) time for each expert, where m is the number of entries in the blackboard. This can be reduced to almost O(1) time if the blackboard entries are stored in some kind of hash. The hash must support lookup based on the semantics of the data, so an expert can quickly tell if something interesting is present.

The majority of the time spent in the blackboardIteration function should be spent in the run function of the expert who gains control. Unless a huge number of experts is used (or they are searching through a large linear blackboard), the performance of each run function is the most important factor in the overall efficiency of the algorithm.

5.9.6 OTHER THINGS ARE BLACKBOARD SYSTEMS

When I first described the blackboard system, I said it had three parts: a blackboard containing data, a set of experts (implemented in any way) that read and write to the blackboard, and an arbiter to control which expert gets control. It is not alone in having these components, however.

Rule-Based Systems

Rule-based systems have each of these three elements: their database contains data, each rule is like an expert—it can read from and write to the database, and there is an arbiter that controls which rule gets to fire. The triggering of rules is akin to experts registering their interest, and the arbiter will then work in the same way in both cases.

This similarity is no coincidence. Blackboard architectures were first put forward as a kind of generalization of rule-based systems: a generalization in which the rules could have any kind of trigger and any kind of rule.

A side effect of this is that if you intend to use both a blackboard system and a rule-based system in your game, you may need to implement only the blackboard system. You can then create "experts" that are simply rules: the blackboard system will be able to manage them.

The blackboard language will have to be able to support the kind of rule-based matching you intend to perform, of course. But, if you are planning to implement the data format needed in the rule-based system we discussed earlier, then it will be available for use in more flexible blackboard applications.

If your rule-based system is likely to be fairly stable, and you are using the Rete matching algorithm, then the correspondence will break down. Because the blackboard architecture is a super-set of the rule-based system, it cannot benefit from optimizations specific to rule handling.

Finite State Machines

Less obviously, finite state machines are also a subset of the blackboard architecture (actually they are a subset of a rule-based system and, therefore, of a blackboard architecture). The blackboard is replaced by the single state. Experts are replaced by transitions, determining whether to act based on external factors, and rewriting the sole item on the blackboard when they do. In the state machines in this chapter I have not mentioned an arbiter. I assumed that the first triggered transition would fire. This is simply the first-applicable arbitration algorithm.

Other arbitration strategies are possible in any state machine. We can use dynamic priorities, randomized algorithms, or any kind of ordering. They aren't normally used because the state machine is designed to be simple; if a state machine doesn't support the behavior you are looking for, it is unlikely that arbitration will be the problem.

State machines, rule-based systems, and blackboard architectures form a hierarchy of increasing representational power and sophistication. State machines are fast, easy to implement, and restrictive, while blackboard architectures can often appear far too general to be practical. The general rule, as we saw in the introduction, is to use the simplest technique that supports the behavior you are looking for.

5.10 ACTION EXECUTION

Throughout this chapter I have talked about actions as if it were clear what they were. Everything from decision trees to rule-based systems generates actions, and I've avoided being clear on what format they might take.

Many developers don't work with actions as a distinct concept. The result of each decision making technique is simply a snippet of code that calls some function, tweaks some state variable, or asks a different bit of the game (AI, physics, rendering, whatever) to perform some task.

On the other hand, it can be beneficial to handle a character's actions through a central piece of code. It makes the capabilities of a character explicit, makes the game more flexible (you can add and remove new types of actions easily), and can aid hugely in debugging the AI. This calls for a distinct concept for actions, with a distinct algorithm to manage and run

This section looks at actions in general and how they can be scheduled and executed through a general action manager. The discussion about how different types of actions are executed is relevant, even to projects that don't use a central execution manager.

5.10.1 TYPES OF ACTION

We can divide the kind of actions that result from AI decisions into five flavors: state change actions, animations, movement, AI requests and interface commands.

State change actions are the simplest kind of action, simply changing some piece of the game state. It is often not directly visible to the player. A character may change the firing mode of its weapon, for example, or use one of its health packs. In most games, these changes only have associated animations or visual feedback when the player carries them out. For other characters, they simply involve a change in a variable somewhere in the game's state.

Animations are the most primitive kind of visual feedback. This might be a particle effect when a character casts a spell or a quick shuffle of the hands to indicate a weapon reload. Often, combat is simply a matter of animation, whether it be the recoil from a gun, sheltering behind a raised shield, or a lengthy combo sword attack.

Animations may be more spectacular. We might request an in-engine cutscene, sending the camera along some predefined track and coordinating the movement of many characters.

Actions may also require the character to make some movement through the game level. Although it isn't always clear where an animation leaves off and movement begins, I am thinking about larger scale movement here. A decision maker that tells a character to run for cover, to collect a nearby power-up, or to chase after an enemy is producing a movement action.

In Chapter 3 on movement algorithms we saw the kind of AI that converts this kind of high-level movement request (sometimes called staging) into primitive actions. These primitive actions (e.g., apply such-and-such a force in such-and-such a direction) can then be passed to the game physics, or an animation controller, to execute.

Although these movement algorithms are typically considered part of AI, I am treating them here as if they were just a single action that can be executed. In a game, they will be executed by calling the appropriate algorithms and passing the results onto the physics or animation layer. In other words, they will usually be implemented in terms of the next type of action.

In AI requests for complex characters, a high-level decision maker may be tasked with deciding which lower level decision maker to use. The AI controlling one team in a real-time strategy game, for example, may decide that it is time to build. A different AI may actually decide which building gets to be constructed. In squad-based games, several tiers of AI are possible, with the output from one level guiding the next level (I will cover specific tactical and strategic AI techniques in Chapter 6).

Finally, Interface Commands do not change the state of the game, but demonstrate to the user what is happening. A command might play a sound effect, display a dialogue snippet, or schedule a particle system.

A Single Action

The action that is output from a decision making tool may combine any or all of these flavors. In fact, most actions have at least two of these components to them.

Reloading a weapon involves both a state change (replenishing ammo in the gun from the overall total belonging to the character) and an animation (the hand shuffle). Running for cover may involve an AI request (to a pathfinder), movement (following the path), and animation (waving hands over head in panic). Deciding to build something may involve more AI (choosing what to build) and animation (the construction yard's chimney starts smoking).

Actions involving any animation or movement take time. State changes may be immediate, and an AI request can be honored straight away, but most actions will take some time to complete.

A general action manager will need to cope with actions that take time; we can't simply complete the action in an instant.

Many developers engineer their AI so that the decision maker keeps scheduling the same action every frame (or every time it is called) until the action is completed. This has the advantage that the action can be interrupted at any time (see the next section), but it means that the decision making system is being constantly processed and may have to be more complex than necessary.

Take, for example, a state machine with a sleeping and on-guard state. When the character wakes up, it will need to carry out a "wake-up" action, probably involving an animation and maybe some movement. Similarly, when a character decides to take a nap, it will need a "goto-sleep" action. If we need to continually wake up or go to sleep every frame, then the state machine will actually require four states, shown in Figure 5.55.

This isn't a problem when we only have two states to transition between, but allowing

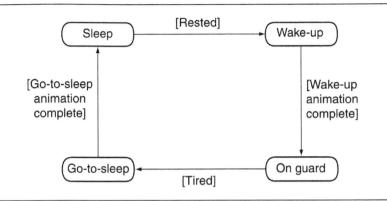

Figure 5.55: State machine with transition states

transitions between five states would involve 40 additional transition states. It soon scales out of control.

If we can support actions with some duration, then the wake-up action will simply be requested on exiting the sleep state. The go-to-sleep action will likewise be carried out when entering the sleep state. In this case, the state machine doesn't need continual processing. After it signals that it is waking up, we can wait until the character has played its waking animation before moving onto the next thing.

Interrupting Actions

Because actions take time, they may start off being sensible things to do, but may end up being stupid long before the action is complete. If a character is sent wandering off toward a power-up, it will appear silly if it carries on toward the power-up after a squad of enemy units spring their ambush: it's time to stop going after the power-up and run away.

If a decision making system decides that an important action is needed, then it should be able to trump other actions currently being carried out. Most games allow such emergencies to even break the consistency of animation. While in normal circumstances a whole animation is played, if the character needs to do a rapid volte-face, the animation can be interrupted for another (possibly with a couple of frames of blending between them to avoid a distinct jump).

Our action manager should allow actions with higher importance to interrupt the execution of others.

Compound Actions

It is rare for a character in a game to be doing only one thing at a time. The action of a character is typically layered. They might be playing a "make-obscene-gesture" animation, while moving around the level, while pursuing an enemy, while using a health pack.

It is a common implementation strategy to split these actions up so they are generated by different decision making processes. We might use one simple decision maker to monitor health levels and schedule the use of a health pack when things look dangerous. We might use another decision maker to choose which enemy to pursue. This could then hand-off to a pathfinding routine to work out a pursuit route. In turn, this might use some other AI to work out how to follow the route and yet another piece of code to schedule the correct animations.

In this scenario, each decision making system is outputting one action of a very particular form. The action manager needs to accumulate all these actions and determine which ones can be layered.

An alternative is to have decision makers that output compound actions. In a strategy game, for example, we may need to coordinate several actions in order to be successful. The decision making system might decide to launch a small attack at a strong point in the enemy defense, while making a full-strength flanking assault. Both actions need to be carried out together. It would be difficult to coordinate separate decision making routines to get this effect.

In these cases the action returned from a decision making system will need to be made up of several atomic actions, all of which are to be executed at the same time.

This is an obvious requirement, but one close to our hearts. One AI system we know of ignored the need for compound actions until late in the development schedule. Eventually, the decision making tool (including its loading and saving formats, the connections into the rest of the game code, and the bindings to the scripting language and other tools) needed rewriting, a major headache we could have avoided.

Scripted Actions

Developers and (more commonly) games journalists occasionally talk about "scripted AI" in a way that has nothing to do with scripting languages. Scripted AI in this context usually means a set of pre-programmed actions that will always be carried out in sequence by a character. There is no decision making involved; the script is always run from the start.

For example, a scientist character may be placed in a room. When the player enters the room, the script starts running. The character rushes to a computer bank, starts the selfdestruct sequence, and then runs for the door and escapes.

Scripting the behavior in this way allows developers to give the impression of better AI than would be possible if the character needed to make its own decisions. A character can be scripted to act spitefully, recklessly, or secretly, all without any AI effort.

This kind of scripted behavior is less common in current games because the player often has the potential to disrupt the action. In our example, if the player immediately runs for the door and stands there, the scientist may not be able to escape, but the script won't allow the scientist to react sensibly to the blockage. For this reason, these kinds of scripted actions are often limited to in-game cutscenes in recent games.

Scripted behavior has been used for many years in a different guise without removing the need for decision making.

Primitive actions (such as move to a point, play an animation, or shoot) can be combined into short scripts that can then be treated as a single action. A decision making system can decide to carry out a decision script that will then sequence a number of primitive actions.

For example, it is common in shooters for enemy characters to use cover correctly in a firefight. A character may lay down a burst of suppressing fire before rolling out of cover and running for its next cover point. This script (fire, roll, run) can be treated as a whole, and the decision making system can request the whole sequence.

The sequence of actions becomes a single action as far as the decision making technique is concerned. It doesn't need to request each component in turn. The "run to new cover" action will contain each element.

This approach gives some of the advantages of the scripted AI approach, while not putting the character at the mercy of a changing game environment. If the character gets blocked or thwarted in the middle of its script, it can always use its decision making algorithms to choose another course of action.

Scripted actions are similar to compound actions, but their elements are executed in sequence. If we allow compound actions to be part of the sequence, then the character can perform any number of actions at the same time and any number of actions in sequence. This gives us a powerful mechanism.

I will return to scripted actions in Chapter 6. When it comes to coordinating the actions of several characters at the same time, scripted actions can be a crucial technology, but they need to have several characteristics that I will describe in Section 6.4.3.

An Aside on Scripts

In my opinion, this kind of action script is an essential element of game AI development. It may seem like I'm belaboring an obvious point here, but the industry has known about scripts for a long time. They aren't new and they aren't clever, so what's all the fuss about?

My experience has shown that developers regularly get caught up in trying new technologies to provide results that would be more cheaply and reliably achieved with this "low-tech" approach. It is tempting to experiment with higher level decision making techniques intended to give the illusion of a deeper intelligence (such as neural networks and emotional and cognitive modeling), where the hard-coded approach is perfectly adequate.

While they could be seen as a hacked approach, it is difficult to overestimate their practical value, especially considering how easy they are to implement. Too often they are dismissed because of the bad reputation of scripted AI. My advice is to use them freely, but don't brag about it in the game's marketing materials!

5.10.2 THE ALGORITHM

The code deals with three different types of action.

Primitive actions represent state changes, animations, movement, and AI requests. In this implementation the action is responsible for carrying out its effect. The implementation notes discussed later cover this assumption in more detail.

In addition to primitive actions, there are compound actions of two types: action combinations and action sequences.

Action combinations provide any set of actions that should be carried out together. A reload action, for example, may consist of one animation action (play the shuffle-hands animation, for example) and a state change action (reset the ammo in the current weapon). All actions in a combination can be executed at the same time.

Action sequences are identical in structure to action combinations but are treated as a sequential set of actions to carry out, one after another. The sequence waits until its first action is complete before going on to another. Action sequences can be used for actions such as "pull door lever," which involves movement (go to the lever) followed by animation (pull the lever) followed by a state change (change the door's locked status). The actions in an action sequence can be action combinations (i.e., carry out a bunch of actions all together, then another bunch, and so on) or vice versa. Compound actions can be nested in any combination to any depth.

Every action (primitive or compound) has an expiry time and a priority. The expiry time controls how long the action should be queued before it is discarded, and the priority controls whether an action has priority over another. In addition, it has methods that we can use to check if it has completed, if it can be executed at the same time as another action, or if it should interrupt currently executing actions. Action sequences keep track of their component action that is currently active and are responsible for updating this record as each subsequent action completes.

The action manager contains two groups of actions: the queue is where actions are initially placed and wait until they can be executed, and the active set is a group of actions that are currently being executed.

Actions from any source are passed to the action manager where they join the queue. The queue is processed, and high-priority actions are moved to the active set, as many as can be executed at the same time, in decreasing order of priority. At each frame, the active actions are executed, and if they complete, they are removed from the set.

If an item is added to the queue and wants to interrupt the currently executing actions, then it is checked for priority. If it has higher priority than the currently executing actions, it is allowed to interrupt and is placed in the active set.

If there are no currently executing actions (they have been completed), then the highest priority action is moved out of the queue into the active set. The manager then adds the next highest priority action if it can be simultaneously executed, and so on until no more actions can be added to the currently active set.

5.10.3 PSEUDO-CODE

The action manager implementation looks like the following:

```
class ActionManager:
       # The queue of pending actions.
2
       queue: Action[]
3
       # The currently executing actions.
5
       active: Action[]
6
7
       # Add an action to the queue.
8
       function scheduleAction(action: Action):
9
            # Add it to the queue.
10
            queue += action
11
12
       # Process the manager.
13
       function execute():
14
            currentTime = getTime()
15
            priorityCutoff = active.getHighestPriority()
16
17
            # Remove expired actions from queue.
            for action in copy(queue):
19
                if action.expiryTime < currentTime:</pre>
20
                     queue -= action
21
22
            # Go through the gueue.
23
            for action in copy(queue):
24
                # If we drop below active priority, give up.
25
                if action.priority <= priorityCutoff:</pre>
26
                     break
27
28
                # If we have an interrupter, do it instead.
29
                if action.interrupt():
30
                     queue -= action
31
32
                     # Interrupter is now the only active, previous
33
                     # active are discarded.
34
                     active = [action]
35
                     priorityCutoff = action.priority
36
37
                else:
38
                     # Check if we can add this action.
39
                     canAddToActive = true
40
                     for activeAction in active:
41
                         if not activeAction.canDoBoth(action):
42
                             canAddToActive = false
43
                             break
44
```

```
45
                    # If we can do both, then do.
46
                    if canAddToActive:
47
                         queue -= action
48
                         active += action
49
                         priorityCutoff = action.priority
50
51
            # Remove or run active actions.
            for activeAction in copy(active):
54
                if activeAction.isComplete():
                    active -= activeAction
55
                else:
56
57
                    activeAction.execute()
```

The execute function performs all the scheduling, queue processing, and action execution. The scheduleAction function simply adds a new action to the queue.

The copy function creates a copy of a list of actions (either the queue or the active set). This is needed in both top-level loops in the process function because items may be removed from the list within the loop.

5.10.4 DATA STRUCTURES AND INTERFACES

The action manager relies on a general action structure with the following interface:

```
class Action:
    expiryTime: float
    priority: float
    function interrupt() -> bool
    function canDoBoth(other: Action) -> bool
    function isComplete() -> bool
```

Fundamental actions will have different implementations for each method. The compound actions can be implemented as sub-classes of this base Action.

Action combinations can be implemented as:

```
class ActionCombination extends Action:
       # The sub-actions.
3
       actions: Action[]
       function interrupt() -> bool:
           # We can interrupt if any of our sub-actions can.
7
           for action in actions:
               if action.interrupt():
                   return true
           return false
10
11
```

```
function canDoBoth(other: Action) -> bool:
12
            # We can do both if all of our sub-actions can.
13
            for action in actions:
14
                if not action.canDoBoth(other):
15
                     return false
16
            return true
17
18
       function isComplete() -> bool:
19
            # We are complete if all of our sub-actions are.
20
            for action in actions:
21
                if not action.isComplete():
22
                     return false
23
            return true
24
25
       function execute():
26
            # Execute all of our sub-actions.
27
            for action in actions:
28
                action.execute()
29
```

Action sequences are just as simple. They only expose one sub-action at a time. They can be implemented as:

```
class ActionSequence extends Action:
       # The sub-actions.
2
       actions: Action[]
3
       # The index of the currently executing sub-action.
       activeIndex: int = 0
       function interrupt() -> bool:
           # We can interrupt if our first sub-actions can.
            return actions[0].interrupt()
10
11
       function canDoBoth(other: Action) -> bool:
12
           # We can do both if all of our sub-actions can If we only
13
           # tested the first one, we'd be in danger of suddenly finding
14
           # ourselves incompatible mid-sequence.
15
            for action in actions:
16
                if not action.canDoBoth(other):
17
                    return false
18
            return true
19
20
       function isComplete() -> bool:
21
            # We are complete if all of our sub-actions are.
22
            return activeIndex >= len(actions)
23
24
       function execute()
25
            # Execute our current action.
26
```

```
actions[activeIndex].execute()

# If our current action is complete, go to the next.
if actions[activeIndex].isComplete():
    activeIndex += 1
```

In addition to the action structures, the manager algorithm has two list structures: active and queue, both of which keep their component actions in decreasing priority order at all times. For actions with identical priority values, the order is undefined. Marginally better performance can be gained by ordering identical priorities by increasing expiry time (i.e., those closer to expiring are nearer the front of the list).

In addition to its list-like behavior (adding and removing items, the clear method), the active list has one method: getHighestPriority returns the priority of the highest priority action (i.e., the first in the list).

5.10.5 IMPLEMENTATION NOTES

The active and queue lists should be implemented as priority heaps: data structures that always retain their content in priority order. Priority heaps are a standard data structure detailed in any algorithms text. They are discussed in more detail in Chapter 4.

In this algorithm, I have assumed that actions can be executed by calling their execute method. This follows the polymorphic structure used for algorithms throughout the book. It may seem odd to have an action manager so that decision makers weren't running arbitrary bits of code, only to then have the actions call an opaque method.

As we saw at the start of this section, actions typically come in five flavors. A full implementation can have five types of actions, one for each flavor. Each type of action is executed in a different way by the game: state changes are simply applied to the game state, animations are handled by an animation controller, movement is handled by movement algorithms found later in this book, AI requests can be processed by any other decision maker, and interface actions are passed to the renderer.

Debugging

One major advantage with channeling all character actions through a central point is the ability to add simple reporting and logging for debugging. In the execute method of each action class we can add code that outputs logging data: the action can carry with it any information that might help debugging (e.g., the decision maker that gave rise to the action, the time it was added to the queue, whether it is complete or not, and so on).

My experience in trying to debug decentralized AI has led me to return to a centralized action system on many occasions. I feel that debugging is the best reason to always use some kind of centralized approach, whether it is as complete as the one above or it is a simple first-in first-out queue.

5.10.6 PERFORMANCE

The algorithm is O(n) in memory, where n is the maximum number of actions in the queue. The algorithm assumes that action producers will behave nicely. If an action producer dumps an action in the queue every frame, then the queue can rapidly grow unwieldy. The expiry time mechanism will help, but probably not fast enough. The best solution is to make sure contributors to the manager do not flood it. In an environment where that can't be guaranteed (when the manager is receiving actions from user scripts, for example), a limit can be placed on the size of the queue. When a new action is added to a full queue, the lowest priority element is removed.

The algorithm is O(mh) in time, where m is the number of actions in the active set, including sub-actions of a compound action, and h is the number of actions in the queue, again including sub-actions (n in the last paragraph refers to actions in the queue excluding subactions). This timing is due to the canDoBoth test, which tries all combinations of items in the queue with those in the active set. When there are many actions in both lists, this can become a major issue.

In this case, we can make the algorithm less flexible. The ability to combine actions in the active list can easily be removed, and we can enforce that all simultaneous actions be explicitly requested by embedding them in an action combination structure. This reduces the algorithm to O(h) in time.

Typically, however, only a few actions are present in the manager at any one time, and the checks do not pose a significant problem.

5.10.7 PUTTING IT ALL TOGETHER

Figure 5.56 shows a complete AI structure using the action manager.

An alarm mechanism is updated every frame and can schedule emergency actions if needed. The queue of actions is then queued. There is a single decision making system, which is called whenever the action queue is empty (it may be made up of many component decision making tools). When a valid action is in the queue, it is sent to be executed. The execution may be performed by sending requests to the game state, the animation controller, the movement AI, or some subsidiary decision maker. If the system runs out of processing time before an action is added to the queue, then it simply returns having done nothing.

This structure represents a comprehensive architecture for building a sophisticated character. It may be overkill for simple, quick-to-implement AI for subsidiary characters. The flexibility it provides can be very useful during AI development, as characters inevitably require more complex behaviors.

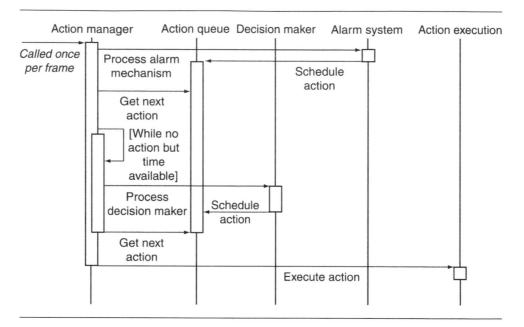

Figure 5.56: The action manager in context

EXERCISES

5.1 Here is part of the specification for a character's AI:

When their health is below 50%, they should heal, unless an enemy is within 20m of them, in which case they should attack. If their health is below 10% they should heal regardless of enemy proximity. If the character has a health pack they should use it to heal, otherwise they should navigate to the nearest healing item.

Assuming that the possible actions are: heal, navigate to healing item, and attack enemy, draw a binary decision tree that will implement this character's behavior.

- 5.2 After playtesting, it is decided that the character in Exercise 5.1 should not navigate to a healing item when an enemy is close (within 20m). Instead they should hide, a new action. What is the minimum modification you can make to the previous decision tree to accommodate this change? Would you design the decision tree differently if you could recreate it from scratch? Why or why not?
- 5.3 Playtesting now determines that the character from Exercise 5.2 is too predictable. Choose one place to add randomness to the decision tree. Draw the resulting tree, and justify your choice in gameplay terms.

- 5.4 Draw a simple finite state machine that implements the behavior specification from Exercise 5.1.
- 5.5 Your answers to Exercises 5.1 and 5.4 both fulfilled the requirements, but are there any situations in the game where they might behave differently?
- 5.6 Add an alarm mechanism to the finite state machine you created in Exercise 5.3 so the character reloads when their weapon is out of ammunition. You should use a hierarchical state machine to achieve this.
- 5.7 A character representing a robotic janitor can perform four actions: it can pick up trash, it can drop the trash, it can move to a location, and it can plug itself in to recharge. There are several charging points around the level. Sketch a state machine for this behavior, using a decision tree to determine at least one of its state transitions.
- 5.8 Assuming moving through the world and picking up a health pack are separate basic actions, draw an implementation of the character specification from Exercise 5.1 as a behavior tree. You should use at least one sequence node.
- 5.9 In the chapter, the following pseudo-code was implemented as a behavior tree:

```
if isLocked(door):
      moveTo(door)
2
      open(door)
      moveTo(room)
```

How might it be implemented as a decision tree? Is either approach better for this behavior? Why or why not?

- 5.10 In Section 2.1.1 the behaviors of the ghosts in Pac-Man were described. Which decision-making tool would you use to implement them? Give a sketch of your design for each of the four ghosts.
- 5.11 In a sequel to Pac-Man, the game designer has added doors to the level. Ghosts can open doors, but this takes time. How would the design you created in Exercise 5.10 change to accommodate this?
- 5.12 A character has the following degrees of membership in fuzzy states:

State	Degree of Membership	Movement Speed
confident	0.4	5
cautious	0.6	3
worried	0.2	2
panicked	0.0	1

Each state has a characteristic movement speed as given in the table. What is the resulting movement speed of the character using the following defuzzification methods:

- a) highest membership,
- b) blending,
- c) center of gravity.

- 5.13 A character is in a conflicted state if they are both confident AND either worried OR panicked. Calculate the degree of membership for the conflicted state for the character in Exercise 5.12.
- 5.14 Rewrite the rule for the conflicted state given in Exercise 5.13 in Combs format. Check the degree of membership for the same character. Should we expect it to be the same?
- 5.15 In a strategy game the following vector represents the friendship of one country to its neighbors:

$$\begin{bmatrix} 0.7 \\ 0.4 \\ 0.5 \\ 0.4 \end{bmatrix}$$

When no countries are taking either cooperative or aggressive action, these friendship levels change according to the Markov matrix:

$$M = \begin{bmatrix} 0.7 & 0.1 & 0.1 & 0.1 \\ 0.1 & 0.7 & 0.1 & 0.1 \\ 0.1 & 0.1 & 0.7 & 0.1 \\ 0.1 & 0.1 & 0.1 & 0.7 \end{bmatrix}$$

If the game continued without either cooperative or aggressive action what would be the stable long-term value of the friendship vector?

5.16 Using the matrix from Exercise 5.15, if the friendship vector began at:

$$\begin{bmatrix} 0.9 \\ 0.7 \\ 0.5 \\ 0.3 \end{bmatrix}$$

what would the stable value be? Is it possible to design a Markov matrix such that the stable value is the same regardless of the starting vector?

5.17 In computer graphics, multiplying by a matrix is also used to add or subtract from the vector. To do this, an additional row in the vector is set to 1, and the matrix has an additional row and column (in mathematical terms this is using 'homogeneous' coordinates). If our friendship vector were:

where the final entry is always one, and does not represent a friendship, what Markov matrix of the form:

$$M = egin{bmatrix} a & b & b & b & c \ b & a & b & b & c \ b & b & a & b & c \ b & b & b & a & c \ 0 & 0 & 0 & 0 & 1 \ \end{bmatrix}$$

would always give stable values of 0.5 per friendship? (Hint: there are multiple solutions, find one.)

- 5.18 A robotic character has the goal to recharge itself. It can do so in two ways: either by returning to its charging point for a complete charge that takes one minute (including journey time); or by using a battery for a 25% charge that takes 30 seconds. In normal operation the robot loses 5% of its charge per minute. At what charge levels would an overall utility GOB choose to return the robot to its charging point?
- 5.19 In Exercise 5.18, how could we tweak the percentage charge and charging time for each method, so that the robot more often uses a battery?
- 5.20 Assuming we have a perfect heuristic, and the same graph in both cases, would IDA* perform better or worse than regular A*, in terms of the number of states it considers?
- 5.21 The game design document contains the following specification for a character's AI:

The character will normally patrol their route. If a lone player can be seen, the character will home in on their location and attack. If the player has backup, the character will instead raise the alarm then wait until their own backup arrives.

Write a series of rules for a rule-based system that will implement this behavior.

5.22 Do the rules you created in Exercise 5.21 depend on a particular arbitration strategy? If so, which strategies are valid?

6

TACTICAL AND STRATEGIC AI

THE DECISION MAKING techniques we looked at in the last chapter have two important limitations: they are intended for use by a single character, and they don't try to infer from the knowledge they have to a prediction of the whole situation.

Each of these limitations is broadly in the category of tactics and strategy. This chapter looks at techniques that provide a framework for tactical and strategic reasoning in characters. It includes methods to deduce the tactical situation from sketchy information, to use the tactical situation to make decisions, and to coordinate between multiple characters.

In the model of AI I've been using so far, this provides the third layer of our system, as shown in Figure 6.1.

It is worth remembering again that not all parts of the model are needed in every game. Tactical and strategic AI, in particular, is simply not needed in many game genres. Where players expect to see predictable behavior (in a two-dimensional [2D] shooter or a platform game, for example), it may simply frustrate them to face more complex behaviors.

There has been a rapid increase in the tactical capabilities of AI-controlled characters over the last ten years, partly because of the increase in AI budgets and processor speeds, and partly due to the adoption of simple techniques that can bring impressive results, as we'll see in this chapter. It is an exciting and important area to be working in, and there is no sign of that changing.

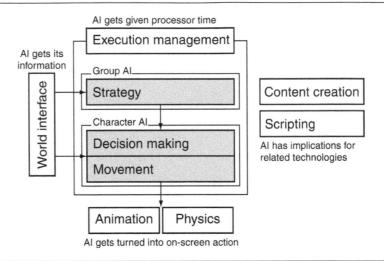

Figure 6.1: The AI model

6.1 WAYPOINT TACTICS

A waypoint is a single position in the game level. We met waypoints in Chapter 4, although there they were called "nodes" or "representative points." Pathfinding uses nodes as intermediate points along a route through the level. This was the original use of waypoints, and the techniques in this section grew naturally from extending the data needed for pathfinding to allow other kinds of decision making.

When we used waypoints in pathfinding, they represented nodes in the pathfinding graph, along with associated data the algorithm required: connections, quantization regions, costs, and so on. To use waypoints tactically, we need to add more data to the nodes, and the data we store will depend on what we are using the waypoints for.

In this section we'll look at using waypoints to represent positions in the level with unusual tactical features, so a character occupying that position will take advantage of the tactical feature. Initially, we will consider waypoints that have their position and tactical information set by the game designer. Then, we will look at ways to deduce first the tactical information and then the position automatically.

6.1.1 TACTICAL LOCATIONS

Waypoints used to describe tactical locations are sometimes called "rally points." One of their early uses in simulations (in particular military simulation) was to mark a fixed safe location that a character in a losing firefight could retreat to. The same principle is used in real-world military planning; when a platoon engages the enemy, it will have at least one pre-determined safe withdrawal point that it can retreat to if the tactical situation warrants it. In this way a lost battle doesn't always lead to a rout.

More common in games is the use of tactical locations to represent defensive locations, or cover points. In a static area of the game, the designer will typically mark locations behind barrels or protruding walls as being good cover points. When a character engages the enemy, it will move to the nearest cover point in order to provide itself with some shelter.

There are other popular kinds of tactical locations. Sniper locations are particularly important in squad-based shooters. The level designer marks locations as being suitable for snipers, and then characters with long-range weapons can head there to find both cover and access to the enemy.

In stealth games, characters that also move secretly need to be given a set of locations where there are intense shadows. Their movement can then be controlled by moving between shadow regions, as long as enemy sight cones are diverted (implementing sensory perception is covered in Chapter 11, World Interfacing).

There are unlimited different ways to use waypoints to represent tactical information. We could mark fire points where a large arc of fire can be achieved, power-up points where powerups are likely to respawn, reconnaissance points where a large area can be viewed easily, quick exit points where characters can hide with many escape options if they are found, and so on. Tactical points can even be locations to avoid, such as ambush hotspots, exposed areas, or sinking sand.

Depending on the type of game you are creating, there will be several kinds of tactics that your characters can follow. For each of these tactics, there are likely to be corresponding tactical locations in the game, either positive (locations that help the tactic) or negative (locations that hamper it).

A Set of Locations

Most games that use tactical locations don't limit themselves to one type or another. The game level contains a large set of waypoints, each labeled with its tactical qualities. If the waypoints are also used for pathfinding, then they will also have pathfinding data such as connections and regions attached.

In practice, locations for cover and sniper fire are not very useful as part of a pathfinding graph. Figure 6.2 illustrates this situation. Although it is most common to combine the two sets of waypoints, it may provide more efficient pathfinding to have a separate pathfinding graph and tactical location set. You would have to do this, of course, if you were using a different method for representing the pathfinding graph, such as navigation meshes or a tilebased world.

We will assume for most of this section that the locations we are interested in are not necessarily part of the pathfinding graph. Later, we'll see some situations in which merging

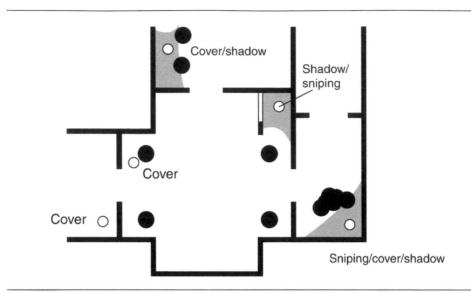

Figure 6.2: Tactical points are not the best pathfinding graph

the two together can provide very powerful behavior with almost no additional effort. In general, however, there is no reason to link the two techniques.

Figure 6.2 shows a typical set of tactical locations for an area of a game level. It combines three types of tactical locations: cover points, shadow points, and sniping points. Some points have more than one tactical property. Most of the shadow points are also cover points, for example. There is only one tactical location at each of these locations, but it has both properties.

Marking all useful locations can produce a large number of waypoints in the level. To get very good quality behavior, this is necessary but time consuming for the level designer. Later in the section we'll look at some methods of automatically generating the waypoint data.

Primitive and Compound Tactics

In most games, having a set of pre-defined tactical qualities (such as sniper, shadow, cover, etc.) is sufficient to support interesting and intelligent tactical behavior. The algorithms we'll look at later in this section make decisions based on these fixed categories.

We can make the model more sophisticated, however. When we looked at sniper locations, I mentioned that a sniper location would have good cover and provide a wide view of the enemy. We can decompose this into two separate requirements: cover and view of the enemy. If we support both cover points and high visibility points in our game, we have no need to specify good sniper locations. We can simply say the sniper locations are those points that

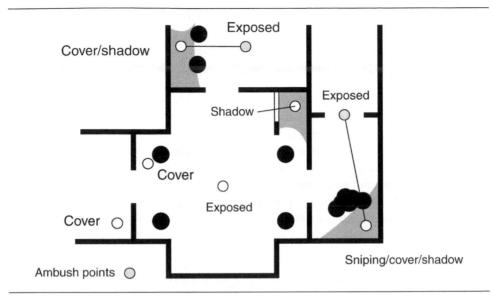

Figure 6.3: Ambush points derived from other locations

are both cover points and reconnaissance points. Sniper locations have a compound tactical quality; they are made up of two or more primitive tactics.

We don't need to limit ourselves to a single location with both properties, either. When a character is on the offensive in a firefight, it needs to find a good cover point very near to a location that provides clear fire. The character can duck into the cover point to reload or when incoming fire is particularly dense and then pop out into the fire point to attack the enemy. We can specify that a defensive cover point is a cover point with a fire point very near (often within the radius of a sideways roll: the stereotypical animation for getting in and out of cover).

In the same way, if we are looking for good locations to mount an ambush, we could look for exposed locations with good hiding places nearby. The "good hiding places" are compound tactics in their own right, combining locations with good cover and shadow.

Figure 6.3 shows an example. In the corridor, cover points, shadow points, and exposed points are marked. We decide that a good ambush point is one with both cover and shadow, next to an exposed point. If the enemy moves into the exposed point, with a character in shadow, then it will be susceptible to attack. The good ambush points are marked in the figure.

We can take advantage of these compound tactics by storing only the primitive qualities. In the example above, we store three tactical qualities: cover, shadow, and exposure. From these we can calculate the best places to lay or avoid an ambush. By limiting the number of different tactical qualities, we can support a huge number of different tactics without making

the level designer's job impossible or flooding the memory with waypoint data that are rarely needed. On the other hand, what we gain in memory, we lose in speed. To work out the nearest ambush point, we would need to look for cover points in shadow and then check each nearby exposed point to make sure it was within the radius we were looking for.

In the vast majority of cases this extra processing isn't important. If a character needs to find an ambush location, for example, then it is likely to be able to think for several frames. Decision making based on tactical locations isn't something a character needs to do every frame, and so for a reasonable number of characters time isn't of the essence.

For lots of characters or if the set of conditions is very complex, however, the waypoint sets can be pre-processed offline, and all the compound qualities can be identified. This doesn't save memory when the game is running, but it removes the need for the level designer to specify all the qualities of every location. This can be taken further, and we can use algorithms to detect even the primitive qualities. I will return to algorithms for automatically detecting primitive qualities later in this section.

Waypoint Graphs and Topological Analysis

The waypoints I have described so far are separate, isolated locations. There is no information as to whether one waypoint can be reached from another. I mentioned at the start of this section the similarity of waypoints to nodes in a pathfinding graph. We can certainly use nodes in a pathfinding graph as tactical locations (although they aren't always the best suited, as we'll see later in Section 6.3 on tactical pathfinding).

But even if we aren't using a pathfinding graph, we can link together tactical locations to give access to more sophisticated compound tactics.

Let's suppose that we're looking for somewhere that provides a good location to mount a hit and run attack. The set of waypoints in Figure 6.4 shows part of a level to consider. Waypoints are connected when one can be reached from the other directly. There are no connections through the wall, for example. In the balcony we have a location (A) with good visibility of the room, a candidate for an attack spot. Similarly, there is one other location in a small anteroom (B) that might be useful.

The balcony is obviously better than the anteroom because it has three exits, only one of which leads into the room. If we are looking to perform a hit and run attack, then we need to find locations with good visibility, but lots of exit routes.

This is a topological analysis. It reasons about the structure of the level by looking at the properties of the waypoint graph. It is a kind of compound tactic, but one that uses the connections between waypoints as well as their tactical qualities and positions.

Topological analysis can be performed using the pathfinding graph, or it can be performed on basic tactical waypoints. It does require connections between waypoints, however. Without these connections, we wouldn't know whether the nearby waypoints constitute exit routes or whether there was a wall between them.

Unfortunately, this kind of topological analysis can rapidly get complicated. It is extremely

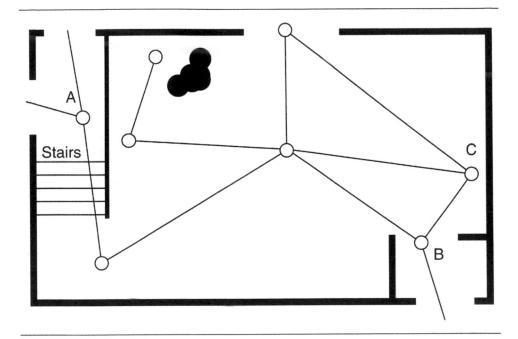

Figure 6.4: Topological analysis of a waypoint graph

sensitive to the density of waypoints. Take location C in Figure 6.4. Once again the shooting position has three exit routes. In this case, however, they all lead to locations in the same vicinity with immediate escape. The character looking for a good hit and run location based on the number of exits alone might mistakenly mount its attack in the middle of the room.

Of course, we can make the topological analysis algorithm more sophisticated. We could look not just at the number of connections, but also where those connections lead, and so on.

In my experience the complexity of this kind of analysis is formidable and beyond what most developers want to spend time implementing and tweaking. In my opinion, there isn't much debate between developing a comprehensive topological analysis system and having a level designer simply specify the appropriate tactical locations. For all but the simplest analysis, the level designer gets the job every time.

Automatic topological analysis comes up from time to time in books and papers. My advice would be to treat it with caution, unless you can spare a couple of months of playing to get it right. The manual way is often less painful in the long run.

Continuous Tactics

To support more complicated compound tactics, we can move away from simple Boolean states. Rather than marking a location as being "cover" or "shadow," for example, we can provide a numerical value for each. A waypoint will have a value for "cover" and a different value for "shadow."

The meaning of these values will depend on the game, and they can have any range that is convenient. For the purpose of clarity, however, let's assume the values are floating points in the range (0, 1), where a value of 1 indicates that the waypoint has the maximum amount of a property (a maximum amount of cover or shadow, for example).

On its own we can use this information to simply compare the quality of a waypoint. If a character is trying to find cover, and it has equally achievable options between a waypoint with cover = 0.9 or cover = 0.6, it should head for the waypoint with cover = 0.9.

We can also interpret these values as a degree of membership of a fuzzy set (the basics of fuzzy logic were described in Chapter 5, Decision Making). A waypoint with a "cover" value of 0.9 has a high degree of membership in the set of cover locations.

Interpreting the values as degrees of membership allows us to produce values for compound tactics using the fuzzy logic rule. Recall that we defined a sniper location as a waypoint that had both a view of the enemy and good cover. In other words,

```
sniper = cover AND visibility
```

If we have a waypoint with cover = 0.9 and visibility = 0.7, we can use the fuzzy rule:

$$m_{(A \text{ AND B})} = \min(m_A, m_B)$$

where m_A and m_B are the degrees of membership of A and B. Adding in our data we get:

$$m_{
m sniper} = \min(m_{
m cover}, m_{
m visibility})$$

= $\min(0.9, 0.7)$
= 0.7

So we can derive the quality of a sniper location and use that as the basis of a character's tactical actions. This example is very simple, using just AND to combine its components. As we saw in the previous section, we can devise considerably more complex conditions for compound tactics. Interpreting the values as degrees of membership in fuzzy states allows us to work with even the most complex definitions made up of lots of clauses. It provides a tried and tested mechanism for ending up with a dependable value.

The disadvantage of using this approach is that each waypoint needs to have a complete set of values stored for it. If we are keeping track of five different tactical properties, then for the non-numeric situation we only need to keep a list of waypoints in each set. There is no wasted storage. On the other hand, if we store a numeric value for each, then there will be five numbers for each waypoint.

We can slightly reduce the need for storage by not storing zero values, although this makes things more complex because we need a reliable way to store both the value and the meaning of that value (if we always store the five numbers, then we can tell what each number means by its position in the array).

For large outdoor worlds, such as those used in real-time strategy (RTS) or massively multiplayer games, we might be driven to save memory. In most shooters, however, the extra memory is unlikely to cause problems.

Context Sensitivity

However, there is still a problem with marking tactical locations in the way I've described so far. The tactical properties of a location are almost always sensitive to actions of the character or the current state of the game.

Hiding behind a barrel, for example, might produce cover only if the character is crouched. If the character stands behind the barrel, it is a sitting duck for incoming fire. Likewise, hiding behind a protruding rock is of no use if the enemy is behind you. The aim is to put the rock between the character and the incoming fire.

This problem isn't limited to just cover points. Any of the tactical locations in this section may be invalid in certain circumstances. If the enemy manages to mount a flank attack, then there is no use heading for a withdrawal location which is now behind enemy lines.

Some tactical locations have an even more complicated context. A sniper point is likely to be useless if everyone knows the sniper is camped there. Unless it happens to be an impenetrable hideout (which is a sign of faulty level design, I would suggest), then sniper positions depend to some extent on secrecy.

There are two options for implementing context sensitivity. First, we could store multiple values for each node. A cover waypoint, for example, might have four different directions. For any given cover point, only some of those directions are covered. These four directions are the states of the waypoint. For cover, we have four states, and each of these may have a completely independent value for the quality of the cover (or just a different yes/no value if we aren't using continuous tactic values). We could use any number of different states. We might have an additional state that dictates whether the character needs to be ducking to receive cover, for example, or additional states for different enemy weapons; a location that provides cover from small arms fire might not protect its inhabitant from an RPG.

For tactics where the set of states is fairly obvious, such as cover or firing points (we can use the four directions again as firing arcs), this is a good solution. For other types of context sensitivities, it is more difficult. In our example of the withdrawal location, it is not obvious how to specify a sensible set of different states for the territory controlled by the enemy.

The second approach is to use only one state per waypoint, as we have seen throughout this section. Rather than treating this value as the final truth about the tactical quality of a waypoint, we add an extra step to check if it is appropriate. This checking step can consist of any check against the game state. In the cover example we might check for line of sight

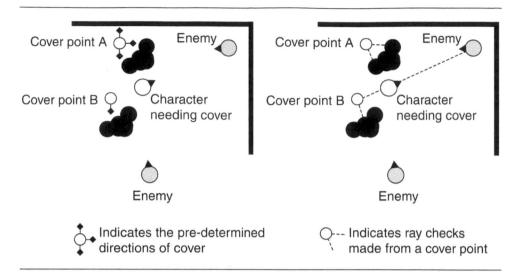

Figure 6.5: A character selecting a cover point in two different ways

with our enemies. In the withdrawal example we might check on an influence map (see Section 6.2.2 on influence mapping later in this chapter) to see if the location is currently under enemy control.

In the sniper example we could simply keep a list of Boolean flags to track if the enemy has fired toward a sniper location (a simple heuristic to approximate if the enemy knows the location is there). This post-processing step has similarities to the processing used to automatically generate the tactical properties of a waypoint. I will return to these techniques later.

As an example of each approach, consider a character that needs to choose a cover point to reload behind during a firefight. There are two cover points nearby that it can select from, as shown in Figure 6.5.

In the diagram on the left of Figure 6.5 the cover points are shown with their quality of cover in each of the four directions. The character works out the direction to each enemy and determines that it needs cover from the south and east directions. So the character checks for a cover point that provides that. Cover point B does, and it selects that point.

In the diagram on the right of Figure 6.5 a runtime check has been used. The character checks the line of sight from both cover points to both enemies. It determines that cover point B does not have a line of sight to either, so it is preferable to cover point A that has a line of sight to one enemy.

The trade-off between these two methods is between quality, memory, and execution speed. Using multiple states per waypoint makes decision making fast. We don't need to perform any tactical calculations during the game. We just need to work out which states we are interested in. On the other hand, to get very high-quality tactics we may need a huge number of states. If we need cover in four directions, both standing and crouched, against

any of five different types of weapons, we'd need 40 states for a cover waypoint. Clearly, this can very quickly become too much.

Performing a runtime check gives us much more flexibility. It allows the character to take advantage of quirks in the environment. A cover point may not provide cover to the north except for attacks from a particular walkway (the position of a roof girder provides cover there, for example). If the enemy is on that walkway, then the cover point is valid. Using a simple state for the cover from northerly attacks would not allow the character to take advantage of this.

On the other hand, runtime checking takes time, especially if we are doing lots of line-ofsight checks through the level geometry. In tactically complicated games, line-of-sight checks may take up the majority of all the AI time used in the game: over 30% of the total processor time in one case I'm familiar with. If you have a lot of characters that have to react quickly to changing tactical situations, this may be unacceptable. If the characters can afford to take a couple of seconds to weigh up their options, then you can split these checks over multiple frames and it is unlikely to be a problem.

In my opinion, only games aimed at hard-core players that really benefit from good tactical play, such as squad-based shooters, need the runtime checking approach. For other games where tactics aren't the focus, a small number of states will be sufficient. It is possible to combine both approaches in the same game, with the multiple states providing a filtering mechanism that reduce the number of different cover waypoints requiring line-of-sight checks.

Putting It Together

We've considered a range of complexities for tactical waypoints, from a simple label for the tactical quality of a location through to compound, context-sensitive tactics based on fuzzy logic. In practice, most games don't need to go the whole way.

Many games can get away with simple tactical labels. If this produces odd behavior, then the next stage to implement is context sensitivity, which provides a huge increase in the competency of the AI.

Next, I suggest adding continuous tactical values and allow characters to make decisions based on the quality of a waypoint.

For highly tactical games where the quality of the tactical play is a selling point for the game, using compound tactics (with fuzzy logic) then allows you to support new tactics without adding or changing the information that the level designer needs to create. So far I haven't worked on a game that has gone this far, although it isn't new in the field of military simulation.

6.1.2 USING TACTICAL LOCATIONS

So far we've looked at how a game level can be augmented with tactical waypoints. However, on their own they are just values. We need some mechanism to include their data into decision making.

We'll look at three approaches. The first is a very simple process for controlling tactical movement. The second incorporates tactical information into the decision making process. The third uses tactical information during pathfinding to produce character motion that is always tactically aware. None of these three approaches is a new algorithm or technique. They are simply ways in which to bring the tactical information into the algorithms we looked at in previous chapters.

For now, our focus will be limited to decision making for a single character. Later, in Section 6.4, I will return to the task of coordinating the actions of several characters, while making sure they remain tactically aware.

Simple Tactical Movement

In most cases a character's decision making process implies what kind of tactical location it needs. For example, we might have a decision tree that looks at the current state of the character, its health and ammo supply, and the current position of the enemy. The decision tree is run, and the character decides that it needs to reload its weapon.

The action generated by the decision making system is "reload." This could be achieved simply by playing the reload animation and updating the number of rounds in the character's weapon. Alternatively, and more tactically, we can choose to find a suitable place to reload, under cover.

This is simply achieved by querying the tactical waypoints in the immediate vicinity. Suitable waypoints (in our case, waypoints providing cover) are found, and any post-processing steps are taken to ensure that they are suitable for the current context.

The character then chooses a suitable location and uses it as the target of its movement. The choice can be simply "the nearest suitable location," in which case the character can begin with the nearest waypoint and check them in order of increasing distance until a match is found. Alternatively, we can use some kind of numeric measure of how good a location is. If we are using continuous values for the quality of a waypoint, this might be what we need. We are not necessarily interested in selecting the best node in the whole level, however. There is no point in running all the way across the map just to find a really secure location to reload. Instead, we need to balance distance and quality.

This approach makes the action decision first, independent of the tactical information, and then applies tactical information to achieve its decision. It is a powerful technique on its own and forms the basis of most squad-based AI. It is the bread and butter of shooters right through to present titles.

It does have a significant limitation, however. Because the tactical information isn't used in the decision making process, we may end up discovering the decision is foolish only after the

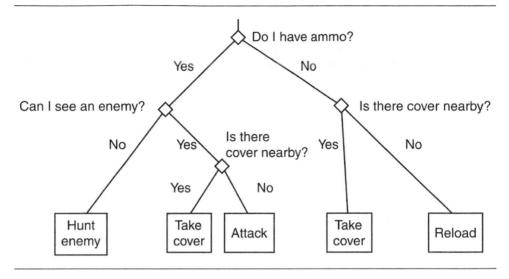

Figure 6.6: Tactical information in a decision tree

decision has been made. We might find, for example, that after making a decision to reload, we can't find anywhere safe nearby to do so. A person in this situation would try something different. For example, they may choose to run away. If the character is committed to the decision, however, it will be stuck and appear foolish.

Games rarely allow the AI to detect this and go back and reconsider the decision.

In most games this isn't a significant problem in practice, particularly if the level designer is clued up. Every area in the game usually has several tactical points of each type (with the exception of sniping points, perhaps, but we normally don't mind if characters go wandering off a long way to find these).

When it is an issue, however, we need to take account of the tactical information in the original decision making process.

Using Tactical Information Like Any Other Data

The simplest way to bring tactical information into the decision making process is to give the decision maker access to it in the same way as it has access to other information about the game world.

If we want to use a decision tree, for example, we could allow decisions to be made based on the tactical context of the character. We might make a decision based on the nearest cover point, as Figure 6.6 shows. The character in this case will not decide to head for cover and then find there is no suitable cover. The decision to move to cover takes into account the availability of cover points to move to.

Similarly, if we are using a state machine we might only trigger certain transitions based on the availability of waypoints.

In both of these cases the code should keep track of any suitable waypoints it finds during decision making so that it can use them after the decision has been made. If the decision tree in the first example ends up suggesting the "take cover" action, then it will need to work out which cover point to take cover in.

This involves the same search for nearby decision points that we had using the simple tactical movement approach previously. To avoid a duplication of effort, we cache the cover point that is found during the decision tree processing. We then use that target in the movement AI and move directly toward it without further search.

Tactical Information in Fuzzy Logic Decision Making

For both decision trees and state machines, we can use tactical information as a yes or no condition, either at a decision node in the decision tree or as a condition of making a state transition.

In both cases we are interested in finding a tactical location where some condition is met (it might be to find a tactical location where the character can take cover, for example). We aren't interested in the quality of the tactical location.

We can go one stage further and allow the decision making to take account of the quality of a tactical location as it makes a decision. Imagine a character is weighing up two strategies. It might camp out behind cover and provide suppression fire, or it might take up a position in shadow ready to lay an ambush to unwary enemies passing by. We are using continuous tactical data for each location, and the cover quality is 0.7 while the shadow quality is 0.9.

Using a decision tree, we would simply check if there is a cover point, and upon finding that there is, the character would follow the suppression fire strategy. There is no sense in weighing up the pros and cons of each option.

If we use a fuzzy decision making system, however, we can use the quality values directly in the decision making process. Recall from Chapter 5 that a fuzzy decision making system has a set of fuzzy rules. These rules combine the degrees of membership of several fuzzy sets into values that indicate which action is preferred.

We can incorporate our tactical values directly into this method, as another degree of membership value.

For example, we might have the following rules:

```
IF cover-point THEN lay-suppression-fire
IF shadow-point THEN lay-ambush
```

For the tactical values given above, we get the following result:

```
lay-suppression-fire: membership = 0.7
lay-ambush: membership = 0.9
```

If the two values are independent (i.e., if it is impossible to do both at once, which we'll assume it is), then we choose lay-ambush as the action to take.

The rules can be significantly more complex, however:

```
IF cover-point AND friend-moving THEN lay-suppression-fire
IF shadow-point AND no-visible-enemies THEN lay-ambush
```

Now if we have the memberships values:

```
friend-moving = 0.9
no-visible-enemies = 0.5
```

we would end up with the results:

```
lay-suppression-fire: membership = min(0.7, 0.9) = 0.7
lay-ambush: membership = min(0.9, 0.5) = 0.5
```

and the correct action is to lay suppression fire.

There are no doubt numerous other ways to include the tactical values into a decision making process. We can use them to calculate priorities for rules in a rule-based system, or we can include them in the input state for a learning algorithm. This approach, using the rulebased fuzzy logic system, provides a simple to implement extension that gives very powerful results. It is not a well-used technique, however. Most games rely on a much simpler use of tactical information in decision making.

Generating Nearby Waypoints

If we use any of these approaches, we will need a fast method of generating nearby way-points. Given the location of a character, we ideally need a list of suitable waypoints in order of distance.

Most game engines provide a mechanism to rapidly work out what objects are nearby. Spatial data structures such as quad-trees or binary space partitions (BSPs) are often used for collision detection. Other spatial data structures such as multi-resolution maps (a tile-based approach with a hierarchy of different tile sizes) are also suitable. For tile-based worlds, we have also used stored patterns of tiles for different radii, simply superimposed the pattern on the character's tile, and looked up the tiles within that pattern for suitable waypoints.

As I said in Chapter 3, spatial data structures for proximity and collision detection are beyond the scope of this book. There is another book in this series [14] that covers the topic. The references appendix lists this and other suitable resources.

Distance isn't the only thing to take into account, however. Figure 6.7 shows a character in a corridor. The nearest waypoint is in an adjacent room and is completely impractical as a cover point. If we simply selected the cover point based on distance, we'd see the character run into a different room to reload, rather than use the crate near the end of the corridor.

We can minimize this problem with careful level design. It is often a sensible idea not to

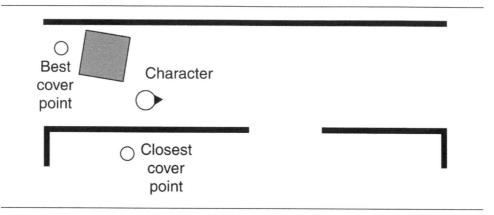

Figure 6.7: Distance problems with cover selection

use thin walls in a game level. As we saw in Chapter 4, this can also confuse the quantization algorithm. Sometimes, however, it is unavoidable, and a better solution is required.

Another approach would be to determine how close each tactical waypoint is by performing a pathfinding step to generate the distance. This then takes into account the structure of the level, rather than using a simple Euclidean distance. We can interrupt the pathfinding when we realize that it will be a longer path than the path to the nearest waypoint we've found so far. Even with such optimizations, this adds a significant amount of processing overhead.

Fortunately, we can perform the pathfinding and the search for the nearest target in one step. This also solves the problem of confusion by thin walls and of finding nearby waypoints. It also has an additional benefit: the route it returns can be used to make characters move, while constantly taking into account their tactical situation.

Tactical Pathfinding

Tactical waypoints can also be used for tactical pathfinding. Tactical pathfinding is a hot topic in game AI, but is a relatively simple extension of the basic A* pathfinding algorithm. Rather than finding the shortest or quickest route, however, it takes into account the tactical situation of the game.

Tactical pathfinding is more commonly associated with tactical analyses, however, so I'll return to a full discussion in Section 6.3 later in the chapter.

6.1.3 GENERATING THE TACTICAL PROPERTIES OF A WAYPOINT

So far I have assumed that all the waypoints for our game have been created, and each has been given its appropriate properties: a set of labels for the tactical features of its location and

possibly additional data for the quality of the tactical location, or context-sensitive information.

In the simplest case these are often created by the level designer. The level designer can place cover points, shadow points, locations with high visibility, and excellent sniper locations. As long as there are only a few hundred cover points, this task isn't onerous. It is the approach used in a large number of shooters. Beyond the simplest games, however, the effort may increase dramatically.

If the level designer has to place context-sensitive information or set the tactical quality of a location, then the job becomes very difficult, and the tools needed to support the designer have to be significantly more complicated. For context-sensitive, continuous valued tactical waypoints, we may need to set up different context states and be able to enter numeric values for each. To make sure the values are sensible, we will need some kind of visualization.

While it is possible for the designer to place the waypoints, all the extra burden makes it unlikely that the level designer will be tasked with setting the tactical information unless it is of the simplest Boolean kind.

For other games we may not need to have the locations placed manually; they may arise naturally from the structure of the game. If the game relies on a tile-based grid, for example, then locations in the game are often positioned at corresponding tiles. While we know where the locations are, we don't know the tactical properties of each one. If the game level is built up from prefabricated sections, then we could have tactical locations placed in the prefabs.

In both cases we need some mechanism for calculating the tactical properties of each waypoint automatically.

This is usually performed using an offline pre-processing step, although it can also be performed as it is needed during the game. The latter approach allows us to generate the tactical properties of a waypoint in the current game context, which in turn can support more subtle tactical behavior. As described in the section on context sensitivity above, however, this has a significant impact on performance, especially if there are a large number of waypoints to consider.

The algorithm for calculating a tactical quality depends on the type of tactic we are interested in. There are as many calculations as there are types of tactics. We will look at the types of waypoints we've used so far in the chapter to give a feel for the types of processing involved. Other tactics will tend to be similar to these types, but may need some modification.

Cover Points

The quality of a cover point is calculated by testing how many different incoming attacks might succeed. We run many different simulated attacks and see how many get through.

We can run a complete simulated attack, but this takes time. It is normally easier to approximate an attack by a line-of-sight test: a ray cast through the level geometry.

For each attack we start by selecting a location in the vicinity of the candidate cover point. This location will usually be in the same or an adjoining room to the cover point. We can test from everywhere in the level, of course, but that is wasteful as most attacks will not succeed. In outdoor levels we may have to check everywhere within weapons range, which is potentially a time-consuming process.

One way to do this is to check attacks at regular angles around the point. We need to first make sure that the location we are checking is in the same room or area as the point it is trying to attack. A point in the middle of a corridor, for example, can be hit from anywhere in the corridor. If the corridor is thin, however, using all the angles around will give a high cover value: most of the angles are covered by the corridor walls. Testing nearby locations that can be occupied, however, will show correctly that the point is 100% exposed.

Being too regular, however, can also lead to problems. If we test just locations around the point at the same height as the point, we might get the wrong value. A character standing behind an oil can, for example, can be covered from the ground level, but would be exposed from a gun at shoulder height. We can solve this problem by checking each angle several times, with small random offsets, and at different heights.

From the location we select, a ray is cast toward the candidate cover point. Crucially, the ray is cast toward a random point in a person-sized volume at the candidate point. If we aim toward just the point, we may be checking if a small point on the floor is covered, rather than the area a character would occupy.

This process is repeated many times from different locations. We keep track of the proportion of rays that hit the volume.

The pseudo-code to perform these checks looks like the following:

```
function getCoverQuality(location: Vector,
2
                             iterations: int,
                             characterSize: float) -> float:
       # Set up the initial angle.
4
       theta = 0
       # We start with no hits.
7
       hits = 0
       # Not all rays are valid.
10
       valid = 0
11
       for i in 0...iterations:
12
           # Create the from location.
13
           from = location
14
           from.x += RADIUS * cos(theta) + randomBinomial() * RAND_RADIUS
15
           from.y += random() * 2 * RAND_RADIUS
16
           from.z += RADIUS * sin(theta) + randomBinomial() * RAND_RADIUS
17
18
           # Check for a valid from location.
19
            if not inSameRoom(from, location):
20
                continue
21
22
           else:
                valid++
23
```

```
24
            # Create the to location.
25
            to = location
26
            to.x += randomBinomial() * characterSize.x
27
            to.y += random() * characterSize.y
28
            to.z += randomBinomial() * characterSize.z
29
30
            # Do the check.
31
            if doesRayCollide(from, to):
32
                hits++
33
34
35
            # Update the angle.
            theta += ANGLE
36
37
        return float(hits) / float(valid)
38
```

In this code, we have used a doesRayCollide function to perform the actual ray cast. rand returns a random number from 0 to 1, and randomBinomial creates a binomially distributed random number from -1 to 1, as before. inSameRoom checks if two locations are in the same room. This can be done very easily with a hierarchical pathfinding graph, for example, or can be calculated using a pathfinder.

There are a number of constants in the function. The RADIUS constant controls how far from the point to begin the attack. This should be far enough so that the attack isn't trivially easy, but not so far that the attack is guaranteed to be in another room. It depends on the scale of your level geometry. The RAND_RADIUS constant controls how much randomness is added to the from location. This should be smaller than RADIUS sin ANGLE; otherwise, we will be moving it farther than it will move to check the next angle, and we'll not cover all the angles correctly. The ANGLE constant controls how many samples around the point are considered. It should be set so that each angle is considered many times (i.e., the smaller the number of iterations, the larger ANGLE should be).

Context-sensitive values can be calculated in the same way as above. Rather than lumping all the results together, we need to calculate the proportion of ray casts that hit coming from each direction or the proportion that hit a crouched or standing character volume, depending on the contexts we are interested in.

If we are running the processing during the game, then there is no reason to choose random directions to test. Instead, we use the enemy characters that the AI is trying to find cover from to check the possibility of hitting the cover point. It is still a good idea to repeat the test several times with different random offsets, however. If time is a critical issue, we can skip this and only check a direct line of sight. This makes the algorithm faster, but it can be foiled by thin structures that happen to block the only ray tested.

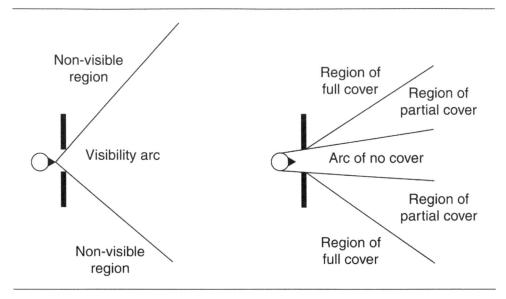

Figure 6.8: Good cover and visibility

Visibility Points

Visibility points are calculated in a similar way to cover points, using many line of sight tests. For each ray cast, we select a location in the vicinity of the cover point. This time we shoot rays out from the waypoint (actually from the position of the character's eyes if it was occupying the waypoint). There is no random component needed around the waypoint. We can use their eye location directly.

The quality of visibility for the waypoint is related to the average length of the rays sent out (i.e., the distance they travel before they hit an object). Because the rays are being shot out, we are approximating the volume of the level that can be seen from the waypoint: a measure of how good the location is for viewing or targeting enemies.

Context-sensitive values can be generated in the same way by grouping the ray tests into a number of different states.

At first glance it might seem like visibility and cover are merely opposites. If a location is a good cover point, then it is a poor visibility point. Because of the way the ray tests are performed, this isn't the case. Figure 6.8 shows a point which has both good cover and reasonable visibility. It's the same logic that has people spying through keyholes: they can see a good amount while maintaining low visibility themselves.

Shadow Points

Shadow points need to be calculated based on the lighting model for a level. Most studios now use some kind of global illumination (radiosity) lighting as a pre-processing step to calculate light maps for in-game use. For titles that involve a great deal of stealth, a dynamic shadow model is used at runtime to render cast shadows from static and moving lights.

To determine the quality of a shadow point, several samples are taken from a charactersized volume around the waypoint. For each sample, the amount of light at the point is tested. This might involve ray casts to nearby light sources to determine if the point is in shadow, or it may involve looking up data from the global illumination model to check the strength of indirect illumination.

Because the aim of a shadow point is to conceal, we take the maximum lightness found in the sampling. If we took the average, then the character would prefer a spot where its body was in very dark shadow but its head was in direct light, over a location where all its body was in moderate shadow. The quality of a hiding position is related to the visibility of the most visible part of the character, not its average visibility as a whole.

For games with dynamic lighting, the shadow calculations need to be performed at runtime. Global illumination is a very slow process, however, and is best performed offline. Combining the two can be problematic. Only in the last five years have developers succeeded in getting simple global illumination models running at interactive frame rates. This uses a form of ray tracing, and while there is interest in using ray tracing more generally as the core rendering mechanism, it is still largely experimental. Even if the experiments successful, we are some years away from that being the state-of-the-art.

Fortunately, in many current-generation games, no global illumination is used at runtime. The environments are simply lit by direct light, and the global illumination is handled with static texture maps. In this case the shadow calculations can be performed over several frames without a severe slowdown.

Compound Tactics

As described earlier, a compound tactic is one that can be assessed by combining a set of primitive tactics. A sniper location might be one that has both cover and good visibility of the level.

If compound tactics are needed in the game, we may be able to generate them as part of a pre-processing step, using the output results of the primitive calculations above. The results can then be stored as an additional channel of tactical information for appropriate waypoints. This only works if the tactics they are using are also available at this time. You can't pre-process a compound tactic based on information that changes during the game.

Alternatively, we can calculate the compound tactical information dynamically during the game by combining the tactical data of nearby waypoints on the fly.

Generating Tactical Properties and Tactical Analysis

Generating the tactical properties of waypoints in this way brings us very close to tactical analysis, a technique I will return to in the next section. Tactical analysis works in a similar way: we try to find the tactical and strategic properties of regions in a game level by combining different concerns together.

Taking tactical waypoints to the extreme, using automatic identification of the tactical properties of a location, would be akin to performing a tactical analysis on a game level. Tactical analysis tends to use larger scale properties—for example, balance of power or influence rather than the amount of cover.

It is not common to recognize the similarity, however. As fairly new techniques in game AI, they both tend to have their own devotees and advocates. It is worth recognizing the similarity and even combining the best of both approaches, as required by your game design.

6.1.4 AUTOMATICALLY GENERATING THE WAYPOINTS

In most games waypoints are specified by the level designer. Cover points, areas that are prone to ambush, and dark corners are all more easily identified by a human being than by an algorithm.

Some developers have experimented with the automatic placement of waypoints. The most promising approaches I have seen are similar to those used in automatically marking up a level for pathfinding.

Watching Human Players

If your game engine supports it, keeping records of the way human players act can provide good information on tactically significant locations. The position of each character is stored at each frame or every few frames. If the character remains in roughly the same location for several samples in a row, or if the same location is used by several characters repeatedly over the course of the game, then it is likely that the location is significant tactically.

With a set of candidate positions, we can then assess their tactical qualities, using the algorithms to assess the tactical quality we saw in the previous section. Locations with sufficient quality are retained as the waypoints to be stored for use in the AI.

It is worth generating far more candidate locations than you will end up using. The assessment of the tactical quality can then filter out the best waypoints from the rest. You do need to be careful in choosing just the best 50 waypoints, for example, because they may be concentrated in one part of the level, leaving no tactical locations in more tactically tight areas (where, conversely, they are probably more important).

A better approach is to make sure the best few locations for each type of tactic in a specific area are kept. This can be achieved using the condensation algorithm (see Section 6.1.5), a technique that can also be used on its own without generating the candidate locations by watching human players.

Condensing a Waypoint Grid

Rather than trying to anticipate the best locations in the game level, we can instead test (almost) every possible location in the level and choose the best.

This is usually done by applying a dense grid to all floor areas in the level and testing each one. First, the locations are tested to make sure they are a valid location for the character to occupy. Locations too close to the walls or underneath obstacles are discarded.

Valid locations are then assessed for tactical qualities in the same way as we saw in the previous section. In order to perform the condensation step, we need to work with real-valued tactical qualities. A simple Boolean value will not suffice.

Normally, we keep a set of threshold values for each tactical property. If a location doesn't make the grade for any property, then it can be immediately discarded. This makes the condensation step much faster.

The threshold levels should be low enough so that many more locations pass than could possibly be needed. This is to avoid discarding locations that are significant, but only marginally. In a room where there is virtually no cover, a location with even very poor cover might be the best place to defend from.

The remaining locations then enter into a condensation algorithm, which ends with only a small number of significant locations in each area of the level for each tactical property. If we used the "watching player actions" technique above, then the tactical locations that resulted could be condensed in the same way as the remaining locations from a grid. Because it is useful in several contexts, it is worth taking a look at the condensation algorithm in more detail.

6.1.5 THE CONDENSATION ALGORITHM

The condensation algorithm works by having tactical locations compete against one another for inclusion into the final set. We would like to keep locations that are either very high quality or a long distance from any other waypoint of the same type.

For each pair of locations, we first check that a character can move between the locations easily. This is almost always done using a line-of-sight test, although it would be better to allow slight deviations. If the movement check fails, then the locations can't compete with one another. Including this check makes sure that we don't remove a waypoint on one side of a wall, for example, because there is a better location on the other side.

If the movement check succeeds, then the quality values for each location are compared. If the difference between the values is greater than a weighted distance between the locations, then the location with the lower value is discarded. There are no hard and fast rules for the weight value to use. It depends on the size of the level, the complexity of the level geometry,

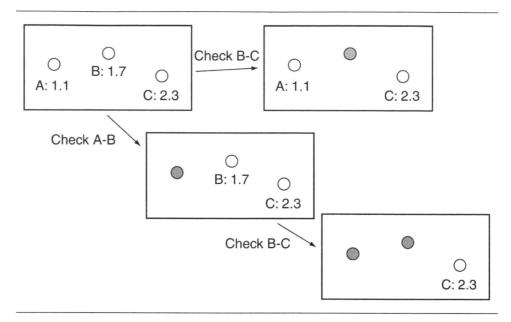

Figure 6.9: Order dependence in condensation checks

and the scale and distribution of quality values for the tactical property. The weight should be selected so that it gives the right number of output waypoints, and that means tweaking by hand so that it looks right. If you use a lower weight value, the difference in quality will be more important, leaving fewer waypoints. Higher weights similarly produce more waypoints.

If there are a large number of waypoints, then there will be a huge number of pairs to consider. Because the final check depends on distance, we can speed this up significantly by only considering pairs of locations that are fairly close together. If we are using a grid representation, this is fairly simple; otherwise, we may have to rely on some other spatial data structure to provide sensible pairs to test.

This condensation algorithm is highly dependent on the order in which pairs of locations are considered. Figure 6.9 shows three locations. If we perform a competition between locations A and B, then A is discarded. B is then checked against C. In this case C wins. We end up with only location C. If we first check B and C, however, then C wins. A is now too far from C for C to beat it, so both C and A remain.

To avoid removing a series of waypoints in this way, we start with the strongest waypoints and work down to the weakest. For each of these waypoints, we perform the competition against other waypoints working from the weakest to the strongest. The first waypoint check, therefore, is between the strongest and the weakest. Because we will only consider pairs of waypoints fairly close to one another, the first check is likely to be between the overall strongest waypoint and the weakest nearby waypoint.

The condensation phase should be carried out for each different tactical property. There is no use discarding a cover point because there is a good nearby ambush location, for example. The tactical locations that make it through the algorithm are those that are left in any property after condensation.

Pseudo-Code

The algorithm can be implemented in the following way:

```
function condenseWaypoints(waypoints: WaypointList,
                                distanceWeight: float):
2
       # We only ever need this squared, so do it now.
       distanceWeightSq = distanceWeight * distanceWeight
5
       # Sort the list in decreasing order.
       waypoints.sortReversed()
       # Loop through.
       while current:
10
            # Get the next waypoint.
11
           current: Waypoint = waypoints.next()
12
13
            # Find and sort its neighbors.
14
           neighbors: WaypointList = waypoints.getNearby(current)
15
            neighbors.sort()
16
17
            # Check each in turn.
           while neighbors:
19
                target: Waypoint = neighbors.next()
20
21
                # If the target's value is higher than
22
                # ours, then we've already performed this
23
                # check (when the target was the current) and
24
                # all subsequent checks on the neighbors.
25
                if target.value > current.value:
26
                    break
27
28
                # Check for easy movement.
29
                if not canMove(current, target):
30
                    continue
31
32
                # Perform competition calculations.
33
                deltaPos = current.position - target.position
34
                deltaPosSq = deltaPos * deltaPos * distanceWeightSq
35
                deltaVal = current.value - target.value
36
                deltaValSq = deltaVal * deltaVal
37
```

```
38
                # Check if the difference is value is significant.
39
                if deltaPosSq < deltaValSq:</pre>
40
                    # They are close enough so the target loses.
41
                    neighbors.remove(target)
42
                    waypoints.remove(target)
43
```

Data Structures and Interfaces

The algorithm assumes we can get position and value from the waypoints. They should have the following structure:

```
class Waypoint:
      # The position of the waypoint.
2
      position: Vector
3
4
      # The value of the waypoint for the tactic we are condensing.
5
      value: float
```

The waypoints are presented in a data structure in a way that allows the algorithm to extract the elements in sequence and to perform a spatial query to get the nearby waypoints to any given waypoint. The order of elements is set by a call to either sort or sortReversed, which orders the elements either by increasing or decreasing value, respectively. The interface looks like the following:

```
class WaypointList:
       # Initializes the iterator to move in order of increasing value.
2
       function sort()
5
       # Initializes the iterator to move in order of decreasing value.
       function sortReversed()
6
       # Return a new waypoint list containing those waypoints that are
8
       # near to the given one.
9
       function getNearby(waypoint: Waypoint) -> WaypointList
10
11
       # Return the next waypoint in the iteration. Iterations are
12
       # initialized by a call to one of the sort functions. Note that
13
       # this function must work in such a way that remove() can be
       # called between calls to next() without causing problems.
       function next() -> Waypoint
17
18
       # Remove the given waypoint from the list.
       function remove(waypoint: Waypoint)
19
```

The Trade-Off

Watching player actions produces better quality tactical waypoints than simply condensing a grid. On the other hand, it requires additional infrastructure to capture player actions and a lot of playing time by testers. To get a similar quality using condensation, we need to start with an exceptionally dense grid (in the order of every 10 centimeters of game space for average human-sized characters). This also has time implications. For a reasonably sized level, there could be billions of candidate locations to check. This can take many minutes or hours, depending on the complexity of the tactical assessment algorithms being used.

The results from these algorithms are less robust than the automatic generation of pathfinding meshes (which have been used without human supervision), because the tactical properties of a location apply to such a small area. Automatic generation of waypoints involves generating locations and testing them for tactical properties. If the generated location is even slightly out, its tactical properties can be very different. A location slightly to the side of a pillar, for example, has no cover, whereas it might provide perfect cover if it were immediately behind the pillar.

When graphs for pathfinding are automatically generated, however, the same kind of small error rarely makes any difference.

Because of this, I am not aware of anyone reliably using automatic tactical waypoint generation without some degree of human supervision. Automatic algorithms can provide a useful initial guess at tactical locations, but you will probably need to add facilities into your level design tool to allow the locations to be tweaked by the level designer.

Before you embark on implementing an automatic system, make sure you work out whether the implementation effort will be worth it for time saved in level design. If you are designing huge, tactically complex levels, it may be so. If there will only be a few tens of waypoints of each kind in a level, then it is probably better to go the manual route.

6.2 TACTICAL ANALYSES

Tactical analyses of all kinds are sometimes known as influence maps. Influence mapping is a technique pioneered and widely applied in real-time strategy games, where the AI keeps track of the areas of military influence for both sides. Similar techniques have also made inroads into squad-based shooters and massively multi-player games. For this chapter, I will refer to the general approach as tactical analysis to emphasize that military influence is only one thing we might base our tactics on.

In military simulation an almost identical approach is commonly called terrain analysis (a phrase also used in game AI), although again that also more properly refers to just one type of tactical analysis. I will describe both influence mapping and terrain analysis in this section, as well as general tactical analysis architectures.

There is not much difference between tactical waypoint approaches and tactical analyses. By and large, papers and talks on AI have treated them as separate beasts, and admittedly the technical problems are different depending on the genre of game being implemented. The general theory is remarkably similar, however, and the constraints in some games (in shooters, particularly) mean that implementing the two approaches would give pretty much the same structure.

6.2.1 REPRESENTING THE GAME LEVEL

For tactical analysis the game level needs to be split into chunks. The areas contained in each chunk should have roughly the same properties for any tactics we are interested in. If we are interested in shadows, for example, then all locations within a chunk should have roughly the same amount of illumination.

There are lots of different ways to split a level. The problem is exactly the same as for pathfinding (in pathfinding we are interested in chunks with the same movement characteristics), and all the same approaches can be used: Dirichlet domains, floor polygons, and so

Because of the ancestry of tactical analysis in RTS games, the overwhelming majority of current implementations are based on a tile-based grid. This may change over time, as the technique is applied to more indoor games, but most current papers and books talk exclusively about tile-based representations.

This does not mean that the level itself has to be built from graphical tiles, of course. Very few games are purely tile based anymore, with notable holdouts among indie games. As we saw the chapter on pathfinding, however, tiles are very often lurking just under the surface. The outdoor sections of RTS, shooters, and other genres normally use a grid-based height field for rendering terrain. For a non-tile-based level, we can impose a grid over the geometry and use the grid for tactical analysis.

I haven't been involved in a game that used non-tile-based domains for tactical analysis, but my understanding is that developers have experimented with this approach and have had some success. The disadvantage of having a more complex level representation is balanced against having fewer, more homogeneous, regions.

My advice would be to use a grid representation initially, for ease of implementation and debugging, and then experiment with other representations when you have the core code robust.

6.2.2 SIMPLE INFLUENCE MAPS

An influence map keeps track of the current balance of military influence at each location in the level. There are many factors that might affect military influence: the proximity of a military unit, the proximity of a well-defended base, the duration since a unit last occupied a location, the surrounding terrain, the current financial state of each military power, the weather, and so on.

There is scope to take advantage of a huge range of different factors when creating a tac-

tical or strategic AI. Most factors only have a small effect, however. Rainfall is unlikely to dramatically affect the balance of power in a game (although it often has a surprisingly significant effect in real-world conflict). We can build up complex influence maps, as well as other tactical analyses, from many different factors, and we'll return to this combination process later in the section. For now, let's focus on the simplest influence maps, responsible for (I estimate) 90% of the influence mapping in games.

Most games make influence mapping easier by applying a simplifying assumption: military influence is primarily a factor of the proximity of enemy units and bases and their relative military power.

Simple Influence

If four infantry soldiers in a fire team are camped out in a field, then the field is certainly under their influence, but probably not very strongly. Even a modest force (such as a single platoon) would be able to take it easily. If we instead have a helicopter gunship hovering over the same corner, then the field is considerably more under their control. If the corner of the field is occupied by an anti-aircraft battery, then the influence may be somewhere between the two (anti-aircraft guns aren't so useful against a ground-based force, for example).

Influence is taken to drop off with distance. The fire team's decisive influence doesn't significantly extend beyond the hedgerow of the next field. The Apache gunship is mobile and can respond to a wide area, but when stationed in one place its influence is only decisive for a mile or so. The gun battery may have a larger radius of influence.

If we think of power as a numeric quantity, then the power value drops off with distance: the farther from the unit, the smaller the value of its influence. Eventually, its influence will be so small that it is no longer felt.

We can use a linear drop off to model this: double the distance and we get half the influence. The influence is given by:

$$I_d = \frac{I_0}{1+d}$$

where I_d is the influence at a given distance, d, and I_0 is the influence at a distance of 0. This is equivalent to the intrinsic military power of the unit. We could instead use a more rapid initial drop off, but with a longer range of influence, such as:

$$I_d = \frac{I_0}{\sqrt{1+d}}$$

for example. Or we could use something that plateaus first before rapidly tailing off at a distance:

$$I_d = \frac{I_0}{(1+d)^2}$$

has this format. It is also possible to use different drop-off equations for different units. In

practice, however, the linear drop off is perfectly reasonable and gives good results. It is also faster to process.

In order for this analysis to work, we need to assign each unit in the game a single military influence value. This might not be the same as the unit's offensive or defensive strength: a reconnaissance unit might have a large influence (it can command artillery strikes, for example) with minimal combat strength.

The values should usually be set by the game designers. Because they can affect the AI considerably, some tuning is almost always required to get the balance right. During this process it is often useful to be able to visualize the influence map, as a graphical overlay into the game, to make sure that areas clearly under a unit's influence are being picked up by the tactical analysis.

Given the drop-off formula for the influence at a distance and the intrinsic power of each unit, we can work out the influence of each side on each location in the game: who has control there and by how much. The influence of one unit on one location is given by the drop-off formula above. The influence for a whole side is found by simply summing the influence of each unit belonging to that side.

The side with the greatest influence on a location can be considered to have control over it, and the degree of control is the difference between its winning influence value and the influence of the second placed side. If this difference is very large, then the location is said to be secure.

The final result is an influence map: a set of values showing both the controlling side and the degree of influence (and optionally the degree of security) for each location in the game.

Figure 6.10 shows an influence map calculated for all locations on a tiny RTS map. There are two sides, white and black, with a few units on each side. The military influence of each unit is shown as a number. The border between the areas that each side controls is also shown.

Calculating the Influence

To calculate the map we need to consider each unit in the game for each location in the level. This is obviously a huge task for anything but the smallest levels. With a thousand units and a million locations (well within the range of current RTS games), a billion calculations would be needed. In fact, execution time is O(nm), and memory is O(m), where m is the number of locations in the level, and n is the number of units.

There are three approaches we can use to improve matters: limited radius of effect, convolution filters, and map flooding.

Limited Radius of Effect

The first approach is to limit the radius of effect for each unit. Along with a basic influence, each unit has a maximum radius. Beyond this radius the unit cannot exert influence, no matter how weak. The maximum radius might be manually set for each unit, or we could use a threshold. If we use the linear drop-off formula for influence, and if we have a threshold

W	W	W	W	W	W	W	W	W	W	W	W	W	W	W	W
W	W	W	W	W ₂	W	W	W	W	W 3	W	W	W	W	W	В
W	W ₄	W	W	W	W	W	W	W_2	W	W	W	W	W	В	В
W	W	W	W	W	W	W	W	W	W	W	W	W	В	В	B 2
W	W	W	W ₂	W	W ₁	W	W	W	W	w	W	W	В	В	В
W	W	W	W	W	W	W	W	W	W	w	W	В	В	В	В
W	W	W	W	W	W	W	W	W	w	W	В	B 2	В	В	В
W	W	W	W	W	W	W	W	W	W	W	В	В	В	В	В
W	W	W	W	W	W	W	W	W	W	В	В	В	В	B 2	В
W	W	W	W	W	W	W	W	W	В	В	В	В	В	В	В
W	W	W	W	w	W	W	W	В	В	В	В	В	В	В	В
W	W	W	W	W	W	W	W	В	В	B 2	В	В	В	В	В
W	В	В	В	В	W	W	В	В	В	В	В	В	В	В	В
В	В	B 2	В	В	В	В	В	В	В	В	В	В	В	В	В
В	В	В	В	В	В	В	В	В	В	В	В	В	В	В	В
В	В	В	В	В	В	В	В	В	В	В	В	В	В	В	В

Figure 6.10: An example influence map

influence (beyond which influence is considered to be zero), then the radius of influence is given by:

$$r = \frac{I_0}{I_t - 1}$$

where I_t is the threshold value for influence.

This approach allows us to pass through each unit in the game, adding its contribution to only those locations within its radius. We end up with O(nr) in time and O(m) in memory, where r is the number of locations within the average radius of a unit. Because r is going to be much smaller than m (the number of locations in the level), this is a significant reduction in execution time.

The disadvantage of this approach is that small influences don't add up over large distances. Three infantry units could together contribute a reasonable amount of influence to a location between them, although individually they have very little. If a radius is used and the location is outside this influence, it would have no influence even though it is surrounded by troops who could take it at will.

Convolution Filters

The second approach applies techniques more common in computer graphics. We start with the influence map where the only values marked are those where the units are actually located. You can imagine these as spots of influence in the midst of a level with no influence. Then the algorithm works through each location and changes its value so it incorporates not only its own value but also the values of its neighbors. This has the effect of blurring out the initial spots so that they form gradients reaching out. Higher initial values get blurred out further.

This approach uses a filter: a rule that says how a location's value is affected by its neighbors. Depending on the filter, we can get different kinds of blurring. The most common filter is called a Gaussian, and it is useful because it has mathematical properties that make it even easier to calculate.

To perform filtering, each location in the map needs to be updated using this rule. To make sure the influence spreads to the limits of the map, we need to then repeat the whole update several times again. If there are significantly fewer units in the game than there are locations in the map (I can't imagine a game when this wouldn't be true), then this approach is more expensive than even our initial naive algorithm. Because it is a graphics algorithm, however, it is easy to implement using graphical techniques.

I will return to filtering, including a full algorithm, later in this chapter.

Map Flooding

The last approach uses an even more dramatic simplifying assumption: the influence of each location is equal to the largest influence contributed by any unit. In this assumption if a tank is covering a street, then the influence on that street is the same even if 20 solders arrive to also cover the street. Clearly, this approach may lead to some errors, as the AI assumes that a huge number of weak troops can be overpowered by a single strong unit (a very dangerous assumption).

On the other hand, there exists a very fast algorithm to calculate the influence values, based on the Dijkstra algorithm we saw in Chapter 4. The algorithm floods the map with values, starting from each unit in the game and propagating its influence out.

Map flooding can usually perform in around $O(\min[nr, m])$ time and can exceed O(nr)time if many locations are within the radius of influence of several units (it is O(m) in memory, once again). Because it is so easy to implement and is fast in operation, several developers favor this approach. The algorithm is useful beyond simple influence mapping and can also incorporate terrain analysis while performing its calculations. We will analyze it in more depth in Section 6.2.6.

Whatever algorithm is used for calculating the influence map, it will still take a while. The balance of power on a level rarely changes dramatically from frame to frame, so it is normal for the influence mapping algorithm to run over the course of many frames. All the algorithms can be easily interrupted. While the current influence map may never be completely up to date, even at a rate of one pass through the algorithm every 10 seconds, the data are usually sufficiently recent for character AI to look sensible.

I will also return to this algorithm later in the chapter, after we have looked at other kinds of tactical analyses besides influence mapping.

Applications

An influence map allows the AI to see which areas of the game are safe (those that are very secure), which areas to avoid, and where the border between the teams is weakest (i.e., where there is little difference between the influence of the two sides).

Figure 6.11 shows the security for each location in the same map as we looked at previously. Look at the region marked. You can see that, although white has the advantage in this area, its border is less secure. The region near black's unit has a higher security (paler color) than the area immediately over the border. This would be a good point to mount an attack, since white's border is much weaker than black's border at this point.

The influence map can be used to plan attack locations or to guide movement. A decision making system that decides to "attack enemy territory," for example, might look at the current influence map and consider every location on the border that is controlled by the enemy. The location with the smallest security value is often a good place to launch an attack. A more sophisticated test might look for a connected sequence of such weak points to indicate a weak area in the enemy defense. A (usually beneficial) feature of this approach is that flanks often show up as weak spots in this analysis. An AI that attacks the weakest spots will tend naturally to prefer flank attacks.

The influence map is also perfectly suited for tactical pathfinding (explored in detail later in this chapter). It can also be made considerably more sophisticated, when needed, by combining its results with other kinds of tactical analyses, as we'll see later.

Dealing with Unknowns

If we do a tactical analysis on the units we can see, then we run the risk of underestimating the enemy forces. Typically, games don't allow players to see all of the units in the game. In indoor environments we may be only able to see characters in direct line of sight. In outdoor environments units typically have a maximum distance they can see, and their vision may be additionally limited by hills or other terrain features. This is often called "fog-of-war" (but isn't the same thing as fog-of-war in military-speak).

The influence map on the left of Figure 6.12 shows only the units visible to the white side. The squares containing a question mark show the regions that the white team cannot see. The influence map made from the white team's perspective shows (incorrectly) that they control

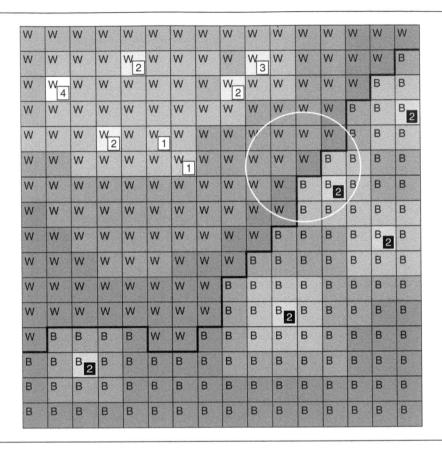

Figure 6.11: The security level of the influence map

a large proportion of the map. If we knew the full story, the influence map on the right would be created.

The second issue with lack of knowledge is that each side has a different subset of the whole knowledge. In the example above, the units that the white team is aware of are very different from the units that the black team is aware of. They both create very different influence maps. With partial information, we need to have one set of tactical analyses per side in the game. For terrain analysis and many other tactical analyses, each side has the same information, and we can get away with only a single set of data.

Some games solve this problem by allowing all of the AI players to know everything. This allows the AI to build only one influence map, which is accurate and correct for all sides. The AI will not underestimate the opponent's military might. This is widely viewed as cheating, however, because the AI has access to information that a human player would not have. It can be quite oblivious. If a player secretly builds a very powerful unit in a well-hidden region of

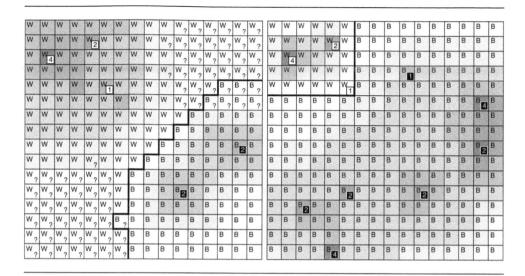

Figure 6.12: Influence map problems with lack of knowledge

the level, they would be frustrated if the AI launched a massive attack aimed directly at the hidden super-weapon, obviously knowing full well that it was there. In response to cries of foul, developers have recently stayed away from building a single influence map based on the correct game situation.

When human beings see only partial information, they make force estimations based on a prediction of what units they can't see. If you see a row of pike men on a medieval battlefield, you may assume there is a row of archers somewhere behind, for example. Unfortunately, it is very difficult to create AI that can accurately predict the forces it can't see. One approach is to use neural networks with Hebbian learning. A detailed run-through of this example is given in Chapter 7.

6.2.3 **TERRAIN ANALYSIS**

Behind influence mapping, the next most common form of tactical analysis deals with the properties of the game terrain. Although it doesn't necessarily need to work with outdoor environments, the techniques in this section originated for outdoor simulations and games, so the "terrain analysis" name fits. Earlier in the chapter we looked at waypoint tactics in depth. These are more common for indoor environments, although in practice there is almost no difference between the two.

Terrain analysis tries to extract useful data from the structure of the landscape. The most common data to extract are the difficulty of the terrain (used for pathfinding or other movement) and the visibility of each location (used to find good attacking locations and to avoid being seen). In addition, other data, such as the degree of shadow, cover, or the ease of escape, can be obtained in the same way.

Unlike influence mapping, most terrain analyses will always be calculated on a locationby-location basis. For military influence we can use optimizations that spread the influence out starting from the original units, allowing us to use the map flooding techniques later in the chapter. For terrain analysis this doesn't normally apply.

The algorithm simply visits each location in the map and runs an analysis algorithm for each one. The analysis algorithm depends on the type of information we are trying to extract.

Terrain Difficulty

Perhaps the simplest useful information to extract is the difficulty of the terrain at a location. Many games have different terrain types at different locations in the game. This may include rivers, swampland, grassland, mountains, or forests. Each unit in the game will face a different level of difficulty moving through each terrain type. We can use this difficulty directly; it doesn't qualify as a terrain analysis because there's no analysis to do.

In addition to the terrain type, it is often important to take account of the ruggedness of the location. If the location is grassland at a one in four gradient, then it will be considerably more difficult to navigate than a flat pasture.

If the location corresponds to a single height sample in a height field (a very common approach for outdoor levels), the gradient can easily be calculated by comparing the height of a location with the height of neighboring locations. If the location covers a relatively large amount of the level (a room indoors, for example), then its gradient can be estimated by making a series of random height tests within the location. The difference between the highest and the lowest sample provides an approximation to the ruggedness of the location. You could also calculate the variance of the height samples, which may also be faster if well optimized.

Whichever gradient calculation method we use, the algorithm for each location takes constant time (assuming a constant number of height checks per location, if we use that technique). This is relatively fast for a terrain analysis algorithm, and combined with the ability to run terrain analyses offline (as long as the terrain doesn't change), it makes terrain difficulty an easy technique to use without heavily optimizing the code.

With a base value for the type of terrain and an additional value for the gradient of the location, we can calculate a final terrain difficulty. The combination may use any kind of function—a weighted linear sum, for example, or a product of the base and gradient values. This is equivalent to having two different analyses—the base difficulty and the gradient—and applying a multitiered analysis approach. We'll look at more issues in combining analyses later in the section on multi-tiered analysis.

There is nothing to stop us from including additional factors into the calculation of terrain difficulty. If the game supports breakdowns of equipment, we might add a factor for how punishing the terrain is. For example, a desert may be easy to move across, but it might take its toll on machinery. The possibilities are bounded only by what kinds of features you want to implement in your game design.

Visibility Map

The second most common terrain analysis I have worked with is a visibility map. There are many kinds of tactics that require some estimation of how exposed a location is. If the AI is controlling a reconnaissance unit, it needs to know locations that can see a long way. If it is trying to move without being seen by the enemy, then it needs to use locations that are well hidden instead.

The visibility map is calculated in the same way as we calculated visibility for waypoint tactics: we check the line of sight between the location and other significant locations in the level.

An exhaustive test will test the visibility between the location and all other locations in the level. This is very time consuming, however, and for very large levels it can take many minutes. There are algorithms intended for rendering large landscapes that can perform some important optimizations, culling large areas of the level that couldn't possibly be seen. Indoors, the situation is typically better still, with even more comprehensive tools for culling locations that couldn't possibly be seen. The algorithms are beyond the scope of this book but are covered in most texts on programming rendering engines.

Another approach is to use only a subset of locations. We can use a random selection of locations, as long as we select enough samples to give a good approximation of the correct result.

We could also use a set of "important" locations. This is normally only done when the terrain analysis is being performed online during the game's execution. Here, the important locations can be key strategic locations (as decided by the influence map, perhaps) or the location of enemy forces.

Finally, we could start at the location we are testing, shoot out rays at a fixed angular interval, and test the distance they travel, as we saw for waypoint visibility checks. This is a good solution for indoor levels, but doesn't work well outdoors because it is not easy to account for hills and valleys without shooting a very large number of rays.

Regardless of the method chosen, the end point will be an estimate of how visible the map is from the location. This will usually be the number of locations that can be seen, but may be an average ray length if we are shooting out rays at fixed angles.

6.2.4 LEARNING WITH TACTICAL ANALYSES

So far I have described analyses that involve finding information about the game level. The values in the resulting map are calculated by analyzing the game level and its contents.

A slightly different approach has been used successfully to support learning in tactical AI. We start with a blank tactical analysis and perform no calculations to set its values. During the game, whenever an interesting event happens, we change the values of some locations in the map.

For example, suppose we are trying to avoid our character falling into the same trap repeatedly by being ambushed. We would like to know where the player is most likely to lay a trap and where it is best to avoid. While we can perform analysis for cover locations, or ambush waypoints, the human player is often more ingenious than our algorithms and can find creative ways to lay an ambush.

To solve the problem we create a "frag-map." This initially consists of an analysis where each location gets a zero. Each time the AI sees a character get hit (including itself), it subtracts a number from the location in the map corresponding to the victim. The number to subtract could be proportional to the amount of hit points lost. In most implementations, developers simply use a fixed value each time a character is killed (after all the player doesn't normally know the amount of hit points lost when another player is hit, so it would be cheating to give the AI that information). We could alternatively use a smaller value for non-fatal hits.

Similarly, if the AI sees a character hit another character, it increases the value of the location corresponding to the attacker. The increase can again be proportional to the damage, or it may be a single value for a kill or non-fatal hit.

Over time we will build up a picture of the locations in the game where it is dangerous to hang about (those with negative values) and where it is useful to stand to pick off enemies (those with positive values). The frag-map is independent of any analysis. It is a set of data learned from experience.

For a very detailed map, it can take a lot of time to build up an accurate picture of the best and worst places. We only find a reasonable value for a location if we have several experiences of combat at that location. We can use filtering (see later in this section) to take the values we do know and expand them out to form estimates for locations we have no experience of.

Frag-maps are suitable for offline learning. They can be compiled during testing to build up a good approximation of the potential for a level. In the final game they will be fixed.

Alternatively, they can be learned online during the game execution. In this case it is usually common to take a pre-learned version as the basis to avoid having to learn really obvious things from scratch. It is also common, in this case, to gradually move all the values in the map toward zero. This effectively "unlearns" the tactical information in the frag-map over time. This is done to make sure that the character adapts to the player's playing style.

Initially, the character will have a good idea where the hot and dangerous locations are from the pre-compiled version of the map. The player is likely to react to this knowledge, trying to set up attacks that expose the vulnerabilities of the hot locations. If the starting values for these hot locations are too high, then it will take a huge number of failures before the AI realizes that the location isn't worth using. This can look stupid to the player: the AI repeatedly using a tactic that obviously fails.

If we gradually reduce all the values back toward zero, then after a while all the character's knowledge will be based on information learned from the player, and so the character will be tougher to beat.

Figure 6.13 shows this in action. In the first diagram we see a small section of a level

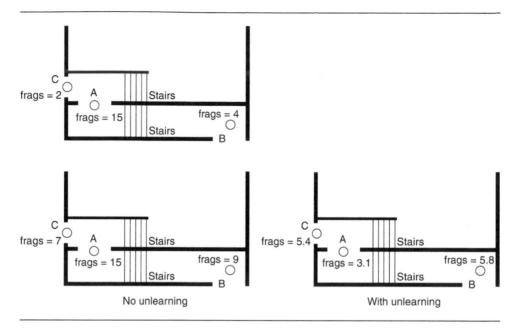

Figure 6.13: Learning a frag-map

with the danger values created from play testing. Note the best location to ambush from, A, is exposed from two directions (locations B and C). We have assumed that the AI character gets killed ten times in location A by five attacks from B and C. The second map shows the values that would result if there was no unlearning: A is still the best location to occupy. A frag provides +1 point to the attacker's location and -1 point to that of the victim; it will take another 10 frags before the character learns its lesson. The third map shows the values that would result if all the values are multiplied by 0.9 before each new frag is logged. In this case location A will no longer be used by the AI; it has learned from its mistakes. In a real game it may be beneficial to forget even more quickly: the player may find it frustrating that it takes even five frags for the AI to learn that a location is vulnerable.

If we are learning online, and gradually unlearning at the same time, then it becomes crucial to try to generalize from what the character does know into areas that it has no experience of. The filtering technique later in the section gives more information on how to do this.

6.2.5 A STRUCTURE FOR TACTICAL ANALYSES

So far we've looked at the two most common kinds of tactical analyses: influence mapping (determining military influence at each location) and terrain analysis (determining the effect of terrain features at each location).

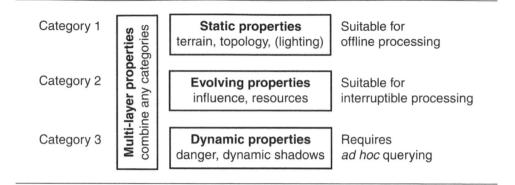

Figure 6.14: Tactical analyses of differing complexity

Tactical analysis isn't limited to these concerns, however. Just as we saw for tactical way-points, there may be any number of different pieces of tactical information that we might want to base our decisions on. We may be interested in building a map of regions with lots of natural resources to focus an RTS side's harvesting/mining activities. We may be interested in the same kind of concerns we saw for waypoints: tracking the areas of shadow in the game to help a character move in stealth. The possibilities are endless.

We can distinguish different types of tactical analyses based on the when and how they need to be updated. Figure 6.14 illustrates the differences.

In the first category are those analyses that calculate unchanging properties of the level. These analyses can be performed offline before the game begins. The gradients in an outdoor landscape will not change, unless the landscape can be altered (some RTS games do allow the landscape to be altered). If the lighting in a level is constant (i.e., you can't shoot out the lights or switch them off), then shadow areas can often be calculated offline. If your game supports dynamic shadows from movable objects, then this will not be possible.

In the second category are those analyses that change slowly during the course of the game. These analyses can be performed using updates that work very slowly, perhaps only reconsidering a handful of locations at each frame. Military influence in an RTS can often be handled in this way. The coverage of fire and police in a city simulation game could also change quite slowly.

In the third category are properties of the game that change very quickly. To keep up, almost the whole level will need to be updated every frame. These analyses are typically not suited for the algorithms in this chapter. We'll need to handle rapidly changing tactical information slightly differently.

Updating almost any tactical analysis for the whole level at each frame is too time consuming. For even modestly sized levels it can be noticeable. For RTS games with their larger level sizes, it will often be impossible to recalculate all the levels within one frame's processing time. No optimization can get around this; it is a fundamental limitation of the approach.

To make some progress, however, we can limit the recalculation to those areas that we are planning to use. Rather than recalculate the whole level, we simply recalculate those areas that are most important. This is an ad hoc solution: we defer working any data out until we know they are needed. Deciding which locations are important depends on how the tactical analysis system is being used.

The simplest way to determine importance is the neighborhood of the AI-controlled characters. If the AI is seeking a defensive location away from the enemy's line of sight (which is changing rapidly as the enemy move in and out of cover), then we only need to recalculate those areas that are potential movement sites for the characters. If the tactical quality of potential locations is changing fast enough, then we need to limit the search to only nearby locations (otherwise, the target location may end up being in line of sight by the time we get there). This limits the area we need to recalculate to just a handful of neighboring locations.

Another approach to determine the most important locations is to use a second-level tactical analysis, one that can be updated gradually and that will give an approximation to the third-level analysis. The areas of interest from the approximation can then be examined in more depth to make a final decision.

For example, in an RTS, we may be looking for a good location to keep a super-unit concealed. Enemy reconnaissance flights can expose a secret very easily. A general analysis can keep track of good hiding locations. This could be a second-level analysis that takes into account the current position of enemy armor and radar towers (things that don't move often) or a first-level analysis that simply uses the topography of the level to calculate low-visibility spots. At any time, the game can examine the candidate locations from the lower level analysis and run a more complete hiding analysis that takes into account the current motion of recon flights.

Multi-Layer Analyses

For each tactical analysis the end result is a set of data on a per-location basis: the influence map provides an influence level, side, and optionally a security level (one or two floating point numbers and an integer representing the side); the shadow analysis provides shadow intensity at each location (a single floating point number); and the gradient analysis provides a value that indicates the difficulty of moving through a location (again, a single floating point number).

In Section 6.1 we looked at combining simple tactics into more complex tactical information. The same process can be done for tactical analyses. This is sometimes called multi-layer analysis, and I've shown it on the schematic for tactical analyses (Figure 6.14) as spanning all three categories: any kind of input tactical analysis can be used to create the compound information.

Imagine we have an RTS game where the placement of radar towers is critical to success. Individual units can't see very far alone. To get a good situational awareness we need to build long-distance radar. We need a good method for working out the best locations for placing the radar towers.

Let's say, for example, that the best radar tower locations are those with the following properties:

- Wide range of visibility (to get the maximum information)
- In a well-secured location (towers are typically easy to destroy)
- Far from other radar towers (no point duplicating effort)

In practice, there may be other concerns also, but we'll stick with these for now. Each of these three properties is the subject of its own tactical analysis. The visibility tactic is a kind of terrain analysis, and the security is based on a regular influence map.

The distance from other towers is also a kind of influence map. We create a map where the value of a location is given by the distance to other towers. This could be just the distance to the nearest tower, or it might be some kind of weighted value from several towers. We can simply use the influence map function covered earlier to combine the influence of several radar positions.

The three base tactical analyses are finally combined into a single value that demonstrates how good a location is for a radar base.

The combination might be of the form:

$$Quality = Security \times Visibility \times Distance$$

where "Security" is a value for how secure a location is. If the location is controlled by another side, this should be zero. "Visibility" is a measure of how much of the map can be seen from the location, and "Distance" is the distance from the nearest tower. If we use the influence formula to calculate the influence of nearby towers, rather than the distance to them, then the formula may be of the form:

$$Quality = \frac{Security \times Visibility}{Tower Influence}$$

although we need to make sure the influence value is never zero.

Figure 6.15 shows the three separate analyses and the way they have been combined into a single value for the location of a radar tower. Even though the level is quite small, we can see that there is a clear winner for the location of the next radar tower.

There is nothing special in the way the three terms have been combined here, and there may be better ways to put them together, using a weighted sum, for example (although then care needs to be taken not to try to build on another side's territory). The formula for combining the layers needs to be created by the developer, and in a real game, it will involve fine tuning and tweaking.

I have found throughout my career building game AI that whenever something needs tweaking, it is almost essential to be able to visualize it in the game. In this case I would support a mode where the tower-placement value can be displayed in the game at any time

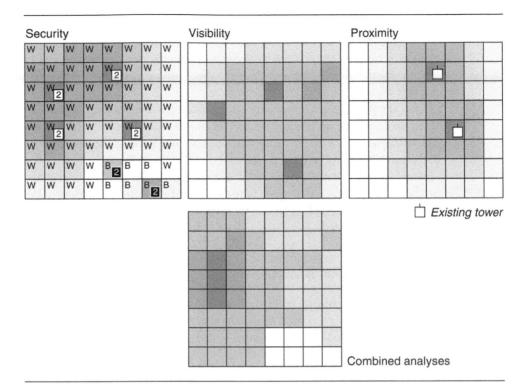

Figure 6.15: The combined analyses

(this would only be part of the debug version, not the final distribution) so the results of combining each feature can be clearly seen.

When to Combine Things

Combining tactical analyses is exactly the same as using compound tactics with waypoints: we can choose when to perform the combination step.

If the base analyses are all calculated offline, then we have the option of performing the combination offline also and simply storing its results. This might be the best option for a tactical analysis of terrain difficulty: combining gradient, terrain type, and exposure to enemy fire, for example.

If any of the base analyses are changed during the game, then the combined value needs to be recalculated. In our example above, both the security level and distance to other towers change over the course of the game, so the whole analysis needs to be recalculated during the game also.

Considering the hierarchy of tactical analyses introduced earlier, the combined analysis

will be in the same category as the highest base analysis it relies on. If all the base analyses are in category one, then the combined value will also be in category one. If we have one base analysis in category one and two base analyses in category two (as in our radar example), then the overall analysis will also be in category two. We'll need to update it during the game, but not very rapidly.

For analyses that aren't used very often, we could also calculate values only when needed. If the base analyses are readily available, we can query a value and have it created on the fly. This works well when the AI is using the analysis a location at a time—for example, for tactical pathfinding. If the AI needs to consider all the locations at the same time (to find the highest scoring location in the whole graph), then it may take too long to perform all the calculations on the fly. In this case it is better to have the calculations being performed in the background (possibly taking hundreds of frames to completely update) so that a complete set of values is available when needed.

Building a Tactical Analysis Server

If your game relies heavily on tactical analyses, then it is worth investing the implementation time in building a tactical analysis server that can cope with each different category of analysis. Personally, I have only needed to do this once, but building a common application programming interface (API) that allowed any kind of analysis (as a plug-in module), along with any kind of combination, allowed a very generic visualization system to be built, and really helped speed up the addition and debugging of new tactical concerns. Unlike the example I gave earlier, in this system only weighted linear combinations of analyses were supported. This made it easier to build a simple data file format that showed how to combine primitive analyses into compound values.

The server should support distributing updates over many frames, calculating some values offline (or during loading of the level) and calculating values only when they are needed. This can easily be based on the time-slicing and resource management systems discussed in Chapter 10, Execution Management (this was our approach, and it worked well).

6.2.6 MAP FLOODING

The techniques developed in Chapter 4 are used to split the game level into regions. In particular, tiles or Dirichlet domains are widely used, with points of visibility and navigation meshes being less practical. Individual tiles in a tile-based game may be too small for tactical analysis, and tiles may benefit from being grouped together into larger regions.

The same techniques used for pathfinding can be used to calculate Dirichlet domains in influence maps. When we have a tile-based level, however, these two different sets of regions can be difficult to reconcile. Fortunately, there is a technique for calculating the Dirichlet domains on tile-based levels. This is map flooding, and it can be used to work out which tile locations are closer to a given location than any other. Beyond Dirichlet domains, map

flooding can be used to move properties around the map, so the properties of intermediate locations can be calculated.

Starting from a set of locations with some known property (such as the set of locations where there is a unit), we'd like to calculate the properties of every other location. As a concrete example we'll consider an influence map for a strategy game: a location in the game belongs to the player who has the nearest city to that location. This would be an easy task for a map flooding algorithm. To show off a little more of what the algorithm can do, we can make things harder by adding some complications:

- · Each city has a strength, and stronger cities tend to have larger areas of influence than weaker ones.
- The region of a city's influence should extend out from the city in a continuous area. It can't be split into multiple regions.
- Cities have a maximum radius of influence that depends on the city's strength.

We'd like to calculate the territories for the map. For each location we need to know the city that it belongs to (if any).

The Algorithm

We will use a variation of the Dijkstra algorithm we saw in Chapter 4.

The algorithm starts with the set of city locations. We'll call this the open list. Internally, we keep track of the controlling city and strength of influence for each location in the level.

At each iteration the algorithm takes the location with the greatest strength and processes it. We'll call this the current location. Processing the current location involves looking at the location's neighbors and calculating the strength of influence for each location for just the city recorded in the current node.

This strength is calculated using an arbitrary algorithm (i.e., we will not care how it is calculated). In most cases it will be the kind of drop-off equation we saw earlier in the chapter, but it could also be generated by taking the distance between the current and neighboring locations into account. If the neighboring location is beyond the radius of influence of the city (normally implemented by checking if the strength is below some minimum threshold), then it is ignored and not processed further.

If a neighboring location already has a different city registered for it, then the currently recorded strength is compared with the strength of influence from the current location's city. The highest strength wins, and the city and strength are set accordingly. If it has no existing city recorded, then the current location's city is recorded, along with its influence strength.

Once the current location is processed, it is placed on a new list called the closed list. When a neighboring node has its city and strength set, it is placed on the open list. If it was already on the closed list, it is first removed from there. Unlike for the pathfinding version of the algorithm, we cannot guarantee that an updating location will not be on the closed list, so we have to make allowances for removing it. This is because we are using an arbitrary algorithm for the strength of influence.

Pseudo-Code

Other than changes in nomenclature, the algorithm is very similar to the pathfinding Dijkstra algorithm.

```
# The strength function has this format.
   function strengthFunction(city: City, location: Location) -> float
2
   # This structure is used to keep track of the information we need for
4
  # each location.
5
  class LocationRecord:
       location: Location
7
       nearestCity: City
       strength: float
9
10
11
   function mapfloodDijkstra(map: Map,
12
                               cities: City[],
                               strengthThreshold: float,
13
                               strengthFunction: function)
14
                               -> LocationRecord[]:
15
16
       # Initialize the open and closed lists.
17
       open = new PathfindingList()
18
       closed = new PathfindingList()
19
20
       # Initialize the record for the start nodes.
21
       for city in cities:
            startRecord = new LocationRecord()
23
            startRecord.location = city.getLocation()
24
            startRecord.city = city
25
            startRecord.strength = city.getStrength()
26
           open += startRecord
27
28
       # Iterate through processing each node.
29
       while open:
30
           # Find the largest element in the open list.
           current = open.largestElement()
33
           # Get its neighboring locations.
34
           locations = map.getNeighbors(current.location)
35
36
           # Loop through each location in turn.
37
           for location in locations:
38
                # Get the strength for the end node.
39
                strength = strengthFunction(current.city, location)
40
41
                # Skip if the strength is too low.
42
                if strength < strengthThreshold:</pre>
43
```

```
continue
44
45
                # .. or if closed and we've found a worse route.
46
                else if closed.contains(location):
47
                    # Find the record in the closed list.
48
                    neighborRecord = closed.find(location)
49
                     if neighborRecord.city != current.city and
50
                             neighborRecord.strength < strength:</pre>
51
                         continue
52
53
                # .. or if it is open and we've found a worse
54
                # route.
55
                else if open.contains(location):
56
                    # Find the record in the open list.
57
                    neighborRecord = open.find(location)
58
                     if neighborRecord.strength < strength:
59
                         continue
60
61
                # Otherwise we know we've got an unvisited
62
                # node, so make a record for it.
63
                else:
64
                     neighborRecord = new NodeRecord()
65
                     neighborRecord.location = location
                # We're here if we need to update the node
                # Update the cost and connection.
                neighborRecord.city = current.city
70
                neighborRecord.strength = strength
71
72
                # And add it to the open list.
73
                if not open.contains(location):
74
                     open += neighborRecord
75
76
            # We've finished looking at the neighbors for the current
77
            # node, so add it to the closed list and remove it from the
78
            # open list.
79
            open -= current
            closed += current
81
82
        # The closed list now contains all the locations that belong to
83
        # any city, along with the city they belong to.
84
        return closed
```

Data Structures and Interfaces

This version of Dijkstra takes as input a map that is capable of generating the neighboring locations of any location given. It should be of the following form:

```
class Map:
      # A list of neighbors for a given location.
2
      function getNeighbors(location: Location) -> Location[]
```

In the most common case where the map is grid based, this is a trivial algorithm to implement and can even be included directly in the Dijkstra implementation for speed.

The algorithm needs to be able to find the position and strength of influence of each of the cities passed in. For simplicity, I've assumed each city is an instance of some city class that is capable of providing this information directly. The class has the following format:

```
class City:
   # The location of the city.
   function getLocation() -> Location
    # The strength of influence imposed by the city.
    function getStrength() -> float
```

Finally, both the open and closed lists behave just like they did when we used them for pathfinding. Refer to Chapter 4, Section 4.2, for a complete rundown of their structure. The only difference is that I've replaced the smallestElement method with a largestElement method. In the pathfinding case we were interested in the location with the smallest pathso-far (i.e., the location closest to the start). This time we are interested in the location with the largest strength of influence (which is also a location closest to one of the start positions: the cities).

Performance

Just like the pathfinding Dijkstra, this algorithm on its own is O(nm) in time, where n is the number of locations that belong to any city, and m is the number of neighbors for each location. Unlike before, the worst case memory requirement is O(n) only, because we ignore any location not within the radius of influence of any city.

Also like in the pathfinding version, however, the data structures use algorithms that are nontrivial. See Chapter 4, Section 4.3 for more information on the performance and optimization of the list data structures.

6.2.7 CONVOLUTION FILTERS

Image blur algorithms are a very popular way to update analyses that involve spreading values out from their source. Influence maps in particular have this characteristic, but so do other proximity measures. Terrain analyses can sometimes benefit, but they typically don't need the spreading-out behavior.

Similar algorithms are used outside of games also. They are used in physics to simulate the behavior of many different kinds of fields and form the basis of models of heat transfer around physical components.

The blur effect inside your favorite image editing package is one of a family of convolution filters. Convolution is a mathematical operation that we will not need to consider in this book. For more information on the mathematics behind filters, I'd recommend Digital Image Processing [17]. Convolution filters go by a variety of other names, too, depending on the field you are most familiar with: kernel filters, impulse response filters, finite element simulation, 1 and various others.

The Algorithm

All convolution filters have the same basic structure: we define an update matrix to tell us how the value of one location in the map gets updated based on its own value and that of its neighbors. For a square tile-based level, we might have a matrix that looks like the following:

$$M = \frac{1}{16} \begin{bmatrix} 1 & 2 & 1 \\ 2 & 4 & 2 \\ 1 & 2 & 1 \end{bmatrix}$$

This is interpreted by taking the central element in the matrix (which, therefore, must have an odd number of rows and columns) as referring to the tile we are interested in. Starting with the current value of that location and its surrounding tiles, we can work out the new value by multiplying each value in the map by the corresponding value in the matrix and summing the results. The size of the filter is the number of neighbors in each direction. In the example above we have a filter size of one.

So if we have a section of the map that looks like the following:

and we are trying to work out a new value for the tile that currently has the value 4 (let's call it v). The following calculation is performed:

$$v = \begin{pmatrix} 5 \times \frac{1}{16} & + & 6 \times \frac{2}{16} & + & 2 \times \frac{1}{16} & + \\ 1 \times \frac{2}{16} & + & 4 \times \frac{4}{16} & + & 2 \times \frac{2}{16} & + \\ 6 \times \frac{1}{16} & + & 3 \times \frac{2}{16} & + & 3 \times \frac{1}{16} \end{pmatrix} = 3.5$$

We repeat this process for each location in the map, applying the matrix and calculating a new value. We need to be careful, however. If we just start at the top left corner of the map

Convolution filters are strictly only one technique used in finite element simulation.

and work our way through in reading order (i.e., left to right, then top to bottom), we will be consistently using the new value for the map locations to the left, above, and diagonally above and left, but the old values for the remaining locations. This asymmetry can be acceptable, but very rarely. It is better to treat all values the same.

To do this we have two copies of the map. The first is our source copy. It contains the old values, and we only read from it. As we calculate each new value, it is written to the new destination copy of the map. At the end of the process the destination copy contains an accurate update of the values. In our example, the values will be:

rounded to three decimal places.

To make sure the influence propagates from a location to all the other locations in the map, we need to repeat this process many times. Before each repeat, we set the influence value of each location where there is a unit.

If there are n tiles in each direction on the map (assuming a square tile-based map), then we need up to n passes through the filter to make sure all values are correct. If the source values are in the middle of the map, we may only need half this number.

If the sum total of all the elements in our matrix is one, then the values in the map will eventually settle down and not change over additional iterations. As soon as the values settle down, we need no more iterations.

In a game, where time is of the essence, we don't want to spend a long time repeatedly applying the filter to get a correct result. We can limit the number of iterations through the filter. Often, you can get away with applying one pass through the filter each frame and using the values from previous frames. In this way the blurring is spread over multiple frames. If you have fast-moving characters on the map, however, you may still be blurring their old location long after they have moved, which may cause problems. It is worth experimenting to get the best balance of performance and quality.

Boundaries

Before we implement the algorithm, we need to consider what happens at the edges of the map. Here we are no longer able to apply the matrix because some of the neighbors for the edge tile do not exist.

There are two approaches to this problem: modify the matrix or modify the map.

We could modify the matrix at the edges so that it only includes the neighbors that exist. At the top left-hand corner, for example, our blur matrix becomes:

$$\frac{1}{9} \begin{bmatrix} 4 & 2 \\ 2 & 1 \end{bmatrix}$$

$$\frac{1}{12} \begin{bmatrix} 1 & 2 & 1 \\ 2 & 4 & 2 \end{bmatrix}$$

on the bottom edge.

This approach is the most correct and will give good results. Unfortunately, it involves working with nine different matrices and switching between them at the correct time. The regular convolution algorithm given below can be very comprehensively optimized to take advantage of single instruction, multiple data (SIMD), processing several locations at the same time, especially on GPU hardware. If we need to keep switching matrices, these optimizations are no longer easy to achieve, and we lose a good deal of the speed (in my experiments for this book, the matrix-switching version can take 1.5 to 5 times as long).

The second alternative is to modify the map. We do this by adding a border around the game locations and clamping their values (i.e., they are never processed during the convolution algorithm; therefore, they will never change their value). The locations in the map can then use the regular algorithm and draw data from tiles that only exist in this border.

This is a fast and practical solution, but it can produce edge artifacts. Because we have no way of knowing what the border values should be set at, we choose some arbitrary value (say zero). The locations that neighbor the border will consistently have a contribution of this arbitrary value added to them. If the border is all set to zero, for example, and a highinfluence character is next to it, its influence will be pulled down because the edge locations will be receiving zero-valued contributions from the invisible border.

This is a common artifact to see. If you visualize the influence map as color density, it appears to have a paler color halo around the edge. The same thing will occur regardless of the value chosen for the border. It can be alleviated by increasing the size of the border and allowing some of the border values to be updated normally (even though they aren't part of the game level). This doesn't solve the problem, but can make it less visible.

Pseudo-Code

The convolution algorithm can be implemented in the following way:

```
# Performs a convolution of the matrix on the source.
   function convolve(matrix: Matrix, source: Matrix, destination: Matrix):
2
       # Find the size of the matrix.
3
       matrixLength: int = matrix.length()
4
       size: int = (matrixLength - 1) / 2
5
6
7
       # Find the dimensions of the source.
       height: int = source.length()
8
9
       width: int = source[0].length()
10
       # Go through each destination node, missing out a border equal to
11
       # the size of the matrix.
12
```

```
for i in size..(width - size):
13
           for j in size..(height - size):
                # Start with zero in the destination.
                destination[i][i] = 0
17
                # Go through each entry in the matrix.
18
                for k in 0..matrixLength:
19
                    for m in 0..matrixLength:
20
                        # Add the component.
21
                        destination[i][j] +=
22
                             source[i + k - size][j + m - size] *
23
                             matrix[k][m]
24
```

To apply multiple iterations of this algorithm, we can use a driver function that looks like the following:

```
function convolveDriver(matrix: Matrix,
                            source: Matrix,
                            destination: Matrix,
                            iterations: int):
       # Assign the source and destination to swappable variables (by
       # reference, not by value).
       if iterations % 2 > 0:
           map1: Matrix = source
8
           map2: Matrix = destination
       else:
10
           # Copy source data into destination so we end up with the
11
           # destination data in the destination array after an even
12
           # number of convolutions.
13
           destination = source
           map1: Matrix = destination
           map2: Matrix = source
17
       # Loop through the iterations.
18
       for i in 0..iterations:
19
           # Run the convolution.
20
           convolve(matrix, map1, map2)
21
22
           # Swap the variables.
23
           map1, map2 = map2, map1
24
```

although, as we've already seen, this is not commonly used.

Data Structures and Interfaces

This code uses no peculiar data structures or interfaces. It requires both the matrix and the source data as a rectangular array of arrays (containing numbers, of whatever type you need).

The matrix parameter needs to be a square matrix, but the source matrix can be of whatever size. A destination matrix of the same size as the source matrix is also passed in, and its contents are altered.

Implementation Notes

The algorithm is a prime candidate for optimizing using SIMD hardware, especially passing to the GPU. The same calculation is being performed on different data, and this can be parallelized. Even if you choose to run it on the CPU, a good optimizing compiler that can take advantage of SIMD processing is likely to automatically optimize these inner loops for you.

Performance

The algorithm is $O(whs^2)$ in time, where w is the width of the source data, h is its height, and s is the size of the convolution matrix. It is O(wh) in memory, because it requires a copy of the source data in which to write updated values.

If memory is a problem, it is possible to split this down and use a smaller temporary storage array, calculating the convolution one chunk of the source data at a time. This approach involves revisiting certain calculations, thus decreasing execution speed.

Filters

So far we've only seen one possible filter matrix. In image processing there is a whole wealth of different effects that can be achieved through different filters. Most of them are not useful in tactical analyses.

We'll look at two in this section that have practical use: the Gaussian blur and the sharpening filter. Gonzalez and Woods [17] contains many more examples, along with comprehensive mathematical explanations of how and why certain matrices create certain effects.

Gaussian Blur

The blur filter we looked at earlier is one of a family called *Gaussian filters*. They blur values, spreading them around the level. As such they are ideal for spreading out influence in an influence map.

For any size of filter, there is one Gaussian blur filter. The values for the matrix can be found by taking two vectors made up of elements of the binomial series; for the first few values these are

$$\begin{bmatrix} 1 & 2 & 1 \\ & \begin{bmatrix} 1 & 4 & 6 & 4 & 1 \end{bmatrix} \\ & \begin{bmatrix} 1 & 6 & 15 & 20 & 15 & 6 & 1 \end{bmatrix} \\ \begin{bmatrix} 1 & 8 & 28 & 56 & 70 & 56 & 28 & 8 & 1 \end{bmatrix}$$

We then calculate their outer product. So for the Gaussian filter of size two, we get:

$$\begin{bmatrix} 1 \\ 4 \\ 6 \\ 4 \\ 1 \end{bmatrix} \times \begin{bmatrix} 1 & 4 & 6 & 4 & 1 \\ 4 & 16 & 24 & 16 & 4 \\ 6 & 24 & 36 & 24 & 6 \\ 4 & 16 & 24 & 16 & 4 \\ 1 & 4 & 6 & 4 & 1 \end{bmatrix}$$

We could use this as our matrix, but the values in the map would increase dramatically each time through. To keep them at the same average level, and to ensure that the values settle down, we divide through by the sum of all the elements. In our case this is 256:

$$M = rac{1}{256} egin{bmatrix} 1 & 4 & 6 & 4 & 1 \ 4 & 16 & 24 & 16 & 4 \ 6 & 24 & 36 & 24 & 6 \ 4 & 16 & 24 & 16 & 4 \ 1 & 4 & 6 & 4 & 1 \end{bmatrix}$$

If we run this filter over and over on an unchanging set of unit influences, we will end up with the whole level at the same influence value (which will be low). The blur acts to smooth out differences, until eventually there will be no difference left.

We could add in the influence of each unit each time through the algorithm. This would have a similar problem: the influence values would increase at each iteration until the whole level had the same influence value as the units being added.

To solve these problems we normally introduce a bias: the equivalent of the unlearning parameter we used for frag-maps earlier. At each iteration we add the influence of the units we know about and then remove a small amount of influence from all locations. The total removed influence should be the same as the total influence added. This ensures that there is no net gain or loss over the whole level, but that the influence spreads correctly and settles down to a steady state value.

Figure 6.16 shows the effect of our size-two Gaussian blur filter on an influence map. The algorithm ran repeatedly (adding the unit influences each time and removing a small amount) until the values settled down.

Separable Filters

The Gaussian filter has an important property that we can use to speed up the algorithm. When we created the filter matrix, we did so using the outer product of two identical vectors:

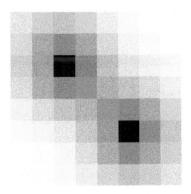

Figure 6.16: Screenshot of a Gaussian blur on an influence map

$$\begin{bmatrix} 1\\4\\6\\4\\1 \end{bmatrix} \times \begin{bmatrix} 1&4&6&4&1\\4&16&24&16&4\\6&24&36&24&6\\4&16&24&16&4\\1&4&6&4&1 \end{bmatrix}$$

This means that, during an update, the values for locations in the map are being calculated by the combined action of a set of vertical calculations and horizontal calculations. What is more, the vertical and horizontal calculations are the same. We can separate them out into two steps: first an update based on neighboring vertical values and second using neighboring horizontal values.

For example, let's return to our original example. We have part of the map that looks like the following:

and, what we now know is a Gaussian blur, with the matrix:

$$M = \frac{1}{16} \begin{bmatrix} 1 & 2 & 1 \\ 2 & 4 & 2 \\ 1 & 2 & 1 \end{bmatrix} = \frac{1}{4} \begin{bmatrix} 1 \\ 2 \\ 1 \end{bmatrix} \times \frac{1}{4} \begin{bmatrix} 1 & 2 & 1 \end{bmatrix}$$

We replace the original updated algorithm with a two-step process. First, we work through each column and apply just the vertical vector, using the components to multiply and sum the values in the table just as before. So if the 1 value in our example is called w, then the new value for w is given by:

$$\begin{array}{c} 5 \times \frac{1}{4} + \\ v = 1 \times \frac{2}{4} + = 3.25 \\ 6 \times \frac{1}{4} \end{array}$$

We repeat this process for the whole map, just as if we had a whole filter matrix. After this update we end up with:

```
5.000 4.750 3.500
1.750 2.750 3.500
4.250 \quad 3.750 \quad 3.250
```

After this is complete, we then go through again performing the horizontal equivalent (i.e., using the matrix $\begin{bmatrix} 1 & 2 & 1 \end{bmatrix}$). We end up with:

exactly as before.

The pseudo-code for this algorithm looks like the following:

```
# Perform a convolution of a matrix that is the outer product of the
   # given vectors, on the given source.
   function separableConvolve(hvector: Vector,
                               vvector: Vector,
5
                               source: Matrix,
                               temp: Matrix,
7
                               destination: Matrix):
8
       # Find the size of the vectors.
9
       vectorLength: int = hvector.length()
10
       size: int = (vectorLength - 1) / 2
11
12
       # Find the dimensions of the source.
       height: int = source.length()
13
       width: int = source[0].length()
14
15
       # Go through each destination node, missing out a border equal to
16
       # the size of the vector.
17
       for i in size..(width - size):
18
           for j in size..(height - size):
19
               # Start with zero in the temp array.
20
               temp[i][j] = 0
21
22
23
               # Go through each entry in the vector.
24
               for k in 0..vectorLength:
25
                   # Add the component.
                    temp[i][j] += source[i][j + k - size] * vvector[k]
26
27
```

```
# Go through each destination node again.
28
       for i in size..(width - size):
29
           for j in size..(height - size):
30
                # Start with zero in the destination.
31
               destination[i][j] = 0
32
33
34
                # Go through each entry in the vector.
                for k in 0..vectorLength:
35
36
                    # Add the component (taking data from temp rather than
37
                    # the source).
38
                    destination[i][j] += temp[i + k - size][j] * hvector[k]
```

We are passing in two vectors, the two vectors whose outer product gives the convolution matrix. In the examples above this has been the same vector for each direction, although it could just as well be different. We are also passing in another array of arrays, called temp, again the same size as the source data. This will be used as temporary storage in the middle of the update.

Rather than doing nine calculations (a multiplication and addition in each) for each location in the map, we've done only six: three vertical and three horizontal. For larger matrices the saving is even larger, a size 3 matrix would take 25 calculations the long way or 10 if it were separable. It is therefore O(whs) in time, rather than the $O(whs^2)$ of the previous version. It doubles the amount of temporary storage space needed, however, although it is still O(wh).

In fact, if we are restricted to Gaussian blurs, there is a faster algorithm (called SKIPSM, discussed in Waltz and Miller [75]) that can be implemented in assembly and run very quickly on the CPU. It is not designed to take full advantage of SIMD hardware, however. So in practice a well-optimized version of the algorithm above will perform almost as well and will be considerably more flexible.

It is not only Gaussian blurs that are separable, although most convolution matrices are not. If you are writing a tactical analysis server that can be used as widely as possible, then you should support both algorithms. The remaining filters in this chapter are not separable, so they require the long version of the algorithm.

The Sharpening Filter

Rather than blur influence out, we might want to concentrate it in. If we need to understand where the central hub of our influence is (to determine where to build a base, for example), we could use a sharpening filter. Sharpening filters act in the opposite way of blur filters: concentrating the values in the regions that already have the most.

A matrix for the sharpening filter has a central positive value surrounded by negative values; for example,

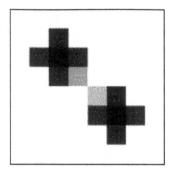

Figure 6.17: Screenshot of a sharpening filter on an influence map

$$\frac{1}{2} \begin{bmatrix} -1 & -1 & -1 \\ -1 & 18 & -1 \\ -1 & -1 & -1 \end{bmatrix}$$

and more generally, any matrix of the form:

$$\frac{1}{a} \begin{bmatrix} -b & -c & -b \\ -c & a(4b+4c+1) & -c \\ -b & -c & -b \end{bmatrix}$$

where a, b, and c are any positive real numbers and typically c < b.

In the same way as for the Gaussian blur, we can extend the same principle to larger matrices. In each case, the central value will be positive, and those surrounding it will be negative.

Figure 6.17 shows the effect of the first sharpening matrix shown above. In the first part of the figure, an influence map has been sharpened once only.

Because the sharpening filter acts to reduce the distribution of influence, if we run it multiple times we are likely to end up with an uninspiring result. In the second part of the figure the algorithm has been run for more iterations (adding the unit influences each time and removing a bias quantity) until the values settle down. You can see that the only remaining locations with any influence are those with units in them (i.e., those we already know the influence of).

Where sharpening filters can be useful for terrain analysis, they are usually applied only a handful of times and are rarely run to a steady state.

6.2.8 CELLULAR AUTOMATA

Cellular automata are update rules that generate the value at one location in the map based on the values of other surrounding locations. This is an iterative process: at each iteration,

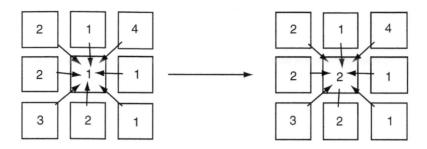

IF two or more neighbors with higher values, THEN increment

IF no neighbors with as high a value, THEN decrement

Figure 6.18: A cellular automaton

values are calculated based on the surrounding values at the previous iteration. This makes it a dynamic process that is more flexible than map flooding and can give rise to useful emergent effects.

In academia, cellular automata gained attention as a biologically plausible model of computing (although many commentators have subsequently shown why they aren't that biologically plausible), but with little practical use.

They have been used in only a handful of games, to my knowledge, mostly city simulation games, with the canonical example being SimCity [135], as described by its creator Will Wright in several conference talks. In SimCity they aren't used specifically for the AI; they are used to model changing patterns in the way the city evolves. I have used a cellular automaton to identify tactical locations for snipers in a small simulation, and I suspect they can be used more widely in tactical analysis.

Figure 6.18 shows one cell in a cellular automaton. It has a neighborhood of locations whose values it depends on. The update can be anything from a simple mathematical function to a complex set of rules. The figure shows an intermediate example.

Note, in particular, that if we are dealing with numeric values at each location, and the update rules are a single mathematical function, then we have a convolution filter, just as we saw in the previous section. In fact, convolution filters are just one example of a cellular automaton. This is not widely recognized, and most people tend to think of cellular automata solely in terms of discrete values at each location and more complex update rules.

Typically, the values in each surrounding location are first split into discrete categories. They may be enumerated values to start with (the type of building in a city simulation game, for example, or the type of terrain for an outdoor RTS). Alternatively, we may have to split a real number into several categories (splitting a gradient into categories for "flat," "gentle," "steep," and "precipitous," for example).

Given a map where each location is labeled with one category from our set, we can apply an update rule on each location to give the category for the next iteration. The update for one location depends only on the value of locations at the previous iteration. This means the algorithm can update locations in any order.

Cellular Automata Rules

The most well-known variety of cellular automata has an update rule that gives an output, based on the numbers of its neighbors in each category. In academic CAs, the categories are often 'off' and 'on', and the rule switches a location (often known as a "cell") on or off depending on the number of on neighbors it has. Figure 6.18 shows such a rule, for two categories, but in this case with more game significance. In the rule, it states that a location that borders at least four secure locations should be treated as secure.

Running the same rule over all the locations in a map allows us to turn an irregular zone of security (where the AI may mistakenly send units into the folds, only to have the enemy easily flank them) into a more convex pattern.

Cellular automaton rules could be created to take account of any information available to the AI. They are designed to be very local, however. A simple rule decides the characteristic of a location based only on its immediate neighbors. The complexity and dynamics of the whole automaton arise from the way these local rules interact. If two neighboring locations change their category based on each other, then the changes can oscillate backward and forward. In many cellular automata, even more complex behaviors can arise, including never-ending sequences that involve changes to the whole map.

Most cellular automata are not directional; they don't treat one neighbor any differently from any other. If a location in a city game has three neighboring high-crime areas, we might have a rule that says the location is also a high-crime zone. In this case, it doesn't matter which of the location's neighbors are high crime as long as the numbers add up. This enables the rule to be used in any location on the map.

Edges can pose a problem, however. In academic cellular automata, the map is considered to be either infinite or toroidal (i.e., the top and the bottom are joined, as are the left and right edges). Either approach gives a map where every location has the same number of neighbors. In a real game this will not be the case. In fact, many times we will not be working on a gridbased map at all, and so the number of neighbors might change from location to location.

To avoid having different behavior at different locations, we can use rules that are based on larger neighborhoods (not just locations that touch the location in question) and proportions rather than absolute numbers. We might have a rule that says if at least 25% of neighboring locations are high-crime areas then a location is also high crime, for example.

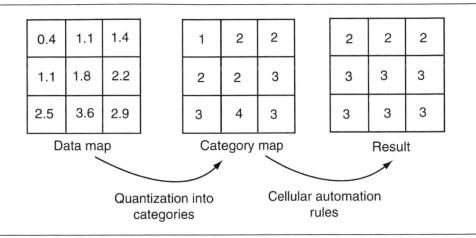

Figure 6.19: Updating a cellular automaton

Running a Cellular Automaton

We need two copies of the tactical analysis to allow the cellular automaton to update. One copy stores the values at the previous iteration, and the other copy stores the updated values. We can alternate which copy is which and repeatedly use the same memory.

Each location is considered in sequence (in any order, as we've seen), taking its input from its neighboring location and placing its output in the new copy of the analysis.

If we need to split a real-valued analysis into categories, this is often done as a preprocessing step first. A third copy of the map is kept, containing integers that represent the enumerated categories. The correct category is filled in each location from the real-numbered source data. Finally, the cellular automaton update rule runs as normal, converting its category output into a real number for writing into the destination map. This process is shown in Figure 6.19.

If the update is a simple mathematical function of its inputs, without branches, then it can often be written as parallel code that can be run on either the graphics card or a specialized vector mathematics unit. This can speed up the execution dramatically, as long as there is some headroom on those chips (if the graphics processing is taking every ounce of their power, then you may as well run the simulation on the CPU, of course).

In most cases, however, update functions of cellular automata tend to be heavily branched; they consist of lots of switch or if statements. This kind of processing isn't as easily parallelized, and so it is often performed in series on the main CPU, with a corresponding performance decrease. Some cellular automata rule sets (in particular, Conway's "The Game of Life": the most famous set of rules, but practically useless in a game application) can be easily rewritten without branches and have been implemented in a highly efficient parallel manner. Unfortunately, it is not always sensible to do so because the rewrites can take longer to run than a good branched implementation.

The Complexity of Cellular Automata

The behavior of a cellular automaton can be extremely complex. In fact, for some rules the behavior is so complex that the patterns of values become a programmable computer. This is part of the attraction of using the method: we can create sets of rules that produce almost any kind of pattern we like.

Unfortunately, because the behavior is so complex, there is no way we can accurately predict what we are going to see for any given rule set. For some simple rules it may be obvious. However, even very simple rules can lead to extraordinarily complex behaviors. The rule for the famous "The Game of Life" is very simple, yet produces completely unpredictable patterns.2

In game applications we don't need this kind of sophistication. For tactical analyses we are only interested in generating properties of one location from that of neighboring locations. We would like the resulting analysis to be stable. After a while, if the base data (like the positions of units or the layout of the level) stay the same, then the values in the map should settle down to a consistent pattern.

Although there are no guaranteed methods for creating rules that settle in this way, I have found that a simple rule of thumb is to set only one threshold in rules. In Conway's "The Game of Life," for example, a location can be on or off. It comes on if it has three on neighbors, and it goes off if it has fewer than two or more than four (there are eight neighbors for each cell in the grid). It is this "band" of two to three neighbors that causes the complex and unpredictable behavior. If the rules simply made locations switch on when they had three or more neighbors, then the whole map would rapidly fill up (for most starting configurations) and would be quite stable.

Bear in mind that you don't need to introduce dynamism into the game through complex rules. The game situation will be changing as the player affects it. Often, you just want fairly simple rules for the cellular automaton: rules that would lead to boring behavior if the automaton was the only thing running in the game.

Applications and Rules

Cellular automata are a broad topic, and their flexibility induces option paralysis. It is worth looking through a few of their applications and the rules that support them.

These are literally unpredictable: in the sense that the only way to find out what will happen is to run the cellular automaton.

Area of Security

Earlier in the chapter I described a set of cellular automata rules that expand an area of security to give a smoother profile, less prone to obvious mistakes in unit placement. It is not suitable for use on the defending side's area of control, but is useful for the attacking side because it avoids falling foul of a number of simple counterattack tactics.

The rule is simple:

A location is secure if at least four of its eight neighbors (or 50% for edges) are secure.

Building a City

SimCity uses a cellular automaton to work out the way buildings change depending on their neighborhood. A residential building in the middle of a run-down area will not prosper and may fall derelict, for example. SimCity's urban model is complex and highly proprietary. While I can guess some of the rules, I have no idea of their exact implementation.

A less well-known game, Otostaz [178], uses exactly the same principle, but its rules are simpler. In the game, a building appears on an empty patch of land when it has one square containing water and one square containing trees. This is a level-one building. Taller buildings come into being on squares that border two buildings of the next smaller size, or three buildings of one size smaller, or four buildings of one size smaller still.

So a level-two building appears on a patch of land when it has two neighboring level-one buildings. A level-three building needs two level-two buildings or three level-one buildings, and so on. An existing building doesn't ever degrade on its own (although the player can remove it), even if the buildings that caused it to generate are removed. This provides the stability to avoid unstable patterns on the map.

This is a gameplay, rather than an AI, use of the cellular automata, but the same thing can be implemented to build a base in an RTS. Typically, an RTS has a flow of resources: raw materials need to be collected, and there needs to be a balance of defensive locations, manufacturing plants, and research facilities.

We could use a set of rules such as:

- 1. A location near raw materials can be used to build a defensive building.
- 2. A location bordered by two defensive positions may be used to build a basic building of any type (training, research, and manufacturing).
- 3. A location bounded by two basic buildings may become an advanced building of a different type (so we don't put all the same types of technology in one place, vulnerable to a single attack).
- 4. Very valuable facilities should be bordered by two advanced buildings.

6.3 TACTICAL PATHFINDING

Tactical pathfinding combines the tactical analyses we've seen earlier in the chapter with the pathfinding techniques from Chapter 4. It can provide quite impressive results when characters in the game move, taking account of their tactical surroundings, staying in cover, and avoiding enemy lines of fire and common ambush points.

Tactical pathfinding has an unfair reputation for being significantly more sophisticated than regular pathfinding. As a marketing feature that may be a benefit, but if it dissuades programmers from attempting implementation, the reputation is unfortunate. In reality it is no different at all from regular pathfinding. The same pathfinding algorithms are used on the same kind of graph representation. The only modification is that the cost function is extended to include tactical information as well as distance or time.

6.3.1 THE COST FUNCTION

The cost for moving along a connection in the graph should be based on both distance/time (otherwise, we might embark on exceptionally long routes) and how tactically sensible the maneuver is.

The cost of a connection is given by a formula of the following type:

$$C = D + \sum_{i} w_i T_i$$

where D is the distance of the connection (or time or other non-tactical cost function—I will refer to this as the base cost of the connection); w_i is a weighting factor for each tactic supported in the game; T_i is the tactical quality for the connection, again for each tactic; and i is the number of tactics being supported. We'll return to the choice of the weighting factors below.

The only complication in this is the way tactical information is stored in a game. As we have seen so far in this chapter, tactical information is normally stored on a per-location basis. We might use tactical waypoints or a tactical analysis, but in either case the tactical quality is held for each location.

To convert location-based information into connection-based costs, we normally average the tactical quality of each of the locations that the connection connects. This works on the assumption that the character will spend half of its time in each region and so should benefit or suffer half of the tactical properties of each.

This assumption is good enough for most games, although it can produce poor results for some level data. Figure 6.20 shows a connection between two locations with good cover. The connection, however, is very exposed, and the longer route around is likely to be much better in practice.

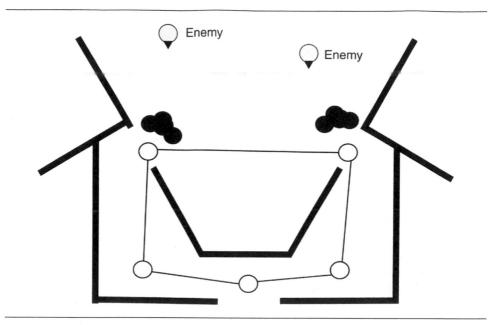

Figure 6.20: Averaging the connection cost sometimes causes problems

6.3.2 TACTIC WEIGHTS AND CONCERN BLENDING

In the equation for the cost of a connection, the real-valued quality for each tactic is multiplied by a weighting factor before being summed into the final cost value. The choice of weighting factors controls the kinds of routes taken by the character.

We could also use a weighting factor for the base cost, but this would be equivalent to changing the weighting factors for each of the tactics. A 0.5 weight for the base cost can be achieved by multiplying each of the tactic weights by 2, for example. I will not use a separate weight for the base cost in this chapter, but you may find it more convenient to have one in your implementation.

If a tactic has a high weight, then locations with that tactical property will be avoided by the character. This might be the case for ambush locations or difficult terrain, for example. Conversely, if the weight is a large negative value, then the character will favor locations with a high value for that property. This would be sensible for cover locations or areas under friendly control, for example.

Care needs to be taken to make sure that no possible connection in the graph can have a negative overall weight. If a tactic has a large negative weight and a connection has a small base cost with a high value for the tactic, then the resulting overall cost may be negative. As we saw in Chapter 4, negative costs are not supported by normal pathfinding algorithms such as A*. Weights can be chosen so that no negative value can occur, although that is often easier said than done. As a safety net, it is worth specifically limiting the cost value returned so that it is always positive. This adds additional processing time and can also lose lots of tactical information. If the weights are badly chosen, many different connections might be mapped to negative values: simply limiting them so they give a positive result loses any information on which connections are better than the others (they all appear to have the same cost).

Speaking from bitter experience, I would advise you at the very least to include an assert or other debugging message to tell you if a connection arises with a negative cost. A bug resulting from a negative weight can be tough to track down (it may only appear in certain very specific gameplay circumstances that can be hard to replicate, and normally results in the pathfinding never returning a result, but it can cause much more subtle bugs, too).

We can calculate the costs for each connection in advance and store them with the pathfinding graph. There will be one set of connection costs for each set of tactic weights.

This works okay for static features of the game such as terrain and visibility. It cannot take into account the dynamic features of the tactical situation: the balance of military influence, cover from known enemies, and so on. To do this we need to apply the cost function each time the connection cost is requested (we can cache the cost value for multiple queries in the same frame, of course).

Performing the cost calculations when they are needed slows down pathfinding significantly. The cost calculation for a connection is in the lowest loop of the pathfinding algorithm, and any slowdown is usually quite noticeable. There is a trade-off. Is the advantage of better tactical routes for your characters outweighed by the extra time they need to plan the route in the first place?

As well as responding to changing tactical situations, performing the cost calculations for each frame allows great flexibility to model different personalities in different characters.

In a real-time strategy game, for example, we might have reconnaissance units, light infantry, and heavy artillery. A tactical analysis of the game map might provide information on difficulty of terrain, visibility, and the proximity of enemy units.

The reconnaissance units can move fairly efficiently over any kind of terrain, so they weight the difficulty of terrain with a small positive weight. They are keen to avoid enemy units, so they weight the proximity of enemy units with a large positive value. Finally, they need to find locations with large visibility, so they weight this with a large negative value.

The light infantry units have slightly more difficulty with tough terrain, so their weight is a small positive value, higher than that of the reconnaissance units. Their purpose is to engage the enemy. However, they would rather avoid unnecessary engagements, so they use a small positive weight for enemy proximity (if they were actively seeking combat, they'd use a negative value here). They would rather move without being seen, so they use a small positive weight for visibility.

Heavy artillery units have a different set of weights again. They cannot cope with tough terrain, so they use a large positive weight for difficult areas of the map. They also are not good in close encounters, so they have large positive weights for enemy proximity. When exposed, they are a prime target and should move without being seen (they can attack from behind a hill quite successfully), so they also use a large positive weight for visibility.

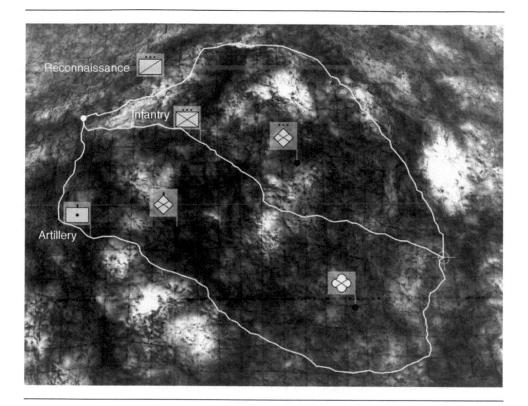

Figure 6.21: Screenshot of the planning system showing tactical pathfinding

These three routes are shown in Figure 6.21, a screenshot for a three-dimensional (3D) level. The black dots in the screenshot show the location of enemy units.

The weights don't need to be static for each unit type. We could tailor the weights to a unit's aggression. An infantry unit might not mind enemy contact if it is healthy, but might increase the weight for proximity when it is damaged. That way if the player orders a unit back to base to be healed, the unit will naturally take a more conservative route home.

Using the same source data, the same tactical analyses, and the same pathfinding algorithm, but different weights, we can produce completely different styles of tactical motion that display clear differences in priority between characters.

MODIFYING THE PATHFINDING HEURISTIC

If we are adding and subtracting modifiers to the connection cost, then we are in danger of making the heuristic invalid. Recall that the heuristic is used to estimate the length of the

shortest path between two points. It should always return less than the actual shortest path length. Otherwise, the pathfinding algorithm might settle for a sub-optimal path.

We ensured that the heuristic was valid by using a Euclidean distance between two points: any actual path will be at least as long as the Euclidean distance and will usually be longer. With tactical pathfinding we are no longer using the distance as the cost of moving along a connection: subtracting the tactical quality of a connection may bring the cost of the connection below its distance. In this case, a Euclidean heuristic will not work.

In practice, I have only come across this problem once. In most cases, the additions to the cost outweigh the subtractions for the majority of connections (you can certainly engineer the weights so that this is true). The pathfinder will disproportionately tend to avoid the areas where the additions don't outweigh the subtractions. These areas are associated with very good tactical areas, and it has the effect of downgrading the tendency of a character to use them. Because the areas are likely to be exceptionally good tactically, the fact that the character treats them as only very good (not exceptionally good) is usually not obvious to the player.

The case where I found problems was in a character that weighted most of the tactical concerns with a fairly large negative weight. The character seemed to miss obviously good tactical locations and to settle for mediocre locations. In this case, I used a scaled Euclidean distance for the heuristic, simply multiplying it by 0.5. This produced slightly more fill (see Chapter 4 for more information about fill), but it resolved the issue.

6.3.4 TACTICAL GRAPHS FOR PATHFINDING

Influence maps (or any other kind of tactical analysis) are ideal for guiding tactical pathfinding. The locations in a tactical analysis form a natural representation of the game level, especially in outdoor levels. In indoor levels, or for games without tactical analyses, we can use the waypoint tactics covered at the start of this chapter.

In either case the locations alone are not sufficient for pathfinding. We also need a record of the connections between them. For waypoint tactics that include topological tactics, we may have these already. For regular waypoint tactics and most tactical analyses, we are unlikely to have a set of connections.

We can generate connections by running movement checks or line-of-sight checks between waypoints or map locations. Locations that can be simply moved between are candidates for maneuvers in a planned route. Chapter 4 has more details about the automatic construction of connections between sets of locations.

The most common graph for tactical pathfinding is the grid-based graph used in RTS games. In this case the connections can be generated very simply: a connection exists between two locations if the locations are adjacent. This may be modified by not allowing connections between locations when the gradient is steeper than some threshold or if either location is occupied by an obstacle. More information on grid-based pathfinding graphs can also be found in Chapter 4.

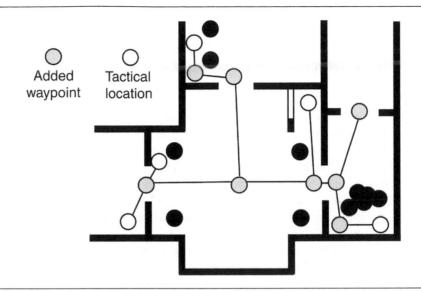

Figure 6.22: Adding waypoints that are not tactically sensible

6.3.5 USING TACTICAL WAYPOINTS

Tactical waypoints, unlike tactical analysis maps, have tactical properties that refer to a very small area of the game level. As we saw in the section on automatically placing tactical waypoints, a small movement from a waypoint may produce a dramatic change in the tactical quality of the location.

To make sensible pathfinding graphs it is almost always necessary to add additional waypoints at locations that do not have peculiar tactical properties. Figure 6.22 shows a set of tactical locations in part of a level; none of these can be easily reached from any of the others. The figure shows the additional waypoints needed to connect the tactical locations and to form a sensible graph for pathfinding.

The simplest way to achieve this is to superimpose the tactical waypoints onto a regular pathfinding graph. The tactical locations need to be linked into their adjacent pathfinding nodes, but the basic graph provides the ability to move easily between different areas of the level.

The developers I have seen using indoor tactical pathfinding have all included the placement of tactical waypoints into the same level design process used to place nodes for the pathfinding (normally using Dirichlet domains for quantization, or navigation meshes with additional manually specified nodes). By allowing the level designer the ability to mark pathfinding nodes with tactical information, the resulting graph can be used for both simple tactical decision making and for full-blown tactical pathfinding.

6.4 COORDINATED ACTION

So far in this book I have presented techniques in the context of controlling a single character. Increasingly, games feature multiple characters who have to cooperate together to get their job done. This can be anything from a whole side in a real-time strategy game to squads or pairs of individuals in a shooter game.

Another change over the last 10 years is the ability of AI to cooperate with the player. It is no longer enough to have a squad of enemy characters working as a team. Many games now need AI characters to act in a squad led by the player. This is often achieved by giving the player the ability to issue orders. An RTS game, for example, sees the player control many characters on their own team. The player gives an order and some lower level AI works out how to carry it out.

But increasingly, designs call for some degree of cooperation without any explicit orders being given. Characters need to detect the player's intent and act to support it. This is a much more difficult problem than simple cooperation. A group of AI characters can tell each other exactly what they are planning (through some kind of messaging system, for example). A player can only indicate their intent through their actions, which then need to be understood by the AI.

This change in gameplay emphasis has placed increased burdens on game AI. This section will look at a range of approaches that can be used on their own or in concert to get more believable team behaviors.

6.4.1 MULTI-TIER AI

A multi-tier AI approach has behaviors at multiple levels. Each character will have its own AI, squads of characters together will have a different set of AI algorithms as a whole, and there may be additional levels for groups of squads or even whole teams. Figure 6.23 shows a sample AI hierarchy for a typical squad-based shooter.

I have assumed this kind of format in earlier parts of this chapter looking at waypoint tactics and tactical analysis. Here the tactical algorithms are generally shared among multiple characters; they seek to understand the game situation and allow large-scale decisions to be made. Later, individual characters can make their own specific decisions based on this overview.

There is a spectrum of ways in which the multi-tier AI might function. At one extreme, the highest level AI makes a decision, passes it down to the next level, which then uses the instruction to make its own decision, and so on down to the lowest level. This is called a topdown approach. At the other extreme, the lowest level AI algorithms take their own initiative, using the higher level algorithms to provide information on which to base their action. This is a *bottom-up* approach.

A military hierarchy is nearly a top-down approach: orders are given by politicians to generals, who turn them into military orders which are passed down the ranks, being inter-

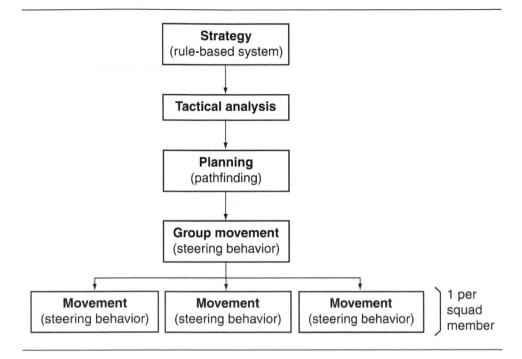

Figure 6.23: An example of multi-tier AI

preted and amplified at each stage until they reach the soldiers on the ground. There is some information flowing up the levels also, which in turn moderates the decisions that can be made. A single soldier might spy a heavy weapon (a weapon of mass destruction, let's say) on the theater of battle, which would then cause the squad to act differently and when bubbled back up the hierarchy could change political policy at an international level.

A completely bottom-up approach would involve autonomous decision making by individual characters, with a set of higher level algorithms providing interpretation of the current game state. This extreme is common in a large number of strategy games, but isn't what developers normally mean by multi-tier AI. It has more similarities to emergent cooperation, and we'll return to this later in this section.

Completely top-down approaches are often used and show the descending levels of decision making characteristic of multi-tier AI.

At different levels in the hierarchy we see the different aspects of AI seen in our AI model. This was illustrated in Figure 6.1. At the higher levels we have decision making or tactical tools. Lower down we have pathfinding and movement behaviors that carry out the highlevel orders.

Group Decisions

The decision making tools used are just the same as those we saw in Chapter 5. There are no special needs for a group decision making algorithm. It takes input about the world and comes up with an action, just as we saw for individual characters.

At the highest level it is often some kind of strategic reasoning system. This might involve decision making algorithms such as expert systems or state machines, but often also involves tactical analyses or waypoint tactic algorithms. These decision tools can determine the best places to move, apply cover, or stay undetected. Other decision making tools then have to decide whether moving, being in cover, or remaining undetected are things that are sensible in the current situation.

The difference is in the way its actions are carried out. Rather than being scheduled for execution by the character, they typically take the form of orders that are passed down to lower levels in the hierarchy. A decision making tool at a middle level takes input from both the game state and the order it was given from above, but again the decision making algorithm is typically standard.

Group Movement

In Chapter 3 I described motion systems capable of moving several characters at once, using either emergent steering, such as flocking, or an intentional formation steering system.

The formation steering system we looked at in Chapter 3, Section 3.7 is multi-tiered. At the higher levels the system steers the whole squad or even groups of squads. At the lowest level individual characters move in order to stay with their formation, while avoiding local obstacles and taking into account their environment.

While formation motion is becoming more widespread, it has been more common to have no movement algorithms at higher levels of the hierarchy. At the lowest level the decisions are turned into movement instructions. If this is the approach you select, be careful to make sure that problems achieving the lower level movement cannot cause the whole AI to fall over. If a high-level AI decides to attack a particular location, but the movement algorithms cannot reach that point from their current position, then there may be a stalemate.

In this case it is worth having some feedback from the movement algorithm that the decision making system can take account of. This can be a simple "stuck" alarm message (see Chapter 11 for details on messaging algorithms) that can be incorporated into any kind of decision making tool.

Group Pathfinding

Pathfinding for a group is typically no more difficult than for an individual character. Most games are designed so that the areas through which a character can pass are large enough for several characters not to get stuck together. Look at the width of most corridors in the squad-

based games you own, for example. They are typically significantly larger than the width of one character.

When using tactical pathfinding, it is common to have a range of different units in a squad. As a whole they will need to have a different blend of tactical concerns for pathfinding than any individual would have alone. This can be approximated in most cases by the heuristic of the weakest character: the whole squad should use the tactical concerns of their weakest member. If there are multiple categories of strength or weakness, then the new blend will be the worst in all categories.

Terrain Multiplier	Recon Unit	Heavy Weapon	Infantry	Squad
Gradient	0.1	1.4	0.3	1.4
Proximity	1.0	0.6	0.5	1.0

This table shows an example. We have a recon unit, a heavy weapon unit, and a regular soldier unit in a squad. The recon unit tries to avoid enemy contact, but can move over any terrain. The heavy weapon unit tries to avoid rough terrain, but doesn't try to avoid engagement. To make sure the whole squad is safe, we try to find routes that avoid both enemies and rough terrain.

Alternatively, we could use some kind of blending weights allowing the whole squad to move through areas that had modestly rough terrain and were fairly distant from enemies. This is fine when constraints are preferences, but in many cases they are hard constraints (an artillery unit cannot move through woodland, for example), so the weakest member heuristic is usually safest.

On occasion the whole squad will have pathfinding constraints that are different from those of any individual. This is most commonly seen in terms of space. A large squad of characters may not be able to move through a narrow area that any of the members could easily move through alone. In this case we need to implement some rules for determining the blend of tactical considerations that a squad has based on its members. This will typically be a dedicated chunk of code, but could also consist of a decision tree, expert system, or other decision making technology. The content of this algorithm completely depends on the effects you are trying to achieve in your game and what kinds of constraints you are working with.

Including the Player

While multi-tier AI designs are excellent for most squad- and team-based games, they do not cope well when the player is part of the team. Figure 6.24 shows a situation in which the high-level decision making has made a decision that the player accidentally subverts. In this case, the action of the other teammates is likely to be noticeably poor to the player. After all, the player's decision is sensible and would be anticipated by any sensible person. It is the multi-tiered architecture of the AI that causes the problems in this situation.

In general, the player will always make the decisions for the whole team. The game design may involve giving the player orders, but ultimately it is the player who is responsible for

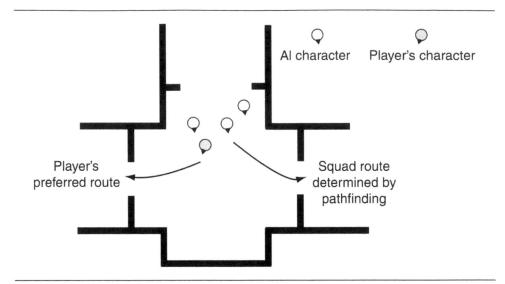

Figure 6.24: Multi-tiered AI and the player don't mix well

determining how to carry them out. If the player has to follow a set route through a level, then they are likely to find the game frustrating: early on they might not have the competence to follow the route, and later they will find the linearity restricting. Game designers usually get around this difficulty by forcing restrictions on the player in the level design. By making it clear which is the best route, the player can be channeled into the right locations at the right time. If this is done too strongly, then it still makes for a poor play experience.

Moment to moment in the game there should be no higher decision making than the player. If we place the player into the hierarchy at the top, then the other characters will base their actions purely on what they think the player wants, not on the desire of a higher decision making layer. This is not to say that they will be able to understand what the player wants, of course, just that their actions will not conflict with the player. Figure 6.25 shows an architecture for a multi-tier AI involving the player in a squad-based shooter.

Notice that there are still intermediate layers of the AI between the player and the other squad members. The first task for the AI is to interpret what the player will be doing. This might be as simple as looking at the player's current location and direction of movement. If the player is moving down a corridor, for example, then the AI can assume that they will continue to move down the corridor.

At the next layer, the AI needs to decide on an overall strategy for the whole squad that can support the player in their desired action. If the player is moving down the corridor, then the squad might decide that it is best to cover the player from behind. As the player comes toward a junction in the corridor, squad members might also decide to cover the side passages. When the player moves into a large room, the squad members might cover the player's flanks

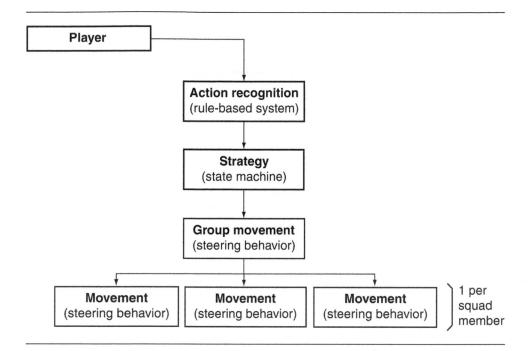

Figure 6.25: A multi-tier AI involving the player

or secure the exits from the room. This level of decision making can be achieved with any decision making tool from Chapter 5. A decision tree would be ample for the example here.

From this overall strategy, the individual characters make their movement decisions. They might walk backward behind the player covering their back or find the quickest route across a room to an exit they wish to cover. The algorithms at this level are usually pathfinding or steering behaviors of some kind.

Explicit Player Orders

A different approach to including the player in a multi-tiered AI is to give them the ability to schedule specific orders. This is the way that an RTS game works. On the player's side, the player is the top level of AI. They get to decide the orders that each character will carry out. Lower levels of AI then take this order and work out how best to achieve it.

A unit might be told to attack an enemy location, for example. A lower level decision making system works out which weapon to use and what range to close to in order to perform the attack. The next lower level takes this information and then uses a pathfinding algorithm to provide a route, which can then be followed by a steering system. This is multi-tiered AI with the player at the top giving specific orders. The player isn't represented in the game by any character. They exist purely as a general, giving the orders.

Shooters typically put the player in the thick of the action, however. Here also, there is the possibility of incorporating player orders. Squad-based games like SOCOM: U.S. Navy SEALs [200] allow the player to issue general orders that give information about their intent. This might be as simple as requesting the defense of a particular location in the game level, covering fire, or an all-out onslaught. Here the characters still need to do a good deal of interpretation in order to act sensibly (and in that game they often fail to do so convincingly).

A different balance point is seen in Full Spectrum Warrior [157], where RTS-style orders make up the bulk of the gameplay, but the individual actions of characters can also be directly controlled in some circumstances.

The intent-identification problem is so difficult that it is worth seeing if you can incorporate some kind of explicit player orders into your squad-based games, especially if you are finding it difficult to make the squad work well with the player.

Structuring Multi-Tier AI

Multi-tier AI needs two infrastructure components in order to work well:

- A communication mechanism that can transfer orders from higher layers in the hierarchy downward. This needs to include information about the overall strategy, targets for individual characters, and typically other information (such as which areas to avoid because other characters will be there, or even complete routes to take).
- A hierarchical scheduling system that can execute the correct behaviors at the right time, in the right order, and only when they are required.

Communication mechanisms are discussed in more detail in Chapter 11. Multi-tiered AI doesn't need a sophisticated mechanism for communication. There will typically be only a handful of different possible messages that can be passed, and these can simply be stored in a location that lower level behaviors can easily find. We could, for example, simply make each behavior have an "in-tray" where some order can be stored. The higher layer AI can then write its orders into the in- tray of each lower layer behavior.

Scheduling is typically more complex. Chapter 10 looks at scheduling systems in general, and Section 10.1.4 looks at combining these into a hierarchical scheduling system. This is important because typically lower level behaviors have several different algorithms they can run, depending on the orders they receive. If a high-level AI tells the character to guard the player, they may use a formation motion steering system. If the high-level AI wants the characters to explore, they may need pathfinding and maybe a tactical analysis to determine where to look. Both sets of behaviors need to be always available to the character, and we need some robust way of marshaling the behaviors at the right time without causing frame rate blips and without getting bogged down in hundreds of lines of special case code.

Figure 6.26 shows a hierarchical scheduling system that can run the squad-based multi-

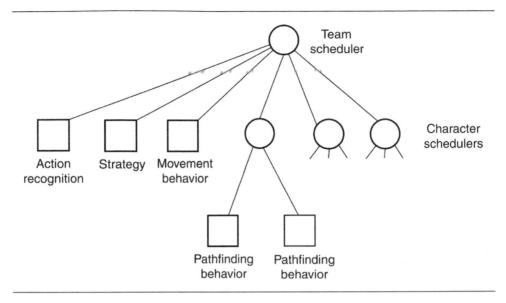

Figure 6.26: A hierarchical scheduling system for multi-tier AI

tier AI we saw earlier in the section. See Chapter 10 for more information on how the elements in the figure are implemented.

6.4.2 EMERGENT COOPERATION

So far we've looked at cooperation mechanics where individual characters obey some kind of guiding control. The control might be the player's explicit orders, a tactical decision making tool, or any other decision maker operating on behalf of the whole group.

This is a powerful technique that naturally fits in with the way we think about the goals of a group and the orders that carry them out. It has the weakness, however, of relying on the quality of the high-level decision. If a character cannot obey the higher level decision for some reason, then it is left without any ability to make progress.

We could instead use less centralized techniques to make a number of characters appear to be working together. They do not need to coordinate in the same way as for multi-tier AI, but by taking into account what each other is doing, they can appear to act as a coherent whole. This is the approach taken in most squad-based games.

Each character has its own decision making, but the decision making takes into account what other characters are doing. This may be as simple as moving toward other characters (which has the effect that characters appear to stick together), or it could be more complex, such as choosing another character to protect and maneuvering to keep them covered at all times.

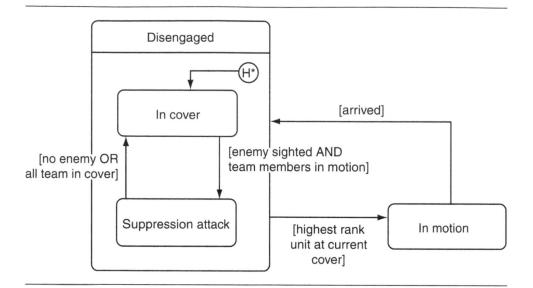

Figure 6.27: State machines for emergent fire team behavior

Figure 6.27 shows an example finite state machine for four characters in a fire team. Four characters with this finite state machine will act as a team, providing mutual cover and appearing to be a coherent whole. There is no higher level guidance being provided.

If any member of the team is removed, the rest of the team will still behave relatively efficiently, keeping themselves safe and providing offensive capability when needed.

We could extend this and produce different state machines for each character, adding their team specialty: the grenadier could be selected to fire on an enemy behind light cover, a designated medic could act on fallen comrades, and the radio operator could call in air strikes against heavy opposition. All this could be achieved through individual state machines.

Scalability

As you add more characters to an emergently cooperating group, you will reach a threshold of complexity. Beyond this point it will be difficult to control the behavior of the group. The exact point where this occurs depends on the complexity of the behaviors of each individual.

Reynolds's flocking algorithm, for example, can scale to hundreds of individuals with only minor tweaks to the algorithm. The fire team behaviors earlier in the section are fine up to six or seven characters, whereupon they become less useful. The scalability seems to depend on the number of different behaviors each character can display. As long as all the behaviors are relatively stable (such as in the flocking algorithm), the whole group can settle into a reasonable stable behavior, even if it appears to be highly complex. When each character can

switch to different modes (as in the finite state machine example), we end up rapidly getting into oscillations.

Problems occur when one character changes behavior which forces another character to also change behavior and then a third, which then changes the behavior of the first character again, and so on. Some level of hysteresis in the decision making can help (i.e., a character keeps doing what it has been doing for a while, even if the circumstances change), but it only buys us a little time and cannot solve the problem.

To solve this issue we have two choices. First, we can simplify the rules that each character is following. This is appropriate for games with a lot of identical characters. If, in a shooter, we are up against 1,000 enemies, then it makes sense that they are each fairly simple and that the challenge arises from their number rather than their individual intelligence. On the other hand, if we are facing scalability problems before we get into double-digit numbers of characters, then this is a more significant problem.

The best solution is to set up a multi-tiered AI with different levels of emergent behavior. We could have a set of rules very similar to the state machine example, where each individual is a whole squad rather than a single character. Then in each squad the characters can respond to the orders given from the emergent level, either directly obeying the order or including it as part of their decision making process for a more emergent and adaptive feel.

This is something of a cheat, of course, if the aim is to be purely emergent. But if the aim is to get great AI that is dynamic and challenging (which, let's face it, it should be), then it is often an excellent compromise.

In my experience many developers who have tried to implement emergent behaviors have struck scalability problems quickly and ended up with some variation of this more practical approach.

Predictability

A side effect of this kind of emergent behavior is that you often get group dynamics that you didn't explicitly design. This is a double-edged sword; it can be beneficial to see emergent intelligence in the group, but this doesn't happen very often (don't believe the hype you read about this stuff). The most likely outcome is that the group starts to do something really annoying that looks unintelligent. It can be very difficult to eradicate these dynamics by tweaking the individual character behaviors.

It is almost impossible to work out how to create individual behaviors that will emerge into exactly the kind of group behavior you are looking for. In my experience the best you can hope for is to try variations until you get a group behavior that is reasonable and then tweak that. This may be exactly what you want.

If you are looking for highly intelligent high-level behavior, then you will always end up implementing it explicitly. Emergent behavior is useful and can be fun to implement, but it is certainly not a way of getting great AI with less effort.

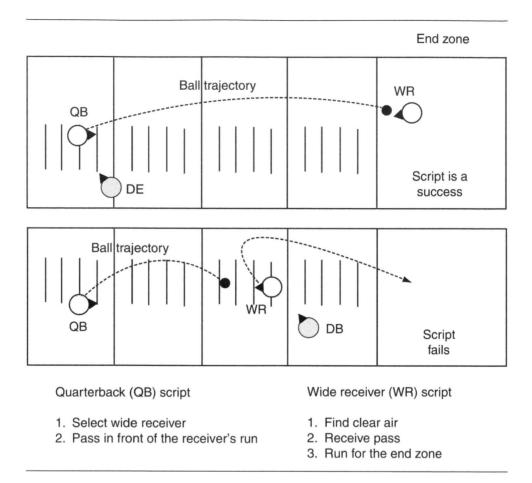

Figure 6.28: An action sequence needing timing data

6.4.3 SCRIPTING GROUP ACTIONS

Making sure that all the members of a group work together is difficult to do from first principles. A powerful tool is to use a script that shows what actions need to be applied in what order and by which character. In Chapter 5 we looked at action execution and scripted actions as a sequence of primitive actions that can be executed one after another.

We can extend this to groups of characters, having a script per character. Unlike for a single character, however, there are timing complications that make it difficult to keep the illusion of cooperation among several characters. Figure 6.28 shows a situation in football where two characters need to cooperate to score a touchdown. If we use the simple action script shown, then the overall action will be a success in the first instance, but a failure in the second instance.

To make cooperative scripts workable, we need to add the notion of interdependence of scripts. The actions that one character is carrying out need to be synchronized with the actions of other characters.

We can achieve this most simply by using signals. In place of an action in the sequence, we allow two new kinds of entity: signal and wait.

Signal: A signal has an identifier. It is a message sent to anyone else who is interested. This is typically any other AI behavior, although it could also be sent through an event or sense simulation mechanism from Chapter 11 if finer control is needed.

Wait: A wait also has an identifier. It stops any elements of the script from progressing unless it receives a matching signal.

We could go further and add additional programming language constructs, such as branches, loops, and calculations. This would give us a scripting language capable of any kind of logic, but at the cost of significantly increased implementation difficulty and a much bigger burden on the content creators who have to create the scripts.

Adding just signals and waits allows us to use simple action sequences for collaborative actions between multiple characters.

In addition to these synchronization elements, some games also admit actions that need more than one character to participate. Two soldiers in a squad-based shooter might be needed to climb over a wall: one to climb and the other to provide a leg-up. In these cases some of the actions in the sequence may be shared between multiple characters. The timing can be handled using waits, but the actions are usually specially marked so each character is aware that it is performing the action together, rather than independently.

Adding in the elements from Chapter 5, a collaborative action sequencer supports the following primitives:

State Change Action: This is an action that changes some piece of game state without requiring any specific activity from any character.

Animation Action: This is an action that plays an animation on the character and updates the game state. This is usually independent of other actions in the game. This is often the only kind of action that can be performed by more than one character at the same time. This can be implemented using unique identifiers, so different characters can understand when they need to perform an action together and when they only need to perform the same action at the same time.

AI Action: This is an action that runs some other piece of AI. This is often a movement action, which gets the character to adopt a particular steering behavior. This behavior can be parameterized—for example, an arrive behavior having its target set. It might also be used to get the character to look for firing targets or to plan a route to its goal.

Compound Action: This takes a group of actions and performs them at the same time.

Action Sequence: This takes a group of actions and performs them in series.

Signal: This sends a signal to other characters.

Wait: This waits for a signal from other characters.

The implementation of the first five types were discussed in Chapter 5, including pseudocode for compound actions and action sequences. To make the action execution system support synchronized actions, we need to implement signals and waits.

Pseudo-Code

The wait action can be implemented in the following way:

```
class Wait extends Action:
       # The unique identifier for this wait.
       identifier: string
3
       # The action to carry out while waiting.
5
       whileWaiting: Action
       function canInterrupt() -> bool:
           # We can interrupt this action at any time.
           return true
11
       function canDoBoth(otherAction: Action) -> bool:
12
           # We can do no other action at the same time, otherwise later
13
           # actions could be carried out despite the fact that we are
14
           # waiting.
15
           return false
16
17
       function isComplete() -> bool:
18
           # Check if our identifier has been completed.
19
           if globalIdStore.hasIdentifier(identifier):
20
               return true
21
22
       function execute():
23
           # Do our wait action.
24
           return whileWaiting.execute()
25
```

Note that we don't want the character to freeze while waiting. We have added a waiting action to the class, which is carried out while the character waits.

A signal implementation is even simpler. It can be implemented in the following way:

```
class Signal extends Action:
      # The unique identifier for this signal.
2
      identifier: string
      # Checks if the signal has been delivered.
      delivered: bool = false
6
      function canInterrupt() -> bool:
8
           # We can interrupt this action at any time.
9
```

```
10
            return true
11
        function canDoBoth(otherAction: Action) -> bool:
12
            # We can do any other action at the same time as this one. We
13
            # won't be waiting on this action at all, and we shouldn't
14
            # wait another frame to carry on with our actions.
15
            return true
16
17
       function isComplete() -> bool:
18
            # This event is complete only after it has delivered its
19
            # signal.
20
            return delivered
21
22
       function execute():
23
            # Deliver the signal.
24
25
            globalIdStore.setIdentifier(identifier)
26
            # Record that we've delivered.
27
            delivered = true
28
```

Data Structures and Interfaces

This code assumes that there is a central store of signal identifiers that can be checked against, called globalIdStore. This can be a simple hash set, but should probably be emptied of stale identifiers from time to time. It has the following interface:

```
class IdStore:
      function setIdentifier(identifier: string)
2
      function hasIdentifier(identifier: string) -> bool
```

Implementation Notes

Another complication with this approach is the confusion between different occurrences of a signal. If a set of characters perform the same script more than once, then there will be an existing signal in the store from the previous time through. This may mean that none of the waits actually waits.

For that reason it is wise to have a script remove all the signals it intends to use from the global store before it runs. If there is more than one copy of a script running simultaneously (e.g., if two squads are both performing the same set of actions at different locations), then the identifier will need to be disambiguated further. If this situation could arise in your game, it may be worth moving to a more fine-grained messaging technique among each squad, such as the message passing algorithm in Chapter 11. Each squad then communicates signals only with others in the squad, removing all ambiguity.

Performance

Both the signal and wait actions are O(1) in both time and memory. In the implementation above, the Wait class needs to access the IdStore interface to check for signals. If the store is a hash set (which is its most likely implementation), then this will be an $O(\frac{n}{b})$ process, where n is the number of signals in the store, and b is the buckets in the hash set.

Although the wait action can cause the action manager to stop processing any further actions, the algorithm will return in constant time each frame (assuming the wait action is the only one being processed).

Creating Scripts

The infrastructure to run scripts is only half of the implementation task. In a full engine we need some mechanism to allow level designers or character designers to create the scripts.

This can be achieved using a simple text file with primitives that represent each kind of action, signal, and wait. Chapter 13, Section 13.3 gives some high-level information about how to create a parser to read and interpret text files of data. Alternatively, a tool can be exposed in the game engine editor to allow designers to build scripts out of visual components. Chapter 12 has more information about incorporating AI editors into the game production toolchain.

The next section on military tactics provides an example set of scripts for a collaborative action used in a real game scenario.

6.4.4 MILITARY TACTICS

So far we have looked at general approaches for implementing tactical or strategic AI. Most of the technology requirements can be fulfilled using common-sense applications of the techniques we've looked at throughout the book. To those, we add the specific tactical reasoning algorithms to get a better idea of the overall situation facing a group of characters.

As with all game development, we need both the technology to support a behavior and the content for the behavior itself. Although this will dramatically vary depending on the genre of game and the way the character is implemented, there are resources available for tactical behaviors of a military unit.

In particular, there is a large body of freely available information on specific tactics used by both the U.S. military and other NATO countries. This information is made up of training manuals intended for use by regular forces.

The U.S. infantry training manuals, in particular, can be a valuable resource for implementing military-style tactics in any genre of game from historical World War II games through to far future science fiction or medieval fantasy. They contain information for the sequences of events needed to accomplish a wide range of objectives, including military op-

erations in urban terrain (MOUT), moving through wilderness areas, sniping, relationships with heavy weapons, clearing a room or a building, and setting up defensive camps.

I have found that this kind of information is most suited to a cooperation script approach, rather than open-ended multi-tier or emergent AI. A set of scripts can be created that represents the individual stages of the operation, and these can then be made into a higher level script that coordinates the lower level events. As in all scripted behaviors, some feedback is needed to make sure the behaviors remain sensible throughout the script execution. The end result can be deeply uncanny: seeing characters move as a well-oiled fighting team and performing complex series of inter-timed actions to achieve their goal.

As an example of the kinds of script needed in a typical situation, let's look at implementations for an indoor squad-based shooter.

Case Study: A Fire Team Takes a House

Let's say that we have a game with a modern military setting where the AI team is a squad of special forces soldiers specializing in anti-terrorism duties. Their aim is to take a house rapidly and with extreme aggression to make sure the threat from its occupants is neutralized as fast as possible. In this simulation the player is not a member of the team but was a controlling operator scheduling the activities of several such special forces units.

The source material for this project was the "U.S. Army Field Manual 3-06.11 Combined Arms Operations in Urban Terrain" [72]. This particular manual contains step-by-step diagrams for moving along corridors, clearing rooms, moving across junctions, and general combat indoors.

Figure 6.29 shows the sequence for room clearing. First, the team assembles in set format outside the doorway. Second, a grenade is thrown into the room (this will be a stun grenade if the room might contain non-combatants or a lethal grenade otherwise). The first soldier into the room moves along the near wall and takes up a location in the corner, covering the room. The second soldier does the same to the adjacent corner. The remaining soldiers cover the center of the room. Each soldier shoots at any target they can see during this movement.

The game uses four scripts:

- Move into position outside the door.
- Throw in a grenade.
- Move into a corner of the room.
- Flank the inside of the doorway.

A top-level script coordinates these actions in turn. This script needs to first calculate the two corners required for the clearance. These are the two corners closest to the door, excluding corners that are too close to the door to allow a defensive position to be occupied. In the implementation for this game, a waypoint tactics system had already been used to identify all the corners in all the rooms in the game, along with waypoints for the door and locations on either side of the door both inside and out.

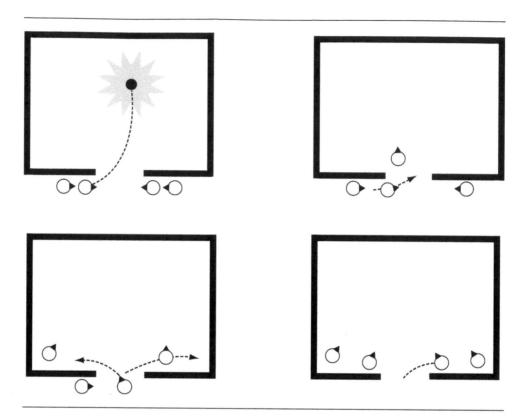

Figure 6.29: Taking a room

Determining the nearest corners in this way allows for the same script to be used on buildings of all different shapes, as shown in Figure 6.30.

The interactions between the scripts (using the Signal and Wait instances we saw earlier) allow the team to wait for the grenade to explode and to move in a coordinated way to their target locations while maintaining cover over all of the room.

A different top-level script is used for two- and three-person room clearances (in the case that one or more team members are eliminated), although the lower level scripts are identical in each case. In the three-person script, there is only one person left by the door (the first two still take the corners). In the two-person script, only the corners are occupied, and the door is left.

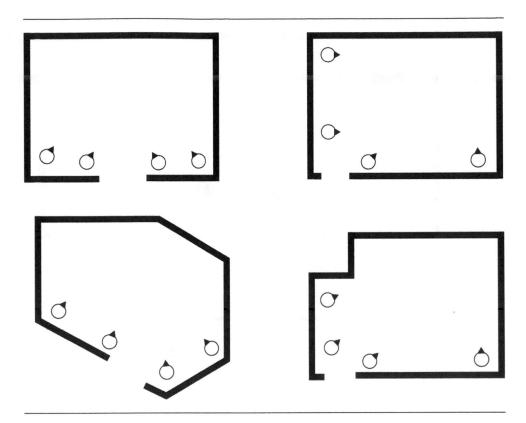

Figure 6.30: Taking various rooms

EXERCISES

- 6.1 Figure 6.31 shows a map with some unlabeled tactical points. Label points that would provide cover, points that are exposed, points that would make good ambush points, etc.
- 6.2 On page 492 suppose that, instead of interpreting the given waypoint values as degrees of membership, we interpret them as probabilities. Then, assuming cover and visibility values are independent, what is the probability that the location is a good sniping location?
- 6.3 Figure 6.32 shows a map with some cover points. Pre-determine the directions of cover and then compare the results to a post-processing step that uses line-of-sight tests to the indicated enemies.
- 6.4 Design a state machine that would produce behavior similar to that of the decision tree from Figure 6.6.

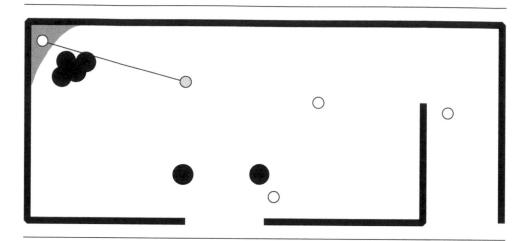

Figure 6.31: Tactical points in part of a game level

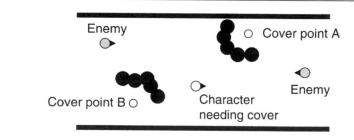

Figure 6.32: Cover points in part of a game level

- 6.5 Using the map from Exercise 6.3 calculate the runtime cover quality of the two potential cover points. Why might it be more reliable to try testing with some random offsets around cover point B?
- 6.6 Suppose that in Figure 6.9 the values of the waypoints are A, 1.7; B, 2.3; and C, 1.1. What is the result of applying the condensation algorithm? Is the result desirable?
- 6.7 Convolve the following filter with the 3×3 section of the map that appeared in Section 6.2.7.

$$M = \frac{1}{9} \begin{bmatrix} 1 & 1 & 1 \\ 1 & 1 & 1 \\ 1 & 1 & 1 \end{bmatrix}$$

What does the filter do? Why might it be useful? What problem can occur at the edges and how can it be fixed?

Figure 6.33: Military forces in a grid-based level

- 6.8 Use a linear influence drop-off to calculate the influence map for the placement of military forces in Figure 6.33.
 - If you are doing this exercise by hand, for simplicity, use the Manhattan distance to calculate all distances and assume a maximum radius of influence of 4. If you are writing code, then experiment with different settings for distance, influence drop-off, and maximum radius.
- 6.9 Use the influence map you calculated in Exercise 6.8 to determine the security level. Identify an area on the border where Black might consider an attack.
- 6.10 If in Exercise 6.9 we only had to calculate the security level at the border, what (if any) military units could we safely ignore and why?
- 6.11 Repeat Exercise 6.9, but this time calculate the security level from White's point of view assuming White doesn't know about Black's military unit of strength 2.
- 6.12 Suppose White uses the answer from 6.11 to mount an attack that moves from right to left along the bottom of the grid, then how might a frag-map help to infer the existence of an unknown enemy unit?
- 6.13 If Black knew that White had incorrect information such as in 6.11, how could Black use it to their advantage? In particular, devise a scheme to determine the best placement of a hidden unit by calculating the quality of a cell based on the cover it provides (better cover increases the chance of the unit remaining hidden), the actual security of the cell, and the (incorrect) perceived security from the enemy's point of view.
- 6.14 Using the map from Exercise 6.8, calculate the influence map by using the same 3×3 convolution filter given at the start of Section 6.2.7. You might want to use a computer to help you answer this question.

7

LEARNING

ACHINE LEARNING (often abbreviated ML, though in this book I will simply call it 'learning') is a hot topic in technology and business, and that excitement has filtered into games. In principle, learning AI has the potential to adapt to each player, learning their tricks and techniques and providing a consistent challenge. It has the potential to produce more believable characters: characters that can learn about their environment and use it to the best effect. It also has the potential to reduce the effort needed to create game-specific AI: characters should be able to learn about their surroundings and the tactical options that they provide.

In practice, it hasn't yet fulfilled its promise, and not for want of trying. Applying learning to your game requires careful planning and an understanding of the pitfalls. There have been some impressive successes in building learning AI that learns to *play* games, but less in providing compelling characters or enemies. The potential is sometimes more attractive than the reality, but if you understand the quirks of each technique and are realistic about how you apply them, there is no reason why you can't take advantage of learning in your game.

There is a whole range of different learning techniques, from very simple number tweaking through to complex neural networks. While most of the attention in the last few years has been focused on 'deep learning' (a form of neural networks) there are many other practical approaches. Each has its own idiosyncrasies that need to be understood before they can be used in real games.

7.1 LEARNING BASICS

We can classify learning techniques into several groups depending on when the learning occurs, what is being learned, and what effects the learning has on a character's behavior.

7.1.1 ONLINE OR OFFLINE LEARNING

Learning can be performed during the game, while the player is playing. This is online learning, and it allows the characters to adapt dynamically to the player's style and provides more consistent challenges. As a player plays more, their characteristic traits can be better anticipated by the computer, and the behavior of characters can be tuned to playing styles. This might be used to make enemies pose an ongoing challenge, or it could be used to offer the player more story lines of the kind they enjoy playing.

Unfortunately, online learning also produces problems with predictability and testing. If the game is constantly changing, it can be difficult to replicate bugs and problems. If an enemy character decides that the best way to tackle the player is to run into a wall, then it can be a nightmare to replicate the behavior (at worst you'd have to play through the whole same sequence of games, doing exactly the same thing each time as the player). I'll return to this issue later in this section.

The majority of learning in game AI is done offline, either between levels of the game or more often at the development studio before the game leaves the building. This is performed by processing data about real games and trying to calculate strategies or parameters from them.

This allows more unpredictable learning algorithms to be tried out and their results to be tested exhaustively. The learning algorithms in games are usually applied offline; it is rare to find games that use any kind of online learning. Learning algorithms are increasingly being used offline to learn tactical features of multi-player maps, to produce accurate pathfinding and movement data, and to bootstrap interaction with physics engines. These are very constrained applications. Studios are experimenting with using deep learning in a broader way, having characters learn higher behavior from scratch. It remains to be seen whether this is successful enough to make major inroads into the way AI is created.

Applying learning in the pause when loading the next level of the game is a kind of offline learning: characters aren't learning as they are acting. But it has many of the same downsides as online learning. We need to keep it short (load times for levels are usually part of a publisher or console manufacturer's acceptance criteria for a game and certainly affects player satisfaction). We need to take care that bugs and problems can be replicated without replaying tens of games. We need to make sure that the data from the game are easily available in a suitable format (we can't use long post-processing steps to dig data out of a huge log file, for example).

Most of the techniques in this chapter can be applied either online or offline. They aren't limited to one or the other. If they are to be applied online, then the data they will learn from

are presented as they are generated by the game. If it is used offline, then the data are stored and pulled in as a whole later.

7.1.2 INTRA-BEHAVIOR LEARNING

The simplest kinds of learning are those that change a small area of a character's behavior. They don't change the whole quality of the behavior, but simply tweak it a little. These intrabehavior learning techniques are easy to control and can be easy to test.

Examples include learning to target correctly when projectiles are modeled by accurate physics, learning the best patrol routes around a level, learning where cover points are in a room, and learning how to chase an evading character successfully. Most of the learning examples in this chapter will illustrate intra-behavior learning.

An intra-behavior learning algorithm doesn't help a character work out that it needs to do something very different (if a character is trying to reach a high ledge by learning to run and jump, it won't tell the character to simply use the stairs instead, for example).

7.1.3 INTER-BEHAVIOR LEARNING

The frontier for learning AI in games is learning of behavior. What I mean by behavior is a qualitatively different mode of action-for example, a character that learns the best way to kill an enemy is to lay an ambush or a character that learns to tie a rope across a backstreet to stop an escaping motorbiker. Characters that can learn from scratch how to act in the game provide a challenging opposition for even the best human players.

Unfortunately, this kind of AI is on the limit of what might be possible.

Over time, an increasing amount of character behavior may be learned, either online or offline. Some of this may be to learn how to choose between a range of different behaviors (although the atomic behaviors will still need to be implemented by the developer). It is doubtful that it will be economical to learn everything. The basic movement systems, decision making tools, suites of available behaviors, and high-level decision making will almost certainly be easier and faster to implement directly. They can then be augmented with intra-behavior learning to tweak parameters.

The frontier for learning AI is decision making. Developers are increasingly experimenting with replacing the techniques discussed in Chapter 5 with learning systems, in particular deep learning. This is the only kind of inter-behavior learning I will look at in detail in this chapter: making decisions between fixed sets of (possibly parameterized) behaviors.

7.1.4 A WARNING

In reality, learning is not as widely used as you might think. Some of this is due to the relative complexity of learning techniques (in comparison with pathfinding and movement algorithms, at least). But games developers master far more complex techniques all the time, for graphics, network and physics simulation. The biggest problems with learning are not difficulty, but reproducibility and quality control.

Imagine a game in which the enemy characters learn their environment and the player's actions over the course of several hours of gameplay. While playing one level, the QA team notices that a group of enemies is stuck in one cavern, not moving around the whole map. It is possible that this condition occurs only as a result of the particular set of things they have learned. In this case, finding the bug and later testing if it has been fixed involves replaying the same learning experiences. This is often impossible.

It is this kind of unpredictability that is the most often cited reason for severely curbing the learning ability of game characters. As companies developing industrial learning AI have often found, it is impossible to avoid the AI learning the "wrong" thing.

When you read academic papers about learning and games, they often use dramatic scenarios to illustrate the potential of a learning character on gameplay. You need to ask yourself, if the character can learn such dramatic changes of behavior then can it also learn dramatically poor behavior: behavior that might fulfill its own goals but will produce terrible gameplay? You can't have your cake and eat it. The more flexible your learning is, the less control you have on gameplay.

The normal solution to this problem is to constrain the kinds of things that can be learned in a game. It is sensible to limit a particular learning system to working out places to take cover, for example. This learning system can then be tested by making sure that the cover points it is identifying look right. The learning will have difficulty getting carried away; it has a single task that can be easily visualized and checked.

Under this modular approach there is nothing to stop several different learning systems from being applied (one for cover points, another to learn accurate targeting, and so on). Care must be taken to ensure that they can't interact in nasty ways. The targeting AI may learn to shoot in such a way that it often accidentally hits the cover that the cover-learning AI is selecting, for example.

7.1.5 OVER-LEARNING

A common problem identified in much of the AI learning literature is over-fitting, or overlearning. This means that if a learning AI is exposed to a number of experiences and learns from them, it may learn the response to only those situations. We normally want the learning AI to be able to generalize from the limited number of experiences it has to be able to cope with a wide range of new situations.

Different algorithms have different susceptibilities to over-fitting. Neural networks particularly can over-fit during learning if they are wrongly parameterized or if the network is too large for the learning task at hand. We'll return to these issues as we consider each learning algorithm in turn.

7.1.6 THE ZOO OF LEARNING ALGORITHMS

In this chapter we'll look at learning algorithms that gradually increase in complexity and sophistication. The most basic algorithms, such as the various parameter modification techniques in the next section, are often not thought of as learning at all.

At the other extreme we will look at reinforcement learning and neural networks, both fields of active AI research that are huge in their own right. The chapter ends with a overview of deep learning. But I will not be able to do more than scratch the surface of these advanced techniques. Hopefully there will be enough information to get the algorithms running. More importantly, I hope it will be clear why they are not yet ubiquitous in game AI.

7.1.7 THE BALANCE OF EFFORT

The key thing to remember in all learning algorithms is the balance of effort. Learning algorithms are attractive because you can do less implementation work. You don't need to anticipate every eventuality or make the character AI particularly good. Instead, you create a general-purpose learning tool and allow that to find the really tricky solutions to the problem. The balance of effort should be that it is less work to get the same result by creating a learning algorithm to do some of the work.

Unfortunately, it is often not possible. Learning algorithms can require a lot of handholding: presenting data in the correct way, parameterizing the learning system, making sure their results are valid, and testing them to avoid them learning the wrong thing.

I advise developers to consider carefully the balance of effort involved in learning. If a technique is very tricky for a human being to solve and implement, then it is likely to be tricky for the computer, too. If a human being can't reliably learn to keep a car cornering on the limit of its tire's grip, then a computer is unlikely to suddenly find it easy when equipped with a vanilla learning algorithm. To get the result you likely have to do a lot of additional work. Great results in academic papers can be achieved by the researchers carefully selecting the problem they need to solve, and spending a lot of time fine tuning the solution. Both are luxuries a studio AI developer cannot afford.

7.2 PARAMETER MODIFICATION

The simplest learning algorithms are those that calculate the value of one or more parameters. Numerical parameters are used throughout AI development: magic numbers that are used in steering calculations, cost functions for pathfinding, weights for blending tactical concerns, probabilities in decision making, and many other areas.

These values can often have a large effect on the behavior of a character. A small change in a decision making probability, for example, can lead an AI into a very different style of play.

Parameters such as these are good candidates for learning. Most commonly, this is done offline, but can usually be controlled when performed online.

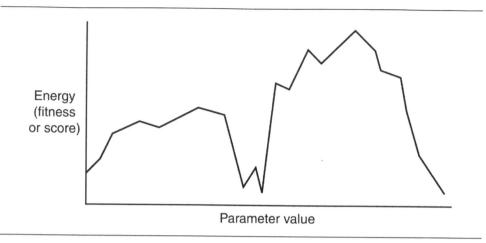

Figure 7.1: The energy landscape of a one-dimensional problem

7.2.1 THE PARAMETER LANDSCAPE

A common way of understanding parameter learning is the "fitness landscape" or "energy landscape." Imagine the value of the parameter as specifying a location. In the case of a single parameter this is a location somewhere along a line. For two parameters it is the location on a plane.

For each location (i.e., for each value of the parameter) there is some energy value. This energy value (often called a "fitness value" in some learning techniques) represents how good the value of the parameter is for the game. You can think of it as a score.

We can visualize the energy values by plotting them against the parameter values (see Figure 7.1).

For many problems the crinkled nature of this graph is reminiscent of a landscape, especially when the problem has two parameters to optimize (i.e., it forms a three-dimensional structure). For this reason it is usually called an energy or fitness landscape.

The aim of a parameter learning system is to find the best values of the parameter. The energy landscape model usually assumes that low energies are better, so we try to find the valleys in the landscape. Fitness landscapes are usually the opposite, so they try to find the peaks.

The difference between energy and fitness landscapes is a matter of terminology only: the same techniques apply to both. You simply swap searching for maximum (fitness) or minimum (energy). Often, you will find that different techniques favor different terminologies. In this section, for example, hill climbing is usually discussed in terms of fitness landscapes, and simulated annealing is discussed in terms of energy landscapes.

Energy and Fitness Values

It is possible for the energy and fitness values to be generated from some function or formula. If the formula is a simple mathematical formula, we may be able to differentiate it. If the formula is differentiable, then its best values can be found explicitly. In this case, there is no need for parameter optimization. We can simply find and use the best values.

In most cases, however, no such formula exists. The only way to find out the suitability of a parameter value is to try it out in the game and see how well it performs. In this case, there needs to be some code that monitors the performance of the parameter and provides a fitness or energy score. The techniques in this section all rely on having such an output value.

If we are trying to generate the correct parameters for decision making probabilities, for example, then we might have the character play a couple of games and see how it scores. The fitness value would be the score, with a high score indicating a good result.

In each technique we will look at several different sets of parameters that need to be tried. If we have to have a five-minute game for each set, then learning could take too long. There usually has to be some mechanism for determining the value for a set of parameters quickly. This might involve allowing the game to run at many times normal speed, without rendering the screen, for example. Or, we could use a set of heuristics that generate a value based on some assessment criteria, without ever running the game. If there is no way to perform the check other than running the game with the player, then the techniques in this chapter are unlikely to be practical.

There is nothing to stop the energy or fitness value from changing over time or containing some degree of guesswork. Often, the performance of the AI depends on what the player is doing. For online learning, this is exactly what we want. The best parameter value will change over time as the player behaves differently in the game. The algorithms in this section cope well with this kind of uncertain and changing fitness or energy score.

In all cases we will assume that we have some function that we can give a set of parameter values and it will return the fitness or energy value for those parameters. This might be a fast process (using heuristics) or it might involve running the game and testing the result. For the sake of parameter modification algorithms, however, it can be treated as a black box: in goes the parameters and out comes the score.

7.2.2 HILL CLIMBING

Initially, a guess is made as to the best parameter value. This can be completely random; it can be based on the programmer's intuition or even on the results from a previous run of the algorithm. This parameter value is evaluated to get a score.

The algorithm then tries to work out in what direction to change the parameter in order to improve its score. It does this by looking at nearby values for each parameter. It changes each parameter in turn, keeping the others constant, and checks the score for each one. If it sees that the score increases in one or more directions, then it moves up the steepest gradient. Figure 7.2 shows the hill climbing algorithm scaling a fitness landscape.

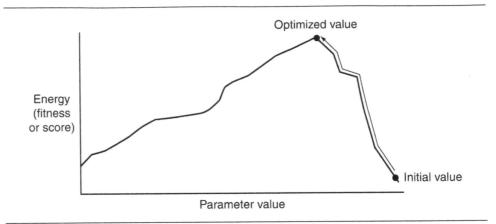

Figure 7.2: Hill climbing ascends a fitness landscape

In the single parameter case, two neighboring values are sufficient, one on each side of the current value. For two parameters four samples are used, although more samples in a circle around the current value can provide better results at the cost of more evaluation time.

Hill climbing is a very simple parametric optimization technique. It is fast to run and can often give very good results.

Pseudo-Code

One step of the algorithm can be run using the following implementation:

```
function optimizeParameters(parameters: float[], func) -> float[]:
       # The best parameter change so far.
2
       bestParameterIndex: int = -1
3
       bestTweak: float = 0
       # The initial best value is the value of the current
6
       # parameters, no point changing to a worse set.
       bestValue: float = func(parameters)
8
       # Loop through each parameter.
10
       for i in 0..parameters.size():
11
           # Store the current parameter value.
12
           currentParameter: float = parameters[i].value
14
           # Tweak it both up and down.
15
           for tweak in [-STEP, STEP]:
16
               # Apply the tweak.
17
               parameters[i].value += tweak
18
```

```
19
                # Get the value of the function.
20
                value: float = func(parameters[i])
21
22
                # Is it the best so far?
23
                if value > bestValue:
24
25
                     # Store it.
                     bestValue = value
26
                     bestParameterIndex = i
27
                     bestTweak = tweak
28
29
                # Reset the parameter to its old value.
30
                parameters[i].value = currentParameter
31
32
       # We've gone through each parameter, check if we
33
       # have found a good set.
34
        if bestParameterIndex >= 0:
35
            # Make the parameter change permanent.
36
            parameters[bestParameterIndex] += bestTweak
37
38
       # Return the modified parameters, if we found a better
39
       # set, or the parameters we started with otherwise.
       return parameters
```

The STEP constant in this function dictates the size of each tweak that can be made. We could replace this with an array, with one value per parameter if parameters required different step sizes.

The optimizeParameters function can then be called multiple times in a row to give the hill climbing algorithm. At each iteration the parameters given are the results from the previous call to optimizeParameters.

```
function hillClimb(initial: float[], steps: int, func) -> float[]:
       # Set the initial parameter settings.
       parameters: float[] = initial
       # Find the initial value for the initial parameters.
       value: float = func(parameters)
       # Go through a number of steps.
8
       for i in 0...steps:
10
           # Get the new parameter settings.
           newParameters: float[] = optimizeParameters(parameters, func)
11
12
           # Get the new value.
13
14
           newValue: float = func(newParameters)
15
16
           # If we can't improve, then end.
```

```
if newValue <= value:
17
                break
18
19
            # Store the new value for next iteration.
20
            value = newValue
21
            parameters = newParameters
22
23
       # We've either run out of steps, or we can't improve.
24
       return parameters
25
```

Data Structures and Interfaces

The list of parameters has its number of elements accessed with the size method. Other than this, there are no special interfaces or data structures required.

Implementation Notes

In the implementation above I evaluate the function on the same set of parameters inside both the driver and the optimization functions. This is wasteful, especially if the evaluation function is complex or time-consuming.

We should allow the same value to be shared, either by caching it (so it isn't re-evaluated when the evaluation function is called again) or by passing both the value and the parameters back from optimizeParameters.

Performance

Each iteration of the algorithm is O(n) in time, where n is the number of parameters. It is O(1) in memory. The number of iterations is controlled by the steps parameter. If the steps parameter is sufficiently large, then the algorithm will return when it has found a solution (i.e., it has a set of parameters that it cannot improve further).

7.2.3 EXTENSIONS TO BASIC HILL CLIMBING

The hill climbing problem given in the algorithm description above is very easy to solve. It has a single slope in each direction from the highest fitness value. Following the slope will always lead you to the top. The fitness landscape in Figure 7.3 is more complex. The hill climbing algorithm shows that the best parameter value is never found. It gets stuck on a small sub-peak on the way to the main peak.

This sub-peak is called a local maximum (or a local minimum if we are using an energy landscape). The more local maxima there are in a problem, the more difficult it is for any

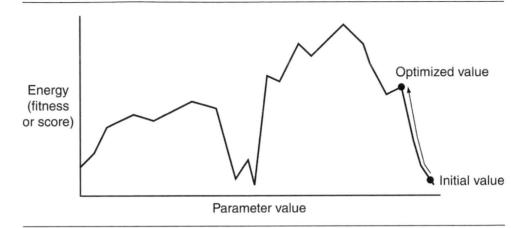

Figure 7.3: Non-monotonic fitness landscape with sub-optimal hill climbing

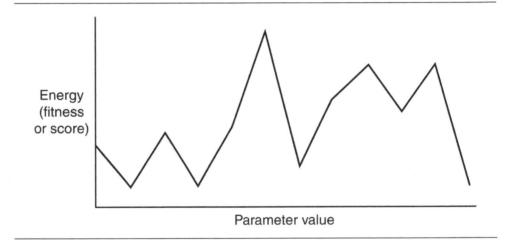

Figure 7.4: Random fitness landscape

algorithm to solve. At worst, every fitness or energy value could be random and not correlated to the nearby values at all. This is shown in Figure 7.4, and, in this case, no systematic search mechanism will be able to solve the problem.

The basic hill climbing algorithm has several extensions that can be used to improve performance when there are local maxima. None of them forms a complete solution, and none works when the landscape is near to random, but they can help if the problem isn't overwhelmed by sub-optima.

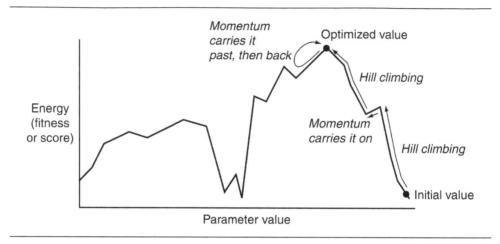

Figure 7.5: Non-monotonic fitness landscape solved by momentum hill climbing

Momentum

In the case of Figure 7.3 (and many others), we can solve the problem by introducing momentum. If the search is consistently improving in one direction, then it should continue in that direction for a little while, even when it seems that things aren't improving any more.

This can be implemented using a momentum term. When the hill climber moves in a direction, it keeps a record of the score improvement it achieved at that step. At the next step it adds a proportion of that improvement to the fitness score for moving in the same direction again, which then biases the algorithm to move in the same direction again.

This approach will deliberately overshoot the target, take a couple of steps to work out that it is getting worse, and then reverse. Figure 7.5 shows the previous fitness landscape with momentum in the hill climbing algorithm. Notice that it takes much longer to reach the best parameter value, but it doesn't get stuck so easily on the way to the main peak.

Adaptive Resolution

So far we have assumed that the parameter is changed by the same amount at each step of the algorithm. When the parameter is a long way from the best value, taking small steps means that the learning is slow (especially if it takes a while to generate a score by having the AI play the game). On the other hand, if the steps are large, then the optimization may always overshoot and never reach the best value.

Adaptive resolution is often used to make long jumps early in the search and smaller jumps later on. As long as the hill climbing algorithm is successfully improving, it will increase the length of its jumps somewhat. When it stops improving, it assumes that the jumps are

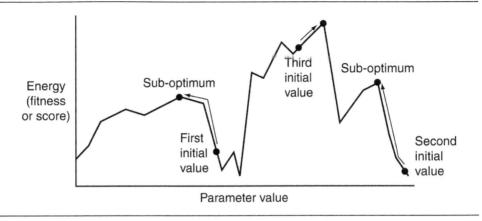

Figure 7.6: Hill climbing multiple trials

overshooting the best value and reduces their size. This approach can be combined with a momentum term or used on its own in a regular hill climber.

Multiple Trials

Hill climbing is very much dependent on the initial guess. If the initial guess isn't on the slope toward the best parameter value, then the hill climber may move off completely in the wrong direction and climb a smaller peak. Figure 7.6 shows this situation.

Most hill climbing algorithms use multiple different start values distributed across the whole landscape. In Figure 7.6, the correct optimum is found on the third attempt.

In cases where the learning is being performed online and the player expects the AI not to suddenly get worse (because it starts the hill climbing again with a new parameter value), this may not be a suitable technique.

Finding the Global Optimum

So far we've talked as if the goal is to find the best possible solution. This is undoubtedly our ultimate aspiration, but we are faced with a problem. In most problems we not only have no idea what the best solution is but we can't even recognize it when we find it.

Let's say in an RTS game we are trying to optimize the best use of resources into construction or research, for example. We may run 200 trials and find that one set of parameters is clearly the best. We can't guarantee it is the best of all possible sets, however. Even if the last 50 trials all come up with the same value, we can't guarantee that we won't find a better set of parameters on the next go. There is no formula we can work out that lets us tell if the solution we have is the best possible one.

Extensions to hill climbing such as momentum, adaptive resolution, and multiple trials don't guarantee that we get the best solution, but compared to the simple hill climbing algorithm they will almost always find better solutions more quickly. In a game we need to balance the time spent looking with the quality of solution. Eventually, the game needs to stop looking and conclude that the solution it has will be the one it uses, regardless if there is a better one out there.

This is sometimes called "satisficing" (although that term has different meanings for different people): we are optimizing to get a satisfactory result, rather than to find the best result.

7.2.4 ANNEALING

Annealing is a physical process where the temperature of a molten metal is slowly reduced, allowing it to solidify in a highly ordered way. Reducing the temperature suddenly leads to internal stresses, weaknesses, and other undesired effects. Slow cooling allows the metal to find its lowest energy configuration.

As a parameter optimization technique, annealing uses a random term to represent the temperature. Initially, it is high, making the behavior of the algorithm very random. Over time it reduces, and the algorithm becomes more predictable.

It is based on the standard hill climbing algorithm, although it is customary to think in terms of energy landscapes rather than fitness landscapes (hence hill climbing becomes hill descent).

There are many ways to introduce the randomness into the hill descent algorithm. The original method uses a calculated Boltzmann probability coefficient. We'll look at this later in this section. A simpler method is more commonly implemented, however, for simple parameter learning applications.

Direct Method

At each hill climbing step, a random number is added to the evaluation for each neighbor of the current value. In this way the best neighbor is still more likely to be chosen, but it can be overridden by a large random number. The range of the random number is initially large, but is reduced over time.

For example, the random range is ± 10 , the evaluation of the current value is 0, and its neighbors have evaluations of 20 and 39. A random number is added from the range ±10 to each evaluation. It is possible that the first value (scoring 20) will be chosen over the second, but only if the first gets a random number of +10 and the second gets a random number of -10. In the vast majority of cases, the second value will be chosen.

Several steps later, the random range might be ±1, in which case the first neighbor could never be chosen. On the other hand, at the start of the annealing, the random range might be ± 100 , where the first neighbor has a very good chance of being chosen.

Pseudo-Code

We can apply this directly to our previous hill climbing algorithm. The optimizeParameters function is replaced by annealParameters.

```
function annealParameters(parameters: float[], func, temp) -> float[]:
        # The best parameter change so far.
 2
        bestParameterIndex: int = -1
 3
        bestTweak: float = 0
 4
 5
        # The initial best value is the value of the current parameters,
 6
        # no point changing to a worse set.
 7
        bestValue: float = func(parameters)
 8
        # Loop through each parameter.
10
        for i in 0..parameters.size():
11
            # Store the current parameter value.
            currentParameter: float = parameters[i].value
            # Tweak it both up and down.
            for tweak in [-STEP, STEP]:
                # Apply the tweak.
                parameters[i].value += tweak
18
19
                # Get the value of the function.
20
                value = func(parameters[i]) + randomBinomial() * temp
21
22
                # Is it the best so far?
23
                # (Remember this is now hill-descent).
24
                if value < bestValue:
25
                    # Store it.
26
                    bestValue = value
27
                    bestParameterIndex = i
28
                    bestTweak = tweak
29
30
                # Reset the parameter to its old value.
31
                parameters[i].value = currentParameter
32
33
       # We've gone through each parameter, check if we have a good set.
34
       if bestParameterIndex >= 0:
35
           # Make the parameter change permanent.
36
           parameters[bestParameterIndex] += bestTweak
37
38
       # Return the modified parameters, if we found a better set, or the
39
       # parameters we started with otherwise.
40
       return parameters
```

The randomBinomial function is implemented as

```
function randomBinomial() -> float:
    return random() - random()
```

as in previous chapters.

The main hill climbing function should now call annealParameters rather than optimizeParameters.

Implementation Notes

I have changed the direction of the comparison operation in the middle of the algorithm. Because annealing algorithms are normally written based on energy landscapes, I have changed the implementation so that it now looks for a lower function value.

Performance

The performance characteristics of the algorithm are as before: O(n) in time and O(1) in memory.

Boltzmann Probabilities

Motivated by the physical annealing process, the original simulated annealing algorithm used a more complex method of introducing the random factor to hill climbing. It was based on a slightly less complex hill climbing algorithm.

In our hill climbing algorithm we evaluate all neighbors of the current value and work out which is the best one to move to. This is often called "steepest gradient" hill climbing, because it moves in the direction that will bring the best results. A simpler hill climbing algorithm will simply move as soon as it finds the first neighbor with a better score. It may not be the best direction to move in, but is an improvement nonetheless.

We can combine annealing with this simpler hill climbing algorithm as follows. If we find a neighbor that has a lower (better) score, we select it as normal. If the neighbor has a worse score, then we calculate the energy we'll be gaining by moving there, ΔE . We make this move with a probability proportional to

$$e^{-\frac{\Delta E}{T}}$$

where T is the current temperature of the simulation (corresponding to the amount of randomness). In the same way as previously, the ${\cal T}$ value is lowered over the course of the process.

Pseudo-Code

We can implement a Boltzmann optimization step in the following way:

```
function boltzmannAnnealParameters(parameters, func, temp):
        # Store the initial value.
 2
        initialValue = func(parameters)
 3
 5
        # Loop through each parameter.
        for i in 0..parameters.size():
 6
            # Store the current parameter value.
 7
            currentParameter = parameters[i].value
 8
 9
            # Tweak it both up and down.
10
11
            for tweak in [-STEP, STEP]:
12
                 # Apply the tweak.
                 parameters[i].value += tweak
13
14
                 # Get the value of the function.
15
                 value = func(parameters[i])
16
17
                 # Is it the best so far?
18
                 if value < initialValue:
19
                     # Return it.
20
                     return parameters
21
22
                # Otherwise check if we should do it anyway.
23
                 else:
24
                     # Calculate the energy gain and coefficient.
25
                     energyGain = value - initialValue
26
                     boltzmannCoeff = exp(-energyGain / temp)
27
28
                     # Randomly decide whether to accept it.
29
                     if random() < boltzmannCoeff:</pre>
30
                         # We're going with the change, return it.
31
                         return parameters
32
33
            # Reset the parameter to its old value.
34
            parameters[i].value = currentParameter
35
36
       # We found no better parameters, return the originals.
37
       return parameters
38
```

The exp function returns the value of e raised to the power of its argument. It is a standard function in most math libraries.

The driver function is as before, but now calls boltzmannAnnealParameters rather than optimizeParameters.

Performance

The performance characteristics of the algorithm are as before: O(n) in time and O(1) in memory.

Optimizations

Just like regular hill climbing, annealing algorithms can be combined with momentum and adaptive resolution techniques for further optimization. Combining all these techniques is often a matter of trial and error, however. Tuning the amount of momentum, changing the step size, and annealing temperature so they work in harmony can be tricky.

In my experience I've rarely been able to make reliable improvements to annealing by adding in momentum, although adaptive step sizes are useful.

7.3 ACTION PREDICTION

It is often useful to be able to guess what players will do next. Whether it is guessing which passage they are going to take, which weapon they will select, or which route they will attack from, a game that can predict a player's actions can mount a more challenging opposition.

Humans are notoriously bad at behaving randomly. Psychological research has been carried out over decades and shows that we cannot accurately randomize our responses, even if we specifically try. Mind magicians and expert poker players make use of this. They can often easily work out what we'll do or think next based on a relatively small amount of experience of what we've done in the past.

Often, it isn't even necessary to observe the actions of the same player. We have shared characteristics that run so deep that learning to anticipate one player's actions can often lead to better play against a completely different player.

7.3.1 LEFT OR RIGHT

A simple prediction game is "left or right." One person holds a coin in either the left or right hand. The other person then attempts to guess which hand the person has hidden it in.

Although there are complex physical giveaways (called "tells") which indicate a person's choice, it turns out that a computer can score reasonably well at this game also. We will use it as the prototype action prediction task.

In a game context, this may apply to the choice of any item from a set of options: the choice of passageway, weapon, tactic, or cover point.

7.3.2 RAW PROBABILITY

The simplest way to predict the choice of a player is to keep a tally of the number of times they choose each option. This will then form a raw probability of that player choosing that action again.

For example, after 20 times through a level, if the first passage has been chosen 72 times, and the second passage has been chosen 28 times, then the AI will be able to predict that a player will choose the first route.

Of course, if the AI then always lays in wait for the player in the first route, the player will very quickly learn to use the second route.

This kind of raw probability prediction is very easy to implement, but it gives a lot of feedback to the player, who can use the feedback to make their decisions more random.

In the above example, the character will position itself on the most likely route. The player will only fall foul of this once and then will use the other route. The character will continue standing where the player isn't until the probabilities balance. Eventually, the player will learn to simply alternate different routes and always miss the character.

When the choice is made only once, then this kind of prediction may be all that is possible. If the probabilities are gained from many different players, then it can be a good indicator of which way a new player will go.

Often, a series of choices must be made, either repeats of the same choice or a series of different choices. The early choices can have good predictive power over the later choices. We can do much better than using raw probabilities.

7.3.3 STRING MATCHING

When a choice is repeated several times (the selection of cover points or weapons when enemies attack, for example), a simple string matching algorithm can provide good prediction.

The sequence of choices made is stored as a string (it can be a string of numbers or objects, not just a string of characters). In the left-and-right game this may look like "LRRLRLLLR-RLRLRR," for example. To predict the next choice, the last few choices are searched for in the string, and the choice that normally follows is used as the prediction.

In the example above the last two moves were "RR." Looking back over the sequence, two right-hand choices are always followed by a left, so we predict that the player will go for the left hand next time. In this case we have looked up the last two moves. This is called the "window size": we are using a window size of two.

7.3.4 N-GRAMS

The string matching technique is rarely implemented by matching against a string. It is more common to use a set of probabilities similar to the raw probability in the previous section. This is known as an N-Gram predictor (where N is one greater than the window size parameter, so 3-Gram would be a predictor with a window size of two).

In an N-Gram we keep a record of the probabilities of making each move given all combinations of choices for the previous N moves. So in a 3-Gram for the left-and-right game we keep track of probability for left and right given four different sequences: "LL," "LR," "RL," and "RR." That is eight probabilities in all, but each pair must add up to one.

The sequence of moves above reduces to the following probabilities:

$$\begin{array}{cccc} & ..R & ..L \\ LL & \frac{1}{2} & \frac{1}{2} \\ LR & \frac{3}{5} & \frac{2}{5} \\ RL & \frac{3}{4} & \frac{1}{4} \\ RR & \frac{0}{2} & \frac{2}{2} \end{array}$$

The raw probability method is equivalent to the string matching algorithm, with a zero window size.

N-Grams in Computer Science

N-Grams are used in various statistical analysis techniques and are not limited to prediction. They have applications particularly in analysis of human languages.

Strictly, an N-Gram algorithm keeps track of the frequency of each sequence, rather than the probability. In other words, a 3-Gram will keep track of the number of times each sequence of three choices is seen. For prediction, the first two choices form the window, and the probability is calculated by looking at the proportion of times each option is taken for the third choice.

In the implementation I will follow this pattern by storing frequencies rather than probabilities (they also have the advantage of being easier to update), although we will optimize the data structures for prediction by allowing lookup using the window choices only.

Pseudo-Code

We can implement the N-Gram predictor in the following way:

```
class NGramPredictor:
      # The frequency data.
2
      data: Hashtable[any[] -> KeyDataRecord]
3
      # The size of the window + 1.
6
      nValue: int
7
      # Register a set of actions with predictor, updating its data. We
```

```
# assume actions has exactly nValue elements in it.
 9
        function registerSequence(actions: any[]):
10
            # Split the sequence into a key and value.
11
            key = actions[0..nValue]
12
            value = actions[nValue]
13
14
            # Make sure we've got storage.
15
            if not key in data:
16
                 keyData = data[key] = new KeyDataRecord()
17
            else:
18
                 keyData = data[key]
19
20
            # Add to the total, and to the count for the value.
21
            keyData.counts[value] += 1
22
            keyData.total += 1
23
24
        # Get the next action most likely from the given one. We assume
25
        # actions has nValue - 1 elements in it (i.e. the size of the
26
        # window).
27
        function getMostLikely(actions: any[]) -> any:
28
            # Get the key data.
29
            keyData = data[actions]
30
31
            # Find the highest probability.
32
            highestValue = 0
33
            bestAction = null
34
35
            # Get the list of actions in the store.
36
            actions = keyData.counts.getKeys()
37
38
            # Go through each.
39
            for action in actions:
40
                # Check for the highest value.
41
                if keyData.counts[action] > highestValue:
42
                    # Store the action.
43
                    highestValue = keyData.counts[action]
                    bestAction = action
45
46
            # We've looked through all actions, if best action is still
47
48
            # null, then its because we have no data on the given window.
            # Otherwise we have the best action to take.
49
            return bestAction
50
```

Each time an action occurs, the game registers the last n actions using the registerActions method. This updates the counts for the N-Gram. When the game needs to predict what will happen next, it feeds only the window actions into the getMostLikely method,

which returns the most likely action or none if no data has ever been seen for the given action.

Data Structures and Interfaces

In the pseudo-code I have used a hash table to store count data. Each entry in the data hash is a key data record, which has the following structure:

```
class KeyDataRecord:
      # The counts for each successor action.
2
      counts: Hashtable[anv -> int]
      # The number of times the window has been seen.
      total: int
```

There is one KeyDataRecord instance for each set of window actions. It contains counts for how often each following action is seen and a total member that keeps track of the total number of times the window has been seen.

We can calculate the probability of any following action by dividing its count by the total. This isn't used in the algorithm above, but it can be used to determine how accurate the prediction is likely to be. A character may only lay an ambush in a dangerous location, for example, if it is very sure the player will come its way.

Within the record, the counts member is also a hash table indexed by the predicted action. In the getMostLikely function we need to be able to find all the keys in the counts hash table. This is done using the getKeys method.

Implementation Notes

The implementation above will work with any window size and can support more than two actions. It uses hash tables to avoid growing too large when most combinations of actions are never seen.

If there are only a small number of actions, and all possible sequences can be visited, then it will be more efficient to replace the nested hash tables with a single array. As in the table example at the start of this section, the array is indexed by the window actions and the predicted action. Values in the array initialized to zero are simply incremented when a sequence is registered. One row of the array can then be searched to find the highest value and, therefore, the most likely action.

Performance

Assuming that the hash tables are not full (i.e., that hash assignment and retrieval are constant time processes), the register Actions function is O(1) in time. The get MostLikely function

is O(m) in time, where m is the number of possible actions (since we need to search each possible follow-on action to find the best). We can swap this over by keeping the counts hash table sorted by value. In this case, registerActions will be O(m) and getMostLikely will be O(1).

In most cases, however, actions will need to be registered much more often than they are predicted, so the balance as given is optimum.

The algorithm is $O(m_n)$ in memory, where n is the N value. The N value is the number of actions in the window, plus one.

7.3.5 WINDOW SIZE

Increasing the window size initially increases the performance of the prediction algorithm. For each additional action in the window, the improvement reduces until there is no benefit to having a larger window, and eventually the prediction gets worse with a larger window until we end up making worse predictions than we would if we simply guessed at random.

This is because, while our future actions are predicted by our preceding actions, this is rarely a long causal process. We are drawn toward certain actions and short sequences of actions, but longer sequences only occur because they are made up of the shorter sequences. If there is a certain degree of randomness in our actions, then a very long sequence will likely have a fair degree of randomness in it. The very large window size is likely to include more randomness and, therefore, be a poor predictor. There is a balance in having a large enough window to accurately capture the way our actions influence each other, without being so long that it gets foiled by our randomness. As the sequence of actions gets more random, the window size needs to be reduced.

Figure 7.7 shows the accuracy of an N-Gram for different window sizes on a sequence of 1,000 trials (for the left-or-right game). You'll notice that we get greatest predictive power in the 5-Gram, and higher window sizes provide worse performance. But the majority of the power of the 5-Gram is present in the 3-Gram. If we use just a 3-Gram, we'll get almost optimum performance, and we won't have to train on so many samples. Once we get beyond the 10-Gram, prediction performance is very poor. Even on this very predictable sequence, we get worse performance than we'd expect if we guessed at random. This graph was produced using an N-Gram implementation which follows the algorithm given above.

In predictions where there are more than two possible choices, the minimum window size needs to be increased a little. Figure 7.8 shows results for the predictive power in a five choice game. In this case the 3-Gram does have noticeably less power than the 4-Gram.

We can also see in this example that the falloff is faster for higher window sizes: large window sizes get poorer more quickly than before.

There are mathematical models that can tell you how well an N-Gram predictor will predict a sequence. They are sometimes used to tune the optimal window size. I've never seen this done in games, however, and because they rely on being able to find certain inconvenient

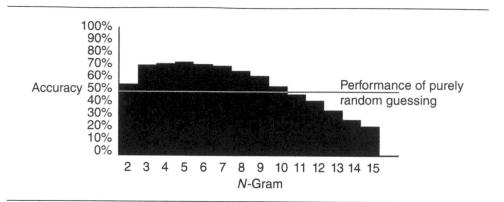

Figure 7.7: Different window sizes

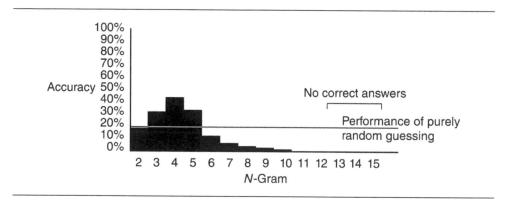

Figure 7.8: Different windows in a five choice game

statistical properties of the input sequence, I suggest it is simpler to just start at a 4-Gram and use trial and error.

Memory Concerns

Counterbalanced against the improvement in predictive power are the memory and data requirements of the algorithm. For the left-and-right game, each additional move in the window doubles the number of probabilities that need to be stored (if there are three choices rather than two it triples the number, and so on). This increase in storage requirements can often get out of hand, although "sparse" data structures such as a hash table (where not every value needs to have storage assigned) can help.

Sequence Length

The larger number of probabilities requires more sample data to fill. If most of the sequences have never been seen before, then the predictor will not be very powerful. To reach the optimal prediction performance, all the likely window sequences need to have been visited several times. This means that learning takes much longer, and the performance of the predictor can appear quite poor. This final issue can be solved to some extent using a variation on the N-Gram algorithm: hierarchical N-Grams.

7.3.6 HIERARCHICAL N-GRAMS

When an N-Gram algorithm is used for online learning, there is a balance between the maximum predictive power and the performance of the algorithm during the initial stages of learning. A larger window size may improve the potential performance, but will mean that the algorithm takes longer to get to a reasonable performance level.

The hierarchical N-Gram algorithm effectively has several N-Gram algorithms working in parallel, each with increasingly large window sizes. A hierarchical 3-Gram will have regular 1-Gram (i.e., the raw probability approach), 2-Gram, and 3-Gram algorithms working on the same data.

When a series of actions are provided, it is registered in all the N-Grams. A sequence of "LRR" passed to a hierarchical 3-Gram, for example, gets registered as normal in the 3-Gram, the "RR" portion gets registered in the 2-Gram, and "R" gets registered in the 1-Gram.

When a prediction is requested, the algorithm first looks up the window actions in the 3-Gram. If there have been sufficient examples of the window, then it uses the 3-Gram to generate its prediction. If there haven't been enough, then it looks at the 2-Gram. If that likewise hasn't had enough examples, then it takes its prediction from the 1-Gram. If none of the N-Grams has sufficient examples, then the algorithm returns no prediction or just a random prediction.

How many constitutes "enough" depends on the application. If a 3-Gram has only one entry for the sequence "LRL," for example, then it will not be confident in making a prediction based on one occurrence. If the 2-Gram has four entries for the sequence "RL," then it may be more confident. The more possible actions there are, the more examples are needed for an accurate prediction.

There is no single correct threshold value for the number of entries required for confidence. To some extent it needs to be found by trial and error. In online learning, however, it is common for the AI to make decisions based on very sketchy information, so the confidence threshold can be small (say, 3 or 4). In some of the literature on N-Gram learning, confidence values are much higher. As in many areas of AI, game AI can afford to take more risks.

Pseudo-Code

The hierarchical N-Gram system uses the original N-Gram predictor and can be implemented like the following:

```
class HierarchicalNGramPredictor:
       # Holds an array of n-grams with increasing n values.
       ngrams: NGramPredictor[]
3
       # The maximum window size + 1.
       nValue: int
       # The minimum number of samples an n-gram must have before
       # its allowed to predict.
       threshold: int
       function HierarchicalNGramPredictor(n: int):
12
           # Store the maximum n-gram size.
13
           nValue = n
14
15
           # Create the array of n-grams.
16
           ngrams = new NGramPredictor[nValue]
17
18
           for i in 0...nValue:
19
               ngrams[i].nValue = i+1
20
21
       function registerSequence(actions: any[]):
22
           # Go through each n-gram.
23
           for i in 0...nValue:
               # Create the sub-list of actions and register it.
               subActions = actions[(nValue - i)..nValue]
               ngrams[i].registerSequence(subActions)
27
28
       function getMostLikely(actions: any[]) -> any:
29
           # Go through each n-gram in descending order.
30
           for i in nValue..0:
31
               # Find the relevant n-gram.
32
               ngram = ngrams[i]
33
34
               # Get the sub-list of window actions.
35
               subActions = actions[i..]
36
37
               # Check if we have enough entries.
38
               if subActions in ngram.data and
39
                        ngram.data[subActions].count > threshold:
40
                    # Get the ngram to do the prediction.
41
                    return ngram.getMostLikely(subActions)
42
43
```

```
# If we get here, it is because no n-gram is over the
45
           # threshold: return no action.
           return null
```

I have added an explicit constructor in the algorithm to show how the array of N-Grams is structured.

Data Structures and Implementation

The algorithm uses the same data structures as previously and has the same implementation caveats: its constituent N-Grams can be implemented in whatever way is best for your application, as long as a count variable is available for each possible set of window actions.

Performance

The algorithm is O(n) in memory and O(n) in time, where n is the highest numbered N-Gram used.

The registerSequence method uses the O(1) registerSequence method of the N-Gram class, so it is O(n) overall. The getMostLikely method uses the O(n) getMostLikely method of the N-Gram class once, so it is O(n) overall.

Confidence

The code above used the number of samples to decide whether to use one level of N-Gram or to look at lower levels. While this gives good behavior in practice, it is strictly only an approximation. What we are interested in is the confidence that an N-Gram has in the prediction it will make. Confidence is a formal quantity defined in probability theory, although it has several different versions with their own characteristics. The number of samples is just one element that affects confidence.

In general, confidence measures the likelihood of a situation being arrived at by chance. If the probability of a situation being arrived at by chance is low, then the confidence is high.

For example, if we have four occurrences of "RL," and all of them are followed by "R," then there is a good chance that RL is normally followed by R, and our confidence in choosing R next is high. If we have 1000 "RL" occurrences followed always by "R," then the confidence in predicting an "R" would be much higher. If, on the other hand, the four occurrences are followed by "R" in two cases and by "L" in two cases, then we'll have no idea which one is more likely.

Actual confidence values are more complex than this. They need to take into account the probability that a smaller window size will have captured the correct data, while the more accurate N-Gram will have been fooled by random variation.

The math involved in all this isn't concise and doesn't buy any performance increase. I've

only ever used a simple count cut-off in this kind of algorithm. In preparing for this book I experimented and changed implementation to take into account more complex confidence values, but there was no measurable improvement in performance.

7.3.7 APPLICATION IN COMBAT

By far the most widespread game application of N-Gram prediction is in combat games. Beatem-ups, sword combat games, and any other combo-based melee games involve timed sequences of moves. Using an N-Gram predictor allows the AI to predict what the player is trying to do as they start their sequence of moves. It can then select an appropriate rebuttal.

This approach is so powerful, however, that it can provide unbeatable AI. A common requirement in this kind of game is to remove competency from the AI so that the player has a sporting chance.

This application is so deeply associated with the technique that many developers don't give it a second thought in other situations. Predicting where players will be, what weapons they will use, or how they will attack are all areas to which N-Gram prediction can be applied.

7.4 DECISION LEARNING

So far I have described learning algorithms that operate on relatively restricted domains: the value of a parameter and predicting a series of player choices from a limited set of options.

To realize the potential of learning AI, we would need to allow the AI to learn to make decisions. Chapter 5 outlined several methods for making decisions; the following sections look at decision makers that choose based on their experience.

These approaches cannot replace the basic decision making tools. State machines, for example, explicitly limit the ability of a character to make decisions that are not applicable in a situation (no point choosing to fire if your weapon has no ammo, for example). Learning is probabilistic; you will usually have some probability (however small) of carrying out each possible action. Learning hard constraints is notoriously difficult to combine with learning general patterns of behavior suitable for outwitting human opponents.

7.4.1 THE STRUCTURE OF DECISION LEARNING

We can simplify the decision learning process into an easy to understand model. Our learning character has some set of behavior options that it can choose from. These may be steering behaviors, animations, or high-level strategies in a war game. In addition, it has some set of observable values that it can get from the game level. These may include the distance to the nearest enemy, the amount of ammo left, the relative size of each player's army, and so on.

We need to learn to associate decisions (in the form of a single behavior option to choose)

with observations. Over time, the AI can learn which decisions fit with which observations and can improve its performance.

Weak or Strong Supervision

In order to improve performance, we need to provide feedback to the learning algorithm. This feedback is called "supervision," and there are two varieties of supervision used by different learning algorithms or by different flavors of the same algorithm.

Strong supervision takes the form of a set of correct answers. A series of observations are each associated with the behavior that should be chosen. The learning algorithm learns to choose the correct behavior given the observation inputs. These correct answers are often provided by a human player. The developer may play the game for a while and have the AI watch. The AI keeps track of the sets of observations and the decisions that the human player makes. It can then learn to act in the same way.

Weak supervision doesn't require a set of correct answers. Instead, some feedback is given as to how good its action choices are. This can be feedback given by a developer, but more commonly it is provided by an algorithm that monitors the AI's performance in the game. If the AI gets shot, then the performance monitor will provide negative feedback. If the AI consistently beats its enemies, then feedback will be positive.

Strong supervision is easier to implement and get right, but it is less flexible: it requires somebody to teach the algorithm what is right and wrong. Weak supervision can learn right and wrong for itself, but is much more difficult to get right.

Each of the remaining learning algorithms in this chapter works with this kind of model. It has access to observations, and it returns a single action to take next. It is supervised either weakly or strongly.

7.4.2 WHAT SHOULD YOU LEARN?

For any realistic size of game, the number of observable items of data will be huge and the range of actions will normally be fairly restricted. It is possible to learn very complex rules for actions in very specific circumstances.

This detailed learning is required for characters to perform at a high level of competency. It is characteristic of human behavior: a small change in our circumstances can dramatically affect our actions. As an extreme example, it makes a lot of difference if a barricade is made out of solid steel or cardboard boxes if we are going to use it as cover from incoming fire.

On the other hand, as we are in the process of learning, it will take a long time to learn the nuances of every specific situation. We would like to lay down some general rules for behavior fairly quickly. They will often be wrong (and we will need to be more specific), but overall they will at least look sensible.

Especially for online learning, it is essential to use learning algorithms that work from general principles to specifics, filling in the broad brush strokes of what is sensible before trying to be too clever. Often, the "clever" stage is so difficult to learn that AI algorithms never get there. They will have to rely on the general behaviors.

7.4.3 FOUR TECHNIQUES

We'll look at four decision learning techniques in the remainder of this chapter. All four have been used to some extent in games, but their adoption has not been overwhelming. The first technique, Naive Bayes classification, is what you should always try first. It is simple to implement and provides a good baseline for any more complicated techniques. For that reason, even academics who do research into new learning algorithms usually use Naive Bayes as a sanity check. In fact, much seemingly promising research in machine learning has foundered on the inability to do much better on a problem than Naive Bayes.

The second technique, decision tree learning, is also very practicable. It also has the important property than you can look at the output of the learning to see if it makes sense. The final two techniques, reinforcement learning and neural networks, have some potential for game AI, but are huge fields that I will only be able to overview here.

There are also many other learning techniques that you can read about in the literature. Modern machine learning is strongly grounded in Bayesian statistics and probability theory, so in that regard an introduction to Naive Bayes has the additional benefit of providing an introduction to the field.

7.5 NAIVE BAYES CLASSIFIERS

The easiest way to explain Naive Bayes classifiers is with an example. Suppose we are writing a racing game and we want an AI character to learn a player's style of going around corners. There are many factors that determine cornering style, but for simplicity let's look at when the player decides to slow down based only on their speed and distance to a corner. To get started we can record some gameplay data to learn from. Here is a table that shows what a small subset of such data might look like:

brake?	distance	speed
Y	2.4	11.3
Y	3.2	70.2
N	75.7	72.7
Y	80.6	89.4
N	2.8	15.2
Y	82.1	8.6
Y	3.8	69.4

It is important to make the patterns in the data as obvious as possible; otherwise, the learning algorithm will require so much time and data that it will be impractical. So the first thing you need to do when thinking about applying learning to any problem is to look at your data. When we look at the data in the table we see some clear patterns emerging. Players are either near or far from the corner and are either going fast or slow. We will codify this by labeling distances below 20.0 as "near" and "far" otherwise. Similarly, we are going to say that speeds below 10.0 are considered "slow," otherwise they are "fast." This gives us the following table of binary discrete attributes:

brake?	distance	speed
Y	near	slow
Y	near	fast
N	far	fast
Y	far	fast
N	near	slow
Y	far	slow
Y	near	fast

Even for a human it is now easier to see connections between the attribute values and action choices. This is exactly what we were hoping for as it will make the learning fast and not require too much data.

In a real example there will obviously be a lot more to consider and the patterns might not be so obvious. But often knowledge of the game makes it fairly easy to know how to simplify things. For example, most human players will categorize objects as "in front," "to the left," "to the right," or "behind." So a similar categorization, instead of using precise angles, probably makes sense for the learning, too.

There are also statistical tools that can help. These tools can find clusters and can identify statistically significant combinations of attributes. But they are no match for common sense and practice. Making sure the learning has sensible attributes is part of the art of applying machine learning and getting it wrong is one of the main reasons for failure.

Now we need to specify precisely what it is that we would like to learn. We want to learn the conditional probability that a player would decide to brake given their distance and speed to a corner. The formula for this is

The next step is to apply Bayes rule:

$$P(A \mid B) = \frac{P(B \mid A)P(A)}{P(B)}$$

The important point about Bayes rule is that it allows us to express the conditional probability of A given B, in terms of the conditional probability of B given A. We'll see why this is important when we try to apply it. But first we're going to re-state Bayes rule slightly as:

$$P(A \mid B) = \alpha P(B \mid A)P(A)$$

where $\alpha = \frac{1}{P(B)}$. As I'll explain later, this version turns out to be easier to work with for our

Here is the re-stated version of Bayes rule applied to our example:

$$P(brake? | distance, speed) = P(distance, speed | brake?)P(brake?)$$

Next we'll apply a naive assumption of conditional independence to give:

$$P(\text{distance}, \text{speed} \mid \text{brake?}) = P(\text{distance} \mid \text{brake?})P(\text{speed} \mid \text{brake?})$$

If you remember any probability theory, then you've probably seen a formula a bit like this one before (but without the conditioning part) in the definition of independence.

Putting the application of Bayes rule and the naive assumption of conditional independence altogether gives the following final formula:

$$P(\text{brake?} \mid \text{distance}, \text{speed}) =$$

$$\alpha P(\text{distance} \mid \text{brake?}) P(\text{speed} \mid \text{brake?}) P(\text{brake?}) \quad (7.1)$$

The great thing about this final version is that we can use the table of values we generated earlier to look up various probabilities. To see how let's consider the case when we have an AI character trying to decide whether to brake, or not, in a situation where the distance to a corner is 79.2 and its speed is 12.1. We want to calculate the conditional probability that a human player would brake in the same situation and use that to make our decision.

There are only two possibilities, either we brake or we don't. So we will consider each one in turn. First, let's calculate the probability of braking:

$$P(\mathsf{brake?} = Y \mid \mathsf{distance} = 792, \mathsf{speed} = 121)$$

We begin by discretizing these new values to give:

$$P(brake? = Y \mid far, slow)$$

Now we use the formula we derived in Equation 7.1, above, to give:

$$P(\text{brake?} = Y \mid \text{far, slow}) = \\ \alpha P(\text{far} \mid \text{brake?} = Y) P(\text{slow} \mid \text{brake?} = Y) P(\text{brake?} = Y)$$

From the table of values we can count that for the 5 cases when people were braking, there are 2 cases when they were far away. So we estimate:

$$P(\text{far} \mid \text{brake?} = Y) = \frac{2}{5}$$

Similarly, we can count 2 out of 5 cases when people braked while traveling at slow speed to give:

$$P(\text{slow} \mid \text{brake?} = Y) = \frac{2}{5}$$

Again from the table, in total there were 5 cases out of 7 when people were braking at all, to give:

$$P(\text{brake?} = Y) = \frac{5}{7}$$

This value is known as the *prior* since it represents the probability of braking prior to any knowledge about the current situation. An important point about the prior is that if an event is inherently unlikely, then the prior will be low. Therefore, the overall probability, given what we know about the current situation, can still be low. For example, Ebola is (thankfully) a rare disease so the prior that you have the disease is almost zero. So even if you have one of the symptoms, multiplying by the prior still makes it very unlikely that you actually have the disease.

Going back to our braking example, we can now put all these calculations together to compute the conditional probability a human player would brake in the current situation:

$$P(\text{brake?} = Y \mid \text{far, slow}) = \alpha \frac{4}{35}$$

But what about the value of α ? It turns out not to be important. To see why, let's now calculate the probability of not braking:

$$P(\text{brake?} = N \mid \text{far, slow}) = \alpha \frac{1}{14}$$

The reason we don't need a is because it cancels out (it has to be positive because probabilities can never be less than 0):

$$\alpha \frac{4}{35} > \alpha \frac{1}{14} \implies \frac{4}{35} > \frac{1}{14}$$

So the probability of braking is greater than that of not braking. If the AI character wants to behave like the humans from which we collected the data, then it should also brake.

7.5.1 **PSEUDO-CODE**

The simplest implementation of a NaiveBayesClassifier class assumes we only have binary discrete attributes.

```
class NaiveBayesClassifier:
    # Number of positive examples, none initially.
    examplesCountPositive = 0
```

```
4
       # Number of negative examples, none initially.
5
       examplesCountNegative = 0
6
       # Number of times each attribute was true for the positive
       # examples, initially all zero.
       attributeCountsPositive[NUM_ATTRIBUTES] = zeros(NUM_ATTRIBUTES)
10
11
       # Number of times each attribute was true for the negative
12
       # examples, initially all zero.
13
       attributeCountsNegative[NUM_ATTRIBUTES] = zeros(NUM_ATTRIBUTES)
14
15
       function update(attributes: bool[], label: bool):
16
           # Check if this is a positive or negative example, update all
17
           # the counts accordingly.
18
           if label:
19
               # Using element-wise addition.
20
                attributeCountsPositive += attributes
21
                examplesCountPositive += 1
22
           else:
23
                attributeCountsNegative += attributes
                examplesCountNegative += 1
25
26
       function predict(attributes: bool[]) -> bool:
27
           # Predict must label this example as a positive or negative
28
           # example.
29
           x = naiveProbabilities(attributes,
30
                attributeCountsPositive,
31
                float(examplesCountPositive),
32
                float(examplesCountNegative))
33
           y = naiveProbabilities(attributes,
34
                attributeCountsNegative,
                float(examplesCountNegative),
36
                float(examplesCountPositive))
37
           return x >= y
38
39
       function naiveProbabilities(attributes: bool[],
40
                                     counts: int,
41
                                    m: float,
42
                                     n: float) -> float:
43
           # Compute the prior.
44
           prior = m / (m + n)
45
46
           # Naive assumption of conditional independence.
47
           p = 1.0
48
49
           for i in 0..NUM_ATTRIBUTES:
50
```

It's not hard to extend the algorithm to non-binary discrete labels and non-binary discrete attributes. We also usually want to optimize the speed of the predict method. This is especially true in offline learning applications. In such cases you should pre-compute as many probabilities as possible in the update method.

7.5.2 IMPLEMENTATION NOTES

One of the problems with multiplying small numbers together (like probabilities) is that, with the finite precision of floating point, they very quickly lose precision and eventually become zero. The usual way to solve this problem is to represent all probabilities as logarithms and then, instead of multiplying, we add. That is one of the reasons in the literature that you will often see people writing about the "log-likelihood."

7.6 DECISION TREE LEARNING

In Chapter 5 I described decision trees: a series of decisions that generate an action to take based on a set of observations. At each branch of the tree some aspect of the game world was considered and a different branch was chosen. Eventually, the series of branches lead to an action (Figure 7.9).

Trees with many branch points can be very specific and make decisions based on the intricate detail of their observations. Shallow trees, with only a few branches, give broad and general behaviors.

Decision trees can be efficiently learned: constructed dynamically from sets of observations and actions provided through strong supervision. The constructed trees can then be used in the normal way to make decisions during gameplay.

There are a range of different decision tree learning algorithms used for classification, prediction, and statistical analysis. Those used in game AI are typically based on Quinlan's ID3 algorithm, which we will examine in this section.

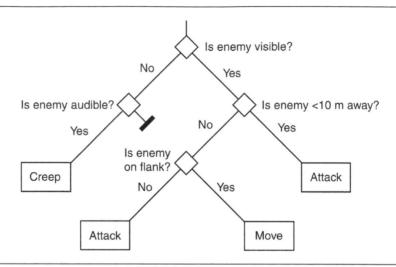

Figure 7.9: A decision tree

7.6.1 ID3

Depending on whom you believe, ID3 stands for "Inductive Decision tree algorithm 3" or "Iterative Dichotomizer 3." It is a simple to implement, relatively efficient decision tree learning algorithm.

Like any other algorithm it has a whole host of optimizations useful in different situations. It has been largely replaced in industrial AI use by optimized versions of the algorithm: C4, C4.5, and C5. In this book we'll concentrate on the basic ID3 algorithm, which provides the foundation for these optimizations.

Algorithm

The basic ID3 algorithm uses the set of observation-action examples. Observations in ID3 are usually called "attributes." The algorithm starts with a single leaf node in a decision tree and assigns a set of examples to the leaf node.

It then splits its current node (initially the single start node) so that it divides the examples into two groups. The division is chosen based on an attribute, and the division chosen is the one that is likely to produce the most efficient tree. When the division is made, each of the two new nodes is given the subset of examples that applies to them, and the algorithm repeats for each of them.

This algorithm is recursive: starting from a single node it replaces them with decisions until the whole decision tree has been created. At each branch creation it divides up the set of examples among its daughters, until all the examples agree on the same action. At that point the action can be carried out; there is no need for further branches.

The split process looks at each attribute in turn (i.e., each possible way to make a decision) and calculates the information gain for each possible division. The division with the highest information gain is chosen as the decision for this node. Information gain is a mathematical property, which we'll need to look at in a little depth.

Entropy and Information Gain

In order to work out which attribute should be considered at each step, ID3 uses the entropy of the actions in the set. Entropy is a measure of the information in a set of examples. In our case, it measures the degree to which the actions in an example set agree with each other. If all the examples have the same action, the entropy will be 0. If the actions are distributed evenly, then the entropy will be 1. Information gain is simply the reduction in overall entropy.

You can think of the information in a set as being the degree to which membership of the set determines the output. If we have a set of examples with all different actions, then being in the set doesn't tell us much about what action to take. Ideally, we want to reach a situation where being in a set tells us exactly which action to take.

This will be clearly demonstrated with an example. Let's assume that we have two possible actions: attack and defend. We have three attributes: health, cover, and ammo. For simplicity, we'll assume that we can divide each attribute into true or false: healthy or hurt, in cover or exposed, and with ammo or an empty gun. We'll return later to situations with attributes that aren't simply true or false.

Our set of examples might look like the following:

Healthy	In Cover	With Ammo	Attack
Hurt	In Cover	With Ammo	Attack
Healthy	In Cover	Empty	Defend
Hurt	In Cover	Empty	Defend
Hurt	Exposed	With Ammo	Defend

For two possible outcomes, attack and defend, the entropy of a set of actions is given by:

$$E = -p_A \log_2 p_A - p_D \log_2 p_D,$$

where p_A is the proportion of attack actions in the example set, and p_D is the proportion of defend actions. In our case, this means that the entropy of the whole set is 0.971.

At the first node the algorithm looks at each possible attribute in turn, divides the example set, and calculates the entropy associated with each division.

Divided by:

Health	$E_{\rm healthy} = 1.000$	$E_{\rm hurt} = 0.918$
Cover	$E_{\rm cover} = 1.000$	$E_{\rm exposed} = 0.000$
Ammo	$E_{\rm ammo} = 0.918$	$E_{\rm empty} = 0.000$

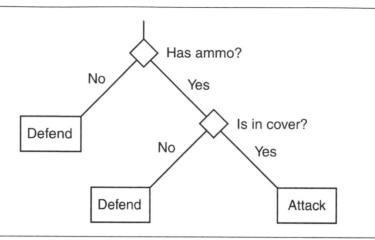

Figure 7.10: The decision tree constructed from a simple example

The information gain for each division is the reduction in entropy from the current example set (0.971) to the entropies of the daughter sets. It is given by the formula:

$$G = E_S - p_{\top} E_{\top} - p_{\perp} E_{\perp}$$

where p_{\top} is the proportion of examples for which the attribute is true, E_{\top} is the entropy of those examples; similarly p_{\perp} and E_{\perp} refer to the examples for which the attribute is false. The equation shows that the entropies are multiplied by the proportion of examples in each category. This biases the search toward balanced branches where a similar number of examples get moved into each category.

In our example we can now calculate the information gained by dividing by each attribute:

$$G_{\text{health}} = 0.020$$

 $G_{\text{cover}} = 0.171$

 $G_{\rm ammo} = 0.420$

So, of our three attributes, ammo is by far the best indicator of what action we need to take (this makes sense, since we cannot possibly attack without ammo). By the principle of learning the most general stuff first, we use ammo as our first branch in the decision tree.

If we continue in this manner, we will build the decision tree shown in Figure 7.10.

Notice that the health of the character doesn't feature at all in this tree; from the examples we were given, it simply isn't relevant to the decision. If we had more examples, then we might find situations in which it is relevant, and the decision tree would use it.

More than Two Actions

The same process works with more than two actions. In this case the entropy calculation generalizes to:

$$E = -\sum_{i=1}^{n} p_i \log_2 p_i$$

where n is the number of actions, and p_i is the proportion of each action in the example set.

Most systems don't have a dedicated base 2 logarithm. The logarithm for a particular base, $\log_n x$, is given by:

$$\log_n x = \frac{\log x}{\log n}$$

where the logarithms can be in any base (typically, base e is fastest, but it may be base 10 if you have an optimized implementation of that). So simply divide the result of whichever log you use by log(2) to give the logarithm to base 2.

Non-Binary Discrete Attributes

When there are more than two categories, there will be more than two daughter nodes for a decision.

The formula for information gained generalizes to:

$$G = E_S - \sum_{i=1}^{n} \frac{|S_i|}{|S|} E_{S_i}$$

where S_i are the sets of examples for each of the n values of an attribute.

The listing below handles this situation naturally. It makes no assumptions about the number of values an attribute can have. Unfortunately, as we saw in Chapter 5, the flexibility of having more than two branches per decision isn't too useful.

This still does not cover the majority of applications, however. The majority of attributes in a game either will be continuous or will have so many different possible values that having a separate branch for each is wasteful. We'll need to extend the basic algorithm to cope with continuous attributes. We'll return to this extension later in the section.

Pseudo-Code

The simplest implementation of makeTree is recursive. It performs a single split of a set of examples and then applies itself on each of the subsets to form the branches.

```
function makeTree(examples, attributes, decisionNode):
      # Calculate our initial entropy.
      initialEntropy = entropy(examples)
```

```
4
       # If we have no entropy, we can't divide further.
5
       if initialEntropy <= 0:
6
           return
       # Find the number of examples.
       exampleCount = examples.length()
10
11
       # Hold the best found split so far.
12
       bestInformationGain = 0
13
       bestSplitAttribute
14
       bestSets
15
16
       # Go through each attribute.
17
       for attribute in attributes:
18
           # Perform the split.
19
           sets = splitByAttribute(examples, attribute)
20
           # Find overall entropy and information gain.
22
           overallEntropy = entropyOfSets(sets, exampleCount)
           informationGain = initialEntropy - overallEntropy
           # Check if we've got the best so far.
26
           if informationGain > bestInformationGain:
27
                bestInformationGain = informationGain
28
                bestSplitAttribute = attribute
29
                bestSets = sets
30
31
       # Set the decision node's test.
32
       decisionNode.testValue = bestSplitAttribute
33
34
       # The list of attributes to pass on down the tree should
35
       # have the one we're using removed.
       newAttributes = copy(attributes)
37
       newAttributes -= bestSplitAttribute
38
39
       # Fill the daughter nodes.
40
       for set in bestSets:
41
           # Find the value for the attribute in this set.
42
           attributeValue = set[0].getValue(bestSplitAttribute)
43
44
       # Create a daughter node for the tree.
45
       daughter = new MultiDecision()
46
47
       # Add it to the tree.
48
       decisionNode.daughterNodes[attributeValue] = daughter
49
50
```

```
# Recurse the algorithm.
51
       makeTree(set, newAttributes, daughter)
```

This pseudo-code relies on three key functions: splitByAttribute takes a list of examples and an attribute and divides them up into several subsets so that each of the examples in a subset share the same value for that attribute; entropy returns the entropy of a list of examples; and entropyOfSets returns the entropy of a list of lists (using the basic entropy function). The entropyOfSets method has the total number of examples passed to it to avoid having to sum up the sizes of each list in the list of lists. As we'll see below, this makes implementation significantly easier.

Split by Attribute

The splitByAttribute function has the following form:

```
function splitByAttribute(examples, attribute):
       # Create a set of lists, so we can access each list
2
3
       # by the attribute value.
      sets = \{\}
      for example in examples:
7
           sets[example.getValue(attribute)] += example
       return sets
```

This pseudo-code treats the sets variable as both a dictionary of lists (when it adds examples based on their value) and a list of lists (when it returns the variable at the end). When it is used as a dictionary, care needs to be taken to initialize previously unused entries to be an empty list before trying to add the current example to it.

This duality is not a commonly supported requirement for a data structure, although the need for it occurs quite regularly. It is fairly easy to implement, however.

Entropy

The entropy function has the following form:

```
function entropy(examples):
2
       # Get the number of examples.
3
       exampleCount = examples.length()
       # Check if we only have one: in that case entropy is 0.
5
       if exampleCount == 0:
6
           return 0
7
8
9
       # Otherwise we need to keep a tally of how many of each
       # different kind of action we have.
10
       actionTallies = {}
11
```

```
12
13
       # Go through each example.
       for example in examples:
14
           # Increment the appropriate tally.
15
           actionTallies[example.action]++
16
17
       # We now have the counts for each action in the set.
18
       actionCount = actionTallies.length()
19
20
       # If we have only one action then we have zero entropy.
21
       if actionCount == 0:
           return 0
23
24
       # Start with zero entropy.
25
       entropy = 0
26
27
       # Add in the contribution to entropy of each action.
28
       for actionTally in actionTallies:
29
           proportion = actionTally / exampleCount
30
           entropy -= proportion * log2(proportion)
31
32
       # Return the total entropy.
33
       return entropy
34
```

In this pseudo-code I have used the log2 function which gives the logarithm to base 2. As we saw earlier, this can be implemented as:

```
function log2(x: float) -> float:
    return log(x) / log(2)
```

Although this is strictly correct, it isn't necessary. We aren't interested in finding the exact information gain. We are only interested in finding the greatest information gain. Because logarithms to any positive power retain the same order (i.e., if $\log_2 x > \log_2 y$ then $\log_2 x > \log_2 y$ $\log_e y$), we can simply use the basic \log in place of \log_2 , and save on the floating point division.

The actionTallies variable acts both as a dictionary indexed by the action (we increment its values) and as a list (we iterate through its values). This can be implemented as a basic hash map, although care needs to be taken to initialize a previously unused entry to zero before trying to increment it.

Entropy of Sets

Finally, we can implement the function to find the entropy of a list of lists:

```
function entropyOfSets(sets, exampleCount):
2
      # Start with zero entropy.
3
      entropy = 0
4
      # Get the entropy contribution of each set.
5
```

```
for set in sets:
6
            # Calculate the proportion of the whole in this set.
7
           proportion = set.length() / exampleCount
8
9
            # Calculate the entropy contribution.
10
            entropy -= proportion * entropy(set)
11
12
       # Return the total entropy.
13
       return entropy
```

Data Structures and Interfaces

In addition to the unusual data structures used to accumulate subsets and keep a count of actions in the functions above, the algorithm only uses simple lists of examples. These do not change size after they have been created, so they can be implemented as arrays. Additional sets are created as the examples are divided into smaller groups. In C or C++, it is sensible to have the arrays refer by pointer to a single set of examples, rather than copying example data around constantly.

The pseudo-code assumes that examples have the following interface:

```
class Example:
       action
2
       function getValue(attribute)
```

where getValue returns the value of a given attribute.

The ID3 algorithm does not depend on the number of attributes. action, not surprisingly, holds the action that should be taken given the attribute values.

Starting the Algorithm

The algorithm begins with a set of examples. Before we can call makeTree, we need to get a list of attributes and an initial decision tree node. The list of attributes is usually consistent over all examples and fixed in advance (i.e., we'll know the attributes we'll be choosing from); otherwise, we may need an additional application-dependent algorithm to work out the attributes that are used.

The initial decision node can simply be created empty. So the call may look something like:

```
makeTree(allExamples, allAttributes, new MultiDecision())
```

Performance

The algorithm is $O(a \log_v n)$ in memory and $O(avn \log_v n)$ in time, where a is the number of attributes, v is the number of values for each attribute, and n is the number of examples in the initial set.

7.6.2 ID3 WITH CONTINUOUS ATTRIBUTES

ID3-based algorithms cannot operate directly with continuous attributes, and they are impractical when there are many possible values for each attribute. In either case the attribute values must be divided into a small number of discrete categories (usually two). This division can be performed automatically as an independent process, and with the categories in place the rest of the decision tree learning algorithm remains identical.

Single Splits

Continuous attributes can be used as the basis of binary decisions by selecting a threshold level. Values below the level are in one category, and values above the level are in another category. A continuous health value, for example, can be split into healthy and hurt categories with a single threshold value.

We can dynamically calculate the best threshold value to use with a process similar to that used to determine which attribute to use in a branch.

We sort the examples using the attribute we are interested in. We place the first element from the ordered list into category A and the remaining elements into category B. We now have a division, so we can perform the split and calculate information gained, as before.

We repeat the process by moving the lowest valued example from category B into category A and calculating the information gained in the same way. Whichever division gave the greatest information gained is used as the division. To enable future examples not in the set to be correctly classified by the resulting tree, we need a numeric threshold value. This is calculated by finding the average of the highest value in category A and the lowest value in category B.

This process works by trying every possible position to place the threshold that will give different daughter sets of examples. It finds the split with the best information gain and uses

The final step constructs a threshold value that would have correctly divided the examples into its daughter sets. This value is required, because when the decision tree is used to make decisions, we aren't guaranteed to get the same values as we had in our examples: the threshold is used to place all possible values into a category.

As an example, consider a situation similar to that in the previous section. We have a health attribute, which can take any value between 0 and 200. We will ignore other observations and consider a set of examples with just this attribute.

Defend 25 Defend Attack 39 17 Defend

We start by ordering the examples, placing them into the two categories, and calculating the information gained.

Category	Attribute Value	Action	Information Gain
A	17	Defend	
В	25	Defend	
	39	Attack	
	50	Defend	0.12
Category	Attribute Value	Action	Information Gain
A	17	Defend	
	25	Defend	
В	39	Attack	
	50	Defend	0.31
Category	Attribute Value	Action	Information Gain
A	17	Defend	
	25	Defend	
	39	Attack	
В	50	Defend	0.12

We can see that the most information is gained if we put the threshold between 25 and 39. The midpoint between these values is 32, so 32 becomes our threshold value.

Notice that the threshold value depends on the examples in the set. Because the set of examples gets smaller at each branch in the tree, we can get different threshold values at different places in the tree. This means that there is no set dividing line. It depends on the context. As more examples are available, the threshold value can be fine-tuned and made more accurate.

Determining where to split a continuous attribute can be incorporated into the entropy checks for determining which attribute to split on. In this form our algorithm is very similar to the C4.5 decision tree algorithm.

Pseudo-Code

We can incorporate this threshold step in the splitByAttribute function from the previous pseudo-code.

```
function splitByContinuousAttribute(examples, attribute):
      # We create a set of lists, so we can access each list
      # by the attribute value.
```

```
bestGain = 0
        bestSets
       # Make sure the examples are sorted.
       setB = sortReversed(examples, attribute)
10
11
       # Work out the number of examples and initial entropy.
       exampleCount = len(examples)
12
       initialEntropy = entropy(examples)
13
       # Go through each but the last example,
       # moving it to set A.
16
17
       while setB.length() > 1:
            # Move the lowest example from A to B.
18
            setB.push(setA.pop())
19
20
           # Find overall entropy and information gain.
21
            overallEntropy = entropyOfSets(setA, setB], exampleCount)
22
            informationGain = initialEntropy - overallEntropy
23
24
           # Check if it is the best.
25
            if informationGain >= bestGain:
26
                bestGain = informationGain
                bestSets = [setA, setB]
29
       # Calculate the threshold.
30
       setA = bestSets[0]
31
       setB = bestSets[1]
32
       threshold = setA[setA.length()-1].getValue(attribute)
33
       threshold += setB[setB.length()-1].getValue(attribute)
34
       threshold /= 2
35
36
37
       # Return the sets.
       return bestSets, threshold
```

The sortReversed function takes a list of examples and returns a list of examples in order of decreasing value for the given attribute.

In the framework I described previously for makeTree, there was no facility for using a threshold value (it wasn't appropriate if every different attribute value was sent to a different branch). In this case we would need to extend makeTree so that it receives the calculated threshold value and creates a decision node for the tree that could use it. In Chapter 5, Section 5.2 I described a FloatDecision class that would be suitable.

Data Structures and Interfaces

In the code above the list of examples is held in a stack. An object is removed from one list and added to another list using push and pop. Many collection data structures have these fundamental operations. If you are implementing your own lists, using a linked list, for example, this can be simply achieved by moving the "next" pointer from one list to another.

Performance

The attribute splitting algorithm is O(n) in both memory and time, where n is the number of examples. Note that this is O(n) per attribute. If you are using it within ID3, it will be called once for each attribute.

Implementation Notes

In this section I have described a decision tree using either binary decisions (or at least those with a small number of branches) or threshold decisions.

In a real game, you are likely to need a combination of both binary decisions and threshold decisions in the final tree. The makeTree algorithm needs to detect what type best suits each algorithm and to call the correct version of splitByAttribute. The result can then be compiled into either a MultiDecision node or a FloatDecision node (or some other kind of decision nodes, if they are suitable, such as an integer threshold). This selection depends on the attributes you will be working with in your game.

Multiple Categories

Not every continuous value is best split into two categories based on a single threshold value. For some attributes there are more than two clear regions that require different decisions. A character who is only hurt, for example, will behave differently from one who is almost dead.

A similar approach can be used to create more than one threshold value. As the number of splits increases, there is an exponential increase in the number of different scenarios that must have their information gains calculated.

There are several algorithms for multi-splitting input data for lowest entropy. In general, the same thing can also be achieved using any classification algorithm, such as a neural network.

In game applications, however, multi-splits are seldom necessary. As the ID3 algorithm recurses through the tree, it can create several branching nodes based on the same attribute value. Because these splits will have different example sets, the thresholds will be placed at different locations. This allows the algorithm to effectively divide the attribute into more than two categories over two or more branch nodes. The extra branches will slow down the final

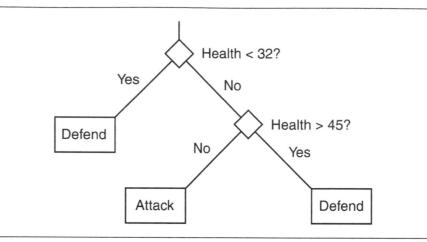

Figure 7.11: Two sequential decisions on the same attribute

decision tree a little, but since running a decision tree is a very fast process, this will not generally be noticeable.

Figure 7.11 shows the decision tree created when the example data above is run through two steps of the algorithm. Notice that the second branch is subdivided, splitting the original attribute into three sections.

7.6.3 INCREMENTAL DECISION TREE LEARNING

So far I have described learning decision trees as a single task. A complete set of examples is provided, and the algorithm returns a complete decision tree ready for use. This is fine for offline learning, where a large number of observation-action examples can be provided in one go. The learning algorithm can spend a short time processing the example set to generate a decision tree.

When used online, however, new examples will be generated while the game is running, and the decision tree should change over time to accommodate them. With a small number of examples, only broad brush sweeps can be seen, and the tree will typically need to be quite flat. With hundreds or thousands of examples, subtle interactions between attributes and actions can be detected by the algorithm, and the tree is likely to be more complex.

The simplest way to support this scaling is to re-run the algorithm each time a new example is provided. This guarantees that the decision tree will be the best possible at each moment. Unfortunately, we have seen that decision tree learning is a moderately inefficient process. With large databases of examples, this can prove very time consuming.

Incremental algorithms update the decision tree based on the new information, without requiring the whole tree to be rebuilt.

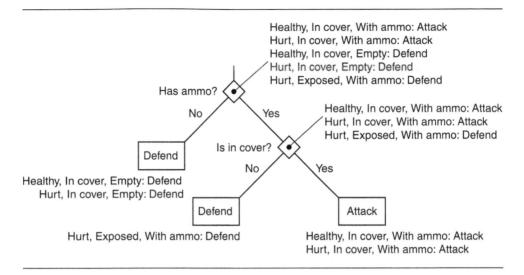

Figure 7.12: The example tree in ID4 format

The simplest approach would be to take the new example and use its observations to walk through the decision tree. When we reach a terminal node of the tree, we compare the action there with the action in our example. If they match, then no update is required, and the new example can simply be added to the example set at that node. If the actions do not match, then the node is converted into a decision node using SPLIT_NODE in the normal way.

This approach is fine, as far as it goes, but it always adds further examples to the end of a tree and can generate huge trees with many sequential branches. We ideally would like to create trees that are as flat as possible, where the action to carry out can be determined as quickly as possible.

The Algorithm

The simplest useful incremental algorithm is ID4. As its name suggests, it is related to the basic ID3 algorithm.

We start with a decision tree, as created by the basic ID3 algorithm. Each node in the decision tree also keeps a record of all the examples that reach that node. Examples that would have passed down a different branch of the tree are stored elsewhere in the tree. Figure 7.12 shows the ID4-ready tree for the example introduced earlier.

In ID4 we are effectively combining the decision tree with the decision tree learning algorithm. To support incremental learning, we can ask any node in the tree to update itself given a new example.

When asked to update itself, one of three things can happen:

- 1. If the node is a terminal node (i.e., it represents an action), and if the added example also shares the same action, then the example is added to the list of examples for that node.
- 2. If the node is a terminal node, but the example's action does not match, then we make the node into a decision and use the ID3 algorithm to determine the best split to make.
- 3. If the node is not a terminal node, then it is already a decision. We determine the best attribute to make the decision on, adding the new example to the current list. The best attribute is determined using the information gain metric, as we saw in ID3.
 - If the attribute returned is the same as the current attribute for the decision (and it will be most times), then we determine which of the daughter nodes the new example gets mapped to, and we update that daughter node with the new example.
 - If the attribute returned is different, then it means the new example makes a different decision optimal. If we change the decision at this point, then all of the tree further down the current branch will be invalid. So we delete the whole tree from the current decision down and perform the basic ID3 algorithm using the current decision's examples plus the new one.

Note that when we reconsider which attribute to make a decision on, several attributes may provide the same information gain. If one of them is the attribute we are currently using in the decision, then we favor that one to avoid unnecessary rebuilding of the decision tree.

In summary, at each node in the tree, ID4 checks if the decision still provides the best information gain in light of the new example. If it does, then the new example is passed down to the appropriate daughter node. If it does not, then the whole tree is recalculated from that point on. This ensures that the tree remains as flat as possible.

In fact, the tree generated by ID4 will always be the same as that generated by ID3 for the same input examples. At worst, ID4 will have to do the same work as ID3 to update the tree. At best, it is as efficient as the simple update procedure. In practice, for sensible sets of examples, ID4 is considerably faster than repeatedly calling ID3 each time and will be faster in the long run than the simple update procedure (because it is producing flatter trees).

Walk Through

It is difficult to visualize how ID4 works from the algorithm description alone, so let's work through an example.

We have seven examples. The first five are similar to those used before:

Healthy	Exposed	Empty	Run
Healthy	In Cover	With Ammo	Attack
Hurt	In Cover	With Ammo	Attack
Healthy	In Cover	Empty	Defend
Hurt	In Cover	Empty	Defend

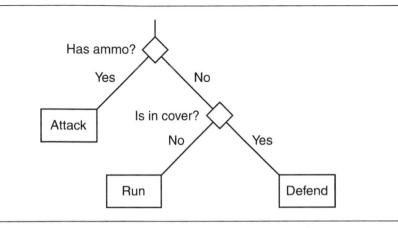

Figure 7.13: Decision tree before ID4

We use these to create our initial decision tree. The decision tree looks like that shown in Figure 7.13.

We now add two new examples, one at a time, using ID4:

With Ammo Defend Hurt Exposed Healthy Exposed With Ammo Run

The first example enters at the first decision node. ID4 uses the new example, along with the five existing examples, to determine that ammo is the best attribute to use for the decision. This matches the current decision, so the example is sent to the appropriate daughter node.

Currently, the daughter node is an action: attack. The action doesn't match, so we need to create a new decision here. Using the basic ID3 algorithm, we decide to make the decision based on cover. Each of the daughters of this new decision have only one example and are therefore action nodes.

The current decision tree is then as shown in Figure 7.14.

Now we add our second example, again entering at the root node. ID4 determines that this time ammo can't be used, so cover is the best attribute to use in this decision.

So we throw away the sub-tree from this point down (which is the whole tree, since we're at the first decision) and run an ID3 algorithm with all the examples. The ID3 algorithm runs in the normal way and leaves the tree complete. It is shown in Figure 7.15.

Problems with ID4

ID4 and similar algorithms can be very effective in creating optimal decision trees. As the first few examples come in, the tree will be largely rebuilt at each step. As the database of examples grows, the changes to the tree often decrease in size, keeping the execution speed high.

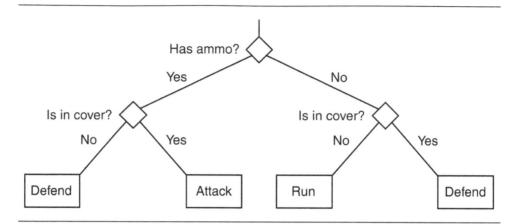

Figure 7.14: Decision tree during ID4

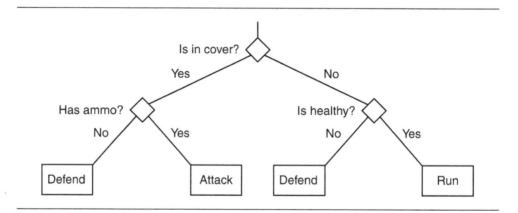

Figure 7.15: Decision tree after ID4

It is possible, however, to have sets of examples for which the order of attribute tests in the tree is pathological: the tree continues to be rebuilt at almost every step. This can end up being slower than simply running ID3 each step. ID4 is sometimes said to be incapable of learning certain concepts. This doesn't mean that it generates invalid trees (it generates the same trees as ID3), it just means that the tree isn't stable as new examples are provided.

In practice, I haven't suffered from this problem with ID4. Real data do tend to stabilize quite rapidly, and ID4 ends up significantly faster than rebuilding the tree with ID3 each time.

Other incremental learning algorithms, such as ID5, ITI, and their relatives, all use this kind of transposition, statistical records at each decision node, or additional tree restructuring operations to help avoid repeated rebuilding of the tree.

Heuristic Algorithms

Strictly speaking, ID3 is a heuristic algorithm: the information gain value is a good estimate of the utility of the branch in the decision tree, but it may not be the best. Other methods have been used to determine which attributes to use in a branch. One of the most common, the gain-ratio, was suggested by Quinlan, the original inventor of ID3.

Often, the mathematics is significantly more complex than that in ID3, and, while improvements have been made, the results are often highly domain-specific. Because the cost of running a decision tree in game AI is so small, it is rarely worth the additional effort. We know of few developers who have invested in developing anything more than simple optimizations of the ID3 scheme.

More significant speed ups can be achieved in incremental update algorithms when doing online learning. Heuristics can also be used to improve the speed and efficiency of incremental algorithms. This approach is used in algorithms such as SITI and other more exotic versions of decision tree learning.

7.7 REINFORCEMENT LEARNING

Reinforcement learning is the name given to a range of techniques for learning based on experience. In its most general form a reinforcement learning algorithm has three components: an exploration strategy for trying out different actions in the game, a reinforcement function that gives feedback on how good each action is, and a learning rule that links the two together. Each element has several different implementations and optimizations, depending on the application.

Later in this section we'll look briefly at a range of reinforcement learning techniques. It is possible to do reinforcement learning with neural networks, both shallow and deep. In game applications, however, a good starting point is the Q-learning algorithm. Q-learning is simple to implement, has been widely tested on non-game applications, and can be tuned without a deep understanding of its theoretical properties.

7.7.1 THE PROBLEM

We would like a game character to select better actions over time. What makes a good action may be difficult to anticipate by the designers. It may depend on the way the player acts, or it may depend on the structure of random maps that can't be designed for.

We would like to be able to give a character free choice of any action in any circumstance and for it to work out which actions are best for any given situation.

Unfortunately, the quality of an action isn't normally clear at the time the action is made. It is relatively easy to write an algorithm that gives good feedback when the character collects a power-up or kills an enemy. But the actual killing action may have been only 1 out of 100 actions that led to the result, each one of which needed to be correctly placed in series.

Therefore, we would like to be able to give very patchy information: to be able to give feedback only when something significant happens. The character should learn that all the actions leading up to the event are also good things to do, even though no feedback was given while it was doing them.

7.7.2 THE ALGORITHM

Q-learning relies on having the problem represented in a particular way. With this representation in place, it can store and update relevant information as it explores the possible actions it can take. I will describe the representation first.

Q-Learning's Representation of the World

Q-learning treats the game world as a state machine. At any point in time, the algorithm is in some state. The state should encode all the relevant details about the character's environment and internal data.

So if the health of the character is significant to learning, and if the character finds itself in two identical situations with two different health levels, then it will consider them to be different states. Anything not included in the state cannot be learned. If we didn't include the health value as part of the state, then we couldn't possibly learn to take health into consideration in the decision making.

In a game the states are made up of many factors: position, proximity of the enemy, health level, and so on. Q-learning doesn't need to understand the components of a state. As far as the algorithm is concerned they can just be an integer value: the state number.

The game, on the other hand, needs to be able to translate the current state of the game into a single state number for the learning algorithm to use. Fortunately, the algorithm never requires the opposite: we don't have to translate the state number back into game terms (as we did in the pathfinding algorithm, for example).

Q-learning is known as a model-free algorithm because it doesn't try to build a model of how the world works. It simply treats everything as states. Algorithms that are not model free try to reconstruct what is happening in the game from the states that it visits. Model-free algorithms, such as Q-learning, tend to be significantly easier to implement.

For each state, the algorithm needs to understand the actions that are available to it. In many games all actions are available at all times. For more complex environments, however, some actions may only be available when the character is in a particular place (e.g., pulling a lever), when they have a particular object (e.g., unlocking a door with a key), or when other actions have been properly carried out before (e.g., walking through the unlocked door).

After the character carries out one action in the current state, the reinforcement function should give it feedback. Feedback can be positive or negative and is often zero if there is no clear indication as to how good the action was. Although there are no limits on the values that the function can return, it is common to assume they will be in the range [-1, 1].

There is no requirement for the reinforcement value to be the same every time an action is carried out in a particular state. There may be other contextual information not used to create the algorithm's state. As we saw previously, the algorithm cannot learn to take advantage of that context if it isn't part of its state, but it will tolerate its effects and learn about the overall success of an action, rather than its success on just one attempt.

After carrying out an action, the character is likely to enter a new state. Carrying out the same action in exactly the same state may not always lead to the same state of the game. Other characters and the player are also influencing the state of the game.

For example, a character in an FPS is trying to find a health pack and avoid getting into a fight. The character is ducking behind a pillar. On the other side of the room, an enemy character is standing in the doorway looking around. So the current state of the character may correspond to in-room1, hidden, enemy-near, near-death. It chose the "hide" action to continue ducking. The enemy stays put, so the "hide" action leads back to the same state. So it chooses the same action again. This time the enemy leaves, so the "hide" action now leads to another state, corresponding to in-room1, hidden, no-enemy, near-death.

One of the powerful features of the Q-learning algorithm (and most other reinforcement algorithms) is that it can cope with this kind of uncertainty.

These four elements—the start state, the action taken, the reinforcement value, and the resulting state—are called the *experience tuple*, often written as < s, a, r, s' >.

Doing Learning

O-learning is named for the set of quality information (Q-values) it holds about each possible state and action. The algorithm keeps a value for every state and action it has tried. The Q-value represents how good it thinks that action is to take when in that state.

The experience tuple is split into two sections. The first two elements (the state and action) are used to look up a Q-value in the store. The second two elements (the reinforcement value and the new state) are used to update the Q-value based on how good the action was and how good it will be in the next state.

The update is handled by the Q-learning rule:

$$Q(s,a) = (1 - \alpha)Q(s,a) + \alpha(r + \gamma \max(Q(s',a')))$$

where α is the learning rate and γ is the discount rate: both are parameters of the algorithm. The rule is sometimes written in a slightly different form, with the $(1 - \alpha)$ multiplied out.

How It Works

The Q-learning rule blends together two components using the learning rate parameter to control the linear blend. The learning rate parameter, used to control the blend, is in the range [0, 1].

The first component Q(s,a) is simply the current Q-value for the state and action. Keeping part of the current value in this way means we never throw away information we have previously discovered.

The second component has two elements of its own. The r value is the new reinforcement from the experience tuple. If the reinforcement rule was

$$Q(s,a) = (1 - \alpha)Q(s,a) + \alpha r$$

We would be blending the old Q-value with the new feedback on the action.

The second element, $\gamma \max(Q(s', a'))$, looks at the new state from the experience tuple. It looks at all possible actions that could be taken from that state and chooses the highest corresponding Q-value. This helps bring the success (i.e., the Q-value) of a later action back to earlier actions: if the next state is a good one, then this state should share some of its glory.

The discount parameter controls how much the Q-value of the current state and action depends on the Q-value of the state it leads to. A very high discount will be a large attraction to good states, and a very low discount will only give value to states that are near to success. Discount rates should be in the range [0, 1]. A value greater than 1 can lead to ever-growing Q-values, and the learning algorithm will never converge on the best solution.

So, in summary, the Q-value is a blend between its current value and a new value, which combines the reinforcement for the action and the quality of the state the action led to.

Exploration Strategy

So far we've covered the reinforcement function, the learning rule, and the internal structure of the algorithm. We know how to update the learning from experience tuples and how to generate those experience tuples from states and actions. Reinforcement learning systems also require an exploration strategy: a policy for selecting which actions to take in any given state. It is often simply called the policy.

The exploration strategy isn't strictly part of the Q-learning algorithm. Although the strategy outlined below is very commonly used in Q-learning, there are others with their own strengths and weaknesses. In a game, a powerful alternative technique is to incorporate the actions of a player, generating experience tuples based on their play. We'll return to this idea later in the section.

The basic Q-learning exploration strategy is partially random. Most of the time, the algorithm will select the action with the highest Q-value from the current state. The remainder, the algorithm will select a random action. The degree of randomness can be controlled by a parameter.

Convergence and Ending

If the problem always stays the same, and rewards are consistent (which they often aren't if they rely on random events in the game), then the Q-values will eventually converge. Further running of the learning algorithm will not change any of the Q-values. At this point the algorithm has learned the problem completely.

For very small toy problems this is achievable in a few thousand iterations, but in real problems it can take a vast number of iterations. In a practical application of Q-learning, there won't be nearly enough time to reach convergence, so the Q-values will be used before they have settled down. It is common to begin acting under the influence of the learned values before learning is complete.

7.7.3 PSEUDO-CODE

A general Q-learning system has the following structure:

```
# The store for Q-values, we use this to make decisions based on
  # the learning.
   store = new QValueStore()
   # Updates the store by investigating the problem.
   function QLearning(problem, iterations, alpha, gamma, rho, nu):
       # Get a starting state.
       state = problem.getRandomState()
       # Repeat a number of times.
       for i in 0..iterations:
11
            # Pick a new state every once in a while.
12
            if random() < nu:
13
                state = problem.getRandomState()
14
15
            # Get the list of available actions.
16
            actions = problem.getAvailableActions(state)
17
18
            # Should we use a random action this time?
19
            if random() < rho:
20
                action = oneOf(actions)
21
22
            # Otherwise pick the best action.
23
            else:
24
                action = store.getBestAction(state)
25
26
            # Carry out the action and retrieve the reward and
27
            # new state.
28
            reward, newState = problem.takeActions(state, action)
29
30
```

```
# Get the current q from the store.
31
           Q = store.getQValue(state, action)
32
33
           # Get the q of the best action from the new state.
34
           maxQ = store.getQValue(
35
               newState, store.getBestAction(newState))
36
37
           # Perform the q learning.
           Q = (1 - alpha) * Q + alpha * (reward + gamma * maxQ)
           # Store the new Q-value.
41
           store.storeQValue(state, action, Q)
42
43
           # And update the state.
44
           state = newState
```

I am assuming that the random function returns a floating point number between zero and one. The oneOf function picks an item from a list at random.

7.7.4 DATA STRUCTURES AND INTERFACES

The algorithm needs to understand the problem—what state it is in, what actions it can take and after taking an action it needs to access the appropriate experience tuple. The code above does this through an interface of the following form:

```
class ReinforcementProblem:
      # Choose a random starting state for the problem.
2
      function getRandomState()
      # Get the available actions for the given state.
      function getAvailableActions(state)
      # Take the given action and state, and return
      # a pair consisting of the reward and the new state.
      function takeAction(state, action)
```

In addition, the Q-values are stored in a data structure that is indexed by both state and action. This has the following form in our example:

```
class QValueStore:
2
      function getQValue(state, action)
3
      function getBestAction(state)
      function storeQValue(state, action, value)
```

The getBestAction function returns the action with the highest Q-value for the given state. The highest Q-value (needed in the learning rule) can be found by calling getQValue with the result from getBestAction.

7.7.5 IMPLEMENTATION NOTES

If the Q-learning system is designed to operate online, then the Q-learning function should be rewritten so that it only performs one iteration at a time and keeps track of its current state and O-values in a data structure.

The store can be implemented as a hash table indexed by an action-state pair. Only action-state pairs that have been stored with a value are contained in the data structure. All other indices have an implicit value of zero. So qetQValue will return zero if the given action state pair is not in the hash. This is a simple implementation that can be useful for doing brief bouts of learning. It suffers from the problem that getBestAction will not always return the best action. If all the visited actions from the given state have negative Q-values and not all actions have been visited, then it will pick the highest negative value, rather than the zero value from one of the non-visited actions in that state.

Q-learning is designed to run through all possible states and actions, probably several times (I will return to the practicality of this below). In this case, the hash table will be a waste of time (literally). A better solution is an array indexed by the state. Each element in this array is an array of Q-values, indexed by action. All the arrays are initialized to have zero Q-values. Q-values can now be looked up immediately, as they are all stored.

7.7.6 PERFORMANCE

The algorithm's performance scales based on the number of states and actions, and the number of iterations of the algorithm. It is preferable to run the algorithm so that it visits all of the states and actions several times. In this case it is O(i) in time, where i is the number of iterations of learning. It is O(as) in memory, where a is the number of actions, and s is the number of states per action. We are assuming that arrays are used to store Q-values in this case.

If O(i) is very much less than O(as), then it might be more efficient to use a hash table; however, this has corresponding increases in the expected execution time.

7.7.7 TAILORING PARAMETERS

The algorithm has four parameters with the variable names alpha, gamma, rho, and nu in the pseudo-code above. The first two correspond to the α and γ parameters in the Q-learning rule. Each has a different effect on the outcome of the algorithm and is worth looking at in detail.

Alpha: The Learning Rate

The learning rate controls how much influence the current feedback value has over the stored Q-value. It is in the range [0, 1].

A value of zero would give an algorithm that does not learn: the Q-values stored are fixed and no new information can alter them. A value of one would give no credence to any previous experience. Any time an experience tuple is generated that alone is used to update the Q-value.

From my experimentation, I found that a value of 0.3 is a sensible initial guess, although tuning is needed. In general, a high degree of randomness in your state transitions (i.e., if the reward or end state reached by taking an action is dramatically different each time) requires a lower alpha value. On the other hand, the fewer iterations the algorithm will be allowed to perform, the higher the alpha value will be.

Learning rate parameters in many machine learning algorithms benefit from being changed over time. Initially, the learning rate parameter can be relatively high (0.7, say). Over time, the value can be gradually reduced until it reaches a lower than normal value (0.1, for example). This allows the learning to rapidly change Q-values when there is little information stored in them, but protects hard-won learning later on.

Gamma: The Discount Rate

The discount rate controls how much an action's Q-value depends on the Q-value at the state (or states) it leads to. It is in the range [0, 1].

A value of zero would rate every action only in terms of the reward it directly provides. The algorithm would learn no long-term strategies involving a sequence of actions. A value of one would rate the reward for the current action as equally important as the quality of the state it leads to.

Higher values favor longer sequences of actions, but take correspondingly longer to learn. Lower values stabilize faster, but usually support relatively short sequences. It is possible to select the way rewards are provided to increase the sequence length (see the later section on reward values), but again this makes learning take longer.

A value of 0.75 is a good initial value to try, again based on my experimentation. With this value, an action with a reward of 1 will contribute 0.05 to the Q-value of an action ten steps earlier in the sequence.

Rho: Randomness for Exploration

This parameter controls how often the algorithm will take a random action, rather than the best action it knows so far. It is in the range [0, 1].

A value of zero would give a pure exploitation strategy: the algorithm would exploit its current learning, reinforcing what it already knows. A value of one would give a pure exploration strategy: the algorithm would always be trying new things, never benefiting from its existing knowledge.

This is a classic trade-off in learning algorithms: to what extent should we try to learn new things (which may be much worse than the things we know are good), and to what extent should we exploit the knowledge we have gained. The biggest factor in selecting a value is whether the learning is performed online or offline.

If learning is being performed online, then the player will want to see some kind of intelligent behavior. The learning algorithm should be exploiting its knowledge. If a value of one was used, then the algorithm would never use its learned knowledge and would always appear to be making decisions at random (it is doing so, in fact). Online learning demands a low value (0.1 or less should be fine).

For offline learning, however, we simply want to learn as much as possible. Although a higher value is preferred, there is still a trade-off to be made.

Often, if one state and action are excellent (have a high Q-value), then other similar states and actions will also be good. If we have learned a high Q-value for killing an enemy character, for example, we will probably have high Q-values for bringing the character close to death. So heading toward known high Q-values is often a good strategy for finding other action-state pairs with good Q-values.

It takes several iterations for a high Q-value to propagate back along the sequence of actions. To distribute Q-values so that there is a sequence of actions to follow, there needs to be several iterations of the algorithm in the same region.

Following actions known to be good helps both of these issues. A good starting point for this parameter, in offline learning, is 0.2. This value is once again my favorite initial guess from previous experience.

Nu: The Length of Walk

The length of walk controls the number of iterations that will be carried out in a sequence of connected actions. It is in the range [0, 1].

A value of zero would mean the algorithm always uses the state it reached in the previous iteration as the starting state for the next iteration. This has the benefit of the algorithm seeing through sequences of actions that might eventually lead to success. It has the disadvantage of allowing the algorithm to get caught in a relatively small number of states from which there is no escape or an escape only by a sequence of actions with low Q-values (which are therefore unlikely to be selected).

A value of one would mean that every iteration starts from a random state. If all states and all actions are equally likely, then this is the optimal strategy: it covers the widest possible range of states and actions in the smallest possible time. In reality, however, some states and actions are far more prevalent. Some states act as attractors, to which a large number of different action sequences lead. These states should be explored in preference to others, and allowing the algorithm to wander along sequences of actions accomplishes this.

Many exploration policies used in reinforcement learning do not have this parameter and assume that it has the value zero. They always wander in a connected sequence of actions. In online learning, the state used by the algorithm is directly controlled by the state of the game, so it is impossible to move to a new random state. In this case a value of zero is enforced.

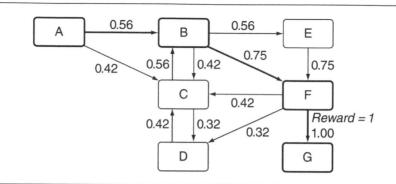

Figure 7.16: A learned state machine

In my experimentation with reinforcement learning, especially in applications where only a limited number of iterations are possible, values of around 0.1 are suitable. This produces sequences of about nine actions in a row, on average.

Choosing Rewards

Reinforcement learning algorithms are very sensitive to the reward values used to guide them. It is important to take into account how the reward values will be used when you use the algorithm.

Typically, rewards are provided for two reasons: for reaching the goal and for performing some other beneficial action. Similarly, negative reinforcement values are given for "losing" the game (e.g., dying) or for taking some undesired action. This may seem a contrived distinction. After all, reaching the goal is just a (very) beneficial action, and a character should find its own death undesirable.

Much of the literature on reinforcement learning assumes that the problem has a solution and that reaching the goal state is a well-defined action. In games (and other applications) this isn't the case. There may be many different solutions, of different qualities, and there may be no final solutions at all but instead hundreds or thousands of different actions that are beneficial or problematic.

In a reinforcement learning algorithm with a single solution, we can give a large reward (let's say 1) to the action that leads to the solution and no reward to any other action. After enough iterations, there will be a trail of Q-values that leads to the solution. Figure 7.16 shows Q-values labeled on a small problem (represented as a state machine diagram). The Q-learning algorithm has been run a huge number of times, so the Q-values have converged and will not change with additional execution.

Starting at node A, we can simply follow the trail of increasing Q-values to get to the solution. In the language of search (described earlier), we are hill climbing. Far from the

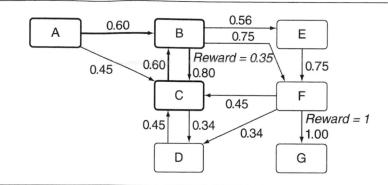

Figure 7.17: A learned machine with additional rewards

solution the Q-values are quite small, but this is not an issue because the largest of these values still points in the right direction.

If we add additional rewards, the situation may change. Figure 7.17 shows the results of another learning exercise.

If we start at state A, we will get to state B, whereupon we can get a small reward from the action that leads to C. At C, however, we are far enough from the solution that the best action to take is to go back to B and get the small reward again. Hill climbing in this situation leads us to a sub-optimal strategy: constantly taking the small reward rather than heading for the solution. The problem is said to be unimodal if there is only one hill and multi-modal if there are multiple hills. Hill climbing algorithms don't do well on multi-modal problems, and Q-learning is no exception.

The situation is made worse with multiple solutions or lots of reward points. Although adding rewards can speed up learning (you can guide the learning toward the solution by rewarding it along the way), it often causes learning to fail completely. There is a fine balance to achieve. Using very small values for non-solution rewards helps, but cannot completely eliminate the problem.

As a rule of thumb, try to simplify the learning task so that there is only one solution and so you don't give any non-solution rewards. Add in other solutions and small rewards only if the learning takes too long or gives poor results.

WEAKNESSES AND REALISTIC APPLICATIONS

Reinforcement learning has not been widely used in game development. It is one of a new batch of promising techniques often taught in undergraduate AI courses, that is receiving interest in the industry.

Like many of these new technologies, the practicality doesn't match some of the potential.

Game development websites and articles written by those outside the industry can appear effusive. It is worth taking a dispassionate look at their real applicability.

Limits of the Algorithm

Q-learning requires the game to be represented as a set of states linked by actions. The algorithm is very sensitive in its memory requirements to the number of states and actions. The state of a game is typically very complex. If the position of characters is represented as a three-dimensional (3D) vector, then there is an effectively infinite number of states. Clearly, we need to group sets of states together to send to the Q-learning algorithm.

Just like for pathfinding, we can divide up areas of the game level. We can also quantize health values, ammo levels, and other bits of state so that they can be represented with a handful of different discrete values. Similarly, we can represent flexible actions (such as movement in two dimensions) with discrete approximations.

The game state consists of a combination of all these elements, however, producing a huge problem. If there are 100 locations in the game and 20 characters, each with 4 possible health levels, 5 possible weapons, and 4 possible ammo levels, then there will be $(100 * 4 * 4 * 5)^{10}$ states, roughly 10^{50} . Clearly, no algorithm that is O(as) in memory will be viable.

Even if we dramatically slash the number of states so that they can be fit in memory, we have an additional problem. The algorithm needs to run long enough so that it tries out each action at each state several times. In fact, the quality of the algorithm can only be proved in convergence: it will eventually end up learning the right thing. But eventually could entail many hundreds of visits to each state.

In reality, we can often get by with tweaking the learning rate parameter, using additional rewards to guide learning and applying dramatically fewer iterations.

After a bit of experimentation, I estimate that the technique is practically limited to around 1 million states, with 10 actions per state. We can run around 1 billion iterations of the algorithm to get workable (but not great) results, and this can be done in reasonable time scales (a few minutes) and with reasonable memory. Obviously, solving a problem once offline with more beefy machines could increase the size somewhat, particularly if the algorithm is implemented to run on the graphics card, but it will still only buy an extra order of magnitude or two.

Online learning should probably be limited to problems with less than 1000 states, given that the rate that states can be explored is so limited.

Applications

Reinforcement learning is most suitable for offline learning. It works well for problems with lots of different interacting components, such as optimizing the behavior of a group of characters or finding sequences of order-dependent actions. Its main strength is its ability to seamlessly handle uncertainty. This allows us to simplify the states exposed to it; we don't have to tell the algorithm everything.

It is not suitable for problems where there is an easy way to see how close a solution is (we can use some kind of planning here), where there are too many states, or where the strategies that are successful change over time (i.e., it requires a good degree of stability to work).

It can be applied to choosing tactics based on knowledge of enemy actions (see below), for bootstrapping a whole character AI for a simple character (we simply give it a goal and a range of actions), for limited control over character or vehicle movement, for learning how to interact socially in multi-player games, for determining how and when to apply one specific behavior (such as learning to jump accurately or learning to fire a weapon), and for many other real-time applications.

It has proven particularly strong in board game AI, evaluating the benefit of a board position. By extension, it has a strong role to play in strategy setting in turn-based games and other slow moving strategic titles.

It can be used to learn the way a player plays and to mimic the player's style, making it one choice for implementing a dynamic demo mode.

An Example Case Study: Choosing Tactical Defense Locations

Suppose we have a level in which a sentry team of three characters is defending the entrance to a military facility. There are a range of defensive locations that the team can occupy (15 in all). Each character can move to any empty location at will, although we will try to avoid everyone moving at the same time. We would like to determine the best strategy for character movement to avoid the player getting to the entrance safely.

The state of the problem can be represented by the defensive location occupied by each character (or no location if it is in motion), whether each character is still alive, and a flag to say if any of the characters can see the player. We therefore have 17 possible positional states per character (15 + in motion + dead) and 2 sighting states (player is either visible or not). Thus, there are 34 states per player, for a total of 40,000 states overall.

At each state, if no character is in motion, then one may change location. In this case there are 56 possible actions, and there are no possible actions when any character is in motion.

A reward function is provided if the player dies (characters are assumed to shoot on sight). A negative reward is given if any character is killed or if the player makes it to the entrance. Notice we aren't representing where the player is when seen. Although it matters a great deal where the player is, the negative reward when the player makes it through means the strategy should learn that a sighting close to the entrance is more risky.

The reinforcement learning algorithm can be run on this problem. The game models a simple player behavior (random routes to the entrance, for example) and creates states for the algorithm based on the current game situation.

With no graphics to render, a single run of the scenario can be performed quickly.

To implement this I would use the 0.3 alpha, 0.7 gamma, and 0.3 rho values suggested

previously. Because the state is linked to an active game state, nu will be 0 (we can't restart from a random state, and we'll always restart from the same state and only when the player is dead or has reached the entrance).

7.7.9 OTHER IDEAS IN REINFORCEMENT LEARNING

Reinforcement learning is a big topic, and one that I couldn't possibly exhaust here. Because there has been such minor use of reinforcement learning in games, it is difficult to say what the most significant variations will be.

Q-learning is a well-established standard in reinforcement learning and has been applied to a huge range of problems. The remainder of this section provides a quick overview of other algorithms and applications.

TD

Q-learning is one of a family of reinforcement learning techniques called Temporal Difference algorithms (TD for short). TD algorithms have learning rules that update their value based on the reinforcement signal and on previous experience at the same state.

The basic TD algorithm stores values on a per-state basis, rather than using action-state pairs. They can therefore be significantly lighter on memory use, if there are many actions per state.

Because we are not storing actions as well as states, the algorithm is more reliant on actions leading to a definite next state. Q-learning can handle a much greater degree of randomness in the transition between states than vanilla TD.

Aside from these features, TD is very similar to Q-learning. It has a very similar learning rule, has both alpha and beta parameters, and responds similarly to their adjustment.

Off-Policy and On-Policy Algorithms

Q-learning is an off-policy algorithm. The policy for selecting the action to take isn't a core part of the algorithm. Alternative strategies can be used, and as long as they eventually visit all possible states the algorithm is still valid.

On-policy algorithms have their exploration strategy as part of their learning. If a different policy is used, the algorithm might not reach a reasonable solution. Original versions of TD had this property. Their policy (choose the action that is most likely to head to a state with a high value) is intrinsically linked to their operation.

TD in Board Game Al

A simplified version of TD was used in Samuel's Checkers-playing program, one of the most famous programs in AI history. Although it omitted some of the later advances in reinforcement learning that make up a regular TD algorithm, it had the same approach.

Another modified version of the TD was used in the famous Backgammon-playing program devised by Gerry Tesauro. It succeeded in reaching international-level play and contributed insights to Backgammon theory used by expert players. Tesauro combined the reinforcement learning algorithm with a neural network.

Neural Networks for Storage

As we have seen, memory is a significant limiting factor for the size of reinforcement learning problems that can be tackled. It is possible to use a neural network to act as a storage medium for Q-values (or state values, called *V*, in the regular TD algorithm).

Neural networks (as we will see in the next section) also have the ability to generalize and find patterns in data. Previously, I mentioned that reinforcement learning cannot generalize from its experience: if it works out that shooting a guard in one situation is a good thing, it will not immediately assume that shooting a guard in another situation is good. Using neural networks can allow the reinforcement learning algorithm to perform this kind of generalization. If the neural network is told that shooting an enemy in several situations has a high Q-value, it is likely to generalize and assume that shooting an enemy in other situations is also a good thing to do.

On the downside, neural networks are unlikely to return the same Q-value that was given to them. The Q-value for a action-state pair will fluctuate over the course of learning, even when it is not being updated (particularly if it is not, in fact). The Q-learning algorithm is therefore not guaranteed to come to a sensible result. The neural network tends to make the problem more multi-modal. As we saw in the previous section, multi-modal problems tend to produce sub-optimal character behavior.

So far I am not aware of any developers who have used this combination successfully, although its success in the TD Backgammon program suggests that its complexities can be tamed.

Actor-Critic

The actor-critic algorithm keeps two separate data structures: one of values used in the learning rule (Q-values, or V-values, depending on the flavor of learning) and another set that is used in the policy.

The eponymous actor is the exploration strategy; the policy that controls which actions are selected. This policy receives its own set of feedback from the critic, which is the usual learning algorithm. So as rewards are given to the algorithm, they are used to guide learning in the critic, which then passes on a signal (called a critique) to the actor, which uses it to guide a simpler form of learning.

The actor can be implemented in more than one way. There are strong candidates for policies that support criticism. The critic is usually implemented using the basic TD algorithm, although Q-learning is also suitable.

Actor-critic methods have been suggested for use in games by several developers. Their separation of learning and action theoretically provides greater control over decision making. In practice, I feel that the benefit is marginal at best. But I wait to be proved wrong by a developer with a particularly successful implementation.

7.8 ARTIFICIAL NEURAL NETWORKS

Artificial neural networks (ANNs, or just neural networks for short) were at the vanguard of the new "biologically inspired" computing techniques of the 1970s. Despite being used in a wide range of applications, their fame diminished until the mid-2010s when they exploded back to prominence as the main technique in deep learning.

Like many biologically inspired techniques, collectively called Natural Computing (NC), and before that other AI techniques, they have been the subject of a great deal of unreasonable hype. Since the successes of the 1960s, AI has always been on the verge of changing the world. Perhaps with deep learning that prospect will come true.

In games, neural networks attract a vocal following of pundits, particularly on websites and forums, who see their potential as a kind of panacea for the problems in AI.

Developers who have experimented with neural networks for large-scale behavior control tend to be more realistic about the approach's weaknesses. The combined hype and disappointment have clouded the issue. AI-savvy hobbyists can't understand why the industry isn't using them more widely, and developers often see them as being useless and a dead end.

Personally, I've never used a neural network in a game. I have built neural network prototypes for a couple of AI projects, but none made it through to playable code. I can see, however, that they are a useful technique in the developer's armory. In particular, I would strongly consider using them as a classification technique, which is their primary strength.

It will undeniably be an interesting ten years in neural-network-based AI. The reality of the games industry is that a strong success by one or two prominent studios can change the way people think about a technique. It is possible that deep learning will cross from its highprofile role in board games and game playing, to be a reliable technique for character design. Equally, it is possible that developers continue to work with simpler algorithms, feeling that they are sufficient, and easier to manage. When I wrote the first edition of this book, I didn't expect the arrival of deep learning. And I can't call what the state-of-the-art will be, when it comes to the fourth edition. For now I personally am keeping it in my toolbox.

In this section I can't possibly hope to cover more than the basics of neural networks or deep learning.

Neural networks are a huge subject, full of different kinds of network and learning algorithms specialized for very small sets of tasks. Very little neural network theory is applicable to games, however. So I'll stick to the basic technique with the widest usefulness. When it comes to deep learning, in this chapter I will gave an overview of the field, but focus on deep neural networks. I will talk about the application of deep learning to board games in Chapter 9. Deep learning builds on the basic algorithms of neural networks, so I will discuss neural networks in their simplest terms in the section, and return to deep learning in the next.

Neural Network Zoology

There is a bewildering array of different neural networks. They have evolved for specialized use, giving a branching family tree of intimidating depth. Practically everything we can think of to say about neural networks has exceptions. There are few things you can say about a neural network that is true of all of them.

So I am going to steer a sensible course. I will focus on a particular neural network in more detail: the multi-layer perceptron. And I will describe one particular learning rule: the backpropagation algorithm (backprop for short). Other techniques will be mentioned in passing.

It is an open question as to whether multi-player perceptrons are the most suited to game applications. They are the most common form of ANN, however. Until developers find an application that is obviously a "killer app" for neural networks in games, I think it is probably best to start with the most widespread technique.

7.8.1 OVERVIEW

Neural networks consist of a large number of relatively simple nodes, each running the same algorithm. These nodes are the artificial neurons, originally intended to simulate the operation of a single brain cell. Each neuron communicates with a subset of the other artificial neurons in the network. They are connected in patterns characteristic of the neural network type. This pattern is the neural network's architecture or topology.

Architecture

Figure 7.18 shows a typical architecture for a multi-layer perceptron (MLP) network. Perceptrons (the specific type of artificial neuron used) are arranged in layers, where each perceptron is connected to all those in the layers immediately in front of and behind it.

The architecture on the right shows a different type of neural network: a Hopfield network. Here the neurons are arranged in a grid, and connections are made between neighboring points in the grid.

Feedforward and Recurrence

In many types of neural networks, some connections are specifically inputs and the others are outputs. The multi-layer perceptron takes inputs from all the nodes in the preceding layer and sends its single output value to all the nodes in the next layer. It is known as a feedforward

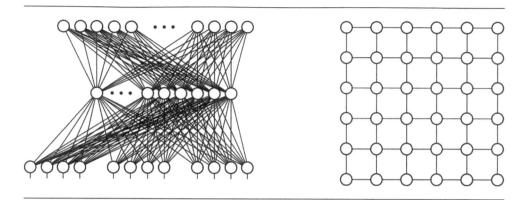

Figure 7.18: ANN architectures (MLP and Hopfield)

network for this reason. The leftmost layer (called the input layer) is provided input by the programmer, and the output from the rightmost layer (called the output layer) is the output finally used to do something useful.

Feedforward networks can have loops: connections that lead from a later layer back to earlier layers. This architecture is known as a recurrent network. Recurrent networks can have very complex and unstable behavior and are typically much more difficult to control.

Other neural networks have no specific input and output. Each connection is both input and output at the same time.

Neuron Algorithm

As well as architecture, neural networks specify an algorithm. At any time the neuron has some state; you can think of it as an output value from the neuron (it is normally represented as a floating point number).

The algorithm controls how a neuron should generate its state based on its inputs. In a multi-layer perceptron network, the state is passed as an output to the next layer. In networks without specific inputs and outputs, the algorithm generates a state based on the states of connected neurons.

The algorithm is run by each neuron in parallel. For game machines that don't have parallel capabilities (at least not of the right kind), the parallelism is simulated by getting each neuron to carry out the algorithm in turn. It is possible, but not common, to make different neurons have completely different algorithms.

We can treat each neuron as an individual entity running its algorithm. The perceptron algorithm is shown figuratively in Figure 7.19.

Each input has an associated weight. The input values (we're assuming that they're zero or one here) are multiplied by the corresponding weight. An additional bias weight is added (it

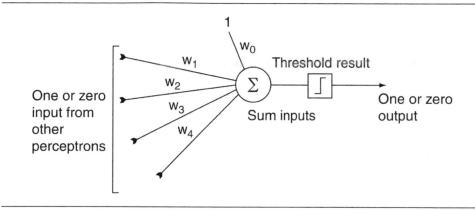

Figure 7.19: Perceptron algorithm

is equivalent to another input whose input value is always one). The final sum is then passed through a threshold function. If the sum is less than zero, then the neuron will be off (have a value of zero); otherwise, it will be on (have a value of one).

The threshold function turns an input weight sum into an output value. We've used a hard step function (i.e., it jumps right from output = 0 to output = 1), but there are a large number of different functions in use. In order to make learning possible, the multi-layer perceptron algorithm uses slightly smoother functions, where values close to the step get mapped to intermediate output values. We'll return to this in the next section.

Learning Rule

So far we haven't talked about learning. Neural networks differ in the way they implement learning. For some networks learning is so closely entwined with the neuron algorithm that they can't be separated. In most cases, however, the two are quite separate.

Multi-layer perceptrons can operate in two modes. The normal perceptron algorithm, described in the previous section, is used to put the network to use. The network is provided with input in its input layer; each of the neurons does its stuff, and then the output is read from the output layer. This is typically a very fast process and involves no learning. The same input will always give the same output (this isn't the case for recurrent networks, but we'll ignore these for now).

To learn, the multi-layer perceptron network is put in a specific learning mode. The task of the learning algorithm is to discover which weights are contributing to the correct answer, and which weights are not. The correct weights can then be reinforced (or possibly left as they are), and the incorrect weights can be changed. Unfortunately, for some input to the network, we are comparing desired outputs to actual outputs. Deciding which weights were important in generating the output is difficult. This is known as the credit assignment problem. The more intermediate layer a network has, more tricky it is to work out where any error has occurred.

There are various learning rules for the multi-layer perceptron. But the credit assignment problem is so complex that there is no one best rule for all situations. Here I will describe 'backpropagation', the most common, and the basis of many variations.

Where the network normally feeds forward, with each layer generating its output from the previous layer, backpropagation works in the opposite direction, working backward from the output.

At the end of this section, I will also describe 1 Hebbian learning, a completely different learning rule that may be useful in games. For now, let us stick with backpropagation and work through the multi-layer perceptron algorithm.

7.8.2 THE PROBLEM

We'd like to group a set of input values (such as distances to enemies, health values for friendly units, or ammo levels) together so that we can act differently for each group. For example, we might have a group of "safe" situations, where health and ammo are high and enemies are a long way off. Our AI can go looking for power-ups or lay a trap in this situation. Another group might represent life-threatening situations where ammo is spent, health is perilously low, and enemies are bearing down. This might be a good time to run away in blind panic. So far, this is simple (and a decision tree would suffice). But say we also wanted a "fight-valiantly" group. If the character was healthy, with ammo and enemies nearby, it would naturally do its stuff. But it might do the same if it was on the verge of death, but had ammo, and it might do the same even in improbable odds to altruistically allow a squad member to escape. It may be a last stand, but the results are the same.

As these situations become more complex, and the interactions get more involved, it can become difficult to create the rules for a decision tree or fuzzy state machine.

We would like a method that learns from example (just like decision tree learning), allowing us to give a few tens of examples. The algorithm should generalize from examples to cover all eventualities. It should also allow us to add new examples during the game so that we can learn from mistakes.

What about Decision Tree Learning?

We could use decision tree learning to solve this problem: the output values correspond to the leaves of the decision tree, and the input values are used in the decision tree tests. If we used an incremental algorithm (such as ID4), we would also be able to learn from our mistakes during the game. For classification problems like this, decision tree learning and neural networks are viable alternatives.

Decision trees are accurate. They give a tree that correctly classifies from the given examples. To do this, they make hard and fast decisions. When they see a situation that wasn't represented in their examples, they will make a decision based on it. Because their decision making is so hard and fast, they aren't so good at generalizing by extrapolating into gray areas beyond the examples. Neural networks are not so accurate. They may even give the wrong responses for the examples provided. They are better, however, at extrapolating (sometimes sensibly) into those gray areas.

This trade-off between accuracy and generalization is the basis of the decision you must make when considering which technique to use. In my work, I've come down on the side of accuracy, but every application has its own peculiarities.

7.8.3 THE ALGORITHM

As an example for the algorithm, I will use a variation of the tactical situation we looked at previously. An AI-controlled character makes use of 19 input values: the distance to the nearest 5 enemies, the distance to the nearest 4 friends along with their health and ammo values, and the health and ammo of the AI. I will assume that there are five different output behaviors: run-away, fight-valiantly, heal-friend, hunt-enemy, and find-power-up. Assume that we have an initial set of 20 to 100 scenarios, each one a set of inputs with the output we'd like to see.

For now, we will use a network with three layers: input layer and output layer, as previously discussed, plus an intermediate (hidden) layer. This would qualify as a 'shallow learning' neural network, but as we will see in the next section, it is likely to be the best approach for this task.

The input layer has the same number of nodes as there are values in our problem: 19. The output layer has the same number of nodes as there are possible outputs: 5. Hidden layers are typically at least as large as the input layer and often much larger. The structure is shown in Figure 7.20, with some of the nodes omitted for clarity.

Each perceptron has a set of weights for each of the neurons in the previous layer. It also holds a bias weight. Input layer neurons do not have any weights. Their value is simply set by the corresponding values in the game.

We split our scenarios into two groups: a training set (used to do the learning) and a testing set (used to check on how learning is going). Ten training and ten testing examples would be an absolute minimum for this problem. Fifty of each would be much better.

Initial Setup and Framework

We start by initializing all the weights in the network to small random values.

We perform a number of iterations of the learning algorithm (typically hundreds or thousands). For each iteration we select an example scenario from the training set. Usually, the examples are chosen in turn, looping back to the first example after all of them have been used.

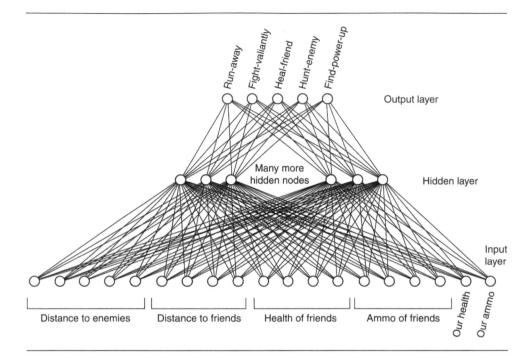

Figure 7.20: Multi-layer perceptron architecture

At each iteration we perform two steps. Feedforward takes the inputs and guesses an output, and backpropagation modifies the network based on the real output and the guess.

After the iterations are complete, and the network has learned, we can test if the learning was successful. We do this by running the feedforward process on the test set of examples. If the guessed output matches the output we were looking for, then it is a good sign that the neural network has learned properly. If it hasn't, then we can run some more algorithms.

If the network continually gets the test set wrong, then it is an indication that there aren't enough examples in the training set or that they aren't similar enough to the test examples. We should give it more varied training examples.

Feedforward

First, we need to generate an output from the input values in the normal feedforward manner. We set the states of the input layer neurons directly. Then for each neuron in the hidden layer, we get it to perform its neuron algorithm: summing the weighted inputs, applying a threshold function, and generating its output. We can then do the same thing for each of the output layer neurons.

We need to use a slightly different threshold function from that described in the intro-

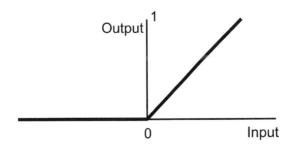

Figure 7.21: The ReLU function

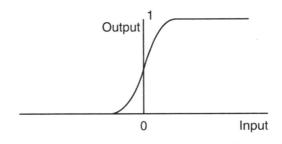

Figure 7.22: The sigmoid threshold function

duction. It is called the ReLU function (short for 'rectified linear unit'), and it is shown in Figure 7.21. For input values below zero, it returns zero just like the step function. For input values greater than zero, the activation increases linearly. This will become important when it comes to learning, because we can differentiate neurons that very strongly fire from those that are more ambivalent about their decision.

This will be the function we will use for learning. Its equation is:

$$f(x) = \max(0, x)$$

or, in some cases a slightly smoother version (sometimes known as 'softplus', but often simply referred to as ReLU, as with the version that uses max):

$$f(x) = \log(1 + e^x)$$

ReLU was introduced in 2011 [16], replacing a decades-old alternative called the 'sigmoid function'. ReLU made a dramatic difference in the ability of large neural networks to learn efficiently. The sigmoid function can still be used on smaller networks, but as the number of intermediate layers increases, and the shallow network becomes deep, ReLU comes to dominate.

The main limitation of ReLU is that it is unbounded. Unlike the step function, there is no upper limit to how much activation a neuron can produce. In some cases this can lead to a network becoming saturated and it's learning becoming stuck. In those cases an alternative may be needed.

Although it is now less often used, Figure 7.22 shows the sigmoid function. For input values far from zero, it acts just like the step function. For input values near to zero, it is smoother, giving us intermediate output. The equation of the function is:

$$f(x) = \frac{1}{1 + e^{-hx}}$$

where h is a tweakable parameter that controls the shape of the function. The larger the value of h, the nearer to the step function this becomes. The best value of h depends on the number of neurons per layer and the size of the weights in the network. Both factors tend to lower the h value. The difficulty of optimizing the h value, and the sensitivity of learning to getting it right, is another reason to prefer ReLU. Because it is relatively new, much of the neural network literature still assumes a sigmoid function, so it is worth being aware of, but from here on we will stick to ReLU.

Backpropagation

To learn, we compare the state of the output nodes with the current pattern. The desired output is zero for all output nodes, except the one corresponding to our desired action. We work backward, a layer at a time, from the output layer, updating all the weights.

Let the set of neuron states be o_i , where j is the neuron, and w_{ij} is the weight between neurons i and j. The equation for the updated weight value is

$$w'_{ij} = w_{ij} + \eta \delta_j o_i$$

where η is a gain term, and δ_j is an error term (both of which I'll discuss below).

The equation says that we calculate the error in the current output for a neuron, and we update its weights based on which neurons affected it. So if a neuron comes up with a bad result (i.e., we have a negative error term), we go back and look at all its inputs. For those inputs that contributed to the bad output, we tone down the weights. On the other hand, if the result was very good (positive error term), we go back and strengthen weights from neurons that helped it. If the error term is somewhere in the middle (around zero), we make very little change to the weight.

The Error Term

The error term, δ_i , is calculated slightly differently depending on whether we are considering an output node (for which our pattern gives the output we want) and hidden nodes (where we have to deduce the error).

For the output nodes, the error term is given by:

$$\delta_j = o_j(1 - o_j)(t_j - o_j)$$

where t_j is the target output for node j. For hidden nodes, the error term relates the errors at the next layer up:

$$\delta_j = o_j(1 - o_j) \sum_k w_{jk} \delta_k$$

where k is the set of nodes in the next layer up. This formula says that the error for a neuron is equal to the total error it contributes to the next layer. The error contributed to another node is $w_{kj}\delta_k$, the weight of that node multiplied by the error of that node.

For example, let's say that neuron A is on. It contributes strongly to neuron B, which is also on. We find that neuron B has a high error, so neuron A has to take responsibility for influencing B to make that error. The weight between A and B is therefore weakened.

The Gain

The gain term, η , controls how fast learning progresses. If it is close to zero, then the new weight will be very similar to the old weight. If weights are changing slowly, then learning is correspondingly slow. If η is a larger value (it is rarely greater than one, although it could be), then weights are changed at a greater rate.

Low-gain terms produce relatively stable learning. In the long run they produce better results. The network won't be so twitchy when learning and won't make major adjustments in reaction to a single example. Over many iterations the network will adjust to errors it sees many times. Single error values have only a minor effect.

A high-gain term gives you faster learning and can be perfectly usable. It has the risk of continually making large changes to weights based on a single input-output example.

An initial gain of 0.3 serves as a starting point.

Another good compromise is to use a high gain initially (0.7, say) to get weights into the right vicinity. Gradually, the gain is reduced (down to 0.1, for example) to provide fine tuning and stability.

7.8.4 PSEUDO-CODE

We can implement a backpropagation algorithm for multi-layer perceptrons in the following form:

```
class MLPNetwork:
       # Holds input perceptrons.
2
       inputPerceptrons
3
4
5
       # Holds hidden layer perceptrons.
6
       hiddenPerceptrons
7
       # Holds output layer perceptrons.
8
9
       outputPerceptrons
10
       # Learn the given output for the given input.
11
       function learnPattern(input, output):
12
           # Generate the unlearned output.
           generateOutput(input)
           # Perform the backpropagation.
15
           backprop(output)
16
17
       # Generate outputs for the given set of inputs.
18
       function generateOutput(input):
19
           # Go through each input perceptron and set its state.
20
           for index in 0..inputPerceptrons.length():
21
                inputPerceptrons[index].state = input[index]
22
23
           # Go through each hidden perceptron and feedforward.
24
           for perceptron in hiddenPerceptrons:
25
                perceptron.feedforward()
27
           # And do the same for output perceptrons.
28
           for perceptron in outputPerceptrons:
29
                perceptron.feedforward()
30
31
       # Run the backpropagation learning algorithm. We
32
       # assume that the inputs have already been presented
33
       # and the feedforward step is complete.
34
       function backprop(output):
35
           # Go through each output perceptron.
           for index in 0..outputPerceptrons.length():
               # Find its generated state.
                perceptron = outputPerceptrons[index]
               state = perceptron.state
41
               # Calculate its error term.
               error = state * (1-state) * (output[index]-state)
43
45
               # Get the perceptron to adjust its weights.
               perceptron.adjustWeights(error)
```

```
47
            # Go through each hidden perceptron.
48
            for index in 0..hiddenPerceptrons.length():
49
                # Find its generated state.
50
                perceptron = outputPerceptrons[index]
51
                state = perceptron.state
52
53
                # Calculate its error term.
54
                sum = 0
55
                for output in outputs:
56
                    weight = output.getIncomingWeight(perceptron)
57
                    sum += weight * output.error
58
                error = state * (1-state) * sum
59
60
                # Get the perceptron to adjust its weights.
61
                perceptron.adjustWeights(error)
62
```

7.8.5 DATA STRUCTURES AND INTERFACES

The code above wraps the operation of a single neuron into a Perceptron class and gets the perceptron to update its own data. The class can be implemented in the following way:

```
class Perceptron:
        # Each input into the perceptron requires two bits of
2
       # data, held in this structure.
3
       class Input:
            # The perceptron that the input arrived from.
5
            inputPerceptron
            # Input weight, initialized to a small random value.
            weight
10
       # Holds a list of inputs for the perceptron.
11
12
13
       # The current output state of the perceptron.
14
15
16
       # The current error in the perceptron's output.
17
       error
18
19
       # Perform the feedforward algorithm.
20
       function feedforward():
21
            # Go through each input and sum its contribution.
22
            sum = 0
23
            for input in inputs:
24
```

```
sum += input.inputPerceptron.state * input.weight
25
           # Apply the thresholding function.
           this.state = threshold(sum)
29
       # Perform the update in the backpropagation algorithm.
30
       function adjustWeights(currentError):
31
            # Go through each input.
32
            for input in inputs:
33
                # Find the change in weight required.
34
                state = input.inputPerceptron.state
35
                deltaWeight = gain * currentError * state
36
                # Apply it.
38
                input.weight += deltaWeight
39
40
            # Store the error, perceptrons in preceding layers
41
            # will need it.
42
            error = currentError
43
44
        # Find the weight of the input that arrived from the
45
        # given perceptron. This is used in hidden layers to
46
        # calculate the outgoing error contribution.
47
        function getIncomingWeight(perceptron):
48
            # Find the first matching perceptron in the inputs.
49
            for input in inputs:
50
                if input.inputPerceptron == perceptron:
                    return input.weight
53
            # Otherwise we have no weight.
54
            return 0
55
```

In this code I've assumed the existence of a threshold function that can perform the thresholding. This can be a simple ReLU function, implemented as:

```
function threshold(input):
    return max(0, input)
```

To support other kinds of thresholding (such as the sigmoid function described above, or the radial basis function described later), we can replace this with a different formula.

The code also makes reference to a gain variable, which is the global gain term for the network.

7.8.6 IMPLEMENTATION CAVEATS

In a production system, it would be inadvisable to implement getIncomingWeight as a sequential search through each input. Most times connection weights are arranged in a data array. Neurons are numbered, and weights can be directly accessed from the array by index. However, the direct array accessing makes the overall flow of the algorithm more complex. The pseudo-code illustrates what is happening at each stage. The pseudo-code also doesn't assume any particular architecture. Each perceptron makes no requirements of which perceptrons form its inputs.

Beyond optimizing the data structures, neural networks are intended to be parallel. We can make huge time savings by changing our implementation style. By representing the neuron states and weights in separate arrays, we can write both the feedforward and backpropagation steps using single instruction multiple data (SIMD) operations (such as those provided on a graphics card). Not only are we working on four neurons at a time, per processing core, but we are also making sure that the relevant data are stored together. For larger networks it is almost essential to use a graphics card implementation, taking advantage of the hardware's many cores and massive parallelization.

7.8.7 PERFORMANCE

The algorithm is O(nw) in memory, where n is the number of perceptrons, and w is the number of inputs per perceptron. In time, the performance is also O(nw) for both feedforward (generateOutputs and backpropagation (backprop). I have ignored the use of a search in the getIncomingWeights method of the perceptron class, as given in the pseudo-code. As we saw in the implementation caveats, this chunk of the code will normally be optimized out.

7.8.8 OTHER APPROACHES

There are many books as big as this filled with neural network theory, I can't hope to discuss it all. But most of the approaches would be of only marginal use to games. By way of a roundup and pointers to other fields, I think it is worth talking about three other techniques: radial basis functions, weakly supervised learning, and Hebbian learning. The first two I've used in practice, and the third is a beloved technique of a former colleague.

Radial Basis Function

The threshold function I introduced earlier is called the ReLU basis function. A basis function is simply a function used as the basis of an artificial neuron's behavior.

The action of a ReLU basis function is to split its input into two categories. High values are given a high output, and low values are given zero output. The dividing line between the

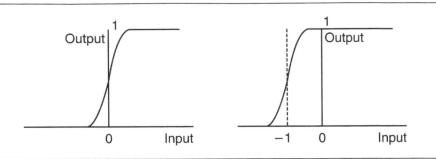

Figure 7.23: Bias and the sigmoid basis function

two categories is always at zero input. The function is performing a simple categorization. It distinguishes high from low values.

So far I've included the bias weight as part of the sum before thresholding. This is sensible from an implementation point of view. But we can also view the bias as changing where the dividing line is situated. For example, let's take a single perceptron with a single input.

To illustrate (because it bears more similarity to the radial basis function I will introduce in a moment), I will return to the alternative sigmoid basis function. Figure 7.23 (left) shows the output from a perceptron when the bias is zero. Figure 7.23 (right) shows the same output from the same perceptron when the bias is one. Because the bias is always added to the weighted inputs, it skews the results.

This is deliberate, of course. You can think of each neuron as something like a decision node in a decision tree: it looks at an input and decides which of two categories the input is in. It makes no sense, then, to always split the decision at zero. We might want 0.5 to be in one category and 0.9 in another. The bias allows us to divide the input at any point.

But categorizations can't always be made at a single point. Often, it is a range of inputs that we need to treat differently. Only values within the range should have an output of one; higher or lower values should get zero output. A big enough neural network can always cope with this situation. One neuron acts as the low bound, and another neuron acts as the high bound. But it does mean you need all those extra neurons.

Radial basis functions (first described in [6]) address this issue by using the basis function shown in Figure 7.24.

Here the range is explicit. The neuron controls the range, as before, using the bias weight. The spread (the distance between the minimum and maximum input for which the output is > 0.5) is controlled by the overall size of the weights. If the input weights are all high, then the range will be squashed. If the weights are low, then the range will be widened. By altering the weights alone (including the bias weight), any minimum and maximum values can be learned.

Radial basis functions can have various mathematical definitions. Most appear as in the figure above, a combination of a mirrored pair of sigmoid basis functions. Like the sigmoid

Figure 7.24: The radial basis function

function, they can also be very slow to learn, but conversely for some problems they fit the data more closely, allowing your network to be much smaller and more efficient.

Weakly Supervised Learning

The algorithm above relies on having a set of examples. The examples can be hand built or generated from experience during the game.

Examples are used in the backpropagation step to generate the error term. The error term then controls the learning process. This is called *supervised learning*: we are providing correct answers for the algorithm.

An alternative approach used in online learning is weakly supervised learning (sometimes called unsupervised learning, although strictly that is something else). Weakly supervised learning doesn't require a set of examples. It replaces them with an algorithm that directly calculates the error term for the output layer.

For instance, consider the tactical neural network example again. The character is moving around the level, making decisions based on its nearby friends and enemies. Sometimes the decisions it makes will be poor: it might be trying to heal a friend when suddenly an enemy attack is launched, or it might try to find pick-ups and wander right into an ambush. A supervised learning approach would try to calculate what the character should have done in each situation and then would update the network by learning this example, along with all previous examples.

A weakly supervised learning approach recognizes that it isn't easy to say what the character should have done, but it is easy to say that what the character did do was wrong. Rather than come up with a solution, it calculates an error term based on how badly the AI was punished. If the AI and all its friends are killed, for example, the error will be very high. If it only suffered a couple of hits, then the error will be small. We can do the same thing for successes, giving positive feedback for successful choices.

The learning algorithm works the same way as before, but uses the generated error term

for the output layer rather than one calculated from examples. The error terms for hidden layers remain the same as before.

I have used weakly supervised learning to control characters in a game prototype. It proved to be a simple way to bootstrap character behavior and get some interesting variations without needing to write a large library of behaviors.

Weakly supervised learning has the potential to learn things that the developer doesn't know. This potential is exciting admittedly, but it has an evil twin. The neural network can easily learn things that the developer doesn't want it to know—things that the developer can plainly see are wrong. In particular, it can learn to play in a boring and predictable way. Earlier I mentioned the prospect of a character making a last stand when the odds were poor for its survival. This is an enjoyable AI to play against, one with personality. If the character was learning solely based on results, however, it would never learn to do this; it would run away. In this case (as with the vast majority of others), the game designer knows best.

Hebbian Learning

Hebbian learning is named after Donald Hebb, who proposed in 1949 [22] that biological neurons follow this learning rule. It is still not clear how much, if any, of a biological neural network conforms to Hebb's rule, but it is considered one of the most biologically plausible techniques for artificial neural networks. It has also proven to be practical, and is surprisingly simple to implement.

It is an unsupervised technique. It requires neither examples nor any generated error values. It tries to categorize its inputs based only on patterns it sees.

Although it can be used in any network, Hebbian learning is most commonly used with a grid architecture, where each node is connected to its neighbors (see Figure 7.25).

Neurons have the same non-learning algorithm as previously. They sum a set of weighted inputs and decide their state based on a threshold function. In this case, they are taking input from their neighbors rather than from the neurons in the preceding layer.

Hebb's learning rule says that if a node tends to have the same state as a neighbor, then the weight between those two nodes should be increased. If it tends to have a different state, then the weight should be decreased.

The logic is simple. If two neighboring nodes are often having the same states (either both on or both off), then it stands to reason that they are correlated. If one neuron is on, we should increase the chance that the other is on also by increasing the weight. If there is no correlation, then the neurons will have the same state about as often as not, and their connection weight will be increased about as often as it is decreased. There will be no overall strengthening or weakening of the connection. This is called Hebb's Rule.

Hebbian learning is used to find patterns and correlations in data, rather than to generate output. It can be used to regenerate gaps in data.

For example, Figure 7.26 shows a side in an RTS with a patchy understanding of the structure of enemy forces (because of fog-of-war). We can use a grid-based neural network with

Figure 7.25: Grid architecture for Hebbian learning

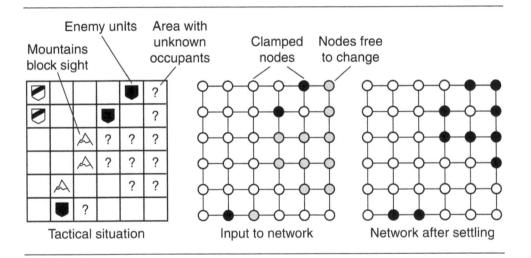

Figure 7.26: Influence mapping with Hebbian learning

Hebbian learning. The grid represents the game map. If the game is tile based, it might use 1, 4, or 9 tiles per node.

The state of each neuron indicates whether the corresponding location in the game is safe or not. With full knowledge of many games, the network can be trained by giving a complete set of safe and dangerous tiles each turn (generated by influence mapping, for example—see Chapter 6, Tactical and Strategic AI).

After a large number of games, the network can be used to predict the pattern of safety.

The AI sets the safety of the tiles it can see as state values in the grid of neurons. These values are clamped and are not allowed to change. The rest of the network is then allowed to follow its normal sum-and-threshold algorithm. This may take a while to settle down to a stable pattern, but the result indicates which of the non-visible areas are likely to be safe and which should be avoided.

7.9 DEEP LEARNING

From the mid-2010s onward, deep learning made it from an academic field into a media sensation. With prominent research promoted out of companies such as Google, and Deep Mind (later acquired by Google), the term became synonymous with AI. So much so that it can be difficult, outside of the specialist AI literature, to get a straight answer on what deep learning really is. It remains to be seen whether this popularity translates into longevity; or whether—as in previous cycles of AI—there follows a period of disillusionment when the limits of the technique become clear.

As an engineering approach, deep learning is strikingly powerful. It is an active area of research in many games development studios, and I would be surprised if applications in games do not follow in the coming years. Where it will be most useful, however, is less clear. Like all AI techniques (such as expert systems, or the original interest in neural networks), understanding the mechanism helps put the technique in context. It is such an active and rapidly changing area of research, and there is such voluminous literature, I cannot hope to give anything more than an overview in this book. A next step would be a textbook such as [18], or the gentler overview in Jeff Heaton's AI for humans series [21].

7.9.1 WHAT IS DEEP LEARNING?

So far we have seen in this chapter examples of artificial neural networks that are *shallow*. They have only a few layers of neurons between their output and input. The multi-layer perceptron was shown with a single hidden layer, though because its output perceptions are also adaptive, it has two in total. The Hebbian network in the previous section consists of only a single layer.

A deep neural network has more layers. There isn't an accepted criteria for how many, for when shallow become deep, but deep neural network models may have half a dozen or more. Unlike multi-layer perceptrons, in some network architectures it isn't easy to say exactly what a layer is (recurrent neural networks, where there are loops, for example). Depending how you count, there may be hundreds or thousands.

Though deep learning is almost synonymous with neural networks, it is not entirely so. Other adaptive processes can be used (such as the decision tree learning we saw earlier in this chapter), or other algorithms used alongside neural network learning (such as Monte Carlo Tree Search in board game playing AI). The vast majority of the work in the area, however, is based on artificial neural networks, even if it draws in other techniques. I will focus on deep neural networks in this overview.

Figure 7.27: A schematic representation of a deep learning system

Figure 7.27 shows a schematic representation of a deep learning system. Each layer may consist of any kind of parameterizable structure, whether an array of perceptrons, an image filter (also known as a convolution, from which convolutional neural networks get their name), even a probabilistic model of human language (used in speech recognition and translation). For the system to be deep, it succeeds or fails as a whole. Which in turn means a learning algorithm must be applied to the whole. All the parameters in all the layers are changed during learning. In practical applications, there may be a combination of this global parameterization, and some local changes presided over by local learning algorithms (sometimes known as a greedy layer-by-layer approach), but it is the overall global learning that makes the system 'deep'.

7.9.2 DATA

In Section 7.8, above, I described the credit assignment problem (CAP). The network is run, an output is generated, and the output is judged for quality. For supervised learning this involves a list of known correct examples to compare to. For weakly or unsupervised learning it may mean testing the output in practice and seeing if it succeeds or fails. In either case, to learn, we need to be able to work backwards from the score and from the parameters which

generated it, to a new set of parameters, which hopefully will do better. The problem of determining which parameters to change is the credit assignment problem. The number of layers of parameters to change is known as the credit assignment path depth. For decades it was generally thought that learning a deep CAP was simply intractable. This changed in the early 2010s for three reasons:

- 1. new techniques in neural networks were developed, such as using the ReLU function rather than the sigmoid function for perceptrons, or 'dropout': resetting neurons at random during backpropagation;
- 2. computer power increased, partly in the way Moore's law predicted, but particularly with the availability of highly parallel and affordable GPU computing;
- 3. larger data sets became available due to large-scale indexing of the web, and more autonomous tools for information gathering in biotechnology.

For games, it is often the last of these three which limits the ability to use deep learning. Deep learning has a lot of parameters to change, and successful learning requires considerably more data than parameters. Consider the situation shown in Figure 7.28. Here we are trying to determine threatening enemies. I have deliberately simplified the situation to fit in a diagram. There are eight scenarios, each labeled whether it is threatening or not. Figure 7.29 shows the network we are using to learn: it has eight nodes in its intermediate layer (for simplicity it is shown as a shallow neural network, if it had a dozen layers the problem would be even more acute).

After learning until the network can correctly classify the situations given, the scenario in Figure 7.30 is presented to the network. It is as likely as not to incorrectly classified this situation. This is not a failure in the learning algorithm, or a mistake in implementation. The data is sparse enough that each neuron in the hidden layer simply learned the correct answer to one input scenario. When a new test is presented, the amount of generalizing the network can do is minimal, the output is effectively random. The network is said to have over-fitted the data. It has learned the input rather than the general rule.

The more parameters to learn, the more data is needed. This can be a problem if you are relying on manually labeled data sets, or if testing the neural network involves playing a game, or simulating part of a game. One of the breakthroughs of deep learning, described in [32], achieved a roughly $\frac{2}{3}$ success rate on the 1.2 million hand labeled ImageNet corpus, using a network with 650,000 neurons in five layers. Acquiring and validating that much data for the character AI in a game is difficult, and a success rate of $\frac{2}{3}$ is unlikely to be impressive to players used to finding and exploiting failures.

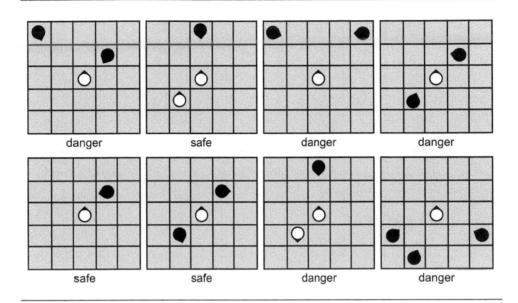

Figure 7.28: Situations for which to learn a strategic threat assessment

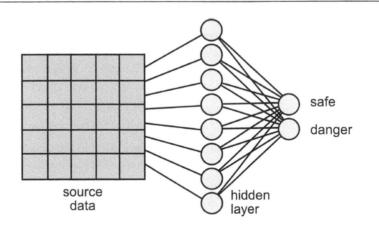

Figure 7.29: The neural network learning a strategic threat assessment

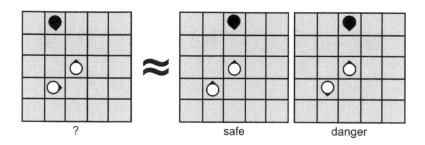

Figure 7.30: A failed strategic threat assessment with a fully trained network

EXERCISES

- 7.1 Chapter 3, Section 3.5.1, discussed aiming and shooting. How might we use hill climbing to determine a firing solution?
- 7.2 Implement a hill climbing approach to determining a firing solution for some simple problems.
- 7.3 In terms of both speed and accuracy, compare the results you obtain from your implementation for Exercise 7.2 to solutions obtained analytically from the equations given in Chapter 3. Use your results to explain why, for many problems, it might not make sense to use hill climbing or any other learning technique to discover a firing solution?
- 7.4 Suppose an AI character in a game can direct artillery fire onto a battlefield. The character wants to cause explosions that maximize enemy losses and minimize the risk to friendly units. An explosion is modeled as a circle with a fixed deadly blast radius r. Assuming the location of all enemy and friendly units is known, write down a function that calculates the expected reward of an explosion at a 2D location (x, y).
- 7.5 If you didn't already, modify the function you wrote down for Exercise 7.4 to take into account the potential impact on morale of friendly fire incidents.
- 7.6 Explain why simple hill climbing might not find the global optimum for the function you wrote down for Exercise 7.4. What techniques might you use instead?
- 7.7 Many fighting games generate special moves by pressing buttons in a particular order (i.e., "combos"). For example, "BA" might generate a "grab and throw" and "BAAB" might generate a "flying kick." How could you use an N-Gram to predict the player's next button press? Why would using this approach to create opponent AI probably be a waste of time? What applications might make sense?
- 7.8 In some fighting games a combo performed when the character being controlled is in a crouching position will have a different effect than when the character is standing.

Does the approach outlined in Exercise 7.7 address this point? If not, how could it be fixed?

7.9 Suppose you have written a game that includes a speech recognizer for the following set words: "go," "stop," "jump," and "turn." Before the game ships, during play testing, you count the frequencies with which each word is spoken by the testers to give the following table:

Word	Frequency	
"go"	100	
"stop"	125	
"jump"	25	
"turn"	50	

Use these data to construct a prior for P(word).

7.10 Carrying on from Exercise 7.9, further suppose that, during play testing, you timed how long it took players to say each word and you discovered that the time taken was a good indicator of which word was spoken. For example, here are the conditional probabilities, given the word the player spoke, that it took them *more than* half a second:

Word	P(length(signal) > 0.5 word)
"go"	0.1
"stop"	0.05
"jump"	0.2
"turn"	0.1

Now suppose that, during gameplay, we time how long it takes a player to utter a word. What is the most likely word the player spoke, given that it took 0.9 seconds to say it? What is its probability? (Hint: Apply Bayes rule:

$$P(A|B) = \alpha P(B|A)P(A)$$

where α is a normalizing constant, then use the prior you constructed in Exercise 7.9 and the given conditional probabilities.)

7.11 Suppose we are trying to learn different styles of playing a game based on when a player decides to shoot. Assume the table below represents data that we have gathered on a particular player:

shoot?	distance-to-target	weapon-type
Y	2.4	pistol
Y	3.2	rifle
N	75.7	rifle
Y	80.6	rifle
N	2.8	pistol
Y	82.1	pistol
Y	3.8	rifle

Using a suitable discretization/quantization of distance-to-target, fill out a new table of
data that will be easier to learn from:

shoot?	distance-to-target-discrete	weapon-type
Y		pistol
Y		rifle
N		rifle
Y		rifle
N		pistol
Y		pistol
Y		rifle

7.12 Using the new table of data you filled out in Exercise 7.11 assume we want to construct a Naive Bayes classifier to decide whether an NPC should shoot or not in any given situation. That is, we want to calculate:

P(shoot?|distance-to-target-discrete, weapon-type)

(for shoot? = Y and shoot? = N) and pick the one that corresponds to the larger probability.

- 7.13 In Exercise 7.12 you only had to calculate the relative conditional probabilities of shooting versus not shooting, but what are the actual conditional probabilities? (Hint: Remember that probabilities have to sum to 1.)
- 7.14 In Exercise 7.12 we made the assumption that, given the shoot action, the distance to the target and the weapon type are conditionally independent. Do you think the assumption is reasonable? Explain your answer.
- 7.15 Re-implement the Naive Bayes classifier class given in Section 7.5 using logarithms to avoid floating-point underflow problems.
- 7.16 Suppose we have a set of examples that look like the following:

Healthy	Exposed	With Ammo	In Group	Close	Attack
Healthy	In Cover	With Ammo	In Group	Close	Attack
Healthy	In Cover	With Ammo	Alone	Far Away	Attack
Healthy	In Cover	With Ammo	Alone	Close	Defend
Healthy	In Cover	Empty	Alone	Close	Defend
Healthy	Exposed	With Ammo	Alone	Close	Defend

Use information gain to build a decision tree from the examples.

- 7.17 Write down a simple rule that corresponds to the decision tree you built for Exercise 7.12. Does it make any sense?
- 7.18 Implement the obstacle avoidance behavior described in Section 3.3.15 and use it to generate some data. The data should record relevant information about the environment and the character's corresponding steering choices.

- 7.19 Take a look at the data you generated from working on Exercise 7.18. How easy do you think the data are to learn from? How could you represent the data to make the learning problem as tractable as possible?
- 7.20 Use the data you generated from working on Exercise 7.18 to attempt to learn obstacle avoidance with a neural network. The problem is probably harder than you imagine, so if it fails to work try re-visiting Exercise 7.19. Remember that you need to test on setups that you didn't train on to be sure it's really working.
- 7.21 Obstacle avoidance naturally lends itself to creating an error term based on the number of collisions that occur. Instead of the supervised approach to learning obstacle avoidance that you tried in Exercise 7.20, attempt a weakly supervised approach.
- 7.22 Instead of the weakly supervised approach to learning obstacle avoidance that you tried in Exercise 7.21, try a completely unsupervised reinforcement learning approach. The reward function should reward action choices that result in collision-free movement. Remember that you always need to test on setups that you didn't use for training.
- 7.23 Given that reliable obstacle avoidance behavior is probably far easier to obtain by hand coding, is trying to use machine learning misguided? Discuss the pros and cons.

8

PROCEDURAL CONTENT GENERATION

PROCEDURAL CONTENT GENERATION is a hot topic in game development. But it is not new. Its use goes back to the 8-bit era of the 1980s. Both *Elite* [82] and *Exile* [181] generated a sizable portion of their content (in the first case a whole galaxy of stars, in the second an underground cave system). Both games were the same each time you played, but the game content was far too big to fit in the 32kB of RAM available. They used procedural generation as a form of compression. Elite in particular proved highly influential, directly leading to games such as *Spore* [137], *Elite: Dangerous* [118] and *No Man's Sky* [119].

In the early 1980s, *Rogue* [139] was first released as freeware for mainframe machines. It featured a procedurally generated dungeon that was different on each play, and permadeath so a level couldn't be repeated over and over until it was beaten. Rogue led to many other noncommercial and hobbyist games, often using similar pure text interfaces. The genre became known as Rogue-likes. Procedural content generation and permadeath crossed into independent commercial games, becoming a phenomenon with titles such as *The Binding of Isaac* [138] and *Spelunky* [146], a burgeoning genre that came to be known as Rogue-lites. Procedural dungeon generation even featured in AAA titles such as *Diablo* [88] and the chalice dungeons of *Bloodborne* [116].

Spore also draws on another thread of procedural content generation: the demo scene. Participants compete to produce the most spectacular audio and visual show, often based on

The genre name Rogue-likes was adopted after a rather zealous campaign to defend 'Rogue-likes' by fans of the earlier games. Other suggestions such as Rogue-like-likes proved too cumbersome.

highly constrained program sizes. This is often a combination of both shaving the size of an executable with hand optimized assembly code, and generating the audio and much of the visuals with procedural content generation. Will Wright, the creator of Spore, recruited prominent demo scene coders to work on that game.

Strategy games such as *Civilization* [147], and its sequels, use procedural level generation to create varied maps for multiplayer games. Landscape generation is ubiquitous enough that most game artists use some kind of content generation—possibly with human modification—to create terrain, even in games with fixed levels. This is procedural content generation used in the studio, rather than running on the game machine. *Minecraft* [142] brought landscape and world generation to a huge audience. Building on a simple block based structure, Mojang over time added generation routines to create mines, villages, temples, and other structures, each intended to evoke the feel of something man made.

And finally, in a survey of games, it would be remiss not to give due credit to *Dwarf Fortress* [81]. In some ways a game that owes a lot to Rogue, particularly in its aesthetics, but where procedural content generation has been pushed into all systems. The world is generated, as are dungeons, characters, back stories, civilizations, even legends and artifacts. A book in this series, [58], contains procedural content generation advice, co-edited by the co-author of Dwarf Fortress.

This survey of procedural content generation illustrates its two main uses: in game, to generate variety; and during development, to make game assets higher fidelity or cheaper to create. In both cases it replaces the work that would otherwise be done by a designer or artist. It is, therefore, an AI task. And unsurprisingly, it uses techniques similar to those already covered in this book. In some cases the connection can be more tenuous. I won't describe in this section the techniques used for procedural synthesis or music composition, because they draw more specifically from audio and music theory. Similarly, game textures are often procedurally generated, but methods for achieving this are based on image filtering and graphical programming techniques. At the other extreme, games such as *Left 4 Dead* [196] and *Earthfall* [120] generate gameplay moments using a 'director' AI: decision making that analyses the state of the game and schedules new enemies and encounters to keep it interesting and challenging to the player. That kind of content generation uses techniques already covered in this book, particularly Chapters 5 and 6. This chapter looks at approaches between these extremes. I will describe several techniques, from simple random number generation to planning shape grammars, that can be used on their own or in combination to create compelling content.

$8.1\,$ pseudorandom numbers

Random numbers have appeared several times already in this book, and each time their use was as simple as calling the random function. We can separate random numbers in programming into three categories:

 True random numbers require specialized hardware that samples thermal noise, nuclear decay, or another stochastic physical phenomena.

- 2. Cryptographic random numbers are not truly random, but are unpredictable and unrepeatable enough that they can be used as the basis of cryptographic software.
- 3. Regular pseudorandom numbers such as those returned by random are based on a seed value, and will always return the same random number for the same seed. Many algorithms for generating pseudorandom numbers are also reversible: given a random number, it is possible to deduce the seed.

Although historically, the default random number generator in an operating system or language runtime has been pseudorandom, increased concerns over computer security have lead some to adopt cryptographic random numbers as standard. In those cases, a simple pseudorandom generator is usually provided in a library. At the time of writing, C/C++, JavaScript and C# still use non-cryptographic random number generators. You may want to check if you are developing in another environment.

In most game code we don't care how a random number is generated. But sometimes it is useful to generate numbers with slightly different properties. Values that are repeatable, or values that cluster in ways that correspond to nature.

8.1.1 NUMERIC MIXING AND GAME SEEDS

Strictly, a pseudorandom number generator using a seed is a 'mixing' function. Given a seed value, it returns an associated number. It is known as a mixing function because any information in the seed value is supposed to be mixed throughout the resulting random number. If two seed values differ only in their first bit, the random numbers that result from each should differ at more than one bit position.

Two identical seed values, however, will always return the same result. This is used in many games with random levels to allow players to share the seed of their run, and have others also attempt the same challenge.

In a game we wish to use more than a single random number, however. We can keep calling random for further values. Behind the scenes, the seed value is being updated. The pseudorandom number generator performs the following update:

$$s_0 \rightarrow s_1, r$$

where s is the seed, subscripts indicate time, and r is the pseudorandom result. The updated seed, s_1 is also fully determined by the initial seed, s_0 . So the sequence of random numbers beginning from a particular seed will always be the same.

The tricky part of using this to produce repeatability in a game, is making sure that the same *number* of calls are performed each time. Imagine the system generating random levels of a dungeon, from an initial seed. We probably don't want a game to generate all levels upfront, as this wastes the player's time. On the other hand, if the player reaches the end of the first level having engaged in no combat (and therefore no random hit rolls), we don't want the second level to be created differently to a player who used the same seed but fought all enemies.

This is accomplished by having several random number generators, often encapsulated as instances of a Random class. Only a master generator is given the game seed, all others are created from that in a specific order. The numbers generated by the master are seeds for the other generators. In code this would look something like:

```
class Random:
       function randomLong(): long
2
3
   function gameWithSeed(seed):
       masterRNG = new Random(seed)
5
       treasureRNG = new Random(masterRNG.randomLong())
       levelsRNG = new Random(masterRNG.randomLong())
7
   function nextLevel():
9
       level += 1
10
       thisLevelRNG = new Random(levelsRNG.randomLong())
11
12
       # Use thisLevelRNG to create the level...
```

Although operating systems and language runtimes provide pseudorandom number generators, often as instantiable classes, some developers use their own. A range of different algorithms provide different trade-offs between performance and bias. This is particularly important if you need your game to run on multiple platforms, or you want to patch or upgrade your game in the future, without invalidating previous seeds. Web browsers, for example, are allowed to choose how to implement JavaScript's Math.random (though as of writing the popular browsers use the same algorithm: 'xorshift'). Other platforms may change their implementation over time, and even minor modifications can remove the guarantee of repeatability. It is safer to find an implementation, and stick to it. The most common algorithm is Mersenne Twister. I will not give pseudo-code here, as implementations are readily available for all platforms and languages. I personally have used the implementation in the Boost C++ library [4] for many years, though even then I copy the source code into the version control repository of each game where I use it, insulating me from changes.

8.1.2 HALTON SEQUENCE

Random numbers often clump together in a way that looks unnatural. When using the number to place random objects, this clumping may be a problem. Instead we would like to be able to choose points that appear somewhat random, and yet are more smoothly distributed over the space. The simplest approach is called a Halton sequence. Figure 8.1 shows a series of points distributed according to a random number, and the same number distributed by a Halton sequence.

The sequence is controlled by small coprime numbers (i.e. integers that do not share any common divisors > 1). One number is assigned to each dimension. For the two-dimensional case, therefore, we need two numbers. Each dimension forms its own sequence of fractions

Figure 8.1: Halton sequences reduce clumping

between zero and one. As an example to describe the process, let's assume that our sequence has a controlling number of n = 3.

First the range (0,1) is split into $\frac{1}{3}$ s. These are used in order. So the sequence so far is

$$\frac{1}{3}, \frac{2}{3}$$

Now the range is split again into $\frac{1}{3^2} = \frac{1}{9}$ parts, which are again used in a particular order (described below), if the value hasn't already been returned earlier in the sequence $(\frac{3}{3} = \frac{1}{3},$ and $\frac{6}{9} = \frac{2}{3}$). The sequence so far is:

$$\frac{1}{3}, \frac{2}{3}, \frac{1}{9}, \frac{4}{9}, \frac{7}{9}, \frac{2}{9}, \frac{5}{9}, \frac{8}{9}$$

This continues for increasing powers of $\frac{1}{3}$.

The order that the $\frac{k}{9}$ parts are used begins at $\frac{1}{9}$ increases by $\frac{1}{3}$, then begins again at $\frac{2}{9}$, and so on.

A two-dimensional sequence using the controlling numbers 2, 3 will begin

$$(\,\frac{1}{2},\,\frac{1}{3}),(\,\frac{1}{4},\,\frac{2}{3}),(\,\frac{3}{4},\,\frac{1}{9}),(\,\frac{1}{8},\,\frac{4}{9}),(\,\frac{5}{8},\,\frac{7}{9}),(\,\frac{3}{8},\,\frac{2}{9}),(\,\frac{7}{8},\,\frac{5}{9})$$

The sequence is more difficult to explain than to implement. One dimension is given by:

```
function haltonSequence1d(base, index):
    result = 0
    denominator = 1
```

Figure 8.2: Repetition in repeated Halton sequences

```
while index > 0:
    denominator *= base
    result += (index % base) / denominator
    index = floor(index / base)
return result
```

where floor rounds a value down to the nearest integer. Two dimensions is then simply:

```
function haltonSequence2d(baseX, baseY, index):
    x = haltonSequence1d(baseX, index)
   y = haltonSequence1d(baseY, index)
    return x, y
```

Large controlling numbers can give obvious artifacts. The sequence of positions for the controlling numbers 11 and 13 begins:

$$(\frac{1}{11}, \frac{1}{13}), (\frac{2}{11}, \frac{2}{13}), (\frac{3}{11}, \frac{3}{13}), (\frac{4}{11}, \frac{4}{13}), (\frac{5}{11}, \frac{5}{13}), (\frac{6}{11}, \frac{6}{13})$$

To avoid this, it is common to skip at least the first n numbers of a sequence controlled by the number n. In simulation applications, many more initial values are often skipped, sometimes hundreds, and in some cases only every k value is used, where k is a number that is coprime to n. for procedural content, however this is rarely needed: using a small controlling number and beginning at the nth value is usually sufficient.

A Halton sequence is neither random nor pseudorandom, it is termed 'quasi-random': it appears random, and is unbiased enough to be used in some statistical simulations, but it does not rely on a seed. It is the same every time.

To avoid repetition we can use different controlling numbers, though as we saw above,

Figure 8.3: Leaf placement with the Golden ratio

larger values display obvious artifacts. Alternatively, we can add a random offset to both dimensions. Figure 8.2 shows a tiled Halton sequence followed by both of these approaches. All three show artifacts that may be a problem in some applications. It is better to begin with a larger area and one covering sequence with low controlling numbers, rather than breaking it into separate chunks.

8.1.3 PHYLLOTAXIC ANGLES

Halton sequences give a pleasing arrangement of objects in two dimensions. To position objects radially around a central axis in a way that looks natural, like leaves or petals, one of the 'metal' ratios is used. The most famous is the golden ratio, ϕ ,

$$\phi = \frac{1 + \sqrt{5}}{2} \approx 1.618033989$$

which is the ratio to which dividing successive numbers in the Fibonacci sequence converges. Other metal ratios are less commonly used, but all are given by other variants of the Fibonacci series.

Figure 8.3 shows leaves positioned at intervals of $\frac{2\pi}{\phi}$ radians (c. 222.4°), and alongside positioned at intervals of $\frac{2\pi}{\phi} \pm r$, where r is a small random number (up to $\frac{\pi}{12}$ radians, in the figure). A very small random offset can make the result less artificially perfect, but in reality leaves do not vary from this angle very much: a larger random offset destroys the effect entirely.

This is not random, unless some random component is added to the Golden ratio, as in the example. But like Halton sequences, it tends to fill the available space, in a way that can

Figure 8.4: A Poisson disk distribution (L) compared to random positions (R)

be stopped at any time. Natural plant development displays these intervals in the placement of leaves (called phyllotaxis),

8.1.4 POISSON DISK

When placing items randomly, it is usually important not to have them overlap. While the Halton sequence will distribute objects over the space in a way that doesn't visually clump, it can't make guarantees about overlapping. A simple solution would be to test each new position, and reject those that overlap an existing position. This can be performed both using the Halton sequence and using random positions. The result is known as a Poisson disk distribution, shown alongside a purely random distribution in Figure 8.4. Where the Halton sequence might be suitable for placing tufts of grass or hair, a Poisson disk distribution is needed for rocks or buildings.

Generating the distribution in this way can be slow. If we know this is our target, we can generate the positions directly, using an algorithm put forward by Robert Bridson in 2007 [5].

Algorithm

The algorithm begins with a single point, the center of the first disk placement. This can be specified (often it is in the center of the area that needs to be filled) or randomly generated. This position is stored, in a list called the 'active list'. We then proceed iteratively.

At each iteration, we select a disk from the active list. We will call this the active disk. A series of surrounding disk locations is generated, each a distance between between 2r and 2r + k from the active disk, where r is the radius of the disks and k is a parameter controlling how dense the packing is. Each generated location is checked, to see if it overlaps any already placed disks. If it does not, it is placed and added to the active list; otherwise the next candidate is considered. If after several attempts, no surrounding disk can be placed, the active disk is removed from the active list, and the iteration ends. The number of failures before this happens is a parameter of the algorithm, which depends somewhat on k. If k is small, then we can limit ourselves to just a few checks (6, for example); if $k \approx r$ then a value around 12 produces a better result.

Pseudo-Code

The algorithm takes as input the initial disk location and radius. It terminates when there are no more locations in the active list.

```
class Disk:
        x: float
2
        y: float
3
        radius: float
4
5
   function poissonDisk(initial: Disk) -> Disk[]:
6
        active = new ActiveList()
7
        placed = new PlacedDisks()
8
9
        active.add(initial)
10
        placed.add(initial)
11
12
        # Use the same radius throughout.
13
        radius = initial.radius
14
15
        outer: while not active.isEmpty():
16
            current = active.getNext()
17
18
            for i in 0..MAX_TRIES:
19
                # Create a new candidate disk.
20
                angle = i / MAX_TRIES * 2 * pi
21
                r = 2 * radius + separation * random()
22
                disk = new Disk(
23
                     current.x + r * cos(angle),
24
                     current.y + r * sin(angle),
25
                     radius
26
                     )
27
28
                # See if it fits.
29
```

```
if placed.empty(disk):
30
                    placed.add(disk)
31
                    active.add(disk)
32
                     continue outer
33
            # We failed to place children of the current disk.
35
            active.remove(current)
37
        return placed.all()
38
```

Data Structures

Two data structures are required: a list in which to store the active locations, and a data structure to hold the placed disks and detect overlaps.

The active list has the following structure:

```
class ActiveList:
2
      function add(disk: Disk)
      function remove(disk: Disk)
3
      function isEmpty() -> bool
4
      function getNext() -> Disk
```

It can be implemented using a language's regular growable array, with a random element selected each iteration. Or it can be implemented as a first-in first-out (FIFO) queue, also provided by most languages. In the latter case earlier disk locations are processed first, so the placement grows from the center.

The data structure to hold placed disks is:

```
class PlacedDisks:
      function add(disk: Disk)
2
      function empty(disk: Disk) -> bool
      function all() -> Disk[]
```

The performance critical part is checking overlaps. This is usually implemented as a grid, where placing a disk stores the record of its position and radius in any grid cells it overlaps, and checking for overlaps queries the appropriate cells. Because disks are never removed once they are placed, it is possible to implement this using two data structures: the grid for checking overlaps, and a simple array for returning the placed disks when the algorithm is complete. For example:

```
class PlacedDisks:
      cells: bool[GRID_WIDTH * GRID_HEIGHT]
2
      disks: Disk[]
3
4
      # Return all cell indexes for the given disk.
5
```

```
function allCells(disk: Disk) → int[]
6
7
       function add(disk: Disk):
8
            # Empty is checked in the poisson disk implementation.
            for cell in allCells(disk):
10
                cells[cell] = true
11
            disks.add(disk)
12
13
       function empty(disk: Disk) -> bool:
14
            for cell in allCells(disk):
15
                if cells[cell]:
16
                    return true
17
            return false
19
       function all() -> Disk[]:
20
            return disks
21
```

Performance

The algorithm is O(n) where n is the number of disks placed. Although it may check for overlaps multiple times before finally removing a disk from the active list, there are only so many locations surrounding a placement within the k margin, and that number does not depend on the number of disks.

The performance of the algorithm is sensitive to the performance of the overlap checking, where most of the time is spent. Using a fine grid this will be O(1), giving O(n) overall, but in the worst case where this data structure is a simple list, the algorithm would be $O(n^2)$. This is particularly problematic since n can often be large in game applications (the number of trees in a forest, for example).

Variable Radii

In the code above, I assumed that all disks we wish to place are the same size. This is often not the case. This algorithm is useful for placing features in a game level (stones or plants, for example), and those features will vary in size. The algorithm is easily extended to accommodate this. Disks are stored as both location and radius (often with an additional identifier to say what is placed there). And surrounding disk locations are generated at a distance between $r_1 + r_2$ and $r_1 + r_2 + k$ from the active disk. The first part of the inner loop becomes:

```
1 # Create a new candidate disk.
angle = i / MAX_TRIES * 2 * pi
nextRadius = randomRange(MIN_RADIUS, MAX_RADIUS)
4  r = curent.radius + nextRadius + separation * random()
5 disk = new Disk(
```

```
current.x + r * cos(angle),
current.y + r * sin(angle),
nextRadius
)
```

This function can be further extended or tweaked depending on the application. We may want a larger space surrounding certain objects, or it may be important not to have two objects next to one another, we can even use different margins depending on the neighbor we wish to place.

Simple modifications to this algorithm are used as the basis of several commercial ecosystem generators.

8.2 LINDENMAYER SYSTEMS

In the last section we saw an algorithm that could position plants in a realistic way. Poisson disk distributions are used to place trees, but the trees themselves need to be modeled or created in another way. There are several commercial packages available for authoring trees, some of them with a widely used runtime components for drawing the tree in a game. SpeedTree, the most widespread, has plug-ins for major game engines, and can be easily integrated with custom code.

To build a tree with code, a recursive approach called 'Lindenmayer Systems' (or L-systems for short) is used. It is a simplified version of the recursive approaches we will return to at the end of this chapter (shape grammars), which are capable of generating a wider range of objects. In this simple form, L-systems are well suited to generating trees and other branching structures.

8.2.1 SIMPLE L-SYSTEMS

The original L-system model was put forward by Aristid Lindenmayer in 1968 [37], as a description of self growth in algae. Applied to trees, it represents the self similarity of branching (the way a trunk splits into boughs, into branches, and into twigs) as a series of rules, like the grammatical rules of language.

- 1. $root \rightarrow branch (1m long)$
- 2. branch $(x \log) \rightarrow \text{branch}(\frac{2x}{3} \log, -50^{\circ}), \text{ branch}(\frac{2x}{3} \log, +50^{\circ})$

Here rule 1 has 'root' as its left-hand side, and so represents the starting rule. Rule 2 shows how successive branches are made from the first. Running this algorithm produces the treelike shape in the first part of Figure 8.5. The second shape is generated in the same way, with a slightly modified second rule:

2. branch $(x \log) \to \text{branch}(\frac{2x}{3} \log, -25^\circ)$, branch $(\frac{1x}{2} \log, +55^\circ)$ Both shapes in the figure are tree-like, in an abstract way, but are not yet realistic. They

Figure 8.5: Two trees generated by simple two-dimensional L-systems

would only be suitable for a highly stylized game. In this section we will concentrate on this simple model, and later expand it to produce more sophisticated results.

Note that these rules on their own do not terminate. The tree would keep branching and growing forever. To avoid this we need some kind of terminating criteria, to stop generating new branches. In this case we may want to stop when the branches are small enough (we will see other reasons to stop below). This can be achieved either by coding the criteria directly into the algorithm, or by using another rule:

3. branch (
$$<\frac{1}{10}$$
m long) \rightarrow

which terminates the rule set, because it has no branches on its right-hand side. It is common to want to terminate the algorithm after a certain number of iterations, rather than at a certain branch length. To do this with rules, we would have to do store the number of previous branches in every new branch, as well as the length and angle.

In practice both approaches are used. Some criteria will be aesthetic, affect the whole tree, or involve the interaction of the generated model with its surroundings. These criteria are much more difficult to incorporate into rules. A global test is added to the rule generation function.

Algorithm

Begin with a list of active branches that contains only the root. Proceed iteratively. At each iteration remove the first item in the list, find a rule that matches and add the right hand side of the matching rule to the active list.

The algorithm proceeds until the active list is empty, or until a global termination criteria

When the algorithm is complete, the tree consists of all the branches that have been generated.

Pseudo-Code

Rule execution is performed by the following code:

```
function lSystem(root: Branch, rules: Rule[]) -> Branch[]:
2
       tree = [root]
       active = [root]
3
       while active:
           current = active.popHead()
           tree.push(current)
           # Find and execute the first matching rule.
           for rule in rules:
10
11
                if rule.matches(current):
                    # Add the new branches.
12
                    results = rule.rhs(current)
13
                    for result in results:
14
                        active.push(result)
15
16
                    break
17
18
19
       return tree
```

Data Structures

The code makes no assumptions about the structure of a branch object. For building trees we need a position, direction, length, and possibly other visual information such as thickness, color and texture. A simple branch object (such as used to generate Figure 8.5) would look like:

```
class Branch:
2
      position: Vector2
      orientation: float
      length: float
```

Most of the work is performed by the Rule objects, which can decide if they match the current active branch, and can generate the resulting branches in any way they choose. They have the following structure:

```
class Rule:
      function matches(branch: Branch) -> bool
2
      function rhs(branch: Branch) -> Branch[]
```

The rules given as examples above could be implemented as:

```
class Rule2a:
       function matches(branch: Branch) -> bool:
2
            return true
3
       function rhs(branch: Branch) -> Branch[]:
5
            a = new Branch(
                branch.end(),
                branch.orientation - 45 * deg,
                branch.length * 2 / 3)
            b = new Branch(
10
                branch.end(),
                branch.orientation + 45 * deg,
12
                branch.length * 2 / 3)
13
            return [a, b]
14
15
   class Rule2b:
16
       function matches(branch: Branch) -> bool:
17
            return true
18
19
       function rhs(branch: Branch) -> Branch[]:
20
            a = new Branch(
21
                branch.end(),
22
                branch.orientation - 25 * deg,
23
                branch.length * 2 / 3)
24
            b = new Branch(
25
                branch.end(),
26
                branch.orientation + 55 * deg,
27
                branch.length / 2)
28
            return [a, b]
```

And the rule designed to terminate when branches get too small would be implemented:

```
class Rule3:
      function matches(branch: Branch) -> bool:
           return branch.length < 0.1
3
      function rhs(branch: Branch) -> Branch[]:
5
           return []
```

The list of active branches is held in a FIFO queue. These are provided by most languages, or are available in standard libraries. In the code I have assumed the add function adds a branch to the end of the queue, and the remove function removes and returns a branch from the start.

Using a FIFO queue makes this algorithm breadth-first: all the branches at one level of recursion are processed before those on the next level of recursion. This corresponds to the original mathematical model of L-systems described in Lindenmayer's paper. It will be important when we return to grammar-based methods for procedural content generation later

in the chapter, but in this case it may not be necessary. Excluding the global termination function, the behavior of the algorithm would be identical whether it operated breadth-first or depth-first. To operate depth-first we can replace the queue with a stack (first-in last-out, or FILO). In this case, one branch is expanded to its fullest extent before the next branch is considered. This is significant because stacks are more memory efficient than queues, and depth-first algorithms typically need less storage than breadth-first algorithms. If we split branches in two 10 times, then we will have a maximum of $2^{10} = 1024$ entries in the queue (right before the terminal branches are processed), where a stack would have a maximum of 11. In practice, 10 splits may be a lot, so this issue might not be relevant, but it is worth bearing

I pointed out that this excludes the global termination function, because that might be coded in such a way that we need an almost complete tree to make a termination decision. If we wish to terminate when a certain number of branches are on the tree, we probably want those branches to be the closest to the root: the tree might look lopsided if boughs near to the trunk are left as stumps. Your choice of how to implement this function may determine what kind of data structure you use for the active list.

All branches are stored in a growable array, when they are first created.

Performance

The algorithm is O(kn) in time and O(n) in space, where n is the number of branches created and k is the number of rules. For trees, there are typically only a fixed handful of rules, independent of the size of the resulting tree, so the algorithm is O(n) for both time and space.

8.2.2 ADDING RANDOMNESS TO L-SYSTEMS

The code above produces trees that are too regular. For a realistic look, we need some measure of randomness. This can appear in two locations: we can add a measure of randomness to rules, so that the branches they output are slightly different; or we can have multiple rules that match and apply one at random.

In the first case this can be done with the code as we have it:

```
class RuleRandom:
       function matches(branch: Branch) -> bool:
2
           return true
3
5
       function rhs(branch: Branch) -> Branch[]:
           a = new Branch(
7
               branch.end(),
8
               branch.orientation + randomRange(-55, -25) * deg,
               branch.length * randomRange(0.4, 0.8))
           b = new Branch(
10
               branch.end(),
```

```
12
               branch.orientation + randomRange(25, 55),
               branch.length * randomRange(0.4, 0.8))
13
           return [a, b]
```

In the second case we need to modify the algorithm slightly. Instead of always using the first rule that matches, we build a list of rules that match the active branch, and choose one at random:

```
function lSystem(root: Branch, rules: Rule[]) -> Branch[]:
 2
        tree = [root]
        active = [root]
 3
        while active:
            current = active.popHead()
            tree.push(current)
            # Find all matching rules.
            matching = []
10
            for rule in rules:
11
                 if rule.matches(current):
12
                     matching.push(rule)
13
14
            if matching:
15
                # Pick a rule at random.
16
                rule = randomChoice(rule)
17
18
19
                # Add the new branches.
                results = rule.rhs(current)
20
                for result in results:
21
22
                     active.push(result)
23
                break
25
26
       return tree
```

If this code is beginning to look familiar, it is because we are iterating toward building a rule-based system, as we saw in Section 5.8. This is not a coincidence. Lindenmayer systems are a form of grammar, and grammars can be seen as a specialization of a rule-based system. A tree specific L-system implementation is still useful, even when the decision-making AI has a complete rule-based system. Partly because decision-making needs to operate on varied and complex data, where the branch data structure in our case can be simpler; and partly because a fixed format is easier to create tools for artists and level designers to tweak their trees.

8.2.3 STAGE-SPECIFIC RULES

For ease of editing, this algorithm is often limited further, so there are several distinct sets of rules. Each set is only applied to one split. So there are one set of rules for the first split (when the trunk splits into the boughs), another for the second (when boughs split into branches), and often a final set to complete the tree (splitting branches into twigs with their leaf clusters). Some tools allow for more steps to be specified, if required, but still limit rules to a single step.

To support this, we can either return different objects from our rules:

```
class BoughRule:
       function matches(branch: Branch) -> bool:
2
           return branch isinstance Trunk
3
       function rhs(branch: Branch) -> Branch[]:
           a = new Bough(
               branch.end(),
7
               branch.orientation + randomRange(-55, -25) * deg,
8
               branch.length * randomRange(0.4, 0.8))
9
           b = new Bough(
10
               branch.end(),
11
               branch.orientation + randomRange(25, 55),
12
               branch.length * randomRange(0.4, 0.8))
13
           return [a, b]
14
```

or store the number of splits within the branch, and keep multiple rule sets:

```
class Branch:
       level: int
       position: Vector2
       orientation: float
       length: float
5
   function lSystem(root: Branch, rules: Rule[][]) -> Branch[]:
       tree = [root]
8
       active = [root]
       while active:
10
           current = active.popHead()
11
           tree.push(current)
12
13
           # Find and execute a rule from the correct level.
14
           for rule in rules[current.level]:
15
                # Remaining algorithm as before.
16
                if rule.matches(current):
17
                    results = rule.rhs(current)
18
                    for result in results:
19
                        active.push(result)
20
                    break
21
       return tree
```

Figure 8.6: A tree generated by a partially random three-dimensional L-system

Figure 8.6 shows the result of a tree created in this way, with the resulting geometry tidied and textures mapped in a 3D modeling package, ready for use in game. The L-system that generated the model structure features randomness, curved branches, and three sets of rules between trunk and twig.

8.3 LANDSCAPE GENERATION

In this chapter I have described techniques for placing objects in an environment and, if those objects are organic, for growing them and placing leaves. Before we consider generating manmade structures, it would be useful to place our objects in a believable landscape.

Real-world landscapes are generated by the complicated interplay of geology and climate. Layers of rock have different physical properties: density, hardness, weight, plasticity, melting point. As the earth's crust moves, forces and temperatures and pressures change, causing the layers of rock to move and buckle, fold and slide over one another. At the same time erosion from wind, temperature changes and precipitation breaks surface rock, gouging out the surface and rearranging it via rivers and glaciers. In some cases it is possible to look at a rock formation and infer the processes that formed it, but the physics is so fiendishly

complicated that prediction is only possible at the most coarse scales. And so, though we draw on some known physical processes to make our landscapes, we do so only for aesthetic effect.

8.3.1 MODIFIERS AND HEIGHT-MAPS

Because we do not attempt to simulate landscape generation, physical processes are applied as a kind of modifier. Given a landscape, we can apply rain erosion to it. We might have another modifier that adds fault lines, and another that produces glacial valleys. Those modifiers can be applied in different orders for different effects. As well as physically based modifiers, we can create others. To produce an island, for example, we can just move the altitude of the edges of the map down below sea level. This does not correspond to the process by which islands are really formed, but it can you give the right effect to our synthetic landscape.

Landscape generation therefore tends to consist of a series of independent modifiers all working on the same data structure. There are two common structures for the data.

For games such as Minecraft or Dwarf Fortress, where the player can excavate below the surface and reveal underlying formations, the landscape data structure will be a three dimensional array. Each element in the array represents a cube of space, containing the type of rock, or empty space for the surface or the inside of a cave. This is unusual, however, and resource intensive enough that the surface landscape tends to be coarse and blocky.

The vast majority of games generate their landscape as a height-map: a two dimensional grid of surface features. Though a height-map suggests only elevation, it may contain several layers of data:

- 1. Elevation, from which height-maps get their name.
- 2. Surface texture: is this patch rocky, grassy, or underwater?
- 3. Water flow: how much water is flowing over this location, and where to?
- 4. X–Z offset: allows locations to move a small amount in directions other than up-and-down, to support overhangs or steep cliffs.
- 5. Gameplay data: is the location traversable?, can it be built upon?, and so on.

with others also possible depending on the landscape generation algorithm used. Not all layers will be present in every system. Many simple landscape generators only provide elevation, and rely on separate tools or artist intervention for adding textures or rivers. Most commercial generators export some texture information, though they may rely on separate modifiers to generate elevation and texture.

I will assume a fairly flexible system in this chapter. There is a square height map with an arbitrary set of named layers (of which only elevation is required):

```
class Landscape:
size: int
elevation: float[size][size]
# optional additional layers...
```

Figure 8.7: Elevation noise, as a height map

To create the landscape, there is a suite of modifiers that can alter the data. The rest of this section looks at some important examples.

8.3.2 NOISE

Landscapes do not vary smoothly. There is variation and changes of elevation at all scales. Look closely and even a seemingly level field will consist of myriad bumps, some of which will be logical, like a drainage ditch or the mound on which a tree is growing, but most will have no obvious reason. They will be effectively random.

This kind of randomness, or noise, appears as variations in local elevation.

The simplest kind of noise modifier would adjust each location by a random elevation change, drawn from a given range. This is easily implement and gives a result similar to that shown in Figure 8.7. The inset part of the figure shows the elevation as a height map, where darker shades represent lower areas. The main part of the figure shows the same height map in 3D.

8.3.3 PERLIN NOISE

The simple noise above is not very realistic. It has its use, particularly when it is scaled down so it produces only the slightest variation in elevation. The problem is that it is uncorrelated.

Figure 8.8: Perlin noise as a height map, with all octaves combined

The elevation of one location is unrelated to the elevation of its neighbors. This is not how noise in nature works. A more realistic approach was put forward by Ken Perlin in 1985, while working on the movie Tron [47]. It is now used extensively in computer graphics, for everything from smoke and clouds, to dirt and weathering. It is so ubiquitous that in 1997 Perlin was awarded an Oscar for technical achievement.

Perlin noise begins with a grid that is coarser than the target. If our landscape has $1024 \times$ 1024 cells, we might create Perlin noise on a 64×64 grid. At each location of the smaller grid we create a random gradient: the slope of the noise in three dimensions. For each location in our original grid, we interpolate the gradient from the four nearest locations on the small grid. This interpolated gradient is then used to calculate the height, which can then be remapped into a desired range.

The size of the small grid will determine how much detail is in the final noise. It is common to combine Perlin noise at successive doublings of scale (known as octaves). For this reason it is useful to have landscapes of size $2^n \times 2^n$, so the octaves will use grids of size $1, 2, 4, \dots n^{n-1}$. Often there will be a parameter to limit which octaves are created, or the relative weights used to combine them. Figure 8.8 shows a landscape generated using Perlin noise with all octaves.

Pseudo-Code

The basic two-dimensional Perlin noise algorithm can be implemented as:

```
class PerlinOctave:
       gradient: float[][][2]
2
       size: int
3
       function PerlinOctave(size: int):
5
           this.size = size
6
7
           # Create a grid of random gradient vectors.
8
           gradient = float[size + 1][size + 1][2]
           for ix in 0...(size + 1):
10
               for iy in 0..(size + 1):
11
                    gradient[ix][iy][0] = randomRange(-1, 1)
12
                    gradient[ix][iy][1] = randomRange(-1, 1)
13
14
       function scaledHeight(
15
                ix: int, iv: int,
16
               x: float, y: float) -> float:
17
           # Calculate the distance across the cell.
18
           dx: float = x - ix:
19
           dy: float = y - iy;
20
21
           # Dot product of the vector across cell and the gradient.
22
           return dx * gradient[ix][iy][0] +
23
                   dy * gradient[ix][iy][1]
24
25
       function get(x: float, y: float) -> float:
26
           # Calculate which cell we are in, and how far across.
27
           ix = int(x / size)
28
           iy = int(y / size);
29
           px = x - ix;
           py = y - iy;
31
32
           # Interpolate the corner heights.
33
           tl = scaledHeight(ix, iy, x, y);
34
           tr = scaledHeight(ix + 1, iy, x, y);
35
           t = lerp(tl, tr, px);
36
           bl = scaledHeight(ix, iy + 1, x, y);
37
           br = scaledHeight(ix + 1, iy + 1, x, y);
38
           b = lerp(bl, br, sx);
39
           return lerp(t, b, sy)
```

And octaves can be combined with:

```
class PerlinNoise:
       octaves: PerlinOctave[]
2
      weights: float[]
3
4
```

```
function PerlinNoise(weights: float[]):
5
            this.weights = weights
6
7
            # Create random octaves doubling in size.
8
            size = 1
9
            for _ in weights:
10
                octaves.push(PerlinOctave(size))
                size *= 2
13
       function get(x: float, y: float) -> float:
14
            result = 0
15
            for i in 0..octaves.length():
16
                weight = weights[i]
17
                height = octaves[i].get(x, y)
18
                result += weight * height
19
            return result
20
```

assuming that weights is an array of weights per octave.

Performance

The generation of two dimensional Perlin noise is $O(n^2)$ in time where n is the dimension of one side of the square landscape (1024 in the above examples). This is per octave. There will be $\log_2 n$ octaves in a complete set, giving a performance $O(n^2 \log n)$ in time. We need to store the random gradients in the coarse grid, which is a maximum of $O(n^2)$ in space. Multiple octaves can reuse the same storage.

8.3.4 FAULTS

A fault is a fracture in rock, where each side of the fracture slides across each other. In threedimensions this is a plane, but seen from above, in a two-dimensional height map, it can be represented as a line. On one side of the line the ground is raised, on the other it is lowered.

In a real landscape this abrupt change in elevation is usually smoothed by layers of rock above the fault, or by weathering of the exposed surface. In a simulated landscape, faults are often added before other modifiers that can smooth the transition.

The simplest fault modifier takes a random line across the landscape, raises all locations on one side and lowers locations on the other. The amount of raising and lowering may be a parameter to the algorithm, or another random quantity. It can be implemented in this way:

```
function faultModifier(landscape: Landscape, depth: float):
2
      # Create random fault epicentre and direction vector.
3
      cx = random() * landscape.size
4
      cy = random() * landscape.size
      direction = random() * 2 * pi
```

```
dx = cos(direction)
6
       dy = sin(direction)
7
8
       # Apply the fault.
       for x in 0..landscape.size:
10
            for y in 0..landscape.size:
11
                # Dot product the location with the fault.
12
                ox = cx - x
13
                oy = cy - y
14
                dp = ox * dx + oy * dy
15
                # Positive dot product goes up, negative down.
17
                if dp > 0:
18
                     change = depth
19
                else:
20
                     change = -depth
21
                landscape.elevation[x][y] += change
22
```

If you are applying a few severe faults to your landscape, a variation of this modifier is used, where the amount of elevation change decreases the further from the fault line:

```
function faultDropoffModifier(landscape: Landscape,
                                   depth: float, width: float):
2
       # Create random fault epicentre and direction vector.
3
       cx = random() * landscape.size
       cy = random() * landscape.size
       direction = random() * 2 * pi
       dx, dy = cos(direction), sin(direction)
       # Apply the fault.
       for x in 0..landscape.size:
10
           for y in 0..landscape.size:
11
                # Dot product the location with the fault.
12
                ox, oy = cx - x, cy - y
13
                dp = ox * dx + oy * dy
14
15
                # Positive dot product goes up, negative down.
16
                if dp > 0:
17
                    change = depth * width / (width + dp)
18
                else:
19
                    change = -depth * width / (width - dp)
20
                landscape.elevation[x][y] += change
21
```

The original version can produce quite useful landscapes on its own, by using large numbers of small faults. Figure 8.9 shows a landscape generated in this way with its characteristic linear elements.

Figure 8.9: A landscape generated from hundreds of faults

8.3.5 THERMAL EROSION

There are two principal varieties of erosion to produce believable landscapes: thermal erosion, and hydraulic erosion.

Of these thermal erosion is much simpler. It is based on the observation that piles of granular material tend to spread out and form structures with a constant slope, characteristic of the material. The more granular a material, the more closely piles conform to these slopes. This slope angle is known as the angle of repose, and landscape features with this angle are called talus or scree slopes. Thermal erosion cracks rock through cycles of heating and cooling, particularly with water seeping into fissures and freezing. This erosion produces a granular material, which forms talus slopes. In mountainous areas they are the characteristic lower slopes of a rock formation.

To simulate thermal erosion, we calculate the difference in height of two adjacent cells, based on the angle of repose. If the angle is θ , and the distance between two cells is d then the height threshold will be:

$$\Delta h = d \tan \theta$$

For each cell in landscape, we look at the four neighboring elevations. If these neighbors are lower, beyond the height threshold, elevation is transferred to them from the original cell. The amount of elevation transferred is proportional to the additional height beyond the

threshold. It will never cause the low point to be raised too high nor the high point to be lowered too much.

This can be implemented with this modifier:

```
function thermalErosion(landscape: Landscape, threshold: float):
       neighbors = [(1, 0), (-1, 0), (0, 1), (0, -1)]
2
3
        # Create a copy of the data to read from while updating.
4
        elevation = copy(landscape.elevation)
5
6
       for x in 1..(landscape.size - 1):
            for y in 1..(landscape.size - 1):
                height = landscape.elevation[x][v]
                limit = height - threshold
10
                for (dx, dy) in neighbors:
12
                    nx = x + dx
13
                    ny = y + dy
14
                    nHeight = landscape.elevation[nx][ny]
15
16
                    # Is the neighbor below the threshold?
17
                     if nHeight < limit:
18
                         # Some of the height moves, from 0 to 1/4 of the
19
                         # threshold, depending on the height difference.
20
                         delta = (limit - nHeight) / threshold
21
                         if delta > 2:
22
                             delta = 2
23
                        change = delta * threshold / 8
24
25
26
                         # Write to the copy.
27
                         landscape.elevation[x][y] -= change
                         landscape.elevation[nx][ny] += change
28
29
30
       # Update the original data.
       landscape.elevation = elevation
31
```

Figure 8.9 shows a landscape generated using Perlin noise softened by simple thermal erosion.

Because talus slopes tend to be characteristic of the base of mountains, this algorithm can be modified to only apply to lower slopes, depending on the scale of your landscape. For generating large areas such as countries or continents, it is not necessary. For maps representing a few kilometres, it may add believability.

Figure 8.10: The effect of simple erosion on a random landscape

8.3.6 HYDRAULIC EROSION

The thermal erosion modifier above does not attempt to simulate the physical process itself, it replicates the effects of that process. The result is a kind of smoothing, reminiscent of real-world erosion processes, but simpler to calculate.

Watercourses and their associated structures (river valleys for example) cannot be produced using that tool. We need a more physically realistic modifier. Hydraulic or fluvial erosion simulates the movement of rainfall over a landscape, along with the material it erodes and deposits.

There are several ways to achieve this. And doing so efficiently is an active area of research. A full solution will be complex, often slow, and require a lot of fine tuning. Commercial land-scape generation tools implement custom hydraulic erosion modifiers that form a significant part of their intellectual property. In this section I will describe a simple method to act as a jumping off point.

Our approach uses a Finite Element Method (FEM) that simulates the movement of water and suspended material at each location in our landscape. This plays well with the landscape data structure we have already defined. Another approach is to use polylines to represent the streams and to propagate drainage basins out as polygons. This is described in [28], and can be very effective (particularly if you need to generate rivers on a map rather than a 3D landscape, for example), but it is more difficult to combine with the other landscape generation tools in this chapter.

In the FEM approach, we iteratively simulate the movement of water in several stages:

- 1. Rain falls across the landscape.
- 2. Water flows are calculated to neighboring locations based on the water height and terrain elevation.
- 3. Material is eroded or deposited from the water.
- 4. Water is moved across the landscape, along with any suspended material.
- 5. Water evaporates.

At step two, the gradient at each point is used to determine the speed and direction that water moves. If water is moving at a high enough speed (i.e. if the gradient is sufficiently high), then elevation will be removed from the location (representing the water picking up material and carrying it downstream). If the water is moving slowly, it can deposit some of the material it is carrying. This is step three. Any remaining material may flow to the neighboring locations based on the water flow, at step four.

For each location in the landscape, therefore, we need several data:

- a the terrain elevation.
- b the amount of water,
- c the amount of material in the water,

and in step two we calculate:

- d the water flowing to each neighboring cell,
- e the overall velocity of water through the cell.

Figure 8.11 shows a landscape refined with hydraulic erosion, showing the distinct patterns of watercourses.

Pseudo-Code

All steps of the hydraulic erosion modifier are highly dependent on being tuned correctly: having just the right amount of rainfall and evaporation, of material picked up and put down, depending on gradient. Even the calculation of waterflow depends on the scale of your landscape, both horizontal and vertical: whether it has gentle rolling hills or steep ravines. The precise calculations for water flow and material vary, but the basic structure can be implemented as:

```
class WaterData:
2
      size: int
       # Source data.
      elevation: float[size][size]
5
      water: float[size][size]
      material: float[size][size]
```

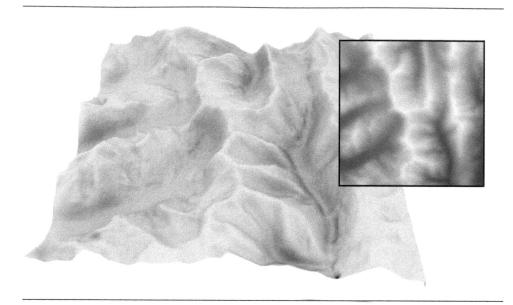

Figure 8.11: The effect of hydraulic erosion on a landscape

```
8
       # Copy, to avoid overwriting.
       previousMaterial: float[size][size]
10
11
       # Calculated data
12
       waterFlow: float[size][size][4]
13
       totalFlow: float[size][size]
14
       waterVelocity: Vector2[size][size]
15
       # Step 1, per location.
17
       function rain(x: int, y: int):
18
           water[x][y] += RAINFALL
19
20
       # Step 2, per location.
21
       function calculateFlow(x: int, y: int):
22
           dirns = [(0, 1, 0), (1, 0, 1), (2, 0, -1), (3, -1, 0)]
23
           # Flows to each neighbor.
24
           totalFlow[x][y] = 0
25
           for i, dx, dy in dirns:
26
                dh = elevation[x][y] - elevation[x + dx][y + dy]
27
                dw = water[x][y] - water[x + dx][y + dy]
28
                waterFlow[x][y][i] += FLOW_RATE * (dh + dw)
29
                if waterFlow[x][y][i] < 0:
30
```

```
waterFlow[x][y][i] = 0
31
                totalFlow[x][y] += waterFlow[x][y][i]
32
33
           # No more than the water we have.
34
            if totalFlow[x][y] > water[x][y]:
35
                prop = water[x][y] / totalFlow[x][y]
36
                for i in 0..4:
37
                    waterFlow[x][v][i] *= prop
38
39
            # Overall flow.
40
            hOut = waterFlow[x][y][0] - waterFlow[x][y][3]
41
            hIn = waterFlow[x+1][y][3] - waterFlow[x-1][y][0]
42
            v0ut = waterFlow[x][y][1] - waterFlow[x][y][2]
43
            vIn = waterFlow[x][y+1][2] - waterFlow[x][y-1][1]
            waterVelocity[x][y] = Vector2(hOut + hIn, vOut + vIn)
45
46
       # Step 3, per location.
47
       function erodeDeposit(x: int, y: int):
48
           waterSpeed = waterVelocity[x][y].magnitude()
49
50
            if waterSpeed > PICK THRESHOLD:
51
                pick = waterSpeed * SOLUBILITY
52
                material[x][y] += pick
53
                elevation[x][y] -= pick
54
55
            elif waterSpeed < DROP THRESHOLD:
56
                prop = (DROP_THRESHOLD - waterSpeed) / DROP_THRESHOLD
57
                drop = prop * material[x][y]
58
                material[x][y] -= drop
                elevation[x][y] += drop
60
61
       # Step 4, per location.
62
       function flow(x: int, y: int, srcMat: float[int][int]):
63
            dirns = [(0, 1, 0), (1, 0, 1), (2, 0, -1), (3, -1, 0)]
64
            # Apply flows to each neighbor
65
            for i, dx, dv in dirns:
66
                waterFlow = waterFlow[x][y][i]
67
                prop = waterFlow / totalFlow[x][y]
68
                materialFlow = prop * srcMat[x][y]
69
70
                water[x][y] -= waterFlow
71
                water[x + dx][y + dy] += waterFlow
72
                material[x][y] -= materialFlow
73
                material[x + dx][y + dy] += materialFlow
74
75
       # Step 5, per location.
76
       function evaporate(x: int, y: int):
77
```

```
water[x][y] *= (1 - EVAPORATION)
78
79
80
   function hydraulicErosion(landscape: Landscape, rain: float):
81
       data = new WaterData(landscape.size)
82
       data.elevation = landscape.elevation
83
       for in ITERATIONS:
85
           # Run each of these in its own loop over cells in
86
           # the landscape.
87
           data.rain(0..size, 0..size)
88
           data.calculateFlow(0..size, 0..size)
89
           data.erodeDeposit(0..size, 0..size)
90
           srcMaterial = copy(material) # Avoid changes mid-update.
91
           data.flow(0..size, 0..size, srcMaterial)
92
           data.evaporate(0..size, 0..size)
93
94
       # Update the original data.
95
       landscape.elevation = data.elevation
```

where parameters to the algorithm are given as constants, indicated with all-capitals variable names.

The flow method is the only one that reads and writes to cell locations other than its own: the material array in particular. We want to avoid the first iteration changing value of the second, which then changes the third, and so on, effectively allowing material to travel across the entire level in one iteration. A copy of the material array is therefore created and this copy is passed into each call. Within flow, we always read from the copy and write to the current array.

Performance

The modifier is $O(n^2)$ in its use of memory, where n is the size of one side of the square landscape. It is $O(kn^2)$ in time, where k is the number of iterations. $k \geq n$ if we assume that water must be allowed to propagate across the entire landscape. In practice, as in the code above, new rainfall is introduced every iteration, and the algorithm simply runs as many times as needed to generate a pleasing result. In this case k is usually considerably more than n, and the algorithm is $O(n^3)$ in time.

Realistic Adjustments

As it stands, this algorithm still represents a fairly crude model of rainfall and river flow. We can make this more sophisticated by modeling the physical processes more closely.

Rather than uniform rainfall across the landscape, we could model prevailing winds, and

have more rainfall on the windward side of slopes. This produces more realistic mountains at a continental scale, but can look odd if your landscape represents only a few square kilometers.

Rather than the velocity of water being dependent only on the gradient of a location, we can store the momentum of the water along with its quantity and the amount of material it is carrying. This will tend to cut channels through small hills.

Sediment suspended in water tends to soften over time. This affects the deposition and erosion rates. In the code above, these are constant, but the approach could be extended by allowing them to vary depending on how far the sediment has moved.

Instead of using global parameters, if you have different areas of the map made of different types of rock, those rocks might have different erosion characteristics. This produces landscapes with distinct regions with different appearance.

These are some suggestions, but there are many other modifications possible. With some parameter tweaking, a basic algorithm produces usable results, however. How sophisticated you want to make it, is an exploratory process and depends on the fidelity you are looking for.

8.3.7 ALTITUDE FILTERING

River valleys may need physical simulation that is realistic, but many other characteristic topographical features can be generated much more simply. One flexible approach is to filter or map altitudes: to apply some function to each individual elevation. This is particularly useful for generating landscapes at the scale of a typical game level, in the region of a few kilometers per side. It is more difficult to use this approach to generate landscapes for a whole continent.

For example, we can generate a landscape featuring a roughly flat dessert plane punctuated by the occasional rocky mesa (known from the scenery of Monument Valley featured in countless movie westerns). This is accomplished using a modifier such as:

```
class DesertFilter:
       # Iterate over each cell in the landscape.
2
       function filter(landscape: Landscape):
3
           for x in 0..landscape.size:
4
               for y in 0..landscape.size:
5
                    height = landscape.elevation[x][y]
                    landscape.elevation[x][y] = newHeight(x, y, height)
       # Calculate the new height for one location.
       function newHeight(x: int, y: int, height: float) -> float:
10
           # Use the logistic function to get an S-curve.
11
           halfMax = MAX_HEIGHT / 2
12
           scaledHeight = SHARPNESS * (height - halfMax / halfMax)
13
           logistic = 1 / (1 + exp(scaledHeight))
14
           return MAX_HEIGHT * (1 + logistic / 2)
```

This flattens lower areas, raises high areas into plateaus, and tapers off intermediate ar-

eas into characteristic concave slopes. The result on a landscape is shown in the first part of Figure 8.12.

The characteristic rounded bottoms of glacial valleys can be achieved with a modifier such as:

```
class GlacierFilter:
      # filter() function as before ...
      function newHeight(x: int, y: int, height: float) -> float:
4
          # Use half the logistic function to get U valleys.
5
          scaledHeight = SHARPNESS * (height - MAX_HEIGHT / MAX_HEIGHT)
6
          logistic = 1 / (1 + exp(scaledHeight))
7
          return MAX_HEIGHT * (1 + logistic / 2)
```

Here low-lying areas are rounded, so a V-shape valley becomes more U-shaped. This is shown in the second part of Figure 8.12.

As a final example, a tiered landscape can be achieved by a function such as:

```
class TieredFilter:
      # filter() function as before ...
2
3
      function newHeight(x: int, y: int, height: float) -> float:
4
          # theta - sin(theta) is smoothly stepped, map in and
5
          # out of the correct range to use it.
          stepProportion = height / MAX_HEIGHT * TIERS
          theta = stepProportion * 2 * pi
          newHeight = theta - sin(theta)
          return newHeight / 2 / pi / TIERS * MAX_HEIGHT
```

A series of lines attract nearby elevations, so a smooth slope becomes a series of steps. This could be achieved by quantizing the value, snapping each altitude to its nearest terrace. But a smoother effect is more pleasing. The result is shown in the final part of Figure 8.12.

In the introduction to the section, I mentioned pulling the borders of a landscape down below sea level, to form an island. This would be a similar modifier, which uses both altitude and x, y location. The code would be:

```
class IslandFilter:
1
       # filter() function as before ...
2
3
       function newHeight(x: int, y: int, height: float) -> float:
4
           halfSize = landscape.size / 2
5
           cx = x - halfSize
6
           cy = y - halfSize
7
           r = sqrt(cx * cx + cy * cy) / halfSize
8
9
           # Fall off to zero the last quarter of the radius.
10
           p = (1 - r) * 4
11
           if p < 0:
12
```

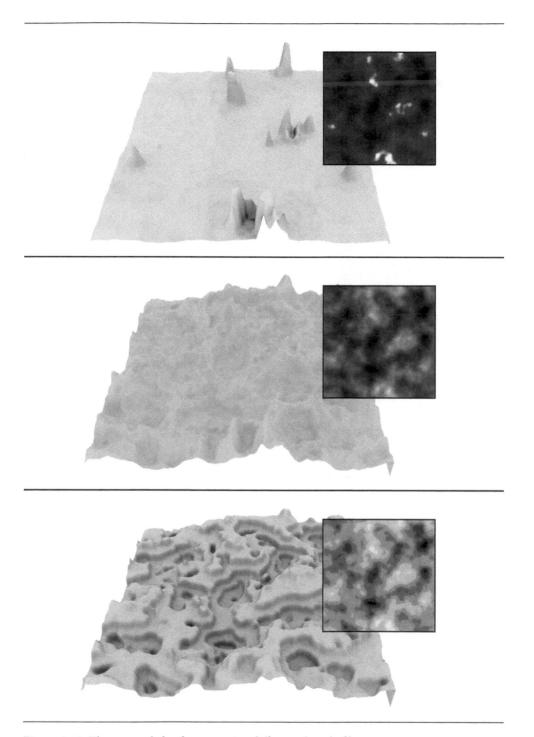

Figure 8.12: Three sample landscapes using different altitude filters

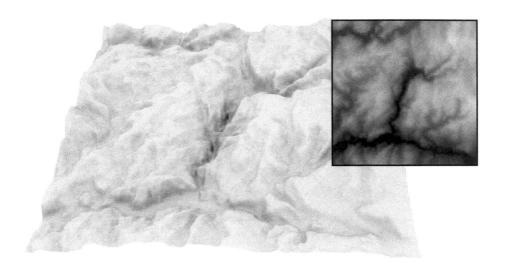

Figure 8.13: Real-world altitude data as a landscape

```
return 0
            elif p >= 1:
14
                return height
15
            else:
16
                return p * height
```

There are many other filtering functions that might be useful, depending on the kind of landscape you want to generate. One I have used to good effect is to modify the altitude by an existing height field bitmap. If the height field is taken from real-world geographic data, this can give a realistic look to the final terrain, without having to base the terrain entirely on an actual location. This is implemented simply as:

```
class BitmapFilter:
      # filter() function as before ...
      function newHeight(x: int, y: int, height: float) -> float:
4
          # Blend controls the amount of change.
5
          return blend * bitmap[x][y] + (1 - blend) * height
```

where bitmap is the loaded array of altitudes, of the same size as the landscape. Figure 8.13 shows the result when this is applied.

8.4 DUNGEONS AND MAZE GENERATION

So far I have focused on content representing natural structures: plants and landscapes in particular. This is the sum total of procedural content generation in many games. If man-made structures are to be added, the procedural content generation is used merely to place them, often using one of the algorithms covered at the start of this chapter. AI can do more, however. In the next section we will see how it can be used to create arbitrary buildings. For now we will limit our attention to one of the oldest procedural content generation tasks: creating mazes, or other underground structures. These may represent different environments, such as cave systems, mines, sewage systems, or even the rooms in a building. Collectively I will refer to them as dungeons, named for the influential fantasy role-playing game Dungeons & Dragons.

Procedurally generated dungeons go right back to Rogue, and have featured prominently in the recent revival of Rogue-lite games. There are many different algorithms and variations, enough to be able to fill a book on their own. In the implementations I'm intimately aware of, each is different, tuned unmodified for the particular game. In this section I will give representative examples of different approaches.

MAZES BY DEPTH FIRST BACKTRACKING

We can split the structures we are trying to build into two features: rooms and corridors. Not every game will use both. Games such as Spelunky and The Binding of Isaac connect rooms together in a grid (in the case of Spelunky, they may not appear as rooms to the player, because the connections are broad enough to make them appear to be part of the same space).

On the other hand, we can create a game level that consists only of corridors. This is a maze. Strictly, a network of corridors is only a maze if it has loops or dead ends. A complicated path that zigzags from start to finish without branching is known as a labyrinth. I will ignore the distinction for the purpose of this chapter.

To create a maze, we can use a simple backtracking algorithm. The level is split into a grid of cells; all of them initially unused. Initially the entrance cell is excavated and this becomes the current cell. Then the algorithm proceeds iteratively. At each iteration a random unused neighbor of the current cell is chosen. The current cell is connected to that neighbor, and the neighbor becomes the new current cell. If there is no unused neighbor, then we return to considering the previous current cell. When we are all the way back to the starting cell, and it also has no more unused neighbors, then the algorithm is complete. The cells are therefore stored on a stack. As a new neighbor becomes the current cell, it is pushed to the top of the stack. If the current cell has no unused neighbors, it is popped from the stack.

Usually mazes have an exit as well as an entrance. If so, the exit appears as a normal unused cell while the algorithm is running, and is then connected after the algorithm completes. The algorithm is guaranteed to spread the maze to all reachable locations in the grid, including the exit.

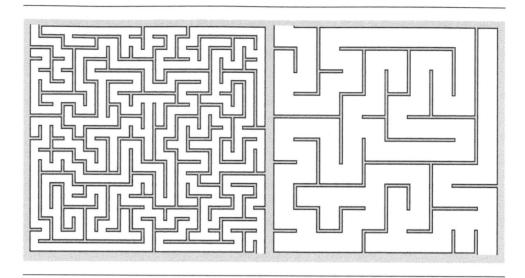

Figure 8.14: Generated mazes

Figure 8.14 shows examples of mazes generated in this way, based on two different sizes of grid.

Pseudo-Code

In code this is:

```
function maze(level: Level, start: Location):
       # A stack of locations we can branch from.
       locations = [start]
       level.startAt(start)
       while locations:
           current = locations.top()
           # Try to connect to a neighboring location.
           next = level.makeConnection(current)
10
           if next:
11
12
               # If successful, it will be our next iteration.
13
               locations.push(next)
           else:
14
               locations.pop()
```

Data Structures

The environment in which the maze is being built has the following structure:

```
class Level:
      function startAt(location: Location)
2
      function makeConnection(location: Location) -> Location
```

Which can be implemented as:

```
class Location:
       x: int
2
       v: int
3
  class Connections:
       inMaze: bool = false
       directions: bool[4] = [false, false, false, false]
7
8
   class GridLevel:
       # dx, dy, and index into the Connections.directions array.
10
       NEIGHBORS = [(1, 0, 0), (0, 1, 1), (0, -1, 2), (-1, 0, 3)]
11
12
       width: int
13
       height: int
14
       cells: Connections[width][height]
15
16
       function startAt(location: Location):
17
           cells[location.x][location.y].inMaze = true
18
19
       function canPlaceCorridor(x: int, y: int, dirn :int) -> bool:
20
           # Must be in-bounds and not already part of the maze.
21
            22
                   0 \le y \le height and
23
                   not cells[x][y].inMaze
24
25
       function makeConnection(location: Location) -> Location:
26
            # Consider neighbors in a random order.
27
            neighbors = shuffle(NEIGHBORS)
28
29
            x = location.x
30
            y = location.y
31
            for (dx, dy, dirn) in neighbors:
32
33
                # Check if that location is valid.
                nx = x + dx
35
                ny = y + dy
36
                fromDirn = 3 - dirn
37
                if canPlaceCorridor(nx, ny, fromDirn):
38
```

```
39
                    # Perform the connection.
40
                    cells[x][y].directions[dirn] = true
41
                    cells[nx][ny].inMaze = true
42
                    cells[nx][ny].directions[fromDirn] = true
43
                    return Location(nx, ny)
44
45
           # null of the neighbors were valid.
46
           return null
```

Performance

The algorithm is O(n) in execution time, where n is the number of cells in the grid. It is O(k)in space, where k is the longest path in the maze (usually this is not the route from the goal to the endpoint, though that may be the longest path the player ever traverses). Although it is possible that $k \propto n$, if the grid is almost a line, it is more common that $k \propto \log n$, and performance may be given as $O(\log n)$ in space.

Caves

Notice that there is nothing that assumes a grid in the pseudo-code for the maze algorithm above, and nothing in the interface for a maze level. The implementation of a maze level is grid based, but the algorithm works as well for other structures.

Rather than generating neighbors using the grid, we can use a similar approach to that in the Poisson disk algorithm (Section 8.1.4). We can try to move the corridor forward in a random direction.

The level interface can then be implemented as:

```
class Location:
       x: float
       y: float
       r: float
       passageFrom: Location = null
   class CavesLevel:
       locations: Location[]
       collisionDetector # Checks whether a cave is blocked.
10
       function startAt(location: Location):
11
           locations.push(location)
12
           collisionDetector.add(location)
13
14
       function makeConnection(location: Location) -> Location:
15
           # Sstart checking in a random direction.
16
```

```
initialAngle = random() * 2 * pi
17
18
            # The next cave will have a random size.
19
            nextRadius = randomRange(MIN_RADIUS, MAX_RADIUS)
20
            offset = r + nextRadius
21
22
            x = location.x
23
            y = location.y
24
            r = location.r
25
            for i in 0.. ITERATIONS:
26
27
                # Try to place the next cave.
28
                theta = 2 * pi * i / ITERATIONS + initialAngle
29
                tx = x + offset * cos(theta)
30
                ty = y + offset * sin(theta)
31
32
                # If there is space in the collision detector, add
33
                # it to the list of cave locations.
34
                candidate = new Location(tx, ty, nextRadius, location)
35
                if collisionDetector.valid(candidate):
36
                    collisionDetector.add(candidate)
37
                    locations.push(candidate)
38
                    return candidate
39
40
            return null
```

Figure 8.15 shows examples of a cave-like maze generated in this way.

Rooms

So far we have begun the algorithm with all locations unused. There is nothing to require this. You may want to begin with areas that are unreachable, that contain mineable resources, or that merely add interest to the maze structure. Similarly, there is nothing to restrict locations to representing sections of corridor. As long as the level data structure can treat them as a single location, rooms can be placed, and the maze generated to connect them.

In pseudo-code this may look something like:

```
class Room:
      width: int
2
      height: int
3
  class GridLevelWithRooms extends GridLevel:
5
6
      unplacedRooms: Room[]
7
      function canPlaceRoom(room: Room, x: int, y: int) -> bool:
8
           inBounds = (
9
```

Figure 8.15: A cave system created with the maze algorithm

```
0 \le x \le (width - room.width) and
10
                0 <= y < (height - room.height))</pre>
11
            if not inBounds:
12
                return false
13
           for rx in x..(x + room.width):
15
                for ry in y..(y + room.height):
16
                    if cells[rx][ry].inMaze:
17
                        return false
18
19
            return true
20
21
       function addRoom(room: Room, location: Location):
22
            for x in location.x..(location.x + room.width):
23
                for y in location.y..(location.y + room.height):
24
                    cells[x][y].inMaze = true
25
                    # If you're using connections to determine where walls
26
                    # are drawn, then set all connections in the room.
27
28
       function makeConnection(location: Location) -> Location:
29
            # Try to fit a room.
30
            if unplacedRooms and random() < CHANCE_OF_ROOM:
31
```

```
x = location.x
32
                y = location.y
33
34
                # Choose a room and work out its origin.
35
                room = unplacedRooms.pop()
36
                (dx, dy, dirn) = randomChoice(NEIGHBORS)
37
                nx = x + dx
38
                ny = y + dy
39
                if dx < 0: nx -= room.width
40
                if dy < 0: ny -= room.height
41
42
                if canPlaceRoom(room, nx, ny):
43
                     # Fill the room.
44
                     addRoom(room)
45
46
                     # Perform the connection.
47
                     cells[x][y].directions[dirn] = true
48
                     cells[x + dx][y + dy].directions[3 - dirn] = true
49
50
                     # Return nothing if rooms aren't part of the main
                     # maze. Otherwise you might return the room exit.
                     return null
            # Otherwise go through the neighbors as before.
55
            return super.makeConnection(location)
```

The ureachable locations and the final maze including rooms are shown in Figure 8.16.

Only Rooms

Instead of the grid representing square sections of corridor, each location may be a room. The maze then consists of rooms with adjoining doors. This is similar to the dungeons in a game such as the original Zelda or The Binding of Isaac (influenced heavily by Zelda). Each room can then be assigned to a different role, or from a suite of possible content. A final level is shown in Figure 8.17

Prefabricated Elements

Just as I illustrated for cave systems, there is nothing that requires rooms to be placed on a grid. If we have a set of prefabricated rooms or corridor sections, each with a list of possible exits, an implementation of the level interface can simply check, for each exit of the current location, whether a room can fit. Such an implementation may look like:

Figure 8.16: A maze using rooms and pre-placed unreachable areas

Figure 8.17: A maze of rooms rather than corridors

```
class Position:
       x: float
2
       y: float
3
       orientation: float
4
5
   class Prefab:
       function getExits(position: Position): Position[]
       function originFromEntry(position: Position): Position
  class Location:
10
       origin: Position
11
       prefab: Prefab
12
       passageFrom: Location = null
13
14
   class PrefabLevel:
15
       prefabs: Prefab[]
16
       locations: Location[]
17
       collisionDetector # Checks whether a prefab is blocked.
18
19
       function startAt(location: Location):
20
           locations.push(location)
21
           collisionDetector.add(location)
22
23
       function makeConnection(location: Location) -> Location:
24
           # Check exits in a random order.
25
           exits = location.prefab.getExits(location.origin)
26
           exits = shuffle(exits)
27
            for exit in exits:
28
                # Choose a random prefab (alternatively try each
29
                # prefab in a random order).
30
                prefab = randomChoice(prefabs)
31
32
                # Find where it would be located if its entry was
33
                # at the given exit from the current location.
34
                origin = prefab.originFromEntry(exit)
                # Check it fits there (this code is the same as
37
                # the cave maze generator).
38
                candidate = new Location(origin, prefab, location)
39
                if collisionDetector.valid(candidate):
40
                    collisionDetector.add(candidate)
41
                    locations.push(candidate)
42
                    return candidate
43
44
            return null
```

Figure 8.18: Prefabricated rooms combined into a maze

The resulting maze combines prefabricated and random elements in a much more believable way, as shown in Figure 8.18.

Thickening Walls

The basic maze algorithm, using the grid level environment, links adjacent cells. Corridors can be placed immediately next to each other without a connection, producing a maze with thin walls. Although this might be acceptable for making a hedge maze, for example, in most cases we want walls to be thicker.

This can be achieved in different ways. The simplest is to take the generated grid and add an extra row or column between each existing pair. If two existing cells are connected, an extra corridor location will be placed in the new row or column between them. This is shown in Figure 8.19. Notice that no dead-ends or extended corridors occur in the added rows or columns, only transitions between the white original corridor locations. For simple mazes this works well, but if you have placed rooms or other prefabricated spaces in the maze, changing the grid scale may distort them.

An alternative solution is to only place new corridor sections a suitable distance from

Figure 8.19: Thickening walls by adding rows and columns

existing corridors. If placing a corridor location would lead to a thin wall, then that location is unavailable. This can be performed by overloading the canPlaceCorridor method of the GridLevel:

```
class ThickWallGridLevel extends GridLevel:
2
       function canPlaceCorridor(x: int, y: int, dirn: int) -> bool:
3
           # All neighbors except the side (including diagonals)
4
           # we came from, must be empty.
5
           from_dx, from_dy, _ = NEIGHBORS[dirn]
           for dx in (-1, 0, 1):
                if dx == from_dx: continue
               for dy in (-1, 0, 1):
9
                    if dy == from_dy: continue
10
                    if not super.canPlaceCorridor(x + dx, y + dy):
11
                        return false
12
13
           return true
```

This provides more interesting mazes, where corridors aren't limited to running every

other grid cell. On the other hand, the algorithm is no longer guaranteed to fill the space. If you are aiming for a particular endpoint, this approach may make it unreachable.

Partially Generated Mazes

In many games, we don't want a maze to fill the entire available area. In fact, we may not care about the bounds of the area at all: providing an effectively infinite space in which to generate the level. Instead, there are alternative criteria for when to stop the building. Criteria such as:

- a minimum or maximum size of the level.
- a minimum or maximum number of branches,
- a fixed set of rooms that must be placed somewhere, or,
- · a minimum or maximum number of dead ends.

These criteria can be used to terminate maze generation by keeping track of data about the maze. To keep track of the size of the level, for example:

```
class SizeLimitedGridLevel extends GridLevel:
       size: int = 0
3
       function makeConnection(location: Location) -> Location:
4
           result = super.makeConnection(location)
5
           if result:
               size += 1
           if canTerminate(now, next):
               return false
           return result
11
12
       function canTerminate(now: Location, next: Location) -> bool:
           return size >= MAX_SIZE
```

where canTerminate may test the details of the connection being added, or any and all data on the level as a whole. It returns true or false to indicate its decision.

8.4.2 MINIMUM SPANNING TREE ALGORITHMS

Backtracking algorithms are fast and easy to implement. They allow a certain degree of customization. In the implementation shown above this is available in the level data structure, and possibly with modifications to the main algorithm to store data and bias the results. In the previous section I showed an example of terminating the algorithm early. Sometimes more customization is required, however. In particular to bias toward making some connections instead of others.

Minimal spanning tree algorithms work on weighted graphs, similar to those we saw in Chapter 4 on pathfinding, and again in Chapter 6 on tactical and strategic AI. Edges in the

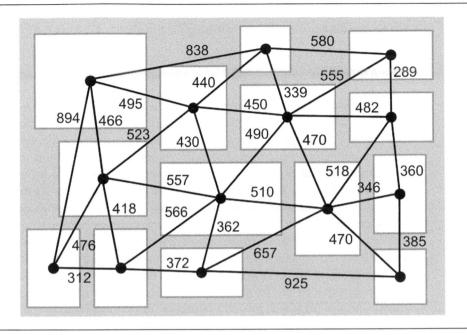

Figure 8.20: A graph of rooms suitable for building a minimum spanning tree

graph represent every possible connection in the maze, and their weights represent the cost of making that connection part of the output. Nodes in the graph represent points where there may be branching, often rooms. A minimal spanning tree algorithm begins at a single point (usually the entrance to the maze) and calculates the network that spreads from that point to reach all nodes in the graph, such that the tree includes the minimum total edge cost.

This is particularly useful if you begin with a set of rooms, and wish to calculate the corridors that link them. The minimum spanning tree algorithm does not help with the placement of the rooms, nor the calculation of all possible connections between them. One approach, used in the indie game TinyKeep [158] and described in [2], places rooms on top of each other and uses the collision response of the game's physics engine to move them into separation. Neighboring rooms are then connected in the graph, and the minimum spanning tree algorithm is run. Placing rooms at random will also work, trying different positions until a room fits, though this may give more separation between rooms. Alternatively, rooms can be added to a grid, or placed with a backtracking algorithm. In Section 8.4.3, below, we will see another approach for laying out rooms: recursive subdivision.

When compiling the graph, costs are usually calculated based on distance. But as we saw when discussing pathfinding graphs, tactical considerations can also be incorporated. A connection between two rooms with difficult enemies might be weighted higher, to encourage the final layout to place intermediate locations that give the player some reprieve. After placing the rooms, the graph may look something like that shown in Figure 8.20.

The Algorithm

There are several different algorithms for constructing a minimum spanning tree. The most commonly used are Prim's algorithm [50] and Kruskal's algorithm [33], though there are several others. If the graph contains a single minimum spanning tree (i.e. there is only one tree with minimum total cost), then all algorithms produce the same result. If you use costs for the connections that are drawn from a relatively small number of values, it is more likely that multiple possible trees have the same total cost. In that case, different algorithms will produce different results. You may have to implement more than one to get the exact appearance you are interested in.

Rather than describe alternative approaches here, I will show Prim's algorithm as an example. It is simple to describe and implement, and it is the most often cited for this purpose.

The algorithm begins by adding all nodes in the graph, with the exception of the starting node, to an unvisited list. The starting node is added to the tree which will grow into the final result. The algorithm then proceeds iteratively. At each iteration we consider all the graph edges from a node in the tree to an unvisited node, and choose the one with the minimum cost. The edge and the unvisited node are added to the tree, the latter is removed from the unvisited list. If there are multiple edges with the same minimum cost, any can be chosen: we could do this at random, though in practical implementation we simply use the first one found. The algorithm terminates when all nodes have been visited. If there are no more edges to consider, and there are still unvisited nodes, those nodes are unreachable.

Figure 8.21 shows Prim's algorithm in progress step-by-step on the graph from Figure 8.20. The first five steps are shown, along with the final tree. Unfilled circles indicate unvisited nodes and solid lines show the minimum spanning tree growing step-by-step.

Pseudo-Code

Prim's algorithm can be implemented:

```
# Basic graph interfaces.
   class Edge:
2
       from: Node
3
       to: Node
4
       cost: float
5
   class Node:
8
       edges: Edge[]
9
  class Graph:
10
11
       nodes: Node[]
```

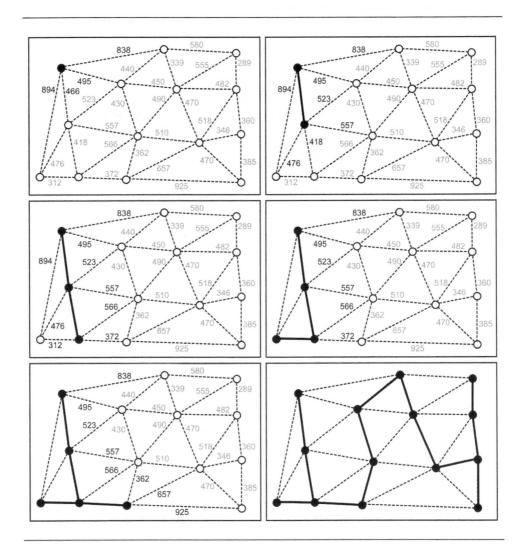

Figure 8.21: Prim's algorithm builds a minimum spanning tree step-by-step

```
12
13
   # Data for Prim's algorithm.
   class UnvisitedNodeData:
       node: Node
       minCostToTree: float = infinity
16
       minCostEdge: Edge = null
17
18
   class UnvisitedNodeList:
19
       function add(node: Node)
20
       function remove(node: Node)
21
22
       function getLowestMinCost() -> UnvisitedNodeData
       function getData(node: Node) -> UnvisitedNodeData
23
       function setData(node: Node, cost: float, edge: Edge)
24
   function primsMST(graph: Graph, start: Node) -> Edge[]:
26
27
       unvisited = new UnvisitedNodeList()
       tree: Edge[] = []
28
29
       # Helper function.
30
       function addNodeToTree(node: Node):
31
            unvisited.remove(node)
32
            for edge in node.edges:
33
                data = unvisited.getData(edge.to):
34
35
                if data and edge.cost < data.minCostToTree:</pre>
36
                    unvisited.setData(edge.to, edge.cost, edge)
37
       # Create initial data, for no connections.
39
       for node in graph.nodes:
40
            unvisited.add(node)
       addNodeToTree(start)
41
42
       while unvisited:
43
           next: UnvisitedNodeData = unvisited.getLowestMinCost()
44
           if next:
45
                tree.push(edge)
46
                addNodeToTree(edge.to)
48
           else:
                # The graph is not fully connected. We could add the
49
                # returned node with addNodeToTree and continue.
50
                # giving multiple disconnected graphs in the result,
51
                # or we can terminate here, as shown.
52
53
                break
54
55
       return tree
```

Performance

The performance of the algorithm depends on the UnvisitedNodeList structure used to hold unvisited nodes and their cost. A naive implementation that searches for the lowest cost node in an array will be $\mathrm{O}(n^2)$ in time, where n is the number of nodes. This is similar to the unvisited list in pathfinding algorithms. And as we saw in Chapter 4, alternative data structures can dramatically improve performance. A priority queue, provided by many programming environments, can improve performance to $\mathrm{O}(e\log n)$ in time, where e is the number of edges in the graph. The naive implementation has optimal space requirement of $\mathrm{O}(e+n)$, but this may increase with other data structures.

Creating the Final Level

Minimum spanning tree algorithms only determine which nodes are connected. They don't specify the shape of the connecting corridors: this needs to be performed as an additional step. It can be as simple as digging a corridor in the direction of the connection until the destination room is encountered, adding a corner if the two ends are not in line. Figure 8.22 shows the final level, generated from the same graph we saw previously, using this approach.

If the game calls for more complex geometry, intermediate structures may be placed along the route. TinyKeep, the example referenced earlier, adds rooms along the corridors containing incidental encounters, where the nodes of the graph represent the main parts of the level.

8.4.3 RECURSIVE SUBDIVISION

The previous two approaches to generating dungeon-like levels have proceeded bottom-up: they begin with a large number of possibilities (locations where corridors or rooms can be placed) and gradually populate this space with content. This is a powerful technique, but produces results that can display a characteristic kind of randomness: elements are placed into the environment in ways that don't always make sense as a whole. As an alternative, we can progress top-down, beginning with the whole space, and refining it into smaller and smaller areas.

The most common and simplest top-down approach is recursive subdivision. Like minimum spanning trees, this is used to layout rooms, which are then later connected by corridors. The algorithm contains a simple approach for determining connections, though it may look predictable. Alternatively, for more control, a minimum spanning tree can be calculated. The two techniques work well together.

Figure 8.22: A complete level generated with Prim's algorithm

Algorithm

The algorithm operates in two phases. In the first phase we subdivide the space to place rooms. In the second we connect them with corridors. The second part can be ignored if you are using a different connection method, such as a minimum spanning tree or backtracking.

Subdivision

We begin with the entire level and proceed recursively. At each step we randomly subdivide the current space in two. If both subdivisions meet certain quality criteria (described below), then we recurse into each in turn. The algorithm terminates when execution returns to the root space.

Quality criteria are usually related to size. If the aim is to place rooms in these subdivided spaces, they must be large enough to accommodate them, and have the appropriate shape. Usually this also involves a surrounding border, in which connecting corridors may be placed.

To build the network of corridors between the rooms, each subdivided space keeps track

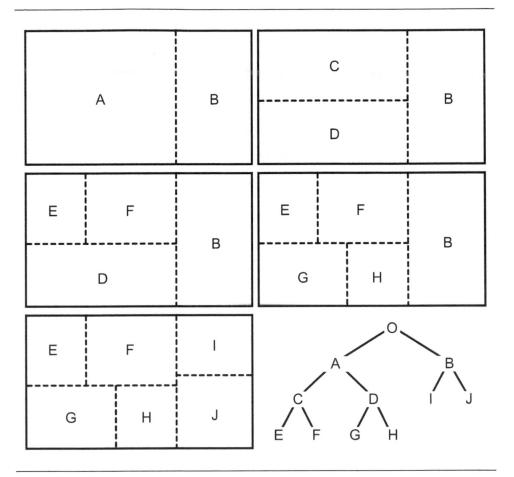

Figure 8.23: Subdivision of an area into rooms

of the smaller spaces into which it is divided. Subdivision thus forms a tree structure, shown in Figure 8.23.

Connection

The tree of spaces represents the connections. When two leaf spaces (i.e. those without further subdivision) have a common parent, a corridor directly connects them. The corridor represents the common parent. Two non-leaf spaces may be connected either by rooms within them, or by their corridors.

This can also be performed recursively. Beginning at the root node. First we make sure both children are themselves connected, recursing into each child if necessary. A leaf space is already considered to be connected.

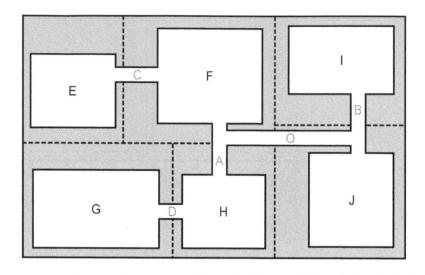

Figure 8.24: Recursively connecting subdivided rooms

Then we connect the children with a corridor. This corridor may connect to either a room in the child (i.e. the only room if it is a leaf, or any room within the subtree otherwise), or its corridor.

The algorithm terminates when the children of the root node are connected. This process is shown in Figure 8.24, for the tree generated in Figure 8.23.

Additional Quality Criteria

As well as using some criteria to determine whether to split or not, we can assess spaces after recursion, to determine whether the sub-tree meets requirements.

For example, we may wish to make sure that there are a certain number of rooms in the tree. This can be achieved by checking when the algorithm recurses back to the root. If enough rooms have been created, the algorithm terminates as usual, otherwise it can recuse again, effectively creating a new subdivision tree. If, as in this example, the criteria are attached to the root node, we create a whole new level until they are met. But criteria can also be given lower down the tree, and only that sub-tree will be rebuilt. We may wish to ensure that areas of the level have a good range of encounters, for example. Or that the tree is wide rather than tall.

The recursive nature of this algorithm means it is trivial to backtrack until these criteria are met. You must ensure, however, that the criteria can be met, otherwise the recursion will continue forever.

Pseudo-Code

Subdivision can be performed by the following code:

```
function subdivide(space: Space):
       while true: # Or add a maximum number of tries.
2
           # Perform the split.
3
           splits = space.split()
            if not splits:
5
                return
           # Test individual quality.
           if not splits[0].validSpace() or
               not splits[1].validSpace():
10
                continue
11
12
           # Test the overall quality.
13
           if candidates:
14
                space.children = candidates
15
                if space.validSubtree():
16
                    return
17
18
       space.children = []
19
```

And connection in this way:

```
function connect(space: Space):
2
       if not space.children:
           space.corridor = null
           return
       children = space.children
       children[0].connect()
       children[1].connect()
10
       space.corridor = new Corridor(
           children[0].getConnectionPoint(children[1]),
11
           children[1].getConnectionPoint(children[0]))
12
```

Data Structures

For subdivision, a Space has the interface:

```
class Space:
      width: int
2
      height: int
3
       parent: Space = null
4
```

```
5
       children: Space[] = []
6
7
       # Quality criteria for this space alone.
       function validSpace() -> bool
10
       # Add quality criteria for children.
       function validSubtree() -> bool
11
12
13
       # Split the space into two random children if possible.
       function split() -> Space[2]
14
```

Quality criteria for subdivisions are checked by the validSpace method. Quality criteria for a sub-tree are given by the validSubtree method.

To support connections, the Space is extended:

```
class Corridor extends Room:
       from: Room
2
       to: Room
3
  class Space:
       # ... other implementation as before...
6
       room: Room
       corridor: Corridor
       function getConnectionPoint(other: Space) -> Room:
           if not corridor:
11
               return room
12
           else:
13
               # Here we return the corridor, but we could also use some
14
               # criteria (such as minimising distance) to return either:
15
               # children[0].getConnectionPoint(other) or
16
               # children[1].getConnectionPoint(other).
17
               return corridor
18
```

Using a different algorithm to connect rooms makes this extension unnecessary.

Performance

As described above, repeating subdivision when quality criteria are not met can mean that this algorithm never terminates, so theoretical performance cannot be calculated. In the absence of those criteria, however, the algorithm is O(n) in time, where n is the number of rooms in the end result. With additional quality criteria, this O(n) becomes the best case, if the criteria are easy to meet. In both cases the algorithm is O(n) in storage.

8.4.4 GENERATE AND TEST

Though some conditions can be enforced as the maze is generated, there will inevitably be some that cannot, or that cannot be enforced easily. Even if you use recursive subdivision, there may be criteria that span across different subtrees. You may wish to ensure that the distance between the guard room and the armory is within a certain range of corridor spaces, or that a maze must have at least some number of dead ends from the start to the end location. It may be possible to design rules that always generate levels with these properties, depending on the algorithm you use, but they can be difficult, and fragile if you later want to modify the parameters.

Instead, with all the random procedural content algorithms in this chapter, a common approach is to generate-and-test:

```
function generate():
      while true:
2
           candidate = generateCandidate()
           if checkQuality(candidate):
               return candidate
```

The danger in this approach is the while loop. As for the repeated subdivision in the previous section, if the random algorithm never or rarely generates a suitable output, this can repeat indefinitely. There is no simple way to avoid this, though it has not prevented developers using generate-and-test harnesses. It just requires deliberate testing for all the parameters that may be possible in your game.

8.5 SHAPE GRAMMARS

In this chapter I have described techniques that cover all but two of the common uses of procedural content generation in games. Those two are texture generation and animation. Texture generation rarely uses AI algorithms: the state of the art is to apply randomized image filters in a sequence authored by an artist. Animation synthesis does use AI, in particular neural networks, via models of the skeleton that rely on physics simulation. Animation synthesis is such a tricky and specific niche that I will not describe it in this chapter. In terms of techniques, the neural network algorithms were outlined in Chapter 7, and physics simulation is beyond the scope of this book.

This section, then, is on the far fringes of the state-of-the-art. The techniques previously covered in this chapter have been either organic (in the case of L-systems for building trees) or large-scale (such as placing rooms, building landscapes or distributing objects). We have seen tools that can be used to place a building, but no way to create the building itself. Shape grammars are an approach to achieving that. But it is important to emphasize their speculative nature. They have been used in technology demonstrations and on the demo scene, but rarely in a production game. A variant of this approach was used to create cities in Spore [137] and buildings in Republic: The Revolution [109], but both games feature graphics considerably more primitive than contemporary games. Procedural content generation of assets is an exciting but very deep rabbit hole. More than one developer I know has fallen down it, and ended up spending far more time than they would simply commissioning the assets, or else has failed to ship their game at all. Here be dragons, proceed with care.

Shape grammars were originally described with respect to painting and sculpture [64]. Later the idea was adopted by architects [42] as a way of describing building design. Describing in this case being the important word: shape grammars are more often used as a way of understanding or modifying a structure rather than generating it from scratch. Shape grammars are named by analogy with the grammars of natural language, and the correspondence works on this level too: it is much easier to use a grammar to understand language than it is to program a computer to speak a language starting from the grammar.

We have already seen one shape grammar in this chapter: Lindenmayer systems. Recall that L-systems begin from an initial root, and apply a series of rules to generate boughs, branches, twigs and leaves. Shape grammars generalize this idea. We begin with an initial root, usually called the axiom when we are not generating trees. And we apply a series of rules. Rules have some feature that they match, along with some additional criteria to determine when they are applicable, and can perform some work on the structure when applied. As I noted in Section 8.2, this also makes them a form of rule-based system, previously described in Section 5.8.

As an example, consider the creation of a skyscraper (the most common use to date for shape grammars). We begin with a footprint of the building, which I will call the *foundation*, and apply the following rule set:

- 1. foundation \rightarrow ground-floor (+4m) + top-of-floor
- 2. $top-of-floor \rightarrow floor (+3m) + top-of-floor$
- 3. top-of-floor (if large enough) \rightarrow top-of-floor | roof
- 4. $top-of-floor \rightarrow roof$

where '+' indicates stacking on top of one another, and '|' indicates a split with the two elements side-by-side. When multiple rules match, one is selected at random. Together these rules can produce buildings similar to those shown in Figure 8.25.

This set of rules lays out the building, but does not determine what it looks like. We need further rules to do that:

- 5. floor \rightarrow outer-wall ...
- 6. outer-wall \rightarrow window-space (3m) ...
- 7. window-space \rightarrow
- 8. window-space → picture-window
- 9. window-space → utility-window

where '...' indicates that multiple objects of that kind can be returned. We would like this to produce the floors shown in the first part of Figure 8.26, but as it stands it is just as likely to produce the floors shown in the second part. To get the desired effect we will need some criteria to make sure utility windows only appear at consistent locations:

Figure 8.25: The construction of skyscrapers using shape grammars

- 7. window-space (if second on wall) \rightarrow
- 8. window-space (if not second or third on wall) \rightarrow picture-window
- 9. window-space (if third on wall) \rightarrow utility-window

The rule set could be further fine-tuned to make utility windows appear every second floor, for example. This process, manually reducing the randomness to get more believable results, is typical. Getting the desired output involves lots of tweaking and visualizing.

We could continue to specify rules to determine exactly how a window is constructed, right down to its constituent polygons and textures (windows are made up of a certain number of panes and a window frame; some panes slide open, some are hinged, some are fixed; window frames have a sill; and so on). But it is more common to end by placing a prefabricated element: a pre-built window from a library of windows. The prefab may have some parameters: it may be able to scale widthwise within a certain range, for example, but typically it is easier to have an artist create these elements than to try to create rules to build them from scratch. It is a balance between the cost of generating art, and the complexity of building the grammar.

Figure 8.26: The placement of windows on a floor, desired and actual

8.5.1 RUNNING THE GRAMMAR

Algorithm and Rule Implementation

To run the shape grammar, we need a forward chaining rule-based system. The algorithm that achieves this was covered in Section 5.8. The difficulty is less in the algorithm itself, and more in how the rules are represented. We are typically dealing with something that has no simple representation in text. So rules either have to be specified using a custom visual format (with the corresponding difficulty of creating an editor to author them), or more commonly they have to be specified as code (which has the downside of needing a programmer, rather than an artist, to create them). Some attempts have been made to create tools for specifying the operations that a rule will carry out, but I am not yet aware of any complete solution that isn't limited to generating one specific thing. There seems little alternative but to resort to some form of code.

Pseudo-Code

The rule-based system can be implemented simply:

```
class Grammar:
    rules: Rule
```

2. The tool 'werkkzeug', used for the creation of demo-scene demos featured some rudimentary operations, enough that the authors used it to create the level for a proof-of-concept first person shooter, 'kkreiger' in 2004. In practice it proved more limited than it appeared, later versions of the tool focused on texture generation, and now it is mostly of historical note.

```
object: Object
3
       function getTriggeredRules() -> Rule[]:
5
            triggered = []
6
            for rule in rules:
7
                if rule.triggers(object):
8
                     triggered.push(rule)
9
            return triggered
10
11
       # Fire one rule among those that trigger, and return it.
12
       function runOne() -> Rule:
13
            triggered = getTriggeredRules()
            if not triggered:
                return null
17
            rule = randomChoice(triggered)
18
            rule.fire(object)
19
            return Rule
20
21
       function run():
22
            while runOne():
23
                pass
24
```

Data Structures

In the implementation of the above, most of the complexity is offloaded into normal objects. These rules can perform any checking they wish before notifying the system that they can fire. And if fired, they can alter the content in any way they choose. They have the following form:

```
class Rule:
       function triggers(object: Object) -> bool
2
       function fire(object: Object)
```

Implementing the rules in this way is flexible, but it hides their grammar-like structure. It is not clear that a rule triggers when it sees a 'window-space', for example, nor that it produces a 'picture-window' as a result.

It is possible to implement an intermediate solution, with a data structure representing the object being created:

```
class Object:
    string: Token[]
```

A target field in the rule holds the name to be matched and a result field holds its replacement. The trigger and fire methods can then be generalized to search for and replace those names:

```
class TargetRule extends Rule:
2
       target: String
       result: String[]
3
       function triggers(object: Object) -> bool:
5
           index = object.string.find(target)
6
           return index >= 0
       function fire(object: Object):
9
           # Change the string.
10
           index = object.string.find(target)
11
12
           object.string.remove(index)
           object.string.insert(index, result)
13
14
15
           # Do the original action too.
           super.fire(object)
16
```

Unfortunately, we are not merely interested in producing a list of names. The final result will be some more complex data structure (a 3D model or some other game content). We will still need to run arbitrary code to check whether a rule will trigger, and more arbitrary code when it fires. The first implementation above is simpler, the alternative is barely more explicit. I will continue by assuming the first version.

Biasing Rules

In the code above, I assumed that all rules that are triggered are equally likely to be chosen to fire. It is possible to extend this approach to return an 'importance' value rather than true or false from the trigger function. The random selection of a rule to fire can then be weighted:

```
class Rule:
1
2
       function triggers(object: Object) -> float
3
       function fire(object: Object)
5
   class Grammar:
       # ... other implementation as before...
6
7
       function runOne() -> bool:
8
           triggered = []
10
           totalImportance = 0
           for rule in rules:
12
                importance = rule.triggers(object):
13
                if importance > 0:
                    totalImportance += importance
14
                    triggered.push((totalImportance, rule))
15
16
```

```
if not triggered:
17
                 return false
18
19
            _, rule = binarySearch(triggered, random() * totalImportance)
20
            rule.fire(object)
21
            return true
22
```

Performance

The algorithm is O(n) in execution time, where n is the number of rules used to create the final result. The original version holds no state, the version that supports weighted triggering is O(k) in memory, where $k \leq n$ and is the number of rules that trigger at a time.

8.5.2 PLANNING

The execution of grammar rules can be seen as building a tree. Figure 8.27 illustrates the rules from our skyscraper example in tree form. This is similar to the parse tree created from a grammar when analyzing a sentence. It shows both the identity of each thing in the final object, and where it came from.

Our initial code is a little more complex. We allow for arbitrary conditions on rules, where the examples always had a single item on the left-hand side. It is possible for a rule to only trigger when multiple things have already been accomplished (an awning is added when there is a door and a shopfront-window for example). In this case the rules form a graph rather than a tree, but the graph is still rooted: we begin with a single item (e.g. the building foundation), and decompose this into parts (floors, windows, roofs).

The implementation of the grammar, above, assumes that we will always be able to choose a rule, and build the required object. In fact, it assumes that the only time no rule will be triggered will be when the object is complete. As the constraints become more complex, it is more likely that the algorithm encounters a dead end: no more rules can be triggered, but the object we are creating is still incomplete.

In this case we need to plan, we need to search for a solution among all the possible sequences of firing rules.

This could be achieved using generate-and-test, if failures are rare. But otherwise a more systematic approach would be beneficial.

We can use several of the search algorithms we have seen in this book. For simplicity, depth first search can be used, as shown below. For larger problems Dijkstra could be used. If we can calculate a heuristic to estimate how close to a complete solution we are, then A* may be a practical choice.

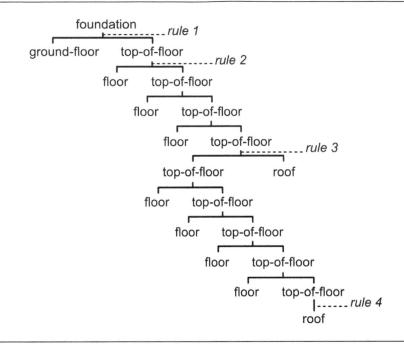

Figure 8.27: The rules of skyscraper building as a tree

Pseudo-Code

The algorithm is implemented in this way:

```
class GrammarPlanner extend Grammar:
       # Return true if we succeed.
2
       function plan(object: Object) -> bool:
3
           progress = []
           topRule = null
5
           do:
               # Modify the object and retrieve a list of all
               # rules that can be triggered, if we need to
               # backtrack.
               objectAfterRule = object.clone()
10
               triggered = runOne(objectAfterRule, triggered)
11
12
               if triggered:
13
                    if not topRule: topRule = triggered.peek()
14
15
                    # Removed the rule we just fired. It will not
16
                   # be needed for backtracking.
17
```

```
triggered.pop()
18
19
                     # Store remaining triggered rules in case we
20
                     # backtrack.
21
                     progress.push((object, triggered))
22
23
                     # Prepare for next iteration.
24
                     object = objectAfterRule
25
                     triggered = null
26
27
28
                 elif progress:
                     # Backtrack.
29
                     object, triggered = progress.pop()
30
31
                 else:
32
                     return false
33
34
            while not topRule.complete(object)
35
36
            return true
37
38
        # Run the next rule from the list of those triggered,
39
        # if given, otherwise from all triggered rules.
40
        function runOne(object: Object,
                         triggered: Rule[]) -> Rule[]:
42
43
            if not triggered:
44
                 triggered = getTriggeredRules(object: Object)
45
                 if not triggered:
46
                     return null
47
                 triggered.shuffle()
48
49
            rule = triggered.peek()
50
            rule.fire(object)
51
            return triggered
52
```

Data Structures

The object we are building now has a clone method, to allow multiple different rules to be tried:

```
class Object:
1
      function clone() -> Object
```

Rules themselves can be asked whether they have been successful, via the complete function:

```
class Rule:
      function complete(object: Object) -> bool
2
      function triggers(object: Object) -> bool
3
      function fire(object: Object)
```

where complete should return true if the task represented by that rule is completed. This is currently only used to determine if the overall planning task is complete.

The code could be extended to store and reuse partial plans: plans that fulfill rules during execution. In that case a rule representing a floor in the skyscraper, for example, would be complete when all its refinements have been added to the object (i.e. its windows have been created, or its doors placed).

Rules that can trigger when the object has not yet been started represent the whole task. If they return true from complete, then the object is considered to be successfully built and the algorithm terminates.

Performance

The problem we are trying to solve is potentially undecidable. We can construct a series of rules with trigger conditions and firing effects that will cause this algorithm to never terminate. In principle, depth first search is O(n) in execution time, where n is the size of the search space: the number of possible objects that can be built from the rules. For many sets of rules this is effectively infinite. Similarly, depth first search is O(k) in memory requirements, where k is the number of rules that could be applied to an object. This again could be infinite.

The search terminates when it finds a successful result. This will be efficient as long as the rules are not so highly constrained as to make finding any solution difficult. In practice, it means experimenting with the rule set to balance the final result and the search efficiency.

Hierarchical Task Networks

The structure of decomposed tasks and general constraints is similar to that used in the AI planning technique known as 'hierarchical task networks' (HTNs). Similar enough that it may seem an obvious choice to use HTN planning.

There are some differences, however. In HTN, rules represent tasks, rather than properties of the resulting object. Tasks can either represent something to be carried out, or a compound task that can be decomposed into others. In most HTN systems compound tasks do not have their own effects, they exist only to be decomposed. In our case all rules can have effects, and they may represent a part of the structure (such as a window), rather than a task (i.e. build a window). The final plan we are looking for is a graph, as shown in Figure 8.27. In HTN, it is typically a sequence of actions to carry out.

It would be possible to adjust our approach by replacing rules such as

2. $top-of-floor \rightarrow floor (+3m) + top-of-floor$

with

 top-off-floor → raise-the-roof create-a-floor top-off-floor to make the correspondence with HTNs more obvious.

One strength of HTN approaches is making ordering constraints explicit. In procedural content generation, the criteria and the effects of a rule are often more concerned with aesthetic qualities and less about task ordering.

The most common search algorithm for HTN planning is a depth first search among sequences of decomposition, known as 'total-order forward decomposition', or TFD.

Though it is more commonly a technique for character decision-making, I know some developers have used HTNs for procedural content generation, particularly when they already have a planner they wish to reuse. But in my own experiments their focus on order constraints tends to make code for procedural content generation less clear and more difficult to tweak.

EXERCISES

- 8.1 As discussed in the chapter, it is useful to have several pseudorandom number generators responsible for creating different parts of the game. If we used cryptographic random number generators, why would this be unnecessary?
- 8.2 If we use a random number generator to generate a random polar coordinate (angle 0-2pi, and distance 0-1), will the result be evenly distributed over the unit circle? Why or why not?
- 8.3 Calculate and plot the first 31 values from the Halton sequence with controlling numbers 29, 31. Why did they form this pattern? Will using higher controlling numbers help?
- 8.4 The second part of Figure 8.2 shows distinct patterns for pairs of large controlling numbers, even when many initial points are skipped. How many points would need to be skipped for these patterns to disappear? Why?
- 8.5 Plot the appearance of leaves around a stem using the silver ratio rather than the golden ratio. The silver ratio is:

$$\delta_S = \frac{2 + \sqrt{8}}{2}$$

what is the approximate angle in degrees between leaves?

- 8.6 Using Bridson's algorithm to generate a Poisson disk distribution, with offsets uniformly sampled between 2r and 2r + k (where r is the radius of each disk and k is some constant), approximately what proportion of the space will be left empty?
- 8.7 Instead of testing neighboring disk locations at random angles, we could systematically test for space at regular intervals. For a disk at a distance of k, how many angles should be tested so the test locations touch but do not overlap?

- 8.8 A small modification to Bridson's algorithm is able to produce the cave mazes shown in Figure 8.15. How do we determine which caves to link with passages?
- 8.9 With no rule to terminate an L-system, a tree will continue having its branches subdivided forever. Why are the trees shown in Figure 8.5 not infinitely large? If a branch is always half the size of its parent, what is the maximum length the chain of branches can be?
- 8.10 The L-system given by the rules:
 - a) root \rightarrow branch (1m long)
 - b) branch $(x \log) \rightarrow \text{branch } (\frac{2x}{3} \log, -25^{\circ}), \text{ branch } (\frac{1x}{2} \log, +55^{\circ})$

has the longer branch always on the right-hand side. Rewrite it, adding rules and conditions if necessary, so the longer branch always points upward.

- 8.11 What would be the effect of using Perlin noise with a grid size equal to the landscape size, and no other octaves?
- 8.12 Fault models can use non-linear fault lines. Assuming the fault is a circle given by (x, y, r), modify the pseudo-code for faultModifier.
- 8.13 Wind erosion has a similar effect to thermal erosion, but is more prominent in the prevailing wind direction. How might the thermal erosion modifier be changed to show this? (Hint: directions are already considered within the code.)
- 8.14 As part of its normal execution, the hydraulic erosion modifier determines where lakes and rivers form in the landscape. What data holds this information?
- 8.15 Slot canyons are narrow and steep sided. Design an altitude filtering function to produce them.
- 8.16 The mazes produced by the backtracking algorithm can always be solved by sticking to the left wall. What modification would be needed to thawrt this strategy?
- 8.17 Levels in *The Binding of Isaac: Rebirth* consist of rooms of size 1×1 , 2×1 , 2×2 or L-shaped 2×2 , with 1×1 removed. They are connected directly with doors, and no intermediate corridors. How might such a level be generated using the backtracking algorithm for maze generation? Give pseudo-code for the level data structure.
- 8.18 Using Prim's algorithm, calculate the minimum spanning tree for the weighted graph example in Figure 4.3, from Chapter 4.
- 8.19 Rather than returning true or false from a quality check, we could return a number. Adjust the generate-and-test harness to accommodate this and return the first solution found that exceeds a particular quality threshold. How might this allow us to avoid generate-and-test repeating indefinitely?
- 8.20 The window replacement rules given in the chapter:
 - a) window-space (if second on wall) \rightarrow
 - b) window-space (if not second or third on wall) → picture-window

- c) window-space (if third on wall) \rightarrow utility-window
- are shown in the first part of Figure 8.26. Sketch what the floor would look like if it could fit seven rather than five windows.
- 8.21 These rules are nonrandom. Adjust them so that some degree of randomness is included, without risking the effect shown in the second part of the figure.
- 8.22 Devise a set of rules for a shape grammar capable of producing a dungeon. It is possible to answer this question replicating either the backtracking maze generation algorithm or the subdivision algorithm.

9

BOARD GAMES

THE EARLIEST application of AI to computer games was as opponents in simulated versions of common board games. In the West, Chess is the archetypal board game, and the last 40 years have seen a dramatic increase in the capabilities of Chess-playing computers.

In the same time frame, other games such as Tic-Tac-Toe, Connect Four, Reversi (Othello), and Go have been studied, in each case culminating in AI that can beat the best human opponents.

The AI techniques needed to make a computer play board games are very different than the others in this book. For the real-time games that dominate the charts, this kind of AI only has limited applicability. It is occasionally used as a strategic layer, making long-term decisions in war games, but even then only when the game has been designed to be somewhat board game like.

The best AI opponents for Go, Chess, Draughts, Backgammon, and Reversi—those capable of beating the best human players—have all used dedicated hardware, algorithms, or optimizations devised specifically for the nuances of their strategy. This may be changing. With the advent of deep learning board game AI, particularly those created by the company Deep Mind, there is some indication that elite-level approaches can be applied to multiple games. As of writing, it remains to be seen whether the success can be replicated by others, or whether even better results can be achieved by further specialization.

For all these games, however, the basic underlying algorithms are shared in common, and can find application in any board game. In this chapter we will look at the minimax family of algorithms, the most popular board game AI techniques. I will also discuss a different family of algorithms that has proven to be superior in many applications: the memory-enhanced test

driver (MTD) algorithms. Both minimax and MTD are tree-search algorithms: they require a special tree representation of the game.

These algorithms are perfect for implementing the AI in board games, but both rely on some knowledge of the game. The algorithms are designed to search for the best move to make, but the computer can't intuit what 'best' means, it needs to be told. At its simplest this can be just "the best move wins the game," which is all we need for a game like Tic-Tac-Toe, where minimax or MTD can search every possible sequence of moves. But for most games, there isn't enough computer power to search all the way to the end of the game, so some knowledge about intermediate states is needed: the best moves lead to the best positions, so how do we determine how good a position is? We use a 'static evaluation function'.

This is the same trade-off I introduced as the "golden rule of AI", when discussing symbolic AI in Chapter 1, Section 1.1: the more search we can do, the less knowledge we need, and vice versa. In the case of reasonably complicated board games, the amount of search we can do is limited by the computer power available, better search algorithms only buy us a little. So the quality of the AI will depend more on the quality of the static evaluation function. This is introduced in the section on the minimax algorithm, but described in detail later in the chapter, with a particular focus on the deep learning approaches to acquiring game knowledge that have recently changed the state-of-the-art.

The final part of this chapter looks at why commercial turn-based strategy games are often too complex to take advantage of this AI; they require other techniques from the rest of this book.

If you're not interested in board game AI, you can safely skip this chapter.

9.1 GAME THEORY

Game theory is a mathematical discipline concerned with the study of abstracted, idealized games. It has only a very weak application to real-time computer games, but the terminology used in turn-based games is derived from it. This section will introduce enough game theory to allow you to understand and implement a turn-based AI, without getting bogged down in the mathematics. For a comprehensive introduction to game theory, see [67], and for a more accessible approach, [61].

9.1.1 TYPES OF GAMES

Game theory classifies games according to the number of players, the kinds of goal those players have, and the information each player has about the game.

Number of Players

The board games that inspired turn-based AI algorithms almost all have two players. Most of the popular algorithms are therefore limited to two players in their most basic form. They can be adapted for use with larger numbers, but it is rare to find descriptions of the algorithms for anything other than two players.

In addition, most of the optimizations for these algorithms assume that there are only two players. While the basic algorithms are adaptable, most of the optimizations can't be used as easily.

Plies, Moves, and Turns

It is common in game theory to refer to one player's turn as a "ply" of the game. One round of all the players' turns is called a "move."

This originates in Chess, where one move consists of each player taking one turn. Because most turn-based AI is based on Chess-playing programs, the word "move" is often used in this context.

There are many more games, however, that treat each player's turn as a separate move, and this is the terminology normally used in turn-based strategy games. This chapter uses the words "turn" and "move" interchangeably and doesn't use "ply" at all. You may need to watch for the usage in other books or papers.

The Goal of the Game

In most strategy games the aim is to win. As a player, you win if all your opponents lose. This is known as a zero-sum game: your win is your opponent's loss. If you scored 1 point for winning, then it would be equivalent to scoring -1 for losing. This wouldn't be the case, for example, in a casino game, when you might all end the night poorer.

In a zero-sum game it doesn't matter if you try to win or if you try to make your opponent lose; the outcome is the same. For a non-zero-sum game, where you could all win or all lose, you'd want to focus on your own winning, rather than your opponent losing (unless you are very selfish, that is).

For games with more than two players, things are more complex. Even in a zero-sum game, the best strategy is not always to make each opponent lose. It may be better to gang up on the strongest opponent, benefiting the weaker opponents and hoping to pick them off later.

Information

In games like Chess, Draughts, Go, and Reversi, both players know everything there is to know about the state of the game. They know what the result of every move will be and what the options will be for the next move. They know all this from the start of the game. This kind of game is called "perfect information." Although you don't know which move your opponent will choose to make, you have complete knowledge of every move your opponent could possibly make and the effects it would have.

In a game such as Backgammon, there is a random element. You don't know in advance of your dice roll what moves you will be allowed to make. Similarly, you can't know what moves your opponent can play, because you can't predict your opponent's dice roll. This kind of game is called "imperfect information."

Most turn-based strategy games are imperfect information; there is some random element to carrying out actions (a skill check or randomness in combat, for example). Perfect information games are often easier to analyze, however. Many of the algorithms and techniques for turn-based AI assume that there is perfect information. They can be adapted for other types of game, but they often perform more poorly as a result.

Applying Algorithms

The best known and most advanced algorithms for turn-based games are designed to work with two-player, zero-sum, perfect information games.

If you are writing a Chess-playing AI, then this is exactly the implementation you need. But many turn-based computer games are more complicated, involving more players and imperfect information.

This chapter introduces algorithms in their most common form: for two-player, perfect information games. As we'll see, they will need to be adapted for other kinds of games.

9.1.2 THE GAME TREE

Any turn-based game can be represented as a game tree. Figure 9.1 shows part of the tree for a game of Tic-Tac-Toe. Each node in the tree represents a board position, and each branch represents one possible move. Moves lead from one board position to another.

Each player gets to move at alternating levels of the tree. Because the game is turn based, the board only changes when one player makes a move.

The number of branches from each board is equal to the number of possible moves that the player can make. In Tic-Tac-Toe this number is nine on the first player's turn, then eight, and so on. In many games there can be hundreds or even thousands of possible moves each player can make.

Some board positions don't have any possible moves. These are called terminal positions, and they represent the end of the game. For each terminal position, a final score is given to each player. This can be as simple as +1 for a win and -1 for a loss, or it can reflect the size of the win. Draws are also allowed, scoring 0. In a zero-sum game, the final scores for each player will add up to zero. In a non-zero-sum game, the scores will reflect the size of each player's personal win or loss. At this point I am only indicating final scores, for positions when the game is over. I will return to the idea of assigning scores to intermediate board positions later.

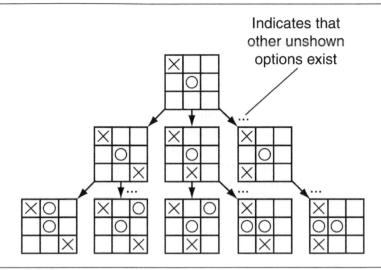

Figure 9.1: Tic-Tac-Toe game tree

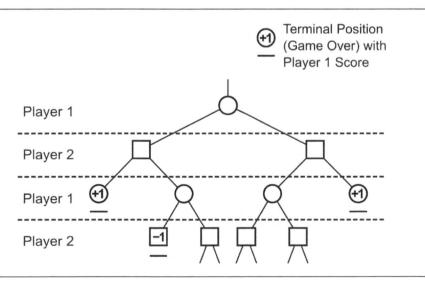

Figure 9.2: Abstract game tree showing terminal and players' moves

Most commonly, the game tree is represented in the abstract without board diagrams, instead showing the final scores. Figure 9.2 assumes the game is zero sum, so it only shows scores for player one.

Branching Factor and Depth

The number of branches at each branching point in the tree is called the branching factor, and it is a good indicator of how difficult a computer will find it to play the game.

Different games also have different depths of tree: a different maximum number of turns. In Tic-Tac-Toe each player takes turns to add their symbol to the board. There are nine spaces on the board, so there are a maximum of nine turns. The same thing happens in Reversi, which is played on an eight-by-eight board. In Reversi, four pieces are on the board at the start of the game, so there can be a maximum of 60 turns (excluding passes, which in Reversi are never voluntary). Games like Chess can have an almost infinite number of turns (the 50-move rule in competition Chess limits this). The game tree for a game such as this would be immensely deep, even if the branching factor was relatively small. Go dwarfs Chess, with more than 10^{48} possible moves in a game, and a maximum branching factor of $19 \times 19 = 361$.

Computers find it easier to play games with a small branching factor and deep tree than games with a shallow tree but a huge branching factor. The ideal searchable game would have a small branching factor and a shallow depth (such as Tic-Tac-Toe), though such games are often also dull for human players. The most interesting games often have very large values for both.

Transposition

In many games, it is possible to arrive at the same board position several times in a game. In many more games it is possible to arrive at the same position by different combinations of moves.

Having the same board position from different sequences of moves is called transposition. This means that, in most games, the game tree isn't a tree at all; branches can merge as well as

Split-Nim, a variation of the Chinese game of Nim, starts with a single pile of coins. At each turn, alternating players have to split one pile of coins into two non-equal piles. The last player to be able to make a move wins. Figure 9.3 shows a complete game tree for the game of 7-Split-Nim (starting with 7 coins in the pile). You can see that there is a large number of different merging branches.

Minimax-based algorithms (those we'll look at in the next section) are designed to work with pure trees. They can work with merging branches, but they duplicate their work for each merging branch. They need to be extended with transition tables to avoid duplicating work when branches merge. The second set of key algorithms in this chapter, MTD, is designed with transposition in mind.

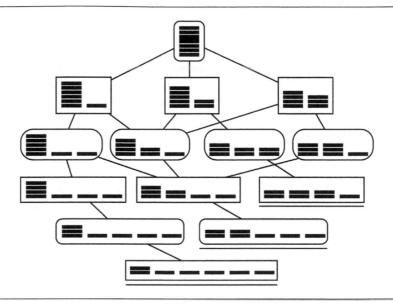

Figure 9.3: The game tree of 7-Split-Nim

9.2 MINIMAXING

A computer plays a turn-based game by looking at the actions available to it this move and selecting one of them. In order to select one of the moves, it needs to know what moves are better than others. This knowledge is provided to the computer by the programmer using a heuristic called the *static evaluation function*.

9.2.1 THE STATIC EVALUATION FUNCTION

In a turn-based game, the job of the static evaluation function is to look at the current state of the board and score it from the point of view of one player.

If the board is a terminal position in the tree, then this score will be the final score for the game. So if the board is showing checkmate to black, then its score will be +1 to black (or whatever the winning score is set to be), while white's score will be -1. It is easy to score a winning position: one side will have the highest possible score and the other side will have the lowest possible score.

In the middle of the game, it is much harder to score. The score should reflect how likely a player is to win the game from that board position. So if the board is showing an overwhelming advantage to one player, then that player should receive a score very close to the winning score. In most cases the balance of winning or losing may not be clear.

Figure 9.4: A one-move decision making process

I will return to a more comprehensive discussion of static evaluation functions and the way they encode game knowledge in Section 9.8, later in this chapter.

The Score Value

In principle, the evaluation function can return any kind of number of any size. In most implementations, however, it returns a signed integer. Several of the most common algorithms in this chapter rely on the evaluation function being an integer. In addition, integer arithmetic is faster than floating point arithmetic on most machines.

The range of possible values isn't too important. The range of scores returned should be less than the scores for winning or losing. If a static evaluation function returns +1000 for a position that is very close to winning, but only +100 for a win, then the AI will try not to win the game because being close seems much more attractive.

Simple Move Choice

With a good static evaluation function, the computer can select a move by scoring the positions that will result after making each possible move, then choosing the move that leads to the highest score. Figure 9.4 shows the possible moves for a player, scored with an evaluation function. It is clear that making the second move will give the best board position, so this is the move to be chosen.

Given a perfect evaluation function, this is all that the AI would need to do: look at the result of each possible move and pick the highest score. Unfortunately, a perfect evaluation function is fantasy. The evaluation functions we will see at the end of this chapter perform reasonably when used this way, but are still easily beaten with search.

The computer works its way down the tree: looking at the other player's possible responses, responses to those responses, and so on.

This is the same process that human players carry out when they look ahead one or more moves. Unlike human players, who rely on an intuitive sense of who is winning, computer heuristics have typically been fairly narrow, limited, and poor. In those cases, the computer needs to lookahead many more moves than a person can.

Figure 9.5: One-move tree, our move

Figure 9.6: One-move tree, opponent's move

The most famous search algorithm for games is minimax. In various forms it dominated turn-based AI until the mid-1990s, and for some games is still the best choice now.

9.2.2 MINIMAXING

If we choose a move, we are likely to choose a move that produces a good position. We can assume that we will choose the move that leads to the best position available to us. In other words, on our moves we are trying to maximize our score (Figure 9.5).

When our opponent moves, however, we assume they will choose the move that leaves us in the worst available position. Our opponent is trying to minimize our score (Figure 9.6).

When we search for our opponent's responses to our responses, we need to remember that we are maximizing our score, while our opponent is minimizing our score. This changing between maximizing and minimizing, as we search the game tree, is called *minimaxing*.

The game trees in Figures 9.5 and 9.6 are only one move deep. In order to work out what our best possible move is, we also need to consider our opponent's responses.

In Figure 9.7, the scores for each board position are shown after two moves. If we make move one, we are at a situation where we could end up with a board scoring 10. But we have to assume that our opponent won't let us have that and will make the move that leaves us with 2. So the score of move one for us is 2; it is all we can expect to end up with if we make that move. On the other hand, if we made move two, we'd have no hope of scoring 10. But regardless of what our opponent does, we'd end up with at least 4. So we can expect to get 4 from move

Figure 9.7: The two-move game tree

two. Move two is therefore better than move one but still not as good as move three, which is our best option.

Starting from the bottom of the tree, scores are bubbled up according to the minimax rule: on our turn, we bubble up the highest score; on our opponent's turn, we bubble up the lowest score. Eventually, we have accurate scores for the results of each available move, and we simply choose the best of these.

This process of bubbling scores up the tree is what the minimaxing algorithm does. To determine how good a move is, it searches for responses, and responses to those responses, until it can search no further. At that point it relies on the static evaluation function. It then bubbles these scores back up to get a score for each of its available moves. Even for searches that only lookahead a couple of moves, minimaxing provides much better results than just relying on a heuristic alone.

9.2.3 THE MINIMAXING ALGORITHM

The minimax algorithm is recursive. At each recursion it tries to calculate the correct intermediate score value of the current board position.

It does this by looking at each possible move from the current board position. For each move it calculates the resulting board position and recurses to find the value of that position.

To stop the search from going on forever (in the case where the tree is very deep), the algorithm has a maximum search depth. If the current board position is at the maximum depth, then it calls the static evaluation function and returns the result.

If the algorithm is considering a position where the current player is to move, then it returns the highest value it has seen; otherwise, it returns the lowest. This alternates between the minimization and maximization steps, giving the algorithm its name.

If the search depth is zero, then it also stores the best move found. This will be the move to make.

Pseudo-Code

We can implement the minimax algorithm in the following way:

```
function minimax(board: Board,
2
                     player: id,
                     maxDepth: int,
3
                     currentDepth: int) -> (float, Move):
       # Check if we're done recursing.
5
       if board.isGameOver() or currentDepth == maxDepth:
            return board.evaluate(player), null
       # Otherwise bubble up values from below.
       bestMove: Move = null
10
       if board.currentPlayer() == player:
11
            bestScore: float = -INFINITY
12
       else:
13
           bestScore: float = INFINITY
14
15
       # Go through each move.
16
       for move in board.getMoves():
17
           newBoard: Board = board.makeMove(move)
18
19
           # Recurse.
20
           currentScore, currentMove = minimax(
21
                newBoard, player, maxDepth, currentDepth+1)
22
23
           # Update the best score.
24
           if board.currentPlayer() == player:
25
                if currentScore > bestScore:
26
                    bestScore = currentScore
27
                    bestMove = move
           else:
29
                if currentScore < bestScore:</pre>
30
                    bestScore = currentScore
31
                    bestMove = move
32
33
       # Return the score and the best move.
34
       return bestScore, bestMove
```

In this code I've assumed that the minimax function can return two things: a best move and its score. For languages that can only return a single item, the move can be passed back through a pointer or by returning a structure.

The INFINITY constant should be larger than anything returned by the board.evaluate function. It is used to make sure that there will always be a best move found, no matter how poor it might be.

The minimax function can be driven from a simpler function that just returns the best move:

```
function getBestMove(board: Board, player: id, maxDepth: int) -> Move:
2
      # Get the result of a minimax run and return the move.
      score, move = minimax(board, player, maxDepth, 0)
3
      return move
4
```

Data Structures and Interfaces

The code above gets the board to do the work of calculating allowable moves and applying them. An instance of the Board class represents one position in the game. The class should have the following form:

```
class Board:
      function getMoves() -> Move[]
2
      function makeMove(move: Move) -> Board
      function evaluate(player: id) -> float
      function currentPlayer() -> id
      function isGameOver() -> bool
```

where getMoves returns a list of move objects (which can have any format, it isn't important for the algorithm) that correspond to the moves that can be made from the board position. The makeMove method takes one move instance and returns a completely new board object that represents the position after the move is made. evaluate is the static evaluation function. It returns the score for the current position from the point of view of the given player. current-Player returns the player whose turn it is to play on the current board. This may be different from the player whose best move we are trying to work out. Finally, isGameOver returns true if the position of the board is terminal.

This structure applies to any two-player perfect information games, from Tic-Tac-Toe to Chess.

More than Two Players

We can extend the same algorithm to handle three or more players. Rather than alternating minimization and maximization, we perform a minimization at any move when we're not a player and a maximization on our move. The code above handles this normally. If there are three players, then:

```
board.currentPlayer() == player
```

will be true one step in three, so we will get one maximization step followed by two minimization steps.

Figure 9.8: Negamax values bubbled up a tree

Performance

The algorithm is O(d) in memory, where d is the maximum depth of the search (or the maximum depth of the tree if that is smaller).

It is O(nd) in time, where n is the number of possible moves at each board position. With a wide and deep tree, this can be incredibly inefficient. Throughout the rest of this section we'll look at ways to optimize its performance.

9.2.4 NEGAMAXING

The minimax routine consistently scores moves based on one player's point of view. It involves special code to track whose move it is and whether the scores should therefore be maximized or minimized to bubble up. For some kinds of games this flexibility is needed, but in certain cases we can improve things.

For games that are two player and zero sum, we know that one player's gain is the other player's loss. If one player scores a board at -1, then the opponent should score it at +1. We can use this fact to simplify the minimax algorithm.

At each stage of bubbling up, rather than choosing either the smallest or largest, all the scores from the previous level have their signs changed. The scores are then correct for the player at that move (i.e., they no longer represent the correct scores for the player doing the search). Because each player will try to maximize their score, the largest of these values can be chosen each time.

Because at each bubbling up we invert the scores and choose the maximum, the algorithm is known as "negamax." It gives the same results as the minimax algorithm, but each level of bubbling is identical. There is no need to track whose move it is and act differently.

Figure 9.8 shows the bubbling up at each level in a game tree. Notice that at each stage the value of the inverted scores is largest at the next level down.

Negamax and the Evaluation Function

The static evaluation function scores a board according to one player's point of view. At each level of the basic minimax algorithm, the same point of view is used to calculate scores. To implement this, the scoring function needs to accept a player whose point of view is to be considered.

Because negamax alternates viewpoints between players at each turn, the evaluation function always needs to score from the point of view of the player whose move it is on that board. So the point of view alternates between players at each move. To implement this, the evaluation function no longer needs to accept a point of view as input. It can simply look at whose turn it is to play.

Pseudo-Code

The modified algorithm for negamaxing looks like the following:

```
function negamax(board: Board,
2
                     maxDepth: int,
                     currentDepth: int) -> (float, Move):
3
       # Check if we're done recursing.
4
       if board.isGameOver() or currentDepth == maxDepth:
5
           return board.evaluate(), null
       # Otherwise bubble up values from below.
       bestMove: Move = null
       bestScore: float = -INFINITY
11
       # Go through each move.
12
       for move in board.getMoves():
13
           newBoard: Board = board.makeMove(move)
14
15
           # Recurse.
16
           recursedScore, currentMove = negamax(
17
               newBoard, maxDepth, currentDepth + 1)
           currentScore = -recursedScore
           # Update the best score.
21
           if currentScore > bestScore:
22
23
               bestScore = currentScore
               bestMove = move
24
25
       # Return the score and the best move.
26
       return bestScore, bestMove
```

Note that, because we no longer have to pass it to the evaluate method, we don't need the player parameter at all.

Data Structures and Interfaces

Because we don't have to pass the player into the Board.evaluate method, the Board interface now looks like the following:

```
class Board:
      function getMoves() -> Move[]
2
       function makeMove(move: Move) -> Board
      function evaluate() -> float
       function currentPlayer() -> id
5
       function isGameOver() -> bool
```

Performance

The negamax algorithm is identical to the minimax algorithm for performance characteristics. It is also O(d) in memory, where d is the maximum depth of the search, and O(nd) in time, where n is the number of moves at each board position.

Despite being simpler to implement and faster to execute, it scales in the same way with large game trees.

Implementation Notes

Most of the optimizations that can be applied to negamaxing can be made to work with a strict minimaxing approach. The optimizations in this chapter will be introduced in terms of negamax, since that is much more widely used in practice.

When developers talk about minimaxing, they often use a negamax-based algorithm in practice. Minimax is often used as a generic term to include a whole raft of optimizations. In particular, if you read "minimax" in a book describing a game-playing AI, it is mostly likely to refer to a negamax optimization called "alpha-beta (AB) negamax." We'll look at the AB optimization next.

9.2.5 AB PRUNING

The negamaxing algorithm is efficient but examines more board positions than necessary. AB pruning allows the algorithm to ignore sections of the tree that cannot possibly contain the best move. It is made up of two kinds of pruning: alpha and beta.

Alpha Pruning

Figure 9.9 shows a game tree before any bubbling up has been done. To more easily see how the scores are being processed, I'll use the minimax algorithm for this illustration.

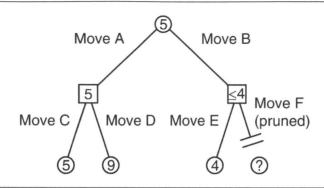

Figure 9.9: An optimizable branch

We start the bubbling up process in the same way as before. If player one makes move A, then their opponent will respond with move C, giving the player a score of 5. So we bubble up the 5. Now the algorithm looks at move B. It sees the first response to B is E, which scores 4. It doesn't matter what the value of F is now, because the opponent can always force a value of 4. Even without considering F, player one knows that making move B is wrong; they can get 5 from move A and a maximum of 4 from move B, possibly even less.

To prune in this way, we need to keep track of the best score we know we can achieve. In fact, this value forms a lower limit on the score we can achieve. We might find a better sequence of moves later in the search, but we'll never accept a sequence of moves that gives us a lower score. This lower bound is called the alpha value (sometimes, but rarely, written as the Greek letter α), and the pruning is called alpha pruning.

By keeping track of the alpha value, we can avoid considering any move where the opponent has the opportunity to make it worse. We don't need to worry about how much worse the opponent could make it; we already know that we won't be giving them the opportunity.

Beta Pruning

Beta pruning works in the same way. The beta value (again, rarely written β) keeps track of an upper limit on what we can hope to score. We update the beta value when we find a sequence of moves that the opponent can force us into.

At that point we know there is no way to score more than the beta value, but there may be more sequences yet to find that the opponent can use to limit us even further. If we find a sequence of moves that scores greater than the beta value, then we can disregard it, because we know we'll never be given the opportunity to make them.

Together alpha and beta values provide a window of possible scores. We will never choose to make moves that score less than alpha, and our opponent will never let us make moves scoring more than beta. The score we finally achieve must lie between the two. As the tree is

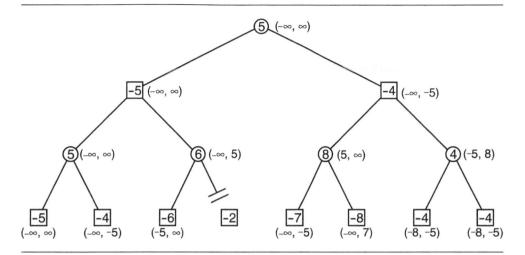

Figure 9.10: AB negamax calls on a game tree

searched, the alpha and beta values are updated. If a branch of the tree is found that is outside these values, then the branch can be pruned.

Because of the alternation between minimizing and maximizing for each player, only one value needs to be checked at each board position. At a board position where it is the opponent's turn to play, we minimize the scores, so only the minimum score can change and we only need to check against alpha. If it is our turn to play, we are maximizing the scores, and so only the beta check is required.

AB Negamax

Although it is simpler to see the difference between alpha and beta prunes in the minimax algorithm, they are most commonly used with negamax. Rather than alternating checks against alpha and beta at each successive turn, the AB negamax swaps and inverts the alpha and beta values (in the same way that it inverts the scores from the next level). It checks and prunes against just the beta value.

Using AB pruning with negamaxing, we have the simplest practical board game AI algorithm. It will form the basis for all further optimizations in this section.

Figure 9.10 shows the alpha and beta parameters passed to the negamax algorithm at each node in a game tree and the result that the algorithm produces. You can see that as the algorithm searches from left to right in the tree, the alpha and beta values get closer together, limiting the search. You can also see the way in which the alpha and beta values change signs and swap places at each level of the tree.

Pseudo-Code

The AB negamax algorithm is structured like the following:

```
function abNegamax(board: Board,
                       maxDepth: int,
2
                       currentDepth: int,
                       alpha: float,
                       beta: float) -> (float, Move):
       # Check if we're done recursing.
       if board.isGameOver() or currentDepth == maxDepth:
           return board.evaluate(player), null
       # Otherwise bubble up values from below.
10
       bestMove: Move = null
11
       bestScore: float = -INFINITY
12
13
       # Go through each move.
14
       for move in board.getMoves():
15
           newBoard: Board = board.makeMove(move)
16
17
           # Recurse.
           recursedScore, currentMove = abNegamax(
                newBoard, maxDepth, currentDepth + 1,
20
                -beta, -max(alpha, bestScore))
21
22
           currentScore = -recursedScore
23
           # Update the best score.
24
           if currentScore > bestScore:
25
                bestScore = currentScore
26
                bestMove = move
27
28
           # If we're outside the bounds, prune by exiting immediately.
29
           if bestScore >= beta:
30
               break
31
32
       return bestScore, bestMove
33
```

This can be driven from a function of the form:

```
function getBestMove(board: Board, maxDepth: int) -> Move:
      # Get the result of a minimax run and return the move.
2
      score, move = abNegamax(board, maxDepth, 0, -INFINITY, INFINITY)
3
      return move
```

Data Structures and Interfaces

This implementation relies on the same game board class as for regular negamax.

Performance

Once again, the algorithm is O(d) in memory, where d is the maximum depth of the search, and order O(nd) in time, where n is the number of possible moves at each board position.

So why the optimization if we get the same performance?

The order of the performance may be the same, but AB negamax will outperform regular negamax in almost all cases. The only situation in which it will not is if the moves are ordered so that no pruning is possible. In this case the algorithm will have an extra comparison that is never true and therefore will be slower.

This situation would only be likely to occur if the moves were ordered deliberately to exploit it. In the vast majority of cases the performance is very much better than the basic algorithm.

9.2.6 THE AB SEARCH WINDOW

The interval between the alpha and beta values in an AB algorithm is called the *search window*. Only new move sequences with scores in this window are considered. All others are pruned.

The smaller the search window, the more likely a branch is to be pruned. Initially, AB algorithms are called with an infinitely large search window: $(-\infty, +\infty)$. As they work, the search window is contracted. Anything that can make the search window smaller, as fast as possible, will increase the number of prunes and speed up the algorithm.

Move Order

If the most likely moves are considered first, then the search window will contract more quickly. The less likely moves will be considered later and are more likely to be pruned.

Determining which moves are better, of course, is the whole point of the AI. If we knew the best moves, then we wouldn't need to run the algorithm. So there is a trade-off between being able to do less search (by knowing in advance which moves are best) and having to possess less knowledge (and having to search more).

In the simplest case it is possible to use the static evaluation function on the moves to determine the correct order. Because the evaluation function gives an approximate indication of how good a board position is, it can be effective in reducing the size of the search through AB pruning. It is often the case, however, that repeatedly calling the evaluation function in this way slows down the algorithm.

An even more effective ordering technique, however, is to use the results of previous min-

imax searches. It can be the results from searches at previous depths when using an iterative deepening algorithm, or it can be the results from minimax searches on previous turns.

The memory-enhanced test family of algorithms explicitly uses this approach to order moves before they are considered. Some form of move ordering can also be added to any AB minimax algorithm.

Even without any form of move ordering, the performance of the AB algorithm can be 10 times better than minimax alone. With excellent move ordering, it can be more than 10 times faster again, which is 100 times faster than regular minimax. This is often the difference between searching the tree to a couple of extra turns in depth.

Aspiration Search

Having a small search window is such a massive speed up that it can be worthwhile artificially limiting the window. Instead of calling the algorithm with a range of $(-\infty, +\infty)$, it can be called with an estimated range. This range is called an aspiration, and the AB algorithm called in this way is sometimes called *aspiration search*.

This smaller range will cause many more branches to be pruned, speeding up the algorithm. On the other hand, there may be no suitable move sequences within the given range of values. In this case the algorithm will return with failure: no best move will be found. The search can then be repeated with a wider window.

The aspiration for the search is often based on the results of a previous search. If during a previous search a board is scored at 5, then when the player finds itself at that board, it will perform an aspiration search using (5 - window size, 5 + window size). The window size depends on the range of scores that can be returned by the evaluation function.

A simple driver function that can perform the aspiration search would look like the following:

```
function aspiration(board: Board, maxDepth: int, prev: float) -> Move:
       alpha = prev - WINDOW_SIZE
2
       beta = prev + WINDOW_SIZE
3
       while true:
           result, move = abNegamax(board, maxDepth, 0, alpha, beta)
           if result <= alpha:
7
               alpha = -NEAR_INFINITY
           else if result >= beta:
               beta = NEAR INFINITY
10
           else:
11
12
                return move
```

9.2.7 NEGASCOUT

Narrowing the search window can be taken to the extreme, having a search window with zero width. This search will prune almost all the branches from the tree, making for a very fast search. Unfortunately, it will prune all the useful branches along with the useless ones. So unless you start the algorithm with the correct result, it will fail. A zero window size can be seen as a test. It tests if the actual score is equal to the guess. Unsurprisingly, in this form it is called "Test."

The version of AB negamax we have considered so far is sometimes called the "fail-soft" version. If it fails, then it returns the best result it had so far. The most basic version of AB negamax will only return either alpha or beta as its score if it fails (depending on whether it fails high or fails low). The extra information in the fail-soft version can help find a solution. It allows us to move our initial guess and repeat the search with a more sensible window. Without fail-soft, you would have no idea how far to move your guess.

The original scout algorithm combined a minimax search (with AB pruning) with calls to the zero-width test. Because it relies on a minimax search, it is not widely used. The negascout algorithm uses the AB negamax algorithm to drive the test.

Negascout works by doing a full examination of the first move from each board position. This is done with a wide search window so that the algorithm doesn't fail. Successive moves are examined using a scout pass with a window based on the score from the first move. If this pass fails, then it is repeated with a full-width window (the same as regular AB negamax).

The initial wide-window search from the first move establishes a good approximation for the scout test. This avoids too many failures and takes advantage of the fact that the scout test prunes a large number of branches.

Pseudo-Code

Combining the aspiration search driver with the negascout algorithm produces a powerful game playing AI. Aspiration negascout is the algorithm at the heart of much of the best gameplaying software in the world, including Chess, Checkers, and Reversi programs that can beat champion players. The aspiration driver is the same as was implemented previously:

```
function abNegascout(board: Board,
                         maxDepth: int,
2
                         currentDepth: int,
3
                         alpha: float,
                         beta: float) -> (float, Move):
5
       # Check if we're done recursing.
       if board.isGameOver() or currentDepth == maxDepth:
7
           return board.evaluate(player), null
9
       # Otherwise bubble up values from below.
10
       bestMove: Move = null
11
       bestScore: float = -INFINITY
12
```

```
13
       # Keep track of the Test window value.
15
       adaptiveBeta: float = beta
16
17
       # Go through each move.
       for move in board.getMoves():
18
           newBoard: Board = board.makeMove(move)
19
20
           # Recurse.
21
           recursedScore, currentMove = abNegamax(
22
                newBoard, maxDepth, currentDepth + 1,
23
24
                -adaptiveBeta, -max(alpha, bestScore))
           currentScore = -recursedScore
26
           # Update the best score.
27
           if currentScore > bestScore:
28
                # If we are in 'narrow-mode' then widen and do a regular
29
                # AB negamax search.
30
                if adaptiveBeta == beta or currentDepth >= maxDepth - 2:
31
                    bestScore = currentScore
32
                    bestMove = move
33
34
                # Otherwise we can do a Test.
35
                else:
36
                    negativeBestScore, bestMove = abNegascout(
                        newBoard, maxDepth, currentDepth,
                        -beta, -currentMoveScore)
39
                    bestScore = -negativeBestScore
40
41
                # If we're outside the bounds, prune by exiting.
42
                if bestScore >= beta:
43
                    return bestScore, bestMove
44
45
                # Otherwise update the window location.
46
                adaptiveBeta = max(alpha, bestScore) + 1
48
       return bestScore, bestMove
```

Data Structures and Interfaces

This listing uses the same game Board interface as previously and can be applied to any game.

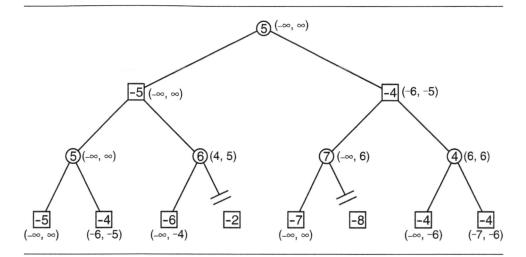

Figure 9.11: The game tree with negascout calls

Performance

Predictably, the algorithm is again O(d) in memory, where d is the maximum depth of the search, and order O(nd) in time, where n is the number of possible moves at each board position.

Figure 9.11 shows the game tree used to introduce AB negamax. The alpha and beta values appear to jump around more than for negamax, but following the negascout algorithm eliminates an extra branch from the search. In general, negascout dominates AB negamax; it always examines the same or fewer boards.

Until recently, aspiration negascout was the undisputed champion of game algorithms. A handful of new algorithms based on the memory-enhanced test (MT) approach have since proved to be better in many cases. Neither is theoretically better, but significant speed ups have been reported with the MT approach. The MT algorithms are described later in this chapter.

Move Ordering and Negascout

Negascout relies on the score of the first move from each board position to guide the scout pass. For this reason it has even better speed ups than AB negamax when the moves are ordered. If the best sequence of moves is first, then the initial wide-window pass will be very accurate, and the scout pass will fail less often.

In addition, because of the need to re-search parts of the game tree, the negascout algo-

rithm benefits greatly from a memory system (see the next section) that can recall the results of previous searches.

Principal Variation Search

Negascout is closely related to an algorithm called Principal Variation Search (PVS). When negascout fails on its scout pass, it repeats the search by calling itself with a wider window. PVS uses an AB negamax call in this situation. PVS also has a number of more minor differences to negamax, but by and large negascout performs better in real applications. Often, the name PVS is ambiguously used to refer to the original negascout algorithm.

9.3 TRANSPOSITION TABLES AND MEMORY

So far the algorithms we have looked at assume that each move leads to a unique board position. As we saw previously, the same board position can occur as a result of different combinations of moves. In many games the same board position can even occur multiple times within the same game.

To avoid doing extra work searching the same board position several times, algorithms can make use of a transposition table.

Although the transposition table was designed to avoid duplicate work on transpositions, it has additional benefits. Several algorithms rely on the transposition table as a working memory of board positions that have been considered. Techniques such as the memoryenhanced test, iterative deepening, and thinking on your opponent's turn all use the same transposition table (and all are introduced in this chapter).

The transposition table keeps a record of board positions and the results of a search from that position. When an algorithm is given a board position, it first checks if the board is in the memory and uses the stored value if it is.

Comparing complete game states is an expensive procedure, since a game state may contain tens or hundreds of items of information. Comparing these against stored states in memory would take a long time. To speed up transposition table checks, a hash value is used.

9.3.1 HASHING GAME STATES

Although in principle any hash algorithm will work, there are particular peculiarities of hashing a game state for transposition tables. Most possible states of the board in a board game are unlikely to ever occur. They represent the result of illegal or bizarre sequences of moves. A good hashing scheme will spread the likely positions as widely as possible through the range of the hash value. In addition, because in most games the board changes very little from move to move, it is useful to have hash values that change widely when only a small change is made to the board. This reduces the likelihood of two board positions clashing when they occur in the same search.

Zobrist Keys

There is a common algorithm for transition table hashing called *Zobrist keys*. A Zobrist key is a set of fixed-length random bit patterns stored for each possible state of each possible location on the board. Chess has 64 squares, and each square can be empty or have 1 of 6 different pieces on it, each of two possible colors. The Zobrist key for a game of Chess needs to be $64 \times 2 \times 6 = 768$ entries long.

For each non-empty square, the Zobrist key is looked up and XORed with a running hash total.

There may be additional Zobrist keys for different elements of the game state. The state of the doubling-die in Backgammon, for example, would need a six-element Zobrist key. A number of other Zobrist keys are required in Chess to represent the triple repetition rule, the 50-move rule, and other subtleties. Some implementations omit these additional keys on the expectation that they are needed so rarely that the software will suffer the ambiguity between the occasional states for faster hashing in the vast majority of cases. This and other issues with transposition tables are discussed later.

Additional Zobrist keys are used in the same way: their values are looked up and XORed with the running hash value. Eventually, a final hash value will be produced.

For implementation, the length of the hash value in the Zobrist key will depend on the number of different states for the board. Chess games can make do with 32 bits, but are best with a 64-bit key. Checkers works comfortably with 32 bits, where a more complex turn-based game may require 128 bits.

The Zobrist keys need to be initialized with random bit-strings of the appropriate size.

There are known issues with the C language rand function (which is often exposed as the random function in many languages), and some developers have reported problems when using it to initialize Zobrist keys. Other developers have reported using rand successfully. Because problems with the quality of random number generation are difficult to debug (they tend to give a reduction in performance that is difficult to track down), it would probably be safer to use one of the many freely available random number generators with better reliability than rand.

Hash Implementation

This implementation shows a trivial case of a Zobrist hash for Tic-Tac-Toe. Each of the nine squares can be empty or have one of two pieces in it; therefore, there are $9 \times 2 = 18$ elements in the array.

```
# The Zobrist key.
zobristKey: int[9 * 2]
```

```
3
  # Initialize the key.
  function initZobristKey():
       for i in 0..(9 * 2):
6
           zobristKey[i] = randomInt()
```

On a 64-bit machine, this implementation uses 64-bit keys (16 bits would be plenty big enough for Tic-Tac-Toe, but 64-bit arithmetic is usually faster). It relies on a function randomInt which returns a random value.

Once the key is set up, boards can be hashed. This implementation of the hash function uses a board data structure containing a nine-element array representing the contents of each square on the board:

```
# Calculate a hash value.
   function hash(ticTacToe: Board) -> int:
2
       # Start with a clear bitstring.
3
       result: int = 0
4
5
       # XOR each occupied location in turn.
7
       for i in 0..9:
           # Find what piece we have.
           piece = board.getPieceAtLocation(i)
10
11
           # If its unoccupied, lookup the hash value and xor it.
           if piece != UNOCCUPIED:
12
13
                result = result xor zobristKey[i * 2 + piece]
14
15
       return result
```

Incremental Zobrist Hashing

One particularly nice feature of Zobrist keys is that they can be incrementally updated. Because each element is XORed together, adding an element is as simple as XORing another value. In the example above, adding a new piece is as simple as XORing the Zobrist key for that new piece.

In a game such as Chess, where a move consists of removing a piece from one location and adding it to another, the reversible nature of the XOR operator means the update can still be incremental. The Zobrist key for the piece and the old square is XORed with the hash value, followed by the key for the piece and the new square.

Incrementally hashing in this way can be much faster than calculating the hash from first principles, especially in games with many tens or hundreds of pieces in play at once.

The Game Class, Revisited

To support hashing, and in particular incremental Zobrist hashing, the Board class we have been using can be extended to provide a general hash method:

```
class Board:
       # The current hash value for this board. This saves it being
2
       # recalculated each time it is needed.
3
       hashCache: int
5
       function hashValue() -> int
6
       function getMoves() -> Move[]
7
       function makeMove(move: Move) -> Board
8
       function evaluate() -> float
9
       function currentPlayer() -> id
10
       function isGameOver() -> bool
```

The hash value can now be stored in the class instance. When a move is carried out (in the move method), the hash value can be incrementally updated without the need for a full recalculation.

9.3.2 WHAT TO STORE IN THE TABLE

The hash table stores the value associated with a board position, so it does not need to be recalculated. Because of the way the scores are bubbled up the tree in negamax algorithms, we also know the best move from each board position (it is the one whose resulting board has the highest inverse score). This move can also be stored, so we can make the move directly if required.

The point of searching is to improve the accuracy of the static evaluation function. A minimax value for a board will depend on the depth of search. If we are searching to a depth of ten moves, then we will not be interested in a table entry that holds a value calculated by searching only three moves ahead: it would not be accurate enough. Along with the value for a table entry, we store the depth used to calculate that value.

When searching using AB pruning, we are not interested in calculating the exact score for each board position. If the score is outside the search window, it is ignored. When we store values in the transposition table we may be storing an accurate value, or we may be storing "fail-soft" values that result from a branch being pruned. It is important to record whether the value is accurate, whether it is a fail-low value (alpha pruned), or is a fail-high value (beta pruned). This can be accomplished with a simple flag.

Each entry in the hash table looks something like the following:

```
class TableEntry:
      enum ScoreType:
2
          ACCURATE
3
          FAIL_LOW
4
```

```
FAIL_HIGH
5
6
       # The hash value for this entry.
       hashValue: int
       # The type and score value.
10
       scoreType: ScoreType
       score: float
13
       # The best move to make (as found on a previous calculation).
14
       bestMove: Move
15
16
       # The depth of calculation at which the score was found.
17
       depth: int
18
```

9.3.3 HASH TABLE IMPLEMENTATION

For speed, the hash table implementation used is often a hash array.

A general hash table has an array of lists; the arrays are often called "buckets." When an element is hashed, the hash value looks up the correct bucket. Each item in the bucket is then examined to see if it matches the hash value. There are almost always fewer buckets than there are possible keys. The key undergoes a modular multiplication by the number of buckets, and the new value is the index of the bucket to examine.

Although a much more efficient hash table implementation can be found in any C++ standard library, it has the general form:

```
class BucketItem:
       # The table entry at this location.
       entry: TableEntry
3
4
       # The next entry in this bucket.
5
       next: BucketItem
6
7
       # Returns a matching entry from this bucket, even if it comes
8
       # further down the list.
9
       function getElement(hashValue):
10
            if entry.hashValue == hashValue:
11
                return entry
12
           if next:
13
                return next.getElement(hashValue)
14
           return null
15
16
   class HashTable:
17
       # The contents of the table.
18
       buckets: BucketItem[MAX_BUCKETS]
19
```

```
20
       # Finds the bucket in which the value is stored.
21
       function getBucket(hashValue: int) -> BucketItem:
22
            return buckets[hashValue % MAX_BUCKETS]
23
24
       # Retrieves an entry from the table.
25
       function getEntry(hashValue: int) -> TableEntry:
26
            return getBucket(hashValue).getElement(hashValue)
```

The aim is to have as many buckets as possible with exactly one entry in them. If the buckets are too full, then it will slow down the lookup and indicate that more buckets are needed. If the buckets are too empty, then there is room to spare, and fewer buckets can be used.

In searching for moves, it is more important that the hash lookup is fast, rather than guaranteeing that the contents of the hash table are permanent. There is no point in storing positions in the hash table that are unlikely to ever be visited again.

For this reason a hash array implementation is used, where each bucket has a size of one. This can be implemented as an array of records directly and simplifies the above code to:

```
class HashArray:
       # The entries.
2
       entries: TableEntry[MAX_BUCKETS]
       # Retrieves an entry from the table.
5
       function getEntry(hashValue: int) -> TableEntry:
6
           entry = entries[hashValue % MAX BUCKETS]
           if entry.hashValue == hashValue:
                return entry
           else:
10
               return null
```

9.3.4 REPLACEMENT STRATEGIES

Since there can be only one stored entry for each bucket, there needs to be some mechanism for deciding how and when to replace a stored value when a clash occurs.

The simplest technique is to always overwrite. The contents of a table entry are replaced whenever a clashing entry wants to be stored. This is easy to implement and is often perfectly sufficient.

Another common heuristic is to replace whenever the clashing node is for a later move. So if a board at move 6 clashes with a board at move 10, the board at move 10 is used. This is based on the assumption that the board at move 10 will be useful for longer than the board at

There are many more complex replacement strategies, but there is no general agreement as to which is the best. It seems likely that different strategies will be optimal for different games. Experimentation is probably required. Several programs have had success by keeping multiple transposition tables using a range of strategies. Each transposition table is checked in turn for a match. This seems to offset the weakness of each approach against others.

9.3.5 A COMPLETE TRANSPOSITION TABLE

The pseudo-code for a complete transposition table looks like the following:

```
class TranspositionTable:
       tableSize: int
2
       entries: TableEntry[tableSize]
       function getEntry(hashValue: int) -> TableEntry:
5
           entry = entries[hashValue % tableSize]
           if entry.hashValue == hashValue:
               return entry
           else:
               return null
10
11
       function storeEntry(entry: TableEntry):
12
           # Always replace the current entry.
13
           entries[entry.hashValue % tableSize] = entry
```

Performance

The getEntry method and storeEntry method of the implementation above are O(1) in both time and memory. In addition, the table itself is O(n) in memory, where n is the number of entries in the table. This should be related to the branching factor of the game and the maximum search depth being used. A large number of checked board positions requires a large table.

Implementation Notes

If you implement this algorithm, I strongly recommend that you add some debug data to it that measures the number of buckets used at any point in time, the number of times something is overwritten, and the number of misses when getting an entry that has previously been added. This will allow you to understand how well the transposition table is performing.

If you rarely find a useful entry in the table, then the table may be badly parameterized (the number of buckets may be too small, or the replacement strategy may be unsuitable, for example). In my experience this kind of debugging information is invaluable when your AI isn't playing as well as you'd hoped.

9.3.6 TRANSPOSITION TABLE ISSUES

Transposition tables are an important tool in getting usable speed from a turn-based AI. They are not a panacea, however, and can introduce their own problems.

Path Dependency

Some games need to have scores that depend on the sequence of moves. Repeating the same set of board positions three times in Chess, for example, results in a draw. The score of a board position will depend on whether it is the first or last time round such a sequence. Holding transposition tables will mean that such repetitions will always be scored identically. This can mean that the AI mistakenly throws away a winning position by repeating the sequence.

In this instance the problem can be solved by incorporating a Zobrist key for "number of repeats" in the hash function. In this way successive repeats have different hash values and are recorded separately.

In general, however, games that require sequence-dependent scoring need to have either more complex hashing or special code in the search algorithm to detect this situation.

Instability

A more difficult problem is instability when the stored values fluctuate during the same search. Because each table entry may be overwritten at different times, there is no guarantee that the same value will be returned each time a position is looked up.

For example, the first time a node is considered in a search, it is found in the transposition table, and its value is looked up. Later in the same search that location in the table is overwritten by a new board position. Even later in the search the board position is returned to (by a different sequence of moves or by re-searching in the negascout algorithm). This time the value cannot be found in the table, and it is calculated by searching. The value returned from this search could be different from the looked-up value.

Although it is very rare, it is possible to have a situation where the score for a board oscillates between two values, causing some versions of a re-searching algorithm (although not the basic negascout) to loop infinitely.

9.3.7 USING OPPONENT'S THINKING TIME

A transposition table can be used to allow the AI to improve its searches while the human player is thinking.

On the player's turn, the computer can search for the move it would make if it were playing. As results of this search are processed, they are stored in the transposition table. When the AI comes to take its turn, its searches will be faster because a lot of the board positions will already be considered and stored.

Most commercial board game programs use the opponent's thinking time to do additional searching and store results in memory.

9.4 MEMORY-ENHANCED TEST ALGORITHMS

Memory-enhanced test (MT) algorithms rely on the existence of an efficient transposition table to act as the algorithm's memory.

The MT is simply a zero-width AB negamax, using a transposition table to avoid duplicate work. The existence of the memory allows the algorithm to jump around the search tree looking at the most promising moves first. The recursive nature of the negamax algorithm means that it cannot jump; it must bubble up and recurse down.

9.4.1 IMPLEMENTING TEST

Because the window size for Test is always zero, the test is often rewritten to accept only one input value (the A and B values are the same). We'll call this value "gamma."

The same test was used in the negamax algorithm, but in that case negamax was called as a test and as a regular negamax, so separate alpha and beta parameters were needed.

Added to the simplified negamax algorithm is the transposition table access code. In fact, a sizable proportion of this code is simply memory access.

Pseudo-Code

The test function can be implemented in the following way:

```
function test(board: Board,
                 maxDepth: int,
2
                 currentDepth: int,
3
                 gamma: float) -> (float, Move):
       if currentDepth > lowestDepth:
           lowestDepth = currentDepth
6
7
       # Lookup the entry from the transposition table.
       entry: TableEntry = table.getEntry(board.hashValue())
10
       if entry and entry.depth > maxDepth - currentDepth:
11
           # Early outs for stored positions.
           if entry.minScore > gamma:
13
               return entry.minScore, entry.bestMove
14
           else if entry.maxScore < gamma:
15
               return entry.maxScore, entry.bestMove
16
17
           else:
               # We need to create the entry.
18
```

```
19
                entry.hashValue = board.hashValue()
                entry.depth = maxDepth - currentDepth
20
                entry.minScore = -INFINITY
21
                entry.maxScore = INFINITY
22
23
       # Now we have the entry, we can get on with the text.
24
       # Check if we're done recursing.
25
       if board.isGameOver() or currentDepth == maxDepth:
26
           entry.minScore = entry.maxScore = board.evaluate()
27
           table.storeEntry(entry)
           return entry.minScore, null
30
       # Now go into bubbling up mode.
31
       bestMove: Move = null
32
       bestScore: float = -INFINITY
33
       for move in board.getMoves():
34
           newBoard: Board = board.makeMove(move)
35
36
           # Recurse.
37
            recursedScore, currentMove = test(
38
                newBoard, maxDepth, currentDepth + 1, -gamma)
39
           currentScore = -recursedScore
40
41
           # Update the best score.
42
            if currentScore > bestScore:
43
                # Track the current best move.
44
                entry.bestMove = move
                bestScore = currentScore
                bestMove = move
48
       # If we pruned, then we have a min score, otherwise we have a max.
49
        if bestScore < gamma:</pre>
50
            entry.maxScore = bestScore
51
       else:
52
           entry.minScore = bestScore
53
54
       # Store the entry and return the best score and move.
55
       table.storeEntry(entry)
56
        return bestScore, bestMove
```

Transposition Table

This version of test needs to use a slightly different table entry data structure. Recall that in a negamax framework the score of a table entry might be accurate, or it may be a result of a "fail-soft" search. Because all searches in MT have a zero-width window, we are unlikely to get an accurate score, but we may build up an idea of the possible range of scores over several searches. The transposition table records both minimum and maximum scores. These act in a similar way to alpha and beta values in the AB pruning algorithm.

Because only these two values need to be stored, there is no need to store the score type. The new table entry structure looks like the following:

```
class TableEntry:
      hashValue: int
2
      minScore: float
      maxScore: float
      bestMove: Move
      depth: int
```

9.4.2 THE MTD ALGORITHM

The MT routine is called repeatedly from a driver routine. It is a driver routine that is responsible for repeatedly using MT to zoom in on a correct minimax value and work out the next move in the process. Algorithms of this type are called memory-enhanced test drivers, or MTDs.

The first MTD algorithms were structured very differently, using complex sets of special case code and search ordering logic. SSS* and DUAL*, the most famous, were both shown to simplify to special cases of the MTD algorithm. The simplification process also resolved some outstanding issues with the original algorithms.

The common MTD algorithm looks like the following:

- Keep track of an upper bound on the score value. Call this gamma (to avoid confusion with alpha and beta).
- Let gamma be a first guess as to the score. This can be any fixed value, or it can be derived from a previous run through the algorithm.
- Calculate another guess by calling Test on the current board position, the maximum depth, zero for the current depth, and the gamma value. (A value slightly less than the gamma value is used normally: gamma $-\epsilon$, where ϵ is smaller than the smallest increment of the evaluation function. This allows the test routine to avoid using the == operator, which causes asymmetries when the point of view is flipped along with the signs of the scores during recursion.)
- If the guess isn't the same as the gamma value, then go back to 3 again. This confirms that the guess is now accurate. Occasionally, numerical instabilities can cause this to never become true, and usually a limit is placed on the number of iterations.
- Return the guess as the score; it is accurate.

MTD algorithms take a guess parameter. This is a first guess as to the minimax value expected from the algorithm. The more accurate this guess is, the faster the MTD algorithm will run.

MTD Variations

The SSS* algorithm was shown to be related to MTD starting with a guess of infinity (known as MT-SSS or MTD+∞). Similarly, the DUAL* algorithm can be emulated by using minus infinity as an initial guess (MTD $-\infty$). The most powerful general MTD algorithm, MTD-f, uses a guess based on the results of a previous search.

There is an MTD variant, MTD-best, which doesn't calculate accurate scores for each board position, but can return the best move. It is marginally faster than MTD-f, but considerably more complex, and does not determine how good moves are. In most turn-based games, it is important to know how good moves are, so MTD-best is not as commonly used.

Memory Size

MTD relies on having a large memory. Its performance degrades badly when collisions occur in the transposition table and different board positions are mapped to the same table entry. In the worst case, the algorithm can be incapable of returning a result if the storage it needs keeps being overwritten.

The size of table required depends on the branching factor, the search depth, and the quality of the hashing scheme. For Chess-playing AI with deep search, tables of the order of tens of megabytes are common (a few million table entries). Smaller searches, or simpler games, may require a couple of orders of magnitude less.

As with all memory issues, care needs to be taken not to fall foul of memory performance issues common with large data structures. It is difficult to properly manage cache performance for a 32-bit PC using data structures over a megabyte in size.

9.4.3 PSEUDO-CODE

The pseudo-code for an MTD implementation that can be used with the test code given previously looks like the following:

```
function mtd(board: Board, maxDepth: int, guess: float) -> Move:
2
      for i in 0..MAX_ITERATIONS:
3
           gamma: float = guess
           guess, move = test(board, maxDepth, 0, gamma-1)
          # If there's no more improvement, stop looking.
7
           if gamma == guess:
               break
       return move
```

In this form, an MTD can be called with infinity as a first guess (MT-SSS), or it can be run as MTD-f with a guess based on a previous search. For this, the static move evaluation can be used, or it can be driven as part of an iterative deepening algorithm that keeps track of the guesses from search to search. Iterative deepening is discussed more fully in Section 9.7.1.

Performance

The order of performance of this algorithm is still the same as previously for time (O(nd),where n is the number of moves per board, and d is the depth of the tree). In memory it is O(s), where s is the number of entries in the transposition table.

MTD-f rivals aspiration negascout as the fastest game tree search. Tests show that MTDf is often significantly faster, but there is still debate as to whether each algorithm can be optimized further to improve its performance. Although many of the top board game-playing programs use negascout, most modern AI now relies on an MTD core.

As with all performance issues in AI, the only sure way to tell which will be faster in your game is to try both and profile them. Fortunately, neither algorithm is complex, and both can use the same underlying code (transposition tables, the AB negamax function, and the game class).

9.5 MONTE CARLO TREE SEARCH (MCTS)

Minimax approaches work well for games with small branching factors, where a good quality static evaluation function is available. Either or both these criteria are often lacking, however. In 1987, Bruce Abramson put forward an alternative random approach [1] that came to be known as Monte Carlo tree search (MCTS). Despite some benefits, its use was overshadowed by minimax approaches until it was successfully used as part of Alpha Go's deep learning technology to defeat the world's best Go players. It is particularly suited for use in deep learning, but not exclusively so: it has been used on its own for AI play in both board and strategy games.

9.5.1 **PURE MONTE CARLO TREE SEARCH**

Monte Carlo methods are random: named for the famous casino in Monaco. They seek to build up an overall result by conducting a large number of random trials. In the case of MCTS, the trials are plays of the game (known as playouts), and the result we are seeking is the best move to make.

Faced with a set of possible moves, we can try each in turn, then carry out a series of random playouts from the resulting positions. The win/loss records of those playouts may approximate how good the move is. Such an approach does not require a static evaluation function. The win/loss record tells us how good a move is: we are effectively discovering the evaluation function.

There is a problem with this approach. The real game will not be played by choosing ran-

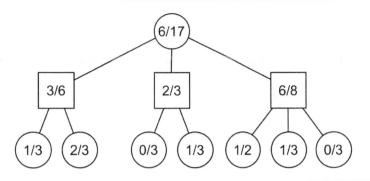

Figure 9.12: A game tree labelled with win statistics

dom moves, and by doing so we are likely to miss the best moves, or the most likely responses by our opponent. When performing the playout, we would like the simulation to be a little more accurate than choosing moves purely at random.

This is achieved by performing the same process recursively. When determining what the opponent's response might be, we look at the win/loss statistics for their moves. Which in turn rely on win/loss statistics for our subsequent moves. Eventually, we run out of this data, and only then we perform the playout at random.

Figure 9.12 shows an example tree for a game that cannot end in a draw, with win/played statistics marked at each node. In each case, the node is shaped for the player about to move, and the win total is from their perspective. If the i=1..n children of a node have win/played values of w_i/p_i , then the node will have totals w/p where

$$w = p - \sum_{i=1}^{n} w_i$$

and

$$p = \sum_{i=1}^{n} p_i$$

Notice that only nodes with statistics are included in the diagram. The tree that the algorithm processes is a subset of the entire game tree: namely the subset for which statistics are available.

The Algorithm

The algorithm is iterative and can be run as many times as we would like. The more iterations, the better it performs. Typically it is left to run until some time limit expires, whereupon the best result is used.

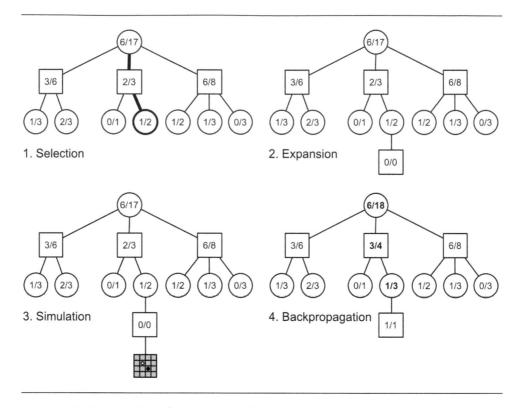

Figure 9.13: One iteration of a pure Monte Carlo tree search

Each iteration works in four steps:

- 1. Selection. Walk down the tree choosing a move based on the totals so far until we reach a node that is not fully explored, i.e. whose children do not all have statistics.
- 2. Expansion. Choose an unexplored move at random and add it as a new node to the subtree.
- 3. Simulation. Play out a purely random game from the new node.
- Backpropagation. Update the totals in the tree based on whether the playout led to a win or loss.

These four steps are illustrated, based on the previous tree, in Figure 9.13.

Over time, the algorithm searches deeper and deeper along the most promising branches. The success statistics bubble back to the top, improving the assessment of which move is the best from the current position (the top of the subtree).

Selecting a Move

In the selection step of the algorithm, we walk down the tree choosing moves based on the win statistics so far. There is a balance to be struck here. On one hand we want to analyse more closely moves that look promising, on the other we want to make sure we explore alternatives sufficiently. As we get more data, and can be more confident in the statistics for a move, it makes sense to bias our search to consider it more deeply. But we don't want to lock-in quirks of the randomness of the algorithm and fixate on a move simply because it happened to look successful at first.

This is a trade-off between exploring for new knowledge and exploiting the knowledge we already have. There are various approaches. One of the simplest and most common, known as UCT (the upper confidence bound applied to trees) weights each possible move u_i according to the formula:

$$u_i = \frac{w_i}{n_i} + k\sqrt{\frac{\ln N}{n_i}}$$

where w_i is the number of wins for the node, p_i is its number of playouts, N is the total number of playouts for all the candidate nodes, and k is a constant that controls the amount of exploration.

At each step in the walk, the node with the highest value of u_i is chosen.

Pseudo-Code

Here is the pseudo-code for performing a Monte Carlo tree search iteration:

```
function mcts(board: Board):
       # 1. Selection
       current: Board = board
       moveSequence: Board[] = [current]
       while current.fullyExplored():
           move: Move = current.selectMove()
           current = current.makeMove(move)
           moveSequence.push(current)
       # 2. Expansion.
10
       move = current.chooseUnexploredMove()
11
       current = current.makeMove(move)
12
       moveSequence.push(current)
13
       # 3. Simulation.
       winner: id = playout(current)
16
17
       # 4. Backpropagation.
18
       for current in moveSequence:
```

```
if winner == current.currentPlayer:
20
21
               current.wins += 1
           current.playouts += 1
```

The function playout performs a purely random playout of the game from the given board position, and returns the result.

If the Monte Carlo tree searches used to return a move for the AI to make, the following simple driver can be used:

```
function mctsDriver(board: Board, thinkingTime: float) -> Move:
      deadline = time() + thinkingTime
2
      while time() < deadline:
          mcts(board)
      # Select a move with no further exploration.
      return board.selectMove(0)
```

Data Structures

The number of wins and the number of playouts needs to be stored for each board position. The pseudocode above assumes the board has the following structure:

```
class Board:
   wins: int = 0
   playouts: int = 0
    function fullyExplored() -> bool
    function selectMove(exploreCoeff: float = EXPLORE) -> Move
    function chooseUnexploredMove() -> Move
    function getMoves() -> Move[]
    function makeMove(move:Move) -> Board
```

The fullyExplored function returns true if all the moves from the current board lead to positions that have win statistics. It can be implemented simply as:

```
class Board:
      function fullyExplored() -> bool:
2
          for move in getMoves():
              next = makeMove(move)
              if next.playouts == 0:
                   return false
          return true
```

Selecting a move is performed by selectMove using the UCT calculation:

```
class Board:
2
       function selectMove(exploreCoeff: float = EXPLORE) -> Move:
            lnN = ln(playouts)
3
            bestMove = None
            bestUCT = 0
5
            for move in getMoves():
6
                next = makeMove(move)
7
                uct = next.wins / next.playouts +
8
                      exploreCoeff * sgrt(lnN / next.wins)
9
                if uct > bestUCT:
10
                    bestUCT = uct
11
                    bestMove = move
12
            return bestMove
```

In this implementation the exploration coefficient can be passed in as a function parameter, though by default it is set to the global value. This allows the same function to be used to return the best move found (i.e. UCT with zero exploration coefficient) by the mctsDriver function, above.

And finally, a random new move is chosen to explore by the chooseUnexploredMove function:

```
class Board:
       function chooseUnexploredMove() -> Move:
2
           unexplored = []
           for move in getMoves():
               next = makeMove(move)
               if next.playouts == 0:
                   unexplored.push(move)
           return randomChoice(unexplored)
```

The remaining functions in the board interface are as before. The implementation may need to be different however. Unlike previously, board positions cannot be generated each time they are needed, they must retain their win data. Applying the same move to the same board should return the same board object. For other trees searches it was enough to return a bored with the same hash. That is possible with this algorithm, but win statistics would then need to be stored in a hash table rather than in the board structure itself.

Performance

Monte Carlo tree search is O(n) in memory where n is the number of nodes in the tree for which win data is available. Execution time is undefined, it is dominated by the length of time required to play out a game. In theory this may be unlimited (though in that case, a practical implementation should terminate with its best guess as to whether the game will be won).

Excluding playout (i.e. assuming the playout time is constant), the algorithm is $O(\log n)$ in time, as it involves walking down the tree and the backpropagation of data back up.

9.5.2 ADDING KNOWLEDGE

Pure Monte Carlo tree search, as described above, is a knowledge-free algorithm. It needs to know nothing about the game, except whether a playout ends in a win. This makes it very appealing for bootstrapping an AI: rapidly producing something that can play the game; or for supporting games where knowledge acquisition is difficult.

It is not a magic bullet, however. The golden rule of AI still applies. The less knowledge we provide, the more search we will have to do.

In practice there are several points where we can introduce more knowledge to the system, reducing search, and potentially improving the quality of the final AI.

Heavy Playouts

Rather than performing a playout purely with random moves, we can choose moves that are more likely to be made. The more sophistication that goes into choosing which move to make during the playout, the heavier that playout is said to be.

At its heaviest, we could perform a playout by having a minimax algorithm play against itself, searching for the best move to make at each turn. But this would largely defeat the object of using MCTS. It also may be counter-productive to the quality of the AI: MCTS produces better results when there is some inaccurate play in the playouts, so it knows to avoid upcoming pitfalls.

It is more common to use heuristics without search. Each possible move is considered and the best is chosen. We have already seen in this chapter a mechanism for this: the static evaluation function. The evaluation heuristics for heavy playouts are often much simpler than the static evaluation functions used in minimax tree search, but this is a difference of degree only. In both cases we evaluate a board position and return a number.

Alternatively, rather than evaluating board positions, it may be possible to create a heuristic that looks only at the move. This depends on the game. Games where board locations fill up with pieces might consider the same move to be approximately as good when played at any time in the tree. This is less successful for games such as Chess.

Win Rate Priors

Another way to introduce knowledge into Monte Carlo tree search is to add nodes to the subtree with an existing value for their win statistics. This is known as biasing their prior, because it affects the likelihood that move will be chosen in the selection phase of the algorithm.

If we select a move using UCT, or a similar criteria, both the number of wins and the

number of playouts is significant. The ratio signifies how good we think the move is, and the number of playouts signifies how confident we are in that assessment. We can calculate the prior in the same way we biased heavy playouts above: using move heuristics or a simplified static evaluation function.

This is a powerful technique but care must be taken. If the prior is too far from the truth, MCTS will take a very large number of iterations to correct the mistake.

The Static Evaluation Function

If we are assessing moves using an evaluation function, we can apply that assessment directly to the selection phase, rather than using the win/played statistics as an intermediate. This involves changing UCT to incorporate the evaluation function:

$$u_i = \frac{w_i}{n_i} + k\sqrt{\frac{\ln N}{n_i}} + ce(B_i)$$

where $e(B_i)$ is the value of the evaluation function on the board after move i, and c is a constant controlling how significant this is to selection. Balancing c and k in this formula requires experimentation.

9.6 OPENING BOOKS AND OTHER SET PLAYS

In many games, over many years, expert players have built up a body of experience about which moves are better than others at the start of the game. Nowhere is this more obvious than in the opening book of Chess. Expert players study huge databases of fixed opening combinations, learning the best responses to moves. It is not uncommon for the first 20 to 30 moves of a Grandmaster Chess game to be planned in advance.

An opening book is a list of move sequences, along with some indication of how good the average outcome will be using those sequences. Using these sets of rules, the computer does not need to search using minimaxing to work out what the best move is to play. It can simply choose the next move from the sequence, as long as the end point of the sequence is beneficial to it.

Opening book databases can be downloaded for several different games, and for prominent games such as Chess commercial databases are available for licensing into a new game. For an original turn-based game, an opening book (if it is useful) needs to be generated manually.

9.6.1 IMPLEMENTING AN OPENING BOOK

Often, opening books are implemented as a hash table very similar to a transposition table. Lists of move sequences can be imported into the software and converted so that each inter-

mediate position has an indication of the opening line it belongs to and the strength of each line.

Notice that, unlike a regular transposition table, there may be more than one recommended move from each board position. Board positions can often belong to many different opening lines, and openings, like the rest of the game, branch out in the form of a tree.

This implementation handles transpositions automatically: the AI looks up the current board position in the opening book and finds a set of possible moves to make.

Opening Book and Evaluation

In addition to using the opening book as a special tool, it can be incorporated into a general purpose search algorithm. The opening book is often implemented as one of the elements of the static evaluation function. If the current board position is part of a recorded opening, then the static evaluation function weights its advice heavily. When the game has progressed beyond the opening book, it is ignored, and other elements of the function are used.

9.6.2 LEARNING FOR OPENING BOOKS

Some programs use an initial opening book library and add a learning layer. The learning layer updates the scores assigned to each opening sequence so that better openings can be selected.

This can be done in one of two ways. The most basic learning technique is to keep a statistical record of the success a program has with each opening. If the opening is listed as being good, but the program consistently loses with it, then it can change the scoring so that it avoids that opening in the future.

A lot of processing, experience, and analysis go into the scores assigned to each opening line in a commercial database. Much of this scoring is based on long histories of international expert games. These are unlikely to be wrong, over all players. But each game-playing AI will have different characteristics. An opening listed in a database as good might end in a tight strategic situation that a human can play well but that causes the computer to suffer lots of horizon effects. Including a statistical learning layer allows the computer to play to its unique strengths.

Some games also learn the sequences themselves. Over many games (typically many thousands) certain opening lines will occur over and over again. Initially, the computer may have to rely on its search to score them, but over time these scores can be averaged (along with information about their statistical likelihood of winning) and recorded.

The larger Chess opening databases, and most opening databases for less popular games, are generated in this way: a strong computer plays itself and records the opening lines that are most favorable.

9.6.3 SET PLAY BOOKS

Although set move sequences are most common at the start of a game, they can also apply later. Many games have set combinations of moves that occur during the game.

For almost all games, however, the range of possible board positions in the game is staggering. It is unlikely that any particular board position will be exactly the same as one in the database. More sophisticated pattern matching is required: looking for particular patterns among the overall board structure.

The most common application of this type of database is for subsections of the board.

In Reversi, for example, strong play along each edge of the board is key. Many Reversi programs have comprehensive databases of edge configurations, along with scores as to how strong they are. The four edge configurations of a board can be easily extracted and the database entry looked up. In the middle-game, these edge scorings are weighted highly in the static evaluation function. Later in the game they are less useful (most Reversi programs can completely search the last 10-15 moves or so of a game, so no evaluation function is needed).

Several programs have experimented with sophisticated pattern recognition to use set plays, particularly in the games of Go and Chess. So far no dominant methods have emerged for general use in all board games.

Ending Database

Very late in some games (like Chess, Backgammon, or Checkers) the board simplifies down. Often, it is possible to pick up an opening book-style lookup at this stage.

There are several commercial ending databases (often called tablebases) for Chess, covering the best way to force mate with different combinations of material. These are rarely required in expert games, however, when a player will resign when they are heading for a known losing ending.

9.7 FURTHER OPTIMIZATIONS

Although the basic game-playing algorithms are each relatively simple, they have a bewildering array of different optimizations. Some of these optimizations, like AB pruning and transposition tables, are essential for good performance. Other optimizations are useful for extracting every last bit of performance.

This section looks at several other optimizations used for turn-based AI. There is not enough room to cover implementation details for most of them. The Appendix gives pointers to further information on implementing them. In addition, specific optimizations used only in a relatively small number of board games are not included. Chess, in particular, has a whole raft of specific optimizations that are only useful in a small number of other scenarios.

9.7.1 ITERATIVE DEEPENING

The quality of the play from a search algorithm depends on the number of moves it can lookahead. For games with a large branching factor, it can take a very long time to look even a few moves ahead. Pruning cuts down a lot of the search, but most board positions still need to be considered.

For most games the computer does not have the luxury of being able to think for as long as it wants. Board games such as Chess use timing mechanisms, and modern computer games may allow players to play at their own speed. Because the minimaxing algorithms search to a fixed depth, there is no guarantee that the search will be complete by the time the computer needs to make its move.

To avoid being caught without a move, a technique called *iterative deepening* can be used. Iterative deepening minimax search performs a regular minimax with gradually increasing depths. Initially, the algorithm searches one move ahead, then if it has time it searches two moves ahead, and so on until its time runs out.

If time runs out before a search has been completed, it uses the result of the search from the previous depth.

MTD Implementation

The MTD algorithm with iterative deepening, MTD-f, appears to be the fastest general purpose algorithm for game search. The MTD implementation discussed previously can be called from the following iterative deepening framework:

```
function mtdf(board: Board, maxDepth: int) -> (float, Move):
       guess: float = 0
2
3
       # Iteratively deepen the search.
4
       for depth in 2..maxDepth:
5
            guess, move = mtd(b, depth, guess)
7
8
            # Check if we need a result.
9
            if outOfTime():
10
                break
11
12
       return guess, move
```

The initial depth for the iterative deepening is two. An initial one level deep search often has no speed advantage; there is little useful information at this level. In some games with large branching factors or when time is short, however, the one level deep search should be included. The function outOfTime returns true if the search should not be continued.

History Heuristic

In algorithms that use transposition tables or other memory, iterative deepening can be a positive advantage to an algorithm. Algorithms such as negascout and AB negamax can be dramatically improved by considering the best moves first. Iterative deepening with memory allows a move to be quickly analyzed at a shallow level and later returned to in more depth. The results of the shallow search can be used to order the moves for the deeper search. This increases the number of prunes that can be made and speeds up the algorithm.

Using the results of a previous iteration to order moves is called the *history heuristic*. It is a heuristic because it relies on the rule of thumb that a previous iteration will produce a good estimate as to the best move.

9.7.2 VARIABLE DEPTH APPROACHES

AB pruning is an example of a variable depth algorithm. Not all branches are searched to the same depth. Some branches are pruned if the computer decides it no longer needs to consider them.

In general, however, the searches are fixed depth. A condition in the search checks if the maximum depth has been reached and terminates that part of the algorithm.

The algorithms can be altered to allow variable depth searches on any number of grounds, and different techniques for pruning the search have different names. They are not new algorithms, but simply guidelines for when to stop searching a branch.

Extensions

The major weakness of computer players for turn-based games is the horizon effect. The horizon effect occurs when a fixed sequence of moves ends up with what appears to be an excellent position, but one additional move will show that that position is, in fact, terrible.

In Chess, for example, the computer may find a series of moves that allow it to capture an enemy queen. Unfortunately, immediately after this capture the opposing player can immediately give checkmate. If the computer had searched at a slightly greater depth, it would have seen this result and not selected the fatal move.

Regardless of how deep the computer looks, this effect may still be present. If the search is very deep, however, the computer will have enough time to select a better move when the trouble is eventually seen.

If the search cannot continue to a great depth because of high branching, and if the horizon effect is noticeable, then the minimax algorithm can use a technique called *extensions*.

Extensions are a variable depth technique, where the few most promising move sequences are searched to a much greater depth. By only selecting the most likely moves to consider at each turn, the extension can be many levels deep. It is not uncommon for extensions of 10 to 20 moves to be considered on a basic search depth of 8 or 9 moves.

Extensions are often searched using an iterative deepening approach, where only the most promising moves from the previous iteration are extended further. While this can often solve horizon effect problems, it relies heavily on the static evaluation function, and poor evaluation can lead the computer to extend along a useless set of options.

Quiescence Pruning

There are many games where the player who appears to be winning can change very rapidly, even with each turn. In these games the horizon effect is very pronounced and can make implementing a turn-based AI very difficult. Often, these frantic changes of leadership are temporary and eventually give rise to stable board positions with a clear leader.

When a period of relative calm occurs, searching deeper often provides no additional information. It may be better to use the computer time to search another area of the tree or to search for extensions on the most promising lines. Pruning the search based on the board's stability is called *quiescence pruning*.

A branch will be pruned if its heuristic value does not change much over successive depths of search. This probably means that the heuristic value is accurate, and there is little point in continuing to search there. Combined with extensions, quiescent pruning allows most of the search effort to be focused on the areas of the tree that are the most critical for good play. This produces a better computer opponent.

9.8 GAME KNOWLEDGE

The algorithms I have focused on so far in this chapter are search algorithms. They efficiently consider possible moves (or as efficiently as a complex game tree will allow). On their own, however, they can play nothing but the simplest of games. They rely on knowledge. In particular, they use two sources of knowledge, one essential and one optional, which allow the algorithms to reason about the game being played.

- 1. The static evaluation function represents knowledge about how good a board position is from one player's perspective.
- 2. Move ordering can dramatically improve the performance of the search by considering the most promising moves first. Where 'most promising' is knowledge about the game.

Move ordering is optional, because it can always be specified in terms of the static evaluation function: the most promising move is the one that leads to a board with a higher score. Until recently, it was uncommon to have a separate and dedicated move ordering function, and it is still unclear whether there is any benefit for most board games. For the very large trees in games such as Go, it has been shown that a different move ordering heuristic can improve the overall performance: namely, the most promising move is the one the opponent is most likely to choose. This may not be the same as the best move, as judged by the static evaluation function. It is regularly different in games such as Go, played against elite human

opponents, who are schooled in a long and well established body of set plays (known as joseki in Go).

If move ordering is to be separated from the static evaluation function, it is a second source of knowledge. This is still uncommon enough that I mention it here for completeness sake, but in the following sections I will focus on the static evaluation function.

Probability and Evaluation

The value returned by the static evaluation function is a probabilistic assessment of the quality of the position. It encodes both how good the position is, and how sure the computer or function author is of that fact. Assuming that 1 represents a certain win, and 0 a certain loss, values close to $\frac{1}{2}$ represent both a draw and a lack of confidence in either other outcome. This makes sense: when going into a board game match, the assumption is that either player could win, both players have an equal opportunity. In a game which allows draws, such as Chess, this may also be the most likely outcome.

In a two player perfect information game, a perfect static evaluation function would assign each position only $0, \frac{1}{2}$ (if the game allowed draws), or 1. In Tic-Tac-Toe, if both players play the best move at each turn, the game will always end in a draw. The empty board has a value of $\frac{1}{2}$. In fact, every board in the tree will have the same value, unless it follows a blundering move. This is shown in Figure 9.14.

A game is said to be weakly solved if the score of the starting position is known, i.e. if we know before playing whether perfect play will lead to win, loss or draw. Tic-Tac-Toe has been solved, as has Checkers (a draw), and Connect 4 (the first player wins). Strongly solving a game goes further, and determines what the optimal move is from any board position. This is equivalent to being able to determine the perfect static evaluation function for any position.

Games which do not have perfect information can also be solved. Guess Who?, for example, is a win for the first player 63% of the time, if both players play perfectly. The static evaluation function at the start of the game, before the cards are drawn, is 0.63, from the perspective of the first player.

Solving even modestly complicated games is a very difficult mathematical challenge. It took years to solve Checkers and Connect 4, and most experts agree that a solution for a game such as Chess is not imminent. Even for most strongly solved games, and all games that have only been weakly solved, a practical AI will need to be probabilistic. Values in the static evaluation function include both the quality of the position and the confidence of the algorithm.

Scoring Function Range

While minimax algorithms can work with 0 for a loss and 1 for a win, negamax assumes that win and loss have the same value but different sign. It is more common to score +k for a win

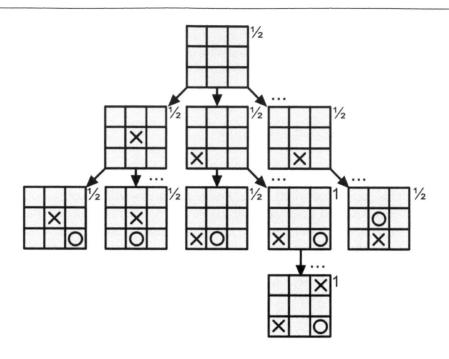

Figure 9.14: Part of the tree of Tic-Tac-Toe showing perfect evaluation

and -k for a loss with 0 being a draw or lack of confidence, with $\pm k$ being the range of the function.

As described previously, some search algorithms require integer values for the static evaluation function. Particularly those that bracket the correct value with an upper and lower bound, and terminate when those limits converge. In practice, scoring +1 for a win and -1 for a loss may not be helpful. Larger values are often used. Some search algorithms work better when the range of values is small (± 100 , for example), while some prefer larger ranges. When setting a small range, it is important to have enough possible values to represent subtle changes in the quality of a position. The algorithm can only distinguish between different values: the bigger the range, the more intermediate values are possible.

Much of the work on turn-based AI has resulted from Chess programs. The scores in Chess are often given in terms of the "value" of a pawn. A common scale assigns a pawn a value of 100. This allows strategic scoring to the level of one hundredth the value of a pawn (known as a 'centipawn'). On this scale the value of a win or loss must be beyond what the static evaluation function can otherwise return. If the function is purely counting pieces with their conventional values (bishop and knight worth three pawns, rooks worth five, the queen

worth eight), a win must score more than 30 pawns (± 3000 centipawns). In practice, much bigger values are used, to accommodate strategic and tactical scoring as well as piece captures, and a range of $\pm 10,000$ or more would be wise.

9.8.1 CREATING A STATIC EVALUATION FUNCTION

Until recent developments in machine learning, static evaluation functions were most often programmed directly. Using machine learning isn't new. One of the early successes of board game playing AI was Arthur Samuel's Checkers program, completed in 1956 [55]. He used a simple form of machine learning to adapt strategies to opponents. The strategies themselves were hand-coded however.

Since 2010, evaluation functions for the top game playing AIs have become the domain of neural networks, in particular deep neural networks with their own embedded tree search separate from the main tree searching algorithm.

In this section I will focus on creating a evaluation functions by hand. In the next section I will introduce machine learning approaches.

Knowledge Acquisition

Creating a static evaluation function for a board game is a knowledge acquisition task. It involves taking the understanding of a good human player and converting that into code. In some cases the programmer is an expert in the game, but in most cases at least other advisers will be needed. Knowledge acquisition has been a long difficulty in AI, particularly in expert systems, which are designed to encapsulate the understanding of a subject expert.

Creating a single evaluation function that includes all the knowledge of an expert is very difficult. So difficult that it is rarely even attempted. Instead, a series of evaluation functions are coded, each capturing one element of the tactical or strategic situation. In Chess, for example, there may be a function that returns the current piece count for each player; another that gives a numeric estimate of each player's control over the center (an important tactical consideration); where another ranks king safety; and so on. In the end there may be tens or even hundreds of these. Figure 9.15 shows a selection from the original paper on Samuel's Checkers program: in that paper he calls them 'parameters'.

The constrained domain of each evaluation makes it much easier to code and test. But the search algorithm requires a single value, and the problem of combining the values into one becomes significant. We shall return to this issue shortly.

If you are creating your own static evaluation function, it is wise to break things down in this way. It also has the advantage of allowing you to begin playing against the computer and testing the AI using just the most obvious tactics, and then to add more as weaknesses in the play come to light.

The parameter is debited with 1 if there are no kings on the board, if either square 7 or 26 is occupied by an active man, and if neither of these squares is occupied by a passive man.

BACK (Back Row Bridge)

The parameter is credited with 1 if there are no active kings on the board and if the two bridge squares (1 and 3, or 30 and 32) in the back row are occupied by passive

CENT (Center Control I)

The parameter is credited with 1 for each of the following squares: 11, 12, 15, 16, 20, 21, 24 and 25 which is occupied by a passive man.

CNTR (Center Control II)

The parameter is credited with I for each of the following squares: 11, 12, 15, 16, 20, 21, 24 and 25 that is either currently occupied by an active piece or to which an active piece can move.

which the active side may advance a piece and, in so doing, force an exchange.

EXPOS (Exposure)

The parameter is credited with 1 for each passive piece that is flanked along one or the other diagonal by two empty squares.

FORK (Threat of Fork)

The parameter is credited with 1 for each situation in which passive pieces occupy two adjacent squares in one row and in which there are three empty squares so disposed that the active side could, by occupying one of them, threaten a sure capture of one or the other of the two pieces.

GAP (Gap)

The parameter is credited with 1 for each single empty square that separates two passive pieces along a diagonal, or that separates a passive piece from the edge of the board.

GUARD (Back Row Control)

Figure 9.15: A selection of the 38 strategies from Samuel's famous Checkers paper

Context Sensitivity

The 'static' in the term static evaluation function refers to the fact that the function should return the same value for the same board position. It does not mean that the same evaluation code runs in the same way every time, however. Particularly when the evaluation function combines simpler functions, the importance of those components my change depending on how far through the game we are.

In the game of Reversi, for example, the player ending with the most counters of their color wins. So having lots of counters of your color may seem like a good thing. And it is, at the end. But midway through the game, the best strategy is often to have the least number of counters, because that gives you control of the initiative in the game. Reversi players call this mobility. There are of course subtleties, and other blunders can easily outweigh this factor (such as allowing your opponent to capture a corner square), but as a general rule, in the middle game, the player with the fewer counters is in control.

If we want to prefer positions with fewer counters in the middle-game, but be greedier in the endgame, then we have two choices. We can either code the function that counts discs in such a way that it scores more disks highly at the end, but penalizes them earlier in the game. Or we can move this complexity up one level in our code, so the disk scoring function always returns the same value, but we weight it differently over time. In practice the best approach is normally some combination of the two. Some functions are easier to code with context sensitivity baked in, others are easier to tweak when combining.

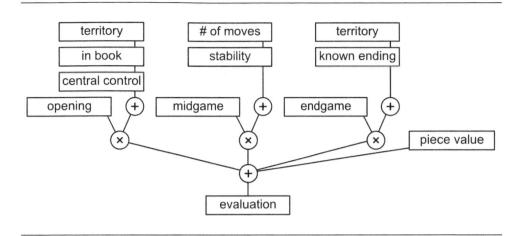

Figure 9.16: Combining multiple context sensitive strategies into a static evaluation function

Combining Scoring Functions

There can be a large number of different scoring mechanisms all working at the same time. One scoring mechanism may look at the number of units each side controls, another may look at patterns for territory control, and yet another might look for specific traps and danger areas. There can be tens or even hundreds of scoring mechanisms in complex games.

All these different scoring functions need to be combined into a single value, so they can be used by the search algorithm.

This can be as simple as adding the scores together with a fixed weight for each. The tricky part is determining what the weights should be. Samuel's Checkers program, mentioned above, used a weighted sum to combine its scoring mechanisms and then added a simple learning algorithm that could change the weights based on its experience. This is a good initial approach, but some hand tuning of parameters it is usually still necessary. I will return to learning weights below.

In the last section I described evaluation functions that change over the course of the game, and said these often are implemented by changing the weights, rather than the functions themselves. A high disk count in Reversi, for example, is vital at the end of the game but can be a problem in the middle. It is customary in Chess, for example, to pay more attention to the number of squares controlled at the start of the game than at the end of the game. It doesn't make sense to have a 'number of squares controlled' function that changes its output over the course of the game. It makes more sense to change the weight.

The overlaid set of scoring functions are like the tactical analyses in Chapter 6: where primitive tactics are combined into a more sophisticated view of the quality of the situation. And the same advice for how to combine them holds for board games.

I have personally had success (in developing AI for Reversi, and another abstract board

game called Atoms) with the simple structure shown in Figure 9.16. Some of the evaluation functions are summed, others are combined by multiplication. One function can represent the strategic concern on the board (such as the number of squares that are controlled), the other can represent the importance of that concern (it can be negative in Reversi in the middle game, and highly positive at the end). Allowing functions to be easily composed in this way makes it simple to visualize the strategy as it is being calculated.

9.8.2 LEARNING THE STATIC EVALUATION FUNCTION

Hand coding a static evaluation function is tedious and error prone. From the very first board game playing AIs, it has been a clear that some kind of machine learning would be very beneficial.

The earliest and simplest approach was to apply machine learning to the weights of individual strategies. The strategies themselves were simple (such as the number of the pieces per player, or the number of locations controlled) and each was implemented by hand. The learning algorithm then decided how important each one should be. This approach was powerful enough to bring an early victory in Checkers [55].

When Tesauro implemented the evaluation function for Backgammon [68], he did not rely on a set of hand coded strategies. Instead he used a shallow neural network to learn the evaluation function from scratch. This was successful enough to allow TD-Gammon to challenge good human players. But it did not become ubiquitous. When IBM's Deep Blue beat Gary Kasparov, then the human world Chess champion, the company was reluctant to give too much detail about its inner workings (beyond details of the hardware it ran on, not surprising for a company selling hardware). They stated only that its evaluation function was 'complex' [24], and ran partially in hardware, and partially in software. Whether it used learning to tune parameters or not, the number of grandmaster consultants on the project suggests that it relied heavily on expert knowledge acquisition.

More recently, developers have tackled Go, long infamous as the most challenging mainstream game for a computer to play. Part of the difficulty has been the lack of success decomposing the strategy into individual concerns. It isn't entirely clear in Go what territory really means before a region is played out to its last move. Expert Go players talk in terms of 'weight' and 'balance', even 'beauty' and 'ugliness', features that are difficult to turn into code. And with no strong suite of component strategies, machine learning to tweak parameters isn't very useful. The innovations in Go have been in developing board game specific deep learning techniques to produced the entire static evaluation function, from a description of the board ([59] and [60]).

In this section, I will describe both approaches. In my experience the simple approach is still useful, particularly for simpler board games.

Weight Parameter Optimization

Given a set of individual strategies, each returning a numeric value, we would like to learn a corresponding series of weights. The value of each strategy is multiplied by its corresponding weight and the results summed to form the output of the static evaluation function.

This learning can be performed in many ways, using almost all of the techniques in Chapter 7, and many besides. Whichever method will be weakly supervised. We don't know the correct value of the static evaluation function, the only thing we have to go on is how successful the AI is. We assume that the better the set of weights, the nearer the static evaluation function becomes to the perfect value, and the better the AI plays.

There are broadly two ways to approach determining success.

- 1. We can play further along in the game, and see if the value of the position becomes clearer, and use this later value to update the earlier weights.
- 2. We can play two versions of the AI against one another, with different weights, and see which wins.

The first approach is essentially the one used in Samuel's Checkers program, where it was known as 'backup'. It effectively uses tree search (using any of the algorithms in this chapter) to improve. If searching several moves ahead improves performance, then perhaps we can learn to have the evaluation function return now, what it will return in several moves of searching.

This is effective, and efficient, but suffers from a severe bootstrapping problem. If the weights are such that the function is terrible, then we will be merely learning the expected future value of a terrible evaluator. To avoid this, some weights are often fixed. In Checkers, this was the piece count, in Chess this might be the total piece value. In both cases, fixing the value anchors the evaluation function, and makes it so that, if the current version plays terribly, this will be reflected in the learning.

Efficiency is less of an issue now than it was in the 1950s. We can easily run hundreds of complete games per second on consumer-grade hardware (assuming we do very little search). It is possible to use a form of hill climbing, using the algorithm we saw in Section 7.2.2 (recall that we can see optimization as either finding high points of fitness or low points of energy: in this case the latter is more common and this algorithm is usually called 'gradient descent'). In summary: from an initial set of random weights, mutate each weight in turn and play a game against the original set. The mutation which leads to the biggest improvement is then committed, and the algorithm begins again. If all mutations are inferior, store the current set, and begin again with new random weights.

To use this approach it is preferable that neither the AI nor the game are very random. If a much worse mutation to the weights can be successful purely by chance, it makes it more likely that the algorithm will detour into a poorer area of the state space, or cycle around between equivalent weights, merely following random chance. The technique supports randomness, in fact, as we saw in Section 7.2.4 on simulated annealing, a little randomness can help avoid local minima. But the more randomness, the slower the algorithm converges to the best weights.

In practice both approaches are often combined. The system will learn weights by playing against itself but also allow those weights to be tweaked in small ways by lookahead search.

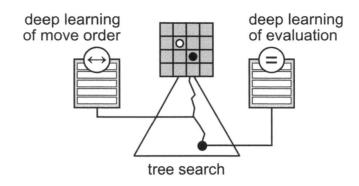

Figure 9.17: A schematic representation of Alpha Go's learning algorithm

Embedding search as part of the learning also applies when we aren't using simpler constituent strategies, as we will see in the next section.

Neural Networks and Deep Learning

In the previous section I described learning the static evaluation function from a vector of individual strategy evaluations. Each component evaluation operates on the current board position to return a number. In many cases this is the most practical, because it allows expert knowledge to contribute to the quality of the AI. With neural networks and particularly the advent of deep learning, however, these intermediate evaluations can be removed and the AI can be tasked with learning the evaluation function directly from the board position.

TD-Gammon, a successful Backgammon playing AI from the 1990s, successfully used this approach. It applied temporal difference (TD) learning, a type of neural network. But the randomness of Backgammon seemed to be particularly suited to this approach, and attempts to apply it to other games—particularly perfect information games—were less successful. It was the advent of Deep Mind's Go playing AIs, culminating in AlphaZero (zero for 'zero knowledge': i.e. it learns everything from scratch) that demonstrated this approach could comfortably outperform a suite of hand optimized strategies in both Go and Chess [60].

Alpha Go Zero uses a deep neural network, consisting of many layers of convolution filters, which take data about the board and convert it into parameters. This is a similar approach to that described in Chapter 6, using filters derived from image processing to calculate tactical information. The specific network architecture is described in the Alpha Go paper, on it's own it is neither revolutionary nor particularly unusual. The innovation lies in the way the network is trained, as shown in Figure 9.17.

The network takes a representation of the board and returns the evaluation function. It also returns an ordering for the possible moves (recall that we saw the ordering of moves is significant to the performance of search). These represent the probability of each move being selected.

The algorithm repeatedly plays itself using the neural network. At each move, it performs a Monte Carlo tree search. The tree search calculates the ordering of moves, i.e. their relative quality. The overall value of the current position is not needed. The network is then trained so that the ordering of moves it generates more closely matches the ordering of moves returned by the tree search. This indirectly improves the evaluation function, but it allows the system to learn much quicker, because it is matching a larger set of criteria, making the credit of assignment problem simpler.

Alpha Go Zero represents the current state-of-the-art in board game AI. The paper gives enough detail for it to be replicated using one of the freely available deep learning toolkits (such as Keras and Google's own TensorFlow). Source code for several replicas are available on GitHub, but as of writing none have achieved the same level of performance reported in the paper.

I have not yet shipped an AI for a board game using this technique, but I have enjoyed experimenting with it. And while I can't claim to have built something as astounding as a world champion Go AI, I have found it relatively easy to create systems that can beat me at simpler games such as Reversi and Atoms. It is an exciting time in board game AI, but the field is in rapid flux. It is not yet clear, for example, whether these approaches will totally supplant handed-tuned engines based on expert knowledge. Though I am basing my opinion purely on intuition, I suspect a fusion of zero-knowledge deep learning and expert knowledge may prove to be stronger still.

9.9 TURN-BASED STRATEGY GAMES

This chapter has focused on board game AI. On the face of it, board game AI has many similarities to turn-based strategy games. Commercial strategy games rarely use the tree-search techniques in this chapter as their main AI tool, however. The complexity of these games means that the search algorithms are bogged down before they are able to make any sensible decisions.

Most tree-search techniques are designed for two-player, zero-sum, perfect information games, and many of the best optimizations cannot be adapted for use in general strategy games.

Some strategy AI can benefit directly from the tree-search algorithms in this chapter if they apply it to specific parts of their strategy. Research and building construction, troop movement, and military action can all form part of the set of possible moves. The board position then represents a set of choices, and it's playout represents a probabilistic guess on how those choices will work. The game interface given above can, in theory, be implemented to reflect parts the most complex turn-based game. This implemented interface can then be used with the regular tree-search algorithms. Monte Carlo tree search in particular is used,

because it does not have to explore the entire tree. It performs better when it cannot search exhaustively.

9.9.1 IMPOSSIBLE TREE SIZE

Unfortunately, for anything more than a small subsystem of complex games, the size of the tree becomes too huge for any of the techniques in this chapter. MCTS only helps when it can explore a reasonable proportion of the available branches: beyond a certain point data becomes so sparse it is no better than guessing.

In a world-building strategy game, for example, imagine the player has 5 cities and 30 units of troops. Each city can change a handful of economic properties to a large range of values (let's say there are 5 properties, each of which can be set to 100 values; that's 500 different options per city, or 2,500 in total). Each troop can move up to 5 or 6 spaces (around 500 possible moves each, for 15,000 different moves). Finally, there is a set of possible moves for the whole side, such as what to research next, nationwide tax levels, whether to change government, and so on. There may be 20,000 different possible moves.

But that's only the start. In one turn a player may choose any combination of moves for different units and cities. While not all of the 20,000 moves can be taken at the same time, a back of the envelope calculation suggests that there would be around 1090 different possible move combinations at each turn.

No computer will ever get near looking at even a single turn's possibilities using the normal minimax algorithm.

Divide and Conquer

Some progress can be made by grouping sets of possible moves together to reduce the number of options at each turn.

General strategies can be considered in place of individual moves. A player might, for example, choose to attack a neighboring nation. In this case the board game AI is acting as the top level in a multi-tier AI.

To achieve the top-level action, a lower level AI may need to take 20 different atomic actions; the high-level strategy dictates which moves it will make.

In this case the minimaxing algorithm works at the level of a strategy game tree shown in Figure 9.18.

This approach is equally applicable to real-time games, by abstracting away from the particular moves and looking at the ebb and flow of the game from an overview.

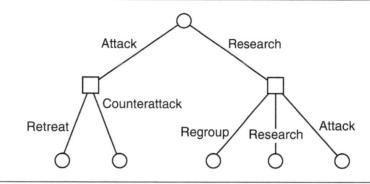

Figure 9.18: A game tree showing strategies

Heuristics

Even with aggressive divide and conquer, the problem remains huge. The strategy game AI has to be heavily based on heuristics, so much so that developers often abandon using minimax to lookahead at all and just use the heuristics to guide the process.

Heuristics used might include territory controlled, the proximity to enemy forces, technological superiority, population contentedness, and so on.

9.9.2 REAL-TIME ALIN A TURN-BASED GAME

It most cases turn-based strategy games have AI very similar to their RTS counterparts (see Chapter 6 for more details).

Most of the algorithms in the RTS chapter are directly applicable to turn-based games. In particular, systems like terrain analysis, influence mapping, strategy scripts, and high-level planning are all applicable to turn-based games. Influence mapping was originally used in turn-based games.

EXERCISES

- 9.1 Devise a scoring function for Tic-Tac-Toe.
- 9.2 Show how minimax values are bubbled up on the tree in Figure 9.19:
- 9.3 Show how negamax values are bubbled up on the tree in Exercise 9.2.
- 9.4 Show how AB minimax values are bubbled up on the tree in Exercise 9.2.
- 9.5 Show how AB negamax values are bubbled up on the tree in Exercise 9.2.

Figure 9.19: Minimax values in a tree

- 9.6 Show how aspirational search values are bubbled up the tree in Exercise 9.2 using the range (5, 20). Comment on your result.
- 9.7 Show how the negascout algorithm operates on the tree in Exercise 9.2.
- 9.8 Devise a Zobrist hash scheme for the game Connect Four (you'll have to look it up if you've never heard of it). (Hint: A board position can be described by specifying whether each of the locations contains a red disc, a yellow disc, or is empty.)

PART III

Supporting Technologies

10

EXECUTION MANAGEMENT

There are only limited processor resources available to a game. Traditionally, most of these have been used to create great graphics: the primary driving force in mass market games. Much of the hard graphical processing is now performed on the GPU, but not all of it. Faster CPUs have also allowed the processor budget given to AI developers to grow steadily, meaning that techniques too costly at one time, can now be implemented on even modest mobile hardware. It is not unheard of for AI to have more than 50% of the processor time, although 5 to 25% is a more common range.

Even with more execution time available, processor time can easily get eaten up by pathfinding, complex decision making, and tactical analysis. AI is also inherently inconsistent. Sometimes you need lots of time to make a decision (planning a route, for example), and sometimes a tiny budget is enough (moving along the route). All your characters may need to pathfind at the same time, and then you may have hundreds of frames where nothing much is happening to the AI.

A good AI system needs facilities that can make the best use of the limited processing time available. There are three main elements to this: dividing up the execution time among the AI that needs it, having algorithms that can work a bit at a time over several frames, and, when resources are scarce, giving preferential treatment to important characters. This chapter looks at these performance management issues to build up a comprehensive AI scheduling tool.

The solution is motivated by AI, and without complex AI it is rarely needed. But developers with a good AI scheduling system tend to use it for many other purposes, too. I have seen a range of applications for the good scheduling infrastructure: incremental loading of new

areas of the level, texture management, game logic, audio scheduling, and physics updates all controlled by scheduling systems originally designed with AI in mind.

10.1 SCHEDULING

Lots of elements of a game change rapidly and have to be processed every frame. Characters on-screen are usually animated, requiring the geometry to be updated to display each frame. The position and motion of objects in the world are processed by the physics system. This needs frequent updating to move objects correctly through space and have them bounce and interact properly. For smooth gameplay, the user's inputs need to be processed quickly and feedback provided on-screen.

In contrast, the AI controlling some of the characters changes much less often. If a military unit is moving across the whole game map, its route can be calculated once and then the path followed until the goal is reached. In a dogfight, an AI plane may have to make complex motion calculations every frame, to stay in touch with its quarry. But once the plane has decided who to go after, it doesn't need to think tactically and strategically as often.

A scheduling system manages which tasks get to run when. It copes with different execution frequencies and different task durations. It should help smooth the execution profile of the game so that no big processing peaks occur. The scheduling system in this section will be general enough for most game applications, AI and otherwise.

A key feature for the design of the scheduler is speed. We don't want to spend a lot of time processing the scheduler code, especially as it is being constantly run, doing tens if not hundreds or thousands of management tasks every frame.

10.1.1 THE SCHEDULER

Schedulers work by assigning a pot of execution time among a variety of tasks, based on which ones need the time.

Different AI tasks can and should be run at different frequencies. We can simply schedule some tasks to run every few frames and other tasks to run more frequently. The AI is sliced and distributed over multiple frames. It is a powerful technique for making sure that the game doesn't take too much AI time overall and that more complex tasks can be run infrequently. It is shown diagrammatically in Figure 10.1.

This conforms to what we'd generally expect of intelligent characters. Real humans make simple split-second decisions all the time, such as basic movement control. We take a little longer to process sensory information (to react to an incoming projectile, for example), but this processing takes a little longer to complete. Similarly, we only make large-scale tactical and strategic decisions infrequently: every few seconds at the most. These large-scale decisions are typically the most time-consuming.

When there are lots of characters, each with its own AI, we can use the same slicing technique to execute only a few of the characters on each frame. If 100 characters have to update

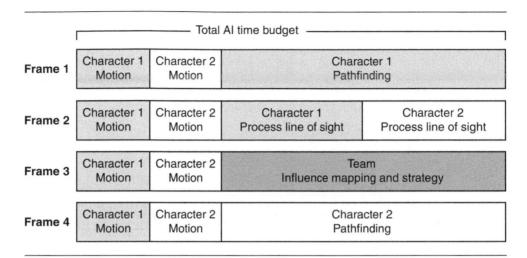

Figure 10.1: AI slicing

their state every 30 frames (once a second), then we can process 3 or 4 characters on each frame.

Frequencies

The scheduler takes tasks, each one having an associated frequency that determines when it should be run.

On each time frame, the scheduler is called to manage the whole AI budget. It decides which behaviors need to be run and calls them.

This is done by keeping count of the number of frames passed. This is incremented each time the scheduler is called. It is easy to test if each behavior should be run by checking if the frame count is evenly divisible by the frequency. The modulo division operation on integers (%) is admittedly among the slowest integer math operations on most hardware, but as it is provided on the hardware, and since we need relatively few of them, it will be plenty fast enough for this use.

On its own, this approach suffers from clumping: some frames with no tasks being run, and other frames with several tasks sharing the budget.

In Figure 10.2 we see a problem with this. There are three behaviors with frequencies of 2, 4, and 8. Whenever behavior B runs, A is always running. Similarly, whenever behavior C runs, both B and A are running. If the aim is to spread out the load, then this is a poor solution.

In this case the frequencies clash because they have a common divisor (a divisor is a number that can be divided into another a whole number of times). So 1, 2, and 3 are the only

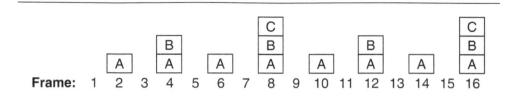

Figure 10.2: Behaviors in phase

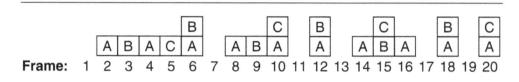

Figure 10.3: Relatively prime

divisors of 6. A common divisor is one that divides into a set of numbers. So 8 and 12 have three common divisors: 1, 2, and 4. All numbers have 1 as a divisor, but that is irrelevant here. It's the higher numbers that cause the problems.

A first step to solving the problem is to try picking frequencies that are relatively prime: those that do not have a number that divides into all of them (except 1, of course).

In Figure 10.3 we've made both behaviors B and C more frequent, but we get fewer clashing problems because they are relatively prime.

Phase

Even relatively prime frequencies still clash, however. The example shows three behaviors at frequencies of 2, 3, and 5. Every 6 frames, behaviors A and B clash, and every 30 frames, all of them clash.

Making frequencies relatively prime makes the clash points less frequent but doesn't eliminate them.

To solve the problem, we add an additional parameter to each behavior. This parameter, called *phase*, doesn't change the frequency but offsets when the behavior will be called. Imagine three behaviors all with a frequency of 3. Under the original scheduler, they will all run at the same time—every three frames. If we could offset these, they could run on consecutive frames, so each frame would have one behavior running, but all behaviors would run every three frames.

Pseudo-Code

We can implement a basic scheduler in the following way:

```
class FrequencyScheduler:
       # The data per behavior to schedule.
2
       class BehaviorRecord:
3
           thingToRun: function
           frequency: int
           phase: int
       # The list of behavior records.
       behaviors: BehaviorRecord[]
       # The current frame number.
11
       frame: int
13
       # Adds a behavior to the list.
14
       function addBehavior(func: function, frequency: int, phase: int):
15
           # Compile and add the record.
16
           record = new Record()
17
           record.functionToCall = func
18
           record.frequency = frequency
19
           record.phase = phase
20
           behaviors += record
21
22
       # Called once per frame.
23
       function run():
           # Increment the frame number.
           frame += 1
           # Go through each behavior.
28
           for behavior in behaviors:
29
                # If it is due, run it.
30
                if behavior.frequency % (frame + behavior.phase):
31
                    behavior.thingToRun()
32
```

Implementation Notes

The phase value is added to the time value immediately before the modular division is performed. This is the most efficient way of incorporating phase. It may seem clearer to check something like the following:

```
time % frequency == phase
```

Having a phase added, however, allows us to use phase values greater than the frequency. If you need to schedule 100 agents to run every 10 frames, then you can do the following:

```
for i in 1..100:
      behavior[i].frequency = 10
2
      behavior[i].phase = i
```

This is less error prone; if the developer changes the frequency but not the phase, the behavior won't suddenly stop being executed.

Performance

The scheduler is O(1) in memory and O(n) in time, where n is the number of behaviors being managed.

Direct Access

This algorithm is suitable for situations where there are a reasonable number of behaviors (tens or hundreds) and when frequencies are fairly small. Checking is needed to make sure each behavior needs to be run. It may be that several behaviors always run together (as in the 100 agents example in the previous implementation notes). In this case, checking each of the 100 is probably wasteful.

If your game has only a fixed number of characters and they all have the same frequency, then you can simply set up an array with all the behaviors that will be run together stored in a list in one element of the array. With a fixed frequency, the element can be accessed directly, and all the behaviors run. This will then be O(m) in time, where m is the number of behaviors to be run.

Pseudo-Code

This might look like the following:

```
class DirectAccessFrequencyScheduler:
       # The data for a set of behaviors with one
2
       # frequency.
3
       class BehaviorSet:
4
           functionLists: function[]
5
           frequency: int
       # The multiple sets, one for each frequency needed.
8
9
       sets: BehaviorSet[]
10
11
       # The current frame number.
```

```
frame: int
12
13
       # Add a behavior to the list.
14
        function addBehavior(func: function, frequency: int, phase: int):
15
            # Find the correct set.
16
            set: BehaviorSet = sets[frequency]
17
            # Add the function to the list.
            set.functionLists[phase] += func
19
20
       # Called once per frame.
21
        function run():
22
            # Increment the frame number.
23
            frame += 1
24
25
            # Go through each frequency set.
26
            for set in sets:
27
                # Calculate the phase for this frequency.
28
                phase: int = set.frequency % frame
29
30
                # Run the behaviors in the appropriate location
31
                # of the array.
32
                for func in functionLists[phase]:
33
                     func()
```

Data Structures and Interfaces

The set's data member holds instances of BehaviorSet. In the original implementation I used the for ... in ... operation to get the elements of the set, in any order. In this implementation the set is also used as a hash table, looking up an entry by its frequency value.

If there is a complete set of frequencies up to the maximum (e.g., if there is a maximum frequency of 5, and there are BehaviorSet instances for frequencies of 4, 3, and 2), then we can use an array lookup by frequency, rather than a hash table.

Performance

This is O(fp) in time, where f is the number of different frequencies, and p is the number of behaviors per phase value. If all the array elements have some content (i.e., all phases have corresponding behaviors) then this will be equal to O(m), as promised.

Storage is O(fFp), where F is the average frequency used.

For a fixed number of behaviors, this may be a good solution, but it is memory hungry and doesn't provide a good performance increase when there are lots of different frequencies and phase values being used.

In this case, the original implementation, with some kind of hierarchical scheduling (discussed later in the section), is probably optimal.

Phase Quality

Calculating good phase values to avoid spikes can be difficult. It is not intuitively clear whether a particular set of frequency and phase values will lead to a regular spike or not. It is naive to expect the developer who integrates the components of the game to be able to set optimal phase values. The developer will generally have a better idea of what the relative frequencies need to be, however.

We can create a metric that measures the amount of clumping that will occur in a frequency and phase implementation. This gives feedback as to the expected quality of the scheduler.

We simply sample a large number of different random time values and accumulate statistics for the number of behaviors that are being run. It will take only a couple of seconds to sample millions of frames' worth of scheduling for tens of tasks. We get minimum, maximum, average, and distribution statistics. Optimal scheduling will have a small distribution, with minimum and maximum values close to the average.

Automatic Phasing

Even with good-quality feedback, changing phase values is not intuitive. It would be better to take the burden of setting phases from the developer.

It is possible to calculate a good set of phases for a set of tasks with different frequencies. This allows the scheduler to expose the original implementation, taking a frequency only for each task.

Wright's Method

Wright and Marshall, the first to write about game AI scheduling in some depth ([77] although it had been widely used by many developers in much the same form), provided a simple and powerful phasing algorithm.

When a new behavior is added to the scheduler, with a frequency of f, we perform a dry run of the scheduler for a fixed number of frames into the future. Rather than executing behaviors in this dry run, we simply count how many would be executed. We find the frame with the least number of running behaviors. The phase value for the behavior is set to the number of frames ahead at which this minimum occurs.

The fixed number of frames is normally a manually set figure found by experimentation. Ideally, it would be the least common multiple (LCM) of all the frequency values used in the scheduler. Typically, however, this is a large number and would slow the algorithm unnecessarily (for frequencies of 2, 3, 5, 7, and 11, for example, we have an LCM of 2310).

Figure 10.4 shows this in operation. The behavior is added with a frequency of 5 frames. We can see that over the next 10 frames (including the current one) frames 3 and 8 have the least number of combined behaviors. We can therefore use a phase value of 3.

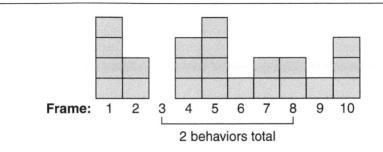

Figure 10.4: Wright's phasing algorithm

This approach is excellent in practice. It has a theoretical chance that it will still produce heavy spikes, if the lookahead isn't at least as large as the size of the LCM.

Single Task Spikes

Using relatively prime frequencies and calculated phase offsets, you can minimize the number of frames that have spikes in AI time by distributing the hard work.

For most cases this approach is sufficient to schedule AI, and it can be very useful for other elements of the game that only have to be performed occasionally. In some circumstances, however, a piece of code is so expensive to run that it will cause a spike all on its own if it is run within a frame.

More advanced schedulers need to allow processes to be run across multiple frames. These are interruptible processes.

10.1.2 INTERRUPTIBLE PROCESSES

An interruptible process is one that can be paused and resumed when needed. Complex algorithms such as pathfinding should ideally be run for just a short time on each frame. After enough total time, a result will be available for use, but it won't finish on the same frame as it started. For many algorithms, the total time that the algorithm uses is far too large for one frame, but in small bites it doesn't jeopardize the budget.

Threads

There is already a general programming tool to implement any kind of interruptible process. Threads are available on all game machines (with the exception of some varieties of embedded processors with such limited capabilities it would be unlikely you'd be able to run complex AI in any case). Threads allow chunks of code to be paused and returned to at a later time.

Most threading systems switch between threads automatically using a mechanism called preemptive multitasking. This is a mechanism where the code is paused, regardless of what it is doing. All of its settings are saved, and then another code is loaded into the processor in its place. This facility is implemented at a hardware level and is often managed by the operating system.

We could take advantage of threads by putting the time-consuming tasks in their own thread. This way we would avoid using a special scheduling system. Unfortunately, despite being simple to implement, this is not often a sensible solution.

Switching between threads involves unloading all the data for the exiting thread and reloading all the data for the new thread. This adds significant time. Each switch involves flushing memory caches and doing a lot of housekeeping. Many developers, rightly so, have avoided using lots of threads. While a few tens of threads may not cause noticeable performance drops on a PC, using a thread in a real-time strategy (RTS) game for each character's pathfinding algorithm would be excessive.

Software Threads

For larger numbers of simultaneous behaviors, a manual scheduler is the most common solution. This requires behaviors to be written so that they return control after processing for a short time. Whereas the hardware can manually muscle in and boot out a threaded process, the scheduler relies on it behaving nicely and surrendering control after a short bout of processing.

This has the advantage that the scheduler doesn't need to manage the clean-up and housekeeping for the change of thread; it assumes that the task saved all the data it needed (and only the data it needed) before returning control.

This scheduling approach is known as "software threads" or "lightweight threads" (although the latter is also used to mean micro-threads; see below) and the overall approach is called "cooperative multitasking."

The scheduling system we've looked at so far can cope with interruptible processes without modification. The difficulty is writing the behaviors to be scheduled. Behaviors scheduled with a frequency of 1 will get called each frame. If the code is written in such a way that it only takes a short time to do a bit more processing and then returns, the repeated calling will eventually provide it time to complete.

Micro-Threads

Although operating systems support threads, they often add a lot of extra processing and overhead. This overhead allows them to better manage thread switching—to track down errors or to support advanced memory management.

This overhead can be unnecessary in a game, and many developers have experimented

with writing their own thread switching code, sometimes called *micro-threads* (or lightweight threads, confusingly).

By trimming down the thread overhead, a relatively speedy threading implementation can be achieved. If the code in each thread is aware of the way threads are switched, then it can avoid operations that expose the shortcuts made.

This approach produces very fast code, but can also be extremely difficult to debug and develop. While it might be suitable for running a small number of key systems, developing the whole game in this way can be a nightmare. Personally, I've always stayed away from it, but I know there are developers who are quite comfortable with mixing the approach with some of the other scheduling techniques in this section.

Hyper-Threads and Multiple Cores

On PCs, and recent generations of consoles, a new approach to threading is possible. Modern CPUs have a number of separate processing pipelines, each working at the same time. The latest PCs and the current generation of games machines have multiple cores: multiple complete CPUs on one sliver of silicon.

In normal operation the CPU splits its execution task into chunks and sends a chunk to each pipeline. It then takes the results and merges them together (sometimes realizing it needs to go back and do something again because the results of one pipeline conflict with those of another).

Hyper-threading is a technology whereby these pipelines are given their own thread to process; different threads literally run at the same time. On multi-core machines each processor can be given its own thread.

It seems clear that this parallel architecture will become increasingly ubiquitous throughout PCs, consoles, and handheld games machines. It is potentially very fast. Threads are still switched in the normal way, however, so for large numbers of threads it still isn't the most efficient solution.

Quality of Service

Console manufacturers have stringent sets of requirements that need to be fulfilled before a game can be released on their platform. Frame rates are an obvious sign of quality to gamers, and all console manufacturers specify that frame rates should be steady.¹ Frame rates of 30, 60, and (with the advent of VR) 90 Hz are most common and require that all game processing be completed in 33, 16, or 11 milliseconds.

1. Frame rates in the technical requirements for a console used to be very strictly enforced. Over the last 10 years this enforcement has become less zealous. It was never unheard of, but is now more common for games to drop frames, or have areas of the game with lower frame rates. The requirements have not been scrapped, however. It just isn't always clear when they will be enforced, and so cannot be completely ignored.

At 60 Hz, if the whole processing uses 16 milliseconds, then everything is fine. If it gets done in 15 milliseconds, that's fine, too, but the console waits around for the extra millisecond doing nothing. That is time that could be used to make the game more impressive—an extra visual effect, a cloth simulation, or a few more bones in the skeleton of the character.

For this reason, time budgets are usually pushed as close to the limit as possible. To make sure the frame rate doesn't drop, it is critical that limits be placed on how long the graphics, physics, and AI will take. It is often more acceptable to have a long-running component than a component that fluctuates wildly.

The scheduling system I have described so far expects behaviors to run for a short time. It trusts that the fluctuations in running time will average out any differences to give a steady AI time. In many cases this is just not good enough and more control is necessary.

Threads can be difficult to synchronize. If a behavior is always being interrupted (i.e., by a thread switch) before it can return a result, then its character might simply stand still and do nothing. A tiny change in the amount of processing can often give rise to this kind of problem, which is very difficult to debug and can be even harder to correct. Ideally, we'd like a system that allows us to control total execution time, while being able to guarantee that behaviors get run. We'd also like to be able to access statistics that help us understand where processing time is being used and how behaviors are taking their share of the pie.

10.1.3 LOAD-BALANCING SCHEDULER

A load-balancing scheduler understands the time it has to run and distributes this time among the behaviors that need to be run.

We can turn our existing scheduler into a load-balancing scheduler by adding simple timing data.

The scheduler splits the time it is given according to the number of behaviors that must be run on this frame. The behaviors that get called are passed timing information so they can decide when to stop running and return.

Because this is still a software threading model, there is nothing to stop a behavior from running for as long as it wants. The scheduler trusts that they will be well behaved. To adjust for small errors in the running time of behaviors, the scheduler recalculates the time it has left after each behavior is run. This way an overrunning behavior will reduce the time that is given to others run in the same frame.

Pseudo-Code

```
class LoadBalancingScheduler:
       # The data per behavior to schedule.
2
3
       class BehaviorRecord:
4
           thingToRun: function
5
           frequency: int
```

```
phase: int
6
7
       # The list of behavior records.
8
       behaviors: BehaviorRecord[]
9
10
       # The current frame number.
11
       frame: int
12
13
       # Adds a behavior to the list.
14
       function addBehavior(func: function, frequency: int, phase: int):
15
            # Compile and add the record.
            record = new Record()
17
            record.functionToCall = func
18
            record.frequency = frequency
19
            record.phase = phase
20
            behaviors += record
21
22
       # Called once per frame.
23
       function run(timeToRun: int):
24
            frame += 1
25
            runThese: BehaviorRecord[] = []
26
27
            # Go through each behavior.
28
            for behavior in behaviors:
29
                # If it is due, schedule it.
30
                if behavior.frequency % (frame + behavior.phase):
31
                    runThese.append(behavior)
32
            # Keep track of the current time.
34
            currentTime: int = time()
35
36
            # Go through the behaviors to run.
37
            numToRun: int = runThese.length()
38
            for i in 0...numToRun:
39
                # Find the time used on the previous iteration.
40
                lastTime = currentTime
41
                currentTime = time()
42
                timeUsed = currentTime - lastTime
43
                # Distribute remaining time to remaining behaviors.
45
                timeToRun -= timeUsed
                availableTime = timeToRun / (numToRun - i)
47
                # Run the behavior.
49
                runThese[i].thingToRun(availableTime)
50
```

Data Structures

The functions that we are registering should now take a time value, indicating the maximum time they should run.

We have assumed that the list of functions we want to run has a length method that gets the number of elements.

Performance

The algorithm remains O(n) in time (n is the total number of behaviors in the scheduler), but is now O(m) in memory, where m is the number of behaviors that will be run. We cannot combine the two loops to give O(1) memory because we need to know how many behaviors we will be running before we can calculate the allowed time.

These values are excluding the processing time and memory of the behaviors. Our whole aim with this algorithm is that the processing resources used by the scheduled behaviors is much greater than those spent scheduling them.

10.1.4 HIERARCHICAL SCHEDULING

While a single scheduling system can control any number of behaviors, it is often convenient to use multiple scheduling systems. A character may have a number of different behaviors to execute—for example, pathfinding a route, updating its emotional state, and making local steering decisions. It would be convenient if we could run the character as a whole and have the individual components be scheduled and allotted time. Then we can have a single toplevel scheduler that gives time to each character, and the time is then divided according to the character's composition.

Hierarchical scheduling allows a scheduling system to be run as a behavior by another scheduler. A scheduler can be assigned to run all the behaviors for one character, as in the previous example. As in Figure 10.5, another scheduler can then allocate time on a per-character basis. This makes it very easy to upgrade a character's AI without unbalancing the timing of the whole game.

With a hierarchical approach, there is no reason why the schedulers at different levels should be of the same kind. It is possible to use a frequency-based scheduler for the whole game and priority-based schedulers (described later) for individual characters.

Data Structures and Interfaces

To support this, we can move from schedulers calling functions to a generic interface for all behaviors:

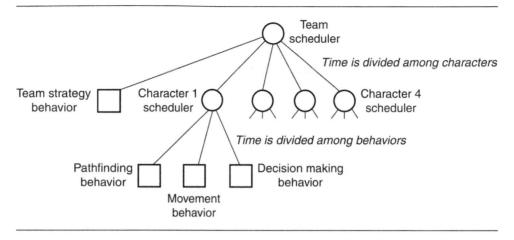

Figure 10.5: Behaviors in a hierarchical scheduling system

```
class Behavior:
    function run(time)
```

Anything that can be scheduled should expose this interface. If we want hierarchical scheduling, then the schedulers themselves also need to expose it (the load-balancing scheduler above has the right method, it just needs to explicitly derive from Behavior). We can make our schedulers work by modifying the LoadBalancingScheduler class in the following way:

```
class LoadBalancingScheduler (Behavior):
    # ... All contents as before ...
```

Since behaviors are now classes rather than functions, we also need to change the way they are called. Previously, we used a function call, and now we need to use a method call, so:

```
entry(availableTime)
becomes:
    entry.run(availableTime)
```

in the LoadBalancingScheduler class.

Behavior Selection

On its own there is nothing that hierarchical scheduling provides that a single scheduler cannot handle. It comes into its own when used in combination with level of detail systems, described later. Level of detail systems are behavior selectors; they choose only one behavior to run.

In a hierarchical structure this means that schedulers running the whole game don't need to know which behavior each character is running. A flat structure would mean removing and registering behaviors with the main scheduler each time the selection changed. This is prone to runtime errors, memory leaks, and hard-to-trace bugs.

10.1.5 PRIORITY SCHEDULING

There are a number of possible refinements to the frequency-based scheduling system. The most obvious is to allow different behaviors to get a different share of the available time. Assigning a priority to each behavior and allocating time based on this is a good approach.

In practice, this bias (normally called *priority*) is just one of many time allocation policies that can be implemented. If we go a little further with priorities, we can remove the need for frequencies entirely.

Each behavior receives a proportion of the AI time according to its priority.

Pseudo-Code

```
class PriorityScheduler:
       # The data per behavior to schedule.
2
       class BehaviorRecord:
3
            thingToRun: function
4
            frequency: int
5
            phase: int
6
7
            priority: float
       # The list of behavior records.
10
       behaviors: BehaviorRecord[]
11
12
       # The current frame number.
       frame: int
13
14
       # Adds a behavior to the list.
15
       function addBehavior(func: function,
16
                              frequency: int,
17
                              phase: int,
18
                              priority: float):
19
            # Compile and add the record.
20
21
            record = new Record()
            record.functionToCall = func
22
            record.frequency = frequency
23
            record.phase = phase
24
```

```
record.priority = priority
25
            behaviors += record
26
       # Called once per frame.
28
       function run(timeToRun: int):
29
            # Increment the frame number.
30
            frame += 1
31
32
            # Keep a list of behaviors to run, and their total
33
            # priority.
34
            runThese: BehaviorRecord[] = []
35
            totalPriority: float = 0
            # Go through each behavior.
            for behavior in behaviors:
39
                # If it is due, schedule it.
40
                if behavior.frequency % (frame + behavior.phase):
41
                     runThese.append(behavior)
42
                    totalPriority += behavior.priority
43
44
            # Keep track of the current time.
45
            currentTime: int = time()
46
47
            # Go through the behaviors to run.
48
            numToRun: int = runThese.length()
49
            for i in 0..numToRun:
50
                # Find the time used on the previous iteration.
                lastTime = currentTime
                currentTime = time()
                timeUsed = currentTime - lastTime
55
                # Distribute remaining time to remaining behaviors
56
                # based on priority.
57
                timeToRun -= timeUsed
58
                availableTime =
59
                    timeToRun * behavior.priority / totalPriority
60
61
                # Run the behavior.
62
                runThese[i].thingToRun(availableTime)
63
```

Performance

This algorithm has the same characteristics as the load-balancing scheduler: O(n) in time and O(m) in memory, excluding the processing time and memory used by the scheduled behaviors.

Other Policies

One priority-based scheduler I worked with had no frequency data at all. It used only the priorities to divide up time, and all behaviors were scheduled to run every frame. The scheduler presumed that every behavior was interruptible and would continue its processing in the follow frame if it did not complete. In this case, having all behaviors running, even for a short time, made sense.

Alternatively, we could also use a policy where each behavior asks for a certain amount of time, and the scheduler splits up its available time so that behaviors get what they ask for. If a behavior asks for more time than is available, it may have to wait for another frame before getting its request. This is usually combined with some kind of precedence order, so behaviors that are more important will be preferred when allocating the budget.

Alternatively, we could distribute time according to bias, then work out the actual length of time behaviors are taking and change their bias. A behavior that always overruns, for example, might be given less time to try to make sure it doesn't squeeze others.

The sky's the limit, no doubt, but there are practical concerns, too. If your game is under high load, it may take some tweaking to find a perfect strategy for dividing up time. I haven't seen a complex game where the AI didn't benefit from some kind of scheduling (excluding games where the AI is so simple that it always runs everything in a frame). The mechanism usually requires some tweaking.

Priority Problems

There are subtle issues with priority-based approaches. Some behaviors need to run regularly, while others don't; some behaviors can be cut into small time sections, while others require their time all at once; some behaviors can benefit from spare time, while others will not improve. A hybrid approach between priority and frequency scheduling can solve some of these issues, but not all.

The same issues arise for hardware and operating system developers who are implementing threads. Threads can have priorities, different allocation policies, and different frequencies. Look for information on implementing threading if you need a really nuts-and-bolts scheduling approach. Game scheduling needs to be far less complex than an operating system, so most games don't need this amount of fine tuning. A simple approach, such as the frequency implementation earlier in this section, is powerful enough.

10.2 ANYTIME ALGORITHMS

The problem with interruptible algorithms is that they can take a long time to complete. Imagine a character trying to plan a route across a very large game level. At the rate of a few hundred microseconds per frame, this could take several seconds to complete.

The player will see the character stand still, doing nothing for several seconds, before

moving off with great purpose. If the perception window isn't very large, this will immediately alert the player, and the character will appear unintelligent. It is ironic that the more complex the processing going on and the more sophisticated the AI, the longer it will take and the more likely the character is to look stupid.

When we do the same process, we often start acting before we have finished thinking. This interleaving of action and thinking relies on our ability to generate poor but fast solutions and to refine them over time to get better solutions. We might move off in the rough direction of our goal, for example. In the couple of seconds of initial movement, we have worked out the complete route. Chances are the initial guess will be roughly okay, so nothing will be out of place, but on occasion we'll remember something key and have to double back (we'll be halfway to the car and realize we've forgotten the keys, for example).

AI algorithms that have this same property are called "anytime algorithms." At any time you can request the best idea so far, but leave the system to run longer and the result will improve.

Putting an anytime algorithm into our existing scheduler requires no modifications. The behavior needs to be written in such a way that it always makes its best guess available before returning control to the scheduler. That way another behavior can start acting on the guess, while the anytime algorithm refines its solution.

The most common use of anytime algorithms is for movement or pathfinding. This is usually the most time-consuming AI process. Certain variations of common pathfinding techniques can be easily made into anytime algorithms. Other suitable candidates are turn-based AI, learning, scripting language interpreters, and tactical analysis.

10.3 LEVEL OF DETAIL

In Chapter 2 I described the perception window: the player's attention that roams selectively during gameplay. At any time the player is likely to be focused on only a small area of the game level. It makes sense to ensure that this area looks good and contains realistic characters, even at the expense of the rest of the level.

GRAPHICS LEVEL OF DETAIL

Level of detail (LOD) algorithms have been used for years in graphics programming. The idea is to spend the most computational effort on areas of the game that are most important to the player. Close-up, an object is drawn with more detail than it is at a distance.

In most graphics LOD techniques, the detail is a function of the geometric complexity: the number of polygons drawn in a model. At a distance even a few polygons can give the impression of an object; closeup, the same object may require thousands of polygons.

Another common approach is to use LOD for texture detail. This is either supported in hardware or at least shimmed in every rendering API. Textures are mipmapped; they are stored in multiple LODs, and distant objects use lower resolution versions. In addition to texture and geometry, other visual artifacts can be simplified: special effects and animation are both commonly reduced or removed for objects at a distance.

Levels of detail are usually based on distance, but not exclusively. In many terrain rendering algorithms, for example, silhouettes of hills at a distance are drawn with more detail than a piece of flat ground immediately next to the player. Distance is only a heuristic, noticeability is the important thing. Anything that is more noticeable to the player needs more detail.

The hemispherical headlight on an old motorbike, for example, jars the eye if it is made of few polygons (human eyes detect corners easily). It may end up accounting for 15% of the polygons in a low polygon model, simply because we don't expect to see corners on a spherical object. In the guts of the bike, however, where there is more detail in reality, we can use fewer polygons, because the eye is expecting to see corners and a lack of smoothness.

There are two general principles here. First, spend the most effort on the things that will be noticed, and second, spend effort on those things that cannot be approximated easily.

10.3.2 AI LOD

Level of detail algorithms in AI are no different to those in graphics: they allocate computer time in preference to those characters that are most important or most sensitive to error, from the player's point of view.

Cars at a distance along the road, for example, don't need to follow the rules of the road correctly; players are unlikely to notice if they change lanes randomly. At a very long distance, players are even unlikely to notice if a lot of cars are passing right through one another. Similarly, if a character in the distance takes 10 seconds to decide where to move to next, it will be less noticeable than if a nearby character suddenly stops for the same duration.

Despite these examples, AI LOD is not primarily driven by distance. We can watch a character from a distance and still have a good idea about what it is doing. Even if we can't watch them, we expect characters to be acting all the time. If the AI applied only when the character was on-screen, then it would look odd when we turn away for a while and turn back to find the same character at exactly the same location, mid-walk. As well as distance, we have to consider how likely it is that a player would watch a character or look to see if it had moved. That depends on the role the character has in the game.

Importance in AI is often dictated by the story of the game. Many game characters are added for flavor; it doesn't matter if they are always walking around the town in a fixed pattern, because only a very few players will notice that. You might end up with hard-core gamers on forums saying, "I followed the blacksmith around the city, and they follow the same route, and never goes to sleep or pee." But that is hardly important to the majority of your players and isn't likely to affect sales.

If a character who is central to the game's story walks around in a circle in the main square, most players will notice. It is worth letting the character have a bit more variety. Of course, this has to be balanced against gameplay concerns. If the character in question has important

information for the player's quest, then we don't want the player to have to search the whole city to track the character down and ask one more question.

Importance Values

Throughout this section I will assume that importance is a single numerical value that applies to each character in the game. Many factors can be combined to create the importance value, as we have seen. An initial implementation can usually make do with distance to start with, simply to make sure everything is up and running.

10.3.3 SCHEDULING LOD

A simple and effective LOD algorithm is based on the scheduling systems discussed previously. Simply using a scheduling frequency based on the importance of a character provides an LOD system.

Important characters can receive more processing time than others by being scheduled more frequently. If you are using a priority-based scheduling system, then both frequency and priority can depend on importance.

This dependence may be by means of a function, where as importance increases the frequency value decreases, or it might be structured in categories, where a range of importance values produces one frequency and another range maps to a different frequency. Frequencies, because they are integers, effectively use the latter approach (although if there are hundreds of possible frequency values, it makes more sense to think of it as a function). Priorities, on the other hand, can work in either way.

Under this scheme characters have the same behavior whether their importance value is high or low. The reduced time available has different effects on the character depending on whether a frequency or priority-based scheduler is used.

Frequency Schedulers

In a frequency-based implementation, less important characters get to make decisions less often.

Characters moving through a city, for example, may keep walking in a straight line between calls to their AI. If the AI is called infrequently, they may overshoot their target and have to double back occasionally. Alternatively, they may not be able to react in time to a collision with another pedestrian.

Priority Schedulers

Priority-based implementations give more time to important behaviors. All behaviors may be run every frame, but important ones can run for longer. We assume that anytime algorithms are being used, so the character can begin to act before its AI processing is complete.

Characters with low importance will tend to make worse decisions than those with high importance. The characters above, for example, will not overshoot their target, but they may elect to go a bizarre route to their destination, rather than a seemingly obvious shortcut (i.e., their pathfinding algorithm may not have time to get the best result). Alternatively, when avoiding another pedestrian, the behavior may not have time to check if the new path is clear, causing the character to collide with someone else.

Combined Scheduling

Combining frequency and priority scheduling can reduce the problems caused with scheduling LOD. Priority scheduling allows AI to be run more often (reducing behavior lock-in such as overshooting), while frequency scheduling allows AI to be run longer (providing better quality decisions).

It is not a silver bullet, however. In both the examples a low-importance character may collide with other characters more often. Combining approaches will not get around the fact that collision avoidance, essential for nearby characters, takes lots of processing power. It is often better to change a character's behavior entirely when its importance drops.

10.3.4 BEHAVIORAL LOD

Behavioral LOD allows a character's choice of behavior to depend on its importance. The character selects one behavior at a time based on its current importance. As its importance changes, the behavior may be changed for another. The aim is that behaviors associated with lower importance require fewer resources.

For each possible importance value there is an associated behavior. At each time step the behavior is selected based on the importance value.

A pedestrian in a role-playing game (RPG), for example, might have fairly complex collision detection, obstacle avoidance, and path following steering when it is important. Pedestrians in the periphery of the action (such as those on a distant walkway or seen from a bridge) can have their collision detection disabled completely. Passing through one another freely isn't nearly as noticeable as you would expect. It is certainly less noticeable than frequent pinball-style collisions. This is because our optic apparatus is tuned for detecting changes in motion more than smooth motion.

Entry and Exit Processing

Behaviors have memory requirements as well as processor load. For games with many characters (such as RPGs or strategy games), it is impossible to keep the data for all possible behaviors of all characters in memory at one time. We want the LOD mechanism to keep memory as well as execution time as low as possible.

To allow the data to be created and destroyed correctly, code is executed when a behavior is entered and when it is exited. The exiting code can clean up any memory used in the previous LOD, and the entry code can set up data correctly in the new LOD ready to be processed.

To support this extra step, the LOD system needs to keep track of the behavior it ran last time. If the behavior it intends to run is the same, then no entry or exit processes are needed. If the behavior is different, then the current behavior's exit routine is called, followed by the new behavior's entry routine.

Behavior Compression

Low-detail behaviors are often approximations of high-detail behaviors. A pathfinding system may give way to a simple "seek" behavior, for example. Information stored in the high-detail behavior can be useful to the low-detail behavior.

To make sure the AI is memory efficient, we normally throw away the data associated with a behavior when it is switched off. At the entry or exit step, behavior compression can retrieve the data that could be useful to the new LOD, convert it to a correct format, and pass it along.

Imagine RPG characters in a market square with complex goal-driven decision making systems. When they are important, they consider their needs and plan actions to meet them. When they are less important, they move around between random market stalls. Using behavior compression, the noticeable join between behaviors can be reduced. When characters move from low to high importance, their plan is set so that the stall they were heading to becomes the first item on the plan (to avoid them turning in mid-stride and heading for a different target). When they move from high to low importance, they don't immediately make a random choice; their target is set from the first item on the plan.

Behavior compression provides low-importance behaviors with a lot more believability. High importance behaviors can be run less often, and they can have a smaller range of importance values for which they are active. The disadvantage is development effort: custom routines need to be written for each pair of behaviors that is likely to be used sequentially. Unless you can guarantee that importance will never change rapidly, single entry and exit routines are not enough; transition routines are required for each pair of behaviors.

Hysteresis

Imagine a character that switched between behaviors at a distance of 10 meters from the player. Closer than this value, the character has a complex behavior, while it is dumber when more distant. If the player happens to be walking along behind the character, it may continually be shifting across the 10-meter boundary.

The switching between behaviors, which may be unnoticeable if it happens occasionally, will stand out if it is rapidly fluctuating. If either of the behaviors uses an anytime algorithm, it is possible that the algorithm will never get enough time to generate sensible results; it will be continually switched out. If the behavior switch has an associated entry or exit processing step, the fluctuation may cause the character to have even less time than if it chose one level or the other.

As with any behavior switching process, it is a good idea to introduce hysteresis: boundaries that are different depending on whether the underlying value (the importance in our case) is increasing or decreasing.

For LOD, each behavior is given an overlapping range of importance values where it is valid. Each time the character is run, it checks if the current importance is within the range of the current behavior. If it is, then the behavior is run. If it is not, then the behavior is changed. If only one behavior is available, then it can be selected. If more than one behavior is available, then we need an arbitration mechanism to choose between them.

The most common arbitration techniques are discussed here.

Choose Any Available Behavior

This is the most efficient selection mechanism. We can find any available behavior by making sure each is ordered by its range and performing a binary search.

The range is controlled by two values (maximum and minimum), but the ordering cannot take this into control, so the binary search may not give a correct result. We need to look at the nearby ranges if the initial behavior is not available. The ordering is most commonly performed by sorting in order of the midpoint of the range.

Choose the First Available Behavior in the List

This is an efficient way of selecting a behavior, because we don't need to check to see how many behaviors are valid. As soon as we find one, we use it. As we saw in Chapter 5, it can provide rudimentary priority control. By arranging possible behaviors in order of priority, the highest priority behavior will be selected.

This approach is also the simplest to implement and will form the basis of the pseudo-code below.

Select the Most Central Behavior

We select the available behavior where the importance value is nearest to the center of its range. This heuristic tends to make the new behavior last longest before being swapped out. This is useful when the entry and exit processing is costly.

Select the Available Behavior with the Smallest Range

This heuristic prefers the most specific behavior. It is assumed that if a behavior can only run in a small range, then it should be run when it can because it is tuned for that small set of importance values.

Fallback Behaviors

The second and fourth selection methods allow for a fallback behavior that is run only when no other is available. Fallback behaviors should have ranges that cover all possible importance values. In method two, the last behavior in the list will never be run if another is available. In method four, the fallback's huge range means that the behavior will always be overruled by other behaviors.

Pseudo-Code

A behavioral LOD system can be implemented in the following way:

```
class BehavioralLOD extends Behavior:
       # The list of behavior records.
       records: BehaviorRecord[]
3
       # The current behavior.
       current: Behavior = null
       # The current importance.
       importance: float
10
       # Finds the right record to run, and runs it.
11
       function run(time: int):
           # Check if we need to find a new behavior.
13
            if not (current and current.isValid(importance)):
14
15
                # Find a new behavior, by checking each in turn.
16
                next: BehaviorRecord = null
17
                for record in records:
18
                    # Check if the record is valid.
19
                    if record.isValid(importance):
20
                        # If so, use it.
21
                        next = record
22
                        break
23
24
                # We're leaving the current behavior, so notify
25
                # it where we're going.
26
                if current and current.exit:
27
                    current.exit(next.behavior)
28
29
```

```
# Likewise, notify our new behavior where we're
30
31
                # coming from.
                if next and next.enter:
32
                    next.enter(current.behavior)
33
34
                    # Set our current behavior to be that found.
35
                    current = next
36
37
           # We should have either decided to use the previous
38
           # behavior, or else we have found a new one, either
39
           # way it is stored in the current variable, so run it.
40
           current.behavior.run(time)
41
```

Data Structures and Interfaces

I have assumed that behaviors have the following structure:

```
class Behavior:
      function run(time: int)
2
```

exactly as before.

The algorithm manages behavior records, which add additional information to the core behavior. Behavior records have the following structure:

```
# The data for one possible behavior.
   class BehaviorRecord:
       behavior: Behavior
3
       minImportance: float
4
       maxImportance: float
5
       enter: function
6
       exit: function
7
8
9
       # Check if the importance is in the correct range.
       function isValid(importance: float) -> bool:
10
           return minImportance >= importance >= maxImportance
```

The enter and exit members hold a reference to a function (they could also be implemented as methods to be overloaded, but then we'd be dealing with multiple sub-classes of behavior record). If there is no setup or breakdown needed, then either can be left unset.

The two functions are called when the corresponding behavior is entered or exited, respectively. They should have the following form:

```
function enterFunction(previous: Behavior)
function exitFunction(next: Behavior)
```

They take the next or previous behavior as a parameter to allow them to support behavior

compression. In a behavior's exit method, it can pass on the appropriate data to the next behavior it has been given.

This is the preferred approach, because it allows the exiting behavior to clear all its data. If the enter function is used to try to interrogate the previous behavior for data, then the data may have already been cleaned up. We could, of course, swap the order of the two calls so that enter is called before exit. Unfortunately, this means that the memory for both behaviors is active at the same time, which can cause memory spikes. On platforms with time-consuming garbage collection, such as Unity, we definitely want the memory used to be stable, and preallocated memory should be reused. It is usually safe to err on that side and have a short time when neither behavior is fully configured.

Implementation Notes

The pseudo-code above is designed so that the behavior LOD can function as a behavior in its own right. This allows us to use it as part of a hierarchical scheduling system, as discussed in the previous section.

In a full implementation, we should also keep track of the amount of time it takes to decide which behavior should be run and then subtract that duration from the time we pass to the behavior. Although the LOD selection is fast, we'd ideally like to keep the timing as accurate as possible.

Performance

The algorithm is O(1) in memory and O(n) in time, where n is the number of behaviors managed by the LOD. This is a function of the arbitration scheme we selected. Using the "choose any available behavior" scheme can allow the algorithm to approach $O(\log n)$ in time. Because we typically deal with very few LODs per character (typically, in our experience four is an absolute maximum), there is no need to worry about O(n) time.

10.3.5 GROUP LOD

Even with the simplest behaviors, large numbers of characters require lots of processing power. In a game world with thousands of characters, even simple motion behaviors will be too much to process efficiently. It is possible to switch characters off when they are not important, but this is easily spotted by the player.

A better solution is to add low levels of detail where groups of characters are processed as a whole, rather than as individuals.

In a role-playing game set over four cities, for example, all the characters in a distant city can be updated with a single behavior: changing an individual's wealth, creating children, killing various citizens, and moving treasure locations. The details of each resident's daily

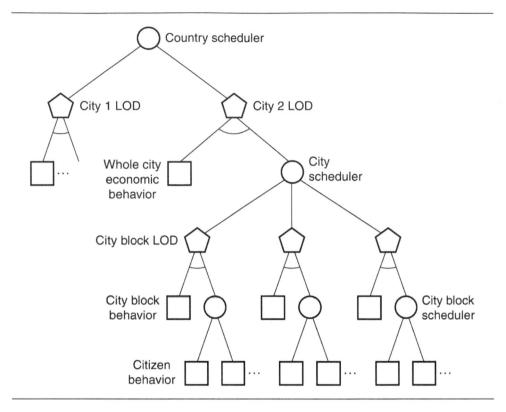

Figure 10.6: Hierarchical LOD algorithms

business are lost, such as a walk to the market to spend money, buy items, take them home, pay taxes, catch plagues, and so on. But the overall sense of an evolving community remains. This is exactly the approach used in *Republic: The Revolution* [109].

Switching to a group is easy to implement using a hierarchical scheduling system. At the highest level, a behavior LOD component selects how to process a whole city. It can use a single "economic" behavior or simulate the individual city blocks. If it chooses the city block approach, it gives control to a scheduling system that distributes the processor time to a set of behavior LOD algorithms for each city block. In turn, these can pass on their time to scheduling systems that control each character individually, possibly using another LOD algorithm. This case is illustrated in Figure 10.6.

If the player is currently in one city block, then the individual behaviors for that block will be running, the "block" behavior will be running for other blocks in the same city, and the "economic" behavior will be running for other cities. This is shown in Figure 10.7.

This combines seamlessly with other LOD or scheduling approaches. At the lowest level

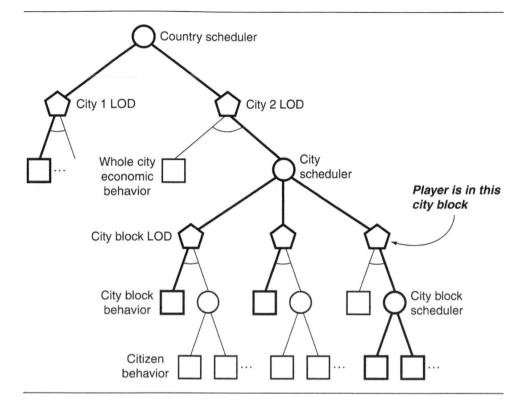

Figure 10.7: The behaviors being run in the hierarchical LOD

of the hierarchy in our example, we could add a priority LOD algorithm that assigns processor time to individuals in the current city block, depending on how close they are to the player.

Probability Distributions

The group LOD approach so far requires that some skeleton data be retained for each character in the game. This can be as simple as age, wealth, and health values, or it can include a list of possessions, home and work locations, and motives.

With very large numbers of characters, even this modest storage becomes too great. Recently, games have begun using a group LOD that merges character data together. Rather than storing a set of values for each character, it stores the number of characters and the distributions for each value.

In Figure 10.8 each set of characters has a wealth value. When they are merged, their individual wealth values are lost, but their distribution is kept. When the high-importance LOD is needed, the compression routine can create the correct number of new characters using the

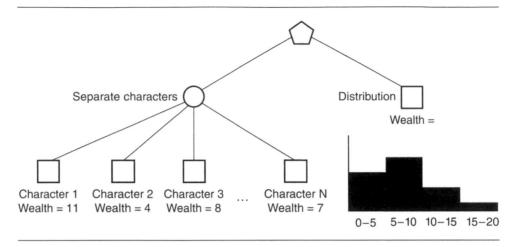

Figure 10.8: Distribution-based group LOD

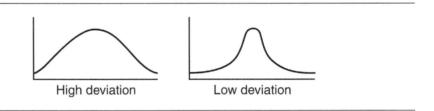

Figure 10.9: Normal distribution curve

same distribution. The individuality of each character is lost, but the overall structure of the community is the same.

Many real-world quantities are distributed in a bell curve: the normal distribution curve (Figure 10.9). This can be represented with two quantities: the mean (the average value—at the highest point of the curve) and the standard deviation (representing how flat the curve is).

Of those quantities that are not normally distributed, the power distribution is usually the closest fit. The power distribution is used for quantities where lots of individuals score low, while a few score high. The distribution of money among people, for example, follows a power law (Figure 10.10). The power law distribution can be represented with a single value: the exponent (which also represents how flat the curve is).

So with one or two items of data, it is possible to generate a realistic distribution of values for a whole set of characters.

To uncompress a behavior, it is normally as easy as creating individual characters with their properties independently sampled from the probability distributions. This does assume

Figure 10.10: Power law distribution

that those properties are independent, however. The age of an adult character and that character's height, for example, can probably be independent. The age of a character and their health, may be more closely related. Combined distributions are possible, tracking how one property varies with a change in the other, but calculating and storing these data can quickly become intractable. Probability distributions only take you so far. A more flexible approach would be to use the procedural content generation techniques in Chapter 8 to create characters when needed. With the obvious downside that those techniques can be time-consuming in themselves. I am not aware of developers using anything but the simplest procedural generation techniques in this context.

10.3.6 IN SUMMARY

In this chapter I described scheduling systems that execute behaviors at different frequencies or that assign different processor resources to each. We looked at mechanisms to change the frequency, the priority, or the whole behavior depending on how important the character is to the player.

In most games, the scheduling needs are fairly modest. An action game may have 200 characters in a game level, and they are often either "off" or "on." We don't need sophisticated scheduling to cope with this situation. We can simply use a frequency-based scheduler for the currently "on" characters.

At a slightly more tricky level, city simulations such as Grand Theft Auto 3 [104] require simulation of a small number of characters out of a theoretical population of thousands. The characters that are not on-screen do not have an identity (other than a handful of characters specific to the story). As the player moves, new characters are spawned into existence based on the general properties of the area of the city and the time of the day. This is a fairly basic use of the group LOD technique.

Countrywide strategy games, such as Republic, go further, requiring characters with distinct identities. The group LOD algorithms we looked at in this chapter were largely devised by Elixir Studios to cope with the huge scalability of that game. They have since been used with variations in a number of other strategy games.

Figure 10.11: A histogram of character professions

EXERCISES

- 10.1 For the situation depicted in Figure 10.2, determine new phases and frequencies so there are no clashes and each behavior runs at least as frequently.
- 10.2 For the situation depicted in Figure 10.4, what would be the best phase to use for a new behavior that must run every 2 frames? Why might it be unfair to include frame 10 in your calculation?
- 10.3 Implement a load-balancing scheduler. First test it with some artificial data, and then, if you can, try incorporating it into some real game code.
- 10.4 Create an environment in which many characters are wandering around randomly. Implement an LOD system that will cause characters near the camera to avoid collisions but allow those farther away to interpenetrate without restriction. What problems would arise with this scheme if characters exploded when they collided?
- 10.5 Suppose we are using the histogram in Figure 10.11 to represent the distribution over professions for a region from which the character is currently far away. If the character is suddenly teleported into the region, then we must populate the region with characters according to the distribution. After randomly selecting 5 characters, what is the probability that they are all blacksmiths? What is the probability that after generating 10 characters we have no soldiers? What consequences could such outcomes have for the game's story line?

WORLD INTERFACING

ONE OF the most difficult things to get right as an AI developer is interaction between the AI and the game world.

Each character needs to get the information they could feasibly know or perceive from the game world at the right time in order for them to act on it. In addition, some algorithms need to have information from the world represented in the correct way for them to process correctly.

To build a general-purpose AI system, we need to have some infrastructure that makes it easy to get the right information to the right bits of AI code in the right format at the right time. With a special-purpose, single-game AI, there may be no dividing line between the world interface and the AI code: if the AI needs some information it can go and find it there and then. In an engine designed to support AI in multiple games, however, it is essential for stability and reusability to have a single central world interface system. Even within one game, it can dramatically assist debugging to have all the information flowing through a central hub, allowing it to be visualized, logged, and inspected.

This chapter will look at building robust and reusable world interfaces using two different techniques: event passing and polling. The event passing system will be extended to include simulation of sensory perception, a hot topic in current-generation game AI.

11.1 COMMUNICATION

It is easy to implement a character that goes about its own business, oblivious to the world around it and to other characters in the game: guards can follow patrol routes, military units can move directly where they're told, and non-player characters can ignore the player.

But that would not look very realistic, or be much fun. Things that happen in the game world need to be acted on correctly, and agents need to know what is happening to themselves and to their colleagues and enemies.

The simplest way to get information from the game world is to look for it. If a character needs to know whether a nearby siren is sounding, for example, the AI code for the character can directly query the state of the siren and find out.

Similarly, if a character needs to know if it will collide with another character, it can look at the positions of each character and calculate its trajectory. By comparing this trajectory with its own, the character can determine when a collision will occur and can take steps to avoid it.

11.1.1 POLLING

Looking for interesting information is called *polling*. The AI code polls various elements of the game state to determine if there is anything interesting that it needs to act on.

This process is very fast and easy to implement. The AI knows exactly what it is interested in and can find it out immediately. There is no special infrastructure or algorithm between the data and the AI that needs it.

As the number of potentially interesting things grows, however, the AI will spend most of its time making checks that return a negative result. For example, the siren is likely to be off more than it is on, and a character is unlikely to be colliding with more than one other character per frame. The polling can rapidly grow in processing requirements through sheer numbers, even though each check may be very fast.

For checks that need to be made between a character and a lot of similar sources of information, the time multiplies rapidly. For a level with a 100 characters, 10,000 trajectory checks would be needed to predict any collisions.

The simplest implementation of polling is for each AI algorithm to request the information it needs, whenever it needs it. Because each character is requesting its own information in an (ad hoc) manner, polling can make it difficult to track where information is passing through the game. Trying to debug a game where information is arriving in many different locations can be challenging.

Polling Stations

There are ways to help polling techniques become more maintainable. A polling station can be used as a central place through which all checks are routed. This can be used to track the requests and responses for debugging. It can also be used to cache data, so complex checks don't need to be repeated for each request. We'll look at polling stations in some depth later in the chapter.

11.1.2 **EVENTS**

There are many situations, like the single siren example, where the polling approach may be optimal. In the collision example, however, each pair of characters is checked twice: once from the first character's perspective, and once from the second. Even if these were cached, polling performs sub-optimally. There are faster ways to consider a whole group of characters in one go, and generate all the collisions at once, rather than step through a list agent by agent.

In these cases, we want a central checking system that can notify each character when something important has happened. This is an event passing mechanism. A central algorithm looks for interesting information and tells any bits of code that might benefit from that knowledge when it finds something.

The event mechanism can be used in the siren example. In each frame when the siren is sounding, the checking code passes an event to each character that is within earshot. This approach is used when we want to simulate a character's perception in more detail, as we'll see later in the chapter.

The event mechanism is no faster in principle than polling. Polling has a bad reputation for speed, but in many cases event passing will be just as inefficient. To determine if an event has occurred, checks need to be made. The event mechanism still needs to do the checks, the same as for polling. The benefit comes because, in many cases, the event mechanism can reduce the effort by doing everybody's checks at once. However, when there is no way to share results, it will take the same time as each character checking for itself. In fact, with its extra message-passing code, the event management approach will be slower.

Imagine the AI for the siren example. The event manager needs to know that the character is interested in the siren. When the siren is ringing, the event manager sends an event to the character. The character is probably not running the exact bit of code that needs to know about the siren, so it stores the event. When it does reach the crucial section, it finds the stored event and responds to it.

Lots of processing has been added by sending an event. If the character polled the siren, it would get the information it needed exactly when it needed it.

It is worth keeping in mind that events are not a panacea. When you can't share the results of a check, event passing can be significantly slower.

Event Managers

Event passing is usually managed by a simple set of routines that either checks for events itself, or can be notified of their occurrence by gameplay code, and then dispatch them to interested parties. Event managers form a centralized mechanism through which all events pass. They keep track of characters' interests (so they only get events that are useful to them) and can queue events over multiple frames to smooth processor use.

Centralized event passing has significant advantages in code modularity and debugging. Because all conditions are being checked in a central location, it is easy to store a log of the checks made and their results. The events passed to each character can easily be displayed or recorded, making debugging complex decision making much easier.

11.1.3 DETERMINING WHICH APPROACH TO USE

As in all things, there is a trade-off to be made here. On the one hand, polling can be very fast, but it doesn't scale well. On the other hand, event passing has extra code to write and is overkill in simple situations.

For sheer execution speed the approach that will give the best performance depends on the application. It is difficult to anticipate in advance.

As a general rule of thumb, if many similar characters all need to know the same piece of information, then it is often faster to use events. If characters only need to know the information occasionally (when they are in a specific state, for example), then it will be faster to poll.

While a combination of some polling and some event passing is often the fastest solution, this has implications for developing the code. Information is being gathered and dispatched in multiple ways, and it can be difficult to work out what is being done where.

Regardless of speed, some developers find that it is easier to manage the game information only using events. You can, for example, print all the events to screen and use them to debug. You can set up special key presses in the game to manually fire events and check that the AI responds correctly. The extra flexibility and the fact that the code is often easier to change and upgrade mean that events are often favored, even when they aren't the fastest approach.

In general, however, some polling is usually required to avoid jumping through silly hoops to get information into the AI. If all remaining polling can be routed through a polling station, then significant improvements in speed and debugging can be gained.

11.2 EVENT MANAGERS

An event-based approach to communication is centralized. There is a central checking mechanism, which notifies any number of characters when something interesting occurs. The code that does this is called an event manager.

The event manager consists of four elements:

- 1. A checking engine (this may be optional)
- 2. An event queue
- 3. A registry of event recipients
- 4. An event dispatcher

The interested characters who want to receive events are often called "listeners" because they are listening for an event to occur. This doesn't mean that they are only interested in simulated sounds. The events can represent sight, radio communication, specific times (a character goes home at 5 P.M. for example), or any other bit of game data.

The **checking engine** needs to determine if anything has happened that one of its listeners may be interested in. It can simply check all the game states for things that might possibly interest any character, but this may be too much work. More efficient checking engines take into consideration the interests of its listeners.

A checking engine often has to liaise with other services provided by the game. If a character needs to know if it has bumped into a wall, the checking engine may need to use the physics engine or collision detector to get a result.

There are many possible things to check, and many of them are checked in different ways: a siren can be checked by looking at a single Boolean value (on or off), collisions may have to be predicted by a geometric algorithm, and a speech recognition engine may need to scan a player's voice input for commands. Because of this, it is normal to have specialized event managers that only check certain types of information (like collisions, sound, or the state of switches in the level). See the sub-sections on broadcasting (Section 11.2.2) and narrowcasting (Section 11.2.2).

In many cases no checking needs to be done at all. In a military squad, for example, characters may choose to tell each other when they are ready for battle. If the characters are implemented using finite state machines, then their "battle-state" will become active, and they can directly send a "ready-for-battle" event to the event manager. These events are placed in the event queue and dispatched to the appropriate listeners as usual.

It is also common to separate the checking mechanism from the event manager. A separate piece of code does the checking every few frames, and if the check comes up, it sends an event directly to an event manager. The event manager then processes it as normal. This checking mechanism is polling the game state (in the same way as a character might poll the game state) and sharing its results with any interested characters.

The implementation of an event manager in Section 11.2.2 includes a method that can be called to directly place an event in the event queue.

In addition to checks, events can also arise from gameplay code. When a score is incremented, for example, the code that performs the increment may already know that the character can now level up. It makes no sense to perform a separate check for this case. The score increment can instead send an event directly to the event manager.

For the event queue, once an event is made known to the event manager (either by being directly passed or through a check), it needs to be held until it can be dispatched. The event will be represented as an Event data structure, and we'll look at its implementation below.

A simple event manager will dispatch every event as it arises, leaving the event listeners to respond appropriately. This is the approach most commonly used in event managers: it has no storage overhead to keep a queue of events, and it requires no complex queue management code.

More complex event managers may track events in a queue and dispatch them to listen-

ers at the best time. This enables the event manager to be run as an anytime algorithm (see Chapter 10), sending out events only when the AI has time remaining in its processing budget. This is particularly important when broadcasting lots of events to lots of characters. If the notification cannot be split over multiple frames, then some frames will have a much greater AI burden than others.

Time-based queuing of events can be very complex, having events with different priorities and delivery deadlines. Notifying a character that a siren is sounding can be delayed by a couple of seconds, but notifying a character that it has been shot should be instantaneous (especially if the animation controller is relying on that event in order to start the "die" animation).

The registry of listeners allows the event manager to pass the correct events on to the correct listeners.

For event managers that have a specialized purpose (like determining collisions), the listeners may be interested in any event that the manager is capable of generating. For others (such as finding out when it is going home time), the listener may have a specific interest (i.e., a specific time), and other events may be useless.

Soldiers, who need to know when it is time to leave for their barracks, aren't interested in being told the time every frame (it's 12:01, it's still 12:01, ...). The registry can be created to accept a description of a listener's interests. This can allow the checker to restrict what it looks for and can allow the dispatcher to only send appropriate events, cutting down on the inefficiency of unnecessary checks and messages.

The format used to register interests can be as simple as a single event code. Characters can register their interest in "explosion" events, for example. A finer degree of control can be supported with characters being able to register more focused interests, such as "explosions of grenades within 50 meters of my current position."

More discriminating registration allows the checking engine to be more focused with what it looks for and reduces the number of unwanted events passed around. On the other hand, it takes longer to decide if a registered listener should be notified or not, and it makes the code more complex, more game specific (because the kinds of things to be interested in often change from game to game), and less reusable between games.

In general, most developers use a simple event code-based registration process and then use some kind of narrowcasting approach (see Section 11.2.2) to limit unwanted notifications.

The event dispatcher sends notification to the appropriate listeners when an event occurs.

If the registry includes information about each listener's interests, the dispatcher can check whether the listener needs to know about the event. This acts as a filter, removing unwanted events and improving efficiency.

The most common way for a listener to be notified of an event is for a function to be called. In object-oriented languages, this is often a method of a class. The function is called, and information about the event can be passed in its arguments.

In the event management systems that drive most operating systems, the event object itself is often passed to the listener. A listener interface of the form:

```
class Listener:
    function notify(event: Event)
```

is very common.

11.2.1 IMPLEMENTATION

We're now ready to put together all the bits to get an event manager implementation.

Pseudo-Code

```
class EventManager:
2
       # Holds data on one registered listener. The same listener may be
       # registered multiple times.
3
       class ListenerRegistration:
4
            interestCode: id
5
           listener: Listener
6
7
       # The list of registered listeners.
       listeners: Listener[]
9
10
       # The queue of pending events.
11
       events: Event[]
12
       # Check for new events, and add them to the queue.
14
       function checkForEvents()
15
16
       # Schedule an event to be dispatched as soon as possible.
17
       function scheduleEvent(event: Event):
18
            events.push(e)
19
20
       # Add a listener to the registry.
21
       function registerListener(listener: Listener, code: id):
22
           # Create the registration structure.
23
            lr = new ListenerRegistration()
24
           lr.listener = listener
25
           lr.code = code
           # And store it.
           listeners.push(lr)
29
30
       # Dispatch all pending events.
31
       function dispatchEvents():
32
           # Loop through all pending events.
33
```

```
while events:
34
                # Get the next event, and pop it from the queue.
35
                event = events.pop()
36
37
                # Go through each listener.
38
                for listener in listeners:
39
                    # Notify if they are interested.
40
                    if listener.interestCode == event.code:
41
                         listener.notify(event)
42
43
       # Call this function to run the manager (from a scheduler for
44
       # example).
45
       function run():
46
           checkForEvents()
47
            dispatchEvents()
48
```

Data Structures and Interfaces

Event listeners should implement the EventListener interface so they can register themselves with the event manager and be notified correctly.

Characters need information about an event that occurs. If a character reports an enemy sighting to its team, the location and status of the enemy need to be included.

In the code above I've assumed that there is an Event structure. The basic Event structure only needs to be able to identify itself. We have used a code data member for this:

```
class Event:
    code: id
```

This is the mechanism used in many windowing toolkits to notify an application of mouse, window, and key press messages.

The Event class can be sub-classed to create a family of different event types with their own additional data:

```
class CollisionEvent:
    code: id = 0x4f2ff1438f4a4c99
    character1: Character
    character2: Character
    collisionTime: int
class SirenEvent:
    code: id = 0x9c5d7679802e49ae
    sirenId: id
```

In a C-based event management system, the same effect can be achieved by including a void* in the event data structure. This can then be used to pass a pointer to any other data structure, as event-specific data:

```
typedef class event_t
2
      unsigned long long eventCode;
3
      void *data;
  } Event;
```

Performance

The event manager is O(nm) in time, where n is the number of events in the queue, and m is the number of listeners registered. It is O(n+m) in memory. This doesn't take into account the time or memory required by the listener to handle the event. Typically, processing in the listeners will dominate the time it takes to run this algorithm.¹

Implementation Notes

It is possible to make a number of refinements to this class. Most obviously, it would be good to allow a listener to receive more than one event code. This can be done with the above code by registering a listener several times with different codes. A more flexible method might use event codes that are powers of two and interpret the listener's interest as a bit mask.

11.2.2 EVENT CASTING

There are two different philosophies for applying event management. You can use a few very general event managers, each sending lots of events to lots of listeners. The listeners are responsible for working out whether or not they are interested in the event.

Or, you can use lots of specialized event managers. Each will only have a few listeners, but these listeners are likely to be interested in more of the events it generates. The listeners can still ignore some events, but more will be delivered correctly.

The scatter-gun approach is called *broadcasting*, and the targeted approach is called *nar*rowcasting.

Both approaches solve the problem of working out which agents to send which events. Broadcasting solves the problem by sending them everything and letting them work out what they need. Narrowcasting puts the responsibility on the programmer: the AI needs to be registered with exactly the right set of relevant event managers.

1. This isn't the case with all event management algorithms. The sense management system we'll meet later is time consuming in its own right.

Broadcasting

We looked at adding extra data in the registry so behaviors could show what their interests were. This isn't a simple process to make general. It is difficult to design a registration system that has enough detail so that listeners with very specific needs can be identified.

For example, an AI may need to know when it hits walls made of one of a set of bouncy materials. To support this, the registry would need to keep hold of all the possible materials for all the objects in the game world and then check against the valid material list for each impact.

It would be easier if the AI was told about all collisions, and it could filter out those it wasn't interested in.

This approach is called *broadcasting*. A broadcasting event manager sends lots of events to its listeners. Typically, it is used to manage all kinds of events and, therefore, also has lots of listeners.

Television programs are broadcast. They are sent through cable or radio signals, regardless of whether or not anyone is interested in watching them. Your living room is being bombarded with all these data all the time. You can choose to switch off the TV and ignore it, or you can watch the program you want to see. Even if you are watching TV, the vast majority of information reaching your TV set is not being displayed.

Broadcasting is a wasteful process, because lots of data are being passed around that are useless to the recipients.

The advantage is flexibility. If a character is receiving and throwing away lots of data, it can suddenly become interested and know that the correct data are available immediately. This is especially important when the AI for a character is being run by a script, where the original programmers aren't aware of what information the script creator might want to use.

Imagine we have a game character wandering around a mushroom patch picking mushrooms. We are interested in having the character know if the player steals one of its mushrooms. We aren't interested in knowing whether doors have been opened on the level. The character is developed so that it ignores all door-open events but responds to stolenmushroom events.

Later in the development process, the level designer adds the mushroom picker's house to the level and wants to edit the AI script to react if the player enters the house.

If the event manager broadcasts events, this wouldn't be difficult. The script could respond to door-open events. If the event manager used a narrowcast approach, the level designer would have to enlist a programmer to register the character with the door-open listener.

Of course, there are ways around this. For example, you could make the registration process part of the script (although you might be expecting too much of the level designers to manipulate event channels). But flexibility will always be higher with a broadcast approach.

Narrowcasting

Narrowcasting solves the difficulty of knowing which AI is interested in which events by requiring the programmer to make lots of registrations to specialized event managers.

If teams of units in an RTS game need to share information, they could each have their own event manager. With one event manager per group, any events will go only to the correct individuals. If there are hundreds of teams on the map, there needs to be hundreds of event managers.

In addition, these teams may be organized in larger groups. These larger groups have their own event managers, which share information around the battalion. Eventually, there is a single event manager per side, which is used to share information globally.

Narrowcasting is a very efficient approach. There are few wasted events, and information is targeted at exactly the right individuals. There doesn't need to be any record of listener's interests. Each event manager is so specialized that all listeners are likely to be interested in all events. This improves speed again.

While the in-game speed is optimized using a narrowcasting approach, setting up characters is much more complex. If there are hundreds of event managers, there needs to be a substantial amount of setup code that determines which listeners need to be wired to which event managers.

The situation is even more complex if the characters change over time. In the RTS example, most of a team may get killed in battle. The remaining members need to be placed into a new team. This means changing registrations dynamically. For a simple hierarchy of event managers, this is still achievable. For more complex "soups" of event managers, each controlling different sets of unrelated events, this may be more effort than it is worth.

Compromising

In reality, there is a compromise to be reached between event managers with complex registration information and those with no explicit interests at all. Similarly, there is a related compromise between narrowcasting and broadcasting.

In reality, developers tend to use simple interest information that can be very quickly filtered. In the example implementation we used an event code. If an event's code matches the listener's interest, then the listener is notified. The event code can be used to represent any kind of interest information, without the event manager needing to know what the code means in the game. This makes it possible to use the same event manager implementation in any number of situations.

Compromising between broadcasting and narrowcasting depends more on the application, particularly the number of events that are likely to be generated. Often, there aren't enough AI events to make broadcasting noticeably slow.

I recommend you use a broadcasting approach when the game is in development. This allows you to play with character behaviors more easily. If you find the event system is slow as development moves on, it can be optimized using multiple narrowcasting managers before release.

An exception to this rule of thumb is for event managers with very specific functions. An event manager that notifies characters at a specific game time (to tell soldiers when to clockoff, for example) would be difficult to incorporate into a broadcasting manager alongside other kinds of event.

11.2.3 INTER-AGENT COMMUNICATION

While most of the information that an AI needs comes from the player's actions and the game environment, games are increasingly featuring characters that cooperate or communicate with each other.

A squad of guards, for example, should work together to surround an intruder. When the intruder's location is known, the guards may cover all exits, waiting until their teammates are in position before launching an attack.

The algorithms for coordinating this kind of action are discussed in Chapter 6. But, regardless of the techniques used, characters need to understand what others are doing and what they intend to do. This could be achieved by allowing each character to examine the internal state of other characters or by polling them for their intentions. While this is fast, it is prone to errors and can require lots of rewriting for every change in the character's AI. A better solution is to use an event mechanism to allow each character to inform others of its intention. You can think of this event manager as providing a secure radio link between members of an AI team.

The basic event mechanism in this chapter is enough to handle cooperative message passing. Using a narrowcasting event manager for each squad ensures that the data get to the right characters quickly and don't confuse members of a different squad.

11.3 polling stations

There are situations where polling is obviously more efficient than events. A character that needs to open a door moves toward it and checks if it is locked. It doesn't make any sense to have the door sending "I'm locked" messages every frame.

Sometimes the checks are time consuming, however. This is especially true when the check involves the game level's geometry. A patrolling guard may occasionally check the status of a control panel from the doorway to the control room. If the player pushes a box in front of the panel, the line of sight will be blocked. Calculating the line of sight is expensive. If there is more than one guard, the extra calculation is wasted.

In an event-based system the check can be made once and for all. In a polling system the check is made by each character individually.

Fortunately, there is a compromise. When polling is the best approach, but checks are time consuming, we can use a structure called a polling station.

A polling station has two purposes. First, it is simply a cache of polling information that can be used by multiple characters. Second, it acts as a go-between from the AI to the game level. Because all requests pass through this one place, they can be more easily monitored and the AI debugged.

Several caching mechanisms can be used to make sure the data are not recalculated too often. The pseudo-code example uses a frame number counter to mark data stale. Data are recalculated once each frame, if necessary. If the data are not requested in a frame, they will not be recalculated.

11.3.1 **PSEUDO-CODE**

We can implement a specific polling station in the following way:

```
class PollingStation:
       # The cache for a boolean property of the game.
2
       class BoolCache:
           value: bool
           lastUpdated: int
       # The cache value for one topic.
       isFlagSafe: BoolCache[MAX_TEAMS]
       # Updates the cache, when required.
10
       function updateIsFlagSafe(team: int)
11
            isFlagSafe[team].value = # ... query game state ...
12
           isFlagSafe[team].lastUpdated = getFrameNumber()
13
14
       # Query the cached topic.
15
       function getIsFlagAtBase(team: int) -> bool:
16
           # Check if the topic needs updating.
17
           if isFlagSafe[team].lastUpdated < getFrameNumber():</pre>
                # Only update if the cache is stale.
                updateIsFlagSafe(team)
21
           # Either way, return its value.
           return isFlagSafe[team].value
23
24
       # ... add other polling topics ...
25
26
       # A polling topic without a cache.
27
       function canSee(fromPos: Vector, toPos: Vector) -> bool:
28
           # ... always query game state ...
29
           return not raycast(from, to)
30
```

11.3.2 PERFORMANCE

The polling station is O(1) in both time and memory for each polling topic it supports. This excludes the performance of the polling activity itself.

11.3.3 IMPLEMENTATION NOTES

The implementation above is for a specific polling station, rather than a generic system. It shows two different polling topics: getIsFlagAtBase and canSee. The former shows the pattern of a cached result, and the latter is calculated each time it is needed.

The caching part of the code relies on the existence of a getFrameNumber function to keep track of stale items. In a full implementation there would be several additional cache classes similar to BoolCache for different sets of data types.

Often, the polling station simplifies the AI as well. In the above code, a character only needs to call the polling station's canSee function. It doesn't need to implement the check itself. In this case, the function always recalculates the sight check; its value is not cached.

The AI doesn't care whether the result is stored from a previous call or whether it needs to be recalculated. It also doesn't care how the result is fetched. This allows the programmers to change and optimize implementations later on without rewriting lots of code.

11.3.4 ABSTRACT POLLING

The listing above is the simplest form of polling station. Often, these kinds of methods can be added to a game world class as a standard interface. They have the disadvantage of being difficult to extend. Eventually, the polling station will be very large and hold lots of data.

The polling station can be improved by adding a central request method where all polls are directed. This request method takes a request code that signals which check is needed. This abstract polling model enables the polling station to be extended without changing its interface and without changing any other code that relies on it. It also helps debugging and logging tools, because all polling requests are channeled through a central method.

On the other hand, there is an extra translation step to work out which request is being delivered, and that slows down execution.

This polling station implementation extends the idea one step further to allow "pluggable" polling. Instances of a polling task can be registered with the station, with each representing one possible piece of data that can be polled. The cache control logic is the same for all topics (the same frame number-based caching as previously).

```
# Abstract class; the base for any pollable topic.
  class PollingTask:
2
      taskCode: id
3
4
      value: any
5
      lastUpdated: int
```

```
6
       # Checks if the cache is out of date.
7
       function isStale() -> bool:
8
            return lastUpdated < getFrameNumber()</pre>
9
10
       # Update the value in the cache - implement in subclasses.
11
       function update()
12
13
       # Get the correct value for the polling task.
       function getValue() -> any:
            # Update the internal value, if required.
16
            if isStale():
17
                update()
18
19
            # Return it.
20
            return value
21
22
   class AbstractPollingStation:
23
       # The tasks registered as a hash-table indexed by code.
24
       tasks: HashTable[id -> PollingTask]
25
26
       function registerTask(task: PollingTask):
27
            tasks[task.code] = task
28
29
       function poll(code: id) -> value:
30
            return tasks[code].getValue()
```

At this point we are almost at the complexity of an event management system, and the trade-off between the two becomes blurred. In practice, few developers rely on polling stations of this complexity.

11.4 SENSE MANAGEMENT

So far we've covered techniques for getting appropriate knowledge into the hands of characters that might be interested. Our concern has been to make sure that a character gets the information it wants to be able to make appropriate decisions.

But, as we all know, wanting something isn't the same as getting it! We need to also make sure that a character is *able* to acquire the knowledge it is interested in.

Game environments simulate the physical world, at least to some degree. A character gains information about its environment by using its senses. So it makes sense to check if a character can physically sense information. If a loud noise is generated in the game, we could determine which characters heard it: a character across the other end of the level may not, and neither would a character behind a soundproof window.

An enemy may be walking right across the middle of a room, but if the lights are out or the character is facing in the wrong direction, the enemy will not be seen.

Simulating sensory perception is relatively new, and sophisticated approaches are still not common (at most, a ray cast check is made to determine if line of sight exists). In some games, however, perception forms a core part of the gameplay. This is most common for visual perception. In games such as Splinter Cell [189], Thief: The Dark Project [132], and Metal Gear Solid [129], the ability of AI characters to see only lit objects forms the basis of the stealth gameplay.

Indications are that this trend will continue. AI software used in the film industry (such as Weta's Massive) and military simulation use more comprehensive models of perception to drive very sophisticated group behaviors.² It seems likely that sensory perception will infiltrate other game designs to become an integral part of strategy games, role-playing games and platformers, as well as action games.

11.4.1 **FAKING IT**

Obviously, we try to take shortcuts whenever possible. There is no point in simulating the way that sound travels from the headphones on a character's head down its ear canal. Some knowledge we can just give to the character.

Even when there is some doubt about knowledge getting through, we can use the methods discussed earlier in the chapter: we could use an event manager per room, for example. Sounds that occur in the room can be communicated to all the characters currently in that room, and registered to the event manager. Here the event manager is being used in a slightly different way than that described earlier. Rather than using its distribution power, we are relying on the fact that information not given to the event manager cannot be gained by its listeners. This is not necessarily the case if characters are polling for data (although we can add filtering code to limit access to a polling station for the same effect).

To make an event manager work for sound notification, we need to make sure that characters change event managers, or adjust the events that they are interested in listening for, whenever they move between rooms. This may work for specific situations, such as a particular style of game level or a very simple game project. It falls short of being a realistic model, however, as loud noises might be heard down a corridor, but gentle noises might be inaudible a meter away.

And what do we do about other senses? Vision is often implemented using ray casts to check line of sight, but this can rapidly get out of hand if lots of characters are trying to see lots of different things.

If we are concerned about accuracy, eventually, we'll need some dedicated sense simulation code.

2. Interestingly, the AI models in this kind of system are typically very simple. The complexity of their behavior is almost entirely generated from the sensory simulation.

11.4.2 WHAT DO WE KNOW?

A character has access to different sources of knowledge in the game. We looked briefly at knowledge at the start of Chapter 5, dividing knowledge into two categories: internal knowledge and external knowledge.

A character's internal knowledge tells it about itself: its current health, equipment, state of mind, goals, and movement. External knowledge covers everything else in the character's environment: the position of enemies, whether doors are open, the availability of power-ups, or the number of its squad members still alive.

Internal knowledge is essentially free, and the character should have direct and unfettered access to it. External knowledge is delivered to the character based on the state of the game. Many games allow characters to be omniscient; they always know where the player is, for example. To simulate some degree of mystery, the behavior of a character can be designed so that it appears not to have knowledge.

A character might be constantly looking at the position of the player, for example. When the player gets near enough, the character suddenly engages its "chase" action. It appears to the player as if the character couldn't see the player until they got close enough. This is a feature of the AI design, not of the way the character gains its knowledge.

A more sophisticated approach uses event managers or polling stations to only grant access to the information that a real person in the game environment might know. At the final extreme, there are sense managers distributing information based on a physical simulation of the world.

Even in a game with sophisticated sense management, it makes sense to use a blended approach. Internal knowledge is always available, but external knowledge can be accessed in any of the following three ways: direct access to information, notification only of selected information, and perception simulation.

The remainder of this section will focus only on the last element: sense management. The other elements have been covered so far in this chapter.

Polling and Notification Revisited

While it is theoretically possible to implement a sensory management system based on polling, I have never seen it done in practice. We could, for example, test the sensory process every time a polling state receives a request for information, only passing on the data if the test passes. There is nothing intrinsically wrong with this approach, but it isn't the one I suggest you take.

Sensory perception feels like it maps more naturally onto notifications: a character discovers information by perceiving it, rather than looking for everything and failing to perceive most of it. Running sense management in a polling structure will mean that the vast majority of polling requests fail—a big waste of performance.

From here on, I will exclusively use an event-based model for our sense management tools. Knowledge from the game state is introduced into the sense manager, and those characters who are capable of perceiving it will be notified. They can then take any appropriate action, such as storing it for later use or acting immediately.

11.4.3 SENSORY MODALITIES

Four natural human senses are suitable for use in a game: sight, touch, hearing, and smell, in roughly decreasing order of use. Taste makes up the fifth human sense, but I've yet to see (or even conceive of) a game where characters make use of taste to gain knowledge about their world.

Let us consider each sensory modality in turn. Their peculiarities form the basic requirements of a sense manager.

Sight

Sight is the most obvious sense. Because it is so obvious, players can tell if it is being simulated badly. This, in turn, means that we'll need to work harder to develop a convincing sight model. Among all the modalities we will support, sight requires the most infrastructure.

A whole range of factors can affect our ability to see something.

Speed

Light travels at almost 300 million ms⁻¹. Unless your game involves very large distances through space, then light will travel across your game level in less than a frame. We can treat vision as being instantaneous.

Sight Cone

First, we have a sight cone. Our vision is limited to a cone shape in front of us, as shown in Figure 11.1.

If a person's head is still, they have a sight cone with a vertical angle of around 120° and a horizontal angle of 220° or so. We are able to see in any direction 360° by moving our neck and eyes, while keeping the rest of our body still. This is the possible sight cone for a character who is looking for information.

People going about their normal business concentrate on a very small proportion of their visual field. We are consciously able to monitor a cone of just a few degrees, but eye movements sweep this cone rapidly to give the illusion of a wider field of view.

Psychological studies indicate that people are very poor at noticing things they aren't specifically looking for. In fact, we are worse at noticing things we are looking for than you might imagine.

One experiment involved a video of a basketball practice through which someone in a fluffy animal costume walked. When asked to count the number of passes made by the bas-

Figure 11.1: A set of sight cones

ketball players, most viewers did not notice the person in the costume standing right in center court, waving their arms.

To get a flavor of these limits, a sight cone of around 60° is often used. It takes into account normal eye movement, but effectively blinds the character to the large area of space it can see but is unlikely to pay any attention to.

Line of Sight

Vision's most characteristic feature is its inability to go around corners. To see something, you need to have a direct line of sight with it.

While this is obvious, it isn't strictly true. If a character stands at one end of a doglegged, dark corridor, it will be unable to see the enemy at the other end. But, as soon as the enemy fires its rifle, the character will see the reflected muzzle flash. Events that emit light behave differently from those that do not, as far as simulation goes. All surfaces reflect light to some extent, allowing it to bounce around corners quite easily.

One sense management system I worked with had this feature. Unfortunately, the effect was so subtle that it wasn't worth the processing effort to simulate (it transpired that the publisher decided that the whole game wasn't worth the effort, and it was canned before publication). Despite its failings, the sense simulation in this game was beyond anything else I have seen, and I will refer to several of its features throughout the rest of this section.

For the purpose of this chapter, I will assume sight only happens in straight lines. To simulate radiosity or effects like mirrors, you will need to extend the framework.

Distance

On the scales modeled in average game levels, human beings have no distance limitation to their sight. Atmospheric effects (fog or haze, for example) and the curve of the Earth limit our ability to see very long distances, but human beings have no problem seeing for millions of light years if nothing is in the way.

There are countless games where distance is used as a limit on vision, however. This is not always a bad thing. In a platform game, Jak and Daxter: The Precursor Legacy [148], for example, we wouldn't want to round every corner to find that enemies from the other side of the clearing have seen us and are incoming. Games often use a convention that enemies only notice the player when the player gets within a certain distance. It deliberately gives characters worse sight than they otherwise would have.

Games that do not adhere to this limitation, such as Tom Clancy's Ghost Recon [170], require different play tactics, usually involving considerably more stealth.

Where distance is significant is in the size of the thing being viewed. All animals can only resolve objects if they appear large enough (ignoring brightness and background patterns for a while). At a human scale, for most game levels, this is not an issue. We can resolve a human being over half a mile away, for example.

In the same way as for sight cones, there is a difference between ability and likelihood. While we can resolve human beings hundreds of meters away, we are unlikely to notice a person at that distance unless we are specifically tasked with looking for them. Even in games that don't limit the distance a character can see, some distance threshold for noticing small objects is advisable.

Brightness

We rely on photons reaching our eye to see things. The light-sensitive cells in the eye get excited when a photon hits them, and they gradually relax over the following few milliseconds. If enough photons reach a cell before it relaxes, then it will get more and more excited and eventually send its signal along to the brain.

We find it notoriously difficult to see in dim light. Splinter Cell uses this feature of human vision to good effect by allowing the player to hide in shadows and avoid detection by guards (even though the player's character has three bright green torches strapped to its forehead).

In reality, we are rarely in dark enough conditions that the light sensitivity of our eyes is the limiting factor in our vision. The vast majority of our problem with seeing in low light isn't a lack of photons, it is a problem of differentiation.

Differentiation

Human sight has evolved based on our survival needs. What we see in our mind's eye as a picture of the outside world is in fact an illusion reconstructed from lots of different signals and a good deal of expectation.

All visual stimuli are filtered and processed. When you tilt your head, for example, the image you see doesn't tilt; we have specialized cells in our visual system that are dedicated to finding the vertical. All the results from the rest of our visual system are then internally rotated back before their output hits our conscious brain. Most of us physically can't see tilted (one reason why most driving games don't tilt the camera as the car corners, and those that do rarely tilt as far as most drivers' heads, nor often in the same direction).

The adaptation that is most significant to sense management is our contrast detectors. We have a whole range of cells dedicated to identifying areas where colors or shades are changing. Some of these cells are dedicated to finding distinct lines at different angles, and others are dedicated to finding patches where there is a change in contrast. In general, we find it difficult to see something without sufficient contrast change. The contrast change can occur in just one color component. This is the basis of those spotty color-blindness tests; if you can't detect the difference between red and green, you can't detect a simultaneous but opposite change in red and green intensity and therefore can't see the number.

What this means is that we cannot see objects that do not contrast with their backgrounds, and we are very good at seeing objects that do contrast. All camouflage works on this principle; it tries to make sure that there is no contrast change between the edge of something and its background. The reason we can't see things in dim light is because there isn't sufficient contrast to see it, not because the photons aren't reaching our eyes.

The Ghost Recon games have a good implementation of background camouflage. If your squad is in military greens, lying among a thicket of foliage, enemy characters would not see them. In the same uniform standing in front of a brick wall, they are sitting ducks.

On the other hand, Splinter Cell, justifiably praised for its hiding-in-shadows gameplay, does not take into account background. Sam Fisher (the character you play) can be standing in a shadow halfway down a very brightly lit corridor, and an enemy at one end of the corridor will not see him. In reality, of course, the enemy would see a huge black silhouette against a bright background and Sam would be rumbled. (To be fair, the level designers work hard to avoid this situation from occurring too often.)

Hearing

Hearing is not limited by straight lines. Sound travels as compression waves through any physical medium. The wave takes time to move, and as it moves it spreads out and is subject to friction. Both factors serve to diminish the intensity (volume) of the sound with distance. Low pitched sounds suffer less friction (because their vibrations are slower) and therefore travel farther than high-pitched sounds.

Low-pitched sounds are also able to bend around obstacles more easily. This is why sound emanating from behind an obstacle sounds muddy and lower in pitch. Elephants emit infrasonic barks below the level of human hearing in order to communicate with other members of their herd several miles away through scrubland foliage. By contrast, bats use high pitched sounds to perceive moths; low-frequency sounds would simply bend around their prey.

These differences are probably too subtle for inclusion in the AI for a game. We will treat all sounds alike: they uniformly reduce in volume over distance until they pass below some threshold. We allow different characters to sense different volumes of sound to simulate acute hearing or deafness resulting from a nearby bomb blast, for example.

As far as AI goes, sound travels through air around corners without a problem, regardless of its pitch. Environmental audio technologies, used to prepare three-dimensional (3D) audio for the player, have more comprehensive capabilities to simulate occlusion. When the player is listening, the effects are significant. However, when determining if a character gets to know something, the effects are not significant.

In the real word, all materials transmit sound to some extent. Denser and stiffer materials transmit sound faster. Steel transmits sound faster than water, and water transmits sound faster than air, for example. For the same reason, air at a higher temperature transmits sound faster.

The speed of sound in air is around 345 meters per second.

In a game implementation, however, we typically divide all materials into two categories: those that do not transmit sound and those that do. Materials that do transmit sound are all treated like air.

Because game levels tend to be quite small, the speed of sound is often fast enough not to be noticed. Many games simulate sound by letting it behave like light, traveling instantaneously. Metal Gear Solid, for example, has no discernible speed of sound, whereas Conflict: Desert Storm [159] does.

If you do intend to use the speed of sound, then it may be worth slowing it down. In a typical third- or first-person game, a speed of sound around 100 meters per second gives a "realistic" and noticeable effect.

Touch

Touch is a sense that requires direct physical contact. It is best implemented in a game using collision detection: a character is notified if it collides with another character.

In stealth games, this is part of the game. If you touch a character (or get within a small fixed distance of it), then it feels you there, whether or not it can see or hear you otherwise.

Because it is easy to implement touch using collision detection, the sense management system described here will not include touch. Collision detection is beyond the scope of this book. There are two books in this series [14] [73] with comprehensive details.

In a production system, it might be beneficial to incorporate touching into the sense manager framework. When a collision is detected, a special touching event is sent between the touching characters. Having this routed through the sense manager allows a character to receive all of its sense information through one route, even though touch is handled differently behind the scenes.

Smell

Smell is a relatively unexplored sense in games. Smells are caused by the diffusion of gases through the air. This is a slow and distance-limited process. The speed of diffusion makes wind effects appear more prominent. While sound can be carried by wind, its fast motion means that we don't notice that it travels downwind faster than upwind. Downwind, smells are significantly more noticeable.

Typically, smells that are not associated with concentrated chemicals (such as the scent of an enemy) travel only a few tens of feet. Animals with better sensitivity to smell can detect human beings at significantly greater distances, given suitable wind conditions. Hunting games are typically the only ones that model smells.

There are other potential uses for smell. The game I mentioned earlier (that modeled indirect light transmission) used smell to represent the diffusion of poisonous gases. A gas grenade could be detonated outside a guard post, for example. The sense manager signaled the guard characters when they could smell the gas. In this case, they responded to the smell by dying.

One of the best uses of smell simulation is in Alien vs. Predator [79]. Here the aliens sense the presence of the player using smell. As the smell diffuses, aliens follow the trail of increasing intensity to find the player's location. This gives rise to some neat tactics. If a character stands for a long time at a good ambush spot and then quickly ducks behind cover, the aliens will follow the trail to the intense spot of smell where it was previously standing, giving the player the initiative to attack.

Fantasy Modalities

In addition to sight, hearing, and smell, there are all sorts of uses you could put the sense manager to. Although we will limit the simulation to these three modalities, their associated parameters mean we can simulate other fictional senses.

Fantasy senses such as aura or magic can be represented using modified vision; telepathy can be a modified version of hearing, and fear, reputation, or charm can be a modified smell. A whole range of spell effects can be broadcast using the sense manager: victims of the spell will be notified by the sense manager, removing the need to run a whole batch of special tests in spell-specific code.

11.4.4 **REGION SENSE MANAGER**

I will describe two algorithms for sense management. The first is a simple technique using a spherical region of influence, with fixed speeds for each modality.

A variation on this technique is used for the majority of games with sense simulation. It is also the approach favored by simulation software for animation (such as Massive) and the military.

The Algorithm

The algorithm works in three phases: potential sensors are found in the aggregation phase; the potential sensors are checked to see if the signal got through, in the testing phase; and signals that do get through are sent in the notification phase.

Characters register their interest with the sense manager along with their position, orientation, and sensory capabilities. This is stored as a sensor, equivalent to the listener structure in the event manager.

In a practical implementation, position and orientation are usually provided as a pointer to the character's positional data, so the character doesn't need to continually update the sense manager as it moves. Sensory capabilities consist of a threshold value for each modality that the character can sense.

The sense manager can handle any number of modalities. Associated with each modality is an attenuation factor, a maximum range, and an inverse transmission speed.

The sense manager accepts signals: messages that indicate that something has occurred in the game level (the equivalent to events in the event manager). Signals are similar to events used in an event manager but have three additional pieces of data: the modality through which the signal should be sent, the intensity of the signal at its source, and the position of the source.

The attenuation factor corresponding to each modality determines how the volume of a sound or the intensity of a smell drops over distance. For each unit of distance, the intensity of the signal is multiplied by the attenuation factor. The algorithm stops processing the transmission beyond the maximum range.

Once the signal's intensity drops below a character's threshold value, the character is unable to sense it. Obviously, the maximum range for a modality should be chosen so that it is large enough to reach any characters that would be able to perceive appropriate signals.

Figure 11.2 shows this process for a sound signal. The sense manager has a registered attenuation of 0.9 for sound. A signal of intensity 2 is emitted from the source shown. At a distance of 1 unit from the source, the intensity of the sound is 1.8, at a distance of 2 units it is 1.62, and so on. Character A has a sound threshold of 1. At a distance of 1.5 units, the sound has an intensity of around 1.7, and character A is notified of the sound. Character B has a threshold of 1.5. At a distance of 2.8 units, the sound has an intensity of 1.49, and character B is not notified.

The inverse transmission speed indicates how long it will take for the signal to travel one unit of distance. We don't use the uninverted speed, because we want to be able to handle the infinite speed associated with vision.

The basic algorithm works in the same way for each modality. When a signal is introduced to the sense manager, it immediately finds all characters within the maximum radius of the corresponding modality (the aggregation phase). For each character it calculates the intensity of the signal when it reaches the character and the time when that will happen. If the intensity is below the character's threshold, it is ignored.

If the intensity test passes, then the algorithm may perform additional tests, depending

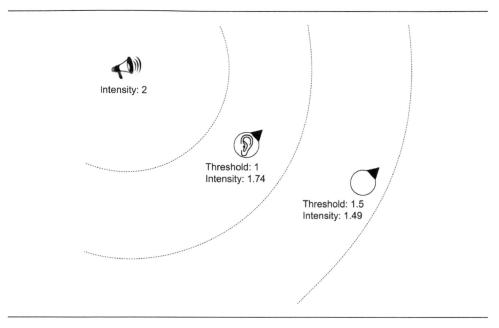

Figure 11.2: Attenuation in action

on the type of modality. If all tests pass, then a request to notify the character is posted in a queue. This is the testing phase.

The queue records store the signal, the sensor to notify, the intensity, and the time at which to deliver the message (calculated from the time the signal was emitted and the time the signal takes to travel to the character). Each time the sense manager is run, it checks the queue for messages whose time has passed and delivers them. This is the notification phase.

This algorithm unifies the way smells and sounds work (sounds are just fast-moving smells). Neither of them requires additional tests; the intensity test is sufficient. Modalities based on vision do require two additional tests in the testing phase.

First, the source of the signal is tested to make sure it lies within the character's current sight cone. If this test passes, then a ray cast is performed to make sure line of sight exists. If you wish to support camouflage or hiding in shadows you can add extra tests here. These extensions are discussed after the main algorithm below.

Notice that this model allows us to have characters with fixed viewing distances: we allow visual signals to attenuate over distance and give different characters different thresholds. If the intensity of visual signal is always the same (a reasonable assumption), then the threshold imposes a maximum viewing radius around the character.

Pseudo-Code

The sense manager can be implemented in the following way:

```
class RegionalSenseManager:
       # A record in the notification queue, ready to notify the sensor
2
       # at the correct time.
3
       class Notification:
           time: int
            sensor: Sensor
6
            signal: Signal
7
8
       # The list of sensors.
9
       sensors: Sensor[]
10
11
       # A queue of notifications waiting to be honored.
12
       notificationQueue: Notification[]
13
       # Introduces a signal into the game. This also calculates the
15
       # notifications that this signal will be needed.
       function addSignal(signal: Signal):
17
            # Aggregation phase.
18
            validSensors: Sensor[] = []
19
20
            for sensor in sensors:
21
                # Testing phase.
22
23
                # Check the modality first.
24
                if not sensor.detectsModality(signal.modality):
                    continue
26
27
28
                # Find the distance of the signal and check range.
                distance = distance(signal.position, sensor.position)
29
30
                if signal.modality.maximumRange < distance:</pre>
31
                    continue
32
                # Find the intensity of the signal and check
33
                # the threshold.
34
                intensity = signal.strength *
35
                             pow(signal.modality.attenuation, distance)
36
                if intensity < sensor.threshold:</pre>
37
                    continue
38
39
                # Perform additional modality specific checks.
40
                if not signal.modality.extraChecks(signal, sensor):
41
                    continue
42
43
                # Notification phase.
44
```

```
45
                # We're going to notify the sensor, work out when.
46
                time = getCurrentTime() +
47
                        distance * signal.modality.inverseTransmissionSpeed
48
49
                # Create a notification record and add it to the queue.
50
                notification = new Notification()
51
                notification.time = time
52
                notification.sensor = sensor
53
                notification.signal = signal
                notificationQueue.add(notification)
56
            # Send signals, in case the current signal is ready to
57
            # notify immediately.
58
            sendSignals()
59
60
        # Flush notifications from the queue, up to the current time.
61
        function sendSignals():
62
            # Notification Phase.
63
            currentTime: int = getCurrentTime()
64
65
            while notificationQueue:
66
                notification: Notification = notificationQueue.peek()
67
68
                # Check if the notification is due.
69
                if notification.time < currentTime:</pre>
70
                    notification.sensor.notify(notification.signal)
                    notificationQueue.pop()
72
73
                # If we are beyond the current time, then stop
74
                # (assuming the queue is sorted).
75
                else:
76
                    break
```

The code assumes a getCurrentTime function that returns the current game time. It also assumes the existence of the pow mathematical function.

Note that the sendSignals function should be called each frame, whether or not any signals have been introduced, to make sure that cached notifications are correctly dispatched.

Data Structures and Interfaces

This code assumes an interface for modalities, sensors, and signals. Modalities conform to the interface:

```
class Modality:
      maximumRange: float
2
      attenuation: float
      inverseTransmissionSpeed: float
      function extraChecks(signal: Signal, sensor: Sensor) -> bool
```

where extraChecks performs modality-specific checks in the testing phase. This will be implemented differently for each specific modality. Some modalities may always pass this test. For sight, we might have:

```
class SightModality:
      function extraChecks(signal: Signal, sensor: Sensor) -> bool
2
           if not checkSightCone(signal.position,
                                 sensor.position,
                                 sensor.orientation):
               continue
           if not checkLineOfSight(signal.position,
                                   sensor.position):
8
               continue
```

where checkSightCone and checkLineOfSight carry out the individual tests; both return true if they pass.

Sensors have the interface:

```
class Sensor:
      position: Vector
2
      orientation: Quaternion
3
       function detectsModality(modality: Modality) -> bool
       function notify(signal: Signal)
```

where detectsModality returns true if the sensor can detect the given modality; the modality is a modality instance. The notify method is just the same as we saw in regular event management: it notifies the sensor of the signal.

Signals have the interface:

```
class Signal:
      strength: float
2
      position: Vector
      modality: Modality
```

In addition to these three interfaces, the code assumes that the notificationQueue is always sorted in order of time. It has the structure:

```
class NotificationQueue:
      function add(notification: Notification)
2
      function peek() -> Notification
3
      function pop() -> Notification
```

where the add method adds the given notification to the correct place in the queue. This data structure is a priority queue, in order to time. Because of its use in the A* algorithm, Chapter 4 has more detail on the efficient implementation of priority queues.

Performance

The regional sense manager is O(nm) in time, where n is the number of sensors registered, and m is the number of signals. It stores pending signals only, so it is O(p) in memory, where p is the number of pending signals. Depending on the speed of the signals, this may approach O(m) in memory but most times will be very much smaller.

Camouflage and Shadows

To support camouflage, we can add an additional test for visual modalities in the SightModality class. After ray casting to check that the signal is in line of sight with the character, we perform one or more additional ray casts out beyond the character. We find the materials associated with the first object that each ray intersects.

Typically, the level designer marks up each material according to its type of pattern. We might have ten pattern types, for example, including brick, foliage, stone, grass, sky, and so on. Based on the material types of the background, an additional attenuation factor is calculated. Suppose the character is wearing green camouflage. The designer might decide that a foliage background gives an additional attenuation of 0.1, while sky gives an additional attenuation of 1.5. The additional attenuation is multiplied by the signal strength and passed on only if the result is higher than the character's threshold.

We can use a similar process to support hiding in shadows. An easier method is simply to make the initial signal strength proportional to the light falling on its emitter. If a character is in full light, then it will send high-strength "I'm here" signals to the sense manager. If the character is in shadow, the signal strength will be lower, and characters with a high-intensity threshold may not notice them.

Weaknesses

Figure 11.3 shows a situation where the simple sense manager implementation breaks down. A sound emitted from character A is heard first by character C, even though C is farther from the source than character B. Transmission is always handled by distance and doesn't take level geometry into account, other than for line-of-sight tests.

This slight timing discrepancy may not be too noticeable. Figure 11.4 shows a more serious situation. Here, character B can hear the sound, even though B is nowhere near the sound source and is insulated by a large barrier.

The code so far has also assumed that characters are always stationary. Take the case in

Figure 11.3: Angled corridor and a sound transmission error

Figure 11.4: Transmission through walls

Figure 11.5: Timing discrepancy for moving characters

Figure 11.5. Two characters both start at the same distance from a sound. One character is moving quickly toward the source. Realistically, character A will hear the sound earlier than character B at the point marked on the diagram. In our model, however, they hear the sound together. This isn't normally noticeable for sounds, since they tend to move much faster than characters. For smells, however, it can be highly significant.

This algorithm for sense management is very simple, fast, and powerful. It is excellent for open air levels or for indoor environments where the thickness of walls is greater than the distance a signal can travel. For the environments common in first- and third-person action games, however, it can give unpleasant artifacts.

Using this kind of sense manager makes it simple to extend your game with additional tests, code for special cases, and heuristics to give the impression of avoiding the algorithm's limitations.

Rather than spend time trying to patch the basic system (which is a valid plan, as long as the patches don't take too much implementation effort), I will describe a more comprehensive solution. Bear in mind, however, that with increased sophistication will come correspondingly greater processing requirements.

FINITE ELEMENT MODEL SENSE MANAGER

To accurately model vision, hearing, and smell would require some serious development effort. In the coding experiments done at my AI middleware company in the early 2000s, we looked at building geometrically accurate sense simulation. The task is formidable, and was totally impractical at the time. I remain reasonably convinced that there is no practical way to do it for even the current generation of hardware.

Instead we devised a mechanism based on finite element models that works well and can be reasonably efficient. We later found out that this was a technique independently devised by at least two other developers (not surprisingly, given its similarity to other game algorithms in this book).

Finite Element Models

A finite element model (FEM) splits up a continuous problem into a finite number of discrete elements. It replaces the difficulty of solving a problem for the infinite number of locations in the continuous world with a problem for a finite number of locations.

Although pathfinding does not strictly use an FEM, it uses a very similar approach. It splits up the continuous problem into finite elements, in very much the same way as we will need to do for our algorithm. (It is not strictly an FEM because it doesn't apply an algorithm to each region in parallel; it applies a once-and-for-all algorithm to the whole model.)

In dividing up the continuous problem into regions, simpler algorithms can be applied. In pathfinding we swap the difficult problem of finding the fastest route through arbitrary 3D geometry with the simpler problem of traversing a graph.

Whenever you use an FEM to solve a problem, you are making a simplifying approximation. By not solving the real problem, you run the risk of getting back only an approximate solution. As long as the approximation is good, the model works.

I described this approximation process for both pathfinding and for tactical analysis in some depth, with tips on how to split the level into regions so the resulting paths are believable, and the tactics coherent. Similarly, when we use an FEM to model perception in a game, we need to choose regions carefully to make sure the resulting pattern of character perception is believable.

The Sense Graph

In just the same way as for pathfinding, we transform the game level into a directed acyclic graph for sense management.

Each node in the graph represents a region of the game level where signals can pass around unhindered. For each smell-based modality, the node contains a dissipation value that indicates how much of the smell will decay per second. A dissipation of 0.5, for example, means a smell loses half its intensity each second. For all modalities, the node contains an attenuation value that indicates how a signal decays for each unit of distance it travels.

Connections are made between pairs of nodes where one or more modalities can pass between the corresponding regions.

Figure 11.6 shows an example. Two separate rooms are divided by a sound-proof, oneway window. The sense graph contains two nodes, one for each room. Room A is connected to Room B, because visual stimuli can pass in that direction, even though sound and smell cannot. Room B is not connected to Room A, however, because no stimuli can pass in that direction.

For each modality, a connection has a corresponding attenuation factor and distance. This

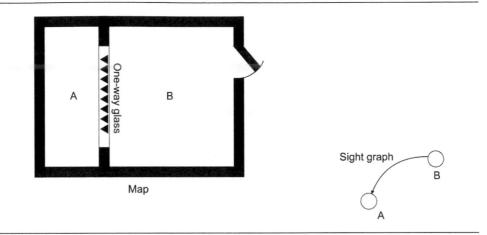

Figure 11.6: Sense graph for one-way glass

allows us to calculate the amount of signal that is passed. In the example above, the connection will have attenuation of 0 for both smell and sound (it allows neither through). It has an attenuation factor of 0.9 for vision, to simulate the fact that the window is darkly tinted. The distance along the connection is given as 1, for simplicity (so the overall attenuation through the window will be 0.9). The main reason for having both attenuation and distance is to allow slow-moving signals (namely, smells) to take time to move along the connection.

Connections also have an associated 3D position for both their ends, shown in Figure 11.7. The connection position is used to work out how a signal transmits across a node from an incoming connection. Because nodes usually border each other, it is common for the start and end points of a connection to be at the same position: the algorithm will cope with this situation. The distance associated with the connection doesn't have to be the same as the 3D distance between its start and end points. They are dealt with entirely separately by the algorithm.

There is no reason for connections to be limited to nearby regions of the level. Figure 11.8 illustrates a long-distance connection that allows only smell through. This is an example from the ill-fated sense-based game I introduced earlier. The connection represents an airconditioning duct, a critical puzzle in the game. The solution involves detonating a poison gas grenade in Room A and letting it pass down the air-conditioning duct to kill the guard standing in Room B. The duct is the only connection between the two rooms.

Another case might be a control room with video links to several rooms in a level; there could be visual links between the conference room and the surveyed areas, even though they are at a distance. Guards in the control room would be notified and react to events caught on camera.

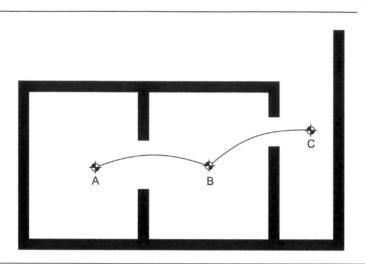

Figure 11.7: Connection positions in a sense graph

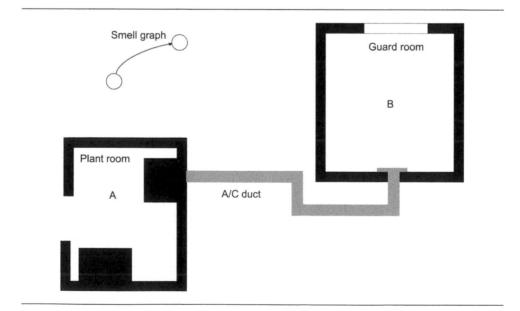

Figure 11.8: Air-conditioning in a sense graph

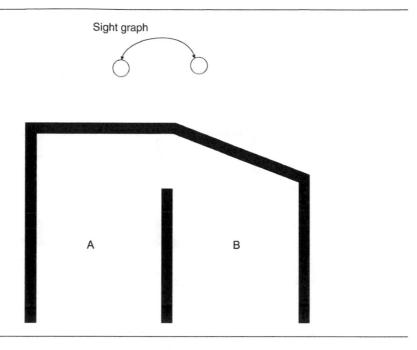

Figure 11.9: Line of sight in a sight-connected pair of nodes

Sight

Sight warrants special mention here. A connection between two nodes should allow sight signals to pass if any location in the destination node is visible from any location in the source. In general, there will be many locations in the destination node that cannot be viewed from many locations in the source. As we'll see, these cases will be trapped by the line-of-sight tests in the algorithm. But the line-of-sight tests won't be considered if the nodes aren't connected. Figure 11.9 shows a connection between two rooms, even though only a very small region of Room B can be seen from Room A, and then only by shuffling into a corner of Room A.

Another consequence of the algorithm below is that all pairs of nodes that have connected lines of sight must have a connection. Unlike for pathfinding, we cannot rely on intermediate nodes to carry information through. This is not true for modalities other than sight. Figure 11.10 shows a correct sense graph for a series of three rooms. Note that there are sight connections between Rooms A and C, even though Room B is in the way. There are no smell or sound connections between Rooms A and C, however.

Sense managers using this model have occasionally used a separate graph for sight, since it is specialized. A particularly sound implementation uses the potentially visible set (PVS) data from the rendering engine to calculate the sight graph. Potentially visible set is the name

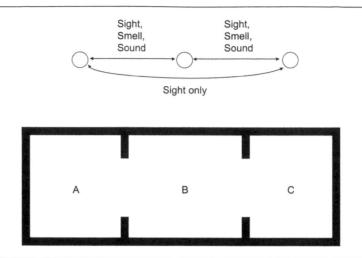

Figure 11.10: The sight sense graph

given to a range of graphics techniques used to cut down the amount of geometry that must be rendered each frame. It is a standard feature of all modern rendering engines.

In the algorithm below I will use one graph for all senses, but since each sense is handled slightly differently it is a relatively simple modification to replace the one graph with two or more.

The Algorithm

The algorithm works in the same three phases as before: aggregating the sensors that might get notified, testing them to check that they are valid, and notifying them of the signal.

As before, the sense manager is notified of signals from external code (often some polling mechanism) that isn't part of the algorithm. The signals are provided along with their location, their intensity, their modality, and any additional data that must be passed on.

The sense manager also stores a list of sensors: event listeners capable of detecting one or more modalities. Again, these provide a list of modalities and intensity threshold values. They will be notified of any signal that they are capable of detecting.

The algorithm is also given the sense graph, along with some mechanism to quantize locations in the game world into nodes in the sense graph. Both sensors and signals need to be quantized into a node before the algorithm can work. This quantization can be performed exactly as for pathfinding quantization. See Chapter 4 on pathfinding for more details. Internally, the sense manager stores sensors on a per-node basis, so it can rapidly find which sensors are present in a given node.

Depending on the modality type, the algorithm behaves slightly differently. In order of increasing complexity, sights, sounds, and smells are handled by different sub-algorithms.

Sight

Sights are the simplest signals to handle. When a sight is introduced, the algorithm gets a list of potential sensors: this is the aggregation phase. This list consists of all the sensors in the same node as the signal and all the sensors in nodes that are connected to that node. Only one set of connections is followed; we don't allow visual signals to carry on spreading around the level. If you need to simulate radiosity, as previously mentioned, then two sets of connections can be followed if, and only if, the visual signal emits light.

The algorithm then moves onto the testing phase. The potential sensors list is tested exactly as in the region sense manager. They are checked to see if they are interested in visual stimuli, whether the signal would have sufficient intensity, whether the signal is in the sight cone, and whether it is in line of sight. Background contrast can also be checked, exactly as before.

The timing and intensity data are calculated based on the position, transmission, and distance data in each connection. This is the same for all three modalities and is detailed below.

If the sensor passes all tests, then the manager works out when it needs to be notified, based on its distance from the stimuli (calculated as a Euclidean distance in three dimensions, unlike the other modalities below). The notification is then added to a notification queue, exactly as before. If sight is always instant in your game, you can skip this step and immediately notify the sensor.

Sound

Sound and smell are treated similarly, but with one major distinction. Smells linger in a region over time. Sounds in our model do not (we're not taking into account echoes, for example, although they can be modeled by sending in fresh sounds every few frames).

We treat sound as a wave, spreading out from its source and getting increasingly faint. When it reaches its minimum intensity limit, it disappears forever. This means that the sound can only be perceived as the wave passes you. If the sound wave has reached the edge of the room, the sound is no longer audible within the room.

To model sounds we begin at the node where the sound source is located. The algorithm looks up all sensors in this node. It marks the node as having been visited. It then follows the connections marked for sound, decreasing the intensity by the amount the connection specifies. It continues this process as far as it can go, working node to node via connections and marking each node it visits.

If it reaches a node where it has already been, it does not process the node again. Nodes are processed in distance order (which is equal to time order if we assume that sound travels at a constant speed). At each node visited, the list of potential sensors is collected.

If the intensity of the sound is below the minimum intensity, then no more nodes are processed. Intensity is calculated the same way for each modality and is described below.

In the testing phase, intensity checks are made for each sensor: those that are capable of receiving the signal have a notification request added to a queue ready for the dispatching phase.

Smell

Smell behaves in a way very similar to sound. Sound keeps track of each node it has passed through and refuses to process previous nodes. Smell replaces this with a stored intensity and associated timing information. Each node can have any lingering intensity of smell, so it stores an intensity value for the smell. To make sure this value is accurately updated, a time value is also stored. The timing value indicates when the intensity was last updated.

Each time the algorithm is run, it propagates its smells to neighbors based on the transmission and distance of intervening connections. It does not propagate if either the source or new destination intensities are below the minimum intensity threshold or if the signal could not reach the destination in the length of time the sense manager is simulating. This simulation time usually corresponds to the duration between sense manager calls (a frame perhaps). Limiting it by time in this way stops the smell from spreading faster through the sense graph than it would through the level.

The smell in a single node dies out based on the dissipation parameter of the node.

To avoid updating a node multiple times per iteration of the sense manager, a time stamp is stored. A node is only processed if its time stamp is smaller than the current time.

At each iteration, it aggregates sensors from each node in which there is an intensity greater than the minimum value. These are then tested in the testing phase for interest in the modality and for intensity threshold. Notification requests are scheduled for those that pass in the normal way.

Calculating Intensity from Node to Node

To calculate the intensity and the journey time of a non-visual stimulus as it moves from node to node, we split the journey into three sections: the journey from its source to the start of the connection, the journey along the connection, and the journey from the end of the connection to the sensor (or to the start of the next connection, if it's traveling multiple steps).

The total length of time is given by the speed of modality divided by the total distance: the distance from signal to the start of the connection (a 3D Euclidean distance), the distance along the connection (stored explicitly), and the distance to the sensor (another 3D distance).

The total attenuation is given by the attenuation factor of each component: the attenuation for the node that the source is in, the attenuation of the connection, and the attenuation of the sensor's node.

Iterative Algorithm

So far we've assumed that all the propagation for sight and sound is handled in one run of the sense manager. Smell, because it creeps around and gradually diffuses, needs to be handled iteratively. Sight works so fast that we need to process all its effects immediately.

Sound may occupy a middle ground. If it travels slowly enough, then it may benefit from being treated like smell: it is propagated by a few nodes and connections each time the sense manager is run. The same time stamp used to update the smell can be used for sound updating, as long as you aren't looking for perfect accuracy with regard to the way the sound wave expands. (We'd ideally like to process nodes from the source outward, but using only one time stamp means we can't do that for every source.)

The sense manager middleware my colleagues built using this algorithm allowed for slowmoving sound of this kind. In practice, however, it was never needed. If sound was handled instantaneously it was equally believable.

Dispatching

Finally, the algorithm dispatches all stimulus events to the sensors that have been aggregated and tested. It does this based on time, exactly as in the region sense manager.

For smells, or slow-moving sound, only the notifications for the immediate future are generated. If sound is handled in one iteration, then the queue may hold a notification for several milliseconds or seconds.

Implementation Notes

If smells are excluded, this algorithm behaves similarly to the region-based sense manager. Using the graph-based representation effectively speeds up detecting candidate sensors (the aggregation phase) and stops additional cases where the original algorithm gave wrong results (such as modalities passing through walls). It is relatively state free (only having to store which nodes have been checked for sound transmission).

Adding smells, or making sound checking split over many iterations, turns it into a very different beast. A lot more state is needed, and smells passing backward and forward between nodes can dramatically increase the number of calculations needed. Although smell has its uses and can enable some great new gameplay, I advise you to only implement it if you need it.

Weaknesses

When sound is processed all in one frame, the same weaknesses apply to this algorithm as to the region sense manager: we can potentially be notified at the wrong time. For very fast-moving characters this might be noticeable. This algorithm has removed the problem for smell and can completely solve the problem if sound is handled iteratively (at the cost of additional memory and time, of course).

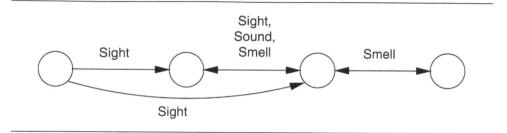

Figure 11.11: An example sense graph

Content Creation

This algorithm provides believable sense simulation and can cope with really interesting level designs: one-way glass, air-conditioning units, video cameras, windy corridors, and so on. FEM sense management, and algorithms like it, are state of the art in sense simulation for games.

As often throughout this book, state of the art is here a synonym for complex. The most difficult element of this algorithm is the source data; specifying the sense graphs accurately requires dedicated tool support. The level designer needs to be able to mark where different modalities can go. A coarse approximation can be made using the level geometry, by firing rays around, but this will not cope with special effects such as glass windows, ducting, or closed-circuit TV.

For now, sense simulation is a luxury, and if your game doesn't make a feature of it, then a simpler solution such as regional sense management or a vanilla event manager is a better option. But the trend is for increasing ubiquity of sense simulation, particularly in firstand third-person action games with stealth elements (they aren't so important in less realistic genres). It may not be long before complex sense simulation is expected.

EXERCISES

- 11.1 Suppose a sound has an intensity of 4 and the attenuation factor is 0.8. If there are 2 characters, one 2 units away from the sound with a threshold of 2.6 and the other 3 units away with a threshold of 2, then will they each hear the sound? How long will it take the sound to reach each of them if the transmission speed is 200?
- 11.2 Draw a level that might plausibly correspond to the sense graph shown in Figure 11.11.
- 11.3 Implement an event manager. First test it with some artificial data and then, if you can, try incorporating it into some real game code.
- 11.4 Implement a polling station. First test it with some artificial data and then, if you can, try incorporating it into some real game code.

12

TOOLS AND CONTENT CREATION

PROGRAMMING makes up a relatively small amount of the effort in a mass market game. Most of the development time goes into content creation, making models, textures, environments, sounds, music, and animation—everything from the concept art to the fine tuning of the level.

Over the last 15 years developers have reduced the programming effort further by reusing technology on multiple titles, creating or licensing a game engine on which several games can run. Adding a comprehensive suite of AI to the engine is a natural extension.

Most developers aren't content to stop there, however. Because the effort involved in content creation is so great, the content creation process also needs to be standardized, and the runtime tools need to be seamlessly integrated with development tools. For more than a decade these complete toolchains have been essential for development of large games. With the explosion in popularity of the Unity engine, they have become crucial to the existence of small studios, independent developers, and hobbyists.

In fact, it is difficult to overstate the importance of the toolchain in modern game development. At the time of the first edition of this book, the toolchain was seen as a major deciding factor in a publisher's decisions to back a project. Now it is almost ubiquitous. It is a rare and brave developer indeed that creates a new game from scratch without a proven toolchain in place.

Partly this is due to their availability. Renderware Studio was a major selling point for Criterion's graphics middleware in the early 2000s. But licensing it was costly and required a detailed agreement with a vendor. Now it is trivial to download Unity or Unreal Engine from

the web, experiment under a simple end user license, and have access to a widely supported and powerful toolchain. These tools are not free, but their ease of use has transformed the industry. In addition to these two market leaders, other systems such as the open source Godot and Amazon's Lumberyard (a fork of the Crytek's Cryengine) also emphasize the same style of game development, with the toolchain and a custom editor application at the core.

12.0.1 TOOLCHAINS LIMIT AI

The importance of toolchains places limits on the AI. Advanced techniques such as neural networks, genetic algorithms, and goal-oriented action planning (GOAP) haven't been widely used in commercial titles. To some degree this is because they are naturally difficult to map into a level editing tool. They require specific programming for a character, which limits the speed at which new levels can be created and the code reuse between projects.

The majority of AI-specific design tools are concerned with the bread-and-butter techniques: finite state machines or behavior trees, movement, and pathfinding. These approaches rely on simple processes and significant knowledge. Toolchains are naturally better at allowing designers to modify data rather than code, so use of these classic techniques is being reinforced.

12.0.2 WHERE AI KNOWLEDGE COMES FROM

Good AI requires a lot of knowledge. As we've seen many times in this book, having good and appropriate knowledge about the game environment saves a huge amount of processing time. And at runtime, when the game has many things to keep track of, processing time is a crucial resource.

The knowledge required by AI algorithms depends on the environment of the game. A character moving around, for example, needs some knowledge of where and how it is possible to move. This can be provided by the programmers, giving the AI the data it needs directly.

When the game level changes, however, the programmer needs to provide new sets of data. This does not promote reuse between multiple games and makes it difficult for simple changes to be made to levels. A toolchain approach to developing a game puts the onus on the content creation team to provide the necessary AI knowledge. This process can be aided by offline processing which automatically produces a database of knowledge from the raw level information.

For years it has been common for the content creation team to provide the AI knowledge for movement and pathfinding. Either explicitly, by marking up the level itself, or by having such data generated automatically from the content they create. More recently, decision making and higher level AI functions have also been incorporated into the toolchain, usually via custom tools integrated into the editor application.

$12.1\,$ knowledge for pathfinding and waypoints

Pathfinding algorithms work on a directed graph: a summary of the game level in a form that is optimal for the pathfinding algorithm. Chapter 4 discussed a number of ways in which the geometry of an indoor or outdoor environment could be broken into regions for use in pathfinding. The same kind of data structure is used for some tactical AI. Fortunately, the same kinds of tool requirements for pathfinding apply for waypoint tactics.

Breaking down the level geometry into nodes and connections can be done manually by the level designer, or it can be done automatically in an offline process. Because manually creating a pathfinding graph can be a time-consuming process (and one that needs to be redone each time the level geometry changes), many developers use automatic processes, at least for an initial draft. Results of purely automatic processes are typically mixed, with more issues showing as the level becomes more complex. Some human supervision is usually required for optimum results.

12.1.1 MANUALLY CREATING REGION DATA

There are three elements of a pathfinding graph that need to be created: the placement of the graph nodes (and any associated localization information), the connections between those nodes, and the costs associated with the connections.

The entire graph can be created in one go, but it is common for each element to be created separately using different techniques. The level designer may place nodes in the game level manually. The connections can then be calculated based on line-of-sight information, and the costs can be calculated likewise algorithmically.

To some extent, the cost and connections between nodes are easy to calculate algorithmically. Placing nodes correctly involves understanding the structure of the level and having an appreciation for the patterns of movement that are likely to occur. This appreciation is much easier for a human operator than an algorithm.

This section looks at the issues involved with manually specifying graphs (mostly the nodes of a graph). The following section examines automatic calculation of graphs, including connections and costs.

To support the manual creation of graph nodes, the facilities of the level editing tool depend on the world representation used.

Tile Graphs

Tile graphs do not normally require designers to manually specify any data in the modeling tool. The layout of a level is normally fixed (an RTS game, for example, typically is always based on a fixed grid, often of a limited number of different sizes).

The cost functions involved in pathfinding also need to be specified. Most cost functions are based on distance and gradient, modified by parameters particular to a given type of character. These values can usually be generated automatically (gradients can be calculated directly from the height values, for example). Character-specific modifiers are usually provided in the character data. An artillery unit, for example, might suffer ten times the gradient cost of a light reconnaissance unit.

Often, the level design tool for a tile-based game can include the AI data behind the scenes. Placing a patch of forest, for example, can automatically increase the movement cost through that tile. The level designer doesn't need to make the change in cost explicit or even need to know that AI data are being calculated.

As a result, no extra infrastructure is required to support pathfinding on tile-based graphs. This is one reason why they have continued to be used so extensively in the AI for games that require a lot of pathfinding (such as RTS), even when the graphics have moved away from sprite tiles.

Dirichlet Domains

Dirichlet domains are a useful world representation in a range of genres. They are applicable (in the form of waypoints) to everything from driving games to shooters to strategy games.

The level editor needs only to place a set of points in the game level to specify the nodes of the graph. The region associated with each point is the volume that is closest to that point than to any other.

Most level editing tools, and all three-dimensional (3D) modeling tools, allow the user to add an invisible helper object at a point. This can be suitably tagged and used as a node in the graph.

As discussed in Chapter 4, Dirichlet domains have some problems associated with them. Figure 12.1 shows two Dirichlet domains in two adjacent corridors. The regions associated with each node are shown. Notice that the edge of one corridor is incorrectly grouped with the next corridor. A character that strays into this area will think it is in a completely different area of the level. Therefore, its planned path will be wrong.

Similar problems with region grouping occur vertically, where one route passes over another. The problems are compounded when different "weights" can be associated with each node (so a larger volume is attracted to one node than to another). This is illustrated in Chapter 4.

Solving this kind of misclassification can involve lots of play testing and frustration on the part of the level designer. It is important, therefore, for tools to support visualization of the regions associated with each domain. If level designers are able to see the set of locations associated with each node, they can anticipate and diagnose problems more quickly.

Many problems can be avoided altogether by designing levels where navigable regions are not adjacent. Levels with thin walls, walkways through rooms, and lots of vertical movement are difficult to properly divide into Dirichlet domains. Obviously, changing the feel of a game is not feasible simply for the sake of the AI mark-up tool.

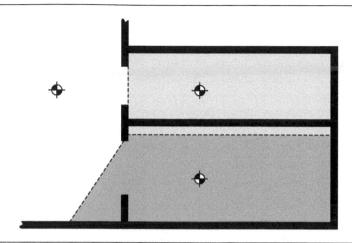

Figure 12.1: Dirichlet domains misclassifying a corridor

Navigation Meshes

The same polygon mesh used for rendering can be used as a navigation mesh for pathfinding. Each floor polygon is a node in the graph, and the connectivity between nodes is given by the connectivity between polygons.

This approach requires the level editor to specify polygons as being part of the "floor." This is most commonly achieved using materials: a certain set of materials is considered to be floors. Every polygon to which one of these materials is applied is part of the floor. Some 3D tools and level editors allow the user to associate additional data with a polygon. This could also be used to manually flag each floor polygon.

In either case, it can be useful to implement a tool by which the level editor can quickly see which polygons are part of the floor. A common problem is to have a set of decorative textures in the middle of a room, which is wrongly marked as "non-floor" and which makes the room unnavigable. This can be easily seen if the floor polygons can be visualized easily.

Navigation meshes have a reputation for being a reliable way of representing the world for pathfinding. They are supported out of the box by both Unity and Unreal Engine, and so have become the most commonly used technique. They are not without issue, however. As discussed in the pathfinding chapter, some level geometry can lead to sub-optimal graphs. Once again, the ability to have a human override the automatically generated graph is very useful.

Bounded Regions

The most general form of pathfinding graph is one in which the level designer can place arbitrary bounding structures to make up the nodes of the graph. The graph can then be built up without being limited to the problems of Dirichlet domains or the constraints of floor polygons.

Arbitrary bounding regions are complex to support in a level design or modeling tool. This approach is therefore usually simplified to the placement of arbitrarily aligned bounding boxes. The level designer can drag a bounding box over regions of the game level to designate that the contents of that box should count as one node in the planning graph. Nodes can then be linked together and their costs set manually or generated from geometrical properties of the node boxes.

12.1.2 AUTOMATIC GRAPH CREATION

With many of the previous approaches, an algorithm can be used to calculate the costs associated with connections in the graph. Approaches based on manually specified points of visibility or Dirichlet domains also use algorithms to determine the connectivity between nodes.

Automatically placing the nodes in the first place is considerably more difficult. For general indoor levels, there is no single optimum technique. In my experience developers who rely on automatic node placement will eventually need to have a mechanism for allowing the level designer to exert some influence and manually improve the resulting graph.

Automatic node placement techniques can be split into two approaches: geometric analysis and data mining.

12.1.3 GEOMETRIC ANALYSIS

Geometric analysis techniques operate directly on the geometry of the game level. They analyze the structure of the game level and calculate the appropriate elements of the pathfinding graph. Geometric analysis is also used in other areas of game development, such as calculating potentially visible geometry, performing global radiosity calculations, and ensuring that global rendering budgets are met.

Calculating Costs

For pathfinding data, most geometric analysis calculates the cost of connections between nodes. This is a relatively simple process, so much so that it is rare to find a game whose graph costs have been set by hand.

Most connection costs are calculated by distance. Pathfinding is usually associated with finding a short path, so distance is the natural metric. The distance between two points can be trivially calculated. For representations where nodes are treated as points, the distance of a connection can be taken as the distance between the two points.

A navigation mesh representation usually has connection costs based on the distance between the centers of adjoining triangles. Bounding region representations can similarly use the center points of regions to calculate distances.

Calculating Connections

Calculating which nodes are connected is also a common application. This is most commonly performed by line-of-sight checks between points.

Point-Based Representations

Point-based node representations (such as Dirichlet domains and point-of-visibility representations) associate each node with a single representative point. A line-of-sight check can be made between each pair of such points. If there is a line of sight between the points, then a connection is made between the nodes.

This approach can lead to vast numbers of connections in the graph. Figure 12.2 shows the dramatic complexity of a visibility-based graph for a relatively simple room.

For this reason, concerns are often raised about the performance of visibility-based graphs. But such concerns are curious, since a simple post-processing step can easily rectify the situation and produce usable graphs:

- 1. Each connection is considered in turn.
- 2. The connection starts at one node and finishes at another. If the connection passes through intermediate nodes on the way, then the connection is removed.
- 3. Only the remaining connections form part of the pathfinding graph.

This algorithm looks for pairs of nodes that are in line of sight but where there is no direct route between them. Because a character will have to pass through other nodes on the way, there is no point in keeping the connection.

The second part of Figure 12.2 shows the effect of applying the algorithm to the original graph.

Arbitrary Bounding Regions

Arbitrary bounding regions are usually connected in a similar way to points. A selection of sample points are chosen within each pair of regions, and line-of-sight checks are carried out. A connection is added when some proportion of the line-of-sight checks passes. Other than using multiple checks for each pair of regions, the process is the same as for a point representation.

Often, the proportion of required passes is set at zero; a connection is added if any of the line-of-sight checks passes. In most cases, if any line-of-sight check passes, then most of them will. As soon as one check passes, you can stop checking and simply add the connection.

- Center of Dirichlet domain
- Limit of domain
- Connection between nodes

Figure 12.2: A visibility-based graph and its post-processed form

For regions that are a long way from each other, a few line-of-sight checks may pass by squeezing through doorways, obtuse angled corners, up inclines, and so on. These pairs of regions should not be connected. Increasing the proportion of required passes can solve the problem but can dramatically increase the time it takes for the connection analysis.

Adding the post-processing algorithm above will eliminate almost all the erroneous connections but will not eliminate false connections that don't have an intermediate set of navigable regions (such as when there is a large vertical gap between regions). A combination of both solutions will improve the situation, but my experience has shown that there will still be problems that need to be solved by hand.

Limitations of Visibility Approaches

The primary problem with line-of-sight approaches is one of navigability. Just because two regions in the level can be seen from one another, it doesn't mean you can move between them.

In general, there is no simple test to determine if you can move between two locations in a game. For third-person action-adventure games, it may take a complex combination of accurate moves to reach a particular location. Anticipating such move sequences is difficult to do geometrically.

Fortunately, the AI characters in such games rarely have to carry out such action sequences. They are normally limited to moving around easily navigable areas.

It is an open research question as to whether geometric analysis can produce accurate graphs in complex environments. Those teams that have succeeded have done so by limiting the navigability of the levels, rather than by improving the sophistication of the analysis algorithms.

Mesh representations avoid some of the problems but introduce their own (jumping, in particular, is difficult to incorporate). To date, data mining (see Section 12.1.4) is the most promising approach for creating pathfinding graphs in levels with complex navigability.

Mesh Representations

Mesh representations explicitly provide the connection information required for pathfinding.

A mesh representation based on triangles has each floor triangle associated with a graph node. The triangle can be optionally connected along each of its three sides to an adjacent floor triangle. There are therefore up to three connections for each node. The connections can be easily enumerated from the geometry data: two triangles are connected if they share two vertices, and both are marked as floor triangles.

It is also possible to connect triangles that meet at a point (i.e., that share only one vertex). This reduces the amount of wiggle that a pathfinding character will display when moving across a dense mesh but can also introduce problems with characters trying to cut corners.

Calculating Nodes

Calculating the placement and geometry of nodes by geometric analysis is very difficult. Most developers avoid it all together. So far the only (semi-) practical solution has been to use graph reduction.

Graph reduction is a widely studied topic in mathematical graph theory. Starting with a very complex graph with thousands or millions of nodes, a new graph is produced that captures the "essence" of the larger graph. In Chapter 4 we looked at the process of creating a hierarchical graph.

To use this approach, the level geometry is flooded with millions of graph nodes. This can often be done simply using a grid: graph nodes are placed every half meter throughout the level, for example. Nodes of the grid that are outside the playing area (in a wall or unreachable from the ground) are removed. If the level is split into sections (which is common in engines that use portals for rendering efficiency), then the grid nodes can be added on a section-by-section basis.

This graph is then connected and costed using the techniques we've looked at so far. The graph at this stage is huge and very dense. An average level can have tens of millions of nodes and hundreds of millions of connections. Typically, creating this graph takes a very large amount of processing time and memory.

The graph can then be simplified to create a graph with a reasonable number of nodes—for example, a few thousand. The structure of the level made explicit at the high-detail level will be captured to some extent in the simplified graph.

Although it sounds simple enough, the graphs produced by this approach are often unsatisfactory without tweaking. They often simplify away key information that a human would find obvious. Research into better simplification techniques is ongoing, but those teams that use this method in their toolchain invariably bank on being able to visualize and tweak the resulting graphs.

12.1.4 DATA MINING

Data mining approaches to graph creation find nodes by looking at movement data for characters in the game world.

The game environment is built, and the level geometry is created. A character is then placed into the level. The character either can be under player control or can be automated. As the character moves around in the level, its position is constantly being logged. The logged position data can then be mined for interesting data.

If the character has moved around enough, then the majority of legal locations in the game level will be in the log file. Because the character in the game engine will be able to use all of its possible moves (jumps, flying, and so on), there is no need for complex calculations required to determine where the character could get to.

Calculating Nodes

Locations that the character is often near will probably consist of junctions and thoroughfares in the game level. These can be identified and set as nodes in the pathfinding graph.

The log file is aggregated so nearby log points are merged into single locations. This can be performed by the condensation algorithm from Chapter 4 or by keeping track of the number of log points over each floor polygon and using the center point of the polygon (i.e., using a polygon-based navigation mesh).

Although it can be used with navigation meshes, data mining is typically used in combination with a Dirichlet domain representation of the level. In this case a node can be placed in each peak area of movement density. Typically, the graphs have a fixed size (the number of nodes for the graph is specified in advance). The algorithm then picks the same number of peak density locations from the graph, such that no two locations are too close together.

Calculating Connections

The graph can then be generated from these nodes using either a points-of-visibility approach or further analysis of the log file data.

The points-of-visibility approach is fast to run, but there is no guarantee that the nodes chosen will be in direct line of sight. Two high-density areas may occur around a corner from

each other. The line-of-sight approach will incorrectly surmise that there is no connection between the two nodes.

A better approach is to use the connection data in the log file. The log file data can be further analyzed, and routes between different nodes can be calculated. For each entry in the log file, the corresponding node can be calculated (using normal localization; see Chapter 4 for more details). Connections can be added between nodes if the log file shows that the character moved directly between them. This produces a robust set of connections for a graph.

Character Movement

To implement a data mining algorithm, a mechanism is needed to move the character around the game level. This can be as simple as having a human player control the character or playing a beta version of the game.

In most cases, however, a fully automatic technique is needed. In this case, the character is controlled by AI. The simplest approach is to use a combination of steering behaviors to randomly wander around the map. This can be as simple as a "wander" steering behavior, but usually includes additional obstacle and wall avoidance.

For characters that can jump or fly, the steering behaviors should allow the character to use its full range of movement options. Otherwise, the log file will be incomplete, and the pathfinding graph will not cover the whole level accurately. Creating an exploring character of this kind is a challenging AI task in itself. Ideally, the character will be able to explore all areas of the level, even those that are difficult to reach. In reality, automatic exploring characters can often get stuck and repeatedly explore a small area of the level.

Typically, automatic characters are only left to explore for a relatively short amount of time (a couple of game minutes at the most). To build up an accurate log of the level, the character is restarted from a random location each time. Errors caused by a character getting stuck are minimized, and the combined log files are more likely to cover the majority of the level.

Limitations

The downside with this approach is time. To make sure that no regions of the level are accidentally left unexplored and to make sure that all possible connections between nodes are represented in the log file, the character will need to be moving around for a very long time. This is particularly the case if the character is moving randomly or if there are areas of the level that require fine sequences of jumps and other moves to reach.

Typically, an average game level (that takes about 30 seconds to cross by a character moving at full speed) will need millions of log points recorded.

Under player control, fewer samples are required. The player can make combinations of moves accurately and exhaustively explore all areas of the level. Unfortunately, this approach is limited by time: it takes a long time for a player to move through all possible areas of a level in all combinations. While an automated character could do this all night, if required (and it

usually is), using a human player for this is wasteful. It would be faster to manually create the pathfinding graph in the first place.

Some developers have experimented with a hybrid approach: having automatic wandering for characters, combined with player-created log files for difficult areas.

An active area for research is to implement a wandering character that uses previous log file data to systematically explore poorly logged areas, trying novel combinations of moves to reach locations not currently explored.

Until reliable exploring AI is achieved, the limitations of this approach will mean that hand optimization will still be needed to consistently produce usable graphs.

Other Representations

So far I have described data mining with respect to point-based graph representations. Meshbased representations do not require data mining approaches; the nodes are explicitly defined as the polygons in the mesh.

It is an open question as to whether general bounding regions can be identified using data mining. The problem of fitting a general region to a density map of log data is certainly very difficult and may be impossible to perform within sensible time scales. To date, the practical data mining tools I am aware of have been based on point representations.

12.2 KNOWLEDGE FOR MOVEMENT

While pathfinding and waypoint tactics form the most common and trickiest toolchain pressure, getting movement data comes in a close second.

12.2.1 **OBSTACLES**

Steering is a simple process when done on a flat empty plane. In indoor environments there are typically many different constraints on character movement. An AI character needs to understand where constraints lie and be able to adjust its steering accordingly. It is possible to calculate this information at runtime by examining the level geometry. In most cases this is wasteful, and a pre-processing step is required to build an AI-specific representation for steering.

Walls

Predicting collisions with walls is not a trivial task. Steering behaviors treat characters as particles with no width, but characters inevitably need to behave as if they were a solid object in the game. Collision calculations can be made by making multiple checks with the level

Figure 12.3: A crevice from automatic geometry widening

geometry (checks from the right and left extremes of the character, for example). But this can cause steering problems and stuck characters.

A solution is to use a separate AI geometry for the level shifted out from all walls by the radius of the character (assuming the character can be represented as a sphere or cylinder). This geometry allows collision detection to be calculated with point locations and lowers the cost of collision prediction and avoidance.

The calculation of this geometry is usually done automatically with a geometric algorithm. Unfortunately, these algorithms often have the side effect of introducing very small polygons in corners or crevices which can trap a character. Figure 12.3 shows a case where the geometry can give rise to a fine crevice that is likely to cause problems for an agent.

For very complex level geometries, an initial simplified collision geometry or support for visualization and modification of the AI geometry in the modeling package may be required.

Obstacle Representation

AI does not work efficiently with the raw polygon geometry of the level. Detecting obstacles by searching for them geometrically is a time-consuming task that always performs poorly.

Collision geometry is often a simplified version of the rendering geometry. Many developers use AI that searches based on the collision geometry.

Often, additional AI geometry needs to be applied to the obstacle so it can be avoided cleanly. The complex contours of an object do not matter to a character that is trying to avoid it altogether. As in Figure 12.4, a bounding sphere around the whole would be sufficient.

As the environment becomes more complex, the constraints on character movement are increased. Whereas moving through a room containing one crate is easy (no matter where the crate is), finding a path through a room strewn with crates is harder. There may be routes through the geometry that are excluded because the bounding spheres overlap. In this case, more complex AI geometry is required.

Figure 12.4: AI geometries: rendering, physics, and AI

12.2.2 HIGH-LEVEL STAGING

Although originally designed for use in the movie industry, AI staging is increasingly being used for game effects. Staging involves coordinating movement-based game events.

Typically, the level designer places triggers in the game level that will switch on or off certain characters. The character AI will then begin to make the characters act correctly. Historically, this has often been observable to the player (characters suddenly coming to life when the player approaches), but now is generally better hidden from sight.

Staging takes this one stage further and allows the level designer to set high-level actions for the characters in response to triggers. Typically, this applies when there are many different AI characters in the scene (such as a swarm of spiders or a squad of soldiers).

The actions set in this way are overwhelmingly movement related. This is implemented as a state in the character's decision making tool where it will execute a parametric movement (usually "move to this location," with the location being the parameter). This parameter can then be set in the staging tool, either directly or as a result of a trigger during the game.

More sophisticated staging requires more complex sets of decisions. It can be supported with a more complete AI design tool, capable of modifying the decision making of a character. Changes to the internal state of the character can then be requested as a result of triggers in the level.

12.3 KNOWLEDGE FOR DECISION MAKING

At the simplest level, decision making can be implemented entirely by polling the game world for information. A character that needs to run away when faced with danger, for example, can look around for danger at each frame and run if the check comes back true. This level of decision making was common in games until the turn of the century.

12.3.1 OBJECT TYPES

Most modern games use some kind of message passing system to moderate communication. The character will stand around until it is told that it can see danger, whereupon it will run away. In this case the decision as to "what is dangerous" doesn't depend on the character; it is a property of the game as a whole.

This allows the developer to design a level in which completely new objects are created, marked as dangerous, and positioned. The character will correctly respond to these objects and run away, without requiring additional programming. The message passing algorithm and the character's AI are constant.

The toolchain needs to support this kind of object-specific data. The level designer will need to mark up different objects for the AI to understand their significance. Often, this isn't an AI-specific process. A power-up in a platform game, for example, needs to be marked as collectible so the game will correctly allow the player to move into it (as opposed to making it impenetrable and having the player bounce off it). This "collectible" flag can be used by the AI: a character could be set so that it defends any remaining collectibles from the player.

Most toolchains are data driven: they allow users to add additional data to an object's definition. These data can be used for decision making.

12.3.2 CONCRETE ACTIONS

In some games, the actions available to a player depend on the objects in the player's vicinity for example, being able to push a button or pull a lever. In games with more complex decision making, the character may be able to use a range of gadgets, technologies, and everyday objects. A character may use a table as a shield or a paperclip to open a lock, for example.

While most games still reserve this level of interaction for the player, people simulation games lead a trend toward wider adoption of characters with broad competencies.

To support this, objects need to tell the character what actions they are capable of supporting. A button may only be pushed. A table may be climbed on, pushed around, thrown, or stripped of its legs and used as a shield. At its simplest, this can be achieved with additional data items: all objects can have a "can be pushed" flag, for example. Then a character can simply check the flag.

But this level of decision making is usually associated with goal-oriented behavior, where actions are selected because the character believes they will help achieve a goal. In this case,

knowing that both buttons and tables can be pushed doesn't help. The character doesn't understand what will happen when such an action is performed and so can't select an action to further its goals.

Pushing a button in an elevator does a very different thing than pushing a table under a hole in the roof; they achieve very different goals. To support goal-oriented behavior, or any kind of action planning, objects need to communicate the meaning of an action along with the action itself. Most commonly, this meaning is simply a list of goals that will be achieved (and those that will be compromised) if the action is taken.

Toolchains for games with goal-oriented AI need to treat actions as concrete objects. An action, like a game object in a regular game, can have data associated with it. These data include the change in the state of the world that will result from carrying out the action, along with prerequisites, timing information, and what animations to play. The actions are then associated with objects in the level.

12.4 THE TOOLCHAIN

So far I have outlined the tool requirements of individual AI techniques. To put a whole game together, these individual functions need to be marshaled so all the game data can be created and brought into the compiled game. The process of exposing these different editing functions, and combining the results together, is known as the 'toolchain': the chain of tools required to make a finished game.

Historically, through to the early 2000s, developers most commonly used a range of different tools, combined with scripts and common file formats to perform the integration. Game engine vendors began to realize that the toolchain was a key pain point for developers, and solutions involving integrated editors began to arise. The two most prominent game engines— Unreal Engine and Unity—are now by far the most widely used toolchains in the industry, and both provide integrated editing applications with extensible support for developer-defined tools. For most developers, the game engine and the editor form an integrated toolchain.

Most, that is, but not all. There are still some studios that prefer to build together a toolchain from different tools, to drive their in-house game engines. Not everyone wants to use an engine such as Unity, and if the engine isn't being used, there is little reason to use the tooling.

This section takes a brief walk through the AI-related elements of a complete toolchain, for both users of prominent game engines and those choosing to go it alone. It considers a range of solutions from custom extensions for game engine editors, through independent behavior editing tools, to plug-ins for 3D modeling software.

12.4.1 INTEGRATED GAME ENGINES

At the start of the chapter, I briefly mentioned Renderware Studio, an early complete toolchain and editing application for the licensable Renderware engine (which was purchased as inhouse technology and taken off the market by Electronic Arts in 2004). Its primary competitors Gamebryo and Unreal Engine also added integrated editors of their own, along with many integrated systems in-house at larger developers. But these engines capable of developing cutting-edge games were marketed at established development studios, with licensing terms and costs to match.

It was Unity, from 2005 onward, that lowered barriers to use and brought the same advantages to a larger market of studios, eventually supporting a growing industry of independent game developers and hobbyists. Although originally being Mac-only, and facing competition from other PC-centric integrated game tools, Unity undeniably won. It is now the most widely used game engine in the world, with millions of developers (possibly tens of millions, up-to-date numbers are difficult to acquire) and its model of an extensible level editor has become the de facto standard.

Built-in Tools

Unity and similar engines (Unreal Engine is the most common, but at the time of writing there is also the open source Godot, and other commercial offerings such as Amazon Lumberyard and CryEngine) provide a basic set of tools out of the box in their editor applications.

At their simplest, it is possible to associate additional data with objects in the level. Custom data slots can be defined, and the level author can fill these slots with data. This could include the value of a pickup, the navigation difficulty of a surface, or the placement of a cover point. All engines support objects that do not appear to the user, which can be used to hold global data, for all characters to access; or placed invisibly into a scene to represent a waypoint, or other localized piece of information. These tools are usually simple lists of key-value pairs where the value can be edited by the level author.

Both Unity and Unreal Engine provide inbuilt support for pathfinding and navigation. And both expose this in the editor, allowing the pathfinding data to be visualized and modified.

In addition, a custom state machine editor is usually provided for fine tuning animation. The resulting state machines can be accessed programmatically, and can be used as the basis of state machine AI. Though, because they are not optimized for this purpose, they may be overly cumbersome compared to a dedicated plug-in (see below).

Additional tools are provided for non-AI applications such as particle effects, sound mixing and font support, but typically no first-class tool support is provided for AI beyond navigation. For this, a plug-in is needed.

Editor Plug-ins

Game engine vendors cannot anticipate all the requirements of every game built using their system. Instead they support plug-in systems, where custom code can overlay data onto the

Figure 12.5: A screenshot of Behavior Designer by Opsive, a behavior tree editing tool for Unity.

main level view, or be given exclusive access to a window in which to draw their own user interface.

The tool requirements in the rest of this section are typically implemented as plug-ins to modify the behavior of the editor. Both Unreal Engine and Unity have a large online store for developers to sell their plug-ins. Chances are, a tool is already available in the store that approximates the needs of your game. Though it may need tweaking, it can at least be used for rapid prototyping and as inspiration for a more customized solution.

Figure 12.5 shows a screenshot of such a tool focused on creating and running behavior trees.

Editor Scripting

Much of the power of integrated editors comes from their scripting language. Integrated scripting avoids the need to implement all game logic in a low-level language such as C++. As described in the next chapter, the ability to write code snippets reduces the need for the simpler decision-making AI techniques. Rather than a decision tree, built using a decision tree editing tool, a script with a list of if-statements can have the same effect.

If written in source code, scripts require a programmer to author. This may be fine for an indie studio where a game designer is also tasked with programming the game, but in larger

teams with more specialization, it may not be feasible. Fortunately, there are more friendly alternatives within reach of technically minded non-programmers.

Out of the box, Unreal Engine (beginning in version 4) supports Blueprints, a visual programming language, with much of the flexibility of a tool for creating AI state machines, behavior trees or decision trees. Similar tools are available in the Unity asset store. At the time of writing, Playmaker by Hutong Games LLC is the most popular, though there are several alternatives.

Section 13.3 in Chapter 13 looks at such visual scripting languages in more detail.

12.4.2 **CUSTOM DATA-DRIVEN EDITORS**

Developers using their own engine must factor in the creation of custom editors to prepare their data.

AI isn't the only area in which a huge amount of extra data is required for a game level. The game logic, physics, networking, and audio require their own sets of information. It is possible to create several separate tools to generate this data, but most developers follow the Unity or Unreal model and bring all editing functions into one application. This can then be reused over all their games. Ownership of such a tool provides the flexibility to implement complex editing functionality tightly integrated with the final game code, in a way that would be difficult in an existing editor.

A former client of mine adopted this approach because their game engine relied on memory-mapped level data, where all the information required to play a level (models, textures, AI, sound, etc.) were stored laid out in memory in exactly the way their C++ code needed it, improving loading times to the point where new sections of a level could be loaded in the background during gameplay. Existing engine editors were too opinionated about how they store their data, so the company developed their own from scratch.

Whatever the motivation, this kind of complete level editing package is often called "data driven" or "object oriented." Each object in the game world has a set of data associated with it. This set of data controls the behavior of the object—the way in which it is treated by the game logic.

It is relatively easy to support the editing of AI data in this context. Often, it is a matter of adding a handful of extra data types for each object (such as marking certain objects as "to be avoided" and other objects as "to be collected").

Creating tools of this kind is a major development project and is not an option for small studios, self-publishing teams, or hobbyists. Even for teams with such a tool, there are limitations to the data-driven approach. Creating a character's AI is not just a matter of setting a bunch of parameter values. Different characters require different decision making logic and the ability to marshal several different behaviors to select the right one at the right time. This requires a specific AI design tool (although such tools are often integrated into the data-driven editor).

12.4.3 AI DESIGN TOOLS

In the same way that modern game engines provide certain tools as standard (namely the ability to mark up a level and navigation tools), the most common custom tools enable the AI to understand the game level better and to get access to the information it needs to make sensible decisions.

As the sophistication of AI techniques increases, and level designers are tasked with implementing more behavior, developers are looking at ways to allow level designers to have access to the AI of characters they are placing. Level designers creating an indoor lab scenario, for example, may need to create a number of different guard characters. They will need to give them different patrol routes, different abilities to sense intruders, and different sets of behaviors when they do detect the player.

Allowing the level designers to have this kind of control requires specialist AI design tools. Without a tool, the designer has to rely on programmers to make AI modifications and set up characters with their appropriate behaviors.

Scripting Tools

The first tools to support this kind of development were based on scripting languages. Scripts can be edited without recompilation and can often be easily tested. Many game engines that support scripting provide mechanisms for editing, debugging, and stepping through scripts. This has been primarily used to develop the game level logic (such as doors opening in response to button presses, and so on). But, as AI has evolved from this level, scripting languages have been extended to support it.

Scripting languages suffer from the problem of being programming languages. Nontechnical level designers can have difficulty developing complex scripts to control character AI.

State Machine Designers

By the mid-2000s, tools supporting the combination of pre-built behaviors became widely available. Some commercial middleware tools fall under this category, such as Havok's AI support, as well as several open source and in-house tools created by large developers and publishers. These tools allow a level designer to combine a palette of AI behaviors.

A character may need to patrol a route until it hears an alarm and investigates, for example. The "patrol route" and "investigate" behaviors would be created by the programming team and exposed to the AI tool. The level designer would then select them and combine them with a decision making process that depends on the state of the siren.

The actions selected by the level designer are often little more than steering behaviors. As discussed in Chapter 3, this is often all that is required for the majority of game character behavior.

Figure 12.6: The SimBionic editor screen

The decision making process favored by this approach is state machines, with the behavior trees a more sophisticated minority option. Figure 12.6 shows a screenshot of the SimBionic FSM tool, originally a commercial middleware offering, now open source.

The best tools of this type have incorporated the debugging support of a scripting language, allowing the level editors to step through the operation of the FSM, seeing visually the current state of a character and being able to manually set their internal properties.

12.4.4 REMOTE DEBUGGING

Getting information out of the game at runtime is crucial for diagnosing the kind of AI problem that doesn't show in isolated tests. Typically, developers add debugging code to report the internal state of the game as it is played. This can be displayed on-screen or logged to file and analyzed for the source of errors.

When running on a PC, it is relatively easy to get inside the running game. Debugging tools can attach to the game and report details of its internal state. On consoles and mobile devices, remote debugging tools exist to connect from the development PC to the test hardware.

While there is a lot that can be done with this kind of inspection, more sophisticated debugging tools are almost always required for anything but the simplest games. Analyzing memory locations or the value of variables is useful for some debugging tasks. But it is difficult to work out how a complex state machine is responding and impossible to understand the performance of a neural network.

A debugging tool can attach to a running game to read and write data for the AI (and any other in-game activity, for that matter). One of the most common applications of remote debugging is the visualization of internal AI state, whether the decisions of the behavior tree, the output of a neural network, or the line of sight tests being performed by sense management. Often, combined with the tools that edit this data, this allows the developer to see and tweak the characters in the game as they run, and sometimes even introduce specific events into an event management mechanism.

Remote debugging requires a debugging application to be running on a PC, communicating over the network to the game, or running on another PC, mobile device or console (or sometimes the same PC). This network communication can cause problems with data reliability and timing (the state of the game may have moved on from what the developer is looking at). Although this has improved in the last decade with the movement of all platforms to always-on internet connectivity, some legacy devices do not support general network communication suitable for this kind of tool.

Internet connected platforms also open the opportunity to access debugging information running on players' machines after the game is released. There can be legal issues of privacy, but this has become a standard tool many developers use to optimize their game in successive patches. Several turnkey solutions are available for in-game analytics, particularly on mobile devices.

12.4.5 PLUG-INS

Although custom level editing tools are now almost ubiquitous, 3D design, modeling, and texturing are still overwhelmingly performed in a high-end modeling package like Autodesk's 3ds Max or Maya, with the open source Blender package popular among smaller independent and hobbyist developers.

Each of these tools has a programmer's software development kit (SDK) that allows new functionality to be implemented in the form of plug-in tools. This allows developers to add plug-in tools for capturing AI data. Plug-ins written with the SDK are packaged into libraries. They are sometimes written in C/C++, but more commonly in a scripting language provided by the package (for example MAXScript for 3DS Max, and Python for Blender).

The internal operation of each software package puts significant constraints on the architecture of plug-ins. It is challenging to integrate with the existing tools in the application, and can be non-intuitive to connect to the undo system, the software's user interface, and the internal format of its data. Because each tool is so radically different and the SDKs each have a very different architecture, what you learn developing for one often will not translate.

For AI support, the candidates for plug-in development are the same as the functionality required in a level editing tool. Because there has been such a substantial shift toward dedicated level editing tools, fewer developers are building AI plug-ins for 3D modeling software.

EXERCISES

- 12.1 Develop a tool that can analyze the placement of waypoints in level geometry and recognize potential problems like the ones illustrated in Figure 12.1. Note that you are not being asked to place the waypoints automatically or resolve problems, just identify them. For the geometry you can, at least to start with, just use a simple grid.
- 12.2 Perform a post-processing step to simplify the links in the graph shown in Figure 12.7.
- 12.3 Figure 12.8 shows a visual representation of a log file of the type that might be generated by recording areas of a level that get visited during a play session.
 - What problems might occur if this log file was used to automatically generate a waypoint graph? What additional information could be recorded in the log file to fix the problem?
- 12.4 Figure 12.9 shows two alternative representations that an AI character might use for an enemy standing on a bridge. The representation on the left uses waypoints and the one on the right a navigation mesh.
 - What kind of problems might occur with the waypoint representation and how might the navmesh fair better in this regard?

Figure 12.7: A dense graph representing a simple room

Figure 12.8: Visited locations in a level

Figure 12.9: Alternative representations for the same situation

13

PROGRAMMING GAME AI

EDITORS and other tools are important for content creation: building the data that gives the game its gameplay. From the obvious visual design of the geometry of levels, to the configuration of AI algorithms that make-up character behavior. As we saw in the previous chapter, different AI approaches will require different tools: extensions to level editing or 3D modeling, or custom tools for visualizing and configuring decision-making. The exact requirement depends on the approach being used.

In contrast, there is one tool that is always necessary. So much so that it can be easily ignored in a discussion of supporting technologies. All AI is programmed. And the programming language has a big impact on the design of the AI.

Most of this book focuses on techniques that are not game specific. Pathfinding or decision trees, for example, are general approaches that can be used in a whole range of games. These techniques need to be implemented. A decade ago, it would not be unreasonable to assume that they would be implemented in C++ as part of the core game code. That has changed radically now. Although game engines are still usually implemented in C and C++, most of the AI is typically implemented in another language. The most common commercial game engines, Unity and Unreal Engine 4 (UE4), provide a pathfinding system written in C++, but if you need any other AI technique (a behavior tree for example, or steering behaviors) it needs to be written, or licensed from a third party. In UE4 this may still involve coding in C++, but in Unity it probably means implementing in C#. In both cases the new code acts as a kind of plug-in, on equal footing with gameplay code rather than core facilities such as networking and 3D rendering.

At the same time, mobile and online development has burgeoned, where implementation languages are constrained by the target platform. Swift (and before that Objective-C) on iOS,

Java (or other JVM languages such as Kotlin) on Android, and JavaScript on the web. Together these trends have meant that AI techniques are being implemented in a much broader range of languages. The next section considers the different requirements different languages place on the techniques described so far in this book.

But general-purpose AI techniques are only one place in which AI code requires programming support. It is common to use small scripts written in an embedded programming language to control character behavior. Often this is easier than using a general-purpose technique, and developing tools to configure it correctly. Provided that the person creating the character behavior is reasonably confident with simple programming tasks, it might be much easier to produce state-based behavior with a series of if-statements rather than dragging blocks and transitions in a general purpose state machine editor.

Commercial game engines always provide some form of scripting support. If you are developing your tool set from scratch, you may need to add your own. Fortunately there are several languages that are easy to integrate. Section 13.2 considers the options. Although increasingly rare, many developers have felt existing options are unsuitable, and developed their own scripting languages. Language design is beyond the scope of this book, but Section 13.3 gives a high level overview of what's involved.

13.1 IMPLEMENTATION LANGUAGE

When I started in the industry in the 1990s, games were written in C, almost exclusively. Parts of the code that needed to run as fast as possible were often re-implemented in assembly language, when developers felt they could do a better job than the compiler (and for some kinds of code they definitely could). When the first edition of this book was released, the industry was begrudgingly migrating to C++. I say begrudgingly, because C++ is a much bigger language, with quite significant performance traps for the unwary: there was genuine debate whether C++ would prove to be performant enough. Many excellent code bases are available from this period, including code to some of the biggest selling titles. The C++ source to Quake 3 [124], for example (available at [25]), is often cited by developers as being one of the most beautiful and well-written C++ code bases.

Two significant changes in the industry in the last 20 years have changed the way games are developed.

The first is the growth of mobile as a major market. While it is possible to develop mobile games in C++ for both iOS and Android, only a tiny minority of game developers do so. Apple encourages iOS developers to use Swift (and prior to Swift, Objective-C), whereas Android relies on the Java virtual machine which can be more easily programmed in Java, or a JVM language such as Kotlin.

The second significant shift is to the use of game engines. Most developers for desktop and console (and increasingly for mobile too) now use existing engines. For big studios such as EA, this may be their own internal engine. For most developers it is Unity and Unreal Engine.

C++ is still the primary language used to build these game engines. And games developed

in UE4 often have parts of their gameplay implemented in C++. But computers are so much faster, much of what was programmed in a low-level language can now be implemented in the engine's scripting language. Blueprint in UE4, and C# in Unity, for example. The explosion in the use of Unity in education, among hobbyists, for mobile, and in the indie development community has meant that C# could now justifiably claim to be the primary language for implementing games. It is difficult to say precisely because it is difficult to measure, but at the very least the suggestion isn't absurd.

Most of the advice in this book is language neutral. In this section I will briefly look at the five languages that, at the time of writing, are the most significant for game implementation: C++, C#, Swift (for iOS), Java (for Android) and JavaScript (for web games and servers). I will summarize each language, and point out any ways in which its peculiarities need to be taken into account when implementing algorithms in this book.

13.1.1 C++

C++ was originally an extension to the C language, to add support for object-oriented programming. It is still mostly a compatible superset, though new features sometimes appear in the two languages at different times. In the past few years, Rust has positioned itself as a new language for writing low-level system code (the kind of software that makes up operating systems or other resource and performance critical applications), but aside from a few notable Rust projects, C++ is still the most popular choice for low-level programming.

C++ is a big language. It has been growing steadily since its first release in 1985. New versions of the standard are now being released every three years, each with its own set of new features and often new syntax. This bloated feature set has been a consistent criticism of C++ for at least the last 15 years. So much so that it has effectively fragmented into multiple languages. Not, as Scheme and Lisp have, because of multiple implementations, but because each company that adopts it tends to tame the complexity by adopting only a subset of the whole language. But rarely the same subset. Features such as its templating language, its comprehensive support for operator overloading, multiple inheritance of classes, runtime type information, and its take on exceptions are all regularly prohibited.

In addition to the core language, C++ also specifies a standard template library (STL). This is a set of fundamental data types implemented using C++ templates. Basic data types which are part of the core in other languages, such as resizable arrays, hash-maps, stacks and queues, are all provided via the STL. Unfortunately implementations of the STL do vary, and as a whole it has a reputation among game developers for being difficult to manage, low performance, or erratic in its memory use. I have worked for more than one company that bans the STL from its code, preferring to create their own non-templated versions of those fundamental data types. The situation is even more complex when common libraries such as Boost can be used to 'correct' some of the problems in the core language. As C++ has developed, it has drawn good ideas from Boost, implementing them slightly differently, and potentially giving another axis of incompatibility.

Although I have tried not to describe any algorithms in this book in C++ specific terms, it is the language I am most familiar with for implementing games. As a result the pseudo-code should translate naturally into C++, depending on the subset of features you or your team wants to use. The availability of good quality data structures is my main assumption. In my experience I have had reasonable success using STL (in particular, after replacing its default memory management with a custom allocator), but if you choose to implement your own data structures, that may be a bigger challenge than using those data structures to implement the AI.

13.1.2 C#

C# was created by Microsoft as a rival to Java, targeting its own common language runtime (CLR). Initial versions of the language were quite Java-like, but over time it has been more willing to change the core, and the languages have grown apart.

Because the common language runtime is proprietary to Microsoft, other developers implemented an open source alternative, called Mono. Because Microsoft open sourced the C# language, only keeping the runtime proprietary, Mono provides a free way of using the language in another project. The Unity engine did exactly that.

In theory this allows any CLR language to be used with the Unity engine. Unity the company only supports C# however, having deprecated it's own JavaScript like scripting language. I am aware of developers using F#, a functional CLR language, but mostly experimentally. The overwhelming majority of code written for Unity is now C#.

A common criticism of the Unity engine is that it lags a long way behind the current version of C#. Partly this is because Mono trails a short way behind Microsoft's CLR, but mostly it is because Unity is very conservative about upgrading the version of Mono it uses in its engine. This can impact you as a developer because online tutorials and resources for C# programmers are often incompatible with the version of the language in the engine. Fortunately, this is mitigated somewhat by the overwhelming number of Unity-specific tutorials and resources, though these are often aimed at more novice programmers.

Perhaps the most impactful difference between C# and C++ is the way Mono manages memory. Rather than explicit allocation and deallocation, Mono keeps track of the memory your program uses, and periodically releases all the memory it can find that is no longer needed. Unfortunately, finding that memory to deallocate (known as garbage collection) takes time, sometimes tens of milliseconds. And worse 'periodically' is difficult to anticipate and impossible to control. Games that rely on this behavior are subjected to occasional slowdowns, frame rate drops, or stuttering.

Fortunately, garbage collection is usually very fast if there is nothing to collect (there are edge cases where it takes time to prove nothing needs collecting, but these are typically rare for normal usage patterns). Garbage collection works by keeping track of which objects know of the existence of which other objects. Starting from a set of known objects, it steps through this graph and marks all the objects that can be reached, either in one step or multiple steps.

If at the end of this process an object is not marked, nothing can access it, and it is free to be collected. This algorithm is known as mark-and-sweep, or tracing garbage collection.

The stuttering of garbage collection can be avoided if your code allocates all the objects it will need in one go (usually when a level is loaded), and then releases them all in one go when the gameplay is complete (before the next level is loaded, for example). There is no way to explicitly allocate or release memory in C#, so we work around the mark and sweep algorithm. At the start of the level we create all the objects we might ever need and keep hold of a reference to them (if they are similar objects we could keep them in an array, for example). This guarantees they are always reachable, and so will not be garbage collected. During the execution of the algorithm, when an object is needed, it is taken from our preallocated block. At the end of the level, references to all the objects are deleted, whether we ended up using them or not. The garbage collector will then detect that they are ready for collection. The speed issues with Mono's garbage collection are so acute that this approach is practically essential. It does not have a significant effect on any of the algorithms presented in this book, but needs to be kept in mind for any C# implementation.

Recently, Mono has implemented a garbage collection system that is much less likely to cause frame drops and stuttering. As of writing, this is available in Unity as an option, but is not enabled by default. When it does become the default garbage collection, the need for object pools will diminish somewhat. But garbage collection will always be a time-consuming and intermittent process. For algorithms such as A*, the number of objects is large enough that some form of pre-allocation will always be advisable.

13.1.3 **SWIFT**

Swift is Apple's language for implementing apps on macOS and iOS. Although it is a compiled language, and in theory any compiled language such as C++ could be used, the operating system APIs are exposed in Swift, and comprehensive support is provided in Apple's Xcode development tool. Unless you use an integrated game engine such as Unity, working with another language on iOS is an uphill challenge.

Swift replaces Apple's older support for the Objective-C language. Objective-C is, like C++, an extension of the C language to support object-oriented programming. The two languages differ dramatically in the way they envisage objects, however, making it difficult to interoperate between the two. Objective-C never saw the same widespread adoption as C++, and use of the language gradually diminished. By the time it was replaced with Swift, programming for Apple devices was the only notable use case for Objective-C. Initially Apple introduced Swift as Objective-C without the C. This was mostly a marketing ploy to ease developers' concerns about learning something new, in reality the languages are very different.

Swift compiles to machine code for particular hardware, unlike C# and Java which compile to bytecode running on a virtual machine. But like Java and C#, Swift code is executed with a comprehensive runtime, handling interfaces to the operating system, and facilities such as

memory management and garbage collection. In practice, there is little difference, and swift feels more like Java or C# than C or C++.

The garbage collection approach Swift uses is different to Mono. At the time of writing it uses automatic reference counting (ARC). In this approach, each object stores a count: referring to the number of places in the code that knows about that object. A variable set to point to the object increases this count. Placing the object in an array also increases it. Or storing it in the member variable of another object. If the variable passes out of scope, the count is decremented. The same happens if the array is deleted or the containing object. If the count reaches zero, that object cannot be reached by any part of the code, so it is safe to delete it. There are reference counting systems that are this simple, but the simple approach can leak memory: never collecting some unused cycles of objects that alone are referenced but as a group can never be reached. For example, if object A is the only thing that knows about object B and object B is the only thing that knows about object A, both A and B can be garbage collected, but they will both have a reference count of 1. These cycles can become complex, with many objects involved. It is these complex cycles that cause garbage collection to slow. The trade-offs of the two approaches (Swift's reference counting and Mono's markand-sweep) are complex and well beyond the scope of this chapter. In practice it seems that Swift's approach is less likely to pause or stutter game code. But less does not mean never. It is still worthwhile to avoid unwanted garbage collection.

To do so, we can use exactly the same approach as we saw for C#. We can pre-allocate all the objects we need, and release our last reference to them at the end of the level. As for the upgraded Mono garbage collection system, Swift's garbage collector typically runs fast enough that problems aren't noticeable unless you are performing many allocations. But problems can often appear without warning, after the game has been running for some time. It is possible, perhaps even best practice, to err on the side of caution and pre-allocate objects in your AI code, whether strictly necessary or not.

13.1.4 JAVA

At the time of writing, Java is comfortably the most popular programming language in the world,1 and has been so as far back as 2001 (with the occasional short-lived challenge from C). It was designed as a general-purpose language with a detailed specification for its bytecode and virtual machine (known as the Java virtual machine, or JVM). By locking down a virtual machine, the language aims to allow source code to be compiled on one machine, and the resulting bytecode to be capable of running on the same or any other machine. Its marketing tagline is "write once, run anywhere." By and large it succeeds in this aim. A Java runtime on two very different machines will have to communicate with two very different underlying

^{1.} The popularity of programming languages is measured by the TIOBE company and has been published at its website [69] since 2001 (though it has partial retrospective data as far back as 1988). The index has been criticized for relying solely on search engines and websites, and the details of its method can certainly be debated, but overall it has proved a useful way of sampling the pulse of the industry.

operating systems, and that can lead to slight differences in behavior, but Java does a good job of trying to smooth over these differences.

It is this ability to compile once and run anywhere which makes it particularly appealing for development of mobile applications. There is a large range of hardware in modern smartphones, and it would be cumbersome to have to acquire the correct compiler definitions, and compile your game for each. Hardware peculiarities don't completely remove the need to test on multiple devices, but the situation would be considerably worse developing in a language that compiles to machine code, such a C++. When Google developed its mobile operating system, Android, it chose Java as the primary development language for this reason.

As a programming language, it has a reputation for being rather verbose. And much of that verbosity comes in the form of boilerplate code: similar patterns that have relatively little functionality, but need to be written in the same way again and again. Editors and other tools make this a little easier by automatically generating some of it, but it still bloats the code and needs to be maintained.

Java also has a reputation for being slow to change. On one level, this is a benefit, meaning well-written code remains idiomatic for a long time. But it also means important productivity improvements and good ideas from other languages are adopted slowly. Type-safe data structures were demanded for more than a decade before they were finally introduced, though the implementation was widely criticized and has recently shown to be unsound [3] (a problem that may extend to some of the other languages in this section, running on the JVM).

Most of the benefits of Java are provided by the JVM. It is the JVM that is designed to run the same compiled code on any platform. When the compiled bytecode is running, the virtual machine does not know or care how that code was generated. In the late 90s I worked briefly for a non-gaming company whose product produced bytecode from a simple dialogue with the user. It is more commonly used to support other languages, such as the functional Scala, the Lisp dialect Clojure, the scripting language Groovy and dozens of others, all compiling to valid JVM bytecode. Because Java provides a very large standard library, also compiled into bytecode, these facilities can be used in any JVM language. Android, likewise, exposes its interfaces in a way that can be called from any language.

Recently Google has endorsed Kotlin, a JVM language developed by JetBrains that has similar features and a similar ethos to Java, but it is much more modern in style. It seems likely that an increasing proportion of Android app development will move to the new language over the coming years. At the same time, mobile game developers are increasingly using multi platform game engines. Which trend will grow faster is difficult to say. It may well be that Kotlin never becomes a significant player in the games industry.

In terms of implementation advice, writing for the JVM is very much like writing for Mono. The JVM uses a mark-and-sweep garbage collector, which can be manually requested by calling System.gc(). Like Mono, the implementation of the garbage collector is not efficient when many small objects have been allocated. It is wise to use the same allocation pooling approach detailed in the previous section.

13.1.5 JAVASCRIPT

JavaScript was created as a scripting language for web pages. It is used in game development for two purposes: to implement games intended to be played on the web, and to build servers for online multiplayer games, using Node.

Like all scripting languages, performance critical code written in JavaScript can sometimes run slowly. It is unusual, therefore, to see sophisticated algorithms written in JavaScript. It is very possible to build a state machine or behavior tree in JavaScript, but planning, pathfinding, minimaxing, or learning, are probably too resource intensive. On the server, these performance critical algorithms can be implemented in C++ and linked into the JavaScript runtime. In the browser, something similar was originally possible, but has now been removed by browser vendors for security reasons.

JavaScript is more widely used in game development as a scripting language, embedded into a game or game engine. Section 13.2, below, describes its use as a scripting language in more depth.

From a language point of view, JavaScript is notable for its use of prototypical inheritance. Prototypical inheritance differs from the more familiar class-based inheritance of languages such as C++ and Python. Recent versions of JavaScript have added a class keyword, to make it more accessible for programmers of other languages, but classes are still implemented under the hood using prototypes.

Prototypes differ from classes in that any object can inherit from any other object. In a class-based language objects come in two flavors: classes and instances. Instances can inherit only from classes, and classes have a limited form of inheritance from one another, usually called subclassing. This is much simpler in prototypical languages. There is only inheritance, and any object can inherit from any other object. The practical upshot of this is that we are not limited to the two level hierarchy of class and instance. In Section 5.4, discussing behavior trees, I described the common need for three levels when defining and instantiating AI. This maps nicely into JavaScript. It has the effect of allowing developers to create one root object for a broad class of characters, then an object can inherit from that to configure the settings for a particular character type (this intermediate stage may be done by a level designer or technical artist), and then a final step can see an object instantiate the character type for an individual character in the level.

Unlike the other languages in this section, JavaScript is single threaded. As a language for augmenting web pages, it was designed to be event driven: the JavaScript runtime monitors for particular events (such as user input, network activity, or scheduled timeouts); when an event occurs, the runtime calls code that has been registered as interested; this code then runs sequentially for as long as it needs; and when there is no more code to run, control returns to the runtime, which waits until another event occurs. Code is guaranteed not to be interrupted while running, and no other code will be run at the same time. This is perfect for simple scripts in a browser, but some things take much longer to complete. We don't want the whole JavaScript process to grind to a halt waiting for a result. In a web browser, this might be querying for data across the network, which in some cases might be measured in seconds.

JavaScript uses callbacks for this (in later versions of JavaScript, these are wrapped in easier to use structures such as promises or 'async', though the underlying behavior is the same). A callback uses the same event process. You register some code to be called when an action completes (when the results from the server is received, for example), then start the action. This allows many callbacks to be waiting for data at any time. It is perfect for many server applications, where the code needs to wait for data from the database, from other services, or for files to be read.

Unfortunately, it is not well suited for situations where the long-running task involves a lot of computation. And many games fall in this category. If the JavaScript engine is performing calculation, it can't continue distributing events to other parts of the code. We can't easily ask a JavaScript routine to execute a pathfinder, and let us know when the pathfinding is complete. The obvious implementation would freeze until pathfinding is done.

There are two solutions. Code can be written to perform 'cooperative multitasking': any long-term process will do a little bit of work, then voluntarily return control to the runtime, expecting that it will be called again to do more work soon. JavaScript can then use those intermissions to call other parts of the code. This works, but requires you to implement algorithms to support it. We saw in Chapter 10 why we might want to do this in any language: to allow long-running algorithms to be split across multiple rendering frames. In JavaScript it goes from being nice-to-have to practically essential.

The second solution is to use multiple JavaScript interpreters, and to write communication code to keep them in sync. Instead of calling the pathfinding function, we pass some message to another process which is capable of pathfinding. That process will then pass a message back when it is complete. This approach is used in the browser, via the Web-Workers API. Again, it is effective, but requires even more coordination code than cooperative multitasking, and because the different processes can't change each others' data, there is typically a large overhead for passing data back and forward in messages (often by converting in and out of the textual ISON format).

13.2 SCRIPTED AI

A significant proportion of the decision making in games uses none of the techniques described in this book. In the early and mid-1990s, most AI was hard-coded using custom written code to make decisions. This is fast and works well for small development teams when the programmer is also likely to be designing the game. It is still the dominant model for platforms with modest development needs, and indie teams where programmers are also responsible for implementing gameplay.

As production becomes more complex, development jobs become more niche. Large games with hundreds of staff tend to divide development tasks into small constrained roles. In the studio there is a need to separate the content (the behavior designs) from the engine. Level designers may be required to design the broad behaviors of characters, without being empowered to edit their code. To facilitate this, many studios use general techniques, and custom editors, as described in the previous chapter.

An intermediate solution is to program a set of techniques and have technically competent level designers combine them using a simple programming language, separate from the main game code. These are often called scripts. Scripts can be treated as data files, and if the scripting language is simple enough, level designers or technical artists can create the behaviors.

A fortuitous side effect of scripting language support is the ability for players to create their own character behavior and to extend the game. Modding is an important financial force in PC games (it can extend their full-price shelf life beyond the eight weeks typical of other titles), so much so that many triple-A titles have some kind of scripting system included (often as part of the engine they use).

There are negatives, however. I remain unconvinced that the widespread use of scripts in a project is particularly scalable, nor that it is easy to generate sophisticated behaviors that way. In my experience it is easy to start scripting, but eventually they become hard to extend and debug.

As well as the scaling issues, this approach misses the point of established AI techniques. They exist because they are elegant solutions to behavior problems, not because programming in C++ is inconvenient. Even if you go to a scripting language, you have to think about the algorithms used in the character scripts. Writing ad hoc code in scripts is as difficult as writing it in C++, and almost certainly lacks debugging tools that are as mature.

Several developers I know have fallen into this trap, assuming that a scripting language means they don't need to think about the way characters are implemented. Even if you are using a scripting language, I'd advise you to think about the architecture and algorithms you use in those scripts. It may be that the script can implement one of the other techniques in this book, or it may be that a separate dedicated implementation would be more practical: alongside or instead of the scripting language.

But, laying aside all these limitations, undoubtedly scripting has several important applications: in implementing nontrivial triggers and game level behavior (which keys open which doors, for example), for iterating game mechanics into something fun to play, and for rapidly prototyping character AI.

This section provides a brief primer for supporting a scripting language powerful enough to run AI in your game. It is intentionally shallow and designed to give you enough information to either get started or decide it isn't worth the effort. Several excellent websites are available comparing existing languages, and a handful of texts cover implementing your own language from scratch.

13.2.1 WHAT IS SCRIPTED AI?

The phrase 'scripted AI' is a little ambiguous. For the purpose of this chapter, it refers to these hand-coded programs written in a scripting language, that control the behavior of characters. In game reviews and marketing material, however, it is often used as a insult, to refer to AI that does the same thing regardless of context, in a way that appears unintelligent. A character who always tries to follow the same patrol route, even when that route is blocked, might be said to have scripted AI, even if that route is generated by a non-technical designer in a level editor. A third use of the term is less pejorative: set pieces may be described as scripted AI. A character running low on health who rolls into cover, erects a barricade, and begins to heal, might be said to have scripted AI. Even if that sequence is implemented as a behavior tree. For the purpose of this chapter I will stick with the first definition: scripted AI is AI written in a scripting language.

13.2.2 WHAT MAKES A GOOD SCRIPTING LANGUAGE?

There are a few facilities that a game will always require of its scripting language. The choice of language often boils down to trade-offs between these concerns.

Speed

Scripting languages for games need to run as quickly as possible. If you intend to use a lot of scripts for character behaviors and events in the game level, then the scripts will need to execute as part of the main game loop. This means that slow-running scripts will eat into the time you need to render the scene, run the physics engine, or prepare audio.

Most languages can be anytime algorithms, running over multiple frames (see Chapter 10 for details). This takes the pressure off the speed to some extent, but it can't solve the problem entirely.

Compilation and Interpretation

Scripting languages are broadly interpreted, byte-compiled, or fully compiled, although there are many flavors of each technique.

Interpreted languages are taken in as text. The interpreter looks at each line, works out what it means, and carries out the action it specifies.

Byte-compiled languages are converted from text to an internal format, called bytecode. This bytecode is typically much more compact than the text format. Because the bytecode is in a format optimized for execution, it can be run much faster.

Byte-compiled languages need a compilation step; they take longer to get started, but then run faster. The more expensive compilation step can be performed as the level loads but is usually performed before the game ships.

The most common game scripting languages are all byte-compiled. Some, like Lua, offer the ability to detach the compiler and not distribute it with the final game. In this way all the scripts can be compiled before the game goes to master, and only the compiled versions need

to be included with the game. This removes the ability for users to write their own script, however.

Fully compiled languages create machine code. This normally has to be linked into the main game code, which can defeat the point of having a separate scripting language. I do know of one developer, however, with a very neat runtime-linking system that can compile and link machine code from scripts at runtime. In general, however, the scope for massive problems with this approach is huge. I'd advise you to save your hair and go for something more tried and tested.

Extensibility and Integration

Your scripting language needs to have access to significant functions in your game. A script that controls a character, for example, needs to be able to interrogate the game to find out what it can see and then let the game know what it wants to do as a result.

The set of functions it needs to access is rarely known when the scripting language is implemented or chosen. It is important to have a language that can easily call functions or use classes in your main game code. Equally, it is important for the programmers to be able to expose new functions or classes easily when the script authors request it.

Some languages (Lua being the best example) put a very thin layer between the script and the rest of the program. This makes it very easy to manipulate game data from within scripts, without having a whole set of complicated translations.

Re-entrancy

It is often useful for scripts to be re-entrant. They can run for a while, and when their time budget runs out they can be put on hold. When a script next gets some time to run, it can pick up where it left off.

It is often helpful to let the script yield control when it reaches a natural lull. Then a scheduling algorithm can give it more time, if it has it available, or else it moves on. A script controlling a character, for example, might have five different stages (examine situation, check health, decide movement, plan route, and execute movement). These can all be put in one script that yields between each section. Then each will get run every five frames, and the burden of the AI is distributed.

Not all scripts should be interrupted and resumed. A script that monitors a rapidly changing game event may need to run from its start at every frame (otherwise, it may be working on incorrect information). More sophisticated re-entrancy should allow the script writer to mark sections as uninterruptible.

These subtleties are not present in most off-the-shelf languages, but can be a massive boon if you decide to write your own.

13.2.3 EMBEDDING

Embedding is related to extensibility. An embedded language is designed to be incorporated into another program. When you run a scripting language from your workstation, you normally run a dedicated program to interpret the source code file. In a game, the scripting system needs to be controlled from within the main program. The game decides which scripts need to be run and should be able to tell the scripting language to process them.

13.2.4 CHOOSING AN OPEN SOURCE LANGUAGE

A huge range of scripting languages are available, and many of them are released under licenses that are suitable for inclusion in a game. Usually, some variation of open source.

While there have been various attempts at commercial scripting languages for the games industry, it is difficult for a proprietary language to compete with the large number of highquality open source alternatives.

Open-source software is released under a licensee that gives users rights to include it in their own software without paying a fee. Some open-source licenses require that the user release the newly created product open source. These are obviously not suitable for commercial games.

Open-source software, as its name suggests, also allows access to see and change the source code. This makes it easy to attract developers to contribute bug fixes and improvements to the code base. As a developer, it provides the confidence to know that problems can be sorted out or modifications made. A company I consulted for, for example, commissioned one of the Lua committers to implement a custom syntax extension, just a few days work that dramatically improved the use of the language in their project.

Modifications are not always advisable, however. Some open-source licenses (in particular the general public license, GPL), even those that allow you to use the language in commercial products, require that you release any modifications to the language itself, or in the worst case any code that you link to that library. This will almost certainly be an issue for your project unless you intend to make your game open source.

Whether or not a scripting language is open source, there are legal implications of using the language in your project. Before using any outside technology in a product you intend to distribute, you should consult an intellectual property lawyer. This book cannot properly advise you on the legal implications of using a third-party language. The following comments are intended as an indication of the kinds of things that might cause concern. There are many others.

With nobody selling you the open source software, nobody is responsible if the software goes wrong. This could be a minor annoyance if a difficult-to-find bug arises during development. It could be a major legal problem, however, if your software causes your customer's PC to wipe its hard drive. With most open-source software, you are responsible for the behavior of the product. The flip side of this is, a well-established open source language has probably been used millions of times by other developers, making a fresh discovery of pathological bugs unlikely.

When you license technology from a company, the company normally acts as an insulation layer between you and being sued for breach of copyright or breach of patent. A researcher, for example, who develops and patents a new technique has rights to its commercialization. If the same technique is implemented in a piece of software, without the researcher's permission, they may have cause to take legal action. When you buy software from a company, it takes responsibility for the software's content. So, if the researcher comes after you, the company that sold you the software is usually liable for the breach (it depends on the contract you sign).

When you use open-source software, nobody is licensing the software to you, and because you didn't write it, you don't know if part of it was stolen or copied. Unless you are very careful, you will not know if it breaks any patents or other intellectual property rights. The upshot is that you could be liable for the breach.

You need to make sure you understand the legal implications of using "free" software. It is not always the cheapest or best choice, even though the up-front costs are very low. Consult a lawyer before you make the commitment.

These kind of legal concerns have motivated developers to create their own languages in the past. Beyond custom scripting for commercial game engines (like UE4's 'blueprints' visual language), this is now rare.

13.2.5 A LANGUAGE SELECTION

Everyone has a favorite language, and trying to pick the best single pre-built scripting language is impossible. Read any programming language newsgroup to find endless "my language is better than yours" flame wars. There are pros and cons, of course, but none is more powerful than your programming team being comfortable with a particular language or syntax.

Out of almost unlimited choices, there are a handful of languages that are repeatedly used. When selecting a language to integrate with your game, it is worth being aware of which languages are the usual suspects and what their strengths and weaknesses are. Bear in mind that it is usually possible to hack, restructure, or rewrite existing languages to get around their obvious failings. Many (perhaps even most) commercial games developers using scripting languages do this in minor ways; some end up with languages almost unrecognizable from where they started. The languages described below are discussed in their out-of-the-box forms.

I will look at four languages in the order I would personally consider them for a new project: Lua, Scheme, JavaScript, and Python.

Lua

Lua is a simple procedural language built from the ground up as an embedding language. The design of the language was motivated by extensibility. Unlike most embedded languages, this isn't limited to adding new functions or data types in C or C++. The way the Lua language works can also be tweaked.

Lua has a small number of core libraries that provide basic functionality. Its relatively featureless core is part of the attraction, however. In games you are unlikely to need libraries to process anything but math and logic. The small core is easy to learn and very flexible.

Lua does not support re-entrant functions. The whole interpreter (strictly the "state" object, which encapsulates the state of the interpreter) is a C++ object and is completely reentrant. Using multiple state objects can provide some re-entrancy support, at the cost of memory and lack of communication between them.

Lua has the notion of "events" and "tags." Events occur at certain points in a script's execution: when two values are added together, when a function is called, when a hash table is queried, or when the garbage collector is run, for example. Routines in C++ or Lua can be registered against these events. These "tag" routines are called when the event occurs, allowing the default behavior of Lua to be changed. This deep level of behavior modification makes Lua one of the most adjustable languages you can find.

The event and tag mechanism is used to provide rudimentary object-oriented support (Lua isn't strictly object oriented, but you can adjust its behavior to get as close as you like to it), but it can also be used to expose complex C++ types to Lua or for tersely implementing memory management.

Another Lua feature beloved by C++ programmers is the "userdata" data type. Lua supports common data types, such as floats, ints, and strings. In addition, it supports a generic "userdata" with an associated sub-type (the "tag"). By default, Lua doesn't know how to do anything with userdata, but by using tag methods, any desired behavior can be added. Userdata is commonly used to hold a C++ instance pointer. This native handling of pointers can cause problems, but often means that far less interface code is needed to make Lua work with game objects.

For a scripting language, Lua is at the fast end of the scale. It has a very simple execution model that at peak is fast. Combined with the ability to call C or C++ functions without lots of interface code, this means that real-world performance is impressive.

The syntax for Lua is recognizable for C and Pascal programmers. It is not the easiest language to learn for artists and level designers, but its relative lack of syntax features means it is achievable for keen employees.

Despite its documentation being poorer than for the other two main languages here, Lua is the most widely used pre-built scripting language in games. The high-profile switch of Lucas Arts from its internal SCUMM language to Lua motivated a swathe of developers to investigate its capabilities. Neither Unity nor UE4 use Lua, but the open source engine Godot briefly supported it, before focusing on it's own custom language.

To find out more, the best source of information is the Lua book *Programming in Lua* [26], which is also available free online.

Scheme and Variations

Scheme is a scripting language derived from LISP, an old language that was used to build most of the classic AI systems prior to the 1990s (and many since, but without the same dominance).

The first thing to notice about Scheme is its syntax. For programmers not used to LISP, Scheme can be difficult to understand.

Brackets enclose function calls (and almost everything is a function call) and all other code blocks. This means that they can become very nested. Good code indentation helps, but an editor that can check enclosing brackets is a must for serious development. For each set of brackets, the first element defines what the block does; it may be an arithmetic function:

```
(+ a 0.5)
```

or a flow control statement:

```
(if (> a 1.0) (set! a 1.0))
```

This is easy for the computer to understand but runs counter to our natural language. Non-programmers and those used to C-like languages can find it hard to think in Scheme for a while.

Unlike the other languages in the section, there are literally hundreds of versions of Scheme, not to mention other LISP variants suitable for use as an embedded language. Each variant has its own trade offs, which make it difficult to make generalizations about speed or memory use. At their best, however (minischeme and tinyscheme come to mind), they can be very, very small (minischeme is less than 2500 lines of C code for the complete system, although it lacks some of the more exotic features of a full scheme implementation) and superbly easy to tweak. The fastest implementations can be as fast as any other scripting language, and compilation can typically be much more efficient than other languages (because the LISP syntax was originally designed for easy parsing).

Where Scheme really shines, however, is its flexibility. There is no distinction in the language between code and data, which makes it easy to pass around scripts within Scheme, modify them, and then execute them later. It is no coincidence that most notable AI programs using the techniques in this book were originally written in LISP.

I have used Scheme a lot, enough to be able to see past its awkward syntax (many of us had to learn LISP as AI undergraduates—it was considered the main AI language until the turn of the 21st century). Professionally, I have never used Scheme unmodified in a game (although I know at least one studio that has), but I have built more languages based on Scheme than on any other language (seven to date). If you plan to roll your own language, I would strongly recommend you first learn Scheme and read through a couple of simple implementations. It will probably open your eyes to how easy a language can be to create.

JavaScript

JavaScript is a scripting language designed for web pages. Despite having Java in the name, it has very little connection with that language. The name is a curiosity of a long defunct marketing agreement between Netscape, the one time browser manufacturer, and Sun Microsystems, then the owner of Java. Strictly, the language is called ECMAScript, often abbreviated ES (particularly with a suffix indicating the specification version, such as ES6), though the former name has stuck and is unlikely to be dislodged.

There isn't one standard JavaScript implementation. Many JavaScript implementations in games or game engines are closer to being inspired by JavaScript rather than implementing the language itself. UnityScript, the deprecated scripting language from the Unity game engine, is one such example. These quasi-JavaScripts may use the same syntax (which is relatively C-like), but in some cases not even support prototypical inheritance.

Of the remaining users of JavaScript, most are games intended to run in the browser. In this case there is no embedded scripting language. The scripts are simply passed to the browser to be run.

Finally, the V8 implementation of JavaScript, created for the Chrome browser, is widely embedded. It is the implementation at the heart of the Node JavaScript system, on which some complete games have been built (and which is used to develop the server side of many more). It can also be embedded rather simply into an existing engine. The support for getting data in and out, and for exposing underlying functions to the JavaScript, is simple and well documented. V8 is also fully re-entrant, and supports multiple isolated interpreters in the same code (so different characters can be running their scripts at the same time).

JavaScript is a strong language for embedding. But perhaps its most significant advantage is its familiarity. As the language of the web, it is known by many programmers. Documentation is voluminous and tutorials abound (though some, it must be said, are written by novices themselves and contain bad advice). With its C-like syntax, however, it can be intimidating to non-programmers, in the way that a more natural and keyword-laden syntax such as Lua or Python avoids.

Python

Python is an easy-to-learn, object-oriented scripting language with excellent extensibility and embedding support. It provides excellent support for mixed language programming, including the ability to transparently call C and C++ from Python. Python has support for re-entrant functions as part of the core language from version 2.2 onward (called Generators).

Python has a huge range of libraries available for it and has a very large base of users. Python users have a reputation for helpfulness, and the comp.lang.python newsgroup is an excellent source of troubleshooting and advice.

Python's major disadvantages are speed and size. Although significant advances in execution speed have been made over the last few years, it can still be slow. Python relies on hash table lookup (by string) for many of its fundamental operations (function calls, variable access, object-oriented programming). This adds lots of overhead.

While good programming practice can alleviate much of the speed problem, Python also has a reputation for being large. Because it has much more functionality than Lua, it is larger when linked into the game executable.

Python 2.X and further Python 2.3 releases added a lot of functionality to the language. Each additional release fulfilled more of Python's promise as a software engineering tool, but by the same token made it less attractive as an embedded language for games. Earlier versions of Python were much better in this regard, and developers working with Python often prefer previous releases.

Python often appears strange to C or C++ programmers, because it uses indentation to group statements, just like the pseudo-code in this book.

This same feature makes it easier to learn for non-programmers who don't have brackets to forget and who don't go through the normal learning phase of not indenting their code.

Python is renowned for being a very readable language. Even relatively novice programmers can quickly see what a script does. More recent additions to the Python syntax have damaged this reputation greatly, but it still seems to be somewhat above its competitors.

Of the scripting languages I have worked with, Python has been the easiest for level designers and artists to learn. On a previous project I wanted to take advantage of this benefit, but the size and speed issues made embedding the language impractical. The solution was to create a new language (see the section below) but use Python syntax.

Other Options

There is a whole host of other possible languages. In my experience each is either completely unused in games (to the best of our knowledge) or has significant weaknesses that make it a difficult choice over its competitors. To my knowledge, none of the languages in this section has seen commercial use as an in-game scripting tool. As usual, however, a team with a specific bias and a passion for one particular language can work around these limitations and get a usable result.

Tcl

Tcl is a very well-used embeddable language. It was designed to be an integration language, linking multiple systems written in different languages. Tcl stands for Tool Control Language.

Most of Tcl's processing is based on strings, which can make execution very slow. Another major drawback is its bizarre syntax, which takes some getting used to, and unlike Scheme it doesn't hold the promise of extra functionality in the end. Inconsistencies in the syntax (such as argument passing by value or by name) are more serious flaws for the casual learner.

Iava

Java is ubiquitous in many programming domains. Because it is a compiled language, however, its use as a scripting language is restricted. By the same token, however, it can be fast. Using JIT compiling (the bytecode gets turned into native machine code before execution), it can approach C++ for speed. The execution environment is very large, however, and there is a sizable memory footprint.

It is the integration issues that are most serious, however. The Java Native Interface (that links Java and C++ code) was designed for extending Java, rather than embedding it. It can therefore be difficult to manage.

Although not as a scripting language, Java has been used to develop games. Minecraft [142], perhaps the biggest indie game of all time, is entirely implemented in Java, as are all its many mods and extensions.

Ruby

Ruby is a modern language with the same elegance of design found in Python, but its support for object-oriented idioms is more ingrained. It has some neat features that make it able to manipulate its own code efficiently. This can be helpful when scripts have to call and modify the behavior of other scripts. It is not highly re-entrant from the C++ side, but it is very easy to create sophisticated re-entrancy from within Ruby.

It is easy to integrate with C code (not as easy as Lua, but easier than Python, for example). Ruby seems like it may be on the wane, however, without ever reaching the audience of the other languages in this chapter. It hasn't been used (modified or otherwise) in any game I am aware of. This is a chicken and egg weakness: with few people to share their embedding experience, it is difficult to get good advice on pitfalls and best practices. That may change rapidly with one or two high-profile deployments.

13.3 CREATING A LANGUAGE

Until the early 2000s, the scripting languages used in games were just as likely to be created by developers specifically for their needs, as they were to be embedded open source languages. In the last 10 years this balance has shifted, but there are still situations where a custom language is useful. Particularly for game styles with very niche requirements.

The PuzzleScript platform by Stephen Lavelle [35], and the Inform 7 interactive fiction system by Graham Nelson [44] are both fascinating rule based languages (rather than procedural, object-oriented or functional) tied deeply to their game engines. Inkle's Ink language [27], developed for its own games, targets a runtime written for the Unity game engine. They are all written for use cases where existing languages would be much more cumbersome.

Commercial game engines include scripting language support, and at one point it was common for these to be custom-designed languages similar to widely available open source offerings. These are no longer actively developed. Unreal Engine had UnrealScript, and Unity had UnityScript. Epic removed UnrealScript from UE4, and UnityScript is in the process of being deprecated. There seems to be little reason to develop and maintain a language from scratch that is so similar to mature languages. UE4 does have its own custom language, Blueprint, which is warranted because it is so unusual: it is a visual language that is somewhere between programming and specifying a behavior tree.

So should you invest in your own language? Consider carefully the pros and cons.

Advantages

When you create your own scripting language, you can make sure it does exactly what you want it to. Because games are sensitive to memory and speed limitations, you can put only the features you need into the language. As discussed above, for example, existing languages often have poor support for re-entrancy: this could be a core part of your design. You can also add features that are specific to game applications and that wouldn't normally be included in a general purpose language. Or, like the rule-based languages I mentioned in the previous section, structure your language in a radically different way.

Because it is created in-house, when things go wrong with the language, you or your team knows how it is built and can often find the bug and create a workaround faster.

Whenever you include third-party code into your game, you are losing some control over it. In most cases, the advantages outweigh the lack of flexibility, but for some projects control is a must.

Disadvantages

Newly created languages tend to have more rudimentary features and be less robust than offthe-shelf alternatives. If you choose a fairly mature language, like those described above, you are benefiting from a lot of development time, debugging effort, and optimization that has been done by other people. Every person who has used that language before you is a kind of quality assurance tester. An in-house language needs to be thoroughly tested, which is an additional expense.

Once your team has built the basic language and moved onto other coding tasks, development stops. There is no community of skilled developers continuing work on the language, improving it and removing bugs at no additional cost to you. Many open source languages provide web sites (often GitHub) where problems can be discussed, bugs can be reported, and documentation can be downloaded.

Many games, especially on the PC, are written with the intention of allowing consumers to edit their behavior. Customers building new objects, levels, or whole mods can prolong a game's shelf life. Using a scripting language custom written for your game, requires users to learn the language. This in turn may mean you need to provide tutorials, sample code, and developer support. Most existing languages have newsgroups or web forums where customers can get advice without contacting you or your team. There will often be a dedicated group of skilled developers on Stack Overflow to answer questions. It is difficult to compete with that, and if you try, it will be very expensive.

If you are a hobbyist, I would recommend creating your own language only as an exercise. Or if you are creating your games commercially, only if your game or game engine has very specific and peculiar features.

13.3.1 **ROLLING YOUR OWN**

Regardless of the look and capabilities of your final language, scripts will pass through the same process on their way to being executed: all scripting languages must provide the same basic set of elements. Because these elements are so ubiquitous, tools have been developed and refined to make it easy to build them.

There is no way I can give a complete guide to building your own scripting language in this book. There are many other books on language construction (although, surprisingly, there aren't any good books I know of on creating a simple scripting language). This section looks at the elements of scripting language construction from a very high level, as an aid to understanding rather than implementation.

The Stages of Language Processing

Starting out as text in a text file, a script typically passes through four stages: tokenization, parsing, compiling, and interpretation.

The four stages form a pipeline, each modifying its input to convert it into a format more easily manipulated. The stages may not happen one after another. All steps can be interlinked, or sets of stages can form separate phases. The script may be tokenized, parsed, and compiled offline, for example, for interpretation later.

Tokenizing

Tokenizing identifies elements in the text. A text file is just a sequence of characters (in the sense of ASCII characters!). The tokenizer works out which bytes belong together and what kind of group they form.

A string of the form:

```
a = 3.2;
```

can be split into six tokens:

```
'a' text
<space> whitespace
'=' equality operator
<space> whitespace
3.2 floating point number
';' end of statement identifier
```

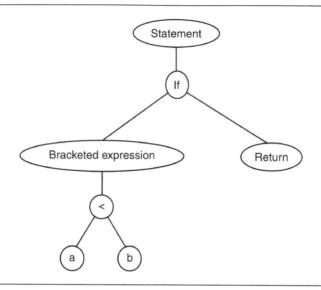

Figure 13.1: A parse tree

Notice that the tokenizer doesn't work out how these fit together into meaningful chunks; that is the job of the parser.

The input to the tokenizer is a sequence of characters. The output is a sequence of tokens.

Parsing

The meaning of a program is very hierarchical: a variable name may be found inside an assignment statement, found inside an IF-statement, which is inside a function body, inside a class definition, inside a namespace declaration, for example. The parser takes the sequence of tokens, identifies the role each plays in the program, and identifies the overall hierarchical structure of the program.

The line of code:

```
if (a < b) return:
```

converted into the token sequence:

```
keyword(if), whitespace, open-brackets, name(a), operator(<).</pre>
name(b), close-brackets, whitespace, keyword(return),
end-of-statement
```

is converted by the parser into a structure such as that shown in Figure 13.1.

This hierarchical structure is known as the parse tree, or sometimes a syntax tree or abstract syntax tree (AST for short). Parse trees in a full language may be more complex, adding additional layers for different types of symbol or for grouping statements together. Typically, the parser will output additional data along with the tree, most notably a symbol table that identifies what variable or function names have been used in the code. This is not essential. Some languages look up variable names dynamically when they run in the interpreter (Python does this, for example).

Syntax errors in the code show up during parsing because they make it impossible for the parser to build an output.

The parser doesn't work out how the program should be run; that is the job of the compiler.

Compiling

The compiler turns the parse tree into bytecode that can be run by the interpreter. Bytecode is typically sequential binary data.

Non-optimizing compilers typically output bytecode as a literal translation of the parse tree. So a code such as:

```
a = 3;
2 if (a < 0) return 1;
  else return 0;
```

could get compiled into:

```
load 3
set-value-of a
get-value-of a
compare-with-zero
if-greater-jump-to LABEL
load 1
return
LABEL:
load 0
return
```

Optimizing compilers try to understand the program and make use of prior knowledge to make the generated code faster. An optimizing compiler may notice that a must be 3 when the IF-statement above is encountered. It can therefore generate:

```
load 3
 set-value-of a
3 load 0
 return
```

Building an efficient compiler is well beyond the scope of this book. Simple compilers are not difficult to build, but don't underestimate the effort and experience needed to build a good solution. There are many hundreds of home-brewed languages out there with pathetic compilers.

Tokenizing, parsing, and compiling are often done offline and are usually called "compiling," even though the process includes all three stages. The generated bytecode can then be stored and interpreted at runtime. The parser and compiler can be large, and it makes sense not to have the overhead of these modules in the final game.

Interpreting

The final stage of the pipeline runs the bytecode. In a compiler for a language such as C or C++, the final product will be machine instructions that can be directly run by the processor. In a scripting language, you often need to provide services (such as re-entrancy and secure execution) that are not easily achieved with machine language.

The final bytecode is run on a "virtual machine." This is effectively an emulator for a machine that has never existed in hardware.

You decide the instructions that the machine can execute, and these are the bytecode instructions. In the previous example,

```
load <value>
  set-value-of <variable>
  get-value-of <variable>
4 compare-with-zero
  if-greater-jump-to <location>
  return
```

are all bytecode.

Your bytecode instructions don't have to be limited to those that might be seen in real hardware, either. For example, there may be a bytecode for "turn the data into a set of game coordinates": the kind of instruction that makes your compiler easier to create but that no real hardware would ever need.

Most virtual machines consist of a big switch statement in C: each byte code has a short bit of C code that gets executed when the bytecode is reached in the interpreter. So the "add" bytecode has a bit of C/C++ code that performs the addition operation. Our conversion example may have two or three lines of C++ to perform the required conversion and copy the results back into the appropriate place.

Just-in-Time Compiling

Because of the highly sequential nature of bytecode, it is possible to write a virtual machine that is very fast at running it. Even though it is still interpreted, it is many times faster than interpreting the source language a line at a time.

It is possible to remove the interpretation step entirely, however, by adding an additional compilation step. Some bytecode can be compiled into the machine language of the target hardware. When this is done in the virtual machine, just before execution, it is called *just-in*time (JIT) compiling. This is not common in game scripting languages but is a mainstay of languages such as Java and Microsoft's .NET bytecode.

Tools: A Quick Look at Lex and Yacc

Lex and Yacc are the two principal tools used in building tokenizers and parsers, respectively. Each has many different implementations and is provided with most UNIX distributions (versions are available for other platforms, too). The Linux variants I have most often used are Flex and Bison.

To create a tokenizer with Lex, you tell it what makes up different tokens in your language. What constitutes a number, for example (even this differs from language to language compare 0.4f to 1.2e-9). It produces C code that will convert the text stream from your program into a stream of token codes and token data. The software it generates is almost certainly better and faster than that you could write yourself.

Yacc builds parsers. It takes a representation of the grammar of your language—what tokens make sense together and what large structures can be made up of smaller ones, for example. This grammar is given in a set of rules that show how larger structures are made from simpler ones or from tokens, for example:

```
assignment: NAME '=' expression;
expression: expression '+' expression;
expression: NAME
```

The first line is a rule tells Yacc that when it finds a NAME token, followed by an equals sign, followed by a structure it knows as an expression (for which two of many rules are shown), then it knows it has an assignment. The first expression rule is defined recursively.

Yacc also generates C code. In most cases, the resulting software is as good as or better than you would create manually, unless you are experienced with writing parsers. Unlike Lex, the final code can often be further optimized if speed is absolutely critical. Fortunately, for game scripting the code can usually be compiled when the game is not being played, so the slight inefficiency is not important.

Both Lex and Yacc allow you to add your own C code to the tokenizing or parsing software. There isn't a de facto standard tool for doing the compiling, however. Depending on the way the language will behave, this will vary widely. It is very common to have Yacc build an AST for the compiler to work on, however, and there are various tools to do this, each with their own particular output format.

Many Yacc-based compilers don't need to create a syntax tree. They can create bytecode output from within the rules using C code written into the Yacc file. As soon as an assignment is found, for example, its byte code is output. It is very difficult to create optimizing compilers this way, however. So if you intend to create a professional solution, it is worth heading directly for a parse tree of some kind.

PART IV

Designing Game AI

14

DESIGNING GAME AI

S of FAR in this book we have seen a whole palette of AI techniques and the infrastructure to allow the AI to get on. I mentioned in Chapter 2 that game AI development is a mixture of techniques and infrastructure with a generous dose of *ad hoc* solutions, heuristics, and bits of code that look like hacks.

This chapter looks at how all the bits are applied to real games and how techniques are applied to get the gameplay that developers want.

On a genre-by-genre basis, I will look at the player expectations and pitfalls of a game's AI. No techniques are included here, just an illustration of how the techniques elsewhere in the book are applied. The classification here is fairly high level and loose, and some games may be marketed as a different genre. But, from an AI point of view, there is a relatively limited set of things to achieve, and I have grouped genres accordingly.

Before diving into each genre, it is worth looking at a general process for designing the AI in your game.

14.1 THE DESIGN

Throughout this book, I have been working from the same model of game AI, repeated once again in Figure 14.1. As well as mapping the possible techniques, this diagram also provides a plan for the areas that need to be considered when designing your AI.

When the AI for a title is designed, the team typically work from a target set of behaviors described in the design document. The AI programmers (often the AI technical lead) work out the simplest set of technologies that will support the designers' vision. This may go back

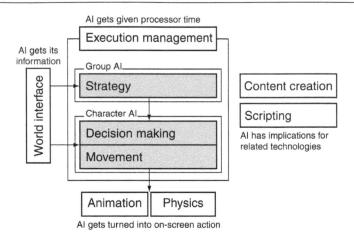

Figure 14.1: The AI model

and forth if something is particularly difficult, or there is a simple opportunity for a more sophisticated result. Once the team has convinced itself that it understands the requirements that these behaviors impose, technologies are selected to implement them, along with an approach for integrating the technologies together. The structure is implemented, including an integration layer between the planned AI and the rest of the game engine. Initially, placeholder behaviors can be used for characters, but with the infrastructure in place, different developers or level designers can start to work on fleshing characters out.

This is, of course, an ideal, a plan of action if I had free reign over a project. In reality, you will face constraints from lots of different directions that will affect your plan of approach. In particular, publisher milestones and teaser gameplay for conferences or early access releases mean that functionality and behaviors need to be implemented early on in the development cycle. In many, if sadly not most projects, content like this is quickly implemented just for the milestone and then removed and rewritten later on. In a significant number of projects, the quick-and-dirty code ends up getting patched and hacked so much that it ends up being impossible to surgically remove and becomes the AI that gets shipped.

These kinds of issues are a normal part of the industry and happen to everyone. Time is tight, resources are limited, and there is always more that could be done. If there was a secret cabal of game AI experts, you wouldn't be blackballed for shipping hacked and half-baked AI code from time to time. On the other hand, quality does get noticed: you can do your career a great service if you think ahead and get reliable and effective AI built. The cabal is ever watching.

14.1.1 **EXAMPLE**

In this section, I will walk through the two-stage design needs (the behaviors required and technologies to achieve them) of a hypothetical game, by way of an example. The game is simple from a gameplay slant, but the AI requirements are varied.

Our game is called "Haunted House," and not surprisingly it is set in a haunted house. It is a well-known haunted house, and people from far and wide pay money to come and visit it. The player owns the house, and the player's job is to keep the customers paying by managing the frights in the house, making sure that visitors get the spooks they are looking for.

Visitors arrive at the house, and the player's aim is to send them fleeing in panic. To do this, the player is given a selection of apparitions and mechanical tricks to apply in the house. Previous visitors inevitably share their experiences, and others will come seeking to debunk or mimic their frights.

The player must also try to keep the visitors from stumbling across the secrets of the house, the tricks of the trade, one-way mirrors, smoke machines, and the ghost's common room.

A variant of this idea can be seen in Ghost Master [177], where a variety of houses are presented with different occupants. The occupants are not expecting to be scared and follow their own Sims-like lives. It also has similarities to games such as Dungeon Keeper [90] and Evil Genius [110].

EVALUATING THE BEHAVIORS

The first task is to design the behaviors that the characters in your game will display. If you are working on your own game, this is probably part of your vision for the project. If you are working in a development studio, it is likely to be the game designer's job.

While the game's designer will have set ideas about how the characters in the game should act, in my experience these are rarely set in stone. Often, designers don't understand what seems trivial, but is truly difficult (and therefore should only be included if it is a central point of the game), and the many seemingly difficult but simple additions that could be made to improve character behavior.

The behavior of characters in the game will naturally evolve as you implement and try new things. This is not just true of hobbyist projects or games with long research and development phases; it is also true of a development project with fixed ideas and a tight time scale. With the best will in the world, you won't completely understand the AI needs of a game before you start to develop it. It is worth planning from the outset for some degree of flexibility.

For example, creating an AI with a fixed set of inputs from the game is just asking for late nights at the end of the project (they'll happen anyway, so why ask for them?). Inevitably, the designers will need some extra AI input at an inconvenient time, and the AI code will need reworking. Because of this, it is always better to err on the side of flexibility rather than raw speed in the initial implementation plan. It is much easier to optimize later on than to de-optimize tangled code to eke out flexibility at the last minute.

So, starting from the set of behaviors we want to see, we have some questions to answer for each of the components of the AI model:

Movement

- Will our characters be represented individually (as in most games), or will we only see their group effects (as in city simulation games, for example)?
- Will our characters need to move around their environment in a more or less realistic manner? Or can we just place them where we want them to go (in a tile-based, turn-based game, for example)?
- Will the characters' motion need to be physically simulated, as in a car game, for example? How realistic does the physics have to be (bearing in mind that it is typically much harder to build movement algorithms to work with realistic physics than it is to tweak the physics so it is less realistic for the AI characters)?
- Will characters need to work out where to go? Can they get by just wandering, following designer-set paths, staying only in one small area, or chasing other characters? Or do we need the characters to be able to plan their route over the whole level with a pathfinding system?
- Will the characters' motion need to be influenced by any other characters? Will chasing/avoiding behaviors be enough to cope with this, or do the characters need to coordinate or move in formations, too?

· Decision making

- This is typically the area in which AI designers get the most carried away. It is tempting, in the pre-production phase of a game, to want to feature all kinds of exotic new techniques. More often than not, the final game ships with state machines or hard coded scripts running all the important stuff.
- What is the full range of different actions that your characters can carry out in the game?
- How many distinct states will each of your characters have? In other words, how are those actions grouped together to fulfill the goals of the character? Note that I'm not assuming you are going to use either state machines or goal-oriented behavior here. Whatever drives your characters, they should appear to have goals, and when acting to achieve one goal they can be thought of as being in one state.
- When will your character change its behavior, switch to another state, or choose another goal to follow? What will cause these changes? What will it need to know in order to change at the right time?
- Will characters need to look ahead in order to select the best decision? Will they need to plan their actions or carry out actions that lead only indirectly to their goals? Do these actions require action planning, or can a more complex state-based or rule-based approach cover them?
- Will your character need to change the decisions it makes depending on how the player acts? Will it need to respond based on a memory of player actions, using some kind of learning?

· Tactical and strategic AI

- Do your characters need to understand large-scale properties of the game level in order to make sensible decisions? Do you need to represent tactical or strategic situations to them in a way that enables them to select an appropriate behavior?
- Do your characters need to work together? Do they need to carry out actions in correct sequences, depending on each other's timing?
- Can your characters think for themselves and still display the group behavior you are looking for? Or do you need some decisions to be made for a group of characters at a time?

Example

In Haunted House I suggest the following initial set of answers to these questions:

- Movement
 - Characters will be represented individually, moving around their environment autonomously. We do not need realistic physical simulation. We can get by with kinematic movement algorithms rather than full steering behaviors. Characters will often want to head for a specific location (the exit, for example) which may require navigation through the house, so we'll need pathfinding.
- Decision making
 - Characters have a small range of possible actions. They can creep about, run, or stand still (petrified). They can examine objects or "act on them": each object has a maximum of one action that can be performed on it (a light switch can be toggled or a door can be opened, for example). They can also console other people in the house.
 - Characters will have four broad types of behavior: scared behavior, in which they will try to recover their wits; curious behavior, in which they will examine objects and explore; social behavior, where they will attempt to keep the group together and console concerned members; and bored behavior, where they head for the customer service desk and ask for a refund.
 - The characters will change their behavior based on levels of fear. Each character has a fear level. When a character passes a threshold, it will enter scared behavior. When a character is near another scared character, it will enter social behavior. If a character's fear level drops very low, it gets bored. Otherwise, it will be in curious mode.
 - Characters will change their fear level by seeing, hearing, or smelling odd things. Each spook and trick has an oddness intensity in each of these three senses. Characters need to be informed when they can see, hear, or smell something and how odd it seems.

- The characters will seek to explore places they haven't been before or will go back to places they or others enjoyed before. They should keep track of visited places and interesting places. Interesting places can be shared among many groups to represent gossip about good frights.
- Tactical and strategic AI
 - Characters need to avoid locations they know to be scary when they are trying to recover their wits. Similarly, they will avoid the boring areas when they are looking for action.

14.1.3 SELECTING TECHNIQUES

With answers to the behavior-based questions, you will have a good idea of how far you need to go in the AI. You may have worked out whether you need pathfinding and what kind of movement behaviors are required, for example, but not necessarily which pathfinding algorithm or which steering arbitration system to use.

This is the next stage: building up a candidate set of technologies that you intend to use.

Most of this is fairly straightforward. If you have decided that you need pathfinding, then A* is the obvious choice. If you know that characters need to move in a formation, then you need a formation motion system. Decision making approaches are a little more tricky, because there are often several ways to get the same effect. The approach you select may have more to do with what you have experience building, what tools you have already licensed, or what existing code you can reuse.

As we saw in Chapter 5, there are no hard and fast rules for selecting a decision making system. Most things you can do with one system, you can do with the others. If you are building your AI from scratch, my recommendation would be to start with a simple technique such as behavior trees or state machines or a simple combination of the two, unless you know of a specific thing you want to do that cannot be achieved with them. Their flexibility has proven its worth so many times that I personally need to have a good reason for using something more complex. Recently, that 'good reason' has most often been the availability of tool-supported behavior trees in the engine I am using.

At this stage, try to avoid getting pulled back into re-designing the behaviors you identified. It is tempting to think that if we used such-and-such exotic technique, then we could show such-and-such cool behavior. It is important to blend the promise of cool effects with the ability to get the other 95% of the AI working in a rock-solid way.

Example

In Haunted House we can fulfill the requirements of our behaviors with the following suite of technologies from this book:

Movement

- Characters will move with kinematic movement algorithms. They can select any direction to move in, at one of their two movement speeds.
- In curious and scared modes, they will select their movement target as a room and use A* to pathfind a route there. They will use a path following behavior to follow the route. We will use a waypoint graph to fit in with the tactical and strategic AI, below.
- In social mode, they will head for scared characters they can see, using a kinematic seek behavior.

· Decision making

- Characters will use a very simple finite state machine to determine their broad behavior pattern and within each state a behavior tree to determine what to actually do about it.
- The state machine has four states: scared, curious, social, and bored. Transitions are based purely on the fear level of a character and the other characters in line of sight.
- In each mode there may be a range of actions available. In curious mode, the character can investigate locations or objects; in scared mode, they want to select the best way to find a safe place to gather their wits. Each of these behaviors is implemented as a decision tree with the various strategies chosen by selectors. Each strategy may in turn have multiple elements, which can be added to sequence nodes in the tree.

Tactical and strategic AI

- To facilitate the learning of scary and safe locations, we keep a waypoint map of the level. When characters change their scared state, they record the event in the map. This is just the same process as creating a frag-map from Chapter 6.

World interface

- Characters need to get information on the sights, smells, and sounds of odd occurrences in the game. This should be handled by a sense management simulation (a region sense manager would be fine).
- Characters also need information on the available actions to take when they are in curious mode. The character can request a list of objects that it can interact with, and we can provide this information from a database of objects in the game. We do not need to simulate the character seeing and recognizing these objects.

Execution management

- There are two technologies, pathfinding and sense management. Both are time consuming.

- With only a few rooms in the house, an individual's pathfinding will not take very long. However, there may be many characters in the house, so we can use a pool of a few planners (one might do it) and queue pathfinding requests. When a character asks for a path, it waits until there is a planner free and then gets its path in one go. We don't need anytime algorithms for pathfinding.
- The sense management system gets called each frame and incrementally updates. It is by design an anytime algorithm distributed over many frames.
- There may be many characters (tens, let's say) in the house at once. Each character is acting relatively slowly; it does not need to process all of its AI each frame. We can avoid using a complex hierarchical scheduling system and simply update a few different characters each frame. With 5 characters per frame updated, 50 characters in the game, and 30 frames per second being rendered, a character will have to wait less than half a second between updates. This delay may actually be useful; having characters wait for fractions of a second before reacting to a fright simulates their reaction time.

I have ended up with only a handful of modules that need implementing for this game. The sense management system is probably the most complex, the others are very standard and have simple components. I have even managed to include the random number generator: the first AI technique we met in Chapter 2.

14.1.4 THE SCOPE OF ONE GAME

Given the range of technologies in this book, you might have expected me to make Haunted House more complex, relying on clever use of lots of different algorithms. In the end, the only thing in our design that is slightly exotic is the sense management system used to notify characters of odd events.

In reality, the AI in games works this way. Fairly simple techniques take the bulk of the work. If there are specific AI-based gameplay effects you are looking for, then one or two unusual techniques can be applied. If you find yourself designing a game with neural networks, sense management, steering pipelines, and a Rete-based expert system, then it's probably time to focus in on what is really important in your game.

Each of the more unusual techniques in this book is crucial in some games and can make the difference between a boring game and really neat character behavior. But, like a fine spice, if they aren't used sparingly to add flavor, they can end up spoiling the final product.

In the remainder of this chapter I will look at a range of commercial games in a variety of genres. In each case, I'll try to focus on the techniques that make the genre unusual: where new innovations can really make a difference.

This chapter only discusses the most commercially significant game genres, the bread and butter for most AI developers. The final chapter of the book, Chapter 15, samples other game genres where AI is specifically tasked with providing the gameplay. These are not large genres with thousands of titles, and they aren't the best selling, but they are interesting for an AI developer because they stretch AI in ways that common genres don't.

14.2 SHOOTERS

First- and third-person shooters are the most financially successful genres and have been in one form or another since the first video games were created. They are a good jumping off point for discussing the AI used for enemy characters in a number of other genres. At the end of the section I will build on the discussion of shooter AI to widen the focus into genres such as adventure games, platforming, melee combat and MMOGs. To begin with, I'll stick with classic shooters.

With the arrival of Wolfenstein 3D [121] and Doom [122], the shooter genre became synonymous with characters moving on foot (possibly with jet packs, as in Tribes II [105]) with a camera tied to the player's character. Enemies usually consist of a relatively small number of on-screen characters.

Games primarily intended to be player-vs-player (PvP), optimized for matches between humans, may have sophisticated practice AI known as 'bots.' To ensure fairness, these computer-controlled characters will have capabilities as similar as possible to those of the player. Shooters providing a campaign mode, or other player-vs-environment (PvE) challenge, tend to rely on a larger number of less complex enemies.

The most significant AI needs for the genre are:

- 1. Movement—control of the enemies
- 2. Firing—accurate fire control
- 3. Decision making—typically simple state machines
- 4. Perception—determining who to shoot and where they are
- 5. Pathfinding—often (but not always) used to allow characters to plan their route through the level
- 6. Tactical AI—often used to allow characters to determine safe positions to move or cover points to lay down fire from

Of these, the first two are the key issues seen in all games of the genre. It is possible to create a shooter using only these tools, particularly the 2D shooters that have come back into vogue with the resurgence of indie games. But in 3D this may look hopelessly naive. For the last 15 years players have increasingly come to expect enemies with some tactical sophistication (such as the use of cover) and who use some pathfinding to avoid getting stuck on the level.

14.2.1 MOVEMENT AND FIRING

Movement is the most visible part of character behavior in all game genres. In 3D shooters, where characters are typically large on-screen, movement and animation together signal 938

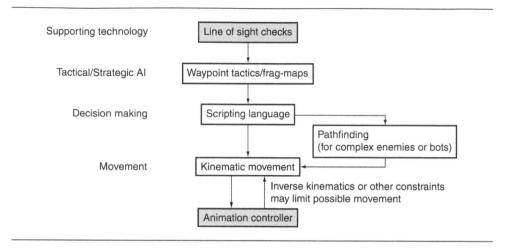

Figure 14.2: A basic AI architecture suited to a first- or third-person shooter

to the player most of the information about what the AI is doing. Some shooters rely very heavily on animation, with some of the most complex sets of animation around. This can include different kinds of movement (creeping, crawling, sprinting), reloading, gestures to allies, even voice acting. It is not unusual for characters to combine tens or hundreds of animation sequences, along with other controllers such as inverse kinematics or rag doll physics. A character in *F.E.A.R. 2: Project Origin* [145] can be running, firing, and looking all at the same time. The first two are animation channels, and the third is a procedural animation controlled by the direction the character is looking (as is the direction, but not the overall movement, of the firing arm).

In *No One Lives Forever 2* [143] ninja characters have sophisticated movement abilities that add to the difficulty of synchronizing movement and animation. They can perform cartwheels, vault over obstacles, and leap between buildings.

Simple movement around the level becomes a challenge. The AI not only needs to work out a route, but also needs to be able to break this motion into animations. Most games separate the two parts: the AI decides where to move, and another chunk of code turns this into animations. This allows the AI complete freedom of motion but has the disadvantage of allowing odd combinations of animation and movement to occur, which can look jarring to the player. This difficulty has been tackled to date by including a richer palette of animations, making it more likely that a reasonable combination can be found.

Several games that use scripting languages to control their characters expose the same controls to the AI as the player uses. Rather than output desired motion or target locations, the AI needs to specify how fast it is moving forward or backward, turning, changing weapons, and so on. This makes it very easy during development to remove an AI character and replace it with a human being (playing over the network, for example). Most titles, including those based on licensing the most famous game engines, have macro commands—for example:

```
sleep 3
gotoactor PathNodeLoc1
gotoactor PathNodeLoc2
agentcall Event_U_Wave 1
sleep 2
gotoactor PathNodeLoc3
gotoactor PathNodeLoc0
```

Because of the constrained, indoor nature of the levels in many shooters, the characters almost certainly need some kind of route finding. This may be as simple as the gotoactor statements in the Unreal script above, or it might be a full pathfinding system. Whatever form this takes (we'll return to pathfinding considerations later), the routes need to be followed. With a reasonably complicated route, the character can simply follow the path. Unfortunately, the game level is likely to be dynamic. The character should react properly to other characters moving about. This is most commonly done using a simple repulsion force between all characters. If characters approach too closely, then they will move apart. In Mace Griffin: Bounty Hunter [197], the same technique is used to avoid collisions between characters on the ground and between combat spacecraft during the deep space sections of the game. Indoors, pathfinding is used to create the routes. In space, a formation motion system is used instead.

The Flood in Halo [91] and its sequels, and the aliens in Alien vs. Predator [167] both move along walls and the ceiling as well as the floor. Neither uses a strictly 21/2 dimensional (2½D) representation for character movement.

Firing AI is crucial in shooters (not surprisingly). The first two incarnations of Doom were heavily criticized for unbelievably accurate shooting (the developers slowed down incoming projectiles to allow the player to move out of the way; otherwise, the accuracy would be overwhelming). More realistic games, such as the ARMA [89] games and the Far Cry [100] series use firing models that allow characters to miss, sometimes tweaked to miss in exciting ways (i.e., they try to miss where the player can see the bullet).

14.2.2 DECISION MAKING

Decision making is commonly achieved using simple techniques such as finite state machines or behavior trees. These can be very rudimentary with just "seen-player" and "not-seenplayer" behaviors.

A very common approach to decision making in shooters is to develop a bot scripting system. A script written in a game-specific or engine-provided scripting language is executed. The script has a whole range of functions exposed to it by which it can determine what the character can perceive. These are usually implemented by directly polling the current game state. The script can then request actions to be executed, including the playing of animations,

1. Not to be confused with Alien vs. Predator [79], the arcade and SNES games of the same name, both of which are sideways scrolling shooters.

movement, and in some cases pathfinding requests. This scripting language is then made available to users of the game to modify the AI or to create their own autonomous characters. This is the approach used in *Unreal* [103] and successive games, and has been adopted in non-shooters (the first example I noticed was the role-playing game *Neverwinter Nights* [83]).

For Sniper Elite [168], Rebellion wanted to see emergent behavior that was different on each play through. To achieve this they applied a range of state machines, operating on waypoints in the game level. Many of the behaviors depended on the actions of other characters or the changing tactical situation at nearby waypoints. A small amount of randomness in the decision making process allowed the characters to behave differently each time and to act in apparent cooperation, without needing any squad-based AI.

A slightly different approach to autonomous AI was created in No One Lives Forever 2 [143]. Monolith blended state machines with goal-oriented behavior. Each character would have a pre-determined set of goals that could influence its behavior. The characters would periodically evaluate their goals and select the one that was most relevant for them at that time. That goal would then take control of the character's behavior. Inside each goal was a finite state machine that was used to control the character until a different goal was selected.

The game uses waypoints (which they call nodes) to make sure characters are in the correct position for behaviors such as rifling through filing cabinets, using computers, and switching on lights. The presence of these waypoints in the vicinity of a character allows the character to understand what actions are available.

Monolith's AI engine continued to undergo development until the company was acquired. In F.E.A.R. [144], the same goal-oriented behavior was used, but the pre-built state machines are replaced by a planning engine that tries to combine available actions in such a way as to fulfill the goal. F.E.A.R. had one of the first full goal-oriented action planning systems.

In Halo 2 [92] and later games in the franchise, decision trees were used to allow AI characters to perform rudimentary planning as they acted. When nodes in a selector in the behavior tree fail, the AI falls back to other nodes representing different plans, giving the AI a breadth of tactical opportunities that would be difficult to specify using a state machine.

14.2.3 **PERCEPTION**

Perception is sometimes faked by placing a radius around each enemy character and having that enemy "come to life" when the player is within it. This is the approach taken by the original Doom. After the success of Goldeneye 007 [165], however, more sophisticated perception simulation became expected. This doesn't necessarily mean a sense management system, but at the very least characters should be informed of what is going on around them through some kind of messages.

In the Tom Clancy's Ghost Recon [170] games, the perception simulation is considerably more complex. The sense management system that provides information to AI characters takes into account the amount of broken cover provided by bushes and tests the background behind characters to determine if their camouflage matches. This is achieved by keeping a set of pattern ids for each material in the game. The line-of-sight check passes through any partially transparent object until it reaches the character being tested. It then continues beyond the character and determines the next thing it collides with. The camouflage id and the background material id are then checked for compatibility.

The Splinter Cell [189] games use a different tack. Because there is only one player character (in Ghost Recon there are many), each AI simply checks to see if it is visible. Each level can contain dynamic shadows, mist, and other hiding effects. The player character is checked against each of these to determine a concealment level. If this is below a certain threshold, then the enemy AI has spotted the player character.

The concealment level does not take into account background in the way that the Ghost Recon games do; if the character is standing in a dark shadow in the middle of a bright corridor, then it will not be seen, even though it would appear to the guards as a big black figure on a bright background. The levels have been designed to minimize the number of times this limitation is obvious.

The AI characters in Splinter Cell also use a cone-of-sight for vision checks, and there is a simple sound model where sound travels in the current room up to a certain radius depending on the volume of the sound. Very similar techniques are used in the Metal Gear Solid [129] series of games.

PATHFINDING AND TACTICAL AI

In Soldier of Fortune 2: Double Helix [166], links in the pathfinding graph were marked with the type of action needed to traverse them. When a character reached the corresponding link in the path, it could then change behavior to appear to have knowledge of the terrain. The link might represent an obstacle to vault over, a door to open, a barrier to break through, or a wall to rappel down. The AI team responsible, Christopher Reed and Ben Geisler, call this approach "embedded navigation."

It is becoming almost universal to incorporate some kind of waypoint tactics in shooters. In the original Half-Life [193], the AI uses waypoints to work out how to surround the player. A group of AI characters will be coordinated so that they occupy a set of good defensive positions that surround the player's current location, if that is possible. In the game an AI character will often make a desperate run past the player in order to take up a flanking position.

Unless your enemy characters always rush the player, as in the original Doom, you will probably need to implement a pathfinding layer. The indoor levels of most shooters can be represented with relatively small pathfinding graphs that are quickly searched. Rebellion used the same waypoint system for their pathfinding and tactical AI in Sniper Elite, whereas Monolith created a completely different representation for No One Lives Forever 2. In Monolith's solution, the area that a character could move to was represented by overlapping "AI volumes," which then formed the pathfinding graph. The waypoints of its action system did not directly take part in pathfinding (except as a goal for the pathfinder to plan to).

At the time of the first edition of this book developers used a range of representations for pathfinding. Since then it has become almost (but not quite) ubiquitous to use navigation meshes to represent internal spaces. It is more effort to unify the navigation mesh approach with robust tactical analysis, and it is not uncommon to see grid-based tactical analysis running side-by-side with navigation meshes for pathfinding.

There are still other viable approaches, however. Monolith's pathfinding volumes are yet another approach, and many games set outdoors still rely on grid-based pathfinding graphs.

Games set primarily indoors naturally break up their levels into sectors, often separated by portals (a rendering optimization technology). These sectors can act naturally as a higher level pathfinding graph for long-distance route planning. This makes hierarchical pathfinding algorithms a natural fit for implementations capable of dealing with large levels.

14.2.5 SHOOTER-LIKE GAMES

Various games use a first- or third-person viewpoint with human-like characters. The player directly controls one character, used as the viewpoint of the game, and enemy characters typically have similar physical capabilities.

In combination with the natural conservatism of game settings, this means that a number of genres that could not be described as shooters use very similar AI techniques. They therefore tend to have the same basic architecture.

Rather than cover the same ground again, I will consider these genres in terms of what they add or remove from the basic shooter setup.

Platform and Adventure Games

Platform games are normally intended for a younger audience than first-person shooters. A major design goal is to make the enemy characters interesting, but fairly predictable. It is common to see obvious patterns designed into a character's behavior. The player is rewarded for observing the action of the enemy and building up an idea of how to exploit its weaknesses.

The same holds true for adventure games, in which enemies become another puzzle to be solved. In Beyond Good and Evil [192], the Alpha Sections, an otherwise impervious enemy, lower their shields for a few seconds after attacking, for example.

In both cases the AI will use similar, but simpler, techniques to those seen in shooters. Movement will typically use the same approach, although platform games often add flying enemies, which will need to be controlled with 2½D (see Chapter 3, Section 3.1.2) or 3D movement algorithms. Adventure games, in particular, place a larger burden on animation to communicate character actions. A small number of games allow their characters to pathfind. Even back as far as Jak and Daxter: The Precursor Legacy [148], navigation was sometimes used. That game adopted a navigation mesh representation to allow characters to move around intelligently. In many platform-type games, movement can be safely kept local.

The state of the art in decision making is still the simplest techniques. Typically, characters

have two states: a "spotted the player" state and a "normal behavior" state. Normal behaviors will often be limited to standing playing a selection of animations or fixed patrol routes. In the Oddworld [156] series, for example, some animals move around randomly using a variation of the wander behavior until they spot the protagonist.

When a character has spotted the player, it will typically home in on the player with a seek or pursue behavior. In some games this homing is limited to aiming at the player and moving forward. Other games extend the capabilities of the moving character. The human enemies in Tomb Raider III [96] and later games of the franchise, for example, grab on and climb up onto blocks to get at Lara. This has increased in each game in the Dark Souls [115] franchise. Different enemies in Dark Souls 3 [117] can navigate far across the level when aggroed (i.e. in their 'home in on the enemy' state), using different features of the environment, including ladders and one-way ledges. And, unlike previous games in the series, they are less likely to get stuck or fall off edges.

Obviously, variations on this exist: some characters might have a few more states, they might call for help, there might be different close-quarters and long-distance actions, and so on. But I can't think of any game in these genres where the characters use fundamentally more complex techniques. This is probably not a coincidence: more complexity would be difficult for the player to interpret, and may appear unfair. Predictable behavior, even at the risk of believability, is often preferable.

14.2.6 MELEE COMBAT

In the previous section I mentioned Dark Souls and its sequels, a game which doesn't sit comfortably in a section on shooters. Although there are many similarities between shooters and melee action games, when it comes to character AI, hand-to-hand combat is fundamentally different to using a firearm. Melee combat mechanics range from simple to complex. At the simple end are uninterruptible attack actions, which succeed when a character is within the weapons range, possibly with some random chance depending on the victim's shield or dodge statistic. At the complex extreme are fighting games, which can feature a bewildering array of mechanics, including cancels, reversals, combos and specials.

Beyond the very simplest games, melee combat is fundamentally and uniquely about timing. Figure 14.3 shows a schematic representation of an example move in a melee combat system. It has several phases:

- 1. A windup period, when the attack animation has begun but it cannot inflict damage, and the character is still vulnerable to attacks themselves.
- 2. An interruptible period, when the character is able to inflict damage, but the attack can still be interrupted or parried by an enemy.
- 3. An invincible period, when the attack is able to inflict damage, but it cannot be interrupted.
- 4. A cool-down period, when the attack is no longer dangerous, but the player cannot begin another action.

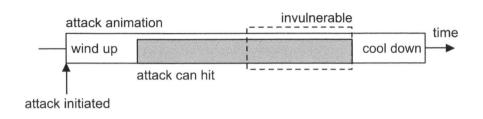

Figure 14.3: The timing of a move in a melee combat game

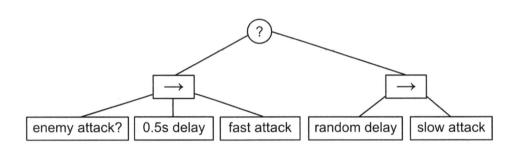

Figure 14.4: A simplified behavior tree incorporating melee timing.

There are several criteria at work here: whether the animation is running and the action is in progress; whether the player is vulnerable to being attacked, interrupted or parried; whether the attack is able to damage the opponent; and whether the player can end the current attack to begin another action. The figure shows one example of how these might be arranged, but each game will sequence them in different ways, often with different characters or even different weapons having their own pattern. In almost all cases, even when the phases are the same, the timing will vary.

The AI in these games has to make decisions about not only which move to execute, but when. This does not require a unique algorithm, the same decision-making tools that we have seen throughout this book can be used, but their content (the particular patterns of state in the state machine, for example, or the nodes in the behavior tree) must be designed in such a way that timing is included. Figure 14.4 shows an example of part of a behavior tree, and Figure 14.5 shows the tree in use, with the timing schema of a successfully defended attack and an attack that gets through.

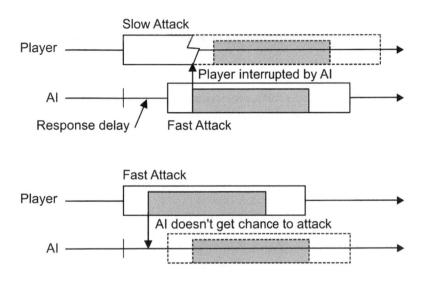

Figure 14.5: The melee behavior tree used in two different scenarios.

In action adventure games with melee combat, part of the skill development of the player is to understand their enemy move set, and how each one will respond to player actions. A simple decision-making algorithm is beneficial in this case. The player will learn that a particular enemy is good parrying slow sword blows, as long as it is relatively consistent in its responses. It can be too robotic, of course. Some randomization is probably necessary, so it only parries four times out of five, for example. But this can be achieved with decision trees, state machines, or behavior trees—simple decision-making approaches that will allow the player to 'learn' the enemy attacks.

Even with simple tools, it is possible to be highly sophisticated, and crafty, with the AI design. In fact, it is relatively simple to implement AI that is impossible to beat, able to respond perfectly to any attack within a frame of it being initiated. Much of the difficulty in implementing these kinds of AI is getting the feel right. Walking the fine line between challenge and fairness. That is where AI becomes more art than science, and no technique will save you from tweaking and play-testing.

MMOGs

Massively multi-player online games (MMOGs) usually involve a large number of players in a persistent world. Technically, their most important feature is the separation between the server on which the game is running and the machines on which the player is playing.

A distinction between client and server is usually implemented in shooters (and many other types of game) also to make multi-player modes easier to program. In an MMOG, however, the server will never be running on the same machine as the client; it will normally be running on a set of dedicated hardware. We can therefore use more memory and processor resources.

Some massively multi-player games have only a marginal need for AI. The only AIcontrolled characters are animals or the odd monster. All characters in the game are played by humans.

While this might be an ideal situation, it is not always practical. The game requires some critical mass of players before it is worth anyone's time playing. Most MMOGs add some kind of AI-based challenge to the game, much like you'd see in any first- or third-person adventure.

With such a huge game world, all the challenges to the AI developer arrive in terms of scale. The technologies used are largely the same as for a shooter, but their implementation needs to be significantly different to cope with large numbers of characters and a much larger world. Whereas a simple A* pathfinder can cope with a level in a shooter and the 5 to 50 characters using it to plan routes, it will likely grind to a halt when 1000 characters need to plan their way around a continent-sized world.

It is these large-scale technologies, particularly pathfinding and sensory perception, that need more scalable implementations. We have looked at some of these. In pathfinding, for example, we can pool planners, use hierarchical pathfinding, or use instanced geometry.

14.3 driving

Driving is one of the most specialized, genre-specific AI tasks for a developer. Unlike other genres, the crucial AI tasks are all focused around movement. The task isn't to create realistic goal-seeking behavior, clever tactical reasoning, or route finding, although all of these may occur in some driving games. The player will judge the competency of the AI by how well it drives the car.

Figure 14.6 shows an AI architecture suited to a racetrack driving game, and Figure 14.7 expands this architecture for use in an urban driving title, where different routes are possible and ambient vehicles share the road.

14.3.1 MOVEMENT

For racing games there are two options for a developer implementing the car motion. The simplest approach is to allow the level designer to create one or more racing lines, along which

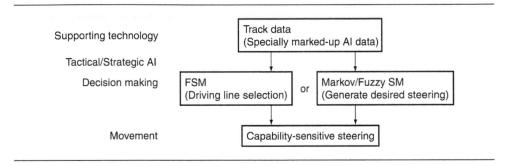

Figure 14.6: AI architecture for race driving

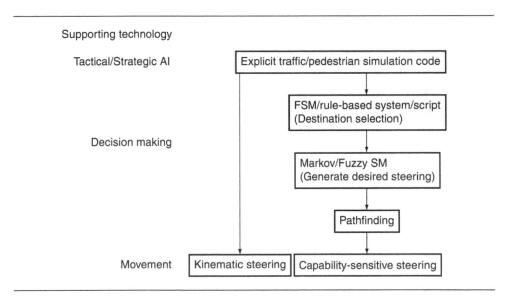

Figure 14.7: AI architecture for urban driving

the vehicle can achieve its optimal speed. This racing line can then be followed rigidly. This may not even require steering at all. Computer-controlled cars can simply move along the predefined path.

Typically, this kind of racing line is defined in terms of a spline: a mathematical curve. Splines are defined in terms of curves in space, but they can also incorporate additional data. Speed data incorporated into the spline allow the AI to look up exactly the position and speed of a car at any time and render it accordingly. This provides a very limited system: cars can't easily overtake one another, they won't avoid crashes in front of them, and they won't be deflected out of the way when colliding with the player. To avoid these obvious limitations, additional code is added to make sure that if the car gets knocked out of position, a simple steering behavior can be engaged to get it back onto the racing line. It is still characterized by the tendency of cars to stream into a crashed car with naive abandon.

Most early driving games, such as *Formula 1* [84], used this approach. It has also been used in many recent games for controlling cars that are intended to be part of the "background," as seen in *Grand Theft Auto 3* [104].

The second approach, used overwhelmingly in recent titles, is to have the AI drive the car—to apply control inputs into the physics simulation so that the car behaves realistically. The degree to which the physics that the AI cars have to cope with is the same as the physics that the player experiences is a critical issue. Typically, the player has somewhat harder physics than the AI-controlled cars, although many games are now giving the AI the same task as the player.

It is very common to still see racing lines being defined for this kind of game. The AI-controlled car tries to follow the racing line by driving the car, rather than having the racing line act as a rail for it to move along. This means that the AI often cannot achieve its desired line, especially if it has been nudged by another car. This can cause additional problems. In the *Gran Turismo* [160] 'driving simulator' franchise, which uses this approach, a car could be knocked out of position by the player. At this point the car would still try to drive its racing line, which would usually result in it out-breaking itself on the next corner and ending up in the gravel trap.

To solve the problem of overtaking, when a slower moving vehicle sits on the racing line, many developers add special steering behaviors: the car will wait until a long straight and then pull out to overtake. This is characteristic overtaking behavior seen in many driving games from Gran Turismo to *Burnout* [98] and is a common overtaking ploy in real world racing with medium- and low-powered cars. Most of the overtaking in the world's fastest racing series (such as Formula One) takes place under braking at corners, however. This can be accomplished using an alternative racing line defined by the level designer. If a car wishes to overtake, it takes up a position on this line, which will ensure that it can brake later and take control of the exit of the corner. In real-life racing, drivers are able to take some defensive action to block potential overtakes (though this may be limited by the rules of the series). This makes such alternative racing lines difficult to define, particularly when the player is being overtaken. Fortunately, less successful AI at this point makes the player feel more skilled, and so is less likely to be negatively reviewed.

A variation on the approach of following the racing line is used in many rally games and is sometimes called "chase the rabbit." An invisible target (the eponymous rabbit) is moved along the racing line using the direct position update method. The AI-controlled vehicle then simply aims for the rabbit; it can be controlled using an "arrive" behavior, for example. As the rabbit is always kept in front of the car, it begins to turn first, making sure that the car steers at the right point. This is particularly suited to rally games, because it makes implementing power slides quite natural. The car will automatically begin steering well before the corner, and if the corner is severe it will steer heavily, causing the physics simulation to allow the back end of the car to slip out a little.

Other developers have used decision making tools as part of the driving AI. The karting simulator Manic Karts [134] used fuzzy decision making in place of racing lines. It determined the left and right extent of the track a short distance in front of the vehicle, as well as any nearby karts, and then used a hand-written Markov state machine to determine what to do next.

Forza Motorsport [188] used neural networks to learn how to drive by observing human players. The final AI that shipped with the game was the result of hundreds of hours of training by the development team.

Until recently, such techniques were rare. They were not widely used enough to suggest that they had provided radically better performance. With the recent dramatic successes in applying deep learning to gameplay, however (for example, [43]), neural networks are enjoying a widespread renaissance across the industry, and are being used in the development of several upcoming racing games. Over the next five years we will see whether this grows from enthusiasm to ubiquity.

14.3.2 PATHFINDING AND TACTICAL AI

With Driver [171], a new genre of driving game emerged. Here there is no fixed track. The game is set on city streets, and the goal is to catch or avoid other cars. A car can take any route it likes, and when running from the police the player will usually weave and double back. A single, fixed racetrack is not applicable for this kind of game.

Many games in this genre have enemy AI following a set path when it is escaping from the player or performing a simple homing-in algorithm when trying to catch them. In Grand Theft Auto 3 and it's sequels, cars are only created for the few blocks surrounding the player's position. When police home in on the player, they are gathered from this area, and additional cars are injected at appropriate positions.

As this kind of game simulates a wider area, however, vehicles begin to need pathfinding to find their route around, especially with a view to catching the player.

The same is true of the use of tactical analysis to work out likely escape routes and block them. The driver uses a simple algorithm to try to surround the player. A tactical analysis based on the current direction the player is moving can then ask police car AI to intercept. The police cars may then use tactical pathfinding to get to their positions without crossing the player's path (to avoid giving the game away).

14.3.3 DRIVING-LIKE GAMES

The basic approach used for driving games can apply to a number of other genres.

Some extreme sports games, such as the arcade-like SSX [106] series and the more recent and simulation flavored Steep [190], have a racing game mechanic (in the latter case among other modes). Overlaid onto the racing system (normally implemented using the same racing line-based AI as for driving games) is commonly a "tricks" sub-game, which involves scheduling animated trick actions during jumps. These can be added at predefined points on the racing line (i.e., a marker that says, when the character reaches this point, schedule a trick of a particular duration) or can be performed by a decision making system that predicts the likely airtime that will result and schedules a trick with an appropriate duration.

Futuristic racers, such as Wipeout [162] and its sequels, are likewise based on the same racing AI technology. It is common for this kind of game to include weapons. To support this, additional AI architecture is needed to include targeting (often, this isn't a full firing solution, as the weapons home in) and decision making (the vehicle may slow down to allow an enemy to overtake it in order to target them).

$14.4\,$ real-time strategy

With Dune II² [198], Westwood created a new genre³ that has become a mainstay of publishers' portfolios. Although it accounts for a small proportion of total game sales, the genre is one of the strongest on the PC platform.

Key AI requirements for real-time strategy games are:

- Pathfinding
- Group movement
- Tactical and strategic AI
- Decision making

Figure 14.8 shows an AI architecture for a real-time strategy (RTS) game. This varies more from game to game than previous genres, depending on the particular set of gameplay elements being used. The model below should act as a useful starting point for your own development.

14.4.1 PATHFINDING

Early real-time strategy games such as Warcraft: Orcs and Humans [85] and Command and Conquer [199] were synonymous with pathfinding algorithms, because efficient pathfinding

- 2. Not to be confused with the original Dune game [99], which was a fairly nondescript graphical adventure.
- 3. Some games historians trace the genre back further to strategy hybrid games like Herzog Zwei [184], but in terms of AI these earlier games are very different.

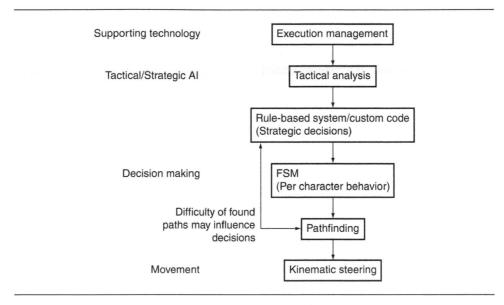

Figure 14.8: AI architecture for RTS games

was the primary technical challenge of the AI. With large grid-based levels (often encompassing tens of thousands of individual tiles), long pathfinding problems (the player can send a unit right across the map), and many tens of units, pathfinding speed is crucial.

Although most games no longer use tile-based graphics, the underlying representation is still grid based. Most games use a regular array of heights (called a height field) to render the landscape. This same array is then used for pathfinding, giving a regular grid-based structure. Some developers pre-compute route data for common paths in each level.

In some StarCraft II [87] levels, destructible terrain can change the navigation graph during gameplay, although typically the change is relatively minor: a handful of connections being added or removed. Games such as Company of Heroes [173] introduced players to fully deformable terrain, where exhaustive pre-computation is difficult.

14.4.2 GROUP MOVEMENT

Games such as Kohan: Ahriman's Gift [187] and Warhammer: Dark Omen⁴ [141] grouped individuals together as teams and had them move as a whole. This is accomplished using a formation motion system with pre-defined patterns.

Warhammer describes itself as a role-playing game because of its character development aspects, but during the levels it plays as an RTS.

In *Homeworld* [172] and its sequels, formations are extended into three dimensions, giving an impression of space flight despite keeping a strong up and down direction.

Where Kohan's formations have a limited size, in Homeworld any number of units can participate. This requires scalable formations, with different slot positions for different numbers of units.

The majority of RTS games now use formations of some kind. Almost all of them define formations in terms of a fixed pattern (given a fixed set of characters in the formation) that moves as a whole. In *Full Spectrum Warrior* [157] (another RTS-like game that describes itself otherwise), the formation depends on the features of the level surrounding it. Next to a wall, the squad assumes a single line, behind an obstacle providing cover, they double up, and in the open they form a wedge. The player has only indirect control over the shape of the formation. The player controls where the squad moves to, and the AI determines the formation pattern to use. The game is also unusual in that its formations only control the final location of characters after they have moved. During movement, the units move independently and can provide cover for each other if requested.

14.4.3 TACTICAL AND STRATEGIC AI

If early RTS games pioneered game AI by their use of pathfinding, then games in the late 1990s did the same for tactical AI. Influence mapping was devised for use in RTS games and has only recently begun to be interesting to other genres (normally in the form of waypoint tactics).

So far the output of tactical and strategic AI has been mostly used to guide pathfinding. An early example was *Total Annihilation* [94], where units take into account the complexity of the terrain when working out paths; they correctly move around hills or other rocky formations. The same analysis is also used to guide the strategic decisions in the game.

A second common application is in the selection of locations for construction. With an influence map showing areas under control, it becomes much simpler to safely locate an important construction facility. Whereas a single building occupies only one location, walls are a common feature in many RTS games, and they are more tricky to handle. The walls in Warcraft, for example, were constructed in advance by the level designer. In *Empire Earth* [179], the AI was responsible for wall construction, using a combination of influence mapping and spatial reasoning (the AI tried to place walls between economically sensitive buildings and likely enemy positions).

There has been a lot of talk in game AI circles about using tactical analysis to plan large-scale troop maneuvers—detecting weak points in the enemy formation, for example—and deploying a whole side's units to exploit this. To some extent this is done in every RTS game: the AI will direct units toward where it thinks the enemy is, rather than just sweep them up the map to a random location. It is taken further in games such as *Empire: Total War* [186], where the AI will try to maneuver outside the range of missile weapons and cannons before

launching attacks on multiple flanks. This is made even more difficult in levels representing naval battles where prevailing wind is an important consideration.

The potential is there to go even further and have the AI reason about possible attack strategies in light of the tactical analysis and the routes that each unit would need to take to exploit any weakness. I have seen few examples of games that have obviously gone this far.

Because tactical analysis is so heavily tied to RTS games, the discussion in Chapter 6 was geared toward this genre. What remains is to analyze the behavior that you expect your computer-controlled side to display and to select an appropriate set of analyses to perform.

1444 **DECISION MAKING**

There are several levels at which decision making needs to occur in an RTS game, so they almost always require a multi-tiered AI approach.

Some simple decision making is often carried out by individual characters. The archers in Warcraft, for example, make their own decisions about whether to hold their location or move forward to engage the enemy.

At an intermediate level, a formation or group of characters may need to make some decisions. In Full Spectrum Warrior, the whole squad can make a decision to take cover when they are exposed to enemy fire. This decision then passes off to each individual character to decide how best to take cover (to lie on the ground, for example).

Most of the tricky decision making occurs at the level of a whole side in the game. There will typically be many different things happening at the same time: correct resources need collecting, research needs to be guided, construction should be scheduled, units need to be trained, and forces need to be marshaled for defense or offense.

For each of these requirements an AI component is created. The complexity of this varies dramatically from game to game. To work out the research order, for example, we could use a numerical score for each advance and choose the next advance with the highest value. Alternatively, we could have a search algorithm such as Dijkstra to work out the best path from the current set of known technologies to a goal technology.

In games such as Warcraft, each of these AI modules is largely independent. The AI that schedules resource gathering doesn't plan ahead to stockpile a certain resource for later construction efforts. It simply assigns balanced effort to collect available resources. The military command AI, likewise, waits until sufficient forces are amassed before engaging the enemy.

Games such as Warcraft 3: Reign of Chaos [86] use a central controlling AI that can influence some or all of the modules. In this case the overall AI can decide that it wants to play an offensive game, and it will skew the construction effort, unit training, and military command AI to that end.

In RTS games, the different levels of AI are often named for military ranks. A general or a colonel will be in charge, and lower down we might have commanders or lieutenants on down to individual soldiers. Although this naming is common, there is almost no agreement about what each level should be called, which can be very confusing. In one game the general AI might be controlling the whole show. In another game it is merely the AI responsible for military action, under the guidance of the king or president AI.

The choice of decision making technology mirrors that for other games. Typically, most of the decision making is accomplished with simple techniques such as state machines and decision trees. Markov or other probabilistic methods are more common in RTS games than in other genres. Decision making for the military deployment is often a simple set of rules (sometimes a rule-based system, but commonly hard-coded IF-THEN statements) relying on the output of a tactical analysis engine.

14.4.5 MOBAS

Multiplayer online battle arenas rose to prominence in the early 2010s to become one of the most significant game genres. What initially began as "Defense of the Ancients"—a player generated mod/map for Warcraft III [86]—grew to prominence with its major competitor League of Legends [175] and its studio developed sequel, Dota 2 [195]. Despite the rush to compete in this popular new genre, few other games achieved a significant commercial success. Though the gold rush moved on (to hero-based shooters and then the Battle Royale craze, in particular), at the time of writing, MOBAs are still the most significant game genre in terms of e-sports. Of the 20 highest prize money e-sport tournaments, 18 are for MOBAs.

The origin of this genre in real-time strategy carries over to the AI. There are two types of characters in the game: heroes and creeps (depending on the game, these may be also called minions or mobs). Heroes are designed to be player controlled. AI bots have been developed to play them, but they are not yet competitive with human players. Creeps are comparable with the individual units in an RTS game. They either move along a fixed lane, or lurk somewhere in the rest of the map (known as the jungle in Dota and League of Legends). Lane creeps typically belong to one of the team of players, and will only attack members of the other team (heroes or creeps). Jungle creeps will attack anyone, either on sight or when attacked themselves. When in their attack state, jungle creeps will home in on the nearest player.

Creeps are designed to be simple and easy to anticipate. A part of the skill in playing the game is manipulating creeps, anticipating their attacks, redirecting their aggression. For this reason the simplest possible AI techniques are usually used. A creep should not behave in a sophisticated way. They should behave as if implemented by a state machine.

Because the movement of creeps is so constrained (moving along the lane, or homing in on an enemy), pathfinding is rarely needed. In games inspired by Dota, teams may have a courier: an autonomous unit that delivers suppliers when summoned to a hero. This character may need to navigate through the level, but is most commonly implemented as a flying unit, with minimal pathfinding.

Overall the AI requirements of a MOBA are typically simpler than the RTS games from which they were derived. Like RTS games, there may be many creeps operating in the level

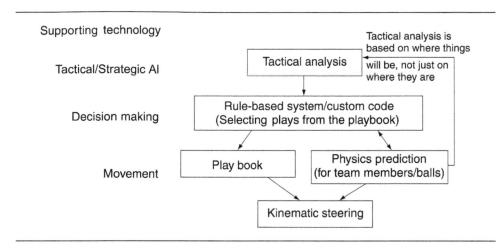

Figure 14.9: AI architecture for sports games

at the same time. But their AI rarely needs anything more sophisticated than basic decisionmaking and steering.

14.5 **SPORTS**

Sports games can range from major league sports franchises such as Madden NFL 18 [108] to pool simulators such as World Snooker Championship (the final yearly release being [102]). They have the advantage of having a huge body of readily available knowledge about good strategies: the professionals who play the game. This knowledge isn't always easy to encode into the game, however, and they face the additional challenge of having players who expect to see human-level competence.

For team sports the key challenge is having different characters react to the situation in a way that takes into account the rest of the team. Some sports, such as baseball and football, have very strong team patterns. The baseball double play example in Chapter 3 (Figure 3.62) is a case in point. The actual position of the fielders will depend on where the ball was struck, but the overall pattern of movement is always the same.

Sports games therefore typically use multi-tiered AI of some kind. There is high-level AI making strategic decisions (often using some kind of parameter or action learning to make sure it challenges the player). At a lower level there may be a coordinated motion system that plays patterns in response to game events. At the lowest level each individual player will have their own AI to determine how to vary behavior within the overall strategy. Non-team sports, such as singles tennis, omit the middle layer; there is no team to coordinate.

Figure 14.9 shows the architecture of a typical sports game AI.

14.5.1 PHYSICS PREDICTION

Many sports games involve balls moving at speed under the influence of physics. This might be a tennis ball, a soccer ball, or a billiard ball. In each case, to allow the AI to make decisions (to intercept the ball or to work out the side effects of a strike), we need to be able to predict how it will behave.

In games where the dynamics of the ball are complex and an integral part of the game (cue games, such as pool, and golf game genres, for example), the physics may need to be run to predict the outcome.

For simpler dynamics, such as baseball or soccer, the trajectories of the ball can be predicted.

In each case, the process is the same as we saw for projectile prediction in Chapter 3. The same firing solutions used for firearms can be used in sports games.

14.5.2 PLAYBOOKS AND CONTENT CREATION

Implementing robust playbooks is a common source of problems in team sports AI. A playbook consists of a set of movement patterns that a team will use in some circumstance. Sometimes the playbook refers to the whole team (an offensive play at the line of scrimmage in football, for example), but often it refers to a smaller group of players (a pick-and-roll in basketball, for example). If your game doesn't include tried and tested plays like this, it will be obvious to fans of the real-world game who buy your product.

The coordinated movement section of Chapter 3 included algorithms for making sure that characters moved at the correct time. This typically needs to be combined with the formation motion system of the same chapter to make sure that the team members move in visually realistic patterns.

Aside from the technology to drive playbooks, care needs to be taken to allow the plays to be authored in some way. There needs to be a good content creation path for plays to get into the game. Typically, as a programmer you won't know all the plays that need to make it to the final game, and you don't want the burden of having to test each combination. Exposing formations and synchronized motion are the key to allowing sport experts to create the patterns for the final game.

14.6 TURN-BASED STRATEGY GAMES

Turn-based strategy games often rely on the same AI techniques used in RTS games. Early turn-based games were either variants of existing board games (3D Tic-Tac-Toe [80], for example) or simplified tabletop war games (Computer Bismark [180] was one of my early favorites). Both relied on the kind of minimax techniques used to play board games (see Chapter 9).

As strategy games became more sophisticated, the number of possible moves at each turn grew vastly. In recent games, such as Sid Meier's Civilization VI [113], there is an almost

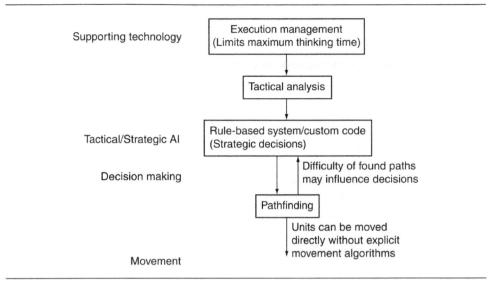

Figure 14.10: AI architecture for turn-based strategy games

unlimited number of possible moves open to the player at each turn, even though each move is relatively discrete (i.e., a character moves from one grid location to another). In games such as the *Worms* series [182], the situation is even more broad. During a player's turn, they get to take control of each character and move them in a third-person manner (for a limited distance representing the amount of time available in one turn). In this case, the character could end up anywhere. No minimax technique can search a game tree of this size.

Instead, the techniques used tend to be very similar to those used in a real-time strategy game. A turn-based game will often require the same kinds of character movement AI. Turn-based games rarely need to use any kind of sophisticated movement algorithms. Kinematic movement algorithms or even a direct position update (just placing the character where it needs to be) is fine. At a higher level, the route planning, decision making, and tactical and strategic AI use the same techniques and have the same broad challenges.

Figure 14.10 shows an AI architecture for turn-based strategy games. Notice the similarity between this and the RTS architecture in Figure 14.8.

14.6.1 **TIMING**

The most obvious difference between turn-based and real-time strategy games is the amount of time that both the computer and the player have to take their turn.

Given that we aren't trying to do a huge number of time-intensive things at the same time (rendering, physics, networking, etc.), there is less need for an execution management system. It is common to use operating system threads to run AI processes over several seconds.

This is not to say that timing issues don't come into play, however. Players can normally take an unlimited amount of time to consider their moves. If there is a large number of possible simultaneous moves (such as troop movements, economic management, research, construction, and so on), then the player can spend time optimizing the combination to get the most of the turn. To compete with this level of applied thinking, the AI has a tough job. Some of this can be achieved by game design: making decisions about the structure of the game that make it easier to create AI tools, choosing physical properties of the level that are easy to tactically analyze, creating a research tree that can be easily searched, and using turn lengths that are small enough that the number of movement options for each character is manageable. This will only get you so far, however. Some more substantial execution management will eventually be needed.

Just like for an RTS game, there is typically a range of different decision making tools operating on specific aspects of the game: an economics system, a research system, and so on. In a turn-based game it is worth having these algorithms able to return a result quickly. If additional time is available, they could be asked to process further. This might be particularly useful for a tactical analysis system that can take longer to perform its calculations.

14.6.2 HELPING THE PLAYER

Another function of the AI in turn-based games (which is also used in some RTS games, but to a much smaller extent) is to help players automate decisions that they don't want to worry about.

In Master of Orion 3 [163], the player could assign a number of different decision making tasks to the AI. The AI then uses the same decision making infrastructure it uses for enemy forces to assist the player.

Supporting assistive AI in this way involves building decision making tools that have little or no strategic input from higher level decision making tools. If we have an AI module for deciding on what planet to build a colony, for example, it could make a better decision if it knew in which direction the side intended to expand first. Without this decision, it might choose a currently safe location near where war is likely to break out.

With this input from high-level decision making in place, however, when the module is used to assist the player, it needs to determine what the player's strategy will be. This is very difficult to do by observation. I am not aware of any games that have tried to do this. Master of Orion 3 uses context-free decision making, so the same module can be used for the player or an enemy side.

15

AI-BASED GAME GENRES

M OST GAMES are fairly modest in the AI techniques they use, and in the behaviors they want to achieve. AI that stands out and is conspicuous is not normally good AI. From time to time, however, games appear that feature specific AI techniques as a game mechanic. The challenge comes from manipulating the mind of characters in the game.

As an AI programmer, it would be lovely to see more of this kind of title, but as yet, there have been relatively few examples based on a limited number of game styles.

This chapter looks at two options for AI-centered gameplay. The genres described are represented by only a handful of commercially successful titles. It is not clear whether more games will be created that use the exact same approach, though each can be mined for interesting behavior and gameplay that can be applied in more mainstream genres.

For each type of game, I will describe a set of technologies that would support the appropriate gameplay. Although some details of the specific games in each genre are available in the public domain, much of the algorithmic specifics are confidential. Even when information is available, the limited number of titles means it is difficult to be general about what works and what doesn't. It is inevitable, therefore, that this discussion will be somewhat speculative. Throughout this chapter I'll try to indicate alternatives.

15.1 TEACHING CHARACTERS

Teaching an inept character to act according to your will has been featured in a number of games. The original game of its kind, Creatures [101] was released in 1996. Now the genre is best known for Black & White [131] from 2001.

A small number of characters (just one in Black & White) have a learning mechanism that learns to perform actions it has seen, under the supervision of the player's feedback. The observational learning mechanism watches the actions of other characters and the player and tries to replicate them. When it replicates the action, the player can give positive or negative feedback (slaps and tickles usually) to encourage or discourage the same action from being carried out again.

15.1.1 REPRESENTING ACTIONS

The basic requirement for observational learning is the ability to represent actions in the game with a discrete combination of data. The character can then learn to mimic these actions itself, possibly with slight variation.

Typically, the actions are represented with three items of data: the action itself, an optional object of the action, and an optional indirect object. For example, the action may be "fight," "throw," or "sleep"; the subject might be "an enemy" or "a rock"; and the indirect object might be "a sword." Not every action needs an object (sleep, for example), and not every action that has a subject also has an indirect object (throw, for example).

Some actions can come in multiple forms. It is possible, for example, to throw a rock or to throw a rock at a particular person. The throw action, therefore, always takes an object, but optionally can take an indirect object also.

In the implementation there is a database of actions available. For each type of action, the game records if it requires an object or indirect object.

When a character does something, an action structure can be created to represent it. The action structure consists of the type of action and details of things in the game to act as the object and indirect object, if required.

```
Action(fight, enemy, sword)
2 Action(throw, rock)
3 Action(throw, enemy, rock)
  Action(sleep)
```

This is the basic structure for representing actions. Different games may add different levels of sophistication to the action structure, representing more complicated actions (that require a particular location as well as indirect object and object, for example).

1. The designer of Creatures, Steve Grand, has written a fascinating book [19] about the internal workings of the creatures. Despite being 20 years old, it is remarkable how it still feels so futuristic.

15.1.2 REPRESENTING THE WORLD

In addition to an action, characters need to be able to build up a picture of the world. This allows them to associate actions with context. Learning to eat food is good, for example, but not when you are being attacked by an enemy. That is the right time to run away or fight.

The context information that is presented is typically fairly narrow. Large amounts of context information can improve performance but dramatically reduce the speed of learning. Since the player is responsible for teaching the character, the player wants to see some obvious improvement in a relatively short space of time. This means that learning needs to be as fast as possible without leading to stupid behavior.

Typically, the internal state of the character is included in the context, along with a handful of important external data. This may include the distance to the nearest enemy, the distance to safety (home or other characters), the time of day, the number of people watching, or any other game-dependent quantity.

In general, if the character isn't provided with a piece of information, then it will effectively disregard it when making decisions. This means that if a decision would be inappropriate in certain conditions, those conditions must be represented to the character.

The context information can be presented to the character in the form of a series of parameter values (a very common technique) or in the form of a set of discrete facts (much like the action representation).

15.1.3 LEARNING MECHANISM

A variety of learning mechanisms is possible for the character. Published games in this genre have used neural networks and decision tree learning; from this book, Naive Bayes and reinforcement learning could also be interesting approaches to try. As an extensive worked example let's look in detail at using a neural network in this section.

For a neural network learning algorithm, there is a blend of two types of supervision: strong supervision from observation and weak supervision from player feedback.

Neural Network Architecture

While a range of different network architectures can be used for this type of game, I will assume that a multi-layer perceptron network is being used, as shown in Figure 15.1. This was implemented in Chapter 7 and can be applied with minimal modification.

The input layer for the neural network takes the context information from the game world (including the internal parameters of the character).

The output layer for the neural network consists of nodes controlling the type of action and the object and indirect object of the action (plus any other information required to create an action).

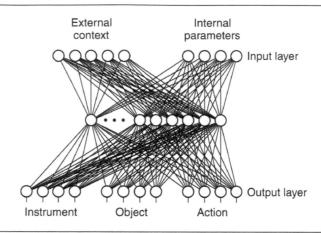

Figure 15.1: Neural network architecture for creature-teaching games

Independent of learning, the network can be used to make decisions for the character by giving the current context as an input and reading the action from the output.

Inevitably, most output actions will be illegal (there may be no such action possible at that time or no such object or indirect object available), but those that are legal are carried out. It is possible to try to discourage illegal actions by passing through a weakly supervised learning step each time one is suggested. In practice, this may improve performance in the short term but can lead to problems with pathological states (see Section 15.1.4) in the longer term.

Observational Learning

To learn by observation, the character records the actions of other characters or the player. As long as these actions are within its vision, it uses them to learn.

First, the character needs to find a representation for the action it has seen and a representation for the current context. It can then train the neural network with this input—output pattern, either once or repeatedly until the network learns the correct output for the input.

Making only one pass through the learning algorithm is likely to produce very little difference in the character's behavior. On the other hand, running many iterations may cause the network to forget the useful behaviors it has already learned. It is important to find a sensible balance between speed of learning and speed of forgetting. The players will be as frustrated with having to re-teach their creature as they will if it is very slow to learn.

Mind-Reading

One significant issue in learning by observation is determining the context information to match with an observed action. If a character that is not hungry observes a hungry character eating, then it may learn to associate eating with not being hungry. In other words, your own context information cannot be matched with someone else's actions.

In games where the player does most of the teaching, this problem does not arise. Typically, the player is trying to show the character what to do next. The character's context information can be used.

In cases where the character is observing other characters, its own context information is irrelevant. In the real world it is impossible to understand all the motives and internal processes of someone else when we see their action. We would try to guess, or mind-read, what they must be thinking in order to carry out that action. In a game situation, we are able to use the observed characters' context information unchanged.

Although it is possible to add some uncertainty to represent the difficulty of knowing another's thoughts, in practice this does not make the character look more believable and can dramatically slow down the learning rate.

Feedback Learning

To learn by feedback the character records a list of the outputs it has created for each of its recent inputs. This list needs to stretch back several seconds, at a minimum.

When a feedback event arrives from the player (a slap or tickle, for example), there is no way to know exactly which action the player was pleased or angry about. This is the classic "credit assignment problem" in AI: in a series of actions, how do we tell which actions helped and which didn't?

By keeping a list of several seconds' worth of input-output pairs, we assume that the user's feedback is related to a whole series of actions. When feedback arrives, the neural network is trained (using the weakly supervised method) to strengthen or weaken all the input-output pairs over that time.

It is often useful to gradually reduce the amount of feedback as the input-output pairs are further back in time. If the character receives feedback, it is most likely to be for an action carried out a second or so ago (any less time and the user would still be dragging their cursor into place to slap or tickle).

15.1.4 PREDICTABLE MENTAL MODELS

There is a common problem in the AI for this kind of game: it is difficult to understand what effect a player's actions will have on the character. At one point in the game it seems that the character is learning very easily, while at other points it seems to ignore the player completely.

The neural network running the character is too complex to be properly understood by any player, and it often appears to be doing the wrong thing.

Player expectations are an essential part of making good AI. As discussed in Chapter 2, a character can be doing something very intelligent, but if it isn't what the player expected to see, it will often look stupid.

In the algorithms above, feedback from the player is distributed over a number of inputoutput actions. This is a common source of unexpected learning. When players give feedback, they are unable to say which specific action, or part of an action, they are judging.

If a character picks up a rock and tries to eat it, for example, the player slaps it to teach it that rocks are bad to eat. A few moments later the character tries to eat a poisonous toadstool. Again, the player slaps it. It seems logical to the player that they are teaching the character what is good and bad to eat. The character, however, only understands that "eating rocks" is bad and "eating toadstools" is bad. Because neural networks largely learn by generalizing, the player has simply taught the character that eating is bad. The creature slowly starves, never attempting to eat anything healthy. It never gets the chance to be tickled by the player for eating the right thing.

These mixed messages are often the source of sudden and dramatic worsening of the character's behaviors. While a player would expect the character to get better and better at behaving in the right way, often it rapidly reaches a plateau and can occasionally seem to worsen.

There is no general procedure for solving these problems. To some extent it appears to be a weakness with the approach. It can be mitigated to some extent, however, by using "instincts" (i.e., fixed default behaviors that perform fairly well) along with the learning part of the brain.

Instincts

An instinct is a built-in behavior that may be useful in the game world. A character can be given instincts to eat or sleep, for example. These are effectively prescribed input-output pairs that can never be completely forgotten. They can be reinforced at regular intervals by running through a supervised learning process, or they may be independent of the neural network and used to generate the occasional behavior. In either case, if the instinct is reinforced by the player, it will become part of the character's learned behaviors and will be carried out much more often.

The Brain Death of a Character

There are combinations of learning that will leave a neural network largely incapable of doing anything sensible. In both Creatures and Black & White, it is possible to render a taught character impotent.

Although it may be possible to rescue such a character, the gameplay involved is unpredictable (because the player doesn't know the real effect of their feedback) and tedious. Because it seems to be an inevitable consequence of the AI used, it is worth considering this outcome in the game design.

15.2 FLOCKING AND HERDING GAMES

Simple herding simulators have been around since the 1980s, but a handful of more successful games appeared in the early 2000s to advance the state of the art. These games involve moving a group of characters through a (normally hostile) game world. Herdy Gerdy [97] is the most developed, although it did not fare well commercially. Pikmin [153], Pikmin 2 [155], and some levels of Oddworld: Munch's Oddysee [156] use similar techniques.

A relatively large number of characters have simple individual behaviors that give rise to larger scale emergence. A character will flock with others of its kind, especially when exposed to danger, and respond in some way to the players (either running from them, as if they were predators, or following after them). Characters will react and run from enemies and perform basic steering and obstacle avoidance. Different types of characters are often set up in a food chain, or ecosystem, with the player trying to keep safe one or more species of prey.

15.2.1 MAKING THE CREATURES

Each individual character or creature consists of a simple decision making framework controlling a portfolio of steering behaviors. The decision making process needs to respond to the game world in a very simple way: it can be implemented as a finite state machine (FSM) or even a decision tree. A finite state machine for a simple sheep-like creature is given in Figure 15.2.

Steering behaviors, similarly, can be relatively simple. Because games of this kind are usually set outdoors in areas with few constraints, the steering behaviors can act locally and be combined without complex arbitration. Figure 15.2 shows the steering behaviors run as the name of each state in the FSM (graze could be implemented as a slow wander, pausing to eat from time to time).

Apart from graze, each steering behavior is either one of the basic goal-seeking behaviors (flee, for example) or a simple sum of goal-seeking behaviors (such as flock). See Chapter 3 on movement for more details.

It is rare to need sophisticated AI for creatures in a herding game, even for predators. Once a creature is able to navigate autonomously around the game world, it is typically too smart to be easily manipulated by the player, and the point of the game is compromised.

15.2.2 TUNING STEERING FOR INTERACTIVITY

In simulations for animation, or background effects in a game, fluid steering motion adds to the believability. In an interactive context, however, the player often can't react fast enough to

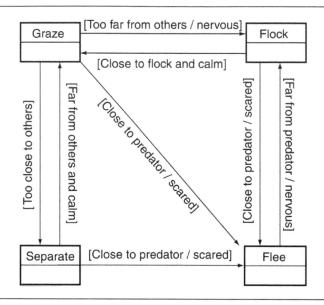

Figure 15.2: A finite state machine for a simple creature

the movement of a group. When a flock starts to separate, for example, it is difficult to circle them with enough speed to bring them back together. Providing the character with this kind of movement ability would compromise other aspects of the game design.

To avoid this problem, the steering behaviors are typically parameterized to be less fluid. Characters move in small spurts, and their desire to form cohesive groups is increased.

Adding pauses to the motion of characters slows down their overall progress and allows the player to circle them and manipulate their actions. This could be achieved by reducing their movement rate, but this often looks artificial and doesn't allow for full-speed, continuous movement when they are directly being chased. Moving in spurts also gives a creature the air of being furtive and nervous, which may be beneficial.

In terms of both speed and cohesion, it is important to reduce the inertia of moving characters. While birds in flocking simulations typically have a lot of inertia (it takes a lot of effort for them to change speed or direction), creatures that are being manipulated by the player need to be allowed to stop suddenly and move off in a new direction.

With high inertia, a decision that leads creatures to change direction will have consequences for many frames and may affect the whole group's motion. With low inertia, the same decision is easily reversed, and the consequences are smaller. This may give less believable behavior, but it is easier (and therefore less frustrating) for the player to control.

It is interesting to note that there are real-world international herding competitions that require years of training. It is difficult to herd a handful of real sheep. A game probably shouldn't require the same level of skill for it to be playable.

15.2.3 STEERING BEHAVIOR STABILITY

As the decision making and steering behaviors of a group of creatures is made more sophisticated, a point often arises when the group doesn't seem to be able to act sensibly on its own. This is often characterized by sudden changes in behavior and the appearance of an unstable crowd. These instabilities are caused by propagation of decisions through a group, often amplified at each step.

A group of sheep, for example, may be grazing quietly. One of them moves too close to its neighbor, who moves out of the way, causing another to move, and so on.

As in all decision making, a degree of hysteresis is required to avoid instability. A sheep may be quite content to have others very near to it, but it will only move toward them (i.e., form a flock) if they move a long way away. This provides a range of distances in which a sheep will not react at all to a neighbor.

There is, however, a kind of instability that arises in a group of different creatures that cannot be solved simply with hysteresis in individual behaviors.

A group of creatures can exhibit oscillations as each causes a different group to change behavior. A predator might chase a flock of prey, for example, until they are out of range. The prey stop moving, they are safe, and there is a delay until the predator stops. The predator is now closer, and the prey start to move again. This kind of oscillation can easily get out of hand and look artificial. Cycles that involve only two species can be tweaked easily, but cycles that only show up when several species are together are difficult to debug.

Most developers place different creatures a distance from each other in the game level or only use a handful of species at a time to avoid the unpredictability when many species come together at a time.

15.2.4 ECOSYSTEM DESIGN

Typically, there are more than one species of creature in a herding game, and it is the interactions of all species that make the game world interesting for the player. As a genre, it provides lots of room for interesting strategies: one species can be used to influence another, which can lead to unexpected solutions to puzzles in the game. At its most basic, the species can be arranged into a food chain, where the player often is tasked with protecting a vulnerable group of creatures.

When designing the food chain or ecosystem of a game, unwanted, as well as positive but unexpected, effects can be introduced. To avoid a meltdown in the game level, where all the creatures are rapidly eaten, some basic guidelines need to be followed.

Size of the Food Chain

The food chain should have two levels above your primary creatures and possibly one level below. Here, "primary creatures" refer to the creatures the player is normally concerned with

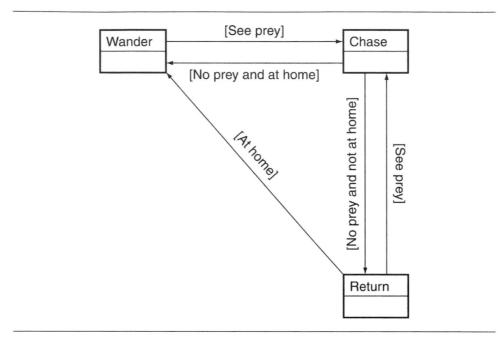

Figure 15.3: The simple behavior of a single predator

herding. Having two levels above the creatures allows for predators to be countered by other predators (much as Jerry the mouse uses Spike the bulldog to get out of scrapes with Tom the cat). Any more levels and there is the risk of the "helpful predator" not being around to help.

Behavior Complexity

Creatures higher in the food chain should have simpler behavior. Because the player is indirectly affecting the behavior of other creatures, it becomes more difficult to control as the number of intermediates increases. Moving a flock of creatures is hard enough. Using that flock to control the behavior of another creature is adding difficulty, and then in turn using that creature to affect yet another—that's a really tall order. By the time you reach the top of the food chain, the creatures need to have very simple behaviors. Figure 15.3 shows a sample high-level behavior of a single predator.

Creatures higher in the food chain should not work in groups. This follows from the previous guideline: groups of creatures working together will almost always have more complicated behavior (even if individually they are quite simple). Although many predators in Pikmin, for example, appear in groups, their behavior is rarely coordinated. They act simply as individuals.

Sensory Limits

All creatures should have well-defined radii for noticing things. Fixing a limit for a creature's ability to notice allows the player to predict its actions better. Limiting a predator's field of view to 10 meters allows the player to take the flock past at a distance of 11 meters. This predictability is important in complex ecosystems, because being able to predict which creatures will react at what time is important for strategy. It follows that realistic sense simulation is not normally appropriate for this kind of game.

Movement Range

Creatures should not move very far on their own accord. The smaller the hinterland of a creature, the better a level designer can put together a level. If a creature can wander at random, then it is possible that it will find itself next to a predator before the player arrives. The player will not appreciate arriving at a location to find the flock has already been eaten. Limiting the range of creatures (at least until they have been affected by the player) can also be accomplished by imposing game world boundaries (such as fences, doors, or gates). Typically, however, the creatures simply sleep or stand around when the player isn't near.

Putting It All Together

As in all AI, the most important part of getting a playable game is to build and tweak characters. The emergent nature of herding games means that it is impossible to predict the exact behavior until you can build and test it.

Providing a great game experience generally requires firm limits on the behavior of creatures in the game, sacrificing some believability for playability.

REFERENCES

BOOKS, PERIODICALS, PAPERS AND WEBSITES

- [1] Bruce D. Abramson. *The Expected-Outcome Model of Two-Player Games*. PhD thesis, Columbia University, New York, NY, USA, 1987. AAI8827528.
- [2] A. Adonaac. Procedural dungeon generation algorithm. *Gamasutra*, March 2015.
- [3] Nada Amin and Ross Tate. Java and Scala's type systems are unsound: The existential crisis of null pointers. In *Proceedings of the 2016 ACM SIGPLAN International Conference on Object-Oriented Programming, Systems, Languages, and Applications*, OOPSLA 2016, pages 838–848, New York, NY, USA, 2016. ACM.
- [4] Boost. Boost C++, 2018. URL: https://www.boost.org/
- [5] Robert Bridson. Fast poisson disk sampling in arbitrary dimensions. In *ACM SIG-GRAPH 2007 Sketches*, SIGGRAPH '07, New York, NY, USA, 2007. ACM.
- [6] David S Broomhead and David Lowe. Radial basis functions, multi-variable functional interpolation and adaptive networks. Technical report, Royal Signals and Radar Establishment Malvern (United Kingdom), 1988.
- [7] James J. Buckley and Esfanfiar Eslami. *An Introduction to Fuzzy Logic and Fuzzy Sets*. Springer, 2002.
- [8] B. Jack Copeland. *Colossus: The Secrets of Bletchley Park's Code-Breaking Computers*. Oxford University Press, 2010.
- [9] Thomas H. Cormen, Charles E. Leiserson, Ronald L. Rivest, and Clifford Stein. *Introduction to Algorithms*. MIT Press, 3rd edition, 2009.
- [10] E. W. Dijkstra. A note on two problems in connexion with graphs. *Numerische Mathematik*, 1(1):269–271, 1959.
- [11] Richard Durstenfeld. Algorithm 235: Random permutation. *Commun. ACM*, 7(7), July 1964.
- [12] David Eberly. Game Physics. CRC Press, 2nd edition, 2010.

- [13] David Eberly. Converting between coordinate systems. URL: www.geometrictools.com/Documentation, 2014.
- [14] Christer Ericson. Real-Time Collision Detection. Morgan Kaufmann Publishers, 2005.
- [15] Joseph C. Giarratano and Gary D. Riley. *Expert Systems: Principles and Programming*. Course Technology Inc, 4th edition, 2004.
- [16] Xavier Glorot, Antoine Bordes, and Yoshua Bengio. Deep sparse rectifier neural networks. In Proceedings of the Fourteenth International Conference on Artificial Intelligence and Statistics, pages 315–323, June 2011.
- [17] Rafael C. Gonzalez and Richard E. Woods. *Digital Image Processing*. Prentice Hall, 2nd edition, 2002.
- [18] Ian Goodfellow, Yoshua Bengio, and Aaron Courville. Deep Learning. MIT Press, 2017.
- [19] Steve Grand. Creation: Life and How to Make It. Harvard University Press, 2003.
- [20] P. E. Hart, N. J. Nilsson, and B. Raphael. A formal basis for the heuristic determination of minimum cost paths. *IEEE Transactions on Systems Science and Cybernetics*, 4(2):100–107, 1968.
- [21] Jeff Heaton. Artificial Intelligence for Humans, Volume 3: Deep Learning and Neural Networks. CreateSpace Independent Publishing Platform, 2015.
- [22] Donald Hebb. The Organization of Behavior. Wiley & Sons, New York, 1949.
- [23] Mary Hillier. Automata & Mechanical Toys: An Illustrated History. Bloomsbury Books, 1988.
- [24] Feng-hsiung Hsu, Murray S. Campbell, and A. Joseph Hoane, Jr. Deep blue system overview. In *Proceedings of the 9th International Conference on Supercomputing*, ICS '95, pages 240–244, New York, NY, USA, 1995. ACM.
- [25] id Software. Quake-III-Arena, 2018.
 URL: https://github.com/id-Software/Quake-III-Arena
- [26] Roberto Ierusalimschy. *Programming in Lua*. lua.org, Distributed by Ingram (US) and Bertram Books (UK), 4th edition, 2016.
- [27] Inkle Studios. ink inkle's narrative scripting language. URL: https://www.inklestudios.com/ink/
- [28] Alex D. Kelley, Michael C. Malin, and Gregory M. Nielson. Terrain simulation using a model of stream erosion. In *Proceedings of the 15th Annual Conference on Computer Graphics and Interactive Techniques*, SIGGRAPH '88, pages 263–268, New York, NY, USA, 1988. ACM.

- [29] S. Koenig, M. Likhachev, and D. Furcy. Lifelong planning A*. Artificial Intelligence Journal, 155:93-146, 2004.
- [30] Richard E. Korf. Depth-first iterative-deepening: An optimal admissible tree search. *Artificial Intelligence*, 27(1):97–109, 1985.
- [31] Major-General M. Kourkolis. APP-6 Military Symbols for Land-Based Systems. NATO Military Agency for Standardization (MAS), 1986.
- [32] Alex Krizhevsky, Ilya Sutskever, and Geoffrey E. Hinton. Imagenet classification with deep convolutional neural networks. In Proceedings of the 25th International Conference on Neural Information Processing Systems - Volume 1, NIPS'12, pages 1097-1105. Curran Associates Inc., 2012.
- [33] Joseph B. Kruskal. On the shortest spanning subtree of a graph and the traveling salesman problem. *Proceedings of the American Mathematical Society*, 7(1):48–50, 1956.
- [34] P. J. van Laarhoven and E. H. Aarts. Simulated Annealing: Theory and Applications. Springer, 1987.
- [35] Stephen Lavelle. PuzzleScript an open-source HTML5 puzzle game engine. URL: https://www.puzzlescript.net/
- [36] Eric Lengyel. Foundations of Game Engine Development, Volume 1: Mathematics. Terathon Software LLC, Lincoln, California, 2016.
- Aristid Lindenmayer. Mathematical models for cellular interaction in development: Parts I and II. Journal of Theoretical Biology, 18, 1968.
- [38] Max Lungarella, Fumiya Iida, Josh Bongard, and Rolf Pfeifer. 50 Years of Artificial Intelligence. Springer Science & Business Media, 2007.
- W. S. McCulloch and W. Pitts. A logical calculus of the ideas immanent in nervous [39] activity. Bulletin of Mathematical Biophysics, 5, 1943.
- [40]Ian Millington. *Game Physics Engine Development*. CRC Press, 2nd edition, 2010.
- [41] Melanie Mitchell. An Introduction to Genetic Algorithms. MIT Press, 2nd edition, 1998.
- [42] William Mitchell. *The Logic of Architecture*. MIT Press, 1990.
- Volodymyr Mnih, Koray Kavukcuoglu, David Silver, Alex Graves, Ioannis Antonoglou, [43]Daan Wierstra, and Martin Riedmiller. Playing Atari with deep reinforcement learning. arXiv:1312.5602 [cs], December 2013.
- Graham Nelson. Inform 7, 2018. URL: http://inform7.com/
- A. Newell and H. A. Simon. Computer science as empirical enquiry: Symbols and search. Communications of the Association for Computing Machinery, 19(3), 1976.

- [46] Gerard O'Regan. A Brief History of Computing. Springer Science & Business Media, 2012.
- [47] Ken Perlin. An image synthesizer. ACM SIGGRAPH Computer Graphics, 19(3):287–296, July 1985.
- [48] Dan Pilone and Neil Pitman. UML 2 in a Nutshell. O'Reilly and Associates, 2005.
- [49] Jamey Pittman. The Pac-Man dossier. Gamasutra, February 2009.
- [50] R. C. Prim. Shortest connection networks and some generalizations. *The Bell System Technical Journal*, 36(6):1389–1401, Nov 1957.
- [51] Craig Reynolds. Steering behaviors for autonomous characters. In *The Proceedings of The Game Developers Conference 1999*, pages 763–782. Miller Freeman Game Group, 1999.
- [52] Timothy J. Ross. Fuzzy Logic with Engineering Applications. Wiley-Blackwell, 4th edition, 2016.
- [53] Stuart Russell. Efficient memory-bounded search methods. In *In ECAI-92*, pages 1–5. Wiley, 1992.
- [54] Stuart Russell and Peter Norvig. *Artificial Intelligence: A Modern Approach*. Pearson Education, 3rd edition, 2015.
- [55] A. L. Samuel. Some studies in machine learning using the game of checkers. *IBM Journal of Research and Development*, 3(3):210–229, July 1959.
- [56] Philip J. Schneider and David Eberly. Geometric Tools for Computer Graphics. Morgan Kaufmann Publishers, 2003.
- [57] Robert Sedgewick and Kevin Wayne. Algorithms. Addison-Wesley Professional, 4th edition, 2011.
- [58] Tanya X. Short and Tarn Adams, editors. Procedural Generation in Game Design. A K Peters/CRC Press, 2017.
- [59] David Silver, Aja Huang, Chris J. Maddison, Arthur Guez, Laurent Sifre, George van den Driessche, Julian Schrittwieser, Ioannis Antonoglou, Veda Panneershelvam, Marc Lanctot, Sander Dieleman, Dominik Grewe, John Nham, Nal Kalchbrenner, Ilya Sutskever, Timothy Lillicrap, Madeleine Leach, Koray Kavukcuoglu, Thore Graepel, and Demis Hassabis. Mastering the game of Go with deep neural networks and tree search. Nature, 529:484, January 2016.

- [60] David Silver, Julian Schrittwieser, Karen Simonyan, Ioannis Antonoglou, Aja Huang, Arthur Guez, Thomas Hubert, Lucas Baker, Matthew Lai, Adrian Bolton, Yutian Chen, Timothy Lillicrap, Fan Hui, Laurent Sifre, George van den Driessche, Thore Graepel, and Demis Hassabis. Mastering the game of Go without human knowledge. *Nature*, 550(7676):354–359, 2017.
- [61] William Spaniel. *Game Theory 101: The Complete Textbook*. CreateSpace Independent Publishing Platform, 2011.
- [62] Anthony Stentz. Optimal and efficient path planning for unknown and dynamic environments. *International Journal of Robotics and Automation*, 10:89–100, 1993.
- [63] Anthony Stentz. The focussed D* algorithm for real-time replanning. In *Proceedings* of the International Joint Conference on Artificial Intelligence, pages 1652–1659, 1995.
- [64] George Stiny and James Gips. Shape grammars and the generative specification of painting and sculpture. In *Information Processing: Proceedings of the IFIP Congress*, volume 71, pages 1460–1465, January 1971.
- [65] Brian Stout. Smart moves: intelligent path-finding. *Game Developer Magazine*, pages 28–35, October 1996.
- [66] Peter Su and Robert L. Scot Drysdale. A comparison of sequential Delaunay triangulation algorithms. In *The Proceedings of the Eleventh Annual Symposium on Computational Geometry*, pages 61–70. Association for Computing Machinery, 1995.
- [67] Steven Tadelis. Game Theory: An Introduction. Princeton University Press, 2013.
- [68] Gerald Tesauro. Temporal difference learning and TD-gammon. *Commun. ACM*, 38(3):58–68, March 1995.
- [69] TIOBE. TIOBE Index, 2018. URL: https://www.tiobe.com/tiobe-index/
- [70] Alan M. Turing. Computing machinery and intelligence. *Mind*, 59, 1950.
- [71] US Army Infantry School. FM 7-8 Infantry Rifle Platoon and Squad. Department of the Army, Washington DC, 1992.
- [72] US Army Infantry School. *FM 3-06.11 Combined Arms Operation in Urban Terrain*. Department of the Army, Washington DC, 2002.
- [73] Gino van den Bergen. Collision Detection in Interactive 3D Environments. Morgan Kaufmann Publishers, 2003.
- [74] Adelheid Voskuhl. Androids in the Enlightenment: Mechanics, Artisans, and Cultures of the Self. University of Chicago Press, 2013.

- Frederick M. Waltz and John W. V. Miller. An efficient algorithm for Gaussian blur using finite-state machines. In Proceedings of the SPIE Conference on Machine Vision *Systems for Inspection and Metrology VII*, 1998.
- [76] David H. Wolpert and William G. Macready. No free lunch theorems for optimization. *IEEE Transactions on Evolutionary Computation*, 1(1), 1997.
- Ian Wright and James Marshall. More AI in less processor time: 'egocentric' AI. Gamasutra, June 2000.

GAMES

This section gives more comprehensive information on the games mentioned in the book. Games are provided with their developer and publisher, the platforms on which the game was published and its year of release. They are ordered by developer name, after the citation style used throughout the book.

Developers tend to change their names often, so this list uses the developer's name as it was when the game was developed. Many games are released on one or two platforms initially and then ported to other platforms later: this list indicates the original platform or platforms for a games release. Where the game was released for more than two platforms, it is indicated as 'multiple platforms'.

- [78] 2015 Inc. Medal of Honor: Allied Assault. Published by Electronic Arts, 2002. PC.
- Activision Publishing Inc., Alien vs. Predator. Published by Activision Publishing Inc., 1993. SNES and Arcade.
- [80] Atari. 3D Tic-Tac-Toe. Published by Sears, Roebuck and Co., 1980. Atari 2600.
- [81] Bay 12 Games. Dwarf Fortress. Published by Bay 12 Games, 2006. Multiple Platforms.
- [82] Ian Bell and David Braben. Elite. Published by Acornsoft Limited, 1984. BBC Micro.
- [83] Bioware Corporation. Neverwinter Nights. Published by Infogrames, Inc., 2002. PC.
- [84] Bizarre Creations. Formula 1. Published by Psygnosis, 1996. PlayStation and PC.
- [85] Blizzard Entertainment Inc. Warcraft: Orcs and Humans. Published by Blizzard Entertainment Inc., 1994. PC.
- [86] Blizzard Entertainment, Inc. Warcraft 3: Reign of Chaos. Published by Blizzard Entertainment, Inc., 2002. PC.
- [87] Blizzard Entertainment Inc. StarCraft II: Wings of Liberty. Published by Blizzard Entertainment Inc., 2010. PC.

- [88] Blizzard Entertainment Inc. and Blizzard North. Diablo. Published by Blizzard Entertainment Inc., 1996. Multiple Platforms.
- [89] Bohemia Interactive Studio s.r.o. ArmA: Combat Operations. Published by Atari, Inc., 2006. PC.
- [90] Bullfrog Productions Ltd. Dungeon Keeper. Published by Electronic Arts, Inc., 1997.
 PC.
- [91] Bungie Software. Halo. Published by Microsoft Game Studios, 2001. XBox.
- [92] Bungie Software. Halo 2. Published by Microsoft Game Studios, 2004. XBox.
- [93] Bungie Software. Halo 3. Published by Microsoft Game Studios, 2007. XBox 360.
- [94] Cavedog Entertainment. Total Annihilation. Published by GT Interactive Software Europe Ltd., 1997. PC.
- [95] Core Design Ltd. Tomb Raider. Published by Eidos Interactive Inc., 1996. Multiple platforms.
- [96] Core Design Ltd. Tomb Raider III: The Adventures of Lara Croft. Published by Eidos Interactive Inc., 1998. Multiple platforms.
- [97] Core Design Ltd. Herdy Gerdy. Published by Eidos Interactive Ltd., 2002. PlayStation 2.
- [98] Criterion Software. Burnout. Published by Acclaim Entertainment, 2001. Multiple platforms.
- [99] Cryo Interactive Entertainment. Dune. Published by Virgin Interactive Entertainment, 1992. Multiple platforms.
- [100] Crytek. Far Cry. Published by UbiSoft, 2004. PC.
- [101] Cyberlife Technology Ltd. Creatures. Published by Mindscape Entertainment, 1997.
 PC.
- [102] Dark Energy Digital Ltd. WSC Real 2011: World Snooker Championship. Published by Dark Energy Sports Ltd., 2011. PlayStation 3, Xbox 360.
- [103] Digital Extremes, Inc. and Epic MegaGames, Inc. Unreal. Published by GT Interactive Software Corp., 1998. Multiple platforms.
- [104] DMA Design. Grand Theft Auto 3. Published by Rockstar Games, 2001. PlayStation 2.
- [105] Dynamix. Tribes II. Published by Sierra On-Line, 2001. PC.

- [106] Electronic Arts Canada. SSX. Published by Electronic Arts, 2000. PlayStation 2.
- [107] Electronic Arts Tiburon. Madden NFL 2005. Published by Electronic Arts, 2004. Multiple platforms.
- [108] Electronic Arts Tiburon. Madden NFL 2018. Published by Electronic Arts, 2017. Multiple platforms.
- [109] Elixir Studios Ltd. Republic: The Revolution. Published by Eidos, Inc., 2003. PC.
- [110] Elixir Studios Ltd. Evil Genius. Published by Sierra Entertainment, Inc., 2004. PC.
- [111] Epic Games, Inc., People Can Fly, and Sp. z o.o. Fortnite: Battle Royale. Published by Epic Games, Inc., 2017. Multiple Platforms.
- [112] Firaxis Games. Sid Meier's Civilization III. Published by Infogrames, 2001. PC.
- [113] Firaxis Games. Sid Meier's Civilization VI. Published by 2K Games, Inc., 2016. Multiple Platforms.
- [114] Firaxis Games East, Inc. Sid Meier's Civilization IV. Published by 2K Games, Inc., 2005. Multiple platforms.
- [115] FromSoftware, Inc. Dark Souls, 2011. PlayStation 3, Xbox 360.
- [116] FromSoftware, Inc. Bloodborne. Published by Sony Computer Entertainment America LLC, 2015. PlayStation 4.
- [117] FromSoftware, Inc. Dark Souls III, 2016. Multiple Platforms.
- [118] Frontier Developments Plc. Elite: Dangerous. Published by Frontier Developments plc, 2015. Multiple Platforms.
- [119] Hello Games Ltd. No Man's Sky. Published by Hello Games Ltd., 2016. Multiple Platforms.
- [120] Holospark. Earthfall. Published by Holospark, 2017. Multiple Platforms.
- [121] id Software, Inc. Wolfenstein 3D. Published by Activision, Apogee and GT Interactive, 1992. PC.
- [122] id Software, Inc. Doom. Published by id Software, Inc., 1993. PC.
- [123] id Software, Inc. Quake II. Published by Activision, Inc., 1997. PC.
- [124] id Software, Inc. Quake III. Published by Activision, Inc., 1999. Multiple Platforms.
- [125] id Software, Inc. Doom 3. Published by Activision, 2004. PC.

- [126] Incog Inc Entertainment. Downhill Domination. Published by Codemasters, 2003. PlayStation 2.
- [127] Ion Storm. Deus Ex. Published by Eidos Interactive, 2000. PC.
- [128] K-D Lab Game Development. Perimeter. Published by 1C, 2004. PC.
- [129] Konami Corporation. Metal Gear Solid. Published by Konami Corporation, 1998. PlayStation.
- [130] Linden Research, Inc. Blood and Laurels. Published by Linden Research, Inc., 2014. iPad.
- [131] Lionhead Studios Ltd. Black & White. Published by Electronic Arts, Inc., 2001. PC.
- [132] Looking Glass Studios, Inc. Thief: The Dark Project. Published by Eidos, Inc., 1998.
 PC.
- [133] LucasArts Entertainment Company LLC. Star Wars: Episode 1 Racer. Published by LucasArts Entertainment Company LLC, 1999. Multiple Platforms.
- [134] Manic Media Productions. Manic Karts. Published by Virgin Interactive Entertainment, 1995. PC.
- [135] Maxis Software, Inc. SimCity. Published by Infogrames Europe SA, 1989. PC / Mac.
- [136] Maxis Software, Inc. The Sims. Published by Electronic Arts, Inc., 2000. PC.
- [137] Maxis Software, Inc. Spore. Published by Electronic Arts, Inc., 2008. Macintosh, PC.
- [138] Edmund McMillen and Florian Himsl. The Binding of Isaac. Published by Edmund McMillen, 2011. PC.
- [139] Glenn Wichman Michael C. Toy and Ken Arnold. Rogue. Freeware, 1982. VAX-11.
- [140] Midway Games West, Inc. Pac-Man. Published by Midway Games West, Inc., 1979. Arcade.
- [141] Mindscape. Warhammer: Dark Omen. Published by Electronic Arts, 1998. PC and PlayStation.
- [142] Mojang AB. Minecraft. Published by Mojang AB, 2010. Multiple Platforms.
- [143] Monolith Productions, Inc. No One Lives Forever 2. Published by Sierra, 2002. PC.
- [144] Monolith Productions, Inc. F.E.A.R. Published by Vivendi Universal Games, 2005. PC.
- [145] Monolith Productions, Inc. F.E.A.R. 2: Project Origin. Published by Warner Bros. Interactive Entertainment Inc., 2009. PC / Mac.

- [146] Mossmouth, LLC. Spelunky. Published by Mossmouth, LLC, 2009. PC.
- [147] MPS Labs. Civilization. Published by MicroProse Software, Inc., 1991. Multiple Platforms.
- [148] Naughty Dog, Inc. Jak and Daxter: The Precursor Legacy. Published by SCEE Ltd., 2001. PlayStation 2.
- [149] Naughty Dog, Inc. The Last of Us. Published by Sony Computer Entertainment America LLC, 2003. PlayStation 3.
- [150] Niantic, Inc., Nintendo Co., Ltd., and The Pokémon Company. Pokémon Go. Published by Niantic, Inc., 2016. Multiple platforms.
- [151] Nicalis, Inc. The Binding of Isaac: Rebirth. Published by Nicalis, Inc., 2014. Multiple Platforms.
- [152] Nintendo Co., Ltd. and Systems Research & Development Co., Ltd. Super Mario Bros. Published by Nintendo Co., Ltd., 1985. Nintendo Entertainment System.
- [153] Nintendo Entertainment, Analysis and Development. Pikmin. Published by Nintendo Co. Ltd., 2001. GameCube.
- [154] Nintendo Entertainment, Analysis and Development. Super Mario Sunshine. Published by Nintendo Co. Ltd., 2002. GameCube.
- [155] Nintendo Entertainment, Analysis and Development. Pikmin 2. Published by Nintendo Co. Ltd., 2004. GameCube.
- [156] Oddworld Inhabitants. Oddworld: Munch's Oddysee. Published by Microsoft Game Studios, 1998. XBox.
- [157] Pandemic Studios. Full Spectrum Warrior. Published by THQ, 2004. PC and XBox.
- [158] Phigames. Tiny Keep. Published by Digital Tribe Entertainment, Inc., 2014. Multiple Platforms.
- [159] Pivotal Games Ltd., Conflict: Desert Storm. Published by SCi Games Ltd., 2002. Multiple Platforms.
- [160] Polyphonic Digital. Gran Turismo. Published by SCEI, 1997. PlayStation.
- [161] Procedural Arts LLC. Façade. Published by Procedural Arts LLC, 2005. PC / Mac.
- [162] Psygnosis. Wipeout. Published by SCEE, 1995. PlayStation.
- [163] Quicksilver Software, Inc. Master of Orion 3. Published by Infogrames, 2003. PC.
- [164] Radical Entertainment. Scarface. Published by Vivendi Universal Games, 2005. Multiple platforms.

- [165] Rare Ltd. Goldeneye 007. Published by Nintendo Europe GmbH, 1997. Nintendo 64.
- [166] Raven Software. Soldier of Fortune 2: Double Helix. Published by Activision, 2002.
 PC and XBox.
- [167] Rebellion. Alien vs. Predator. Published by Atari Corporation, 1994. Jaguar.
- [168] Rebellion. Sniper Elite, 2005. Multiple platforms.
- [169] Rebellion. Cyberspace, Unreleased. Nintendo Game Boy.
- [170] Red Storm Entertainment, Inc. Tom Clancy's Ghost Recon. Published by Ubi Soft Entertainment Software, 2001. PC.
- [171] Reflections Interactive. Driver. Published by GT Interactive, 1999. PlayStation and PC.
- [172] Relic Entertainment. Homeworld. Published by Sierra On-Line, 1999. PC.
- [173] Relic Entertainment. Company of Heroes. Published by THQ Inc., 2006. PC.
- [174] Revolution Software Ltd. Beneath a Steel Sky. Published by Virgin Interactive, Inc., 1994. PC.
- [175] Riot Games, Inc. League of Legends. Published by Riot Games, Inc., 2009. Multiple Platforms.
- [176] SEGA Entertainment, Inc. Golden Axe. Published by SEGA Entertainment, Inc., 1987.
 Arcade.
- [177] Sick Puppies Studio and International Hobo Ltd. Ghost Master. Published by Empire Interactive Entertainment, 2003. PC.
- [178] Sony Computer Entertainment. Otostaz. Published by Sony Computer Entertainment, 2002. PlayStation 2 (Japanese Release Only).
- [179] Stainless Steel Studios Inc. Empire Earth. Published by Sierra On-Line, Inc., 2001. PC.
- [180] Strategic Simulations, Inc. Computer Bismark. Published by Strategic Simulations, Inc., 1980. Apple II.
- [181] Superior Software Ltd. Exile. Published by Peter J. M. Irvin, Jeremy C. Smith, 1988. BBC Micro.
- [182] Team 17. Worms 3D. Published by Sega Europe Ltd, 2003. Multiple platforms.
- [183] Team Cherry. Hollow Knight. Published by Team Cherry, 2017. Multiple Platforms.
- [184] TechnoSoft. Herzog Zwei. Published by TechnoSoft, 1989. Sega Genesis.

- [185] The Creative Assembly Ltd. Rome: Total War. Published by Activision Publishing, Inc., 2004. PC.
- [186] The Creative Assembly Ltd. Empire: Total War. Published by SEGA of America, Inc., 2009, PC.
- [187] TimeGate Studios. Kohan: Ahriman's Gift. Published by Strategy First, 2001. PC.
- [188] Turn 10 Studios. Forza Motorsport. Published by Microsoft Game Studios, 2005. Xbox.
- [189] Ubi Soft Montreal Studios. Splinter Cell. Published by Ubi Soft Entertainment Software, 2002. Multiple Platforms.
- [190] Ubisoft Annecy Studios. Steep, 2016. Multiple Platforms.
- [191] Ubisoft Divertissements Inc. Far Cry 2. Published by UbiSoft, 2008. Multiple platforms.
- [192] UbiSoft Montpellier Studios. Beyond Good and Evil. Published by UbiSoft Entertainment, 2003. Multiple platforms.
- [193] Valve Corporation. Half-Life. Published by Sierra On-Line, 1998. PC.
- [194] Valve Corporation. Half-Life 2. Published by Valve Corporation, 2004. PC.
- [195] Valve Corporation. Dota 2. Published by Valve Corporation, 2013. Multiple Platforms.
- [196] Valve South and Valve Corporation. Left 4 Dead. Published by Valve Corporation, 2008. Multiple Platforms.
- [197] Warthog Games. Mace Griffin: Bounty Hunter. Published by Vivendi Universal Games, 2003. Multiple platforms.
- [198] Westwood Studios. Dune II. Published by Virgin Interactive Entertainment, 1992. PC.
- [199] Westwood Studios. Command and Conquer. Published by Virgin Interactive Entertainment, 1995. PC.
- [200] Zipper Interactive. SOCOM: U.S. Navy SEALs. Published by SCEA, 2002. PlayStation 2.

INDEX

A	AB negamax, 755, 757, 772
A* algorithm, 196	AB pruning, 755–759, 787
algorithm, 215–219	Abramson, Bruce, 776
data structures and interfaces,	AB search window, 759–760
222–226	Acceleration due to gravity, 121
Dijkstra algorithm and, 203, 222,	Action combinations, 472, 474
237	Action execution, 469
dynamic version (D*), 275, 278	algorithm and pseudo-code,
fill patterns, 235–236	474–476
general implementation, 227	data structures and interfaces,
goal-oriented action planning,	476-478
422–429	debugging, 478
heuristic function, 215-216, 222,	implementation and performance,
226, 227–228, 230–237,	478–479
259-261	interrupting, 471
hierarchical pathfinding, 257-264	types of actions, 469-473, 478
IDA*, 276, 422–429	Action prediction learning, 592-602
improvements and variations, 257,	Actions, goal-oriented behavior, 406-407
274–278	Actions as concrete objects, 889-890
infinite graphs and, 288	ActionScript, 18
interpreting nodes as states,	Actions tasks, behavior trees, 338-339
280-281	Actor-critic algorithm, 641-642
interruptible pathfinding, 277	Actuation, 50-51, 170-178
low-memory algorithms, 275-277	capability-sensitive steering, 173
LPA*, 275, 278	combined steering behaviors, 174
node array A*, 228–230	output filtering, 171–173
performance, 227-228	range of motion limitations
priority queues and heaps, 223-225	human characters, 174
pseudo-code, 219-222	motor vehicles, 175-177
SMA*, 276–277	tracked vehicles, 177
terminating, 217–219	steering pipeline algorithm,
variation for large graphs, 230	111–112, 114
See also Heuristic function for A*	Adaptive resolution, 586–587
pathfinding algorithm	Adventure game AI design, 942–943

Agent-based AI, 13	Arbitration for steering behaviors, 96,
Aiming and shooting, See Firing	106–108, See also Steering
solutions	pipeline
Aircraft roll, pitch, and yaw, 188-191	Arbitration in rule-based systems,
AI requests as actions, 470	444-446
AI task scheduling, See Scheduling	ARMA, 939
AI-world interfacing, See World	Arrive algorithm, 53-54, 60-63
interfacing	Artificial intelligence (AI), 4, 24
Alarm behaviors, state machine	academic historical development,
representation, 323-324	5–8
Algorithms, 14, 27	AI level of detail, 822-823, See also
Aliasing failure, 31	Level of detail
Alien vs. Predator, 857, 939	animation overlap, 41
Align steering behavior, 63-67, 180-182	defining, 4
looking where you're going, 72–73,	golden rule of, 6, 742
185	psychological approaches, 25
Alpha-beta (AB) negamax, 755, 757, 772	researcher motivations, 4–5
AlphaGo, 9, 776	sources of knowledge for, 876
AlphaGo Zero, 7, 796–797	See also Game artificial intelligence
Alpha parameter in Q-learning, 633-634	Artificial neural networks (ANNs), 642,
AlphaZero, 796	See also Neural networks
Altitude filtering, 701–704	Aspiration negascout, 761-764
Amazon's Lumberyard, 30, 876, 891	Aspiration search, 760
Ambush points, 489	Atoms, 793, 797
Anchor points in formation motion, 149	Attractive steering behavior, 84
AND, fuzzy logic representation,	Augmented reality (AR), 34
383-384	Automata, 5
Android platforms, 33-34, 902, 907	Automatic reference counting (ARC), 906
Angular velocity, 48, See also Rotation	
Animation, 469	В
actuation and matching animations,	Backgammon, 641, 741, 744, 765, 794
170-171	Backpropagation in neural networks,
AI overlap, 41	650-651
illusions of intelligence, 25	Backtracking algorithm for maze
movement planning, 285-291	generation, 705–716
procedural content generation, 727	Backward chaining, 435
shooter game AI design, 938	Ballistics, 120–123
Annealing simulation, 7, 588-592	projectiles with drag, 126-128
Anytime algorithms, 820-821, 911	rotation and lift, 128
Apple iPhone, 33	See also Firing solutions
Apple's implementation language (Swift),	Baseball double play, 165
18, 30, 34, 902, 905–906	Basins of attraction, 100

Basis functions, 655–657	finite state machines, 468
Bayesian learning approaches (naive	performance, 467
Bayes classifiers), 603	pseudo-code, 464
Bayes networks, 375	rule-based systems, 468
Behavioral data creation and destruction,	steering behaviors, 466
825	symbolic approach, 6
Behavioral level of detail (LOD), 824-829	Blender, 896
Behavior changes, 24	Blending steering behaviors, 96
Behavior compression, 825	priorities, 103–106
Behavior design, 931–934	weighted blending, 96–100
Behavior trees, 297, 338	Blood and Laurels, 10
adding data to, 364-369	Bloodborne, 669
concurrency and timing, 355–364	Blueprints visual programming language,
Decorators, 349–355, 362–364, 373	893, 903, 920
example, 340-344	Board games, 741-742, 956-958
hierarchical state machines, 338	game AI model, 10–11
instantiating, 369–373	game knowledge, 788-797, See also
limitations, 373–374	Static evaluation function
non-deterministic composite tasks,	game theory, 742-746
347–349	hashing game states, 764–769
Parallel task, 356-364	horizon effect, 787–788
performance and implementation,	iterative deepening, 786-788
346-347	knowledge acquisition, 791–794
pseudo-code, 345-346	memory-enhanced test approach,
reactive planning, 344–345	763, 772–776
reusing, 365, 369–373	minimaxing, 746, 749-750
state machine hybrids, 374	AB pruning, 755–759, 787
tasks, 338–340, 365	algorithm and pseudo-code,
Beneath a Steel Sky, 9	750-753
Beta pruning, 756–757	extensions, 787–788
Beyond Good and Evil, 942	move ordering, 760, 763, 788-789
Binary decision trees, 303-305	negamaxing, 753-759, 787,
Binary space partition (BSP) trees, 84	789–790
Black & White, 9, 23, 960, 964	negascout, 761-764
Blackboard architectures, 461-468	Monte Carlo tree search, 776
adding data to behavior trees,	opening books and set plays,
365–369	783–785
blackboard language, 466-467	quiescence pruning, 788
cooperative steering behaviors,	static evaluation function, 747–749,
107–108	754, 783, 788–797
data structures and interfaces,	Temporal Difference (TD)

464-466

reinforcement learning	C++, 18, 29, 902-904
algorithms, 640–641	decision tree implementation and,
transposition tables, 424, 764–771	308
hashing game states, 764–769	hash table implementation, 768
implementation and	Lua scripting language and, 915
performance, 770	memory allocation and
replacement strategies, 769–770	deallocation, 30–31
using opponent's thinking time,	pathfinding implementation, 901
771–772	random number generation, 671
variable depth approaches, 787-788	standard template library, 903–904
weakly and strongly solved games,	virtual functions and, 30
789	Cache memory, 31–32
See also Turn-based strategy games	Camouflage, 863
Boltzmann probabilities, 590–592	Capability-sensitive steering, 173
Boolean operators	Cave system generation, 708–709
database matching for rule-based	Cellular automata, 542–547
systems, 432–433	Center of gravity defuzzification, 381
decision trees and, 302	Center of mass, 44, 150–151
fuzzy logic, 383-384	Centroid of area defuzzification, 381
in pseudo-code, 16	Chady, Marcin, 108
Boolean values, defuzzification, 382	Changes in character behavior, 24
Boost, 904	Character behavior design, 931-934
Bot scripting systems, 939	Character learning, See Learning
Bottom-up approach, 554-555	Chase the rabbit, 77, 949
Bounding overwatch, 166–167, 170	Checkers, 640, 761, 789, 791, 793, 794
Branch prediction, 29	Checking engine, 839
Bridson, Robert, 676	Chess, 25, 741, 743, 771
Brightness and light perception, 854	aspiration negascout, 761
Broadcasting, 843–844	combining scoring functions, 793
Bucketed priority queues, 224–225	ending databases or tablebases, 785
Building generation, 727–730	game tree branching factor, 746
Buildings and pathfinding graph	horizon effect, 787-788
instantiation, 267–273	knowledge acquisition for static
Burnout, 948	evaluation function, 791
Bytecode, 911, 924	level of AI requirements, 10
Byte-compiled languages, 911	opening books, 783
	scoring values, 26, 790–791
C	Zobrist keys, 765
C, 18, 30, 902	Civilization, 670
parser builder, 925	CLIPS, 458
random number generation, 671	Cloture, 907
C#, 18, 29, 671, 904–905	Cluster heuristic for A*, 233–235

Coherence, 80-82, 248-249	Gaussian blur, 537-538
Collision avoidance, 57, 68, 85-89	implementation and performance,
collision detection problems, 92-94	537, See also Convolution
obstacle and wall avoidance, 90-94,	filters
886-887	neural networks and, 661, 796
pseudo-code, 88–89	separable, 538-541
separation behavior, 82	Conway's "The Game of Life," 545–546
shooter game AI design, 939	Cooperative arbitration steering
touch implementation using	behaviors, 106-108
collision detection, 856	Cooperative multitasking, 812
Combs method for creating fuzzy rules,	Cooperative scripts, 564–571
392–394	Coordinated group behaviors, 554
Company of Heroes, 951	decision making, 556, 561
Compilation of scripting languages,	emergent cooperation, 561-563
911-912, 923-924	including the player, 557-560
Complexity of game AI, 21-24	inter-agent communication, 846
Composite tasks, 339, 347–349	military tactics, 568-571
Compound actions, 472, 474	movement, 556
Compound tactics, 488-490, 505	multi-tier AI, 554-561
Computer Bismark, 956	pathfinding, 556–557
Condensation algorithm for waypoint	real military tactics, 568-571
generation, 507–511	scalability, 562–563
Condition-action rules, 433-434	scripting, 564-571
Conditions and behavior trees, 338,	See also Formation motion
360-361	Coordinated group movement, See
Conflict: Desert Storm, 856	Formation motion
Connect Four, 741, 789	Corner trap problem, 93-94
Consoles and game AI, 33	Cost functions for pathfinding, 252-253,
Constraints, steering pipeline, 110–111,	548, 877–878
114, 117–119	Cover point generation, 501-503, See also
Content creation, procedural, See	Waypoint tactics
Procedural content generation	Cover points for tactical formation
Content creation tools, See Tools and	movement, 167-170
content creation	CPUs, 28-29
Continuous pathfinding, 278-285	Creatures, 9, 960, 964
Contrast detectors, 855	Credit assignment problem (CAP), 646,
Convolutional neural networks, 661, 796	661–662
Convolution filters, 516, 532-542, 661	Crosswind adjustment, 129
algorithm and pseudo-code,	Crowd simulations, separation behavior,
533-536	82
data structures and interfaces,	CryEngine, 876, 891
536-537	Cryptographic random numbers, 671

CUDA, 28	knowledge representation, 298–299,
Custom data-driven editors, 893	307–308
<i>P</i>	learning, 576, 602–604, See also
D	Decision learning
D* algorithm for dynamic pathfinding,	Markov systems, 399–405
275, 278	melee combat AI design, 944–945
Dark Souls, 12, 943	message passing system, 889
Data-driven editors, 893	platform and adventure game AI
Data mining, 884–886	design, 942-943
Data representations, 17–18	RTS game AI design, 953–954
Data reuse, pathfinding applications,	rule-based systems, 431–461
267–273, 275, 278	shooter game AI design, 939–940
Data structures, 14	state machines, 314-336
Debugging	tools and content creation, 889-890
action management, 478	using tactical information, 496-499
justification systems, 460–461	See also Action execution; Behavior
tools, 895–896	trees; Blackboard architectures;
transposition tables, 770	Decision trees; Fuzzy logic;
Decision learning, 602-604	Goal-oriented behavior;
decision tree learning, 604,	Rule-based decision making
609-626, 646-647	systems; State machines
naive Bayes classifiers, 604-609	Decision tree learning, 604, 609-610,
See also Decision tree learning	646-647
Decision making, 297–299	with continuous attributes, 618-622
action execution, 469-480	ID3 algorithm, 609-622
actions as concrete objects, 889-890	incremental learning and ID4,
AI design example, 934	622-626
AI design questions, 932	See also ID3 algorithm
behavior trees, 338–374	Decision trees, 609–610
blackboard architectures, 461-468	algorithm, 300-305
coordinated groups, 556, 561	balancing, 309–310
custom hard-coding, 909	binary, 303–305
decision trees, 299–314, 604,	branching, 303–305
609-610	combinations and complexity,
fuzzy logic, 374-399	302–303
fuzzy state machines, 395–400	cooperative steering behaviors,
game AI model, 10–12, 297, 298f	107–108
goal-oriented action planning,	early game AI, 9
416–422	implementation and performance,
goal-oriented behavior, 405-431	308
helping the player, 958	knowledge representation, 307–308
	learning, 299

merging and loops, 310	Development tools, See Tools and content
pseudo-code, 305-307	creation
random, 311–314	Diablo, 669
state machine combinations,	Differentiation and vision, 854-855
335–337	Dijkstra, Edsger, 203, 353
state machine-decision tree	Dijkstra algorithm, 196, 203-214
combination, 335-337	A* algorithm and, 203, 222, 237
symbolic approach, 6	data structures and interfaces,
Decomposers, 109–110, 114, 117	211–212
Decorators, 349–355, 362–364, 373	graphs, 212
Deep Blue, 794	influence map calculation, 516
Deep learning, 7, 431, 575, 642, 660–664	map flooding in influence maps,
early game AI, 9	529–532
Monte Carlo tree search, 776	performance and weaknesses,
static evaluation functions, 796–797	213–214
See also Neural networks	pseudo-code, 209-211
Deep Mind, 741	terminating, 207–208
Defuzzification, 377, 378–383	Directed acyclic graphs (DAGs), 310,
Delaunay triangulation, 243	448, 866
Delegated steering behaviors, 68	Directed weighted graphs, 200-201
Designing game AI, 929–931	DirectX, 32
character behaviors, 931–934	DirectX 11, 28
drivers and racers, 946-950	Dirichlet domains, 238, 242-244
driving-like games, 950	map flooding in influence maps,
ecosystems, 967–969	528-532
flocking and herding games,	points of visibility, 247
965–969	support tools, 878
game AI model, 929-930	Discontentment, 410–412
melee combat, 943-945	Distance limitations for sight, 854
MMOGs, 946	Division schemes for pathfinding world
multiplayer online battle arenas,	representation, 237, 238,
954-955	242-248, See also Pathfinding
platform and adventure games,	world representations
942-943	Doom, 939, 940, 941
real-time strategy, 950-955	Dota 2, 953
selecting techniques, 934-936	Double play, 165
shooter-like games, 942–943	Drag, 59, 126-128, 129
shooters, 937-942	Draughts, 741, 743
sports, 950, 955-956	Drift in formation motion, 150–151
teaching characters, 960-965	Driving games
turn-based strategy, 956–958	AI challenges, 9
	AI design, 946-950

physical constraints, 285	Euclidean distance heuristic for A*,
DUAL*, 774-775	232–233
Dune II, 950	Evade, 71–72
Dungeon and maze generation, 718	Evaluation functions, See Static
cave systems, 708–709	evaluation function
depth first backtracking, 705-716	Event casting, 843–846
generate-and-test approach, 727	Event dispatcher, 840
minimum spanning tree algorithms,	Event managers, 837–843
716–721	event casting, 843–846
prefabricated rooms or corridor	sense management, 850
sections, 711–714	Event passing, 837–838
recursive subdivision, 721-726	Evil Genius, 931
rooms, 709–711	Execution management, 803-804
Dungeon Keeper, 931	AI design example, 934–935
Dungeons and Dragons, 705	Decorators and behavior trees,
Dwarf Fortress, 670, 688	352-355
Dynamic movement, 43	level of detail, 821-834
Dynamic pathfinding, 274–275, 278–285	scheduling, 804-820, 833
Dynamic priority rule arbitration, 445	See also Level of detail; Scheduling
	Experts in blackboard systems, 462
E	Expert systems, 6, 7, 431
Earthfall, 670	justification, 460-461
Ecosystem design, 967-969	knowledge acquisition, 461, 791,
Editor plug-ins, 891-892, 896-897	794
Elevation features, landscape generation,	recommended resource, 458
701–704	Rete algorithm, 448
Elite: Dangerous, 669	See also Deep learning; Rule-based
Embedded languages, 913	decision making systems
Emergent cooperation, 561–563	Extensions, 787–788
Emergent formations, 146–147	External knowledge, 298, 851
Empire Earth, 952	Extreme sports games, 950
Empire: Total War, 952	
Ending databases, 785	F
Energy landscapes and parameter	F#, 904
learning, 580–581	Façade, 10
Energy metric, 410–441	Face steering behavior, 72, 182–184
Engineering-focused AI development,	Far Cry, 939
7–8	Faults, 689–692
Entropy, ID3 algorithm for decision	F.E.A.R., 9
learning, 611–613	F.E.A.R. 2: Project Origin, 938, 940
Erosion, 694–701	Feedback learning, 963

Feedforward networks, 643-644,	tactical movement and cover points
648-650	166–170
Fibonacci sequence, 675	two-level steering, 147-156
Filters, See Convolution filters	two-level steering extension,
Finite element method (FEM)	156–158
simulation, 696, 865-874	See also Coordinated group
Finite state machines (FSMs), 315-316	behaviors; Flocking behaviors;
blackboard architectures, 468	Herding behavior
emergent team behaviors, 562	Formula 1, 948
flocking and herding games, 965	Fortnite: Battle Royale, 239
hard-coded, 320-322	Forward chaining, 434-435
See also State machines	Forza Motorsport, 949
Firing solutions, 123–126	Frag-map, 522-523
iterative targeting, 128–133	Frame rates, 50, 813–814
projectile rotation and lift, 128	Frequency-based scheduling, 805-806,
projectiles with drag, 127-128, 129	823
shooter game AI design, 939	Full Spectrum Warrior, 9, 952, 953
Fitness landscapes and parameter	Functions in pseudo-code, 16
learning, 580-581	Fuzzification, 377-378
Flee algorithm, 53, 59-60	Fuzzy control, 385
Flocking behaviors, 57, 67, 98-99, 146,	Fuzzy logic, 374–375
562, 965-969, See also	algorithm and pseudo-code,
Formation motion; Herding	386-390
behavior	algorithm implementation and
Floor polygons, navigation meshes and	performance, 390-392
pathfinding, 247–252	Boolean operators and truth tables,
Fog-of-war, 517	383-384
Footfall planning, 291	data structures and interfaces, 390
Formation motion, 143–144, 556	decision making problem, 385-386
drift, 150–151	defuzzification, 377, 378-383
dynamic slots and plays, 164-166	driving AI design, 949
emergent formations, 146-147	fuzzification, 377–378
fixed formations, 144-145	fuzzy rules, 385-388, 390, 392-394
formations of formations, 156-158	fuzzy sets, 375-377
invisible leader approach, 148-149	probabilistic methods vs., 375
moderating, 149–150	scalability problem, 391-392
RTS game AI design, 951-952	tactical information and decision
sample defensive circle pattern,	making, 498-499
154–156	waypoint tactics, 492
scalable formations, 145	Fuzzy rules, 385-388, 390, 392-394
slot roles and slot costs, 158-164	Fuzzy sets, 375–377
	Fuzzy state machines, 385, 395–400

G	Gamma parameter in Q-learning, 634
Game AI programming, See	Garbage collection, 30-31, 904-905, 906
Programming game AI	907
Game artificial intelligence (game AI),	Gaussian blur filter, 537-538
21, 24	Gaussian filters, 516, 537
academic AI development context,	Gear VR, 34
5–8	Genetic algorithms, 6, 7n
AI engines, 35–38	Geometric analysis, pathfinding graph
algorithms, 27	creation, 880-884
animation overlap, 41	Gesture commands, 25
complexity, 21–24	Ghost Master, 405, 931
defining AI, 4	Go, 741, 743, 746, 776, 788, 794
design tools, 894–895	Goal-oriented action planning (GOAP),
golden rule of AI, 6, 742	416–422
hacks, 25	early game AI, 9
heuristics, 26–27	with iterative deepening A* (IDA*).
historical development, 8-10	422–429
platform differences, 32–34	Goal-oriented behavior (GOB), 405-406
scalability, 33	actions, 406-407
speed and memory constraints,	discontentment values, 410-412
28-32	goals and motives, 406-407
tool concerns, 37, See also Tools and	need for planning, 416
content creation	problematic interactions, 410
virtual and augmented reality, 34	selecting actions, 408–410
world interface system, See World	smelly GOB, 429-431
interfacing	timing, 412–415
Game artificial intelligence (game AI)	Godot, 30, 34, 876, 891, 915
design, See Designing game AI	Golden Axe, 8–9
Game artificial intelligence (game AI)	Goldeneye 007, 9, 940
model, 10–14	Golden ratio (ϕ), 675
decision making, 11-12, 297, 298f	Golden rule of AI, 6, 742, 782
design, 929-930	GPUs, 28
infrastructure, 12–13	Grand, Steve, 9, 960 <i>n</i>
movement, 11	Grand Theft Auto 3, 13, 833, 948, 949
pathfinding, 195, 196f	Gran Turismo, 948
strategy, 12	Graphics card drivers, 28
tactical and strategic AI, 485, 486f	Graphics level of detail, 821–822
Gamebryo, 891	Graphs, 196–203
Game development, 3	automatic graph creation, 880-886
Game engines, 35–38	directed acyclic
Game theory, 742–746	decision trees, 310
Game tree 744-746	Rete algorithm, 448

for sense management, 866	Euclidean distance, 232–233
directed weighted, 200-201	fill patterns, 235–236
infinite, 288	hierarchical pathfinding, 259-261
movement planning, 287-288	modifying for tactical pathfinding,
for tactical pathfinding, 552	551-552
terminology, 202	open goal pathfinding, 274
weighted, 198-200, 716	performance, 227–228
See also Pathfinding graphs	quality, 236
Gravity, acceleration due to, 121	underestimating and
Group coordinated behavior, See	overestimating, 231
Coordinated group behaviors	Heuristics, 26–27
Group level of detail (LOD), 829-833	Heuristic search, 6
Group movement, See Formation motion	Hidden layers, 647, 660
Guess Who? 789	Hierarchical multi-tier AI, 554-555
	Hierarchical N-Grams, 599-602
H	Hierarchical pathfinding, 257-264
Hacks in game AI, 25	algorithm performance, 264
Half-Life, 9, 12, 941	data structures and interfaces,
Half-Life 2, 11–12	263-264
Halo, 9, 939	distance heuristics, 260-261
Halo 2, 338, 940	on exclusions, 264
Halo: Combat Evolved, 314	instanced geometry, 267-273
Halton sequence, 672-675	pathfinding graph, 258-261
Hard and soft roles in formations,	pathfinding on hierarchical graph,
158–159	261–264
Hard-coded FSM, 320-322	problematic results, 265-266
Hardware issues, 28–32	pseudo-code, 262-263
Hashing game states, 764–769	Hierarchical scheduling, 816-818
Hearing, 855-856, 871-872, See also	Hierarchical state machines, 323-335
Sense management	algorithm, 326-328
Hebbian learning, 658–660	algorithm implementation and
Hebb's Rule, 658	performance, 334-335
Height fields, 951	behavior trees and, 338
Herding behavior, 22–23, 965–969, See	examples, 328-330
also Flocking behaviors;	polymorphic structure, 334
Formation motion	pseudo-code, 330-334
Herdy Gerdy, 22–23, 965	Hierarchical task networks (HTNs),
Herzog Zwei, 950n	736–737
Heuristic function for A* pathfinding	Hill climbing and parameter learning,
algorithm, 215-216, 222, 226	581-588
choosing, 230–237	Hill descent (annealing), 588-592
cluster, 233-235	History heuristic, 787

Hole fillers (jumpable gaps), 142-143	turn-based games and, 799
Hollow Knight, 11	See also Tactical analysis
Homeworld, 145, 952	Inform 7, 919
Hopfield network, 643, 644f	Instantiating behavior trees, 369-373
Horizon effect, 787–788	Instinct behaviors, 964
Hydraulic erosion, 696–701 Hyper-threads, 813	Integrated game engines, 890–893, See also specific engines
Hysteresis, 825–826, 967	Intellectual property issues, 913–914
11/81010518, 023-020, 907	Interface Commands, 470
I	Internal knowledge, 298–299, 851
Ice hockey games, 133	Internal knowledge, 298–299, 831 Interpreted languages, 911, 924
ID3 algorithm, 609–622	- 0
basic algorithm, 610–611	Interruptible pathfinding, 277
with continuous attributes, 618–622	Interruptible processes, 811–814
	Interrupting actions, 471
data structures and interfaces, 617, 621	iOS device platforms, 33–34
	iOS implementation language (Swift), 18
entropy and information gain, 611–613	30, 34, 902, 905–906
	iPhone, 33
a heuristic algorithm, 627	Iterative deepening, 786–788
ID4 incremental algorithm and, 623–626	Iterative deepening A* (IDA*), 276, 422–429
implementation and performance,	Iterative Dichotomizer 3, See ID3
617–618, 621	algorithm
pseudo-code, 613-617, 619-620	Iterative targeting, 128–133
ID4 algorithm, 623–626	ITI, 626
ID5 algorithm, 626	
IDA*, 276, 422–429	J
Imperfect information, 744	Jak and Daxter: The Precursor Legacy,
Importance values, level of detail, 823	854, 942
Incremental decision tree learning,	Java, 18, 29, 34, 902, 906-907, 924
622-627	Java Native Interface, 919
Indentation in pseudo-code, 15	JavaScript, 18, 902, 908-909, 917
Independent facing, 48	prototype-based object orientation,
Inductive Decision tree algorithm 3, See	370
ID3 algorithm	random number generation, 671,
Inertia, 50	672
Infinite graphs, 288	Java virtual machine (JVM), 902,
Influence mapping, 512-519	906–907
convolution filters, 516, 532-542	Jumping, 133–143
graphs for tactical pathfinding, 552	achieving the jump, 135
map flooding, 516-517, 528-532	hole fillers (jumpable gaps), 142-143
RTS game AI design, 952	jump links, 142

jump points, 134–138 League of Legends, 953 landing pads, 138–142 Learning, 575–576
pathfinding and, 142 annealing (hill descent), 588–592
Justification in expert systems, 460–461 balance of effort, 579
Just-in time (JIT) compiling, 919, 924 Boltzmann probabilities, 590–592
decision making and, 576, 602–604,
Keras, 797 See also Decision tree learning
Kinematic movement, 42–43, 51–56 energy and fitness landscapes and
Kingsley, Chris, 22–23 values, 580
Knowledge feedback, 963
move ordering, 788–789 Hebbian learning, 658–660
sense management and, 851 hill climbing, 581–588
sources for AI, 876 intra- and extra-behavior, 576
static evaluation function, 788 mind-reading, 963
Knowledge acquisition, 461, 791–794 neural networks and, 642–660,
Knowledge representation 961–962
decision making and, 298–299 offline or online, 576
decision trees and, 307–308 opening books for board games, 784
Knowledge vs. search tradeoffs, 6, 235, over-fitting, 578
742, 782 parameter modification, 579–592
Kohan: Ahriman's Gift, 951–952 player action prediction, 592–602
Kotlin, 902, 907 hierarchical N-Grams, 599–602
Kruskal's minimum spanning tree N-Gram game applications, 602
algorithm, 718 N-Grams, 593–597
N-Grams for different window
L sizes, 597–598
Landing pads for jumping, 138–142 string matching, 593
Landscape generation, 670, 687–704 window size, 597–599
altitude filtering, 701–704 predictability and testing problems,
faults, 692–693 576, 578
hydraulic erosion, 696–701 predictable mental models, 963–964
modifiers and height-maps, reinforcement learning and
688–689 Q-learning, 627–642, See also
noise, 689–692 Reinforcement learning
simple noise, 689 representing actions, 960
thermal erosion, 694–695 representing the world, 961
"tree" generation using static evaluation functions, 794–797
Lindenmayer systems, 680–687 strong supervision, 603
Largest of Maximum defuzzification, 381 tactical analysis and, 521–523
Lavelle, Stephen, 919 teaching characters, 960–965

weak supervision, 603, 657-658	Massive, 857
See also Deep learning; Neural	Massively multiplayer online games
networks; Q-learning	(MMOGs), 30, 257, 267, 278,
Left 4 Dead, 670	946
Left-handed coordinates, 47n	Master of Orion 3, 958
Left of Maximum (LM) defuzzification,	Matrix mathematics, 46–47
380	Maximin distance, 260, 266
Level of detail (LOD), 13, 821	MAXScript, 896
AI LOD, 822–823	Maya, 896
behavioral, 824-829	Maze generation using backtracking,
graphics applications, 821-822	705–716
group, 829–833	caves, 708-709
importance values, 823	prefabricated elements, 711-714
scheduling systems and, 817-818,	rooms, 709–711
823-824	thickening walls, 714–716
Lex, 925	See also Dungeon and maze
Lifelong planning A* (LPA*), 275, 278	generation
Light speed, 852	Mean of Maximum (MoM)
Lightweight threads, 812, 813	defuzzification, 381
Lindenmayer systems (L-systems),	Medal of Honor games, 12
680–687, 728	Melee combat games, 11-12
Linear velocity, 47–48	AI design, 943–945
Line of sight, 853	N-Gram prediction, 602
Lisp, 18, 903, 907, 916	Memory-enhanced test (MT) approach,
Load-balancing schedulers, 814-816	763, 772–776, 786
Localization, 237, 239, 243, 248-249	Memory-enhanced test drivers (MTDs),
"Look where you're going" behavior, 60,	774–775
72–73, 185	Memory issues, 30–32
LPA*, 275, 278	allocation and deallocation, 30-31
Lua, 17, 18, 911, 912, 914-915	C++ vs. C#, 904
Lumberyard, 30, 876, 891	cache, 31-32
	garbage collection, 30-31, 904-905
M	906, 907
Mace Griffin: Bounty Hunter, 939	LPA* low-memory variation for
Machine learning, 575, See also Learning	pathfinding, 275–277
Madden NFL 18, 955	neural networks for storage for
Manic Karts, 949	Q-values, 641
Map flooding in influence mapping,	Mersenne Twister, 672
516-517, 528-532	Message passing systems, 889
Markov systems, 399-405	Metal Gear Solid, 9, 850, 941
Markov processes, 400-402	Microsoft's .NET bytecode, 924
Markov state machine, 402-405	Micro-threads, 812-813

Military hierarchy, 554-555 arriving, 53-54, 60-63 Military simulation characters as points, 44 RTS game AI and, 9 coordinated groups, See also terrain analysis, 511 Formation motion Military tactics, 568-571 driving/racing game AI design, Mind-reading, 963 946-949 Minecraft, 670, 688, 919 dynamic, 43 Minimaxing, 746, 749-750 evade, 71-72 AB pruning, 787 flee, 53, 59-60 AB search window, 759-760 flocking/herding, 965-969 algorithm and pseudo-code, forces and actuation, 50-51 750-753 game AI model, 10-11 aspiration negascout, 761-764 high-level staging, 888 aspiration search, 760 jumping, 133-143 extensions and variable depth kinematic, 42-43, 51-56 techniques, 787-788 kinematics, 47-48 extension to multiple players, motor control, 170–178 750-753 platform and adventure game AI iterative deepening, 786-788 design, 942 move ordering, 760, 788-789 predicting physics, 120-133, See negamaxing, 753-759, 789-790 also Physics simulation Minimum distance heuristic for pursue, 68-71 pathfinding, 259-261, 265-266 seek, 51-53, 58-59 Minimum spanning tree algorithms, shooter game AI design, 937-939 716-721 splines, 948 Minischeme, 916 steering behaviors, 42-43, 56-95 Mobile platforms, 33–34, 902, 907 steering behaviors, combining, Model-free algorithms, 628 95 - 120Model of game AI, See Game artificial tools and content creation, 886-888 intelligence (game AI) model two dimensions, 43-45 Modulo division, 805 2?D, 45-46, 177 Mono, 904-905 types of actions, 469-473 Monte Carlo tree search (MCTS), third dimension, 177-191, See also 776-783, 797-798 Three-dimensional (3D) Motor control, 170-178, See also movement Actuation updating position and orientation, Motor vehicle range of motion, 175-177 Movement algorithms, 41-43, 128-133, vector and matrix math, 46-47 143-170, 188-191 wandering, 54-56, 73-76 AI design example, 934 See also Actuation; Orientation; AI design questions, 932 Pathfinding; Rotation; Steering anytime algorithms, 820-821 behaviors; Steering pipeline;

Three-dimensional (3D)	decision tree learning vs., 646-647
movement	deep learning, 642, 660-664,
Movement planning, 285, 287	796–797
animations, 285–291	driving AI design, 949
example, 289–291	evaluation functions, 791, 794,
footfalls, 291	796–797
planning graph, 287–288	feedforward, 643-644, 648-650
Move ordering, 760, 788–789	Hebbian learning, 658–660
MTD- <i>f</i> , 776, 786	hidden layers, 647, 660
Multi-core CPUs, 29	Hopfield network, 643, 644f
Multi-layer perceptron, 643–655,	implementation and performance,
961–962	655
backpropagation, 650-655	learning rules, 645-646
feedforward, 643-644, 648-650	memory storage for Q-learning, 641
hidden layers, 647, 660	multi-layer perceptron, 643-655
learning rules, 645-646	natural computing, 6–7
neuron algorithm, 644-645	Natural Computing (NC), 642
parallelism, 644, 655	neuron algorithm, 644-645
See also Neural networks	parallelism, 644, 655
Multi-layer tactical analysis, 525-527	pseudo-code, 651-653
Multi-player game networking issues, 133	radial basis function, 655-657
Multiplayer online battle arenas	recurrent network architecture, 644
(MOBAs), 954-955	ReLU function, 649-650, 655-656
Multi-tier AI approach, 554-555,	sigmoid threshold function,
560-561	649–650, 656
	suggested resources, 7n
N	teaching characters, 961–962
Naive Bayes classifiers, 604–609	weakly supervised learning,
Narrowcasting, 843, 845	657–658
Natural computing (NC), 6–7, 642	Neverwinter Nights, 940
Navigation apps, 252	Newton-Euler-1 integration update, 49
Navigation meshes (navmeshes), 238,	N-Gram predictors, 593–597
247–252, 879, 942	combat game applications, 602
Negamaxing, 753-759, 772, 789-790	hierarchical, 599-602
Negascout, 761-764, 787	window size and, 597–598
Networking issues, 133	Nim, 746
Neural networks, 642–647, 961–962	Nintendo GameBoy Advance, 33
algorithm, 647–651	Node, 908, 917
backpropagation, 650–655	Node array A*, 228–230
convolutional, 661, 796	Noise-based landscape generation,
credit assignment problem, 646,	689–692
661–662	No Man's sky, 669

No One Lives Forever 2, 938, 940, 941	Parameter-based learning, 579–592
Norvig, Peter, 7	annealing (hill descent), 588-592
NOT, fuzzy logic representation, 384	Boltzmann probabilities, 590-592
Nu parameter in Q-learning, 634-635	energy and fitness landscapes and
	values, 580
0	hill climbing, 581-588
Objective-C, 34, 902, 905	Parser building tool, 925
Object-oriented polymorphism, 30	Parsing, 922–923
Obstacle and wall avoidance, 90-94	Partial-order constraints, 347–349
Oculus Rift, 34	Pathfinding, 195-196, 237
Oddworld, 943	A* algorithm, 196, 215–237
Oddworld: Munch's Oddysee, 965	anytime algorithms, 820–821
OpenCL, 28	content creation tools, 877–886
Open goal pathfinding, 274	continuous, 278–285
Opening books in board games, 783–785	coordinated groups, 556-557
Open-source software, 913–914	cost functions, 252–253, 548,
OR, fuzzy logic representation, 384	877-878
Orientation, 44–45, 184	costs and weighted graphs, 198-200
align, 63-67, 180-182	decomposer for steering pipeline,
face steering behavior, 72, 182–184	109–110, 114, 117
independent facing, 48	Dijkstra algorithm, 196, 203-214
looking where you're going, 60,	driving/racing game AI design, 949
72–73, 185	dynamic, 274-275, 278
quaternion representation for 3D,	early game AI, 9
178–179, 180, 184	finite element models and, 866
2½ D, 46	game AI model, 195, 196f
updating position and orientation,	graphs, See Pathfinding graphs
48-50	heuristic function for A*, See
vector and matrix math, 46-47	Heuristic function for A*
See also Movement algorithms;	pathfinding algorithm
Rotation; Steering behaviors	hierarchical, 257-264
Orthonormal basis, 44	interruptible, 277
Othello, 741	jumping and, 142
	low-memory algorithms, 275-277
P	memory allocation and
Pac-Man, 8, 21, 24, 26-27, 41	deallocation, 31
Parallel processing, 29	open goal, 274
behavior trees and, 355-364	path smoothing, 253-256
multi-layer perceptrons (neural	pooling, 277–278
networks), 644, 655	programming languages for
threads and, 813	implementation, 901
Parallel task in behavior trees, 356-364	RTS game AI design, 950-951, 952

D. (1. C. 11
Path following, 76–82
Path representation in steering pipeline
algorithm, 115–116
PC game AI issues, 32–33
Perception simulation, See Sense
management
Perception window, 24
Perfect information, 744
Performance characteristics, 15
Performance management, See Execution
management
Perlin noise, 689–692
Phasing, task schedulers, 806–811
Physics simulation, 120, 170
aiming and shooting, 120
drag, 59
firing solutions, 120, 123-126
iterative targeting, 128–133
projectile trajectory, 120–123
sports games, 956
updating position and orientation,
48-50
Pikmin, 965
Pikmin 2, 965
Pitch, 188-191
Planning, behavior tree implementation
(reactive planning), 344-345
Planning, movement, See Movement
planning
"Plant" or "tree" generation, 680-687, 728
Platform differences and game AI, 32-34
Platform games, 11, 942-943
Playbooks for team sports games, 956
Player action prediction learning,
592-602
Player cooperation in coordinated team
actions, 557-560
Player help function of turn-based game
AI, 958
Playmaker, 893
PlayStation Portable (PSP), 33
Playstation VR, 34

Plug-ins, 891–892, 896–897	Processor issues, 28–30
Points of visibility, 238, 244-247	Programming game AI, 3
Poisson disk, 676-680	AI engines, 35–38
Polling, 836–837	building a language, 919-925
sensory management and, 851	commercial game engines, 901, See
stations, 836-837, 846-849	also Unity; Unreal Engine
Polling stations, 836–837, 846–849	implementation languages, 18,
Polymorphism, 30, 334	901-903
Pong related games, 8, 41, 120	C#, 904-905
Pool simulators, 133, 955	C++, 902-904
Predicting player actions, 592–602	Java and JVM, 906-907
Predictive path following, 77	JavaScript, 908-909
Preemptive multitasking, 812	Swift, 905-906
Prefabs, 370	scripted AI, 909-919
Prim's minimum spanning tree	See also Scripting languages; specific
algorithm, 718–721	programming or scripting
Principal Variation Search (PVS), 764	languages
Priority-based blended steering	Projectile movement, 120-133, See also
behaviors, 103-106	Ballistics; Firing solutions
Priority-based scheduling, 818–820, 824	Prototype-based object orientation, 370
Priority queues and heaps, A*	Prototypical inheritance, 908
pathfinding algorithm,	Pseudo code, 15-17
223–225	Pseudorandom numbers, 670-680, See
Procedural content generation, 669-670	also Random (or
assets (like building), 727-730	pseudo-random) number
dungeons and mazes, 705-727	generation
generate-and-test approach, 727	Psychological approaches, 25
hierarchical task networks, 736-737	Pursue, 68-71, 133
landscape generation, 670, 687-704	PuzzleScript platform, 919
modifiers and height-maps,	Python, 17, 18, 896, 917-918, 923
688-689	
Perlin noise, 689–692	Q
random and pseudorandom	Q-learning
numbers, 670-680	algorithm, 628–631
shape grammars, 727-737	data structures and interfaces, 632
texture generation, 727	implementation and performance,
"tree" generation using	633
Lindenmayer systems,	limitations, 638
680–687, 728	model-free algorithm, 628
See also Dungeon and maze	neural networks for storage, 641
generation; Landscape	parameters (alpha, gamma, rho, and
generation	nu), 633–636

pseudo-code, 631-632	Re-entrant scripts, 912
representation of the world,	Regional sense manager, 857–865
628-629	Registry of listeners, 840
reward values, 636-637	Reinforcement learning, 627-642
Temporal Difference (TD)	actor-critic, 641-642
algorithms, 640–641 Quake II, 25	choosing tactical defense locations
Quake 3, 902	neural networks for storage, 641
Quantization, 237, 239, 243, 248–249	realistic applications, 638–639
Quaternions, 178–179, 180, 184	sensitivity to reward values, 636
Quiescence pruning, 788	Temporal Difference (TD)
Quieceenee pruning, 700	algorithms, 640–641
R	weaknesses, 637–638
Racing games, See Driving games	See also Q-learning
Radial basis function, 655–657	ReLU function, 649–650, 655
Radians, 64	Remote debugging tools, 895–896
Rally points, 486–488	Renderware Studio, 875, 890–891
Random (or pseudo-random) number	Representations, 17–18
generation, 25, 670–680	Republic: The Revolution, 727, 830
avoiding overlapping using Poisson	Repulsion steering behavior, 82
disk, 676–680	Resource management, See Execution
categories, 670–671	management
numeric mixing and game seeds,	Rete algorithm, 448–457
671–672	Reusing behavior trees, 365, 369–373
phyllotaxic angles (golden ratio, for	Reusing programming technology, 875
example), 675–676	Reversi, 741, 743, 746, 761, 785, 793, 793
reducing clumping using Halton	Reynolds, Craig, 42-43, 69, 98
sequence, 672-675	Rho parameter in Q-learning, 634–635
wandering implementation, 56	Right of Maximum defuzzification, 381
Random decision trees, 311-314	Risk, 10
Randomness and behavior trees, 347-349	Rogue, 669, 705
Randomness in tree-generating	Rogue-likes, 669
L-systems, 684–685	Rogue-lites, 669, 705
Random rule arbitration, 445	Role-playing games (RPGs), 9-10
Reactive planning, 344–345	Roll, pitch, and yaw, 188–191
Real-time strategy (RTS) games	Room generation, 709–711
AI design, 950–955	Rotation, 45, 48
early game AI, 9	projectile movement calculation,
multiplayer online battle arenas	128
(MOBAs), 954–955	roll, pitch and yaw, 188-189
See also Turn-based strategy games	steering behaviors, 65
Recurrent network, 644	three dimensions, 178-179

three dimensions, faking axes,	combined frequency- and
188–191	priority-based, 824
Ruby, 17, 919	frame rate requirements, 813–814
Rule-based decision making systems,	frequency-based, 805-806, 823
297, 431–432	hierarchical, 816–818
algorithm and pseudo-code,	level of detail systems and, 817–818,
436–437	823-824
blackboard architectures, 468	load-balancing schedulers, 814-816
condition-action rules, 433–434	phase, 806–811
database matching, 432–433	priority-based, 818–820, 824
database rewriting rules, 434, 460	pseudo-code, 807–809
data format, 435–436	quality of service, 813–814
data structures and interfaces,	schedulers, 804–811
438-443	threads and interruptible processes,
database, 438	811-814
IF-clauses, 439-440	Scheme, 903, 916
item matching, 440-443	Scope chain, 368
rules, 438	Scripted actions, 472–473
expert systems and, 460-461	Scripted AI, 909–919, See also Scripting
extensions, modifications, and	languages
optimizations, 457–458	Scripting bots, 939
justification, 460–461	Scripting group actions, 564-571
managing large rule sets, 458-459	Scripting languages, 29, 910-911
forward and backward chaining,	AI design tools, 894
434–435	compilation and interpretation,
Rete algorithm, 448–457	911–912
rule arbitration, 444–446	creating, 919–925
unification, 446-448	stages of language processing,
using wildcards, 446	921–924
Runtime-type information (RTTI), 308,	tools, 925
466–467	embedding, 913
Russell, Stuart, 7	extensibility and integration, 912
	integrated editors, 892-893
S	Java, 919, 924, <i>See also</i> Java
Samuel's Checkers program, 640, 791, 793	JavaScript, See JavaScript
Scala, 907	Lua, 17, 18, 911, 912, 914-915
Scalability issues, 33	open-source, 913–914
emergent team behaviors, 562–563	Python, 17, 18, 917–918, 923
fuzzy logic, 391–392	re-entrancy, 912
Scalable formation structures, 145	Ruby, 17, 919
Scheduling, 804–811, 823, 833	Scheme, 903, 916
anytime algorithms, 820–821	shooter game AI design, 939–940

Shape grammars, 727–737
Sharpening filter, 541–542
Shooter game AI design, 937–943
Sid Meier's Civilization VI, 12, 956–957
Sight, 852–855, 869, 871, See also Sense
management
Sight cone, 852–853
Sigmoid threshold function, 649-650,
656
SimBionic, 895
SimCity, 543
SIMD processors, See Single instruction,
multiple data (SIMD)
processing
Simplified memory-bounded A*,
276–277
Simulated annealing, 6-7, 588-592
Single instruction, multiple data (SIMD)
processing, 29
convolution algorithm and, 535
neural networks, 655
Slot roles and costs in formations,
158–166
SMA*, 276–277
Smallest of Maximum defuzzification,
380
Smell, 857, 872
Smelly GOB, 429-431
Sniper Elite, 940, 941
Sniper locations, 487, 488-489
Snooker simulators, 133, 955
Soft roles in formations, 159–160
Software threads, 812
Soldier of Fortune 2: Double Helix, 941
Sound perception (hearing), 855-856,
871-872, See also Sense
management
Sound speed, 856
Space Invaders, 8
Speed of light, 852
Speed of sound, 856
Spelunky, 669, 705

C-1: 040	combining agains functions
Splines, 948	combining scoring functions, 793–794
Splinter Cell, 11, 850, 854, 855, 941	
Split-Nim, 746	context sensitivity, 792
Spore, 669, 670, 727	knowledge acquisition, 791–794
Sports games	learning, 794–797
AI challenges, 9	negamaxing, 755
AI design, 950, 955–956	neural networks and, 791, 794,
SSS*, 774–775	796–797
SSX, 950	scoring function range, 789-791
Stable equilibria, 100, 105	Statics, 44–45
Standard template library (STL), 903–904	Steam, 34
StarCraft II, 951	Steep, 950
Star Wars: Episode 1 - Racer, 25	Steering behaviors, 42-43, 56-57
State change actions, 469	actuation and, 173-174
State machines, 297, 314-316	align, 63-67, 180-182
AI design tools, 894-895	arbitration, 106–108
alarm behavior representation,	arrive, 60-63
323-324	attraction, 84
algorithm and pseudo-code,	capability-sensitive, 173
316-317, 321-322	coherence, 80-82
algorithm performance and	collision avoidance, 57, 85-89
implementation, 320	combining, 95-120
behavior tree hybrids, 374	actuation, 174
blackboard architectures, 468	arbitration, 96
coordinated group actions, 562	blending, 96
data structures and interfaces,	cooperative arbitration, 106–108
317–320	priority-based system, 103-106
decision tree combinations, 335-337	steering pipeline, 108–120
early game AI, 8	weighted blending, 96–100
flocking and herding games, 965	delegated, 68
fuzzy state machines, 395–400	evade, 71-72
hard-coded, 320-322	face, 72, 182-184
hierarchical, 323–335	family tree, 96f
Markov systems, 399–405	flocking, 67, 98–99, 147, 965–967
Q-learning representation of the	jumping and, 134, 135
world, 628–629	looking where you're going, 72–73,
symbolic approach, 6	185
transition implementation, 318–320	navigating into narrow passages,
UML format, 315	101–102
State vectors, 400–401	obstacle and wall avoidance, 90–94
Static evaluation function, 747–749, 783,	path following, 76–82
788–789, 791	pursue, 68–71
, ,	r

rotations, 65	Subclassing, 908
seek and flee, 58–60	Super Mario Brothers, 11
separation, 82–84	Super Mario Sunshine, 11
stable equilibria, 95 <i>f</i>	Superscalar architectures, 29
three-dimensional movement,	Supervised learning algorithms, 603,
179–180	657–658
align, 180–182	Swift, 18, 30, 34, 902, 905–906
face, 182–184	Symbolic systems, 5–6
faking rotation axes (roll, pitch &	Symbolic systems, 5–6
yaw), 188–191	Т
looking where you're going, 185	Tablebases, 785
wander, 185–187	
tools and content creation, 886–888	Tactical analysis, 511–512
	building server for, 528 cellular automata, 542–547
two-level formation steering, 147–156	
	combining analyses, 527–528 convolution filters, 516, 532–542
two-level steering extension, 156–158	
	Dijkstra algorithm, 203
variable matching, 57–58	driving/racing game AI design, 949
velocity matching, 67, 135 wall and obstacle avoidance, 90–94,	game level representation, 512
886–887	generating tactical properties and, 506
wander, 73-76, 185-187	influence maps, 512-519, 799, See
See also Formation motion;	also Influence mapping
Movement algorithms;	learning, 521-523
Movement planning;	map flooding, 516-517, 528-532
Three-dimensional (3D)	multi-layer analysis, 525-527
movement	reinforcement learning application,
Steering pipeline, 108	639-640
algorithm and pseudo-code,	RTS game AI design, 953
108–113	tactical pathfinding, 500, 548-553
algorithm performance, 116	tactical waypoint approaches and,
data structures and interfaces, 113–116	511–512, See also Waypoint tactics
example components, 116–119	terrain analysis, 511, 519–521
Strategic game AI, 12, See also Real-time	updating complexity, 524–525
strategy (RTS) games; Tactical	See also Tactical and strategic AI
and strategic AI	Tactical and strategic AI, 485
Strategy, game AI model, 10–12	AI design example, 934
String matching for action prediction,	AI design questions, 933
593	coordinated action, 554–571, See
Strongly solved games, 789	also Coordinated group
Strong supervision, 603	behaviors
0 - 1	

fuzzy logic decision making,	Thermal erosion, 694–695
498-499	The Sims, 9, 11, 25, 405, 415, 416, 430
game AI model, 12, 485, 486f	Thief: The Dark Project, 9, 850
primitive and compound tactics,	Threads
488-490	hyper-threads, 813
real military tactics, 568-571	interruptible process
RTS game AI design, 952-953	implementation, 811-814
waypoint tactics, 486-511	micro-thread, 812-813
See also Tactical analysis; Waypoint	preemptive multitasking, 812
tactics	priority-based scheduling and, 820
Tactical formation movement, 166-170,	synchronization issues, 814
See also Formation motion;	Three-dimensional (3D) movement, 177
Waypoint tactics	quaternion representation, 178-179
Tactical pathfinding, 253, 500, 517,	180, 184
548-553	rotation, 178–179
cost functions, 548	steering behavior conversion,
graphs, 552	179–180
pathfinding heuristic modification,	align, 180–182
551-552	face, 182-184
using waypoints, 553	looking where you're going, 185
weights, 549-551	wandering, 185-187
Tactical waypoints, See Waypoint tactics	3ds Max, 896
Tag game, 68-69	3D Tic-Tac-Toe, 956
Targeters, steering pipeline, 108-109,	Tic-Tac-Toe, 741, 742, 744, 746, 765-766
113, 116–117	789, 956
Task scheduling, See Scheduling	Tile-based games
Tasks in behavior trees, 338-340, 365	map flooding in influence maps,
Tcl, 17	528-532
Teaching characters, 960-965	pathfinding world representation
Team coordinated tactical actions, See	problems, 252
Coordinated group behaviors	Tile graphs, 238–242, 877–878
Team sports games, 955-956	Time allocation scheduling, See
Temporal Difference (TD) algorithms,	Scheduling
640-641	TinyKeep, 717, 721
TensorFlow, 797	Tinyscheme, 916
Terrain analysis, 511, 519-521	Tokenization, 921-922, 925
Terrain rendering level of detail, 822	Tomb Raider, 52
Texture detail, 821–822	Tomb Raider III, 943
Texture generation, 727	Tom Clancy's Ghost Recon, 854, 940-941
The Binding of Isaac, 52, 669, 705	Tools and content creation, 37, 875-876,
"The Game of Life," 545–546	901
The Last of Us, 9	debugging, 895-896

knowledge for decision making,	<i>Tron</i> (film), 690
889-890	Truth tables, 383–384
knowledge for movement, 886-888	Turing, Alan, 5
knowledge for pathfinding and	Turn-based strategy games, 744, 797-799
waypoints, 877-886	AI design, 956-958
automatic graph creation,	helping the player, 958
880-886	See also Board games
manually creating region data,	Two-dimensional movement, 43-45
877-880	2?D, 45-46, 177
the toolchain, 890	
AI design tools, 894-895	U
built-in tools, 891	Unified Modeling Language (UML), 315,
custom data-driven editors, 893	442
debugging, 895-896	Unity, 902
editor plug-ins, 891-892,	align algorithm and, 64
896-897	C# implementation, 18, 903, 904
editor scripting, 892-893	collision detection/avoidance and,
integrated game engines, 890-893	91
limitations for AI, 876	garbage collection, 30
See also Unity; Unreal Engine	instantiation using prefabs, 370
Top-down approach, 554–555	navigation mesh support, 879
Topographical features, landscape	navmesh support, 879
generation, 701-704	pathfinding implementation, 901
Topological analysis and tactical	PC game AI issues, 32
waypoints, 490-491	physics simulation, 170
Total Annihilation, 952	polymorphism and, 30
Touch, 856	quaternion application, 178
Tracked vehicles, 177	scripting language, 917, 919-920
Trajectory simulation, See Ballistics	toolchain, 875-876, 890-893
Transition matrices, 400-402	built-in tools, 891
Transposition in game theory, 746	editor scripting tools, 893
Transposition tables, 424, 764	plug-ins, 891–892
debugging, 770	variable frame rates and, 50
hashing game states, 764-769	UnityScript, 917, 920
issues, 771	Unreal, 940
memory-enhanced test algorithms	Unreal Engine, 902
and, 772–774	align algorithm and, 64
pseudo-code and performance, 770	Blueprints visual programming
replacement strategies, 769-770	language, 893, 903
using opponent's thinking time,	collision detection/avoidance and,
771–772	91
"Tree" generation, 680–687, 728	editor scripting tools, 893

garbage collection, 30	Warcraft: Orcs and Humans, 950
navigation mesh support, 879	Warcraft 3: Reign of Chaos, 953
pathfinding implementation, 901	Warhammer: Dark Omen, 9, 951
PC game AI issues, 32	Water erosion simulation, 696-701
physics simulation, 170	Waypoint tactics, 486
scripting language support, 919	automatic placement of waypoints,
toolchain, 875–876, 890–893	506-512
Unreal Engine 4 (UE4), 902-903, 920	condensing waypoint grid, 507-511
UnrealScript, 919–920	context sensitivity, 493–495
U.S. infantry training manuals, 568–569	continuous tactics, 492–493
, 8	generating nearby waypoints,
V	499-500
V8, 917	generating waypoint tactical
Validity of pathfinding world	properties, 500–506
representations, 238–239, 240,	compound tactics, 505
244, 250	cover points, 501–503
Variable depth approaches, 787-788	placement by level designer, 501,
Variable frame rates, 50	506
Variable matching, 57–58	shadow points, 505
Vector mathematics, 46-47	tactical analysis, 506
Velocity, 47-48	visibility points, 504
Velocity matching, 67, 135	primitive and compound, 488-490
Virtual functions, 30	runtime checking, 495
Virtual machine, 924	shooter game AI design, 941-942
Virtual reality (VR), 34	tactical analysis and, 511-512, See
Visibility map for terrain analysis, 521	also Tactical analysis
Visibility points, 505	tactical locations or rally points,
Vision, See Sight	486-488
Visual contrast detectors, 855	tactical pathfinding, 500, 553
Vive, 34	topological analysis, 490-491
Voice recognition, 8	using tactical locations, 496–500
Voronoi polygons, 242, See also Dirichlet	Weakly solved games, 789
domains	Weakly supervised learning, 603,
Vulkan, 28, 32	657–658
	Weighted blending, 96–100
W	Weighted Dirichlet domain, 242, 243
Wall and obstacle avoidance, 90–94,	Weighted graphs, 198–201, 716
886–887	Weights for tactical pathfinding, 549–551
Wall construction, 952	Wildcards, 446
Wander steering behavior, 54–56, 73–76,	Wipeout, 950
185–187	World interfacing, 835
Warcraft, 9, 26–27, 952, 953	AI design example, 934

1010 INDEX

ecosystem design, 967–969
event casting, 843–846
event managers, 837–843
event passing, 837–838
inter-agent communication, 846
polling, 836–838
polling stations, 836–837, 846–849
sense management, 849–874
See also Pathfinding world
representations; Sense
management
World Snooker Championship, 955
Worms, 957
Wright's phasing algorithm, 810

Write, Will, 670

X *x*-axis, 44

Y Yacc, 925 Yaw, 188–191 *y-a*xis, 44

Z
z-axis, 44
Zelda, 711
Zero-sum game, 743
Zobrist keys and hashing, 765–767